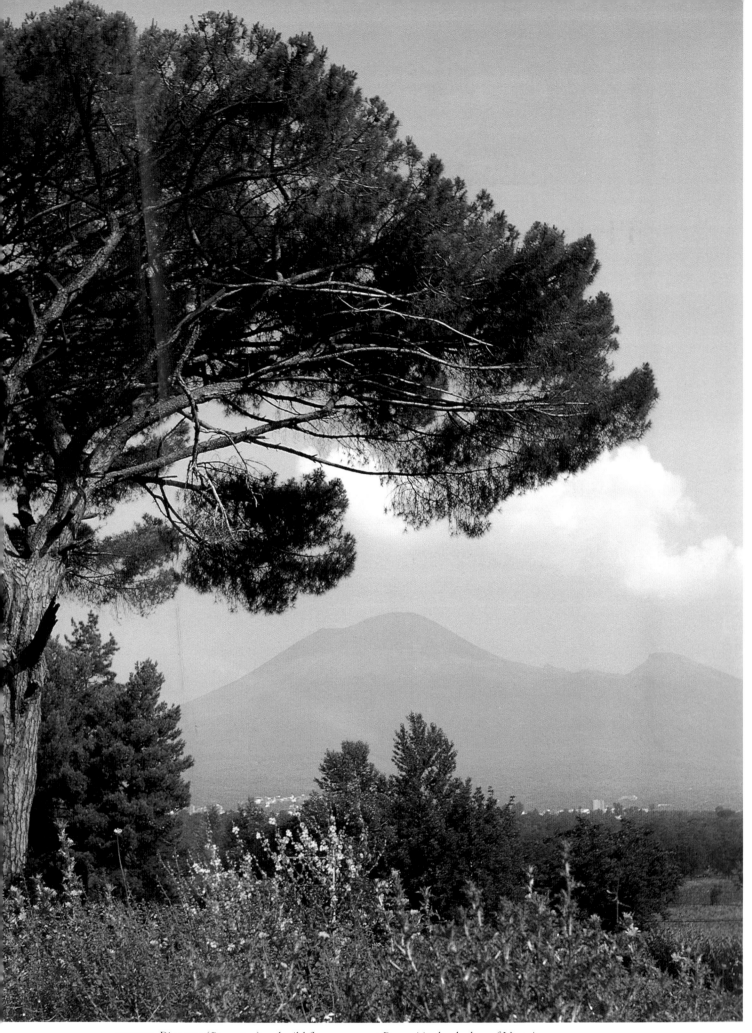

FIGURE 1 Pine tree (*Pinus pinea*) and wild flowers grow at Pompei in the shadow of Vesuvius.

THE NATURAL HISTORY OF POMPEII

The sudden destruction of Pompeii, Herculaneum, and the surrounding Campanian countryside following the eruption of Vesuvius in A.D. 79 preserved the remarkable evidence that has made possible this reconstruction of the natural history of the local environment. Following the prototype established by Pliny the Elder in his *Natural History*, various aspects of the natural history of Pompeii are discussed and analyzed by a team of eminent scientists, most of whom have collaborated with Wilhelmina Feemster Jashemski during her many years of excavating gardens and farmland in the Vesuvian area.

This volume brings together the work of geologists, soil specialists, paleobotanists, botanists, paleontologists, biologists, chemists, dendrochronologists, ichthyologists, zoologists, ornithologists, mammologists, herpetologists, entomologists, and archaeologists, affording a thorough picture of the landscape, flora, and fauna of the ancient sites. The detailed and rigorously scientific catalogues, which are copiously illustrated, provide a checklist of the flora and fauna upon which future generations of scholars can continue to build.

Wilhelmina Feemster Jashemski is Professor Emerita of Ancient History at the University of Maryland at College Park, where she pioneered the field of ancient Roman garden archaeology. She is a former Senior Fellow at Dumbarton Oaks, Washington, D.C. She was given the Tatiana Warscher Award in Archaeology by the American Academy in Rome, the Bradford Williams Award by the American Society of Landscape Architects, and the Gold Medal for Distinguished Archaeological Achievement, the highest honor of the Archaeological Institute of America. Her many publications include the monumental two-volume *The Gardens of Pompeii, Herculaneum and the Villas Destroyed by Vesuvius*.

Frederick G. Meyer, retired Supervisory Botanist in charge of the Herbarium at the U.S. National Arboretum, Washington, D.C., has collected plants in Pompeii, Ethiopia, Japan, southwestern Europe, and throughout the United States. He was awarded the prestigious Frank A. Meyer Gold Medal for Plant Exploration and the Gold Medal of the Garden Clubs of America for Plant Exploration. His publications include studies of the carbonized plant material found in the Vesuvian sites; *The Flora of Japan,* in the English translation, co-edited with Egbert Walker; and *The Great Herbal of Leonard Fuchs,* vol. 1 commentary by Frederick G. Meyer, Emily Trueblood, and John Heller, vol. 2 facsimile.

THE NATURAL HISTORY
OF POMPEII

Edited by

WILHELMINA FEEMSTER JASHEMSKI

University of Maryland

FREDERICK G. MEYER

U.S. National Arboretum, Washington, D.C.

CAMBRIDGE
UNIVERSITY PRESS

PUBLISHED BY THE PRESS SYNDICATE OF THE UNIVERSITY OF CAMBRIDGE
The Pitt Building, Trumpington Street, Cambridge, United Kingdom

CAMBRIDGE UNIVERSITY PRESS
The Edinburgh Building, Cambridge CB2 2RU, UK
40 West 20th Street, New York, NY 10011–4211, USA
477 Williamstown Road, Port Melbourne, VIC 3207, Australia
Ruiz de Alarcón 13, 28014 Madrid, Spain
Dock House, The Waterfront, Cape Town 8001, South Africa

http://www.cambridge.org

First published 2002

Printed in the United Kingdom at the University Press, Cambridge

Typeface Centaur MT 11.5/13.5 and Trajan Bold *System* QuarkXPress® [GH]

A catalogue record for this book is available from the British Library.

Library of Congress Cataloging-in-Publication Data
The natural history of Pompeii / edited by Wilhelmina Feemster Jashemski and
Frederick G. Meyer.
p. cm.
Includes bibliographical references (p.).
ISBN 0-521-80054-4 (hb)
I. Natural history – Italy – Pompeii (Extinct city) I. Jashemski, Wilhelmina Mary Feemster,
1910–. Meyer, Frederick G., 1917–

QH152.N36 2001
508.337′7 – dc21
2001025503

Quotations reprinted by permission of the publishers and the Trustees of the Loeb Classical Library:

From Pliny the Younger Vol. 1, number 55, translated by Betty Radice, Cambridge, Mass.,
Harvard University Press, 1969.

From Pliny Vols. 3, 4, 5, Loeb Classical Library Vols. 353, 370, 371, translated by H. Rackham,
Cambridge, Mass.,
Harvard University Press, 1940, 1960, 1961, and Vols. 6, 7, 8, Loeb Classical Library
Vols. 392, 393, 418,
translated by W. H. S. Jones, Cambridge, Mass., Harvard University Press, 1951, 1956, 1963.

From Seneca Vol. 10, Loeb Classical Library Vol. 457, translated by T. H. Corcoran,
Cambridge, Mass., Harvard University Press, 1974.

The Loeb Classical Library® is a registered trademark of the President and Fellows of
Harvard College.

ISBN 0 521 80054 4 hardback

CONTENTS

List of Illustrations *page* vii
Preface xv
Contributors xvii
Abbreviations xix
Ancient Authors Cited or Quoted xxi

1 Introduction 1
 Wilhelmina F. Jashemski

2 The Vesuvian Sites before A.D. 79: The
 Archaeological, Literary, and Epigraphical
 Evidence 6
 Wilhelmina F. Jashemski

3 Mount Vesuvius before the Disaster 29
 Haraldur Sigurdsson

4 The Eruption of Vesuvius in A.D. 79 37
 Haraldur Sigurdsson and Steven Carey

5 Paleosols of the Pompeii Area 65
 J. E. Foss, M. E. Timpson, J. T. Ammons,
 and S. Y. Lee

6 Plants: Evidence from Wall Paintings,
 Mosaics, Sculpture, Plant Remains,
 Graffiti, Inscriptions, and Ancient Authors 80
 Wilhelmina F. Jashemski, Frederick G. Meyer,
 and Massimo Ricciardi

7 Pollen Analysis of Soil Samples from the
 A.D. 79 Level: Pompeii, Oplontis,
 and Boscoreale 181
 G. W. Dimbleby and Eberhard Grüger

8 Wood Associated with the A.D. 79 Eruption:
 Its Chemical Characterization by
 Solid-State ^{13}C as a Guide to the
 Degree of Carbonization 217
 Patrick G. Hatcher

9 Identification of the Woods Used in the
 Furniture at Herculaneum 225
 Stephan T. A. M. Mols

10 Dendrochronological Investigations at
 Herculaneum and Pompeii 235
 Peter Ian Kuniholm

11 Environmental Changes in and around
 Lake Avernus in Greek and Roman
 Times: A Study of the Plant and Animal
 Remains Preserved in the Lake's
 Sediments 240
 Eberhard Grüger, Barbara Thulin, Jens Müller,
 Jürgen Schneider, Joachim Alefs,
 and Francisco W. Welter-Schultes

12 Fish: Evidence from Specimens, Mosaics,
 Wall Paintings, and Roman Authors 274
 David S. Reese

13 Marine Invertebrates, Freshwater Shells,
 and Land Snails: Evidence from
 Specimens, Mosaics, Wall Paintings,
 Sculpture, Jewelry, and Roman
 Authors 292
 David S. Reese

14 Insects: Evidence from Wall Paintings,
 Sculpture, Mosaics, Carbonized Remains,
 and Ancient Authors 315
 Hiram G. Larew

15 Amphibians and Reptiles: Evidence from
 Wall Paintings, Mosaics, Sculpture,
 Skeletal Remains, and Ancient Authors 327
 Liliane Bodson and David Orr

Contents

16 Birds: Evidence from Wall Paintings,
 Mosaics, Sculpture, Skeletal Remains,
 and Ancient Authors 357
 George E. Watson

17 Mammals: Evidence from Wall Paintings,
 Sculpture, Mosaics, Faunal Remains, and
 Ancient Literary Sources 401
 Anthony King

18 Health and Nutrition at Herculaneum: An
 Examination of Human Skeletal Remains 451
 Sara Bisel and Jane Bisel

19 In Conclusion 476

English, Latin, and Italian Index 479
Index of Greek Words 501

LIST OF ILLUSTRATIONS

1. Pine tree (*Pinus pinea*) and wild flowers grow at Pompei in the shadow of Vesuvius, ii
2. Map of the Bay of Naples area, 3
3. Air view of Pompeii in fertile Campanian plain, 8
4. Plan of Pompeii, 9
5. Plan of forum and adjoining buildings, 10
6. Balloon photograph. Forum and adjoining buildings, 11
7. View of the forum toward the Temple of Jupiter, Juno, Minerva, and Vesuvius, 12
8. View of the forum toward the Eumachia building and the municipal buildings, 12
9. The Grand Palaestra, 13
10. Sarnus lararium, 14
11. Plan of the House of Pansa, 15
12. View of lower garden from the terrace, House II.ii.2, 17
13. Cleaning lapilli from a root cavity, 18
14. Pouring cement into a reinforced cavity, 18
15. The cavity filled with cement, 18
16. The cast after the surrounding soil has been removed, 18
17. Garden painting (west panel of S wall), House of Venus Marina, 19
18. Plan of the House of Polybius, 20
19. Garden of the House of the Gold Bracelet, 21
20. Plan of the House of the Gold Bracelet, 21
21. Plan of vineyard II.v, 22
22. Cavities left by stake and root, 23
23. Cast of stake (left) and vine root, with its side root reaching behind the stake, 23
24. Plan of market-garden orchard I.xv, 24
25. Balloon photograph. Land contours of I.xv, 24
26. Country road in front of *villa rustica*, Boscoreale, 25
27. Plan of the Villa of Poppaea, Oplontis, 26

28. Mount Vesuvius as it appeared before the A.D. 79 eruption. Lararium painting in House of the Centenary, 31
29. Prior to the A.D. 79 eruption, the activity of Vesuvius is revealed by soil profiles and sand quarries around the volcano, 33
30. A marble relief on a shrine, House of Lucius Caecilius Jucundus in Pompeii showing the effects of the A.D. 62 earthquake, 34
31. The Castellum Aquae (Pompeii waterworks) on the left. Two mules narrowly escaping the collapsing Vesuvius Gate, 35
32. A photograph of the 1872 explosive eruption of Mount Vesuvius, displaying a Plinian eruption column of the same type, although much smaller, as that produced during the larger event in A.D. 79, 38
33. The route of Pliny the Elder during his fatal voyage from Misenum to Stabiae at the time of the A.D. 79 eruption, based on the Letters of Pliny the Younger, 39
34. Painting of Pliny the Younger and his mother at Misenum, by the Swiss painter Angelica Kauffmann (1741–1807), 41
35. The A.D. 79 eruption consisted of two main stages, 42
36. Typical view of the light gray pumice-fall deposit from the early stages of the A.D. 79 eruption, exposed in the quarry of Pozzelle, on the south flank of Mount Vesuvius, 43
37. Map showing the fallout pattern of the Plinian pumice layer from the A.D. 79 eruption, dispersed primarily to the southeast of the crater, 43
38. The brown pyroclastic surge layer (S-2) at Terzigno, sandwiched between pale gray pumice-fall units, 45

39. The A.D. 79 volcanic deposit in the Necropolis on the south edge of Pompeii, 45

40. Pyroclastic flow deposit from the A.D. 79 eruption exposed in Cava Montone quarry on the west slopes of Mount Vesuvius, 45

41. Typical cross section through the A.D. 79 deposit at Terzigno quarry, 6 km east of the Vesuvius crater, 46

42. The fallout of the initial explosive phase was distributed mainly to the east of the volcano, forming layer A-1, 47

43. The A.D. 79 deposit in the Necropolis, south of the city walls of Pompeii, 49

44. Cast of a victim of the A.D. 79 eruption, 50

45. Herculaneum from the west, 51

46. The excavations of the Herculaneum waterfront, 52

47. Two chambers at the waterfront of Herculaneum during excavation, 53

48. The lowermost surge unit on the beach of Herculaneum (S-1), 55

49. Victims in Herculaneum crowded in the entrance of a waterfront chamber, 56

50. A victim buried in the S-1 pyroclastic surge at the Herculaneum waterfront, 56

51. The skeletons of a female and child embracing in a Herculaneum waterfront chamber, 57

52. The chronology of the A.D. 79 eruption, based on evidence from Pliny the Younger's letters and studies of the volcanic deposits, 59

53. Distribution of surge deposits in the region around Vesuvius during the A.D. 79 eruption, 61

54. Satellite image of Mount Vesuvius and surrounding area showing locations of study sites, 66

55. General stratigraphic sequence of Somma–Vesuvius volcanic activity and associated paleosols, 67

56. Ottaviano quarry showing stratification of volcanic sediments, 67

57. Morphologic characteristics of soil profiles of Pompeii, Boscoreale, and Oplontis, 68

58. Particle-size distribution of soil profile, Boscoreale, 69

59. Particle-size distribution of soil profile, Garden of Polybius, Pompeii, 70

60. Particle-size distribution of soil profile, Pompeii Orchard, 70

61. Pedologic column, Ottaviano quarry, 71

62. Pedologic column, Pozzelle quarry, 71

63. Pozzelle quarry site showing volcanic materials below the A.D. 79 surface, 73

64. Pompeii paleosol (A.D. 79 surface), Pozzelle quarry, 74

65. Ba/Pb relationships of paleosols, Ottaviano quarry, 75

66. Distribution of Ba/Pb ratios in soils at Boscoreale, Oplontis, Pompeii Orchard, and Polybius, 76

67. Extractable P in soils at Boscoreale, Oplontis, Pompeii Orchard, and Polybius, 77

68. Generalized diagram showing relationship of solum thickness (A + B horizons) and soil age from paleosols in the Pompeii area, 77

69. Mount Vesuvius landscapes, 78

70. Detail of a marble sculpture at the entrance to the Building of Eumachia: acanthus plant and flower spikes, 86

71. Aloe plant. House of Mars and Venus, 88

72. Oleander and strawberry tree, House of the Fruit Orchard, 90

73. Detail of strawberry tree on S wall of *diaeta*, House of the Gold Bracelet, 90

74. Giant reed, House of the Little Fountain, 91

75. Wild asparagus, House of the Vettii, 92

76. Big quaking grass in carbonized hay, Oplontis, 95

77. Wild morning glory, Villa of San Marco, Stabiae, 96

78. Wild morning glories (at right), young date palm, camomiles, opium poppies, and Madonna lilies, House of the Gold Bracelet, 97

79. Carbonized chestnuts found in the upper lapilli, peristyle garden, Villa of Poppaea, Oplontis, 98

80. Cornflowers, roses, Madonna lilies, and other flowers in detail of a flower panel set in the ceiling, I. vi.11, 99

81. Carbonized carob pods, 99

82. Lemon tree, House of the Fruit Orchard, 101

83. Garland of fruit, flowers, and wheat; lemons near Cupid, 101

84. Mosaic: basket of fruit with lemon and citron, 102

85. Three hazelnuts in a fragment of wall painting, 103

86. Painting of a seaside villa with cypress trees, 105

87. Cypress root preserved by the A.D. 79 eruption, 105

88. Quince and plums in a glass bowl. Wall painting (room 23), Villa of Poppaea, Oplontis, 106

89. Bermuda grass in carbonizd hay, Oplontis, 107

90. Flowering umbel of wild carrot in carbonized hay, Oplontis, 108

91. Carnation and goldfinch in the lower peristyle, Villa of Diomede, Pompeii, 108

92. Basket of figs. Wall painting in triclinium (room 14), Villa of Poppaea, Oplontis, 110

93. Geranium seed in carbonized hay, Oplontis, 112

94. Ivy mound, House of Ceius Secundus, 112

95. Marble herm. Bacchic head of a little girl wearing an ivy garland and ivy in her hair, garden in House of the Ephebe, 113

96. Marble sculpture of a satyr carrying a thrysus tipped with ivy in the S peristyle wall, House of the Golden Amorini, 114
97. Silver cup trimmed with ivy from Herculaneum, 114
98. Painting of iris on the W peristyle wall, I.vii.1, 116
99. Painting of water iris with water deity, Pompeii water tower, 117
100. Carbonized walnuts, 117
101. Painting of bottle gourds in the S portico, House of the Cervi, Herculaneum, 118
102. Painting of bottle gourds, Samnite House, Herculaneum, 118
103. Stylized laurel trees on the marble altar, Temple of Vespasian, Pompeii, 120
104. Painting of Madonna lilies, House of the Gold Bracelet, 122
105. Madonna lilies in a painting on the tomb of Vestorius Priscus, Pompeii, 122
106. Pale flax in carbonizd hay, Oplontis, 123
107. Apples in a bowl of fruit, House of Julia Felix, Pompeii, 124
108. Wild mallow pollen in carbonized hay, Oplontis, 125
109. Stock, butterfly, and swallow pictured in the lower peristyle, Villa of Diomede, Pompeii, 125
110. Mulberry tree, House of Venus Marina, 127
111. Mushrooms and three dead thrushes above in a still-life painting. Partridge hanging on left and two quinces, 128
112. Carbonized myrtle berries, 129
113. Three Graces wearing myrtle crowns and carrying myrtle twigs, 130
114. Earthenware drinking cup decorated with myrtle, 130
115. Narcissus painted in the lower peristyle, Villa of Diomede, Pompeii, 131
116. Oleander, jay, and strawberry tree, House of the Gold Bracelet, 132
117. Vessel elements of wood from oleander branch, Villa of Poppaea, Oplontis, 133
118. Footed dish of black olives, fish, and turtledoves in a still-life painting, 134
119. Silver cup decorated with olive leaves and fruit, 135
120. Common millet, Italian millet, and two quails, 137
121. Capsule of corn poppy found in carbonized hay, Oplontis, 138
122. Mosaic: opium poppy fruit, House of the Faun, 139
123. Carbonized dates, Herculaneum, 140
124. Painting of a bird and two dates, House of Trebius Valens, Pompeii, 141
125. Hart's tongue fern in the room off the atrium, House of the Fruit Orchard, 142
126. Carbonized pine cone, Herculaneum, 143
127. Umbrella pines and cypress trees in the peristyle painting, House of the Little Fountain, 143
128. Large pinecone sculptured on a marble garden support, House of the Golden Amorini, 144
129. Domestic pigeon and wood pigeon perched on a plane tree, House of the Gold Bracelet, 145
130. Lamp with a plane tree handle, 146
131. Wall painting of a parrot with bird cherries, 147
132. Wall painting of cherry (sour) tree in the room off the atrium, House of the Fruit Orchard, 148
133. Wall painting of bird and two purple plums, House of Trebius Valens, Pompeii, 149
134. Wall painting fragments with yellow plums, House of the Gold Bracelet, 149
135. Still-life painting with a pair of almonds with husks, dates, figs, and a money bag, 150
136. Almonds in a garland on altar of the Temple of Vespasian, Pompeii, 150
137. Peach pit. Boscoreale Antiquarium, 151
138. Wall painting of peaches, Pompeii, 151
139. Leaf fragments of bracken fern in carbonized hay, Oplontis, 152
140. Carbonized pomegranates, *villa rustica*, Oplontis, 153
141. Pomegranate in a basket of fruit. Entrance, House of the Vettii, 153
142. Pomegranate flowers and fruit on the lararium, I.xiii.12, 153
143. Bird and large pear, Shop I.vii.5, 155
144. Stucco civic crown of holly oak above the door, House of Messius Ampliatus, 155
145. Leaf of a pubescent oak in carbonized hay, Oplontis, 156
146. Fragments of a wall painting with common or English oak, House of the Gold Bracelet, 156
147. Laurel, roses, a warbler, and Solomon's seal in a garden painting, House of the Gold Bracelet, 159
148. Fragment of bramble in carbonized hay, Oplontis, 160
149. Carbonized floret of Italian or foxtail millet, Pompeii storeroom, 161
150. Carbonized seed of Italian carchfly in carbonized hay, Oplontis, 162
151. Golden oriole and sorb apples, 163
152. Still-life painting with salsify or oyster plant, 164
153. Carbonized spikelet of emmer wheat. Casa del Bel Cortile, Herculaneum, 165
154. Emmer wheat in a drawing of destroyed wall painting, House of Triptolemus (VII.vii.5), 166
155. Corinthian column decorated with emmer wheat, Villa of Fannius Synistor, Boscoreale, 167
156. Fragments of a wall garden painting with laurustinus (viburnum): water triclinium, House of the Gold Bracelet, 168

157. Copy of a destroyed painting at the base of the N wall of room d, House of M. Epidius Sabinus, Pompeii, 169
158. Violet in carbonized hay, Oplontis, 170
159. Detail of a cross section of grapevine stem in carbonized hay, Oplontis, 171
160. Grapevine with fruit, Casa del Tramezzo di Legno, Herculaneum, 172
161. Grapevine garland with cupids, House of Menander, Pompeii, 173
162. Cluster of grapes in the banquet hall, House of the Sibyl, Pompeii, 173
163. Cupid treading grapes, Blue Glass Vase, 173
164. Garden of Polybius. Location of five large tree-root cavities and the ten pollen sampling points, 186
165. Representation of relative absolute frequencies of selected taxa in Garden of Polybius, 187
166. Plan of the *villa rustica*, Boscoreale, with locations of the studied soil samples, 196
167A. Distribution of pine and grape pollen at Boscoreale, NE quarter: pollen grains per 1 g of soil, 200
167B. Distribution of pine and grape pollen at Boscoreale, SW quarter: pollen grains per 1 g of soil, 200
168. Plan of E part of the Villa of Poppaea, Oplontis, 201
169. NMR spectra of cellulose and lignin, 220
170. NMR spectrum of charcoalified wood from a burn site in the Dismal Swamp, Virginia, 220
171. NMR spectra of fresh wood from spruce, degraded wood, and highly degraded wood, 220
172. NMR spectra of two samples from Boscoreale, 221
173. NMR spectra of wood samples from Oplontis, 221
174. NMR spectra of apparently carbonized *Ficus carica* fruit from Pompeii, 221
175. NMR spectra of samples collected from Vesuvian sites during the 1988 field trip, 222
176. NMR spectra of both carbonized and biologically degraded wood from Herculaneum, 223
177. NMR spectra of wood from the large beam transected by the interface between the two surge events at Herculaneum, 224
178. Bed, Herculaneum III.10–11, 229
179. Amphora rack, Herculaneum V.6, 229
180. Cradle, Herculaneum III.14, 229
181. Table, Herculaneum V.5, 230
182. *Abies alba*, cross section, 231
183. *Abies alba*, tangential section, 231
184. *Buxus*, tangential section, 231
185. *Buxus*, cross section, 231
186. *Carpinus*, cross section, 231
187. *Carpinus*, tangential section, 231
188. Growth profiles for fir and spruce from Herculaneum and Pompeii compared with South German oak, 237
189. An unburned cross section of spruce with tree rings from 291 B.C. to 129 B.C., 238
190. A burned cross section of fir with rings from 145 B.C. to A.D. 11, 239
191. Italy and the western part of the Phlegrean Fields with Lake Avernus, 241
192. Aerial view of Lake Avernus showing former Lake Lucrinus and Portus Julius, 242
193. View across Lake Avernus to Cape Miseno in the south, 243
194. Bathymetric map of Lake Avernus indicating the coring sites and the position of the echography profile no. 12 shown in Figure 195, 244
195. The echography profile no. 12 and the position of the coring site AV14 K2, 244
196. Stratigraphy of section 3 of core AV14 K2 and correlation of diatom and pollen zones, 245
197. Chemical and mineralogical data of section 3 of core AV14 K2, 247
198. Pollen diagram, 248
199. Concentrations of main pollen types, 249
200. Frequencies of diatoms and diatom fragments, 252
201. Changes of abundance of ecologically different groups of diatoms, 253
202. Diatom diagram, 254
203. Distribution and frequencies of freshwater gastropods, 260
204. Frequencies and distribution of mollusk shells, 261
205. Mollusk diversity, 261
206. Synopsis of the ecological changes of Lake Avernus as indicated by the different groups of fossils, 265
207. A slightly calcified Characean tube, indicating carbonate-rich shallow freshwater, 405–18 cm core depth (zone B), 267
208. A half tube of a more intensively calcified Characean tube, 405–18 cm core depth (zone B), 267
209. An intensively calcified Characean tube with diatoms on and within the calcareous crust, 405–18 cm core depth (zone B), 267
210. Detail of a limestone crust on a Characean tube with trapped diatoms, 405–18 cm core depth (zone B), 267
211. The shell of a small irregular endobenthonic sea urchin (*Echincyamus*), 280–90 cm core depth (zone F), 268
212. Detail of the shell in Figure 211, 268
213. Shells of marine benthonic organisms, partly broken, corroded, and overgrown by serpulids, 355–65 cm core depth (zone D), 268
214. Shells of marine benthonic organisms, mostly

broken, and some shells of (allochthonous) freshwater gastropods, one piece of a calcified Characeaen tube (allochthonous), 365–70 cm core depth (zone D), 268

215. Shells of freshwater gastropods, some calcified Characean tubes, indicating carbonate-rich shallow freshwater, 405–10 core depth (zone B), 269

216. A calcified Characeae oogonium, 405–18 cm core depth (zone B), 269

217. Shells of freshwater gastropods, some calcified Characean tubes, indicating carbonate-rich freshwater, 410–15 cm core depth (zone B), 269

218. Partly broken shells of freshwater gastropods, 415–18 cm core depth (zone B), 269

219. Mostly broken shells of marine benthonic mollusks (nearly exclusively of *Mytilus*, one sculptured venerid mollusk), 260–70 cm core depth (zone F), 270

220. Mostly well-preserved marine benthonic mollusks, 270–80 cm core depth (zone F), 270

221. Well-preserved, corroded, and broken shells of marine benthonic mollusks, 280–90 cm core depth (zone F), 270

222. Well-preserved, intensively corroded, or broken shells of marine benthonic mollusks, and one broken spine of a sea urchin, and one broken tube fragment of a branched serpulid, 290–300 cm core depth (zone F), 270

223. Partly broken shells of marine benthonic mollusks and serpulids, 300–310 cm core depth (zone E), 271

224. Mostly broken shells of marine benthonic mollusks and some small shells of freshwater gastropods (allochthonous), 350–55 cm core depth (zone E), 271

225. Fish pool with amphorae for fish in garden of Pompeii, House VIII.ii.14 of the late 1st century B.C., 275

226. Large fish mosaic, House of the Faun (VI.xii.2), Pompeii, 276

227. Key to fish mosaic, House of the Faun, 276

228. Large fish mosaic from Pompeii, House VIII.ii.16, 277

229. Key to fish mosaic from Pompeii, House VIII.ii.16, 277

230. Fish painting on the E wall in a room to the south of the vestibule, House of the Vetti, Pompeii, 278

231. An old drawing of a garden painting, Villa of Diomede, Pompeii. In the center a well-stocked fish pool, 278

232. Large bone of Flying gurnard (*Dactylopterus volitans*), 279

233. Anchovy (*Engraulis encrasicolus*) bones from *Garum* shop I.xii.8, 281

234. Red mullet (*Mullus*) in mosaic, House of the Grand Duke of Tuscany (VII.iv.65), 283

235. Painting: red mullet (*Mullus*) below, asparagus above, 284

236. Comber (*Serranus cabrilla*). Lower right, four chaffinches on left. Above, teal on left, male shelduck on right. Top, cat with small hen, 287

237. Triton or trumpet shell, labial view (*Charonia nodifera*), 294

238. Triton or trumpet shell, exterior view (*Charonia nodifera*), 294

239. Triton or trumpet shell, labial view (*Charonia nodifera*), 294

240. Triton or trumpet shell, exterior view (*Charonia nodifera*), 294

241. Cowrie, dorsal view (*Luria lurida*), 295

242. Cowrie, ventral view (*Luria lurida*), 295

243. Limpet (*Patella ferruginea*), 298

244. Prickly cockle (*Acanthocardia tuberculata*), 300

245. Cockle shells (*Acanthocardia tuberculata*) on mosaic nymphaeum in House of Neptune and Amphitrite, Herculaneum, 301

246. Scallop (*Pecten jacobaeus*) holed in both ears, 303

247. Marine crab on a *Pecten*. Fountain sculpture in House of Julius Felix, Pompeii, 304

248. Indo-Pacific textile cone (*Conus textile*), 306

249. Indo-Pacific panther cowrie, dorsal view (*Cypraea pantherina*), 307

250. Indo-Pacific panther cowrie, ventral view (*Cypraea pantherina*), 307

251. Indo-Pacific black-lip pearl oyster, exterior view (*Pinctada margaritifera*), 308

252. Indo-Pacific black-lip pearl oyster, interior view (*Pinctada margaritifera*), 308

253. Indo-Pacific giant clam (*Tridacna squamosa*), 308

254. Sea urchin (*Paracentrotus lividus*), 311

255. Unworked red coral (*Corallium rubrum*), 311

256. Carbonized scavenger beetle, *Microgramme ruficollis*, from hay, *villa rustica*, Oplontis, 317

257. Hind quarters of a carbonized beetle, from hay, *villa rustica*, Oplontis, 317

258. Bean with bruchid beetle in hole, 317

259. Flylike insect and grasshopper, Eucmachia, 318

260. Shop on the Decumanus Maximus, Herculaneum, in which galls were found in *dolia*, 320

261. Bag of preserved galls in the Herculaneum *deposito*, 320

262. Cutaway of a carbonized gall from Herculaneum showing remnants of a wasp, 320

263. Bee/butterfly-like insect, Eumachia, 321

264. Antlike insect, Eumachia, 321

265. Butterfly, roses, and wild strawberry, Villa of Diomedes, 321

266. Butterfly wings. Mosaic top from garden table in Garden of the Tannery, Pompeii, 322

267. Wall painting of a cricket/grasshopper, Villa Poppaea, Oplontis, 323

268. Wall painting of a grasshopper or butterfly, Villa Poppaea, Oplontis, 323

269. Line drawing of a grasshopper in a chariot, 323

270. A cricket on a mosaic garland, 324

271. A cricket/grasshopper in a bird's beak, Eumachia, 324

272. Aphid-like insect, *villa rustica*, Oplontis, 325

273. Spiderlike carving, Eumachia, 325

274. Anuran on a water lily pad. Nile mosaic (detail), House of the Faun (VI.xii), 330

275. Bronze "frog." Fountain device, Pompeii, 331

276. Toads or frogs, lizards, tortoises or turtles, and snakes on Sabazius's bronze hand, House of the Birii (II.i.12), 331

277. Tortoise or turtle, lizard, and snake on Sabazius's terra-cotta vase, House of the Birii (II.i.12), 332

278. Hermann's Tortoise (*Testudo hermanni*), top view, 333

279. Hermann's Tortoise (*Testudo hermanni*), bottom view, 333

280. Stork pecking at a lizard. Painting, House of the Epigrams (V.i.18), 334

281. Lizard on the marble lararium relief, atrium, House of L. Caecilius Jucundus (V.i.26), 334

282. So-called lizard in foliage scrolls, Eumachia entrance, 335

283. Rat snake, *Elaphe longissima*, climbing a small fig tree on the E wall of a room, off the E side of the peristyle, House of the Fruit Orchard (I.ix.5), 336

284. Egret and cobra. Painting on the low wall enclosing the peristyle, House of Adonis (V.vii.18), 337

285. Monumental fountain device, Great Palaestra, Herculaneum, 343

286. Infant Hercules strangling two snakes. Marble statuette, House of M. Loreius Tiburtinus or of D. Octavius Quartio (II.ii.2), 344

287. Two (stolen) gold bracelets from Herculaneum, 345

288. Drawing of a gold bracelet from Terzino, Ranieri quarry Villa 2, 346

289. Key to snakes: scutellation features, 347

290. Nile crocodile (*Crocodylus niloticus*). Nile mosaic (detail) from the exedra (37), House of the Faun (VI.xii), 350

291. Lararium painting from a garden in Pompeii, I.xi.15. Two Type I serpents flanking a painted altar, 351

292. Detail of Figure 291. Serpent (Type I) from the garden painting, 351

293. Detail of a lararium painting, House of Polybius, Pompeii, IX.ix.3. Two flanking Type II serpents beneath a pair of painted Lares, 352

294. A falconer with a tethered hawk on his wrist, 358

295. Two bird peddlers carrying their live wares in basket cages, 358

296. A rock partridge, 363

297. Two mallard duck pairs, 365

298. A greylag goose, perhaps domestic, 366

299. An eagle with a writhing snake, 366

300. A gray heron amid its leafy domain; a song thrush perched above a small pine tree, 368

301. A dark-eyed little owl stalking a lizard, 369

302. A cattle egret and a magpie; below, an unidentified songbird, 370

303. A parakeet and a greenfinch with walnuts, 371

304. A pair of hawfinches and cherries, 372

305. A carefully rendered hovering rockdove, 373

306. A domestic pigeon, 374

307. A wood pigeon, 374

308. A hooded carrion crow and a house sparrow, 375

309. Three fighting quails with victor's trophy, 376

310. A cuckoo with cherries, 377

311. A vividly red-breasted robin, 378

312. A robin in flight, 378

313. A pair of snipes in wetland habitat, 379

314. Four fighting cocks with a trophy and a palm frond, 380

315. A rooster with a pinecone, a date, and a fig, 381

316. A woodchat shrike and a jay, 381

317. A pair of swallows in flight, 382

318. A wryneck and pears, 383

319. A black-eared wheatear and a song thrush, 385

320. A female common wheatear and grapes, 385

321. A male golden oriole with oleander and strawberry trees in fruit, 386

322. A female golden oriole in a lemon tree, 387

323. A caricature of a crested tit, 387

324. A peacock with two dates, a fig, and a double almond, and a date and fig below, 389

325. A male redstart with pears, 390

326. A purple gallinule, 391

327. A purple gallinule with fruits of the sea, 392

328. A purple gallinule and pears, 392

329. A purple gallinule eating a pomegranate, 392

330. Two parakeets and a dove on a basin with a pomegranate and a cat below, 393

331. A dark-eyed tawny owl, 395

332. A blackcap in flight, 396

333. A sacred ibis holding a sheaf of wheat, 397

334. A blackbird with strawberry tree fruit, 398

335. A song thrush alighting on a strawberry tree, 399

336. A fine example of a *venatio* painting, or *paradeisos*,

from the garden of the House of the Ceii, Pompeii, 404

337. Graph of Campanian bone percentages for ox, sheep/goat, and pig, 406

338. Possible depictions of cheetahs, in a pair walking in opposite directions, in a small formal vignette in the tablinum, House of M. Lucretius Fronto, Pompeii, 408

339. A bull on the base of altar in the Temple of Vespasian, forum of Pompeii, 409

340. A guard dog, with a gem-studded collar, painted on a wall of the *caupona* of Sotericus, Pompeii, 412

341. Plaster cast of a guard dog, that died because it was left chained to the *fauces* of the House of M. Vesonius Primus, Pompeii, in a doomed attempt to protect the owner's property, 413

342. A bronze garden sculpture of a short-haired billy goat standing in a rather formal pose, Nocera, 415

343. Cupids leading a goat loaded with a flower basket, House of the Vettii, Pompeii, 416

344. Antlers and frontals of a roe deer from Pompeii, 417

345. Marble garden sculpture of a red deer, beset by small hunting dogs, House of the Stags, Herculaneum, 418

346. Marble garden sculpture of a dolphin rescuing a Cupid from an octopus, House of Ceres, Pompeii, 419

347. A dormouse, probably *Eliomys quercinus,* on the Eumachia portal, Pompeii, 420

348. Two donkeys rest from their labor at the mill during the celebration of the Vestalia, 421

349. A mule or horse skeleton in a stable (I.viii.12), Pompeii, 422

350. Life-size marble equestrian statue of M. Nonnius Balbus, Herculaneum, 423

351. A pair of gazelles, Villa of Papyri, Herculaneum, 427

352. A well-delineated mongoose, somewhat more sharp-nosed than in actuality, advances on a rearing snake. Nilotic mosaic, House of the Faun, Pompeii, 429

353. Hare or rabbit on the Eumachia portal, Pompeii, 430

354. Hare nibbling grapes, 431

355. Four African elephants drawing a chariot of a goddess on the shop sign of Verecundus, 432

356. Still life of a crouching rabbit, apparently asleep, beside four figs, 436

357. Graffito of an oryx, House of the Cryptoporticus, 437

358. A short-wooled sheep standing next to four containers of cheese and a bunch of wild asparagus in a still life from Herculaneum, 438

359. A well-depicted lion, leopard, and bull in a *venatio* painting, garden of the House of M. Lucretius Fronto, Pompeii, 439

360. A fine bronze garden sculpture group, House of the Citharist, Pompeii, showing a wild boar being attacked by two dogs, 443

361. Cast of a fairly complete pig at the *villa rustica,* Boscoreale, embellished a little, but nevertheless displaying a smallish animal with the straight snout expected of an unimproved breed, 445

362. A bear devouring fruit in the shade of a tree, House of M. Lucretius Fronto, Pompeii, 446

363. Partially excavated skeletons, Herculaneum, 452

364. Sara Bisel preserving and drying cleaned bones, 453

365. Herculaneum, A.D. 79: a profile of the population by age and sex, 454

366. Child growth to age 12: a comparison of Herculaneum and modern America, 456

367. Child and adolescent growth of females aged 12 to 17 years: a comparison of Herculaneum and modern America, 457

368. Child and adolescent growth of males aged 10 to 17 years: a comparison of Herculaneum and modern America, 457

369. Bone lead in three ancient populations, 459

370. Bone lead in Herculaneum by sex, 460

371. Erc86: muscle insertions of humeri, 461

372. Erc65: skeleton with jewelry, 462

373. Erc65: periodontal disease, 463

374. Erc46: skull, 463

375. Erc8: green stick fracture, 464

376. Erc11: jewelry, 464

377. Erc10: lateral view of teeth, showing lines of hyperplasia on the upper first molar and the site of extraction of the opposing molar, 465

378. Erc52: fetus, 466

379. Erc98: unusual bony outgrowths on pelvic rami

380. Erc28: lumbar vertebrae with Schmorl's herniations, 467

381. Erc28: teeth with industrial wear, 467

382. Erc 26: femur with enlarged adductor tubercle, 468

383. Erc27: fused thoracic vertebrae, 469

384. Erc62: anterior view of knees, showing abnormal wear on condyles and patellae, 470

385. Erc49: forearms with fractured right radius, 470

386. Erc49: left and right metatarsals, 471

387. Erc105: heads of femora with pelvic fragments, 473

PREFACE

Many people through the years have had an important part in the development of this book, which grows out of the generous and enthusiastic cooperation of the many scientists and other specialists, both in the United States and in Europe, who have made the study of the gardens preserved by Vesuvius an exciting project – one that has crossed the boundaries of many disciplines. This collaboration has resulted in bringing together a body of specialized information that makes possible a natural history of the Vesuvian sites.

Research for this project has spanned almost half a century. In addition to those who have written chapters in this book, through the years various other scholars, many now deceased, have made important contributions. Their part in the project is acknowledged in Chapter 2.

It is a great pleasure to express gratitude to those who have contributed to this book. Our work in the Vesuvian sites was made possible because of the gracious hospitality and enthusiastic cooperation of the various archaeological Superintendents and Directors of Excavations in the Vesuvian sites. Professor Alfonso de Franciscis, Superintendent for the Provinces of Naples and Caserta from 1961 to 1976, gave a new direction to my research, generously granting me permission to excavate in the gardens of Pompeii and Torre Annunziata. My debt to Dr. Giuseppina Cerulli Irelli, Director of Excavations at Pompeii from 1970 to 1978 and Superintendent of Antiquities at Pompeii from 1981 to 1984, is exceedingly great for her friendship and great personal interest and help in our work. I owe Dr. Stefano De Caro, Director of Excavations at Pompeii from 1978 to 1985, and now Superintendent of Antiquities at Naples, a deep debt of gratitude for his friendship, for his help in solving many a difficult

archaeological problem, and for his continued interest in this book. Chapter 2 is better because of his careful reading. Dr. Antonio D'Ambrosio gave expert help at Oplontis and in the *deposito* at Pompeii; as Director of Excavations at Pompeii he has continued to be helpful. Dr. Giovanni Guzzo, the present Superintendent of Antiquities at Pompeii, has shown continued interest in our work. We especially thank him for making available the photo of the north wall of the *diaeta* in the House of the Bracelet.

I acknowledge with gratitude the many grants that have made my work possible, beginning with a grant from the American Philosophical Society. A Biomedical Service Support Grant aided my research on the medicinal plants used at Pompeii. Funds for my excavations in the Vesuvian sites were granted by the General Research Board of the University of Maryland and in large part by the National Endowment for the Humanities, beginning with the award of a Senior Fellowship in 1968–9 and generous research grants from 1972 to 1978. Dumbarton Oaks, Washington, D.C., also supported my excavations. The authorities at Pompeii and other Vesuvian sites generously furnished heavy equipment and additional workmen for my excavations. I am grateful to the National Geographic Research Committee for a grant that enabled Eberhardt Grüger, Hiram Larew, John Foss, and Patrick Hatcher to do additional research in the Vesuvian sites for this book. This grant also made possible a subsequent working session of most of the authors of this book in Silver Spring, Maryland.

We gratefully acknowledge the generous grant from the Kress Foundation that made possible the many color photos in the book. The National Geographic graciously gave us photos taken when Sara Bisel and Haraldur Sigurdsson were working at Hercu-

laneum. We also thank Victoria I and Mary Todd for making the map that appears at the beginning of our book (Fig. 2) and Tebebe Sellassie Lemma, who generously helped prepare two figures in Chapter 7.

I express my warm gratitude to Frederick G. Meyer, who from the beginning, as co-editor, has contributed much to this book. He has read every chapter carefully and made many helpful suggestions. This book has been truly a cooperative effort. Other authors have read many chapters and made many helpful suggestions. I thank especially Hiram Larew, George Watson, and Massimo Ricciardo for their generous help. George Watson contributed not only his scientific acumen but also his computer skills in the final effort of preparing the book for press. Massimo Ricciardo has read the entire book twice and gave indispensable help in checking proof and making the index. Margaret Koebke and Ellsworth and Doris Johnson also generously contributed their computer skills.

It has been a pleasure to work with Beatrice Rehl, Senior Editor, Arts and Classics, of the Cambridge University Press, who from our first conversation envisioned the book as we hoped it might be published. We have been fortunate to have Françoise Bartlett as our meticulous and enthusiastic Managing Editor. She and her staff have done much to improve this book. The handsome page layouts were designed by Christina Viera. We also express our gratitude to Alan Gold, the Production Controller who so capably supervised the production of this book.

Finally, my greatest debt and one that never can be adequately expressed is to my physicist husband, who played such a major role in my work. Taking leave without pay from his laboratory, he was every season an active member of our excavation team until his untimely death in 1982. His many contributions include an extensive photographic documentation of the Vesuvian sites. He also mapped the gardens and measured the locations of the excavated root cavities. He supervised the buying of equipment and took complete charge of the payroll and all finances. And in between seasons he spent countless evenings at the drawing board, making numerous plans and drawings, some of which appear in this book. It was his scientific approach that enabled him to suggest new techniques used in our work and to solve many archaeological problems. Many of his photographs have found their way into the pages of this book.

Wilhelmina F. Jashemski
Silver Spring, Maryland
August 2001

CONTRIBUTORS

Joachim Alefs, Systematics AG, TÜV-Informatik-Service Müchen, Westendstr. 199, 80686 München, Germany

J. T. Ammons, Professor of Plant and Soil Sciences, University of Tennessee, Knoxville, Tennessee

Jane F. Bisel, Freelance Editor, Rochester, Minnesota

† Sara C. Bisel, Archaeologist, Physical Anthropologist funded by grants from The National Geographic Society, Washington, D.C.

Liliane Bodson, Professor of Classics, University of Liège, Liège, Belgium

Steven Carey, Professor of Oceanography, University of Rhode Island, Kingston, Rhode Island

† G. W. Dimbleby, Professor Emeritus and Chair, Department of Human Environment, Institute of Archaeology, University of London, United Kingdom

J. E. Foss, Professor Emeritus of Plant and Soil Sciences, University of Tennessee, Knoxville, Tennessee

Eberhard Grüger, Professor of Botany, Albrecht von Haller Institute for Plant Sciences, University of Göttengen, Germany

Patrick G. Hatcher, Professor of Chemistry and Director of the Ohio Mass Spectometry Consortium and of the Environmental Molecular Sciences Institute, Department of Chemistry, Ohio State University, Columbus, Ohio

Wilhelmina F. Jashemski, Professor Emerita of Ancient History, University of Maryland, College Park, Maryland

Anthony King, Professor of Archaeology, King Alfred's College, Winchester, United Kingdom

Peter Ian Kuniholm, Professor of the History of Art and Archaeology and Director of the Aegean Dendrochronology Project and of the Malcolm and Carolyn Wiener Laboratory for Aegean and Near Eastern Dendrochronology, Cornell University, Ithaca, New York

Hiram G. Larew, Director of International Programs, U.S. Department of Agriculture, Washington, D.C.

S. Y. Lee, Research Scientist, Oak Ridge National Laboratory, Oak Ridge, Tennessee

Frederick G. Meyer, Retired Supervisory Botanist of the Herbarium, U. S. National Arboretum, Washington, D. C.

Stephan T. A. M. Mols, Assisstant Professor of Classical Archeology, Catholic University of Nijmegan, The Netherlands

Jens Müller, Ludwig Maximilian University Munich, Gärching, Germany

David Orr, Director, Center for Cultural Resources, Valley Forge National Historical Park, Valley Forge, Pennsylvania

David S. Reese, Research Scientist, Peabody Museum of Natural History, Yale University, New Haven, Connecticut

Massimo Ricciardi, Professor of Systematic Botany, University of Naples Federico II, Portici, Italy

Jürgen Schneider, Professor of Geology, Institute for Geology and Dynamics of the Lithosphere, University of Göttingen, Germany

Haraldur Sigurdsson, Professor of Oceanography, University of Rhode Island, Kingston, Rhode Island

Barbara Thulin, Geovetenskapliga Institutionen, University of Uppsala, Sweden

M. E. Timpson, Senior Project Manager, Peterson Environmental Consulting, Eagan, New Mexico

George E. Watson, Retired Curator of Birds and Department Chair, Vertebrate Zoology, National Museum of Natural History, Smithsonian Institution, Washington, D.C.

Francisco W. Welter-Schultes, Institute for Zoology and Anthropology, University of Göttingen, Germany

ABBREVIATIONS

Apicius Apicius *The Roman Cookery Book*

Aelian *NA* Aelian *Natura Animalium*

Aristotle *HA* Aristotle *Historia Animalium*

Bdl *Bullettino dell'Istituto di corrispondenza archeologica*

Cato *RR* Cato *De re rustica*

CIL *Corpus inscriptionum Latinarum*

Columella *Arb.* Columella *De arboribus*

Columella *RR* Columella *De re rustica*

Dioscorides Dioscorides *De Materia Medica*

ILS *Insriptiones Latinae Selectae*

Livy Livy *History of Rome (Ab Urbe Condita)*

Martial Martial *Epigrams*

NM Naples Museum (National Archaeological Museum of Naples)

NS *Notizie degli scavi*

Ovid *Met.* Ovid *Metamorphoses*

PAH Fiorelli *Pompeianorum antiquitatum historia*

Petronius Petronius *Satyricon*

Pliny *HN* Pliny the Elder *Natural History*

SEM Scanning Electron Microscope photograph

Seneca *Q. Nat.* Seneca *Naturalis Quaestiones*

Strabo Strabo *Geography*

Theophrastus *Hist. pl.* Theophrastus *Enquiry into Plants*

USDA United States Department of Agriculture

Varro *RR* Varro *De re rustica*

Vitruvius Vitruvius *On Architecture*

ANCIENT AUTHORS CITED OR QUOTED

Aelian *De Natura Animalium.* Loeb Classical Library of Harvard University Press (hereafter LCL). 3 vols. Trans. by A. F. Schoenfield. London and Cambridge, Mass., 1958–59.

Aeschylus *Agamemnon Libation-bearers, Eumenides, Fragments.* LCL. Vol. 1. Trans. by Herbert Weir Smyth, updated by H. Lloyd-Jones. Cambridge, Mass., 1926, 1957.

Apicius *The Roman Cookery Book.* Trans. by Barbara Flower and Elisabeth Rosenbaum. Peter Neville, London and New York, 1960.

Appian *Roman History.* Vol. 3. *The Civil Wars.* LCL. Trans. by Horace White. Cambridge and London, 1933.

Apuleius, *Apologia* in *Opera Quae Supersunt.* Vol 2. Ed. by Rudolfus Helm. Teubner, Leipzig, 1912.
 Metamorphoses. LCL. Trans. by J. Arthur Hanson. Cambridge, Mass., 1989.

Arrian *Anabasis Alexandri, Indica.* 2 vols. LCL. Trans. by P. A. Bunt. London and New York, 1976–83.

Aristophanes *Peace. Birds. Frogs.* LCL. Trans. by Benjamin Bickley Rogers. London and New York, 1950.
 Birds. Lysistrata. Women at the Thesmophoria. LCL. Trans. by Jeffrey Henderson. Cambridge, Mass., 2000.

Aristotle *Historia Animalium.* LCL. 3 vols. Trans. by A. L. Peck. Cambridge, Mass., 1965, 1970, 1991.

Athenaeus *The Deipnosophists.* LCL. 7 vols. Trans. by Charles Burton Gulick. Cambridge, Mass., and London, 1951–57.

Calpurnius Siculus, Titus *Eclogues.* Ed. by C. H. Keene. Bristol Classical Press, London, 1996.

Cato *De Re Rustica* and Varro *Res Rusticae.* LCL. Trans. by W. D. Hooper, revised by H. B. Ash. Cambridge and London, 1954.

Orationes. Ed. by H. Jordan. Teubner, Leipzig, 1860.

Catullus Tibullus. *Pervigilium Veneris.* LCL. Trans. by F. W. Cornish, J. P. Postgate, J. W. MacKail. 1911; revised 1950, 1962, 2nd rev. ed. by G. P. Gould. Cambridge, Mass, 1988.

Celsus *De Medicina.* LCL. 3 vols. Trans. by W. J. Spencer. London, 1935–38.

Cicero *De Finibus.* LCL. Trans. by Harris Rackham. London and New York, 1914.
 De Naturae Deorum. LCL. Trans. by Harris Rackham. Cambridge, Mass., 1933, 1956.
 De Senectute. De Amicitia. De Divinatione. LCL. Trans. by W. A. Falconer. London and New York, 1992.
 The Verrine Orations. LCL. Vols. 7 and 8. Trans. by L. H. G. Greenwood. Cambridge, Mass., 1928–35.
 Letters to Atticus. LCL. Trans. by D. R. Shackleton Bailey. Cambridge, Mass., 1999.
 Pro Murena, Pro Sulla included in *Orations,* Vol. 10. LCL. Trans. by C. Macdonald. Cambridge, Mass., and London, 1976.

Columella *De Re Rustica.* LCL. 3 vols., Vol. 1 trans. by H. B. Ash, Cambridge, Mass., and London, 1960; Vol. 2 trans. by E. S. Forster and E. H. Hefner, Cambridge, Mass., and London, 1968 (rev. ed.); Vol. 3 (includes *De Arboribus*) trans. by E. S. Forster and E. H. Hefner, Cambridge, Mass., and London, 1968 (rev. ed.).

Curtius Rufus, Quintus. *History of Alexander.* LCL. 2 vols. Trans. by J. C. Rolfe. Cambridge, Mass., 1946–56.

Cyranides. Ed. by C. E. Ruelle in F. de Mély, *Les Lapidaires de l'Antiquité et du Moyen Age.* Vol. 2. E. Leroux, Paris, 1898–99.

Dio Cassius *Roman History.* LCL. 9 vols. Trans. by Earnest Cary. Cambridge, Mass., and London, 1961–69.

Dio Chrysostom *Discourses.* LCL. 5 vols. Trans. by J. W. Cohoon and H. Lamar Crosby. Cambridge, Mass., 1932–51.

Diodorus Siculus *Library of History.* Vol. 3. LCL. Trans. by C H. Oldfather. Cambridge, Mass., and London, 1938.

Diogenes Laertius *Lives of Eminent Philosophers.* LCL. 2 rev. vols. Trans. by R. D. Hicks. Cambridge, Mass., and New York, 1931; reprinted, 2000.

Dionysius of Halicarnassus *Roman Antiquities.* LCL. Trans. by E. Cary. Cambridge, Mass., and London, 1937.

Dioscorides *De Materia Medica Libri Quinque.* Ed. by Max Wellman. 3 vols. Weidmanns, Berlin, 1906–14; reprinted Berlin 1958 (best text, no translation).
The Greek Herbal of Dioscorides. Ed. by Robert T. Gunther. Hafner, New York, 1934; reprinted 1968.

Diphilus, in John Maxwell Edmonds, *The Fragments of Attic Comedy.* Vol. IIIa. E. J. Brill, Leiden, 1961.

Epictetus. *Discourses. Fragments. The Encheiridion.* LCL. 2 vols. Trans. by C. H. Oldfather. Cambridge, Mass., and London, 1925–28.

Euripides. LCL. 6 vols. in progress: Vol. 1. *Cyclops, Alcestis, Medea.* Vol. 2. *Children of Heracles, Hippolytus, Andromache, Hecuba.* Vol. 3. *The Suppliant Women, Electra, Heracles.* Vol. 4. *Trojan Women, Iphigenia among the Taurians, Ion.* Vol. 5. *Helen, Phoenician Women, Orestes.* Trans. by David Kovacs. Cambridge, Mass., 1994, 1995, 1998, 2000, 2002 (in press).

Festus, Sextus Pompeius *De Verborum Significatu.* Facsimile reprint of 1913 Leipzig edition. Ed. by Wallace Martin Lindsay. Teubner, Stuttgart, 1997.

Firmicus Maternus, Julius, *Mathesis.* 3 vols. Trans. by Pierre Monat. Les Belles Lettres, Paris, 1992–97.

Florus *Epitome of Roman History.* LCL. Trans. by E. S. Forster. Cambridge, Mass., and New York, 1929.

Gaius *Institutiones.* Ed. by Bernhard G. A. Kuebler. Teubner, Leipzig, 1935.

Galen. *Opera Omnia.* 20 vols. Ed. by Carolus Gottlob Kühn. C. Cnobloch, Leipzig, 1821–33. Reprinted by G. Olms, 1964–65.
Galen on Food and Diet. Selections, translations and notes by Mark Grant. Routledge, London and New York, 2000.

Gellius, Aulus *Attic Nights.* LCL. 3 vols. Trans. by J. C. Rolfe. London and New York, 1927–59.

Grattius, *Cynegetica.* Ed. by F. Vollmer. Teubner, Leipzig, 1911.

Greek Elegy and Iambus. Vol. 1. Elegiac Poets from Callimus to Critias (including Tyrtaeus, Mimmermus, Solon, Phocylides, Xenophanes, Theognis). LCL. Trans. by J. M. Edmunds. London and New York, 1931.

Greek Lyric Poets. Vol. 1. Sappho and Alcaeus. LCL. Trans. by David A. Campbell. Cambridge, Mass., and London, 1982.

Herodotus *The Persian Wars.* LCL. Trans. by A. D. Godley. London and New York, 1921–24.

Hesychius of Alexandria *Hesychiou tou Alexandreos lexikon.* Ed. by Ailios Diogeneianos and Maurigius Schmidt. Georgiades, Athens, 1975.

Horace *Odes and Epodes.* LCL. Trans. by C. E. Bennett; reprint of 1927 rev. ed. Cambridge, Mass., and London, 1968.
Satires, Epistles. LCL. Trans. by H. R. Fairclough. London and New York, 1926.

Isidorus of Seville *Origines.* Ed. by Wallace Martin Lindsay. Clarendon Press, Oxford, 1911.

Juvenal and Persius. LCL. Trans. by G. G. Ramsey. Rev. ed. Cambridge and London, 1957.

Livy *History of Rome.* LCL. Vol. 4. Trans. by B. O. Foster. London, 1926.

Lucan *The Civil War (Pharsalia).* LCL. Transl. by J. D. Duff. London and New York, 1928, 1957.

Lucretius *De Rerum Natura.* LCL. Trans. by W. H. D. Rouse. 3rd rev. ed. Introduction, notes and index by M. F. Smith. Cambridge, Mass., 1975.

Luke *The New Testament.* Revised Standard Version. T. Nelson, New York, 1946.

Martial Epigrams. LCL. 3 vols. Trans. by W. C. A. Ker. New York and London, 1919–20.

Mela, Pomponius. *De Chorographia.* Ed. by Carolus Frick. Teubner, Leipzig, 1880.

Meleager included in *Greek Anthology.* LCL. Vol. 4. Trans. by W. R. Paton. Cambridge, Mass., and London, 1990.

Nicander *Theriaka, The Poems and Poetical Fragments.* Trans. by A. S. F. Gow and A. F. Scholfield. Cambridge University Press, Cambridge, 1953.

Oppian, *Cynegetica,* included in *Oppian, Colothus, Tryphiodorus.* LCL. Trans by A. W. Mair. Cambridge, Mass., 1928.

Ovid "On Painting the Face," in *The Art of Love and Other Poems.* LCL. Ed. and trans. by J. H. Mosley. London, 1985.
Fasti. LCL. Trans. by J. G. Frazer. New York and London, 1931.
Heroides and Amores. LCL. Trans. by Grant Showerman. London, 1986.
Metamorphoses. LCL. Trans. by F. J. Miller. Vol. 1, Cambridge, Mass., 1976; Vol. 2, Cambridge, Mass., 1977.
Tristia. Ex Ponto. LCL. Vol. 6. Ed. by Arthur Leslie Wheeler. London and New York, 1924.

Paulus *Festus.* Ed. by Wallace Martin Lindsay. Teubner, Leipzig, 1913.

Pausanias *Description of Greece.* Vol. 4, books VIII.22-X. Arcadia, Boeotia, Phocis and Ozolian Locri. LCL. Trans. by W. H. S. Jones. Cambridge, Mass., and London, 1935.

Pelagonius *Ars Veterinaria.* Ed. by K. D. Fischer. Teubner, Leipzig, 1980.

Petronius *Satyricon.* LCL. Trans. by M. Hesiltine, rev. ed. by E. H. Warmington. Cambridge, Mass., 1956.

Plautus *The Merchant. The Braggart Warrior. The Haunted House. The Persian.* LCL. Vol. 3. Trans. by Paul Nixon. London, 1968.

 Stichus. Trinummus. Truculentus. The Tale of the Travelling Bag. Fragments. LCL. Vol. 5. Trans. by Paul Nixon. London, 1984.

Pliny the Elder *Natural History.* LCL. Vols. 3, 4, 5. Trans. by H. Rackham. Cambridge, Mass., and London, 1940, 1960, 1961. Vols. 6, 7. Trans. by W. H. S. Jones. Cambridge, Mass., and London, 1951, 1956, 1963.

Pliny the Younger *Letters and Panegyricus.* LCL. 2 vols. Trans. by Betty Radice. Cambridge, Mass., and London, 1969.

Plutarch *De Sollertia Animalium* included in *Moralia.* LCL. Vol 12. Trans. by Harold Cherniss and W. C. Helmbold. Cambridge, Mass., and London, 1976.

 The Parallel Lives. LCL. 3 vols. Trans. by B. Perrin. Cambridge, Mass., and London, 1916; reprinted 1951.

Polybius *The Histories.* LCL. 6 vols. Trans. by W. R. Paton. London and New York, 1922–27.

Propertius *Elegies.* LCL. Trans. by G. P. Gould. Cambridge, Mass., 1990.

Res Gustae Divi Agusti. LCL. Includes Velleius Paterculus, *Compendium of Roman History.* Rev. ed. trans. by F. W. Shipley. Cambridge, Mass, 1979.

Scribonius Largus *Compositiones.* Ed. by Sergio Sconnocchia. Teubner, Leipzig, 1983.

Scriptores Historiae Augustae. Ed. by E. Hohl. Teubner, Stuttgart, 1971; Penguin. Selections trans. by A. Birley, Harmondsworth, England, and Baltimore, 1976.

Scriptores Historiae Augustae. LCL. 3 vols. Trans. by David Magie. Cambridge, Mass., 1953–54.

Seneca the Younger. LCL. Vol. 6, *Epistles,* 93–124. Trans. by R. M. Gummere. Vol. 10. *Naturalis Quaestiones.* Trans. by Thomas H. Corcoran. Cambridge, Mass., and London, 1974.

Sidonius Apollinaris *Poems. Letters.* LCL. 2 vols. Trans. by W. B. Anderson Cambridge, Mass., and London, 1936.

Siliius Italicus *Punica.* LCL. 2 vols. Trans. by F. D. Duff. New York, 1934.

Solinus *Collectanea Rerum Memorabilium.* Trans. by Arthur Golding. I. Charlewoode for Thomas Hacket, London, 1587; reproduced in facsimile with introduction by George Kish by Scholars' Facsimiles & Reprints, Gainesville, Fla., 1995.

Soranus of Ephesus *Gynecology.* Trans. and ed. by Oswei Temkin, et al. Johns Hopkins, Baltimore, 1956.

Statius *Sylvae.* LCL. Trans. by J. H. Mozley. New York, 1928.

Strabo *Geography.* LCL. 8 vols. Trans. by H. L. Jones. New York and London, 1931–49.

Suetonius *The Lives of the Caesars.* LCL. 2 vols. Trans. by J. C. Rolfe. New York and London, 1914.

Tacitus *The Histories.* LCL. Vols. 2 and 3 (part). Trans. by Clifford H. Moore. London and New York, 1951–52.

 The Histories. The Annals. LCL. Vols. 3 (part), 4, 5. Trans. by John Jackson. Cambridge, Mass., and London, 1951–52.

Tertullian *De Pallio und die stilistische Entwicklung Tertulliana.* By Gösta Säflund. C. W. K. Gleerup, Lund, 1955.

Theocritus included in *Greek Bucolic Poets.* LCL. Trans. by J. M. Edwards. New York and London, 1950.

Theophrastus *De Causis Plantarum.* LCL. 3 vols. Trans. by B. Einarson and George K. K. Link. Cambridge, Mass., and London, 1976–90.

 De Igne, A post-Aristotelian View of the Nature of Fire. Trans. by V. Coutant. Van Gorcum, Assen, 1971.

 Enquiry into Plants. LCL. 2 vols. Trans. by Sir Arthur Hort. New York and London, 1961.

Tibullus. LCL. Trans. by F. W. Comish. New York and London, 1912.

Varro *De Lingua Latina.* LCL. Trans. by Roland G. Kent. Cambridge, Mass, 1977.

 Saturae Menippeae. F. Oehler. G. Bassi, Quedlinburg, Germany, 1844.

Vegetius Renatus, Flavius *De Re Militari.* Ed. by A. Onnerfors. Teubner, Stuttgart, 1995.

Vegetius Renatus, Publius *Digestorum Artis Mulomedicinae.* Ed. by Ernestus Lommatzsch. Teubner, Leipzig, 1903.

Vitruvius *On Architecture.* LCL. 2 vols. Trans. by Frank Granger. Cambridge, Mass., and London, 1955, 1956.

Virgil *Eclogues, Aeneid and Minor Poems.* LCL. 2 vols. Trans. by H. Rushton Fairclough. New York and London, 1922.

Xenophon *Anabasis.* LCL. Trans. by Carleton L. Brownson, rev. by John Dillery. Cambridge, Mass., 1998.

THE NATURAL HISTORY OF POMPEII

1

INTRODUCTION

Wilhelmina F. Jashemski

This book grows out of my many years of excavating the ancient gardens at Pompeii and the other Vesuvian sites, and the remarkable discoveries of the many eminent, internationally known scientists who have cooperated with me through the years. When a number of scientists began finding important data that could not be assigned to a specific garden but was very important for the entire region, as for example, windblown pollen, they asked me to write papers jointly with them for their respective scientific journals. It soon became obvious that this would mean that significant new scientific information that would be of interest to many different types of readers would be buried in specialized journals. We realized the importance of bringing together this unique material in one volume. At this point I invited Frederick G. Meyer, botanist in charge of the herbarium at the U.S. National Arboretum in Washington, D.C., who had been cooperating with me in my work, to be co-editor of the volume. When we began to assemble the findings of the various scientists, it became obvious that we had the materials for a natural history of the Vesuvian sites.

We define natural history in the older, more inclusive sense as given in the *Oxford English Dictionary:* "the systematic study of all natural objects, animal, vegetable and mineral." Our group took our clue from the *Natural History (Naturalis Historia)* of the famed Roman writer, Pliny the Elder (A.D. 23/24–79), the prototype of all subsequent works on natural history. This encyclopedic work consists of thirty-seven books, Book 1 being a detailed table of contents of the material discussed in the remaining thirty-six books; these cover, as the author says, "the world of nature" (*HN* Preface 13). He repeatedly stresses that the gifts of nature are there to serve man. The subjects discussed are: cosmology (Book 2), geography (Books 3–6), man (Book 7), mammals and reptiles (Book 8), fish and other marine animals (Book 9), birds (Book 10), insects (Book 11), plants and their various uses including medicinal (Books 12–27), drugs obtained from fauna (Books 28–32), and last, minerals and stones (Books 33–37).

Pliny's method was to bring together, for the first time, the scattered material on these subjects. He says that he perused about 2,000 volumes and collected "20,000 noteworthy facts obtained from one hundred authors . . . with a great number of other facts in addition that were either ignored by our predecessors or have been discovered by subsequent experience" (*HN* Preface 17). His nephew, Pliny the Younger, lists his uncle's works in a letter replying to an inquiry from Baebius Macer, who wanted to acquire them (*Letters* 3.5). In this letter Pliny describes the way in which his uncle worked, finding time to write seven works, filling 102 *libri,* or volumes. The *Natural History,* "a learned and comprehensive work as full of variety as nature itself," was the last of his uncle's many works, and the only one that survives. The younger Pliny's description of his uncle is important to anyone evaluating the elder Pliny's work. He vividly recounts how his uncle, although a busy man who practiced at the bar, held important offices of state, and was a friend and confidant of emperors, combined a "penetrating intellect with amazing powers of concentration and the capacity to manage with a minimum of sleep." He even got up in the middle of the night to work. "When not too busy . . . a book was read aloud while he made notes and extracts. He made extracts of everything that he read. While travelling he kept a secretary at his side with book and notebook."

Fortunately, Pliny is meticulous in citing his sources

(there are more than one hundred!), which are given in Book 1 after the summary of the contents of each book. He is the only ancient author known to have systematically acknowledged his sources (Isager 1991: 29). For information in the chapters pertaining to zoology Pliny relied heavily on Aristotle's various works on animals, especially his *Historia Animalium.* As the son of a physician, Aristotle (384–322 B.C.) was introduced to Greek medicine and biology at an early age. Aristotle's pupil and friend Theophrastus (c. 372–278 B.C.), whose two works on plants are the counterpart of his teacher's biological works, is an important source for Pliny's chapters on plants. Aristotle and Theophrastus were the first to systematically apply the principles of classification to the animal and vegetable worlds.

Pliny's purpose was to write a useful, comprehensive book. His subject is man and his relationship with nature. No author, he tells us, had previously attempted to bring together in one work all of this material (*HN* Preface 14). His book was to be easily consulted. For this reason he placed the table of contents in Book 1, so his readers could quickly locate the particular subject in which they were interested (*HN* Preface 33). This is the first preserved book that contains a table of contents, today a commonplace in books. The *Natural History* has been criticized for its lack of literary polish. But Pliny was not writing a book to please literary critics or to entertain his readers (*HN* Preface 16).

In the past Pliny has been looked upon as being merely an uncritical compiler, a view revised by recent scholarship. In 1979, the nineteen hundredth anniversary of Pliny's death, scholars from all over the world, representing the many fields discussed in the *Natural History,* gathered at Como, the hometown of the Plinys, for a conference. The proceedings were published in four volumes. Two subsequent Pliny conferences followed, at Nantes and at London, with the proceedings of both conferences published. Numerous other publications followed, reevaluating Pliny's work. It is true that his work is uneven, on occasion even contradictory, but its value lies in the fact that he records what was believed at the time. Pliny was aware that his "compilation of past knowledge" was "vital to future developments" (Beagon 1992: 21).

Pliny was not a scientist, but he had an inquiring mind and was a keen observer, often recording his personal observations. Various passages in the *Natural History* indicate firsthand knowledge of parts of the empire, especially Germany, where Pliny had had military service, and Spain, where he had served as financial procurator (Isager 1991: 43, 46; Beagon 1992: 2–6). His discussion of agriculture "includes clear evidence of a personal interest in the latest developments, and its emphasis upon organization bears the unmistakable stamp of the military and administrative background of its author" (Beagon 1992: 21; see also Isager 1991: 46).

Pliny's knowledge of Italy is also reflected in his writing. He knew the area discussed in our book, for at the time of his death he was in command of the Roman fleet stationed at Misenum, across the Bay of Naples from Vesuvius. He died when trying to rescue friends during the eruption of Vesuvius in A.D. 79. Pliny the Younger, in answer to an inquiry from the historian Tacitus, described his uncle's death and the eruption of Vesuvius in two valuable letters (see Chap. 4).

Pliny was especially interested in plants, particularly medicinal ones. Stannard (1965: 423), in his article "Pliny and Roman Botany," would go so far as to call Pliny "The Father of the History of Botany." Pliny made use of illustrated Greek herbals, which could be helpful in associating Greek plants with those in his native Italy. But he points out the limitations of such illustrations (*HN* 25.8). Most important, Pliny studied the actual plants. He tells us

> I at least have enjoyed the good fortune to examine all but a very few plants through the devotion to science of Antonius Castor, the highest authority of our time; I used to visit his special garden, in which he would rear a great number of specimens.
>
> *HN* 25.9

Stannard comments, "were it not for this passage, we should never know about the ancient prototype of the modern physic garden." It is in his chapters on botany that Pliny comes closest to making a genuine contribution to science, including important information regarding the introduction of new horticultural and agricultural species into Italy.

The members of our group shared this ancient spirit of discovery. As work on our *Natural History* progressed, there were a number of difficult problems that individual scientists were trying unsuccessfully to solve. At my suggestion several scientists began to share their thinking, hoping that joint efforts might bring solutions. The question of carbonization was particularly troublesome. Why had I found carbonized and partially carbonized plant material in certain gardens, or parts of gardens, and not throughout the excavations? Some even claimed that the material had been carbonized before the eruption! Vulcanologists, paleobotanists, chemists, geochemists, and archaeologists were each working individually on this problem. They suggested it would be extremely valuable if they could meet and discuss their common problems.

In 1986 Dumbarton Oaks in Washington, D.C., made it possible for me to invite the various scientists from Europe, Canada, and the United States for a sym-

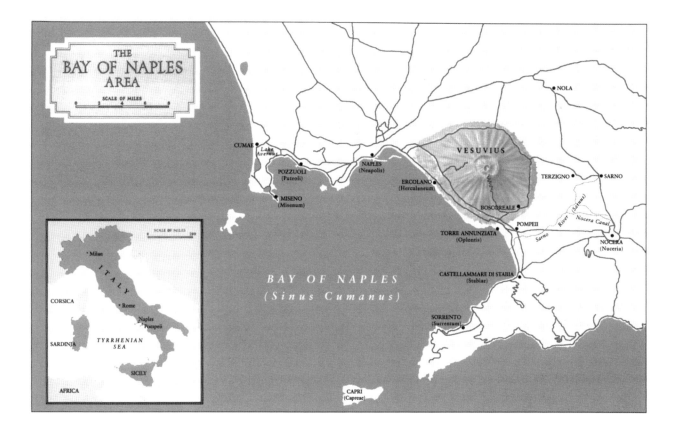

THE
BAY OF NAPLES
AREA
SCALE OF MILES

BAY OF NAPLES
(*Sinus Cumanus*)

ITALY

VESUVIUS

NOLA

CUMAE
Lake
Averno
POZZUOLI
(Puteoli)
NAPLES
(Neapolis)
MISENO
(Misenum)
ERCOLANO
(Herculaneum)
TERZIGNO
SARNO
BOSCOREALE
POMPEII
River (Sarnus)
Nocera Canal
TORRE ANNUNZIATA
(Oplontis)
Sarno
NOCERA
(Nuceria)
CASTELLAMMARE DI STABIA
(Stabiae)
SORRENTO
(Surrentum)
CAPRI
(Capreae)

Milan
ITALY
CORSICA
Rome
Naples
Pompeii
SARDINIA
TYRRHENIAN
SEA
SICILY
AFRICA
SCALE OF MILES

posium, opened by a public lecture given by the vulcanologist Haraldur Sigurdsson, followed by two days of working sessions. These sessions proved to be extremely productive. Small groups tackled common problems, and we had meetings of the entire group in which reports were given by each author, and the scope, area, and time frame of our book were discussed. Most of the evidence collected pertained to the Vesuvian sites at the time of the eruption in A.D. 79. Because of the lack of subsoil excavation there was little evidence from earlier periods. When such evidence was available, as for example the bones found in the Pompeii forum excavations, it was included and compared with that dating from the time of the eruption.

The Vesuvian area from which evidence was collected comprises an area of approximately 225 square kilometers, including Pompeii, Herculaneum, Stabiae, and the villas in the surrounding countryside (see map, Fig. 2).

The evidence from pollen reports was disappointing, because volcanic ash does not provide ideal conditions for the preservation of pollen. If it were possible to get a good lake sediment core, pollen, as well as other valuable evidence for natural history, would be perfectly preserved. But there was no lake in the Vesuvian area. Nearby Lake Averno, though not in the area of the A.D. 79 ash fall from Vesuvius, is in Campania, which included the Vesuvian sites. Campania is a small area with the same geologic history, flora, and fauna. Most exciting was the suggestion that if it were possi-

FIGURE 2 Map of the Bay of Naples area. Victoria I and Mary Todd.

ble to get intact cores, the Lake Averno sediments would yield important evidence for the natural history of the area. Several in our group, as a result of their discussions, felt the need of further fieldwork. Eberhard Grüger of the University of Göttingen and colleagues from his university, the University of Vienna, and the University of Sweden (each an outstanding specialist) were successful beyond their greatest expectations in getting excellent cores at Lake Averno. They were able to get a picture of the flora of the area from about 2000 B.C. through the Roman period, to the present. There was plentiful evidence of ancient pollen. They also got a complete stratification of the marine shells, brackish and freshwater mollusks, foraminifera, ostracods, and diatoms. These are illustrated in scanning electron microscope (SEM) photographs (see Chap. 11).

In 1989, three years after the Dumbarton Oaks symposium, a majority of the authors were able to meet at my home for another valuable working symposium. Our book was taking shape. As in Pliny's *Natural History*, some of our chapters are largely narrative, others (Chaps. 6, 12–17) are catalogues of plants, fish, aquatic mollusks, land snails, echinoderms, insects, reptiles, amphibians, birds, and mammals. In each catalogue, an effort was made to collect and record all available evidence for the topic discussed, as known

from material remains (bones, shells, carbonized plant material), wall paintings (many no longer extant, or today badly preserved), mosaics, sculpture, jewelry, and the writings of ancient authors. The various uses or special significance, many times religious, of the flora and fauna are carefully noted. These catalogues give the first comprehensive picture of all the known flora and fauna of the Vesuvian area at the time of the eruption. The catalogues of fauna in this book are the first ever compiled for the Vesuvian area.

The catalogue of plants is the longest and lists 184 plants known in the Vesuvian area at the time of the eruption. The previous catalogue of plants, now more than 100 years old, had only 50 plants, and it was concerned only with the plants at Pompeii. Plant remains are more numerous, and flora is better represented in wall paintings and mosaics, than the fauna. Like humans, the birds and other mobile animals generally escaped as the eruption progressed. In Pliny's *Natural History,* most of the subjects are treated in individual books, but he devotes sixteen of the twenty-six books to plants and their uses. The extraordinary discovery of perfectly preserved carbonized hay in the *villa rustica* at Oplontis provided many important additions to our catalogue of plants. Massimo Ricciardi and Giuseppa Grazia Aprile studied this material and were able to identify 130 taxa of flowering plants and ferns, representing 34 families and 82 genera. Of these, 106 are identifiable to species, 16 to genus, and 8 only to family (Ricciardi and Aprile 1988). This new material adds 81 species, 37 genera, and 1 family to the list of 408 plants believed to be known to the Romans in Italy in the first century A.D. (Saccardo 1909). The catalogue of plants does not include those known only from spores and pollen; our pollen finds (see Chap. 7) added 69 more plants to the list, making a total of 253 known plants in the Vesuvian area. The pollen identified in the cores taken at Lake Averno added only 8 plants not in our list. But this was to be expected. However, because the pollen was protected and had not been destroyed, there was much more pollen of each plant in the lake sediments. It may be noted that the flora throughout Campania is essentially uniform.

More recently the Superintendency of Pompeii has taken soil samples for pollen analysis at three sites: in the garden of the House of the Chaste Lovers at Pompeii (Ciarallo and Lippi 1993); in the farmland of the *villa rustica* of L. Caecilius Jucundus in the località Settetermini in the commune of Boscoreale; and in the località S. Abbondio in the commune of Pompeii, very close to the ancient course of the Sarno and not far from the ancient coast (Lippi 1993). The pollen reported from these three sites adds 26 plants not previously known in the Vesuvian area, which brings the total number of plants to 279. (See the list of plants known from spores and pollen in Table 5, at the end of Chapter 6.)

In an effort to make this book as comprehensive as possible, three other scholars were invited to contribute their valuable finds. Because of the importance of man in any discussion of natural history, the late Sara Bisel, who was studying the recently found human skeletons preserved at Herculaneum, agreed to contribute a chapter on this subject. Later Stephan T.A.M. Mols studied the furniture found at Herculaneum, identifying the woods used. His findings are included in a short chapter. The dendrochronologist Peter Ian Kuniholm had asked me early in my work at Pompeii if I had any wood charcoal of sufficient size to preserve tree rings, but unfortunately I had none. Years later, large amounts were found at Herculaneum, and the new Superintendency gave him permission to study generous samples. That study is just now being concluded in time to include in this volume.

The methodologies used by the individual authors are discussed in the context of their subject area in their respective chapters.

In this book the archaeological evidence uniquely preserved by the eruption of Vesuvius is examined in the light of the comments of the ancient authors, and the information in the inscriptions and graffiti, as well as in comparison with modern practices, which so strikingly continue those of antiquity. To this are added the findings and interpretations of many distinguished scientists, all of which makes possible for the first time a natural history of the ancient Vesuvian sites and adjoining area, such as can be written for no other ancient site.

But the Vesuvian sites still hold many secrets. Unfortunately, much of the material evidence for natural history at Pompeii has been lost forever. Most of the city had been excavated before I began salvaging plant material, bones, and shells for the first time. Our spectacular finds occurred in only a small part of the totally excavated area, often in the recently excavated sites from which most of the lapilli that contained precious evidence for natural history had been hurriedly removed.

Excavation today is proceeding more slowly, and rightfully so. The current Superintendency stresses the importance of preserving every scrap of evidence and ensuring that archaeologists work closely with scientists in many disciplines who can aid in identifying and interpreting the new evidence. Emphasis is placed on preserving and studying previously excavated areas. The limited subsoil excavations of the University of Bradford in the House of the Vestals (VI.i.7), excavated in the nineteenth century, those of the University

of Reading/British School at Rome in the House of Amarantus (I.ix.11–12), excavated in 1952–3, and the Italian excavations in the House of the Wedding of Hercules (VII.ix.47), done in 1820, have demonstrated the value of such investigations. Addresses at Pompeii have three numbers: the region, insula or city block, and the house number (see Fig. 4). Faunal remains and poorly preserved botanical evidence (mostly seeds) recovered from rubbish pits, drains, cesspits, and ritual pits, where votive remains had been buried, throw light on the natural history of pre–A.D. 79 Pompeii.

Succeeding generations of archaeologists and scientists will bring to their work increasingly sophisticated techniques, not even dreamed of today. This book is only the beginning. Slowly the Vesuvian sites will reveal their secrets.

REFERENCES

Atti del convegno di Como, 27–29 settembre 1979. 4 vols. 1980. Tecnologia, economia e società nel mondo romano, 1982. Plinio il Vecchiio sotto il profilo storico e letterario, 1982. Plinio e la natura, 1983. La citta antica come fatto di cultura.

Beagon, Mary. 1992. *Roman Nature: The Thought of Pliny the Elder.* Clarendon Press, Oxford.

Bon, Sara E., and Rick Jones. 1997. *Sequence and Space in Pompeii.* Oxbow Monograph 77, Oxford.

Carafa, Paola. 1997. What Was Pompeii before 200 B.C.? Excavations in the House of Joseph II, in the Triangular Forum and in the House of the Wedding of Hercules. In *Sequence and Space in Pompeii,* pp. 113–31. Oxbow Monograph 77, Oxford.

Ciaraldi, M. 1996. The Botanical Remains. In *Anglo-American Pompeii Project 1996,* edited by Sara E. Bon, Rick Jones, B. Kurchin, and D. P. Robins, pp. 17–34. Bradford Archaeological Sciences Research, Bradford.

Ciaraldi, M., and Jane Richardson. n.d. Food, Ritual and Rubbish in the Making of Pompeii. Unpublished.

Ciarallo, Annamaria, and Marta Mariotti Lippi. 1993. "The Garden of 'Casa dei Casti Amanti' Pompeii, Italy." *Garden History* 21: 111–15.

French, Roger. 1994. *Ancient Natural History: Histories of Nature.* Routledge, London and New York.

French, Roger, and Frank Greenaway, eds. 1986. Science in the Early Roman Empire: Pliny the Elder, His Sources and Influence. Proceedings of the London Pliny Conference.

Fulford, Michael, and Andrew Wallace-Hadrill. 1999. Toward a History of Pre-Roman Pompeii: Excavation beneath the House of Amarantus (I.9.11–12), 1995–8. In *Papers of the British School at Rome,* Vol. 67, pp. 37–144. British Academy, London.

Isager, Jacob. 1991. *Pliny on Art and Society: The Elder Pliny's Chapters on the History of Art* (especially the first four sections). Routledge, London and New York.

Lippi, Marta Mariotti. 1993. Contributo alla conoscenza del paesaggio vegetale dell'area di Pompei nel 79 d.C. In *Parchi e Giardini Storici, Parchi Letterari,* Vol. 3, pp. 141–45.

Pline l'ancien, témoin de son tempo. 1987. Salamanca-Nantes. Proceedings of the 1985 Pliny Nantes Conference.

Ricciardi, M., and G. G. Aprile. 1988. Identification of Some Carbonized Plant Remains from the Archaeological Area in Oplontis. In *Studia Pompeiana & Classica in Honor of Wilhelmina F. Jashemski,* edited by Robert I. Curtis, vol.1, pp. 317–30. Aristide D. Caratzas, Publisher, New Rochelle, N.Y.

Richardson, Jane, Gill Thompson, and Angelo Genovese. 1997. New Directions in Economic and Environmental Research at Pompeii. In Sara E. Bon and Rick Jones, *Sequence and Space in Pompeii,* pp. 88–101. Oxbow Monograph 77, Oxford.

Saccardo, Pier Andrea. 1909. *Cronologia della Flora Italiana.* Bologna. Tipografia del Seminario. Padua. (Reprinted in 1971 by Edagricole, Bologna.)

Stannard, Jerry. 1965. "Pliny and Roman Botany." *Isis:* 420–5.

Wallace-Hadrill, Andrew. 1990. "Pliny the Elder and Man's Unnatural History." *Greece and Rome* 23: 80–96.

2

THE VESUVIAN SITES BEFORE A.D. 79
THE ARCHAEOLOGICAL, LITERARY, AND EPIGRAPHICAL EVIDENCE

Wilhelmina F. Jashemski

Campania is the fairest of all regions not only in Italy but in the whole world. Nothing can be softer than its climate; indeed it flowers twice a year. Nowhere is the soil more fertile; for which reason it is said to have been an object of contention between Liber and Ceres. . . . Here are the vine-clad mountains . . . Vesuvius the fairest of them all. . . . Toward the seacoast lie the cities of . . . Naples, Herculaneum and Pompeii.

<div align="right">Florus Epitome of Roman History 1.11.3–6</div>

Tragedy overtook the prosperous Campanian cities of Pompeii, Herculaneum, and the many villas in the surrounding countryside when Vesuvius erupted in A.D. 79. Sealed through the centuries in volcanic debris, these sites have preserved for us intimate details about many aspects of Roman life otherwise unknown. In this chapter, after briefly surveying what is known about the early history of these sites, a more detailed description of Pompeii and several villas will enable the reader to visualize places that are frequently mentioned in other chapters in this book.

HISTORY

Both Pompeii and Herculaneum were Roman cities at the time of their destruction, but they had been Roman for only a small part of their existence. Their origins are lost in antiquity. Legend recounts that both Pompeii and Herculaneum were founded by the Greek hero Herakles on his return from Spain (Solinus *Collectanea Rerum Memorabilium* 2.5 for Pompeii; Dionysius of Halicarnassus *Roman Antiquities* 1.45 for Herculaneum). According to tradition, the earliest settlers were Oscans, the indigenous population of Campania. The Greek geographer Strabo, who lived at the beginning of the Christian era, said that both Pompeii and Herculaneum were occupied in turn by Oscans, Etruscans, Pelasgians, Samnites, and Romans (Strabo 5.4.8). But our only reliable evidence is archaeological, and to date this is scanty.

The origins of the city and its urban development have been much debated by scholars. Subsoil excavations would undoubtedly answer many questions about the early history of both Pompeii and Herculaneum. But the authorities are understandably reluctant to undertake extensive stratigraphic excavation, for this would necessitate the destruction of the Roman cities, which continue to be studied by scholars with significant results and are enjoyed by millions of visitors every year. However, limited subsoil excavations, some down to virgin soil, in various previously excavated sites are discovering exciting new evidence relating to the origin and urban development of Pompeii (see Fulford and Wallace-Hadrill 1999: 103–12, for a list of the principal subsoil excavations at Pompeii and the significance of the evidence derived from them).

Continuing subsoil excavations will make possible a better understanding of the early city. The present available archaeological evidence suggests that Pompeii was founded by the Etruscans, in the territory of the indigenous Oscans, between the end of the seventh century and the beginning of the sixth century B.C. The only inscriptions found on the pottery dedicated in the archaic Temple of Apollo, adjacent to the forum, are Etruscan. There was a very strong Greek influence, nevertheless, from the neighboring colonies and the settlements on the Gulf of Naples. This explains the presence of Greek pottery and the style of the architec-

tural terra-cottas of the two archaic temples, the so-called Doric temple in the triangular forum, and the Temple of Apollo (De Caro 1986: 21).

Toward the end of the fifth century B.C. the warlike Samnites, an Italic tribe, descended from their mountain homes and conquered Campania. At that time both Pompeii and Herculaneum became Samnite towns, within the league dominated by the Nucerians, and they remained so for almost four centuries. Although formally independent, since the third century B.C. both cities were politically in the orbit of Rome probably as "allies" (*socii*).

The first mention of Pompeii in history is found in the writings of the Roman historian Livy (9.38.2–3), who says that during the Second Samnite War a Roman allied fleet (*socii navales*) landed at Pompeii (in 310 B.C.) but set out toward Nuceria to pillage. In the third, and mostly in the second century B.C., Pompeii became a prosperous, handsome city. Archaeological evidence indicates that this was a period of monumental building under strong Hellenistic influence. Fine temples were built, the colonnades in the forum and in the triangular forum, the impressive basilica at the edge of the forum, the large theater, and the Stabian Baths. The streets were lined with luxurious homes, such as the House of Sallust, the House of Pansa, the House of the Faun, and the House of the Centenary, among others. This brilliant period of Pompeian architecture, never again to be equaled, is known as the tufa period, from the fine-grained, easily worked gray tufa, a volcanic dust hardened by water into rock, quarried in the vicinity of Nuceria, that was used at that time.

The complete subjugation and Romanization of Campania did not come until the Social War (90–88 B.C.). The Greek historian Appian in his discussion of this war includes the Pompeians in the list of Italic allies that joined together against Rome (*Civil Wars* 1.39). Because of this, Pompeii was beseiged by the Roman general L. Cornelius Sulla in 89 B.C., but apparently without success. The stone balls with which Sulla bombarded the walls can still be seen adorning some of the ancient gardens. Pompeii submitted, but the city appears to have been left unpillaged. Herculaneum, however, was conquered in 89 B.C. and became a Roman *municipium* (Velleius Paterculus *Compendium of Roman History* 2.16–21). Stabiae was completely destroyed by Sulla, and from then on that city ceased to exist (Pliny *HN* 3.70). Pompeii's punishment came later, in 80 B.C., with the settlement on land confiscated from the Pompeians of a colony of Sulla's veterans. The name of the colony, *Colonia Cornelia Veneria Pompeianorum,* was derived from the gens name of L. Cornelius Sulla and from the goddess Venus, whom he especially revered. Pompeii now became a Roman city, with a new constitution and new magistrates. Latin became the official language and Venus Pompeiana the tutelary deity of the city.

P. Cornelius Sulla, probably the nephew of L. Cornelius Sulla, was the leader of the colony. We learn from Cicero that dissensions arose between the Pompeians and the colonists, but Cicero seemed to feel that Sulla settled the veterans with a minimum of friction (*Pro Sulla* 62). The colonists developed a real interest in the city. Additional buildings were erected, including the covered theater, the amphitheater, and the Forum Baths, buildings that were functional but lacking the beauty of those built in the previous tufa period. Among the new buildings are three that show the loyalty of the Pompeians to the cult of the emperor (discussed later in this chapter). Two of these were built by wealthy women. Few additional houses were needed.

The literary sources are equally scant for the imperial period. Most of our information about the history of Pompeii is derived from the architectural evidence together with the epigraphical evidence. The inscriptions are numerous and of many different kinds. There are the monumental inscriptions cut in stone on public buildings, statue bases, and tombs. Painted inscriptions on buildings throughout the city recommend candidates for public office, announce animal hunts and gladiatorial combats in the amphitheater, and sometimes advertise buildings for rent. The most important inscriptions relating to business transactions are the wax tablets that contain receipts found in the house of the banker, L. Caecilius Jucundus. Other information is obtained from the inscriptions found on amphoras giving their contents. There are also the stamps found on bricks and on pottery. Most plentiful are the thousands of graffiti scratched on the walls throughout the city. Love is the most prominent theme. Some graffiti tally bills, others give the prices of items for sale, record the birth of pets, record proverbs, or give quotations from Vergil or other poets. Children practiced writing their alphabets on the walls.

Only three events before the final destruction of Pompeii are mentioned by the historians. According to Suetonius (*Claudius* 2.7.1), Drusus, the eldest son of the emperor Claudius, choked to death on a pear at Pompeii, which suggests that the emperor owned property in the area. Tacitus reports a fight that broke out in the amphitheater in A.D. 59, during the reign of Nero between the Pompeians and the Nucerians, so serious that it had to be settled in Rome (Tacitus *Annals* 14.17). On February 5, in A.D. 62, just seventeen years before its final destruction, Pompeii suffered a severe earthquake that brought life to a sudden halt (see Chap. 3). The event is mentioned by the historian Tacitus (15.22); Seneca reports that Pompeii suffered the worst damage, but Herculaneum and Nuceria were not without

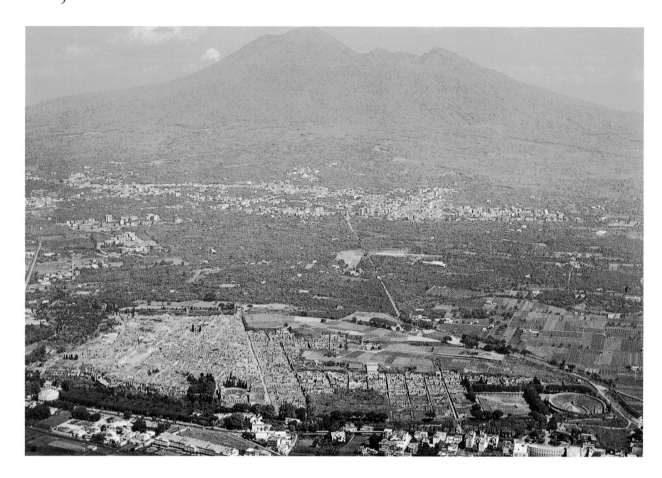

FIGURE 3 Air view of Pompeii in fertile Campanian plain. Photo: Courtesy of Pompeii Tourist Board.

damage (Seneca *Q. Nat.* 6.1.1–3, 6.27.1). It is Pompeii that furnishes the most detailed evidence and documents the magnitude of the calamity. Scarcely a building was left undamaged. The public buildings around the forum were virtually destroyed. Two sculptured reliefs in the House of Jucundus vividly portray the effects of the earthquake (see Chap. 3 and Figs. 30, 31).

After the earthquake the aqueduct, introduced during the reign of the emperor Augustus (27 B.C.–A.D. 14), was no longer functioning. But the Pompeians set to work with great energy to clear the rubble. Dumps were set up both within and outside the city. Work began on the aqueduct to get it functioning, at least partially, as soon as possible. The Pompeians began to beautify their city. The little temple of the Egyptian goddess Isis was completely rebuilt. The inscription above the entrance to the courtyard of the temple says that after the earthquake Numerius Popidius Celsius, at his own expense, rebuilt the temple of Isis from its foundation; in recognition of his generosity, even though he was only six years old, the members of the city council admitted him without cost to their rank (*CIL* X 846). The temple was obviously paid for by the father, who as a freedman would not be eligible for membership on the city council. Restoration and rebuilding of most structures took much longer. Homes were patched up to become habitable, but all of this was far from accomplished when the final catastrophe brought an end to the city.

THE CITY OF POMPEII

Pompeii gives us our most complete picture of life in Campania at the time of the eruption, for here we have a complete city preserved and approximately three-fourths excavated. At Herculaneum, because of the rocklike nature of the fill, which makes excavation very difficult, only four city blocks with parts of four or five others have been excavated. (For the way in which Herculaneum was covered see Sigurdsson, Chap. 4; for wood studies that throw light on the nature of the eruption see Hatcher, Chap. 8.) But at Pompeii it is possible to get the feel of the entire city, to study its plan and land use, the distribution and character not only of its public buildings but also of its places of business and homes, and to experience the role of the garden in the life of the people. Pompeii is oval in shape, as determined by the contour of the prehistoric lava flow on which it was built (Figs. 3, 4). On the west, south, and east the city walls follow the edge of the lava stream.

The public buildings at Pompeii were for the most

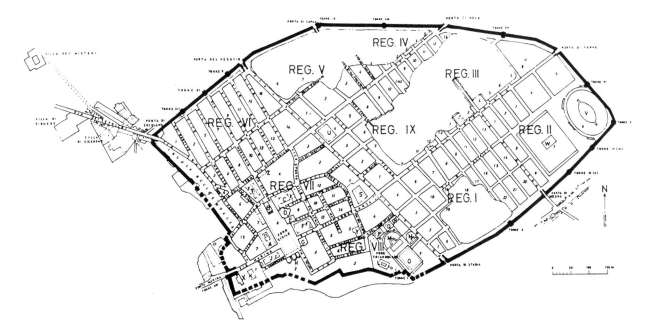

part grouped in three areas; in the area of the so-called triangular forum, around the forum, and at the eastern edge of the city. The triangular forum, located at a height of twenty-three meters above sea level, overlooking the bay, had more the character of a Greek acropolis. It was here that the previously mentioned sixth century B.C. Doric temple was built. The theater, built during the tufa period, utilized in the Greek manner the natural slope to the east of the triangular forum. The adjacent smaller covered theater was built by the Romans. Also in this group was the little temple, formerly believed to be the temple of Zeus Meilichios (De Caro, 1991: 42), which served as the Capitolium during the rebuilding of the badly damaged Capitolium in the forum; the temple of Isis (mentioned earlier); and the old Samnite Palaestra.

The second area in which public buildings were located was the forum, the heart of every Roman town (Fig. 5). Around the forum at Pompeii was grouped an impressive array of public buildings connected with the religious, political, and religious life of the town (Fig. 6). Towering behind the majestic temple on the north, which was dedicated to the Capitoline triad, Jupiter, Juno, and Minerva, was Vesuvius, even more impressive in antiquity, before its great size was diminished (Fig. 7). At the northeast edge of the forum was the Macellum, a large provision market. To the south was a building usually identified as a shrine built to the Lares, the guardian deities of the city, as an act of expiation after the earthquake. Next was the small temple, with a beautiful sculptured altar, built by the public priestess Mamia to the Genius of the Emperor (commonly referred to as the Temple of Vespasian), one of the buildings that showed the popularity of the imperial cult at Pompeii (*CIL* X 816). Next was the large and

FIGURE 4 Plan of Pompeii: H. Eschebach. When Guiseppe Fiorelli became director of the excavations in 1860, he divided the city into nine regions. Each region was subdivided into numbered *insulae*, or blocks, and each entrance in each block was assigned a number. Thus each door has an address of three numbers.

important building given to the city by Eumachia, also a public priestess, and dedicated to Concordia Augusta and Pietas, showing reverence for the imperial family (*CIL* X 810). This building, which balanced the older basilica, had some of the same uses. The large rectangular central court was enclosed by a portico on all four sides, with a corridor behind the portico on three sides. The prominently displayed statue of Eumachia, dedicated by the fullers, would indicate that the building was useful to their trade (*CIL* X 813). It may have served as a place for fairs of various trades, and perhaps also as a market. Its porticoes provided a shady place to stroll and talk. It is quite possible that the interior court was planted, as was the Portico of Livia and some of the other porticoes in Rome. Fortunately, the beautiful marble relief that framed the wide entrance, sculptured with acanthus and other plants, birds, insects, small mammals, and reptiles, has been well preserved (Fig. 8).

Opposite the Temple of Jupiter, Juno, and Minerva, on the south end of the forum, dominated by the Lattari Mountains in the distance, were three buildings devoted to municipal government. The large basilica facing the southwest corner of the forum, one of the handsome buildings erected by the Samnites during the tufa period, is believed to have served as a place for the administration of justice, perhaps as a banking center, and on some days a market. Immediately to the west of

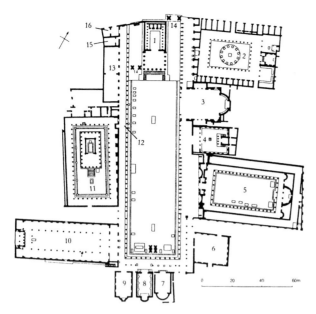

FIGURE 5 Plan of forum and adjoining buildings: (1) Temple of Jupiter, Juno, and Minerva; (2) Market (Macellum); (3) Sanctuary of the City Lares; (4) Temple of Vespasian; (5) Eumachia building; (6) Voting hall (*comitium*); (7–9) Municipal buildings; (10) Basilica; (11) Temple of Apollo; (12) Control of weights and measures; (13) Market buildings; (14) Commemorative arches; (15) Public latrines; (16) City treasury. Plan: Ward-Perkins.

the basilica was the commanding site of the Temple of Venus Pompeiana. The rebuilding of this temple after the earthquake had only just begun before the eruption. Across from the Temple of Venus was the precinct of the Temple of Apollo, a site long dedicated to worship. This handsome temple, built during the tufa period, underwent various changes, was renovated during the time of Nero, but was badly damaged by the earthquake and not yet restored in A.D. 79. (De Caro 1986: 24–25).

In the recess of the outside east wall of the Temple of Apollo, on the west side of the forum, was the *mensa ponderaria*, the limestone table containing bowl-shaped cavities that were the official dry and liquid measures. A close examination shows that the original cavities in the table were enlarged and the names of the Samnite measures erased when they were brought into conformity with the Roman standard. Next, on the west side of the forum, are market buildings and a spacious public latrine, and finally the city treasury, as well as the jail, both located on the forum, as the architect Vitruvius suggested. Even though the forum was located near the west edge of the city, where a sufficiently large level space was available, no one was more than a fifteen-minute walk from its throbbing activity. Here people came to worship, to buy and sell, to conduct the business of the city, to discuss the latest civic questions, and not least, to meet friends and exchange the

gossip of the day. The colonnade around the forum furnished shelter from inclement weather. The Temple of Fortuna Augusta, protectress of the imperial family (*CIL* X 820), was only a short distance north of the forum.

The third area with public buildings was located at the eastern edge of the city. Here, on still vacant land, the Romans built the amphitheater and the Grand Palaestra, a large area for exercise and sports, enclosed on three sides with a portico, and with a huge swimming pool in the center (Fig. 9). This choice of site followed the tradition of locating buildings used by large numbers of people away from the forum and the center of the city. Public buildings not located in or nearby these three areas were the three public baths, which were conveniently located at major crossroads in the city. The large Central Baths at the intersection of the Via Nola and the Via Stabiana had not been completed at the time of the eruption.

Scattered throughout the city were many small shops. No zoning laws confined them to certain areas of the city. During business hours they were completely open to the street. Many were wine and food shops, with a counter facing the sidewalk, so that customers could be served without entering the shop. In some of the huge terra-cotta dolia embedded in the masonry counters, excavators have found, at both Pompeii and Herculaneum, the foodstuffs offered for sale. Perfectly preserved in carbonized form were quantities of nuts, beans, chickpeas, grains, and fruits (see Chap. 6). Carbonized oak galls were found in a Herculaneum shop (for their use see Chap. 14). Other shops sold such things as flowers, tools, pots, and pans.

There were also various businesses that required more space, such as bakeries, marble-working shops, a woodworking shop, a *garum* shop (fish sauces were a staple of the Roman diet; see Chap. 12), a tannery, and many dye shops and fulleries. These businesses were located in residences that had been damaged by the earthquake. But the prosperity of this extremely fertile region was based primarily on agricultural products, wine being the most important. We learn from Cato that Pompeii was a good place to buy both wine and oil mills. The millstones were made of lava. The best plows for turning black loam were from Campania. Nola and Capua were the best places to buy copper vessels (Cato *RR* 22.4, 13.2–3).

Pompeii was a busy, commercial city. Archaeological evidence indicates that it enjoyed considerable trade with many places in the Roman Empire. The port of Pompeii at the mouth of the Sarnus River also served

(*Opposite*) FIGURE 6 Balloon photograph. Forum and adjoining buildings. Photo: Julian Whittlesey Foundation.

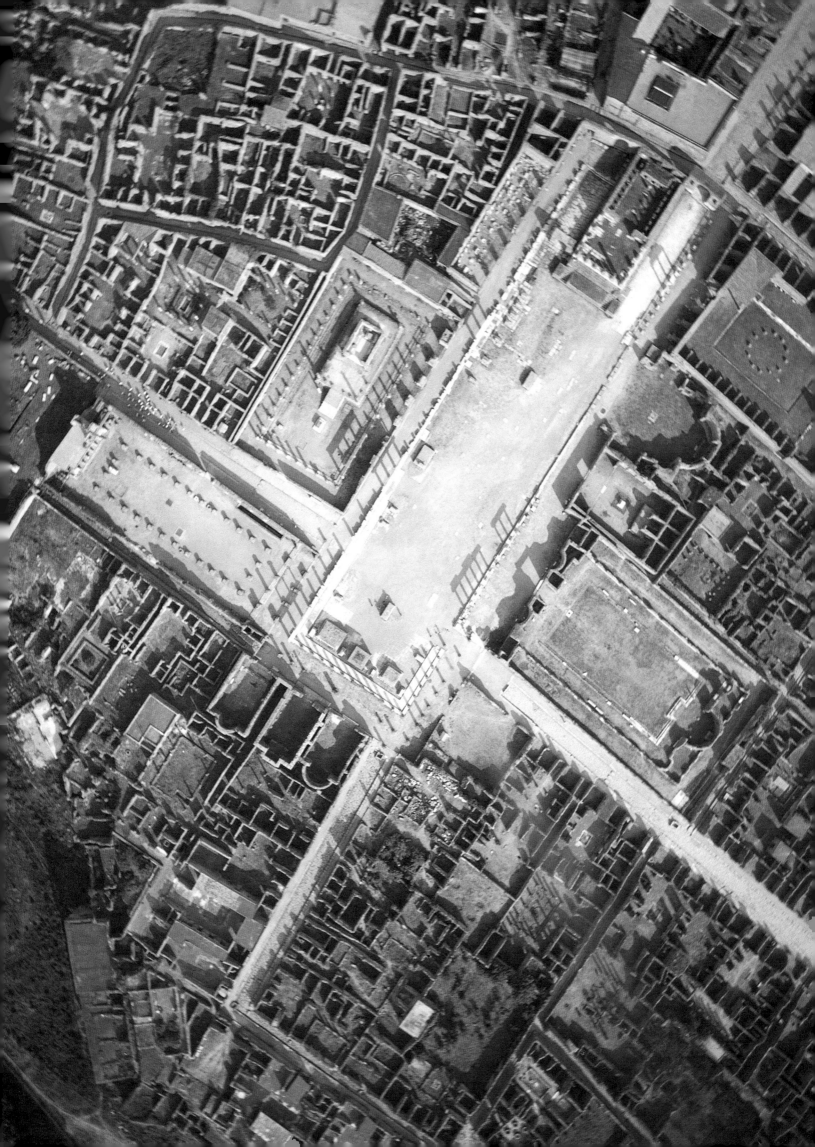

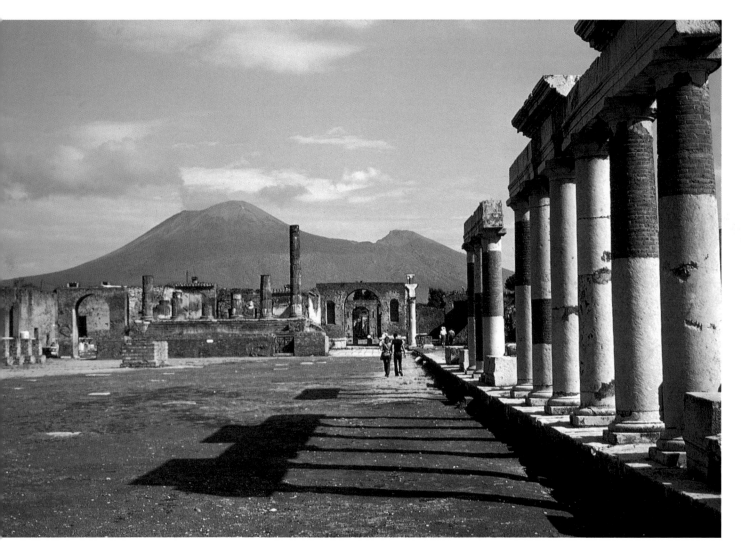

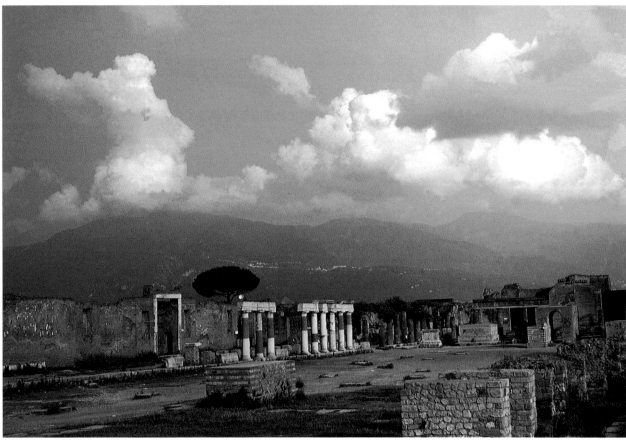

FIGURE 9 The Grand Palaestra. Illustration: M. Sasek.

the towns in the interior and the villas in the surrounding countryside. We learn from Strabo (5.4.8) that Pompeii served as the port for Nuceria and Nola. Their products would be brought to the port of Pompeii, and if to be sold abroad would be transferred to seagoing vessels. Imports for these cities would arrive at the port of Pompeii.

There were probably many market-gardens in the Sarnus valley, as there are today. Pompeii was known for its onions and cabbage. In antiquity the Sarnus was a broad, navigable river that carried much produce. The painting on the front of a large lararium (household shrine) in a small garden (I.xiv.6–7) in the southeast part of Pompeii preserves valuable evidence of this river traffic in agricultural produce (Fig. 10). The river god Sarnus is shown pouring water into the river. The narrow channel of water, which surrounded the lararium on three sides, suggests a continuation of the river. Agricultural produce, thought to be onions, is being brought to the riverbank, weighed, and then loaded on a boat in the river (Fig. 10). The exact location of the port of Pompeii has not yet been determined because of the change in the coastline, which now extends farther into the sea, but the port is thought to be not far from the Porta di Stabia in the area of Bottara, where a shrine to Neptune was identified (Chap. 4).

There were numerous restaurants, inns, stables, and a few large hotels in Pompeii, understandably concentrated near the city gates, the forum, and the amphitheater, indicating that they served many visitors coming to the city. Wall paintings and the many graffiti found on the walls give a lively picture of activities in these places. Sometimes prices are given, but unfortunately

not quantities. One interesting graffito on the wall of an inn (IX.vii.24–25) gives the cost of a variety of items for eight consecutive days (*CIL* IV 5380). Among the items listed are cheese, bread, oil, wine, onions, leeks, dates, grits (*halica*), incense, and women.

It is the preservation of its many houses and gardens, however, that makes Pompeii unique. At some ancient sites in other parts of the Roman world, streets of houses have been excavated, but never an entire city. From the exterior, the many houses at Pompeii look much alike, for they have unpretentious and monotonous facades, broken only occasionally by projecting second stories or balconies. In antiquity cities were laid out to conserve space, so that the city would be easily defensible. The city was normally divided into blocks, or *insulae*, and the houses built contiguously, sharing party walls. The Pompeian house had an inward orientation with the house enclosing the garden to ensure privacy. Windows on the street were small and high; some had grates, a few had opaque glass. Facades, which were large expanses of unbroken walls, were open invitations for professionally painted electoral notices, announcements of spectacles to be held in the amphitheater, and the many graffiti that make the city come alive.

It is only when one leaves the bustling street and enters the house that Pompeian homes begin to take on individuality, for behind the monotonous facades there is a great variety that reflects more than three hundred years of architectural development. As mentioned earlier, the homes of the earliest inhabitants are for the most part unknown to us, for they lie below subsequent construction and await subsoil excavation. During a recent project to supply water and fiber-optic cable throughout Pompeii, which necessitated running trenches along the pavements of most of the major streets, it was possible to make stratigraphic investiga-

(*Opposite above*) FIGURE 7 View of the forum toward the Temple of Jupiter, Juno, and Minerva and Vesuvius. Photo: S. Jashemski.

(*Opposite below*) FIGURE 8 View of the forum toward the Eumachia building and the municipal buildings. Photo: S. Jashemski.

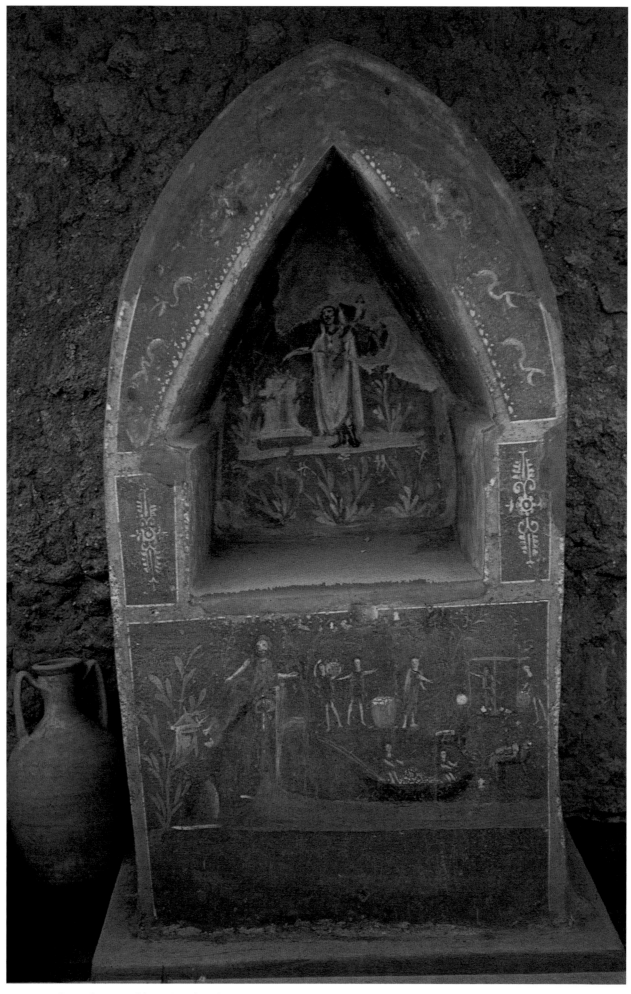

FIGURE 10 Sarnus lararium. Photo: S. Jashemski.

tions, which revealed important information (Nappo 1997: 91–120).

From earliest times the garden played a basic role in Roman life, for the *hortus,* or garden plot, formed a significant part of the primitive *heredium* (hereditary estate). The garden was an essential aspect of the early Italic house. The earliest known houses at Pompeii had gardens at their rear. It has often been said that when the peristyle became an important part of the house, the house of this period was created by adding the Hellenistic peristyle to the rear of the old Italic house. But the peristyle took on a very different aspect in the Italic house. The peristyle served much the same function in the Hellenistic house as did the atrium in the Italic house, namely that of a courtyard that gave access to the various rooms about it. When the Italians added the peristyle to the atrium house, they transformed it by making it into a garden, instead of leaving it as a beaten clay court or paving it with cobblestones, cement, or mosaics, as in the classical Greek and Hellenistic houses. No Greek domestic architecture has been found that shows evidence of having been planted.

The House of Pansa (Fig. 11) is one of the most significant old Samnite houses. It was a large house that occupied a city block. Behind the atrium was a peristyle garden enclosed by a portico on four sides and with a large pool in the center. At the rear of the house a colonnade looked out on a large garden (26.5 × 30.5 m), which occupied almost a third of the *insula,* a garden reminiscent of those found at the rear of earlier Italic houses. The planting pattern at the time of the eruption was perfectly preserved when the house was excavated in the early nineteenth century. A plan made by the excavator shows the garden systematically laid out in rectangular plots about two and one-half meters wide, separated by paths that were also used as irrigation channels. The layout is precisely that recommended by Pliny the Elder, who gives directions for making the plots and bordering them "with sloping rounded banks, surrounding each plot with a furrowed path to afford access for a man and a channel for irrigation" (*HN* 19.60). The plan of the garden in the House of Pansa is clearly that of a produce, not an ornamental, garden – the same plan as is used in the produce gardens in the Pompeii area today. In this house, even though a peristyle was added, the garden plot at the rear was retained.

A house-by-house survey of domestic architecture at Pompeii shows that there was by no means a typical dwelling, but it does show that the one-family house was usual, rather than the apartment building that later characterized domestic architecture in Rome and Ostia. The house might have an atrium and peristyle, or only an atrium, or only a peristyle. Some of the larger houses had two atria and two or more peristyles,

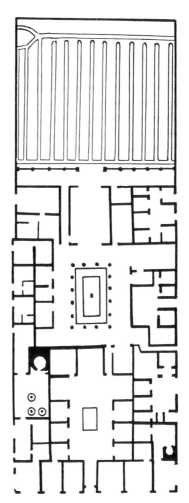

FIGURE 11 Plan of the House of Pansa: H. Eschebach.

or sometimes a garden plot at the rear. Gardens might have a portico supported by columns or a covered passageway without columns on one, two, three, or four sides. These houses are not as universal as has been thought. Only about three hundred such homes have been found in the part of Pompeii excavated thus far. The more humble citizens occupied the numerous smaller homes of irregular plan. Many were commercial in character, with living quarters above, to the rear, or at the side of the shop. Most houses had no more than two stories. But during the Roman period, when the city walls were no longer needed for protection, multistoried houses with terraces and roof gardens, which had spectacular views toward the bay, were built over the walls in the southwestern and western part of the city. The recently excavated mansion of Fabius Rufus, built over the west wall, had four stories. Roof gardens were the target of Seneca the Younger's acid pen in a passage in which he deplores the unnatural practice of planting the tops of houses with trees, with their roots where the roofs should be (*Epistulae* 122). Pliny (*HN* 15.47) speaks of imported trees that were particularly suited for such gardens.

Pompeii was a city of gardens and trees (Fig. 12), as

was Herculaneum (see Jashemski 1993 for a plan and description of every known garden in the Vesuvian area). The garden, as we have seen, was a significant factor in the development of the house. In addition to the peristyle gardens, some very large, some very small, there were also many courtyard gardens (which had no passageways on one or more sides), some "no larger than a professor's desk," as the Russian archaeologist Tatiana Warscher aptly described them to me. An elegant house might have as many as three or four large gardens. But even the poor, if at all possible, made places in their modest houses for a tiny garden. We find that those who lived in rooms behind their shops, as many of the petty tradesmen did, allotted precious space to gardens. The desire for a bit of green, a few herbs and flowers, appears to have been an intrinsic part of the Roman character. There were also many cultivated areas, some attached to humble houses, within the city walls at Pompeii — vineyards, orchards, a large commercial fruit, nut, and vegetable garden, and a commercial flower garden.

Gardens were also found in public places, such as temples and palaestras. Much of life was lived in the out-of-doors. There were gardens connected with inns, restaurants, hotels, schools, and various places of business. Gardens are likewise found outside the city gates, connected with the tombs that line the roads leading to Pompeii (see Jashemski 1979 for a discussion of the various types of gardens).

When I began studying the gardens of Pompeii I found that the incomplete publication, or lack of publication, and the scanty photographic documentation of these sites made a careful on-site examination of every garden necessary. It took many summers to clear away the weeds, brambles, and weed trees that hid many of the gardens, and to study, document, and photograph every garden in the Vesuvian sites. It was only after I had located every garden in the excavated area at Pompeii that it was possible to compute the percentage of space devoted to gardens, as well as to other purposes, and to note the way in which each function was distributed in the city. A summary of land use at Pompeii shows that gardens attached to houses occupied 2.6 hectares or 5.4 percent of the excavated area; large food-producing areas occupied 9.7 percent; gardens attached to various public buildings and businesses (entertainment, temples, industrial and commercial use, and government) account for another 2.6 percent. In other words, buildings occupied 64.7 percent, gardens and cultivated areas 17.7 percent, streets and fora another 17.7 percent. More than one-third of the excavated city was open space. This figure would perhaps be even larger if the entire city were to be excavated, for the indications are that there is a greater percentage of open space in the area still unexcavated. Pompeii, because of the way in which it has been preserved, is the only ancient city for which such a study of land use is possible. The amount of open space and of land under cultivation tells us a great deal about the quality of life in this ancient city. Ancient Pompeii, with its many open areas of green — gardens, parks, vineyards, orchards, and vegetable plots — must have been very beautiful. Limited excavations at Herculaneum show that the garden there, too, was important in both public and domestic architecture.

In addition to examining every garden previously excavated, I have had the good fortune of excavating many gardens in Pompeii, at the luxurious villa at Oplontis, and farmland at the recently discovered *villa rustica* at Boscoreale. It is from these excavations, in which I have been assisted by many eminent scientists, that much new evidence has accumulated regarding the natural history of Pompeii and other Vesuvian sites.

The first consideration in any planted area is the soil. John Foss, on many trips to the Vesuvian area, has studied the ancient soils, compared them to the modern soils, and has contributed important new information to our knowledge of the ancient gardens (see Chap. 5).

In our excavations all evidence for what had been grown was carefully salvaged and studied. Soil contours, the size and shape of root cavities, planting patterns, and the distance between roots all furnish important evidence. In the Pompeian area, it is possible to remove with special tools the lapilli that filled the cavities, as the roots of the trees and bushes gradually decayed following the eruption (Fig. 13). We then reinforce the cavities with heavy wire and fill them with cement (Fig. 14), which is allowed to harden for three days or more (Fig. 15). When the soil around the cast is removed, the shape of the ancient root is revealed (Fig. 16). The next step is the identification, if possible, of the root. On this matter we had the expertise of Carlo Fideghelli, who has made a study of the shapes of living tree roots in Italy. The technique used in making casts of root cavities was first developed by Giuseppe Fiorelli, Director of Excavations at Pompeii (1860–1875), to make casts of bodies of individuals who perished during the eruption.

In some sites we found carbonized vegetables, fruits, nuts, and seeds, which have been studied and identified by Frederick G. Meyer (see Chap. 6). This new evidence is important because it is the first time such material has been found in situ showing where and how the food was grown. The only carbonized food found previously had been produce offered for sale in shops or found in homes. The carbonized roots and stems identified by Francis Hueber, paleobotanist at the Smithsonian Institution, and Joan Sheldon, at the Institute of Archaeol-

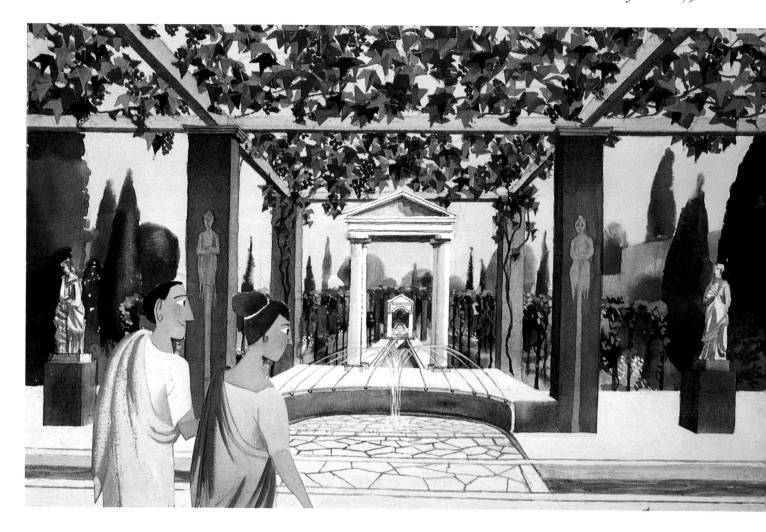

FIGURE 12 View of lower garden from the terrace, House II.ii.2. Illustration: M. Sasek.

ogy, University of London, add further information of value (Chap. 6). Soil samples taken for pollen and spore identification were studied by G. W. Dimbleby and since his retirement by Eberhard Grüger (see Chap. 7). John Kingsolver identified the carbonized insects; Gary Hevel insects in the wall paintings; Hiram Larew the insects in the sculpture, in some paintings, and those found in the carbonized galls (see Chap. 14). The reptiles and amphibians in the wall paintings, sculpture, and mosaics, and the reptile bones are discussed by Liliane Bodson (see Chap. 15). The snakes in the lararium paintings have been studied by David Orr (see Chap. 15).

The Pompeians spent much time in their gardens, which served as another room. Here they worked and played. Many gardens had masonry triclinia, couches on which the family and their guests reclined to eat during the long summer months. Discarded bones and shells tossed into the garden during a meal are another valuable source of information about the natural history of the area. The presence of altars, near many triclinia in the garden, show that the garden was also a place of worship. The animal bones found in these gardens have been identified by the late Henry Setzer, curator of mammals and director of the African Mammal Project at the Smithsonian Institution (Chap. 17),

the shells by David Reese (Chap. 13), and the bird bones by Storrs L. Olson, curator, department of zoology at the Smithsonian Institution, and George Watson (Chap. 16). The animal bones that were the remains of public sacrifice were identified by Anthony King, who discusses mammals in Chapter 17. The fish bones found are discussed by David Reese (Chap. 12).

A modest garden was often made to appear larger by painting the picture of a garden on one or more of the walls that enclosed the garden. Behind a painted fence, plants and trees, along with statues and fountains too large for the actual garden, could be pictured (Fig. 17). These paintings offer a valuable source of information about the plants known to the ancient Campanians (see Chap. 6). In a few cases, an entire room within the house was painted to represent a garden. These are better preserved because they were not exposed to the elements. Garden paintings in two houses at Pompeii, the House of the Fruit Orchard (I.ix.5) and the House of the Wedding of Alexander or the House of the Gold Bracelet (VI. insula occid. 42), will be cited frequently, both because of the quality of

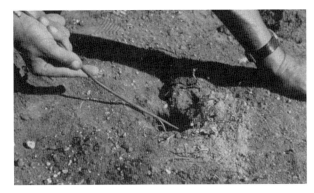

FIGURE 13 Cleaning lapilli from a root cavity. Photo: S. Jashemski.

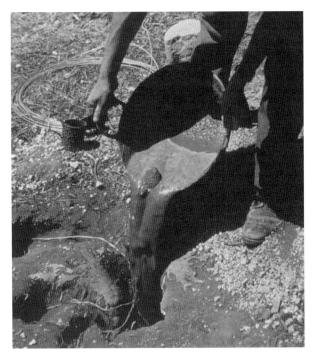

FIGURE 14 Pouring cement into a reinforced cavity. Photo: S. Jashemski.

their paintings and because of their good state of preservation at the time of excavation. Birds, often portrayed with a remarkable fidelity to detail, were an important part of garden paintings. These have been identified by George Watson (Chap. 16). The fish pool was a popular aspect of many gardens. Some garden paintings even picture fish in the pools. The fish in the garden paintings have been identified by Eugenie Clark (Chap. 12). In spite of their importance in Pompeian life, little attention has been paid to garden paintings by scholars in the past, who were more interested in the other paintings within the house, addressing themselves to the various styles of wall paintings and the many mythological paintings.

Many garden walls also contained huge paintings of almost life-size wild animals. It seems very natural and charming to see the size of a modest garden enlarged through a garden painting. But if the owner

had greater aspirations, he might include in his garden decoration, in addition to fountains, trees, birds, and flowers, also lakes or streams in a mountainous setting full of wild animals. Recent scholarship suggests that such animal paintings reflect the great enthusiasm for the animal hunts in the amphitheater (Chap. 17). Henry Setzer identified the animals in these paintings.

SITES MENTIONED FREQUENTLY

The location of a garden, its sculptures, and paintings give us important information about its appearance, but only excavation can tell us how a garden or piece of cultivated land actually looked at the time of the eruption. A brief description of my excavations in six gardens and cultivated areas, each of a different type, will illustrate the various kinds of evidence found that will be discussed at greater length in subsequent chapters of this book and will enable the reader to visualize the context in which the evidence was found. A seventh

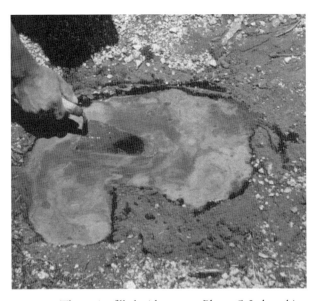

FIGURE 15 The cavity filled with cement. Photo: S. Jashemski.

FIGURE 16 The cast after the surrounding soil has been removed. Photo: S. Jashemski.

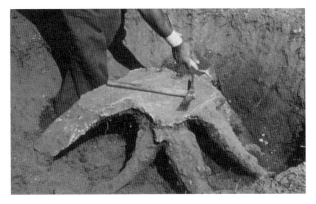

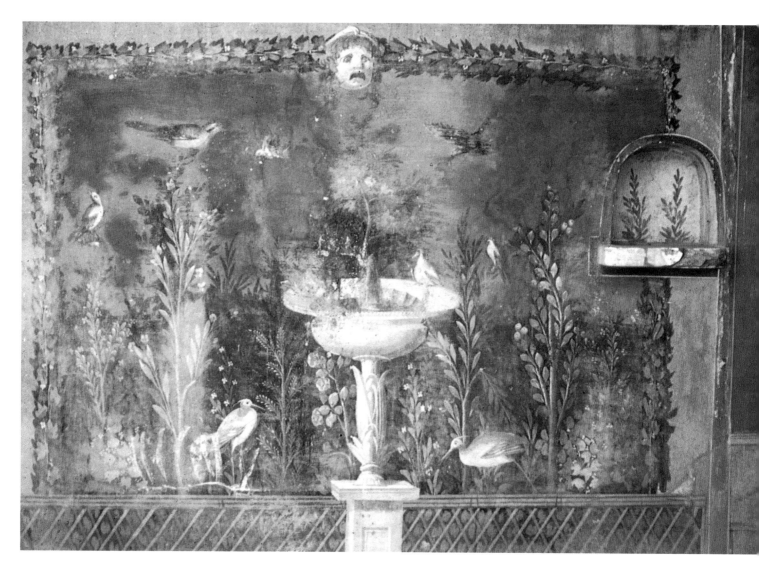

FIGURE 17 Garden painting (west panel of S wall), House of Venus Marina. Photo: S. Jashemski.

site, the *villa rustica* at Oplontis, is where the carbonized hay was found. An eighth site, a formal garden in the House of the Chaste Lovers (IX.xii.6, 7) at Pompeii, was excavated more recently by the Superintendency of Pompeii.

INFORMAL GARDEN. HOUSE OF POLYBIUS (IX.xiii.1–3) (Fig. 18)

Unfortunately, few excavators have been interested in soil contours, root cavities, or plant and animal remains. Much precious evidence that might have been recovered at the time of excavation has been irretrievably lost through careless excavation in the past. When it became apparent that there was a peristyle garden in the House of Polybius at Pompeii, this afforded a rare opportunity to scientifically excavate a peristyle garden for the first time. This noble Samnite house on the Via dell'Abbondanza is one of the oldest and most interesting in the city. The garden was enclosed by a portico on the north, east, and south. Under the east portico is a large cistern, which stored the water carefully collected from the roof during the rainy season.

When water from the cistern was needed, a bucket on a rope was lowered through an opening in the floor. This cistern furnished the entire water supply for the house and garden until the time of the eruption, for the owners had not availed themselves of the more plentiful water made available by the introduction of the aqueduct.

We were greatly surprised to find the root cavities of five large trees in this small garden, as well as the cavities of smaller trees and shrubs and those of stakes that had supported the branches of some trees, heavy with fruit or nuts. (Jashemski 1979: 25–30; 1993: App. 1, no. 517, pp. 249–51). In the center part of the garden, lying in a southeast-northwest direction, were the marks left by an exceptionally long and narrow ladder (8.00 m long, 0.50 m wide at the bottom, 0.30 m wide at the top). The ladder was shaped so as to fit into fruit trees that were tall and full of dense branches and was exactly the same size as the light wooden ladders used today in this area to pick cher-

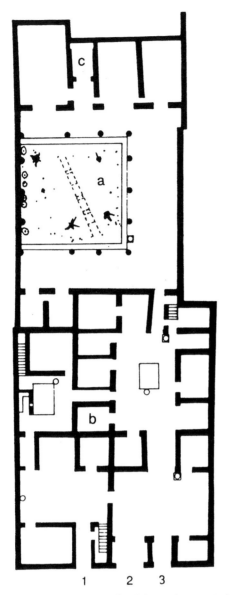

FIGURE 18 Plan of the House of Polybius. Plan: H. Eschebach. Garden details: S. Jashemski.

ries, pears, and apples. Fragments of four-holed planting pots, three on the sides, one on the bottom, were found in the root cavities of smaller trees that had been planted in the pots and then espaliered on the west wall of the garden.

FORMAL GARDEN. HOUSE OF THE GOLD BRACELET
(VI. *insula occidentalis* 42).

The generous use of water made possible by the introduction of the aqueduct greatly altered the appearance of the Pompeian garden. Before this time, plantings requiring a minimum amount of water had been used. Trees were a natural choice, for they needed water only until they became well established. After the aqueduct was built, pools and fountains were introduced, adding

charm and variety to many gardens. The garden of the House of the Gold Bracelet, which I excavated in 1983, was such a garden (Jashemski 1993: App. 1, no. 313, pp. 166–7; App. 2, nos. 60, 61, pp. 348–58). This beautiful three-storied house was one of those built over the city walls after they were no longer needed for protection. The small formal garden that stretched out at the rear of the lower level of this house is of considerable importance, for it is the first formal garden to be scientifically excavated in an elegant house. A beautiful, high, vaulted *diaeta* (garden room), its walls decorated with exceptionally beautiful garden paintings, opened on the north end of the east side of the garden. These paintings pictured many accurately portrayed birds, flowers, and trees. Most of the adjacent exedra, also decorated with fine, but less well preserved garden paintings, was occupied by a marble water triclinium, dominated by an apsed mosaic fountain. Water flowed down over steps and then rose in a jet in the middle of the masonry triclinium. Such couches were, of course, made comfortable with pillows. The water eventually emptied into a pool at the east end of the garden. Water rose in a jet from the low column in the middle of the pool and from the twenty-eight jets around the rim of the pool. The shells and bones of fish, animals, and a bird found along the north garden wall near the house were probably the remains of meals eaten in the water triclinium.

The garden was laid out formally with passageways on three sides, leaving a rectangular area with slightly raised borders. Within this rectangle, soil contours outlined an oval bed with mounded borders, which left trapezoidal beds at each corner of the garden (Figs. 19, 20). The size and location of the root cavities suggest a formal hedge, perhaps box.

The Pompeian garden was essentially a green garden. The major plants were evergreen (e.g., box, myrtle, laurel, oleander, rosemary, acanthus, and ivy), which were attractive the year round. The ancient authors seldom mention flowers in the garden, but amid the greenery would be a few flowers in season — the dainty white flowers of the myrtle, the greenish yellow blossoms of the ivy, the pale yellow flowers of the laurel, on occasion the white flower clusters of the viburnum, and accents of color, if the garden included the oleander, which is often pictured in the garden paintings (see Chap. 6, no. 103), the rose, or the violet. Pliny the Elder says only the rose and the violet (*viola*, here stock, see Chap. 6, no. 91) were cultivated in the garden (*HN* 21.14). The Madonna lily and the opium poppy were probably sometimes grown, for they are pictured in the garden paintings. Also depicted in the garden paintings are the large white morning glory, the

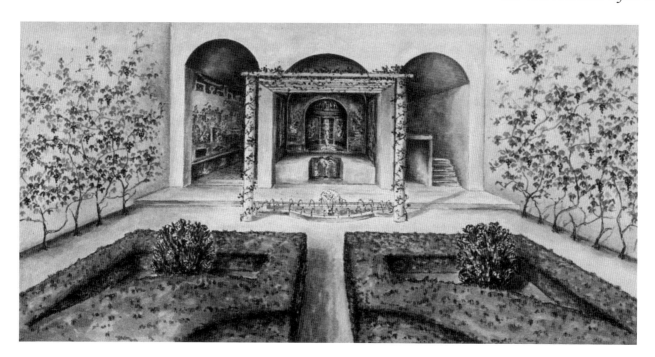

FIGURE 19 Garden of the House of the Gold Bracelet. Illustration: Victoria I.

camomile, and the corn marigold, which are still common in the Vesuvian countryside. They would have been among the meadow flowers, but they probably crept into the formal gardens, as they do today as weeds.

Modern taste would prefer more flowers, but among the Romans flowers were used most often in garlands and crowns. Bouquets were not in vogue in Roman times. Our most detailed information about the flowers known to the ancient Romans is the famous passage in Pliny (*HN* 21.14–69), in which he describes the flowers used in making garlands. Most favored were the rose, the Madonna lily, and the violet (stock). Many of the flowers used in making garlands were wildflowers, such as grew in the meadow "bright with wild flowers" outside Pliny the Younger's Tuscan villa, which he says is as well worth seeing for its natural beauty as his formal garden (*Letters* 5.6).

I LARGE VINEYARD (II.v) (Fig. 21)

Through the years as I excavated at Pompeii, I discovered sizable areas within the city devoted to agriculture. For more than two hundred years the large city block to the north of the amphitheater was known as the *Foro Boario*, or Cattle Market, a name given to it by the early excavators, who uncovered only a small part of it in 1755, and then partially recovered it. In 1814 the south wall of the *insula*, including the entrance, was excavated. In the 1950s most of the *insula* was excavated, down to the A.D. 79 level, and later covered with backfill, with the exception of a small area in the northeast corner and another on the northwest. Only

FIGURE 20 Plan of the House of the Gold Bracelet: (a) garden, (b) garden room, (c) water triclinium.

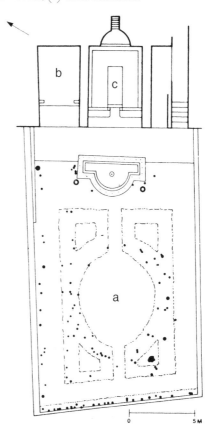

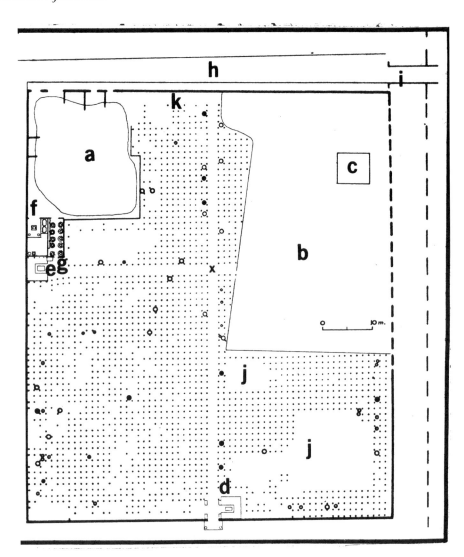

FIGURE 21 Plan of vineyard II.v: (a, b) unexcavated areas, (d, e) masonry triclinia, (h) Via dell'Abbondanza, (x) intersection of paths. Dots indicate grapevine roots; circles indicate tree roots.

subsoil excavation could tell if this large *insula* had been planted, as I suspected. I have found that even in previously excavated sites it is possible to find ancient root cavities if the site had not been overgrown and modern roots destroyed all evidence of the ancient roots. My preliminary subsoil excavations in 1966 proved that the area had been planted. Work was continued in 1968, and in 1970 an additional area still covered with original lapilli was excavated. At the end of the 1970 season we had found a total of 2,014 vine-root cavities and 2,014 stake cavities (Figs. 22, 23). The vines, which were almost exactly four Roman feet apart, had been trained on a trellis with a rectangular frame (*vitis compluviata*). Two well-preserved examples of layering to propagate new vines were found. It became obvious that the Cattle Market actually was a vineyard (Jashemski 1979: 201–18; 1993: App. 1, no. 146, pp. 89–90). Two intersecting paths divided the vineyard into four parts. It was clear that the posts along the paths supported an arbored passageway similar to those in the Pompeii area today. The carefully cut posts, and also the stakes, were probably of chestnut,

recommended by Pliny because of its obstinate durability; modern vintners still use chestnut stakes because they are slow to decay. The ancient writers recommended planting both the willow and the poplar in the vineyard to furnish withes, a practice also still found in the Pompeii area today.

We found the cavities of fifty-eight trees planted along the paths, along the edges of the vineyard, and at intervals throughout the interior of the vineyard. Two carbonized olives found by one tree-root cavity probably identified one of the trees planted in the vineyard. The carbonized broad bean found there may indicate that beans were planted under the vines.

The vintner probably did a thriving business serving guests from the amphitheater at the two masonry triclinia in the vineyard. We found fifty bones and two teeth nearby. When these were identified by Dr. Setzer he discovered that eleven bones had cleaver marks, evidence that the bones had been split for the marrow, which was considered a delicacy. It became obvious why the early excavators had labeled this site the *Foro Boario*. They had found bones near the triclinium at the

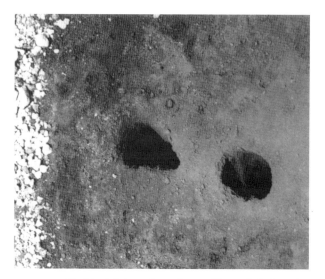

FIGURE 22 Cavities left by stake and root. Photo: S. Jashemski.

FIGURE 23 Cast of stake (left) and vine root, with its side root reaching behind the stake. Photo: S. Jashemski.

entrance to the vineyard and mistook this area for the Cattle Market.

GARDEN OF THE HOUSE
OF THE SHIP *EUROPA* (I.xv)

The House of the Ship *Europa* (I.xv.3), which takes its name from the large graffito of a ship labeled EVROPA found on the north wall of the portico, together with the adjacent house (I.xv.1) and the large, open, split-level area at their rear, formed a common property. The once elegant House of the Ship *Europa* had obviously been converted to a commercial establishment by the time of the eruption, and it was by no means certain that the open area had been planted. The soil had been badly damaged by the passage of trucks at the time of original excavation, but when we made subsoil excavations in 1972 we found that it had been planted (Figs. 24, 25) (Jashemski 1979: 233–42; 1993; App. 1, no. 107, pp. 61–3). In the lower garden there were two carefully laid out vegetable gardens. The one on the north consisted of nine distinct plots separated by furrows; the one in the southwest part had five plots, separated by furrows. The thirty-one irregularly spaced root cavities in these vegetable gardens appeared to be those of small trees, probably fruit or nut trees, such as we find in similar vegetable plots in the area today. The root cavities of the vegetables were too small to have been preserved, but a succession of vegetables would probably have been grown.

Most of this lower garden, however, was planted in vines. The regularly spaced small root cavities (2 to 4 cm in diameter) and the fact that there were no stake cavities would indicate that the vines were not over two years old, not old enough to be staked or to bear much fruit. The space between the two rows that ran down

the center of the garden was slightly higher and served as a path to give the gardeners access to the various parts of the garden.

The root cavities, somewhat irregularly spaced and of varying size, at the back of the lower garden, on the narrow ramps along the two side walls, and in the upper garden where the soil had not been destroyed were probably those of trees. A considerable number of carbonized fruits, nuts, and vegetables were found preserved where they had been grown. Meyer identified filbert and almond shells, perfectly preserved whole grapes with seeds, caramelized because of their high sugar content, and a carbonized fig. The large number of broad beans or horse beans found in various places in this garden strongly suggests intercultivation among the vines and trees, a method still widely practiced in the Pompeii area. With tiny tweezers, Kingsolver extracted the hind leg of a bruchid, or strawberry weevil, from one of the ancient insect-infected beans, and from another bean a nearly complete bruchid weevil. This area appears to have been a commercial garden, producing vegetables, fruits, nuts, and grapes.

Henry Setzer identified dog, pig, sheep, perhaps goat, and chicken bones found in this garden. The two femurs of a dog, probably a watchdog or pet, indicate that the dog was about 45 cm high at the shoulder. The other bones may be those of domestic animals trapped in the garden during the eruption. It is possible that animals may have been kept in the building in the southeast corner of the garden, for it was not uncommon to find animals within the city. There were no tool marks to indicate that the bones had been split for marrow. Nor was there a triclinium in this garden. But it appears to have been a usual practice to discard bones in the garden after a meal, and these

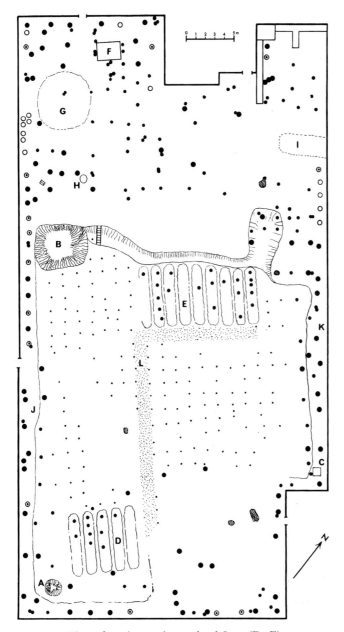

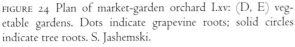

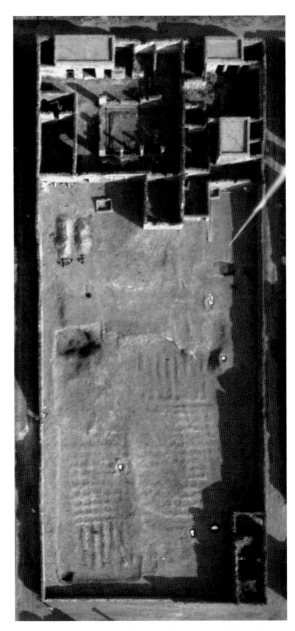

FIGURE 24 Plan of market-garden orchard I.xv: (D, E) vegetable gardens. Dots indicate grapevine roots; solid circles indicate tree roots. S. Jashemski.

FIGURE 25 Balloon photograph. Land contours of I.xv. Julian Whittlesey Foundation.

bones may represent remains from the meals of the workmen.

VILLA RUSTICA. BOSCOREALE

At the time of the eruption the countryside was dotted with a large number of villas. Of those discovered, few are still visible today since many were found on private property and only partially excavated. The owners were anxious to fill in the temporary excavations and return the valuable land to cultivation. These villas differed greatly in size, luxuriousness, and function. Most appear to have been agricultural estates (*villae rusticae*) devoted to raising food crops.

During construction of a new apartment complex

at Boscoreale, in the località Villa Regina on the lower slopes of Vesuvius, one kilometer north of Pompeii, when eighty large cement pillars were put into the ground, evidence was found of an ancient rustic villa. Fortunately, the villa and the land immediately surrounding it were declared a permanent archaeological zone. This is an unusually important site because it afforded the first opportunity in the entire Vesuvian area to excavate farmland attached to a villa. This land was excavated during the summers of 1980, 1982, and 1983 (Jashemski 1993; App. 1, no. 590, pp. 288–91). We found that most of the area surrounding the villa had been planted as a vineyard. But this one was very different from the large vineyard across from the amphitheater at Pompeii, or the one in the garden of

the House of the Ship *Europa*, described earlier. The vines at Boscoreale were not systematically planted at a uniform distance apart; they were informally staked, supported by both stakes and trees, as found in many vineyards in the area today. In addition, there were thirty-four trees at Boscoreale, most of which were in the vineyard. The partially carbonized olives and almonds found in the vineyard help to identify some of the trees. There were also many grape seeds and stems.

A country lane running through the vineyard led directly to the main entrance of the villa. The ruts left by the wheels of the carts traveling over this lane were the same distance apart (1.32 m) as the wheels of the ancient cart found in the villa.

The villa building contained two rooms in which the grapes were pressed. After the juice was extracted, it was fermented in the eighteen dolia embedded in the peristyle courtyard.

To the right of the main entrance of the villa was a small vegetable garden, with a cistern in the middle to provide the necessary water. The garden was divided into small plots separated by irrigation channels, which also served as paths, similar to those in the vegetable plots at Pompeii.

A roadway led from the main entrance to the country road that passed in front of the villa. The country road was unusually deep, but it was the same width as the lane that ran through the vineyard. Along the edge of the road on the villa side there was a row of four huge trees, quite unlike the small fruit and nut trees in the vineyard (Fig. 26). Analyses of the woody material found in the root cavities made it possible for Dr. Hueber to identify the large tree on each side of the

roadway leading to the villa as an umbrella pine. The other two trees were definitely angiosperms (broad-leafed deciduous trees), but the woody material was too damaged to make it possible to identify the trees as to species. Both the size and shape of the root cavities suggest that these trees were plane trees, or perhaps poplars.

We wondered if the contents of the amphoras or other containers found in the kitchen might reflect crops raised at the villa. To determine the contents, we made scrapings. At the University of Maryland, after preparation, each sample was viewed in the scanning electron microscope and an energy-dispersive X ray was performed by Myron E. Taylor, manager of the electron microscope facility and Franz Kasler, professor of chemistry. This showed that the contents of the amphoras included wine, olive oil, and *garum*. Wine was produced at the villa. Olives were raised, but no press has yet been found. *Garum*, a popular fish sauce, would certainly be in any well-stocked kitchen.

Other evidence tells us about life on this country villa. Cement poured into a cavity in the volcanic ash preserved the appearance of a pig raised on the premises (Fig. 361). Among the bones found in the vineyard were those of pig, sheep or goat, cow, a toad or frog, and a dog. The bones of a coot, a waterbird, were found in a trash pile that included remains from meals, located in the area around the tree near the main entrance of the villa.

Remains from meals and other refuse were also found at the edge of the neighboring property on the south side of the country road. Here we found the bones of a rail, another waterbird. Only the bill of a chaffinch was found; songbirds were considered a table

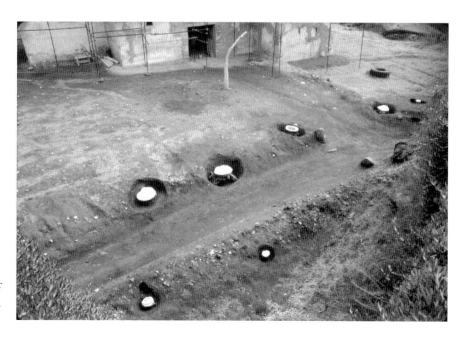

FIGURE 26 Country road in front of *villa rustica*, Boscoreale. Photo: F. Heuber.

FIGURE 27 Plan of Villa of Poppaea, Oplontis.

delicacy. There were also bones of a dormouse, of a weasel, and of a marten. There was also the partial skeleton of a small rodent, a pine vole, and an almost complete skeleton of a rat snake. This property was also planted in vines.

VILLA OF POPPAEA. OPLONTIS (Fig. 27)

A very different type of villa was the luxurious one at Oplontis (modern Torre Annunziata), believed to have belonged to Poppaea, the wife of the emperor Nero. Thus far the villa has thirteen gardens, which I have excavated (Jashemski 1979: 289–314; 1993: App. 1, nos. 593–605, pp. 293–301; App. 2, nos. 116–21, pp. 375–79). For the first time, villa gardens could be excavated using the most recent techniques. The gardens inside the villa were like those in the city houses, which were essentially inward looking and not set in a garden landscape, as was the villa. In this villa thus far one of the

interior gardens was a peristyle garden, and there were five courtyard gardens. The walls of the five courtyard gardens were decorated with garden paintings to make the small gardens appear larger. But it is only in the villa that we find the great formally planted exterior, porticoed gardens that utilized the magnificent view of the sea and mountains, beckoning the visitor from both land and sea. The layout of the rear garden is intimately related to the villa architecture. The original villa, built during the middle of the first century B.C., was compact in plan, with a large atrium as a nucleus and several interior gardens.

The rooms of the east wing, built during the empire (A.D. 50–70), looked out on an Olympic-size swimming pool (60 × 17 m) and two handsome gardens; one at the south end and an impressive sculpture garden to the east of the pool. In the sculpture garden an avenue of thirteen trees (thus far) has been found. In front of each tree was a statue base. Six of the almost life-size marble statues and herms that stood on them have been found. Beginning at the south, there was a head of Hercules on the marble shaft in

front of the third root cavity from the south, next a statue of an ephebe (a male Greek youth) in front of the fourth root cavity, and then a large white marble figure identified as Nike (Victory), in front of the fifth cavity. Balancing these in corresponding positions along the north side of the pool was another Nike of the same size in front of the tenth root cavity, then a statue of Artemis or an Amazon, lacking the head, still standing on the base in front of the eleventh root cavity, and next a head of Hercules on the marble shaft in front of the twelfth root cavity (De Caro 1987).

The tree-root cavities and other cavities were carefully emptied of lapilli, studied, and then filled with cement, to make casts of the roots. Counting from the south, root cavities I, II, IV, V, X, and XI were all those of large trees. The fragments of branches found behind base I were too deteriorated to identify the tree as to species, but the tree was definitely an angiosperm (shade tree). The size and shape of the root cavities led Carlo Fideghelli to identify these trees as probably plane trees. These cavities reminded us of those of the avenue of older plane trees in the large garden at the rear of the villa. Only root cavity XIII seemed to depart from the symmetry of the plantings. Instead of a plane tree in this location, which symmetry would suggest, this tree left a cavity that had the appearance of a cypress and suggests that at the north end of the pool the garden may have made a transition to another planting pattern. Eberhard Grüger found cypress pollen in the soil samples taken from this area.

The four statue bases VI to IX were directly opposite the large open room in the middle of the east wing, and the plantings behind these statues were carefully planned to provide a splendid picture when viewed across the water from this room. The woody material found in these root cavities was analyzed by Francis Hueber. The plant behind statue base VI was an oleander (Fig. 117). The root behind statue base IX, similar in size and shape, also appeared to be that of an oleander. He identified the woody material in the root cavity of the tree behind statue base VIII, which had been air-layered in an amphora, as a lemon. The cavity behind statue base VII, similar in size and shape, also appeared to be a lemon. The picturesque plantings behind these four statues were framed on each side by large plane trees. At a distance behind statue bases VI and IX was a low base, and behind each of the bases were plentiful carbonized remains of branches, which Hueber identified as oleander. The complexity and beauty of this garden, which extends farther to the north, south, and east, will become clearer only with further excavation. We can only speculate concerning its relation to the nearby Bay of Naples to the south.

VILLA RUSTICA. OPLONTIS

Another villa at Oplontis must be briefly mentioned, the *villa rustica* of L. Crassius Tertius, discovered by chance during the construction of a school (Jashemski 1979: 320–6). No garden has been found at this villa, but it was in this villa that several cubic meters of carbonized hay, apparently gathered in a vineyard on land connected with the villa, was discovered (see Chap. 1). More recently a quantity of similar, but less well preserved carbonized material was found in the *villa rustica* at Terzigno. The villa of L. Crassius Tertius has also yielded significant evidence of hazelnuts and carbonized pomegranates grown and stored there (see Chap. 6).

FORMAL GARDEN. HOUSE
OF THE CHASTE LOVERS (IX.xii.6, 7)

The formal peristyle garden in this luxurious house, on the via dell'Abbondanza, excavated by the Superintendency of Pompeii, was laid out in geometrically shaped beds enclosed by a lattice fence of reeds. This was a fortuitous find, for it is the first time archaeological evidence for such fences, so common in garden paintings, has been found in the Vesuvian sites. Among the fragments of carbonized plants, they identified the reeds *Arundo donax*. L. and *Phragmites australis* (Cav.) Trin., *Juniperus* sp., and *Rosa* sp. (Chap. 6). Pollen added further information (Ciarallo and Lippi 1993).

Little did the inhabitants of Pompeii, Herculaneum, and the surrounding villas suspect that Vesuvius, which through the millennia had been enriching their fertile soil, would soon reawaken from its long quiescence. All too soon this vibrant civilization was covered with lapilli and remained forgotten for centuries. But uniquely preserved is the abundance of material that makes this book possible.

REFERENCES

Ciarallo, Annamaria, and Marta Mariotti Lippi. 1993. "The Garden of 'Casa dei Casti Amanti' Pompeii, Italy." *Garden History* 21: 110–16.

De Caro, Stefano. 1986. *Saggi nell'area del tempio di Apollo a Pompei.* Naples.
 1987. The Sculpture of the Villa of Poppaea at Oplontis. In *Ancient Villa Gardens,* Dumbarton Oaks Colloquium on the History of Landscape Architecture, no. 10, pp. 102–14.
 1991. La città sannitica: urbanistica e architettura. In *Pompei,* edited by Fausto Zevi, Vol. 1. Banco di Napoli, Naples. Reprinted, Guida, Naples, 1992.

Eschebach, Hans. 1970. *Die Städtebauliche Entwicklung des antiken Pompeji.* F. H. Kerle Verlag, Heidelberg.

Foss, Pedar W., and J. J. Dobbins, eds. Forthcoming. *Pompeii and the Ancient Settlements under Vesuvius.* Routledge,

London and New York (contains chapters by experts on the various aspects of the Vesuvian sites).

Fulford, Michael, and Andrew Wallace-Hadrill. 1999. Towards a History of Pre-Roman Pompeii: Excavations beneath the House of Amarantus (I.9.11–12), 1995–8. In *Papers of the British School at Rome,* Vol. 67. The British Academy, London.

Mau, August. 1910. *Pompeii.* Reprinted, Aristide Caratzas, Publisher, New Rochelle, N.Y.

Jashemski, Wilhelmina F. 1979. *The Gardens of Pompeii, Herculaneum and the Villas Destroyed by Vesuvius.* Vol. 1. Caratzas Brothers, New Rochelle, N.Y.

1993. *The Gardens of Pompeii, Herculaneum and the Villas Destroyed by Vesuvius.* Vol. 2, Appendices. Aristides Caratzas, Publisher, New Rochelle, N.Y.

Nappo, Salvatore Ciro. 1997. Urban transformation at Pompeii in the Late Third and Early Second Century B.C. In *Domestic Space in the Roman World; Pompeii and Beyond,* edited by Ray Laurence and Andrew Wallace-Hadrill, pp. 91–120. *Journal of Roman Archaeology,* Supp. series no. 22.

Ward-Perkins, John, and Amanda Claridge. 1976. *Pompeii A.D. 79.* Carlton Cleeve Limited, London.

3

MOUNT VESUVIUS BEFORE THE DISASTER

Haraldur Sigurdsson

INTRODUCTION

For the last two million years, the region of central and southern Italy has been the scene of active volcanism, characterized by explosive eruptions. This region is known among geologists as the Roman Comagmatic Province and extends along the Tyrrhenian coast, from the Vulsini area in northern Latium to Vesuvius in the south. In north Latium the volcanic activity became largely extinct about one hundred thousand years ago, but the Romans have ever since enjoyed the beautiful volcanic landscape created by this activity, such as the scenic Lake Bolsena in the caldera of Vulsini volcano, and Lake Vico. Farther south, however, in the Campanian volcanic region, activity has continued up to the present day, as recorded in legend, history, and in the volcanic stratigraphy of Vesuvius and the Phlegraean Fields.

In the mind of the Romans, the active volcanoes in Campania were closely linked with the underworld. In Vergil's great epic the *Aeneid* (written between 30 and 19 B.C.), the vivid story of Aeneas's descent to the underworld has its setting in the volcanic landscape of the Phlegraean Fields (from the Greek φλεγυρός, for burning), a region with numerous eruptions, steaming hot springs, and sulfurous fumaroles. The hero, Aeneas, has as his guide the Cumean Sibyl, who lives in a grotto near the Cumae volcano in the Phlegraean Fields in the vicinity of Naples. They make their descent to Hades in a deep cave sheltered by a black lake and gloomy forest. Over this lake no flying bird could survive, because of the poisonous vapors that streamed from it.

The Phlegraean Fields figure in legend long before Roman times. In Homer the Phlegraean Fields are inhabited by the terrifying and ferocious giants the Laestrygones, who hurled rocks at Ulysses' ships to prevent them from landing – an obvious reference to volcanic eruption. The monstrous giants were buried under the Phlegraean Fields after their defeat by the gods of Olympus.

According to legend, the giants' violent attempts to free themselves caused the shaking of the earth and fiery outbursts, or volcanic eruptions. The latest eruption in the Phlegraean Fields took place in 1538, when explosive activity built up the scoria cone Monte Nuovo (Rosi and Sbrana 1987).

East of the Phlegraean Fields rises Mount Vesuvius (Fig. 28). Although lacking the mythical lore of the Phlegraean Fields, Vesuvius has a much more prominent volcanic history in the past thousands of years, and its violent explosive eruptions have repeatedly laid waste to large areas of Campania. This chapter reviews the volcanic history of the mountain and the precursors of the great eruption of A.D. 79.

EARLY EVOLUTION

Most of the early activity in Vesuvius consisted of numerous small eruptions of lavas, accompanied by minor pyroclastic eruptions, which have built up the ancestral Somma stratovolcano. The age of the ancestral Somma volcano is not known, but a K-Ar age (based on the time-dependent radioactive decay of the element potassium in rocks) of 0.3 million years was observed for a lava from a 1,345 m deep well drilled near the volcano (Principe et al. 1982).

The earliest known major explosive eruption of

Vesuvius occurred about 25,000 years ago, forming the so-called Codola pumice-fall deposit (Arnó et al. 1987). Recently another important early event has also been recognized: the Sarno eruption, which occurred about 22,000 years ago. About 17,000 years ago the third major explosive eruption occurred, which deposited a widespread layer known as the Basal pumice (Delibrias et al. 1979). These and other major explosive eruptions of the volcano produced very high (tens of km) columns of ash and pumice above the volcano, resulting in widespread fallout. They are events of the sort that occurred in 79 A.D., as witnessed by the Plinys, and are therefore termed Plinian eruptions in volcanological parlance.

These early events may be regarded as marking the termination of Somma's activity and the birth of Vesuvius. This activity resulted in a composite central volcano, consisting of the older Monte Somma and the younger cone of Vesuvius. During these early and huge explosive eruptions, the summit of Monte Somma may have collapsed, thus forming the caldera-like structure in which the modern cone of Vesuvius is nestled. The Monte Somma caldera wall has restricted the spread of lava flows from Vesuvius; consequently, lava flows younger than 17,000 years are not found on the north flank of Monte Somma. Similarly, the caldera rim later influenced and retarded the northward distribution of pyroclastic flows and surges in A.D. 79.

The Codola eruption was the first of Vesuvius's eight major explosive eruptions in the past 25,000 years. These highly explosive eruptions produced Plinian pumice-fall deposits, often associated with pyroclastic flows and surges. Typically, a period of quiescence of 1,400 to 4,000 years has preceded each Plinian explosive event, as marked by well-developed paleosols under the Plinian deposits. Each Plinian eruption is regarded as the beginning of a new eruptive cycle. The major volcanic cycle that preceded the A.D. 79 eruption was the fifth cycle of Vesuvius's activity and began with the Plinian eruption of the Avellino pumice, which was deposited on a thick paleosol radiocarbon dated as 3,360 ± 40 years before present, or about 1600 to 1700 B.C. (Vogel et al. 1990). This great Vesuvius eruption is therefore virtually indistinguishable in time from the even larger Minoan explosive eruption of Thera (Santorini) in the Aegean Sea. Lirer et al. (1973) studied the ash- and pumice-fall deposit from the Bronze Age Avellino eruption and established that fallout occurred primarily to the east and east-northeast of the volcano during this event. This eruption was very similar in magnitude, composition and extent to that of A.D. 79, and it also produced pyroclastic flows and surges in the final stages of the event. The event also had a severe environmen-

tal impact on the Campania region, and Bronze Age ceramics buried by the Avellino pumice attest that the Vesuvius region was inhabited at that time (Albore Livadie 1981).

PRE–A.D. 79 VOLCANIC ACTIVITY

The soils underlying the A.D. 79 pumice deposit reveal a number of volcanic ash layers, which show that a number of small- to moderate-size eruptions occurred in Vesuvius prior to the great event that devastated Pompeii and Herculaneum. It is potentially of great importance to establish in detail the evolution of the volcano just before the great explosive event, as such knowledge will aid in predicting or forecasting future lethal eruptions. We would like to know, for example, the period of dormancy or quiescence before the A.D. 79 eruption, and also the style of activity during the last minor eruption preceding the great disaster.

Near the volcano, as seen in sand quarries at the village of Terzigno about 6 km southeast of the crater, the interval between the Bronze Age Avellino eruption and the A.D. 79 eruption is marked by the deposition of more than ten meters of relatively thin volcanic ashes and sands. This deposit contains a valuable record of the low-level activity of the volcano between the great eruptions, spaced some 1,700 years apart, but so far a systematic study of these numerous smaller eruptions has not been carried out. At Terzigno, the thick and light gray Avellino pumice-fall deposit is overlain by a paleosol, which has been dated by the radiocarbon method at 3,000 years, indicating a three- to four-hundred-year break in activity after the Avellino eruption (Rosi and Santacroce 1986; Arnó et al. 1987).

During the period of about 1,700 years, following the Bronze Age Avellino eruption, a series of at least eight relatively minor explosive eruptions occurred in Vesuvius (Fig. 29). The first of these events (eruption "A" of Rosi and Santacroce 1986) spread a white pumice-fall layer over the soil on top of the Avellino deposit. This was followed by deposition of two other ash units from the same episode. In the Terzigno area, the A eruption deposit is covered by a thick layer of sands and gravels, representing a long period of erosion of loose volcanic ashes from the flanks of the volcano above. The next eruption (B) was also explosive, depositing both a greenish gray pumice layer containing limestone fragments and fine ash beds. Again, a sand and gravel deposit was laid down during a long period of erosion of the volcano's flanks, but conditions during these erosive periods were not suitable for the development of permanent soils on and around the volcano, because of the rapid erosion and reworking of the loose

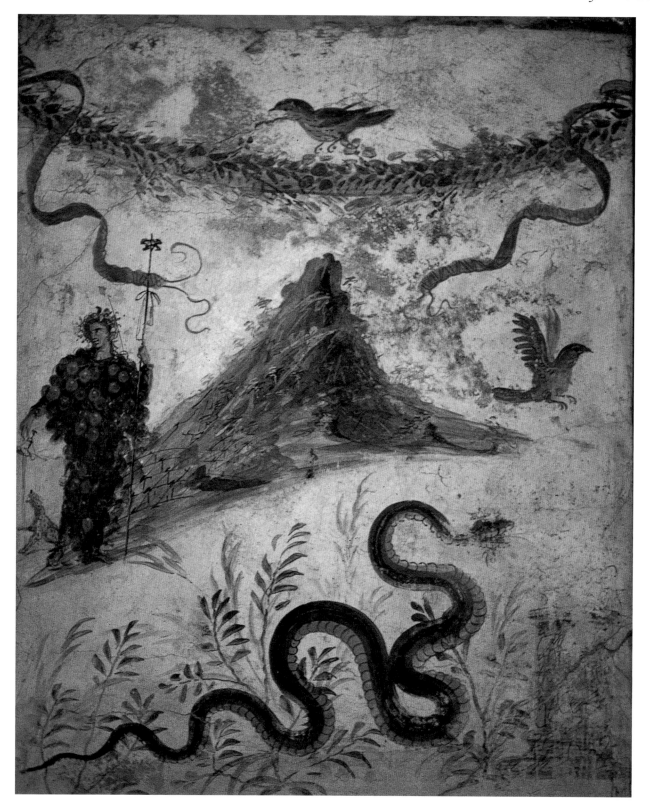

FIGURE 28 Mount Vesuvius as it appeared before the A.D. 79 eruption. Lararium painting in House of the Centenary (NM inv. no. II2286). Photo: S. Jashemski.

deposits by water and wind. The third explosive eruption in this sequence, probably around 1000 B.C., is the eruption C of Rosi and Santacroce (1986). It deposited first a series of three ash- and lapilli-fall layers, followed by the emplacement of a pumice-rich and hot mudflow deposit in the Terzigno area. After yet another period of volcanic quiescence, erosion, and deposition of fluviatile sands, the fourth eruption took place (D), depositing ash falls, a surge bed, and mudflow.

The four final volcanic events, prior to the great eruption of A.D. 79, were small explosive eruptions that deposited thin and dark layers of ash, lapilli, and fine scoria around the volcano (eruptions E, F, G, and H). These episodes were followed by a long period of volcanic quiescence but erosion of the loose deposits from the flanks of Vesuvius, during which a two-meter-thick

layer of fluviatile sands and gravels was deposited over the Terzigno area. The duration of this break in activity before the A.D. 79 eruption can be crudely inferred from the thickness of the reworked sand layer. The total thickness of reworked sands deposited at Terzigno in the 1,700-year interval between the Avellino and the A.D. 79 eruptions is about 5.4 m (excluding the primary volcanic layers). Of this, the final period of quiescence prior to A.D. 79 represents 2.2 m thickness, or equivalent to a period of dormancy of the volcano of about 700 years. It is no wonder that the Romans did not consider the mountain a threat and were probably not even aware of its volcanic character until that fateful day in A.D. 79.

It is commonly regarded that the magnitude of an explosive eruption increases with the length of the repose period preceding that eruption. This would also seem to be the case of the A.D. 79 event, and its exceptional violence and intensity may thus be directly related to the very long 700-year period of quiescence of Vesuvius. During such a long period of repose, magma may be accumulating at a steady rate in the subterranean reservoir of the volcano, leading to a buildup of magma volume that causes the melting and assimilation of rocks surrounding the reservoir and an increase in the volatile content of the magma. The longest known dormancy period for the volcano in historical times was about 300 years preceding the 1631 eruption, which also was a violent explosive event, although much smaller than the A.D. 79 eruption. By comparison the current dormant period since the 1944 eruption is only 56 years.

THE VOLCANO BEFORE A.D. 79

The earliest historical information about Vesuvius dates from the first century B.C. In 73 B.C. a revolt of slaves led by the gladiator slave Spartacus posed a serious threat to the cities around Vesuvius, and this episode gives in a curious way a glimpse of the volcano before the eruption. The details of Spartacus's life are sketchy, but some of his deeds were recorded in the second century A.D. by Appian (*Civil Wars* I.116 f) and Plutarch. He was sold into slavery in the gladiator school in Capua near Vesuvius, where he organized a breakout with seventy other gladiators and sought shelter in the crater of Vesuvius. The band of gladiators was besieged in the crater by Claudius Glaber, who was sent from Rome to mop up this trouble. According to Plutarch:

> [The] hill . . . had but one ascent, and that a narrow and difficult one . . . everywhere else there were smooth and precipitous cliffs. But the top of the

hill was covered with a wild vine of abundant growth, from which the besieged cut off the serviceable branches, and wove those into strong ladders of such strength and length that when they were fastened to the top they reached along the face of the cliff to the plain below. On these they descended safely, all but one man, who remained above to attend to the arms. When the rest had got down, he began to drop the arms, and after he had thrown them all down, got away himself also last of all in safety. Of all this the Romans were ignorant, and therefore their enemy surrounded them, threw them into consternation by the suddenness of the attack, put them to flight, and took their camp. They were also joined by many of the herdsmen and shepherds of the region, sturdy men and swift of foot, some of whom they armed fully, and employed others as scouts and light infantry.
>
> Plutarch *Crassus* 9.1–3

Soon Spartacus's army numbered 70,000 men and the Romans were to experience other humiliating defeats by the slave army near Vesuvius and again near Herculaneum. Spartacus was finally conquered after having defeated nine Roman armies, and crucified outside Rome.

The tale of Spartacus contains meager but very important information about the topography of Vesuvius some one hundred and fifty years before the great eruption of A.D. 79. The chroniclers of the rebellion of Spartacus note that in earlier days the volcano was covered by a dense forest famous for its wild boars. By the first century B.C. the primeval forest had given way to the axe and the plough. Writing at the time of Augustus in the first century A.D., the Greek geographer Strabo (63 B.C.–A.D. 30) identified Vesuvius as an extinct volcano, with a barren and ash-colored summit:

> Above these places lies Mt. Vesuvius, which save for its summit has dwelling places all round, on farm-lands that are absolutely beautiful. As for the summit, a considerable part of it is flat, but all of it is unfruitful and looks ash-colored, and it shows pore-like cavities in masses of rock that are soot-colored on the surface, these masses of rock looking as though they had been eaten by fire; and hence one might infer that in earlier times this district was on fire and had craters of fire and then because the fuel gave out, was quenched.
>
> Strabo 4.5.8

Before the A.D. 79 eruption, Vesuvius is generally believed to have been a single truncated cone. The idea that Vesuvius had a single peak before A.D. 79 stems mainly from Strabo's statement that the summit of Vesuvius is in large part flat. Similarly, Dio Cassius (66.21–24), writing in the third century A.D., states that

once Vesuvius was equally high at all points. A wall painting of Vesuvius from this time has survived in the lararium of the House of Centenary in Pompeii and has generally been taken as the appearance of Vesuvius prior to the A.D. 79 eruption (Fig. 28) (NM inv. no. 112286). The volcano is shown as a single, steep peak, with the lower slopes covered by a network of vineyards, and with trees and bushes growing to near the summit, where the slopes were too steep for cultivation but supplied firewood and land for grazing. This was the pastoral aspect of the slumbering giant up to A.D. 79.

Other Roman wall paintings of a twin-peaked mountain have, however, been described from Herculaneum (Preusse 1934; Stothers and Rampino 1983), and thus the question of the pre-eruption topography remains open. These observations are not necessarily contradictory, however, as today the volcano has the aspect of a single peak from some directions, but it is twin-peaked when seen from other viewpoints. It is clear nevertheless that the Monte Somma ridge influenced the distribution of the deposits of the A.D. 79 eruption and therefore caldera collapse must have occurred either before or in the early stages of this eruption.

Pliny the Elder was familiar with the Campanian region. In his day Campania was a blessed and fruitful country, clad with vines that supplied wines famous throughout the Roman world. He mentions ancient Neapolis, a colony of the Chalcidians, and also Herculaneum and Pompeii, "not far from Vesuvius" (*HN* 5.62). Nowhere in his writings, however, is there an indication that he was aware of the volcanic nature of this mountain. Although Pliny includes much information about volcanoes in his *Natural History*, he expresses no views on volcanic processes or on what makes volcanoes erupt, unlike two of his contemporaries. Strabo believed that volcanoes were formed by fires of subterranean origin and suggested that they were the safety valves for pent-up subterranean vapors. He recognized the volcanic nature of Vesuvius, although the volcano had not erupted in his lifetime. Seneca (2 B.C.–A.D. 65) gave a list of volcanoes known in his time, including Etna, Vulcano, Stromboli, and Santorini, but notably not Vesuvius. His ideas of volcanic activity were remarkably similar to our own, as he regarded volcanoes as the vents through which molten material issues onto the earth's surface from subterranean reservoirs. Pliny was, of course, very familiar with the writings of his contemporary and must have been aware of Seneca's views about volcanic processes. Many other historians writing in the Augustan Age (31 B.C.–A.D. 14), including Diodorus Siculus (*Library of History* 4.21.5) and Vitruvius (2.2), recognized Vesuvius's volcanic character.

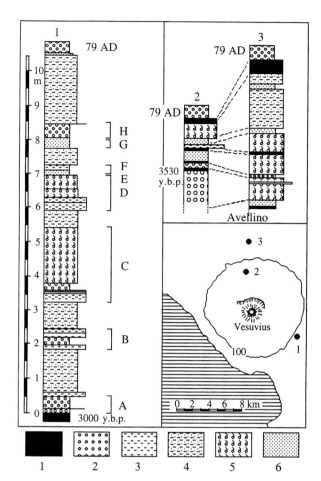

FIGURE 29 Prior to the A.D. 79 eruption, the activity of Mount Vesuvius is revealed by soil profiles and sand quarries around the volcano. The figure modified from Arnó et al. (1987) shows three sections through the pre–A.D. 79 deposits. The insert map shows the location of these sections (1, 2, and 3) around the volcano. Section 1 is at Terzigno, southeast of the crater; section 2 is east of Saint Anastasia; and section 3 is northwest of Somma Vesuviana. Legend to deposit symbols: (1) paleosoil, with C-14 age dates indicated, (2) pumice-fall deposit, (3) sandy surge deposit, (4) fluviatile sands and other reworked deposits, (5) ash flow deposit; (6) ash fall deposit. The letters A to H indicate the deposits from eight relatively minor eruptions, which Arnó et al. (1987) have identified in the interval between the Avellino eruption and A.D. 79. It is estimated that the time interval between the last of these events (eruption H) and the A.D. 79 eruption is 700 years.

THE A.D. 62 EARTHQUAKE AND OTHER PRECURSORS

Large volcanic eruptions are typically preceded by a variety of signals that can be felt or observed at the surface months or years before the eruption begins; the A.D. 79 eruption of Vesuvius was no exception. These symptoms may include inflation of the volcano and surrounding land, earthquakes, increased thermal activity, change in groundwater table, and increased volcanic gas emission. Minor phreatic or steam explosions also typically occur shortly before the main eruption, and evidence has been presented showing that a phreatic

eruption preceded the main A.D. 79 event (Sigurdsson et al. 1985). All of these phenomena are linked to the upward flow of magma within the earth's crust, either from a deep source to a reservoir at 5 to 10 km below the volcano or out of the magma reservoir toward the surface via a narrow conduit.

On February 5, A.D. 62, the volcano gave the first signs of returning to activity, when a large earthquake rocked the area, centered near Pompeii. Seneca wrote a contemporary account of the earthquake and other pre-eruption phenomena under the heading De Terrae Motu (Earthquakes) in Book VI of his large work *Quaestiones naturales.*:

> I have just heard that Pompeii, the famous city in Campania, has been laid low by an earthquake which also disturbed all the adjacent districts. The city is in a pleasant bay, back aways from the open sea, and bounded by the shores of Surrentum and Stabiae on one side and the shores of Herculaneum on the other; the shores meet there. In fact, it occurred in days of winter, a season which our ancestors used to claim was free from such disaster. This earthquake was on the Nones of February, in the consulship of Regulus and Verginius. It caused great destruction in Campania, which had never been safe from this danger but had never been damaged and time and again had got off with a fright. Also, part of the town of Herculaneum is in ruins and even the structures which are left standing are shaky. The colony of Nuceria escaped destruction but still has much to complain about. Naples also lost many private dwellings but no public buildings and was only mildly grazed by the great disaster; but some villas collapsed, others here and there shook without damage. To these calamities others were added: they say that a flock of hundreds of sheep was killed, statues were cracked, and some people were deranged and afterwards wandered about unable to help themselves. The thread of my proposed work, and the concurrence of the disaster at this time, required that we discuss the causes of these earthquakes.

Yet certain things are said to have happened peculiar to this Campanian earthquake, and they need to be explained. I have said that a flock of hundreds of sheep was killed in the Pompeian district. There is no reason you should think this happened to those sheep because of fear. For they say that a plague usually occurs after a great earthquake, and this is not surprising. For many death-carrying elements lie hidden in the depths. The very atmosphere there, which is stagnant either from some flaw in the earth or from inactivity and the eternal darkness, is harmful to those breathing it. Or, when it has been tainted by the poison of the internal fires and is sent out from its long stay it stains and pollutes this pure, clear atmosphere and offers new types of disease to those who breathe the unfamiliar air. I am not surprised that sheep have been infected, sheep which have a delicate constitution, the closer they carried their heads to the ground, since they received the afflatus of the tainted air near the ground itself. If the air had come out in greater quantity it would have harmed people too; but the abundance of pure air extinguished it before it rose high enough to be breathed by people.

In several places in Italy a pestilential vapor is exhaled through certain openings, which is safe neither for people nor for wild animals to breathe. Also, if birds encounter the vapor before it is softened by better weather they fall in mid-flight and their bodies are livid and their throats swollen as though they had been violently strangled.

As long as this air keeps itself inside the earth, flowing out only from a narrow opening, it has power only to kill the creatures which look down into it and voluntarily enter it. When it has been hidden for ages in the dismal darkness underground it grows into poison, becomes more deadly by the very delay, becomes worse the more sluggish it is. When it has found a way out it lets fly the eternal evil and infernal night of gloomy cold and stains darkly the atmosphere of our region.

Seneca *Q. Nat.* 6.1.1–2, 27.1–4, 28.1–2

From Seneca and other sources it is evident that the earthquake was strongest in Pompeii and Herculaneum but affected a larger area, including Nuceria and Naples, where the gymnasium collapsed. In Pompeii, the Vesuvius and Herculaneum Gates to the city fell, and aqueducts and waterworks were broken, including

FIGURE 30 A marble relief on a shrine in the House of Lucius Caecilius Jucundus in Pompeii showing the effects of the A.D. 62 earthquake – the tottering monumental arch, then the collapse of the Capitolium flanked by equestrian statues. Photo: S. Jashemski.

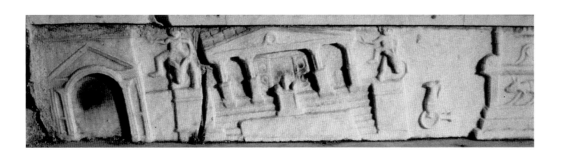

FIGURE 31 The Castellum Aquae (Pompeii waterworks) on the left. Two mules narrowly escaping the collapsing Vesuvius Gate. Photo: S. Jashemski.

lead pipes that served as plumbing to residential houses. The Roman Senate sent aid for restoration, which was still in progress seventeen years later when the volcano dealt the death blow. According to Dio, Herculaneum suffered even greater damage, although restoration proceeded much faster and was mostly complete by the time of the eruption. Still, an inscription records that restoration of the temple of Mater Deum in Herculaneum was not completed until A.D. 76. Earthquakes are common in Campania and the people probably took this one in stride. A sculptured relief on the lararium (household shrine) in the House of the banker L. Caecilius Jucundus vividly portrays the collapse of the temple in the forum (Fig. 30). Not without humor, the artist shows equestrian statues with the riders throwing out their arms and legs as if to break the fall. A second relief found in this house gives further details; the Vesuvius Gate is shown toppling; two mules and a cart have been thrown up in the air (Fig. 31).

The death of hundreds of sheep by mysterious poisoning on the slopes of Vesuvius, as reported by Seneca, is perhaps the best evidence that the volcano was returning back to life in A.D. 62 and that the earthquake was also related to the volcano. Increased emission of volcanic gases commonly occurs before eruptions, including large quantities of carbon dioxide. Such gases are frequently lethal to livestock, and in Iceland, for example, flocks of sheep are often killed as they wander into pools of the invisible but suffocating carbon dioxide, which, because of its higher density, gathers in depressions and valleys. Sheep have been suffocated in this way in the region of Hekla Volcano. The dangers of this invisible killer gas were well documented in the town of Vestmannaeyjar on Heimaey south of Iceland in 1973, where large quantities of carbon dioxide flowed out of the volcano during an eruption. The gas collected in a thin ground layer that was often so thin that seagulls could safely walk along the deserted ash-covered street with their heads above the gas layer, whereas the shorter sparrows and snow-buntings keeled over by suffocation.

Two years after the earthquake, or in the spring of A.D. 64, Emperor Nero gave a public concert in the theater in Naples. During his performance an earthquake struck again, but Nero continued as if nothing had happened. The theater collapsed, however, as soon as the performance was over and the audience had left (Suetonius *Nero* 20.2). Descriptions indicate that this earthquake may have had its origins under the volcanic island of Ischia to the west, and probably not in Vesuvius.

In Campania most of the year A.D. 79 was uneventful until June 24, when news came of the death of Emperor Vespasian and the rise of his son Titus. Emperor Vespasian fell ill with fever in Campania and died on June 23, 79, exactly two months before the eruption of Vesuvius. Titus, who was already a co-ruler in the last years of his father's reign, assumed the title Imperator Titus Flavius Vespasianus after Vespasian's death.

In mid-August, about six weeks after Titus became emperor, earthquake activity was renewed, as documented by Pliny the Younger. The shocks were small but frequent and caused only minor damage. By August 20 the earthquake tremors increased in strength and noises were heard like distant thunder. At the same time springs ceased to flow and wells dried up. Unknown to the Pompeians, the volcano was waking from a slumber that had lasted for seven hundred years.

REFERENCES

Albore Livadie, C. 1981. "Palma Campania (Napoli)—Resti di abitati dell'età del Bronzo Antico." *Atti della Accademia Nazionale dei Lincei. Notizie degli Scavi di Antichità* 8, 59–101.

Albore Livadie, C., G. D'Alessio, G. Mastrolorenzo, and G. Rolandi. 1986. L'eruzioni del Somma-Vesuvio in epoca protostorica. In *Tremblements de Terre, éruptions Volcaniques et Vie des Hommes dans la Campanie Antique*, edited by C. Albore Livadie, pp. 55–66. Publications du Centre Jean Berard, Naples.

Arnó, V., C. Principe, M. Rosi, R. Santacroce, A. Sbrana, and M. E Sheridan. 1987. Eruptive History. In *Somma-Vesuvius*, edited by R. Santacroce, pp. 53–103. 114 CNR Quaderni de La Ricerca Scientifica, Rome.

Delibrias, G., G. M. DiPaola, M. Rosi, M. and R. Santacroce. 1979. "La storia eruttiva del complesso vulcanico Somma Vesuvio ricostruita dalle successioni piroclastiche del Monte Somma." *Rendiconti Società Italiana di Mineralogia e Petrologia* 35: 411–38.

Grant, M. 1968. *Gladiators.* Penguin Books, London.
 1976. *Cities of Vesuvius: Pompeii and Herculaneum.* Penguin Books, New York.

Lirer, L. T. Pescatore, B. Booth, and G. P. L. Walker, 1973. "Two Plinian Pumice-Fall Deposits from Somma-Vesuvius, Italy." *Geological Society of America, Bulletin* 84: 759–72.

Preuss, P., 1934. "Ein Wort zur Vesuvgestaltung und Vesuvtatigkeit im Altertum." *Klio, Beitrage zur alten Geschichte* 27: 295–310.

Principe, C., M. Rosi, R. Santacroce, and A. Sbrana. 1982. *Workshop on Explosive Volcanism: Guidebook on the Field Excursion to Phlegrean Fields and Vesuvius.* Consiglio Nazionale delle Richerche Italia, Rome.

Rosi, M., and R. Santacroce. 1986. L'attività del Somma-Vesuvio precedente l'eruzione del 1631: dati stratigrafici e vulcanologici. In *Tremblements de Terre, éruptions Volcaniques et Vie des Hommes dans la Campanie Antique,* edited by C. Albore Livadie, pp. 15–33. Publications du Centre Jean Berard, Naples.

Rosi, M., R. Santacroce, and M. E. Sheridan. 1981. "Volcanic Hazards of Vesuvius (Italy)." *Bulletin du Bureau des Recherches Géologiques et Minières* 4: 169–79.

Rosi, M., and A. Sbrana. 1987. *Phlegrean Fields.* Quaderni, 114, Consiglio Nazionale delle Ricerche Italia, Rome.

Sigurdsson, H., S. Carey, W. Cornell, and T. Pescatore. 1985. "The Eruption of Vesuvius in A.D. 79." *National Géographic Research* 1: 332–87.

Stothers, R. B., and M. R. Rampino. 1983. "Volcanic Eruptions in the Mediterranean before A.D. 630 from Written and Archaeological Sources." *Journal of Geophysical Research* 88: 6357–71.

Vogel, J. S., W. Cornell, D. E. Nelson, and J. R. Southon. 1990. "Vesuvius/Avellino, One Possible Source of Seventeenth-Century B.C. Climatic Disturbances." *Nature* 344: 534–7.

THE ERUPTION OF VESUVIUS IN A.D. 79

Haraldur Sigurdsson and Steven Carey

INTRODUCTION

Because it encapsulated and preserved two Roman cities in its deposits, the A.D. 79 eruption of Vesuvius may be considered of unique cultural significance. The eruption is moreover of great importance for the history of science, as it is the first volcanic event for which we have a detailed eyewitness report in the letters of Pliny the Younger. For volcanology, however, the archaeological excavations in the buried Roman cities have provided a unique opportunity to study the destructive force of an explosive eruption, as recorded in its deposits on the streets and within buildings, as well as the effects of high-velocity flow of hot volcanic ejecta on the objects of everyday life and on the inhabitants themselves.

The destruction of Pompeii and Herculaneum during the A.D. 79 eruption has been the subject of many studies, beginning with the visit of Dolomieu to Herculaneum in the eighteenth century. In early studies (e.g., Ippolito 1950), the fate of the cities was attributed to a very heavy and rapid fall of pumice and ash in the case of Pompeii and inundation by mudflows in the case of Herculaneum. This view was held by Rittmann (1950) and echoed widely in the geological literature. During this time the field of volcanology was evolving rapidly, driven largely by observations of explosive eruptions at many different volcanoes. In particular, the 1902 eruption of Mont Pelee on the island of Martinique dramatically illustrated the devastating potential of explosive eruptions. On the morning of May 9, the town of St. Pierre, including virtually all of its 25,000 inhabitants, was laid to waste within a few minutes by a cloud of hot volcanic gas and particles that had traveled down the slopes of the volcano at hurricane speed. These deadly clouds were described as glowing avalanches or *nuées ardentes* by Lacroix (1908) because of the transport of incandescent fragments (Fig. 32).

Following the recognition of *nuées ardentes* in 1902, some geologists began to see the Vesuvius eruption in a new light (Lacroix 1908). In two insightful papers, Merrill (1918; 1920) proposed that the eruption had produced *nuées ardentes* and made several observations that supported his case. Merrill's work went unnoticed, however, and Rittmann's view prevailed (Maiuri 1977). In the last two decades, a tremendous progress has been made toward an understanding of *nuées ardentes* through observational and theoretical studies. These clouds were found to evolve into two parts as they travel down the slope of a volcano. The base becomes a high-concentration mixture of gas and particles, called a pyroclastic flow, that tends to follow the local topography over which it flows. In contrast, the upper part of the *nuée ardente* is a low-concentration, highly turbulent mixture of gas and particles called a pyroclastic surge. Because of the high degree of inflation, surges commonly extend over a much larger area than their associated pyroclastic flows. Destructive as they are, surges often leave only very thin deposits. For example, a surge that completely destroyed the village of Naranjo during the 1982 eruption of El Chichon in Mexico left only a 3 cm thick deposit. Such a layer can easily be overlooked during the study of a thick volcanic sequence, but in terms of eruptive processes it might represent the most destructive phase of an eruption. In addition, surge deposits may be misinterpreted because they often resemble reworked, cross-bedded volcaniclastic deposits.

As deposits of the A.D. 79 eruption were examined in the light of a new appreciation for these processes, it became clear that both pyroclastic surges and flows were

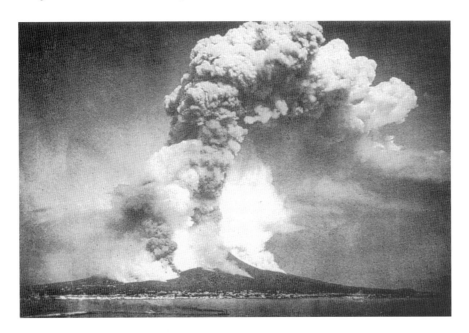

FIGURE 32 A photograph of the 1872 explosive eruption of Mount Vesuvius, displaying a Plinian eruption column of the same type, although much smaller, as that produced during the larger event in A.D. 79. In addition to the high vertical column above the volcano, a dark and dense cloud flows along the ground to the left of the crater. This may be a small version of a glowing avalanche or *nuée ardente*, of the type later recognized at Mont Pelée. The 1872 eruption also produced lava flows, and one of these is shown in Figure 40. This is one of the earliest known photographs of a volcanic eruption.

an important part of this event (Lirer et al. 1973; Sparks and Walker 1973). Sheridan et al. (1981) identified surge and pyroclastic flow deposits in the lower sequence at Herculaneum but still proposed mudflows and lahars for the upper layers. We presented a new reconstruction of the eruption on the basis of a combination of the stratigraphic evidence from the volcanic deposits and the letters of Pliny the Younger (Sigurdsson, Cashdollar, and Sparks 1982), where we contrasted the different effects of the pumice fall, pyroclastic surges, and pyroclastic flows on communities around the volcano and established a chronology for the main events during the eruption. While that paper was in press, new discoveries were made at the excavation of the Herculaneum waterfront that throw a new light on the fate of the population of that city. These we have documented (Sigurdsson et al. 1985). We have also described in detail the general deposits resulting from the A.D. 79 eruption of Vesuvius and reconstructed the processes that occurred during this event (Carey and Sigurdsson 1987; Sigurdsson, Cornell, and Carey 1990; Sigurdsson et al. 1994). In this chapter we present a synthesis of the A.D. 79 eruption that describes the nature, sequence, and timing of the volcanic processes that took place during the event and the effects that these processes had on the cities of Pompeii and Herculaneum and the villas in the surrounding region of Campania.

A CONTEMPORARY ACCOUNT OF THE ERUPTION: THE PLINYS

The A.D. 79 eruption of Vesuvius is intimately connected to Pliny the Elder, and it is indeed because of the death of this famous Roman during the eruption that we have a vivid contemporary account of the disaster. At the time of the eruption, Pliny was in command of the Roman naval port of Misenum, 32 km across the bay from Vesuvius (Fig. 33). At Misenum Pliny was accompanied by his sister and her seventeen-year old son, Pliny the Younger. During the two days of the eruption, the Pliny family was to experience grave danger, which led to Pliny the Elder's death, whereas Pliny the Younger and his mother narrowly escaped. At the request of the historian Cornelius Tacitus, Pliny the Younger wrote down his recollections of the circumstances of his uncle's death during the eruption in a letter, about twenty-four to twenty-eight years after the event:

> On 24 August,[1] in the early afternoon, my mother drew his attention to a cloud of unusual size and appearance. He had been out in the sun, had taken a cold bath, and lunched while lying down, and was then working at his books. He called for his shoes and climbed up to a place which would give him the best view of the phenomenon. It was not clear at that distance from which mountain the cloud was rising (It was afterwards known to be Vesuvius); its general appearance can best be expressed as being like an umbrella pine, for it rose to a great height on a sort of trunk and then split off into branches, I imagine because it was thrust upwards by the first blast and then left unsupported as the pressure subsided, or else it was borne down by its own weight so that it spread out and gradually dispersed. Sometimes it looked white, sometimes

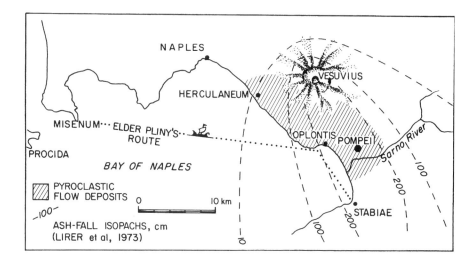

FIGURE 33 The route of Pliny the Elder during his fatal voyage from Misenum to Stabiae at the time of the A.D. 79 eruption, based on the Letters of Pliny the Younger. Also shown is the main pumice-fallout deposit from the initial Plinian phase, trending southerly.

blotched and dirty, according to the amount of soil and ashes it carried with it. My uncle's scholarly acumen saw at once that it was important enough for a closer inspection, and he ordered a boat to be made ready, telling me I could come with him if I wished. I replied that I preferred to go on with my studies, and as it happened he had himself given me some writing to do.

As he was leaving the house he was handed a message from Rectina, wife of Tascus whose house was at the foot of the mountain, so that escape was impossible except by boat. She was terrified by the danger threatening her and implored him to rescue her from her fate. He changed his plans, and what he had begun in a spirit of inquiry he completed as a hero. He gave orders for the warships to be launched and went on board himself with the intention of bringing help to many more people besides Rectina, for this lovely stretch of coast was thickly populated. He hurried to the place which everyone else was hastily leaving, steering his course straight for the danger zone. He was entirely fearless, describing each new movement and phase of the portent to be noted down exactly as he observed them. Ashes were already falling, hotter and thicker as the ships drew near, followed by bits of pumice and blackened stones, charred and cracked by the flames: then suddenly they were in shallow water, and the shore was blocked by the debris from the mountain. For a moment my uncle wondered whether to turn back, but when the helmsman advised this he refused, telling him that Fortune favors the brave and they must make for Pomponianus at Stabiae. He was cut off there by the breath of the bay (for the shore gradually curves round a basin filled by the sea) so that he was not as yet in danger, though it was clear that this would come nearer as it spread. Pomponianus had therefore already put his belongings on board ship, intending to escape if the contrary wind fell. This wind was of course full in my uncle's favor, and he was able to bring his ship in. He embraced his terrified friend, cheered and encouraged him, and thinking he could calm his fears by showing his own compo-

sure, gave orders that he was to be carried to the bathroom. After his bath he lay down and dined; he was quite cheerful, or any rate he pretended he was, which was no less courageous.

Meanwhile on Mount Vesuvius broad sheets of fire and leaping flames blazed at several points, their bright glare emphasized by the darkness of night. My uncle tried to allay the fears of his companions by repeatedly declaring that these were nothing but bonfires left by the peasants in their terror, or else empty houses on fire in the districts they had abandoned. Then he went to rest and certainly slept, for as he was a stout man his breathing was rather loud and heavy and could be heard by people coming and going outside his door. By this time the courtyard giving access to his room was full of ashes mixed with pumice-stones, so that its level had risen, and if he had stayed in the room any longer he would never have got out. He was wakened, came out and joined Pomponianus and the rest of the household who had sat up all night. They debated whether to stay indoors or take their chance in the open, for the buildings were now shaking with violent shocks, and seemed to be swaying to and fro as if they were torn from their foundations. Outside on the other hand, there was the danger of falling pumice-stones, even though these were light and porous; however, after comparing the risks they chose the latter. In my uncle's case one reason outweighed the other, but for the others it was a choice of fears. As a protection against falling objects they put pillows on their heads tied down with cloths.

Elsewhere there was daylight by this time, but they were still in darkness, blacker and denser than any ordinary night, which they relieved by lighting torches and various kinds of lamps. My uncle decided to go down to the shore and investigate on

the spot the possibility of any escape by sea, but he found the waves still wild and dangerous. A sheet was spread on the ground for him to lie down, and he repeatedly asked for cold water to drink. Then the flames and smell of sulfur which gave warning of the approaching fire drove the others to take flight and roused him to stand up. He stood leaning on two slaves and then suddenly collapsed, I imagine because the dense fumes choked his breathing by blocking his windpipe which was constitutionally weak and narrow and often inflamed. When daylight returned on the 26th – two days after the last day he had been seen – his body was found intact and uninjured, still fully clothed and looking more like sleep than death.

Letters 16

The letter deals primarily with his uncle's death and mentions only incidentally the natural phenomena during the volcanic disaster and the dangers facing Pliny the Younger and his mother. These other factors clearly aroused Tacitus's interest, for he requests further information, to which Pliny the Younger replies:

So the letter which you asked me to write on my uncle's death has made you eager to hear about the terrors and hazards I had to face when left at Misenum, for I broke off at the beginning of this part of my story. 'Though my mind shrinks from remembering, I will begin. After my uncle's departure I spent the rest of the day with my books, as this was the reason for staying behind. Then I took a bath, dined, and then dozed fitfully for a while. For several days past there had been earth tremors which were not particularly alarming because they are frequent in Campania, but that night the shocks were so violent that everything felt as if it were not only shaken but overturned. My mother hurried into my room and found me already getting up to wake her if she were still asleep. We sat down in the forecourt of the house, between the buildings and the sea close by. I don't know whether I should call this courage or folly on my part (I was only seventeen at the time) but I called for a volume of Livy and went on reading as if I had nothing else to do. I even went on with the extracts I had been making. Up came a friend of my uncle's who had just come from Spain to join him. When he saw us sitting there and me actually reading, he scolded us both – me for my foolhardiness and my mother for allowing it. Nevertheless, I remained absorbed in my book [Fig. 34].

By now it was dawn, but the light was still dim and faint. The buildings around us were already tottering, and the open space we were in was too small for us not to be in real and imminent danger if the house collapsed. This finally decided us to leave the town. We were followed by a panic-stricken mob of people wanting an act on someone else's decision in preference to their own (a point in which fear looks like prudence), who hurried us on our way by pressing hard behind in a dense crowd. Once beyond the buildings we stopped, and there we had some extraordinary experiences which thoroughly alarmed us. The carriages we had ordered to be brought out began to run in different directions though the ground was quite level, and would not remain stationary even when wedged with stones. We also saw the sea sucked away and apparently forced back by the earthquake: at any rate it receded from the shore so that quantities of sea creatures were left stranded on dry sand. On the landward side a fearful black cloud was rent by forked and quivering bursts of flame, and parted to reveal great tongues of fire, like flashes of lightning magnified in size.

At this point my uncle's friend from Spain spoke up still more urgently: "If your brother, if your uncle is still alive, he will want you both to be saved; if he is dead, he would want you to survive him – why put off your escape?" We replied that we would not think of considering our own safety as long as we were uncertain of his. Without waiting any longer, our friend rushed off and hurried out of danger as fast as he could.

Soon afterwards the cloud sank down to earth and covered the sea; it had already blotted out Capri and hidden the promontory of Misenum from sight. Then my mother implored, entreated and commanded me to escape as best I could – a young man might escape, whereas she was old and slow and could die in peace as long as she had not been the cause of my death too. I refused to save myself without her, and grasping her hand forced her to quicken her pace. She gave in reluctantly, blaming herself for delaying me. Ashes were already falling, not as yet very thickly, I looked round: a dense black cloud was coming up behind us, spreading over the earth like a flood. "Let us leave the road while we can still see," I said, "or we shall be knocked down and trampled underfoot in the dark by the crowd behind." We had scarcely sat down to rest when darkness fell, not the dark of a moonless or cloudy night, but as if the lamp had been put out in a closed room. You could hear the shrieks of women, the wailing of infants, and the shouting of men; some were calling their parents, others their children or their wives, trying to recognize them by their voices. People bewailed their own fate or that of their relatives, and there were some who prayed for death in their terror of dying. Many besought the aid of the gods, but still more imagined there were no gods left, and that the universe was plunged into eternal darkness forever more. There were people, too, who added to the real perils by inventing fictitious dangers: some reported that part of Misenum had collapsed or another part was on fire, and though their tales were false they found others to believe them. A gleam of light returned, but we took this as a warning of the approaching flames rather than daylight. However, the flames remained some

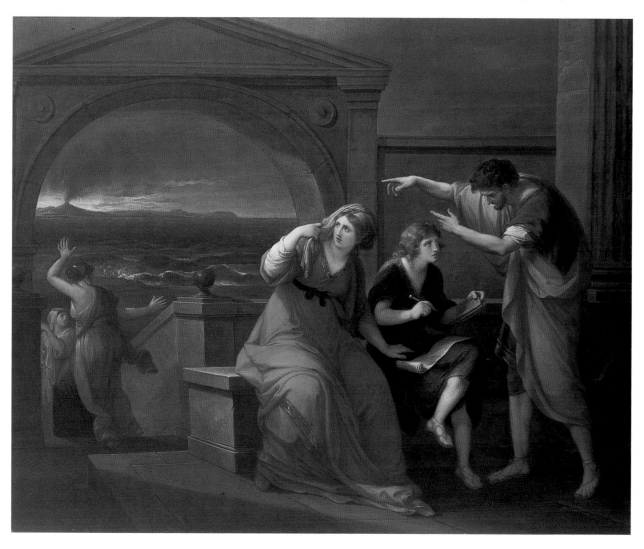

distance off; then darkness came on once more and ashes began to fall again, this time in heavy showers. We rose from time to time and shook them off, otherwise we should have been buried and crushed beneath their weight. I could boast that not a groan or cry of fear escaped me in these perils, had I not derived some poor consolation in my mortal lot from the belief that the whole world was dying with me and I with it.

At last the darkness thinned and dispersed into smoke or cloud; then there was genuine daylight, and the sun actually shone out, but yellowish as it is during an eclipse. We were terrified to see everything changed, buried deep in ashes like snowdrifts. We returned to Misenum where we attended to our physical needs as best we could, and then spent an anxious night alternating between hope and fear. Fear predominated, for the earthquakes went on, and several hysterical individuals made their own and other people's calamities seem ludicrous in comparison with their frightful predictions. But even then, in spite of the dangers we had been through and were still expecting, my mother and I had still no intention of leaving until we had news of my uncle.

Letters 20

FIGURE 34 Painting of Pliny the Younger and his mother at Misenum by the Swiss painter Angelica Kauffmann (1741–1807). The artist drew on Pliny's letters in composing this image, which is faithful to the eyewitness description of the eruption and the reactions of Pliny the Younger, his mother, and their Spanish friend. In Kauffmann's painting we see the young Pliny looking up from studying a volume of Livy's writing as his uncle's Spanish friend urges him and his mother to flee from the danger of the eruption. The sea is rough, and a tidal wave threatens the coast. The household staff is running away in a state of panic. (Oil on canvas, 103 × 127.5 cm; 1785. The Art Museum, Princeton University. Museum purchase, gift of Franklin Kissner.) Photo: Clem Fiori.

In the field of science Pliny's letters 16 and 20 in Book 6 will remain classic as the first eyewitness report of an explosive volcanic eruption so powerful that it is repeated on our planet only about once in a thousand years. The veracity of Pliny's report is supported by the fact that it can be reconciled to a high degree with the geologic evidence in the volcanic deposits (Sigurdsson et al. 1985). Although the mysterious death of this important Roman must have raised questions at the time, there is no evidence that the events were documented until A.D. 103 to 107 in these two letters.

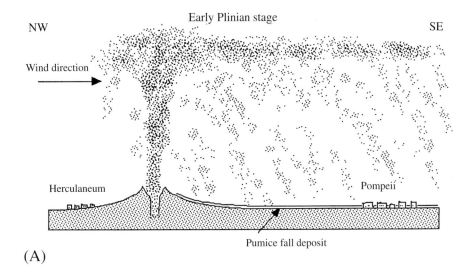

Early Plinian stage

NW SE

Wind direction

Herculaneum Pompeii

Pumice fall deposit

(A)

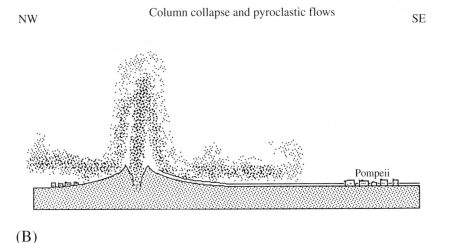

Column collapse and pyroclastic flows

NW SE

Pompeii

(B)

FIGURE 35 The A.D. 79 eruption consisted of two main stages. In the initial Plinian explosive phase (A) Vesuvius produced a high column of ash and pumice, towering 15–30 km above the volcano. The products were carried by high-altitude winds to the southeast of the volcano and deposited a major pumice-fallout layer over Pompeii during the first hours of the eruption. Herculaneum is upwind, and virtually no fallout occurred in this city during the Plinian stage. About halfway through the event, the style of the eruption changed dramatically (B) as the column collapsed, producing a fountain of ash and pumice over the volcano, which generated ground-hugging pyroclastic flows and surges. The first of these flows reached Herculaneum with total destruction and loss of life, but did not reach Pompeii. The eruption alternated six times between stages A and B, and each successive surge and pyroclastic flow extended further over the region, finally also engulfing distant sites such as Pompeii during the generation of the third and fourth surges.

VOLCANIC PROCESSES

Pliny the Younger's description of the eruption suggests that several different types of volcanic processes took place during the A.D. 79 event. Indeed, this is confirmed by studies of the volcanic deposits that interred the cities of Pompeii and Herculaneum (Sigurdsson et al. 1985). The nature, sequence, and timing of these processes can be inferred from the physical properties and relative stratigraphic position of different eruptive units. Fallout of pumice (lapilli) and other fragments from a towering eruption cloud several tens of kilometers in height above the volcano was an important process during most of the event, particularly at the beginning (Fig. 35). During this Plinian phase, named in honor of Pliny the Younger, hot gas and particles are ejected from the crater, rise convectively above the volcano to great heights, and spread out to form an anvil-shaped cloud that Pliny described as resembling an umbrella pine. Pumice and other fragments gradually settle out of this cloud and are carried along by the prevailing winds (Fig. 35A). This activity produces a

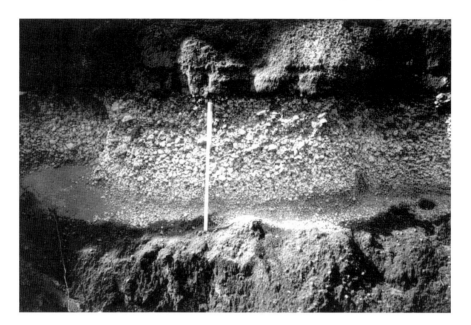

widespread fall deposit that mantles the local topography, like snowfall, and decreases in thickness downwind from the volcano (Figs. 36 and 37). Typically the A.D. 79 fall deposit is well sorted, and grain size decreases systematically with distance from the source. The general term that is commonly applied to the fragments (pumice and lithics) ejected from explosive eruptions is *tephra.*

In Oplontis, Boscoreale, and many other sites south of the volcano, layers of thin, dark gray, fine-grained but poorly sorted ash occur within the upper part of the pumice-fall deposit. These layers contain fragments of roof tiles and other building material, as well as carbonized wood (Fig. 38) and in some cases human skeletons. The occurrence of cross-bedding and dune structures in some of the layers indicates transport of a bed-load by traction and saltation, and rules out fallout of tephra (Fig. 39). Following studies of the deposit in Pompeii, it was proposed that these distinctive layers were the products of pyroclastic surges (Sigurdsson, Cashdollar, and Sparks 1982; Sigurdsson, 1985). These deposits thus are more informative than surge deposits of most other volcanoes, as they contain abundant examples of the effects of surges on buildings and common objects, providing evidence of the type and magnitude of the physical processes involved.

In Herculaneum, Oplontis, and several other regions around Vesuvius, the surge layers are associated with pyroclastic flow deposits. They are thick (several to tens of meters) and massive layers of partly indurated, very poorly sorted tephra (Fig. 40), generally lacking building fragments and other artifacts, but clearly deposited at high temperature (Kent et al. 1981). Each pyroclastic flow is underlain by a surge layer, but the latter has a much more extensive distribution radially around the volcano. The pyroclastic flows, on the other hand, form

FIGURE 36 Typical view of the light gray pumice-fall deposit from the early stages of the A.D. 79 eruption, exposed in the quarry of Pozzelle, on the south flank of Mount Vesuvius. The pumice-fall layer is overlain by a dark gray pyroclastic surge (S-1). Photo: S. Sigurdsson.

FIGURE 37 Map showing the fallout pattern of the Plinian pumice layer from the A.D. 79 eruption, dispersed primarily to the southeast of the crater. Contour lines show lines of equal thickness, in centimeters. Note that the deposit attained a great thickness over the region around Pompeii, or over 2 m.

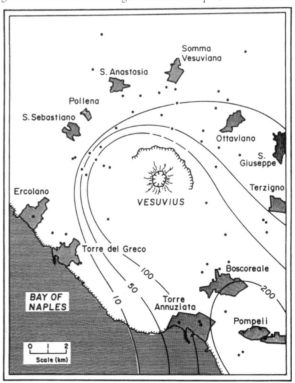

localized valley fills and fans and their distribution is clearly controlled by the local topography.

Juxtapositions in the field indicate that flows and surges are closely related and that they were probably generated during the same event. The origin of pyroclastic flows and pyroclastic surges during the A.D. 79 eruption of Vesuvius is best accounted for by the collapse of the eruption column (Sparks and Wilson 1976). During column collapse the mixture of hot gas and particles coming out of the vent is unable to rise to great heights above the volcano and, instead, collapses to a gravity-driven flow that travels down the slopes of the volcano at high speed (Fig. 35B). Collapse occurs primarily because the eruption column is unable to incorporate enough outside air and heat to keep it buoyant. Such *nuées ardentes* and their lethal effects are well known from studies of the eruptions of Mont Pelée in 1902 (Lacroix 1904), Mount Lamington in 1951 (Taylor 1958), and El Chichon in 1982 (Sigurdsson, Carey, and Espindola 1984).

The uppermost layers of the deposit from the A.D. 79 eruption are dark gray, silty-sandy beds that rarely extend more than 15 km from the volcano. They are characterized by abundant accretionary lapilli, and many show cross-bedding or dune structures. The presence of accretionary lapilli is good evidence of deposition from water-rich eruption clouds; these layers can be interpreted as products of phreatomagmatic explosions (explosions resulting from the interaction of groundwater with magma in the volcano's conduit) that generated wet surges and ash fall. Condensation of water in these clouds enhanced aggregation of fine ash particles and led to the formation of accretionary lapilli. Since the total deposit from the A.D. 79 eruption of Vesuvius is complex, and multilayered, Sigurdsson et al. (1985) proposed a scheme to identify the various layers. Thus the fallout layers are numbered sequentially from A-1 (the basal fine ash) to A-9. Similarly, the pyroclastic surge layers are numbered from S-1 to S-7. Pyroclastic flow deposits are labeled F-1 to F-6, from lowermost to topmost flow.

BEGINNING OF THE ERUPTION

In Pliny the Younger's letter we read that it was almost the seventh hour[2] (*"hora fere septima"*) when Pliny's mother drew his uncle's attention to the eruption cloud over Vesuvius, as seen across the Bay from Misenum (Fig. 33). It was therefore shortly before noon when Pliny the Younger's mother draws their attention to an eruption in progress, which supports the assumption that the main eruption began between 11 and 12 noon. The eruption seen from Misenum must have been the

beginning of the Plinian phase, as Pliny's vivid description matches that of modern observations of this type of activity. This phase initiated the fallout of coarse pumice over the area southeast of Vesuvius.

Our field studies in the spring of 1983 showed that the pumice fall was not, in fact, the first product of the A.D. 79 eruption, contrary to all previous findings (Sigurdsson et al. 1985). In the region of Campania around Vesuvius the Roman soil is a dark brown, humus-rich layer up to 1 m thick and easily identified because of its high content of artifacts and its peculiar undulating surface. Near Terzigno, for instance, undulations have an amplitude of 20 to 30 cm and a wavelength of about 1 to 2 m (Fig. 41). In three dimensions they actually consist of low, conical mounds that often contain a hollow, vertical pipe, 2 to 10 cm in diameter. The mounds are so widespread and uniform that they can only be products of Roman cultivation and most likely are analogous to the mounds of soil piled up around the base of vines in the vineyards of Campania today. On top of the soil just to the east of the volcano, the first deposit from the A.D. 79 eruption consists of a very fine ash layer (A-1), overlain by coarse pumice fall (F-1). This layer is best exposed around the villas at Terzigno to the east and at Cava Montone, northwest of Vesuvius. It contains vesicular to poorly vesicular glass and crystal fragments and was produced by the fallout of ash.

The distribution of this initial fine ash fall is almost due east of the crater (Fig. 42). This is clearly quite different from the southeasterly dispersal of the subsequent pumice fallout and indicates that the initial explosion produced a low eruption column that was dispersed easterly by low-level local winds and was not subject to stratospheric winds. The presence of small accretionary lapilli, the high degree of fragmentation, and the variable vesicularity of the tephra indicate a phreatomagmatic explosion, that is, an explosion involving some interaction between groundwater and magma in the vent. This ash fall did not reach the cities of Pompeii or Herculaneum, but their residents may have seen the small eruption cloud over the summit and the eastward-trending ash plume, drifting with the surface wind.

Minor steam explosions are typical opening shots in large explosive volcanic eruptions. Such explosions may be phreatic, involving steam and old fragmented rocks only, or phreato-magmatic, in which case some juvenile magma is ejected. Mount St. Helens, for example, fired off small phreatic explosions for twenty-two days before the climactic blast and Plinian explosion on May 18, 1980. Mount St. Helens was, however, in a very different condition from Vesuvius. The Cascades volcano was covered with an ice cap that was rapidly melting, seeping down into cracks of the expanding volcanic cone, where it burst into steam on coming

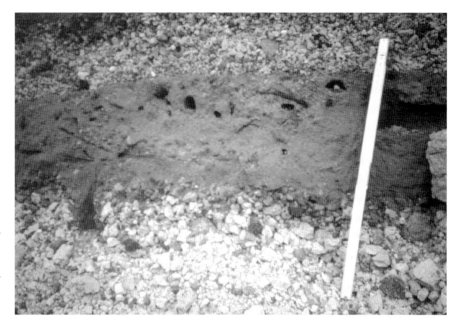

FIGURE 38 The brown pyroclastic surge layer (S-2) at Terzigno, sandwiched between pale gray pumice-fall units. The upper part of the surge contains black fragments of charcoal, representing plant remains carbonized by the hot surge cloud. See Figure 41 for a general view of the A.D. 79 deposit in this quarry. Photo: H. Sigurdsson.

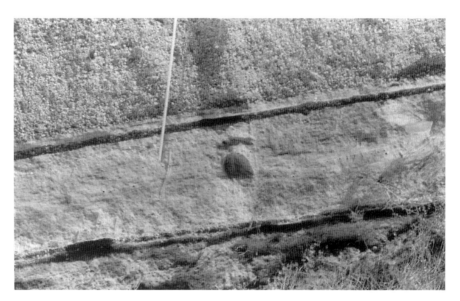

FIGURE 39 The A.D. 79 volcanic deposit in the Necropolis on the south edge of Pompeii. At base is the thick pale gray pumice fall, overlain by about 10 cm of dark gray surge (S-4), which is in turn overlain by thick and sandy cross-bedded surges (S-5 and S-6). Note a brick fragment in the surge bed at the far left. Photo: H. Sigurdsson.

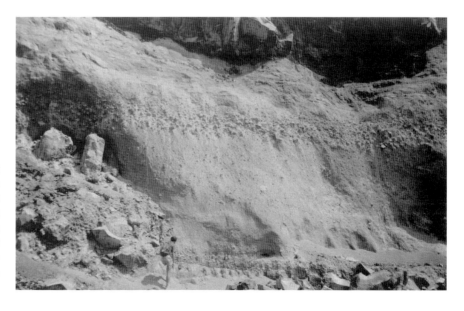

FIGURE 40 Pyroclastic flow deposit from the A.D. 79 eruption exposed in Cava Montone quarry on the west slopes of Mount Vesuvius. The 10 m thick pyroclastic flow overlies brown soil and is overlain by dark lava flow from an 1872 eruption. Note the person at the base for scale. Photo: H. Sigurdsson.

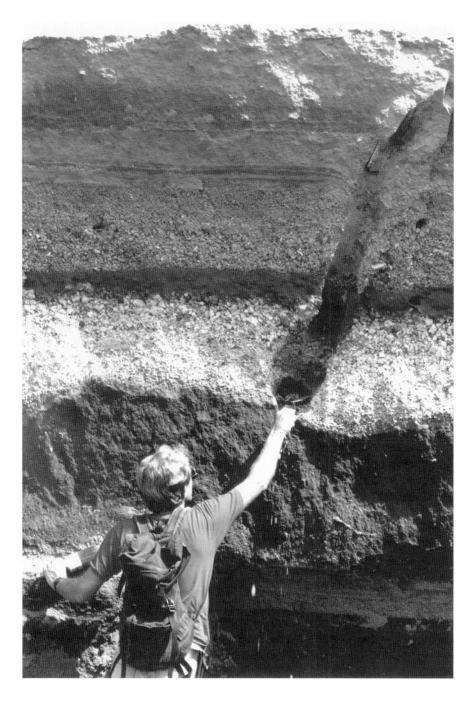

FIGURE 41 Typical cross section through the A.D. 79 deposit at Terzigno quarry, 6 km east of the Vesuvius crater. At base is the Roman soil, with conical mounds and undulations typical of the Roman vineyard cultivation. At the base of the A.D. 79 deposit, directly on top of the soil, is the fine-grained, gray A-1 ash fallout from the beginning of the eruption, forming a 4 cm layer. This layer is overlain by a coarse light gray pumice-fall deposit (A-2), the S-2 surge layer (dark gray), and other pumice-fall and surge units from the eruption. Note several older pumice-fall layers from earlier Vesuvius eruptions in the soil beneath the Roman level. See Figure 38 for a detail of one of the A.D. 79 surge deposits. Photo: O. Louis Mazzatenta; © National Geographic Society.

into contact with hot rock. Vesuvius, on the other hand, is a relatively well-drained, dry cone, with a deep groundwater table. It is therefore likely that the phreatic explosions were few and occurred on the same day as the climactic eruption on August 24, A.D. 79.

While the eyewitness report from Misenum and historical evidence tell us nothing about the onset of the phreatomagmatic explosions that produced the initial ash-fall layer, the volcanic stratigraphy is more helpful in timing this first explosive activity of the volcano. First, in all localities where the A-1 layer is exposed and overlain by the pumice-fall deposit, there is no evidence of erosion of the first ash before deposition of the pumice fall (Fig. 41). Furthermore, in the vicinity of two *villae rusticae* in the Terzigno quarry the fine ash layer is present even on the pavement immedi-

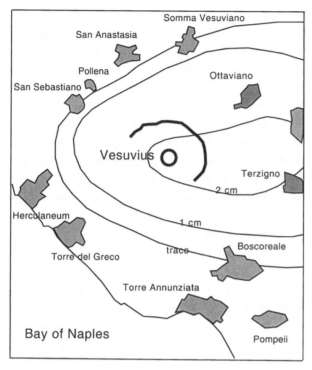

FIGURE 42 The fallout of the initial explosive phase was distributed mainly to the east of the volcano, forming layer A-1. Contours are lines of equal thickness, in centimeters. This fallout was probably generated by a relatively small explosion, predating the major noontime eruption column seen by Pliny the Younger from Misenum.

ately in front of the main entrance to the villa. These observations suggest that there was insufficient time for any erosion of the A-1 layer to occur before the onset of the main pumice-producing eruption, and that in the northern *villa rustica* at Terzigno the pumice fall followed so rapidly on the heels of the A-1 ash fall that the villa's residents had not found time to sweep or clean the doorstep. It would therefore seem likely that the phreatomagmatic explosions occurred during the night and morning of August 24 in the 5- to 10-hour period before the great noontime paroxysmal eruption.

The stratigraphic evidence thus indicates that some minor volcanic activity had started in Vesuvius before the great explosion witnessed by Pliny from Misenum, which up to now has been generally assumed to represent the beginning of the A.D. 79 eruption. We know from the very limited extent of layer A-1 that the initial phreatic explosions were of very low magnitude and thus it is unlikely that they were seen from Misenum. If seen, they would have been interpreted as normal weather clouds around the summit of the volcano. However, this initial activity would have been alarming in certain areas, especially close to and east of Vesuvius. It is possible that Rectina's plea for help, sent to Pliny the Elder at Misenum from her villa "under the mountain," was triggered by this event, in other words, that Rectina's villa was within the A-1 ash fall. We

know from Pliny the Younger that as his uncle "was leaving the house he was handed a message from Rectina" shortly after the main paroxysmal eruption had begun. If Rectina lived at the foot of Vesuvius more than 30 km from Misenum (Fig. 33), then it is difficult to visualize that her message could reach Pliny in such a short time if her alarm was due to the noontime paroxysmal explosion. The Roman military had at its disposal semaphore and other signaling procedures that enabled rapid communication, but it is unlikely that Rectina had access to such methods. If Rectina's residence at the foot of the volcano was, however, affected by the earlier activity that produced the ash-fall layer A-1, then her messenger could have traveled several hours on horseback to Misenum and caught up with Pliny the Elder before he set out on the bay.

PUMICE FALLOUT

The main pumice fall that began at noon on August 24 produced a deposit that is relatively coarse, with a distinct color change in the middle (Fig. 41) from a lower white part (unit A-2) to an upper greenish gray part (units A-3 and higher). The color change is the result of a change in composition of the erupting magma and thus reflects the compositional gradient in the volcano's reservoir. The fallout stage of the eruption can therefore be divided into two phases: the earlier white pumice and the later gray pumice. This compositional change in the fallout deposit also corresponds to an important change in density of the tephra. In the white pumice layer, tephra density ranges from 0.5 to 0.6 g/cm³, but it increases in the gray pumice to a maximum of about 0.9 g/cm³ in the middle of the gray fallout layer. This density variation may have influenced the eruption column behavior. The axis of fallout of both gray and white pumice layers is to the southeast (Fig. 33). The isopach fallout axes are remarkably close, trending 155° for the gray and 140° for the white pumice. This may indicate either a slight shift of the stratospheric wind direction during eruption or a slightly different wind direction at the stratospheric level where the gray pumice was being transported.

In general, Plinian fallout deposits thicken toward the source. The A.D. 79 pumice deposit is an exception to this rule, however, as seen in Figure 37. Both the gray and the white pumice deposit bulge just south of Pompeii (10 to 15 km from the crater), and consequently the pumice deposit becomes thinner northward, from a maximum of about 280 cm in Pompeii to about 180 cm in the saddle north of Pompeii (about 5 km from the crater). During the A.D. 79 eruption, the maximum thickness of the pumice fallout was thus

attained 10 to 15 km from the source. The volume of the white and the gray pumice fallout deposits has been determined on the basis of the isopach map (Fig. 37), giving 6.4 cubic km and 2.5 cubic km tephra volume for the gray and the white pumice layers, respectively, corresponding to 2.6 cubic km and 1 cubic km dense-rock-equivalent volume.

On the basis of the total volume of gray and white tephra erupted during the Plinian phase and the duration of each event (as estimated from the relative thickness of each layer and a total duration of nineteen hours), the height of the eruption column has been calculated (Carey and Sigurdsson 1987). Accordingly, with a duration of seven hours for the white pumice fallout (Plinian stage) and twelve hours for the gray pumice fallout, eruption columns would be 27 km and 33 km, respectively.

VOLCANIC DEPOSITS IN POMPEII

The A.D. 79 volcanic deposits have been removed from most of Pompeii or are inaccessible for study, but there are excellent sections just outside the city walls, at the Herculaneum Gate to the west, eastward to the Vesuvius Gate, the Nola Gate, and in the Necropolis near the Nocera Gate. These localities provide a composite section through the deposit and an opportunity to reconstruct the volcanic processes that affected the people and city of Pompeii.

No trace remains in Pompeii of the initial fine ash fall that affected areas to the north and east farther up the slopes of the volcano. The initial explosive phase of the eruption may have been witnessed from Pompeii — with an excellent view of the summit — but without direct consequences it probably generated only curiosity. The citizens of Pompeii became directly aware of the eruption sometime in the early afternoon of August 24 as coarse pumice fall began to plunge the city into darkness.

Pumice and lithics rained continuously from early afternoon on August 24 to early the next morning, according to accounts of Pliny the Younger. During this time 130 to 140 cm of white pumice (A-2) accumulated, on top of which another 110 to 130 cm of gray pumice was laid down (A-3 to A-5, Fig. 43). Although the pumice layer appears relatively homogeneous, the diameter of lithics and pumice change systematically, reflecting a general increase in height of the eruption column during the Plinian phase. For example, relatively large, dense pieces of pumice are concentrated about 10 cm above the base of the gray pumice layer.

Pompeii happened to be located on the secondary thickness maximum of the fallout deposit and thus received the thickest accumulation of pumice and lithic fall. During the first hours of pumice fall, the residents of Pompeii were not in significant danger. Most of the fragments were only a few centimeters in size, and it is likely that many people placed pillows or articles of clothing on their head to protect themselves from the pelting rain of pumice and lithics. Because these fragments were much coarser than other types of dusty volcanic ash, breathing was probably not a problem. As this material accumulated, however, residents were at risk from the collapse of roofs. This may have occurred about halfway through deposition of the white pumice, when it had reached a thickness of 40 cm. With most structures collapsing or unsafe for habitation, an exodus from the city is likely to have begun. Escape of most of Pompeii's residents can thus be attributed to roof collapse during the extended yet comparatively innocuous Plinian fallout phase.

During the eruption, the nature of volcanic activity changed dramatically, from pumice fallout to the generation of pyroclastic surges and flows (Fig. 35B). At the climax of the eruption and in later stages, the eruption oscillated six times between these two styles of activity. Pompeii is situated about 10 km from the volcano and was not exposed to the first two deadly surge clouds. The first pyroclastic surge to reach Pompeii swept against the north wall of the city in the early morning of August 24, depositing dark gray ash near the Herculaneum Gate (S-3). Neither the Vesuvius Gate, 200 m to the east, nor other sites in the Pompeii area show evidence of this surge. Therefore it is possible that the surge cloud did not extend inside the city walls but flowed just west of Pompeii over the Villa of the Mysteries and Villa of Diomedes. The surge must, however, have caused alarm and almost unbearable conditions in the city. Evidence from Mount St. Helens in 1980 and El Chichon in 1982 indicates a peripheral zone of high heat associated with the distal ends of surge clouds (Moore and Sisson 1981; Sigurdsson et al. 1985).

Within the city, 3 cm of pumice and lithic fall (A-6) accumulated before the next surge (S-4) overwhelmed the interior of the city. Unlike the fallout of pumice during the Plinian phase, the conditions within the surge cloud were lethal to the remaining residents of Pompeii. This is not surprising considering the physical environment inside a surge cloud. A number of studies of recent eruptions indicate that surge clouds travel at high speed (100 to 300 km/hr) and that they are extremely turbulent (Kieffer 1981; Rosenbaum and Waitt 1981). Consequently, fragments of rocks, building material, and tiles are hurled along in the cloud as lethal projectiles. Second, surge clouds can have tem-

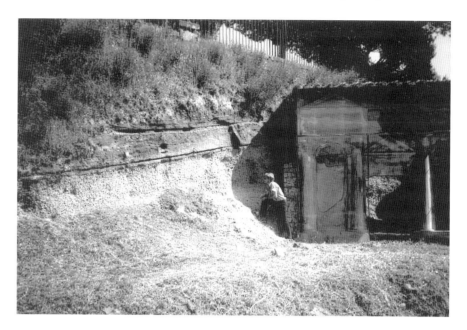

FIGURE 43 The A.D. 79 deposit in the Necropolis, south of the city walls of Pompeii. The lower part of the deposit is the 240 cm thick pumice fall from the initial Plinian stage of the eruption. This is overlain by a 10 cm thick S-4 surge layer. On top of that is a massive S-6 surge, with roof tiles and bricks. The tomb on the right was largely buried by the pumice fall-out, but its upper walls and roof were broken down by the surge clouds. Photo: H. Sigurdsson.

peratures of 100 to 400° C. The Mount St. Helens surge cloud, for example, singed hair (120° C) and melted plastics (350° C). Third, the surge cloud is probably low in free oxygen content and may carry harmful volcanic gases in toxic concentration. Autopsies of twenty-six of the sixty-seven known fatalities of the 1980 Mount St. Helens surge blast show that eighteen, or the great majority, died of asphyxiation, whereas five died of thermal effects and three of injuries (Eisele et al. 1981). The asphyxiation was caused by an occlusive plug of volcanic ash, mixed with mucus in the larynx, trachea, and upper airway. Some of the victims had little or no ash in the airway and were diagnosed as having died by thermal shock. They were not burnt, but rather baked or cooked in the hot deposit, resulting in mummification of hands and feet and desiccation and shrinking of internal organs. The tympanic membranes in the Mount St. Helens victims were all intact (Eisele et al. 1981), indicating that the pressure wave associated with the surge was not sufficient to cause injury, that is < 0.1 to 0.5 bars. The three victims who died from injuries were struck by flying rocks or falling trees. Chemical analyses of blood from the victims did not show any evidence of high content of toxic gases in the surge cloud. Most of the surge victims in Pompeii, Herculaneum, and elsewhere around Vesuvius must have suffered a similar fate.

The majority of human remains discovered in the Pompeii excavations have been found on top of the pumice-fall layer, lying within surge deposits S-4 and S-5 (Fig. 43), but principally buried by the thick S-6 surge. Because of their fine-grained, silty nature, the surges have preserved molds of the victims, sometimes including clothing (Fig. 44). With time, the soft tissues have decayed, leaving only bones in the hollow cavities. In 1860 Giuseppe Fiorelli developed the ingenious tech-

nique of making plaster casts of these impressions before the surrounding surge deposits were disturbed. Many hundreds of casts of the dead in Pompeii have since been made in this manner. In 1966, for example, casts of thirteen victims were made in the Garden of the Fugitives, where they fell in various groups of adults and children on top of the pumice-fall deposit. Thus evidence is compelling that the S-4 surge was the lethal event in Pompeii. Since detailed stratigraphic studies of the deposit have not yet been feasible inside Pompeii, the extent of building damage resulting from the S-4 surge cannot be judged. By this time the ground-floor levels of buildings had already been buried and only the upper stories protruded above the pumice blanket.

A brief period of gray pumice and lithic fall (A-7) blanketed the S-4 surge deposit. This deposit is present near the Herculaneum Gate and the Vesuvius Gate but is missing in other sections, presumably due to erosion by the following surges. Shortly thereafter a more energetic surge (S-5) once again overwhelmed the entire city, leaving 0.5 to 11 cm of cross-bedded ash. Since the A-7 fall is often missing, the S-5 surge lies directly on top of the S-4 surge layer in some sections, producing a distinctive doublet. This surge extended to Tricino, 3 km east-northeast of Pompeii, but did not reach Bottaro, directly south of Pompeii (Winkes 1982).

The rain of pumice on the city continued but from

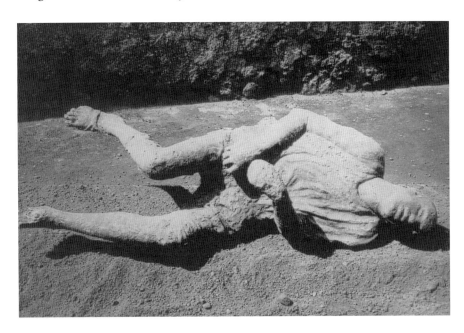

FIGURE 44 Cast of a victim of the A.D. 79 eruption. Photo: H. Sigurdsson.

an eruption column of diminished altitude and with an increasing content of dense lithic fragments (A-8). Only 2.5 to 4.5 cm of fall accumulated before the invasion of the most destructive surge cloud to strike Pompeii, leaving up to 180 cm of material in its wake (S-6). The deposit consists of distinct lower and upper units. The lower unit is relatively massive and flowlike and contains tiles and other building fragments as evidence of its destructive force. The upper unit is pumice-poor, cross-bedded, and finer grained and contains dune structures of 1.2 to 1.5 m wavelength and 10 to 30 cm amplitude.

The S-6 surge was clearly the agent of major destruction in Pompeii. It toppled the walls of most buildings that protruded above the level of the volcanic deposit and transported building fragments some distance. Finally, the bodies of victims killed by the earlier S-4 surge were largely buried by the thick S-6 surge layer. The S-6 surge extended at least as far east as Tricino, where it deposited a 30 cm thick layer, and to Bottaro in the south where the deposit is 32 cm thick. Pliny the Elder was at the distal edge of the largest surge (S-6) when he died at Stabiae on the morning of August 25 (Sigurdsson Cashdollar, and Sparks 1982; Sigurdsson et al. 1985). In excavations of the Villa Ariadne near Stabiae, the 2 m pumice-fall deposit is overlain by a 1 cm surgelike layer, which may be the distal facies of the S-6 surge, but further work is required to establish its southern limit.

After the deposition of the S-6 surge, the ground surface in Pompeii and elsewhere around Vesuvius was characterized by low dunes. These dunes were buried by dark gray ash with common accretionary lapilli (C-1). The layer's relatively uniform thickness and distribution suggest an origin in fallout; it represents the transition to the phreatomagmatic phase of the eruption. Two

brief periods of relatively dry lithic fall (A-9 and A-10), with abundant lava and carbonate fragments, directly followed deposition of C-1, but a minor surge (S-7) was emplaced between these falls. These layers are overlain by a total of 60 to 80 cm thick, undifferentiated accretionary lapilli layers and thin silty-to-sandy surges from the final stages of the A.D. 79 eruption.

HERCULANEUM

The cities of Herculaneum and Pompeii experienced the A.D. 79 eruption in very different ways, in terms of both timing and destructive effects, due to differences in their distance from the volcano, the effects of wind, and the local topography. Thus while Herculaneum was totally spared the fallout of ash and pumice that gradually buried Pompeii, the city of Herculaneum suffered severe destruction by the first surge, well before the fourth surge overwhelmed Pompeii (Fig. 35B).

Previous reconstructions of the physiography of Herculaneum in Roman times picture a city situated on a high bluff overlooking a broad, flat coastline (Maiuri 1977; Pistolesi 1836) with the beach about 300 m west of the city. Recent excavations indicate that major revision of this picture is required, although they support the idea that the city was situated on a bluff about 15 to 20 m above sea level, with a splendid view of the Bay of Naples to the west and the cone of Vesuvius to the east (Sigurdsson et al. 1985). The discovery of a beach at the very foot of the bluff during the excavations in 1982 indicates, however, that the city was not separated from the ocean by a low stretch of land but was situated on a hill or headland with the ocean waves lapping at its base.

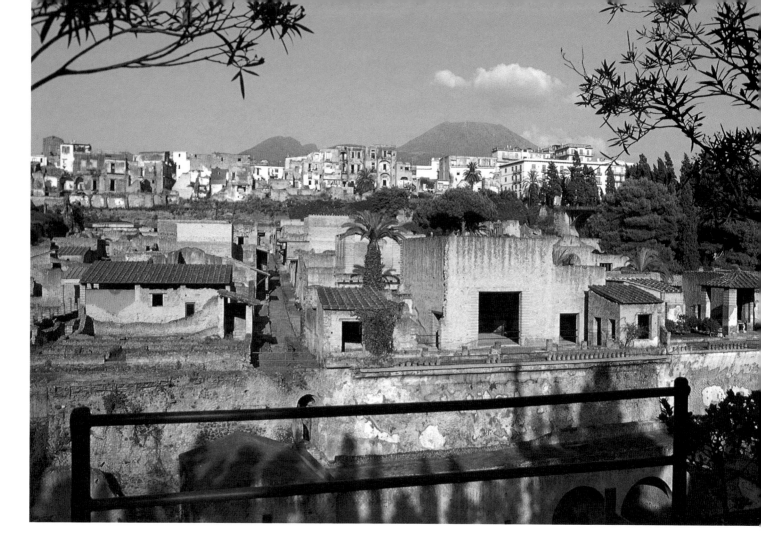

Early in its history the ocean front of the city was fortified by a massive wall that covered the rocky outcrops of the bluff from sea level to street level in the city (Fig. 45). Later this wall was no longer required for defense, and the open waterfront beyond the wall was developed by the construction of the luxurious Suburban Thermae (Fig. 46) and the Sacred Area. This development was at the water's edge and therefore required foundations that could take the pounding of the waves. The problem was solved by constructing a series of arches, which form the base of the Sacred Area, along the waterfront. Ten arches have been uncovered so far, five on either side of the long flight of steps leading from sea level to the city's Marine Gate, but many probably remain to be discovered in the unexcavated area to the northwest. Each arch forms a vault or chamber, 3.75 m high, 3.15 m wide, and 3.85 m deep. In these chambers, many residents of Herculaneum sought shelter when their city was overwhelmed by the first pyroclastic surge during the A.D. 79 eruption (Fig. 47). On the southern part of the waterfront, the magnificent Suburban Thermae were also constructed outside the city wall. The Thermae were not supported by arches but were built directly on the waterfront, so that bathers only had to descend a short flight of steps to the small beach and the ocean. This convenience meant that the Thermae were fully exposed to the waves, and therefore the builder cleverly

FIGURE 45 Herculaneum from the west. In the foreground is the city wall, rising above the waterfront. In the background is the modern city of Ercolano, on top of the unexcavated districts of Herculaneum. In the distance rises the cone of Mount Vesuvius and the rim of Somma on the left. Photo: H. Sigurdsson.

designed a lip or ledge on the exterior walls about 4 m above sea level to deflect the spray from the breaking waves away from the large windows of the bathhouse.

THE HERCULANEUM BEACH IN ROMAN TIMES

We have been able to reconstruct the position of the beach and shoreline of Herculaneum prior to the A.D. 79 eruption from exposures in the new excavations (Sigurdsson et al. 1985). The beach consists of three deposits: tuff, black beach sand, and gravel. The oldest is massive, consolidated tuff, which forms bedrock in Herculaneum. The tuff is a pumice-rich and consolidated pyroclastic flow in origin, probably formed by an early eruption of Vesuvius at an unknown time. Catalano (1957) has attributed a bedrock formation in excavation under the Palaestra to the yellow Neapolitan tuff. The tuff exposed at the beach is clearly not the yellow Neapolitan tuff, and unfortunately the Palaestra outcrop is no longer exposed. In Roman times the tuff

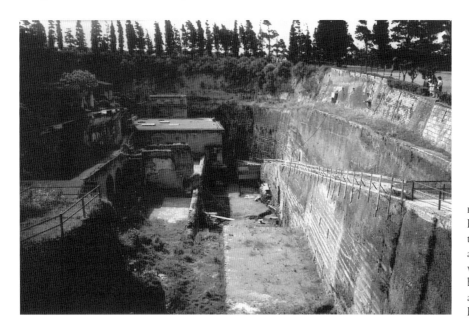

FIGURE 46 The excavations of the Herculaneum waterfront. The 23 m thick pyroclastic flow deposits form a sheer wall to the right of the excavated area. At base is the Roman beach, with the Suburban Thermae and the city wall on the left. Photo: H. Sigurdsson.

formed a wave-cut platform along the Herculaneum shoreline. It is best exposed in the floor of a recent (1982) tunnel that trends away from the Roman beach and toward the area directly underneath the new Herculaneum Museum. The tunnel section shows that the tuff formed a reef 10 to 20 m offshore, which was probably exposed at low tide. The surface of the tuff has been worked and fashioned to provide a slipway for large boats. A 3 m long keel-groove and holes for supporting beams are exposed on the tuff surface in the tunnel, indicating that the larger vessels were pulled up here for maintenance on the reef.

Black beach sand is the second deposit on the Herculaneum shoreline and overlies the tuff. The beach sand is derived from erosion of volcanic rocks. It is thickest (0.5 m) in front of the Suburban Thermae and the chambers and thins rapidly away from shore, pinching out completely some 10 m from the waterfront. The youngest deposit on the Herculaneum beach, before the A.D. 79 eruption, is a gravel layer. It is thickest (0.6 m) in front of the Thermae, thins gradually along the waterfront in front of the chambers, and pinches out to the north of the Marine Gate steps. The gravel is composed primarily of rounded pebbles of limestone, lava, and rubbish (fragments of pottery, tiles, stucco, broken glass, bones, seashells) in a matrix of black sand. The degree of rounding of fragments in the gravel varies systematically within the area. The upper part of the deposit (in front of the Thermae) consists of angular fragments, whereas rounded fragments dominate where the deposit is exposed at lower levels. The transition from rounded to angular fragments occurs at about 4 m below present sea level. The boundary between rounded and angular fragments in the gravel is significant because it provides evidence of the location of sea level in Herculaneum at the time of

the A.D. 79 eruption. Clearly this deposit results from dumping building rubble and other rubbish on top of the black beach sand. Some of the material was within reach of the wave action of the surf, resulting in rounding of the fragments, while upper parts of the deposit were above sea level and escaped rounding. Pre-eruption sea level was at the boundary between angular and rounded material; this is about 4 m below present sea level. Herculaneum has thus undergone major subsidence in the 1900 years since the eruption. This subsidence may have occurred rapidly after the eruption, due to deflation of the magma reservoir under the volcano — such deflations are a common consequence of large eruptions. Alternatively, the subsidence may be part of regional tectonic tilting and long-term structural events in the Bay of Naples.

The gravel shows that part of the Herculaneum beach was a rubbish dump in A.D. 79. This is surprising since the dump was located in front of the elegant Suburban Thermae. There are, however, some indications that the rubbish dump may have been a very recent feature on the Herculaneum beach at the time of the eruption. The rubbish-derived gravel rests on black beach sand, as stated earlier. The normal beach environment thus was characterized by a wave-cut rock platform of tuff, with lenses of black beach sand at the waterfront. The large protruding masonry lip at 4.6-m elevation on the exterior walls of the Suburban Thermae indicates that surf would pound the waterfront during storms. At the time of deposition of the black beach sand, the beach appears to have been exposed and active, with surf up to the buildings at the waterfront. The overlying gravel, on the other hand, suggests that activity of the surf may have decreased, as shown by the angular character of the fragments that constitute the upper part of the deposit.

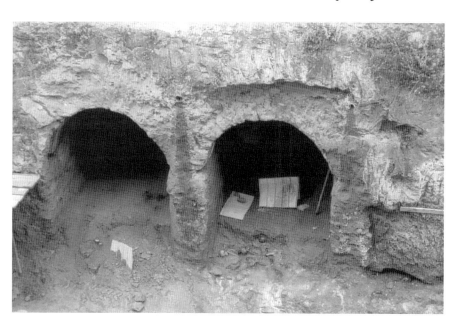

FIGURE 47 Two chambers at the waterfront of Herculaneum during excavation. On either side are unexcavated chambers. A skeleton of a female victim lies in the mouth of one chamber. Photo: H. Sigurdsson.

This suggests that surf was not active along the entire beach at this time. The decrease in surf action may be due to shallowing of the beach, that is, uplift. It is possible that the Herculaneum area, and indeed all of the Vesuvius region, underwent inflation some months or years before the A.D. 79 eruption, either when magma rose to higher levels in the earth's crust or when the magma chamber rose under the volcano. Such inflation or bradyseism would lead to uplift and a drop in sea level at Herculaneum, reducing surf action around the rubbish tip in front of the Suburban Thermae. Such uplift was probably no more than 0.5 to 1 m, but the population must have noticed it, and if it was accompanied by earthquake activity, it must have caused unrest in the town as in Pozzuoli today. The major earthquake that struck the Vesuvius area on February 5, 62, (Dio Cassius) seriously damaged buildings in Herculaneum, calling for radical restoration or complete rebuilding. An inscription records, for example, the restoration of the temple of the Mater Deum, financed by Emperor Vespasian. The gravel formation on the Herculaneum beach may well date from this catastrophe and represent building rubble cleared out of the city after the earthquake.

The 79 beach was 2 to 4 m wide in front of the steps to the Suburban Thermae, narrowing to less than 1 m in front of the chambers. The sea was very shallow off the shore of Herculaneum. Within the area exposed by the current excavations, the maximum depth of water was 0.5 to 0.7 m, which occurred in the region from the Marine Gate steps to the new tunnel. The shallow nature of the harbor suggests that wooden jetties or wharfs were probably constructed, as often depicted in contemporary wall paintings of real or imaginary Roman harbors. An obvious place for such a jetty would have been in line with the steps to the Marine Gate, toward the tunnel. The extraordinary amount of planks and timber found in the first surge layer on the waterfront may be evidence of a former jetty.

VOLCANIC STRATIGRAPHY IN HERCULANEUM

The nucleus of Herculaneum, which has been fully cleared, is surrounded by a 10–23 m high, nearly vertical bank of the volcanic deposit from the A.D. 79 eruption (Fig. 46). The best exposure is in the 23 m high wall of deposits overlying the beach, which forms the type section for this locality and is described in detail following. Other good exposures can be found in the network of tunnels in the Palaestra in the southeastern part of the city. We found that the previous estimates of <20 cm of accumulated ash and pumice fall during the initial phase of the eruption proved much too high (Sigurdsson, Cashdollar, and Sparks 1982). Instead, our new studies showed that the entire fallout in Herculaneum was probably only around 1 cm (Sigurdsson et al. 1985). The insignificant thickness of this layer contrasts sharply with the >1 m thick layer of pumice fall that accumulated south of the volcano during the same period. In most parts of Herculaneum the ash-fall layer is absent, presumably because of erosion by the overlying surge.

Even though Herculaneum was not subject to pumice fall, its residents were likely to be in a state of alarm from the earthquakes, the lightning, and the sight of a towering eruption cloud over the summit of Vesuvius. Some may have started to flee the city, but those who remained would not have been able to escape the first pyroclastic surge (S-1) that engulfed the

city and deposited up to 1.5 m of ash in the early morning of August 25, (Fig. 48). The deposit from this event contains a high proportion of carbonized and uncarbonized wood, indicating that the surge cloud was extremely hot when it entered the city. In areas below 1 m elevation, that is, below the pre-eruption sea level, the S-1 surge layer is underlain by a 10 cm sandy cross-bedded gray layer that contains fragments of charcoal and roof tiles, some 15 cm long. This is likely to have been associated with the entrance of the surge into the water.

On the beach the S-1 surge deposit grades into an unusual layer that consists of abundant carbonized thatch and other vegetation. It is thickest in front of the Suburban Thermae and was most likely formed from vegetation stripped off the vineyards on the flanks of the volcano, transported in the head of the surge, and then deposited immediately before the main surge layer was laid down. Wood planks and other timber associated with the thatch layer were stripped off of structures from the city and other buildings farther upslope from Herculaneum.

In Herculaneum the passage of the first surge must have been a sudden event and the surge cloud probably dispersed within minutes. On the beach this surge is overlain by a pyroclastic flow (F-1). Such a sequence of surge overlain by pyroclastic flow is typical of deposits from a *nuée ardente* eruption (Sparks, Self, and Walker 1973). The F-1 flow is a massive, consolidated deposit that contains some charcoal, but fragments of tiles and other building material are generally few. It is <1.5 m thick but thins northward along the beach and pinches out near the new tunnel. The layer reappears in the tunnel and persists to the west.

The deposits of the first surge and pyroclastic flow are closely related in the field and it is likely that they were derived from a single *nuée ardente*. The highly inflated surge cloud engulfed the area and swept over all the surrounding terrain on its route radially from the crater. It probably reached Herculaneum two to five minutes after the collapse of the eruption column. On the other hand, the pyroclastic flow, although generated simultaneously, followed the local topography and flowed along riverbeds and valleys. Herculaneum was situated on a low hill, with shallow valleys to the north and south (Pistolesi 1836). The flow traveled around the hill and emerged onto the beach from the valley south of the town, but it did not flood the town except for the Palaestra. It then advanced into the sea, at least 40 m beyond the former coastline, as shown by sections in the new tunnel, and formed a new shoreline.

About one hour later a second pyroclastic surge overwhelmed Herculaneum and deposited as much as 1.5 m of poorly consolidated dark gray ash (S-2). The most distinctive feature of this layer is the high content of building material, including bricks, roof tiles, stucco, column parts, and wall portions. The largest components of this type are two wall fragments, each about 1 m long and weighing about 500 kg, which were transported at least 10 m. Charcoal fragments are common in this layer, but uncarbonized wood is absent, unlike in the S-1 surge. The presence of large wall fragments and coarser grain size is evidence that the S-2 surge cloud had greater carrying capacity and was more violent than the earlier surge cloud. The second surge was clearly responsible for widespread destruction of masonry in the city and carried a particularly large load of terra-cotta roof tiles. Similarly, the presence of charcoal and absence of uncarbonized wood also indicate that the second surge cloud was hotter than the first. The velocity of the second surge cloud was probably checked somewhat at the waterfront, in the lee of the city walls and the chambers. This reduction in velocity may have led to deposition of the larger building materials on the beach.

The second surge layer is immediately overlain by a massive pyroclastic flow (F-2), 5 m thick, consolidated, pumice-rich, and devoid of internal structures, except steam pipes. It carried some building fragments near the base. The contact between flow and surge is indistinct in places and the two layers were probably deposited in very rapid succession. The pyroclastic flow is thinnest in front of the Thermae and thickens to the southeast and northwest, indicating that the flow advanced as two lobes, one on either side of the city, and that the lobes coalesced on the beach. The F-2 flow swamped the waterfront and filled in the boat chambers completely. This thick blanket of dense, hot pyroclastic flow boiled the underlying water and caused an explosive rise of steam. Such steam expulsion gave rise to numerous vertical steam pipes in the lower part of the pyroclastic flow.

In the great bank of deposits revealed by excavation of the waterfront, the F-2 pyroclastic flow is overlain by a 10 cm thick sandy surge layer (S-3). This is in turn overlain by a third massive 10 m thick pyroclastic flow; it is pumice-rich and contains a higher concentration of lithics than flow F-2. Its upper surface slopes gently from northwest to southeast, indicating flow from north of the city. About 3 m above its base the pyroclastic flow contains a lens rich in 10–20 cm lithic fragments of lava and carbonate. Samples of these lithics have yielded important information on the emplacement temperature of the flow (Kent et al. 1981), which in turn has contributed to determining the origin of the massive layers that buried the city.

The origin of the deposits that buried Hercula-

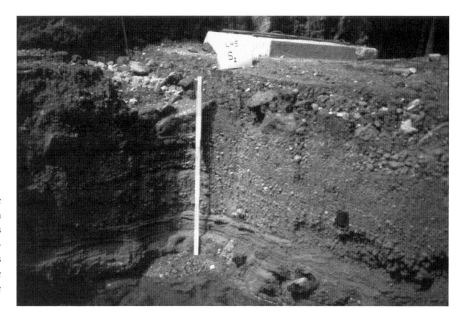

FIGURE 48 The lowermost surge unit on the beach of Herculaneum (S-1). The pumice-rich deposit is cross bedded and contains carbonized and charred wood. This unit also contains skeletons of the Herculaneum population on the beach and in the chambers.

neum has been a source of controversy for many years. We have shown that the city was buried by the products of *nuées ardentes,* depositing thin surge layers and thick pyroclastic flows (Sigurdsson, Cashdollar, and Sparks 1982; Sigurdsson et al. 1985). Previous scholars – Corti (1944; 1951), Etienne (1974), Maiuri (1977), and Mau (1899) – have on the other hand interpreted the Herculaneum deposits as mudflows. Sheridan et al. (1981) have also proposed that the upper section of the Herculaneum deposits are mudflows (lahars) but have recognized that the lower deposits were surges and pyroclastic flows. Several features of these deposits support a pyroclastic flow origin and high emplacement temperatures. The flows have common vertical lithic-rich and fines-depleted pipes (degassing structures or steam pipes). The typical association of a fine-grained, thin, basal surge layer at the base of each flow is also evidence for an origin in pyroclastic flow (Sparks, Self, and Walker 1973). Direct measurements of the flow emplacement temperature have also been made. First, Maury's (1976) studies of the common carbonized wood fragments in Herculaneum have demonstrated that the wood was heated to at least 400° C. His results have been further supported by paleomagnetic studies of the deposits by Kent et al. (1981), who have examined the remnant magnetism of lithics, bricks, and pumice from the F-3 pyroclastic flow. It is clear from this work that after emplacement, the lithic clasts became partially remagnetized at 350 to 400° C in the pyroclastic flows.

The third flow is overlain by a surge layer 15–60 cm thick (S-4). The fourth flow (F-4) is a massive, pumice-rich pyroclastic flow, ranging from 2–3 m in thickness. This flow and other flows in the waterfront exposure are well-consolidated deposits, whereas the overlying flows and outcrops of pyroclastic flows in the high-lying parts of Herculaneum are relatively poorly consolidated. The consolidation is thus local and cannot be attributed to welding, but it is probably related to cementation and crystallization on grain boundaries from a vapor phase rising from the underlying beach and surges, soaked in seawater. The fourth flow, overlain by a sandy, cross-bedded surge (S-5), is dune-bedded and varies in thickness from 10 to 120 cm. The fifth pyroclastic flow (F-5) is a 2–3 m thick, poorly consolidated pumice flow. It is covered by a thin (8 cm) cross-bedded surge (S-6) that is typically richer in sand-sized lithics than lower surges. The topmost pyroclastic flow (F-6) has a maximum thickness of 1 m but pinches out to the south. The section is capped by a 60 cm thick sequence of dark gray, silty surges.

THE VICTIMS IN HERCULANEUM

The dramatic discovery of hundreds of victims of the eruption during excavations of the waterfront in 1982 throws new light on the demise of the population of Herculaneum during the eruption (see Chap. 18). We now know that the fleeing population got only as far as the waterfront. It must be emphasized that only an 85 m long strip of the waterfront has been excavated so far. Certainly hundreds, if not thousands, of victims are still interred along the beach and waterfront southeast and northeast of the new excavations.

The S-1 surge layer deposited on the beach in front of the chambers and the Thermae contains many human skeletons. Inside the chambers, the layer is virtually crammed with more skeletons (Fig. 49). The lowest layer is the black beach sand, mixed with minor rounded pottery fragments and pebbles. It forms a

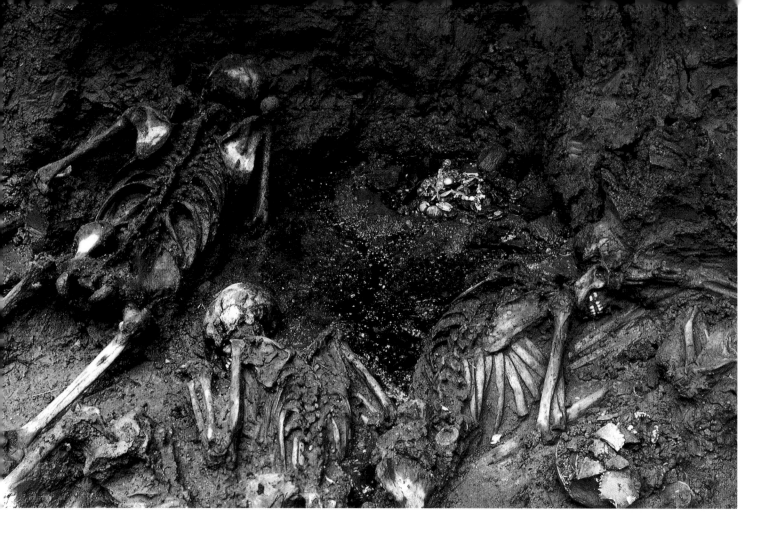

FIGURE 49 (*Above*) Victims in Herculaneum crowded in the entrance of a waterfront chamber. Many carried jewelry and other small precious objects. Photo O. Louis Mazzatenta; © National Geographic Society.

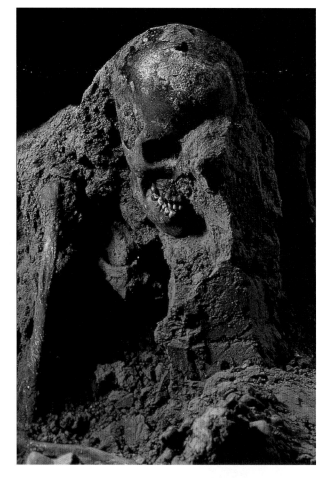

FIGURE 50 A victim buried in the S-1 pyroclastic surge at the Herculaneum waterfront. The top of the skull protruded into the overlying pyroclastic flow (F-1) and was carbonized in the hotter flow deposit. Photo: H. Sigurdsson.

10–15 cm cover on the chamber floors and was probably carried in by surf during storms. This suggests that the chambers were open to the sea, although some were probably used to store boats and fishing gear. The boats were probably stored on large crossbeams in the upper part of the chambers. But no boats were in the chambers at the time of the eruption. Had they all been put out to sea by people fleeing the impending disaster?

All of the human skeletons, as well as the skeleton of a horse, occur within the S-1 surge layer. Many rest directly on the beach, covered by the surge, while others lie within the surge deposit, 5 to 15 cm above the surface of the black beach sand. All skeletons lying within the S-1 surge are uncarbonized; thus it is clear that this surge cloud was hot enough to carbonize seasoned and dry wood but not hot enough to carbonize green wood or bones covered by flesh. Extremities — heels, knees, and elbows, as well as hips and skulls — of several victims protruded out of the first surge layer into the much hotter second surge (S-2); these parts of the skeletons are carbonized (Fig. 50).

The highest concentration of victims occurs inside the chambers: Each contains fifteen to forty skeletons, about three persons per square meter. Groups of victims also occur immediately in front of the chambers, particularly on the northwestern part of the beach. The great majority of these lie with the head toward the chamber. Similarly, skeletons inside the chambers are generally oriented with the head toward the end wall or the south corner of the chamber. Most victims seem to be in a natural position, huddled together, curled up, embracing (Fig. 51), or with hands and arms over the face. A thorough study of the position of the skeletons has not been undertaken, but preliminary analysis indicates that most victims lie on the side (47 percent), while others lie facedown (37 percent) or, more rarely, on the back (16 percent). The horse is in the mouth of one of the chambers and partly on top of human skeletons. The stratigraphic evidence shows clearly that these people were killed by the effects of the first surge. It is likely that the surge cloud was not hot enough to cause thermal shock. Once engulfed in the hot cloud, the people would suffer severe burns, gasp for air, and soon choke on ash lining the trachea, dying of burns and asphyxia within minutes.

The preservation of victims' remains in Herculaneum is, at first sight, very different from that in Pompeii. In Herculaneum the remains are skeletons embedded in relatively soft, wet volcanic ash, and no hollows of the soft tissue remain. In Pompeii, on the other hand, the victims formed hollow cavities in the deposit, where the soft tissues have decayed, leaving an impression of

FIGURE 51 The skeletons of a female and child embracing in a Herculaneum waterfront chamber. Photo O. Louis Mazzatenta; © National Geographic Society.

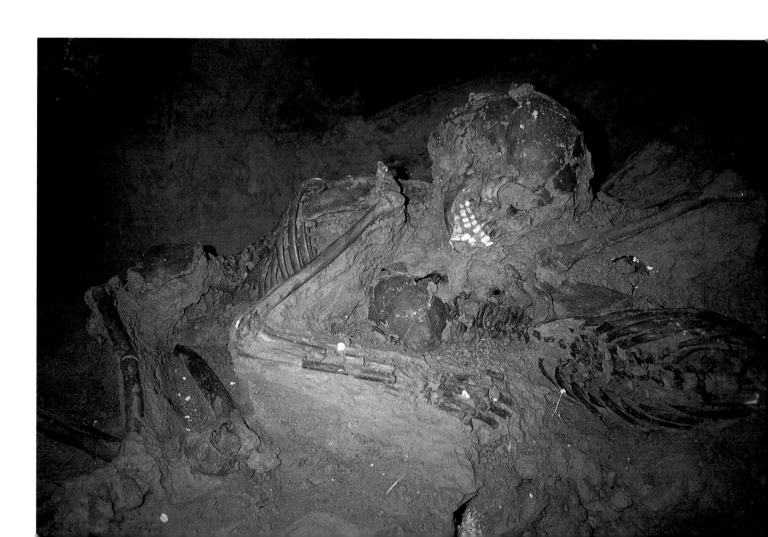

the body at the time of death while the skeleton remains inside the cavity (Fig. 44). The different states of preservation in the two cities does not in any way reflect different processes during the eruption, since the populations in both cities were killed by surge activity. The different preservation reflects, instead, the level of the groundwater table in the two cities after the eruption. In Herculaneum the bodies were buried at a level below the posteruption groundwater table. The deposit consequently remained soft and plastic. As the soft tissue decayed, the surrounding deposit, under the weight of the 20 cm thick layers, gradually enclosed the skeleton. In Pompeii, however, the victims were buried in the surge layer about 2.5 m above street level, on top of the porous pumice-fall deposit. The bodies were therefore well above the groundwater table and covered by only 2 m of overburden. The fine ash of the surge deposit hardened quickly around the body before decay of the soft tissues became advanced, forming a perfect cast of the body. The deposit was well drained through the underlying pumice and did not become waterlogged.

COURSE OF THE ERUPTION

We have so far described the A.D. 79 eruption from the perspective of its effects on the two well-known Roman cities of Herculaneum and Pompeii. However, the effects of the eruption were not limited to these areas; its impact was felt over a large portion of Campania and beyond. Our stratigraphic studies can be combined with the letters of Pliny the Younger to reconstruct the evolution and regional impact of the eruption. In his first letter, Pliny notes the appearance of the Plinian eruption cloud above Vesuvius, as seen from Misenum, around the seventh hour (about 12 noon). While this event marks the beginning of the eruption of the white pumice, which started to accumulate as the A-2 pumice layer of Pompeii a few minutes later, it does not mark the first event in the eruption. This occurred when lower-level explosions generated the A-1 ash-fall deposit, which may have taken place earlier that morning or the previous night. The chronologic scheme proposed herein (Fig. 52) is based on four assumptions. First, the beginning of the Plinian phase and subsequent A-2 pumice fall is taken as 12 noon on August 24. Second, the most widespread surge (S-6) is taken to correspond to the surge of "black cloud" that Pliny the Younger watched spread across the Bay of Naples and that set him in flight from Misenum shortly after daybreak (near 7 A.M.) on the second day of the eruption. Third, the relative thickness of the eight pumice-fall layers at Boscoreale is used as a measure of duration of the Plinian events,

assuming a constant rate of accumulation. Fourth, the surges are regarded as instantaneous events, and thus surge thickness is excluded from this time scale.

The high eruption column, which the Plinys observed from Misenum at about 12 noon on August 24, marks the beginning of the Plinian phase. During the next twelve hours, the eruption column increased steadily from a height of 14 to 33 km over the volcano, ejecting pumice and ash into the stratosphere (Carey and Sigurdsson 1987; Fig. 52). It is clear from Pliny's description that the top of the eruption column mushroomed into a very broad cloud, connected to Vesuvius by a long trunk thus resembling an umbrella pine (Fig. 35A). Because of the stratospheric wind shear, the cloud was drawn into an elongated plume to the southeast, resulting in the fall of coarse pumice near the volcano and fine ash at greater distance. During the first seven hours of activity, Vesuvius erupted white pumice, which was deposited downwind over the regions southeast of the volcano as a blanket of pumice fall (Fig. 33). The location of maximum pumice-fall accumulation was displaced downwind, to the area of Pompeii, because of stratospheric wind shear on the eruption column and the fragmentation characteristics of the magma. On land, the pumice deposit can be traced as far as Agropoli, 74 km southeast of Vesuvius. Much of the distal ash fall has been eroded, however, and accounts written shortly after the eruption tell of much more extensive ash fall. Dio Cassius, writing in about A.D. 150, notes that ash fall occurred in North Africa, Egypt, Palestine, and elsewhere in the Levant following the eruption.

The southeasterly trend of the fallout, which reflects the stratospheric wind direction prevailing during the eruption, is unusual for tephra fallout from Vesuvius. More typical is the fallout pattern of the Avellino pumice (3,500 years before present; Lirer et al. 1973) or the 1906 pumice (Rosi et al. 1981), which have fallout axes trending east-northeast of Vesuvius. These trends are in agreement with the average wind direction in the stratosphere for September to May above southern Italy, which has an azimuth near 260° or just south of west (Cornell, Carey, and Sigurdsson 1983). In summer, however, the stratospheric winds are from the east. The A.D. 79 eruption occurred at a time when the stratospheric winds were shifting from their summer to autumn pattern, and the rather anomalous southeasterly fallout direction may thus result from the eruption occurring during a transitional period of the stratospheric winds. This was an unfortunate coincidence for Pompeii and other districts to the southeast of Vesuvius, because they lay in the area of maximum pumice fall (Fig. 37), with accumulation rates of 10 to 15 cm/hr.

People in Pompeii, Oplontis, and elsewhere in the

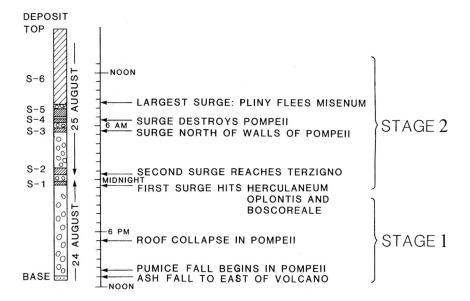

FIGURE 52 The chronology of the A.D. 79 eruption, based on evidence from Pliny the Younger's letters and studies of the volcanic deposits (Carey and Sigurdsson 1987). During the Plinian event, the eruption column height varied greatly, as shown on the vertical axis. Periodic collapse of the column led to generation of the deadly surges and pyroclastic flows.

zone of heavy pumice fall were faced with two problems during the afternoon and evening of August 24. First, the pumice fall was accompanied by the fall of dense lithic fragments, some fist-sized. These lithics, falling at terminal velocities of over 50 m/s, were dangerous projectiles and surely injured or killed some people outdoors. Fortunately, pyroclastics of this type were only 10 percent of the total fall. Calculations, using the mean size of pyroclasts at Pompeii, the average accumulation rate, and an assumed 40 percent porosity in the fall deposit, show that the frequency of lithic fall with diameters of 1.5 cm or larger was roughly 70 fragments/min/m². Second, the weight of accumulating pumice would have collapsed roofs in Pompeii during the afternoon, probably after two or three hours of pumice fall. This must have led to widespread evacuation of buildings and exodus from the city. Pompeii and other areas southeast of Vesuvius were, however, in darkness at this time, caused by the dense eruption plume overhead.

During excavation at Fondo Bottaro in 1899 to 1902 a large villa was discovered, with an adjoining row of twenty shops or *tabernae* (Winkes 1982). The villa stood on the south side of the estuary of the Sarno River and thus probably overlooked the harbor of Pompeii. The row of twenty shops, which extended south of the villa, must have lined the major road or highway between Pompeii and Stabiae. When the volcanic deposit was excavated from the portico in front of the shops, skeletons were found in front of almost every *taberna*. Thus nine human skeletons were, for example, found inside and in front of the *thermopolium* (*taberna* number seven), accompanied by a great many valuables, such as jewelry, coins, silverware, and objects in bronze, glass, and terra-cotta. The discoveries at Fondo Bottaro give an important glimpse of the fate of people in flight from

the volcano south of Pompeii and indicate that a vast number of the population of the city may have perished in flight during the second phase of the eruption.

During the evening, after seven hours of white pumice fall, the composition of the erupting magma changed, and gray pumice was now produced. As the gray pumice erupted, the height of the eruption column increased significantly, up to about 33 km (Carey and Sigurdsson 1987). This is shown, for example, by the marked increase in diameter of lithics within the fall deposit across the white-gray boundary at Pompeii. The Plinian eruption of gray tephra continued for five hours, depositing tephra to the southeast of the volcano, where 150 cm of pumice had accumulated by this time.

During the first twelve hours of activity the heavy pumice fall mainly affected an area southeast of Vesuvius, bounded by Terzigno to the east and Oplontis to the west (Fig. 37). Other areas around the volcano were relatively unaffected, except for minor pumice fall on the upper slopes and a light dusting of ash fall in Herculaneum. Just after midnight on August 24 the style of activity changed as Vesuvius produced the first of six pyroclastic surges and flows (Fig. 35B), which were to interrupt the pumice fall during the next seven hours, killing people within a 10 km radius from the crater. The first surge (S-1) spread over the south and west flank of Vesuvius, overwhelming Villa Regina at Boscoreale, Oplontis, and all the west coast to Hercu-

laneum (Fig. 53). Small tongues of this surge extended down the valleys above Somma Vesuviana and Ottaviano on the north and northeast flank. This first and smallest of the surges did not, however, reach the *villae rusticae* at Terzigno nor the city of Pompeii. The effects of this surge were remarkably similar to the effects of the surges of the 1982 eruption of El Chichon in Mexico, which devastated nine towns and villages (Sigurdsson, Carey, and Espindola 1984). The effects of the S-1 surge are best studied and most dramatic in Herculaneum. During the preceding twelve-hour period of activity, the city had received only a light sprinkling of ash fall, less than 1 cm thick. With the erupting volcano in full view, and being only 7 km from the crater, the population must have been uneasy. Many Herculaneans must have left their city during this period and fled toward safety in Naples to the north, where these lucky refugees became permanent residents of the Herculaneum Quarter.

People remaining in Herculaneum may have seen the precursor of the surge as a *nuée ardente* sweeping down the cone of the volcano. During the 1980 Mount St. Helens eruption, the main surge moved at 60 to 250 m/s (Moore and Rice 1984). The S-1 surge was, however, much finer grained and of smaller extent, and probably more similar to the southern Mount St. Helens surge, which traveled at only 30 m/s. Even at this lower velocity, the surge would have taken no more than four minutes to reach Herculaneum. People in the city were without doubt on the alert that night, and probably in the streets watching the spectacle of the ominous eruption column, with its lower trunk glowing from incandescent tephra and its upper part illuminated by flashes of lightning. The cascade of the *nuée ardente* down the flank would have been immediately noticed and recognized as a threat. Flight from the eruption to the waterfront and along the coast toward Naples is the most obvious solution.

Just after midnight when the eruption column had grown to its peak height, the first surge cloud swept into Herculaneum at sufficient velocity to topple the colonnade and portico around the Palaestra and to transport building rubble 2 to 4 m. It probably left most walls intact but stripped the roof tiles off some buildings. Temperatures in the surge were high enough to carbonize dry wood but not green wood. When the surge poured over the waterfront in the lee of the great city wall, its velocity decreased locally, so that deposition increased on the beach and the adjacent chambers. As the hot surge entered the ocean it caused the water to boil and give off small steam explosions. People on the beach and in the chambers were engulfed in a burning hot and swirling ash cloud that carried flying roof tiles and other debris. Thus one of the victims may

have been struck down by the red tile found resting against her forehead. Breathing in the surge cloud was impossible, and like the victims of Mount St. Helens, the Herculaneans were burnt to death and asphyxiated.

The northward spread of the first *nuée ardente* was apparently restricted by the 300 m high arcuate Monte Somma rim. Only two minor lobes of the S-1 surge surmounted this barrier and flowed down the valleys above Somma Vesuviana and Ottaviano (Fig. 53). This indicates that the body of the *nuée ardente* in the Valle del Gigante exceeded 300 m in thickness. A large part of the surge was funneled down the Valle del Gigante and onto the lowlands to the west, over the Cava Montone area and toward Herculaneum. The *nuée ardente* segregated early into a fast-moving surge and a more slowly moving pyroclastic flow. The flow reached Herculaneum shortly after the surge, and came into the city from the east, flowing into the Palaestra where it filled a large cross-shaped swimming pool. The flow did not advance through the city but rather down a valley along its southern edge and onto the beach in front of the Suburban Thermae. Here the pyroclastic flow (F-1) engulfed and carbonized a large boat on the beach and advanced into the ocean before coming to rest. Where exposed on the waterfront, the F-1 flow rests directly on top of the S-1 surge. Here the flow contains gas pipes, produced by the escape of steam expelled from the underlying surge, which by now had become soaked by seawater.

Fall of gray pumice continued as before, following the emplacement of the first surge and flow, and led to accumulation of pumice-fall layer A-4, during one hour, south of the volcano. The height of the eruption column had, however, decreased to 22 km in response to the collapse that generated the first pyroclastic surge and flow (Fig. 52). Elsewhere, the new desertlike surface created by the first surge remained bare, with protruding, smoking, carbonized tree trunks and steam rising from rivers and the coast. One hour later, near 1 A.M., the second *nuée ardente* was generated from the crater and formed a surge with a volume about three times that of the first event. The S-2 surge cloud spilled out the Valle del Gigante and over the Somma rim to the north, devastating all the north flank of Vesuvius within 7 km of the crater (Fig. 53). It destroyed the *villae rusticae* at Terzigno beyond the reach of the first surge but ran its course south of Boscoreale before reaching Pompeii.

On the west flank the surge left a deposit similar to that of the May 18, 1980, Mount St. Helens blast, and was probably moving at 100 to 200 m/s. In Herculaneum, where its effects were particularly severe, it struck with sufficient force to break down the masonry walls and roofs unaffected by the first surge. The surge

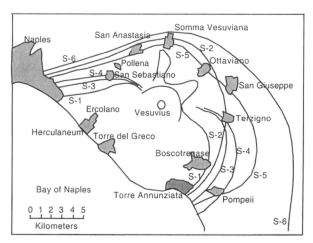

FIGURE 53 Distribution of surge deposits in the region around Mount Vesuvius during the A.D. 79 eruption.

was closely followed by the pyroclastic flow F-2, which flowed north of Herculaneum and onto the beach. Flows also advanced down valleys on the north flank leading to Pollena, Santa Anastasia, and Somma Vesuviana, but no pyroclastic flows are known to have affected the south flank at this time. In many southern outcrops, the S-2 surge is split by a thin pumice-fall layer, from which the surge can be inferred to have come in two rapid pulses to the south.

Pumice fall continued after passage of the great S-2 surge, and the A-5 gray pumice layer accumulated during about four hours, until about 5 A.M. (Fig. 52). During this Plinian phase a larger proportion of lithics was erupted than before, probably indicating increased erosion of the vent. These included both lavas and fragments from the carbonate basement. Around 5:30 A.M. the third surge was generated (Fig. 53). It extended even farther south, running up against the northern city wall of Pompeii but not entering the city. The surge was followed by a pyroclastic flow in the northwest, which flowed directly over the remains of Herculaneum and completely buried the city so that only the theater protruded. This and subsequent flows extended the new coastline an additional 400 m to the west of the Herculaneum waterfront.

The pumice fall was now darker and more lithic-rich. It continued for about an hour, until 6:30 A.M., forming layer A-6. Subsequently a fourth surge was generated (S-4), which followed the previous pattern and spread even farther south, this time overwhelming Pompeii and Bottaro. As the surge cloud came over the northern city wall of Pompeii, it rolled over an area already blanketed by 2.4 m of pumice fall. Most roofs had collapsed, and only the walls of two- and three-story buildings stood above the bleak wasteland. Most of the inhabitants had abandoned the city to escape the collapsing roofs, but a surprising number of people were moving about on top of the pumice fall when the

lethal fourth surge struck at about 6:30 A.M.. Their deaths are tragically recaptured in the plaster casts of hollows in the deposits (Fig. 44). They were asphyxiated in the surge cloud, which tore through the city, removing roofs and collapsing many walls.

The fourth surge was followed by the fifth surge a few minutes later. Even larger, it was accompanied by a pyroclastic flow in many areas to the south, such as Oplontis. The large surge cloud that passed over Pompeii (S-6) continued to the south and overwhelmed the city of Stabiae (Fig. 33), where Pliny the Elder had sought refuge in the villa of his friend Pomponianus, 14 km south of the crater. The previous afternoon Pliny had abandoned his plans of making landfall on the southwest coast under the volcano because of the very heavy fall of hot pumice and lithics on his ships and because sailing near the coast was made impossible by thick floating rafts of pumice. He therefore gave up his rescue mission and headed for the comparative safety of Stabiae to the south (Fig. 33). Judging from the stratigraphic section at the Villa Ariadne (Sigurdsson, Cashdollar, and Sparks 1982), nearly 2 m of pumice fall accumulated at Stabiae during the eruption. It is not surprising, as Pliny the Younger states, that his uncle had difficulty opening his door the next morning, because of the thick pumice layer in the courtyard: "They debated whether to stay indoors or take their chance in the open, for the buildings were now shaking with violent shocks, and seemed to be swaying to and fro, as if they were torn from their foundations. Outside, on the other hand, there was the danger of falling pumice-stones, even though they were light and porous; however, after comparing the risks they chose the latter." The black eruption plume overhead caused darkness at Stabiae "blacker and denser than any ordinary night," but they could see daylight underneath the cloud, probably to the northeast and west.

"Then the flames and smell of sulfur which gave warning of the approaching fire drove the others to take flight." This event must represent the advance of the sixth and largest surge over the south flank toward Stabiae at about 7 A.M. on August 25. At Villa Ariadne the surge deposited a 5 cm layer on top of the pumice fall and thus clearly affected Stabiae. By his nephew's admission, Pliny the Elder was an overweight man with a weak constitution, and he did not take flight with the others but collapsed in the arms of his two slaves as he choked in the dusty surge cloud. Near the volcano the sixth surge left a major deposit, which is often 0.5–1 m thick in outcrops. It grades upward into a pyroclastic flow, for example, at Oplontis and Boscoreale; thicker parts of this deposit at Pompeii also resemble pyroclastic flow.

Severe earth tremors also threatened Pliny the

Younger and his mother that morning at Misenum and they decided to abandon the tottering buildings and leave town. En route they witnessed a tidal wave and over the volcano "a fearful black cloud was rent by forked and quivering bursts of flame, and parted to reveal great tongues of fire, like flashes of lightning magnified in size." They were witnessing the great *nuée ardente* that generated the sixth surge about 7 A.M., and took the life of Pliny the Elder. "Soon afterwards the cloud sank down to earth and covered the sea; it had already blotted out Capri and hidden the promontory of Misenum from sight." Both are about 30 km from Vesuvius. Pliny the Younger then describes their experience as they fled the surge cloud rolling across the Bay of Naples.

There can be no doubt that the surge traveled across the Bay of Naples and reached Misenum, where fine ash from the turbulent surge cloud settled. It must have cooled on its long path, because Pliny mentions no heat. The deposit left by the surge at Misenum was probably only a few centimeters and soon eroded away, because no deposit remains today. The passage of a surge cloud over a long distance across water was also documented in the 1883 Krakatau eruption in Indonesia, where surge clouds from the volcano engulfed islands and settlements on the south coast of Sumatra (Sigurdsson, Carey, and Madeville 1991).

THE WANING ERUPTION AND AFTERMATH

The activity of Vesuvius following the sixth and largest surge is not chronicled by Pliny, but the deposits bear evidence of continued eruption. Within 10 km of the volcano this later activity laid down surges and accretionary lapilli beds consisting of at least twenty units. Many of these beds are pumice-free and mostly composed of lithics, thus indicating the small role of juvenile magma at this stage. These deposits were probably formed by a large number of small phreatic or phreatomagmatic explosions, resulting from the interaction of groundwater and magma remaining in the volcano's conduit (Sheridan et al. 1981). This activity may have persisted for days or weeks.

When the eruption came to an end, pyroclastic surges that left a deposit with a volume equivalent to 0.23 cubic km of dense rock had totally devastated 300 square km around Vesuvius. By comparison, the volcano produced about 0.14 cubic km of pyroclastic flows during the eruption and 0.16 cubic km of accretionary lapilli beds during the final phreatomagmatic phase. These figures do not take into account the

unknown volumes of tephra that entered the Bay of Naples. Including 2.6 cubic km of gray pumice and 1 cubic km (dense-rock equivalent) of white pumice, the total deposit produced by the eruption is thus equivalent to about 4 cubic km of dense rock; about 90 percent was magmatic material, and the remainder rock fragments torn from the walls of the Vesuvius conduit.

Titus hastened to Campania on receiving news of the eruption and its widespread destruction and returned there again the following year. He appointed two "curatores restituendae Campaniae" to organize aid and reconstruction in the region, and these appointments were drawn by lot from those of consular rank. Titus provided the necessary funds from his own resources and from the property of the many people who had died in the eruption without heirs. Contemporary accounts indicate that refugees from the devastated areas around Vesuvius fled to the neighboring towns of Capua, Nola, Neapolis, and Surrentum, and the shrewd Titus gave special privileges to the towns that had offered assistance to these refugees.

Except for brief remarks by the Latin poets Martial (4.44) and Statius (*Silvae* 4.4.78–86), the first mention of the A.D. 79 Vesuvius eruption after Pliny the Younger's letters is Dio Cassius (56.21–24), who gives a garbled account of the event, influenced by superstition and mythology, one and a half centuries after the eruption. From Dio's account we learn that Vesuvius was still active in his time, with minor explosions usually occurring "every year." We furthermore learn that the volcanic ash from the 79 eruption reached not only Rome, "filling the air overhead and darkening the sun," but also Africa, Syria and Egypt. In Rome the ashfall was blamed for the terrible pestilence that also visited the city at this time.

The A.D. 79 eruption may also be described in a Coptic Gnostic text discovered at Nag' Hammadi entitled "The Apocalypse of Adam," which reads as follows (Bohlig and Labib, 1963): "Fire, pumice and asphalt will be thrown upon these people. And fire and dazzling will come over those aeons and the eyes of the manifestations of the luminaries will become dark. And the aeons will not see by them in those days. And great clouds of light come down upon them and also other clouds of light come down upon them from the great aeons." Goedicke (1968) has suggested that the author of the Apocalypse used Pliny's account of the eruption in describing a cosmic warning of the impending coming of the Savior of the World.

NOTES
1 Most versions of Pliny's *Letters* give *IX Kal. sept.* (August 24) as the date of the eruption (e.g., Codex Lauren-

tianus Mediceus 47.36, f. 87; sec. IX). For a different view, i.e., that the eruption took place on *IX Kal. decembris* (November 23), see Pappalardo (1990).

2 The translation of the "seventh hour" to the modern twenty-four-hour day requires some knowledge of Roman time-keeping (Boorstin 1983). The Romans had sundials and water clocks but paid no attention to the seasonal variations in the length of the day. Their hours were therefore elastic, and one hour was one-twelfth the time of daylight on that day. *Hora prima* (the first hour) began at sunrise and *hora duodecima* (the twelfth hour) ended at about sunset. At the winter solstice in Rome, for example, the first hour lasted from 7:33 A.M. to 8:17 A.M. and the twelfth hour began at 3:42 P.M. and ended at 4:27 P.M. Being exactly in the middle, the seventh hour would always begin precisely at noon, regardless of the time of year.

REFERENCES

Bohlig, A., and P. Labib. 1963. *Koiptisch-Gnostische Apokalypsen aus Codex V von Nag Hammadi.* Wissehschaftliche Zeitschrift der Martin-Luther-Universitaat Halle-Wittenberg, Sonderband, 107.

Boorstin, D. 1983. *The Discoverers.* Random House, New York.

Carey, S., and H. Sigurdsson. 1987. "Temporal Variations in Column Height and Magma Discharge Rate during the A.D. 79 Eruption of Vesuvius." *Geological Society of America, Bulletin* 99: 303–14.

Catalano, V. 1957. "Note geologiche ercolanesi. Materiali piroclastici anteriori all'eruzione del 79 d. Cr. rinvenuti sollo l'area della Palestra in Ercolano." *Atti della (Reale) Accademia Nazionale dei Lincei; Rendiconti della classe di Scienze Fisiche, Matematiche e Naturali* 24: 113–17.

Cornell, W., S. Carey, and H. Sigurdsson. 1983. "Computer Simulation of Transport and Deposition of the Campanian Y-5 Ash. *Journal of Volcanology and Geothermal Research* 17: 89–109.

Corti, E. C. C. 1944. *Untergang und Auferstehung von Pompeji und Herculaneum.* 6th ed. F. Bruckmann, Munich.

——— 1951. *The Destruction and Resurrection of Pompeii and Herculaneum.* Routledge and Kegan Paul, London.

Eisele, J. W., R. L. O'Halloran, D. T. Reay, G. R. Lindholm, L. V. Lewman, and W. J. Brady. 1981. "Deaths during the May 18, 1980 Eruption of Mount St. Helens. *New England Journal of Medicine* 305: 931–6.

Etienne, R. 1974. *Pompeji: das Leben in einer antiken Stadt.* Philipp Reclam, Stuttgart.

Goedicke, H. 1968. "An Unexpected Allusion to the Vesuvius Eruption in A.D. 79." *Classical Journal* 25: 340–1.

Ippolito, F. 1950. "Sul meccanismo del seppellimento di Pompei e di Ercolano." *Pompeiana* 1950: 387–95.

Kent, D. V., D. Ninkovich, T. Pescatore, and R. S. J. Sparks. 1981. "Paleomagnetic Determination of Emplacement Temperature of Vesuvius A.D. 79 Pyroclastic Deposits." *Nature* 290: 393–6.

Kieffer, S. W. 1981. Fluid Dynamics of the May 18 Blast at Mount St. Helens. In *The 1980 Eruption of Mount St. Helens, Washington,* pp. 379–400. Professional Paper 1250. U.S. Geological Survey, Washington, D. C.

Lacroix, A. 1904. *La Montagne Pélée et ses Eruptions.* Masson et Cie, Paris.

——— 1908. "Les derniers jours d'Herculaneum et de Pompeii interprétés à l'aide de quelques phénomènes récents du volcanisme." *Bulletin de la Société de Géographie* 18: 5.

Lirer, L., T. Pescatore, B. Booth, and G. P. L. Walker. 1973. "Two Plinian Pumice-Fall Deposits from Somma Vesuvius, Italy." *Geological Society of America, Bulletin* 84: 759–72.

Maiuri, A. 1958. "Pompeii." *Scientific American* 198: 68–78.

——— 1977. *Herculaneum.* Istituto Poligrafico dello Stato, Rome.

Mau, A. 1899. *Pompeii: Its Life and Art.* Macmillan, New York.

Maury, R. C. 1976. "Evolution à haute température des materiaux organiques dans les formations volcaniques ou à leur contact." *Bulletin du centre des Recherches de Pau, France-Société Nationale des Pétroles d'Aquitaine* 10: 289–300.

Merrill, E. T. 1918. "Notes on the Eruption of Vesuvius in A.D. 79." *American Journal of Archeology* 22: 304–9.

——— 1920. "Further Note on the Eruption of Vesuvius in A.D. 79." *American Journal of Archeology* 24: 262–8.

Moore, J. G., and C. J. Rice. 1984. Chronology and Character of May 18, 1980, Explosive Eruptions of Mount St. Helens. In *Explosive Volcanism, Inception, Evolution and Hazards,* pp. 133–42. National Academy of Sciences Press, Washington, D. C.

Moore, J. G., and T. W. Sisson. 1981. Deposits and Effects of the May 18 Pyroclastic Surge. In *The 1980 Eruption of Mount St. Helens, Washington,* pp. 421–38. Professional Paper 1250. U.S. Geological Survey, Washington, D. C.

Pappalardo, U. 1990. "L'eruzione Pliniana del Vesuvio nel 79 d.C.: Ercolano." *PACT.* 25, 198–215.

Pistolesi, E. 1836. *Real Museo Borbonico, Descritto ed Illustrato.* Tipografia delle belle Arti, Rome.

Rittmann, A. 1950. "L'eruzione Vesuviana del 79, studio magmalogico e vulcanologico." *Pompeiana* 1950: 456–74.

Rosenbaum, J. G., and R. B. Waitt. 1981. Summary of Eyewitness Accounts of the May 18 Eruption. In *The 1980 Eruptions of Mount St. Helens,* pp. 53–68. Washington, Professional Paper, 1250. U.S. Geological Survey, Washington, D. C.

Rosi, M., R. Santacroce, and M. F. Sheridan. 1981. "Volcanic Hazards of Vesuvius, Italy." *Bulletin du Bureu des Recherches Géologiques et Miniéres* IV (2): 169–79.

Sheridan, M. F., F. Barberi, M. Rosi, and R. Santacroce. 1981. "A Model for Plinian Eruptions of Vesuvius." *Nature* 289: 282–5.

Sigurdsson, H., S. Carey, W. Cornell, and T. Pescatore. 1985. "The Eruption of Vesuvius in A.D. 79." *National Geographic Research* 1: 332–87.

Sigurdsson, H., S. Carey, and J. M. Espindola, 1984. "The 1982 Eruptions of El Chichon Volcano, Mexico: Stratigraphy of Pyroclastic Deposits." *Journal of Volcanology and Geothermal Research* 23: 11–37.

Sigurdsson, H., S. Carey, and C. Mandeville. 1991. "Krakatau: Submarine Pyroclastic Flows of the 1883 Eruption of Krakatau Volcano." *National Geographic Research* 7: 310–27.

Sigurdsson, H., S. Cashdollar, and R. S. J. Sparks. 1982. "The Eruption of Vesuvius in A.D. 79: Reconstruction

from Historical and Volcanological Evidence." *American Journal of Archeology* 86: 39–51.

Sigurdsson, H., W. Cornell, and S. Carey, 1990. "Influence of Magma Withdrawal on Compositional Gradients during the A.D. 79 Vesuvius Eruption." *Nature* 345: 519–21.

Sigurdsson, H., T. Pescatore, A. Varone, and A. M. Ciarallo. 1994. The Eruption of Vesuvius A.D. 79. Volcanology, Sedimentology and Archeology. In *Excursion Guide A4,* pp. 83–104. Fifteenth International Association of Sedimentologists, April 1994.

Sparks, R. S. J., S. Self, and G. P. L. Walker. 1973. "Products of Ignimbrite Eruptions." *Geology* 1: 115–18.

Sparks, R. S. J., and G. P. L. Walker, 1973. "The Ground Surge Deposit: A Third Type of Pyroclastic Rock." *Nature* 241: 62–4.

Sparks, R. S. J., and L. Wilson. 1976. "A Model for the Formation of Ignimbrite by Gravitational Column Collapse." *Journal of the Geological Society of London* 132: 441–51.

Taylor, G. A. M. 1958. "The 1951 Eruption of Mount Lamington, Papua." *Australia Bureau of Mineral Resources, Geology and Geophysics Bulletin* 38: 1–117.

Winkes, R. 1982. Roman Paintings and Mosaics. In *Catalogue of the Classical Collection.* Rhode Island School of Design, Providence, R.I.

5

PALEOSOLS OF THE POMPEII AREA

J. E. Foss, M. E. Timpson, J. T. Ammons, and S. Y. Lee

INTRODUCTION

The geologic and pedologic (soils) history of the Pompeii area is dominated by the volcanic activity of Mount Vesuvius. Cornell (2000) and Sigurdsson et al. (1985) have summarized the complex and frequent volcanic activity in Campania during the past 50–100,000 years. Soil formation is evident on some of the volcanic deposits of the Pompeii area; this study will concentrate on those soils formed between 1871 Y.B.P. (A.D. 79) and approximately 17,000 Y.B.P. (~15,000 B.C.). Soils formed on these older volcanic sediments and subsequently covered and preserved with volcanic ash and pumice are termed paleosols.

Paleosols, or fossil soils, are important in interpreting the geologic and archaeological history of an area. Paleosols, as with present-day soils, have properties that reflect the climate, vegetation, geologic material, topography, and length of weathering time in an area. The characteristics generally studied in paleosols include the morphology, physical properties, chemical constituents, and mineralogy. Thus, by analyzing paleosols, a determination can be made of the environmental factors responsible for the development of a particular paleosol and subsequently a landscape or geographic area.

Many archaeological investigations in the United States today incorporate the use of paleosols in the interpretation of the stratigraphy and environmental history of sites. Nikiforoff (1943) suggested the term archaeopedology for the branch of soil science that deals with the interpretation of paleosols for archaeology. Today, archaeopedology (pedo-archaeology or geoarchaeology) is a rapidly growing subdiscipline of soil science and geology in the United States as well as in Europe, Japan, and other countries.

The preservation of paleosols depends on a minimal amount of disturbance during burial by deposition of geological material on the preexisting surface. Volcanic deposition, such as airborne pumice and ash, generally results in excellent preservation of the previous surface. Exposures of paleosols in the Pompeii area show little disturbance or destruction of the preexisting soils following volcanic events. This is particularly evident in the preservation of buried A horizons (former surfaces). In alluvial systems, another important landscape for archaeological studies, many of the paleosols lack A horizons because they are so vulnerable to erosion by water flowing over the soil surface.

The study of the geologic history and the occurrence of paleosols in the Pompeii area has revealed a complex history of volcanic activity prior to the massive eruption of A.D. 79 (Sigurdsson et al. 1985; Arnó et al., 1987; Lirer et al. 1973; Foss, 1989). The present study was undertaken to develop a more complete pedologic history of the Pompeii area prior to A.D. 79. This information, along with geological, archaeological, palynological, and botanical contributions, is necessary to evolve a systematic reconstruction of the physical history of Pompeii prior to A.D. 79 and the events leading to the development of landscapes and the environment experienced by the people of that era.

In addition to interpreting environmental and geologic history, soils are also important in the success and prosperity of agriculture for civilizations. People of the Pompeii area were fortunate to have land resources that were conducive to a highly productive agriculture. The volcanic soils were very fertile and had excellent water-holding properties. This chapter, then, will also provide information on the soil as a natural resource important in agriculture and in the

J. E. Foss, M. E. Timpson, J. T. Ammons, and S. Y. Lee

development of the extensive gardens and orchards described in Pompeii.

SITE DESCRIPTION

The study area of this investigation included sites located around the base of Mount Vesuvius. The archaeological sites sampled include Pompeii (garden in the House of Polybius: IX.xiii.1 and Orchard site: I.xxi), Torre Annunziata (Oplontis), Herculaneum, and Boscoreale; quarries sampled include Ottaviano, Terzigno, and Pozzelle. Figure 54 is a satellite image of the Mount Vesuvius area showing the major cities and landmarks.

The present climate of the Pompeii area is Mediterranean, with most of the precipitation coming during the winter; approximately 70% of precipitation occurs from September to March. The annual precipitation is about 830 mm. Some variation in the annual precipitation in the cities surrounding Mount Vesuvius is expected because of the orographic (topographic) influence of the volcano. The average annual temperature is 25° C, with the July and January temperatures averaging 35° C and 13° C, respectively. During the period of soil weathering from 1920 to 17,000 Y.B.P. climatic fluctuations from the current conditions just described were undoubtedly experienced in the Pompeii area.

The native vegetation of the area consisted of trees such as the evergreen oaks and shrubs such as laurel, myrtle, Spanish and Scotch broom, oleander, and strawberry tree (*Arbutus unedo*), a vegetation known as the maquis. The same vegetation exists today, except in areas where agriculture has encroached.

Soils in the Pompeii area were derived from volcanic materials, with pumice and ash dominating landscapes. The stratigraphic sequence and associated paleosols shown in Figure 55 will be used to reference much of the discussion regarding soils of the Pompeii area in this chapter. In the study sites, a great deal of stratification was noted, especially in the quarries such as Ottaviano (Fig. 56). The stratification is the result of numerous periods of volcanic activity prior to A.D. 79; the various periods of addition of volcanic materials

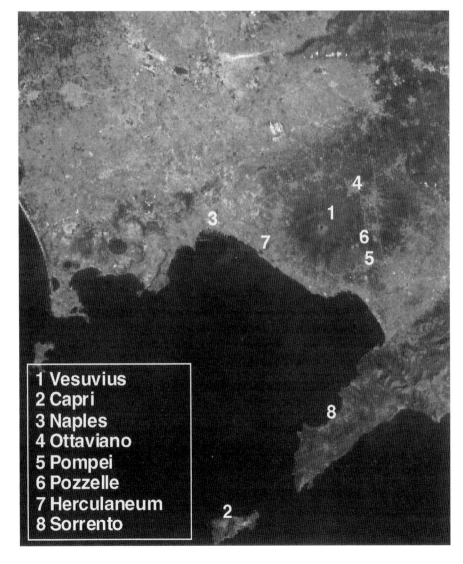

1 Vesuvius
2 Capri
3 Naples
4 Ottaviano
5 Pompei
6 Pozzelle
7 Herculaneum
8 Sorrento

FIGURE 54 Satellite image of Mount Vesuvius and surrounding area showing locations of study sites.

66

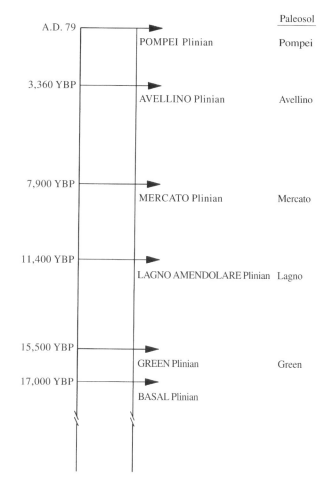

		Paleosol
A.D. 79	POMPEI Plinian	Pompei
3,360 YBP	AVELLINO Plinian	Avellino
7,900 YBP	MERCATO Plinian	Mercato
11,400 YBP	LAGNO AMENDOLARE Plinian	Lagno
15,500 YBP	GREEN Plinian	Green
17,000 YBP	BASAL Plinian	

(Right) FIGURE 55 General stratigraphic sequence of Somma–Vesuvius volcanic activity (after Arnó et al., 1989) and associated paleosols. The date for the Avellino paleosol is from Vogel et al. (1990).

(Below) FIGURE 56 Ottaviano quarry showing stratification of volcanic sediments. Paleosols noted in the plate are A = Avellino, M = Mercato, and L = Lagno. Photo: J. Foss.

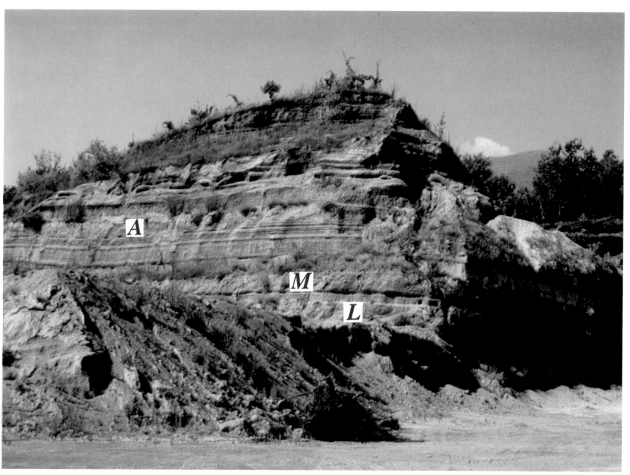

are well recorded in the pedologic sections. The development of soils indicates periods of stability and weathering when there was little volcanic deposition occurring. Interpretation of soil morphology can develop a chronology of active deposition and weathering periods.

RESULTS AND DISCUSSION

GENERAL MORPHOLOGICAL CHARACTERISTICS

Figure 57 shows the general morphological characteristics of soil profiles sampled below the A.D. 79 level at Pompeii (Polybius and Orchard sites), Boscoreale, and Oplontis. All profiles exhibited numerous pedologic (development) and lithologic (textural) discontinuities and buried surfaces (Ab horizons). The buried Ab horizons represent previous surfaces where organic matter from plants and animals decomposed into humus and developed an A horizon. In addition to A horizons, some of the profiles (e.g., Pompeii-Polybius at 150 to 190 cm) had developed Bw (cambic) horizons. The B horizons or subsoils represent a greater degree of weathering than just the accumulation of degraded organic matter in A horizons.

The color (Munsell notation) of individual horizons is shown to the right of the profile. Color is determined by matching the moist or dry color of the soil to the color chip in the Munsell book. Surface horizons (Ab or Ap) are darker in color than the subsoils (B horizons) or relatively unweathered material (C horizons); most of these horizons were dark brown (10YR 3/3), very dark grayish brown (10YR 3/2), black (10YR 2/1), or brown to dark brown (10YR 4/3). Generally the darker the color, the greater the content of organic matter. For example, in the Avellino paleosol at Ottaviano quarry, the surface horizon had a color of 10YR 3/3 and a total C content of 0.9 percent, whereas the Mercato surface horizon with a color of 10YR 2/1 had a C content of 2.3 percent The more strongly developed subsoil horizons were mainly dark yellowish brown (10YR 4/4, 3/4) or brown to dark brown (10YR 4/3); these colors are generally related to the content of iron coatings on the soil particles resulting from iron movement into subsoils from leached zones above. Transitional horizons (e.g., AB, BA, B.C.) will generally have colors grading between the A, Bw, and C horizons.

Field textures of the soils (Fig. 57) are mainly sandy loam (sl), loam (l), loamy sands (ls), sand (s), or silt loam (sil). In these relatively young soils, very little modification of textures from the initial volcanic materials is evident. Strong contrasts in texture (e.g. silt loam as compared to loamy sands) are termed lithologic discontinuities. The discontinuities are related to changes in deposition patterns and activity of the volcano; thus, they provide a guide to the volcanic history of the region. When the discontinuities are accompanied by evidence of soil weathering or formation of horizons, they give additional information on volcanic history. As noted in Figure 57, many of the discontinuities were accompanied by soil weathering.

Tentative correlation of the various sections of the pedologic column with previously identified paleosols by Arnó et al. (1987) is given to the left of the morpho-

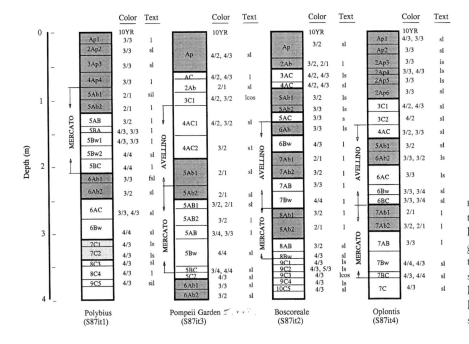

FIGURE 57 Morphologic characteristics of soil profiles of Pompeii, Boscoreale, and Oplontis. Color is given in the Munsell notation. Field textures include: l = loam, sl = sandy loam, sil = silt loam, ls = loamy sand, fsl = fine sandy loam, lcos = loamy coarse sand, and s = sand (Scudder et al. 1996).

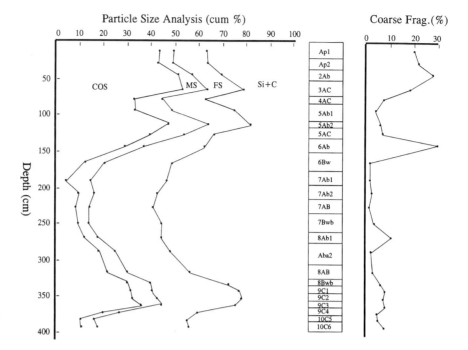

FIGURE 58 Particle-size distribution of soil profile, Boscoreale.

logic description. The dominant paleosols are the Avellino (dated at 3360 B.P.), the Mercato (7900 B.P.), and the Lagno (11,400 B.P.) (Vogel et al. 1990 and Santacroce 1983).

PEDOLOGIC HISTORY AT SAMPLING SITES

Boscoreale

Figure 57 shows the general morphological characteristics of the soil described and sampled in the vineyard at Boscoreale. The dominant features of the soil profile are the numerous pedologic and lithologic discontinuities occurring in the section. Ten discontinuities were noted in the profile, and five major buried A horizons or surfaces were recognized. The buried A horizons had black to dark grayish brown (10YR 2/1–3/2) colors.

Figure 58 shows the particle-size distribution of the various horizons at Boscoreale. The upper portion (top 1.5 m) of the column is coarse textured with sand (2–0.05 mm) contents greater than 60 percent. With depth the sand content drops to nearly 40 percent at 2 m and then increases to 80 percent at 3.5 m. Also in Figure 58, the content of coarse fragments (>2 mm) exhibits variation with depth. An increase in coarse fragments is noted in some of the buried A horizons; this is especially evident at the top of the A.D. 79 Pompeii paleosol, in addition to the top of the Avellino and Mercato paleosols. This increase is probably related to the input of coarse fragments, especially pumice, corresponding to the start of an episode of volcanic activity.

A soil sample was collected for 14-carbon dating from the buried A horizon of the Mercato paleosol at Boscoreale at a depth of 265–310 cm. The date from the soil sampled was 8200 ± 230 years B.P., which is nearly equivalent to the date range of the Mercato paleosol reported by Alessio et al. (1974) and Delibrias et al. (1979).

Pompeii Orchard and Garden in the House of Polybius

Two profiles were sampled in the ancient city of Pompeii. These sites had been sampled previously from the A.D. 79 surface to a depth of 1 m (Foss 1989). Figure 57 shows the characteristics of the profiles sampled to depths of nearly 4 m. These profiles show numerous buried A horizons associated with periods of stability or weathering when little volcanic material was deposited. The profiles at Polybius and Pompeii Orchard were different in that the soil at Polybius had a well-developed Mercato paleosol but showed little evidence of the complete Avellino paleosol as did that at the Pompeii Orchard. Although the reason for this anomaly is not evident, some possibilities for explaining it are (1) erosion removed the Avellino paleosol at Polybius or (2) perhaps Polybius was occupied at the time of the eruption and the volcanic sediment was removed or deposited on a previous structure. Additional study is needed to elucidate the contrasts in sediment pattern at these two locations in Pompeii.

Figures 59 and 60 show the particle-size distribution of the profiles at Pompeii. These two profiles show that the Mercato paleosol has the highest content of silt and clays (fines) in the pedologic column; silt and clay exceeds 50 percent in the Mercato soil. The discontinu-

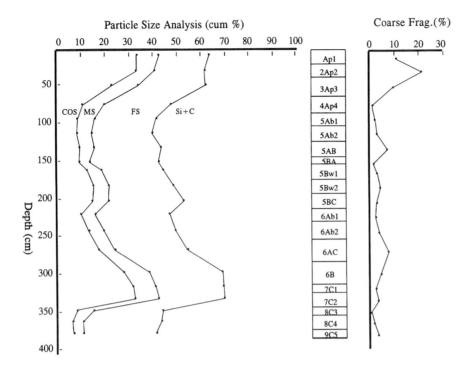

FIGURE 59 Particle-size distribution of soil profile, Garden of Polybius, Pompeii.

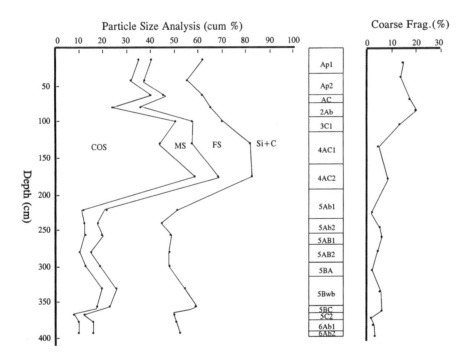

FIGURE 60 Particle-size distribution of soil profile, Pompeii Orchard.

ity at 350 cm in the Pompeii Orchard and 200 cm in the Polybius profiles probably indicates the beginning of the Lagno I paleosol. Additional study and 14-carbon dates are needed to verify this possibility.

Oplontis

The Oplontis profile below the A.D. 79 surface is similar to the one sampled at Boscoreale in that both the Avellino and Mercato paleosols are well expressed and are found at similar depths.

The particle-size distribution is similar to the Pompeii Orchard soil. The Mercato paleosol is finer textured than the Avellino soil; this relationship in texture is also characteristic of paleosols at Pompeii. The sediment deposited between Avellino and A.D. 79 had combined silt and clay contents around 30 percent; this value is similar to the silt and clay contents of comparably aged sediment in the Boscoreale column.

Textural profiles at Pompeii, Boscoreale, and Oplontis show the coarse fragment (>2 mm) content in the upper meter to be between 8 and 25 percent (Figs. 58–60). These values for coarse fragments of the volcanic materials deposited between 3360 Y.B.P. (Avellino) and 1871 Y.B.P. (A.D. 79) are much higher than for those

deposits prior to 3360 Y.B.P. The energy of eruptions between 3360 Y.B.P. and 1920 Y.B.P. appears to have been greater than previous eruptions.

Ottaviano Quarry

The pedologic column of the Ottaviano quarry is summarized in Figure 61. The column is dominated by the Avellino and Mercato pumice layers and their associated paleosols. Other thinner paleosols are located from the A.D. 79 surface (1871 Y.B.P.) to the Avellino pumice. Two paleosols below the Mercato paleosols are probably associated with the Lagno Amendolare (11,400 Y.B.P.) and Greenish deposits (15,500 Y.B.P.). A thin weathered zone was also observed above the basal scoria at this locale.

The Avellino paleosol has a dark surface (17 cm) underlain by a B horizon from 17 to 31 cm. A darker zone from 31 to 38 cm was probably an older surface (A horizon) that has lost organic matter from decomposition and is now in the position of a B horizon. Under the former A horizon is a rather well-developed B horizon that shows some clay and Fe translocation.

Some physical and chemical properties of the Avellino paleosol are given in Table 1. The detailed particle-size analyses indicate several discontinuities (e.g., 31 cm, 38 cm, and 56 cm) in the profile; these are probably the result of breaks in sedimentation rate or pattern from Mount Vesuvius. The length of these intervals in the Avellino paleosol is not known, but on the basis of morphological properties it could have been several hundred years. The development of a Bw horizon above the buried 2Ab (31–38 cm) indicates perhaps 200

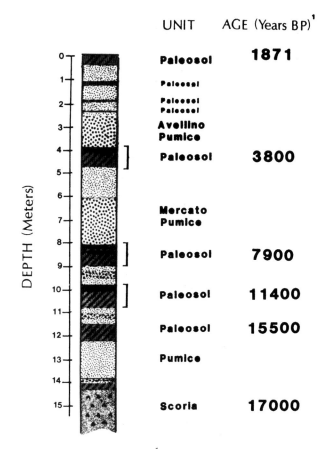

Dates from Arnó et al. (1987)

FIGURE 61 Pedologic column, Ottaviano quarry (Scudder, Foss, and Collins 1996).

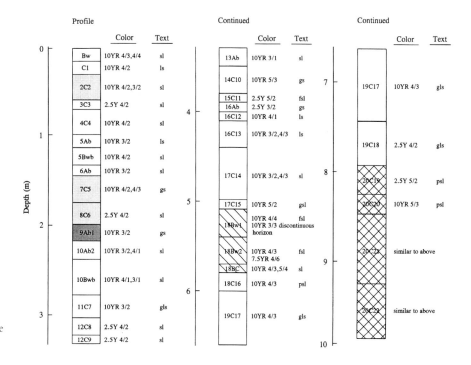

FIGURE 62 Pedologic column, Pozzelle quarry.

Table 1. Particle-size analyses, pH, free Fe, and total C of the Avellino and Mercato paleosols sampled at Ottaviano quarry.

		Particle-Size Analysis (%)										
		Sand Fractions									Free Fe	Total C
Horizon	Depth (cm)	vc	c	m	f	vf	Sand	Silt	Clay	pH	(%)	(%)
Avellino Paleosol												
A	0–17	12.9	11.6	6.8	11.4	10.6	52.5	42.0	5.5	8.4	0.35	0.95
Bw	17–31	13.7	9.0	4.8	10.2	10.8	48.5	45.3	6.2	8.3	0.55	0.89
2Ab	31–38	14.1	10.6	6.6	10.7	11.0	53.0	39.5	7.5	8.2	0.53	0.90
2Bw1	38–56	11.0	9.6	6.4	11.7	10.4	49.1	43.4	7.5	8.2	0.27	0.55
2Bw2	56–67	6.7	9.5	8.0	12.0	10.14	46.3	44.5	9.2	8.0	0.88	0.26
2BC	67–84	19.5	12.0	8.9	7.2	12.0	59.6	33.1	7.3	8.1	0.50	0.18
Mercato Paleosol												
A	0–5	5.6	12.3	8.9	8.6	17.2	52.6	36.5	10.7	8.4	0.71	2.29
E	5–8	7.7	13.9	8.8	14.4	10.6	55.4	38.1	6.5	8.4	0.11	0.70
2Ab	8–12	4.8	9.8	5.4	10.6	11.2	41.8	47.4	10.8	8.2	0.17	2.55
2Bw1	12–28	3.9	7.9	5.3	11.0	12.9	41.5	55.5	3.0	8.5	1.48	1.04
2Bw2	28–40	2.8	13.0	9.3	16.1	14.7	55.9	38.5	5.6	8.2	0.96	0.54
2BC	40–56	1.8	6.8	7.0	15.6	16.7	47.9	48.1	4.0	8.8	0.65	0.56
2C1	56–75	5.0	9.2	7.5	10.8	23.2	55.7	40.3	4.0	8.5	0.46	0.78
3Ab	75–83	9.8	8.1	4.5	4.0	33.0	59.4	36.9	3.7	8.7	0.37	0.53
3Bw	83–95	15.4	7.7	3.5	8.7	18.8	54.1	41.4	4.5	8.3	0.38	0.99
4C2	95–103	11.0	6.9	2.5	8.3	12.7	41.4	53.8	4.8	8.2	0.17	0.48

years of weathering. Although the present-day soils are acid in the Pompeii area, the Avellino paleosol is alkaline and contains secondary calcium carbonates. This characteristic has resulted from the leaching action of water moving carbonates from above and depositing them in the paleosols. Recharging of paleosols with bases such as Ca from overlying younger calcareous materials is quite common. Carbonates were especially noted just above the zone of a strong textural discontinuity in the volcanic material.

The Mercato paleosol at Ottaviano quarry had two thin (4–5 cm) surface organic layers; the lower one was present at all sites but was discontinuous at certain locations. This feature indicates deposition of additional volcanic sediment after the formation of the A horizon at 8–12 cm. A weakly developed B horizon was present at 12–56 cm. The B horizon exhibited some structural development and iron translocation (Table 1). A somewhat darker horizon was also evident at 75–83 cm; this may also be another surface that has been incorporated as a B horizon. Textural analyses (Table 1) also indicate discontinuities at 8 cm, 75 cm, and 95 cm. As with the Avellino paleosol, the Mercato paleosol contained free carbonates and high pH values throughout (Table 1). Accumulation of carbonates was especially noted just above the discontinuity at 1 m.

Pozzelle Quarry

Sigurdsson et al. (1985) have described in detail the deposition of A.D. 79 volcanic materials in the Pozzelle quarry. Volcanic layers deposited prior to A.D. 79 are exposed in the central portion of the quarry. Figure 62 shows the pedologic column sampled and described at the Pozzelle quarry. Several other paleosols are noted between the Avellino paleosol and the A.D. 79 surface. Artifacts recovered at 5 m were associated with the top of the Avellino paleosol (Fig. 63).

Figure 64 illustrates the thin, weakly developed Pompeii paleosol occurring at the A.D. 79 surface. In most areas at the Pozzelle, Ottaviano, and Terzigno quarries, the Pompeii paleosol is 15 to 30 cm in thickness.

In areas to the south of Pompeii, the Pompeii paleosol has different characteristics than at the Terzigno or Pozzelle quarries. For example, 1 km east of Castellammare di Stabia, the Pompeii paleosol (A.D. 79 surface) is 72 cm in thickness and shows one major pedologic discontinuity at 45 cm (Table 2). Based on this profile, the region was stable for perhaps 400 to 500 years before the A.D. 79 eruption. This was preceded by

(*Opposite*) FIGURE 63 Pozzelle quarry site showing volcanic materials below the A.D. 79 surface. The Avellino paleosol occurred at 5.1–5.8 m below the A.D. 79 surface. Photo: J. Foss.

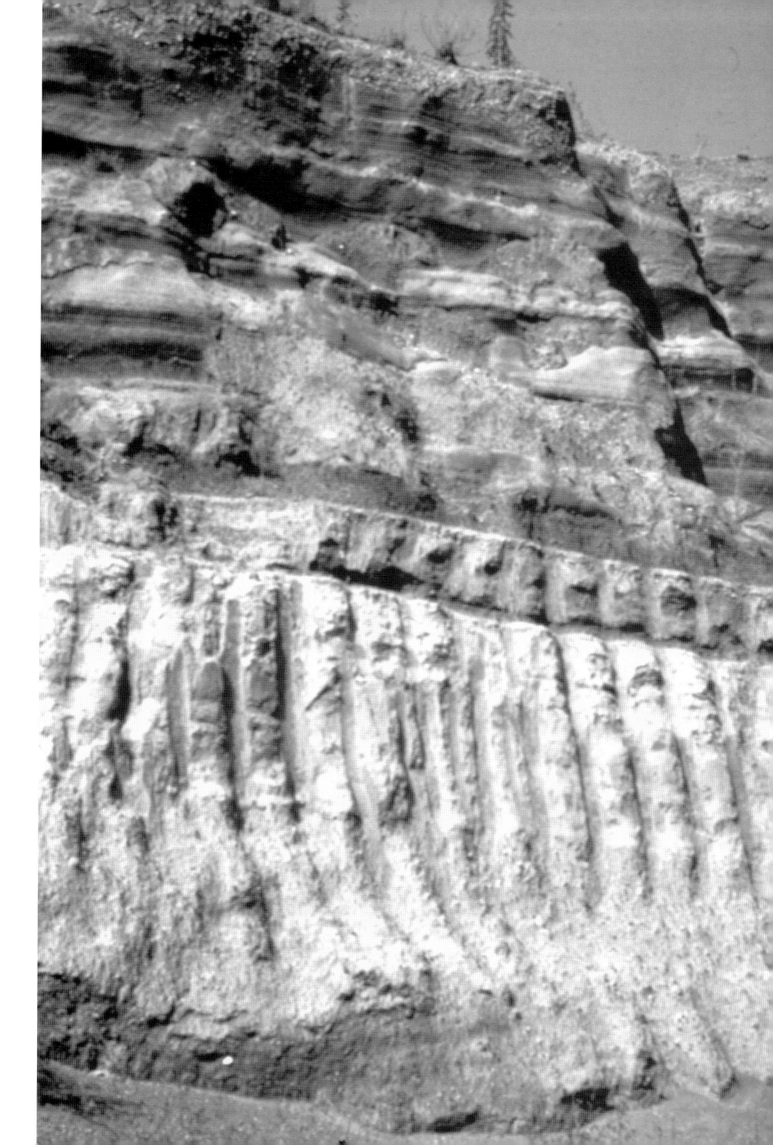

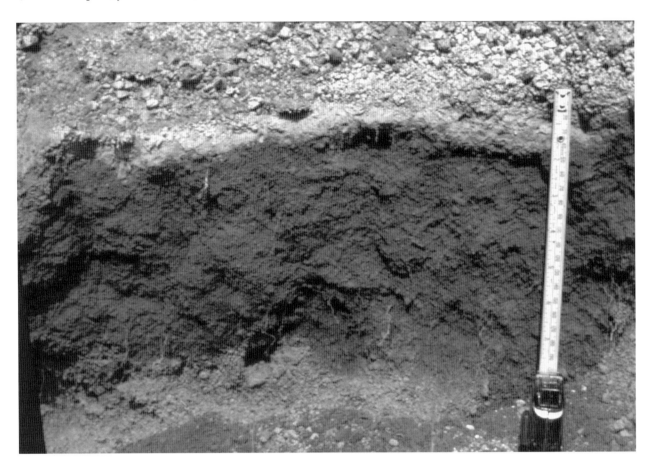

FIGURE 64 Pompeii paleosol (A.D. 79 surface), Pozzelle quarry. Photo: J. Foss.

a period of volcanic deposition, and an earlier period of stability that lasted 300 to 400 years.

On the Amalfi road, about 5 km north of Agerola, the Pompeii paleosol below the A.D. 79 pumice was about 2 m in thickness. This amount of weathering indicates a period of perhaps 8,000–10,000 years of stability or periods without appreciable volcanic activity adding sediments to the soil system.

Particle-size analyses of sediments below the A.D. 79 surface at the Pozzelle quarry indicate wide fluctuations

Table 2. *Profile description of Pompeii paleosol (A.D. 79 surface) approximately 1 km east of Castellammare di Stabia.*

Horizon	Depth (cm)	Color	Texture
Bw	0–25	10YR 4/3	sl
BC	25–45	10YR 4/3, 4/4	sl
2Ab	45–62	10YR 3/2	sl
2AB	62–72	10YR 3/3	sl
2C1	72–100	2.5Y 4/2	sl
3C2	100–120	Stratified	sl, gs
4Ab	120–142	10YR 3/3	sl
5 C	142+	Stratified material with some cementation	

in coarse fragments and finer fractions with depth. Wide fluctuations in particle size may be expected at sites near the volcano and as different depositional units in primary volcanic deposits are sampled.

Herculaneum

The paleosols underlying the A.D. 79 surface at Herculaneum (Pompeii paleosol) were composed of essentially a series of A horizons to a depth of 1 m (Table 3). Apparently, as in Pompeii, the additions of volcanic ash and pumice prior to the A.D. 79 eruption were incorporated into the soils of the Palaestra and gardens and thus resulted in a thickened topsoil. As a result of coarse fragments (mainly yellow tuff), auger borings were possible only to about 1 m. Other types of excavation procedures are needed to investigate the volcanic sediments and paleosols at greater depths.

The paleosols at Herculaneum had physical and chemical properties similar to the paleosols at Pompeii, Oplontis, and Boscoreale. The pH ranged from 8.3 to 8.8 and total carbon from 1.0 to 2.2 percent. Particle-size analyses illustrated the dominance of the sand fractions (55 to 77%) in the <2 mm sized particles.

ELEMENTAL ANALYSES

Elemental analyses were made on paleosols sampled in the Pompeii area. Although twenty-five elements were

investigated, only a few are reported here. Elemental analyses were made by Inductively Coupled Argon Plasma Emission Spectroscopy using an acid extractant consisting of a 5:1 ratio of HCl:HNO$_3$ with a total molarity of 0.72 M (Lewis et al. 1993).

One of the most interesting and significant findings is the relationship between the contents of Ba (barium) and Pb (lead) in the paleosols. Figure 65 shows the amount of Ba and Pb in the Avellino, Mercato, Lagno, and Green paleosols at the Ottaviano quarry. The Mercato paleosol contained large amounts of acid-extractable Ba (100 to 330 ppm) and low levels of extractable Pb (6–9 ppm). The Avellino paleosol, however, contained high levels of Pb (9–20 ppm) and low levels of Ba (less than 100 ppm). The Lagno and Green paleosols contained little Pb, with the Green paleosol having the lowest content of Ba of all the paleosols examined. The relationship of Ba and Pb in these paleosols provides a method of tracing and mapping the soils by chemical properties rather than by more expensive 14-carbon dating or less precise stratigraphic relationships.

The Ba/Pb ratios of profiles at Boscoreale, Oplontis, Pompeii Orchard, and Pompeii Polybius are plotted with depth in Figure 66. The high Ba/Pb ratios of the Mercato paleosol are noted at 2.5–3.0 m in Boscoreale, Oplontis, and Pompeii Orchard and at 1.5–2.0 m in Pompeii Polybius. The Ba/Pb ratios, 14-carbon date at

Boscoreale, particle-size lots, and soil morphology provide sufficient information to delineate the Mercato and Avellino paleosols at these sites.

Table 4 summarizes the data on Ba and Pb contents and ratios in the paleosols of the Pompeii area. The most diagnostic ratio was associated with the Mercato paleosol; the average Ba/Pb ratio of 27.9 at four locations is quite different from all the other paleosols. The limited number of observations of the Pompeii paleosol (A.D. 79 surface) and the similarity of

Table 3. *Profile descriptions of paleosols described below the A.D. 79 surface at Herculaneum.*

Horizon	Depth (cm)	Color	Texture	Carbonates
S88It4	Herculaneum			
Ap1	0–10	10YR 3/3	gsl	slight
Ap2	10–35	10YR 4/2	sl	slight
Ap3	35–50	10YR 4/2	gsl	slight
Ap4	50–70	10YR 3/2	sl	moderate
Ap5	70–95	10YR 4/3	pum sl*	slight
Ap6	95–120	10YR 5/4	pum sl	slight
S88It5	Herculaneum	Paleosol	Garden I	
Ap1	0–15	10YR 3/2	sl	moderate
Ap2	15–35	10YR 3/3	sl	moderate
Ap3	35–60	10YR 3/2	sl	moderate
Ap4	60–85	10YR 4/2, 3/2	gsl	moderate
Ap5	85–100	10YR 4/2	gsl	slight
S88It6	Herculaneum	Paleosol	Garden II	
Ap1	0–15	10YR 3/2	sl	weak
Ap2	15–25	10YR 3/2	sl	moderate
Ap3	25–45	10YR 4/2	sl	slight
Ap4	45–70	10YR 3/2, 4/2	gsl	slight
Ap5	70–100	10YR 3/2, 4/2	gsl	slight

*pum = pumaceous.

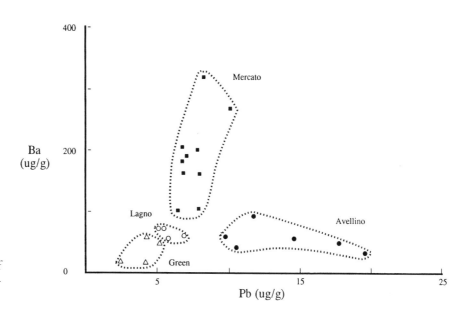

FIGURE 65 Ba/Pb relationships of paleosols, Ottaviano quarry (Scudder, Foss, and Collins 1996).

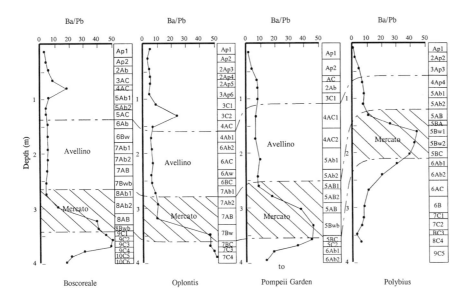

FIGURE 66 Distribution of Ba/Pb ratios in soils at Boscoreale, Oplontis, Pompeii Orchard, and Polybius (Scudder, Foss, and Collins 1996).

Ba/Pb ratios to the Avellino paleosol make this ratio of limited use to distinguish these two paleosols. In the Pompeii Orchard profile, the buried A horizon at 370–400 cm is believed to be the Lagno paleosol; the Ba/Pb ratio of 15.7 (Table 4) appears to be similar to the ratio of the Lagno paleosol sampled at the Ottaviano quarry.

SOIL GENESIS OF PALEOSOLS

The genesis of paleosols in the Pompeii area follows similar weathering processes to present-day soils. The specific processes and their approximate sequence that characterize the development of the paleosols from 1871 Y.B.P. to 17,000 Y.B.P. are as follows:

1. Addition of organic matter to soil surfaces.
2. Translocation of bases (e.g., Ca, Mg, Na) from surface horizons to subsoils.
3. Translocation of iron from A to B horizons.
4. Physical alteration of subsoils to form blocky structural units.
5. Some weathering of primary minerals to form clays and their subsequent translocation to lower horizons (e.g., Avellino profile).
6. Addition of phosphorous compounds in paleosols with an age of 3200 Y.B.P. and younger by associated inhabitants.
7. Some disruption and erosion of certain paleosols (e.g., Lagno and Green paleosols).
8. After development, leaching of carbonates from

Table 4. The content of Ba, Pb, and Ba/Pb ratios of paleosols in the Pompeii area.

Location	Paleosol	No. of Samples	Ba (μg/g) Range	Ba (μg/g) Mean	Pb (μg/g) Range	Pb (μg/g) Mean	Ba/Pb Ratio (\bar{x})
Ottaviano Quarry	Avellino	6	29.0–87.6	59.2	10.0–19.8	14.4	4.7
	Mercato	10	96.9–314.9	185.7	6.7–10.3	7.1	23.7
	Lagno	4	51.9–68.4	61.1	5.3–7.1	6.0	10.3
	Green	4	12.9–53.3	31.1	2.6–5.4	4.2	7.1
Terzigno Quarry	Pompeii	2	30.1–68.0	49.1	9.6–11.8	10.7	4.6
Boscoreale	Avellino	6	36.0–76.7	59.3	7.6–16.4	13.2	4.5
	Mercato	5	70.9–33.5	214.8	5.9–20.6	10.5	27.0
Pompeii Garden	Avellino	3	61–105	77.3	9.1–11.2	10.2	7.6
	Mercato	5	116–587	357.6	6.6–15.9	13.0	29.9
	Lagno	2	68–89	78.5	4.9–5.0	5.0	15.7
Polybius	Avellino			Not Present			
	Mercato	6	106–686	372.3	7.2–17.6	14.2	30.9
Pozzelle Quarry	Pompeii	2	29.4–37.4	33.4	4.9–8.3	6.6	5.1
	Avellino	4	16.4–36.3	24.9	9.3–14.3	11.9	3.1

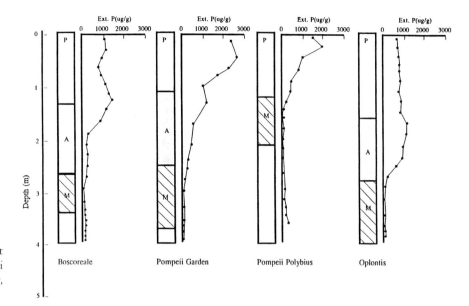

FIGURE 67 Extractable P in soils at Boscoreale, Oplontis, Pompeii Orchard, and Polybius (Scudder, Foss, and Collins 1996).

overlying volcanic sediments has added bases to previously leached soils, thus resulting in pH values greater than 7.0.

Most of the processes outlined here are acting simultaneously on the soil parent material; thus, the resulting paleosol is a function of the combined major processes just mentioned and many more minor processes not listed.

The P (phosphorous) content of soils has been used as an indicator of human activity in a number of archaeological sites. Phosphorous is of special interest in archaeology not only because of the amount generated by humans in their waste products and fertilizer but also because P is relatively immobile in most soils. Figure 67 shows the acid-extractable P in soil profiles at Boscoreale, Pompeii (Orchard and Polybius), and Oplontis. The P contents in the Pompeii paleosol (upper 0.5 m) and the Avellino are generally between 500 and 2600 µg/g; these values are greater than the background values for P as indicated lower in the profiles. The Mercato paleosol has P values less than 200 µg/g except at Polybius, where the Mercato paleosol is close to the surface and the Avellino paleosol is absent. The P values provide evidence of human activity throughout the time period of the Pompeii paleosol (1871 Y.B.P.) and the development of the Avellino paleosol (3360 Y.B.P.).

The study of paleosols developed on volcanic ash and pumice near Mount Vesuvius has permitted an analysis of numerous soil profiles with different degrees and times of weathering. Figure 68 shows the general relationship between thickness of solum (A + B horizons) and the length of weathering or age of the soil. For example, a soil with a solum of 50 cm would

have an approximate age of 1,500 years (see Figure 68). Although this is a first attempt at relating soil thickness to age in the Pompeii area, the chart should be useful in evaluating the approximate age of paleosols. As more information is obtained on paleosol thicknesses and ages of paleosols, this age chart will be revised.

SOIL FERTILITY

The quality of soils for agricultural purposes and gardens (Jashemski 1979) is related to the following major characteristics:

1 Chemical properties (e.g., N, P, K, Ca)
2 Water-holding capacity
3 Physical characteristics (structure and tilth)
4 Thickness of soil

FIGURE 68 Generalized diagram showing the relationship of solum thickness (A + B horizons) and soil age from paleosols in the Pompeii area (Scudder, Foss, and Collins 1996).

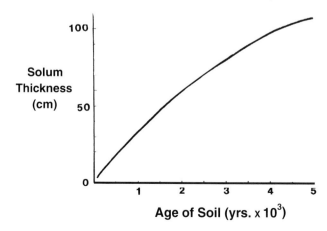

The paleosols of Pompeii have very favorable chemical characteristics for growing a variety of crops. The N (nitrogen) content of soils is related to the organic matter status of profiles, and the soils of Pompeii are generally high in organic matter (generally greater than 1.5 percent). The P and K contents are also very favorable for plant growth. The secondary nutrients, Ca, Mg, and S, also occur in high levels. The slightly acid nature of soils in modern Pompeii is probably indicative of the original paleosols prior to leaching of overlying volcanic sediments. The slightly acid pH would also be conducive to growing a variety of crops.

The water-holding capacity of volcanic soils is high considering the textures are generally sandy loam. As pointed out in an earlier study (Foss 1989), a modern soil in Pompeii had 11.8 cm of available water per meter of soil. Other investigators have also noted the high water-holding capacity of volcanic soils (Youngberg and Dryness 1964).

FIGURE 69 Mount Vesuvius landscapes. Photo: J. Foss.

Soils developed on pumice and ash generally have good tilth, that is, they are easy to work over a wide content of moisture. The high organic matter and low clay contents of these soils result in good aggregation; the well-aggregated soil also permits good infiltration of water whether from rain or irrigation.

The thickness of soils is quite variable in the paleosols. At Pompeii, Boscoreale, and Oplontis the surface paleosols were essentially a series of A horizons with high organic matter content; thus, these soils would not have a limitation of soil depth that would impede root development or water-holding capacity. At the Pozzelle quarry, on the other hand, the Pompeii paleosol is quite thin (less than 20 cm) over a coarse textured C horizon. In this case, soil thickness could limit agricultural potential, especially from the water-holding aspect. Other examples of thin soils (Pompeii paleosol) over coarse-textured C horizons were noted at the Terzigno and Ottaviano quarries. The Avellino paleosol, however, was generally 1 m in thickness at all locations examined; this thickness

would provide ample water-holding capacity for most crops.

PRESENT-DAY LANDSCAPES OF MOUNT VESUVIUS

Figure 69 depicts the present-day landscape of Mount Vesuvius. Soil development on Mount Vesuvius varies from essentially no soil development (Area A), to formation of a thin horizon (Area B), to a soil that has developed A and B horizons (Area C). Much of the variation in development is related to the establishment of vegetation and the stability of slopes. Area A, for example, has little vegetation, and soil particles are easily moved by gravity or rainfall activity; thus, soil development cannot proceed because of unstable surfaces and lack of vegetation for organic matter accumulation and production of acids to enhance weathering.

In landscape Area C, where the 1944 pumice and ash were deposited, soil development under a pine forest (*Pinus pinea* L., umbrella pine; *Pinus halepensis* Mill., Aleppo pine) has resulted in a soil with a thickness of 15–30 cm (Timpson et al. 1989). In cultivated areas the soil on this landscape contains a series of dark colored A and AC horizons; the average thickness observed was about 40 cm. Near the ancient city of Pompeii, a modern-day soil profile described earlier consisted of a series of A and Bw horizons to a depth of 156 cm (Foss 1989). This soil reflects the numerous periods of volcanic deposition and stability since the A.D. 79 eruption.

REFERENCES

Arnó, V., C. Principe, M. Rosi, R. Santacroce, A. Sbrana, and M. F. Sheridan. 1987. Eruptive History. In *Progetto Finalizzato Geodinomica Monografie Finali*, edited by R. Santacroce. Vol. 8, *Somma-Vesuvius*.

Alessio, M., F. Bells, S. Improta, G. Belluomini, G. Cortesi, and B. Turi. 1974. "University of Rome Carbon-14 Dates xii." *Radiocarbon* 16: 358–67

Delibrias, G., G. M. DiPaola, G. M. Rosi, and R. R. Santacroce. 1979. "La storia eruttiva del complesso vulcanico Somma-Vesuvio ricostruita dalle successioni piroclastiche del Monte Somma." *Rendiconti Società Italiana di Mineralogia e Petrologia* 35: 411–38.

Foss, J. E. 1989. Paleosols of Pompeii and Oplontis. In *Studia Pompeiana & Classica*, edited by R. L. Curtis. Aristide D. Caratzas, Publisher, New Rochelle, N.Y.

Jashemski, W. F. 1979. *The Gardens of Pompeii, Herculaneum and the Villas Destroyed by Vesuvius.* Vol. 1. Caratzas Brothers, New Rochelle, N.Y.

Lewis, R. J., J. E. Foss, M. W. Morris, M. E. Timpson, and C. A. Stiles. 1993. Trace Element Analysis in Pedo-Archaeology Studies. In *Proceedings of the First International Conference on Pedo-Archaeology*, edited by J. E. Foss, et al., pp. 81–8, Special Publication 93-03, University of Tennessee Agriculture Experiment Station, Knoxville.

Lirer, L., T. Pescatore, B. Booth, and G. P. L. Walker. 1973. "Two Plinian Pumice-Fall Deposits from Somma-Vesuvius, Italy." *Geological Society of America, Bulletin* 84: 759–72.

Nikiforoff, C. C. 1943. "Introduction to Paleopedology." *American Journal of Science* 241: 194–200.

Santacroce, R. 1983. "A General Model for the Behavior of the Somma-Vesuvius Volcanic Complex." *Journal of Volcanology and Geothermal Research* 17: 237–48.

Scudder, S. J., J. E. Foss, and M. E. Collins. 1996. "Soil Science and Archaeology." *Advances in Agronomy* 57: 1–76.

Sigurdsson, H., S. N. Carey, W. Cornell, and T. Pescatore. 1985. "The Eruption of Vesuvius in A.D. 79." *National Geographic Research* 1: 332–87.

Timpson, M. E., J. E. Foss, J. T. Ammons, and S. Y. Lee. 1989. "Soil Development on Recent (1944) Volcanic Pumice in the Mt. Vesuvius Area." *Agronomy Abstracts*, p. 272.

Vogel, J. S., W. Cornell, D. E. Nelson, and J. R. Southorn. 1990. "Vesuvius/Avellino, One Possible Source of Seventeenth-Century B.C. Climatic Disturbances." *Nature* 144: 534–7.

Youngberg, C. T., and C. T. Dryness. 1964. "Some Physical and Chemical Properties of Pumice Soils in Oregon." *Soil Science* 97: 391–9.

6

PLANTS

EVIDENCE FROM WALL PAINTINGS, MOSAICS, SCULPTURE, PLANT REMAINS, GRAFFITI, INSCRIPTIONS, AND ANCIENT AUTHORS

INTRODUCTION

Wilhelmina F. Jashemski

The earliest attempts to identify the plants known to the ancient Pompeians were based primarily on the plants pictured in the wall paintings and mosaics. The many examples portrayed in the wall paintings in the Vesuvian area constitute a unique and precious source of information regarding ancient plants. Plants and plant motifs were used not only in decorating garden walls; they are found throughout the house. Fruit so real it appears to have just been picked is found dramatically painted alone, with birds, or piled high in a beautiful glass vase or wicker basket; at other times it is combined with other subjects in still-life paintings. Plants are also found in mythological paintings, in which crowns, garlands, or branches realistically painted frequently have important symbolic significance. Garlands painted on the walls – simple ones of ivy, myrtle, or laurel, and elaborate ones made of various kinds of foliage, fruits, flowers, and nuts – are reminiscent of actual garlands that decorated the house on festal days. Stylized motifs derived from plant material are also found. As we have seen (see Chap. 2), a garden painting often extended the limited space of a garden. In a few houses the walls of an interior room were decorated with garden paintings. At times plants found at the base of a garden wall suggest a continuation of the actual planting of the garden. Similar plants found at the base of walls within the house help to bring the feeling of the garden indoors. Mosaics picture fewer plants.

The first person to identify the plants in the wall paintings and mosaics was Joachim Schouw, a professor of botany at the University of Copenhagen, who visited Pompeii and in 1851 published a list of thirty different plants that he had identified. He devoted a short chapter in his popular little book *Die Erde, die Pflanzen, der Mensch* to the *Pflanzen Pompeji* (pp. 31–6 in the English translation). He did not believe that all of the plants pictured had been grown in the Pompeii area in antiquity. He put the lotus, the Egyptian bean (*Nelumbo nucifera* Gaertner), and the date palm, three plants found in the Nile River scenes, in this category. He lists twenty-five other plants that he identified in the wall paintings: laurel, stone-pine, cypress, Aleppo pine, oleander, ivy, dwarf-palm, barley, Italian millet, asparagus, onion, radish, turnip, a kind of small gourd, olive, grape, fig, pear, apple, cherry, almond, plum, peach, pomegranate, and medlar, all found growing in the Vesuvian area, which he believed represented plants that grew there in antiquity. He also noted that pine nuts, wheat, barley, a glass of olives (plants represented in the paintings), and charred wheat and broad beans had been found in the excavations. This brings his total to thirty. Schouw's essay is interesting but brief, and he fails to tell the reader where most of the plants were found. He refers to only one specific mosaic, the famous Nile mosaic in the House of the Faun, and to one painting, that of two quails pecking at grain (see nos. 111, 150).

In 1879 Orazio Comes, professor of botany in the R. Scuola Superiore di Agricoltura at Portici, published *Illustrazione delle piante rappresentate nei dipinti pompeiani*, a study of fifty plants that he had identified in the wall paintings, sculpture, and mosaics. The plants are arranged in alphabetical order, under their botanical names. He gives a botanical description of each plant and notes something of the mythology or history con-

nected with the plant. At the end of his study he lists twenty plants that he labeled as doubtful identifications, or as plants not actually visible in the Pompeian depictions. Eight of these plants had been mentioned by Schouw, but Comes had been unable to locate them. He felt sure that the artists were painting actual plants, and had represented them faithfully, even though some of the more stylized paintings were modified for ornamental purposes. His study, which he laments had to be completed in forty days, upon publication became the standard work on the subject and universally cited and quoted. Unfortunately, it is without illustrations, and the plants are all too frequently discussed without note of their exact location.

Carbonized fruits, nuts, and seeds found in the excavations furnish valuable historic information about the plants raised or available in the area at the time of the eruption. In 1903 the German botanist M. C. L. Wittmack made a careful study of all the carbonized material from the excavations in the Naples Museum. Of the 160 samples that he examined, about 130 were seeds, fruits, or vegetables. The others were wood, cork, fishnet, and other miscellaneous items. In his publication he identifies twenty-three different fruits, seeds, nuts, and other items, describing each in detail, with the museum inventory number and the location of each item. Unfortunately, only a few of the carbonized remains that he cites can still be found in the National Museum at Naples. Other more recently excavated carbonized plant material is displayed in the Antiquarium at Boscoreale, in the storerooms at Pompeii and Herculaneum, and in the houses or shops in which it was found.

A later study of the fruits pictured in the wall paintings by Professor Domenico Casella, of the Istituto di Coltivazioni Arboree, Faculty of Agriculture of the University of Naples, was the next work on plant material of the area. He believed that he could identify many modern fruit varieties in these paintings. His study, "La frutta nelle pitture pompeiane," was published in *Pompeiana* in 1950, with five photographs and three drawings, showing details of the fruit. In two subsequent illustrated articles he defended his identifications, which rightfully have been challenged by other botanists, of the pineapple (*Ananas comosa* (L.) Merril), mango (*Mangifera indica* L.), and the custard-apple (*Anona squamosa* L.), all tropical plants unknown in Europe in antiquity. The fruit identified as pineapple is the cone of the umbrella pine. The fruit he called custard-apple and mango cannot be identified.

The remarkable garden paintings found in 1951 in two small rooms of the House of the Fruit Orchard (I.ix.5) on the Via dell'Abbondanza (see Chap. 2) were described by A. Maiuri the following year ("Nuove pitture di giardino a Pompei," *Bollettino d'Arte* 1 (1952): 5–12). Some of the plants pictured are identified, but the walls of the two rooms are completely covered with garden paintings and contain important plant material not discussed in the article. The most recent garden paintings to be discovered are the exceptionally beautiful and well preserved ones that decorate the walls of the *diaeta* (garden room) in the House of the Gold Bracelet and the less well-preserved ones in the adjacent exedra (see Chap. 2).

As I studied the ancient plants, and the work of my predecessors, the need for a thorough, up-to-date study of all the evidence became obvious. Such an undertaking would require an examination of all the artistic representations of plants; those in the garden paintings, those pictured elsewhere in the house, and evidence in mosaics and sculpture. Because of the influence of artistic tradition and the use of pattern books by artists, this evidence also needed to be studied in connection with the carbonized remains of plants, as well as all references to specific plants in the graffiti, the inscriptions, and information from the ancient Greek and Roman authors. Only in this context would it be possible to determine if the plants pictured in the paintings were those cultivated or available in the area. Such a study is an important chapter in the history of plants.

This part of the research has been an exciting but slow and tedious undertaking, encompassing many years. As I carefully went over the work of Comes, the only study concerned with all the plants represented in the paintings (and only those of Pompeii), and a work now more than a hundred years old, I found myself wishing again and again that his plant descriptions might have been accompanied by illustrations. In many cases it is impossible to accept or reject his identification when no photographs are included in his study. I have tried to check every plant representation mentioned by him, but it was discouraging to discover how few of the paintings he cites are still in existence. In many houses I discovered that the painting had completely faded and disappeared, in others the plaster with the painting had fallen from the wall. Many times it was difficult to locate the painting mentioned because the specific wall, sometimes even the room, was unrecorded by Comes. The work has been slow because frequently it was necessary to first weed the garden, and at times even remove the weeds or weedy trees growing in rooms, before a painting could be examined. In this tedious way we discovered garden paintings excavated many years ago but not mentioned in the excavation reports, or ever photographed. Now these have all been documented with color photographs.

A complete photographic record became increasingly important. In 1955, my husband began pho-

tographing all the plant material represented in the paintings, sculpture, and mosaics, both in the earlier excavations and in the more recent ones. Many of the paintings had never been photographed, and some are no longer in existence because of weather damage. For example, I especially wanted to photograph in color a garden painting in a house on the Via di Nola, for I had seen a drawing of this garden painting made at the time of excavation. We found the garden overgrown with brambles and small weed trees, but we had worked our way through the overgrowth, and pulled back enough of the vines to see that the painting was still visible. When we arrived a year later, we were told that the house had been cleared of vegetation and we went with anticipation to photograph the painting. Much to our dismay, we found that it had been loosened by the rains, and was only a little heap of plaster at the base of a bare wall. In the new excavations, we had found an exceptionally interesting lararium painting, with unusual flowers that we went back to examine further the following year, only to find that it, too, was no longer in existence. Exposed to the elements, the plaster had fallen from the wall. Fortunately, we had photographed this important painting the previous year.

A definitive study of the ancient plants in the Vesuvian area requires a knowledge of both botany and Roman civilization, and the close cooperation of specialists in each field. In this study I have been fortunate to have as collaborators Frederick G. Meyer and Massimo Ricciardi. The method we have followed in studying the thousands of photographs of plants was to catalogue first those that could be specifically identified. For example, when we brought together all of the representations of the myrtle that were realistically painted, it was then easy to identify those that were stylized and less clearly painted. The artists who made these paintings were concerned not with botanical accuracy but more with capturing the essential characteristics of a given plant, fruit, or flower as they had observed it. In fact, more attention was given to the fruit and flowers than to the leaves and stems. Artists varied as to their competence. Although pattern books were available, we had the impression that the artist was painting flowers and fruit that were familiar to him. For a description of every known garden painting in the Vesuvian area, together with our identification of the plants, illustrations, and bibliography, see W. Jashemski (1993: 313–81). The plants found in wall paintings other than garden paintings are discussed in this chapter for the first time.

Early in my work at Pompeii, at the suggestion of Frederick Meyer, I began to prepare herbarium specimens of plants growing in the Vesuvian area and to compare them with the plants painted on the walls. My

specimens and those subsequently collected by Frederick Meyer on four trips to the Vesuvian area are deposited in the U.S. National Arboretum herbarium in Washington, D.C. This material has proved to be highly useful in the identification of the ancient plants.

Our work has impressed us with the importance of maintaining a detailed file of all the plants that we have identified in the wall paintings, together with photographs and specific locations. How often we have wished that a photo of a plant identified by Comes were in existence. Even when he discussed a plant in a painting preserved in the National Museum in Naples, it has frequently been difficult to locate the painting. If much plant material was represented in a painting or mosaic, it has often been impossible to tell how Comes identified specific leaves, fruits, or flowers. This has been especially true of the beautiful mosaics and paintings of garlands, which contain so many different fruits, flowers, nuts, and leaves. We have made an effort in this chapter to use illustrations generously and to give the specific location of each plant discussed.

The more we worked with the wall paintings and mosaics the more we felt that the plants pictured were those growing in the area at the time of the eruption, including the sacred or Indian lotus (see no. 102) and the date palm (see no. 117), which were excluded by Schouw (see discussion under these plants). The water lily lotus (see no. 105), also excluded by Schouw, would not have been grown at Pompeii, along with perhaps a few other species mentioned in the following catalogue, but they would have been well known. We found no examples of the Aleppo pine, dwarf palm, small gourd, or medlar listed by Schouw.

This brings us to the carbonized remains of plant materials, which furnish indisputable evidence that specific plants were grown, or at least used at the time of the eruption. At times the carbonized evidence is the only evidence that we have for specific plants. The earlier specimens studied by Wittmack had all been found in shops or homes. During my extensive excavations through the years in the gardens and cultivated land at Pompeii, and in the villas at Oplontis and Boscoreale, many carbonized fruits, vegetables, nuts, and seeds were found in situ (see Chap. 2). This material has been identified by F. G. Meyer, who has also reexamined all the carbonized material reported by Wittmack now extant (see Meyer, 1988). Such carbonized plant remains owe their survival to chance. They are preserved only in areas covered by pyroclastic flows, for such flows furnish sufficient heat to carbonize plant material.

In some sites, where the heat was less intense, we found partially carbonized material. At times sufficient woody material was preserved to permit definite or

partial identification. See, for example, the large trees along the country road in front of the *villa rustica* at Boscoreale (see Chap. 2, also Jashemski 1993: 288). But when generous samples of what appeared to be partially carbonized roots or branches found in the peristyle garden of the House of Polybius at Pompeii were sent to Joan Sheldon at the Institute of Archaology, University of London, for examination, she discovered that all woody material had been replaced by calcium carbonate.

In the course of my excavations small fragments of carbonized wood were found on the soil and occasionally when emptying the lapilli from a root cavity. Joan Sheldon also analyzed these fragments. She found that those in the root cavities were aboveground wood, not root-wood, and that more than one species of wood often occurred in the same cavity. The horticultural methods recommended by the ancient agricultural writers suggest some of the ways in which extraneous charcoal could be introduced into garden soil. Wood-ash was used as fertilizer, and planting holes were prepared by lighting fires in them (see Jashemski 1979: 260). Among the fragments Joan Sheldon identified were beech, ash, laurel, *Prunus* (species unidentified), grapevine, chestnut, hazelnut, walnut, elm, poplar, oak, cypress, and hawthorn. Some fragments may have come from prunings in the garden that were burned (many represented young growth); other fragments were brought in wood-ash as fertilizer. She also identified carbonized fragments of two stakes used to prop large trees in the garden in the House of Polybius as ash and hazelnut. These are all important, for they represent local flora.

A branch found in the rear garden of the Villa of Poppaea at Oplontis had the appearance of fresh wood, but analysis showed most of the cellular structure had been destroyed. After many hours in the laboratory, Francis Hueber, of the Smithsonian Institution, was able, by treating the sample with chromic and nitric acid in combination, to isolate a few olive cells. The tree was an olive tree (Jashemski 1979: 300).

The plants identified in the carbonized hay found in the *villa rustica* at Oplontis (see Chap. 1) are discussed in this chapter. Very few of the plants identified in the carbonized hay had been known from other evidence to have existed in this area in antiquity.

The carbonized plant material that has been randomly preserved represents only a portion of the plants that grew in this area in antiquity. We still lack the remains of many plants that we know were present during the Roman period.

Graffiti also furnish valuable evidence. The Pompeians frequently scribbled lists of items bought or sold, or for sale on the wall of their home or shop.

More rarely a drawing of a specific plant is found, such as the delightful sketch of a man wearing a laurel wreath found in the peristyle of the Villa of the Mysteries. A graffito from the Grand Palaestra gives us our only evidence of the peony. Labels on amphoras or other containers sometimes give the names of the plants or plant products that had been stored in them. This is the first time that this kind of evidence has been used in a study of the plant material of this area.

The writings of the ancient authors are another important source of information. The evidence gleaned from them is of two kinds. We are told of specific fruits and vegetables for which Campania was well known: the cabbages and onions of Pompeii were highly thought of; the Naples area produced the best varieties of chestnuts; the figs of Pompeii were highly prized, and those from Herculaneum are mentioned. General references to plants known to the Romans are often important sources of information. But it is not always possible to know exactly what plant an ancient writer is referring to, especially if he mentions only the name of the plant and does not describe it. Some plants, which have had the same name since antiquity, can be identified without difficulty. For example, the ancient cyclamen (Greek κυκλάμινος, Latin *cyclaminus*), the ancient crocus (Greek κρόκος, Latin *crocus*), and the ancient chicory (Greek κιχόριον, Latin *cichorium*) are the same plants we know by these names today. In some cases, however, unless the plant is described in some detail, the particular species cannot be determined. Identification becomes very difficult when the ancient authors refer to one plant by several different names. For example, the Romans gave the name violet (*viola*) to several very different plants (see no. 182).

It was not until the eighteenth century, when the Swedish botanist Carl Linnaeus devised a system of plant classification and consistently assigned to each known plant a Latin binomial, or binary name (one for the genus, one for the species) that greater stability in plant nomenclature was established.

The mentions in the ancient authors vary from scattered references in poetry and prose to the more detailed descriptions in the works of the agricultural writers Cato, Varro, and Columella, and in the elder Pliny's *Natural History.* The oldest agricultural manual, the *De agri cultura,* written by the farmer-statesman Cato (234–149 B.C.), is a loosely organized series of shrewd and pithy comments, based on practical experience. Varro (116–27 B.C.), known as Rome's greatest scholar, began the *De re rustica,* a more polished and longer work, when he was eighty years old, as a practical manual for his wife Fundania who had just bought a farm. The longest and most comprehensive of the agricultural

manuals was written by Columella, a native of a Roman *municipium* (present-day Cadiz) in southern Spain, who lived in the early part of the first century A.D.

As pointed out in Chapter 1, any study of ancient Roman plants relies heavily upon the *Natural History* of Pliny, who was a contemporary of Columella. Pliny drew heavily upon the works of his predecessors, both Greek and Roman writers. One of the authorities most frequently cited is Diocles of Carystus, a physician who had great fame in Athens about 350 B.C. and is the first author of an herbal known by name. Because of the importance of plants in medicine, works were written that described plants with their names and medicinal uses. Such works are known as herbals. Charles Singer (1927) shows that the herbal "assumed a definite literary form in the fourth century B.C. and this form has persisted with comparatively little alterations throughout the ages."

We have seen that Theophrastus was another Greek authority cited by Pliny (see Chap. 1). In his two works, *Enquiry into Plants* and *Aetiology of Plants* (both preserved), we have botanical works of a scientific nature, in which more than 400 kinds of plants are described. The ninth book of Theophrastus's *Enquiry into Plants* does not have the scientific character of the rest of the work and may have been written by another author after Theophrastus died. Chapters 9 to 12 were obviously extracted from an herbal, and they form the earliest preserved remains of a Greek herbal.

Another herbalist frequently mentioned by Pliny is Crateuas, the rhizotomist, or herb-gatherer, who served as the physician of Mithridates VI of Pontus (120–63 B.C.), who was also an herbalist. Crateuas's herbal, which has not survived, contained paintings of plants, under which he wrote their names and properties. This would be valuable to the reader in the days before

plants had scientific names. Books 20–27 of Pliny's *Natural History* are for the most part an herbal concerned with the medicinal uses of plants. Among the Roman authors cited by Pliny are Cato, Varro, and Columella.

Pliny nowhere mentions the great herbal of Dioscorides of Anazarba, a skilled Greek physician from Asia Minor, who wrote about A.D. 40–80 (Riddle 1985: xvii). There is no evidence that they knew each other, even though they lived at the same time. The herbal of Dioscorides includes more than 500 plants and became the standard work for centuries in both the East and West. Written in Greek, it is better known by its Latin title, *De Materia Medica* (*The Materials of Medicine*). Dioscorides points out that he knew plants from studying them in the field, and not merely from books. He studied carefully, however, and extensively used the works of those who came before him. Of these, he spoke most favorably of Crateuas. Certain passages in Dioscorides are very similar to some in Pliny. But the text of Dioscorides is much to be preferred. It is obvious that Pliny had read or heard Greek similar to the text of Dioscorides. But since Pliny is so scrupulous about listing his sources, we must conclude that both Dioscorides and Pliny had a common source, from which they borrowed extensively. There is no possibility that Dioscorides could have been copying Pliny, for the errors in Pliny's text are due to a lack of understanding of the Greek. It is possible that Crateuas, who is cited by both Pliny and Dioscorides, was a common source. Pliny, however, was much more than a mere compiler or copyist. He had a deep interest in plants and his contributions in this field are considerable (see Chap. 1).

The relative importance of the different kinds of evidence varies from plant to plant, as will be noted in the discussion of the individual plants.

CATALOGUE OF PLANTS

Wilhelmina F. Jashemski, Frederick G. Meyer, and Massimo Ricciardi

In this catalogue, all the plants in the Vesuvian area at the time of the eruption that are known from the actual remains examined, or are identified in the wall paintings, mosaics, or sculpture, or are mentioned in the graffiti, inscriptions, or ancient authors, are listed and the evidence cited. An effort has been made to make the evidence cited as complete as possible. In

the case of some common plants, however, such as the ivy, grape, and myrtle, which are ever present in the wall paintings, and other plants pictured frequently, this has been impossible, and only a few typical examples have been cited. The plants are arranged in alphabetical order according to their scientific name. A list of the plants known from spores

and pollen is given at the end of this chapter in Table 5.

The importance of plants to the ancient Romans becomes obvious in the plant descriptions that follow. Plants furnished food for man and beast. Ornamental plants adorned gardens and furnished shade. Plants were a basic motif in wall paintings and sculpture. Many plants had deep religious significance. Plants were also a source of medicine, building materials, and textiles. They were used for making furniture, ships, tools, baskets, perfume, oil, pens, and musical instruments. They were also used in tanning leather, and they furnished dye for leather, cloth, and hair. Pliny (*HN* 22.1) marvels at Nature's gift of so many different kinds of plants created for the needs or pleasure of mankind.

1. *ACACIA* sp.

English, acacia; Italian, *acacia*

WALL PAINTINGS

The characteristic leaf of the acacia confirms the identification by Comes (1879) of the small tree in the lower left of the large garden painting in the right panel on the N wall in the House of Adonis (VI.vii.18). When we examined this painting in 1966, it was possible, by putting water on the faded plaster, to bring out details otherwise not visible. The tree had a few yellow flowers still intact, a butterfly on the left, and a very large bird perched on the lower branch. This painting is strikingly similar to the painting of an acacia tree filled with oversize birds in the tomb of the Egyptian lord Khnumhotep at Beni Hasan. Comes (1879: 7) believed that he could identify yellow acacia flowers mixed with other flowers in a garland painted on the walls of the atrium of House VII.vii.5, but little of the atrium exists today.

REFERENCES IN ANCIENT AUTHORS

Theophrastus (*Hist. pl.* 4.2.8) refers to acacia as acantha (ʼἀκανϑα). Pliny refers to it as thornwood (*spina*). He says that its wood is used for the ribs of ships, its seed for tanning leather, and its flower in garlands. It grows near Thebes in a forest region nearly 40 miles from the Nile (*HN* 13.63). He says that gum (*acacia*) derived from this tree was important in medicine (*HN* 24.109, 20.233). Vergil (*Georgics* 2.118–19, 4.133) refers to this tree as *acanthus,* which Comes (1879: 7–8), Abbe (1965: 129), and others identify as the acacia. Dioscorides (1.133) describes the acacia (ʼακακία) and comments on its medicinal uses.

REMARKS

The acacia was well known to the Italians. The Pompeians could have seen it in Egypt, for there was trade between Pompeii and Egypt, or it could have been imported and perhaps grown in pots. The gum referred to by Pliny is a valuable product known as gum arabic. It is readily water-soluble and is used in various ways; in the manufacture of inks, as a mucilage, and in medicine. Hepper (1990: 22) mentions *Acacia nilotica* (L.) Delile, with yellow flowers, as a native of Egypt, and probably the one depicted in the House of Adonis.

2. *ACANTHUS MOLLIS* L.

English, acanthus; Italian, *acanto*

WALL PAINTINGS

Clumps of soft acanthus are among the plants pictured at the base of a garden wall or, at times, at the base of a wall in a room. In the House of Adonis (VI.vii.18), on the garden side of the low wall that joined the columns, to the N of the E entrance, there is an acanthus to the left of an egret teasing a snake; the acanthus has two blossom spikes (only the tip of the third spike is preserved) (Fig. 284). In the House of the Fruit Orchard (I.ix.5) there is an acanthus between two hart's-tongue ferns at the base of the E wall in the room to the E of the atrium. Less well preserved are the two plants in the House of the Silver Wedding (V.ii.1), at the base of the S wall in the room to the E of the atrium, but they are of interest because each plant is carefully portrayed and shown in flower. The paintings listed by Comes, at the base of the wall in the House of the Little Fountain (VI.viii.23) and in the House of Epidius Rufus (IX.i.20/30), are no longer visible.

SCULPTURE

The beautiful acanthus leaf was a favorite motif of sculptors. The marble jambs and lintel that frame the entrance of the Building of Eumachia on the E side of the forum at Pompeii were carved with a magnificent decoration of an acanthus scroll. At the base of the jamb, on each side of the entrance, is a clump of acanthus (*A. mollis*) from which rise flower spikes in high relief (Fig. 70). The smooth leaf of *A. mollis* also decorates the capitals of Corinthian columns of the tufa period, such as those in the Pompeii basilica.

MOSAICS

The stylized acanthus leaves in various mosaic borders appear to be borrowed motifs, probably from Pergamum (see Castriota 1995: Chap. 1; see pp. 21, 62, 121, 122, 124 for the suggestion that the acanthus is the symbol of Apollo).

REFERENCES IN ANCIENT AUTHORS

The acanthus was a common plant both in ornamental gardens and in the wild landscape. Pliny gives a good description of the *acanthus:*

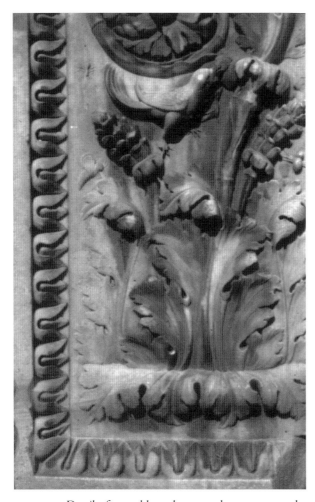

FIGURE 70 Detail of a marble sculpture at the entrance to the Building of Eumachia: acanthus plant and flower spikes. Photo: S. Jashemski.

There are two kinds of acanthus, a plant of the ornamental garden and of the city, which has a broad, long leaf, and covers the banks of borders and the flat tops of the raised portions of gardens; one is thorny and curled, which is the shorter [i.e., the spiny acanthus, *Acanthus spinosus* L.]; the other is smooth [i.e., the smooth acanthus, *Acanthus mollis* L., of Roman gardens].

HN 22.76

At Pliny the Younger's Tuscan villa, the bed below the terrace in front of the colonnade was planted with a bed of acanthus, which he describes as waving or rippling (*Letters* 5.6).

Dioscorides (3.19) says acanthus ('ἀκανθα) grows in gardens and in rocky and moist places. It has a smooth stalk of two cubits, the head like a thyrsus. Columella (*RR* 9.4.4) lists the acanthus among the wild plants whose flowers are loved by bees. The poet Vergil speaks of "soft acanthus" (*Georgics* 4.123) and "laughing acanthus" (*Eclogues* 4.20), and he says that Helen of Troy's veil was woven with a border of acan-

thus flowers (*Aeneid* 1.649). The acanthus also had medicinal uses (Pliny *HN* 22.76; Dioscorides 3.19).

Vitruvius (4.1.9) preserves the charming story, perhaps apocryphal, of how the sculptor Callimachus was inspired to use the acanthus leaf as the motif for some capitals that he was carving for the Corinthians. The acanthus on the Corinthian columns of Greece is *A. spinosus*, a plant widespread in Greece. At Pompeii, later sculptural representations of the acanthus with more spiny leaves, as on the supports of the marble table in the atrium of the House of Cornelius Rufus (VIII.iv.15) (incorrectly identified as *A. mollis* by Comes), suggest that the sculptor was more influenced by Greek models than by the local flora.

REMARKS

Acanthus mollis L. occurs at low elevations in hills, shady places, and coastal areas of Italy. The plants now growing in the Pompeian excavations probably are indigenous.

3. *AGROSTIS STOLONIFERA* L.
English, bent grass; Italian, *capellini*

MATERIAL EXAMINED

Some panicles of this grass were found in the carbonized hay at Oplontis.

REMARKS

Bent grass is not very common today in the Vesuvian area. It occurs mainly in moist meadows.

4. *AIRA CARYOPHYLLEA* L.
English, silver hairgrass; Italian, *nebbia, capellini*

MATERIAL EXAMINED

Some upper branches of panicles and glumes of this grass were found in the carbonized hay at Oplontis.

REMARKS

This annual grass occurs throughout the Mediterranean region.

5. *ALLIUM CEPA* L.
English, onion; Italian, *cipolla*

MATERIAL EXAMINED

Herculaneum: (1) carbonized remains of globose and apparently solitary tunicated bulbs in the Casa a Graticcio (III.13–15) (inv. no. 248); (2) broken pieces of about five bulbs in the Casa dei Cervi (IV.21) (inv. no. 640); (3) seventeen carbonized bulbs on the Decumanus Maximus (inv. no. 2325); (4) six carbonized

bulbs on the Decumanus Maximus (inv. no. 13); (5) about fifteen bulbs in the Casa del Bel Cortile, (V.8) (without inv. no.). There is a dish of well-preserved carbonized onions in the National Museum, Naples (Meyer 1988: 195–6).

CAST

Maiuri made a cast of the imprint of a thick layer of onions in cubiculum 16 of the Villa of the Mysteries (Maiuri 1947: 236, Fig. 99).

GRAFFITI

The onion (*cepa*) is listed in a long graffito, which records a bill for food in the atrium of a hotel-restaurant at Pompeii (IX.vii.24–25) (*CIL* IV 5380). A graffito found in House V.iii.10 has the word *cepa*, and the same word probably can be read in the Gladiatorial Barracks (V.v.3) at Pompeii (*CIL* IV 6722, 4422).

WALL PAINTINGS

A badly preserved bunch of onions can be identified in House V.ii at Herculaneum, on the E wall of the atrium above and slightly to the S of the door leading into the E room. A still-life painting, now destroyed, in the peristyle of House VIII.iv.4 pictured an onion in a glass, a radish, and a lobster (Helbig 1868: no. 1713).

REFERENCES IN ANCIENT AUTHORS

The onion was well known at Pompeii. The city gave its name to a variety, *Pompeiana cepa*, and Columella (*RR* 12.10.1) gives a recipe for preserving it. Pliny mentions the onion numerous times and describes a large number of varieties (*HN* 19.101–7), with directions for their cultivation and storage. He says that there are no wild onions (*HN* 20.39), that is, wild examples of the cultivated onion, which is true.

Apicius gives recipes for onions served as a vegetable and as a seasoning in many dishes. The onion was also used for medicinal purposes (Pliny *HN* 20.43; Dioscorides [κρόμυον] 2.181).

REMARKS

Modern authorities say that *A. cepa* is a domesticated plant, but its wild progenitors are unknown (Zohary and Hopf 1994: 185). According to Stearn (1978), the cultivated onion shows a close morphological affinity to *A. oschaninii* S. Fedtsch. found wild in northern Iran, Afghanistan, and other areas in central Asia.

6. *ALLIUM PORRUM* L.
English, leek; Italian, *porro*

GRAFFITO

The leek (*porrum*) was used at Pompeii, for the name occurs twice in the long graffito listing food sold at the hotel-restaurant (IX.vii.24–25) (*CIL* IV 5380).

REFERENCES IN ANCIENT AUTHORS

Theophrastus speaks often of the leek (πράσον). Pliny mentions the leek (*porrum*) many times. He refers to two kinds of leek, *porrum capitatum*, headed leek (*HN* 20.48), and *porrum sectivum*, probably chives (*A. schoenoprasum* L.) (*HN* 20.44). Martial (3.47.8) speaks of "each kind of leek" (*utrumque porrum*).

Apicius gives many recipes for using leeks, both as a vegetable (3.10.1–4) and as an ingredient in vegetable stew (4.5.1), in barley soup (4.4.2), with beans (5.6.1–4), with beets (3.11.1), in a sauce for meat slices (7.6.12), in bouquet garni or chopped as seasoning, in broth, in *conchida* of peas, in fricassees, with lentils, with dried peas, stewed with quinces, in stuffing for suckling pig, boiled with truffles, and with veal or beef. The leek was also used for medicinal purposes (Pliny *HN* 20.48–9; Dioscorides [πράσον] 2.179).

REMARKS

Modern writers speak of the garden leek, known only in cultivation, but of a Mediterranean or Near Eastern origin. It dates from the second millennium B.C. in Egypt and Mesopotamia and has been known in Europe since antiquity.

7. *ALLIUM SATIVUM* L.
English, garlic; Italian, *aglio*

MATERIAL EXAMINED

The carbonized remains of five well-preserved flattened garlic bulblets, commonly called "cloves" or "toes," are known from Herculaneum, in the Casa dell'Alcova (IV.3–4) (inv. no. 375). Additional material from Herculaneum (inv. no. 2059) may be onion or garlic. The material is poorly preserved, and positive identification is not possible. In the Naples Museum (inv. no. 84633) there are about fifty carbonized garlic cloves. The same material was cited by Wittmack as questionably being this species (Meyer 1988: 196).

GRAFFITI

Garlic is mentioned in two graffiti at Pompeii. One, in the peristyle of M. Holconius Rufus reads *aliu(m)* (*CIL* IV 2070); the other at IX.viii.2 reads *allio a(sses)* II (*CIL* IV 5246). The Romans spelled the word with both a single and a double "l". A third graffito (*CIL* IV 3485) was originally thought to refer to the *aliari*, the dealers in garlic (Mau 1902: 384), but Della Corte,

(1965: 90) has shown that this electoral notice was put up by the gamblers, or dice-throwers (*aleari*).

REFERENCES IN ANCIENT AUTHORS

Theophrastus (*Hist. pl.* 7.4.7) refers to garlic as *skorodon* (σκόροδον). He mentions a variety called Cyprian, which was not cooked but used in salads (*Hist. pl.* 7.4.11). Pliny gives a good description of the garlic (*alium*) (*HN* 19.111–16). In the same passage he mentions several kinds of garlic and gives detailed directions for their culture. Pliny (*HN* 19.113) says "to prevent garlic having an objectionable smell it is advised to plant them when the moon is below the horizon and to gather them when it is in conjunction." Garlic had many medicinal uses (*HN* 20.50–7). Pliny says it was used to induce sleep; and it was believed to be an aphrodisiac "when pounded with fresh coriander and taken in neat wine" (*HN* 20.57). See also Dioscorides (2.182).

Apicius uses garlic as a seasoning in only two recipes (4.1.3, 9.13.3). Horace devotes his third Epode to the guilty garlic, which had seasoned a dish at Maecenas's table and given him an attack of indigestion.

REMARKS

According to Zohary and Hopf (1994: 183), the wild ancestry of cultivated garlic is clearly related to a wild leek, *A. ampeloprasum* L., distributed in the Mediterranean Basin.

8. *ALOE VERA* (L.) BURM. F.

English, common aloe; Italian, *aloe*

WALL PAINTINGS

There is a good example of the common aloe in the House of M. Caesius Blandus (House of Mars and Venus) (VII.i.40) in the room to the right of the tablinum (Fig. 71). The plant is painted at intervals at the base of the wall and appears to be growing out of the ground. It is easily recognized by its long pointed leaves, which are spiny on the edges. We were able to identify five plants in the room, even though the paintings are now badly damaged. Comes found only one aloe in the same house, in the fauces, but none are visible there today. A less carefully painted aloe can probably be identified in a painting from the House of the Epigrams (V.i.18), now in the National Museum (Fig. 280). These are the earliest known illustrations of any species of aloe.

REFERENCES IN ANCIENT AUTHORS

Theophrastus does not mention the aloe. Pliny gives a good description of the plant:

FIGURE 71 Aloe plant, House of Mars and Venus. Photo: S. Jashemski.

The *aloe* bears a resemblance to the squill, but it is larger, and has more fleshy leaves, and with slanting streaks. Its stem is tender, red in the center . . . ; the root is single, as if it were a stake sunk in the ground. It has an oppressive smell, and a bitter taste.

HN 27.14

Pliny (*HN* 14.68) reports that a dealer in the province of Narbonenses used aloe for adulterating the flavor and color of his wine. Juvenal *Satires* (6.180) speaks of the bitterness of aloe. The aloe always has been highly prized as a medicinal plant. Pliny gives a detailed discussion of its many medicinal uses (*HN* 20.142; 21.76; 26.59, 61; 27.17–20). Dioscorides' description of the aloe (ἀλόη) (3.25) is very similar to Pliny's.

REMARKS

The aloe has been cultivated in Egypt since remote times. Today, common aloe is widely used for treating burns and as a skin softener. It occurs wild in the Mediterreanean region to the south of Portugal.

9. *ANAGALLIS* sp.

English, scarlet pimpernel, blue pimpernel; Italian, *mordigallina, bellichina*

MATERIAL EXAMINED

Fruiting branches were found in the carbonized hay at Oplontis. The only species to which these *Anagallis* fragments could be referred are *A. arvensis* L. and *A. foemina* Miller.

REFERENCES IN ANCIENT AUTHORS

Theophrastus speaks of the pimpernel (κόρχορος) that has become proverbial for its bitterness (*Hist. pl.* 7.7.2). Pliny (*HN* 25.144) refers to two kinds of *anagallis:* "the male with scarlet flowers, and the female with the blue one. . . . The blue-flowered kind blossoms first." Pliny (*HN* 25.144, 166; 26.35, 55, 80, 90, 118, 119, 144) lists the various medicinal uses of anagallis. Dioscorides (2.209) also knew two kinds of *anagallis* (ἀναγαλλίς): "that with an azure flower is called female, that of Phoenician [red] color is called male." He gives various other names by which *anagallis* is called, including "κόρκορος," the pimpernel. He lists a variety of medicinal uses.

REMARKS

Both species of pimpernel occur in open grassy places in many areas of Europe, including Italy. Formerly used in medicine, it is at present employed as a home remedy as a diaphoretic and diuretic, and for cirrhosis of the liver. It is called "the poor man's weatherglass," for its flowers open in the sun but close when the sun is behind a cloud.

10. *ANTHEMIS ARVENSIS* L.

English, corn camomile; Italian, *camomilla bastarda*

MATERIAL EXAMINED

Some flower heads with fruits were found in the carbonized hay at Oplontis.

WALL PAINTINGS

Small white daisylike flowers with yellow centers, which could be either the corn camomile (*Anthemis arvensis* L.) or the very similar wild camomile (*Chamomilla recutita* (L.) Rauschert), are pictured in the garden paintings in the *diaeta* in the House of the Gold Bracelet (VI. ins. occid. 42) at Pompeii, at the left of the fountain on the N wall (Fig. 129); on the E wall (Fig. 78); and on the S wall (Fig. 147). Similar small white daisylike flowers with yellow centers are pictured on the garland at the base of the garden painting on the N wall in the House of Apollo (VI.vii.23) and also in a garland in the Naples Museum (inv. nos. 8525, 8526).

REFERENCES IN ANCIENT AUTHORS

Pliny (*HN* 22.53–4) says *anthemis* is most highly praised by Asclepiades. Some call it white chamomile: "It

is gathered in spring on thin soils or near foot paths, and put by for making chaplets. At the same season physicians also make up into lozenges the pounded leaves, as well as the blossom and the root." He continues, listing its various medicinal uses. See also Dioscorides (3.154).

REMARKS

Corn camomile occurs as a weed in cultivated fields of the Mediterranean region. It grows throughout the excavations today.

11. *ANTHOXANTHUM ODORATUM* L.

English, sweet vernal grass; Italian, *paleino odoroso*

MATERIAL EXAMINED

Many inflorescences of this grass were found in the carbonized hay at Oplontis.

REMARKS

This grass is much used as a forage grass for the fragrance it gives to the hay.

12. *APHANES ARVENSIS* L. (*ALCHEMILLA ARVENSIS* (L.) SCOP.)

English, field lady's mantle, parsley piert; Italian, *erba ventaglina*

MATERIAL EXAMINED

A single well-preserved stem fragment with leaves was found in the carbonized hay at Oplontis.

REMARKS

This plant is a widespread annual in cultivated ground and other open habitats in Europe, including Italy. The herb is a stimulant and a diuretic used for kidney and bladder ailments.

13. *ARBUTUS UNEDO* L.

English, strawberry tree; Italian, *corbezzolo, arbuto*

WALL PAINTINGS

The strawberry tree is beautifully depicted in the garden paintings in two houses at Pompeii. In the House of the Fruit Orchard in the room off the E side of the atrium there are two wall paintings of strawberry trees laden with the characteristic warty red fruit, one on the right panel of the N wall, and one on the right side of the center panel on the S wall (Fig. 72). In the same house two trees in fruit, but not so well preserved, flank the fig tree on the E wall in the room off the E side of the peristyle. Maiuri identified these as sorb trees, but close examination of the fruit from a ladder showed the characteristic warty fruit of the strawberry tree.

FIGURE 72 Oleander and strawberry tree, House of the Fruit Orchard. Photo: S. Jashemski.

The strawberry tree in fruit is also pictured in the garden paintings in two rooms in the House of the Gold Bracelet. On the N wall of the *diaeta* there is (1) a low shrublike strawberry tree to the right of the fountain and (2) another to the right of the Faun herm (Jashemski 1993: 348, fig. 406). (3) On the E wall, a much taller strawberry tree frames each side of the niche in the center of the wall (Figs. 116, 321; for the entire wall see Jashemski 1993: 12–13, figs. 8, 10). (4) The S wall, which is similar to the N wall (but much less of it is preserved, especially on the right end), has a clump of small, well-preserved strawberry trees at the left end of the wall (Fig. 73) (see also Jashemski 1993: 354 and fig. 16). Most of the room to the right was

occupied by a water triclinium, and the walls had been decorated with garden paintings. The S wall is better preserved, but portions of the wall are barely visible. (5) In the left panel of the S wall a strawberry tree, on which a song thrush is alighting, is preserved (Fig. 335).

A detail of a wall painting taken from Pompeii many years ago, and now in the Naples Museum, pictures a blackbird and three easily recognizable fruits of the strawberry tree (Fig. 334). Comes had apparently seen not the painting but only the drawing of the painting in *Pitture di Ercolano* (Accademia Ercolanese 1757: vol. 1, t. 46), for he includes the *Arbutus unedo* in his list of plants labeled doubtful and not actually recognizable in Pompeian paintings. We found the painting in a storeroom of the museum.

REFERENCES IN ANCIENT AUTHORS

The Romans believed that acorns and the fruit of the *arbutus,* or strawberry tree, were once the food of ancient man, and that when these failed Ceres taught man agriculture (Vergil *Georgics* 1.148–9). The colorful fruit of this tree became a symbol of the golden age before man had to work. According to Lucretius (*De rerum natura* 5.941), the fruit of the *arbutus,* which ripens in winter with crimson color, was abundant in that far-off

FIGURE 73 Detail of strawberry tree on S wall of *diaeta,* House of the Gold Bracelet. Photo: S. Jashemski.

time, and even larger than in his day. Ovid also speaks of the *arbutus* loaded with ruddy fruit (*Met.* 10.101–2).

Pliny (*HN* 15.98–9) distinguishes between the strawberry fruit that grows low on the ground (*fraga*, i.e., *Fragaria vesca* L.) and that which grows on a tree. He describes the tree as "a sort of shrub; the fruit takes a year to mature," the blossoms of next year's crop flowering while the current crop is ripening. He says that the fruit is not esteemed and was called *unedo* because after eating a single fruit one had enough! He says that the fruit of the *arbutus* or *unedo* is difficult to digest and is injurious to the stomach (*HN* 23.151), a statement also found in Dioscorides (1.175). Columella uses both names; he recommends the ripe fruit of the *unedo* as a fish food (*RR* 8.17.13) and the fruit of the *arbutus* for pigs (7.9.6). According to Vergil, bees also fed on the *arbutus* (*Georgics* 4.181).

REMARKS

This evergreen shrub or small tree probably did not grow in gardens, but its windblown pollen found at Boscoreale shows that it grew nearby. It occurs today on the southern slopes of Vesuvius, and elsewhere in the Pompeii area.

14. *ARENARIA LEPTOCLADOS* (REICHENB.) GUSS.

English, thyme-leafed sandwort; Italian, *arenaria (a rami sottili)*

MATERIAL EXAMINED

A single stem and leaves with some calyces from the flowers were found in the carbonized hay at Oplontis.

REMARKS

This species occurs especially in fields and gardens over a wide range in Europe.

15. *ARUNDO DONAX* L.

English, giant reed; Italian, *canna*

WALL PAINTINGS

The giant reed (*Arundo donax* L.), with inflorescence, can probably be identified in the House of the Little Fountain (VI.viii.23), in the room to the S of the S entrance, where it is used to frame wall painting panels (Fig. 74). Less carefully painted are those in the House of Loreius Tiburtinus (II.ii.2) on the N wall in the room NW of the small peristyle; and in the atrium of the House of the Prince of Naples (VI.xv.7/8). Comes identifies the giant reed in the House of the Little Fountain and in the House of Meleager (VI.ix.2) as *A. plinii* Turra, but this is a much smaller reed.

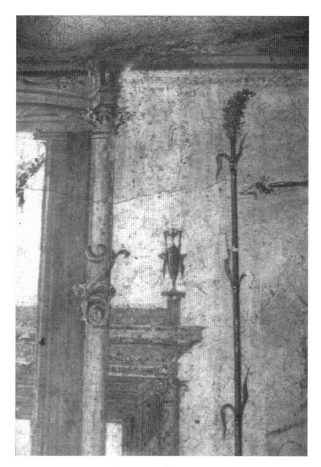

FIGURE 74 Giant reed, House of the Little Fountain. Photo: S. Jashemski.

It is more difficult to identify the reed associated with the river god Sarnus in the various wall paintings. Both *Arundo donax* L., which grows along the Sarno River today, and *Phragmites australis* (Cav.) Trin. ex Steudel (see no. 118) were known. Reeds can be seen in many lararia paintings in which the river god is pictured as one of the penates. He often wears a crown of reeds, holds a reed in his hand, and is usually surrounded by reeds. See, for example, the lararia painting in the garden of I.xiv.7; in the kitchen of House V.i.23; in the peristyle of the Fullonica VI.viii.20; on the W wall of the pistrinum of the House of the Labyrinth (VI.xi.9–10); and on the N garden wall of IX.iii.20. In the *castellum aquae* at Pompeii a water deity holding a reed is pictured. A river god, his head crowned with reed, no longer visible, was painted below the steps and just above the pool in the garden of the House of the Centenary (IX.viii.3/6). Comes does not mention the reeds in the lararia paintings.

REFERENCES IN ANCIENT AUTHORS

Theophrastus (*Hist. pl.* 4.11.1) is speaking of *Arundo donax* when he refers to the reed for making pipes as a kind of *calamos* (κάλαμος). Pliny points out twenty-eight kinds of reeds (*HN* 24.85, 16.156–74), using the

Latin words *harundo* and *calamus* interchangeably, and even classifies certain plants that are not reeds as *harundo*. He does, however, in one passage (*HN* 24.86–7) distinguish between "the Cyprian reed (*harundo Cypria*), which is called *donax*," and the common reed (*vulgaris harundo*). He says that "reeds are of various lengths and thicknesses. The one called *donax* throws out the most shoots; it only grows in watery places" (*HN* 16.165). He speaks of the medicinal uses of the Cyprian reed, called *donax* (*HN* 24.86–7, 32.140). Dioscorides (1.114) mentions several plants under the heading κάλαμος. One "is thick and hollow, growing about rivers, which is called *donax*, by some *Cypria*." He cites its medicinal uses.

REMARKS

The giant reed is widely distributed in the Mediterranean area as a wild and naturalized plant, often cultivated as an ornamental. It grows along the Sarno Canal, near the excavations, and we found it a pest where it had taken over excavated gardens. The hollow stems are used for making reeds for musical instruments, baskets, and other articles.

16. *ASPARAGUS ACUTIFOLIUS* L.

English, asparagus; Italian, *asparago selvatico*

WALL PAINTINGS

Bunches of asparagus have been identified in the following still-life paintings at Pompeii: (1) House of the Vettii (VI.xvi.1) on the E wall of the room on the NE corner of the peristyle with three baskets of cheese (Fig. 75) (Mau 1896: 57); (2) House of Chlorus and Caprasia (IX.ii.10) in a lunette on the E wall in the room to the E of the peristyle (Warscher, personal communication); (3) House of the Cryptoporticus

(I.vi.2/16) in the center of the W wall of the triclinium to the E of the atrium (Spinazzola, 1953: vol. 1, 543, fig. 601), a large bunch of asparagus and three woven baskets (*fiscellae*) filled with ricotta, and a shepherd's crook; Temple of Isis at Pompeii (three paintings): (4) on the E wall of the portico, a bunch of asparagus (now in the Naples Museum, inv. no. 8716) (Elia 1941: 18; Anonymous, *Alla Ricerca*, 1992: 42); (5) on the same portico, two small bunches of asparagus (NM inv. no. 8537; Elia 1941: 18, fig. 22; Anonymous, *Alla Ricerca*, 1992: 40. pl. xii); (6) on the S portico three baskets of cheese and a shepherd's crook (NM inv. no. 9909; Helbig 1868: no. 1717; Anonymous *Alla Ricerca*, 1992: 49); (7) a painting from Pompeii, find spot unknown (Fig. 235; NM inv. no. 8638; Helbig 1868: no. 1708); (8) At Herculaneum, in the House of the Relief of Telephus (Ins. or. I.2–3), four baskets of cheese on the W wall of the room to the N of the atrium (Fig. 358).

Bunches of asparagus are frequently represented with pastoral motifs such as shepherd crooks and baskets of ricotta cheese. It seems very probable that the asparagus for the tables of Romans was mainly collected from the wild by shepherds watching their herds, as they still do in many places in southern Italy. The goat depicted in the painting from the House of the Vettii is thus significant. *Asparagus acutifolius* is a typical plant of the *macchia mediterranea*, a very poor pasture on which only goats can survive by tearing off the hard and often thorny leaves of shrubs and herbs of this vegetation.

REFERENCES IN ANCIENT AUTHORS

Theophrastus (*Hist. pl.* 6.4.1–2) has a good description of asparagus (ἀσφάραγος), which he says belongs to the class of plants that consist only of

FIGURE 75 Wild asparagus, House of the Vettii. Photo: S. Jashemski.

spines. The Romans knew both the wild and cultivated asparagus. Asparagus was highly regarded by the Romans as a food and was considered most beneficial to the stomach (Pliny *HN* 20.102). Cato (*RR* 161.1–4) gives detailed directions for the culture of asparagus (*asparagus*), which is repeated by Pliny (*HN* 19.145–50) in his long discussion of this plant. He says that "of all the cultivated vegetables, asparagus needs the most delicate attention." He discusses its origin from wild asparagus and says the fact that Cato treated the subject in the last topic of his book shows that it was a novelty just creeping in. Pliny says the kind that grows wild on the island of Nesita off the coast of Naples is deemed by far the best asparagus.

Apicius gives recipes for cooking asparagus (3.3, 4.5.6). Columella (*RR* 12.7.1–3) gives a recipe for pickling it. Asparagus was also used for medicinal purposes (Pliny *HN* 20.108–11; Dioscorides 2.152). Asparagus was common enough to be used in figures of speech. A favorite expression of the emperor Augustus was "quicker than boiled asparagus" (Suetonius *Augustus* 87).

REMARKS

Wild asparagus (*A. acutifolius*) is widespread in southern Europe, found largely in scrub and open woodlands. The cultivated species is *A. officinalis* L. Wild asparagus is still considered a delicacy.

17. *AVENA BARBATA* POTT EX LINK

English, slender oat; Italian, *avena selvatica*

MATERIAL EXAMINED

Spikelets and glumes of this grass were found in the carbonized hay at Oplontis.

REFERENCES IN ANCIENT AUTHORS

Cato (*RR* 37.5) and Vergil (*Georgics* 1.154) speak of oats as a weed. Pliny is probably referring to the wild oat when he says that *bromus*, a species of oat, grows among the weeds of the corn (wheat) crop (*HN* 22.161).

REMARKS

This annual grass occurs mainly along roadsides, in waste places, and as a weed in cultivated areas. It is widespread throughout the Mediterranean region and very common in the Vesuvian area.

18. *AVENA SATIVA* L.

English, oat; Italian, *avena*

MATERIAL EXAMINED

In the Casa del Bel Cortile (V.8) (inv. no. 1895) at Herculaneum, a few carbonized caryopses and florets

of oat found as a contaminant in a sample of emmer wheat were identified by B. R. Baum, of the Canadian Department of Agriculture (Meyer 1998: 207, 219 n. 91).

REFERENCES IN ANCIENT AUTHORS

Pliny is speaking of the cultivated oat when he says that barley "degenerates into oats, in such a way that the oat itself counts as a kind of corn, inasmuch as the races of Germany grow crops of it and live entirely on oatmeal porridge" (*HN* 18.149). He gives the planting time for oats (*HN* 18.205), but the Romans used oats only as cattle fodder. Columella (*RR* 2.10.24, 32) speaks of oats as cattle fodder. Pliny says that medicinally "oatmeal boiled in wine removes moles" (*HN* 22.137). See Dioscorides (2.116, 4.140) for other medicinal uses.

REMARKS

Domesticated oats developed primarily in northern Europe. It is a good sexually reproductive species that evolved from a primitive *A. sativa* prototype in prehistoric times. The domesticated oat is unknown in the wild (Meyer 1998: 206).

19. *BETA VULGARIS* L.

English, beet; Italian, *bieta, bietola*

GRAFFITI

The beet (*beta*) appears twice in graffiti found at Pompeii. One, in House VII.ii.30 (*CIL* IV 4888, 4889), records the purchase or sale of vegetables. The word *beta* also appears in an enigmatic graffito found on the wall of the atrium in House VI.xiv.30: "C. Hadius Ventrio eques natus Romanus inter beta(m) et brassica(m)" (*CIL* IV 4533). This may be a slurring reference to this individual's rise to wealth from humble origins (Day 1932: 189).

REFERENCES IN ANCIENT AUTHORS

Theophrastus makes numerous references to the beet (τεῦτλον). He says the white kind has a better flavor than the red (*Hist. pl.* 7.4.4). Pliny (*HN* 19.117) lists beets among the vegetables to be grown in the kitchen garden. In a long description (*HN* 19.132–5) in which he describes the two kinds of beets, the spring and the autumn beet, named according to their time of sowing, he discusses their cultivation and their use. Columella (*RR* 10.254, 326) also lists the beet among the vegetables to be grown in the home garden. Apicius gives a number of recipes for using beets (3.11.1–2, 4.4.2, 4.5.1)

According to Pliny, the fresh root of either the white or dark beet was used for a variety of medicinal purposes (*HN* 20.69–71). Dioscorides (2.149) mentions

both the black and white beet and gives their medicinal uses. Martial (33.47.9) lists beets "among the abundance of the rich country," and "not unserviceable to a sluggish stomach."

REMARKS

Both the dark and white beets mentioned by the ancient authors are forms of the leaf beet, *Beta vulgaris* L., and are identical except for the color of the leaf. The ancients ate only the beet leaf; the beet root was used for medicine. These are forms known only in cultivation, derived from the wild beet, *B. vulgaris* L. subsp. *maritima* (L.) Arcangeli, found in coastal areas of southern and western Europe. Another group with fleshy roots includes the garden beet, the sugar beet, and the mangel.

20. *BLACKSTONIA PERFOLIATA* (L.) HUDSON (*CHLORA PERFOLIATA* (L.) L.)

English, yellow-wort; Italian, *centauro giallo*

MATERIAL EXAMINED

The middle part of a stem consisting of three nodes bearing three pairs of leaves was found in the carbonized hay at Oplontis.

REMARKS

Yellow-wort is a slender greenish gray annual with bright yellow flowers. It occurs in meadows and other open areas in Italy and in grassy places in the maquis.

21. *BRASSICA OLERACEA* L.

English, cabbage; Italian, *cavolo*

GRAFFITI

Two graffiti found at Pompeii mention cabbage. In House VII.ii.30 (supra no. 19), the word used is *col(iculum)* (= *cauliculum*), the diminutive of *caulia (colis)*, which means "stalk" or "stem," but is often synonymous with *brassica,* the Latin word for cabbage. The word *brassica* also occurs in the enigmatic graffito discussed earlier (see no. 19).

REFERENCES IN ANCIENT AUTHORS

Among the Romans the cabbage (*brassica*) was a table luxury, and a number of varieties were grown. Cato distinguishes three varieties (*RR* 157.1–2), which Pliny quotes (*HN* 19.136–7), but Pliny, writing more than a century later, lists seven varieties, one of which was the Pompeian cabbage (*HN* 19.139–41). He uses *brassica,* also the diminutive *cauliculus,* four times in the passage in which he discusses cabbage:

The Pompeii cabbage is taller, and has a thick stock near the root, but grows thicker between the leaves, these being scantier and narrower, but their tenderness is a valuable quality. This cabbage cannot stand cold, which actually promotes the growth of Bruttian cabbage.

Columella (*RR* 10.127–35) also mentions the cabbage raised at Pompeii. Martial (3.47.7) lists cabbage (*caules*) among the vegetables grown. The cabbage had many medicinal uses (Pliny *HN* 20.78–89; Dioscorides 2.146).

REMARKS

Zohary and Hopf (1994) indicate that the edible cabbage was well known in Greek and Roman times.

22. *BRASSICA RAPA* L. subsp. *RAPA* (*B. CAMPESTRIS* L.)

English, turnip; Italian, *rapa*

MATERIAL REPORTED

Wittmack (1904: 61) reported a large dish of turnip or rapeseed in the Naples Museum, but we were unable to locate it.

WALL PAINTINGS

The drawing of a Pompeii wall painting now destroyed (*Pitture di Ercolano*, vol. 2, p. 52, pl. 8) depicts four bunches of vegetables (Fig. 152). Helbig (1868, no. 1669) identified a bunch of asparagus (but see no. 160, here), various radishes, and two bunches of yellow *Rüben* (carrots) (see no. 142). The round vegetables in the center, which Helbig took for radishes, are more probably turnips. The Romans knew only the long white radish. Schouw (1851: 35) lists turnips as one of the vegetables pictured in the wall paintings but cites no example. Comes (1879: 23) cites Schouw, but since he was unable to identify any turnip he lists it among the doubtful plants not visible in the paintings.

REFERENCES IN ANCIENT AUTHORS

Theophrastus (*Hist. pl.* 1.6.6) says the turnip (γογγυλίς) has a fleshy root. We would expect to find turnips used at Pompeii, for Pliny (*HN* 18.126–30) says that the utility of the turnip (*rapum, rapa*) surpassed that of any other plant. It was valuable as a food for animals, birds, and man, who used the turnip tops as well as the root. He says that the turnip was especially esteemed north of the Po River, where it ranked only after wine and wheat. Pliny claims to have seen turnips over forty pounds in weight. Cato (*RR* 5.8, 6.1, 35.2) gives directions for planting turnips. According to Varro (*RR* 1.59.3), some cut up turnips and preserved them in mustard.

Columella (*RR* 2.10.22) speaks of turnips as a filling food for country people and as an important winter food for animals. Apicius gives directions for preserving turnips (1.12.8), boiling them with seasonings (3.12.1–2), and cooking them with crane or duck (6.2.3). Dioscorides (2.134) says the root of the turnip (γογγύλη) is nourishing; the tender tops are also eaten. He lists various medicinal uses. On one occasion turnips were hurled at Vespasian as an insult (Suetonius *Vespasian* 4.3)

REMARKS

The turnip is known only as a cultivated food plant of ancient origin from ancestors dating from the fist millennium B.C., according to Zohary and Hopf (1994).

23. *BRIZA MAXIMA* L.

English, big quaking grass; Italian, *sonaglini*

MATERIAL EXAMINED

A few well-preserved and many incomplete spikelets of this grass were found in the carbonized hay at Oplontis (Fig. 76).

REMARKS

This grass is widely distributed throughout the Mediterranean region in dry, sunny meadows.

24. *BRIZA MINOR* L.

English, little quaking grass; Italian, *brillantina*

MATERIAL EXAMINED

Glumes on panicle branches of this grass were found in the carbonized hay at Oplontis.

REMARKS

This grass is very similar to *B. maxima*, but more slender. It occurs in Italy and elsewhere in southern and western Europe and is cultivated as a garden ornamental.

25. *BROMUS DIANDRUS* ROTH subsp. *DIANDRUS*

English, (large) brome grass; Italian, *forasacchi squala*

MATERIAL EXAMINED

Some spikelets of this grass were found in the carbonized hay at Oplontis.

REMARKS

This grass is very common along roads and in abandoned ground in the Mediterranean region.

26. *BROMUS HORDEACEUS* L. (*B. MOLLIS* L.)

English, soft brome grass; Italian, *spigolina*

FIGURE 76 Carbonized big quaking grass hay, Oplontis. Photo: M. Ricciardi.

MATERIAL EXAMINED

A few spikelets of this grass were found in the carbonized hay at Oplontis.

REMARKS

This grass is widespread throughout most of Europe, especially in grasslands and scrub margins.

27. *BROMUS MADRITENSIS* L.

English, Spanish brome grass; Italian, *forasacchi (dei muri)*

MATERIAL EXAMINED

Panicle branches with spikelets of this grass were found in the carbonized hay at Oplontis.

REMARKS

This species is more densely clumped, with smaller spikelets than *B. diandrus*, and is dark purple at maturity. It occurs along field margins and in waste places in the Mediterranean region.

28. *BUNIAS ERUCAGO* L.

English, corn rocket; Italian, *cascellore*

MATERIAL EXAMINED

Many mature fruits were found in the carbonized hay at Oplontis.

REMARKS

This hairy herb is locally common in waste places in southern Europe, including Italy. It is used in soups or cooked like spinach, with a flavor similar to cabbage.

29. *CALAMINTHA NEPETA* (L.) SAVI

(*SATUREJA CALAMINTHA* (L.) SCHEELE)
English, calamint savory; Italian, *nepetella, mentuccia*

MATERIAL EXAMINED

The basal and middle part of a stem was found in the carbonized hay at Oplontis.

REMARKS

This aromatic perennial herb, with small white or lilac flowers, grows along roadsides and in disturbed ground in many areas of Europe, chiefly in the Mediterranean region.

30. *CALENDULA ARVENSIS* L.
English, wild calendula, field marigold; Italian, *calendola*

MATERIAL EXAMINED

Some spiny, incurved achenes were found in the carbonized hay at Oplontis.

REMARKS

This usually much branched annual with orange flower heads occurs mainly in cultivated areas and in waste ground in the Mediterranean region.

31. *CALYSTEGIA SEPIUM* (L.) R. BR.
English, wild morning glory, great white hedge bindweed; Italian, *campanelli, vilucchione*

WALL PAINTINGS

The wild morning glory can be identified in two sites. In the Villa of San Marco at Stabiae, the vine and flowers were used as an effective motif to outline a wall panel to the right of the large window of the *frigidarium* looking into the enclosed garden (Fig. 77). When we first examined the wall painting, we could see only a few faint traces of flowers. But after the painting had been carefully cleaned the delicate beauty of the flowers was completely visible. The plant is accurately portrayed; even the bracts, calyx, and alternate leaves of the vine are shown. More recently, a spectacular and accurately painted plant was found in the garden painting in the *diaeta* in the House of the Gold Bracelet, at the lower left of the E wall (Fig. 78). One flower is shown in profile, one open-face, and two in semiprofile. This is the first time this flower has been reported.

REFERENCES IN ANCIENT AUTHORS

The Romans knew this plant as the *convolvulus* (from the Latin *convolvo:* "to entwine"). Pliny mentions it only once (*HN* 21.23) and gives a naïve but picturesque description of its flower, in an aside, in his description of the Madonna lily:

FIGURE 77 Wild morning glory, Villa of San Marco, Stabiae. Photo: S. Jashemski.

There is a flower not unlike the lily growing on the plant called the *convolvulus* that springs up among shrubs. Without perfume, and without the yellow anthers in the center, it resembles the lily only in color, being as it were a first attempt by Nature when she was learning to produce lilies.

Dioscorides (4.145) refers to this plant as *smilax leia* (σμῖλαξ λεία) and describes it as having leaves like ivy, but being softer, smoother, and thinner. It vines around trees and has many small, round, white flowers. Arbors are made of it in summer, but it sheds its leaves in the fall. It has small black seeds. He lists its medicinal uses.

REMARKS

The wild morning glory is widely dispersed in Europe, in hedges, in bushy places, and edges of woods. It is not cultivated today, for it becomes a pest if allowed to grow unchecked. It grows in the excavations.

32. *CARDUUS PYCNOCEPHALUS* L.
English, slender thistle; Italian, *cardo saettone*

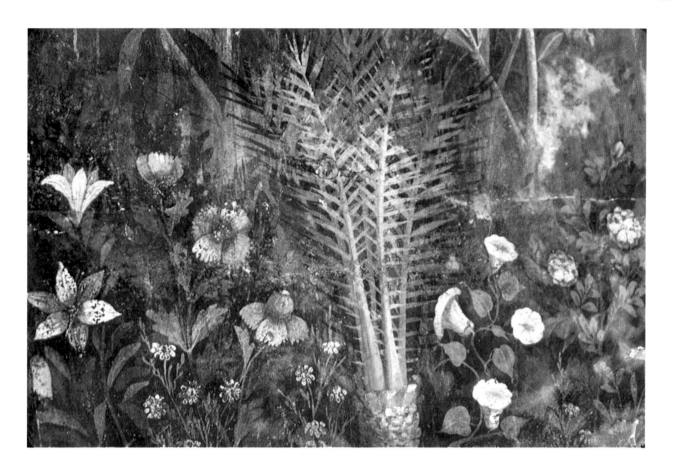

MATERIAL EXAMINED

A few capitula were found in the carbonized plant remains at Oplontis.

REFERENCES IN ANCIENT AUTHORS

In Pliny the name *carduus* is mainly used as a generic term for thistles and many other spiny members of the daisy family (*HN* 18.153; 21.91, 94), including artichoke (*HN* 19.152–153).

REMARKS

A robust annual with flower heads with purple florets; a weed in waste places and along roadsides throughout the Mediterranean region.

33. *CAREX DISTACHYA* DESF.

English, Mediterranean sedge; Italian, *carice mediterranea*

MATERIAL EXAMINED

Some inflorescence fragments were found in the carbonized hay at Oplontis.

REFERENCES IN ANCIENT AUTHORS

Vergil (*Georgics* 3.231) speaks of the bull being defeated in the love fight for the heifer "resting on spiny shrubs and grazing on the sharp sedge (*carex*),"

FIGURE 78 Wild morning glories (at right), young date palm, camomiles, opium poppies, and Madonna lilies, House of the Gold Bracelet. Foto Foglia.

while Columella (*RR* 12.15.1) notes that "shepherd's hurdles woven with straw, sedges or ferns" could protect after sunset "drying figs from dew and sometimes from rain."

REMARKS

It occurs frequently in shady evergreen woodlands and in the maquis of the Mediterranean region.

34. *CASTANEA SATIVA* MILLER

English, European chestnut; Italian, *castagno*

MATERIAL EXAMINED

Naples Museum: a dish of well-preserved carbonized chestnuts without endocarp. This material may be the same as no. 84632 cited by Wittmack. At Herculaneum: twelve whole nuts in a dish at no. 13 on the Decumanus Maximus (inv. no. 2943–2). At Oplontis: in the *deposito*, two carbonized nuts without exocarp found during the excavation of the Villa of Poppaea (Fig. 79). Carbonized nuts were also found in the carbonized hay at Oplontis.

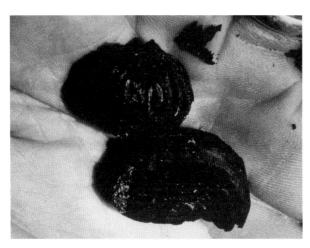

FIGURE 79 Carbonized chestnuts found in the upper lapilli, peristyle garden, Villa of Poppaea, Oplontis. Photo: S. Jashemski.

WALL PAINTINGS

Casella (1950: 369) identified a chestnut on the S wall of the tablinum in the House of the Moralist (III.iv.2–3) and among fruit on the wall at the right, entering the vestibule of the House of the Ephebe (I.vii.10–12), but both paintings were so damaged when we examined them forty years ago that it was not possible to identify any chestnuts. Comes (1879: 18) identified a chestnut tree in a drawing of a destroyed painting from Pompeii (*Pitture di Ercolano*, vol. 3, t. 61, 63), and he thought he could probably identify chestnut trees among those in garden paintings, but he gives no examples. We have been unable to find chestnut trees in any extant garden paintings.

AMBER

For an amber charm worked in the form of a chestnut in the Herculaneum *deposito*, see Scatozza Höricht (1989: NE 3100A).

REFERENCES IN ANCIENT AUTHORS

Castanea was the classical Latin name for the chestnut, a name derived from the Greek *kastana* (κάστανα). Pliny (*HN* 15.92) describes it in detail. It was used as a food for both man and pigs. The best chestnuts came from Tarentum and from Naples. Apicius (5.2.2) gives a recipe for chestnuts and lentils combined in one dish.

The chestnut was also important for making stakes used as vine props (Pliny *HN* 17.147), as is still done today in the Pompeii area. It resists decay.

REMARKS

The European chestnut has been known from antiquity for its edible nuts and valuable timber. It occurs in well-drained, calcifuge soils, mainly in mountainous areas of southern Europe from Italy eastward and north to Hungary; it is also extensively cultivated.

35. *CENTAUREA CYANUS* L.
English, cornflower, bluebottle; Italian, *fiordaliso*

WALL PAINTINGS

The small blue flowers in the unique ceiling painting in the House of the Calavii (I.vi.11) in a room off the E side of the atrium appear to be cornflowers. Although they are stylized, the artist correctly pictures them with the notched rays that are typical of the cornflower (Fig. 80).

REFERENCES IN ANCIENT AUTHORS

Pliny mentions the cornflower twice, perhaps three times. In the first passage (*HN* 21.48) he says that it "declares its color by its name" (*cyanus*), which means azure, or dark blue. He lists it as one of the flowers that were unmentioned at the time of Alexander the Great, for writers immediately after his death were silent about it. This silence according to Pliny is clear proof that the *cyanus* became popular subsequently, but he points out that it was discovered by the Greeks, since Italy used only the Greek name *kuanos* (κύανος) for this flower. But this flower is native in Italy. The earliest mention of this flower that we have found is the *kuanos* in the *Garland* of Meleager, who lived ca. 140–70 B.C. (*Greek Anthology* 4.1.40).

In the second passage, Pliny (*HN* 21.68) notes the blooming time of the *cyanus*. In the third passage (*HN* 21.147), a medicinal use of the *cyanus* is listed, but some scholars read *cytinus,* calyx of pomegranate.

REMARKS

The cornflower is widespread in the Mediterranean area and naturalizes in grain fields. It is a common garden ornamental.

36. *CERASTIUM* sp.
English, mouse-ear chickweed; Italian, *peverina*

MATERIAL EXAMINED

A single inflorescence branch bearing a calyx was found in the carbonized hay at Oplontis, but it was too fragmentary to identify to species.

37. *CERATONIA SILIQUA* L.
English, carob, St. John's bread; Italian, *carrubo*

MATERIAL EXAMINED

Naples Museum: a dish of well-preserved carob pods (without inv. no.) (Fig. 81). This may be the same sample that Wittmack cited as no. 84628 in the Naples Museum. He also reported seeing whole pods in the Museum at Pompeii, but these can no longer be found. At Herculaneum: about fifty broken pieces

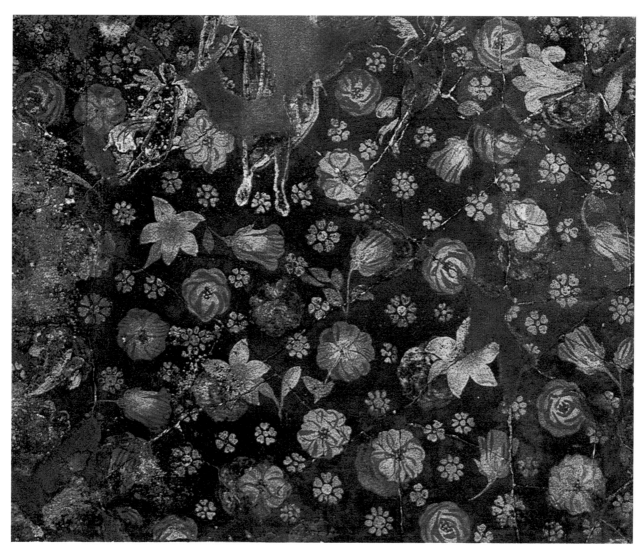

FIGURE 80 Cornflowers, roses, Madonna lilies, and other flowers in detail of a flower panel set in the ceiling, I.vi.11. Photo: S. Jashemski.

FIGURE 81 Carbonized carob pods. Photo: Alinari 19030.

Wilhelmina F. Jashemski, Frederick G. Meyer, and Massimo Ricciardi

of carob pods in the *deposito* (inv. no. 2316) (Meyer 1988: 191–2).

WALL PAINTINGS

Casella (1950) reported two carob pods painted on a wall in the triclinium of the Casa dei Cervi (IV.21) at Herculaneum, and two others painted on the lararium on the right as one enters the House of the Ephebe (I.vii.10–12) at Pompeii, but we are unable to confirm this report, for the paintings are no longer in existence. Casella says that all four pods have the characteristics noted by Pliny.

REFERENCES IN ANCIENT AUTHORS

The Romans did not have a special name for this tree. They sometimes used the Greek name *keratia* (κερατέα), or they simply used the expression *siliqua*, or *siliqua Graeca* (Greek pod). According to Pliny (*HN* 13.59), the Ionians called the tree *keronia* (κερωνία). He accurately describes the carob as an evergreen tree that has pods. Columella (*RR* 5.10.20; *Arb.* 25.1) refers to it as *siliqua Graeca*, which some people call κεράτιον. Pliny (*HN* 13.59) gives a long description of the tree. He also says, "The husk itself is eaten. It is not longer than a man's finger, and occasionally curved like a sickle, and it has the thickness of a man's thumb."

Wine was made from the Syrian carob (Pliny *HN* 14.103). Columella (*RR* 7.9.6) lists the carob tree among those furnishing food for pigs. In the New Testament parable the Prodigal Son "would gladly have fed on the pods [carobs, or κεράτιον] that the swine ate" (Luke 15:16). The belief held by the Eastern Christians that St. John ate carob pods has given them the name of St. John's bread. The carob also had medicinal uses (Pliny *HN* 26.52).

REMARKS

The carob grows to 10 m high, with strongly scented white flowers and 30 cm long, sickle-shaped flat brown pods. It is native to the Mediterranean region and is also cultivated there. In ancient times the pods yielded fodder for stock because of the high sugar content, but they were seldom served as food for humans because of their high fiber content. Superior modern cultivars of the carob have been developed in the Mediterranean countries that are now used for human consumption (Meyer 1988: 191).

38. *CHRYSANTHEMUM SEGETUM* L.
English, corn marigold; Italian, *ingrassabue, occhio di bue*

MATERIAL EXAMINED

Many flowering and fruiting capitula were found in the carbonized hay at Oplontis.

WALL PAINTINGS

Large yellow corn marigolds with notched rays can be seen in the garden paintings of the *diaeta* in the House of the Gold Bracelet, to the right of the fountain on the N wall (Fig. 129), to the right of the gallinule on the E wall (Fig. 326), and on the S wall to the right and at the base of the staked rose (Fig. 147). They can also be identified in the garland framing a painting in the Naples Museum (inv. no. 9805). Comes identified the crudely painted yellow, daisylike flowers on the altar in the peristyle of House VII.vii.5 as *Chrysanthemum segetum*.

REFERENCES IN ANCIENT AUTHORS

Pliny (*HN* 26.87) mentions *chrysanthemum*, but the specific plant cannot be identified. Dioscorides (4.58) says that the chrysanthemum or βούφθαλμον (ox eye) was so named because it had flowers that were yellow, bright, shiny, and eyelike. It could be that the plant described by Dioscorides is the corn chrysanthemum since in the Vesuvian area the vernacular name to designate this species is *uocchie 'e voie* (eye of ox).

REMARKS

This plant occurs mainly in cultivated ground and other open habitats of the Mediterranean region. It is likely to have been one of the plants commonly used by the Romans for garlands.

39. *CICER ARIETINUM* L.
English, chickpea, garbanzo; Italian, *cece*

INSCRIPTIONS

The word *cicer* was found lettered on two amphoras that had once held chickpeas (*CIL* IV 5728, 5729).

MATERIAL EXAMINED

Herculaneum: about 4.0 kg of broken and whole chickpeas, contaminated with a small amount of bitter vetch *Vicia ervilia* (L.) Willd., was found on the Decumanus Maximus (inv. no. 2314). Chickpeas are not mentioned by Wittmack (Meyer 1988: 190).

REFERENCES IN ANCIENT AUTHORS

Cicer was the classical Latin name for the chickpea. The cognomen of M. Tullius Cicero, the well-known Roman senator, came from this common crop (Pliny *HN* 18.10). Columella (*RR* 2.10.19) was the first author to use the epithet *arietinum* in reference to the seed, which resembles the shape of a ram's head. See also Varro (*RR* 1.23.2).

Pliny (*HN* 18.124–5) describes several varieties of the chickpea that differ in size, color, shape, and flavor. The chickpea is described as having round pods,

100

whereas those of other leguminous plants are long and broad and fit the shape of the seed.

The chickpea is mentioned by Horace as a staple of Roman food, along with leeks (*Satires* 1.6.115), beans (*faba* or broad bean), and lupines (*Satires* 2.3.182). Apicius gives recipes for them (5.8.1–2, 4.4.2). Many medicinal uses of the chickpea are listed by both Pliny (*HN* 22.148–50, 26.124) and Dioscorides ('ερέβινθος) (2.126).

REMARKS

The domesticated chickpea, a cultigen of ancient and uncertain origin, probably came from somewhere in the Near East, the center of distribution of the genus *Cicer.* Ladizinsky and Adler (1976) propose *C. reticulatum* Ladiz., recently described as being from southeastern Turkey, as its most likely progenitor. Like *C. arietinum, C. reticulatum* has the propensity to delay shattering of the seeds from the dry pods. Seeds, carbon-dated to 5730–5000 B.C., have been found in deposits at Hacilar near Burdur, Turkey. The chickpea also is known from Bronze Age Lachish, Jericho, and Arad sites in the Near East. By Roman times it was well known in Italy (Meyer 1988: 190).

40. *CITRUS LIMON* (L.) BURM. F.

English, lemon; Italian, *limone*

WALL PAINTINGS

Beautiful paintings of fruiting lemon trees were found in the House of the Fruit Orchard. A spectacular lemon tree loaded with accurately painted yellow fruit dominates the left panel of the E wall in the room off the E side of the atrium (Fig. 82); another lemon tree with golden fruit and a female oriole sitting on a branch, in the room off the peristyle, above the window, is in the middle panel of the S wall (Fig. 322). In a garland painting in the Naples Museum (inv. no. 8526) the three fruits to the left of the Eros have the characteristic shape and color of lemons (Fig. 83).

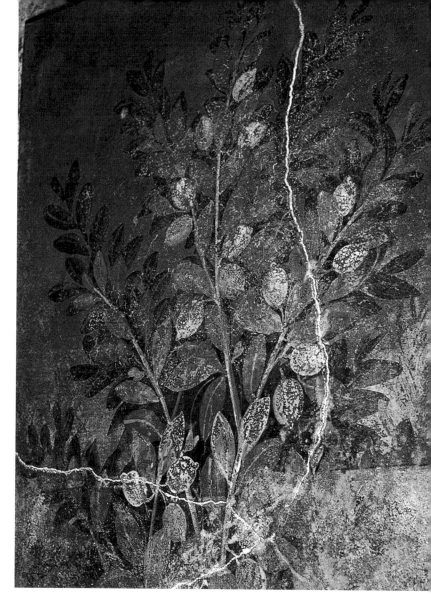

FIGURE 82 Lemon tree, House of the Fruit Orchard. Photo: S. Jashemski.

FIGURE 83 Garland of fruit, flowers, and wheat; lemons near Cupid (NM inv. no. 8526). Photo: S. Jashemski.

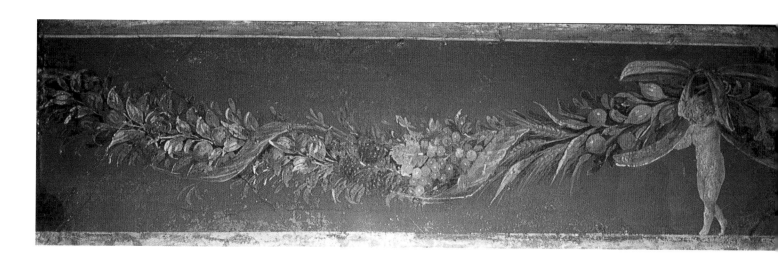

Wilhelmina F. Jashemski, Frederick G. Meyer, and Massimo Ricciardi

MATERIAL EXAMINED

Carbonized wood from a tree air-layered in a broken amphora behind statue base VIII in the sculpture garden in the Villa of Poppaea at Oplontis was identified as lemon by Hueber. For the possibility that trees planted in pots with several holes, growing in protected areas along garden walls, might be lemon trees see Jashemski 1979: 79 (House of Polybius), 285 (Garden of Hercules), 240 (House of the Ship *Europa*).

REFERENCES IN ANCIENT AUTHORS

Tolkowsky (1938) points out the difficulty of identifying the lemon in passages from ancient authors, owing to the absence during antiquity of a terminology to designate the different species of citrus fruits:

> Due to the fact that the citron was the first citrus fruit known to the classical world, the name given to it by the Latin writers, *citrus*, was subsequently extended to all other plants which, as they successively found their way into the Mediterranean world, were, on account of their similarity in botanical character, felt to be closely related to the citron itself.
>
> p. xii

Linnaeus later used *Citrus* as the generic name for the species included in this genus. Tolkowsky points out that because the lemon lacked a Latin name, it was believed to be unknown in antiquity and a latecomer in Europe. But the Romans clearly knew the lemon and painted lemon trees with accurately portrayed fruit. They also distinguished the lemon and citron as two distinct fruits, as a mosaic of about A.D. 100 in the Terme Museum at Rome (inv. no. 58596) shows (Fig. 84). The lemon (second fruit from the left) and the citron (fourth fruit from the left) are each accurately portrayed, showing their different characteristics and relative size.

When the citron was first introduced into the Western world it was known as the Median or Persian apple. Theophrastus says that the tree is grown in pots with a hole in them (*Hist. pl.* 4.4.3).

Vergil, who is the first Latin writer to mention this tree, calls it the Median apple (*Georgics* 2.126–7). His description of the tree gives the impression that he had seen it growing (*Georgics* 2.131–5). By Pliny's time, however, the Romans had given a name to this tree. He explains that "the Greeks call the fruit Medic apple which we know as *citreum*" (*HN* 15.47). Pliny usually calls the tree *citrus* or *citrea*, and the fruit *malum citreum* or *citreum*. He says the trees (*citreae*) bear all the year round (*HN* 16.107), and the tree is grown from seeds and from layers (*HN* 17.64). Either the fruit or the seed are taken in wine to counteract poisons (*HN* 23.105). "Because of its great medicinal value various nations have tried to acclimatize it in their own countries, importing it in earthenware pots provided with breathing holes for the roots" (*HN* 12.15–6).

Dioscorides (1.166) also speaks of the Median or Persian apple, or *cedromela* (κεδρομήλα), which the Romans call *citria*. Theophrastus, Pliny, and Dioscorides all appear to be describing the citron. Petronius, writing during the first century A.D., describes Trimalchio, who prides himself on producing on his numerous estates everything that he needs: "wool, lemons (*cedrae*), pepper" (*Satyricon* 38, Penguin trans.). It is quite possible that the translation "lemon" is correct, for lemons were grown in the Pompeii area at the time the

FIGURE 84 Mosaic: basket of fruit with lemon and citron. Terme Museum, Rome (inv. no 58596). Photo: S. Jashemski.

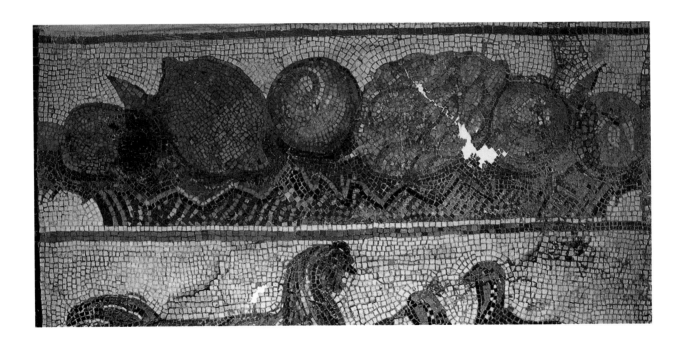

Satyricon, which is believed to have taken place in a Campanian site, was written.

REMARKS

The evidence clearly shows that the lemon was known in the Vesuvian area before the eruption, even though there was no specific Latin (or Greek) name for this tree. The Vesuvian evidence is the earliest documentation of the lemon from antiquity. Swingle (1943: 398) says, "The origin of the lemon is a mystery . . . it probably originated in southeastern Asia."

41. *CONVOLVULUS ARVENSIS* L.

English, small field bindweed; Italian, *vilucchio, convolvolo*

MATERIAL EXAMINED

The basal portion of a leaf was found in the carbonized hay at Oplontis.

REFERENCES IN ANCIENT AUTHORS

Pliny (*HN* 21.23) mentions *convolvulus* only once, identified as *Calystegia sepium* (see no. 31). Because they are close relatives, the ancients did not distinguish between *Calystegia* and *Convolvulus*.

REMARKS

This plant is an aggressive perennial weed that invades fields and gardens. It is widely distributed in Europe.

42. *CORYLUS AVELLANA* L.

English, hazelnut; Italian, *nocciolo, nocciolo d'Europa*

MATERIAL EXAMINED

In the garden of the House of the Ship *Europa* (I.xv.3) at Pompeii, two pieces of carbonized hazelnut shell were found in situ in 1972 (Jashemski 1979: 241). The larger shell fragment reveals about three-quarters of the shell, including the broad hilum. In the hardened volcanic ash in the *villa rustica* at Oplontis imprints of hazelnuts that had been stored there were found perfectly preserved, even though the nuts had completely disintegrated. Small pieces of carbonized hazelnut wood found in several gardens were probably the remains of fertilizer. Carbonized fragments of one of the stakes used to prop the limbs of a large tree in the garden in the House of Polybius were identified as hazelnut.

WALL PAINTINGS

Three hazelnuts can be identified in a small fragment of a wall painting in the Museum at Castellammare di Stabia (Fig. 85). Casella identified hazelnuts

FIGURE 85 Three hazelnuts in a fragment of wall painting. Castellammare di Stabia Museum. Photo: S. Jashemski.

on the S wall of the peristyle of the House of the Cervi (IV.21) at Herculaneum. The painting is now badly preserved, but Casella's photograph (1950: 9, fig. 4), taken many years ago, shows a branch with three easily identified nuts and a leaf. Casella also reported another picture in the same house that shows a little basket filled with hazelnuts and dried fruits. He does not locate the painting, but he is probably referring to the one we have discussed under *Juglans regia* L. (see no. 72). It is difficult to identify any hazelnuts in this painting. Casella (1950: 370) also identified hazelnuts in a painting in the Naples Museum (inv. no. 8628), but we were unable to locate this painting. According to Schefold (1957), the painting in the Naples Museum, inv. no. 8628, is Helbig (1868), nos. 1686, 1689, and 1691, which is illustrated by Beyen (1938: pl. VII). But Helbig describes no. 1689 as an overturned basket containing indistinct fruit, perhaps olives.

REFERENCES IN ANCIENT AUTHORS

The hazelnut is indigenous to the Pompeii area and abundant on the lower slopes of Vesuvius. One of the names of this nut, *abellana*, and the botanical name, *C. avellana*, derive from Abella, a town to the north of Vesuvius famous for its fruit trees and nuts (Pliny *HN* 15.88–9). The Romans also called the hazelnut *corylus*, a name sometimes used by Pliny. He says that the hazelnut (*corylus*) was used for torches (*HN* 16.75). He also warns against planting the *corylus*, as well as cabbage and all sorts of garden vegetables, near grapevines, unless it is a long way off, for these plants make vines ailing and sickly (*HN* 17.240). This warning is repeated by Vergil (*Georgics* 22.299), a warning certainly not heeded by vinegrowers in the Pompeii area today. Growers now plant various trees including the hazelnut near the edge of their vineyards, and at intervals throughout the vineyard. The hazelnut is often an important cash crop.

Apicius calls for the hazelnut (*nux Abellana*) in one

of his recipes for homemade sweets (7.13.4). But Pliny adds the warning that the hazelnut "puts more fat on the body than one would think at all likely" (*HN* 23.150). Hazelnuts had only limited medicinal use (Pliny *HN* 23.150; Dioscorides 1.179 [καρύα ποντικά]).

REMARKS

The hazelnut is a shrub or small tree, widespread over most of Europe. It was well known in Campania in ancient times and is still much grown in the Pompeii area.

43. *CRATAEGUS* sp.
English, hawthorn; Italian, *biancospino*

MATERIAL EXAMINED

The small carbonized fragments of *Crataegus* wood found in the rear garden of the Villa of Poppaea at Oplontis appeared to be hawthorn (probably *Crataegus monogyna* Jacq.), perhaps from pruning a living hedge, and was either burned in the garden or brought in from outside.

44. *CREPIS NEGLECTA* L.
English, hawk's-beard; Italian, *radicchiella minore*

MATERIAL EXAMINED

Numerous peduncles with capitula and ripe achenes were found in the carbonized hay at Oplontis.

REMARKS

This plant is widely distributed in the Mediterranean region in sunny, rocky places.

45. *CUPRESSUS SEMPERVIRENS* L.
English, cypress; Italian, *cipresso*

MATERIAL EXAMINED

Small fragments of cypress charcoal were identified in the sculpture garden of the Villa of Poppaea at Oplontis (Jashemski 1979: 314; 1993: 299).

WALL PAINTINGS

The cypress gives a noble character to the Pompeian landscape today, and it is one of the trees most easily recognized in the landscape paintings on the ancient walls. We mention only a few. There are many cypresses in the beautiful painting of a seaside villa from Pompeii, now in the Naples Museum (inv. no. 9482) (Fig. 86), in the painting from the Villa of Agrippa Postumus at Boscotrecase (NM inv. no. 14750), and at Pompeii on the S and W garden walls in the House of the Little Fountain (VII.viii.23)

(Fig. 127), in the garden painting in the House of Stallius Eros (I.vi.13), and in small paintings of villas in the *tablinum* in the House of M. Lucretius Fronto (V.iv.a/11). Schouw (1859) and Comes (1879) list the cypress.

PLANT MATERIAL REPORTED

During the work of reclaiming the Sarno Plain in the nineteenth century about 100 cypresses were found, their roots in the ancient soil, their trunks in the pumice of A.D. 79. This discovery was reported to the Reale Accademia delle Scienze. To study this most unusual find, the Accademia named a commission of experts, Michele Tenore, Luigi Palmieri, Arcangelo Scacchi, and Oronzo Gabriele Costa, the most distinguished scientists of their time in the fields of botany, geology, vulcanology, and zoology. They confirmed that trees had been covered during the eruption of A.D. 79 and could be identified as *Cupressus sempervirens* L. The trees arranged in rows NE to SW in quincunx formation at a distance of 2.64 to 3.17 m apart, crossed the new channel of the Sarno. One of the trunks was about 40 cm in diameter. From this the experts inferred that the tree was about thirty-six years old in A.D. 79. They attributed the perfect preservation of the wood, still in its natural state (Tenore tells of an intricately carved chest made from it), to the nature of the cypress, which is most resistant to decay, and to the oxide, iron hydrate, probably formed by the moisture from the trunks in contact with the lapilli.

In 1990 during an excavation in the locality S. Abbondio, near the location of the trees found in the previous century, more trunks of cypress trees were found. The best preserved one, 100 cm high and 330 cm in diameter, was taken to the Antiquarium at Boscoreale for further study (Fig. 87). (See *Relazione*, September 27, 1858, in *Atti*; and *Memoria*, January 27, 1867; Ruggiero 1879: 9–12; Ciarallo, 1990: 213–4).

REFERENCES IN ANCIENT AUTHORS

The cypress (*cupressus*) is mentioned often by the agricultural writers, who give detailed directions for its culture, and also by the poets. Cato (*RR* 48.1–2, 151.1–4) gives instruction for gathering the seed, planting, and propagation. Varro (*RR* 1.15) recommends using cypress trees on the boundaries of an estate, as he did at his place on Vesuvius. He says that such a planting of trees made the boundaries more secure, prevented the servants from quarreling with the neighbors, and made it unnecessary to fix the property boundaries by lawsuits. The cypress was also used for topiary work (Pliny *HN* 16.140).

The wood of the cypress was much in demand

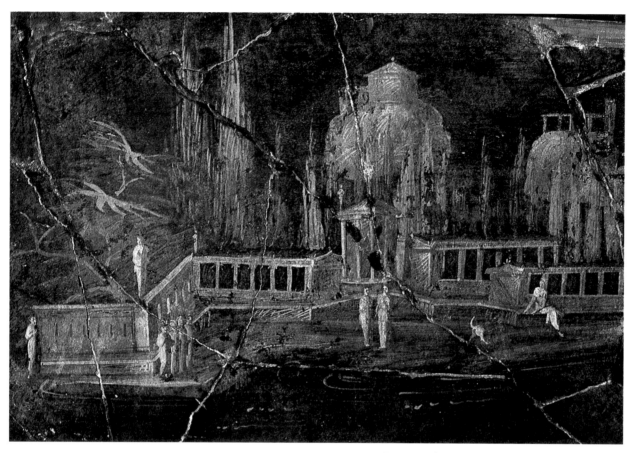

FIGURE 86 Painting of a seaside villa with cypress trees (NM inv. no. 9482). Photo: S. Jashemski.

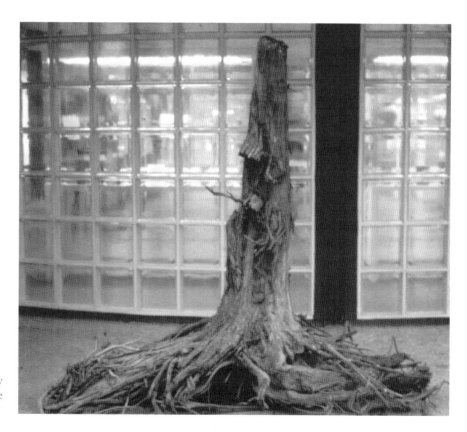

FIGURE 87 Cypress tree preserved by the A.D. 79 eruption. Boscoreale Antiquarium. Photo: F. Meyer.

because of its resistance to decay. Theophrastus (*Hist. pl.* 5.4.2) says the doors of the Temple at Ephesus were made of cypress (κυπάριττος) for this reason (see also Pliny *HN* 16.215) and he claims that the island of Cyprus was named for this tree (*Hist. pl.* 5.100.2). Columella (*RR* 4.26.1) and Pliny (*HN* 17.174) recommend it for vine props because of this property. Since cypress retains its polish it was also used for making valuable articles (Pliny *HN* 16.216). The poets speak of the *cupressus funebris* (Horace *Epodes* 5.18; Ovid *Met.* 10.106–42), because cypress was a favorite tomb tree in antiquity, as it still is today. According to Pliny (*HN* 16.139–41), the cypress was sacred to Dis, and was placed at the door of a house as a sign of a funeral. He says that there are two kinds of cypress – one pyramidal, which is the female tree, the other with branches spreading outward, which is the male tree. Folk notions about "male" and "female" trees are still held today. The workmen at Pompeii explained the differences between the trees in the row of cypresses along the E side of the garden of Julia Felix in exactly this way.

The cypress was also known as *Cyparissus* (Vergil *Aeneid* 3.680), from the name of the grieving youth Cyparissus, who was changed by Apollo into a cypress (Ovid *Met.* 10.106–41). This myth is the subject of several wall paintings at Pompeii.

Pliny (*HN* 20.16; 23.88, 139; 24.15, 32; 26.135, 161) and

Dioscorides (1.102) list the many medicinal uses of the cypress (κυπάρισσος).

REMARKS

The Italian cypress is a coniferous evergreen tree, narrowly columnar in the common cultivated form, attaining a height of 30 m. The wild type has ascending to spreading branches and is not as tall. The wood is hard, fragrant, and resists decay. In the wild it is a tree of the Aegean region, namely Greece and Turkey, but it is now found throughout the Mediterranean area.

46. *CYDONIA OBLONGA* MILL.

English, quince; Italian, *cotogno, mela cotogna*

WALL PAINTINGS

The quince can be easily identified in the beautiful painting of a glass bowl filled with fruit on the W wall in room 23 in the luxurious Villa of Poppaea at Oplontis (Fig. 88), and in a similar painting in a room from the Villa of P. Fannius Synistor at Boscoreale, now in the Metropolitan Museum in New York. Quinces are also pictured with grapes above the cornice on the wall in room 23 in the villa at Oplontis.

FIGURE 88 Quince and plums in a glass bowl. Wall painting (room 23), Villa of Poppaea, Oplontis. Photo: S. Jashemski.

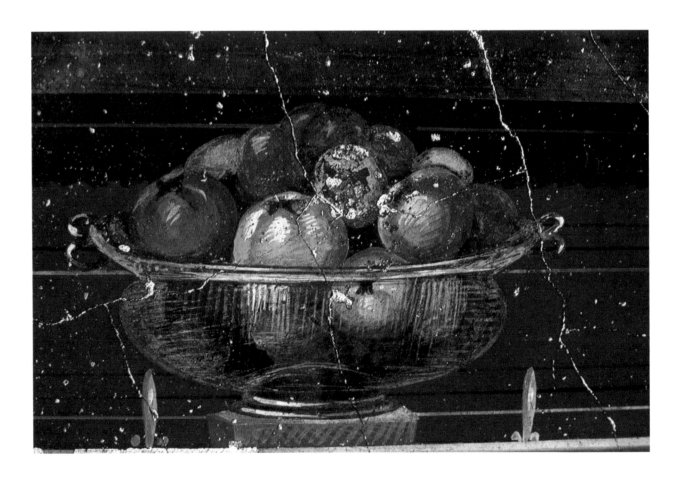

There are quinces in two still-life paintings from Herculaneum, now in the Naples Museum (inv. no. 8644 = Helbig 1868: no. 1604, and inv. no. 8647 = Helbig 1868: no. 1694). The quince on the elevation in no. 8647 is the more carefully painted (Fig. 111), but both paintings have two elements in common, the dead partridge hung on a hook on the left of the picture, and one (NM inv. no. 8644) or two quinces (NM inv. no. 8647) to the right. Helbig (no. 1604) incorrectly identifies the fruit as apples. Comes (1879: 60) identified the quince in a painting in the Naples Museum (inv. no. 86), perhaps the old number of one of the paintings just mentioned.

According to Casella (1950: 373), the bear pictured on the N wall of the peristyle in the House of M. Lucretius Fronto is eating a quince, but we found the painting too damaged to identify the fruit (Fig. 362). Comes (1879) also reports a bear eating a quince in two paintings, which Casella says are now destroyed.

MOSAICS

Quinces can also be identified in the garland mosaic from the House of the Faun, now in the Naples Museum (inv. no. 9994). Comes (1879) also lists this quince.

REFERENCES IN ANCIENT AUTHORS

Theophrastus mentions the quince twice (*Hist. pl.* 2.2.5, 4.8.11). Cato (*RR* 7.3) lists the quince (*cotonea*) among the fruits that he recommends planting on a suburban farm and suggests the varieties to plant. Varro (*RR* 1.59.1) also lists varieties of the *cotonea*, as does Columella (*RR* 5.10.19), who calls the quince *cydonia*. Pliny (*HN* 15.37–8) gives a good description of this fruit, which he says "we call *cotonea* and the Greeks *cydonea.*" He mentions several varieties.

The fruit of the quince was dedicated to Venus and was considered a symbol of love and happiness. Pliny (*HN* 23.100–3) and Dioscorides (1.160) give its medicinal uses.

REMARKS

Terpó (1968: 64–5) and also De Candolle (1884) say the quince is indigenous to northern Iran, the southern Caucasus area, and the Kopet Dag range. It is naturalized elsewhere and widely cultivated in Europe.

47. *CYNODON DACTYLON* (L.) PERS.

English, Bermuda grass; Italian, *gramigna*

MATERIAL EXAMINED

Fragments of stolons and some whole inflorescences were found in the carbonized hay at Oplontis (Fig. 89).

FIGURE 89 Bermuda grass in carbonized hay, Oplontis. Photo: M. Ricciardi.

REFERENCES IN ANCIENT AUTHORS

Pliny says that Bermuda grass (*gramen*) is "the very commonest of plants, trails its knotted blades along the ground and from them and out of the head sprout many new roots" and that "to draught cattle no other plant is more attractive" (*HN* 24.178).

Dioscorides (4.30) describes *agrostis* (ἄγρωστις) as creeping, with branches full of joints, stems rooting at nodes, and small leaves that are pasture for grazing cattle. Columella (*RR* 8.5.12) recommends putting some Bermuda grass in the straw of the nest for brooding hens.

REMARKS

Bermuda grass aggressively spreads as a weed along roadsides and disturbed ground throughout much of Europe. Forms of it have importance as a lawn grass. Formerly in the Vesuvian area it yielded a very good forage for horses and donkeys.

48. *CYNOSURUS ECHINATUS* L.

English, hedgehog dog's-tail, rough dog's-tail grass; Italian, *ventolana, covetta*

MATERIAL EXAMINED

One inflorescence was found in the carbonized hay at Oplontis.

REMARKS

This plant occurs in abandoned fields, roadsides, forest margins, and in dry open habitats in Campania and the Mediterranean region.

49. *CYTISUS SCOPARIUS* (L.) LINK

English, Scotch broom; Italian, *ginestra dei carbonai, ginestrone*

MATERIAL EXAMINED

Numerous legumes were found in the carbonized hay at Oplontis.

REMARKS

Scotch broom is a much branched green-stemmed shrub with numerous golden yellow flowers. In the Vesuvian area it occurs mainly in pine woodlands.

50. *DAUCUS CAROTA* L.

English, wild carrot, Queen Anne's lace; Italian, *carota selvatica*

MATERIAL EXAMINED

Leaves and many flowering umbels were found in the carbonized hay at Oplontis (Fig. 90).

REFERENCES IN ANCIENT AUTHORS

Pliny speaks of four kinds of wild carrot (*daucus*), some of which "grow everywhere on earthy hills and cross-paths," having "leaves like those of coriander, a stem a cubit high and round heads" (*HN* 25.111). Dioscorides (3.83) knew three kinds of *daukos* (δαῦκος), the third of which could be more probably identified with the wild carrot, having "coriander leaves, white flowers, top and seeds similar to dill and terminal umbels like parsnip."

REMARKS

Wild carrot is a hairy annual, with much-divided leaves and tiny white flowers with a single purple flower in the middle forming an umbrella-shaped flower head. It occurs throughout Europe and it is abundant at Pompeii. The cultivated carrot was already being planted toward the end of the first millennium in Europe, according to Zohary and Hopf (1994).

51. *DIANTHUS CARYOPHYLLUS* L.

English, carnation, wild carnation, pink; Italian *garofano (selvatico)*

WALL PAINTING

The many-petaled flowers with carnation-like foliage in a no longer extant painting in the lower peri-

FIGURE 90 Flowering umbel of wild carrot in carbonized hay, Oplontis. Photo: M. Ricciardi.

style of the Villa of Diomede suggest the cultivated carnation; they are preserved in a painting in the Naples Museum, as well as in a drawing in *Gli ornati delle pareti* (Fig. 91). If so, this is the first time this flower has been identified in the Vesuvian sites. *D. caryophyllus* is the name usually used for the domesticated carnation, a cultigen of ancient and uncertain origin, but closely related to *D. sylvestris* Wulfen. (Tutin 1964: vol. 1, 195).

MOSAICS

The ten stalks, each with a single bicolored pinkish

FIGURE 91 Carnation and goldfinch in the lower peristyle, Villa of Diomede, Pompeii.

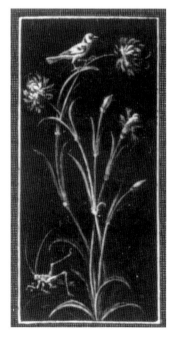

flower, in the garland mosaic from the House of the Faun (NM inv. no. 9944) suggest the wild single-flowered carnation, *D. sylvestris* Wulfen. If so, this is the first time the wild carnation has been identified in a Vesuvian mosaic or painting. The plants show the swollen tubular calyx and the thin, slightly recurved leaves of this carnation, but they have only four petals, not five, perhaps a stylized version adapted to mosaic. The wild carnation is widespread today in the mountains of Campania, where it occurs mainly on screes and in rock crevices. Comes (1879: 11) identified the flowers in this mosaic as possibly *Agrostemma githago* L., but that is hardly possible.

REFERENCES IN ANCIENT AUTHORS

There are few references to the carnation in the ancient writers. Theophrastus calls the carnation "flowers of Zeus" (διόσανθος), identified as the carnation *Dianthus inodorus* (now called *D. sylvestris*) in the Loeb edition. It was used for chaplets (*Hist. pl.* 6.1.1), had no fragrance (*Hist. pl.* 6.6.2), and blossomed in the summer (*Hist. pl.* 6.8.3). The generic name *Dianthus*, meaning flower of Zeus, is derived from the Greek Δῖος (of Zeus) and ᾽ἀνθος (flower).

REMARKS

The genus *Dianthus* includes numerous species that grow wild throughout the Old World, from Africa to Europe and eastward to Japan. Very little is known about the history of the carnation, but it is generally accepted that it dates from antiquity as a garden flower.

52. *ECHIUM* sp.
English, viper's bugloss; Italian, *viperina*

MATERIAL EXAMINED

The faded upper part of one inflorescence was found in the carbonized hay at Oplontis, and it is probably either *E. vulgare* L. or *E. plantagineum* L., but the fragmentary material is impossible to identify to species.

REFERENCES IN ANCIENT AUTHORS

Pliny lists two kinds of *echios* and says that the second one "is marked by a prickly down, and also has little heads like a viper's" (*HN* 25.104). Dioscorides (4.27) also likens the seeds of the *echion* (᾽ἐχιον) to the head of a viper.

REMARKS

The generic name *Echium* is derived from the Greek *echis* (᾽ἐχις): viper. According to the Doctrine of Signatures, the shape of the flower resembles a striking snake and its seed a viper's head. It was believed that it

could be used to neutralize the poison of vipers and to cure epilepsy.

53. *FAGUS SYLVATICA* L.
English, beech; Italian, *faggio*

MATERIAL EXAMINED

Small fragments of carbonized beech wood found in various gardens were probably the remains of wood-ash used as fertilizer.

REFERENCES IN ANCIENT AUTHORS

Theophrastus speaks of both mountain and lowland forms of beech (ὀξύη) (*Hist. pl.* 3.11.5); it is a timber tree (*Hist. pl.* 5.1.4); it doesn't decay in water (*Hist. pl.* 5.4.4); and it has various uses, which he mentions. Pliny has many references to the beech (*fagus*): the acorn is good to feed pigs (*HN* 16.25); the wood is good for use in water (*HN* 16.218); and it is easily worked and is good for veneer (*HN* 16.229). Both Pliny (*HN* 24.14, 28.191) and Dioscorides (1.144) give various medicinal uses of the beech.

REMARKS

The beech grows normally at higher elevations. It is in the Lattari Mountains south of Pompeii.

54. *FICUS CARICA* L.
English, fig; Italian, *fico*

MATERIAL EXAMINED

The fragmented material of ancient fig syconiums, with the "seeds" embedded in the receptacle, probably represents figs with solid pulp, as in most but not all caprifigs. Carbonized figs were found in situ in three gardens at Pompeii: (1) in the House of C. Julius Polybius (IX.xiii.1–3), broken fragments in four locations (Jashemski 1979: 29); (2) in a humble house on the Via Nocera (I.xiv.2), a small fragment of fig syconium (Jashemski 1993: 60); and (3) in the House of the Ship *Europa* (I.xv.3), a fragment of fig syconium with "seeds" embedded in the pulp. The fruit fragments include the outer skin, pericarp, and carbonized pulp with embedded "seeds" (Jashemski 1979: 24). Material examined in the *deposito* at Pompeii includes (1) inv. no. 18082B from an unknown site at Pompeii, many whole and distorted figs; (2) inv. no. 18080B, many whole and distorted figs; broken pieces show numerous small "seeds" embedded in the carbonized pulp; (3) without number, a dish with twenty poorly preserved whole figs.

At Herculaneum, about 1,000 well-preserved whole carbonized figs with characteristic pyriform shape (inv. no. 2319) were found on the Decumanus Maximus.

Material in the Naples Museum includes a dish of carbonized figs without number in a storeroom in the museum attic (Meyer 1988: 197–8).

MATERIAL REPORTED

Remains of burned figs were found in the refuse of sacrifices at the Temple of Isis (Mau 1902: 195).

WALL PAINTINGS

Figs are one of the fruits most often found in the wall paintings. Schouw said the fruits most often eaten in his day were figs and grapes and that those were the fruits that he found depicted in wall paintings most frequently. We cite only a few examples, to show the various contexts in which figs are pictured. A beautiful fig tree laden with fruit is dramatically painted in the House of the Fruit Orchard, in the center of the E wall of the room off the E side of the atrium (Fig. 283). There is a handsome wicker basket piled high with figs on the rear wall in the triclinium (room 14) in the Villa of Poppaea (Fig. 92). Baskets of figs are found in (IX.ii.10) at Pompeii on the E wall in the room to the E of the peristyle, at the far right of the lunette of a rooster; in the Naples Museum (inv. no. 8640); and elsewhere. They are also shown in a bowl or box of assorted fruit, as, for example, in the painting in the Naples Museum from the House of Julia Felix (II.iv) (Fig. 107). They are shown with birds as in the House

of Trebius Valens (III.ii.1), with a rabbit as in the still life from the portico of the temple of Isis at Pompeii (Fig. 356), and with a goose (inv. no. 8749). There are figs, almonds, and dates in two Naples Museum paintings (inv. nos. 8643, 8645). Figs and other offerings (pinecones, eggs, and dates) are pictured on the altar in the lararium painting on the N wall of the room off the S of the atrium in House VI.xvi.15.

MOSAIC

Below the mosaic of a boxer, a cock looks at a box on which are a date, pinecone, and a fig (Fig. 315).

REFERENCES IN ANCIENT AUTHORS

Ficus is the classical Latin name for the fig. In Greek, the fig was known as *sykon* (σῦκον), from which the pomological term for the fig, syconium, is derived. Figs were among the most highly esteemed fruit of ancient Campania, and remain so today. Both Columella and Pliny have numerous references to the fig (*ficus*) with detailed directions for its culture, and many varieties are listed (Columella *RR* 5.10.10–11, 10.414–18, 11.2.59; *Arb.* 21.1–2; Pliny *HN* 15.68–73, 81–83; 17.155). Pliny describes twenty-nine named varieties, including

FIGURE 92 Basket of figs. Wall painting in the triclinium (room 14), Villa of Poppaea, Oplontis. Photo: S. Jashemski.

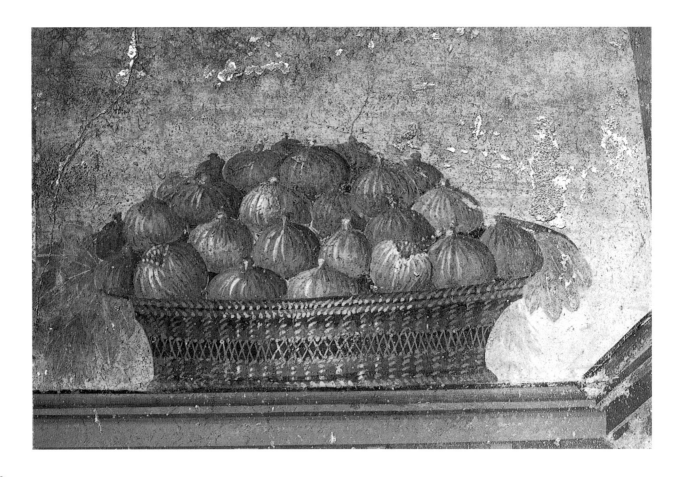

one called the Herculaneum fig (*HN* 15.72). This fig is also mentioned by Cato (*RR* 8.1).

The fig was eaten fresh and dried (Columella *RR* 12.14.1). It was sometimes preserved by making it into a fig paste (Columella *RR* 12.15.3–4). Apicius (1.12.4) gives a recipe for preserving fresh figs in honey, as well as two recipes for ham with figs (7.9.1–2). Figs were used for making vinegar (Columella *RR* 12.17.1–2; Pliny *HN* 14.103). They were also used as food for bees (Columella *RR* 9.14.15; Pliny *HN* 21.82) and for fish (Columella *RR* 8.17.13, 15; 14.15). Figs had numerous medicinal uses (Pliny *HN* 23.117–30; Dioscorides 1.183). The poets also speak of figs. Horace refers to the first ripe figs denoting the beginning of autumn (*Epistles* 7.5).

REMARKS

Condit (1947: 10–11) suggests that the fig was probably first cultivated in southern Arabia, its probable place of origin. From this center, the fig spread to western Asia, from Turkey to Afghanistan. According to Condit, fig culture dates from the eighth century B.C. in Italy, where both caprifigs and parthenocarpic figs were grown.

55. *FILAGO VULGARIS* LAM.

English, fluffweed, cudweed; Italian, *bambagina (comune)*

MATERIAL EXAMINED

A few capitula on stem fragments were found in the carbonized hay at Oplontis.

REMARKS

This plant is a common annual in much of Europe.

56. *FRAGARIA VESCA* L.

English, wild strawberry; Italian *fraga, fragola*

REFERENCES IN ANCIENT AUTHORS

The strawberry is not mentioned in Theophrastus. Pliny (*HN* 15.98) distinguishes between the ground strawberry (*fraga*) and the strawberry tree (*unedo;* see no. 13). He lists the strawberry as one of the few wild plants used for food by the Romans (*HN* 21.86). Ovid (*Met.* 1.104) speaks of gathering strawberries from the mountainside. Vergil (*Eclogues* 3.92) warns children gathering flowers and strawberries of the snake that lurks in the grass.

WALL PAINTING

The strawberry is found in a painted copy in the Naples Museum of a no longer extant painting (on the lower part of a pillar of the portico) in the lower peristyle in the Villa of Diomede at Pompeii (Fig. 265).

The fruit and leaves which are realistically depicted are part of a stylized design.

REMARKS

The wild strawberry has small edible red fruit. It occurs throughout most of Europe. The modern cultivated strawberry, a hybrid of two American species, was unknown in Europe until the eighteenth century.

57. *FRAXINUS* sp.

English, ash; Italian, *frassino*

MATERIAL EXAMINED

Small pieces of carbonized ash found in gardens appeared to be remains of wood-ash brought in as fertilizer, valuable for its potash content. Carbonized fragments of a stake used to prop a large tree in the garden in the House of Polybius were identified as ash.

REFERENCES IN ANCIENT AUTHORS

Theophrastus describes the ash (βουμέλιος) (*Hist. pl.* 3.11.4–5) but has more references to the manna ash (μελία) (*F. ornus* L.), which he says is a tree of mountain and plain (Hist. pl. 3.4.4.). Pliny says the ash (*fraxinus*) is the most productive of all timber trees (*HN* 16.62–4), "the most compliant wood in work of any kind" (Pliny *HN* 16.228). He lists its medicinal uses (*HN* 24.46). Vergil speaks of the mighty ash, used to shape forks and strong stakes (*Georgics* 2.66.359).

REMARKS

Three native species of ash occur in Italy, valuable for the wood used in making handles, furniture, and baskets. They are also used for shade trees.

58. *GALACTITES* sp.

Italian, *scarlina*

MATERIAL EXAMINED

A single capitulum was identified in the carbonized hay at Oplontis, possibly *Galactites tomentosa,* but the identification is doubtful as it lacks many of the diagnostic characters. *Galactites tomentosa* Moench is the only species that grows in Italy today.

59. *GALIUM* sp.

English, bedstraw, cleavers; Italian, *attacca-mani, attacca-vesti*

MATERIAL EXAMINED

A single node with a leaf fragment and a fruit was found in the carbonized hay at Oplontis. Seeds of an unidentified species of *Galium* were found in a sample of bitter vetch (*Vicia ervilia* (L.) Willd.) at Herculaneum.

FIGURE 93 Geranium seed in carbonized hay, Oplontis. SEM photo: F. Hueber.

REFERENCES IN ANCIENT AUTHORS

Theophrastus (*Hist. pl.* 7.14.3) speaks of the *aparine* (ἀπαρίνη) having "the peculiarity that it sticks to clothes owing to its roughness, and it is hard to pull away." Pliny (*HN* 27.32) says: "*Aparine* . . . is branchy, hairy, and with five or six leaves arranged at intervals in a circle around the branches." He adds that "it grows in cornfields, or gardens, or meadows and is so prickly as even to cling to the clothes." From this description, the plant to which Pliny refers is probably *Galium aparine* L. Dioscorides (3.104) speaks of *galion* (γάλιον) having "leaves lying round about like a circle . . . the flowers white, the seeds round, the herb sticks to clothes, and shepherds use it instead of a strainer, to take the hairs out of milk."

60. *GASTRIDIUM VENTRICOSUM* (GOUAN) SCHINZ & THELL.

English, (large) nit grass; Italian, *codino maggiore*

MATERIAL EXAMINED

Upper parts of plants with panicles were found in the carbonized hay at Oplontis.

REMARKS

Nit grass grows in grassy places, cultivated fields, and margins of the maquis.

61. *GERANIUM PURPUREUM* VILL.

English, herb Robert; Italian, *erba cimicina, cicuta rossa*

MATERIAL EXAMINED

One calyx with style remains was found in the carbonized hay at Oplontis.

REMARKS

This plant is found in damp and shady places in southern and western Europe, including Italy.

62. *GERANIUM ROTUNDIFOLIUM* L.

English, round-leaved crane's-bill, round-leaved geranium; Italian, *geranio malvaccino*

MATERIAL EXAMINED

Fruiting mericarps and some branchlets with leaf lobes were found in the carbonized hay at Oplontis (Fig. 93).

REFERENCES IN ANCIENT AUTHORS

Pliny mentions two kinds of geranium (*geranion*), one resembling "hemlock, but with smaller leaves and shorter in the stem . . . on the tips of the stems are miniature heads of cranes" (*HN* 26.108). Dioscorides (3.17) also knew the plant (γεράνιον) as one that had "no medicinal use."

REMARKS

This plant is rather widespread throughout much of Europe and is very common in waste places and gar-

FIGURE 94 Ivy mound, House of Ceius Secundus. Photo: S. Jashemski.

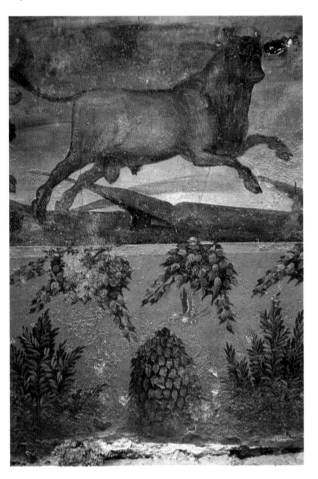

dens in the Vesuvian area. It has small pale pink flowers. The name geranium is derived from the Greek γέρανος (crane), because the shape of the fruit resembles a crane's head.

63. *HEDERA HELIX* L.

English, ivy; Italian, *edera*

WALL PAINTINGS

Ivy is one of the plants most frequently found in the wall paintings. It grew in the ancient gardens and was a favorite plant for making crowns, as well as the garlands used in decorating both homes and public places. These uses are represented in the wall paintings. The topiary mounds of ivy painted at the base of garden or peristyle walls suggest a continuation of those planted in the garden. Beautiful examples can be seen in the House of Ceius Secundus (I.vi.15) (Fig. 94) and in the House of the Vettii (VI.xv.1). Such paintings can also be found inside the house, for example, in the room to the left of the atrium in the Fullonica of Stephanus (I.vi.7).

Ivy is also found in the garden paintings. In the House of Venus Marina (II.iii.3) two ivy mounds covered with clusters of whitish dots, which probably represent flowers, can be seen in the right panel of the S garden wall. There is a mound of ivy covered with umbels of yellow fruit (subsp. *poetarum* Nyman) in the House of the Fruit Orchard on the E wall of the room to the E of the atrium. Mounds of ivy, together with very stylized vines in flower, are a part of the delicate wall decoration in the room to the N of the peristyle in the House of the Centenary (IX.viii.3/6).

Branches of ivy painted on the wall in the garden of Ceius Secundus and in the peristyle of the Villa of Poppaea at Oplontis probably reflect the use of ivy branches in decorating for special occasions. Bunches of ivy also decorate the lower part of the engaged columns in the peristyle garden of the Villa of Poppaea. Long ivy garlands, each leaf carefully painted, as if sewn to a band, from which hang ribbons (*taeniae*), are draped across each panel in the room to the S of the atrium in I.xv.1. Large ivy garlands are held by female figures in the room off the NE corner of the peristyle in the Gladiators' Barracks (V.v.3). Ivy garlands also frame the garden paintings in the House of Venus Marina and the House of Ceius Secundus.

SCULPTURE

Ivy often decorated small garden sculptures. The charming Bacchic head of a little girl in the garden of the House of the Ephebe (I.vii.10–12/19) wears a garland of ivy leaves and flowers around her neck, and ivy

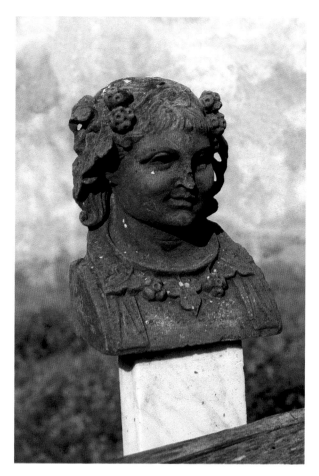

FIGURE 95 Marble herm. Bacchic head of a little girl wearing an ivy garland and ivy in her hair, garden in House of the Ephebe. Photo: S. Jashemski.

in her hair (Fig. 95). A delicate ivy vine in bloom twines around a marble support in the peristyle of the House of the Vettii (VI.xv.1). A more stylized ivy entwines a tree trunk sculptured on one side of the post of a pinax in the House of the Golden Cupids (VI.xvi.7). A marble sculpture of a satyr carrying a thyrsus tipped with ivy is inserted in the S peristyle wall of this house (Fig. 96). Three small marble fragments in the Antiquarium at Herculaneum are exquisitely sculptured with ivy leaves and fruit.

SILVERWARE

Ivy leaves and berries decorate a silver cup from Herculaneum, now in the Naples Museum (inv. no. 25379) (Fig. 97).

MOSAICS

Ivy leaves and flowers can be identified in the mosaic garland from the House of the Faun (NM inv. no. 9994). In the mosaic of the actors from the Villa of Cicero at Pompeii, the aulos player is appropriately wearing a crown of ivy (NM inv. no. 9985), for the aulos was connected with the cult of Dionysus.

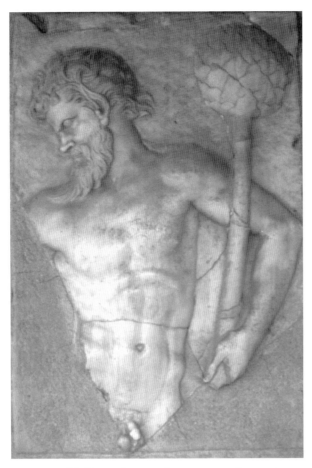

FIGURE 96 Marble sculpture of a satyr carrying a thyrsus tipped with ivy in the S peristyle wall, House of the Golden Cupids. Photo: S. Jashemski.

FIGURE 97 Silver cup trimmed with ivy from Herculaneum (NM inv. no. 25379). Photo: S. Jashemski.

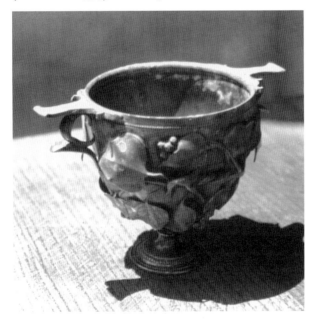

REFERENCES IN ANCIENT AUTHORS

The ivy (κιττός) is mentioned many times by Theophrastus in the *Enquiry*. Pliny (*HN* 16.144–52) describes the ivy (*hedera*) at length. He says there are three kinds, black, white (probably another plant), and a third called helix, and these in turn are divided into others. The *helix* has the most varieties. Ivy was closely associated with the god Dionysus (Ovid *Fasti* 3.766). The worshipers of Dionysus wreathed themselves with ivy. Poets were also decked with the ivy crown, for Dionysus was their patron (Horace *Odes* 1.1.29; Vergil *Eclogues* 7.25). Martial (1.76–7) speaks of the ivy of Bacchus.

REMARKS

Umbels of black fruit are produced on the adult branches with unlobed leaves. The ivy is a well-known evergreen woody climber, widespread throughout most of Europe, and it is still abundant at Pompeii and the other Vesuvian sites.

64. *HOLCUS LANATUS* L.

English, common velvet grass; Italian, *bambagina*

MATERIAL EXAMINED

Some panicles were found in the carbonized hay at Oplontis.

REMARKS

This grass occurs in damp meadows throughout Europe. It provides good fodder, especially for horses.

65. *HORDEUM MURINUM* L. subsp. *LEPORINUM* (LINK) ARCANGELI

English, mouse barley; Italian, *orzo selvatico, grano canino*

MATERIAL EXAMINED

Spikes and single spikelets were found in the carbonized hay at Oplontis.

REFERENCES IN ANCIENT AUTHORS

Pliny says that besides cultivated barley "there is also a plant, called *phoenicea* by the Greeks and mouse barley (*hordeum murinum*) by our countrymen" (*HN* 22.135). It seems highly probable that the plant he speaks of can be identified with *Hordeum murinum* L., whose remains have been found in the carbonized material at Oplontis.

REMARKS

This plant is widespread throughout the Mediterranean region along roadsides and in waste places.

66. *HORDEUM VULGARE* L.

English, six-rowed barley; Italian, *orzo*

MATERIAL EXAMINED

Pompeii: (1) *deposito* (inv. no. 9194), a small amount of hulled barley florets is mixed with Italian millet; (2) *deposito* (inv. no. 9212), originally from I.ix.8, 500 grams of covered barley florets. Herculaneum: (1) V.iii (inv. no. 378), a mixed sample of hulled barley and emmer wheat; (2) at the Casa del Bel Cortile (V.8) (inv. no. 1895), in part, a small sample of mature barley florets. In the Naples Museum: (1) a dish of carbonized barley florets; (2) a dish of hulled barley florets, without number (Meyer 1988: 203).

GRAFFITI

A graffito scratched on the *villa rustica* in the *fundo Juliano* at Boscoreale records barley raised there: HORDEVM CCDLXX VI (*CIL* IV 5430). See also the graffito found at Pompeii at V.iii.10: (H)ORD(E)I SEMENTE(M) M VII.VI (*CIL* IV 6722).

REFERENCES IN ANCIENT AUTHORS

Theophrastus speaks very often of barley, calling it *krithe* (κριθή); he describes it carefully (*Hist. pl.* 8.4.1–2) as compared with other cereals. *Hordeum* was the classical Latin name for barley; Pliny (*HN* 18.78) says that "some ears of barley have two rows of grains and some more, up to as many as six." But according to Helbaek, two-rowed barley (*H. distichon* L.) did not reach Europe before the Middle Ages. Pliny (*HN* 18.72) refers to barley as "the oldest among human foods, as is proved by the Athenian ceremony [a prize of barley was given to the victors in the Eleusinian games] recorded by Menander, and by the name given to gladiators, who used to be called 'barley-men.'" Barley is the softest of all grains, and according to Pliny, its chaff was considered the best; for straw, nothing else compared with it. Pliny also mentions varieties of barley, some larger and smoother or shorter and rounder, lighter or darker in color, the kind with a purple shade being of a rich consistency for porridge. The most prolific kind of barley was produced at New Carthage in Spain in the month of April (*HN* 18.80). In earlier times barley bread was very popular, but the grain was no longer used for that purpose in Pliny's day (*HN* 18.75).

REMARKS

Barley is one of the world's oldest cultivated cereal grains. Six-rowed barley reached Europe long before the Roman period, coming first to Greece, probably by 6000 B.C. It was well known in Italy during the Roman period. Barley was a grain with wild progenitors found in the Fertile Crescent.

67. *HYPERICUM PERFORATUM* L.

English, common St. John's-wort; Italian, *erba di S. Giovanni*

MATERIAL EXAMINED

A few upper parts of flowering stems were found in the carbonized hay at Oplontis.

REFERENCES IN ANCIENT AUTHORS

Pliny has several references to *hypericum*, but it is difficult to identify the species to which he is referring. He speaks of two kinds of *hypericum*, the first having a stem "thin, reddish and a cubit high" (*HN* 26.85) and the second "called by some caro . . . more fleshy and less red" (*HN* 26.86). He refers to another St. John's-wort, *androsaemon* (man's blood), or as others have called it, *ascyron*. As it is not unlike *hypericum*, having a stem that when crushed gives out a juice the color of blood, Dioscorides (3.172) says that *askuron* (ἄσκυρον) is a branched shrub having leaves like rue and yellow flowers that when crushed by fingers yield a bloody juice; hence it is called *androsaemon*.

REMARKS

Popular fantasy has always been struck by the blood-colored liquid that oozes from the peduncles when the plants are pulled up and by the translucent dots of the leaves. It was believed to give protection against lightning and devils, and to obtain this protection it was collected on St. John's (S. Giovanni's) day. It grows in dry sunny places throughout Europe. St. John's-wort was a popular medicinal plant in antiquity, as it is today.

68. *HYPOCHOERIS GLABRA* L.

English, (smooth) cat's ear; Italian, *costolina (liscia)*

MATERIAL EXAMINED

Some achenes with pappus were found in the carbonized hay at Oplontis.

REFERENCES IN ANCIENT AUTHORS

Theophrastus (*Hist. pl.* 7.11.3) mentions several edible plants, one of which, "cat's ear" or *upochoiris* (ὑποχοιρίς) "is smoother and has a more cultivated appearence, and is also sweeter" (*Hist. pl.* 7.11.4).

REMARKS

Cat's ear is an annual herb with poorly branched stems arising from a basal rosette of a few leaves. The flower heads with bright yellow florets are almost conical when the fruits are ripe. It occurs in dry grasslands and coastal areas of the Mediterranean region.

69. *IRIS FOETIDISSIMA* L.

English, stinking iris; Italian, *giglio dei morti, iris puzzolente*

WALL PAINTINGS

Iris, or irislike plants are frequently depicted at the base of a wall, but they are so stylized and poorly painted that identification of most of these plants is very difficult. The iris with very narrow leaves and small flowers painted on the W part of the N wall of the peristyle garden in the Villa of Poppaea at Oplontis suggests *Iris foetidissima*, a plant that grows wild at Pompeii.

REFERENCES IN ANCIENT AUTHORS

Pliny (*HN* 21.143) says some authorities call the wild iris *xyris*. It is called ξυρίς in Theophrastus (*Hist. pl.* 9.8.7). Dioscorides (4.22) adds the important identifying information that it had red seeds in little cases like beans.

REMARKS

This plant is a unique species of iris with evergreen leaves that are fetid when broken; its flowers are dull violet, tinged with dull yellow; its seeds are orange-scarlet. It is widespread in southern and western Europe, eastward to northeastern Italy, and was introduced at Pompeii. Comes does not mention this iris, but it was known in antiquity and undoubtedly pictured.

70. *IRIS* sp.

English, iris; Italian, *giaggiolo, iride, ireos*

WALL PAINTINGS

The iris with large flowers depicted on the W wall of the peristyle in the House of P. Paquius Proculus (I.vii.1) suggests *I. germanica* L., *I. pallida* Lam., or *I. albicans* Lange, plants that could have been grown in Pompeian gardens (Fig. 98). Comes (1879) believed that he could identify examples of both *I. germanica* and *I. florentina* (a name no longer used because it is confused with *I. germanica* L. and *I. albicans* Lange), but we have been unable to identify any iris that he cited.

REFERENCES IN ANCIENT AUTHORS

Pliny (*HN* 21.41, 140–2) says that the flowers of the red iris (*iris rufa*) are multicolored like the rainbow, hence the name "iris." This iris, commonly believed to be *I. germanica*, was considered by Pliny to be the best, and he gives its many medicinal uses. He also refers to a white iris (*candida*), which could be *I. albicans*.

REMARKS

I. germanica, I. pallida, and *I. albicans* are known only as garden plants. According to many authorities *I. flo-*

FIGURE 98 Painting of iris on the W peristyle wall, I.vii.1. Photo: S. Jashemski.

rentina is closely related to *I. germanica*. Orris root is obtained from *I. florentina*.

71. *IRIS PSEUDACORUS* L.

English, water iris; Italian, *giaggiolo acquatico, iride gialla, spadone, coltellacci*

WALL PAINTINGS

Iris with yellow flowers is pictured with a water deity at the water's edge in the *castellum aquae* (water tower) at Pompeii (Fig. 99). Although crudely painted it clearly depicts the water iris, for this is the only European iris that grows in an aquatic habitat. It occurs today at the edge of the Sarno River near Pompeii. Comes believed that he could identify this iris in three houses at Pompeii and in a painting in the Naples Museum, but we have not been able to locate any of these paintings.

REFERENCES IN ANCIENT AUTHORS

Pliny (*HN* 25.157) refers to *I. pseudacorus* when he says:

Acoron has the leaves of the iris, only narrower and with a longer foot-stalk; it has dark roots and is less veined, though in other respects these too are like the iris, pungent to the taste, with a not unpleasant smell and carminative. . . . They are found wherever there are watery districts.

Pliny (*HN* 14.111) includes *acoron* among the herbs used in making wine. It had many medicinal uses

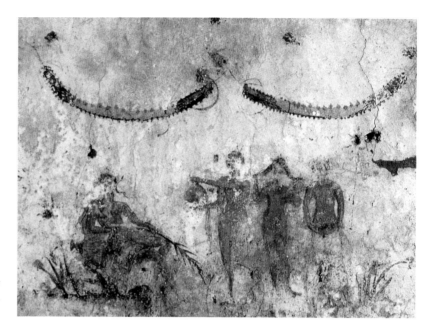

FIGURE 99 Painting of water iris with water deity, Pompeii water tower. Photo: S. Jashemski.

(Pliny *HN* 25.159, 164; 26.28, 35, 45, 74, 77, 80, 91, 127, 137, 160, 163). Dioscorides (1.2) calls its root ἄκορον.

REMARKS

In Europe, *I. pseudacorus* is nearly universal in wet places.

72. *JUGLANS REGIA* L.
English, English or Persian walnut; Italian, *noce*

WALL PAINTINGS

There are two easily recognizable English walnuts, together with two halves, painted between two birds on the N wall of the tablinum in the Villa of the Mysteries at Pompeii (Fig. 303). In one of the halves the nutmeats are clearly visible. The walnut is also found in the painting of a plate of assorted fruit, on the W wall of the peristyle of the Casa dei Cervi (IV.21) at Herculaneum.

MATERIAL EXAMINED

Naples Museum: a dish of well-preserved unbroken walnuts without husks (Fig. 100). At Herculaneum: (1) in IV.7, many broken nuts, including many half shells; (2) in the *deposito* (inv. no. 2326), nine carbonized nuts, including halves and six whole ones. Walnut shells and shell fragments were also found in the carbonized hay at Oplontis. Walnut charcoal found in gardens was probably the remains of wood-ash used as fertilizer.

AMBER

For an amber charm found at Herculaneum (inv. no. E3100 B), worked in the form of a walnut, see Scatozza Höricht (1989: 67).

REFERENCES IN ANCIENT AUTHORS

The walnut is mentioned by Theophrastus (*Hist. pl.* 3.14.4), who calls it the Persian nut. *Juglans* was the classical name for the walnut, a contraction from Jovis glans, the nut of Jupiter, or Jove's acorns. Pliny (*HN* 15.87) says that the Greek names for the walnut prove that it "was sent to us from Persia by the kings, the best kind of walnut being called in Greek the 'Persian' and the 'Royal.'" Pliny (*HN* 15.86–8) gives a good description of the nut.

According to Varro (as recorded in Servius's commentary on Vergil's *Eclogues* 8.30), walnuts were scattered at weddings, celebrated under the auspices of Jupiter, to ensure that the bride would be as fertile as Juno. See also Vergil (*Eclogues* 8.30) and Pliny (*HN* 15.86) for the walnut as a fertility charm at weddings.

The walnut was not greatly favored as a food, but Pliny (*HN* 23.147) does say that freshly gathered nuts

FIGURE 100 Carbonized walnuts. Naples Museum. Photo: Alinari 19029.

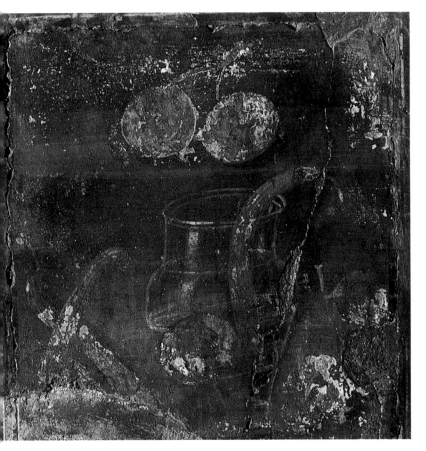

FIGURE 101 Painting of bottle gourds in the S portico, House of the Cervi, Herculaneum. Photo: S. Jashemski.

were more agreeable. Apicius, who makes generous use of other nuts in his recipes, calls for walnuts only twice (6.5.3, 9.13.2). But the walnut was greatly esteemed for medicinal purposes (Pliny *HN* 23.147–9; Dioscorides 1.178). Walnuts were also used for dyeing wool, and the young nuts were a source of red hair-dye (Pliny *HN* 15.87).

REMARKS

In Europe the walnut is indigenous to the Carpathian Mountains, the Balkan Peninsula, Romania, and Crete, then eastward to Turkey, Iraq, Iran, Afghanistan, and Pakistan, to the Himalayas. It is an introduced tree in Italy, but was known in the Vesuvian area in antiquity.

73. *JUNIPERUS* sp.
English, juniper; Italian, *ginepro*

MATERIAL EXAMINED

In the garden of the House of the Chaste Lovers (IX.xii.6, 7), excavated by the Superintendency at Pompeii, the carbonized wood found in six root cavities, 15 cm in diameter, was identified as *Juniperus* sp. (Ciarallo and Lippi 1993: 110–11).

REFERENCES IN ANCIENT AUTHORS

Pliny mentions the juniper briefly in a number of passages, but both Pliny and Dioscorides (1.103) speak highly of its medicinal uses. Pliny (*HN* 24.54) says that the juniper (*juniperus*) "even above all other remedies, is warming and alleviates symptoms." Dioscorides speaks of the juniper (ἄρκευθος) as a less prickly cedar, "bearing round fruit as big as that of myrtle berries."

REMARKS

In Italy six species of juniper trees are known.

74. *LAGENARIA SICERARIA* (MOLINA) STANDLEY (*L. VULGARIS* SER.)
English, bottle gourd; Italian, *zucca da vino*

WALL PAINTINGS

The bottle gourd is pictured twice at Herculaneum: in the S portico of the Casa dei Cervi (IV.21) there is one gourd in a tall glass vase and two outside the vase (Fig. 101); in the Samnite House (V.1–2) on the N wall of the cubiculum to the S of the entrance, there are two bottle gourds in a glass bowl (Fig. 102).

REFERENCES IN ANCIENT AUTHORS

Theophrastus (*Hist. pl.* 1.11.4, 1.13.3, 7.2.9) describes the bottle gourd (σικύα) and says that it takes its shape from the vessel in which it is grown (*Hist. pl.* 7.3.5). Pliny lists the bottle gourd (*cucurbita*) among the plants grown in the kitchen garden. In his long discussion of this vegetable (*HN* 19.69–74), he says that it grows rapidly, covering roofs and trellises with a light shade. It grows in various sizes and shapes, often that of a coiled serpent, mostly by means of sheathes of plaited wicker, in which it is enclosed after it has shed its blossom. Gourds are known to attain a length of three meters. It is used as food, when green, with the rind scrapped off or peeled. Mature gourds were used as containers for water or food. Pliny claims that the seeds nearest the neck of the plant produce long

FIGURE 102 Painting of bottle gourds, Samnite House, Herculaneum. Photo: S. Jashemski.

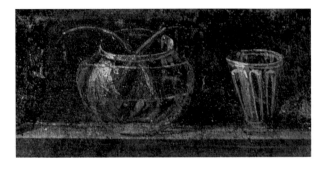

gourds, and that the seeds in the middle grow round gourds. Columella (*RR* 10.380–8, 11.3.49–50) gives much the same information. Propertius (4.2.43) speaks of it as being swollen at one end.

REMARKS

The bottle gourd is of African origin, but it spread to other parts of the old world in prehistoric times. It occurs in a wide diversity of forms, but only as a cultivated plant. It is used in many ways, as containers for carrying water and food and for storage of grain, and as musical instruments. At Pompeii young gourds are used as food.

75. *LAGURUS OVATUS* L.
English, hare's-tail grass, rabbit-tail grass; Italian, *piumino*

MATERIAL EXAMINED

Spikelets and single florets were found in the carbonized hay at Oplontis.

REMARKS

Hare's-tail grass occurs in dry waste places and disturbed ground in the Mediterranean region; it is extremely common in the Vesuvian area.

76. *LAPSANA COMMUNIS* L.
English, nipplewort; Italian, *lassana, grespignolo*

MATERIAL EXAMINED

A few capitula with achenes were found in the carbonized hay at Oplontis.

REMARKS

This weedy annual has ovate leaves and pale yellow florets. It occurs in low woodland and scrub areas throughout Europe.

77. *LATHYRUS APHACA* L.
English, yellow vetchling; Italian, *fior-galletto, vetriolo*

MATERIAL EXAMINED

Some legumes were found in the carbonized hay at Oplontis.

REFERENCES IN ANCIENT AUTHORS

Theophrastus (*Hist. pl.* 8.5.3) lists the *aphake* (ἀφάκη) among the leguminous plants having "flat pods and seeds." Pliny says, "Aphaca has very slender and tiny leaves. Taller than the lentil it also bears larger pods" (*HN* 27.38).

REMARKS

Yellow vetchling occurs along roadsides and hedges in the Mediterranean region.

78. *LATHYRUS CLYMENUM* L.
English, purple pea vine, purple vetchling; Italian, *cicerchia porporina*

MATERIAL EXAMINED

A number of legumes were found in the carbonized hay at Oplontis.

REMARKS

Purple vetchling is widespread in scrub and meadows in the maquis vegetation of the Mediterranean region.

79. *LATHYRUS SPHAERICUS* RETZ.
English, pea vine, vetchling; Italian, *cicerchia (sferica)*

MATERIAL EXAMINED

Numerous legumes were found in the carbonized hay at Oplontis.

REMARKS

The flowers are small and orange-red. The plant is widespread in the Mediterranean area.

80. *LAURUS NOBILIS* L.
English, bay tree, Grecian laurel; Italian, *alloro, lauro*

SCULPTURE

A stylized laurel tree is depicted on each side of a crown of oak leaves on the marble altar in the Temple of Vespasian, on the E side of the forum at Pompeii (Fig. 103). In 27 B.C. the Roman Senate voted that a civic crown of oak leaves should be placed above the door of the House of Augustus, and a laurel placed on each side of the door (*Res Gestae* 34; Dio Cassius 53.16; Ovid *Fasti* 3.137–9; Pliny *HN* 15.127 ff.; Martial 8.1). Coins of Augustus show the crown of oak leaves with the laurel on each side; these appeared on the coins of Vespasian and Titus after A.D. 74 (Mattingly 1960: pl. 28.1). There is an oak crown between two laurels above the door of the House of Messius Ampliatus (II.ii.4) on the Via dell'Abbondanza. The laurels, which were painted, are today scarcely visible, but a drawing in Spinazzola (1953: vol. 1, fig. 157, p. 134) shows them at the time of excavation. The stucco wreath is better preserved. Stucco laurel wreaths decorated two lararia in Pompeii: in the House of the Double Lararia (VII.iii.13) a large wreath (dia. 0.70 m) on the right-side wall of the lararium in the garden (Boyce, 1937: no.

FIGURE 103 Stylized laurel trees on the marble altar, Temple of Vespasian, Pompeii. Photo: S. Jashemski.

266, pl. 32.1), and in House V.iv.9 above and to the right of the lararium in the atrium (Boyce 1937: no. 124, pl. 4.5).

WALL PAINTINGS

Maiuri (1952: 8) identified laurel with berries in the garden paintings in the House of the Fruit Orchard in the room to the E of the atrium, and behind the fence in the paintings in the room off the W side of the peristyle. They are also pictured in the *diaeta* (Fig. 147) and in the water triclinium in the House of the Gold Bracelet.

The laurel was sacred to Apollo, and many paintings show the god crowned with laurel and holding a laurel branch (NM inv. no. 9541). Other paintings picture the attributes of Apollo such as the laurel branch, the cithaera, and the quiver (Helbig 1868: no. 191, gives many other examples). The Muses are also pictured with laurel crowns (see Helbig 1868).

GRAFFITI

A graffito on the N wall of the atrium in the Villa of the Mysteries shows a bald-headed old man crowned with laurel, and above are the small letters *Rufus est (imperator)* (*CIL* IV 9226). Another graffito at Pompeii shows a victorious gladiator crowned with a laurel wreath (Fiorelli 1875: xiii). In both graffiti the leaves in the crown are shown as distinctly opposite, not alternate, but we should not expect a hurriedly

drawn graffito to be botanically correct. It is also quite possible that such crowns were made by stitching leaves on a band.

REMAINS

The laurel was popular as a garden plant. Mau (1902: 295; see also Fiorelli 1862: *PAH* vol. 2, p. 253) reports that "the remains of a branch of laurel with the bones and eggs of a dove that had nested in it" were found in front of the two lararia in the large peristyle in the House of the Faun (VI.xii).

INSCRIPTIONS

Two amphoras (shape XII) bore the label LAVRIS (*CIL* IV 6048).

REFERENCES IN ANCIENT AUTHORS

The laurel is mentioned very often in Latin literature. Pliny the Younger had laurels at his Tuscan villa, even though they were sometimes killed by winter frost (*Letters* 5.6). Laurel crowns and branches figure importantly in Roman life. Victorious generals wore laurel crowns on their heads and carried laurel branches in their hands, while their lictors bore fasces bound with laurel. Pliny discusses at length the place of honor assigned to the laurel in triumphs (*HN* 15.133–7). Poets were crowned with laurel. The ancestral images were decorated with laurel on special family occasions (Cicero *Pro Murena* 88). Laurel leaves were eaten to give an individual the power to prophesy (Tibullus 2.5.63). A wet branch of laurel was used in lustrations, to sprinkle the objects to be purified (Juvenal 2.15). The custom of making a crown of laurel with berries for young scholars is the origin of the title baccalaureate. The laurel was also important in cooking. The recipes of Apicius (7.4.1, 7.5.2, 8.1.2, 8.1.10, 8.6.11, 8.7.9) use the laurel berry, as well as sprigs and shoots. The berries are usually counted out carefully. The laurel also had many medicinal uses (Pliny *HN* 23.152–8; Dioscorides 1.106).

REMARKS

The laurel is indigenous to and widespread in the Mediterranean region. It has been widely cultivated since antiquity and is common in the Vesuvian area. It is still used as a medicinal plant at Pompeii (Jashemski 1999: 63).

81. *LENS CULINARIS* MEDIKUS

English, lentil; Italian, *lente, lenticchia*

MATERIAL EXAMINED

Pompeii: carbonized seeds in the *deposito* (inv. no. 1893); Herculaneum: (1) in the Casa della Stoffa

(IV.19–20) (inv. no. 692), about 1 kg of well-preserved carbonized lentils; (2) in the Casa dei Due Atrii on Cardo III (inv. no. 2015), about 0.50 kg of carbonized lentils; Naples Museum: a dish of hulled lentils (without inv. no.).

INSCRIPTION

An amphora (style X) at Pompeii (VIII.v–vi.15) that contained lentils bore that label in Greek (φακαι) (*CIL* IV 6580).

REFERENCES IN ANCIENT AUTHORS

The lentil was an important food crop (Cato *RR* 35.1, 116; Columella *RR* 2.10.15; Vergil *Georgics* 1.228). Pliny (*HN* 18.123) says that the lentil (*lens*) was sown in the autumn or spring and that it likes a thin soil and a dry climate.

It was believed that a lentil diet caused an even temperament. Mixed with beets (of which the Romans used only the tops), they were made into a salad (Pliny *HN* 19.133). Apicius (4.4.2; 5.2.1–3) gives various recipes for lentils. The medicinal uses of the lentil were many (Pliny *HN* 20.75; 22.61, 142–7; Dioscorides 2.129). Pliny (*HN* 18.10) says the cognomen of the Lentulus family was given to them because they were the best growers of lentils.

REMARKS

The lentil did not reach Italy until the Iron Age. It is a cultigen known only in cultivation, with *L. orientalis* Popow as the wild progenitor.

82. *LEOPOLDIA COMOSA* (L.) PARL. (*MUSCARI COMOSUM* (L.) MILL.)

English, tassel hyacinth, purse tassel; Italian, *lampascione, cipollaccio*

MATERIAL EXAMINED

Some scape fragments and fruits were found in the carbonized hay at Oplontis.

REFERENCES IN ANCIENT AUTHORS

It is probable that the tassel hyacinth could be identified with one of the edible plants called *bolbos* (βολβός) by Greek authors and *bulbi* by Roman writers. Theophrastus makes frequent mention of the βολβός, which is "propagated by a piece root" (*Hist. pl.* 7.2.1). Among edible roots are the purse tassels (*Hist. pl.* 7.12.2). Pliny lists six different kinds of *bulbi*, "among which the most praised are those from Megara" (*HN* 19.93). The purse tassel is probably the edible plant "that is bitter and resembles the squill" that Dioscorides (2.200) calls the edible bulb (βολβός εδώδιμος). Apicius (7.14.1–4) also gives some recipes for using *bulbi*.

REMARKS

This plant occurs in grasslands and fields in the Mediterranean region. The bulbs are eaten as a vegetable in some Mediterranean countries.

83. *LILIUM CANDIDUM* L.

English, Madonna lily; Italian, *giglio di S. Antonio*

WALL PAINTINGS

The Madonna lily has been identified at five sites in Pompeii. In the unique ceiling painting in the House of the Calavii (I.vi.11) in a room off the E side of the atrium, lilies, roses, and smaller flowers are scattered at random (Fig. 80). It has also been found in three garden paintings and one tomb painting. The lily blossoms in the House of the Fruit Orchard, in the room off the E side of the atrium, in the narrow panel beside the window on the S wall, were badly preserved at the time of excavation, but four flowers, at different stages of development, are visible. On the garden wall in the House of Adonis (VI.vii.18), although badly faded, in 1966 it was possible, by putting water on the wall, to identify a lily, previously unreported, with at least five blossoms. Comes puts the Madonna lily on his list of doubtful plants. He overlooks the one in the House of Adonis, probably because it is not mentioned in the excavation report. He cites only one stylized marble flower, in the House of Cornelius (VIII.iv.15). The best-preserved lilies are found on the E wall of the *diaeta* in the House of the Gold Bracelet (Fig. 104).

The tomb of the young aedile Vestorius Priscus, just outside the Vesuvius Gate at Pompeii, has a badly preserved painting of the funeral banquet of this young man: it shows the scattering of flowers among which Spano identified two Madonna lilies and other flowers that appear to be crocuses (Fig. 105). Anchises, the father of Aeneas, called for lilies and purple blossoms to scatter on the shade of Marcellus (Vergil *Aeneid* 6.1280–2).

REFERENCES IN ANCIENT AUTHORS

Theophrastus has many references to the lily, which he calls *krinon* (κρίνον) or occasionally *leirion* (λείριον). Pliny says the lily was second only to the rose in fame (*HN* 21.23). He gives a beautiful description of the lily (*lilium*):

> No flower grows taller; sometimes it reaches three cubits, its neck always drooping under the weight of a head too heavy for it. The flower is of an exceeding whiteness, fluted on the outside, narrow at the bottom and gradually expanding in width after the fashion of a basket. The lips curve outwards and upwards all around; the slender pistil and stamens, the color of saffron, standing upright

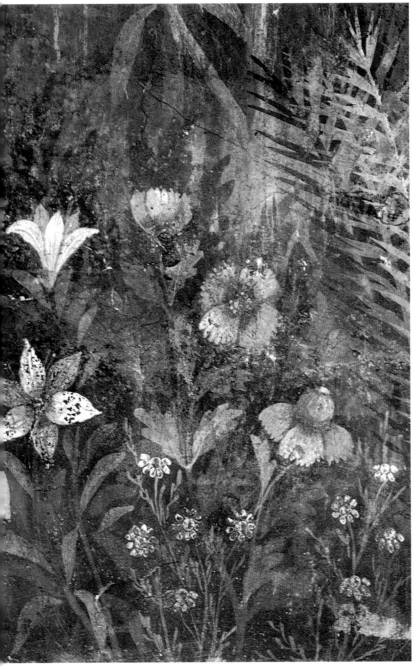

FIGURE 104 Painting of Madonna lilies, House of the Gold Bracelet. Foto Foglia.

FIGURE 105 Madonna lilies in a painting on the tomb of Vestorius Priscus, Pompeii. Photo: S. Jashemski.

in the center. So the perfume of the lily, as well as its color is two-fold, there being one for the corolla, and another for the stamens, the difference being slight. In fact when it is used to make ointment or oil the petals too are not despised.

HN 21.23

The Romans were able to enjoy, even in winter, both lilies and roses (Martial 4.22), as well as grapes; they were raised under glass in a greenhouse (Martial 4.18; see also nos. 143 and 183 here).

Pliny (*HN* 21.70) lists the lily as one of the flowers to be planted for bees; garden and chaplet flowers are closely associated with bee culture, which can be a source of great profit at a slight expense. Columella (*RR* 9.4.4) also lists the lily among the flowers loved by bees. He says white lilies (*candida lilia*) sown between the furrows in the garden make a brilliant show. Vergil (*Aeneid* 6.707–9) uses the simile of bees swarming around snow-white lilies and in the *Georgics* (4.130–1) mentions the white lilies in the garden of the old man Corycus. Varro (*RR* 1.35.1) gives the time for planting lilies.

The lily had various medicinal uses (Pliny *HN* 21.126–7, 133; 25.40). Dioscorides (3.116) calls this lily the royal lily (κρίνον βασιλικόν), and says it was used for making crowns, as well as for medicinal purposes.

REMARKS

The lily referred to by the classical authors was the Madonna lily. It was known in the twenty-sixth dynasty in ancient Egypt for making a perfume. Undoubtedly it was cultivated in the Vesuvian area at the time of the eruption. As a wild plant the Madonna lily occurs in Greece, the former Yugoslavia, and Turkey.

84. *LINUM BIENNE* MILL.

English, pale flax; Italian, *lino*

MATERIAL EXAMINED

Many capsules on stem fragments were found in the carbonized hay at Oplontis (Fig. 106).

REMARKS

Additional fragments make possible the more accurate identification of this material. Earlier designated as the flax plant *Linum usitatissium* L. (Ricciardi and Aprile 1988: 321), it can now be identified as *L. bienne*, which according to Zohary and Hopf (1994) is the wild progenitor of flax, since it shows close morphological and genetic affinities to that plant. Pale flax occurs in the Mediterranean Basin, western Europe, areas of North Africa, and the Near East. It also occurs in the Vesuvian area. Unlike flax, *L. bienne* has no economic value.

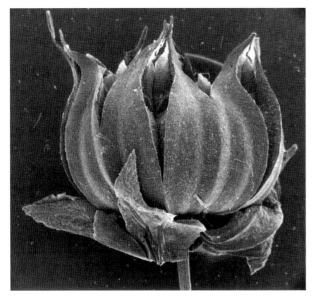

FIGURE 106 Pale flax in carbonized hay, Oplontis. SEM photo: F. Hueber.

85. *LOLIUM* sp.

English, ryegrass; Italian, *loglierella*

MATERIAL EXAMINED

Poorly preserved spikelets were found in the carbonized hay at Oplontis, but the identification to species of the material is not possible.

REFERENCES IN ANCIENT AUTHORS

Theophrastus has numerous references to darnel (αἴρα). Pliny regards darnel (*lolium*) "among pestilences of the soil" (*HN* 18.153). He quotes Vergil (*Georgics* 1.153) who calls darnel unfruitful, but Pliny points out that it had various medicinal uses (*HN* 22.160). Columella (*RR* 8.8.6) says it was one of the best foods for pigeons. Dioscorides (2.122) gives many medicinal uses of darnel and says it grows among wheat.

REMARKS

The carbonized material at Oplontis was probably either common darnel or perennial ryegrass (*L. perenne* L.), or poison darnel (*L. temulentum* L.). Both are widespread in Europe.

86. *LOTUS ANGUSTISSIMUS* L.

English, slender bird's foot trefoil; Italian, *ginestrino (sottile)*

MATERIAL EXAMINED

Many legumes and nearly whole plants with leaves, flowers, and fruits were found in the carbonized hay at Oplontis.

REMARKS

This plant occurs in open dry places in southern Europe, extending to southern England and northern Ukraine.

87. *LUPINUS ALBUS* L.

English, lupine; Italian, *lupino, canaioli*

INSCRIPTIONS

The lupine was grown at Pompeii, for a certain Felicio identifies himself as a *lupinarius,* or dealer in lupines, in an electorial notice (*CIL* IV 3423) in which he backed a candidate. In another election notice (*CIL* IV 3483) he calls himself a *lupinipolus,* apparently another term for a dealer in lupines.

REFERENCES IN ANCIENT AUTHORS

Theophrastus makes frequent mention of the lupine (θέρμος) and gives directions for sowing it; he says that it "is not eaten green by any animal" because of its bitterness (*Hist. pl.* 3.2.1, 8.1.3, 8.2.1, 8.5.2, 8.5.4, 8.7.3, 8.11.8).

Columella (*RR* 2.10.1) recommends the lupine (*lupinus*) ahead of all other legumes because it requires the least labor, costs less, and of all crops sown is the most beneficial to the land. It restores worn-out vineyards, flourishes in poor soil, is good fodder for cattle, and can be used by humans, too (in time of crop failure). Pliny (*HN* 18.135–6) speaks highly of the lupine as food for both men and hoofed quadrupeds. He gives detailed instructions for its culture and points out that fields and vineyards are enriched by a crop of lupines. He lists its various medicinal uses (*HN* 18.133–6; 22.154–7). In a very evocative passage he declares:

> She [Nature] had already formed the remarkable group of the Pleiads in the sky; yet not content with these she has made other stars on the earth as though crying aloud: Why gaze at the heavens, husbandman? . . . Lo and behold, I scatter special stars for you among the plants. . . . I have given you plants that mark the hours, and in order that you may not even have to avert your eyes from the earth to look at the sun, the heliotrope and the lupine revolve keeping time with him.
>
> *HN* 18.251–2

REMARKS

The lupine is a native of the Balkan Peninsula and Aegean region. It is found in the Vesuvian area as an introduced plant and is cultivated for its edible seeds and for fodder.

88. *LUPINUS ANGUSTIFOLIUS* L. subsp. *ANGUSTIFOLIUS*

English, blue lupine; Italian, *lupino selvatico*

MATERIAL EXAMINED

Many legumes were found in the carbonized hay at Oplontis.

REFERENCES IN ANCIENT AUTHORS

Theophrastus (*Hist. pl.* 1.3.6) also refers to the wild lupine as *thermos* (ϑέρμος) and describes it among the plants that "do not submit to cultivation at all." Pliny says, "There are also wild lupines, with weaker properties than the cultivated in every respect except their bitterness" (*HN* 22.154). He speaks of the merits of the wild lupine, listing its many medicinal uses (*HN* 22.154–7).

REMARKS

Blue lupine occurs in grasslands of the Mediterranean region.

89. *MALUS* sp.

English, apple; Italian, *melo*

MATERIAL EXAMINED

A small carbonized fruit, 125 mm in diameter, identified as *Malus,* about two-thirds intact, was found in situ in the N garden of the Villa of Poppaea at Oplontis (Jashemski 1979: 303; Meyer 1988: 212).

WALL PAINTINGS

The identification of a typical *Malus* fruit in a Vesuvian site is highly gratifying, since this helps to confirm our identification of apple fruit in numerous wall paintings. It is often pictured with one or two birds, as in the E room on the side of the atrium in the House of M. Lucretius Fronto (V.iv.a/11) and in the House of Ceius Secundus (I.vi.15), where two birds face the two apples between them, and in Shop I.vii.5, where a bird faces an apple. A still life in the House of Meleager (VI.ix.2) shows two apples on the lower level, with two dead birds in the window or shelf above.

The apple tree in fruit is pictured in the garden painting on the S wall in the House of Venus Marina (II.iii.3), to the right of the statue of Mars, in the left (E) panel, and to the right of the fountain in the W panel.

There are apples in paintings of various bowls or baskets of assorted fruit, as in the beautiful glass bowl of assorted fruit in the painting from the House of Julia Felix (Fig. 107). Apples are also depicted in garlands in three paintings in the Naples Museum (inv. nos. 9838, 9850, 9807) and in the garland in the Villa of the Mysteries.

MOSAICS

Apples are depicted in the garland framing the mosaic of a Cupid riding a lion from the House of the Faun (NM inv. no. 9991).

FIGURE 107 Apples in a bowl of fruit, House of Julia Felix, Pompeii (NM inv. no. 8611). Photo: S. Jashemski.

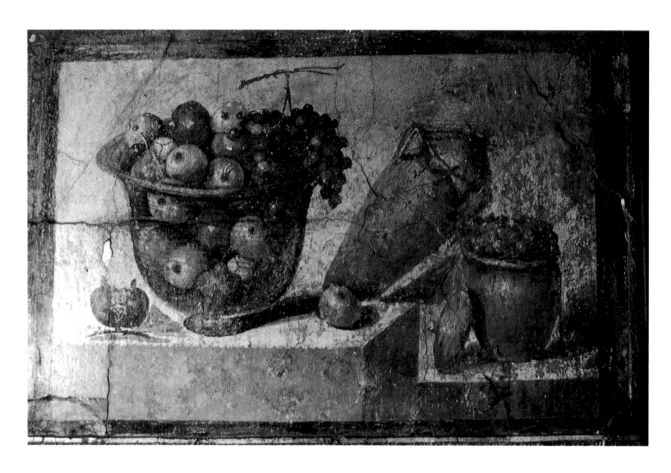

REFERENCES IN ANCIENT AUTHORS

Malus was the classical Latin name for the apple. Theophrastus has many references to the apple. Dioscorides gives the medicinal uses of both the apple, *melea* (μηλέα) (1.159), and wild crabapples (’αγρι-όμηλα) (1.163). Pliny mentions a number of apple varieties growing in Italy, also the wild apple with a “horrible sourness . . . so powerful that it will blunt the edge of a sword” (*HN* 15.52). Apicius gives directions for keeping apples fresh (1.12.2) and for using them in cooking (4.3.4).

REMARKS

According to Zohary and Hopf (1994), apples were extensively grown in the Old World in classical times, but later than the olive, date, and grape. The apples of Pompeii were undoubtedly all of the cultivated class. Authorities agree that the cultivated apple was derived from wild apple ancestors found in southeastern Europe, the Caucasus, and the Near East. It is still widely grown in the Vesuvian area.

90. *MALVA SYLVESTRIS* L.

English, wild mallow, cheese flower; Italian, *malva*

MATERIAL EXAMINED

Branches bearing leaves, pollen, and fruit were found in the carbonized hay at Oplontis (Fig. 108).

REFERENCES IN ANCIENT AUTHORS

Theophrastus (*Hist. pl.* 7.7.2) says the mallow *malache* (μαλάχη) is one of the plants suitable for food that “need the action of fire.” Pliny says: “both kinds of mallow (*malva*), the cultivated and the wild are highly praised” (*HN* 20.222). Dioscorides (2.144) also knew the wild mallow “growing in abandoned fields.”

REMARKS

Wild mallow occurs as a weed along roadsides in disturbed ground and waste places throughout most of Europe. Flowers are pink to purple with darker veins. It is common in the Vesuvian area. The fresh leaves collected during flowering are used medicinally and also as an herbal tea (Jashemski 1999: 68).

91. *MATTHIOLA INCANA* (L.) R. BR.

English, stock; Italian, *violacciocca*

WALL PAINTINGS

The shape of the inflorescences and the leaves, as well as the thickness of the root, of the stylized plant preserved in the drawing and painting of a no longer preserved wall painting in the lower peristyle of the Villa of Diomede at Pompeii suggests the stock (Fig.

FIGURE 108 Wild mallow pollen in carbonized hay, Oplontis. SEM photo: F. Hueber.

109). One would expect stock to be pictured, for it was a very important coronary flower.

REFERENCES IN ANCIENT AUTHORS

The white violet described by Theophrastus and Pliny is the stock. Theophrastus contrasts the white violet with the black one (see no. 182), saying that the white violet (’ίον τὸ λευκόν) is sweet-scented, has woody roots, has leaves on the stem, varies in color, and has a life of up to three years (*Hist. pl.* 6.6.2–3, 6.8.5, 7.8.3). Pliny (*HN* 21.27) says that there are several kinds of violet (*viola*); the white violet is a cultivated species. The “violet beds” (*violaria*) mentioned by the ancient authors were probably the stock. Pliny (*HN* 21.131) gives various medicinal uses of the white violet (*viola alba*). Columella (*RR* 9.4.4, 10.97) lists the stock

FIGURE 109 Stock, butterfly, and swallow in the lower peristyle, Villa of Diomede, Pompeii.

(*leucoion*) among the flowers planted in the garden. Dioscorides (3.138) describes stock (λευκόϊον) as having flowers that are white, azure, purple, and yellow. The yellow one, which he says is best for medical use, is probably the wallflower, *Cheiranthus cheiri* L.

REMARKS

Stock is a short-lived perennial or biennial; flowers are white, pink, violet, or purple and sweet-scented, especially in the evening. It occurs on seaside rocks in southern and western Europe, and is widely cultivated elsewhere.

92. *MEDICAGO ARABICA* (L.) HUDSON
English, spotted alfalfa, yellow trefoil; Italian, *erba medica (araba)*

MATERIAL EXAMINED

A few legumes were found in the carbonized hay at Oplontis.

REMARKS

Spotted alfalfa occurs in waste places and is widely spread in southern Europe. It is indigenous to the Vesuvian area.

93. *MEDICAGO INTERTEXTA* (L.) MILL.
English, (twisted) alfalfa; Italian, *erba medica (intrecciata)*

MATERIAL EXAMINED

Many legumes were found in the carbonized hay at Oplontis.

REMARKS

This plant occurs in the Mediterranean area to Portugal.

94. *MEDICAGO LUPULINA* L.
English, hop clover, yellow clover; Italian, *lupulina*

MATERIAL EXAMINED

A few well-preserved fruiting shoots were found in the carbonized hay at Oplontis.

REMARKS

This clover occurs in dry pastures and meadows throughout Europe. It is indigenous to the Vesuvian area, and is occasionally cultivated as a green fodder for livestock and for hay.

95. *MEDICAGO MINIMA* (L.) BARTAL.
English, little alfalfa, black medic; Italian, *erba medica (minima)*

MATERIAL EXAMINED

A few legumes were found in the carbonized hay at Oplontis.

REMARKS

This species is widespread in dry open habitats in many parts of Europe. It is indigenous to the Vesuvian area.

96. *MEDICAGO ORBICULARIS* (L.) BARTAL.
English, button clover; Italian, *erba medica (orbicolare)*

MATERIAL EXAMINED

Many legumes were found in the carbonized hay at Oplontis.

REMARKS

This plant occurs in meadows and sunny slopes of the Mediterranean region.

97. *MEDICAGO TRUNCATULA* GAERTNER
English, (truncated) alfalfa; Italian, *erba medica (troncata)*

MATERIAL EXAMINED

A few legumes were found in the carbonized hay at Oplontis.

REMARKS

This species closely resembles *Medicago intertexta* (L.) Mill. It grows in hedges and scrub margins of the Mediterranean region.

98. *MORUS NIGRA* L.
English, mulberry; Italian, *gelso nero, gelso moro*

WALL PAINTINGS

The mulberry in fruit is pictured twice in the garden paintings of the House of Venus Marina (II.iii.3). On the S wall, E panel there is a mulberry tree in front of which a heron is standing; the song thrush perched on the stylized pine at the right is eating a mulberry fruit (Fig. 300). There is a similar tree behind the fountain in the garden painting on the outside of the N wall of the little room jutting into the SE corner of the garden (Fig. 110). The artist portrays the leaves in a very stylized manner, those of the apple and mulberry tree in the same house being much alike. This is the first time the mulberry has been identified in Campanian garden paintings.

REFERENCES IN ANCIENT AUTHORS

The mulberry (συκάμινος) is mentioned by Theophrastus in various passages. He says the fruit has

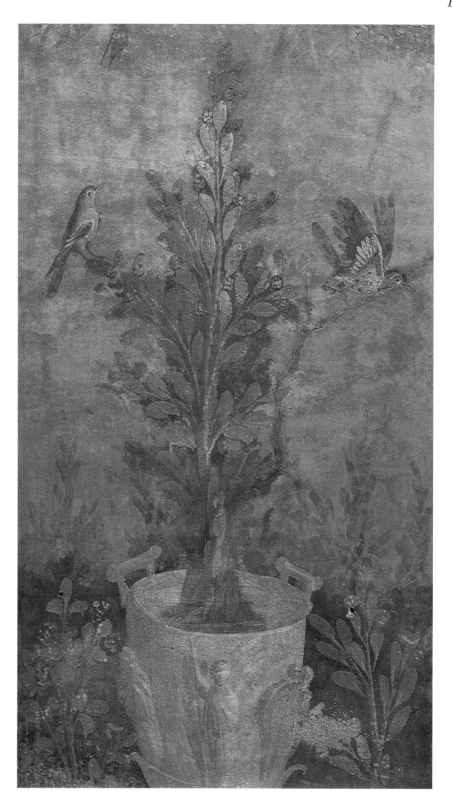

FIGURE 110 Mulberry tree, House of Venus Marina. Song thrush in flight at right. Photo: S. Jashemski.

the flavor of wine (*Hist. pl.* 1.12.1). Pliny has many references to this tree (*morus*). As he says, it

> buds the latest among cultivated trees and only when cold weather is over . . . , owing to which it has been called the wisest of trees; but when its budding has begun it breaks out all over the tree so completely that it is completed in a single night with a veritable crackling (*HN* 16.102). . . . When you see the mulberry budding, after that you need not fear damage from cold.
>
> *HN* 18.253

Pliny the Younger (*Letters* 2.17) says that the garden of his Laurentine villa was thickly planted with mulberry and fig trees. The mulberry had many medicinal uses (Pliny *HN* 27.57, 34.133; Dioscorides 1.180).

REMARKS

The mulberry with dark purple fruit is an early introduction in Italy and elsewhere in Europe. It is widely cultivated for its fruit and it is considered to be a native of central Asia.

99. *MUSHROOMS*

English, mushroom; Italian, *funghi*

WALL PAINTINGS

Mushrooms (*fungi* of the class Basidiomycetes) have been found in three wall paintings. These were examined by Kent H. McKnight and others of the Mycology Laboratory at the U.S. Department of Agriculture Research Center at Beltsville, Maryland, who report that none of these mushrooms can be accurately identified to genus and species. Genera can often be recognized by microscopic detail, but such details are not present in the wall paintings. We can be sure they were edible, for they are pictured with food.

The still life from Herculaneum, now in the Naples Museum (inv. no. 8647) (Fig. III) and one of four framed together, shows on the lower level five mushrooms (and above, three dead thrushes), which the mycologists report are probably one of the stipitate Hydnaceae, such as *Dentium repandum* (Fr.) S. F. Gray or possibly a chanterelle such as *Cantharellus cibarius* Fr.

A still life, in the room to the right of the fauces, in the Casa del Mobilio Carbonizzato (V.5) at Herculaneum pictures on the far right, on the upper level, two mushrooms "very likely a member of the Boletaceae, possibly a species of *Boletus* or *Leccinum*," according to McKnight. The two mushrooms to the far right on the lower level cannot be identified. A still life in the House of the Dioscuri (VI.ix.6), on the W wall of the S peristyle, shows a basket containing fruit, a pinecone, and on the right, next to a bunch of grapes, a mushroom that, according to McKnight, could be a species of *Boletus*.

REFERENCES IN ANCIENT AUTHORS

Theophrastus distinguishes the mushroom and truffles (μύκης) from green plants (*Hist. pl.* 1.11.1); as an example of a plant with a very smooth stem (*Hist. pl.* 1.5.3); among plants that have no roots (*Hist. pl.* 1.6.5); and as growing from the roots of oaks or beside them (*Hist. pl.* 3.7.6). Pliny has many references to the mushroom, which he refers to several times as *boletus*, but most often as *fungus*. He says the most esteemed mushrooms (*boleti*) grow around the roots of the oak (*HN* 16.31). The entire life of mushrooms (*boleti*) from beginning to end is not more than seven days (*HN* 22.95). "Among the things which it is rash to eat, I would include mushrooms (*boleti*) . . . although they make choice eating" (*HN* 22.92). Few of his references are descriptive. In his longest passage (*HN* 22.96) he says:

> . . . the texture of mushrooms (*fungi*) is rather flabby, and there are several kinds of them. . . . the safest have firm red flesh, less pale than that of the *boleti*.

Comes (1879) says this mushroom is the one pictured in the Naples Museum (inv. no. 8647), which he incorrectly identifies as *Agaricus deliciosus* L. Pliny continues:

> next comes the white kind, the stalk of which is distinguished by a kind of flamen's cap; a third kind, hog *fungi* are very well adapted to poisoning. . . . What great pleasure can there be in such a risky food?
>
> *HN* 22.96

Pliny describes some of the poisonous mushrooms (*boleti*) as easily recognizable by their being of a pale red

FIGURE III Mushrooms and three dead thrushes above in a still-life painting. Partridge hanging on left and two quinces (NM inv. no. 8647). Photo: S. Jashemski.

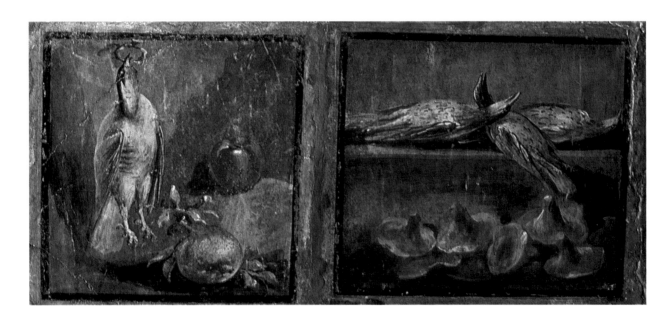

color, of a putrid appearance, and of a leaden hue inside (*HN* 22.92). The Romans were well aware of poisonous mushrooms. In fact, most of Pliny's numerous references to mushrooms are in connection with antidotes for mushrooom (*fungi*) poisoning. He admits, however, that mushrooms were considered a delicacy, "the only kind of food that keenly appreciative individuals prepare with their own hands, feeding on them in anticipation and handling them with amber knives and equipment of silver" (*HN* 22.99). Apicius gives a number of recipes for preparing *fungi* and *boleti* (7.15.1–6).

REMARKS

Wild mushrooms are still widely used for food in many parts of Europe.

100. *MYRTUS COMMUNIS* L.
English, myrtle; Italian, *mirto*

PLANT MATERIAL

A large bowl of carbonized myrtle berries from Pompeii in the Naples Museum (inv. no. 84674?) is known only from an Alinari photo, no. 19030 (Fig. 112). The original material has been lost.

WALL PAINTINGS

The myrtle, sometimes in flower, appears very often in the wall paintings, as a specimen plant, in wreaths, garlands, and crowns, and in garden paintings. Only a few typical examples will be cited. Beautifully painted myrtle bushes with opposite leaves and white flowers, represented by clusters of white dots, can be seen in the House of Ceius Secundus (I.vi.15) at the base of the garden wall, along with mounds of ivy; in the House of the Centenary (IX.viii.3/6) at the base of the E and the N walls in the room off the NE corner of the peristyle; and also in the Naples Museum painting inv. no. 8758. A realistic wreath of myrtle leaves and white blossoms frames the small round sacred landscape on the N wall of the atrium of the House of the Lovers (I.x.10–11).

The garden paintings on each side of the door on the N wall of the Garum Shop (I.xii.8) represent a myrtle thicket with white blossoms, and they are framed by a myrtle garland (Jashemski 1979: 130–1, 195). Myrtle bushes with white buds or blossoms are also pictured in the garden paintings in the room off the atrium in the House of the Fruit Orchard, on the N and S walls, and perhaps on the N, E, and W walls in the room off the peristyle. There is a myrtle with white flowers in the garden painting on the S wall in the House of Venus Marina (Fig. 300).

The Three Graces are pictured wearing myrtle crowns and carrying myrtle twigs in the Naples

FIGURE 112 Carbonized myrtle berries (NM inv. no. 84674?). Photo: Alinari 19030.

Museum painting inv. no. 9235 (Fig. 113). The participants in the wedding celebration pictured in the Villa of Mysteries appropriately wear myrtle crowns.

EARTHENWARE

The myrtle is portrayed on a pair of two-handled glazed earthenware *canthari* (handled drinking vessels) in the Naples Museum (inv. nos. 13315, 13316) (Fig. 114). The berries are shown in profile and are very realistically portrayed; the flowers are modeled individually and shown with a frontal view. The cup illustrates the description of Pliny (*HN* 16.112) in which he says the myrtle "bears fruit both on the sides and at the end of their branches."

BRONZE

Two myrtle berries and leaves decorate a bronze lamp in the Naples Museum (without inv. no.) (Roux and Barré 1875–7: pl. 10).

MOSAIC

A sprig of myrtle shows two carefully depicted berries and five leaves; there are four fish above and three ducks below (Fig. 234).

REFERENCES IN ANCIENT AUTHORS

The myrtle (*myrtis, mirtum*) is mentioned frequently by both the prose writers and the poets. Cato (*RR* 8.2) lists the myrtle as one of the flowers for crowns or garlands that should be grown in a garden located near a town. Pliny (*HN* 15.118–26) has a long discussion of the myrtle but incorrectly includes other plants, such as the wild myrtle, which is butcher's broom (*Ruscus aculeatus* L.).

The myrtle quite properly adorns Pompeii, the city

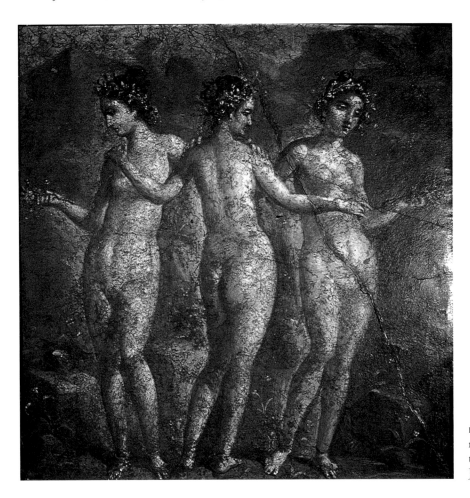

FIGURE 113 Three Graces wearing myrtle crowns and carrying myrtle twigs (NM inv. no. 9235). Photo: S. Jashemski.

of Venus, for the myrtle was sacred to her (Pliny *HN* 12.3, 15.119–20; Vergil *Eclogues* 7.61–2). Vergil (*Georgics* 1.28) bids Augustus encircle his brow with his mother's sacred myrtle. According to Ovid (*Fasti* 4.141–4), when Venus was born from the sea she hid among the myrtles so the satyrs would not see her nude. The myrtle was the symbol of lovers and their poets.

A myrtle wreath was worn by generals celebrating an ovation, as well as a triumph, but the laurel was especially assigned to triumphs (Pliny *HN* 15.125).

FIGURE 114 Earthenware drinking cup decorated with myrtle. Naples Museum. Photo: S. Jashemski.

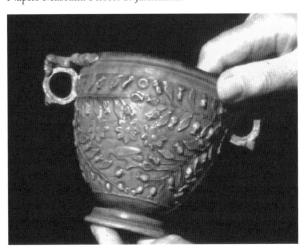

The myrtle berry was a source of both wine and oil (Columella *RR* 12.38.1–8; Pliny *HN* 15.118, 123). Pliny says that the myrtle berry took the place of pepper, before black pepper was known in Italy. Myrtle berries were used frequently by Apicius. This may explain their presence in the mosaic in which they are shown with fish and ducks (Fig. 234). Pliny (*HN* 15.124; 23.87, 159–64) and Dioscorides (1.155) list the various medicinal uses of myrtle.

REMARKS

The myrtle is one of the most widespread and common shrubs in the Mediterranean maquis. Myrtle berries are a basic ingredient in a popular tonic at Pompeii (Jashemski 1999: 72).

101. *NARCISSUS* sp.

English, narcissus, Italian, *narciso*

WALL PAINTING

The shape and length of the corona of a flower in a no longer extant painting in the lower peristyle of the Villa of Diomede at Pompeii suggests the common daffodil, *Narcissus pseudonarcissus* L. (Fig. 115). The leaves and stem of the plant are incorrectly depicted, but Roman painters were notoriously careless in this respect.

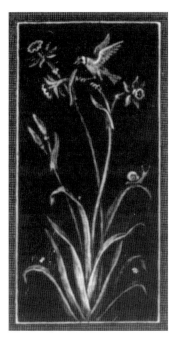

FIGURE 115 Narcissus painted in the lower peristyle, Villa of Diomede, Pompeii. Photo: S. Jashemski.

REFERENCES IN ANCIENT AUTHORS

The ancient authors make various references to the narcissus, or flowers that have been so designated, but it is difficult to identify the species referred to. Theophrastus (*Hist. pl.* 6.8.1) knew different types of narcissus (νάρκισσος). He lists a narcissus that flowers in the spring, which the Loeb editors identify as the pheasant's eye (*Narcissus poeticus* L.), and the polyanthus narcissus (λείριον), identified as *Narcissus tazetta* L. He also mentions a narcissus that blooms very late (*Hist. pl.* 6.6.9), as does Pliny (*HN* 21.25), perhaps (*N. serotinus* L.).

Dioscorides (4.101) describes the narcissus as having leaves like the leek, but much smaller and narrower, longer than a span, on which is a white flower with a center of saffron color, or sometimes purple. It grows best in hilly places and has a good scent. The roots are bulbous. He gives various medicinal uses. This is a good description of the pheasant's eye narcissus.

Pliny says scent is no longer made from the narcissus flower (*HN* 113.6); oil is made from the narcissus (*HN* 15.30).

Ovid (*Met.* 3.402–510) recounts the tale of the beautiful Narcissus, who fell in love with his image reflected in a clear pool; he wasted away because of unrequited love and was changed into the flower with "yellow center girt with white petals" that bears his name.

REMARKS

N. pseudonarcissus grows wild today in Italy and can be found in Capri and on the Alburni Mountains in the province of Salerno. Saccardo (1909) lists this species among the plants known by the ancient Romans.

102. *NELUMBO NUCIFERA* GAERTNER

English, sacred lotus, Indian lotus; Italian, *loto egizio, fior di loto*

MOSAICS

The sacred lotus is beautifully represented in the famous Nile mosaic from the House of the Faun (NM inv. no. 9990) (Fig. 352). The leaves, flowers, buds, and seed pods are individually portrayed. It is less carefully pictured in a small mosaic with four ducks (NM inv. no. 9983).

WALL PAINTINGS

The sacred lotus can also be identified in Egyptian paintings such as those in the House of the Pygmies and in a painting with a hippopotamus (NM inv. no. 8608). Many small paintings show ducks and lotus leaves that are less realistically painted, such as those in the House of the Centenary and in the House of the Vettii.

REFERENCES IN ANCIENT AUTHORS

The sacred lotus was known in Egypt by the time of Herodotus, who gives a good description of it:

> Other lilies also grow in the river, which are like roses; the fruit of these is found in a calyx springing from the root by a separate stalk, and is most like to a comb made by wasps; this produces many eatable seeds as big as an olive-stone, which are eaten both fresh and dried.
>
> *The Persian Wars* 2.92

According to Pliny, who mentions the lotus only twice, it was grown in Italy by his time. In one passage he calls it the Egyptian bean (*faba Aegyptia*):

> It also grows in Egypt where it has a thorny stalk which makes the crocodiles keep away from it for fear of injuring their eyes. The stalk is six meters long at most and the thickness of a finger: if it had knots in it, it would be like a soft reed; it has a head like a poppy, is rose colored, and bears not more than 30 beans on each stalk; the leaves are large; the actual fruit is bitter even in smell, but the root is a very popular article of diet with the natives, and is eaten raw and cooked in every sort of way; it resembles the roots of reeds. The Egyptian bean grows also in Syria and Cilicia, and at the Lake of Torone in Chalcidice.
>
> *HN* 18.121–2

In the second passage he calls it *colocasia*, a name by which it was also known:

> In Egypt the most famous plants of this kind [i.e., wild plants used for food] is the *colocasia*, called by

some *cyamos;* they gather it out of the Nile. The stalk of the stem when boiled and chewed breaks up into spidery threads, but the stem itself is handsome, jutting out from leaves which, even when compared with those of trees, are very broad. . . . So much do the people of the Nile appreciate the bounty of their river that they plait *colocasia* leaves into vessels of various shapes, which they consider make attractive goblets. The *colocasia* is now grown in Italy.

HN 21.87

Dioscorides (2.128) gives a good description of the sacred lotus, which he calls the Egyptian bean (Αἰγύπτιος κύαμος). He calls its root *colocasia* (κολοκασία). Columella (*RR* 8.15.4), speaking of the *colocasia*, which he, too, calls the Egyptian bean, says that "the middle part of the pond should be made of earth, so that it may be sown with the *colocasia* and other green stuff which lives in or near water and provides shade for the haunts of the waterfowl."

The small paintings of ducks shaded by the sacred lotus very likely record a common scene in the Italian countryside. Dioscorides (2.128) gives the medicinal uses of the sacred lotus. *Colocasia* today refers to a tropical plant, especially *Colocasia esculenta* (L.) Schott, the taro.

REMARKS

The sacred lotus is a widespread Asian plant. It made its way to Egypt from India during the Persian period (Hepper 1990: 11). The sacred lotus has many uses in addition to its beautiful flowers. Both the root and seed are eaten widely in Asia.

103. *NERIUM OLEANDER* L.
English, oleander; Italian, *oleandro*

WALL PAINTINGS

The oleander is the plant most frequently found behind the painted fence in the garden paintings. We mention only a few examples at Pompeii: in the House of the Fruit Orchard, in the room off the E side of the atrium, in the center of the center panel on the S wall; also on the other two panels on this wall; in the center panel of the E wall and to the right of the door on the W wall; and on the W wall of the room off the E side of the peristyle. There are beautifully painted oleanders on the N and E walls in the *diaeta* of the House of the Gold Bracelet (Fig. 116); those on the S wall are only partially preserved, as are those on the S wall of the adjacent water triclinium. See also the garden painting in the House of Romulus and Remus (VII.vii.10), in the House of Venus Marina, and at Herculaneum, in the Casa del Tramezzo di Legno (III.11). It can be seen in the panels with garden details that separate the ani-

FIGURE 116 Oleander, jay, and strawberry tree, House of the Gold Bracelet. Foto Foglia.

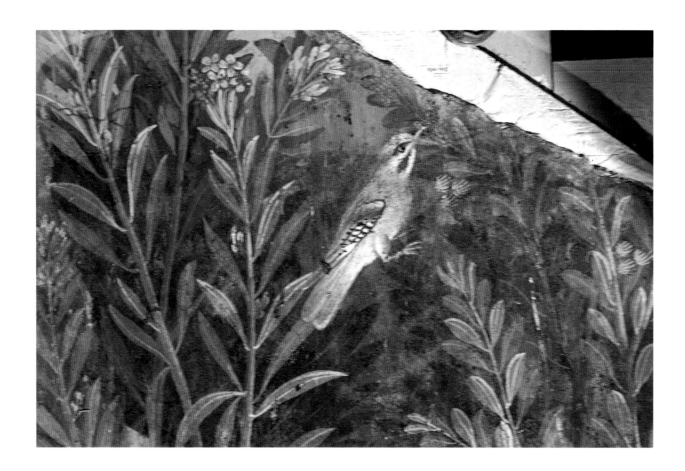

Plants

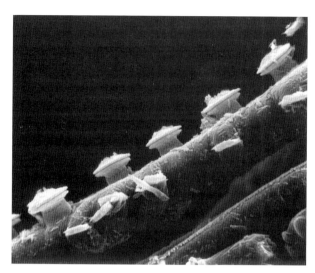

FIGURE 117 Vessel elements of wood from an oleander branch, Villa of Poppaea, Oplontis. SEM photo: F. Hueber.

mal paintings in the Gladiatorial Barracks (V.v.3) at Pompeii.

MATERIAL EXAMINED

Many fragments of carbonized oleander wood were found in the sculpture garden of the Villa of Poppaea at Oplontis (Fig. 117).

IMPRINT OF LEAF

The cast of an imprint of an oleander leaf found in the Villa of S. Marco at Stabiae is now in the Antiquarium at Boscoreale (inv. no. 497/1).

REFERENCES IN ANCIENT AUTHORS

Theophrastus (*Hist. pl.* 1.9.3) lists the oleander among the wild trees that are evergreen and calls it wild daphne (ἀγρία δάφνη), distinguishing it from true daphne. It is rarely mentioned by the Latin authors. Pliny (*HN* 16.79, 24.90) describes the oleander (*rhododendron*) briefly as an evergreen that resembles a rose-tree and throws out shoots from the stem. He notes that it did not even have a Latin name; the Greek names *rhododendron* (rose-tree), *rhododaphne* (rose-bay), and *nerion* were used. Dioscorides (4.82) calls it *nerion* (νήριον), but says that some call it *rhododaphne* (ῥοδοδάφνη), some *rhododendron* (ῥοδόδενδρον). He describes it as a shrub, having longer and thicker leaves than the almond, but the flower like a rose, and a fruit like that of the almond, as with a horn, which being opened is full of a downy nature, like thistle-down, with a sharp-pointed and long, woody root. He says that it grew in areas along the sea, and along rivers, but he also knew it as an ornamental shrub in gardens ("enclosed greens"), so we cannot assume that it was not used because it is only infrequently mentioned. The many fragments of carbonized oleander wood found in the sculpture garden

in the Villa of Poppaea at Oplontis shows that it was a valued garden plant. Pliny (*HN* 17.98) gives directions for growing it both by layering and from seed.

The flowers of the oleander were used in making chaplets, but it was not one of the flowers most commonly used for this purpose (Pliny *HN* 21.51). Both Dioscorides (4.82) and Pliny (*HN* 24.90) say that the leaves are poisonous to quadrupeds, sheep, and goats; if they drink the water in which these leaves have been steeped they will be killed by it. In a district in Pontus, honey made from oleanders was poisonous (Pliny *HN* 21.77). Even so, the oleander had medicinal uses (Pliny *HN* 24.90; 26.111, 146 *oenothera* = oleander).

REMARKS

The oleander is found throughout the Mediterranean area, from southern Portugal east to India, occurring usually in riverbeds and along streams. It is also abundant in North Africa.

The Linnean name, *Nerium oleander*, is Greek in origin, with the generic name derived from the Greek word for water, νήρος, because of the natural habitat of the plant; and the specific epithet derived from the Greek root meaning to kill (ολ-, from ολλύω) and man (ἀνήρ, ἀνδρός). Because of the well-known toxicity of the plant, in the Vesuvian area the vernacular name "flowers of the dead" (*fiori di morto*) retains the Greek meaning of its name.

104. *NYMPHAEA ALBA* L.

English, white water lily; Italian, *ninfea*

WALL PAINTINGS

The flower of the large white water lily is pictured on the upper wall in the N room on the W side of the peristyle in the House of M. Obellius Firmus (IX.(xiv).4/2).

MOSAIC

Three nymphaea buds are pictured in a mosaic from the House of the Faun (NM inv. no. 9993).

REFERENCES IN ANCIENT AUTHORS

Pliny (*HN* 25.75–6) gives a good description of the white water lily, which he calls *nymphaea*:

It grows in watery places, with large leaves on top of the water and others growing out of the root; the flowers are like the lily, and when the blossom is finished a head forms like that of a poppy; the stem is smooth.

The water lily had many medicinal uses (Pliny *HN* 25.132; 26.32, 44, 45, 76, 81, 94, 144, 163; Dioscorides 3.148).

REMARKS

The white water lily is found throughout Italy today and was known to the ancient Romans. It is still used in Italy as a medicinal plant. It occurs throughout most of Europe.

105. *NYMPHAEA* sp.

English, lotus; Italian, *ninfea*

MOSAIC

Two leaves are depicted floating on the water in the Nile mosaic from the House of the Faun (NM inv. no. 9990). A frog sits on the upper leaf (Fig. 274). Without flowers the identification of this water lily is not possible. It could be either the white water lily (*N. lotus* L.) or the blue water lily (*N. coerulea* Savigny), both of which occur in Egypt.

106. *OLEA EUROPAEA* L.

English, olive; Italian, *olivo*

MATERIAL EXAMINED

At Pompeii, the following carbonized material was found in situ: (1) in an ancient vineyard (III.vii), two fragments of olive stone (Jashemski 1993: 104); (2) in a vineyard II.v, two nearly whole skeletonized olives (Jashemski 1979: 210, fig. 308, p. 211); (3) in a small garden I.xxi.3, two small fragments of olive stone (Jashemski 1993: 72); (4) in the *deposito*, one sample (without inv. no.), carbonized whole olive stones; another sample (without inv. no.), whole carbonized olive fruit. Naples Museum: a dish of well-preserved carbonized olives (without number).

Schouw reported in 1859 that a glass had been dug up at Pompeii containing preserved olives, which agreed perfectly with modern olives. A glass filled with olives was also found in the garden of the Casa del Marinaio (VII.xv.2) (excavated in 1872). According to Fiorelli (1875) they were in the Naples Museum, but this material can no longer be found. At Herculaneum in the Casa del Salone Nero (VI.13/11) (inv. no. 940), several hundred carbonized olives are preserved.

A single wood cell from a big branch in the N garden of the Villa of Poppaea at Oplontis was identified by Hueber as olive. (Jashemski 1979: 300, figs. 456, 457, and 483; 1993: 296–7). In the *villa rustica* at Boscoreale, one whole fruit, fruit fragments, and broken olive stones were found (Jashemski 1993: 288); in the carbonized hay at the *villa rustica* at Oplontis, carbonized olive leaves were found.

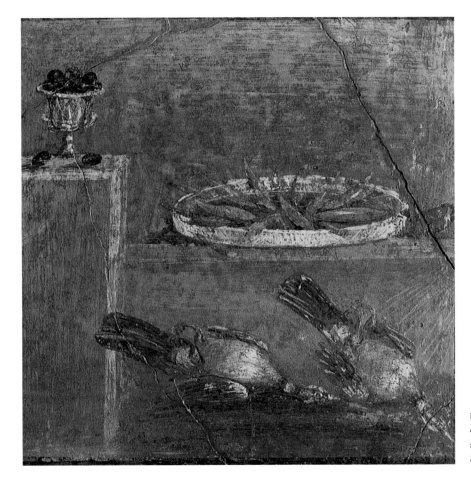

FIGURE 118 Footed dish of black olives, fish, and turtledoves in a still-life painting (NM inv. no. 8634). Photo: S. Jashemski.

INSCRIPTIONS

The olive was one of the most valuable crops of ancient Italy. Labeled containers are evidence of olives sold and stored. A small two-handled vase was labeled OLIVA ALBA DVLCE P.C.E. (*CIL* IV 2610). An amphora found in the peristyle of the House of M. Gavius Rufus (VII.ii.16) still had the label OLIVA (*CIL* IV 5598b). The fragment of another amphora had the label OLIVAS (*CIL* IV 5762).

WALL PAINTINGS

In spite of the great importance of the olive, it is seldom pictured. A still-life painting from Pompeii (NM inv. no. 8634) shows a footed dish full of black olives with two olives by the foot (Fig. 118). Comes (1879: 49) reported several examples of olive trees in paintings no longer preserved.

SILVER

A silver cup found at Pompeii, a part of the silver hoard in the House of Menander (I.x.4), has olives with leaves sculptured in high relief and realistic enough to be a botanical model (Fig. 119; NM inv. no. 25514).

REFERENCES IN ANCIENT AUTHORS

The olive (*olea*) is mentioned frequently in Latin literature. Ovid (*Fasti* 5.265) says, "If the olive-trees have blossomed well, most buxom will be the year." According to Pliny (*HN* 15.1), the olive was introduced to the Romans by the Greeks during the reign of Tarquinius Priscus, but it seems likely that it was introduced into Magna Graecia and Sicily prior to this time. Pliny (*HN* 15.1–24) continues with a detailed discussion of the distribution of the olive, its culture, the production of olive oil, and the uses of the olive. He describes eleven varieties known by the Romans. He says that the best olive oil in the world was produced in the district of Venafro. Imported olives, however, from Egypt and Syria were preferred for the table to those grown in Italy. Not only was the olive an important food (olive oil was the ancient equivalent of butter), but it served as the substitute for soap, for use in the baths, for ointment, and as fuel for lamps. The olive also had many medicinal uses. Most parts of the plant were used: the leaves, flowers, fruit, bark of the root, ash of the tree, and the oil, especially the green oil (Pliny *HN* 23.69–75; Dioscorides 1.138, 139). The olive branch was the well-known symbol of peace (Vergil *Aeneid* 8.116).

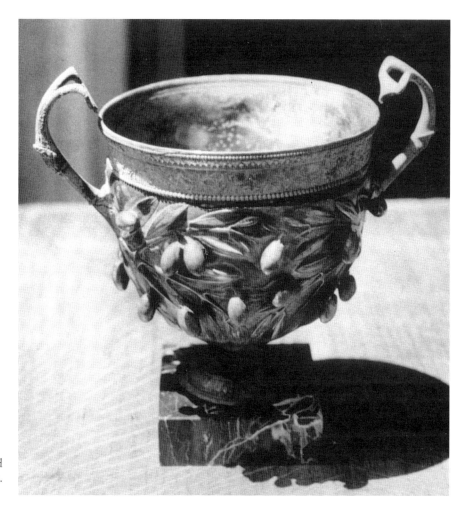

FIGURE 119 Silver cup decorated with olive leaves and fruit (NM inv. no. 25514). Photo: S. Jashemski.

REMARKS

The cultivated olive yields (up to 50 percent by weight) a valuable oil used for cooking, soap-making, table use, and medicine. The cultivated olive was derived from the oleaster (*O. europaea* L. var. *sylvestris* Brot.), a spiny shrub found from the Punjab in India west to Portugal, the Canary Islands, and Morocco. After grapes for making wine, the olive was the most valuable crop in Roman times.

107. *ORNITHOPUS COMPRESSUS* L.

English, (common) bird's foot; Italian, *uccellina comune*

MATERIAL EXAMINED

Many legumes and legume fragments were found in the carbonized hay at Oplontis.

REMARKS

The plant is a small greenish gray annual, with yellow flowers and compressed legumes. It occurs in the dry, sandy, disturbed ground of the Mediterranean region and is indigenous to the Vesuvian area.

108. *ORNITHOPUS PINNATUS* (MILL.) DRUCE

English, (pinnate) bird's foot; Italian, *uccellina pennata*

MATERIAL EXAMINED

A few legumes were found in the carbonized hay at Oplontis.

REMARKS

This plant is similar to the previous species but smaller, with round legumes. It occurs in arid fields and sunny meadows of the Mediterranean region and is indigenous to the Vesuvian area.

109. *OROBANCHE* sp.

English, broomrape; Italian, *orobanche, succiamele*

MATERIAL EXAMINED

Stem fragments with flowers and fruits were found in the carbonized hay at Oplontis.

REFERENCES IN ANCIENT AUTHORS

The broomrape is probably the plant that Theophrastus (*Hist. pl.* 8.8.5) calls *aimodoron* (αἱμόδωρον). Pliny gives a very good description of broomrape (*orobanche*) as "a plant that kills vetches and leguminous plants. . . . Its stem is leafless, fleshy and red. It is eaten by itself, or, when young, boiled in a saucepan" (*HN* 22.162).

REMARKS

Orobanche is a genus of parasitic plants. A positive identification of our material to species is not possible.

110. *PAEONIA* sp.

English, peony; Italian, *peonia*

GRAFFITO

We learn from a graffito on the twelfth column of the Grand Palaestra (II.vii) that a plant named *paeonia* was known as a medicinal plant at Pompeii. Della Corte (1965: 401) interprets this graffito *pompeianis pae<v>oniam (praebete)* (*CIL* IV 8544) and the crude sketch of a man below to mean that the man, perhaps a patron of the victorious strangers who had defeated the Pompeians in an athletic contest, is recommending the peony as medicine for the wounded Pompeians.

REFERENCES IN ANCIENT AUTHORS

The peony (παιωνία) is mentioned briefly by Theophrastus (*Hist. pl.* 9.8.6) in connection with a superstition that this plant "should be dug up at night, for if a man does it in the day-time and is observed by a woodpecker . . . he risks the loss of his eyesight," a superstition repeated by Pliny (*HN* 25.29). Pliny (*HN* 26.131) says that hemorrhage is checked by the red (unripe) seed of the *paeonia*, and that the root also is styptic. These properties would make it an appropriate treatment for wounded athletes. He recommends that the black (mature) seed be taken in hydromel for the diseases of women. He describes the peony at length in two passages:

> The first plant to be discovered was the paeony, which still retains the name of the discoverer [Paeon, the physician of the gods], it is called by some *pentorobon*, by others *glycyside*, for an added difficulty in botany is the variety of names given to the same plant in different districts. It grows on shaded mountains, having a stem among the leaves about four fingers high, which bear on its top four or five growths like almonds, in them being a large amount of seed, red and black.
>
> *HN* 25.29

In a second passage Pliny (*HN* 27.84–6) repeats the same description, adding the erroneous information, found also in Dioscorides (3.157), that there are two kinds of peonies, the male and the female. Dioscorides writes at some length about the peony and its numerous uses.

REMARKS

It is difficult to know what plant the Pompeians referred to as peony, but four species of *Paeonia* occur in Italy.

111. *PANICUM MILIACEUM* L.

English, common millet, broomcorn; Italian, *miglio*

MATERIAL EXAMINED

At Herculaneum, several grams of common millet were found in a house on the Decumanus Maximus (inv. no. 2327).

WALL PAINTING

In the painting of two quails (Fig. 120; NM inv. no. 8750), the quail on the left is feeding on common millet (not barley as Schouw 1859 says).

GRAFFITO

Millet (*milium*) is mentioned in a proverb scratched on a column in the peristyle of the House of M. Holconius Rufus at Pompeii that advises, "If you want to waste your time, scatter millet and pick it up again" (*moram si quaeres, sparge miliu[m] et collige*). (*CIL* IV 2069).

REFERENCES IN ANCIENT AUTHORS

Common millet was well known to ancient Greek and Roman writers. Theophrastus (*Hist. pl.* 1.11.2) and Dioscorides (2.119) call it *kenchros* (κέγχρος). Pliny says that "millet (*milium*) flourishes well in Campania, where it is used for making white porridge; it also makes extremely sweet bread" (*HN* 18.102). He said that millet was used for making several kinds of bread, "but there is no grain heavier in weight or that swells more in baking" (*HN* 18.54). The grains of ripe millet were used for making a kind of artificial wine (*HN* 14.101) and for making leaven, "which if dipped in unfermented wine and kneaded it will keep for a whole year" (*HN* 18.102).

REMARKS

Although known since ancient times, common millet is an alien plant in Europe. Li (1970) suggests that *P. miliaceum* is of Chinese origin. It is unknown as a wild plant. Vavilov (1926) supports a Chinese origin for common millet and suggests that it was moved westward into Europe by nomadic peoples, who planted it as their favorite crop. It is still a waif at Pompeii.

112. *PAPAVER APULUM* TEN.

English, (Apulic) poppy; Italian, *papavero (pugliese)*

MATERIAL EXAMINED

Two ripe capsules were found in the carbonized hay at Oplontis.

REMARKS

This small annual, up to 40 cm in height, has small flowers 4–5 cm in diameter, with red petals and a dark

FIGURE 120 Common millet, Italian millet, and two quails (NM inv. no. 8750). Photo: S. Jashemski.

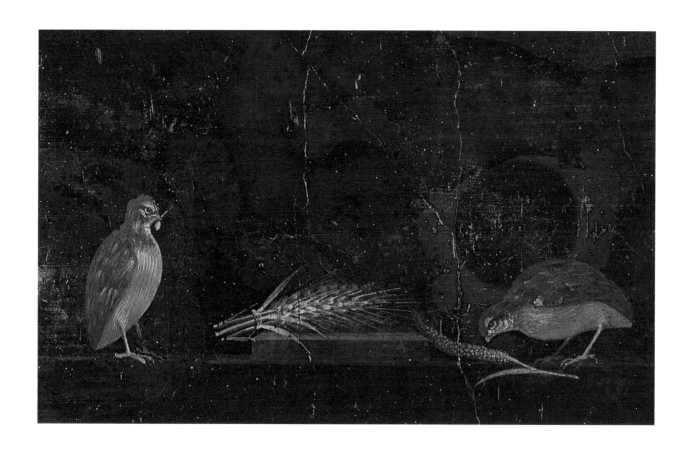

blotch at the base. It occurs in stony and sunny areas in southern Italy, Sicily, and in the Balkan Peninsula to the Turkish Aegean Islands.

113. *PAPAVER RHOEAS* L.

English, corn poppy; Italian, *papavero, rosolaccio*

MATERIAL EXAMINED

Capsules of *P. rhoeas* were found in the carbonized hay at Oplontis (Fig. 121) represented by two subspecies still found in the Vesuvian area, *P. rhoeas* L. subsp. *rhoeas* and *P. rhoeas* L. subsp. *strigosum* (Boenn.) Pignatti (Ricciardi, and Aprile 1988: 320).

WALL PAINTINGS

We have found the corn poppy in only two garden paintings, both thus far unnoticed. In the House of the Fruit Orchard, in the room off the E side of the atrium, poppies are depicted at the foot of the standing Egyptian statue painted on the N end of the E wall, and to the left of the seated Egyptian statue painted on the N end of the E wall. At Herculaneum, there are corn poppies in the garden painting in Sacellum A in the Sacred Area. Comes mentions inaccurately depicted poppies in four paintings in the Naples Museum, but these can no longer be found.

REFERENCES IN ANCIENT AUTHORS

The poppy was a common plant in antiquity, and both cultivated and wild varieties were known. The

FIGURE 121 Capsule of corn poppy found in carbonized hay, Oplontis. Photo: M. Ricciardi.

Latin word for poppy was *papaver*, the Greek *mekon* (μήκων). Pliny in describing the poppy says:

> There are three kinds of cultivated poppy. . . . The third kind is called by the Greeks *rhoeas* and in our country the wild poppy; it does indeed grow uncultivated, but chiefly in fields sown with barley; it resembles rocket and grows 46 cm high, with a red flower, which falls very quickly, and which is the origin of its Greek name.
>
> *HN* 19.168–69

In another passage, after having described several kinds of both wild and cultivated poppies, Pliny says:

> Intermediate between the cultivated poppy and the wild is a third kind, for though growing on cultivated land it is self-sown; we have called it *rhoeas* or roving poppy.
>
> *HN* 20.204

It is difficult to identify all the varieties described by Pliny, but it seems certain that the poppy called *rhoeas* in these passages is *P. rhoeas*, the corn poppy so common in fields in summer. Vergil speaks of the poppy of Ceres (*cereale papaver*) (*Georgics* II.212–13). Dioscorides (4.64) gives the medicinal uses of this poppy, which "grows in the fields in the spring."

REMARKS

The corn poppy is an annual, up to 25–90 cm in height, with four-petaled deep scarlet flowers with a black blotch at the base. It is widespread in fields over much of Europe and is indigenous to the Vesuvian area.

114. *PAPAVER SOMNIFERUM* L. subsp. *SETIGERUM* (DC.) CORB. (*PAPAVER SETIGERUM* DC.)

English, (bristle-bearing) poppy; Italian, *papavero (setoloso)*

MATERIAL EXAMINED

Three well-preserved capsules were found in the carbonized hay at Oplontis.

REMARKS

This poppy is closely related to the opium poppy, from which it differs in being rarely more than 60 cm (the opium poppy up to 1.5 m) and having leaves more deeply and acutely lobed, with longer bristles and smaller flowers and fruits. It is probably a native of the western Mediterranean region. It occurs as a weed in vineyards and other cultivated areas and is indigenous to the Vesuvian area.

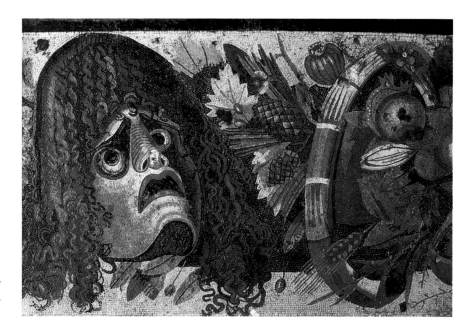

FIGURE 122 Mosaic: opium poppy fruit, House of the Faun (NM inv. no. 9994). Photo: S. Jashemski.

115. *PAPAVER SOMNIFERUM* L.

English, garden or opium poppy; Italian, *papavero da oppio*

WALL PAINTINGS

The only opium poppies found in a garden painting are the beautifully and accurately painted plants with lavender flowers in the *diaeta* in the House of the Gold Bracelet, on the far left (Fig. 78) and far right of the E wall, on the N wall to the left of the faun herm, and on the S wall to the right of the girl herm. In the Macellum at Pompeii, a painting no longer visible depicted a priestess holding two long-stemmed seed pods of the opium poppy in her left hand (preserved in Roux and Barré 1875–7: vol. 1, pl. 14).

MOSAICS

The opium poppy is shown in fruit and probably in flower and bud in the mosaic from the House of the Faun (Fig. 122; NM inv. no. 9994), incorrectly identified as *P. rhoeas* by Comes.

GLASS

Seed pods of the opium poppy are beautifully depicted on the famous Blue Glass Vase (NM inv. no. 13521).

REFERENCES IN ANCIENT AUTHORS

Theophrastus (*Hist. pl.* 9.12.3–5) speaks of several kinds of poppy (μήκων). He says that poppies have "very small seeds" (*De causis plantarum* 2.12.1) "borne in a vessel" (*Hist. pl.* 1.11.2); "the collection of juice is made . . . from the head" (*Hist. pl.* 9.8.2). Pliny in describing the poppy says:

There are three kinds of cultivated poppy (*papaver*): the white, the seed of which in old days used to be roasted and served with honey at second course; it is also sprinkled on the top crust of country loaves, an egg being poured on to make it stick. . . . The second kind of poppy is the black poppy, from which a milky juice is obtained by making an incision in the stalk. The third kind is called by the Greeks *rhoeas*.

HN 19.169

Pliny (*HN* 20.202) correctly notes that the heads of cultivated poppies are round, while those of the wild poppy are long and small. He gives detailed instructions for making opium from the black or opium poppy (*HN* 20.198–200, 203), but he warns that "if too large a dose be swallowed the sleep even ends in death. It is called opium" (*HN* 20.199). Vergil speaks of the sleep-bringing poppy (*soporiferum papaver*) (*Aeneid* 4.486).

Cato (*RR* 79) gives a recipe for *globi* (fried cheese cakes that are spread with honey and sprinkled with poppy seed); also for *savillum*, a kind of sweet cheesecake that is sprinkled with poppy seed (*RR* 84). Dioscorides (4.65) speaks of the opium poppy that is grown in gardens, its seed made into bread.

REMARKS

The horticultural forms of the opium poppy are widely cultivated for their beautiful flowers. Poppy seeds are used as a condiment in bread and pastries and as a source of oil. The plant is a strong soporific and the source of opium, which is derived from the narcotic latex, as Pliny observes. The opium poppy is native of the western and central Mediterranean region. It has been widely cultivated since ancient times in Europe and many parts of Asia.

116. *PETRORHAGIA VELUTINA* (GUSS.) P. W. BALL & HEYWOOD

English, little leaved tunic flower, clove pink; Italian, *garofanina (vellutata)*

MATERIAL EXAMINED

A few inflorescences with bracts were identified in the carbonized hay at Oplontis.

REMARKS

Common in dry fields and meadows in the Mediterranean region. Its dried flowers are occasionally used for tea.

117. *PHOENIX DACTYLIFERA* L.

English, date palm; Italian, *dattero, palma da datteri*

MATERIAL EXAMINED

Pompeii: in the *deposito,* about forty to fifty whole carbonized dates (without inv. no.); in the garden of the House of the Ship *Europa,* a single carbonized date seed was found. At Herculaneum: on the Decumanus Maximus, a few hundred excellently preserved whole carbonized dates (inv. no. 2313) (Fig. 123). In the Naples Museum: a dish of whole carbonized dates (Meyer, 1988: 201).

REMAINS REPORTED

Remains of burned dates were found along with those of figs, pine nuts, and pinecones in the pits containing the refuse from sacrifices at the Temple of Isis (Mau 1902: 115).

WALL PAINTINGS

In the garden paintings a young date palm is frequently pictured, usually in the center of the panel, as on the N wall of a *Caupona* I.xi.16; on the W garden

FIGURE 123 Carbonized dates, Herculaneum. Photo: USDA.

wall in the House of the Ephebe (V.vii.10–12); and in the three panels on the N garden wall of a house destroyed by bombing in World War II (VII.vi.28) (Jashemski 1993: 363, fig. 427, p. 362). A palm tree is shown on each side of a fountain in the preserved portion of the garden painting in House I.ix.13. A palm tree can also be identified in the garden painting of the House of the Fruit Orchard in the room to the E of the atrium. In the *diaeta* of the House of the Gold Bracelet there are two palm trees on both the N and S walls and on the E wall (Fig. 78). At Herculaneum, the date palm can be identified at least three times in the fragmentary wall paintings preserved in Sacellum A, one to the left of the fountain, and in the center of the panel at each end of the N wall.

The only date palms that we have found pictured with fruit in garden paintings are the badly preserved ones on the sides of the two elaborate mosaic fountains in front of the large outdoor triclinium in the garden (II.ix.6) to the W of the amphitheater at Pompeii and in the no longer extant garden painting in the House of the Amazons (VI.ii.14) preserved in a watercolor in the Deutsches Archäologisches Institut in Rome, (negative no. 732 392) (Jashemski 1993: 340, fig. 396, p. 341).

The date palm in Egyptian landscape paintings is pictured with an elongated trunk and a crown of foliage with pinnately divided leaves. It is often shown bearing fruit. At Pompeii, the Egyptian paintings in the House of the Pygmies (IX.v.9) show pygmies climbing a palm. There are date palms in the House of Apollo (VI.ii.11/15) on the NW garden wall; in the House of Ceius Secundus (I.vi.15) on the E garden wall; and in the small fragment of an Egyptian painting in the Sarno Baths. In some of these paintings the date palm is shown growing in a pot or dolium. A number of potted palms can be seen in the cubiculum from Boscoreale in the Metropolitan Museum in New York. The date palm is also pictured in the two paintings of Isis worship found at Herculaneum (Jashemski 1979: 139, fig. 218).

Dates are pictured among the offerings to the deities on the altar in many lararia paintings, as in the House of the Ephebe (V.vii.10–12) and in House VI.xvi.15 at Pompeii and in the lararium painting in the Museum at Castellammare di Stabia.

Dates often appear in still-life paintings, frequently with figs, almonds, or other nuts. Dates are pictured with figs and pine nuts in House VI.xvi.15 at Pompeii, with figs and a large pinecone in a Naples Museum painting (without inv. no.), and with two figs and two pairs of almonds (NM inv. no. 8645). Dates in the still-life painting of a straw plate of assorted fruits and nuts in the peristyle of the House of the Cervi (IV.21) at Herculaneum may represent the finger-date, "a long

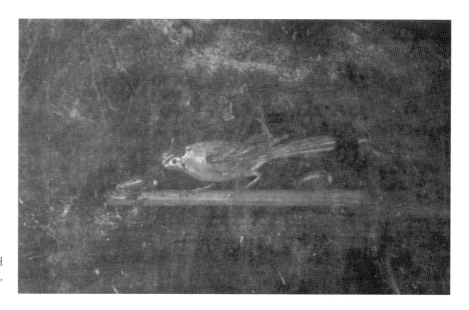

FIGURE 124 Painting of a bird and two dates, House of Trebius Valens, Pompeii. Photo: S. Jashemski.

very slender date, sometimes of curved shape" that was offered to the gods (Pliny *HN* 13.46). A basket containing dates, figs, and other offerings is one of six representations of sacrificial tables pictured in the underground triclinium in House I.vi.2 at Pompeii. Today at every Christmas Eve dinner in Campania dried fruits (figs, dates, apricots, grapes) and nuts (almonds, hazelnuts, chestnuts, walnuts) are served; this tradition can be considered an interesting continuation of a Roman custom.

At Pompeii, a bird is pictured along with two dates in the House of Trebius Valens (III.ii.1) (Fig. 124).

The date palm, symbol of victory, is found in many wall paintings. It can be seen in a number of small paintings in the room off the N side of the atrium in the House of the Vettii (VI.xv.1) with fighting cocks, fighting quails, and in the still life of victory prizes. The palm leaves identified by Casella in the garlands in the House of the Silver Wedding (V.ii.1), upon close examination, are certainly pine needles.

MOSAICS

There is a date palm on the left edge of the large Nile mosaic from the House of the Faun (Fig. 352). A mosaic with a fighting cock shows a palm of victory on the table (NM, Santangelo collection).

STUCCO

There is a date palm bearing fruit in the stucco relief on the SW corner of the Palaestra in the Stabian Baths.

GRAFFITO

The date (*palma*) is listed in a graffito on the N wall of an inn (IX.vii.24–5) that gives the cost of a variety of items (*CIL* IV 5380).

REFERENCES IN ANCIENT AUTHORS

Theophrastus has many references to the *phoinix* (φοῖνιξ), the Greek name of the date palm. This plant according to Pliny (*HN* 13.42) has a remarkable ability; "it dies off and then comes to life again of itself – a peculiarity which it shares with the phoenix." The Romans called the date palm *palma*, a general term for all palms.

Columella (*RR* 11.2.90) mentions several uses of the date palm, including making baskets, employing the fruit as a spice in making wine (*RR* 12.20.5), and using the bark in making oil (12.53.2). Pliny (*HN* 13.30) has a lengthy discussion of the date palm. He tells us that it was common in Italy as a garden plant, even though it did not bear fruit (*HN* 13.26). The dates from Judaea were especially esteemed. The many named varieties fell into two main classes, dry dates that kept well, and the soft ones that were poor keepers (*HN* 13.49). The date palm had various medicinal uses (Pliny *HN* 23.97–100; Dioscorides 1.48). The fruit, flowers, leaves, and "bark" were all used.

REMARKS

Dates were well known to the Romans from sources outside Italy. The fruit found at Pompeii would have been imported. Although the date palm has been planted on the north shore of the Mediterranean since antiquity and was undoubedly grown at Pompeii, in Europe it produces fruit in only one small area in southeastern Spain. Zohary and Hopf (1994) identify the Near East "as the initial place of *P. dactylifera* domestication."

118. *PHRAGMITES AUSTRALIS* (CAV.) TRIN. EX STEUDEL

English, common reed; Italian, *cannuccia di palude*

MATERIAL EXAMINED

The common reed was used as backing for plaster in making the ceiling of the luxurious villa at Oplontis. At the time of excavation the imprint of the reeds in the plaster was well preserved; fragments of reed still in the plaster were identified as *P. australis*. See Vitruvius (7.3.2) for the use of reeds in ceilings. Blake reports that reeds were used in the ceiling of Nero's Golden House in Rome:

> Reeds were normally used in the construction of all the ceilings in the Pompeian area, and in the major part of the Roman world. . . . Panels of tied reeds were suspended to the beams of the ceiling and their lower face was stuccoed and painted *in situ*. This technique has been long used, up to modern times. In Italian it is known as "*soffitto ad incannucciato.*"
>
> Letter from Stefano De Caro, March 16, 1992

REFERENCES IN ANCIENT AUTHORS

Theophrastus (*Hist. pl.* 4.11.1) contrasts the pliant reed (κάλαμος ὁ πλόκιμος) with the pole reed or reed used in making pipes. Pliny, as we have seen (see no. 15), also distinguishes the common reed from *donax*. In speaking of the many uses of reeds, he says, "in other parts of the world as well reeds also provide very light ceilings for rooms. And reeds serve as pens for writing, especially Egyptian reeds" (*HN* 16.156–7)
. The reed used in Egypt for making pens was *P. australis* (Hepper 1990: 30). Both Pliny (*HN* 32.141) and Dioscorides (1.114) speak of the medicinal uses of *phragmites*.

REMARKS

The common reed occurs in marshy areas. It is widespread in much of Europe.

119. *PHYLLITIS SCOLOPENDRIUM* (L.) *NEWMAN* (*ASPLENIUM SCOLOPENDRIUM* L.)

English, hart's-tongue fern; Italian, *lingua cervina scolopendria*

WALL PAINTINGS

This is the first time the hart's-tongue fern has been reported in a Vesuvian wall painting. The sori (reproductive spore area) are clearly visible in some of the fronds to the right of the bird on the inside of the low wall enclosing the pseudo-peristyle in the House of Adonis (VI.vii.18) (Fig. 284). Two ferns flank an acanthus at the base of the E wall in the small room to the E of the atrium in the House of the Fruit Orchard (Fig. 125). Others can be seen at the base of the walls in the garden and peristyle colonnade in the House of Trebius Valens (III.ii.1), also in II.i.12 and in the *diaeta* in the House of the Gold Bracelet on the black dado below the lattice fence. For a color drawing of the painting of the fern (no longer visible) at the base of a wall in the House of M. Epidius Sabinus (IX.1.22/29), see Fig. 157.

REFERENCES IN ANCIENT AUTHORS

The hart's-tongue fern is seldom mentioned by the ancient writers. Dioscorides (3.121) calls it *phullitis* (φυλλῖτις) and provides a brief description of the plant. He says that the plant consists of six or seven upright, leathery leaves that are smooth on the upper side, with thin little worms on the back of the leaf (sporangia); it grows in gardens and shady places. The paintings of these plants at the base of a garden wall suggest a continuation of the actual plantings found in the garden. Neither Theophrastus nor Pliny mentions this plant.

FIGURE 125 Hart's tongue fern in the room off the atrium, House of the Fruit Orchard. Photo: S. Jashemski.

REMARKS

The hart's-tongue fern is not found in the Vesuvian area today, but it was collected by F. G. Meyer on the Sorrento peninsula, at Amalfi. It would undoubtedly have been familiar to the ancient Pompeians.

120. *PINUS PINEA* L.
English, umbrella pine, stone pine; Italian, *pino domestico, pino da pinoli*

MATERIAL EXAMINED

Pompeii: a dish of broken seeds (testa) without kernels in the *deposito* (without inv. no.); in the peristyle garden of the House of C. Julius Polybius (IX.xiii.1–3), a small carbonized cone scale and two portions of seed testas split lengthwise were found in situ. Herculaneum: (1) seven nearly intact cones and a larger number of cone scales and unbroken seeds found on the Decumanus Maximus; (2) Casa del Bel Cortile (V.8), a few whole and broken seeds in a dish; (3) a cone three-quarters intact with a few seeds was found on the Decumanus Maximus no. 13 (Fig. 126; inv. no. 2324). Oplontis, Villa of Poppaea: seed coats, cone scales, and the basal portion of a cone. Naples Museum: (1) a dish of whole unbroken pine nuts; (2) cones with a broken central axis.

The woody material found at Boscoreale in the tree-root cavities on each side of the roadway leading to the villa was identified as that of umbrella pine by F. Hueber.

MATERIAL REPORTED

Burnt pine kernels were found among the remains of offerings in the Temple of Isis.

FIGURE 126 Carbonized pinecone, Herculaneum. Photo: USDA.

FIGURE 127 Umbrella pines and cypress trees in the peristyle painting, House of the Little Fountain. Photo: S. Jashemski.

WALL PAINTINGS

The umbrella pine with its branches arranged in a characteristic umbrella-shaped crown is easily recognized. For good examples, see the large landscape on the S garden wall in the House of the Little Fountain (VIII.viii.23) (Fig. 127), and the W wall of the garden in the House of the Hunt (VII.iv.28). The umbrella pine in the garden painting in the House of Romulus and Remus (VII.vii.13) is no longer visible, but it is preserved in a watercolor (Jashemski 1993: 263, fig. 428)

The large cone of the umbrella pine (mistaken for a pineapple by Casella) is frequently pictured on house-

hold altars in lararium paintings, often with one or two eggs, dates, figs, and nuts: in the Casa dell'Ara Massima (VI.xvi.15); in the Casa del Cenacolo (IV.ii.h); and in the no longer visible lararium painting in the *pistrinum* IX.iii.10–12 (Boyce 1937: no. 409, pl. 26.1).

SCULPTURE

A marble pinax in the garden of the House of the Golden Cupids (VI.xvi.7) shows a Silenus approaching a burning altar with a plate piled high with fruit and a large pinecone, convincing evidence that the pinecone was one of the offerings. A large cone of umbrella pine is sculptured on a decorative marble garden support in the same garden (Fig. 128). Since the pinecone was associated with the worship of Dionysus, it is appropriately found in this garden, which has so many Dionysiac symbols in its decoration. The pinecone is often found at the top of the thyrsus.

TERRA-COTTA

The handsome cone of the umbrella pine, usually with its cone scales tightly closed, is an attractive art motif. An elegant lamp of glazed terra-cotta, found at Herculaneum, has the exact shape and characteristics of this cone.

MOSAICS

The pinecone is pictured on a rise in front of a rooster, together with a fig and a date (Fig. 315). The cone and pine needles in the mosaic garland from the House of the Faun (NM inv. no. 9994) are probably *P. pinea.* Both the immature green cone, which does not mature until the second year, and a mature cone are shown.

REFERENCES IN ANCIENT AUTHORS

Pliny (*HN* 16.38–9) distinguishes three species of pines in Italy: *pinus, pinaster,* and *tibulus.* These have been identified as *P. pinea* L., *P. pinaster* Aiton, and probably *P. halepensis* Mill., respectively (Abbe 1965: 7). We have identified only *P. pinea* in the ancient Vesuvian sites. When Vergil speaks of the pine as a garden tree, he is referring to *P. pinea:* "The ash is most beautiful in the forest, the pine in the garden (*pinus pulcherrima*), the poplar by the river, the fir on the mountain heights" (*Eclogues* 7.65–6).

In the *Georgics* (2.442–3) he speaks of the pine as useful timber for ships. The umbrella pine and the cypress were considered the best woods to resist decay and wood worm.

The edible nuts of *P. pinea* were considered a delicacy by the ancient Romans. Columella (*RR* 12.57.2) gives a recipe for making a gourmet mustard using pine nuts, and for their use in salad (*RR* 12.59.3). Apicius fre-

FIGURE 128 Large pinecone sculptured on a marble garden support, House of the Golden Amorini. Photo: S. Jashemski.

quently calls for pine nuts in his recipes, in making such delicacies as sausages (2.5.1), salads (4.1.1), various sweets (4.2.16; 7.12.1, 4), and as an ingredient for various sauces (10.2.3). Pinecones were also used for rubbing the brims and necks of wine vats (Columella *RR* 12.30.2).

REMARKS

The umbrella pine is indigenous to many regions along the north shore of the Mediterranean from Portugal to Syria, mainly in coastal areas. It is common in the vicinity of Pompeii. Pine nuts are still much used.

121. *PLANTAGO LAGOPUS* L.

English, (hare's-foot) plantain; Italian, *piantaggine (piede di lepre)*

MATERIAL EXAMINED

One flowering spike was found in the carbonized hay at Oplontis.

REFERENCES IN ANCIENT AUTHORS

Theophrastus (*Hist. pl.* 7.11.2) says: "An example of the plants which have a spike is *arnoglosson* (᾽αρνόγλωσσον). Pliny (*HN* 25.80) knew two kinds of plantain (*plantago*),

a smaller one living in meadows and a larger one. He lists many medicinal uses (*HN* 26).

REMARKS

P. lagopus differs from *P. lanceolata* in being smaller in all its parts and having a hairy flower spike. It occurs in dry, sandy places in southern Europe and the Mediterranean region.

122. *PLANTAGO LANCEOLATA* L.

English, buckhorn plantain, ribwort plantain; Italian, *lingua di cane, lanciuola, mestolaccio*

MATERIAL EXAMINED

Numerous flowering and fruiting spikes were found in the carbonized hay at Oplontis.

REMARKS

This plant occurs along roadsides and disturbed sites throughout Europe. The young leaves are occasionally eaten as a vegetable.

123. *PLATANUS ORIENTALIS* L.

English, Oriental plane tree; Italian *platano*

IMPRINT OF LEAF

The cement cast in the Antiquarium at Stabiae of the imprint of a leaf found in the volcanic mud in the peristyle in the Villa of San Marco at Stabiae has the appearance of a plane tree leaf (Jashemski 1979: 331, fig. 529).

ROOT CAVITIES

The plane was a popular shade tree in ancient Campania as it still is today. Casts made by Maiuri of the root cavities of two rows of trees planted around the edge of the enclosed area on the north, west, and east of the Grand Palaestra at Pompeii were identified as plane trees. The recommendation of Vitruvius (5.11.4) that plane trees be planted in palaestras supports this identification. Casts made of the double rows of large tree-root cavities on each side of the pool and the imprint of a plane tree leaf in the peristyle of the Villa of San Marco at Stabiae also suggest plane trees. The peristyle has been replanted today with plane trees. Huge carbonized tree trunks were found in the muddy fill in the Palaestra at Herculaneum, which Maiuri concluded had also been planted with trees, probably plane trees, although no attempt was made to identify the carbonized material, and we were unable to locate any of it. For the possible identification of the two huge road trees at Boscoreale as planes, see Chapter 2. The cavities of the large tree roots in the sculpture garden along the swimming

pool in the Villa of Poppaea suggest that they were plane trees (see Chap. 2). The plane tree was the largest shade tree grown in the ancient Vesuvian sites. It has the largest girth of any European tree.

WALL PAINTING

A beautiful plane tree with many seed pods is pictured behind the fountain on the north wall of the *diaeta* in the House of the Gold Bracelet (Fig. 129). Maiuri (*NS* 1939: 194) identified the trees in the famous painting of the fight between the Pompeians and the Nucerians (NM inv. no. 112222) as plane trees, perhaps because he had located several large tree root cavities on the E and N sides of the Grand Palaestra at Pompeii (the locale of this painting) similar to those he had found inside the Palaestra.

FIGURE 129 Domestic pigeon and wood pigeon perched on a plane tree, House of the Gold Bracelet. Foto Foglia.

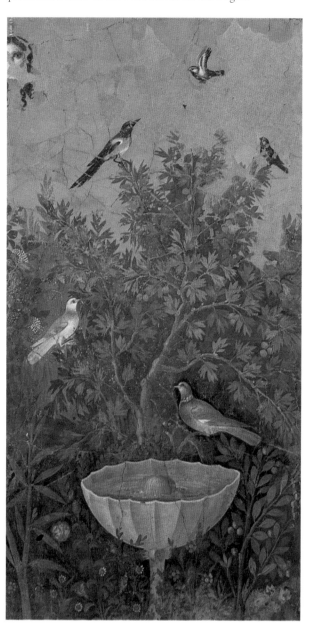

MOSAIC

Both Comes (1879) and Tenore (1833) identified the tree trunk in the mosaic from the House of the Faun (NM inv. no. 10020) depicting the battle between Alexander the Great and Darius as *P. orientalis,* but this stylized trunk is difficult to identify.

TERRA-COTTA

A beautiful lamp in the Naples Museum (inv. no. 22958) has a large plane tree leaf for the handle (Fig. 130).

REFERENCES IN ANCIENT AUTHORS

Theophrastus has many references to the plane tree (πλάτανος) but says that it was rare in Italy (*Hist. pl.* 4.5.6). Pliny (*HN* 12.6–12) has a long discussion of the plane tree (*platanus*), and tells how it was imported from another climate merely for the sake of its shade. It was first brought to the island of Diomedes in the Ionian Sea, then to Italy by way of Sicily. He discusses famous plane trees and comments on their great size. The Latin authors speak with appreciation of the shade of the plane tree. Ovid (*Met.* 10) speaks of the "genial plane-tree," Cicero of "the shade-giving plane" (*De Divinatione* 2.30.63), and Vergil of the plane tree that gives shade to wine drinkers (*Georgics* 4.146). Horace, too, speaks of lying in careless ease under the tall plane (*Odes* 2.11.13). Both Pliny (*HN* 24.44–5) and Dioscorides (1.107) discuss the medicinal uses of the plane tree.

REMARKS

The Oriental plane is indigenous to the Balkans, Greece, Albania, and Turkey, to India; it also occurs wild in some very restricted areas of southern Italy and Sicily. The cross, *P. acerifolia* (Aiton) Willd. also known as the London plane, is a hybrid of *P. occidentalis* and *P. orientalis* and is one of the most common street trees in Europe.

124. *POA ANNUA* L.

English, annual bluegrass, (annual) meadowgrass; Italian, *fienarola (annuale)*

MATERIAL EXAMINED

A few panicle fragments and spikelets were found in the carbonized hay at Oplontis.

REMARKS

This small, annual bluegrass is widely distributed throughout Europe.

125. *POLYCARPON TETRAPHYLLUM* (L.) L.

English, manyseed, allseed; Italian, *migliarina*

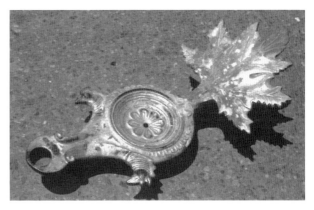

FIGURE 130 Lamp with a plane tree handle. (NM inv. no. 22958). Photo: S. Jashemski.

MATERIAL EXAMINED

A single inflorescence was found in the carbonized hay at Oplontis.

REMARKS

This plant occurs in sandy places among stones and bricks and along streets in the Mediterranean region. It is indigenous to the Vesuvian area.

126. *POLYGONATUM* sp.

English, Solomon's seal; Italian, *sigillo di Salomone*

WALL PAINTING

The low white flower on the south wall in the *diaeta* of the House of the Gold Bracelet, to the right of the stake on which a songbird is perched (Fig. 147), has the appearance of Solomon's seal. The painting is too stylized to identify the plant as to species.

REMARKS

Each year this plant produces on its rhizome a single stem, which bears leaves and little hanging white flowers. The stem falls in autumn, leaving the cicatrices. The name of the plant derives from these rounded, cup-shaped cicatrices on the upper surface of its rhizome, each of which looks like a seal. Two species of *Polygonatum* grow in southern Italy, especially in the beech woods of the Apennines.

127. *POPULUS* sp.

English, poplar; Italian, *pioppo*

MATERIAL EXAMINED

The poplar charcoal found in the garden of Polybius was probably in the wood-ash used as fertilizer.

REFERENCES IN ANCIENT AUTHORS

The poplar is mentioned often by the ancient authors. Theophrastus knew both the black poplar

(αἴγειρος) (*Populus nigra* L.) and the white poplar (λεύκη) (*Populus alba* L.), as did the Romans (Pliny *HN* 16.85). The poplar provided withes for tying grapevines (Pliny *HN* 16.176). It was also sacred to Hercules (Vergil *Georgics* 2.66; Pliny *HN* 12.3).

128. *POTENTILLA REPTANS* L.
English, creeping cinquefoil; Italian, *cinquefoglio*

MATERIAL EXAMINED

Stems, leaves, and a few flowers were found in the carbonized hay at Oplontis.

REMARKS

This plant occurs throughout Europe, especially in wet grasslands.

129. *PRUNUS AVIUM* L.
English, bird cherry, sweet cherry; Italian, *ciliegio*

WALL PAINTING

In the House of the Ephebe (I.vii.10–12), a parrot is pictured with two carefully painted cherries having the long pedicels that make it possible to identify the cherry as the bird cherry (Fig. 131). Birds are pictured frequently with cherries, but the fruit is usually too stylized to identify.

REFERENCES IN ANCIENT AUTHORS

Cerasus was the name used by the Romans for the sour cherry (*P. cerasus* L.). The name was derived from the Greek *kerasos* (κέρασος). According to de Candolle (1884), the Greek name referred to the sweet cherry or gean (*P. avium* L.).

Pliny (*HN* 15.102) mentions cherry trees without distinguishing between sour and sweet cherries. He says that these fruits were unknown in Italy before the time of Lucullus, who is credited with the importation of cherries into Italy from Pontus in modern Turkey in 74 B.C. But Varro (*RR* 1.39.2) in 34 B.C. recommends grafting cherries in midwinter, as if they were already a commonplace fruit in Italy and not a recent introduction. Pliny (*HN* 15.103–4) names six varieties of cherries and records that

FIGURE 131 Wall painting of a parrot with bird cherries. Photo: S. Jashemski.

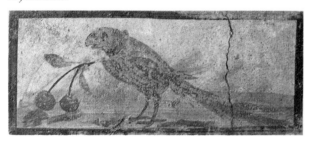

"the highest rank belongs to bigaroon [*Duracina*, hardberry] cherry called by the Campanians the Plinian cherry." Whether this was a sweet or sour cherry cannot be ascertained, because it is no longer grown. Several more listed by Pliny as cherries were probably not true cherries.

INSCRIPTIONS

An amphora (style IV) has the label CER AL|S///. Wax tablet 42.6 has the entry *cer(asis) alb (is)* (*CIL* IV 2562). The entry, white cherry, probably refers to the bird cherry, which at times has a whitish fruit.

REMARKS

A white or light variety of the bird cherry grows in the Pompeii area today.

130. *PRUNUS CERASUS* L.
English, sour cherry; Italian, *amarena, marena*

MATERIAL EXAMINED

Several carbonized fruits were found in situ in the garden of Hercules (II.viii.6) at the base of the lararium. The broken segments show a portion of the thick black stone (endocarp). The small size of the stone, about 5.0 mm in diameter, as compared with the size of the carbonized stone of *P. avium*, which is 7.0–8.0 mm in diameter (Renfrew 1973: 143), and the identification of *P. cerasus* in garden paintings in the House of the Fruit Orchard strongly suggest that the carbonized material represents *P. cerasus.* Wittmack (1904: 52) mentions the cherry but gives no species identification.

WALL PAINTINGS

Fruit trees are seldom pictured in wall paintings, but there are two cherry trees with bright fruit in the garden paintings in the House of the Fruit Orchard, one in the room to the E of the atrium on the E panel of the N wall (Fig. 132), and another, less well preserved, on the W panel of the N wall in the room off the peristyle. In the House of the New Hunt (VII.x.3/14), the artist has painted what appear to be cherries, but the leaves are poorly depicted, and two nearby shrubs with like foliage bear oleander flowers and pomegranates.

MOSAICS

Both Comes (1879: 56) and Casella (1950: 373) identify cherry foliage and fruit in the mosaic from the House of the Faun (NM inv. no. 9994), and this seems probable. Also see NM inv. no. 9991.

REFERENCES IN ANCIENT AUTHORS

Vergil (*Georgics* 2.17–8) lists the cherry (*cerasus*) as a tree that multiplies from the roots in a very dense thicket. This is true of *P. cerasus* and not *P. avium*. The cherry trees

FIGURE 132 Wall painting of a cherry (sour) tree in the room off the atrium, House of the Fruit Orchard. Photo: S. Jashemski.

pictured in the House of the Fruit Orchard have many shoots from the roots. Apicius (1.12.4) has only one recipe for cherries, with directions for preserving them.

REMARKS

Zohary and Hopf (1994) assert that the sour cherry (*P. cerasus*) is of hybrid origin, probably derived under domestication in Europe from an accidental cross of domesticated sweet cherry (*P. avium*) and ground cherry (*P. fruticosa* Pallas). The sour cherry is unknown in the wild. It has been cultivated in the Vesuvian area from antiquity.

131. *PRUNUS DOMESTICA* L.

English, plum; Italian *prugno, susino*

WALL PAINTINGS

Schouw lists the plum but gives no locations. Comes lists the plum as doubtful and not able to be actually seen in the paintings. Beautiful and unmistakable examples of the plum have been found in the more recent excavations. There are two plum trees pictured in the House of the Fruit Orchard in the room to the E of the peristyle; in the right panel of the N wall there is a tree with purple fruit (Jashemski 1979: fig. 389); and in the center panel of this wall there is a tree with yellow fruit, though only a small part of this tree was preserved at the time of excavation.

In the House of Trebius Valens (III.ii.1), on the W wall of the *ala* (side room) to the W of the atrium, there are two very carefully painted purple plums and a

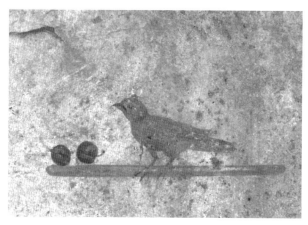

FIGURE 133 Wall painting of a bird and two purple plums, House of Trebius Valens, Pompeii. Photo: S. Jashemski.

bird. The characteristic crease (sulcus) of the plum on the right is quite pronounced (Fig. 133). At Oplontis, a beautiful glass bowl is piled high with quinces and blue and purple plums (Fig. 88). They are found in a similar bowl of fruit pictured in the cubiculum from the villa at Boscoreale in the Metropolitan Museum in New York (Beyen 1938: vol. I, pl. 65). There is a beautifully painted branch of yellow plums found in the buried fragments of an earlier very fine wall painting in the House of the Gold Bracelet (Fig. 134). A painting in the Naples Museum (inv. no. 9612) shows two plums and other fruit on a rise, with figs below. This appears to be the painting that Helbig (1868: no. 1678) describes, even though Schefold (1957) equates it with Naples Museum inv. no. 9621. Helbig (no. 1684) also reports a peach with a plum on the left in a painting now destroyed, in *Pitture di Ercolano* (1757: vol. I, p. 73).

REFERENCES IN ANCIENT AUTHORS

Theophrastus has many references to the plum (κοκκυμηλέα). The plum (*prunus*) was known to Cato

FIGURE 134 Wall painting fragments with yellow plums, House of the Gold Bracelet. Photo: F. Hueber.

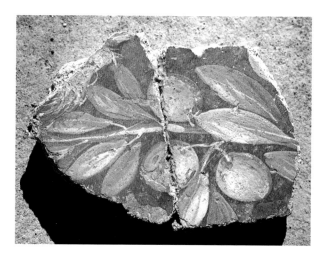

(*RR* 133.2), who gives directions for layering it. Pliny (*HN* 15.41–3) knew a large number of plums, which he describes in detail. Among foreign fruit trees he mentions the damson from Damascus, which had been grown in Italy for a long time. The recipes of Apicius call for plums more often than any other fruit except the date. The dried fruit is mentioned as a laxative by Martial (13.29). Pliny (*HN* 23.132–3) and Dioscorides (1.174) enumerate the medicinal uses of the plum.

REMARKS

The cultivated plums (*P. domestica* L. subsp. *domestica*) and the damsons (*P. domestica* L. subsp. *insititia* (L.) C. K. Schneider) are of hybrid origin of parentage found in the Caucasus. The blue and purple plums so beautifully portrayed at Pompeii and Oplontis are identified as *P. domestica* subsp. *domestica*.

132. *PRUNUS DULCIS* (MILL.) D. A. WEBB
English, almond; Italian, *mandorlo*

MATERIAL EXAMINED

Pompeii: a fragment of carbonized almond shell (endocarp) was found in situ in the peristyle garden of the House of Polybius (Jashemski 1993: 249) and another in the garden of the House of the Ship *Europa* (Jashemski 1979: 241). Four carbonized fragments of almond shell were also found in situ in the vineyard of the *villa rustica* at Boscoreale (Jashemski 1993: 288).

Herculaneum: (1) on the Decumanus Maximus (inv. no. 2315), a large number of whole carbonized almonds without husk; (2) in the Casa del Bel Cortile (V.8), several broken almond shells, a few with outer husk (exocarp) still intact; (3) in a shop (ins. or. II.9, inv. no. 1167) several badly broken pieces of almond shell in a bowl, some with outer husk.

Naples Museum: (1) fifty to sixty complete almond fruits with husks; (2) a few complete almond fruits with husk, and a few broken shells; (3) a dish of almond shells and kernels in the storeroom in the museum attic (inv. no. 84638). This material was cited by Wittmack.

Boscoreale: four fragments of almond shell (Meyer 1988: 210).

WALL PAINTINGS

The almond is found both in still-life paintings and among the offerings in lararium paintings. The almond fruit is pictured in pairs in several still-life paintings: one from Pompeii (NM inv. no. 8645 = Helbig no. 1682) shows two figs, two dates, two coins, and a pair of almonds in the plate in the upper half of the picture, with another pair of almonds beside the plate; a second painting (NM inv. no. 8643 = Helbig no. 1703)

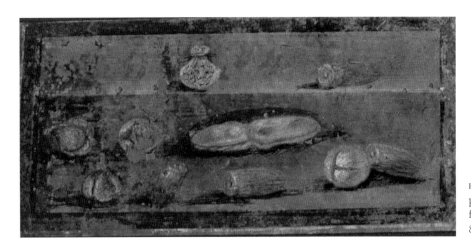

FIGURE 135 Still-life painting with a pair of almonds with husks, dates, figs, and a money bag (NM inv. no. 8643). Photo: S. Jashemski.

includes a pair of almonds with husks, together with dates, figs, and a money bag (Fig. 135). A painting in the House of the Lovers (I.x.10–11), on the N wall of the cubiculum to the N of the vestibule, includes a peacock, figs, dates, and a pair of almond fruits with husks (Fig. 324).

Among the offerings on the altar in the lararium painting in the House of the Ephebe (I.vii.10–12/19), one, perhaps two pairs of almond fruit can be identified. Two or more pairs could still be seen in 1961 among the offerings on the W wall of the tomb of Vestorius Priscus.

Roux and Barré (1875–7: vol. 5, pl. 48) show a drawing of a still-life with figs, dates, and on the upper shelf a pair of almond fruits. Helbig (no. 1676) describes a painting in the Naples Museum (but he gives no inv. no.) with five figs on a grape leaf on the right and three unshelled almonds on the left. Schefold (1957) says this is Rizzo (1929) pl. 153.2; Helbig cites *Pitture di Ercolano*, vol. 2, p. 11. We have been unable to find either painting in the Naples Museum.

Schouw (1859) recognized almonds in the Pompeian paintings but did not mention any specific examples. Casella identified almonds in a still-life painting in the House of the Little Fountain at Pompeii, and in the House of the Cervi at Herculaneum, but we have been unable to verify either identification.

MOSAIC

Comes (1879: 13) identified an almond branch with characteristic foliage, laden with nuts, in a mosaic from the House of the Faun. Presumably he refers to the garland mosaic (inv. no. 9994), but we do not find any almonds in this mosaic. Perhaps he took the olives for almonds.

SCULPTURE

Comes (1879: 13) and Casella (1950: 371) plausibly identified the almond, together with its leaves and flowers, in the garlands sculptured on the marble altar in the Temple of Mercury, later called the Temple of Vespasian, on the E side of the Pompeii forum (Fig. 136).

BONE

A bone charm very realistically carved to represent an almond was found at Herculaneum (inv. no. 2584; Scatozza Höricht 1989: fig. 162).

REFERENCES IN ANCIENT AUTHORS

Columella often mentions the almond (*amygdala*). He says that it is the first nut tree to bloom in the spring, and he gives directions for planting, grafting, and making the tree more productive (*RR* 11.2.11, 96; *Arb* 22.1, 25.1). He lists it among the trees to be grown especially for bees (*RR* 9.4.3).

Pliny (*HN* 15.90) gives a good and detailed description of the almond. By his time many named varieties of almonds were grown in Italy, including both sweet and bitter types, the latter known botanically as *P. dulcis* (Mill.) D. A. Webb var. *amara* (DC.) H. E. Moore. The bitter almond was a source of oil. An oil made in Egypt from bitter almonds was used for making perfume (Pliny *HN* 13.8, 19). Pliny recommends almond oil to cleanse and smooth the skin, make the body sup-

FIGURE 136 Almonds in a garland on altar of the Temple of Vespasian, Pompeii. Photo: S. Jashemski.

FIGURE 137 Peach pit. Boscoreale Antiquarium. Photo: F. Meyer.

ple, and improve the complexion; it can also be used with honey to remove spots from the face (*HN* 23.85).

The almond was also used in cooking. Apicius uses the almond more than any other nut except pine kernels. Columella gives a recipe for using almonds for making mustard (*RR* 12.57.2), as well as an elaborate salad (*RR* 12.59.3–4). The almond was also used to adulterate spices (Pliny *HN* 12.36). Almonds were used medicinally, but the bitter almond was considered more efficacious than the sweet almond (Pliny *HN* 23.144–5; Dioscorides 1.176). Some believed that eating about five bitter almonds "before a carouse" would prevent intoxication.

REMARKS

The domesticated almond has been known since prehistoric times in Near Eastern countries where this common nut is believed to have originated. The domesticated almond probably developed as a selection from wild almonds with sweet kernels, which sometimes occur in nature. In Europe the domesticated almond is known from various Bronze and Iron Age sites in Cyprus.

133. *PRUNUS PERSICA* (L.) BATSCH

English, peach; Italian, *pesco*

MATERIAL EXAMINED

A peach pit found at Pompeii in II.ii is displayed in the Antiquarium at Boscoreale (Fig. 137).

WALL PAINTINGS

There is a beautiful, accurate painting of a branch with five unripe peaches from Pompeii (Fig. 138; NM inv. no. 8645 = Helbig 1683). One fruit is depicted with a section removed to show the stone. A half-filled glass of water completes this still life. This is the left one of three paintings framed together. A similar painting, with four peaches but without the glass of water, is on the right.

Three peaches can also be identified in a painting in the Naples Museum (inv. no. 8764 = Helbig no. 1676; Helbig incorrectly identifies the peaches as almonds). Helbig lists three additional paintings with peaches,

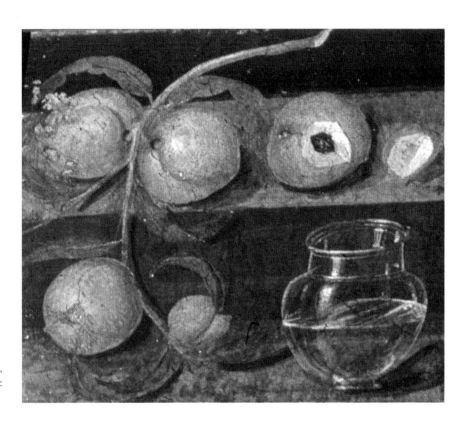

FIGURE 138 Wall painting of peaches, Pompeii (NM inv. no. 8645). Photo: S. Jashemski.

two of which Schefold equates with pictures in the Naples Museum: (1) Helbig no. 1633 (NM inv. no. 8734), a bird before a peach branch, from Herculaneum; (2) Helbig no. 1685 (NM inv. no. 8616), a peach and a pomegranate, from Herculaneum; (3) Helbig no. 1684 a peach branch and a plum from Pompeii (drawing in *Pitture di Ercolano*, vol. 2. p. 64). Schouw listed peaches among the fruit he found. Comes reported peaches in the triclinium of the House of Siricius, but these are no longer visible, also in *Pitture di Ercolano*, vol. 1, pl. 2a. Maiuri (1952: 10) identified the tree in fruit in the House of the Fruit Orchard on the W panel, above the window on the S wall in the room off the W side of the peristyle as a peach, but close examination shows it is a pomegranate (see no. 135).

REFERENCES IN ANCIENT AUTHORS

It is not surprising that the peach is not mentioned more often, for it was a recent importation into Italy. Pliny (*HN* 15.45) lists it among the exotics that have been introduced in Italy. He says, "the *persica* (peach) . . . is shown by its very name to be an exotic even in Asia Minor and in Greece, and to have been introduced from Persia."

Columella mentions the peach tree twice (*RR* 5.10.20; 9.4.3). Martial (13.46), a younger contemporary, mentions it once. There are no references to the peach earlier than the time of Pliny and Columella in the Latin authors. Pliny (*HN* 23.132) discusses the medicinal uses of the peach, its juice, its leaves, and its pits. It is not listed by Dioscorides.

REMARKS

As a wild plant the peach is of Chinese origin. It is one of the few plants of eastern Asia known in antiquity in Europe, along with millet. It was known to the Romans by the first century A.D., as attested by the wall paintings at Pompeii.

134. *PTERIDIUM AQUILINUM* (L.) KUHN
English, bracken fern, eagle fern; Italian, *felce aquilina*

MATERIAL EXAMINED

One large and some small leaf fragments were found in the carbonized hay at Oplontis (Fig. 139).

REFERENCES IN ANCIENT AUTHORS

Bracken fern could probably be identified with the plant that Greek authors call *pteris* (πτέρις) (Theophrastus, *Hist. pl.* 9.20.5). Dioscorides (4.186) says that πτέρις has "leaves without stem, flowers and fruits" and "a root that lies shallow, black, somewhat long, having many shoots." Vergil (*Georgics* 2.189) speaks of

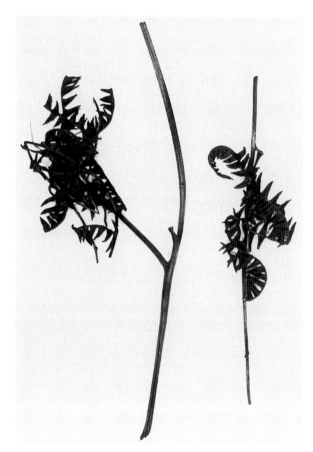

FIGURE 139 Leaf fragments of bracken fern in carbonized hay, Oplontis. Photo: M. Ricciardi.

bracken (*filix*) detested by the plow, and Pliny says that "ferns are of two kinds, neither having blossom or seed. Some Greeks call *pteris* . . . the kind from the sole root of which shoot out several other ferns" (*HN* 27.78). According to Columella (*RR* 7.3.8), the sheepfold should always be strewn with well-dried ferns (*filix*) or straw.

REMARKS

The bracken fern occurs in abandoned fields and pastures, mainly in mountainous areas. It grew at Pompeii in antiquity and is still found there in some abundance.

135. *PUNICA GRANATUM* L.
English, pomegranate; Italian, *melograno, granato*

MATERIAL EXAMINED

At Oplontis, in the *villa rustica*, more than a ton of well-preserved immature fruit was found, carefully preserved between layers of straw. This find represents the only carbonized remains of this fruit from a Vesuvian site (Fig. 140).

WALL PAINTINGS

The pomegranate is one of the fruits most often represented in the wall paintings and mosaics. It is pic-

FIGURE 140 Carbonized pomegranates, *villa rustica,* Oplontis. Photo: USDA.

tured alone, or with a few leaves, with birds, in bowls or baskets of assorted fruits, among offerings on an altar, in garlands, and only rarely on the tree. We cite only a few examples of each. The fruit can be seen alone at Pompeii on the W wall in the atrium of the House of Menander (I.X.4); with two birds in the House of P. Paquius Proculus (I.vii.1) on the S wall in the room to the left of the entrance; in IX.ii.10 in the lunette on the E wall of the room to the E of the atrium; in the House of the Lovers (I.x.10–11) in the lunette at the top of the E wall of the triclinium; in the House of the Ephebe on the N wall in room 4 off the atrium at the entrance; in the House of Achilles (IX.v.2) in the center panel of the room to the left of the entrance; in Shop I.vii.5 in the room to the left of the entrance; under the portrait of the child Successus in House I.ix.3 in the room to the left of the atrium; and in the House of the Little Fountain, there is a gallinule eating pomegranate seeds (Fig. 329). Paintings in the Naples Museum show pomegranates with a rooster and a hen (inv. no. 9714); a goose with two pomegranates and a fig (inv. no. 8647); and a still life of

FIGURE 141 Pomegranate in a basket of fruit. Entrance, House of the Vettii. Photo: S. Jashemski.

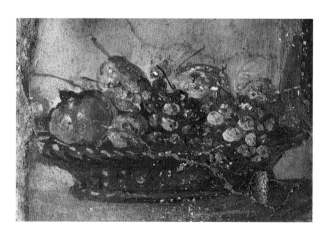

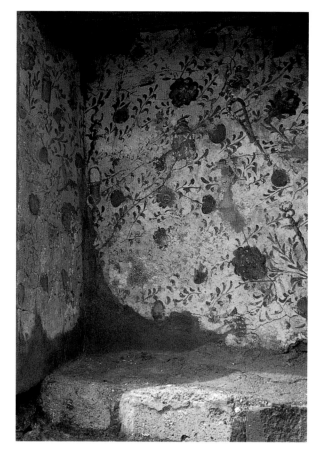

FIGURE 142 Pomegranate flowers and fruit on the lararium, House I.xiii.12. Photo: S. Jashemski.

a dead bird, a pomegranate with a long stem and leaves, and another fruit, perhaps a quince (inv. no. 8647).

Pomegranates appear in bowls or baskets of assorted fruit, as in the painting from the House of Julia Felix, now in the Naples Museum, which also has a split pomegranate fruit on the table to the left of the bowl (Fig. 107); in a basket of fruit to the right of Arcadia in the large painting from the Basilica at Herculaneum (NM inv. no. 9008); in the basket of fruit at the bottom of the painting of the Centaur (NM inv. no. 9044); and in the low basket of fruit underneath Priapus in the vestibule of the House of the Vettii (Fig. 141).

The fruit appears among the offerings on the altar in the painting in the House of Obellius Firmus (IX.(xiv).4/2) at Pompeii, on the S wall in the room SW of the peristyle. A few crudely painted fruits and leaves, together with spectacular pomegranate flowers, form the overall pattern that decorated the interior of the lararium in House I.xiii.12 (Fig. 142).

Pomegranates appear in garlands in the painting from the villa at Boscoreale (without inv. no.) in the Naples Museum. At Pompeii, a garland composed entirely of pomegranates and leaves in the House of the Silver Wedding (V.ii.1), on the S wall of the exedra, has fruit not entirely developed and blossoms not

yet wide open; they are shown in the same way in the gold schoolroom on the S side of the peristyle in this house. The wall paintings and mosaics show both mature and less mature fruit. Both can be seen in the House of Chlorus and Caprasia (IX.ii.10), the less mature fruit in I.vii.5.

Fruit trees are rarely found in wall paintings, with the exception of those in the House of the Fruit Orchard. But the pomegranate tree is an exception. In the House of Adonis (VI.vii.18) at Pompeii there is a small pomegranate tree with large fruit to the left of the sleeping child. An oversize bird perches on the tree. In the garden painting on the E wall of House I.ii.10, upon cutting away weed trees and vines, we found branches of a shrublike pomegranate tree and brightly painted fruit. In the House of the New Hunt (VII.x.3/14) there is a shrublike tree with characteristic pomegranate fruit, but with poorly depicted foliage. In the House of the Fruit Orchard a pomegranate tree with immature fruit (not a peach tree as identified by Maiuri) is depicted on the S wall of the room off the E side of the peristyle. There are small trees with pomegranate fruit in the garden paintings in the House of Venus Marina (II.iii.3) on the E and S walls of the peristyle. Two very fine pomegranate trees were found at the time of excavation in the peristyle of the Villa of Diomede. No trace of them remains today, but they are preserved in drawings (Fig. 231 and Jashemski 1979: fig. 179; 1993: fig. 435).

A pomegranate tree is depicted in the tomb of Vestorius Priscus outside the Vesuvian Gate, on the E wall to the left of the low door on the N. It is appropriate here, as the pomegranate was a symbol of death.

MOSAICS

A detail of a mosaic in the Naples Museum (Santangelo collection) shows a cock and pomegranates. Pomegranates are often found in mosaic garlands, as in the garland from the House of the Faun (NM inv. no. 9994); in the garlanded borders of the mosaic of the School at Athens (Naples Museum inv. no. 123545); in the mosaic of doves drinking from a bowl (Naples Museum inv. no. 114281); and in the doves and cat mosaic (NM inv. no. 9992).

GLASS VASE

Pomegranates appear in the garlands on both the vintage side of the Blue Glass Vase (NM inv. no. 13521) and on the side with the cupid playing the cithara.

REFERENCES IN ANCIENT AUTHORS

Cato (*RR* 133.2) gives directions for propagating the pomegranate (*malus Punica*) by layering and recommends several medicinal uses of the plant (*RR* 126, 127).

Pliny describes the pomegranate at length (*HN* 13.112–13, 15.100). He says that it is the only fruit that has corners. The unripe fruit is used for tanning leather. The large cache of unripe fruit found in the *villa rustica* at Oplontis had probably been harvested for tanning leather, since the unripe fruit is known to be high in tannin content. The flower is used for dyeing cloth. It gave its name to a special color, *Punicum*, or purple. Both Pliny (*HN* 23.106–13, 30.50) and Dioscorides (1.151–3) list various medicinal uses of the pomegranate, a plant with astringent properties.

REMARKS

The pomegranate is a cultigen that occurs as a wild plant from the Balkan region to northern India. It has been cultivated since prehistoric times. Because of its many seeds, the pomegranate is regarded as a fertility symbol. The bark supplies the color of yellow Moroccan leather. In botanical terms, the fruit of the pomegranate is unique among flowering plants.

136. *PYRUS COMMUNIS* L.

English, pear; Italian, *pero*

MATERIAL EXAMINED

Carbonized pears are known from only two unnumbered accessions of material in the Naples Museum. In one bowl the fruits are relatively small; in the other, they are larger and better preserved. The pear is not mentioned by Wittmack (1904).

CARBONIZED WOOD

A portion of an intact carbonized tree trunk (2 m long × 30–35 cm in diameter with four large stubs of branches that lengthened the trunk another 60–90 cm) was found during the excavation of the Casa dell'Albergo at Herculaneum in 1928. The wood was treated, sectioned, and identified as *P. communis* L. (see Trotter 1932; 1–6, pls. 1, 2).

WALL PAINTINGS

Pears are pictured individually with birds at Pompeii, as on the W atrium wall in the House of Menander; in Shop I.vii.5 in the room to the left of the entrance (Fig. 143); and on the N wall of ambient 81 in the Villa of Poppaea at Oplontis. At other times they are pictured in a bowl or basket of assorted fruit, as in the large glass bowl of fruit from the House of Julia Felix (Fig. 107), which contains several pears of the same variety as those pictured in the shop; or in the basket of fruit under Priapus (VI.xv.1) (Fig. 141). A unique example of a tree laden with pears was found in the House of the Fruit Orchard on the S wall of the room off the E side of the peristyle (Jashemski 1979, fig. 388).

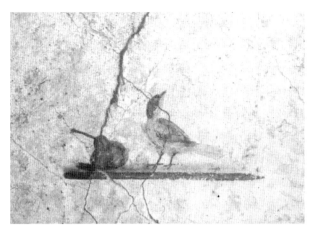

FIGURE 143 Bird and large pear. Shop I.vii.5. Photo: S. Jashemski.

MOSAICS

Stylized pears can be identified in mosaic garlands, such as the one that frames the Dove mosaic (NM inv. no. 11438); in the garland border around the mosaic of the School of Athens; and in the garland mosaic from the House of the Faun. In this mosaic the pear is not shown in its entirety but is partly covered by the ring.

REFERENCES IN ANCIENT AUTHORS

Theophrastus (*Hist. pl.* 1.14.4) distinguishes between wild and cultivated pears and says that the cultivated varieties had received names. By Roman times the pear (*pirus*) was well developed as a cultivated fruit in Italy. Sophisticated methods had been established for its culture, including grafting by inarching, which Varro (*RR* 1.40.5) mentions. Cato mentions five varieties (*RR* 7.3–4), Pliny (*HN* 15.53) more than thirty varieties. Pliny (*HN* 23.115–16) and Dioscorides (1.167) discuss the medicinal uses of the pear.

REMARKS

Many pomologists believe that *P. communis* is a hybrid complex derived from several species of *Pyrus* native to Europe and the Near East, with the greatest concentration of pear species occurring in the trans-Caucasus region (Meyer 1988: 211).

137. *QUERCUS ILEX* L.

English, holly oak, holm oak; Italian, *leccio, elce*

MATERIAL EXAMINED

The cast of the imprint of a leaf identified as *Quercus ilex* L. from the Villa of S. Marco at Stabiae is displayed in the Antiquarium at Boscoreale (inv. no. 497/2).

BRONZE

A bronze candelabra in the Naples Museum (without inv. no.) shaped to represent a branch of holly oak has four leaves and two acorns that are easily recognizable.

STUCCO

A civic crown of oak leaves modeled in stucco appears between two painted laurels above the door of the House of Messius Ampliatus (Fig. 144). A close examination of the leaves showed that they are *Q. ilex*.

REFERENCES IN ANCIENT AUTHORS

Theophrastus speaks of the holm oak (πρῖνος). The *ilex* is mentioned frequently by the Latin writers; the adjectives *iligneus* and *ilignus* are also found. Cato (*RR* 5.7–8) says that if bedding runs short, the leaves of the holm oak can be used for bedding down sheep and cattle. Columella (*RR* 6.3.7) recommends the leaves for win-

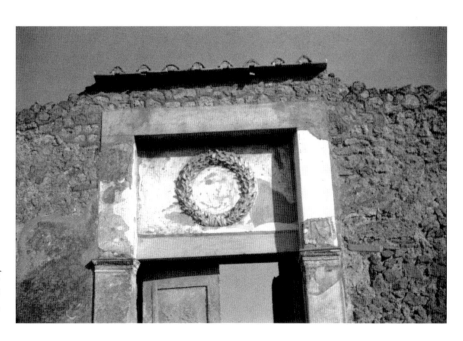

FIGURE 144 Stucco civic crown of holly oak above the door, House of Messius Ampliatus. Photo: S. Jashemski.

ter fodder and the acorns for pigs (*RR* 7.9.6, 9.1.5). Pliny (*HN* 16.74, 80) lists the holm oak among the trees that do not shed their leaves and among the trees that spread from the mountains to the valleys. According to Pliny:

> The civic crown was first made of the leaves of the holm-oak (*ilex*), but afterwards preference was given to a wreath from the winter oak (*aesculus*) [durmast oak *Q. petraea*] which is sacred to Jove, and also a variety was made with common oak (*quercus*) [*Q. robur* L.]
>
> *HN* 16.11

Pliny adds that the tree growing in a particular locality was used, but the honor of providing a civic crown always fell to an acorn-bearing tree.

The wood of the holm oak was used for veneering luxury furniture. It is most reliable for things subjected to friction, such as the axles of wheels (*HN* 16.229). Pliny mentions a number of famous holm oaks, several older than the city of Rome (*HN* 16.237). Vergil has various references to the holm oak. He speaks of bees hiding their swarms in the hollow shell of a decayed holm oak (*Georgics* 2.452–3).

REMARKS

The triangular forum at Pompeii is today planted with a beautiful grove of the evergreen holm oak (*Q. ilex*). It is native to the Mediterranean region and one of the most representative and widespread trees of this vast area.

138. *QUERCUS PUBESCENS* WILLD.

English, pubescent oak; Italian, *roverella*

MATERIAL EXAMINED

One whole leaf and some leaf fragments were found in the carbonized hay at Oplontis (Fig. 145).

REMARKS

The pubescent oak can be a tree up to 25 m, or sometimes a shrub. It is the most common of deciduous oaks in southern Italy.

139. *QUERCUS ROBUR* L.

English, common or English oak; Italian, *rovere*

WALL PAINTINGS

Branches with leaves and acorns of the English oak are pictured in fragments of a fine earlier wall painting found in the House of the Gold Bracelet (Fig. 146).

MOSAICS

Leaves and acorns of the English oak are frequently represented in both mosaics and sculpture. They can be

FIGURE 145 Leaf of a pubescent oak in carbonized hay, Oplontis. Photo: M. Ricciardi.

identified in the mosaic garland from the House of the Faun, in the garland bordering the School of Athens, and in the garland border of the Dove mosaic.

SCULPTURE

The leaves and acorns of the civic crown depicted on the marble altar of Vespasian at Pompeii are probably those of the English oak. A more stylized civic crown of oak leaves and acorns is sculptured on each end of the altar-type tomb monument of the Augustalus, C. Calventius Quietus, located on the Street of the Tombs outside the Herculaneum Gate. A dormouse nibbling an acorn of *Q. robur*, identifiable by its long peduncle, can be seen on the upper left side of the

FIGURE 146 Fragments of a wall painting with common or English oak, House of the Gold Bracelet. Photo: F. Hueber.

marble sculpture framing the entrance of the Building of Eumachia (Fig. 347). On the base of a marble candelabra, a deer and faun are shown under the branch of an oak tree, on which the leaves and acorns of *Q. robur* are realistically portrayed (Spinazzola 1928: 50).

GLASS

Leaves and acorns of *Q. robur* are found in the garlands of the Blue Glass Vase in the Naples Museum.

TERRA-COTTA

Two lamps found in the lamp factory (I.xx.3), now in the *deposito* at Pompeii, are decorated with wreaths of *Q. robur*.

REFERENCES IN ANCIENT AUTHORS

Theophrastus mentions the oak (δρῦς) several times. *Quercus* was the classical Latin name for the oak. Vergil (*Georgics* 3.332) speaks of Jove's great oak spreading out its giant branches. Pliny devotes many chapters of Book 26 to the oak. The Romans knew many different kinds of oak. Pliny (*HN* 16.19) mentions six kinds (*robur, quercus, aesculus, cerris, ilex, suber*), which can perhaps be identified as the Valonia oak (*Q. macrolepis* Kotschy); common or English oak (*Q. robur* L.); durmast oak (*Q. petraea* (Mattuschka) Liebl.); Turkey oak (*Q. cerris* L.); holm oak (*Q. ilex* L.); and corkoak (*Q. suber* L.). Pliny says:

> Their leaves with the exception of the holm oak are heavy, fleshy and tapering, with wavy edges and they do not turn yellow when they fall like beech leaves. . . . The best and largest acorns grow on the common oak.
>
> *HN* 16.19–20

REMARKS

The acorns depicted in the mosaics and sculpture at Pompeii, with the possible exception of those on the altar of Vespasian can be identified as *Q. robur*, because of their acorns with long peduncles. The English oak occurs over most of Europe, except parts of the Mediterranean region, but it occurs in Italy, where it has been planted since antiquity.

140. *RANUNCULUS* sp.

English, buttercup; Italian, *ranuncolo*

MATERIAL EXAMINED

Fragmentary material with achenes and one receptacle with achenes were found in the carbonized hay at Oplontis.

141. *RAPHANUS RAPHANISTRUM* L.

English, wild radish; Italian, *ramolaccio, rapastrello, rafano*

MATERIAL EXAMINED

Fruits and broken fruit segments were found in the carbonized hay at Oplontis.

REFERENCES IN ANCIENT AUTHORS

Theophrastus refers to the wild radish as ῥάφανος ἡ ἀγρία ("wild cabbage"). He says, "The wild form has a small round leaf, it has many branches and many leaves, and further a sharp medicinal taste; wherefore physicians use it for the stomach" (*Hist. pl.* 7.4.4). He adds, "A peculiarity of 'wild cabbage'. . . is that its stems are rounder and smoother than in the cultivated kind" (*Hist. pl.* 7.6.2). Pliny's only mention of "wild radish" (*raphanos agria*) is erroneous (*HN* 20.22).

REMARKS

Wild radish occurs in the Mediterranean region and elsewhere throughout Europe as a weed of cultivated fields.

142. *RAPHANUS SATIVUS* L.

English, radish; Italian, *radice, ravanello*

WALL PAINTINGS

The radish can be identified in a still-life painting on the S wall of the oecus-triclinium in the House of the Cryptoporticus (I.vi.2/16). The painting shows grapes and a dish of figs on the upper level, a bird, and a basket containing a bunch of long white radishes below (Spinazzola 1953: vol. 1, fig. 582, p. 522; vol. 3, pl. xxxii). The radish was identified by Helbig (1868) in three paintings at Pompeii that are no longer in existence, but drawings of two of these have been preserved. He identified several radishes in the still life painting described earlier (see no. 22, Fig. 152 in this chapter), but the two bunches of vegetables that he identified as yellow Rüben (carrots) would have been the long white radish. Helbig (no. 775, p. 154) also identifies a radish on the ground in a small painting in the Casa dei Bronzi (House of the Black Walls). For a drawing of this painting see *Real Museo Borbonico* 11.16; Reinach (1922: 89.2, cf. Schefold 1937: 188). Helbig (1868: no. 1713) also lists a radish, along with an onion and a lobster in a glass in a still-life painting in House VIII.vi.4. No drawing exists for this painting. Schouw (1859) lists the radish among the plants he identified, but Comes (1879: 74) puts it among the plants he considers doubtful or not actually seen.

REFERENCES IN ANCIENT AUTHORS

The radish (*raphanus*) was considered an extremely valuable article of food, especially in winter, among the Romans. Cato (*RR* 35.2), Columella (*RR* 11.3.47, 59), and Pliny (*HN* 19.83–5) give directions for its culture.

Pliny (*HN* 19.81) names two varieties, the Monte Compatri radish, named from its locality, a long and semitransparent radish, and another shaped like a turnip, which he says appears to have been imported from Syria only lately. The long, semitransparent white radish seems to have been more common. Both Pliny (*HN* 18.130) and Theophrastus (*Hist. pl.* 7.6.2) speak of the radish as having a long root. This would appear to be the long radish pictured in the House of the Cryptoporticus, and in Helbig (no. 1669). Pliny (*HN* 19.83) says the radish is so fond of the cold that in Germany it grows as big as a baby child. The Egyptians held the radish in high esteem because of the oil made from its seed (*HN* 19.79). Pliny (*HN* 19.86–7) pokes fun at the Greeks who rated the radish so far above all other articles of food that in the Temple of Apollo at Delphi they dedicated as a votive offering a radish modeled in gold, though only a silver beetroot and a turnip of lead. He adds that the Greek author Moschion wrote a whole volume about the radish.

Apicius gives only one recipe for the radish (3.14). Both Pliny (*HN* 19.86, 87; 20.23–8; 22.125; 23.16, 94; 25.59) and Dioscorides (2.137) list the many medicinal uses of radishes. They were also considered an antidote for intoxication (*HN* 17.240).

REMARKS

The cultivated radish is a cultigen of unknown origin. Heywood and Zohary (1995: 391) suggest that it is probably derived from *Raphanus raphanistrum* L., with which it is fully interfertile. Some authorities believe it had an eastern Asian origin because of the well-known Japanese radish (daikon) and other forms in China not found in the West. Only the long white radish has been identified in the paintings at Pompeii.

143. *ROSA* sp.

English, rose; Italian, *rosa*

WALL PAINTINGS

A dramatic picture of a thorny red rose in bud and flower is depicted in the garden painting on the E wall in the *diaeta* in the House of the Gold Bracelet (Fig. 147). A rosebush in flower is pictured in the garden painting in the House of Venus Marina (II.iii.3) to the left of the fountain in the W panel. In the same house, the flowering bush to the left of the fountain in the garden painting on the S wall of the little room off the SE corner of the peristyle also appears to be a rose. The rose is pictured growing behind a low fence in the garden painting in the room off the E side of the peristyle in the House of the Fruit Orchard, as well as in the room off the E side of the atrium. Similar roses are found in Sacellum A at Herculaneum on the S wall to

the right of the fountain. Various fragments of the earlier painted wall in the House of the Gold Bracelet have pink roses. A beautiful painting of roses in full bloom and tight bud found in the Villa of Diomede is now destroyed (Fig. 265).

There are many carefully painted roses among the strewn blossoms portrayed in the unique ceiling in House I.vi.1 (Fig. 80). Many are full blown with numerous petals, and there are seven with five upright petals; but there are also many wide open buds and a few tight buds. More than one kind of rose seems to be represented. Those with dark striations at the edge of the petals and those with the top three petals painted in a lighter color are probably an artist's convention, and not another kind. Crudely painted roses decorate the altar in the garden in House VII.vii.5.

The rose was a very popular garland flower. Roses can be identified in the painted garland from Boscoreale and in the garland held by cupids.

Comes (1879) lists the rose in the House of the Little Fountain (location in house not given) and in a painting in the Naples Museum (inv. no. 1340), in each corner of which there is a rosebud with red petals, but we have been unable to locate these.

MOSAIC

Comes (1879: 65–6) also reports a rose in a mosaic from the House of the Faun (specific mosaic not cited). We have been unable to locate it. There is no rose in the famous mosaic garland with the masks in the House of the Faun that he cites so often, nor in the Nile mosaic. This leaves the mosaic of the cupid on a panther, and perhaps he is referring to the six-petaled flower in the lower right of the garland border, but the flower is so stylized that it is difficult to identify.

CARBONIZED MATERIAL

Ciarallo and Lippi (1993: 110–11) report that fragments of carbonized wood found in six root cavities, with an average diameter of 3 cm, in the garden of the House of the Chaste Lovers were identified as *Rosa* sp.

REFERENCES IN ANCIENT AUTHORS

Theophrastus knew both the wild rose (κυνόσ-βατος) (*Hist. pl.* 3.18.4; 9.8.5) and the cultivated rose (ῥοδωνία) (*Hist. pl.* 6.6.4–5).

Although the rose (*rosa*) was the favorite flower of the Romans, the lily "came nearest to the rose in fame" (Pliny *HN* 21.22). Roses grown in greenhouses were available in the winter (Martial 4.22, 13.127). Martial (66.80) speaks of the winter roses that Egypt proudly sent to the emperor.

The roses of Campania were the most noted. Pliny mentions many kinds of roses:

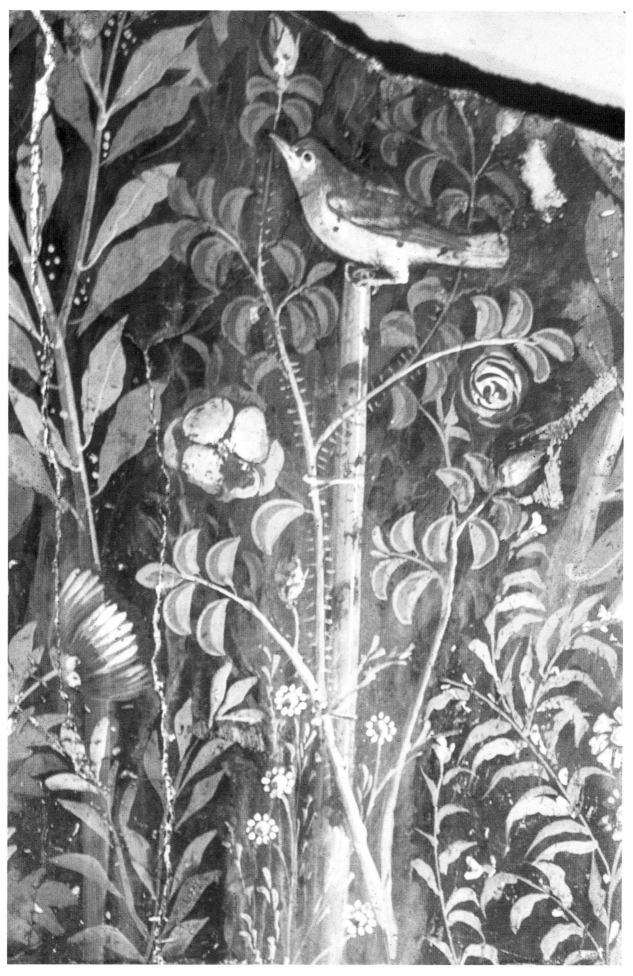

FIGURE 147 Laurel, roses, a warbler, and Solomon's seal in a garden painting, House of the Gold Bracelet. Foto Foglia.

The most famous kinds of roses recognized by our countrymen are those of Praeneste and those of Campania. . . . Roses differ in the number of their petals. . . . Those with the fewest petals have five. . . . There is one kind called the hundred-petaled rose. In Italy this . . . grows in Campania. . . . The hundred petaled variety is never put into chaplets, except at the ends where these are as it were hinged together, since neither in perfume or appearance is it attractive.

HN 21.16–18

The wild rose of Campania was equally famous:

The land is in crop all the year round, being sown once with Italian millet and twice with emmer wheat; and yet in spring the fields having had an interval of rest produce a rose with a sweeter scent than the garden rose, so far is the earth never tired of giving birth; hence there is a common saying that the Campanians produce more scent than other people do oil.

HN 18.111

Vergil (*Georgics* 4.119) speaks of the rose beds of Paestum that bloom twice a year.

Rose perfume was extremely popular, and it was the wild rose that was used for this purpose, because it had a stronger scent. Egypt was famous for its production of unguents, but Campania with its abundance of roses ran a close second (Pliny *HN* 13.26).

REMARKS

The rose had a special claim to honor at Pompeii. It was the flower of Venus, and Venus Pompeiana was the tutelary deity of Pompeii. Comes (1879) identified the roses that he found at Pompeii as the Damask rose. He agrees with Sprengel who believed that the much renowned rose of Paestum was the Damask rose (*R. xbifera* Poiret). None of the roses depicted in wall paintings at Pompeii can be identified with any degree of accuracy.

144. *ROSTRARIA CRISTATA* (L.) TZVELEV (*LOPHOCHLOA CRISTATA* (L.) HYL.)

English, prairie June grass; Italian, *paléo (cristato)*

MATERIAL EXAMINED

Many inflorescences were found in the carbonized hay at Oplontis.

REMARKS

Prairie June grass is an annual, with a characteristic softly hairy, lobed inflorescence. It occurs mainly in waste and stony places and in fissures of walls and roads.

FIGURE 148 Fragment of bramble in carbonized hay, Oplontis. Photo: M. Ricciardi.

145. *RUBUS ULMIFOLIUS* SCHOTT

English, bramble, elm-leaved blackberry; Italian, *rovo, mora di rovo*

MATERIAL EXAMINED

Stem and branch fragments with poorly preserved leaves were found in the carbonized hay at Oplontis (Fig. 148). The material lacks diagnostic characters that would confirm the identification of our carbonized material. But *Rubus ulmifolius* is the most widespread species of bramble growing today in the Vesuvian area.

MOSAIC

The berry above the left ring in the mosaic from the House of the Faun (NM inv. no. 9994) has the appearance of a blackberry.

REFERENCES IN ANCIENT AUTHORS

Vergil (*Georgics* 3.315) speaks of the "prickly brambles." Pliny lists different kinds of brambles (*rubus*) and says, "Not even brambles did Nature create for harmful purposes, and so she has given them their blackberries, that are food even for man" (*HN* 24.117).

Pliny also says that after the thorns were cut off, bramble served as ties for grapevines (*HN* 16.176). Pliny (*HN* 24.118–20) and Dioscorides (4.37) give many medicinal uses of the bramble and also recommend it as a hair dye. According to Columella (*RR* 11.3.4–5), a living hedge, made by planting prickly bushes, especially brambles, was preferred to a constructed wall.

REMARKS

The elm-leaved blackberry, an extremely variable species, occurs along almost every roadside, hedge, and waste place in southern Italy. It is one of the most pernicious, weedy species in the Mediterranean flora. Its fruit is commonly eaten fresh or made into jam or fruit juice. It is a serious pest in the excavations at Pompeii.

146. *RUMEX ACETOSELLA* L.

English, sheep sorrel; Italian, *acetosa minore*

MATERIAL EXAMINED

Fragments of the inflorescence with fruits were found in the carbonized hay at Oplontis.

REFERENCES IN ANCIENT AUTHORS

Theophrastus (*Hist. pl.* 7.4.1) calls the sorrel *lapathon* (λάπαθον) and includes it among the herbs of which "there is one kind"; it has a fleshy root (*Hist. pl.* 7.2.8). He says also (*Hist. pl.* 7.6.1) that the wild species "has a pleasanter taste than the cultivated" and is suitable for food, but it needs "the action of fire" (*Hist. pl.* 7.7.2). Pliny says that sorrel (*lapathum*) "is the only one of all the plants of which the wild variety is better" (*HN* 19.184) and lists its many medicinal uses. Dioscorides (2.140) lists three kinds of sorrel, the last being the wild one, "small, similar to plantain, soft and not so tall."

REMARKS

Sheep sorrel occurs mainly in sandy and rocky places. In the Vesuvian area it is one of the plants found on the summit of Mount Vesuvius on the inner and outer slopes of the crater.

147. *RUMEX BUCEPHALOPHORUS* L. subsp. *BUCEPHALOPHORUS*

English, dock sorrel; Italian, *rómice capo di bue*

MATERIAL EXAMINED

Fragments of the inflorescence with fruits were found in the carbonized hay at Oplontis.

REMARKS

Dock sorrel is common in sandy and rocky places, especially near the sea in the Mediterranean region.

148. *RUMEX PULCHER* L.

English, fiddle-leaved dock; Italian, *rómice cavolaccio*

MATERIAL EXAMINED

A few secondary branches of fruiting shoots were found in the carbonized hay at Oplontis.

REMARKS

This plant occurs along roadsides and in disturbed areas of the Mediterranean region.

149. *SCROPHULARIA PEREGRINA* L.

English, annual figwort; Italian, *scrofularia annuale*

MATERIAL EXAMINED

Pedicels bearing a few ripe capsules were found in the carbonized hay at Oplontis.

REMARKS

Figwort grows in cultivated fields and waste places in the Mediterranean region.

150. *SETARIA ITALICA* (L.) BEAUV.

English, Italian or foxtail millet; Italian, *panico*

MATERIAL EXAMINED

Pompeii *deposito:* (1) (inv. no. 9194) from I.ix.8, 200–300 g of well-preserved carbonized florets (Fig. 149); (2) (inv. no. 11227–8) from I.ix.15, a few whole carbonized florets found as a contaminant of *Vicia faba* L. var. *minor* (Peterm. em. Harz) Beck (inv. no. 1127-B; see no. 178 here). Naples Museum: a dish of well-preserved florets without inv. no. (Meyer 1988: 206).

WALL PAINTINGS

Italian millet is pictured only once. In a painting from Herculaneum (Fig. 120) there is a beautifully executed head of Italian millet from which the quail on the right is eating.

REFERENCES IN ANCIENT AUTHORS

Millet appropriately appears in a painting with quails, for Pliny (*HN* 18.53–4), in describing common millet (*P. miliaceum* L.) and Italian millet, comments that both are accessible to small birds in what can only be called joint ownership with the grower, for these grains are contained in thin skins, which leaves them unprotected. He had previously pointed out that wheat

FIGURE 149 Carbonized floret of Italian or foxtail millet, Pompeii storeroom. Photo: USDA.

and barley were protected against birds and small animals by a fence of beard. *Panicum* was the Latin name for panic or Italian millet. Pliny (*HN* 18.53–4) gives a detailed and accurate description of it and clearly differentiates panic from common millet (*P. miliaceum*) by its panicles or tufts with "a head that drops languidly and a stalk that tapers gradually almost into a twig; it is heaped with very closely packed grains, with a corymb that is at its longest a foot in length."

The ancient Romans used Italian millet for food. Pliny says that it was used for bread, but that common millet was more commonly used for that purpose (*HN* 18.54). He says that in Gaul, especially Aquitaine, and in Italy along the Po, Italian millet was added to beans and that in the Black Sea area it was said to be preferred to any other food (*HN* 18.101). The physician Diocles called Italian millet (*panicum*) the honey of cereals (*NH* 22.131), perhaps because a Greek name for it was μελίνη (Dioscorides 2.120) (μέλι the Greek word for honey).

REMARKS

In Europe, Italian millet or panic has been cultivated at least since the Bronze Age, ca. 2000 B.C., and in China since 6000 B.C. The domesticated plant is unknown in the wild, but *Setaria viridis* (L.) Beauv. seems likely to have been its ancient wild progenitor. Today Italian millet is grown chiefly for birdseed and fodder (Meyer 1988: 205–6).

151. *SHERARDIA ARVENSIS* L.

English, field madder; Italian, *toccamano*

MATERIAL EXAMINED

Upper parts of fruiting stems were found in the carbonized hay at Oplontis.

REMARKS

Field madder is a common weed in fields and meadows in the Mediterranean region.

152. *SIDERITIS ROMANA* L.

English, iron woundwort, ironwort; Italian, *stregonia comune*

MATERIAL EXAMINED

Inflorescences with calyces and some stem remains with leaves were found in the carbonized hay at Oplontis.

REMARKS

This small hairy annual has minute sessile leaves and flowers with a small white corolla. It occurs in stony

and sandy areas in the maquis in the western and central Mediterranean region.

153. *SILENE GALLICA* L.

English, French or English catchfly; Italian, *silene (gallica)*

MATERIAL EXAMINED

Many stems with capsules were found in the carbonized hay at Oplontis.

REMARKS

This plant occurs in the Mediterranean region in open dry habitats, often in meadows, and in the maquis.

154. *SILENE ITALICA* (L.) PERS.

English, Italian catchfly; Italian, *silene (italica)*

MATERIAL EXAMINED

Many calyces and ripe capsules were found in the carbonized hay at Oplontis (Fig. 150).

REMARKS

Italian catchfly occurs in open woodlands and hedges in the Mediterranean region.

155. *SILENE LATIFOLIA* POIRET subsp. *ALBA* (MILL.) GREUTER & BURDET (*SILENE ALBA* (MILL.) E. H. L. KRAUSE)

English, evening campion, white campion; Italian, *silene (bianca)*

MATERIAL EXAMINED

A few calyces and a node bearing leaf fragments were found in the carbonized hay at Oplontis.

FIGURE 150 Carbonized seed of Italian catchfly in carbonized hay, Oplontis. SEM photo: F. Hueber.

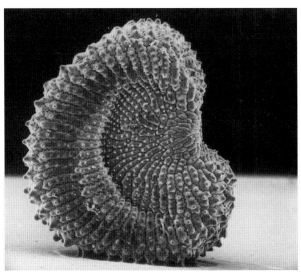

REMARKS

This plant is widespread in Europe, occurring often as a weed in shady areas and waste places. In the past it was used as a potherb and in soups.

156. *SONCHUS ASPER* (L.) HILL

English, prickly sow thistle; Italian, *cicerbita, crespigno*

MATERIAL EXAMINED

Some capitula with ripe achenes were found in the carbonized hay at Oplontis.

REFERENCES IN ANCIENT AUTHORS

Theophrastus (*Hist. pl.* 7.8.3) mentions the sow thistle, which he calls *sonchos* (σόγκος), among the thistlelike plants. Pliny knew of two kinds of sow thistle: "Sow-thistle too is edible . . . both the pale kind . . . and the dark. Both are like lettuce, except that they are prickly, with a stem a cubit high . . . which on being broken streams with a milky juice" (*HN* 22.88).

It is quite possible that the two plants could be identified as *Sonchus asper* (L.) Hill. and *Sonchus oleraceus* L., respectively. Dioscorides (2.159) says that there are two kinds of *sonchos* (σόγκος), a wild and prickly one and a more tender edible one.

REMARKS

The sow thistle is a variable species in waste places and urban areas throughout Europe.

157. *SORBUS DOMESTICA* L.

English, sorb apple, service apple; Italian, *sorbo domestico*

WALL PAINTINGS

One of the crude paintings of a bird and fruit in shop I.vii.5 pictures two fruits painted with little care, but the long peduncle in the painting suggests the sorb apple (Fig. 151).

REFERENCES IN ANCIENT AUTHORS

Theophrastus has many references to the sorb (ὄη). Cato (*RR* 7.4) says the sorb apple (*sorbum*) can be preserved in boiled must, or dried. Columella (*RR* 5.10.19) says sorb apples have no small charm and gives directions for preserving them (*RR* 12.16.4). Pliny has many references to the sorb, including a list of several varieties (*HN* 15.85). He also says that vinegar can be made from the sorb (*HN* 14.103). He also gives directions for preserving them and lists their medicinal uses. Apicius (4.2.33) gives directions for making a patina (a kind of cake) using sorb apples.

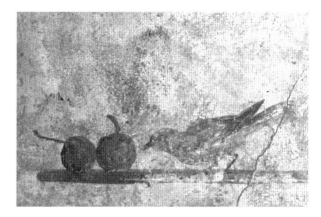

FIGURE 151 Golden oriole and sorb apples. Photo: S. Jashemski.

REMARKS

The sorb apple grows wild in southern Europe and the Mediterranean, extending to central Germany. It is cultivated for its fruit.

158. *STELLARIA MEDIA* (L.) VILL.

English, chickweed; Italian, *centocchio, budellina, paperina*

MATERIAL EXAMINED

The upper part of a single stem with fruit was found in the carbonized hay at Oplontis.

REMARKS

Chickweed occurs throughout Europe, often as a weed of cultivation. It is common in the Vesuvian area.

159. *TARAXACUM* sp.

English, dandelion; Italian, *soffione, tarassaco, pisciulletto*

MATERIAL EXAMINED

A receptacle with involucral bracts was found in the carbonized hay at Oplontis.

REMARKS

The carbonized material is too fragmentary to identify to species.

160. *TRAGOPOGON PORRIFOLIUS* L.

English, salsify, oyster plant, goat's beard; Italian, *barba di becco*

WALL PAINTING

The bunch of vegetables pictured on the left in a painting from Pompeii no longer extant but preserved in a drawing (*Pitture di Ercolano*, vol. 2, p. 52, pl. 8; Roux and Barré 1875–7: vol. 4, pl. 63; Helbig 1868: no. 1669; see also nos. 22, 142 in this chapter) appears to be salsify, or goat's beard (Fig. 152), or possibly black salsify,

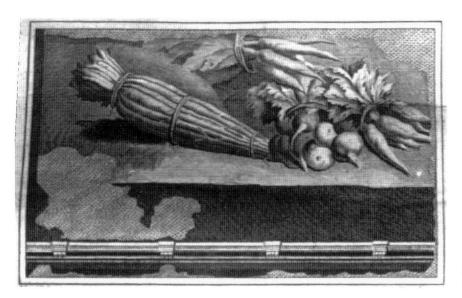

FIGURE 152 Still-life painting with salsify or oyster plant (left).

which is very similar and is also eaten. Helbig incorrectly identified the plant as asparagus.

REFERENCES IN ANCIENT AUTHORS

Theophrastus (*Hist. pl.* 7.7.1) says that τραγο-πώγων (goat's beard in Greek), which some call κόμη (hair) "has a long sweet root . . . and on top is the large mass of grey pappus [as the apical tuft of hairs or bristles on the fruits of dandelion], from which it gets its name 'goat's beard'." Pliny (*HN* 27.142) also calls this plant *tragopogon*, referred to by some as *come.* He says it is eaten but never used in medicine.

REMARKS

Salsify, or goat's beard, has been known since antiquity as a vegetable. This is the first time it has been identified in Campanian wall paintings.

161. *TRIFOLIUM ANGUSTIFOLIUM* L.

English, (slender-leaved) clover; Italian, *trifoglio (angustifoglio)*

MATERIAL EXAMINED

Inflorescence fragments with a few flowers were found in the carbonized hay at Oplontis.

REMARKS

This slender annual has very narrow leaflets and long cylindrical heads; its flowers are pink. It occurs in dry places in southern Europe and the Mediterranean area.

162. *TRIFOLIUM ARVENSE* L.

English, rabbit-foot clover, hare's foot; Italian, *trifoglio (arvense)*

MATERIAL EXAMINED

Flowering heads were found in the carbonized hay at Oplontis.

REMARKS

This plant occurs in sandy areas and is widespread over most of Europe.

163. *TRIFOLIUM BOCCONEI* SAVI

English, (Boccone's) clover; Italian, *trifoglio (di Boccone)*

MATERIAL EXAMINED

A few poorly preserved flowers were found in the carbonized hay at Oplontis.

REMARKS

This clover occurs in pinewoods and dry places in the Mediterranean region.

164. *TRIFOLIUM CAMPESTRE* SCHREBER

English, large hop clover; Italian, *trifoglio (campestre)*

MATERIAL EXAMINED

Many branches and whole inflorescences were found in the carbonized hay at Oplontis.

REMARKS

This annual has erect or ascending hairy stems. It is very common in dry grassy places and on sunny hillsides. It occurs over most of Europe.

165. *TRIFOLIUM CHERLERI* L.

English, Cherler's clover; Italian, *trifoglio (di Cherler)*

MATERIAL EXAMINED

Flowering heads with the basal portion of involucral bracts were found in the carbonized hay at Oplontis.

This clover occurs on maritime sands and is widespread in the Mediterranean region.

166. *TRIFOLIUM GLOMERATUM* L.
English, cluster clover; Italian, *trifoglio (glomerato)*

MATERIAL EXAMINED

Peduncles with flowering heads were found in the carbonized hay at Oplontis.

REMARKS

This plant occurs in dry places in southern and western Europe.

167. *TRIFOLIUM LAPPACEUM* L.
English, burdock clover; Italian, *trifoglio (lappaceo)*

MATERIAL EXAMINED

A few heads with flowers were found in the carbonized hay at Oplontis.

REMARKS

This clover grows in dry open places of the Mediterranean region.

168. *TRIFOLIUM PRATENSE* L.
English, red clover; Italian, *trifoglio pratense, trifoglio violetto, trifoglio rosso*

MATERIAL EXAMINED

Many flowering branches were found in the carbonized hay at Oplontis.

REMARKS

Red clover occurs in meadows and pastures throughout Europe. It is widely cultivated for forage.

169. *TRIFOLIUM RESUPINATUM* L.
English, Persian clover, shabdar; Italian, *trifoglio (resupinato)*

MATERIAL EXAMINED

Peduncles with flowering heads were found in the carbonized hay at Oplontis. The identification to species of the material is uncertain.

REMARKS

This clover occurs in grassy places and cultivated ground. It is probably not native to the Mediterranean region.

170. *TRIFOLIUM SUBTERRANEUM* L.
English, subterranean clover; Italian, *trifoglio (sotterraneo)*

MATERIAL EXAMINED

Fruiting heads were found in the carbonized hay at Oplontis.

REMARKS

The inflorescence has a few heads of creamy white flowers; the fruit matures underground like the peanut. It grows along edges of woods and shady places of the Mediterranean region and is indigenous to the Vesuvian area.

171. *TRIGONELLA BALANSAE* BOISS. & REUTER (*TRIGONELLA CORNICULATA* (L.) L.
English, (little-horned) fenugreek; Italian, *fieno greco (cornicolato)*

MATERIAL EXAMINED

A few legumes were found in the carbonized hay at Oplontis.

REMARKS

This plant has bright yellow flowers clustered in dense racemes at the apex of its branches. It is widespread in cultivated ground and the waste places in the Mediterranean region.

172. *TRITICUM DICOCCON* SCHRANK
English, emmer wheat; Italian, *farro*

MATERIAL EXAMINED

Herculaneum: (1) Casa del Bel Cortile (inv. no. 1895), approximately one-half bushel of unthreshed spikelets and caryopses, remarkably well preserved (Fig. 153). (2) Casa della Stoffa (inv. no. 962), mixed with lentils, poorly preserved; (3) IV.iii (inv. no. 378), approximately one-half bushel of well-preserved caryopses. Naples Museum: a dish of carbonized grains without seedcoat (without inv. no.).

FIGURE 153 Carbonized spikelet of emmer wheat, Casa del Bel Cortile, Herculaneum. Photo: USDA.

Pinto da Silva suggested that some additional materials that he examined from Pompeii and Herculaneum could be either emmer or common wheat. Because of poor preservation it was not possible to identify common bread wheat (*T. aestivum* L.) with certainty. Wittmack mentions wheat (*weizen*) but without specific reference to emmer (Meyer 1988: 204).

WALL PAINTINGS

A good example of emmer wheat can be identified in a garland in the Naples Museum (without inv. no.) (Fig. 83); in a garland with fruit and wheat in the House of the Crytoporticus (I.vi.2/16) in the S hall, before the room with the Dionysiac paintings; in a now destroyed painting in the House of Triptolemus (VII.vii.5) known only from a drawing (Fig. 154); in a

painting in the Antiquarium at Castellammare di Stabia (inv. no. 2525); and in a painting from the peristyle of the Villa of P. Fannius Synistor in the Metropolitan Museum in New York (Fig. 155).

MOSAIC

A good example can be identified in the mosaic from the inner end of the fauces of the House of the Faun (NM inv. no. 9944).

REFERENCES IN ANCIENT AUTHORS

Pliny (*HN* 18.61–2) mentions three kinds of wheat grown in Italy: common wheat (*siligo*), *T. aestivum* L.; emmer (*far*), *T. dicoccon* Schrank; and hard or macaroni wheat (*triticum*), *T. durum* Desf. Pliny (*HN* 18.62) says that "according to Verrius emmer was the only corn

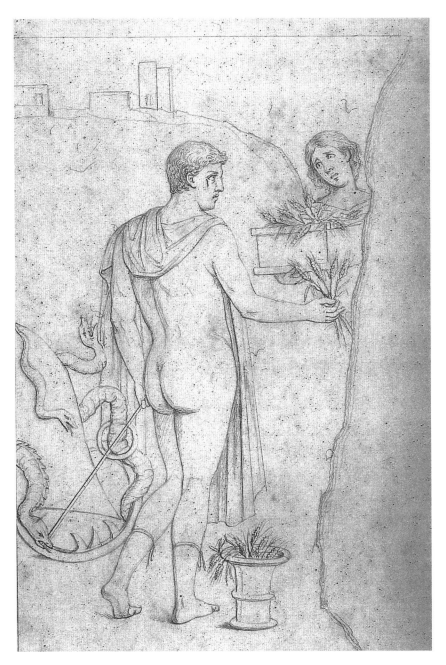

FIGURE 154 Emmer wheat in a drawing of a destroyed wall painting, House of Triptolemus (VII.vii.5).

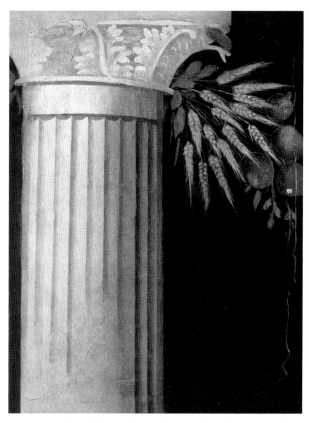

FIGURE 155 Corinthian column decorated with emmer wheat, Villa of Fannius Synistor, Boscoreale. Photo: The Metropolitan Museum, Roger's Fund, 1903 (03.14.1).

[wheat] used by the Roman nation for 300 years" and that (*HN* 18.92) the "best emmer makes the sweetest bread." The Greek tragic poet Sophocles, in his play Triptolemus, praised Italian wheat before all other kinds, "mainly for its whiteness" (*HN* 18.65).

REMARKS

Emmer was "the cereal of ancient agricultural populations," according to Percival (1921). Emmer is probably a Celtic word from ancient Gaul. Today it has ceased to be grown commercially in most parts of the world except Ethiopia. Emmer is still used extensively by wheat breeders for its disease resistance, which can be bred into modern wheat hybrids. It is unknown as a wild plant (Meyer 1988; 203–4).

173. *ULMUS* sp.
English, elm; Italian, *olmo*

MATERIAL EXAMINED

Elm charcoal found in the garden of Polybius was probably used as fertilizer.

REFERENCES IN ANCIENT AUTHORS

Theophrastus has many references to the elm, *ptelea* (πτελέα). Its wood is strong, does not decay, and is used for shipbuilding, carpenter's tools, and many other purposes (*Hist. pl.* 5.4.2; 5.7.3, 7–8). Pliny lists similar qualities and uses of the elm (*ulmus*) (*HN* 16.210–11, 218–19, 230). The bark, leaves, and branches all have medicinal uses (Pliny *HN* 24.48; Dioscorides 1.111). Vergil often speaks of the elm, a sturdy tree, rich in leaves, on which vines are trained (*Georgics* 2.221).

REMARKS

Only *Ulmus minor* Mill. is a native of the Vesuvian area.

174. *VERONICA ARVENSIS* L.
English, wall or common speedwell; Italian,
veronica (dei campi)

MATERIAL EXAMINED

Upper parts of the inflorescence with ripe fruit were found in the carbonized hay at Oplontis.

REMARKS

The imprint of Christ's face on the veil of the pious woman Veronica was called *Veronicon* (true image). In the Middle Ages the name *Veronica* was given to the flower of this genus because it called to mind a human face. It occurs on walls and dry, open habitats and in cultivated areas in most of Europe.

175. *VIBURNUM TINUS* L.
English, viburnum, laurustinus, laurustine; Italian,
tino

WALL PAINTINGS

Several examples of laurustinus can be identified in the garden paintings in the room off the E side of the atrium in the House of the Fruit Orchard: a bush with characteristic evergreen leaves and corymbs of white flowers behind the seated Egyptian statue in the center of the E panel on the S wall; a lower bush in front of the oleanders on the right side of the same panel with shadow leaves painted in dark bluish green. Only the top part of the bush on the center panel of the N wall is preserved, but it is easily identified by the clusters of blue-black fruit. It has the same shadow leaves. In the room off the E side of the peristyle, the plant pictured above the door (the lower part of the painting missing) is laurustinus. The low foliage under the arbutus trees in the end panels on the E wall of this room might be laurustinus leaves, but there are no flowers.

In the House of the Gold Bracelet there are laurustinus bushes in flower on the N and S walls of the *diaeta*, also on the S wall of the water triclinium (Fig. 156).

Less carefully painted examples can be identified in the bedroom off the N side of the peristyle in the

FIGURE 156 Fragments of a wall garden painting with laurustinus (viburnum): water triclinium, House of the Gold Bracelet. Photo: S. Jashemski.

House of C. Julius Polybius (IX.xiii.1–3), and perhaps in the garden paintings in the garden at the rear of the atrium in the Villa of Poppaea. The shrub to the right of the fountain in the N panel of the E wall seems to have the same white flowers. There is a lower plant with similar flowers on the left side of the fountain.

A beautiful laurustinus in flower, but no longer visible, in the House of M. Epidius Sabinus (IX.i.20/30), on the dado of the N wall of the large room opening off the E end of the N portico in the lower peristyle, is preserved in a painting by Mau (1882: vol. 2, pl. 16) (Fig. 157).

REFERENCES IN ANCIENT AUTHORS

Pliny mentions the laurustinus (*tinus*) only twice, and both times in connection with the laurel. He says that some take the *tinus* to be the wild laurel, but there is a difference, for the fruit of the *tinus* is dark blue (*HN* 15.128). The English name, laurustinus, preserves the Latin *tinus*, as well as the erroneous connection with the laurel. Pliny says the *tinus* can be propagated by planting the berries or by layering (*HN* 17.60–1).

Laurustinus is also mentioned by the poets. Ovid (*Met.* 10.98) speaks of its dark blue berries (*bacis caerula*

tinus). The *tinus* is mentioned twice in Vergil's fourth *Eclogue* (11.112, 141), quite appropriately in connection with bees, for this winter-flowering shrub is valuable as one of the earliest flowers available to bees. The *tinus* is one of the flowers mentioned in the *Culex* (line 407) (*Appendix Vergiliana*).

REMARKS

This evergreen shrub is widely distributed in the maquis vegetation of the Mediterranean area and it is often cultivated.

176. *VICIA DISPERMA* DC.

English, (two-seeded) vetch; Italian, *veccia (a due semi)*

MATERIAL EXAMINED

Branchlets of the inflorescence with some legumes were found in the carbonized hay at Oplontis.

REMARKS

This very slender annual has leaves with a terminal tendril and pale pink flowers. It is widespread in the Mediterranean region in meadows and among hedges.

177. *VICIA ERVILIA* (L.) WILLD.

English, bitter vetch; Italian, *veccioli, mochi*

MATERIAL EXAMINED

Pompeii, Antiquarium: (1) (inv. no. 18095B) several hundred grams of carbonized bitter vetch seeds, both whole and broken; (2) (without inv. no.) several hundred grams of unbroken bitter vetch seeds. Seeds of an unidentified species of *Galium* were found in the sample as a weed contaminant. Herculaneum: Decumanus Maximus, now in the *deposito* (inv. no. 2314), seeds of bitter vetch identified as a contaminant in a 4 kg. sample of carbonized chickpeas (*Cicer arietinum* L.); (2) Ins. or. II.10 (inv. no. 1663), bitter vetch seeds mixed with lentil seeds. Bitter vetch was not mentioned by Wittmack.

REFERENCES IN ANCIENT AUTHORS

Ervum was the classical Latin name for bitter vetch, also called fitch. Pliny (*HN* 22.151–3) lists a number of medicinal uses for bitter vetch but indicates that it was not eaten as food because it caused vomiting, intestinal trouble, heaviness in the head and stomach, and enfeeblement of the knees. After the seeds have soaked for several days, they are very good food for cattle and other beasts of burden. Bitter vetch was used in still another way, "when barley bread used to be made, the actual barley was leavened with flour of bitter vetch or chickeling," that is, *Lathyrus sativus* L. (Pliny *HN* 18.103).

REMARKS

As a wild plant *V. ervilia* is recorded only in Turkey, where archaeological material has been carbon dated to 7500–6400 B.C. Elsewhere in the Mediterranean region and the Near East bitter vetch occurs as an introduced weed in grain fields and waysides. By the Roman period bitter vetch was well known in Italy. It has never throughout history been used regularly as a food for

FIGURE 157 Copy of a destroyed painting at the base of the N wall of room d, House of M. Epidius Sabinus, Pompeii. Photo: Sarah Gladden.

humans, although it probably has been employed as a famine food. Mostly it has been used as fodder. The plant is very toxic to pigs, horses and poultry, but ruminants and man are highly resistant (Meyer 1988: 189).

178. *VICIA FABA* L. VAR. *MINOR* (PETERM. EM. HARZ) BECK

English, broadbean; Italian, *fava*

MATERIAL EXAMINED

Broad beans have been found more frequently than any other carbonized food plant in the sites destroyed by Vesuvius.

Pompeii: (1–3) *Deposito*, three samples (without inv. nos.); (4) (inv. no. 11277-B) from I.ix.15; (5) House of the Ship *Europa* (I.xv), three samples found in situ in different parts of the garden, many with insect holes (Jashemski 1979: 242); (6) in large vineyard II.v, a carbonized bean found in situ (Jashemski 1979: 210); (7) I.xiv.2, a few very fragile beans found in situ (Jashemski 1979:97).

Herculaneum: (1) *Deposito* (inv. no. 2329), about three-quarters of a kg of broken and whole broad beans; (2) *deposito* (inv. no. 708), broken and whole beans; (3) shop in Ins. or. II.13, a glass full of broad beans, some with insect holes.

Naples Museum: two dishes with carbonized broad beans (without inv. no.).

Oplontis: (inv. no. NG4) two seed fragments, probably broad bean, found in situ in the Villa of Poppaea (Jashemski 1993: 292; Meyer 1988: 188–9).

GRAFFITO

A graffito scratched on the *villa rustica* in the fundo Juliano at Boscoreale records the broad beans raised there: FABA M DLXXXVII (*CIL* IV 5430).

INSCRIPTIONS

A small amphora (shape II) found at Pompeii was labeled *lomentum* (*CIL* IV 2597) and when opened was found to contain a pastelike mixture. According to Pliny (*HN* 18.117), *lomentum* was made from broad beans and was used in bread made for sale to increase the weight. *Lomentum* was also used by Roman ladies to preserve the smoothness of their skin. An urceus (shape VI) found in the peristyle of VIII.ii.14 was labeled LOMENTVM FLOS EX LACTE ASININO VTICENSE (*CIL* IV 5738).

REFERENCES IN ANCIENT AUTHORS

Pliny (*HN* 18.117) says that among leguminous plants "the highest place of honor belongs to the broad bean (*faba*). . . . Beans are used in a variety of ways for all kinds of beasts and especially for man." As a delicacy broad beans occupied a high place for the table in Roman times. One of the noble families of Rome, the Fabii, derived their name from this plant. Pliny (*HN* 22.140–1) and Dioscorides (2.127) list the medicinal uses of the broad bean.

REMARKS

The wild progenitors of the cultigen, *V. faba*, have not been identified. A central Asian center of domestication, including Afghanistan and surrounding countries, is suggested for the small-seeded, autogamous form *V. faba* var. *minor*. The large, flat-seeded, allogamous form var. *major* Harz., grown today, is a much later development (Meyer 1988: 187–8). Broad beans are still a common vegetable at Pompeii.

179. *VICIA LUTEA* L.

English, (yellow) vetch; Italian, *veccia (gialla)*

MATERIAL EXAMINED

A single legume was found in the carbonized hay at Oplontis.

REMARKS

The species resembles in size and shape of the leaves *V. sativa* L., common vetch, but differs in the pale yellow flowers and characteristic hairy legume. It grows along roadsides and in sunny places of the Mediterranean region.

180. *VICIA SATIVA* L.

English, common vetch; Italian, *veccia dolce*

MATERIAL EXAMINED

Legumes and a single leaf on a branch were found in the carbonized hay at Oplontis.

REFERENCES IN ANCIENT AUTHORS

Theophrastus (*Hist. pl.* 2.4.2, 8.2.5) calls the vetch *orobos* (ὄροβος). Pliny says "Vetch (*vicia*) also enriches the soil, and it too entails no labor for the farmer" (*HN* 18.137). Columella (*RR* 2.7.1) includes vetch among plants that can make up for winter pasture shortage.

REMARKS

Common vetch occurs wild over most of Europe. It is cultivated as green manure, green fodder, and a hay crop for winter pasturage.

181. *VICIA VILLOSA* ROTH

English, hairy vetch, Russian vetch, winter vetch; Italian, *veccia (villosa)*

MATERIAL EXAMINED

Branchlets bearing a few legumes were found in the carbonized hay at Oplontis.

REMARKS

This vetch occurs wild over much of Europe and is widely cultivated for fodder.

182. *VIOLA ARVENSIS* MURRAY

English, violet, viola; Italian, *viola, violetta*

MATERIAL EXAMINED

Capsules and single seed valves were found in the carbonized plant material at Oplontis (Fig. 158). Because of the fragmented condition of the material an accurate identification is difficult, but Ricciardi and Aprile now identify it as more probably the wild violet *V. arvensis* Murray.

FIGURE 158 Violet in carbonized hay, Oplontis. SEM photo: F. Hueber.

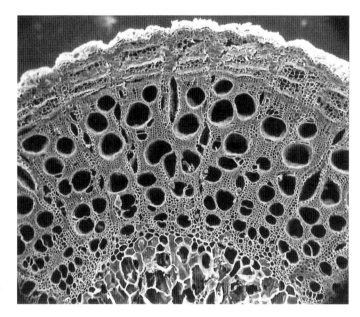

FIGURE 159 Detail of a cross section of grapevine stem in carbonized hay, Oplontis. SEM photo: F. Hueber.

REFERENCES IN ANCIENT AUTHORS

Violets are mentioned often by the ancient writers. Theophrastus describes two kinds of violets: the black one, (ἴον τὸ μέλαν) and the white one (ἴον τό λευκόν). He says (*Hist. pl.* 6.6.7) that "The black violet differs from the white . . . in that in the former the leaves are broad, lie close to the ground, are fleshy and there is much root." Pliny (*HN* 21.27, 130–1) says there are several kinds of violets, "the purple, the yellow, and the white." But it is difficult to identify all the violets Pliny refers to, for his descriptions are by no means precise. He says that the purple violet is wild, with a broader leaf coming straight from the root. Dioscorides (4.122) describes a purple violet that he says has a pleasant-smelling little blossom that springs from the center of the root in long stalks and has leaves similar to ivy. Botanists are agreed that the black violet described by Theophrastus and Dioscorides is the sweet violet, *V. odorata* L., which has a very fragrant flower, and that the white violet described by Theophrastus and Pliny is the stock, not a true violet (see no. 91). Both Pliny (*HN* 21.130–131) and Dioscorides (4.122) list the medicinal uses of violets.

REMARKS

The violet occurs on cultivated ground nearly everywhere in Europe. It is indigenous to the Vesuvian area.

183. *VITIS VINIFERA* L. subsp. *VINIFERA*

English, grape; Italian, *vite, uva*

VINEYARDS EXCAVATED

Most important for our knowledge of the grape in the Vesuvian area are the actual vineyards excavated by Jashemski and the casts made of the ancient roots, which reveal not only their size but also the planting pattern. For the large, formally laid out vineyard across from the amphitheater at Pompeii, see Chapter 2. Other vineyards excavated include the one at the House of the Ship *Europa* (I.xi.10) (Jashemski 1993: 61; 1979: 174); at I.xx.1 (Jashemski 1979: 227–9); at III.vii (Jashemski 1979: 228–30); and at the *villa rustica* at Boscoreale (Jashemski 1993: 288).

MATERIAL EXAMINED

At Pompeii carbonized grapes were found in situ in the vineyard at I.xv (Jashemski 1979: 241). Many carbonized grape seeds were found in the vineyard at Boscoreale (Jashemski 1993: 288). Grape leaves, tendrils, and twig fragments were identified in the carbonized hay at Oplontis (Fig. 159). There is a dish of whole carbonized grape seeds in the Naples Museum.

WALL PAINTINGS

The grape is one of the plants most often represented in the wall paintings. We cite here a few examples of the various ways in which it is used. The famous lararium painting from the House of the Centenary shows Bacchus, god of wine, clothed in a huge bunch of purple grapes and the slopes of Vesuvius in the background covered with vineyards laid out in a quincunx pattern (Fig. 28). Paintings of vines planted in a quincunx, today faintly preserved, are also found in the House of the Hunt (VII.iv.48) on the W garden wall, and in the House of the Great Fountain (VI.viii.22), in the upper part of the W garden wall to the left of the fountain.

There are several pictures of the *vindemia*, or vintage: on the N wall of the triclinium in the House of the Vettii cupids are shown gathering and pressing grapes; a painting now destroyed showed satyrs treading grapes

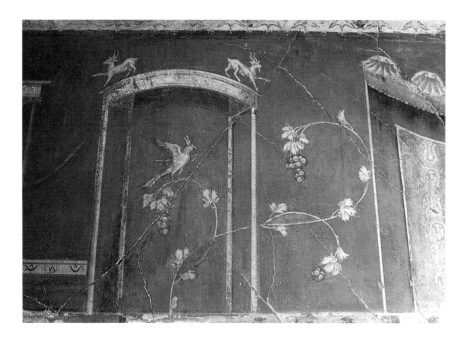

FIGURE 160 Grapevine with fruit, Casa del Tramezzo di Legno, Herculaneum. Photo: S. Jashemski.

(Zahn 1859: vol. 3, p.13); there is a painting of cupids gathering grapes in the House of M. Lucretius (IX.iii.5/24) (Jashemski 1979: 224, fig. 327); and one of cupids gathering grapes in the House of the Centenary (IX.viii.3/6).

Grape arbors are pictured with grapes hanging from a trellis (NM inv. no. 9964). The grapevine heavy with large clusters of ripe fruit is a popular decorative motif, as in the House of the Prince of Naples (VI.xv.7/8) in the room off the E side of the peristyle; in the tablinum of the House of Trebius Valens (III.ii.1), where the bunches of grapes (not currants as Casella 1950: 379, says) are almost larger than the deer; in the Naples Museum (inv. no. 9638) where goats are reaching for the ripe fruit; in the Casa del Tramezzo di Legno (III.11) at Herculaneum on the N wall of the room off the SW corner of the atrium Fig. 160); in the House of the Golden Cupids (VI.xvi.7), in the room off the SW corner of the peristyle, a garland of grapevines heavy with fruit frames the Autumn panel; and in the room off the N peristyle in the House of C. Julius Polybius (IX.xiii.1–3) (Jashemski, 1979: 222, fig. 327). There is a grapevine garland with fruit, amid which cupids fly, in the House of Menander (Fig. 161).

A beautiful garland of white grape leaves is painted across four black panels on the W wall of room 6 in the Villa of the Mysteries. There is a similar treatment of grape leaves in the Villa di Arianna at Stabiae, and another in the Naples Museum (inv. no. 9779). The view in a modern vineyard of the sun shining through the grape leaves giving them a similar translucent quality suggests the inspiration of the ancient artist.

Grapes were also combined in garlands with other fruit and flowers as in the garland from Boscoreale in the Naples Museum, and in the yellow room off the S side of the peristyle in the House of the Silver Wedding (V.ii.1).

A cluster of grapes is frequently pictured with a bird (as in the center of a panel in Shop I.vii.5, Fig. 320), with two birds (in the atrium of the House of Siricus VII.i.47), with a cock (on the E wall in IX.ii.10), or with a rabbit (NM inv. no. 8644).

Sometimes large clusters of grapes are shown alone, as in the banquet hall of the House of the Sibyl (II.i.12) (Fig. 162); in the lunette above the door in the passageway to the W of the tablinum in the House of the Silver Wedding; and in the fragment of a wall painting in the Museum at Castellammare di Stabia.

Grapes are also found in baskets or bowls of fruit included in many larger paintings: in the picture of Arcadia; in the painting of the Centaur; at the foot of Priapus in the vestibule in the House of the Vettii (Fig. 141); and in the huge glass bowl of fruit from the House of Julia Felix (Fig. 107).

SCULPTURE

A marble fountain in the Naples Museum (without inv. no.) takes the form of a rabbit and a cluster of grapes.

MOSAICS

Grapes are combined with other fruit, flowers, and leaves, as in the mosaic garland from the House of the Faun and in other garlands in the Naples Museum: inv. nos. 9991, 124 545, 114 281.

GLASS

On the Blue Glass Vase (NM inv. no. 13521) a vintage scene is pictured, in which a cupid treads grapes while his companions accompany him with music or bring more grapes (Fig. 163).

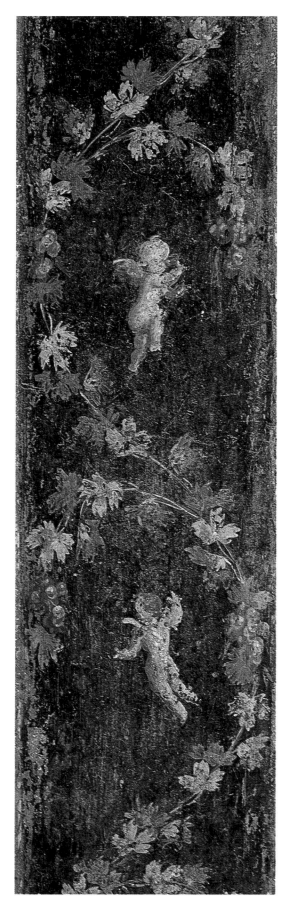

FIGURE 161 Grapevine garland with cupids. House of Menander, Pompeii. Photo: S. Jashemski.

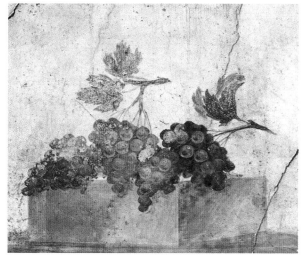

FIGURE 162 Cluster of grapes in the banquet hall, House of the Sibyl, Pompeii. Photo: S. Jashemski.

FIGURE 163 Cupid treading grapes, Blue Glass Vase (NM inv. no. 13521). Photo: S. Jashemski.

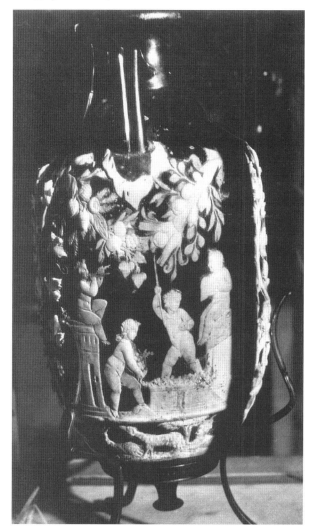

REFERENCES IN ANCIENT AUTHORS

The grape was so important in Italy that Pliny (*HN* 14.8) was able to say that "supremacy in respect of the vine (*vitis*) is to such a degree the special distinction of Italy that even with this one possession she can be thought to have vanquished all the good things of the world." Both Pliny and Columella have more to say about growing vines than any other plant. Grapes were even ripened in winter in greenhouses (Martial 8.68). Numerous varieties of grapes were grown. The variety Pompeiana was commonly grown on the slopes of Vesuvius and in the Pompeii area. Both red and white wines were produced that were sweet or dry.

INSCRIPTIONS ON AMPHORAS

For a discussion of the many inscriptions on amphoras that contained wine, see J. Andreau (1974: chap. 4) and F. Zevi (1966: 208–24).

REMARKS

According to Zohary and Hopf (1994), "the earliest signs of *Vitis* cultivation comes from the Levant." The earliest archaeological evidence of the domesticated grape comes from Egypt and Syria during the fourth millennium B.C. In Palestine seeds of grapes date from 3000 B.C. in Bronze Age sites in Jericho. The Romans brought viticulture to Europe. The wild grape, *Vitis sylvestris* C. C. Gmelin is now considered, according to Zohary and Hopf, to be the wild race of the cultivated grape, which is a native of an area from Turkey, Greece, and the former Yugoslavia, to Italy, France, and Spain.

184. *VULPIA MYUROS* (L.) C. C. GMELIN

English, rattail fescue; Italian, *paléo (sottile)*

MATERIAL EXAMINED

Spikelets and inflorescence fragments were found in the carbonized hay at Oplontis.

REMARKS

Rattail fescue is a small annual, widely distributed in Europe and the Mediterranean area.

IN CONCLUSION

The 184 plants discussed in this chapter are those for which evidence, other than pollen, was preserved by the A.D. 79 eruption of Vesuvius. The evidence, which comes primarily from the urban sites Pompeii and Herculaneum, and a few villas, gives a good picture of the popular ornamental plants that adorned the many home gardens, parks, and other public places, as well as plants that had religious significance and those used for medicine and other purposes, especially food.

Few excavations have explored the flora of the countryside. But most of the food consumed was produced outside the city. The carbonized hay in the *villa rustica* at Oplontis adds many plants, including many weeds, not otherwise known, that grew in meadows and vineyards. Windblown pollen also gives valuable evidence for the vegetation of the countryside, the maquis, and the mountain slopes. The excavations of the Superintendency in the farmland of the *villa rustica* of Caecilius Jucundus in the località Settetermini in the commune of Boscoreale and in the località S. Abbondio in the commune of Pompeii (see Chap. 1) add further evidence.

Current subsoil excavations are contributing valuable new evidence for the flora of Pompeii dating from the early pre-Roman phases up through the Roman pre–A.D. 79 levels. The evidence from these excavations is limited, and the quality often poor; there are usually only a few carbonized or mineralized seeds, which makes identification difficult. The main sources of evidence in the University of Reading/ British School at Rome excavations (see Fulford and Wallace Hadrill 1999: 95–102, 139–44) are burnt waste from crop cleaning, mineralized latrine contents, and burnt votive offerings, mostly food. They report evidence for emmer wheat, hulled six-row barley, common millet, foxtail millet, chickpea, field bean, lentil, opium poppy, walnut, hazelnut, olive, fig, pear, grape, pomegranate, pinenuts, and locust (carob) bean, all found in the food plants known in A.D. 79. In addition they report durum or bread wheat, one carbonized seed of the elder (*Sambucus nigra* L.), and several weeds for which there was no evidence in A.D. 79. In the evidence from the University of Bradford and Italian subsoil excavations, still under study, fewer plants are reported and only two weeds, but they list several plants not preserved in the A.D. 79 evidence, namely durum wheat, sesame, rowan, pea, peppercorn, and melon (Ciraldi and Richardson, unpublished, which they generously made available to us). The nature and the amount of evidence for each plant is not reported. As these subsoil excavations continue they will add greatly to our knowledge of the natural history of the Vesuvian sites.

Table 5. List of spores and pollen found in the Vesuvian sites.

1. Pompeii I.xiv.2
2. Pompeii II.viii.6, Garden of Hercules
3. Pompeii IX.xiii.1-3, Garden in House of Polybius
4. Oplontis, villa of Poppaea
5. Boscoreale, *villa rustica* in the località Villa Regina
6. Pompeii VI.ins. occid.42, House of the Gold Bracelet
7. Pompeii IX.xii.6-7, House of the Chaste Lovers
8. *villa rustica* of L. Cornelius Jucundus in the località Settetermini in the commune of Boscoreale
9. In the località S. Abbondio in the commune of Pompeii

Sites 7–9 were excavated by the Superintendency. See Chap. 1, nn. 2–4.
For pollen found in other Pompeian sites see Table 6 on p. 184.

	1	2	3	4	5	6	7	8	9
Spores									
Ferns and Fern Allies									
Anogramma leptophylla					x				
Dryopteris sp.					x				
Dryopteris type		x	x	x					
Equisetum sp.					x		x		
Filicales								x	x
Ophioglossum sp.					x				
Polypodiaceae					x	x			
Polypodium sp.	x	x	x	x	x	x			
Polypodium cambricum subsp. *serrulatum*							x		
Pteridophyta							x		
Pteridium aquilinum	x	x	x	x	x	x			
Hepaticae (Hornmosses)									
Anthoceros laevis				x	x	x			
Anthoceros punctatus				x	x	x			
Algae									
Pediastrum boryanum				x	x				
Pediastrum kawraiskyi				x					
Pollen									
Conifers and Flowering Plants									
Abies sp.			x						
Allioideae								x	
Alnus sp.									x
Anemone type				x	x	x			
Anthemis sp.							x	x	x
Apiaceae				x	x	x	x		x
Arbutus unedo					x				
Artemisia sp.				x	x	x	x		x
Asteraceae Asteroideae		x	x	x	x	x	x	x	x
Asteraceae Cichorioideae		x	x	x	x	x	x	x	x
Betula sp.				x	x	x			
Boraginaceae				x	x				
Brassica sp.								x	x
Brassicaceae				x	x	x	x	x	x
Buxus sempervirens					x			x	x
Caltha sp.					x				
Calystegia sepium					x				
Campanula sp.							x		
Campanulaceae				x	x				
Cannabaceae									x
Carpinus betulus				x	x	x	x	x	x
Caryophyllaceae		x	x	x	x	x		x	x
Castanea sativa		x	x		x			x	x

(continued)

Table 5. *(continued)*

Pollen	1	2	3	4	5	6	7	8	9
Conifers and Flowering Plants									
Centaurea jacea type				x					
Cerastium sp.							x		
Ceratonia siliqua				x	x				
Chenopodiaceae		x	x	x			x	x	x
Chenopodiaceae/Amaranthaceae				x	x	x			
Cirsium sp.	x	x							
Cistus cf. *monspeliensis*				.		x			
Clematis sp.									x
Convolvulus sp.					x				
Cornus mas								x	x
Corylus avellana							x	x	x
Cupressaceae				x	x			x	x
Cyperaceae							x	x	x
Dianthus type				x					
Ephedra distachya type					x				
Ephedra fragilis type				x	x				
Ericaceae			x	x	x				x
Erica sp.				x	x	x			
Erodium type					x				
Euphorbia sp.								x	x
Fabaceae				x	x		x	x	x
Fagus sylvatica				x	x				
Fallopia convolvulus (= *Polygonum convolvulus*)				x	x	x			
Fraxinus sp.		x						x	x
Fraxinus excelsior type					x				
Fraxinus ornus				x	x	x			
Geranium sp.			x						
Geranium sp. (reticulata type)				x	x	x			
Geranium sp. (striata type)					x				
Hedera helix				x	x				
Helianthemum/Cistus type				x					
Humulus/Cannabis type				x					
Hydrocharitaceae							x		
Ilex aquifolium					x				
Impatiens sp.						x			
Juglans regia		x	x	x	x	x	x	x	x
Juniperus sp.							x		
Knautia arvensis type					x	x			
Knautia sp.								x	
Lamiaceae								x	x
Lamium sp.								x	x
Ligustrum vulgare					x				
Ligustrum sp.					x				
Liliaceae		x		x		x			x
Lotus sp.								x	x
Lychnis type				x		x			
Malvaceae		x		x	x	x	x		
Mercurialis annua					x				
Myrtus communis				x			x		x
Olea type				x	x	x			
Olea europaea	x	x	x	x				x	x
Ostrya/Carpinus orientalis type				x	x	x			
Ostrya carpinifolia									x

176

Table 5. *(continued)*

Pollen	1	2	3	4	5	6	7	8	9
Conifers and Flowering Plants									
Paliurus sp.				x					
Papaver sp.								x	x
Phillyrea sp.				x	x	x			
Picea sp.			x	x	x				
Pinaceae	x	x	x	x					
Pinus sp.				x	x	x	x	x	x
Pistacia sp.					x				x
Plantago sp.		x					x	x	x
Plantago coronopus type					x				
Plantago lanceolata		x	x	x	x	x		x	x
Plantago major/media				x					
Platanus orientalis					x		x	x	
Plumbago sp.				x					
Poaceae	x	x	x	x	x	x	x	x	x
Poaceae (cereals)							x		
Poaceae (*Hordeum* group)								x	x
Polygonum aviculare type				x	x				
Polygonum persicaria type					x				
Populus sp.							x	x	x
Potentilla type			x						
Primulaceae								x	
Quercus sp.		x	x	x			x		
Quercus ilex/coccifera type					x				
Quercus pubescens								x	x
Quercus pubescens/robur type				x	x	x			
Ranunculaceae	x			x					x
Ranunculus type					x	x			
Rhamnus cathartica/alaternus type				x					
Rosa sp.							x		
Rosaceae		x		x	x			x	x
Rubiaceae					x				x
Rubus sp.									x
Rumex sp.				x			x	x	x
Salix sp.				x			x	x	x
Sambucus nigra								x	
Sanguisorba sp.									x
Scabiosa columbaria type						x			
Scabiosa sp.									x
Scrophulariaceae						x			x
Succisa sp.		x	x						
Tordylium sp.									x
Tilia sp.			x	x	x	x			
Tribulus sp.									x
Trifolium sp.				x					
Triticum type				x	x				
Typha angustifolia type					x				
Typha latifolia					x				
Ulmus sp.		x		x	x	x			
Urtica sp.				x					
Urticaceae							x		x
Viburnum sp.									x
Vitis vinifera				x	x		x		x

Wilhelmina F. Jashemski, Frederick G. Meyer, and Massimo Ricciardi

REFERENCES

Abbe, Elfriede M. 1965. *The Plants of Virgil's Georgics.* Cornell University Press, Ithaca, N.Y.

Accademia Ercolanese. 1757–79. *Le Pitture Antiche di Ercolano e Contorni.* 5 vols. Regia Stamperia, Naples.

Andreau, Jean. 1974. *Les Affaires de Monsieur Jucundus.* Collection de l'Ecole Française de Rome 19, Rome.

Anonymous. 1992. *Alla Ricerca di Iside, Analisi, Studi e Restauri dell'Iseo Pompeiano nel Museo di Napoli.* Arti, Rome.

Anonymous. 1992. *Domus, Viridaria, Horti Picti Exhibition in Pompeii.* Bibliopolis Edizioni di Filosofia e Scienze. Arte Tipografica, Naples.

Anonymous. 1796–1808. *Gli Ornati delle Pareti ed i Pavimenti delle Stanze dell'Antica Pompei Incisi in Rame.* 3 vols. Stamperia Reale, Naples.

Barré, Louis, and Henry Roux ainé. 1875–7. *Herculanum et Pompéi: recueil général des peintures, bronzes, mosaiques etc.* 8 vols. Firmin Didot, Paris.

Beyen, Hendrik G. 1938–60. *Die Pompejanische Wanddekoration vom Zweiten bis zum Vierten Stil.* 2 vols. Nijhoff, Den Haag.

Blake, Marion E. 1930. *The Pavements of the Roman Buildings of the Republic and the Early Empire.* Memoirs of the American Academy in Rome 8, Rome.

Boyce, George K. 1937. *Corpus of the Lararia of Pompeii.* Memoirs of the American Academy in Rome 14, Rome.

Casella, Domenico. 1950. La frutta nelle pitture pompeiane. In *Pompeiana, Raccolta di Studi per il II Centenario degli Scavi di Pompei,* pp. 355–86. Macchiaroli, Naples.

1956. "A proposito di raffigurazioni di Ananas, Mango e Annona squamosa in dipinti pompeiani." *Rivista dell'Ortoflorofrutticoltura Italiana anno 81 40,* nos. 3–4: 117–33.

1957. "Ancora a proposito di raffigurazioni di Ananas, Mango e Annona squamosa in dipinti pompeiani." *Rivista dell'Ortoflorofrutticoltura Italiana anno 82 41,* nos. 9–10: 467–75.

Castriota, David. 1995. *The Ara Pacis Augustae and the Imagery of Abundance in Later Greek and Early Roman Imperial Art.* Princeton University Press, Princeton, N.J.

Cerulli Irelli, Giuseppina, et al. 1993. *La Peinture de Pompéi Témoignage de l'Art Romain dans la Zone Ensevelie par le Vésuve en 79 ap. J. C.* 2 vols. Hazan, Paris.

Ciaraldi, M. 1996. The Botanical Remains. *Anglo-American Pompeii Project 1996,* edited by Sara E. Bon, Rick Jones, B. Kurchin, and D. P. Robins. Bradford Archaeological Sciences Research, Bradford.

Ciaraldi, M., and Jane Richardson. n.d. Food, Ritual and Rubbish in the Making of Pompeii. Unpublished.

Ciarallo, Annamaria. 1990. "Località S. Abbondio, antico bosco di cipressi." *Rivista di Studi Pompeiani* 4: 213–15.

Ciarallo, Annamaria, and Marta Mariotti Lippi. 1993. "The Garden of 'Casa dei Casti Amanti' Pompeii, Italy." *Garden History* 21: 110–16.

Comes, Orazio. 1879. *Illustrazione delle piante rappresentate nei dipinti pompeiani.* Francesco Giannini, Naples.

Condit, Ira J. 1947. *The Fig.* Chronica Botanica Company, Waltham, Mass.

Conticello, Baldassarre. 1990. Room (oecus) with Garden Paintings (n. 163). In *Rediscovering Pompeii.* Ministero per i Beni Culturali e Ambientali. Soprintendenza Archeologica di Pompei. Exhibition from IBM Italia. New York City, 12 July–15 September 1990. L'Erma di Bretschneider, Rome.

Croisille, Jean-Michel. 1965. *Les Natures Mortes Campaniennes.* Latomus, Bruxelles-Berchem.

Day, John. 1932. "Agriculture in the Life of Pompeii." *Yale Classical Studies* 3: 166–208.

De Caro, Stefano. 1994. *Il Museo Archeologico Nazionale di Napoli.* Electa Napoli, Naples.

De Candolle, Alphonse. 1884. *Origin of Cultivated Plants.* Keegan, Paul, French & Company, London.

De Gubernatis, Angelo. 1878–82. *La Mythologie des Plantes ou les Légendes du Regne Végétal.* 2 vols. C. Reinwald and Company, Paris.

Della Corte, Matteo. 1965. *Case ed Abitanti di Pompei.* 3rd ed. Fausto Fiorentino Editore, Naples.

Elia, Olga. 1941. Le pitture del Tempio di Iside. In *Monumenti della Pittura Antica Scoperti in Italia Sezione 3, Pompei, Fascicolo 3–4.* Istituto Poligrafico dello Stato, Rome.

Fiorelli, Giuseppe. 1860. *Pompeianarum antiquitatum historia.* Vol. 1. Stabilimento Poliglota, Naples.

1862. *Pompeianarum antiquitatum historia.* Vol. 2. Stabilimento Poliglota, Naples.

1862. *Pompeianarum antiquitatum historia.* Vol. 3. Stabilimento Poliglota, Naples.

1873. *Gli Scavi di Pompei dal 1861 al 1872.* Tipografia Italiana, Naples.

1875. *Descrizione di Pompei.* Tipografia Italiana, Naples.

Francissen, Frans P. M. 1987. "A Century of Scientific Research on Plants in Roman Mural Paintings (1879–1979)." *Rivista di Studi Pompeiani* 1: 111–12.

Fulford, Michael, and Andrew Wallace-Hadrill. 1999. Towards a History of Pre-Roman Pompeii: Excavations Beneath the House of Amarantus (I.9.11–12), 1995–8. In *Papers of the British School at Rome.* Vol. 67. The British Academy, London.

Grimal, Pierre. 1984. *Les Jardins Romains à la Fin de la République et aux Deux Premiers Siècles de l'Empire.* 3rd ed. Librairie Arthème Fayard, Paris.

Helbaek, Hans. 1966. "Commentary on the Phylogenesis of *Triticum* and *Hordeum.*" Economic Botany 20: 350–60.

Helbig, Wolfgang. 1868. *Wandegemälde der vom Vesuv Verschütteten Städte Campaniens.* Breitkopf und Härtel, Leipzig.

Hepper, Nigel F. 1990. *Pharaoh's Flowers: The Botanical Treasures of Tutankamun.* The Stationery Office, London.

Heywood, Vernon H., and Daniel Zohary. 1995. "A Catalogue of the Wild Relatives of Cultivated Plants Native to Europe." *Flora Mediterranea* 5: 375–91.

Jashemski, Wilhelmina F. 1979. *The Gardens of Pompeii, Herculaneum and the Villas Destroyed by Vesuvius.* Vol. 1. Caratzas Brothers, New Rochelle, N.Y.

1993. *The Gardens of Pompeii, Herculaneum and the Villas Destroyed by Vesuvius.* Vol. 2, Appendices. Aristide Caratzas, New Rochelle, N.Y.

1999. *A Pompeian Herbal: Ancient and Modern Medicinal Plants.* University of Texas Press, Austin.

Ladizinsky, G., and A. Adler. 1976. "The Origin of the Chickpea, *Cicer arietinum* L." *Euphytica* 25: 211–17.

Lehman, Phyllis W. 1953. *Roman Wall-Paintings from Boscoreale*

in the Metropolitan Museum of Art. Monographs on Archaeology and Fine Arts 5. Cambridge, Mass.

Li, Hui Lin. 1970. "The Origin of Cultivated Plants in Southeast Asia." *Economic Botany* 24: 3–19.

Maiuri, Amedeo. 1939. *Notizie degli scavi di Artichità*, p. 194.

 1947. *La Villa dei Misteri.* 2nd ed. 2 vols. Istituto Poligrafico dello Stato, Rome.

 1952. "Nuove pitture di giardino a Pompei." *Bollettino d'Arte* 1: 5–12.

Matteucig, Giorgio. 1974. "Lo studio naturalistico zoologico del portale di Eumachia nel Foro Pompeiano." *Bollettino della Società dei Naturalisti in Napoli* 83: 177–242.

Mattingly, Harold. 1960. *Roman Coins from the Earliest Times to the Fall of the Western Empire.* Quadrangle Books, Chicago.

Mau, August. 1882. *Geschichte der Decorativen Wandmalerei in Pompeji.* 2 vols. G. Reimer, Berlin.

 1896. *Römische Mitteilungen*, p. 57.

 1902. *Pompeii, Its Life and Art.* Translated by Francis W. Kelsey, 2nd ed. Macmillan, New York. (Reprinted in 1982 by Caratzas Brothers Publishers, New Rochelle, N.Y.)

Meyer, Frederick G. 1988. Food Plants Identified from Carbonized Remains at Pompeii and Other Vesuvian Sites. In *Studia Pompeiana & Classica in Honor of Wilhelmina F. Jashemski*, edited by Robert I. Curtis, Vol. 1, pp. 183–229. Aristide D. Caratzas, New Rochelle, N.Y.

Murr, Josef. 1890. *Die Pflanzenwelt in der Griechischen Mythologie.* Wagner, Innsbruck. (Reprinted in 1969 by Bouma, Gröningen.)

Percival, John. 1921. *The Wheat Plant.* Duckworth & Company, London.

Pignatti, Sandro. 1982. *Flora d'Italia.* 3 vols. Edagricole, Bologna.

Pitture di Ercolano. See Accademia Ercolanese.

Real Museo Borbonico. 1824–57. 16 vols. Stamperia Reale, Naples.

Reinach, Salomon. 1922. *Répertoire des Peintures Greques et Romaines.* Leroux, Paris.

Renfrew, Jane M. 1973. *Paleoethnobotany: The Prehistoric Plants of the Near East and Europe.* Columbia University Press, New York.

Ricciardi, Massimo, and Giuseppa Grazia Aprile. 1988. Identification of Some Carbonized Plant Remains from the Archaeological Area of Oplontis. In *Studia Pompeiana & Classica in Honor of Wilhelmina F. Jashemski*, edited by Robert I. Curtis, Vol. 1, pp. 318–30. Aristide Caratzas, New Rochelle, N.Y.

Ricciardi, Massimo, Giuseppa Grazia Aprile, Vincenzo La Valva, and Giuseppe Caputo. 1986. "La flora del Somma-Vesuvio." *Bollettino della Società dei Naturalisti in Napoli* 95: 3–121.

Riddle, John M. 1985. *Dioscorides on Pharmacy and Medicine.* University of Texas Press, Austin.

Rizzo, Giulio. 1929. *La Pittura Ellenistico-Romana.* Treves, Milan.

Rostovzeff, Michael. 1957. *The Social and Economic History of the Roman Empire.* 2nd ed. 2 vols. Clarendon Press, Oxford.

Roux et Barré *See* Barré, Louis, and Henry Roux aîné.

Ruggiero, Michele. 1879. Della eruzione del Vesuvio nell'anno LXXIX. In *Pompei e la Regione Sotterrata dal Vesuvio nell'Anno LXXIX. Memorie e Notizie Pubblicate dall'Ufficio Tecnico degli Scavi delle Provincie Meridionali*, pp. 9–12. Francesco Giannini, Naples.

Saccardo, Pier Andrea. 1909. *Cronologia della Flora Italiana.* Tipografia del Seminario, Padua. (Reprinted in 1971 by Edagricole, Bologna.)

Scatozza Höricht, Lucia Amalia. 1989. *I Monili di Ercolano.* L'Erma di Bretschneider, Rome.

Schefold, Karl. 1957. *Die Wände Pompejis. Typographische Verzeichnis der Bildmotive.* W. De Gruyter, Berlin.

Schouw, Joachim F. 1851. *Die Erde, die Pflanzen und der Mensch.* C. B. Lorck, Leipzig. (English translation edited in 1859 by H. G. Bohn, London.)

Sheldon, Joan. 1978. Charcoal Analyses. Typescript.

Singer, Charles. 1927. "The Herbal in Antiquity and Its Transition to Later Ages." *Journal of Hellenistic Studies* 47: 1–52.

Sogliano, Antonio. 1879. Le pitture murali campane scoverte negli anni 1867–1879. In *Pompei e la Regione Sotterrata dal Vesuvio nell'Anno LXXIX. Memorie e Notizie Pubblicate dall'Ufficio Tecnico degli Scavi delle Provincie Meridionali*, pp. 87–243. Francesco Giannini, Naples.

Spano, Giuseppe. 1943. "La tomba dell'edile C. Vestorio Prisco in Pompei." *Atti della Reale Accademia d'Italia—Memorie della Classe di Scienze Morali, Storiche e Filologiche* serie 7, no. 3: 237–315.

Spinazzola, Vittorio. 1928. *Le Arti Decorative in Pompei e nel Museo Nazionale di Napoli.* Bestetti e Tuminelli, Milan.

 1953. *Pompei alla Luce degli Scavi Nuovi di Via dell'Abbondanza (Anni 1910–1923).* 3 vols. Libreria di Stato, Rome.

Stannard, Jerry. 1965. "Pliny and the Roman Botany." *Isis* 56, no. 4: 420–5.

Stearn, W. T. 1978. "European Species of *Allium* and Allied Species of *Alliaceae.*" *Annales Musei Goulandris* 4: 83–198.

Swingle, Walter T. 1943. *The Botany of* Citrus *and Its Wild Relatives of the Orange Subfamily.* University of California Press, Berkeley and Los Angeles.

Tenore, Michele. 1833. "Di alcune piante effigiate nel gran musaico pompeiano." *Annali Civili del Regno delle Due Sicilie* 3: 18–25.

Tenore, Michele, Arcangelo Scacchi, Oronzo Gabriele Costa, and Luigi Palmieri. 1879. "Rapporto alla Reale Accademia delle Scienze intorno a taluni alberi trovati nel bacino del Sarno." *Annali delle Bonificazioni che si Vanno Operando nel Regno delle Due Sicilie, Anno I*, 2: 311–27.

Terpó, András. 1968. Genus *Cydonia* In *Flora Europaea*, edited by T. G. Tutin et al., Vol. 2, pp. 64–5. Cambridge University Press, Cambridge.

Tolkowsky, Samuel. 1938. *Hesperides: A History of the Culture and Use of Citrus Fruits.* J. Bale, Sons & Curnow, Ltd., London.

Trotter, Alessandro. 1932. "Identificazione di un tronco d'albero carbonizzato rinvenuto nei recenti scavi di Ercolano." *Annali del Regio Istituto Superiore Agrario di Portici*, serie 3, no. 5: 1–6.

Tutin, Thomas G. 1964. Genus *Dianthus.* In *Flora Europaea*, edited by T. G. Tutin et al., Vol. 1, p. 195. Cambridge University Press, Cambridge.

Vavilov, Nicolai Ivanovich. 1926. "Studies on the Origin of

Cultivated Plants. *Bulletin of Applied Botany and Plant Breeding* 16: 178–80. (English translation in 1992 by D. Löve. Cambridge University Press, Cambridge.)

Warscher Suslow, Tatjana S. 1935–60. *Codex Topographicus Pompeianus.* Typescripts in Deutsches Archäologisches Institut, Rome.

 1942. *Flora Pompeiana.* Typescript in Deutsches Archäologisches Institut, Rome.

Wittmack, Ludwig M. C. 1904. "Die in Pompeji Gefunde-nen Pflanzlichen Reste." *Beiblatt zu den Botanischen Jahr-büchern 73, Band XXXIII* 3: 37–66.

Zahn, Wilhelm. 1827–59. *Die Schönsten Ornamente und Merk-würdigsten Gemälde aus Pompeji, Herkulanum und Stabiae.* 3 vols. G. Reimer, Berlin.

Zevi, Fausto. 1966. "Appunti sulle anfore romane." *Archeolo-gia Classica* 18: 208–24.

Zohary, Daniel, and Maria Hopf. 1994. *Domestication of Plants in the Old World.* 2nd ed. Clarendon Press, Oxford.

7

POLLEN ANALYSIS OF SOIL SAMPLES
FROM THE A.D. 79 LEVEL
POMPEII, OPLONTIS, AND BOSCOREALE

POMPEII AND OPLONTIS

G. W. Dimbleby

In a book dealing specifically with the natural history of the Vesuvian area, it is appropriate to concentrate on the nature of the evidence and how it occurs rather than on the archaeological implications. Though not the ideal medium for preserving pollen, terrestrial soils as opposed to waterlogged deposits have proved useful in archaeological contexts, particularly when they have been buried by later material (Dimbleby 1985). When Professor Jashemski, in 1972, asked me to look at three samples from the garden soils at Pompeii, buried beneath the layer of lapilli, I was skeptical about this being a practicable proposition. I had always avoided garden soils for the following reasons:

1 Gardens are usually on fertile soil, which favors microbiological decomposition of organic matter, including pollen. As a result, pollen numbers are likely to be low and the condition of preservation very poor.

2 Pollen often cannot be identified beyond the family level, thus many cultivated plants and weeds in the same family may be indistinguishable. For example, the family Compositae contains showy flowers, such as chrysanthemums and asters, as well as common weeds such as groundsel, daisies, and ragwort.

3 Some plants in gardens are not allowed to flower, so their presence would not be recorded in the pollen sample. Sedge plants (e.g., box) are kept trimmed, and many vegetables and salad plants are harvested before flowering. The pollen content of an ancient garden is not a clear answer as to what may have been grown in that garden.

When I examined Professor Jashemski's three samples (from the garden of Hercules) I found some

pollen in them; unexpectedly, some of this was olive (*Olea*) pollen, so the matter had to be investigated.

SAMPLING AND COUNTING

Following the positive result on the first three samples submitted by Professor Jashemski, she collected further samples from the garden of Hercules and, subsequently, material from a number of other gardens. For the most part samples could only be taken in the few places still covered by lapilli. From such a pattern there is clearly no basis for estimating the variation of the pollen content of the soil over a garden as a whole, so with this in mind, we carried out sampling on a grid pattern in the rear garden of the Villa of Poppaea at Oplontis. Fifty-six samples were taken on a 2 m grid, but unfortunately, this project had to be abandoned after sixteen samples were analyzed on account of the absence of pollen, despite the use of techniques to concentrate the pollen. At this site most of the lapilli had been removed, leaving only a very thin covering, and the soil had been badly damaged by scaffolding erected during restoration of the villa.

In general, the amount of pollen was very low, amounting to only a few thousand grains (of pollen and fern spores) per gram of soil, a level that makes counting to a statistically acceptable total extremely time-consuming and often not achievable. Only three samples of the many examined had absolute frequencies (abundance) exceeding 10,000 grains/g, whereas in normal soil pollen analysis one looks for frequencies several times or even hundreds of times greater than this. To add to the difficulties the pollen was generally in a poor state of preservation.

Some explanation is needed here about the termi-

nology used in the discussions that follow. It has been explained that identification cannot always be achieved to species level. As a result, in these analyses some identifications are to species, others to genus, and some cannot be more precise than the family. To accommodate this heterogeneity it is common practice to refer to all these categories as taxa (taxon, sing., taxa, pl.).

METHODS

The method used to extract pollen involves acetolysis, to reduce organic matter, and treatment with hydrofluoric acid, to reduce the mineral component of the soil. Details of this treatment have been published elsewhere (Dimbleby 1985, Appendix 1). In his section, Professor Grüger describes a more up-to-date variant of the same process. The chief difference between us is the method of calculating absolute pollen frequency. I counted the pollen in a drop of known volume, whereas he has used a more recent technique of introducing *Lycopodium* spores as an alien control. The two methods appear to give results of the same order.

The most obvious difference between our two accounts is the number of taxa identified. This may be partly because of the fact that my work has been concentrated in northern Europe, so that my reference collection of materials does not cover the floras of southern Europe. Another factor that may contribute is the great variation between the Vesuvian gardens in the richness and state of preservation of pollen in their soils. But I also have to admit that there have been great advances in the technology – optical equipment, computers, and so on – since I carried out this exploratory work on Professor Jashemski's samples in the early 1970s.

CONDITIONS OF PRESERVATION

In the Vesuvian sites the pollen concentrations are low and the pollen is in poor condition. In view of the alkalinity of the soil, ranging from pH 7.8 to 8.2, it is surprising there is any pollen at all. In a Mediterranean climate one would expect the temperature and moisture regime to favor rapid microbiological activity. Professor John Foss comments in this volume on the fertility of the local soils, which have been enriched through the centuries by successive eruptions (see Chap. 5).

The fact that these deposits are of volcanic origin may hold the key to the question of pollen preservation. A detailed palynological study has been made of volcanic soils in the Colombian Andes. Salomons (1986) has shown that though there are variations in the preservation of pollen according to altitudinally dependent local climates, soils at the lower and warmer altitudes showed increased microbiological activity. Nevertheless, pollen was found in considerable quantities and in a good state of preservation in the alkaline soils. An explanation advanced is that in these soils there are mineral-organic aggregates in which pollen is locked up and protected. The active mineral agent is allophane, a noncrystalline product of mineral breakdown that is characteristically, though not exclusively, found in volcanic soils (Fitzpatrick 1971). It appears that allophane absorbs bacterial enzymes and so limits the breakdown of organic matter, including pollen. Moreover, the mineral-organic aggregates are themselves relatively insoluble, so limiting chemical and biological attack. This also means that the aggregates do not become translocated downward through the soil by percolating water. In fact, Salomons claims that even in deposits consisting of coarse lapilli there was no detectable movement of pollen downward. This would mean that a layer of lapilli is an adequate protection of the buried soil against contamination from later pollen.

The significance of such a process will vary, and if one can regard the Pompeii soils as comparable to those at lower levels in the Colombian Andes, it means that while much pollen may be destroyed, a certain amount will be protected. I have inferred a similar process involving organic matter to account for the relative immobility of pollen even in nonvolcanic soils (Dimbleby 1985: 2–3).

POLLEN DISTRIBUTION AND DISPERSAL

In most of the gardens only a series of spot samples could be taken, for there were only a few places where there was still enough lapilli to protect the soil. Apart from the abortive attempt at Oplontis already mentioned, it was only in the gardens of Hercules and Polybius at Pompeii that a series of samples could be taken. In these two gardens there was much variation in the representation of the taxa identified. It was not that the list of taxa varied greatly – it was surprisingly consistent throughout these analyses – but several taxa in occasional samples reached very high percentages. For example, olive pollen reached high values in a number of samples (maximum 94.6 percent), as did *Polypodium* (maximum 93.2 percent). Less commonly high values were reached by the Pinaceae (maximum 37.7 percent) and Gramineae (maximum 40.6 percent); for details of these taxa see the later discussion.

The amount of pollen in a soil sample depends upon the rate of deposition and the rate of decay. The rate of deposition depends upon the level of pollen production by different species and upon the proxim-

ity of the flowering plants to the point of sampling. Soil pollen, in contrast to that from wet deposits, is likely to be most influenced by local sources of origin. Differences arise, too, because of different susceptibilities of different taxa to microbiological attack. The fern spores, in particular, are strongly resistant, and their consistent occurrence throughout these analyses may suggest that some spores may not have originated from contemporary pollen rain but may be relics from an earlier age of vegetation. On the other hand, it does not seem possible to account for the very high frequencies of *Polypodium* spores, and to a lesser extent *Pteridium* (bracken) spores, solely on this basis.

At the levels of frequency of pollen found in these samples, the question of "background noise" (alien pollen), that is, pollen coming in from outside areas, becomes a potentially disturbing matter. In Table 6 the total list of taxa is presented with an indication of the occurrence of each taxon in the analyses carried out on these twelve gardens. From this it will be seen that some taxa are present in most gardens:

12 gardens	Pinaceae, *Pteridium*
11 gardens	*Polypodium*, Gramineae
10 gardens	*Olea*, *Dryopteris* type
9 gardens	*Juglans*, *Plantago* spp.
8 gardens	Compositae (Liguliflorae), *Quercus*
7 gardens	*Corylus*, *Alnus*, Caryophyllaceae

Taxa coming in from some other site might be expected to be generally present, which this list does seem to indicate. It is significant that all of the taxa mentioned here have wind-disseminated pollen or spores except the Liguliflorae, the Caryophyllaceae, and, most remarkably, the olive (*Olea*). It may also be noted that in addition to their transport by wind, the pollen of Pinaceae and fern spores are very resistant to decay and could have been deposited from an earlier time.

Without laying too much emphasis on this incomplete analysis, we could argue that the pollen from distant sources includes Pinaceae, Gramineae, *Plantago*, possibly *Juglans* (walnut), *Alnus* (alder), *Quercus* (oak), and fern spores. Most of the herbs, being of low stature, are more likely to be garden weeds. This is not to say that all the pollen of the taxa listed here comes from a distance; there is the possibility that a proportion comes from the gardens themselves.

THE GARDENS

In Table 7 the gardens are listed to show the number of samples that were analyzed for each, and of those the number that yielded usable counts of at least 150.

Let us first consider the gardens for which there are very few samples giving adequate totals.

GARDENS WITH ONE VALID SAMPLE

1. Oplontis SE Peristyle (ambient 59) (Fig. 27, plan)

Pollen in the greatest abundance in this garden is of Pinaceae (37.7 percent), probably *Pinus pinea*, a prolific pollen producer. But the relatively low percentage of pine pollen in the sample is insufficient to indicate the presence of this tree in this garden. Olive pollen is present but at only 12 percent, and being an insect-pollinated species it may well have been in the garden, though it is a heavy producer of pollen; it is very poorly represented in one other sample from this garden. The remainder of the pollen sample is mostly of grasses and weeds. There is a high percentage of unknown (Varia) (see later discussion under Individual Taxa), at 10.2 percent. This category may include wild and cultivated plants not covered by our reference collection.

2. Garden of the House of the Ship *Europa* (I.xv) (Fig. 24, plan)

Here, too, grasses and weeds dominate the spectrum, also with a high Varia content (15 percent) — see Oplontis. The second sample did not yield an adequate count but showed a similar spectrum.

3. I.xiv.2

The count in this sample was dominated by 93 percent *Polypodium*. Olive was only 4.2 percent, but its absolute frequency was comparable with that of other samples where it reached high percentages. In other words, on a percentage basis it was swamped by *Polypodium*. Olive could well have been present in this garden, but we have only one sample for analysis. *Polypodium* frequency was so high that it can hardly be a "relic" at this site.

GARDEN WITH TWO VALID SAMPLES

1. I.xxii Large Orchard

Both samples from this garden gave acceptable counts, but they were completely different from each other. The first sample is dominated by fern spores (*Polypodium* 48 percent, *Pteridium* 24.5 *percent*) and a small amount of *Juglans* (walnut) 8.2 percent and *Olea* (olive) 6.7 percent. Walnut is wind-pollinated, and this value probably indicates its presence in the neighborhood but not necessarily in the garden. Olive is insect-pollinated so the source is more likely to be nearby. The second sample shows olive pollen totally dominant (76.1 percent), which must indicate its presence in the garden. Dr. Fideghelli

Table 6. Presence of all taxa according to locations sampled.

	A	B	C	D	E	F	G	H	I	J	K	L
Trees and Shrubs												
cf. *Abies*								+	+			
Alnus			+	+		+	+	+		+	+	
Betula			+		+		+			+		
Castanea						+		+				
Fraxinus						+						
Juglans		+		+	+	+	+	+	+	+	+	
Picea								+				
Pinaceae	+	+	+	+	+	+	+	+	+	+	+	+
Quercus		+			+	+	+	+	+	+	+	
Tilia			+						+			
Ulmus						+						
Olea	+	+	+	+	+	+	+	+	+	+		
Corylus			+	+		+	+	+	+	+		
cf. *Salix*										+		
Ericaceae			+					+			+	
Grasses and Herbs												
Gramineae	+	+	+	+	+	+	+	+		+	+	+
Cereal		+		+						+		
Caryophyllaceae		+	+	+		+	+	+		+		
Chenopodiaceae			+		+	+	+	+		+		
Compositae												
Artemisia			+	+			+					
cf. *Cirsium*	+					+						
Liguliflorae		+		+	+	+	+	+		+	+	
Tubuliflorae		+		+		+	+	+	+			
Cyperaceae						+	+					
cf. Geraniaceae								+				
Liliaceae						+	+					
Malvaceae				+		+	+					+
cf. Myrtaceae				+								
Plantago sp.		+	+	+	+	+		+		+	+	+
Ranunculaceae	+				+		+			+		
Rosaceae						+						
Potentilla								+				
Rumex				+						+		
Succisa		+				+	+	+				
cf. *Trifolium*										+		
Umbelliferae			+									
Urtica											+	
Fern Spores												
Dryopteris type		+	+	+		+	+	+	+	+	+	+
Polypodium	+	+	+	+	+	+	+	+	+	+		+
Pteridium	+	+	+	+	+	+	+	+	+	+	+	+

Key to Gardens

Pompeii

- A. I.xiv.2
- B. I.xv House of the Ship *Europa*
- C. I.xxi.2 Garden of the Fugitives
- D. I.xxi.3 Small north garden
- E. I.xxii Orchard
- F. II.viii.6 Garden of Hercules
- G. III.vii. Vineyard
- H. IX.xiii.1–3 Polybius

Oplontis (see plan of Oplontis, Fig. 27)

- I. Rear garden, ambient 56
- J. SE peristyle, ambient 59
- K. Tiny raised garden, ambient 61
- L. Ambient 60

Table 7. *Numbers of samples analyzed from individual gardens, with numbers reaching usable totals.*

Garden	No. of Samples Examined	No. Giving Usable Totals	Published
Pompeii			
I.xiv.2	1	1	Jashemski 1993: 59
I.xv Europa	2	1	
I.xxi Fugitives	12	0	
I.xxi.3 Small N garden	6	3	Jashemski 1993: 72
I.xxii Orchard	2	2	Jashemski 1979: 257
II.viii.6 Hercules	10	9	Jashemski 1993: 94–5
III.vii Vineyard	10	0	
IX.xiii.1–3 Polybius	10	8	Jashemski 1993: 250–1
Oplontis			
N garden, ambient 56	10	0	
SE peristyle, ambient 59	13	1	Jashemski 1993: samples 1, 2
Tiny garden, ambient 61	1	0	Jashemski 1993: sample 5
Ambient 60*	2	0	Jashemski 1993: samples 3, 4

**Strip of soil between portico and W side of swimming pool.*

identified the large tree-root cavity near the SE corner of the triclinium as that of an olive about thirty years old.

GARDEN WITH THREE VALID SAMPLES

1. I.xxi.3 Small North Garden

Though six samples were taken from this garden only three gave adequate values, virtually identical, with olive pollen at 94.6, 84.3, and 87.9 percent, respectively. Moreover, in two of the three other samples it shows similar dominance. This remarkable consistency might suggest not only the presence of flowering olive trees in the garden but also that the trees provided so much shade that little else was able to flower. The sixth sample, interestingly, included a large Varia count (see later discussion).

GARDENS WITH A LARGER NUMBER OF VALID SAMPLES

1. Garden of Hercules II.viii.6

The samples that contained very high levels of *Polypodium* had been taken near the walls; those showing high levels of olive pollen were from garden beds. It seems clear that the fern *Polypodium* was growing on walls or adjacent roofs, and there can be little doubt that there were olive trees in the garden. The presence of a pollen cluster in one of the 1972 samples that came from this garden is an indication that there were olive trees nearby, for such clusters usually arise from fallen flowers or anthers. Dr. Fideghelli identified the large tree-root cavity nearby as that of an olive tree.

Even those samples dominated by *Polypodium* contained sizable frequencies of olive pollen, suggesting that there was more than one olive tree in this garden.

2. Garden in the House of C. Julius Polybius IX.xiii.1–3 (Table 8, Figs. 164, 165)

This garden contained five large tree-root cavities and many smaller ones. Along the W wall six of the cavities had the soil around them shaped in a high mound surrounded by a water channel that gave the appearance of a sombrero. The ten pollen samples all gave positive counts, though for two the count was inadequate.

In Table 8 the main pollen taxa are shown in relation to the five tree sites. From this table it is clear that the samples adjacent to three of the tree-root cavities were high in olive pollen; the other two were not. There was some inconsistency among other samples; the olive pollen percentages did not necessarily follow the nearness of the samples to these three trees.

In fact it was the inconsistency between adjacent samples that cast doubt on the value of the percentages. It was therefore decided to plot the frequencies (i.e., the number of pollen grains and spores per gram of soil) separately. In Figure 165 each taxon is shown in a separate diagram of the garden. As the different taxa vary so much in their pollen production, the largest frequency for each one is indicated by a large circle, the same diameter for each taxon. For those with lower frequencies the diameters are reduced pro rata.

It cannot be said that these diagrams produce any clear-cut answers, but they do show some interesting rela-

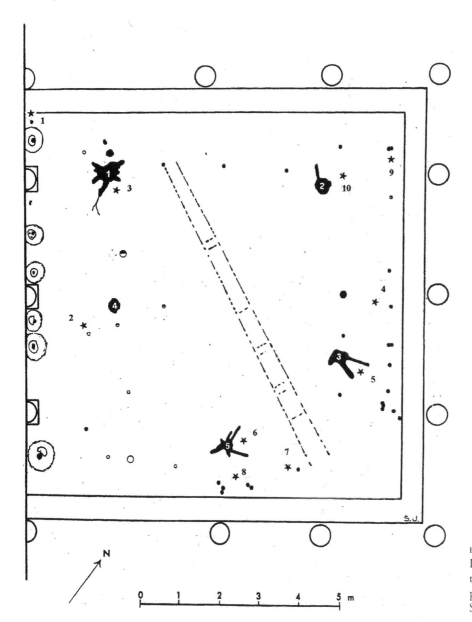

FIGURE 164 Garden of Polybius. Location of five large tree-root cavities and the ten pollen sampling points. S. Jashemski and Tebebe Sellasie Lemma.

Table 8. Polybius. Spectra of samples collected adjacent to tree-root cavities.

Tree No.	Pollen Sample No.	Pinaceae	Juglans	Olea	Corylus	Gramineae	Plantago	Polypodium	Pteridium
1	III	7.2	1.2	63.2	1.2	0.4	—	12.0	6.4
2	X	28.3	—	1.0	1.0	4.0	1.0	17.2	24.2
3	V	9.0	4.5	5.2	3.9	11.0	0.6	26.5	21.9
4	II	6.6	0.6	48.2	7.8	—	0.6	12.0	12.7
5	VI	6.1	2.0	63.7	1.6	3.3	—	4.5	5.3
6	VII	6.8	1.0	56.0	2.6	4.7	1.0	13.1	4.7

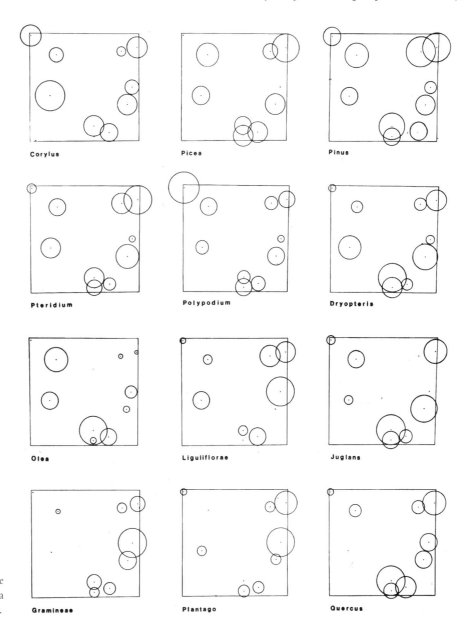

FIGURE 165 Representation of relative absolute frequencies of selected taxa in Garden of Polybius. G. Dimbleby.

tionships. For example, one group is mainly confined to the right-hand side of the diagrams and hardly shows at all on the opposite side (viz., *Quercus, Plantago,* Gramineae, *Juglans*). Others are more uniformly present across the sampling points (*Corylus, Picea, Pinus, Pteridium, Dryopteris* type). All of these would come into the category of "background noise"; so this does not tell us very much. The taxon that stands out is olive (*Olea*), which clearly reaches its highest concentrations around trees 1, 4, 5, and 6 and confirms the percentages shown (Table 8, Fig. 165).

Though in this case the two approaches give us the same answer, frequencies are not subject to the serious flaw inherent in percentages, namely that if there is a predominance of one of the taxa, especially if it may have a different origin from the other pollen in the sample, it depresses all other percentages until they become meaningless. The only answer to this shortcoming is to make much higher counts, which on this sort of material is not feasible.

INDIVIDUAL TAXA

In order to assess the implications of the pollen values, it is necessary to appreciate some of the botanical differences between the plants whose pollen has been recorded. Some outline notes on those taxa that feature most prominently in the foregoing analysis may therefore be helpful.

1. Common Polypody (probably *Polypodium australe* Fée sens. lat.)

This fern is widespread from the United Kingdom and middle Europe to Russia and the Mediterranean area, including Italy. Its rarity today in the Vesuvian sites would appear to reflect changes in aridity and related habitat changes since Roman times. Normally polypody grows on walls, on tree trunks, and in hedgerows in moist climates, such as in the United Kingdom. In our analysis of spore content and frequency, the highest

peaks were found around the edges of gardens, suggesting that it was associated with walls or roofs. It would be favored by moisture, such as blocked drainage from a roof. The polypody has no obvious utility value, although it is sometimes cultivated in gardens.

2. Bracken (*Pteridium aquilinum* (L.) Kuhn)

This cosmopolitan fern is widespread on a variety of soils, though it favors the more acid ones. It spreads aggressively by rhizomes and is intolerant of deep shade. The garden soils of the Vesuvian area, being alkaline, would not favor it, though I have seen it growing on comparable soils. Bracken is widely used as a bedding for animals, and it is frequently used in gardens and fields as a mulch or green manure. By this practice, the spores of bracken could be introduced at high concentrations into soils in which the plant was not actually growing.

3. Olive (*Olea europaea* L.)

Though insect-pollinated, this tree does produce large quantities of pollen. Peak values were so high, however, that it is difficult to believe that they do not represent flowering trees in their respective gardens. In one or two samples, clusters of pollen were found, varying from five to twenty or more pollen grains. These clusters probably came from a nearby fallen flower (or even a dead bee).

4. Grasses (Gramineae)

Grass pollen is produced in great quantity in many open landscapes, giving very high percentages in the pollen rain. The values in these analyses are only moderately high, with the highest being 40.6 percent in the garden of the House of the Ship *Europa*. Where such peaks occur they are usually accompanied by other taxa that are generally regarded as weeds, such as Compositae, *Plantago,* and Ranunculaceae. The obvious interpretation is that the spectra reflect conditions of weed and grass growth in at least part of the garden. Such plants demand light and do not flower freely in the shade. In the garden of the House of Polybius grasses are most strongly represented where the values of olive pollen are lowest.

5. Pine Family (Pinaceae)

This family of conifers includes the various Mediterranean species of the genus *Pinus*, of which *P. pinea* L., the umbrella or stone pine, is probably the main pollen contributor to the pollen rain. Trees of the Pine family are wind-pollinated and heavy pollen producers. On the whole the incidence of Pinaceae pollen is not high in these gardens; the highest occurrence, 37.7 percent in the SE peristyle garden in the Villa of Poppaea at Oplontis, probably indicates a tree in the neighborhood. Most of

the samples contain some pollen of this taxon, suggesting that it was a component of the local pollen rain.

6. English or Persian Walnut (*Juglans regia* L.)

One would expect to find evidence of this introduced nut tree in the Pompeii area. It is wind-pollinated, and the pollen is recorded in small numbers in several of the samples. Carbonized remains of walnuts were found at Pompeii and Herculaneum, but there is no confirmation that the tree was grown in any of the gardens.

7. Hazelnut (*Corylus avellana* L.)

The hazelnut or cobnut is a large shrub or small tree, found throughout southern Europe and Asia Minor. It is wind-pollinated and a prodigious pollen producer. None of the counts in this analysis give values high enough to suggest that it might have been grown in any of the gardens. A closely related species, the filbert (*C. maxima* L.), occurs in southeastern Europe. It is a tree valued for its nuts. Carbonized remains of hazelnut have been found in the garden of the House of the Ship *Europa* (Jashemski 1979). Casts of hazelnuts were found in the *villa rustica* of L. Crassus Tertius at Oplontis. The two species could not be identified on pollen alone.

8. Varia

This category records pollen that, although in a good condition, could not be identified. Usually it is possible to keep Varia well below 5 percent, but much depends on the completeness of the reference collection. As mentioned earlier, our reference collection is deficient in taxa from the Mediterranean area. In three of the gardens, namely in the SE peristyle garden at Oplontis, the garden of the House of the Ship *Europa,* and Garden I.xxi.3, exceptionally high pollen values were recorded. In I.xxi.3 only one of the five samples showed a high Varia value, and half of the grains put in this category were of one taxon that could not be identified, clearly a case of inadequate reference material.

9. Taxa Not Recorded in the Counts

In the botanical evidence from other sources of material (see Chap. 6), many taxa were mentioned that were not found in the pollen lists. In some cases this may be due to the impossibility of taking identifications of pollen beyond the family level. This limitation could apply to the family Rosaceae, which includes important plants, such as almond, peach, plum, apple, and pear, as well as soft fruits, such as *Rubus* spp. The pollen of this family does not preserve well; as insect-pollinated plants, they do not produce much pollen. Professor Grüger found the pollen of the vine (*Vitis vinifera* L.) at a low level, but he does not record it at more than 20 percent in the vineyard at Boscoreale.

FURTHER OBSERVATIONS ON SOIL CONDITIONS

DEPTH OF LAPILLI

Reference has already been made to the significance of Salomons's work on the soils of the Colombian Andes, in which he suggested a mechanism that could reduce the decay and downward movement of pollen through a layer of lapilli. This understanding could be of fundamental importance in any future investigation of soils beneath volcanic deposits. What is still uncertain is whether there is a critical minimal depth of lapilli necessary to give protection to ancient soils buried beneath them and whether this depth is related to the size of the overlying deposit.

WOOD DECAY

The condition of wood and tree roots in and under the layer of lapilli provides additional evidence about the microbiological activity that has been at work, and so is of relevance to pollen survival.

In the rear garden of the Villa of Poppaea at Oplontis the branch of a large tree was excavated in the layer of lapilli. It was badly decayed. In other places in the lapilli there were cavities where trees had completely rotted away. This rotting shows that in the covering of lapilli there was enough aeration to allow aerobic decay, though the largest piece of wood had not been totally consumed even after 1,900 years.

In a number of gardens tree-root cavities occurred that had become filled with lapilli as the root wood rotted away. Again it was apparent that even at the old soil level aerobic decomposition had been able to take place continuously.

The pH of the lapilli is 8.2, and in the buried soils values range from 7.8 to 8.2. At such values microbiologi-cal decomposition should be active, given that the other soil factors, such as aeration or moisture, are not limiting.

CONDITION OF THE POLLEN

The pollen grains we found in the ancient soil are only the outer shells – the living contents had broken down early on. These empty shells have walls, which are impregnated with a substance, sporopollenin, that is resistant to decay to varying degrees according to its composition. We have said enough about the conditions that favor the decomposition of pollen, mainly by bacteria, but there are other agencies that also damage the pollen shells. Chemical attack and mechanical abrasion are two. Earthworms are important where they occur because they ingest soil and pass it through their bodies and void it in casts. Some pollen grains survive this process, but they emerge deformed and often fragmented, which adds to the problem of identification.

Damage by heat has a recognizable effect on the pollen shells; they become badly blistered and distorted, but no evidence was seen of this effect in any of our samples.

CONCLUSIONS

In spite of the unexpected discovery of olive pollen in the trial samples, which led to a more comprehensive investigation, my reservations about pollen analysis of garden soils proved well founded. With only a few exceptions, such as the olive, it has not been possible to specify what plants were grown in individual gardens. Generally we cannot separate weeds from garden plants on the basis of pollen. It has been extremely useful, however, to examine the question of alien pollen in our analyses, for such pollen gives important evidence regarding the plants growing in the surrounding area.

BOSCOREALE, OPLONTIS, AND POMPEII

Eberhard Grüger

INTRODUCTION

This section deals with the pollen found in soil samples taken during Professor Jashemski's excavations in 1982 and 1983 at three sites: (1) the *villa rustica* at Bosco-reale (see Chap. 2), (2) the sculpture garden along the swimming pool at the Villa of Poppaea at Oplontis (see Chap. 2), and (3) the garden of the House of the Gold Bracelet at Pompeii (see Chap. 2). Between 1982 and 1990 I studied the samples that were collected after

Professor Dimbleby's retirement, together with some samples of the modern soils.

METHODS

Pollen concentration in the soil samples turned out to be low or nonexistent. Assuming first that this was the effect of too small a soil sample (2 g), I enlarged their size (10–35 g). The "normal" procedure in pollen preparation was changed, which resulted in higher pollen counts; the pollen frequencies (or pollen concentrations, i.e., the number of pollen grains and spores found in 1 g of soil), however, remained small.

Most of the samples have been treated as follows: The air-dried material was weighed and gently boiled in a 10 percent potassium hydroxide solution. To remove the coarse fraction the suspension of the fine-grained material was decanted, and the samples were washed thoroughly several times with water. Thus about half of the soil material could be removed. Acetolysis and treatment with hydrochloric and hydrofluoric acids followed. The last step reduced the sample volume to a minimum. To further concentrate the pollen and spores, the samples were sieved in an ultrasonic water bath (50 kH) using a 5 × 8 micron sieve. To calculate the pollen concentrations, a known number of marker grains (in this case, *Lycopodium* spores) was added to (most of) the samples after weighing them, that is, before further treatment in the laboratory (Stockmarr 1971). The marker grains were counted together with the fossil pollen grains. When only part of a sample is counted, the quotient "number of added to number of counted marker grains" can be used as a factor to calculate the total number of fossil pollen grains and spores that the sample contained.

Preservation of the pollen exines (outer pollen coat) was usually sufficient for identification, but many pollen grains were crumpled. More than 100 pollen types have been distinguished, but not all of them could be identified. Those unable to be identified are listed as "Varia." In a few cases the high Varia values (e.g., Boscoreale, SW quarter, sample 9) represent mainly one pollen type, a wide-reticulate, tricolpate pollen, similar to the pollen of Oleaceae, but certainly not of *Olea, Ligustrum,* or one of the other members of that family identified in this study. The results of the counts are listed in Tables 9 and 11.

SOURCE AND PRESERVATION OF POLLEN IN SOILS

The pollen found in the soil of a garden or a vineyard derives mainly from the flora of the site. Anthers (with pollen) and flowers falling to the ground will strongly influence the pollen spectra of soil samples, whereas pollen transported by wind from other areas will be less important. Depending on the chemical and physical conditions in the soil, the pollen exines will decompose in the course of time. It can be assumed that the pollen precipitation of several years will be present in a soil sample.

Many studies have been undertaken to determine soil conditions that preserve pollen (see the publications of Dimbleby, Havinga, or Salomons, where more titles relevant to these problems are cited).

Pollen decomposition is most intensive in biologically active soils, though no indications of a direct microbial attack to the pollen wall could be observed until now (Rowley, Rowley, and Skvarla 1990). Microbial activity, which is related to moisture and temperatures in the soil, seems to improve conditions for chemical oxidation of the pollen walls.

This conclusion agrees with the results of the investigations of Salomons on the influence of environmental factors on the degree of pollen decomposition in tephra soils of the Colombian Andes. Here, the best pollen preservation was found in samples from sites of more than 3,000 m height above sea level, where cool and relatively dry climatic conditions prevail.

Pollen is best preserved in acid environments, a fact successfully used for dating burial mounds and for environmental reconstructions in northwestern and northern Europe (e.g., Groenman-vanWaateringe 1986; van Zeist 1967; and others).

A compilation of pollen precipitation values from different regions in northern Europe and North America (Grosse-Brauckmann 1978) shows that about 2,000 to 4,000 pollen grains fall on each cm^2 of the ground during one year. The highest values are usually found in forests, the lower ones in agricultural areas. Extremes can be two to three times greater, and lower values are also possible. Comparable studies in Italy seem to be lacking, but similar figures are to be expected for the area under consideration.

SITES AND SAMPLES

BOSCOREALE (TABLES 9a AND 9b)

The *villa rustica* at Boscoreale was surrounded by a vineyard. The excavated area measures about 45 × 50 m. Root cavities of thirty-two trees were found in this area. Two (29, 30) were identified by charred wood as *Pinus pinea* (see Chap. 2; for English plant names see Table 14). Eighteen samples were collected in the vineyard area northeast of the *villa rustica* in 1982. An addi-

Table 9a. Boscoreale, villa rustica, *NE quarter. Pollen content of fossil soil samples: percentages.*

Sample Number	1	2	3	4	6	8	9	11	13	16	18
Basic Sum	787	531	117	1151	648	382	408	373	257	316	787
Pollen of trees and shrubs	24.7	18.8	24.8	30.3	17.9	12.0	10.8	21.7	33.1	18.0	21.6
Pollen of nonwoody species	68.7	73.1	73.5	32.6	72.7	85.3	81.4	75.9	62.6	73.1	58.4
Spores	6.6	8.1	1.7	37.1	9.4	2.6	7.8	2.4	4.3	8.9	19.9
Trees and Shrubs											
Alnus	0.5	2.3	0.9	0.8		2.1	0.5	2.7	1.2	1.9	0.8
Arbutus				0.2							
Betula		0.2			0.2			2.1			0.3
Buxus											
Carpinus betulus	0.1						0.5				0.1
Castanea											
Ceratonia											
Cistus cf. *monspeliensis*											
Corylus	4.2	0.4	0.9	0.6	0.3	1.6	2.0	2.4	0.4	8.9	0.9
Cupressaceae	2.5	5.1	6.0	1.8	0.2		0.2		0.8		0.4
Ephedra distachya type											0.1
Ephedra fragilis type		0.2						0.3		0.9	
Erica		0.4		0.2		0.3					0.5
Ericaceae p.p.				0.2							
Fagus					0.2			0.3	0.4		
Fraxinus excelsior type				0.1							
Fraxinus ornus	0.3					0.8					
Hedera							0.2				
Helianthemum/Cistus type											
Humulus/Cannabis type											
Ilex											
Juglans	4.3	0.6	2.6	1.0	2.8	2.4	1.7	2.4	7.4	3.5	0.1
Ligustrum											
Myrtus											
Olea type	1.5	0.9		0.3	0.9	1.6	1.7	0.5	2.7		0.5
Ostrya/Carpinus orientalis type	0.3	1.3	0.9								
Paliurus											
Phillyrea	0.4	0.4		0.1					2.7	0.3	
Picea											
Pinus	7.6	3.2	12.8	2.2	13.0	1.0	2.2	8.8	14.0	1.9	16.1
Pistacia		0.2		0.1							
Platanus	0.1										
Quercus ilex/coccifera type	0.1	0.2				0.3					
Quercus pubescens/robur type	1.3	2.1		0.8	0.3	1.3	1.0	1.6	2.3		1.5
Rhamnus cathartica/alaternus t.											
Salix		0.2									
Tilia											
Ulmus		0.8	0.9	0.3	0.2	0.5	0.5	0.3		0.6	0.3
Vitis	1.4	0.6		21.7		0.3	0.2	0.3	1.2		
Nonwoody Species											
Anemone type	0.9	1.3		0.4		0.3	2.5	0.5	0.4	1.3	0.1
Artemisia	1.4	2.1	1.7	0.9	0.9	5.2	10.0	1.9	1.2	4.7	7.2
Boraginaceae											
Caltha							0.2				

(continued)

Sample Number	1	2	3	4	6	8	9	11	13	16	18
Basic Sum	787	531	117	1151	648	382	408	373	257	316	787
Nonwoody Species											
Calystegia											
Campanulaceae											
Caryophyllaceae	0.9	0.8	4.3	0.5	5.7	0.5	1.0		1.2	0.9	1.5
Centaurea jacea type											
Cerealia type		0.4		0.3	0.8		0.5		0.8		0.1
Chenopodiaceae/											
Amaranthaceae	18.4	30.9	37.6	6.4	13.0	33.2	30.9	29.5	8.6	6.3	2.9
Compositae Liguliflorae	3.6	2.3	1.7	2.4	1.9	2.1	1.5	4.0	1.9	5.1	8.6
Compositae Tubuliflorae	2.9	6.0	4.3	1.1	2.2	1.3	1.7	0.3	1.2	5.4	3.8
Convolvulus											
Cruciferae	5.3	1.7	3.4	0.8	1.9		0.5	0.5	3.5		0.4
Cyperaceae	2.0	8.1	2.6	6.7	2.9	5.2	6.6	4.8	12.1	6.3	10.2
Dianthus type											
Erodium type											0.1
Geranium (reticulate type)	0.1			0.2	1.1		0.2	1.6	0.4	2.2	
Geranium (striate type)										7.0	
Gramineae	24.8	6.4	11.1	8.3	22.5	18.1	12.0	18.5	24.5	23.1	18.3
Impatiens											
Indeterminata	4.6	9.4	2.6	2.4	7.6	1.6	5.6	3.8	5.4	4.4	3.8
Knautia arvensis type	0.1				6.0						
Liliaceae											
Lychnis type											
Malvaceae	1.3	0.2		1.4	4.3	9.2	3.9	6.4	0.4	2.2	0.4
Mercurialis annua											
Papilionaceae											
Plantago coronopus type				0.1							
Plantago lanceolata	0.4	0.2			0.2	0.3	0.2	0.3	0.4	0.6	0.1
Plantago sp.		0.2				0.3					
cf. *Plumbago*											
Polygonum aviculare type					0.2	0.3	0.5				0.4
Polygonum convolvulus type	0.4	0.6	3.4					0.5		0.6	
Polygonum persicaria type											
Ranunculus type	0.1			0.1	0.9	3.9	0.2		0.4		0.1
Rosaceae p.p.		0.2									
Rubiaceae						0.3	0.2	0.3			
Rubus type											
Scabiosa columbaria type											
Scrophulariaceae											
Triticum type	0.1							1.9			
Typha angustifolia type					0.2						
Typha latifolia											
Umbelliferae						0.5		0.3			
Varia	1.4	2.4	0.9	0.6	0.6	3.1	2.9	0.8	0.4	2.8	0.3
Ferns											
Anogramma									0.3		
Dryopteris	0.3										
Equisetum											

(*continued*)

Table 9a. (continued)

Sample Number	1	2	3	4	6	8	9	11	13	16	18
Basic Sum	787	531	117	1151	648	382	408	373	257	316	787
Ferns											
Ophioglossum	0.1			0.1			0.2		0.8		
Polypodiaceae	0.6		0.9	0.2	0.9	0.5	0.5			0.3	1.7
Polypodium	0.8		0.9	0.3	1.4	0.8	2.2	0.8	1.6	4.4	1.0
Pteridium	4.6	8.1		36.1	6.9	0.8	3.7	1.1	1.6	2.2	16.5
Pteris	0.1										
Hornmosses											
Anthoceros laevis						0.5		0.3		1.3	0.6
Anthoceros punctatus	0.1			0.3	0.2		1.2		0.4	0.6	0.1
Algae											
Pediastrum boryanum											
Pediastrum kawraiskyi											

Table 9b. Boscoreale, villa rustica, *SW quarter. Pollen content of fossil soil samples: percentages.*

Sample Number	1	2	4	5	6	8	9	10	11	12	13	14	15
Basic Sum	219	982	661	291	191	298	271	638	222	342	257	578	415
Pollen of trees and shrubs	28.3	66.0	9.8	15.8	28.3	24.2	5.2	41.4	17.6	33.6	32.3	19.6	63.1
Pollen of nonwoody species	54.3	31.0	36.3	73.2	69.1	66.8	91.9	53.1	80.2	64.0	61.1	76.5	35.4
Spores	17.4	3.1	53.9	11.0	2.6	9.1	3.0	5.5	2.3	2.3	6.6	4.0	1.4
Trees and Shrubs													
Alnus	6.4	0.1	0.3	0.3		0.7		0.9	0.5		1.6	0.9	
Arbutus													
Betula	3.2	0.1			2.0	0.7			0.5		0.4		
Buxus													0.2
Carpinus betulus													
Castanea								0.6					
Ceratonia						0.7							
Cistus cf. *monspeliensis*													
Corylus	5.9	0.6	3.0	0.7		1.7		1.7		1.2	0.8	0.7	
Cupressaceae				0.3								0.5	
Ephedra distachya type													
Ephedra fragilis type	0.5							0.2					
Erica		0.9						0.2					
Ericaceae p.p.										0.3		0.2	
Fagus	0.9			0.3					0.5				
Fraxinus excelsior type		0.1		0.3									
Fraxinus ornus		12.0		2.4						0.3	0.4		1.4
Hedera						0.3						0.2	
Helianthemum/Cistus type													
Humulus/Cannabis type													
Ilex								0.2					
Juglans	1.8	9.2	0.9	3.4		0.3	1.8	2.7	0.5	5.6	0.4	1.2	3.6
Ligustrum		0.6											
Myrtus													
Olea type	2.3	30.7	0.6	1.7		1.0	0.4	3.9	0.9	3.5	1.2	1.0	0.5
Ostrya/Carpinus orientalis type		0.1	0.3					0.3				0.3	0.2

(continued)

Sample Number	1	2	4	5	6	8	9	10	11	12	13	14	15
Basic Sum	219	982	661	291	191	298	271	638	222	342	257	578	415

Trees and Shrubs

	1	2	4	5	6	8	9	10	11	12	13	14	15
Paliurus													
Phillyrea		5.6							0.9	2.6	0.4		0.2
Picea						0.3							
Pinus	3.2	2.4	2.1	3.4	27.2	14.8	1.5	27.9	11.3	18.7	26.1	9.2	54.5
Pistacia													
Platanus													
Quercus ilex/coccifera type					0.5			0.8				0.2	
Quercus pubescens/robur t.	1.8	1.1	0.8	2.4	0.5	2.3	0.4	1.1	2.3	0.3	1.2	1.7	1.2
Rhamnus cathartica/alaternus type													
Salix													
Tilia	1.4	0.1								0.3			
Ulmus	0.9	3.2	0.5						0.5	0.3			1.0
Vitis		0.1	0.5	0.3			0.4	0.9		0.6		3.5	0.2

Nonwoody Species

	1	2	4	5	6	8	9	10	11	12	13	14	15
Anemone type	0.5	1.0		2.7	1.6		0.7	1.4		1.5	6.6	0.2	2.9
Artemisia	0.5		1.2	4.5		1.7		1.6			0.4	3.5	
Boraginaceae												0.2	
Caltha													
Calystegia				0.3							0.4		
Campanulaceae							0.4						
Caryophyllaceae	0.5	0.5	2.7	1.7		0.3		1.4	1.4		2.7	1.0	2.2
Centaurea jacea type													
Cerealia type	0.5	0.7					0.4	0.2					1.4
Chenopodiaceae/Amaranthaceae	11.9			8.9	11.5	13.1		5.3	0.5	7.3	0.4	20.8	0.5
Compositae Liguliflorae	0.9	0.6	0.9	6.2	34.6	27.9	0.4	4.9		2.6	2.3	2.1	0.2
Compositae Tubuliflorae	0.9	0.1	0.6	1.7	4.7	3.7		1.6	0.5	1.2	0.4	3.3	0.2
Convolvulus		0.8		1.0							0.4	0.5	0.5
Cruciferae		0.1	1.5	7.9	0.5	1.3		3.1	3.6	0.9	2.3	1.2	0.7
Cyperaceae	2.3	2.2	0.2	3.1	1.6	4.7		1.9	1.4	3.5	1.2	11.8	0.2
Dianthus type													
Erodium type											0.4		0.2
Geranium (reticulate type)	0.9		0.6	2.4	1.6	0.7	0.7	1.7	6.8	0.9	1.6	0.3	1.4
Geranium (striate type)													
Gramineae	16.4	14.2	7.4	3.4	8.9	4.4	2.6	16.3	25.7	25.7	8.6	15.2	15.9
Impatiens													
Indeterminata	7.8	6.4	14.2	8.9	1.0	2.0	6.6	3.1	22.5	6.7	5.1	6.9	2.4
Knautia arvensis type			2.1				0.7	1.7	0.5	0.6	5.1	0.3	3.6
Liliaceae													
Lychnis type													
Malvaceae	3.2	0.9	0.2	6.9	2.6	5.4	1.8	4.5	8.6	7.9	21.4	1.0	1.4
Mercurialis annua								0.2					
Papilionaceae												0.3	
Plantago coronopus type													
Plantago lanceolata	5.0	0.2	2.6	1.4			2.6	0.8	0.5		0.4	0.2	0.5
Plantago sp.													
cf. *Plumbago*													
Polygonum aviculare type				0.7		0.7		0.3		1.2		2.2	
Polygonum convolvulus type								0.8		0.6		2.4	

(continued)

Table 9b. (continued).

Sample Number	1	2	4	5	6	8	9	10	11	12	13	14	15
Basic Sum	219	982	661	291	191	298	271	638	222	342	257	578	415
Nonwoody Species													
Polygonum persicaria type										0.3			
Ranunculus type				1.4					5.0	1.2			0.2
Rosaceae p.p.	0.5												
Rubiaceae		0.1						0.2		1.2			
Rubus type													
Scabiosa columbaria type													
Scrophulariaceae													
Triticum type		0.4									0.4		
Typha angustifolia type								0.5					
Typha latifolia		0.1											
Umbelliferae													
Varia	2.7	2.5	2.1	10.0	0.5	1.0	74.9	1.4	3.6	0.9	1.2	1.9	0.7
Ferns													
Anogramma		0.2					0.4	0.2				0.2	0.2
Dryopteris						0.7							
Equisetum						0.3							
Ophioglossum													
Polypodiaceae	0.9	1.1	0.3	1.7	1.0	2.0		3.6	0.9		2.3		0.5
Polypodium	14.2	1.6	53.6	9.3	1.6	1.3	2.6	0.9	1.4	1.2	4.3	0.7	0.7
Pteridium	2.3					4.7		0.2		0.9		2.8	
Pteris										0.3			
Hornmosses													
Anthoceros laevis								0.3					
Anthoceros punctatus		0.1						0.3				0.3	
Algae													
Pediastrum boryanum													
Pediastrum kawraiskyi													

tional fifteen samples were collected in 1983 to the southwest of the vineyard along a country lane running a few meters south of the villa through the vineyards and along a vegetable garden. Seven of these samples were taken less than 5 m away from the former site of a pine tree (Fig. 166).

OPLONTIS (TABLE 9c)

The Villa of Poppaea at Oplontis by contrast was a very luxurious one. Thirteen pollen samples were taken from the sculpture garden adjacent to a 60 m long swimming pool (Fig. 168). There was a row of thirteen statue bases parallel to the long axis of the pool, behind each of which a shrub or a tree had grown. *Nerium oleander* was identified, and there are indications of *Citrus lemon* and *Platanus orientalis* (see Chap. 2). A specimen of *Cupressus* had probably grown at the end of this row of trees and shrubs. Sample 2 was taken about 6 m away from the *Nerium oleander* under a supposed lemon tree, and samples 6 and 8 were taken near the supposed cypress tree.

POMPEII (TABLE 9c)

The House of the Gold Bracelet at Pompeii had a small (approx. 12.4 × 17.5 m) formal garden enclosed by walls. Root cavities in the garden indicate a formal

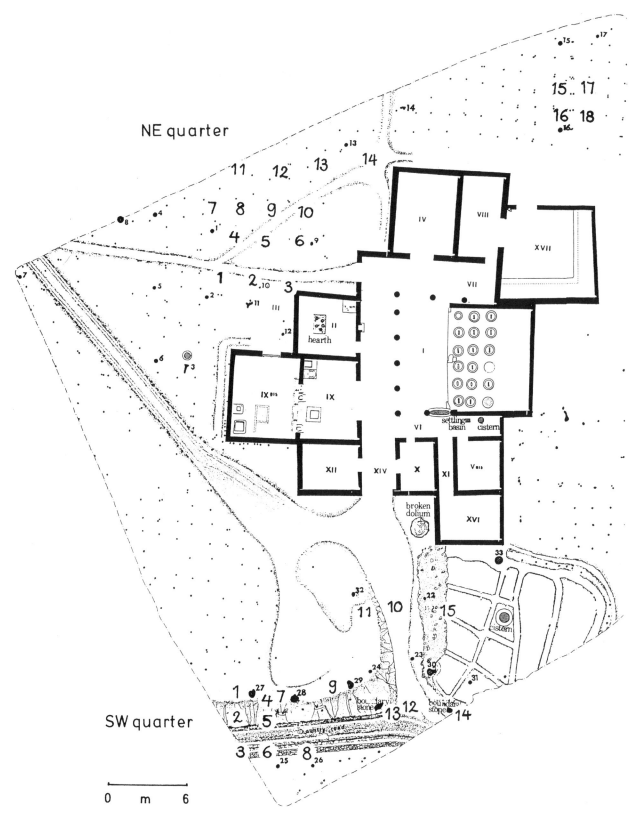

NE quarter

SW quarter

0 m 6

FIGURE 166 Plan of the *villa rustica*, Boscoreale (Jashemski 1987),
with locations of the studied soil samples.

Table 9c. *Oplontis, Villa of Poppaea; and Pompeii, House of the Gold Bracelet. Pollen content of fossil soil samples: percentages.*

Sample Number	Villa of Poppaea							House of the Gold Bracelet			
	1	*2*	*6*	*7*	*8*	*11*	*13*	*1*	*2*	*3*	*4*
Basic Sum	332	378	508	160	199	105	660	2445	500	142	132
Pollen of trees and shrubs	44.9	46.6	11.2	13.8	16.6	56.2	13.9	10.3	14.2	9.9	13.6
Pollen of nonwoody species	49.4	48.1	78.9	81.3	66.3	13.3	78.9	17.1	67.0	64.1	67.4
Spores	5.7	5.3	9.8	5.0	17.1	29.5	7.0	72.6	18.6	26.1	18.9
Trees and Shrubs											
Alnus	0.3	1.6	0.4	1.9	1.5	3.8	0.9	0.4	0.6	0.7	0.8
Arbutus								0.1			
Betula	0.3			1.3	1.0	5.7	0.5		0.4		2.3
Buxus											
Carpinus betulus	0.3							0.1			
Castanea								0.1			
Ceratonia			0.4		0.5			0.1			
Cistus cf. *monspeliensis*								0.1			
Corylus	1.8	11.4		2.5	5.0	36.2	1.7	1.2	0.8	0.7	7.6
Cupressaceae		2.9									
Ephedra distachya type											
Ephedra fragilis type	0.3	0.8	0.2								
Erica							0.6	0.3	0.4		
Ericaceae p.p.	0.3			0.6							
Fagus	0.3	0.3									
Fraxinus excelsior type											
Fraxinus ornus							0.2	0.1			
Hedera		0.3	1.0		0.5		2.4	0.1			
Helianthemum/Cistus type		0.3									
Humulus/Cannabis type			0.2								
Ilex											
Juglans	1.8	2.1					0.8	2.1	3.2	2.8	
Ligustrum											
Myrtus		1.1									0.8
Olea type	0.6	0.3				1.0			0.6	0.7	0.8
Ostrya/Carpinus orientalis type	0.3						0.2				0.8
Paliurus	0.3										
Phillyrea	0.3	0.3					0.2	0.2			
Picea					0.5	1.0		0.1			
Pinus	34.9	23.0	8.3	7.5	5.5	4.8	4.8	4.9	8.0	3.5	0.8
Pistacia											
Platanus											
Quercus ilex/coccifera type											
Quercus pubescens/robur t.	2.7	1.3	0.6		1.0		0.9	0.2			
Rhamnus cathartica/alaternus t.							0.5				
Salix										0.7	
Tilia					0.5	1.0		0.1	0.2	0.7	
Ulmus		1.1	0.2		0.5	2.9	0.2	0.4			
Vitis	0.3						0.3	0.1			
Nonwoody Species											
Anemone type	0.6					1.0				0.7	
Artemisia	4.2	2.1	1.6	1.9	0.5		1.5	0.1		0.7	1.5
Boraginaceae	0.6	0.5									

(continued)

	Villa of Poppaea							House of the Gold Bracelet			
Sample Number	1	2	6	7	8	11	13	1	2	3	4
Basic Sum	332	378	508	160	199	105	660	2445	500	142	132
Nonwoody Species											
Caltha											
Calystegia											
Campanulaceae								0.8			
Caryophyllaceae	1.2	0.5	0.6	0.6	1.0		0.8	1.8	0.8		4.5
Centaurea jacea type		0.3									
Cerealia type			0.4				0.8	0.1			
Chenopodiaceae/											
Amaranthaceae	11.7	11.6	11.0	18.8	15.1		12.6	0.1	0.2		3.0
Compositae Liguliflorae	12.3	9.3	26.4	33.8	18.1	1.0	27.1	0.9	0.8		3.0
Compositae Tubuliflorae	1.5	1.9	2.8	1.9	1.5	1.9	3.0	0.7	0.2	0.7	6.8
Convolvulus											
Cruciferae	4.5	6.1	3.3	1.3	2.5		4.2	2.1	0.2	0.7	4.5
Cyperaceae	1.8	2.6	16.7	8.1	13.1		8.6	0.3	1.2	0.7	0.8
Dianthus type		0.8									
Erodium type											
Geranium (reticulate type)			0.2				0.2	0.8			12.9
Geranium (striate type)											
Gramineae	3.6	1.9	6.5	4.4	5.5	2.9	9.2	3.1	1.8	2.1	11.4
Impatiens								0.1			
Indeterminata	3.0	3.4	7.5	8.1	5.0	1.9	7.0	3.4	14.8	20.4	10.6
Knautia arvensis type								1.3			
Liliaceae	0.3										
Lychnis type		0.3									
Malvaceae	1.8	0.3	0.6	1.3	1.0	1.0	0.6	0.2			6.1
Mercurialis annua											
Papilionaceae			0.2		1.0		0.3				
Plantago coronopus type											
Plantago lanceolata	0.3	0.5					0.2	0.7			0.8
Plantago sp.											
cf. *Plumbago*	0.3										
Polygonum aviculare type			0.2		1.0		0.5				
Polygonum convolvulus type	0.3							0.1			0.8
Polygonum persicaria type											
Ranunculus type								0.1			
Rosaceae p.p.		0.3				1.0	0.2				
Rubiaceae								0.1			
Rubus type								0.1			
Scabiosa columbaria type								0.1			
Scrophulariaceae								0.1			
Triticum type						1.0					
Typha angustifolia type											
Typha latifolia											
Umbelliferae											
Varia	1.2	5.6	1.0	0.6	0.5	1.9	1.5	0.1	47.0	38.0	0.8

(continued)

Table 9c. (continued)

Sample Number	Villa of Poppaea							House of the Gold Bracelet			
	1	2	6	7	8	11	13	1	2	3	4
Basic Sum	332	378	508	160	199	105	660	2445	500	142	132
Ferns											
Anogramma											
Dryopteris											
Equisetum											
Ophioglossum											
Polypodiaceae	1.5	1.1	1.2			12.4	2.4	0.4	1.0	1.4	6.8
Polypodium	1.2	0.5	1.6	1.9	7.5	8.6	0.9	69.9	16.6	24.6	12.1
Pteridium	3.0	3.7	4.9	1.3	7.5	8.6	2.6	2.1	0.8		
Pteris							0.2				
Hornmosses											
Anthoceros laevis			0.4					0.1			
Anthoceros punctatus			1.8	1.9	2.0		0.9		0.2		
Algae											
Pediastrum boryanum						1.0			0.2		
Pediastrum kawraiskyi							0.2				

hedge and some shrubs or small trees. The soil was badly damaged and only four samples for pollen analysis were taken from this garden.

MODERN SOIL SAMPLES

To understand better the meaning of the ancient pollen spectra, recent soil samples were collected in the Medieval Garden and the nearby Arboretum of the Old Botanical Garden of the University of Göttingen in Germany over a period of three years, each year at the same place. Thanks to the help of friends it was also possible to get samples from the modern surfaces of vineyards and cultivated land at Boscoreale, Oplontis, Mount Vesuvius, Pozzelle, Torre del Greco, and in the Parco Gussone in Portici, at Naples in the garden of a former cloister (now Dipartimento di Scienze della Terra, Largo San Marcellino), and from two places at Rome, namely the park of the Villa Medici and the Forum Romanum (Table 14). For the pollen content of the modern Italian samples see Table 13.

PRESENTATION
OF THE POLLEN DATA

Altogether fifty ancient soil samples have been studied by pollen analysis, using two modes of calculating the pollen counts:

1 Percentage values have been calculated based on the total number of pollen grains and spores. Counts of less than 100 pollen grains and spores were disregarded for statistical reasons. Therefore, Tables 9 a–c show percentage values for thirty-five samples only.

2 Pollen concentration was calculated for most of the samples. See Tables 11 a–c. As no *Lycopodium* tablets had been added to the first studied samples, pollen concentrations could be calculated for forty-one samples only.

DISCUSSION

The pollen counts from Boscoreale, Oplontis, and Pompeii have, as in all pollen analytical data, a qualitative and a quantitative aspect. Tables 9 a–c and 11 a–c and Figures 167 a and b show that much of the original pollen must have been lost since its deposition, a fact that necessarily makes any quantitative interpretation appear doubtful. It must also be realized that pollen identification may indicate a specific plant species, but more often points to only a genus or family.

The original source of the pollen found in the soil samples varied. Pollen of *Fagus sylvatica* and *Carpinus betulus* certainly had been airborne from distant mountains, whereas pollen of *Alnus, Betula, Fraxinus excelsior* type, some *Quercus* species, *Tilia* and *Ulmus,* and others may have come from nearby submontane areas, such as

Location of pollen samples and sample numbers as in fig. 166.

					15	17
					16	18
	11	12	13	14		
7	8	9	10			
	4	5	6			
	1	2	3			

Grape pollen concentration (Vitis)

					0	0
					0	0
	(1)	0	6	0		
0	(1)	(1)	0			
	159	0	0			
	15	(1)	0			

Pine pollen concentration (Pinus)

					0	(1)
					1	41
	7	0	76	(1)		
0	(1)	3	(1)			
	16	(1)	82			
	83	(5)	(5)			

FIGURE 167A Distribution of pine and grape pollen at Boscoreale, NE quarter: pollen grains per 1 g of soil.

Location of pollen samples and sample numbers as in fig. 166

					11	10	15
1	4	7	9	pine		pine	
2	5				13	12	14
3	6	8					

Grape pollen concentrations (Vitis)

					0	8	1
0	8	0	(1)	pine		pine	
(1)	1				0	(1)	2
0	0	0					

Pine pollen concentrations (Pinus)

					5	240	244
1	37	0	1	pine		pine	
9	10				41	8	6
0	3	7					

FIGURE 167B Distribution of pine and grape pollen at Boscoreale, SW quarter: pollen grains per 1 g of soil.

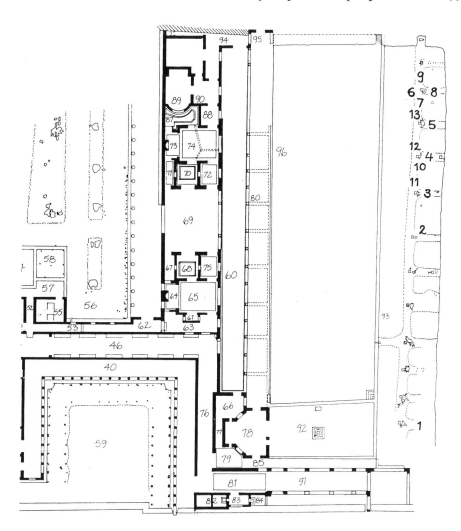

FIGURE 168 Plan of E part of the Villa of Poppaea at Oplontis (Jashemski 1987), with the locations of the studied soil samples.

from the slopes of Mount Vesuvius. Pollen of the non-woody species, especially insect-pollinated plants, such as weedy Caryophyllaceae, Compositae, Cruciferae, *Geranium,* and Malvaceae, was derived from plants growing where the soil samples were taken. Wind-pollinated plants, such as grasses and *Artemisia* species, also flourished in these sites.

Although not all of the pollen types identified were identical in all three sites, the pollen and spore floras of the vineyard area of Boscoreale and of the gardens of Oplontis and Pompeii do not differ substantially.

Remains of a *Pediastrum* species (green algae) were found at Oplontis near the big swimming pool and in the gardens at Pompeii near the pools and fountains.

Interpreting the mean pollen percentage values of the samples from Boscoreale, Oplontis, and Pompeii (Table 10), we may conclude from the low tree values that these sites were not forested but were inhabited. It is striking (Tables 9 a–c and 11 a–c) that the pollen values differ so much from one sample to the other, given that the samples were taken a few meters apart. At Boscoreale (SW quarter) the pollen values of *Pinus* range from 1.5 to 54.5 percent and from 1 to 244 pine

pollen grains per 1 g of soil; these extremes were found even under pine trees (samples 9 and 15, Fig. 167b, Tables 9b and 11b). *Vitis* pollen was present in seven of the eleven vineyard samples from Boscoreale (NE quarter) only. Although a maximum of 21.7 percent is reached, the values of *Vitis* are mostly below 1.5 percent (Tables 9a and 11a, compare also Fig. 167a). Even the values of common weeds differ a great deal, not only at Boscoreale but also at the other two sites.

These examples show that the answers to questions like "Were grapes cultivated on the plot?" or "Did a pine tree grow nearby?" would in such cases depend solely on the selection of the pollen samples. The great number of studied samples allows us to conclude that the pollen content of a single sample will only accidentally mirror the vegetational situation during the time of pollen deposition. This is in agreement with the findings of Adam and Mehringer (1975), who in their studies of surface samples from southern Arizona found that only a mixture of not less than five samples will represent the local pollen rain.

The pollen concentration values (Tables 11 a–c) show similar variations: 3 to 3,053 pollen grains and

Table 10. Pollen content of fossil soil samples: means of the percentage values listed in Tables 9a–c.

	Boscoreale NE	Boscoreale SW	Oplontis Villa P	Pompeii House of GB
Basic Sum	523	413	335	805
Pollen of trees and shrubs	21.2	29.6	29.0	12.0
Pollen of nonwoody species	68.9	61.0	59.5	53.9
Spores	9.9	9.4	11.5	34.1

Trees and Shrubs

	NE	SW	Villa P	House of GB
Alnus	1.23	0.89	1.48	0.61
Arbutus	0.02			0.01
Betula	0.25	0.53	1.25	0.67
Buxus		0.02		
Carpinus betulus	0.07		0.04	0.02
Castanea		0.05		0.01
Ceratonia		0.05	0.13	0.01
Cistus cf. monspeliensis				0.01
Corylus	2.04	1.25	8.37	2.57
Cupressaceae	1.54	0.07	0.42	
Ephedra distachya type	0.01			
Ephedra fragilis type	0.13	0.05	0.18	
Erica	0.12	0.08	0.09	0.18
Ericaceae p.p.	0.02	0.04	0.13	
Fagus	0.07	0.13	0.08	
Fraxinus excelsior type	0.01	0.03		
Fraxinus ornus	0.09	1.27	0.02	0.03
Hedera	0.02	0.04	0.60	0.01
Helianthemum/Cistus type			0.04	
Humulus/Cannabis type			0.03	
Ilex		0.01		
Juglans	2.61	2.42	0.67	2.04
Ligustrum		0.05		
Myrtus			0.15	0.19
Olea type	0.97	3.67	0.26	0.52
Ostrya/Carpinus orientalis type	0.22	0.10	0.06	0.19
Paliurus			0.04	
Phillyrea	0.35	0.75	0.10	0.04
Picea		0.03	0.21	0.01
Pinus	7.54	15.56	12.69	4.30
Pistacia	0.03			
Platanus	0.01			
Quercus ilex/coccifera type	0.05	0.11		
Quercus pubescens/robur t.	1.11	1.31	0.93	0.06
Rhamnus cathartica/alaternus t.			0.06	
Salix	0.02			0.18
Tilia		0.14	0.21	0.24
Ulmus	0.39	0.48	0.68	0.10
Vitis	2.33	0.50	0.09	0.01

Nonwoody Species

	NE	SW	Villa P	House of GB
Anemone type	0.70	1.47	0.22	0.18
Artemisia	3.39	1.02	1.69	0.58
Boraginaceae		0.01	0.16	
Caltha	0.02			
Calystegia		0.06		
Campanulaceae		0.03		0.20
Caryophyllaceae	1.57	1.11	0.67	1.79
Centaurea jacea type			0.04	
Cerealia type	0.25	0.24	0.16	0.01

Chenopodiaceae/

	NE	SW	Villa P	House of GB
Amaranthaceae	19.79	6.16	11.54	0.84
Compositae Liguliflorae	3.19	6.43	18.27	1.19
Compositae Tubuliflorae	2.74	1.45	2.06	2.11
Convolvulus		0.25		
Cruciferae	1.64	1.79	3.14	1.89
Cyperaceae	6.14	2.61	7.29	0.75
Dianthus type			0.11	
Erodium type	0.01	0.05		
Geranium (reticulate type)	0.53	1.51	0.05	3.41
Geranium (striate type)	0.63			
Gramineae	17.05	12.67	4.85	4.60
Impatiens				0.01
Indeterminata	4.65	7.22	5.14	12.31
Knautia arvensis type	0.56	1.13		0.33
Liliaceae			0.04	
Lychnis type			0.04	
Malvaceae	2.70	5.07	0.93	1.57
Mercurialis annua		0.01		
Papilionaceae		0.03	0.21	
Plantago coronopus type	0.01			
Plantago lanceolata	0.24	1.08	0.14	0.37
Plantago sp.	0.04			
cf. Plumbago			0.04	
Polygonum aviculare type	0.12	0.39	0.24	
Polygonum convolvulus type	0.50	0.29	0.04	0.22
Polygonum persicaria type		0.02		
Ranunculus type	0.53	0.60		0.03
Rosaceae p.p.	0.02	0.04	0.20	
Rubiaceae	0.07	0.11		0.01
Rubus type				0.01
Scabiosa columbaria type				0.01
Scrophulariaceae				0.01
Triticum type	0.18	0.06	0.14	
Typha angustifolia type	0.01	0.04		
Typha latifolia		0.01		
Umbelliferae	0.07	0.10	0.31	0.01
Varia	1.48	7.96	1.76	21.48

Ferns

	NE	SW	Villa P	House of GB
Anogramma	0.02	0.09		
Dryopteris	0.02	0.05		
Equisetum		0.03		
Ophioglossum	0.11			
Polypodiaceae	0.51	1.11	2.65	2.42
Polypodium	1.29	7.17	3.17	30.83
Pteridium	7.42	0.83	4.51	0.72
Pteris	0.01	0.02	0.02	

Hornmosses

	NE	SW	Villa P	House of GB
Anthoceros laevis	0.24	0.02	0.06	0.03
Anthoceros punctatus	0.27	0.06	0.94	0.05

Algae

	NE	SW	Villa P	House of GB
Pediastrum boryanum			0.1	0.1
Pediastrum kawraiskyi			0.1	

spores were found in 1 g of soil. The average value of 290 grains is much less than the number of pollen grains that would fall on 1 cm² of soil surface during one year. Though pollen decays over time, a fairly large amount of it should stay in the soil for several years, a fact that lets the extremes just cited appear even more surprising. It is also astonishing to find that pollen of *Citrus* and *Nerium* has not been found at the sites where these plants were grown at Oplontis.

This evidence possibly suggests that pollen decomposition was very intensive during Roman times in the alkaline fossil soils (compare the pH values of Table 12)

under the warm and moist climatic conditions of the Naples area. Since irrigation was practiced, it could have intensified pollen decay. Knowing that the pollen content of soil samples from the Old Botanical Garden of the University of Göttingen in Germany usually amounts to much more than 11,000 pollen grains and spores per 1 g of soil, I studied some samples from the recent soil from the area of Naples and Rome. Treated in exactly the same manner as the ancient soil samples, pollen and spore concentrations of 9,331 to almost 80,000 were found in the nine samples (Table 13).

Table 11a. *Boscoreale, NE quarter. Pollen and spore concentrations of fossil soil samples: grains per 1 g of soil.*

Sample Number	1	4	6	9	11	13	15	16	18
Lycopodium added/counted = Q	16.94	15.44	12.40	5.31	5.92	42.71	1.00	1.00	4.92
Weight of sample (g) = W	12.22	24.33	12.75	18.84	27.52	20.17	10.27	7.24	15.37
Factor = Q/W	1.39	0.63	0.97	0.28	0.22	2.12	0.10	0.14	0.32
Pollen grains/1 g of soil	1019	459	571	106	78	521	5	40	202
Spores + algae/1 g of soil	72	271	59	9	2	23	1	4	50
Trees and Shrubs									
Alnus	6	6		1	2	6		1	2
Arbutus		1							
Betula			1		2				1
Buxus									
Carpinus betulus	1			1					0.2
Castanea									
Ceratonia									
Cistus cf. *monspeliensis*									
Corylus	46	4	2	2	2	2		4	2
Cupressaceae	28	13	1	0.2		4			1
Ephedra distachya type									0.2
Ephedra fragilis type					0.2			0.2	
Erica		1					0.2		1
Ericaceae p.p.		1							
Fagus			1		0.2	2			
Fraxinus excelsior type		1							
Fraxinus ornus	3								
Hedera				0.2					
Helianthemum/Cistus type									
Humulus/Cannabis type									
Ilex									
Juglans	47	8	18	2	2	40		2	0.2
Ligustrum									
Myrtus									
Olea type	17	2	6	2	0.2	15	0.2		1
Ostrya/Carpinus orientalis type	3						0.2		
Paliurus									
Phillyrea	4	1				15		0.2	
Picea									
Pinus	83	16	82	3	7	76		1	41
Pistacia		1							

(continued)

Trees and Shrubs

Platanus	1								
Quercus ilex/coccifera type	1								
Quercus pubescens/robur type	14	6	2	1	1	13			4
Rhamnus cathartica/alaternus t.									
Salix									
Tilia									
Ulmus		3	1	1	0.2			0.2	1
Vitis	15	159		0.2	0.2	6			

Nonwoody Species

Anemone type	10	3		3	0.2	2	1	1	0.2
Artemisia	15	6	6	12	2	6	0.2	2	18
Boraginaceae									
Caltha				0.2					
Calystegia									
Campanulaceae									
Caryophyllaceae	10	4	36	1		6	0.2	0.2	4
Centaurea jacea type									
Cerealia type		2	5	1		4			0.2
Chenopodiaceae/Amaranthaceae	201	47	82	36	24	47	0.2	3	7
Compositae Liguliflorae	39	18	12	2	3	11	0.2	2	22
Compositae Tubuliflorae	32	8	14	2	0.2	6	0.2	2	10
Convolvulus									
Cruciferae	58	6	12	1	0.2	19			1
Cyperaceae	22	49	18	8	4	66		3	26
Dianthus type									
Erodium type									0.2
Geranium (reticulate type)	1	1	7	0.2	1	2		1	
Geranium (striate type)							0.2	3	
Gramineae	270	60	142	14	15	133	2	10	46
Impatiens									
Indeterminata	50	18	48	6	3	30	0.2	2	10
Knautia arvensis type	1		38						
Liliaceae									
Lychnis type									
Malvaceae	14	10	27	5	5	2	0.2	1	1
Mercurialis annua									
Papilionaceae									
Plantago coronopus type		1							
Plantago lanceolata	4		1	0.2	0.2	2		0.2	0.2
Plantago sp.									
cf. *Plumbago*									
Polygonum aviculare type			1	1					1
Polygonum convolvulus type	4				0.2			0.2	
Polygonum persicaria type									
Ranunculus type	1	1	6	0.2		2			0.2
Rosaceae p.p.									
Rubiaceae				0.2	0.2		0.2		
Rubus type									
Scabiosa columbaria type									
Scrophulariaceae									
Triticum type	1					2			
Typha angustifolia type			1						
Typha latifolia									
Umbelliferae					0.2				
Varia	15	4	4	3	1	2	0.2	1	1

(continued)

Sample Number	1	4	6	9	11	13	15	16	18
Nonwoody Species									
Ferns									
Anogramma					0.2				
Dryopteris	3								
Equisetum									
Ophioglossum	I	I		0.2		4			
Polypodiaceae	7	I	6	I			0.2	0.2	4
Polypodium	8	3	9	3	I	8	I	2	3
Pteridium	50	264	44	4	I	8		I	42
Pteris	I								
Hornmosses									
Anthoceros laevis					0.2			I	2
Anthoceros punctatus	I	3	I	I		2		0.2	0.2
Algae									
Pediastrum boryanum									
Pediastrum kawraiskyi									

Table 11b. Boscoreale, SW quarter. Pollen and spore concentrations of fossil soil samples: grains per 1 g of soil.

Sample Number	1	2	3	4	5	6	7	8	9	10	11	12	13	14	15
Lycopodium added/counted = Q	2.97	7.76	4.59	22.77	22.74	1.00	9.33	1.56	9.64	10.36	3.84	3.65	12.56	1.78	24.59
Weight of sample (g) = W	24.33	20.00	13.00	8.70	22.72	18.41	12.22	10.41	31.65	7.67	19.00	27.52	20.41	16.11	22.74
Factor = Q/W	0.12	0.39	0.35	2.62	1.00	0.05	0.76	0.15	0.30	1.35	0.20	0.13	0.62	0.11	1.08
Pollen grains/1 g of soil	22	369	10	798	259	10	9	41	80	814	44	44	148	61	442
Spores + algae/1 g of soil	5	12	1	932	32	0.2	1	4	2	47	1	1	10	3	6
Trees and Shrubs															
Alnus	2	0.2		5	I		I	0.2		8	0.2		2	I	
Arbutus															
Betula	I	0.2					I	I			0.2		I		
Buxus															I
Carpinus betulus															
Castanea										5					
Ceratonia								0.2							
Cistus cf. monspeliensis															
Corylus	2	2	I	52	2		I	I		15		I	I	0.2	
Cupressaceae					I									0.2	
Ephedra distachya type															
Ephedra fragilis type	0.2									I					
Erica				16						I					
Ericaceae p.p.												0.2		0.2	
Fagus	0.2				I						0.2				
Fraxinus excelsior type		0.2			I										
Fraxinus ornus		46			7							0.2	I		6
Hedera								0.2						0.2	
Helianthemum/Cistus type															

(continued)

Table 11b. *(continued)*

Sample Number	1	2	3	4	5	6	7	8	9	10	11	12	13	14	15
Trees and Shrubs															
Humulus/Cannabis type															
Ilex										1					
Juglans	0.2	35		16	10			0.2	2	23	0.2	3	1	1	16
Ligustrum		2													
Myrtus															
Olea type	1	117	0.2	10	5			0.2	0.2	34	0.2	2	2	1	2
Ostrya/Carpinus orientalis type		0.2		5						3				0.2	1
Paliurus															
Phillyrea		21									0.2	1	1		1
Picea									0.2						
Pinus	1	9		37	10	3		7	1	240	5	8	41	6	244
Pistacia															
Platanus															
Quercus ilex/coccifera type						0.2				7				0.2	
Quercus pubescens/robur type	0.2	4		13	7	0.2		1	0.2	9	1	0.2	2	1	5
Rhamnus cathartica/alaternus t.															
Salix															
Tilia	0.2	0.2										0.2			
Ulmus	0.2	12		8							0.2	0.2			4
Vitis		0.2		8	1				0.2	8		0.2		2	1
Nonwoody Species															
Anemone type	0.2	4			8	0.2			1	12		1	10	0.2	13
Artemisia	0.2			21	13			1		14			1	2	
Boraginaceae														0.2	
Caltha															
Calystegia					1								1		
Campanulaceae									0.2						
Caryophyllaceae	0.2	2		47	5			0.2		12	1		4	1	10
Centaurea jacea type															
Cerealia type	0.2	3							0.2	1					6
Chenopodiaceae/Amaranthaceae	3			26	1			6		46	0.2	3	1	13	2
Compositae Liguliflorae	0.2	2	0.2	16	18	4		12	0.2	42		1	4	1	1
Compositae Tubuliflorae	0.2	0.2	0.2	10	5	0.2		2		14	0.2	1	1	2	1
Convolvulus		3			3								1	0.2	2
Cruciferae		0.2	0.2	26	23	0.2	2	1		27	2	0.2	4	1	3
Cyperaceae	1	9		3	9	0.2		2		16	1	2	2	8	1
Dianthus type															
Erodium type													1		1
Geranium (reticulate type)	0.2		1	10	7	0.2	1	0.2	1	15	3	0.2	2	0.2	6
Geranium (striate type)															
Gramineae	4	54	2	128	10	1	1	2	2	140	12	12	14	10	71
Impatiens															
Indeterminata	2	24	1	246	26	0.2	3	1	5	27	10	3	8	4	11
Knautia arvensis type				37					1	15	0.2	0.2	8	0.2	16
Liliaceae															
Lychnis type															
Malvaceae	1	3	1	3	20	0.2	1	2	2	39	4	4	34	1	6
Mercurialis annua										1					

(continued)

Table 11b. (continued)

Sample Number	1	2	3	4	5	6	7	8	9	10	11	12	13	14	15
Papilionaceae														0.2	
Plantago coronopus type															
Plantago lanceolata	1	1	1	44	4		1		2	7	0.2		1	0.2	2
Plantago sp.															
cf. Plumbago															
Polygonum aviculare type					2			0.2		3		1		1	
Polygonum convolvulus type										7		0.2		2	
Polygonum persicaria type												0.2			
Ranunculus type					4						2	1			1
Rosaceae p.p.	0.2														
Rubiaceae		0.2								1		1			
Rubus type															
Scabiosa columbaria type															
Scrophulariaceae															
Triticum type		2											1		
Typha angustifolia type										4					
Typha latifolia		0.2													
Umbelliferae										3				1	
Varia	1	10	0.2	37	29	0.2		0.2	62	12	2	0.2	2	1	3
Ferns															
Anogramma		1							0.2	1				0.2	1
Dryopteris								0.2							
Equisetum								0.2							
Ophioglossum															
Polypodiaceae	0.2	4	1	5	5	0.2		1		31	0.2		4		2
Polypodium	4	6	0.2	926	27	0.2	1	1	2	8	1	1	7	0.2	3
Pteridium	1							2		1		0.2		2	
Pteris												0.2			
Hornmosses															
Anthoceros laevis										3					
Anthoceros punctatus		0.2								3				0.2	
Algae															
Pediastrum boryanum															
Pediastrum kawraiskyi															

Table 11c. *Oplontis and Pompeii. Pollen and spore concentrations of fossil soil samples: grains per 1 g of soil.*

Sample Number	Villa Poppaea													House of the Gold Bracelet			
	1	2	3	4	5	6	7	8	9	10	11	12	13	1	2	3	4
Lycopodium added/counted = Q	4.12	5.06	5.87	5.34	23.68	5.01	4.31	5.58	8.02	3.44	7.41	4.39	1.96	31.03	8.50	11.18	2.62
Weight of sample (g) = W	2.61	18.11	10.53	20.84	21.93	26.40	17.50	24.53	4.33	31.21	35.37	23.10	35.36	24.85	35.63	24.98	13.66
Factor = Q/W	1.58	0.28	0.56	0.26	1.08	0.19	0.25	0.23	1.85	0.11	0.21	0.19	0.06	1.25	0.24	0.45	0.19
Pollen grains/1 g of soil	494	100	7	3	9	87	37	38	32	2	15	3	34	837	97	47	21
Spores + algae/1 g of soil	30	6	6	1	2	9	2	8	5	1	6	1	3	2216	22	17	5
Trees and Shrubs																	
Alnus	2	2		1	1	0.2	1	1	2	0.2	1		0.2	11	1	0.2	0.2
Arbutus														1			
Betula	2						0.2	0.2	2	0.2	1	0.2	0.2		0.2		1
Buxus																	
Carpinus betulus	2									0.2				2			
Castanea														1			
Ceratonia						0.2		0.2		0.2				1			
Cistus cf. monspeliensis														1			
Corylus	9	12	1				1	2	2	0.2	8	1	1	36	1	0.2	2
Cupressaceae		3															
Ephedra distachya type																	
Ephedra fragilis type	2	1				0.2											
Erica													0.2	10	0.2		
Ericaceae p.p.	2						0.2										
Fagus	2	0.2								0.2							
Fraxinus excelsior type												0.2					
Fraxinus ornus													0.2	4			
Hedera		0.2				1		0.2					1	1			
Helianthemum/Cistus type		0.2															
Humulus/Cannabis type						0.2											
Ilex																	
Juglans	9	2											0.2	65	4	2	
Ligustrum		1															
Myrtus																	0.2
Olea type	3	0.2									0.2				1	0.2	
Ostrya/Carpinus orientalis type	2												0.2				0.2
Paliurus	2																
Phillyrea	2	0.2											0.2	5			
Picea								0.2			0.2			1			

Taxon	1	2	3	4	5	6	7	8	9	10	11	12	13	14	15	16
Pinus	183	24	1	0.2	4	8	3	3	1	0.2	2		150	10	2	0.2
Pistacia																0.2
Platanus																
Quercus ilex/coccifera type																
Quercus pubescens/robur type	14			0.2		1	0.2	0.2				0.2	7	1		
Rhamnus cathartica/alaternus t.											0.2					
Salix															0.2	
Tilia		1	0.2	0.2			0.2		0.2				1	0.2	0.2	
Ulmus	1		1	1	0.2	0.2	0.2	1			0.2		12	0.2	0.2	
Vitis	2			0.2			0.2	0.2			0.2		1			
Nonwoody Species																
Anemone type	3					0.2		0.2							0.2	0.2
Artemisia	22	2	1	0.2		2	1	1	1	0.2	1		2	0.2	0.2	0.2
Boraginaceae	3	1	0.2													
Caltha																
Calystegia																
Campanulaceae	6												25			
Caryophyllaceae		1	1		1	0.2	0.2	0.2	1		0.2		55	1		1
Centaurea jacea type	0.2	0.2														
Cerealia type				0.2	0.2					0.2	0.2		1			
Chenopodiaceae/Amaranthaceae	62	12		11	0.2	7	7	19		0.2	5		4	0.2		1
Compositae Liguliflorae	65	10		25	0.2	8	13	4	0.2		10		29	1		1
Compositae Tubuliflorae	8	2		3	0.2	1	1		0.2	0.2	1		22	0.2	0.2	2
Convolvulus																
Cruciferae	24	6		3		1	0.2	4		0.2	2		65	0.2	0.2	1
Cyperaceae	9	3	1	16	0.2	6	3		0.2	0.2	3		10	1	0.2	0.2
Dianthus type	1	1														
Erodium type																
Geranium (reticulate type)				0.2							0.2		24			3
Geranium (striate type)																
Gramineae	19	2	1	6	0.2	3	2		1	0.2	3		95	2	1	3
Impatiens													1			
Indeterminata	16	4	1	7	0.2	2	3		0.2	0.2	3		104	18	13	3
Knautia arvensis type													40			
Liliaceae	2															
Lychnis type	0.2	0.2														
Malvaceae	9	0.2	3	1	0.2	0.2	0.2	2	0.2	0.2	0.2		6			2
Mercurialis annua																
Papilionaceae				0.2		0.2	0.2				0.2					

(continued)

Table 11c. (*continued*)

	Villa Poppaea													*House of the Gold Bracelet*			
Sample Number	1	2	3	4	5	6	7	8	9	10	11	12	13	1	2	3	4
Nonwoody Species																	
Plantago coronopus type																	
Plantago lanceolata	2	1											0.2	22			0.2
Plantago sp.	2																
cf. Plumbago																	
Polygonum aviculare type						0.2							0.2	4			
Polygonum convolvulus type	2							0.2									0.2
Polygonum persicaria type																	
Ranunculus type														4			
Rosaceae p.p.		0.2									0.2		0.2	1			
Rubiaceae														1			
Rubus type														1			
Scabiosa columbaria type														1			
Scrophulariaceae														1			
Triticum type											0.2						
Typha angustifolia type																	
Typha latifolia																	
Umbelliferae		0.2					0.2	0.2					0.2	1			
Varia	6	6				1	0.2	0.2		0.2	0.2		1	4	56	24	0.2
Ferns																	
Anogramma																	
Dryopteris																	
Equisetum																	
Ophioglossum																	
Polypodiaceae	8	1				1				0.2	3	0.2	1	14	1	1	2
Polypodium	6	1	6			2	1	3		1	2	1	0.2	2135	20	16	3
Pteridium	16	4		1	2	5	0.2	3		0.2	2	0.2	1	64	1		
Pteris													0.2				
Hornmosses																	
Anthoceros laevis						0.2								4			
Anthoceros punctatus						2	1	1					0.2		0.2		
Algae																	
Pediastrum boryanum											0.2				0.2		
Pediastrum kawraiskyi										0.2	0.2	0.2	0.2				

Table 12. pH values of recent and fossil soil samples.

Fossil Soil Samples	Sample No.	pH Value
Boscoreale, SW quarter	6	7.8
	8	8.02
	9	7.9
	12	8.03
Oplontis, Villa of Poppaea	1	7.93
	2	7.7
	8	7.8
	13	8.07
Pompeii, House of the Gold Bracelet	2	8.2
	3	8.2
Recent Soil Samples (1990)		
Oplontis, near excavation		7.1
Napoli, Largo San Marcellino		7.3
Roma, Monte Pincio		7.61
Roma, Forum Romanum		7.52
Göttingen, Arboretum		7.35
Göttingen, Medieval Garden		7.76

As pH values are similar (Table 12), and without indications that the climatic conditions during the first century A.D. differed significantly from those of the modern period, it must be concluded that most of the ancient pollen has vanished. It is not clear whether this happened before or during the eruption of Vesuvius or during the following two millennia.

Accidental pollen decay must also be the reason for the dissimilarity of the pollen values of other samples nearby. At least the pollen of wind-pollinated species should be evenly represented in all samples. Therefore percentage values, even those based on statistically sufficient pollen counts, cannot be used to identify a specific type of actual vegetation. It is obvious that pollen analysis can under such circumstances contribute only little to the reconstruction of the former vegetation. Great concentration values can serve as indicators only for those species that produced the specific pollen type, but major components of the former vegetation of the area may not necessarily be presented in the pollen spectra, and thus pollen analysis will only detect an accidental selection of pollen types.

G. W. Dimbleby, who did the first pollen analyses on soils from Pompeii, reports high counts of olive pollen and of *Polypodium* spores in several samples. Only one sample of my material yielded great amounts of *Olea* pollen (sample 2 of Boscoreale, SW quarter), where one-third (30.7 percent) of all pollen grains (including the spores) were of *Olea*. Nearby a car-

bonized olive was found, along with many fragments of carbonized olives, which suggests that there was an olive tree. The next highest value of *Olea* (3.9 percent) was found in sample 10, which was taken on the lane leading to the *villa rustica*. At all other places and in all other samples *Olea* values were smaller, even in the samples next to that with the *Olea* maximum and despite the presence of carbonized olives. Therefore it appears doubtful whether pollen spectra from soil samples do reliably prove the former presence of a specific plant species near the sampling site.

Percentage values of *Polypodium* spores were rather large in the four samples from the small garden of the House of the Gold Bracelet in Pompeii (12.1, 16.6, 24.6, and 69.9 percent). Great amounts of these spores have also been found in some (samples 1, 4, 5), but not all (!) samples taken around tree 27 at the country lane in the SW quarter of Boscoreale. It seems reasonable to assume that *Polypodium* grew at these sites in some abundance, on the tree and walls around the garden or on the ground.

Polypody spores were found in all but one sample, which indicates that either this fern was quite common in the area or that its spores are more resistant to decomposition than pollen grains.

It has been pointed out in this chapter that pollen studies for the various reasons indicated do not make it possible to identify reliably the specific plants grown in each garden, but other types of evidence discussed in this book, such as carbonized plant material, the shape of root cavities, soil contours, and so on, are helpful. Also, as the major components of the Campanian flora are wind-pollinated, their pollen grains cannot give help in reconstructing the plantings of a specific garden. They are, however, a most valuable source of information for the ancient flora of the area, as our studies of the pollen content of samples from Lake Avernus (see chap. 11) show.

ACKNOWLEDGMENTS

The help of many colleagues and friends made this study possible. First of all I have to thank Professor W. F. Jashemski for letting me participate in her project, for her continuous encouragement and patience when progress was slow, and for providing grants. John Foss was always ready to help in the field and participate in discussions. He, E. Pettry, Massimo Ricciardi, Filippo Russo, and Jürgen Schneider kindly supplied recent soil samples. Helmut Bartens did most of the laboratory work, and Karin Fischer measured the pH values. I owe sincere thanks to all of them.

Table 13. Pollen and spore concentrations of modern Italian soil samples: grains per 1 g of soil.

	Boscoreale	Pozzelle	Torre del Greco	Mt. Vesuvius	Portici	Napoli	Oplontis	Villa Medici	Forum Romanum
Lycopodium added/counted = Q	346.15	1085.00	409.09	228.81	465.52	424.53	158.45	912.16	553.28
Weight of sample (g) = W	15.40	22.00	16.72	14.15	23.00	7.53	9.00	6.15	6.17
Factor (Q/W)	22.48	49.32	24.47	16.17	20.24	56.38	17.61	148.32	89.67
Pollen grains	27940	19431	20185	12144	16860	28809	9313	79944	46540
Spores	45	395	196	49			18		90

Trees and Shrubs

	Boscoreale	Pozzelle	Torre del Greco	Mt. Vesuvius	Portici	Napoli	Oplontis	Villa Medici	Forum Romanum
Acer	22		24						
Aesculus								148	
Alnus		247	122	178		56		148	
Betula			73						
Buxus								148	
Cedrus			122			56	35	2373	179
Cistus cf. monspeliensis									179
Citrus							18		
Corylus	90	2614	147	210	81	56	106		179
Cupressaceae		49	122				35		90
Ephedra fragilis type	22			16					
Erica			24	32					
Fagus			49	32					
Fraxinus ornus			24	49			18	148	179
Hedera	22				142	56	35		
Juglans	22		24	323	20	113	18	148	
Ligustrum			24			113			
Myrtus			3328	16	20	169	70	297	179
Olea		247	196	243	20				
Ostrya	45	99	98	129					
cf. Parthenocissus								297	
Phillyrea			73	65					
Picea			49						
Pinus	1191	4636	3058	2571	283	677	194	10679	6905
Platanus			24					593	
Quercus ilex/coccifera type	45	296	4747	16	11618	17816	282	18540	1345
Quercus pubescens/robur type	225	493	343	485	1255	733	18	12459	986
Tilia								148	359
Ulmus		49						148	
Vitis	45	5770	122	1488	121	56	70		90

Nonwoody Species

	Boscoreale	Pozzelle	Torre del Greco	Mt. Vesuvius	Portici	Napoli	Oplontis	Villa Medici	Forum Romanum
Anemone type			24						
Apiaceae	22		73	16	40		35		
Artemisia	112	148	98	97	121	113	123	148	90
Boraginaceae				16					
Calystegia				16					
Caryophyllaceae	45	592	465	32	20		35	445	1345
Cerealia type	270	296	171	129			18	297	
Chenopodiaceae	4046	247	1737	372	223	226	2993	593	269
Compositae Liguliflorae	1349	197	489	517	162	507	475	1038	17934

(continued)

Table 13. (continued)

	Boscoreale	Pozzelle	Torre del Greco	Mt. Vesuvius	Portici	Napoli	Oplontis	Villa Medici	Forum Romanum
Nonwoody Species									
Compositae Tubuliflorae	90	1282	98	259	61		123	1928	3228
Cruciferae	2810	49	73	129	20	113	493		628
Cyperaceae	45	296	24	65	61	226	35	445	179
Dianthus type							35		
Geranium	22			16					
Gramineae	1528	838	1908	2992	405	507	264	4005	5470
Indeterminata	270	641	563	760	425	5694	1268	9789	3139
Liliaceae			24					10531	
Malvaceae					20				269
Mercurialis annua	15172		49	340	20		1285		90
Onagraceae								148	90
Papilionaceae		49		65					
Plantago lanceolata	22		49	16	20		35	297	986
Plantago sp.			24			56			538
Polygonum aviculare type	22		1199	16	1336		35		
Rosaceae				16			53		
Rumex		49							
Scrophulariaceae		49							
Urticaceae							229		
Varia	382	197	318	420	364	1466	880	4005	1614
Ferns									
Anogramma	22								
Dryopteris			98						
Polypodiaceae	22	49	24	16					
Polypodium		49							
Pteridium		296	24	32			18		90
Mosses									
Sphagnum			49						

Table 14. Latin and English names of plants the pollen of which was found in the sediments of Lake Averno (L), in the Roman soils (S), and in recent soil samples (R). T = pollen type. Pollen types represent more taxa than the named species or genus.

Abies	L	Fir	*Corylus (avellana)*	LSR	European filbert, hazel
Acer	LR	Maple	Cruciferae (=Brassicaceae)	LSR	Mustard family
Aesculus	R	Horse chestnut	*Cryptogramma*	L	a fern
Allium vineale	TL	Crow garlic	*Cucumis melo*	L	Melon
Alnus	LSR	Alder	Cupressaceae	TLSR	Cypress family
Amaranthaceae	TLS	Amaranth family	*Cupressus*		Cypress
Anogramma	LSR	a fern	Cyperaceae	LSR	Sedge family
Anemone	TLSR	Anemone	*Dianthus*	TSR	member of Pink family
Anthemis	TL	Member of the Tubuliflorae	Dipsacaceae	L	Teasel family
			Dryopteris	SR	a fern
Anthoceros	LS	Hornwort	*Echium*	L	Viper's bugloss
Apiaceae	L	Parsley family	*Ephedra*	LSR	Joint fir
Arbutus	LS	Strawberry tree	*Equisetum*	S	Horsetail
Armeria	TL	Sea pink	*Erica*	LSR	Heath
Artemisia	LSR	Mugwort, wormwood	*Erodium*	TS	Heron's bill
Asteraceae	LSR	Composite family	*Euphorbia*	L	Spurge
Avena	TL	Oat	*Euphrasia*	L	Eyebright
Betula	LSR	Birch	Fabaceae	L	Puls family
Bidens	TL	Member of the Tubuliflorae	*Fagus*	LSR	Beech
			Fallopia convolvulus (Polygonum)	TL	Black bindweed
Boraginaceae	LSR	Borage family	*Ficus carica*	LS	Fig tree
Botrychium	L	Moonwort	*Fraxinus excelsior*	TLS	European ash
Botryococcus	L	Green algae	*Fraxinus ornus*	LSR	Flowering ash
Brassicaceae	L	Mustard family	*Genista*	TL	Member of the Puls family
Buxus	LSR	Box			
Caltha	S	Marsh marigold	*Geranium*	LSR	Cranesbill
Calystegia	SR	Bellbine	Gramineae (= Poaceae)	LSR	Grasses
Campanulaceae	LS	Bellflower family	*Hedera*	LSR	Ivy
Cannabis	TLS	Hemp	*Helianthemum*	TLS	Rockrose
Carpinus betulus	LS	European hornbeam	*Hordeum*	TL	Barley
Carpinus orientalis	TLS	Oriental hornbeam	*Humulus*	TLS	Hop
Caryophyllaceae	LSR	Pink family	*Ilex*	LS	Holly
Castanea sativa	LS	European Chestnut	*Impatiens*	S	Balsam
Cedrus	R	Cedar	Indeterminata	LSR	not determinable, corroded grains
Celtis	L	Hackberry			
Centaurea cyanus	TL	Cornflower	*Juglans*	LSR	Walnut
Centaurea jacea	TLS	Brown-rayed knapweed	*Juniperus*	TLS	Juniper
Centaurea montana	TL	Mountain bluet	*Knautia arvensis*	TLS	Field Scabious
Ceratonia	LS	Carob, St. John's bread	Lamiaceae	L	Mint family
Cercis	L	Judastree	*Ligustrum*	SR	Privet
Cerealia	TLSR	Cereals	Liliaceae	LSR	Lily family
Chenopodiaceae	TLSR	Goosefoot family	*Limonium*	TL	Sea lavender
Cichoriaceae	LSR	Composite family	*Lychnis*	TS	member of Pink family
Cistus	TLSR	Cistus	Malvaceae	LSR	Mallow family
Citrus	LSR	Lemon, citron	*Mentha*	TL	Mint
Cladium	L	Saw sedge	*Mercurialis annua*	LSR	Annual mercury
Compositae Liguliflorae	LSR	Cichoriaceae	*Myrtus communis*	TLSR	True myrtle
Compositae Tubuliflorae	LSR	Asteraceae	*Nerium oleander*	L	Common oleander
Convolvulus (arvensis)	TLS	Bindweed, cornbine	*Nymphaea*	L	White water-lily

(continued)

Table 14. *(continued)*

Olea europaea	LSR	Common olive, Olive tree	*Prunus*	TLS	Cherry, Plum	
Onagraceae	R	Evening-primrose family	*Pteridium*	LSR	Bracken	
Ophioglossum	S	Adder's tongue	*Pteris*	S	a fern	
Ostrya carpinifolia	TLSR	European hophornbeam	*Quercus ilex/coccifera*	TLSR	Holly/Kermes oak, evergreen	
Paliurus	LS	Christ's Thorn				
Papilionaceae (= Fabaceae)	SR	Puls family	*Quercus pubescens/robur*	TLSR	Pubescent/Common oak, deciduous	
Parietaria	TL	Pellitory of the wall				
Parthenocissus	R	Woodbine	*Ranunculus*	TLS	Buttercup, Crowfoot	
Pediastrum	LS	Green algae	*Rhamnus alaternus*	TL	Italian buckthorn	
Phillyrea	LSR	Mock privet	*Rhamnus cathartica*	TS	Common buckthorn	
Picea	LSR	Spruce	Rosaceae	LSR	Rose family	
Pinus	LSR	Pine	Rubiaceae	LS	Madder family	
Pistacia	LS		*Rubus*	TS	Bramble, blackberry	
Pistacia lentiscus		Mastiche tree, evergreen	*Rumex*	LSR	Dock	
Pistacia terebinthus		Terebinth pistache, deciduous	*Salix*	LS	Willow	
			Sanguisorba minor	TLS	Salad burnet	
Plantago coronopus	TS	Buckhorn plantain	*Scabiosa*	TLS	Scabious	
Plantago lanceolata	LSR	Ribwort	Scrophulariaceae	LSR	Figwort family	
Plantago major	TL	Rat-tail plantain	*Secale*	L	Rye	
Plantago maritima	TL	Sea plantain	*Solanum nigrum*	L	Black nightshade	
Plantago media	TL	Hoary plantain	*Sphagnum*	LSR	Peat moss	
Platanus	LSR	Planetree	*Taxus*	L	Yew	
Plumbago	S	member of Leadwort family	*Thalictrum*	L	Meadow Rue	
			Thymelaeaceae	L	Mezereum family	
Poaceae	L	Grass family	*Tilia*	LSR	Linden, lime	
Polygonum amphibium	TL	Amphibious bistort	*Triticum*	TLS	Wheat	
Polygonum aviculare	TLSR	Knotgrass	*Typha angustifolia*	TLS	Lesser reedmace	
Polygonum bistorta	TL	Bistort	*Typha latifolia*	LS	Great reedmace	
Polygonum convolvulus	TS	Black bindweed	*Ulmus*	LSR	Elm	
Polygonum persicaria	TLS	Persicaria	Umbelliferae (= Apiaceae)	LSR	Parsley family	
Polypodiaceae	LSR	Fern family	*Urtica*	TL	Nettle	
Polypodium	LSR	Polypody	*Valeriana*	L	Valerian	
Populus	L	Poplar	Varia	LSR	well-preserved, but unknown pollen types	
Potamogeton	L	Pondweed				
Poterium	TLS	member of the Rose family	*Viburnum tinus*	L	Laurustinus	
			Viscum	L	Mistletoe	
Prunella	TL	Self-heal	*Vitis*	LSR	Grape	

REFERENCES

Adam, David P., and Peter J. Mehringer. 1975. "Modern Pollen Surface Samples – an Analysis of Subsamples." *Journal of Research U.S. Geological Survey* 3: 733–6.

Dimbleby, Geoffrey W. 1976. "Pollen as Botanical Evidence of the Past. *Landscape Architecture* May 1976: 217–23.

 1985. *The Palynology of Archaeological Sites.* Academic Press, London.

Dimbleby, Geoffrey W., and J. G. Evans. 1974. "Pollen and Land-Snail Analysis of Calcareous Soils." *Journal of Archaeological Science* 1: 117–33.

Fitzpatrick, Ewart A. 1971. *Pedology.* Oliver and Boyd, Edinburgh.

Groenman-van Waateringe, Willi. 1986. Grazing Possibilities in the Neolithic of the Netherlands. In *Anthropogenic Indicators in Pollen Diagrams,* edited by Karl-Ernst Behre, pp. 187–202. Balkema, Rotterdam.

Grosse-Brauckmann, Gisbert. 1978. "Absolute Annual Pollen Deposition Rates at Various Sampling Sites in the Federal Republic of Germany." *Flora* 167: 209–47.

Havinga, Albert Jan. 1984. "A 20-Year Experimental Investigation into the Differential Corrosion Susceptibility of Pollen and Spores in Various Soil Types." *Pollen and Spores* 26: 541–58.

Jashemski, Wilhelmina F. 1979. *The Gardens of Pompeii, Herculaneum and the Villas Destroyed by Vesuvius.* Vol. I. Caratzas Brothers, New Rochelle, N.Y.

 1987. Recently Excavated Gardens and Cultivated Land of the Villas at Boscoreale and Oplontis. In *Ancient Roman Villa Gardens,* edited by Elisabeth Blair Macdougall, pp. 31–75. Dumbarton Oaks Colloquium on the History of Landscape Architecture X, Washington, D.C.

 1993. *The Gardens of Pompeii, Herculaneum and the Villas Destroyed by Vesuvius.* Vol. 2, appendices. Aristide Caratzas, New Rochelle, N.Y.

Rowley, John R., Joanne S. Rowley, and John J. Skvarla. 1990. "Corroded Exines from Havinga's Leaf Mold Experiment." *Palynology* 14: 53–79.

Salomons, Johannes Barwold. 1986. "Paleoecology of Volcanic Soils in the Colombian Central Cordillera (Parque Nacional Natural de los Nevados)." *Dissertationes Botanicae* 95: 1–212.

Shivas, M. G. 1961. "Contribution to the Cytology and Taxonomy of Species of *Polypodium* in Europe and America." *Journal of the Linnean Society (Botany)* 58 (no. 370): 13–25 and 27–38.

Stockmarr, Jens. 1971. Tablets with Spores Used in Absolute Pollen Analysis. *Pollen et Spores* 13: 615–21.

Van Zeist, Willem. 1967. "Archaeology and Palynology in the Netherlands." *Review of Palaeobotany and Palynology* 4: 45–65.

WOOD ASSOCIATED
WITH THE A.D. 79 ERUPTION

ITS CHEMICAL CHARACTERIZATION
BY SOLID STATE ¹³C AS A GUIDE
TO THE DEGREE OF CARBONIZATION

Patrick G. Hatcher

INTRODUCTION

The eruption of Mount Vesuvius in southern Italy in the year A.D. 79 charred and/or buried vast amounts of wood in its fiery holocaust, which claimed and laid to waste the coastal Roman towns of Pompeii and Herculaneum. The demise of residents of these villages has become the treasure of modern archaeology as excavation of the ruins from volcanic debris has provided countless preserved artifacts that have given us a glimpse of materials and society of the time (Jashemski 1979, 1993). Most notable as artifacts are wood and other plant materials. Volcanic eruptions are well-known instruments for charring and morphological preservation of wood and plant parts in the geologic record. Radiologic dating of charred wood has given us a valuable means by which successive volcanic eruptions in tectonically active areas such as the Vesuvian region (Vogel et al. 1990) have been dated and mapped. Extreme heat generated by volcanic emanations usually chars plant material through a pyrolytic mechanism in the absence of oxygen. The resultant charcoal represents material with a chemical composition that is drastically different from that of the fresh plant. Fresh plants are chemically composed primarily of polymers of cellulose and lignin. Other components of plants, such as resins, gums, and the suberin that is usually present in bark, exist only as minor components. When charcoalified (carbonized), these components of plants are transformed into a material having a drastically different composition in that the primary chemical components are complex aromatic macromolecules. Physically, the structure of plant material is retained during charcoalification (carbonization).

Wood that becomes entrained (caught and trapped with the sedimentary debris) in low-temperature sedimentary deposits or even volcanic deposits having insufficient heat for charcoalification will also be altered chemically. Microbiological degradation is the primary process responsible for wood alteration. If such a process occurs under aerobic conditions where fungi proliferate, both the physical and chemical structures of the wood are destroyed rapidly. Wood degraded in such fashion rarely survives. However, wood buried under anaerobic conditions survives well, morphologically. Chemically, wood can be altered severely. Microorganisms capable of anaerobic degradation appear to selectively degrade the cellulose polymers, leaving behind the lignin (Fengel and Wegener 1984). The brittle lignin maintains the physical structure of cells and tissues, making it difficult to differentiate such degraded wood from charcoalified wood, at least to the naked eye.

Charcoal can easily be differentiated from anaerobically degraded wood by chemical analysis, as well as by microscopic means (Scott and Jones 1991). The lignin of degraded wood is vastly different from the complex aromatic components of charcoal. Analytical differentiation can be made by use of numerous methods such as elemental analysis, infrared spectroscopy, chemical degradations coupled with analysis of products, and solid-state ¹³C nuclear magnetic resonance (NMR) spectroscopy. This latter method has recently been shown to provide a rapid way to quantitatively differentiate the average chemical composition of wood.

At the outset of this project, I was approached to join the team effort to study the A.D. 79 eruption of Vesuvius due to my association with the late Irving A.

Breger, who had been involved in analysis of carbonized plant fragments. I have used solid-state ^{13}C NMR in studies of degraded and coalified wood and felt it appropriate to utilize this technique to examine and characterize wood associated with the volcanic deposits from the A.D. 79 eruption. The most obvious utility of this method is to differentiate wood that is charcoalified from wood that has not been heated to sufficient temperatures to carbonize it. The nature of wood entrained in eruption debris and ash could provide some clues as to the temperature of the eruption deposit.

Analysis of some wood samples from different locales near Pompeii, provided to me by Wilhelmina Jashemski, indicated the existence of both charcoal and degraded wood. It was clear to me that some of the A.D. 79 deposits had not been subjected to sufficient heat for carbonization yet others were. What was not clear was the juxtaposition of individual samples within the various volcanic units associated with the eruption. It was important to travel to a site where wood samples from the various units could be collected. In late June 1988, I traveled to Pompeii to join in a team effort to collect samples from Vesuvian sites. I thank the National Geographic Society for financial assistance in this venture. This chapter discusses the results obtained from samples collected during this trip to Pompeii and from samples made available to me prior to my trip.

SAMPLES AND METHODS

Table 15 lists all samples collected in June 1988 with a description of the samples and collection sites. Samples provided prior to the field trip are also listed in Table 15. Samples collected on the 1988 field trip were primarily from the excavations at Herculaneum, although one sample was collected from the *villa rustica* at Boscoreale and another from Poppaea's villa at Oplontis. The sample from Boscoreale was wood from a press in the grape crushing room. The wood was encased in concrete, poured during excavation into the cavity formed by the decay of the original structure. At Oplontis, the wood was collected adjacent to the cast of a tree root near the pool at Poppaea's villa.

Samples collected at Herculaneum were primarily from a freshly excavated part of the east cut near the Suburban Baths. The wall of the excavation vividly revealed various units of volcanic surge events associated with Herculaneum. Wood in the form of large machined beams and rounded poles was entrained in two major pyroclastic surge events. The lower unit was probably the first pyroclastic surge to have hit Herculaneum in A.D. 79. Samples of large and small beams in both units were sampled. Also, one large beam appeared to be transected by the interface between the two units. Samples of wood above and below the interface were collected. The wood above the interface appeared darker in color than the wood below the interface, suggesting that the former had been more carbonized.

All samples were collected in plastic bags and transported to the laboratory, whereupon they were freeze-dried. Dried samples were ground to a powder in a mortar and pestle and stored in glass bottles. Analysis of samples involved ^{13}C NMR by the technique of cross polarization and magic-angle spinning. This is a spectroscopic technique that yields peaks whose lateral position on a frequency scale (measured in parts per million, ppm, frequency) defines the concentrations of such structures. The peaks actually represent the various types of carbon structures. Peaks in the range of 0–50 ppm represent aliphatic carbons like those in waxes, resins, or fats. Peaks between 50 and 100 ppm represent carbons in alcohols and carbohydrates (cellulose). Aromatic carbons like those of lignin and charcoal usually yield peaks between 100 and 160 ppm.

RESULTS AND DISCUSSION

NMR SPECTRA OF WOOD

Before I present the NMR results for wood samples from the Pompeii area, it is important to show some NMR spectra of different components of wood, cellulose, and lignin. Figure 169 illustrates these spectra. Cellulose has NMR peaks in a fairly narrow region, at 65, 72, 84, and 105 ppm. Lignin, however, is characterized by peaks spanning a broader region that overlaps with the region for cellulose. Notably, peaks at 55, 74, 115, 132, and 150 ppm characterize lignin. Peaks at 150 and 55 ppm are the most characteristic of lignin. Lignin from gymnosperms can be distinguished from that of angiosperms by the exact position of the peak at about 150 ppm. The former have the peak centered at 148 ppm, whereas the latter show a peak at 153 ppm. The other peak characteristic of lignin, which is located at 55 ppm, is from methoxy carbons of lignin.

While the presence of lignin and cellulose can be qualitatively examined by detection of peaks in the respective regions of the NMR spectra, the relative amounts of lignin or cellulose can be estimated by measuring the areas under the peaks attributed to these components. Exact relative measurements are somewhat difficult to make due to the fact that some peaks of cellulose overlap those of lignin. Also, the presence of substances other than lignin and cellulose, which have peaks that overlap the regions of interest, can hamper exact measurements. These substances include

Table 15. Description of samples collected from the Vesuvian area.

Sample Name or Number	Description
Collected prior to 1988 Field Trip	
Ficus carica	Sample of *Ficus carica* fruit collected in the garden of the House of Polybius, Pompeii
hay	Sample of apparently carbonized hay collected from the *villa rustica* at Oplontis
Olea europaea	Wood from a tree in the rear garden at Poppaea's villa, Oplontis
Nerium oleander	Wood from oleander in the garden along the pool at Oplontis
tree #28	Unidentified wood from the *villa rustica* at Boscoreale
Boscoreale wood	Another unidentified wood from the *villa rustica* at Boscoreale
Collected during 1988 Field Trip	
P-88-5	Unidentified wood collected at the base of a root cast near the pool at Oplontis. The sample was found intermixed with gravel around the root cast and did not appear attached to the cast. Visual appearance was similar to that of charcoal.
P-88-6	Wood from part of the wine press in the *villa rustica* at Boscoreale in the grape crushing room. Sample was from the center of the fulcrum, which was encased in concrete, probably from an attempted cast.
P-88-13	Sample from a large (10 × 15 cm cross section) wood beam protruding from a newly excavated cut on the northeast side of the excavations at Herculaneum. This particular beam had been entrained within the first surge event represented by pyroclastic debris flow; however, the upper part of the beam was partly exposed to the second surge event whereupon it appeared to have been carbonized. The wood sample was collected from the part of the beam affected only by the first surge.
P-88-14	Wood sample collected from the beam described above for sample P-88-13. This sample was from the part of the beam exposed to the second surge event as delineated by its darker appearance and by the discontinuity of the deposit at the interface between the first and second surges.
P-88-15	Another large beam of similar dimensions as P-88-13. This sample was entrained entirely within the first surge unit. Visually, the sample had the appearance of fresh wood.
P-88-16	An apparently carbonized beam (16 × 35 cm cross section) entrained entirely within the second surge unit.
P-88-17	A round post (8 cm diameter) entrained within the second surge unit and apparently carbonized.
P-88-18	Another small post of similar diameter as P-88-17 but entrained entirely within the first surge unit. Visually, the specimen appeared uncarbonized.

resins, tannins, and altered lignin and cellulose. The altered lignin and cellulose may have chemical compositions totally unlike the original respective materials. Consequently, the NMR technique remains mostly qualitative and only semiquantitative when samples have been altered by heat or microbial activity.

Wood that is carbonized by heat of fire — charcoal — takes on a chemical composition totally unlike that of fresh wood. Figure 170 shows an NMR spectrum of charcoal; the NMR spectrum of fresh wood is shown in Figure 171. Note that the spectrum of fresh wood is mostly composed of peaks due to cellulose at 65, 72, 84, and 105 ppm with minor peaks due to lignin at 55, 132, and 150 ppm. Charcoal, however, shows few peaks in the region of cellulose (50–110 ppm); the major peak is a broad one centered at 130 ppm. This peak is characteristic of the complex aromatic macromolecular compounds in charcoal. These are unlike the aromatic

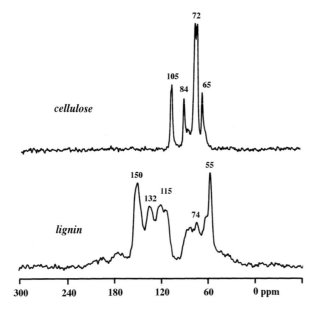

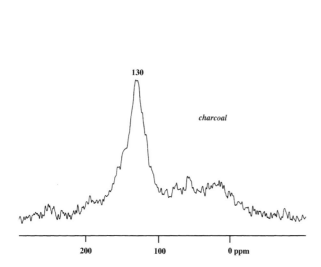

FIGURE 169 *(Left)* NMR spectra of cellulose and lignin. The cellulose was from Whatman filter paper, and the lignin was isolated from spruce wood by the sodium papaperiodate method as described by Hatcher et al. (1982). The peak resonance positions are indicated by numbers above the peaks. The horizontal scale is in ppm of frequency relative to the standard tetramethylsilane.

FIGURE 170 *(Below left)* NMR spectrum of charcoalified wood from a burn site in the Dismal Swamp, Virginia.

FIGURE 171 *(Below)* NMR spectra of fresh wood from spruce, degraded wood, and highly degraded wood. The latter two spectra are from samples provided by Caroline Preston, Forestry, Canada, from trees degraded on the forest floor in British Columbia.

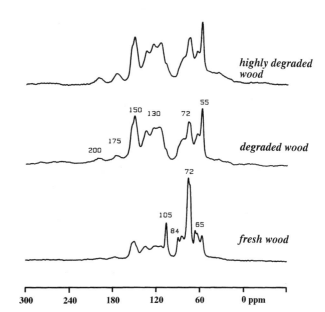

compounds in lignin in that they lack oxygen substituents on the rings. The aromatic region of NMR spectra of lignin contains many peaks that can be attributed to oxygen substituents of lignin. The broad peak for aromatic carbons of charcoal displays no fine structure, indicating that they are not highly substituted by oxygen atoms.

Wood that is degraded by microorganisms is vastly different from charcoal but somewhat similar to fresh wood. Figure 171 shows NMR spectra of wood degraded in a forest from British Columbia. Note that with increasing degradation, the peaks for cellulose (65, 72, 84, 105 ppm) decrease in comparison with fresh wood while those of lignin (55, 133, 150 ppm) increase. This reflects the well-known selective degradation of cellulose and the relative resistance of lignin to degradation. With increasing degradation, lignin is also altered, as reflected by the relative decrease of the peaks at 55 and 150 ppm and increase of peaks at 130, 175, and 200 ppm. The peaks at 175 and 220 ppm are those of carbonyl and carboxyl carbons as would be found in oxidized lignin. The relative increase of the peak at 130 ppm reflects the fact that the aromatic rings of lignin lose oxygen substituents during degradation.

NMR SPECTRA OF SAMPLES COLLECTED PRIOR TO THE FIELD TRIP

The NMR spectra of wood, fruit, and one sample of carbonized hay from principally two sites, Oplontis and Boscoreale, are shown in Figures 172, 173, and 174. The spectra indicate varied compositions. Some samples (Boscoreale wood, *Ficus carica* fruit, and hay) are clearly carbonized as indicated by a large, broad peak

for aromatic carbons at 130 ppm and a secondary peak at 175 ppm for carboxyl carbons. Other samples show peaks characteristic of cellulose (72 and 105 ppm), indicative of the fact that these samples have not been subjected to carbonization temperatures. Large peaks at 130, 175, and 200 ppm in these spectra are reminiscent of degraded lignin rather than well-preserved lignin. Thus, the NMR data show that both carbonized and microbiologically degraded wood can be found in excavations around Pompeii.

The significance of whether wood is carbonized or not with this suite of samples cannot be evaluated with regard to events occurring at each site due to the lack of geological control. However, wood buried by pumice lapilli is unlikely to have been subjected to the high temperatures necessary for carbonization. Thus, the samples that appear to be uncarbonized were probably protected from the high heat that came with the first pyroclastic surge. Microbial degradation was primarily responsible for the degradation of wood protected from carbonization.

WOOD FROM OPLONTIS AND BOSCOREALE COLLECTED ON THE FIELD TRIP

The NMR spectra of the two samples collected in 1998 are shown in Figure 175. Wood was collected from around the concrete-filled cast of the roots of a tree near the pool at Oplontis. The sample appeared charcoalified visually and the NMR spectrum seems to verify this conclusion. However, the spectrum is poor due to a low sample size. The broad, unresolved envelope is probably an artifact of low sample size. Nonetheless, a large unresolved peak at 130 ppm is somewhat characteristic of charcoal.

FIGURE 172 *(Right)* NMR spectra of two samples from Boscoreale. The asterisk indicates an artifact spinning sideband that is not a spectral peak.

FIGURE 173 *(Below)* NMR spectra of wood samples from Oplontis.

FIGURE 174 *(Below right)* NMR spectra of apparently carbonized *Ficus carica* fruit from Pompeii. The asterisk indicates an artifact.

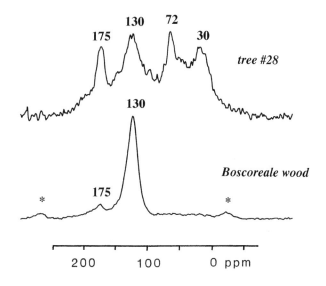

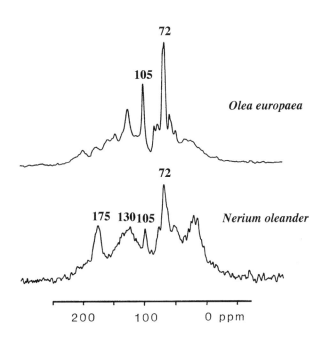

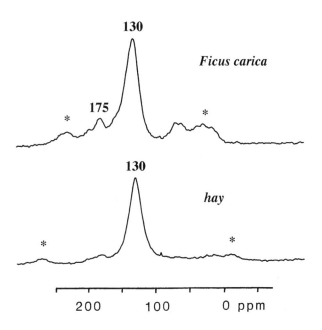

wood from Oplontis near pool

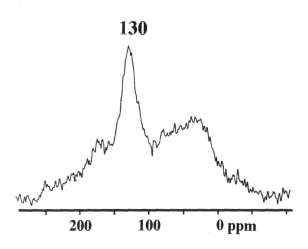

P-88-5

wood from Boscoreale grape crushing room

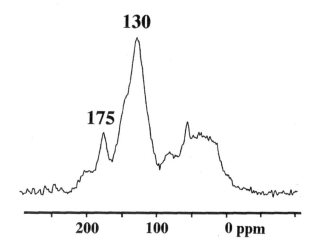

P-88-6

FIGURE 175 NMR spectra of samples collected from Vesuvian sites during the 1988 field trip.

Wood collected from the grape crushing room at Boscoreale also appeared to be more like charcoal than degraded wood (Fig. 175). The large unresolved peak at 130 ppm is like that of charcoal. However, some small spectral features, notably the peak at 55 ppm and the shoulder at about 150 ppm, are probably attributable to lignin or lignin-derived material. The relatively large peak at 175 ppm for carboxyl carbon is not characteristic of charcoal but more characteristic of oxidized or biodegraded wood. I suspect that this sample of wood has been severely biodegraded rather than charcoalified.

Both samples mentioned here were recovered from strata initially buried by pumice during the earliest stages of the A.D. 79 eruption. I would expect the samples to be preserved from the effects of extreme heat. This is inconsistent with the NMR data for the sample from Oplontis, which appears to be charcoalified. It is possible that the small fragment is indeed charcoal that inadvertently fell into the cast of the tree during excavation of the site. The wood from Boscoreale was extracted from the core of what was a wooded fulcrum of a lever used in the grape crushing room. It is unlikely that this wood was disturbed from its original position. That its NMR spectrum appears to have remnants of lignin and be unaffected by high temperatures is consistent with the fact that pumice entombed the wood prior to the volcanic heat surges that followed the initial pumice fall.

WOOD FROM HERCULANEUM

The first major volcanic event to influence the city of Herculaneum in A.D. 79 was an intense flow of pyroclastic debris that entombed the city and some of the inhabitants. This initial debris flow event entrained significant quantities of wood from both natural vegetation and presumably stockpiles of cut lumber. Many of the wood samples were cut posts and beams, probably used for construction purposes. Following the initial surge event, a second and possibly more surges swept through Herculaneum and completely entombed the city. A clear demarcation between the first and second unit was evident at the sampling site.

The NMR spectra of wood samples from both units are shown in Figure 176. The wood from the second unit is clearly carbonized as deduced by the presence of a broad peak for aromatic carbons at 130 ppm in the spectra and a strong resemblance to charcoal (Fig. 170). However, the wood samples from the first surge event (P-88–18 and P-88–15) are clearly not carbonized. The presence of NMR peaks for cellulose and lignin, as are typically present in NMR spectra of wood and degraded wood (Figs. 169 and 170), gives a clear indication that this wood has only been subjected to partial microbial degradation and is not carbonized. Sample P-88–18 appears to have been degraded to a greater extent than P-88–15 due to the relatively smaller peaks for cellulose (65, 72, 105 ppm) and larger peaks for lignin (55, 132, 150 ppm). This is possibly due to the fact that sample P-88–18 was a smaller diameter post than sample P-88–15 and bacteria would degrade

smaller posts more rapidly than larger ones. Both samples appear degraded in comparison to modern wood due to the reduced amounts of cellulose. From measurement of the exact position of the peak at 150 ppm (e.g., 148 ppm) it is likely that both of these wood samples were from gynmosperm wood rather than angiosperms.

One of the beams embedded in the exposed face at Herculaneum appeared to have been mostly buried within the first surge unit, but a portion of the beam must have been exposed at the time the second surge event came through. The evidence for such an exposure was apparent from examination of the interface between the two surges, which could be observed to transect the beam. Wood below the interface appeared to have a lighter shade of black, compared with wood above the interface. The entire sample might have been collected and visually labeled charcoal at first glance. The NMR spectra of wood sampled above (P-88–14) and below (P-88–13) the transition are shown in Figure 177. The wood below the transition is clearly not carbonized. This wood has all the characteristics of

FIGURE 176 NMR spectra of both carbonized and biologically degraded wood from Herculaneum. The asterisk indicates an artifact.

microbially degraded wood in that NMR peaks for cellulose and lignin are clearly present, like other degraded wood samples from the first surge unit (Fig. 176). Partial carbonization is indicated by the fact that some methoxyl groups (peak at 55 ppm) can be observed and the peak attributable to oxygen-substituted carbons at 150 ppm is apparent. These two peaks are undoubtedly derived from components of the carbonized wood that are traceable to lignin that has been subjected to elevated temperature but not carbonized.

CONCLUSIONS

The study of wood entrained in the pyroclastic surges that buried Herculaneum has provided an important conclusion regarding the temperatures associated with A.D. 79 events. All collected wood samples entrained within the first surge to reach Herculaneum appear to have survived temperatures necessary for carbonization (greater that 350° C). Thus, this surge event could have been relatively cool. One could argue that the wood samples were preserved because they were green or fresh wood and expulsion of water during initial heating effectively protected the organic matter in wood. I discount this argument simply because the wood sam-

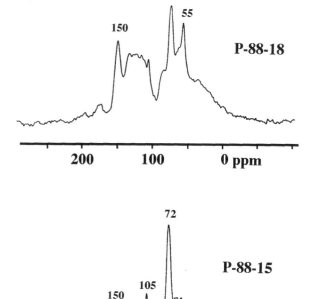
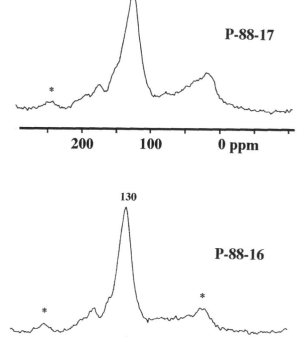

Unaltered wood

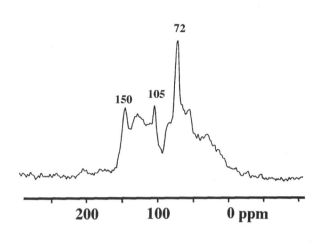

P-88-13

Carbonized wood

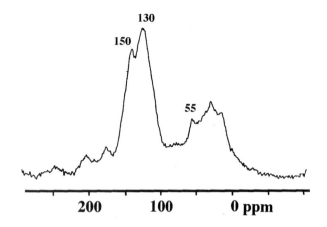

P-88-14

FIGURE 177 NMR spectra of wood from the large beam transected by the interface between the two surge events at Herculaneum.

ples were cut and probably air-dried lumber, and it is unlikely that all the samples had been freshly cut lumber. The second surge event appears to have had a sufficient temperature to carbonize wood. All wood samples collected in this unit were carbonized, even wood samples entrained in the first surge but exposed to the onset of the second surge event. It is interesting that heat from the successive surges overlying the first surge did not penetrate downward to carbonize the samples entrained in the first unit.

Examination of wood from the other sites around Pompeii give varied results. Some samples appear to be carbonized while others are clearly not carbonized but microbially degraded. Early pumice fall during the A.D. 79 eruption was of insufficient temperature for carbonization, and wood buried by pumice is not carbonized but microbially degraded if present. The fact that cavities of roots and, at times, trunks and branches of trees buried by pumice could be observed during excavation at Vesuvian sites indicates that microbial degradation has effectively been complete. Relating the degree of carbonization of wood to geologic events surrounding the A.D. 79 eruption has not been possible due to the paucity of samples from sites other than Herculaneum. There is also the possibility that wood samples could have been redistributed geologically during excavation or even during burial and subsequent degradation. For example, as pumice-buried uncar-

bonized wood is microbially degraded to form the well-known cavities of which casts were made, material at the pumice/pyroclastic debris contact may fall into the empty cavity. This material may have survived degradation because it was carbonized by the surge event, which may explain the finding that wood at the base of a tree at Oplontis appears carbonized.

Finally, I can conclude that the NMR method used in this study can easily distinguish between carbonized and degraded wood. Degraded wood shows peaks in NMR spectra that can be related to lignin and cellulose. The NMR spectrum of carbonized wood is different, lacking the sharp peaks assigned to lignin and cellulose but having a broad peak for the complex aromatic compounds usually found in charcoal.

REFERENCES

Fengel, D., and G. Wegener. 1984. *Wood: Chemistry, Ultrastructure, Reactions.* Walter de Gruyter, Berlin.

Hatcher, P. G., Breger, I. A., Szeverenyi, N. M., and G. E., Maciel. 1982. Nuclear magnetic resonance studies of ancient buried wood: II. Observations on the origin of coal from lignite to bituminous coal. *Organic Geochemistry* 4: 9–18.

Jashemski, W. M. F. 1979. *The Gardens of Pompeii, Herculaneum and the Villas Destroyed by Vesuvius.* Vol. 1. Caratzas Brothers, New Rochelle, N.Y.

1993. *The Gardens of Pompeii, Herculaneum and the Villas Destroyed by Vesuvius.* Vol. 2. Aristide Caratzas, New Rochelle, N.Y.

Scott, A. C., and T. P. Jones. 1991. *Microscopy and Analysis* 24: 13–15.

Vogel, J. S., W. Cornell, D. E. Nelson, and J. R. Southon. 1990. *Nature* 344: 534–7.

IDENTIFICATION OF THE WOODS USED IN THE FURNITURE AT HERCULANEUM

Stephan T. A. M. Mols

Few scientific analyses of Roman wooden furniture have been published.[1] Our current knowledge of the types of wood used is therefore largely based on written sources. M. H. Jameson (1987: 488) in his review of R. Meiggs (1982), referring specifically to Herculaneum, observes: "It is dismaying to learn that the largest collection of ancient wood, from Herculaneum, has never been examined." This has now changed and the analyses conducted as part of my wider research into the Herculaneum furniture offer a chance to compare the data derived from written sources with data based on the analysis of wood samples. The results can also provide a clue to trees in the Vesuvian area prior to the eruption.[2] We begin with a survey of the written sources, then present the results of our analysis of the wood samples, and, finally, compare the two very different pictures that our two very different sources suggest.

LITERARY AND EPIGRAPHICAL SOURCES

The literary and epigraphical sources were assembled over a century ago by H. Blümner (1879: 245–96), and I have drawn substantially on his work, together with the additions and nuances contributed by subsequent scholars. A recent study of wood in antiquity by R. Meiggs develops a hypothetical model to complement the written sources. Lacking scientific wood analyses, he outlines a pattern of probability and forms a hypothesis about the Roman use of wood based on the types of trees still to be found in Italy.

The most important contemporary source on the subject is Pliny's *Historia Naturalis (HN)*, particularly Books 12 to 16, which tell us about the specific uses of different woods. Pliny usually relies on the *Historia Plantarum* of Theophrastus, dating from the Hellenistic period. We also find scattered information taken from other authors.

It is clear that both indigenous and imported woods were available in the Roman period. Some were suitable for constructing objects, while others had a more decorative value (Meiggs 1982: 279). Several woods were imported for their attractive grain, such as *citrus*, a wood that is frequently mentioned in the Latin texts. Ebony, which was very popular in Egypt and Greece, was possibly also imported. Both woods, *citrus* and ebony, were very expensive and the objects made from them were luxury articles.

Although the texts are almost wholly silent on the subject, most Romans undoubtedly possessed furniture made of cheaper, more accessible materials. Because the price and the ready supply of wood was important to both the cabinetmaker and the customer, we can assume that most furniture was made from local varieties of trees that grew close to the places where they were worked. Another important criterion, as Pliny points out, was the suitability of the wood for the task. In Book 16 of the *Historia Naturalis* he lists the qualities of different types of wood, beech (*fagus* 16.229), for example.[3] In some circumstances the grain also played a role in the choice.[4] Maple (*acer*), which (unlike *citrus*) grew in Italy, was of good quality, pleasing appearance, and, above all, affordable. Cypress was available and probably also used. Boxwood (*buxus*) and lime (*tilia*) were used for carving and turning. However, we hear virtually nothing in the texts about the woods that were used for simple and everyday furniture. It can be assumed that beech was put to many uses, and oak is likely to have been popular. Willow (*salix*), ash (*fraxinus*), olive

(*olea*), and turpentine tree (*terebinthus*) are other possibilities.[5] Cedar, so popular in Egypt, is never mentioned in connection with the work of cabinetmakers.[6]

The following survey lists, in alphabetical order, the types of wood that the written sources directly state were used to make furniture. To these are added other woods that can reasonably be assumed to have been worked into furniture because they are named in the texts as material for other objects. We begin, however, by examining the Latin words used to describe wood in general, insofar as it relates to furniture.

Two words, *materia* and *lignum,* are used as general terms for wood.[7] Seneca (*Epistles* 17.12 and 95.72–3) uses the term *ligneus* for wooden beds and Suetonius (*Augustus* 43.1) mentions the same word for wooden terracing. However, the term *materia* occurs much more frequently to mean the wood from which artifacts were fashioned.[8] Nor is this surprising, since the term *lignum* seems to have been mainly used to indicate firewood, whereas *materia* referred to building timber. The specific difference between *lignum* and *materia* is given by Ulpian in the Digest.[9] *Materia* is also the most common word used to describe wood for the furniture industry.[10]

Abies – Silver Fir

Although the Latin sources nowhere mention the wood of the silver fir[11] in relation to furniture, Pliny (*HN* 16.225) tells us that it is particularly well suited for interior woodwork and doors.[12] Theophrastus considered it good for making beds, stools, and tables.[13] We can thus assume that it was also used for Roman furniture. Most of the texts that refer to this wood relate to shipbuilding[14] or architectural usage (*CIL* I 698.119; Vitruvius 2.9.6–7). It is also mentioned in connection with the Trojan Horse (Vergil *Aeneid* 1.175–8). We know from the written sources that the tree grew abundantly on the Italian peninsula[15] but the quality of the wood seems to be highly dependent on the precise source. With regard to the trade in this type of timber, one important source is *CIL* VI 9104, which refers to an *abietarius,* a dealer in fir. Another is a passage in Paulus (*Festus* 25 L) that mentions the trade itself.[16] From this last text we can draw the cautious conclusion that a large trade in this kind of timber existed, because *abietaria negotia* was for a time the general term used to describe the timber trade as a whole. For the presence in Herculaneum of large timber from Austria see Chapter 10 in this book by Peter Ian Kuniholm.

Acer – Maple

Maple[17] is often mentioned as a basic material for furniture. According to the ancient texts it was primarily made into tables[18] and *solia* (armchairs) (Ovid *Fasti* 3.359; Vergil *Aeneid* 1.175–8). There is one reference to a *fulcrum* made of maple[19] and it appears elsewhere in relation to a door (Ovid *Met.* 4.486–7). According to Pliny (*HN* 16.68), what was known as *bruscum* (timber obtained from abnormal burls on the roots) was used to make a specific type of table.[20]

Buxus – Boxwood

According to Vergil, boxwood[21] is suitable for turning.[22] Considering the nature of the wood, we can assume that it was also used for the turned components of furniture.[23] There is one reference to an auction of boxwood in Pompeii, which appears on wax tablet no. 5 from the archive of Caecilius Jucundus.[24]

Citrus

In the texts, the wood that is mentioned most often in relation to furniture is *citrus.*[25] *The Oxford Latin Dictionary* correctly equates this wood with *Callitris quadrivalvis.* Classical authors tell us that the timber was obtained from Mauretania (we read of this source in Strabo 17.3.4 and Pliny *HN* 13.91). The spectacular mottled grain obtained from burls on the roots was highly prized.[26] *Citrus* tabletops were invariably mounted on ivory legs, and the link between citruswood and ivory is reflected in the epigraphical sources where the craftsmen *citrarii* and *eborarii* are also found in combination.[27] These so-called *mensae citreae* were very expensive, and the value of such pieces increased with the size of the top (if it were fashioned from a single piece of wood). The form of the top was round, which explains why the term *orbis* was also used for this type of table. In poetry the table served as a general symbol for great wealth and luxury.[28] This is apparent from the fact that the cost of the wood is sometimes compared with that of gold, which is much cheaper. The table also crops up, and with the same meaning, in the prose sources.[29] Moreover, whenever this type of wood is mentioned in relation to pieces of furniture larger than tables, such as beds (Persius *Saturae* 1.52–3), cupboards (Seneca *De Tranquillitate animi* 9.6), or in architectonic decorations,[30] the extremes of luxury are implied.

The most extensive description of the wood is given by Pliny (*HN* 13.91–102), who covers its provenance, use, and value. According to him, the finest variety came from the Mons Ancorarius in Mauretania Citerior, which, at the time he was writing, had been entirely deforested. The most prized pieces for making tables came from burls on the roots. These have a particularly attractive grain that, Pliny says, would be surpassed in beauty by maple burls, were they to grow to a similar size (*HN* 16.66, 16.68, 16.185). Pliny notes that Theophrastus mentions this wood without writing

about tables, which suggests that the rise of the luxury tables should probably be sought in the time of Cicero.[31] This is confirmed by Varro (*RR* 3.2.4). It is possible that the trade in citruswood had been stimulated by the war against Jugurtha (107–105 B.C.), as R. Meiggs (1982: 288) has proposed. Seneca had a surprising aversion for tables with a spectacular grain, by which he undoubtedly meant *mensae citreae:* the grain would distract the eyes of the company and arouse voluptuousness and jealousy.[32]

Cupressus – Cypress

Cypress[33] is mentioned only twice in relation to a piece of furniture. According to the commentator Porphyrio, a passage in Horace (*Ars Poetica* 330–2) relates to a scroll chest: the cypress wood protects the writings against damage from insects. This is due to the strong scent given off by the high level of resin in the wood (Vitruvius 2.9.13).

(H)ebenus – Ebony

Ebony[34] seldom appears in the written sources and is only once mentioned in connection with furniture. Its rarity is confirmed by Apuleius.[35] The wood, which had to be imported from India and Ethiopia,[36] was deemed a great luxury (Lucan *Bellum Civile* 10.117; Ovid *Met.* 11.610). R. Meiggs (1982: 286) thinks that a passage in Ovid (*Met.* 11.610), in which ebony is mentioned in combination with furniture, has been taken from Greek literature. As justification for this view he makes suspect use of the *argumentum ex silentio:* that is, that ebony was not a popular wood among the elite because it never appears in Roman satire. In my view, since citruswood probably served as the mark or commonplace to convey great luxury, any mention of ebony would have been superfluous.

Fagus – Beech

Contrary to what one would expect, beech[37] is mentioned only once in relation to furniture, even though it is relatively strong, easy to work, and cheap. The tree was very common on the Italian peninsula.[38] Martial (2.43.10) placed a beech table opposite a *mensa citrea*, thereby suggesting that simple pieces of furniture were made out of this cheap wood. Columella (*RR* 12.47.5) mentions small beech chests.

Ficus – Fig

Horace (*Satires* 1.8.1–3) mentions a fig[39] trunk (most likely *Ficus sycamorus*) from which a bench or a statue of Priapus could be made, according to taste. However, Porphyrio, in his commentary on this passage, rightly observes that this type of wood is not suitable for the making of objects.

Ilex – Holm Oak

The word *ilex* probably refers to the holm oak.[40] Although it can be assumed that this wood was used a great deal for furniture, it appears only twice in this regard in the written sources. Pliny mentions an oaken table with a veneer of citruswood in the possession of the emperor Tiberius, (Pliny *HN* 13.94). Terence mentions oak in connection with bed legs (Terence *Adelphi* 585). Another word, *quercus*, also appears meaning "oak," although it is not used in relation to furniture. It is difficult to grasp the precise difference between the two terms in the Latin texts.

Nux – Walnut

The *nux*, which can be identified as the walnut (*Juglans regia L.*),[41] is mentioned by Juvenal as a wood for simple dining tables.[42] The tree grew locally.

Olea – Olive

We meet olive wood[43] only in Cicero (*De Divinatione* 2.86), who mentions a small chest of this wood. The twisted way in which the tree grows, together with its modest girth, makes olive suitable only for smaller artifacts (Pliny *HN* 17.30).

Salix – Willow

Ovid mentions willow[44] in connection with bed legs and a bed and thereby implies the plainness of the furniture (Ovid *Met.* 8.656 and 8.659, respectively). Pliny (*HN* 16.174) mentions willow rods, which were used for wickerwork in *cathedrae* (seats with backrests).

Terebinthus – Turpentine Tree

The only reference to a piece of furniture made from turpentine wood[45] comes in Propertius (*Elegiae* 3.7.49–50), who mentions it as the material for a bed.

Tilia – Lime

Lime[46] is mentioned only in Columella (*RR* 12.47.5), as a wood for small chests.

ANALYSES OF SAMPLES FROM HERCULANEUM

In July 1991 permission was granted to take some fifty wood samples from furniture in Herculaneum. One sample was also taken from a bed leg in the Casa del Fabbro (I.10.7) at Pompeii. These samples were subjected to examination under a binocular microscope and through a microscope lit from above. This apparatus proved effective for the study of softwood. For hardwood (and for further examination of the soft-

Stephan T. A. M. Mols

wood) a JEOL JSM T 300 scanning electron microscope was used (15 kv), the samples first being coated with a fine gold film using a Balzer's sputter unit. This method caused no problems as far as the softwoods were concerned, but the hardwood could not initially be studied due to random light flecks caused by the layer of modern paraffin wax that had been applied to the furniture following their discovery. After dissolving the wax in xylene and a second treatment from the sputter unit, we could examine samples successfully with the scanning electron microscope. Those samples that could not be identified seem to have come from the modern wax layer and contained no wood.[47] For the identification of wood types, the tables in the works of F. H. Schweingruber (1978 and 1990) were used, along with the computer program "Guess."[48] The results are summarized as follows:

	No. of Samples
Abies alba	
Casa del tramezzo di legno (III.10–11), bed (Figs. 178, 182, 183)	5
Casa a graticcio (III.13), 1st floor, room 5, bed	5
Casa a graticcio (III.13), 1st floor, room 5, child's bed	1
Casa a graticcio (III.14), 1st floor, room 1, bed	3
Casa a graticcio (III.14), 1st floor, room 2, *biclinium*	4
Casa dell'alcova (IV.3–4), *biclinium*	3
Insula V.17, bed	2
Insula orientalis II.9, bed	8
Insula orientalis II.10, bed	1
stool	1
Insula V.6, amphora rack (Fig. 179)	3
Insula orientalis II.9, amphora rack	1
Casa a graticcio (III.14), 1st floor, room 1, small cupboard	2
Quercus sp.	
Insula orientalis I.1a, cradle (Fig. 180)	1
Juglans sp.	
Casa del mobilio carbonizzato (V.5), table, top (Fig. 181)	1
Buxus sp.	
Casa del mobilio carbonizzato (V.5), table, leg (Figs. 184, 185)	1
Carpinus sp.	
Insula VI.19–22, Collegio degli Augustali, table, leg (Figs. 186, 187)	1
Acer sp.	
So-called *Decumanus Maximus,* chest, back	1
Unidentifiable	
Insula V.17, bed	1
Insula orientalis II.9, bed	1
Insula V 17, cupboard	2
Insula orientalis I.1a, table	1
So-called *Decumanus Maximus,* bench	1
Fagus sp.	
Pompeii, Casa del fabbro, bed leg	1

Samples were analyzed from only eighteen of the forty-one pieces of furniture preserved in Herculaneum – permission for more samples was not forthcoming. However, on the basis of these results we can conclude, with the necessary caution, that the furniture in the town was predominantly made of wood from the silver fir (*Abies alba*), with more occasional use of hardwood. The breakdown of the samples is *Abies alba* 39, hardwood 5, unknown 6. All the identifiable samples taken from beds are *Abies alba*, and beds were probably made almost entirely from this wood. This hypothesis seems to be confirmed whenever more than one sample from a single bed is analyzed (which was allowed in some cases). The exceptions are the legs (although these have survived from only a few beds) and the marquetry in the bed from *Insula orientalis* II.10. *Abies alba* is also used for a stool (except for the marquetry seat), two amphora racks, and a cupboard. This wide distribution seems to indicate that other types of wood were used only for specific purposes. In the modern period silver fir is little used for furniture in Italy because the wood is not well suited for this purpose (Giordano 1980; 153–4). However, there is a wide variation in the quality of the timber. The tree usually grows on mountainsides, and as Meiggs (1982: 119) writes: "Quality depends largely on climate, temperature and soil, and of the four varieties [of fir] in the Mediterranean area *Abies alba*, the silver fir, which was limited to Italy and Sicily, and Macedon, had the highest reputation." It is possible that before the eruption of Vesuvius the slopes of the volcano were partly covered with silver fir. This would have made the timber available in great quantities, and of a quality that must have been quite good, due to the fertile volcanic soil.[49] *Abies alba* is also found frequently as the wood for wax tablets in Pompeii,[50] and the timber might well have been felled on other hillsides close to Vesuvius. We will only be able to identify the precise location of these forests, it seems, when we have access to data from ground borings.

Four of the smaller pieces are made of other types of wood. These are objects that, in comparison to the

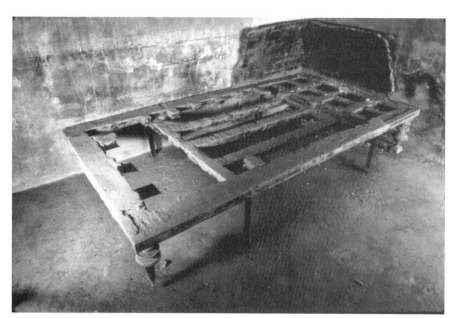

FIGURE 178 Bed, Herculaneum III.10–11. Photo: L. Mazzatenta. Courtesy National Geographic.

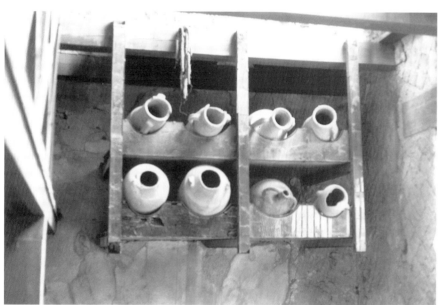

FIGURE 179 Amphora rack, Herculaneum V.6. Photo: T. Mols.

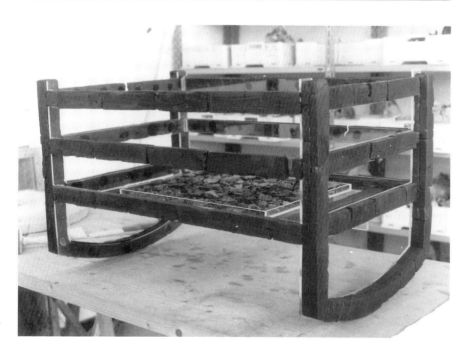

FIGURE 180 Cradle, Herculaneum III.14. Photo: T. Mols.

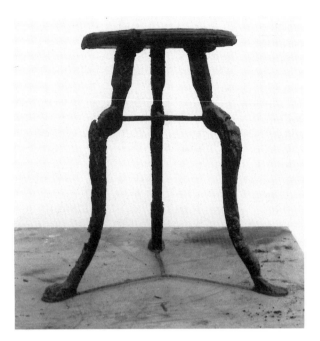

FIGURE 181 Table, Herculaneum V.5. Photo: T. Mols.

large fir pieces, are assembled from elements of modest width and thickness; namely, a cradle (oak/*Quercus*), two tables (one with box/*Buxus* legs and a walnut/*Juglans* top, the other made of hornbeam/*Carpinus*), and a chest (maple/*Acer*). The small components in these pieces required a certain sturdiness, as did the carved sections and the elements produced on the lathe (for which fir is unsuited).

The bed leg from Pompeii, for example, is turned beech/*Fagus.* The table legs include carved decorations that are also difficult to accomplish in fir, and in these pieces hardwood is preferred. The indications are that these woods had partly to be supplied from elsewhere, but none of them had far to come since they were all available in Italy. *Quercus* and *Juglans* were also found in the boat that was excavated on the beach at Herculaneum in 1982.[51] A wax tablet made of *Buxus* has come to light in the Casa del Bicentenario.[52] *Quercus* and *Fagus* have been found in Pompeii, the latter in large quantities.[53] In the written sources, however, there is no relation established between furniture and either *Carpinus* (hornbeam) or *Quercus.*[54]

In almost all cases, whenever more than one sample was taken from a single piece of furniture, only one kind of wood was found. This was always *Abies alba* in the case of furniture that is still in position at the excavations. Of the smaller pieces now in the site depot, permission was granted to take two samples in one case only. From this it appears that two types of wood were used in a table, boxwood (*Buxus*) for the legs and walnut (*Juglans*) for the top: the first is a wood that lends itself well to carving and the second has an attractive mottled grain. That this was a combination occurring

more often in antiquity is apparent from eight tables found in the tumulus MM in Gordion.[55] This particular example would suggest that there are probably different woods used in other tables at Herculaneum. The same may be true of beds, although in this research only a single wood was found. It can be assumed that the bed legs were turned, and for this *Abies alba* would not have been used. We would expect rather a hardwood like *Buxus* or *Fagus,* as in the Pompeii sample. We find *Abies alba* again in the stool, but the veneer is clearly from another wood. Precisely which sort has not been established. In the chest we find *Acer,* and in all the other storage cabinets that were analyzed it is again *Abies alba.*

CONCLUSIONS

When we compare the data from the ancient texts with the results of the analyses of the Herculaneum wood samples, several conclusions can be drawn. It seems that more than half of the written sources that mention types of wood in relation to furniture refer to only one type of wood and one piece of furniture: the *mensa citrea.* From the texts in which this type of table appears, it can be concluded that it was the definitive luxury article that only a few could afford. Read without discrimination, the written sources might give the impression that *mensae citreae* were very common compared with furniture made of other, cheaper types of wood, for about these the sources are virtually silent. It is also obvious that common oak (*Quercus robur*) must have been used for furniture, but on this subject the ancient authors have very little to say. Thus when we rely on the frequency with which wood is mentioned in relation to furniture, the picture derived from the texts is a misleading one. Because one type of table, made of a particular type of wood, happens to form part of a cliché used to convey great luxury, these tables often appear, while virtually no attention is given to the wood of ordinary functional furniture.

On the basis of these analyses of the wood samples we can conclude that silver fir was much used for furniture in Herculaneum. It was considered adequate for the task, even though more suitable hardwoods were available in Italy. Silver fir was undoubtedly present in large quantities in the immediate vicinity of Herculaneum, and this wood was chosen because transport costs were low and the end product could thus remain affordable. Pliny (*HN* 16.225) called *abies* a wood that was very useful for interior woodwork, easy to plane, and the best of all woods to glue. Other woods were used for specific purposes and sometimes had to be supplied from farther afield. It is here that the literature

FIGURE 182 *Abies alba,* cross section. Photo: SEM.

FIGURE 183 *Abies alba,* tangential section. Photo: SEM.

FIGURE 184 *Buxus,* tangential section. Photo: SEM.

FIGURE 185 *Buxus,* cross section (slightly oblique). Photo: SEM.

FIGURE 186 *Carpinus,* cross section. Photo: SEM.

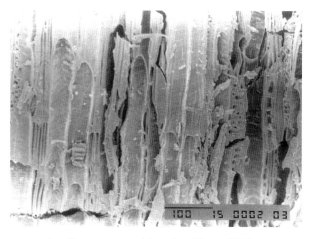

FIGURE 187 *Carpinus,* tangential section. Photo: SEM.

is important, as when Vergil (Georgics 2.449–50) points out the suitability of boxwood for turning, or when Pliny (*HN* 16.231) tells us the types of wood that could best be used for veneer. The hardwood found in the Herculaneum furniture would seem to confirm the argument. The fact that some of the woods found here, such as oak (*Quercus*) and hornbeam (*Carpinus*), are not mentioned in the written texts as materials for furniture illustrates the dangers of making judgments on the

subject based solely on these sources. Of course, the analyses of samples from Herculaneum primarily contribute to our knowledge of the local situation and on their own provide no final evidence for the use of wood for furniture in the wider Roman world. But it is still possible to come to conclusions that have a wider application. Thus, in the main, local woods will have been used, providing they were present in sufficient quantities. At the same time, there was undoubtedly

knowledge of the specific properties of a wide range of woods. This means that woods other than those available in the immediate vicinity will have been chosen for particular purposes.

NOTES

Translation: R. Bland, Amsterdam. Translations of Latin texts are made by the author. This chapter is based on material from my book on the wooden furniture found in Herculaneum (Mols 1999).

1 Some examples of furniture from which samples have been analyzed are Vaulina and Wasowicz 1974: 164–5, cat. 94, chair seat made of maple (*Acer*); id. 166–9, fragments of a round table made of cypress (*Cupressus*) (cf. also Vaulina and Wasowicz 1974: 23–5 and 175–7, annexe 3); a bed from Roman Egypt (from Thebes?) now in the Royal Ontario Museum, acc. 910.27, frame made of cluster pine (*Pinus pinaster*) and the rest of mulberry (*Morus*) (cf. Needler 1963: 1–2); a table leg from Bergkamen-Oberaden made of *Acer* (cf. Kühlborn 1990: 182–4. Other wooden artifacts have also been analyzed, e.g., ships from Nemi (cf. Ucelli 1938: 138–40, note 10, analyzed by C. Sibilia); fragments of Roman coffins from the Crimea (cf. Pinelli and Wasowicz 1986: 50–1 and 55, decoration *Pinus*, a *Cupressus* board, and 175, no. 89 small box of box/*Buxus*; boat at Herculaneum. For the use of wood in architecture, see Adam 1984: 91–105. A very thorough survey of timber used in shipbuilding is given by Rival 1991: 11–98. Richter 1966: 122–3, deals only with written sources.

2 Cf. Ciarallo 1990: 24, "Nuovi studi, sui legni di Ercolano in particolare, potranno forse aiutarci a ricostruire l'economia forestale e l'ambiente anche in questa zona."

3 Cf. Meiggs 1982: 296.

4 Cf. Squarciapino: 44.

5 *Fraxinus* (*Fraxinus excelsior*) is not mentioned in the written sources, but judging by the present day it may well have been used for furniture: cf. Blümner 1879: 267–8, Giordano 1980: 172. In antiquity the tree was indigenous to Italy, but it is now rare, except in the country north of the Fagetum. It is ivory-colored, attractive, and strong and is still used for furniture.

6 Cedar: *Pinus cedrus*, perhaps *Cedrus libani* (cf. Blümner 1879: 254, and Giordano 1980: 366 and 367. De Waele 1949: 251, believes that it is *Cedrus libani* A. Richard. Cf. Pliny *HN* 16.203.

7 *Materia*: adjective, *materiarius*; *lignum*: adjective, *ligneus*, *lignosus*.

8 For example, Charisius *Ars Grammatica* 5, p. 403, 6: *Materia fabris apta* (*Materia*, suitable for carpentry).

9 *Digesta* (Ulpianus) 32.55 preface: *Ligni appellatio nomen generale est, sed sic separatur, ut sit aliquid materia, aliquid lignum. Materia est quae ad aedificandum fulciendum necessaria est, lignum, quidquid conburendi causa paratum est.* (*Lignum* is a general term, but it encompasses two meanings, sometimes referring to *materia*, and sometimes to *lignum*. *Materia* is the wood required for building and shoring-up, *lignum* is wood prepared for burning.).

10 Texts that mention *materia* in relation to furniture are Varro *De Lingua Latina* 8.32 (bed); *Digesta* (Pomp.) 32.57 (chest and cupboard); *Digesta* (Paulus) 32.88.1–2 (cupboard). Isidorus (*Origenes* 19.19.4) uses the term generally for the material from which furniture is made. Two texts refer to the term *tabula* (beam), out of which to make a piece of furniture: Gaius *Institutiones* 2.79 and *Digesta* (Gaius) 41.1.7.7. Another name for the form of wooden elements from which to make objects is *planca* (plank). Texts that employ this term are Festus *De verborum significatu* 258 L. and Paulus *Festus* 259 L., the second of which reads: *Plancae tabulae planae, ob quam causa et Planci appellantur, qui supra modum pedibus plani sunt.* (*Plancae* are flat planks, which is the reason why people with unusually flat feet are called *Planci*.)

11 Adjective, *abiegn(e)us*: see, for example, Vitruvius 7.3.1. *Abies alba*: cf. Giordano 1980: 153–4. The wood is white or yellowish white in color.

12 Pliny *HN* 16.225: *Firmissima in rectum abies, eadem valvarum pagini et ad quaecumque libeat intestina opera aptissima sive Graeco sive Campano sive Siculo fabricae artis genere, spectabilis ramentorum crinibus, pampinato semper orbe se volvens ad incitatos runcinae aptus, eadem e cunctis maxime sociabilis glutino in tantum ut findantur ante qua solida est.* (The strongest is fir in a vertical position; it is also very good for door panels and for every sort of interior woodwork, be it in Greek, Campanian or Sicilian style. The wood typically produces curly shavings, which always spiral in the form of a vine branch following strong strokes of the plane; this is the best of all woods for gluing, so much so that the wood itself will split before a joint.)

13 Theophrastus *Hist. pl.* 3.10.1. For the qualities of *Abies alba* see also Theophrastus *Hist. pl.* V.1.5–12.

14 Livy, *Ab Urbe Condita* 28.45.18; Sidonius Apollinaris *Epistles* 8.12.5; Vergil *Georgics* 2.68; Vergil *Aeneid* 5.662–3. Cf. also Rival 1991: 36–42.

15 Theophrastus *Hist. pl.* 5.8.1 and 5.8.9; Pliny *HN* 16.197. Cf. Rival 1991: appendix 6.

16 Paulus *Festus* 25 L.: *Abietaria negotia dicebantur, quam materi(ar)am nunc dicimus, videlicet ab abietibus coemendis.* (The name for what we now call the timber trade was *abietaria negotia* [fir dealing]. The term is of course derived from the buying up of fir.) Cf. *Edictum Diocletiani* 12.1: *materia abiegnia* (building fir.)

17 Adjective: *acern(e)us*. Perhaps *Acer pseudoplatanus* L. is meant (cf. Blümner 1879: 246–8, and Giordano 1980: 156). The tree still grows in Italy today and can reach a height of 38 m. The wood is yellowish white in color, reasonably resistant against burrowing insects, and easy to work. It is still used to make furniture and for fine cabinetwork.

18 Horace *Satires* 2.8.10–11; Martial 14.90 tit.; Ovid *Met.* 12.254–5 (in the description of the conflict between the Lapiths and the Centaurs); Pliny *HN* 16.185; Strabo 12.13.2.

19 Ovid *Epistulae ex Ponto* 3.3.13–14. A *fulcrum* was a part structural, part decorative feature of a *triclinium* bed. There is possibly some reference to parts of beds made from maple in Pliny (*HN* 16.68). The term *lectus pavoninus* in Martial (14.85 tit.), where the adjective is usually regarded as referring to maple, cannot, in our

opinion, be interpreted in this sense. The type of wood is not specifically mentioned and the description is too vague to be able to identify it with any particular wood. Cf. also Pliny *HN* 16.97.

20 For *Acer* in shipbuilding see Rival 1991: 72–4.

21 *Buxus sempervirens*: adjective *buxeus* (cf. Blümner 1879: 252–4; Giordano 1980, 159. *Buxus* also came from the Apennine peninsula or from Corsica. Nowadays it grows in central Europe. It is yellowish in color, quite heavy, and very hard. It is still used today for cabinetwork and above all for turning. Cf. also Meiggs 1982: 281–2.

22 Vergil *Georgics* 2.449: *torno rasile buxum* (boxwood, easily made smooth on the lathe).

23 For boxwood in shipbuilding see Rival 1991: 76–7.

24 *CIL* IV Suppl. I, 284: *Ob auxionem buxiaria(m)* (because of an auction of boxwood). Cf. Andreau 1974: 313–14.

25 Adjective *citreus* (cf. Giordano 1980: 903; *Tetraclinis articulata* (Vahl). The tree is still to be found in the mountains of Algeria and Morocco, Spain and Malta. An extensive description of this wood is given by Meiggs 1982, 286–91.

26 Giordano (1980: 903) ascribes the phenomenon to damage caused to the cambium by grazing animals. The modern trade name for wood that is obtained from these rare excrescences is "Tisswood." Cf. also Blümner 1879: 274.

27 Among others, *CIL* VI 9258.9 and VI 33885.4. The former inscription mentions *citrarii* from Naples.

28 Apuleius *Metamorphoses* 2.19; Juvenal *Satires* 11.117–31; Lucan *Bellum civile* 9.426–30; id. 10.144–6; Martial 2.43.9–10, 9.22.5–6, 9.59.7–10, 10.80.1–2, 10.98, 12.66.5–7, 14.89, 14.90.1, 14.91, 14.139 [138]; Seneca *Consolatio ad Helviam* 11.6; Statius *Silvae* 3.3.94–5, 4.2.38–9; regarding the text in Lucanus, Hunink (1992: 199–200) further argues that the wood serves as an image to suggest that the exotic is beautiful.

29 Dio Cassius 61.10.3; Cicero *In Verrem* 2.4.37; *Digesta* (Paulus) 19.1.21.2; Petronius *Satyricon* 119.26–30; Pliny *HN* 5.12 and 37.204; Tertullian, *De Pallio* 5.5.

30 Apuleius *Metamorphoses* 5.1; Cato *Orationes* fragm. 1, apud Festum 282 L.; Varro *Saturae Menippeae* 182 (*Gerontodidaskalos*) (= Varro, apud Non. p. 86 M). Horace mentions a table with a leg of citrus wood and a top of marble.

31 Pliny *HN* 13.102: *De mensis tamen tacuit (sc. Theophrastus), et alias nullius ante Ciceronianam vetustior memoria est, quo noviciae apparent.* (Theophrastus is silent about tables, however, and elsewhere there is no reference which goes back further than Cicero's time, which makes them look like a recent trend.) Theophrastus does indeed mention the wood, in *Hist. pl.* 5.3.7.

32 Seneca *De Tranquillitate animi* 1.7: *Placet minister incultus et rudis vernula, argentum grave rustici patris sine ullo nomine artificis, et mensa non varietate macularum conspicua nec per multas dominorum elegantium successiones civitati nota, sed in usum posita, quae nullius convivae oculos nec voluptate moretur nec accendat invidia.* (My favorite servant is an untrained and inexperienced house slave, my favorite silver is my father's heavy country set without a maker's stamp, and my favorite table does not attract attention with its spectacular grain, nor is it renowned amongst the bourgeoisie for the pedigree of its previous owners, but it is a table to be used, which will not distract the eyes of the company nor provoke voluptuousness and jealousy.) Tertullian *De Pallio* 5.5 calls this wood structure *ligneas maculas* (flecked or mottled wood).

33 *Cupressus sempervirens* L. (cf. Blümner 1879: 257–8; Giordano 1980: 163–4; Meiggs 1982: 293–4. The wood grows on the Apennine peninsula and is still used today to make furniture. Cf. Pliny *HN* 16.139–41.

34 Giordano (1980: 420) identifies this wood as *Diospyros crassiflora* Hieron, which now grows in Nigeria and the Cameroon. Cf. also Blümner 1879: 258–9 and Meiggs 1982: 282–6.

35 Apuleius *Apologia* 61: *hebeni loculos . . . ex illa potius materia rariore et durabiliore uti faceret adhortatum* (an ebony box . . . he instructed him preferably to make the statuette out of this rarer and more expensive wood).

36 Isidorus *Origines* 17.7.36; Pomponius Mela *De Chorographia* 3.80; Pliny *HN* 6.197, 12.17; Vergil *Georgics* 2.116–17.

37 *Fagus sylvatica* L. (cf. Blümner 1879: 250; Giordano 1980: 159; Meiggs 1982: 295. The tree currently grows in the Alps and the Apennines. It can reach a maximum height of 38 m. The heartwood is quite dense and the color is a light pink-brown. Beech is widely used in furniture today. For beech in shipbuilding, cf. Rival 1991: 64–6.

38 Theophrastus *Hist. pl.* 5.8.3 refers to *Latium* as an area rich in beech.

39 *Ficus sycamorus* L. Cf. Giordano 1980: 177.

40 Adjective: *ilign(e)us, iliceus*. Cf. Blümner 1879: 263–4 and Giordano 1980: 165. The holm oak (*Quercus ilex*) nowadays is very common in Central and Southern Italy. The wood is very heavy and difficult to work.

41 The wood is solid and durable, easy to work, and still used for furniture today. Cf. Blümner 1879: 293; Giordano 1980: 182; Meiggs 1982: 421. For walnut in shipbuilding, cf. Rival 1991: 62–4.

42 Juvenal *Satires* 11.117–19: *Illa domi natas nostraque ex arbore mensas/ tempora viderunt; hos lignum stabat ad usus,/ annosam si forte nucem deiecerat Eurus.* (In those days one saw tables homemade from local woods; if the southwest wind happened to bring down an old nut tree, that was what the wood was used for.)

43 Adjective: *oleagin(e)us. Olea europaea* L. (cf. Blümner 1879: 280, Giordano 1980: 183–4. The tree is still found in Italy and can grow to 15 or 20 m high. The wood is very durable, but only small objects can be made from it since the trunks are not thick. Today the wood is used in Italy for cabinetmaking, carving, and turning.

44 Cf. Blümner 1879: 294 and Giordano 1980: 198–9. This wood is indigenous. Adjective: *salign(e)us*.

45 *Terebinthus* (*Pistacia terebinthus* L.) (cf. Blümner 1879: 290, Giordano 1980: 203–4. This tree still grows in Italy today and is used for fine cabinetwork.

46 Adjective: *tiliagineus. Tilia cordata* Mill. or *Tilia platyphylla* Scop.? (cf. Blümner 1879: 278; Giordano 1980: 204. The wood was imported from Corsica and Paphlagonia in Asia Minor; it grows today in the Alps and the Apennines. The wood is whitish in color, quite soft, and is still used for carving and turning.

47 A method that shows some similarities with that

described here, and with which we became acquainted only after our analyses of the Herculaneum samples, was applied by P. Warnock and M. Pendleton (1991: 107, 110) to wood from the diptych from the Ulu Burun shipwreck, identified by them as *Buxus*. A greasy substance found on the surface was here removed by rinsing the sample several times in distilled water and warm xylene, then in a solution of xylene and amylacetate, and finally in amylacetate alone. The sample was then dried using the critical point. For the rest the two methods correspond.

48 Computer Assisted Multiple Entry Key for Computer Assisted Wood Identification; wood databases compiled by Dr. E. A. Wheeler, program designed by Dr. C. A. LaPasha.

49 In a presentation (given on July 3, 1992, in the auditorium of the Pompeii excavations) of the results of research by Prof. Rosanna Caramiello of the Departimento di Biologia Vegetale of the University of Turin, who has also analyzed a number of wood samples from the *Therme Suburbane* in Herculaneum, it appears that here too the majority of the samples was *Abies alba*. Here too it was proposed that the slopes of Vesuvius could have been covered with this conifer.

50 Cf. Varro 1990: 148–9.

51 Cf. Ferroni and Meucci 1989: 110.

52 Cf. Pugliese Carratelli 1950: 278. For boxwood wax tablets from other places, see Warnock and Pendleton 1991: 107.

53 Cf. Bonghi Jovino 1984: 352–5 and tav. 184.

54 *Carpinus*: Pliny *HN* 16,67, 16.73–4, 16.226; Vitruvius 2.9.12; cf. Blümner 1879: 294–5; (not in Meiggs 1992); it is a very hard and compact wood that is used in building and in carpentry; the tree still grows in Italy (cf. Giordano 1980: 160. *Quercus*: Pliny *HN* 16.17; cf. Blümner 1879: 260–6 (with references to the ancient literature), Meiggs 1982: 45–6 and 295, Giordano 1980: 194; it was probably present in great quantities on the Apennine peninsula.

55 Cf. Aytug 1988: 366–7, who performed the analyses.

REFERENCES

Adam, Jean-Pierre. 1984. *La construction romaine: matériaux et techniques.* Picarel, Paris.

Andreau, Jean. 1974. *Les affaires de Monsieur Jucundus* (= Collection de l'Ecole Française de Rome 19). Rome.

Aytug, B. 1988. Le mobilier funéraire du roi Midas I. In *Wood and Archaeology: Acts of the European Symposium Held at Louvain-la-Neuve, October 1987* (= Pact 22), edited by Tony Hackens, André V. Munaut, and Claudine Till, pp. 357–68. Counseil de l'Europe, Strasbourg.

Blümner, Hugo. 1879. *Technologie und Terminologie der Gewerbe und Künste bei Griechen und Römern* II. Teubner, Leipzig (= Hildesheim 1969).

Bonghi Jovino, Maria. 1984. *Ricerche a Pompei. L'Insula 5 della Regio VI dalle origini al 79 d.C.* L'Erma di Bretschneider, Rome

Ciarallo, Annamaria. 1990. Le problematiche botaniche dell'area archeologica vesuviana. In *Archeologia e botanica,*

edited by Marisa Mastroroberto, pp. 17–32. L'Erma di Bretschneider, Rome.

Ferroni, A. M., and Costantino Meucci. 1989. Prime osservazioni sulla barca di Ercolano: il recupero e la costruzione navale. In *Il restauro del legno* I, edited by G. Tampone, pp. 105–12. Messaggerie toscane, Florence.

Giordano, G. 1980. *I legnami del mondo, dizionario enciclopedico.* Ceschina, Rome.

Hunink, Vincent Chr. 1992. "Deserta stamus in urbe. Het beeld van Italië in Lucanus' Bellum Civile." *Hermeneus* 64: 198–204.

Jameson, Michael H. 1987. "Review of Meiggs 1982." *American Journal of Archaeology* 91: 488–9.

Kühlborn, J.-S. 1990. Die augusteischen Militärlager an der Lippe. In *Archäologie in Nordrhein-Westfalen, Geschichte im Herzen Europas,* edited by Hansgerd Hellenkemper, Heinz Guenter Horn, H. Koschik, and B. Trier (Hg.), pp. 169–86. Römisch-Germanisches Museum der Stadt, Cologne.

Meiggs, Russell. 1982. *Trees and Timber in the Ancient Mediterranean World.* Clarendon Press, Oxford.

Mols, Stephan T. A. M. 1999. *Wooden Furniture in Herculaneum: Form, Technique and Function,* Gieben, Amsterdam.

Needler, Winifred. 1963. *An Egyptian Funerary Bed of the Roman Period in the Royal Ontario Museum.* University of Toronto, Toronto.

Pinelli, Paul, and Alexandra Wasowicz. 1986. *Musée du Louvre, Catalogue des bois et stucs grecs et romains provenant de Kertch.* Ministère de la Culture et de la Communication, Paris.

Pugliese Caratelli, Giovanni. 1950. L'instrumentum scriptorium nei monumenti pompeiani ed ercolanesi. In *Pompeiana. Raccolta di studi per il secondo centenario degli scavi di Pompei,* pp. 266–78. Naples.

Richter, Gisela M. A. 1966. *The Furniture of the Greeks, Etruscans and Romans.* Phaidon Press, London.

Rival, Michel. 1991. *La charpenterie navale romaine.* Editions du centre national de la recherche scientifique, Paris.

Schweingruber, Fritz H. 1978. *Mikroskopische Holzanatomie.* Eidgenössische Anstalt für das forstliche Versuchswesen, Zug.
 1990. *Anatomie europäischer Hölzer.* Haupt, Stuttgart.

Squarciapino, Maria. 1941. *Artigianato e industria* (= Mostra della Romanità, Civiltà Romana 20). Rome.

Ucelli, Guido. 1938. *Le Navi di Nemi.* Libreria dello Stato, Rome.

Varone, Antonio. 1990. Iscrizioni. In *Rediscovering Pompeii. Catalogue of the Exhibition by IBM Italia, New York City, 1990,* edited by Baldassare Conticello and Antonio Varone, pp. 148–9. L'Erma di Bretschneider, Rome.

Vaulina, H. Maria., and Alexandra Wasowicz. 1974. *Bois grecs et romains de l'Ermitage,* Żaklad Narodowy im. Ossolínskich, Wroclaw.

Waele, Ferdinand J. de. 1949. Bossen, bomen en toegepast hout in oud-Syrië. In *Hout in alle tijden* I, edited by W. B. Boerhave Beekman, pp. 579–87. Kluwer, Deventer/Batavia.

Warnock, P., and M. Pendleton. 1991. "The Wood of the Ulu Burun Diptych," *Anatolian Studies* 41: 107–10.

10

DENDROCHRONOLOGICAL INVESTIGATIONS AT HERCULANEUM AND POMPEII

Peter Ian Kuniholm

Dendrochronology is the scientific technique of identifying patterns of tree-ring growth in ancient wood or charcoal samples and matching them with known dated sequences to provide information of use to archaeologists in dating buildings, furniture, and other wooden objects. Sixteen partially burned timbers from Herculaneum and seven from Pompeii, mostly fir (*Abies* sp.) but with an admixture of spruce (*Picea* sp.), have been combined into a tree-ring chronology that extends for 362 years, beginning in 290 B.C. and ending in A.D. 72. The ring-growth patterns show that the wood is Alpine, possibly from western Austria. We believe that this wood may have been floated down the Adige River to the Po estuary from which it could have been easily transported by ship to the port cities of Herculaneum and Pompeii. So far most of the timbers that have been studied appear to have been imported, but additional timbers that we have sampled from Herculaneum do not fit the Alpine curve and may be locally grown material from high in the Apennines.

In twenty-five years of trying to build tree-ring chronologies for the eastern Mediterranean region, we have found our two biggest problem periods to be the Roman and Hellenistic, simply for lack of suitable samples.[1] In the summer of 1996 our Roman period wood supply increased dramatically when we acquired fifty-four timbers from Herculaneum and four from Pompeii. These were supplemented in 1997 by an additional eleven timbers from Herculaneum and sixteen from Pompeii, and in 1998 by thirteen timbers, all from Herculaneum. In the vaulted Roman cellars of the so-called *Scavi Novi* at Herculaneum was a carpenter's workshop stacked with timbers, some showing signs of use and reuse, all of which have now been stored for safekeeping in the excavation *cantieri*. When Mount

Vesuvius erupted in A.D. 79, those timbers started to burn, but the burning was almost immediately extinguished by some 30 m of ash and tephra that fell on the site, protecting the wood until the present day. The reducing atmosphere (lack of oxygen) created by the smothering tephra had the same effect as a charcoal kiln, preventing total combustion of the wood; and the beams, a mixture of fir, spruce,[2] and pine, with occasional cypress and a bit of oak, were splendidly preserved. From this carpenter's pile alone we collected forty-two specimens. The tephra cover over the last two millennia must also have made the environment more or less anaerobic, for the unburned parts of the timbers were extraordinarily well preserved.

Even before measurement began (see Stokes and Smiley 1968; Schweingruber 1988; Eckstein 1984; Baillie 1995; and Kuniholm forthcoming for discussions of the various techniques of tree-ring matching), we knew that we would have a tree-ring data set that should show various end dates with A.D. 79 as the latest possible terminus. We now have a 362-year chronology for Herculaneum beginning in 290 B.C. and ending with one timber with a last ring grown in A.D. 72, only seven years before the Big Bang that brought the life of the two communities to an end. Other timbers in the same woodpile, particularly the ones showing signs of use and reuse, were cut over a period of two centuries. End dates of all of them are 123, 121, 89, 87, 86, 23, 18, 15, 9, and 6 (two samples) B.C., and A.D. 3, 9, 10 (two samples), 13, 20, 51, and 72, not really surprising since this was a carpenter's timber supply. How we determined these dates will be explained later on.

In the current excavations south of the Villa dei Papiri and immediately adjacent to it a deep trench has revealed Roman buildings preserved up to the roof,

also buried under some 30 m of lapilli, ash, and tephra. From several of these buildings we have now collected another forty-four timbers, many of which crossdate with the material from the carpenter's shop. The last existing ring in this trench is 49 years earlier than the last ring in the workshop, that is, A.D. 23. Since the bark is missing in both cases, we do not have a difference in felling years between the one lot and the other, but this is a promising start and we trust that future collection from the Herculaneum excavations and other locales will reinforce and extend this new Roman chronology.

At Pompeii we were able to collect burned wood in 1996 from the House of the Chaste Lovers (Casa dei Casti Amanti). This was not as long-lived as the Herculaneum wood, and until now it has resisted all our attempts to date it. A second set of wood samples from Pompeii, acquired in 1997, begins in 99 B.C. and has a last-preserved ring at A.D. 37. Since this latter Pompeian wood is without provenance (i.e., from anywhere in the old excavations), the archaeological information that could be acquired by measuring it is minimal.

Although the destruction date at Herculaneum and Pompeii is well known, it has been difficult on purely archaeological grounds to determine when any given building was constructed (for an up-to-date discussion and current bibliography of these houses see Wallace-Hadrill 1994). We hope to be able to provide answers to these and other questions as collection and measurement continue at these two sites. It is particularly gratifying to see that more of the newly emerging wood at Herculaneum is being saved for future study. Now that our colleagues in the Soprintendenza know what we need, there is every hope that we will be able to add to the datable material collected thus far. Already we can point to end dates for timbers with known provenances in the new excavations near the Villa dei Papiri of 41 B.C., 22 B.C., 17 B.C., 6 B.C., and A.D. 23. In order to understand what this means archaeologically and architecturally for the specific parts of the specific buildings from which they were retrieved, we must consult with the excavators who are now preparing their preliminary publication.

The dates quoted here deserve explanation. That the Romans were cutting wood at all times is no surprise to anybody (Ciarallo et al. 1993). But at both Herculaneum and Pompeii we can now tell, with a fairly high degree of certainty, from where they probably imported some of it, and that is a piece of worthy new information, indeed exciting. The fit that allows us to derive these dates is between fir (*Abies* sp.) and some spruce (*Picea* sp.) from Herculaneum/Pompeii matched against the previously established South German oak chronology. When Maryanne Newton, one of our graduate students, first spotted this extraordinarily

good fit, we tried to determine whether the published ring sequences from any fir forests in Italy fit with the Alpine oaks. Starting with modern forests in Calabria, we examined *Abies* tree-ring data from the entire length of the Apennines all the way to north of Florence, and the result was always the same: no fit at all — until we got to the Black Forest near Freiburg in southern Bavaria, where the local firs and oaks fit splendidly with each other and with the Calabrian firs. So we proposed in 1997 that what we have at Herculaneum, and to a certain extent at Pompeii, is a population of fir and some spruce timbers imported from the Alps.

In 1997 we started our summer's fieldwork by visiting the Stuttgart-Hohenheim dendrochronology lab where most of the South German oak chronologies were built, and our colleagues there agreed that the Herculaneum wood is indeed Alpine. Our proposed fit covering the 362 years between 290 B.C. and A.D. 72 was confirmed by Dr. Michael Friedrich and Dr. Marco Spurk, against several new unpublished Alpine fir chronologies developed in collaboration with a large working group of a dozen researchers in several countries. Enough *Abies* information is in hand in Hohenheim to span the last 3,000 years. The fit between the Alpine fir chronologies and Herculaneum/Pompeii fir, is much better than Alpine oak versus Herculaneum/Pompeii fir as one would expect, with statistical scores somewhat better in the east (their unpublished Hallstatt-3 chronology) than the west.

Before we had found these dendrochronological cross dates, we had sent samples to Dr. Bernd Kromer in Heidelberg for radiocarbon wiggle-matching. He reported a date for what was then the beginning of our sequence at Herculaneum at 240 B.C. ± 15 years, the center point of which is only two years earlier than the dendrochronologically-derived date of 238 B.C. for the sample that he measured. The agreement between the two dates is so close that we have concluded there is no need to perform any further radiocarbon determinations.

All of this means that some enterprising Roman timber merchant could have gone north to a seaport like Venice or Genoa and brought wood south from there to Herculaneum and Pompeii. We have no literary testimony for this specific trade route, but here at Herculaneum/Pompeii is the mute evidence for its existence. It is difficult to imagine *any* timbers, much less ones the size of those we saw excavated at Herculaneum (maximum dimension 4.51 m × 0.37 m × 0.15 m), being transported over the Alps. A quick look at the available river systems in northwest Italy does not show an obvious fluvial transport mechanism. But now Dr. Kurt Nicolussi at the University of Innsbruck kindly reports (personal communication 1997) that he has a peat bog in the valley of Lermoos near the Austrian/German

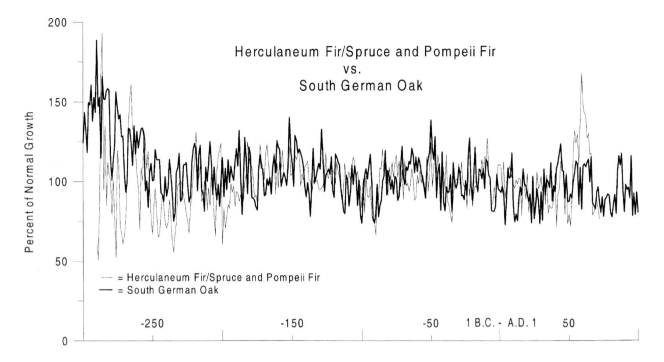

FIGURE 188 Growth profiles for fir and spruce from Herculaneum and Pompeii compared with South German oak.

frontier beyond where the Via Julia Claudia crossed the River Inn, from which he has constructed a 500-year-long *Abies* chronology that forms part of the long, absolutely dated Alpine sequence previously cited. If a fir tree growing in the Dolomites or anywhere in western Austria could have been dragged to the headwaters of the Adige and floated downstream to the Po, or, similarly, a fir growing in the Carnic Alps could have been floated down the Piave to Venice, it would have been a relatively easy matter for Roman timber merchants to have transported them, either as timbers still in the round or as sawn planks, to Herculaneum, Pompeii, or anywhere else in the Mediterranean, for that matter.

All of this information is the good news. Now for the bad news: what we have at Herculaneum is Alpine fir, but that does not help us with the B.C./A.D. transition period in the Aegean, which is why we went to sample the wood at Herculaneum in the first place. All is not lost, however. There are additional timbers that we sampled at Herculaneum that do not fit very well, if at all, with the Alpine curve, and they just might be the locally grown (or at least non-Alpine) material we wanted all along. It is these samples that we are using to try to find fits with Roman-period wood from Greece and Turkey, so far without success.

SIGNIFICANCE FOR FUTURE WORK

Excavators at all Italian archaeological sites need to be on the lookout for wood or charcoal. Figure 188 shows the Herculaneum/Pompeii fir and German oak graphs compared. For readers who prefer quantification, the t-score

between fir and oak is 4.44, the overlap is 362 years, the trend coefficient is 59.0 percent, and the D-score is 40. Figure 189 shows an unburned cross section of spruce with tree rings from 291 B.C. to 129 B.C., and Figure 190 shows a burned cross section of fir with rings from 145 B.C. to A.D. 11. Absolute dates for the Roman period are now possible. Care needs to be taken to ensure that any fragments preserving the bark (and therefore the cutting year) are not discarded. For information regarding sample collection, please see specific guidelines on our Web site: www.arts.cornell.edu/dendro/. A final note is that our earliest end dates for the wood at Herculaneum and Pompeii are all *Picea* (spruce), and the latest are *Abies* (fir). In the current excavations south of the Villa dei Papiri the end dates for spruce timbers are 129, 112, and 85 B.C.; and the end dates for fir are 60, 48, 41, 30, 24, 17, 11, 11, 6, 6, and 2 B.C., and A.D. 26, 28, and 46. Does that mean the Romans chose spruce over fir during the Republic, and imported fir only when spruce was no longer available? Our data base is small, but there is so far not one exception to the spruce-equals-early-and-fir-equals-late rule. The notion that the Campanian timber merchants could have been selective in their choice of wood, either to import or to use, should not be surprising, and it will be worth keeping statistical track of details like this as more wood of the Roman period is excavated.

ACKNOWLEDGMENTS
The Malcolm and Carolyn Wiener Laboratory for Aegean and Near Eastern Dendrochronology is supported by the National Science Foundation, the Mal-

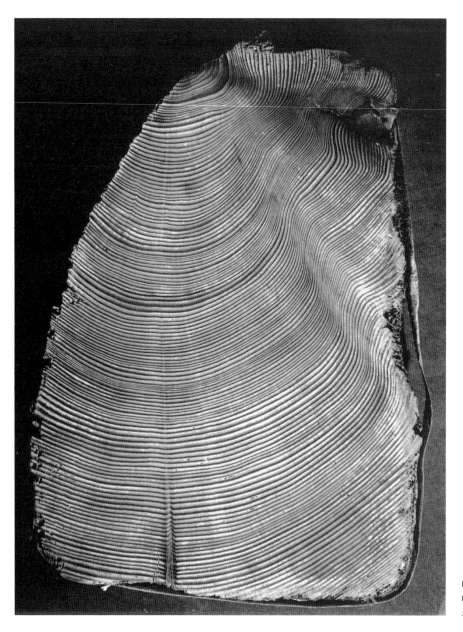

FIGURE 189 An unburned cross section of spruce with tree rings from 291 B.C. to 129 B.C.

colm H. Wiener Foundation, and individual patrons of the Aegean Dendrochronology Project. We thank Professor Pietro Giovanni Guzzo, Soprintendente; Dr. Mario Pagano, Deputy Soprintendente; and Dott. Annamaria Ciarallo of Pompeii; Professor Andrew Wallace-Hadrill and Dr. Joanne Berry of the British School in Rome, and all their colleagues for their kind assistance. We also thank Dr. Werner Schoch of the Swiss Federal Forestry Research Institute for confirming the species identifications. Sample preparation and measurements were made by students in History of Art/Classics/Archaeology 309 supervised by Jennifer Fine, Maryanne Newton, Laura Steele, and Isabel Tovar.

NOTES

1 Hundreds of stone buildings survive from these periods, many with beam holes that are usually empty.

Stroll around the Baths of Caracalla in Rome, for example, and see hundreds of places where beams once upon a time *were*. Now, at best, they contain only pigeon nests. Until 1996 most of our Roman period wood had come from oak pilings salvaged from the River Kupa in Pannonia at Siscia (modern Sisak or Celtic Segestica, unpublished); from boxwood logs that formed part of the cargo of the Comacchio ship (Kuniholm et al. 1992); from miscellaneous coffins throughout the Balkans and the Aegean (Kuniholm and Striker 1987; Kuniholm 1996); and from oak pilings from the bridge where the Appian Way crosses the Garigliano River or ancient Liris (Ruegg 1995).

2 *Abies alba,* the only fir at present in northern, central, and eastern Europe, ranges south along the Apennines; *Picea abies,* the only spruce widespread in northern and central Europe, does not occur in peninsular Italy but ranges in the Alps and in the mountains of the northern Balkans south to the Pindus Range in Epirus and Greek Macedonia.

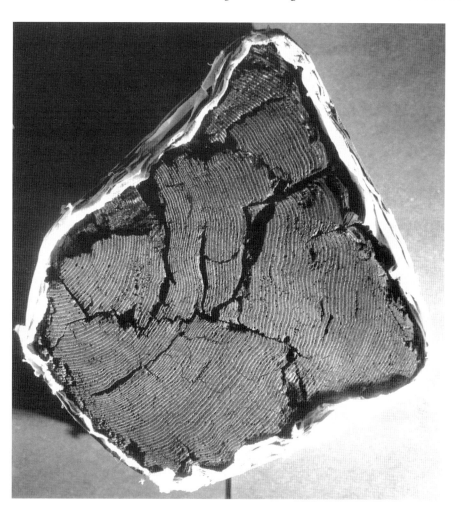

FIGURE 190 A burned cross section of fir with tree rings from 145 B.C. to A.D. 11.

REFERENCES

Baillie, M. G. L. 1995. *A Slice Through Time: Dendrochronology and Precision Dating.*. Batsford, London

Ciarallo, A. et al., eds. 1993. *Paesaggi e Giardini del Mediterraneo, Parchi e Giardini Storici, Parchi Letterari.* Vol. 3. *Conoscenza, tutela e valorizzazione.* Ministero per i Beni Culturali e Ambientali, Pompeii. (See especially the chapter by M. Borgongino, "La flora vesuviana del 79 d.C," pp. 115–40.)

Eckstein, D. (with M. G. L. Baillie and H. Egger). 1984. *Dendrochronological Dating: E.S.F. Handbooks for Archaeologists* No. 2. European Science Foundation, Strasbourg.

Kuniholm, P. I. 1996. Long Tree-Ring Chronologies for the Eastern Mediterranean. In Archaeometry '94: *The Proceedings of the 29th International Symposium on Archaeometry,* edited by Ş. Demirci, A. M. Özer, and G. D. Summers, pp. 401–9. Tübitak, Ankara.

———. 2001. "Dendrochronology and Other Applications of Tree-ring Studies in Archaeology." In *Handbook of Archaeological Sciences,* edited by D. R. Brothwell and A. M. Pollard, pp. 33–44. John Wiley and Sons, London.

Kuniholm, P. I., C. B. Griggs, S. L. Tarter, and H. E. Kuniholm. 1992. "A 513-Year *Buxus* Dendrochronology for the Roman Ship at Comacchio (Ferrara)." *Bollettino di Archeologia* 16–18: 291–302.

Kuniholm, P. I., and C. L. Striker. 1987. "Dendrochronological Investigations in the Aegean and Neighboring Regions, 1983–1986." *Journal of Field Archaeology* 14(4): 385–98.

Ruegg, S. Dominic. 1995. *Underwater Investigations at Roman Minturnae: Liris-Garigliano River.* Part I. Paul Åströms Förlag, Jonsered, Sweden.

Schweingruber, F. H. 1988. *Tree Rings: Basics and Applications of Dendrochronology.* Reidel, Dordrecht.

Stokes, M. A., and T. Smiley. 1968. *An Introduction to Tree-Ring Dating.* University of Chicago Press, Chicago.

Wallace-Hadrill, Andrew. 1994. *Houses and Society in Pompeii and Herculaneum.* Princeton University Press, Princeton.

ENVIRONMENTAL CHANGES IN AND AROUND LAKE AVERNUS IN GREEK AND ROMAN TIMES

A STUDY OF THE PLANT AND ANIMAL REMAINS PRESERVED IN THE LAKE'S SEDIMENTS

Eberhard Grüger, Barbara Thulin, Jens Müller, Jürgen Schneider, Joachim Alefs, and Francisco W. Welter-Schultes

LAKE AVERNUS AND ITS SURROUNDINGS

Lake Avernus (Lago d'Averno; 14°4' E, 40°(50'20" N) is located in Campania, about 15 km west of Naples, somewhat less than 30 km west of Mount Vesuvius and Pompeii, and in the volcanic region of the Phlegraean Fields 900 m north of the Gulf of Pozzuoli (Fig. 191). The lake is less than 1000 m from east to west and 750 m from north to south. It covers an area of about 0.55 km². Water depth was 33 m in the spring of 1989. The water level of the lake is almost equal to that of the nearby sea.

The lake developed in a crater that was formed when Mount Averno erupted 3,800 radiocarbon years ago (Rosi and Sbrana 1987). Slow movements of the land surface, uplift as well as sinking (bradyseismic movements), hot springs, occasional escape of steam and gases, and the eruption of Monte Nuovo in A.D. 1538 immediately southeast of the lake indicate continued volcanic activity in the area even in historic times. The name of the lake might derive from the Greek word *aornos,* meaning "without birds," as the toxic gases were known to the Greeks.

The slopes of the modern crater are steep and up to 110 m above the lake. To the east of Lake Averno, Monte Nuovo rises to a height of 133 m. The surroundings of the lake are hilly due to many volcanic cones. Monte Barbaro, with an elevation of 336 m, is located within a radius of 2 km of the lake. Most of the area, however, is lower than 50 m above sea level.

The crater area is now heavily urbanized and culti-

vated. Even the narrow fringe of arable land around the lake is used intensively for gardening, viticulture, and growing fruits. Nevertheless, with its few buildings and little traffic, the area around the lake is still a quiet, idyllic place.

The area has a Mediterranean climate with hot summers and mild and rainy winters. The annual mean temperature is 16.8° C at Naples. Monthly mean temperatures range from 9° C (January) to 25° C (August). Frost may occur from November to March. Precipitation measures up to 895 mm a year, but only about a third of it falls during spring and summer with a minimum of less than 20 mm during July and August, the two hottest months.

HISTORY OF THE REGION

Although a colorful picture of prehistoric, especially neolithic cultures in southern Italy is given in the literature (Guilaine 1976; Ridgway and Ridgway 1979; Frederiksen 1984; Follieri 1987; Pallotino 1987; Hopf 1991; and others), archaeological and archaeobotanical information about the area is scarce for the period before Greek colonization.

Kyme (Cumae or Cuma), believed to be the earliest of the Greek settlements in Italy, was established about 750 B.C. on the site of an earlier settlement only 2 km northwest of Lake Avernus (Fig. 191). It was the most influential community in the Gulf of Naples region for several hundred years. Much later, ca. 529/528 B.C.,

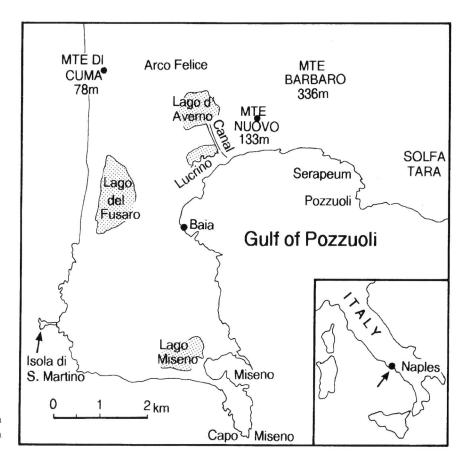

FIGURE 191 Italy and the western part of the Phlegrean Fields with Lake Avernus.

Dikaiarchia (Puteoli, modern Pozzuoli) was founded 4 km east southeast of the lake and developed into one of the most important harbors in the Mediterranean. The area was repeatedly a site of battles fought by the Etruscans and the Samnites against the Greeks in pre-Roman times.

Roman influence appeared in the fourth century B.C. and increased considerably later on. During the second century B.C. wealthy Romans began erecting villas along the coast of the Gulf of Baiae, the westernmost part of the Gulf of Pozzuoli and the Bay of Naples (d'Arms 1970). The Roman population grew rapidly during the first century B.C., so that Strabo (ca. 64 B.C.–A.D. 20), when describing the land along the Bay of Naples, could state, "the whole of the Gulf [the stretch of land from the cape of Misenus to Sorrentum] is garnished, in part of the cities which I have just mentioned, and in part by the residences and plantations, which, since they intervene in unbroken succession, present the appearance of a single city" (5.4.8). Puteoli and Baiae with their hot springs were part of this urban area and were connected by the Via Herculanea, a road built along the shore that separated Lake Lucrinus from the sea. Here fish hatcheries and oyster beds were maintained. Oysters from Lake Lucrinus were much in demand by the first century B.C. As the shoreline on which the Via Herculanea was built was sinking in Roman times, it was reinforced in

the years between 48 and 44 B.C. The road was destroyed by a seaquake in A.D. 496, and immediately repaired by Theoderic (Di Fraia and Gaudino 1982).

Despite its proximity to the highly developed coastal area, Lake Avernus seems to have remained remote and infrequently visited. It was considered a holy place, the entrance to the underworld, where the hot waters of the Styx reached the earth's surface. The "steep hill-brows were thickly covered with a wild and untrodden forest of large trees" (Strabo 5.4.5).

This idyllic state was ended abruptly in 37 B.C. when Portus Julius, a military harbor, was built on the seashore next to Lake Lucrinus. A military shipyard was constructed at the base of the narrow crater, a canal was dug to connect Lake Avernus via Lake Lucrinus to the harbor and so to the sea, and a tunnel leading to Cumae was made (Fig. 192, see also the map published by Pagano, Reddè, and Roddaz 1982). Up to 20,000 workers were employed in this extraordinary undertaking (Parascandola 1947), which must have resulted in an ecological catastrophe, a disaster for the fauna and flora of the area. Devastation reached even the environs of Cumae: the famous pine forests along the coast of the Tyrrhenian Sea (Gallinariae silvae) were cut at this time.

The military harbor was in use for a short time, perhaps only two decades. It was closed under Augustus (27 B.C.–A.D. 14), who rededicated Avernus to cult and religion. Oyster-breeding in Lake Lucrinus recov-

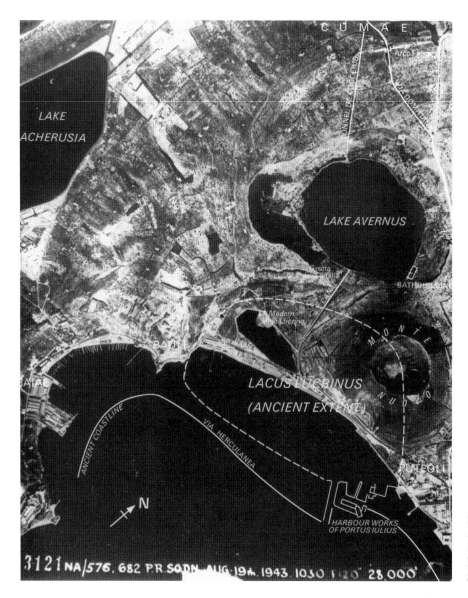

FIGURE 192 Aerial view of Lake Avernus showing former Lake Lucrinus and Portus Julius. From Frederickson 1984; courtesy British School in Rome.

ered its importance (Maiuri 1958). Vergil (70 to 19 B.C.) in the Georgics (2.161–4, completed ca. 30 B.C.) reported the improvements around Avernus associated with the construction of the naval harbor. Later, in the *Aeneid* (3.442), he used the site as a mythological setting and described Lake Avernus as a place with rustling woods. Scholars argue that this would not have been accepted by contemporary readers if the area had remained devastated and the harbor was still busy at that time (Maiuri 1958; Pagano et al. 1982). A return to more natural conditions around Lake Avernus can be assumed for a time shortly after deforestation. A complete reestablishment of the natural vegetation must be ruled out, for the development of the area continued. The older part of the so-called Temple of Apollo, which in fact was a bath building on the eastern shore of Lake Avernus (Figs. 192, 193), dates from the second half of the first century A.D. (Pagano et al. 1982; Sbordone 1984) and the Via Domitiana, which passed the crater on its northeast side, was completed in A.D. 95.

Campania was highly developed in Roman times

(d'Arms 1970). The coastal area along the Bay of Naples, especially that along the Gulf of Baiae, was the preferred place of residence of Roman emperors and other wealthy people because of the mild climate, the thermal springs, and the beauty of the landscape. Agriculture was profitable on the fertile soils. Strabo (5.4.3) tells us "that in the course of one year, some of the plains are seeded twice with spelt, the third time with millet, and others still the fourth time with vegetables. And indeed it is from here that the Romans obtain their best wine." Fruit-growing was also common.

The barbarian invasions of the fourth to sixth centuries caused radical changes. Giacomini and Fenaroli report vast areas of fallow land in Campania as early as A.D. 395. Puteoli was abandoned by its inhabitants, who fled to Naples during Totila's ravages in A.D. 545. It was ten years before they started to reconstruct the city (Parascandola 1947). According to Frederiksen the population along the coast had abandoned this area by the sixth century. It is likely that the use of the thermal bath on the shore of Lake Avernus ended during one

of these periods. Naples became the center of Campania. Lake Avernus was no longer near important cities but was in the hinterland. With depopulation, fauna and flora gradually regained their natural state.

The sinking of the land that began in Roman or pre-Roman times was interrupted by periods of uplift, especially in seventh and sixteenth centuries (Cinque, Russo, and Pagano 1991). By the tenth century, Lake Lucrinus and the Roman buildings bordering it had disappeared below sea level (they are still underwater), and the sea reached Lake Avernus (Lirer et al. 1987; Parascandola 1947).

On September 29, A.D. 1538, the volcano Monte Nuovo, on the southeastern shore of Lake Avernus, erupted. A castle and the village of Tripergole, renowned in the twelfth century for its baths, were destroyed and Lake Lucrinus was partly filled with volcanic ashes. During the eruption the adjacent part of the sea temporarily went dry.

A painting by Jakob Philipp Hackert (1794, Fig. 193) in the Neue Pinakothek in Munich shows Lake Avernus and its environs almost exactly as they look today, the slopes partly wooded, partly grazed, the ruins of the so-called Temple of Apollo near the shore, and dry land separating Lake Avernus from Lake Lucrinus. In the eighteenth century the area remained isolated because of malaria. To correct this situation there were plans to open the canal to the sea again.

The area around Lake Avernus was clearly less populated and less utilized after the fall of the Roman Empire. The area revived at the beginning of the modern era.

FIELDWORK

Fieldwork was carried out from a floating platform in April 1989. First, thirteen echo-sounding profiles were made over the lake with an echograph (210/215 kHz). Twelve short gravity cores and three long piston cores

FIGURE 193 View across Lake Avernus to Cape Miseno in the south. Painting of Jacob Philipp Hackert (1794), Neue Pinakothek, Munich.

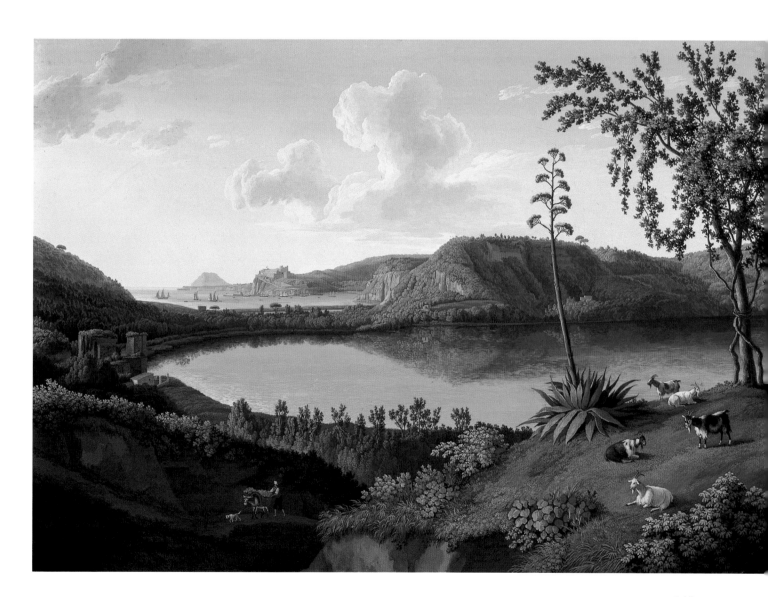

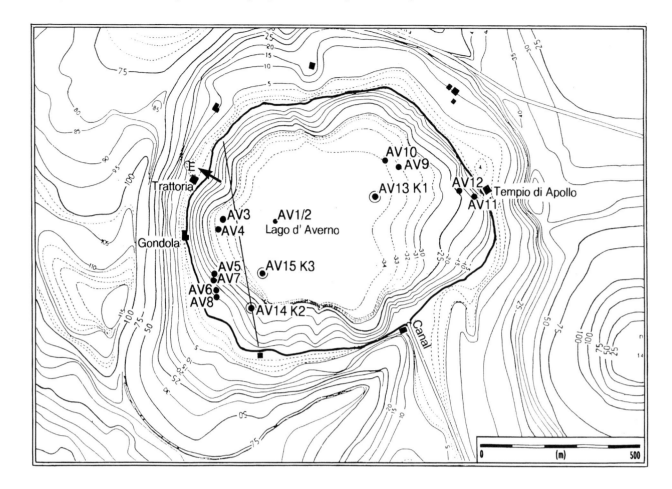

FIGURE 194 *(Above)* Bathymetric map of Lake Avernus (from Del Castillo et al. 1963) indicating the coring sites and the position of the echography profile no. 12 shown in Figure 195. AV13 K1, AV14 K2, and AV15 K3: piston cores. AV 1–12: short cores. The paper deals with part (section 3) of AV14 K2. E = entrance of the Roman tunnel to Cumae.

FIGURE 195 *(Right)* The echography profile no. 12 and the position of the coring site AV14 K2.

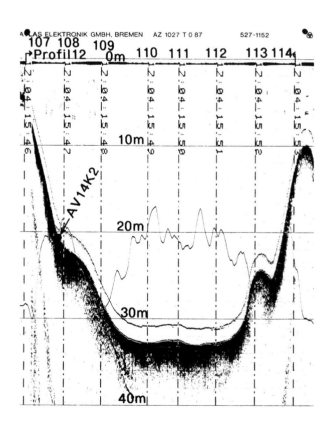

(58 mm in diameter) were taken (Figs. 194, 195). A thick layer of coarse, gray volcanic pumice from Monte Nuovo, a few decimeters below the surface, could not be penetrated with the available coring equipment. A comparable layer was not found on the western side of the lake. Therefore, the long piston core AV 14 K2 was taken about 125 m off the southwestern shore of the lake at a depth of 20.3 m (Figs. 194, 195). Of its five overlapping parts, only portion 3 (250 to 424 cm depth, fig. 196) has been studied in detail thus far.

The investigations reported in this chapter include sedimentary and mineralogical analyses by Müller and Schneider, the identification of marine shells by Schneider, of brackish and freshwater mollusks by Welter-Schultes, of foraminifera and ostracods by Alefs, of diatoms by Thulin, and pollen analyses by Grüger.

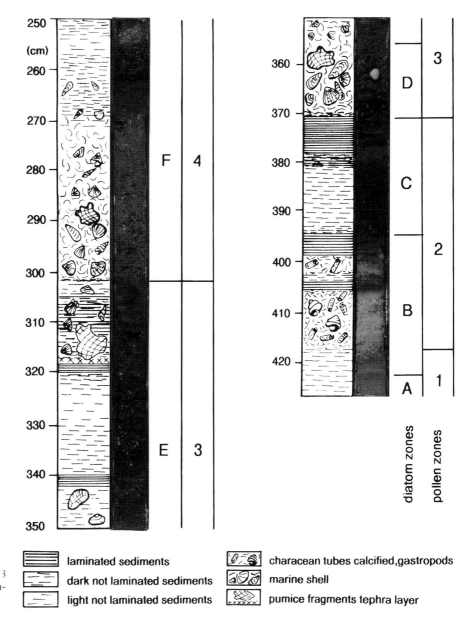

FIGURE 196 Stratigraphy of section 3 of core AV14 K2 and the correlation of diatom and pollen zones.

laminated sediments	characean tubes calcified, gastropods
dark not laminated sediments	marine shell
light not laminated sediments	pumice fragments tephra layer

METHODS

The cores (58 mm in diameter) were cut in half lengthwise in the laboratory. The sediments were then photographed and a realistic drawing of the sedimentary record was made (Fig. 196). A simplified version of this drawing is added to most of the diagrams. All analyses were done on the same core.

Sediment Analyses

The relative proportions of Mg-calcite, aragonite, and calcite of the sediments were determined by X-ray diffractometry using a peak-area method (Müller and Müller 1967). Absolute contents of carbonate minerals were calculated based on inorganic carbon analyzed spectrometrically (Leco CS-125), as were organic carbon and total sulfur. The noncarbonate content was calculated as the difference of total inorganic carbon and carbonates.

Analysis of the Faunal Remains

For this analysis one-half of the core was cut into pieces 5 or 10 cm long, then dried and sieved. Representative samples of the >63 micron fraction were used for the qualitative analysis of foraminifera and ostracods and of the other faunal remains except for freshwater mollusk shells, of which quantitative data was analyzed.

Diatom Analysis

Preparation of (about 0.5 ml) samples for the quantitative analysis followed standard methods. They were dried at 40° C, weighed, and treated with 30 percent hydrogene peroxide, then heated to 80° C. The samples were then allowed to stand 1 to 4 days until oxidation was finished. To calcareous samples 10 percent hydrochloric acid was added and heated to 70° C for about twenty minutes. The samples were repeatedly washed with distilled water. Suspended clay particles

were removed by repeated decanting (after four hours of standing). Tests proved that no diatoms were lost during this procedure. Immediately after weighing and shaking the vials, 0.1 μl and 0.2 μl, respectively, of the suspension were dropped on a slide and dried at room temperature. The slides were mounted in G.B.J. mountant and analyzed using a Leitz Ortholux microscope with a magnifying power of 1,000.

For identification, taxonomy, and ecological data, the publications of Cholnoki; Fabri and Leclerq; Hustedt; Krammer and Lange-Bertalot; Peragallo; and Salden have been used.

Pollen Analysis

Preparation of the about 1 ml sediment samples included treatment with hydrochloric and hydrofluoric acids, with potassium hydroxide solution, acetolysis, and sieving in an ultrasonic water bath (50 kH) to remove particles of less then 5 × 8 micron in size. Percentage values are based on the total of pollen of woody plants (about 1,000 pollen grains). Their pollen curves are shown densely hatched in the pollen diagram (Fig. 198). Pollen concentrations were calculated as described by Stockmarr by adding two *Lycopodium* spore tablets to each sample before chemical treatment started.

THE DATA AND THEIR INTERPRETATION

STRATIGRAPHY AND SEDIMENTOLOGY

Section 3 (250–425 cm) of core AV 14 K2 was taken in one piece with a modified Kullenberg piston corer, which allows taking undisturbed sediment cores of up to 2 m in length. The photograph of the sediment column (Fig. 196) and the mineralogical and chemical data (Fig. 197) show important sedimentological changes, even discontinuities. The data indicate that radical changes of the aquatic and terrestrial ecosystems occurred repeatedly during the time of deposition.

Based on the pollen and diatom records, two different zonations of the sequence were developed, of which the pollen zones (1 to 4) fit the terrestrial record, whereas zones A to F are based on the changes of the lake's diatom flora.

The mineralogical record starts in zone B. The light colors of the sediments, the great amounts of calcite in the lower part of zone B (400–20 cm), and the finds of a great number of calcified tubes and oogonia of Characeae prove the existence of a well-aerated freshwater lake. (Characeae are specialized green algae, including stoneworts and brittle worts, that precipitate out of the surrounding water a covering layer of cal-

cium carbonate. Their egg cells, which are enclosed by long sterile cells, are called oogonia.) Decreasing and later low values of the noncarbonate minerals indicate that input of allochthonous (foreign) detritus was small during that time.

The overlying fine-grained and partly well laminated sediment, especially that between 370 and 390 cm, between 310 and 340 cm, and around 260 cm, shows higher values of sulfur and organic carbon. This indicates relatively calm, microaerobic to anaerobic conditions (at least in the hypolimnion or surface layer) and low sedimentation rates for zone C, almost all of zone E, and the uppermost part of zone F.

Aragonite and especially Mg-calcite, carbonate phases that primarily derive from shell material of marine organisms, were found for the first time in sediments of zone C, although in small amounts only. Diatoms, foraminifera, and ostracods indicate a slight marine influence. These findings coincide with the occurrence of undisturbed, dark sediments and might indicate a change to slightly meromictic conditions starting at the end of zone B and continuing throughout zone C. In meromictic lakes only a part (= meros) of the water column mixes during the yearly cycle, resulting in a sterile anaerobic layer, that is, a layer lacking oxygen, at the bottom.

A hiatus is indicated at the C/D boundary between zone C and zone D (and probably another one at the bottom of zone F). Here a layer of graded and very coarse material with shells and shell debris overlies fine-grained sediments. Many of the shells are broken, partly corroded, and overgrown with serpulids (Figs. 213, 214). The shells must have been exposed at the sediment surface during a time of low sedimentation. The lowest values of sulfur and organic carbon were found at this level, together with much Mg-calcite and aragonite. Some sudden event seems to have stirred up the earlier-deposited sediments, causing a separation of the fine-grained fraction and thus the discontinuity.

Zone E (301–55 cm) represents a phase of undisturbed sedimentation as the smooth course of the curves of the sedimentological parameters shows. The fossils also prove marine conditions for this time. A thin ash layer and the large piece of pumice above 318 cm could not be attributed to any of the known volcanic events in the region.

The sediments of the lower part of zone F (270–301 cm) resemble those of zone D. They are lighter and much coarser than the underlying layers and contain numerous fragments and shells of marine organisms. Many of them are badly corroded and show boreholes made by the sponge *Cliona* (Fig. 221). Others are overgrown by serpulids. Again one must conclude that the shells were exposed for some time at the sedimentation

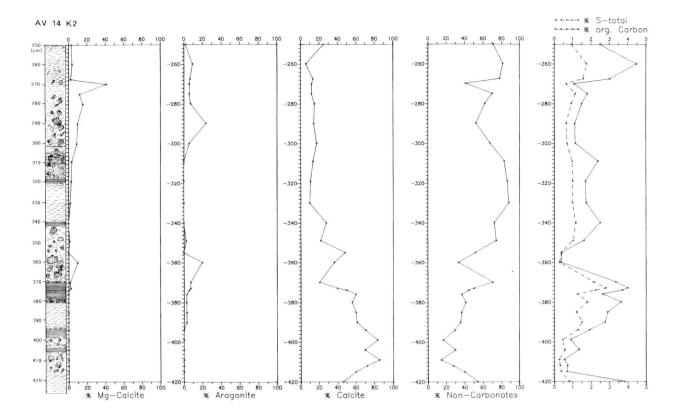

AV 14 K2

% Mg-Calcite % Aragonite % Calcite % Non-Carbonates

— — — % S-total
······ % org. Carbon

FIGURE 197 Chemical and mineralogical data of section 3 of core AV14 K2.

surface. The values of noncarbonate material, consisting essentially of resedimented tephra derived from the surroundings of the lake, as well as sulfur and organic carbon, are lower than in the samples from the preceding zone E, those of Mg-calcite and aragonite greater. Above 270 cm the sulfur, organic carbon, and noncarbonate values are high again, whereas the Mg-calcite curve drops to low values. Sedimentation was undisturbed again during this part of zone F.

POLLEN

Three different areas must be distinguished as sources of the pollen found in the sediments of Lake Avernus: (1) the narrow fringe of low-lying moist land around the lake, (2) the well-drained, steep inner slopes of the crater, and (3) the hinterland. Although the crater is sufficiently wide to allow winds to descend into the basin dropping pollen from the hinterland vegetation, the vegetation inside the crater must be better represented in the pollen record than that from the hinterland for aerodynamic reasons.

Changes of the surrounding vegetation will result in changed inputs of pollen into the forming sediments and will thus be reflected in the pollen diagrams (Figs. 198, 199, Table 16).

Major changes in the pollen curves permit subdivision of the pollen diagram (Fig. 198) into four zones (1–4). Two of the zone boundaries (between zones 2 and 3 at 371 cm and between 3 and 4 at 301 m depth) coincide with the lower limits of layers rich in shells of

marine mollusks. Pollen analysis of adjacent samples revealed that there is a hiatus (of unknown extent) between zones 2 and 3. Another hiatus might exist between zones 3 and 4, but pollen analytical evidence is not unequivocal in this case.

Zone 1 (417–25 cm)

This zone, of which the pollen diagram (Fig. 198) shows the uppermost two samples only, continues downward for more than half a meter in another portion of the core. It is characterized by the prevalence of oak pollen, about 60 percent of the total woody pollen. Deciduous oak species (*Quercus pubescens* type) contributed slightly more than evergreen species (*Quercus ilex* type). Another 15 percent of the pollen grains came from other trees or shrubs such as *Ostrya*, the European hophornbeam (and/or from *Carpinus orientalis*, the Oriental hornbeam), 5 percent from *Corylus* (hazel), and about 4 percent from *Erica*. The pollen percentages of *Alnus* (alder, see Table 14 for further English plant names), *Carpinus betulus*, *Pistacia*, *Ulmus*, *Pinus*, *Phillyrea*, *Fraxinus ornus* (names arranged in decreasing order of importance), and a greater number of sparsely represented woody species add up to about 10 percent. Small quantities of pollen of *Olea* (olive) and *Vitis* (grape), plant species, either cultivated or wild, have been found in almost all samples, but *Juglans* (walnut), *Castanea* (chestnut), and *Platanus* (plane-tree) are absent in zone 1. The remaining 5 percent repre-

247

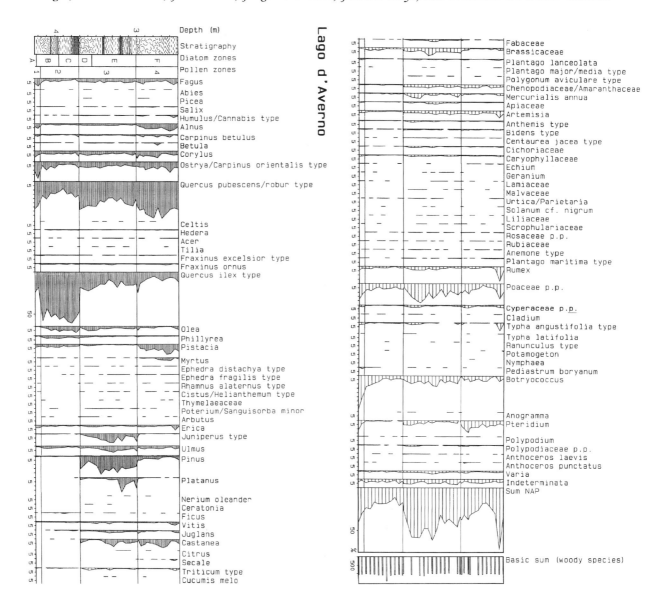

FIGURE 198 Pollen diagram. The sum of pollen grains of woody taxa (= densely hatched curves) serves as the basic sum for the percentage calculations.

sent long-distance transported montane pollen, chiefly *Fagus* (beech) and a few grains of *Abies* (fir).

Nonarboreal pollen (NAP) values in zone 1 range from 10 percent to 40 percent (average 22 percent). The principal constituents of the herbaceous vegetation were grasses, sedges, *Artemisia* (mugwort), and other Compositae (daisy family) and undeterminable species of the carrot, cabbage, goosefoot, amaranth, and pink families (Apiaceae, Brassicaceae, Chenopodiaceae, Amaranthaceae, and Caryophyllaceae). A few grains of the *Triticum* (wheat) type have been found, and pollen of *Plantago lanceolata* (ribwort) is present in almost all samples (max. 1.7 percent).

The high proportions of arboreal pollen types indicate that the area adjacent to Lake Avernus and its hinterland were forested during the time of deposition of

the sediments of zone 1. Evidence of agriculture during this period is meager. Human impact on the land is indicated by some NAP types, especially by *Plantago lanceolata* and *Artemisia* and probably *Pteridium,* the bracken fern (Behre).

Zone 2 (371–417 cm)

Zone 2 represents a period with a preponderance of typical Mediterranean tree and shrub species. The evergreen oak pollen doubled compared with zone 1, but deciduous oaks do not reach half their preceding values; the mean total oak pollen increases by 8 percent on average (max. 74 percent). The curves of *Olea, Pistacia,* and *Phillyrea* reach significantly higher levels than in zone 1 (up to 8 percent, 4 percent, and 3 percent, respectively), and pollen grains of *Fraxinus ornus, Ulmus, Hedera, Myrtus, Ephedra, Juglans, Vitis,* and *Ficus* have been found slightly more frequently. The rise of the pollen values of these taxa is compensated not only by the lower deciduous oak values (less than 15 percent) but

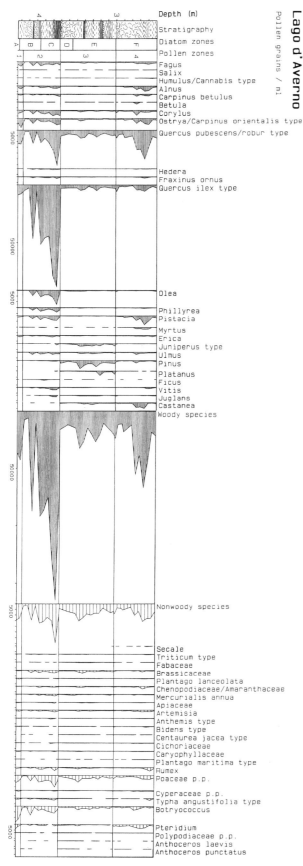

Lago d'Averno

Pollen grains / ml

FIGURE 199 Concentrations of main pollen types (number of grains/1 ml of sediment).

also by decreases in *Ostrya, Erica* (to below 5 percent and 1 percent, respectively), and other less important constituents of the tree vegetation.

The NAP values (11–25 percent), among them those of grasses and *Artemisia,* are lower in zone 2, and those of *Plantago lanceolata* and *Pteridium* are significantly lower. On the other hand, common weeds such as *Mercurialis annua* (mercury) and *Urtica/Parietaria* (nettle family) have gained importance, and a few pollen grains of the *Triticum* type have been found in almost all samples.

Thus the vegetation around the lake must have consisted predominantly of evergreen oaks during the time of zone 2. *Pistacia* (evergreen mastiche tree and/or deciduous terebint pistache) and *Phillyrea,* often associated with evergreen oaks today, had also become more common. Apparently a *Quercus ilex* forest or its degraded macchia form had developed. A *Quercus ilex* forest is the climax vegetation in this part of the Mediterranean region.

The lower NAP values in zone 2 rule out any farming around the ancient lake. If olive (*Olea*) was cultivated, grasses and other weeds would have been found under the trees, but the increase of the *Olea* percentages coincides with a decrease of the NAP values. Thus *Olea* was either a constituent of the oak woods or was cultivated in the hinterland to a greater extent than before. The same holds true probably for the grapes (*Vitis*). On the other hand, *Mercurialis annua* and *Urtica/Parietaria* most likely indicate disturbances caused by man. A few well-beaten tracks around the lake would probably have been sufficient to allow these common weeds to spread and to produce the stated small quantities of pollen. These changes and the reduction of the *Plantago* and *Pteridium* values indicate a major change of land use and a further reduction of human impact on the vegetation in the crater.

Zone 3 (301–71 cm)
This zone begins above a hiatus, the cause (and length) of which will be discussed later. The pollen diagram shows significant changes:

- much lower values of evergreen oaks (now usually below 15 percent), of *Pistacia* and *Phillyrea* (both mostly below 1 percent), but again more pollen of deciduous trees, mainly of oaks, but also of other genera;
- much increased percentages of a great number of NAP types (maximum 62 percent, average 45 percent);
- the appearance of formerly rare or unrepresented tree species, such as *Pinus, Juniperus* type, *Juglans, Castanea,* and *Platanus.*

Table 16. *Frequency and distribution of rare pollen types (number of grains/depth). If one grain was found in a sample, depth only is given. If the values of a pollen type are included in a summarizing curve, the latter's name is added in parentheses.*

Zone 4	*Knautia arvensis* type 340
Allium vineale type (Liliaceae) 250	*Mentha* type (Lamiaceae) 2/305, 320, 325, 2/330, 335
Armeria/Limonium 250	*Paliurus* 360
Buxus 297	*Pediastrum kawreiskii* 350
Campanulaceae 300	*Polygonum amphibium* type 355
Centaurea montana type 300	*Polygonum bistorta* type 340
Coleogeton (Potamogeton) 10/250	*Polygonum persicaria* type 330
Convolvulus type 250	*Populus* 340
Cryptogramma 2/300	*Prunella* type (Lamiaceae) 2/302, 325
Eupotamogeton (Potamogeton) 275	*Sphagnum* 315, 2/360
Fallopia convolvulus type 292	*Taxus* 360
Mentha type (Lamiaceae) 250	*Viburnum tinus* 320
Paliurus 265	*Viscum* 350, 2/360
Polygonum amphibium type 255	
Polygonum persicaria type 250	**Zone 2**
Populus 2/275	*Allium vineale* type (Liliaceae) 410
Prunella type (Lamiaceae) 300	Boraginaceae 395
Scabiosa type 290, 300	*Botrychium* type 415
Sphagnum 290	*Eupotamogeton (Potamogeton)* 390
Taxus 260, 265	*Knautia arvensis* type 400
	Mentha type (Lamiaceae) 390
Zone 3	*Polygonum bistorta* type 410
Avena type (Cerealia) 302	*Prunella* type (Lamiaceae) 410
Botrychium type 302, 350	*Scabiosa* type 380
Buxus 345	*Sphagnum* 400
Campanulaceae 350	*Valeriana* 390
Centaurea cyanus type 320, 345	
Cercis 330	**Zone 1**
Cistus salviifolius 305	*Cercis* 420
Convolvulus type 330	*Fallopia convolvulus* type 424
Cryptogramma 315	*Hordeum* type (Cerealia) 420
Dipsacaceae p.p. 370	*Mentha* type (Lamiaceae) 424
Euphorbia 345	*Polygonum bistorta* type 424
Euphrasia (Scrophulariaceae) 320	*Prunella* type (Lamiaceae) 420
Genista type (Fabaceae) 320	*Thalictrum* 420
Ilex 360	*Viscum* 420

Indications of human impact on the vegetation are strong in zone 3. All of the NAP types, which appear in the pollen diagram (from Brassicaceae to Poaceae) or are listed in Table 16, may represent weed species. Most of them, such as *Plantago lanceolata*, *Artemisia*, chenopods, *Mercurialis annua*, *Centaurea* sp., Malvaceae, and *Pteridium*, a fern, had been present in the region earlier, but now they could spread.

The spreading of weeds and other nonwoody plants is a result of the destruction of the forests around Lake Avernus. Bare ground is indicated by the spores of two *Anthoceros* species (liverworts). As such soils could easily be eroded, the sedimentation rate in the lake increased. Consequently, pollen concentration drops from about 100,000 pollen grains per ml of sediment in zone 2 to less than 30,000 in zone 3 (Fig. 199).

In addition, weed vegetation producing less pollen than the previous forests contributed to the decrease of pollen concentration. If so, also the relative proportion of pollen of the plant cover of the hinterland must have increased in the pollen precipitation.

After deforestation, the inner slopes of the crater were used as a commercial or industrial area as was the case when Lake Avernus served as a military harbor with a shipyard and other military facilities along its shore. As an industrial area, it would have favored the expansion of weeds.

Fig (*Ficus*) and olive (*Olea*) pollen was low in zone 3, even less than in zone 2, which suggests that they were not cultivated to any extent in the crater area at that time. Pollen of the *Triticum* type, including wheat and a few species of wild grasses, range from 0.1 to 2.5

percent, those of *Vitis* (grape) from 0.5 to 2.8 percent. It is impossible to decide whether the increase of pollen percentages indicates that wheat and grapes were cultivated only in the hinterland or also around the lake. The dense oak woods bordering the lake during the preceding period might have acted as a pollen filter, preventing pollen from the hinterland to reach the lake as suggested by the curve of distantly transported *Fagus* pollen in zone 2. Slight increases of pollen deposition following deforestation of the slopes might therefore merely be the result of a general increase of pollen input from areas beyond the crater rim. Modern pollen percentages of *Triticum* and *Vitis* are similar (Table 17), and since vineyards and gardens surround the lake today, one might assume that grapes were grown near the lake at that time, but not wheat. The six (3 + 3) pollen grains of *Citrus* (lemon or citron) and *Cucumis melo* (melon) registered in the upper part of zone 3 most likely originate from plants cultivated near the lake, as the two species are insect-pollinated.

The total NAP in zone 3 is much smaller (average 45 percent) than that of the recent sample (83 percent, Table 17), although the assemblage of pollen types is similar. Does that mean that extensive areas around the lake did not produce any pollen as they were built up with houses or were bare of any vegetation?

A few remarks must be made on plants that reach high pollen values for the first time in the pollen diagram. *Castanea* and *Platanus*, chestnut and planetree, both introduced tree species, were first cultivated near the lake during the time of zone 3. The *Juniperus* type comprises the pollen of several different tree or shrub species. Pollen of this type might have come from *Cupressus sempervirens* (cypress), an introduced tree species, or from one of the Mediterranean juniper species, possibly *Juniperus oxycedrus*. Cypress would have been planted as an ornamental tree, whereas the light-demanding junipers would have grown on dry or waste land, as on the slopes of the crater. Not damaged by browsing animals, *Juniperus* would have survived there like a weed as long as reforestation was hindered.

Pines (*Pinus*) are indigenous to the coastal area. The famous Gallinaria silva along the shore near Cumae was a pine forest. It was cut at the same time as the woodland around Lake Avernus, when Portus Julius was constructed, to build ships for the Roman navy. A forest of *P. pinea* still exists in the same area according to Fenaroli. Modern pollen values (Table 17) produced by the few pine trees along the road that leads to the lake and others on Monte Nuovo are similar to those of zone 3. This evidence justifies the assumption that a few pine trees grew near the lake at that time. The pine pollen values of zone 2 show just how small the share of pine pollen from the natural stands a few kilometers away was.

Table 17. Percentages of the most common pollen types of a surface sediment sample of Lake Averno.

Woody Plants	
Alnus	7.5
Carpinus betulus	0.5
Castanea	3.5
Citrus	0.2
Corylus	4.8
Erica	3.2
Fagus	0.3
Humulus/Cannabis type	0.7
Juglans	1.3
Juniperus type	2.5
Myrtus	1.0
Olea	7.5
Ostrya/Carpinus orientalis type	1.8
Phillyrea	1.2
Pinus	11.8
Pistacia	1.2
Platanus	0.7
Quercus ilex type	23.9
Quercus pubescens/robur type	21.1
Ulmus	1.5
Vitis	1.5
Nonwoody Plants	
Anthemis type	2.0
Apiaceae	0.7
Artemisia	5.6
Bidens type	1.2
Brassicaceae	5.8
Caryophyllaceae	0.5
Chenopodiaceae/Amaranthaceae	12.4
Cichoriaceae	1.0
Cyperaceae p.p.	2.5
Echium	0.8
Mercurialis annua	3.8
Plantago lanceolata	1.5
Plantago major/media type	0.3
Poaceae p.p.	26.9
Rumex	7.0
Triticum type	0.3
Ferns	
Pteridium	1.2

Modern *Juglans* pollen values are similar to those in zone 3. *Ulmus* pollen was much more frequent. Both tree species probably grew in the crater in antiquity. *Juglans* was desirable for the walnuts. Columella, in the first century after the birth of Christ, recommended planting elm trees (*ulmus*) as fodder and as support for the vines in the vineyards (*RR* 9.2.19). Thus the rise of the elm curve might indicate the establishment of a vineyard at the time of zone 3.

Whether the older of the sediments of zone 3 can

date from the time when Lake Avernus was connected with the sea by a canal and served as a military harbor will be discussed later. If so, the pollen record could easily be explained. It would reflect the much disturbed vegetation of the harbor area with a few ornamental shade and fruit trees and also grapes or even a vineyard probably at the more distant part of the basin.

Zone 4 (250–301 cm)

Zone 4 starts at the lower limit of another layer, which is rich in shells of marine bivalves. Though some pollen curves show rather abrupt changes at the beginning of zone 4, others do not. Therefore it remains unclear whether or not a hiatus exists at this level.

The most conspicuous changes in the pollen diagram are as follows:

- the sudden decline of the curves of juniper type, of *Pinus* and *Platanus;*
- a further lowering of the *Quercus ilex* type values;
- decreasing total NAP, caused by changes in a few pollen curves only;
- a rise of the curves in deciduous oaks, *Pistacia* and *Alnus.*

The disappearance of the light-demanding junipers and pines and of cultivated planetrees when deciduous oaks were spreading and NAP values were decreasing can only mean a considerable reduction, if not the end of human activities in the crater basin. At this time, stands of *Alnus* (alder) developed on the lake shore while *Pistacia* and *Myrtus* (myrtle) formed thickets on the crater slopes, and habitats that supported weeds, such as *Mercurialis annua,* disappeared.

This pattern existed during most of the period of zone 4 except at its very end. The pollen diagram shows remarkable changes in the uppermost two or three samples of this zone. First, the pollen values of some cultivated plants and weeds rise (*Vitis, Triticum* type, *Secale,* Poaceae, *Plantago lanceolata*). Other curves follow at the next (255 cm) level (*Juglans, Olea, Erica, Artemisia, Humulus/Cannabis* type, *Rumex, Typha,* and others). Here the total NAP reaches 72 percent, but it drops to 35 percent in the uppermost sample. Deciduous oaks, *Myrtus, Pistacia,* and, surprisingly, *Castanea,* lost importance during this time. It probably was a short period of intensive land use, contemporaneous with the reoccurrence and temporary dominance of freshwater diatoms in Lake Avernus (Fig. 201). The influence of freshwater was also sufficient to allow plants like *Typha* (cattail) to grow on the shore of Lake Avernus. This phase of reduced salinity and renewed land use must be related to a period of uplift.

The concentration diagram (Fig. 199) offers further evidence. Concentration values are about the same in the lower half of zone 4 as in zone 3, but above 280 cm

all major pollen curves show a synchronous rise. This increase of concentrations is not accompanied by floristic change and therefore signifies a lowering of the annual nonpollen sedimentation rate as usually follows reduced human impact and the closing of the vegetational cover. Pollen concentration dropped again to low values when land use around the lake started anew at the end of zone 4.

DIATOMS

Diatoms are unicellular algae with a silicified cell wall (frustule) composed of two valves, which, under normal conditions, are preserved in the sediments of lakes and oceans and allow species determination in most cases. The results of the diatom analyses are presented in Figures 200–2 and Table 18. Changes in abundance of the diatom species separate the diatom diagrams into six zones, A to F, which are concordant with the pollen zones 1 to 4 (see Fig. 196 and the diagrams).

The frequencies of diatoms and diatom fragments vary greatly throughout the core (Fig. 200). The lowest sample (424 cm, zone A) contains less than 8.4 million diatoms per gram of sediment, which is a very low figure. Diatom concentration is distinctly greater in all

FIGURE 200 Frequencies of diatoms and diatom fragments.

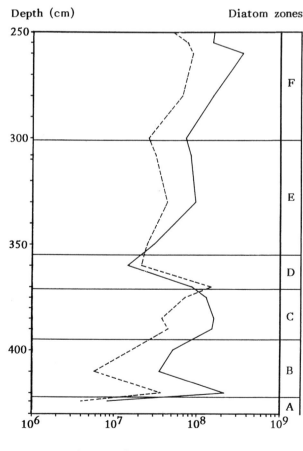

Depth (cm) Diatom zones

―――― Diatom valves per gram sediment
------ Diatom fragments per gram sediment

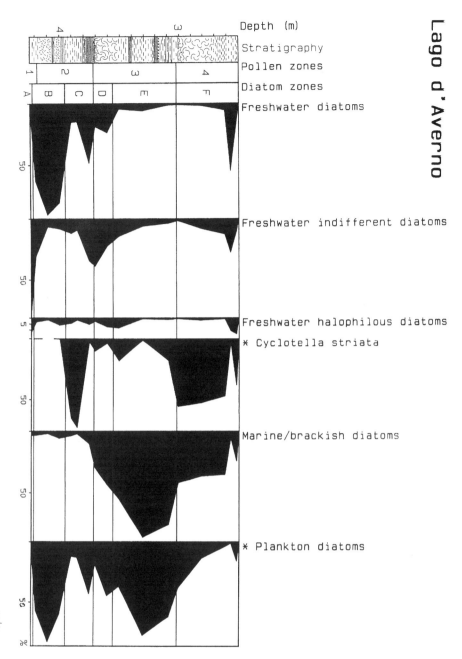

Lago d'Averno

FIGURE 201 Changes of abundance of ecologically different groups of diatoms.

other samples. Ranging from 36 million to more than 220 million in zone B and reaching 165 million in zone C, diatom concentrations decrease to 15 million in zone D but increase again in zones E and F to reach almost 400 million near the top of the core.

The ratio of broken to not broken diatom valves changes throughout the profile. Diatom fragments are much less frequent than complete diatoms in the lower part of the profile up to 390 cm, but to become more numerous in zone C and are most common (more than 150 millions per gram) at a depth of 370 cm, the base of zone D. In zone D more fragments were found than complete valves. Higher up in the profile, the number of diatom fragments decreases considerably, and in most of zones E and F their concentration is again significantly lower than that of complete diatoms.

Many diatom species are excellent ecological indi-

cators. Their occurrence can depend on the trophic status of the available body of water, on water depth, on salinity, and so on. Diatom assemblages in sediments thus reflect former water conditions. To reconstruct changes of salinity of Lake Avernus, freshwater species, freshwater indifferent species that tolerate low salt content, freshwater halophilous species that prefer moderately brackish water, and fully brackish or marine species that occur in water with a higher salt concentration are distinguished (following Kolbe 1927; Hustedt 1927–66, 1937–39; Simonsen 1962).

Figure 201 presents curves summarizing the percentages of the diatom species belonging to these different ecological groups. The figure also shows the curve of a *Cyclotella* species belonging to the difficult *C. striata* complex. Because of its small size (7 to 18 μ) and the number of striae on its valves (16 to 28 per 10 μ), we are most

likely dealing with *Cyclotella hakanssoniae,* as described by Håkansson et al. Like the other members of the *C. striata* complex, *C. hakanssoniae* is a brackish water species. As the species is also reported from streams and rivers, its curve was placed between those of the freshwater halophilous and the brackish/marine species. Figure 201 shows also the percentages of planktonic and benthic or epiphytc diatoms. Floating planktonic species require deeper water, benthic species live in shallow water, and epiphytic diatoms live on algae and plants.

The diatom flora developed as follows (Fig. 202).

Zone A (425–422 cm)

The one sample studied contained few diatoms, mainly freshwater indifferent species, with the most abundant, *Epithemia smithii,* exceeding 20 percent. Other epiphytic species occurring in the littoral include *Epithemia argus, Amphora lybica,* and *Cocconeis placentula.* The group of halophilous diatoms is also represented by littoral species. *Campylodiscus echeneis,* a typical member of the lagoonal flora in the Baltic (Florin 1977), has its greatest abundance (almost 3 percent) in zone A. Freshwater diatom remains are rare, for example, *Achnanthes thermalis* (found also in sulfurous and thermal springs) reaches almost 1 percent only. The little occurrence of only two planktonic species, halophilous *Cyclotella meneghiana* (4.6 percent) and freshwater *C. ocellata* (1.7 percent), suggests a low water level.

Zone B (422–395 cm)

The percentages of freshwater diatoms increase to more than 90 percent, with a dominance of *Cyclotella ocellata* accompanied by *C. iris,* which occurs in this zone only. The percentages of the benthic freshwater species *Navicula subtilissima* increase to 19 percent at 4 m. *Achnanthes thermalis,* which indicates some influence of sulfurous springs, has its maximum value (2.2 percent) at 410 cm. *Campylodiscus echeneis* and most of the other members of the freshwater halophilous group, except *Mastogloia smithii,* diminish in quantity. *Campylodiscus* no longer occurs. The diatom flora of zone A, which indicates shallow, slightly brackish water, has changed to a typical freshwater flora in zone B. Planktonic species represent more than 50 percent of all diatoms in zone B, suggesting a greater water depth.

Zone C (395–371 cm)

In the two lower samples, the littoral *Cyclotella hakanssoniae* dominates with 65 percent and 73 percent, respectively. Higher in zone C, where *C. hakanssoniae* is not dominant, benthic marine *Dimerogramma minor* and freshwater indifferent *Opephora martyi,* which tolerates fairly large salt concentrations, gain importance (15.6 percent). In the uppermost fraction, the freshwater

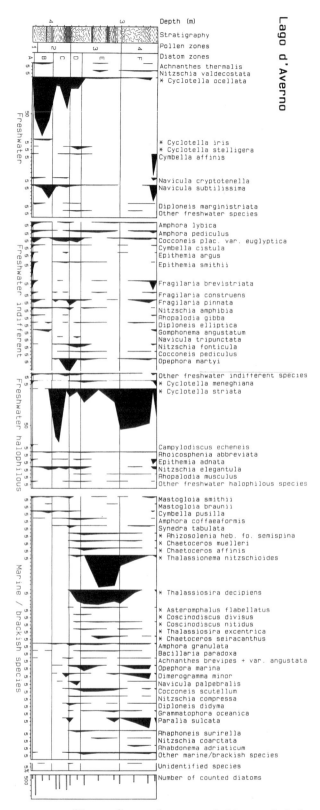

FIGURE 202 Diatom diagram (percentages). Names of planktonic diatoms are marked by an asterisk.

diatom *C. ocellata* becomes most abundant (43 percent), and the curve of *Navicula subtilissima,* another freshwater species, shows the same trend (to 3.6 percent at the 375 cm level). Thus a decreasing influence of salt water is inferred. Salinity was, however, larger than in zone B. The plankton rate continues to be large.

Table 18. Frequency and distribution of rare diatom species (number of specimens).

Zone F	Depth (cm)				
	250	255	260	280	300
Achnanthes conspicua		3			
Achnanthes sp.		1			
Cocconeis pellucida	2			6	2
Coscinodiscus nitidus	2				
Diploneis interrupta	2			1	
Gomphonema angustatum	13				
Gomphonema olivaceum var. staurophorum		17			
Mastogloia pumila	1	3			
Navicula cuspidata	2			1	2
Navicula duerrenbergiana		1	4		
Navicula viridula		6			
Nitzschia vermicularis		1		2	
Synedra ulna	1				
Synedra undulata	1	2	3		
Triceratium repletum	1		1		

Zone E	Depth (cm)		
	308	330	350
Achnanthes conspicua	1		
Cocconeis pellucida	1	1	4
Diploneis interrupta	1		
Navicula duerrenbergiana		1	
Navicula viridula		1	3
Nitzschia constricta		3	
Nitzschia umbonata	1		
Pleurosigma salinarum	1	1	1
Rhabdonema arcuatum	2		2
Sceptroneis caducea	2		
Thalassiosira sp.	1	1	1

Zone D	Depth (cm)	
	360	370
Achnanthes delicatula	1	
Actinocyclus sp.	1	
Aulacosiera cf. juergensi		6
Aulacosiera sp.	3	7
Cocconeis quarnerensis		2
Coscinodiscus divisus	3	
Diploneis smithii		3
Gomphonema insigne	2	
Gyrosigma peisonis	1	1
Mastogloia pumila	1	4
Navicula detenta	1	
Navicula viridula	4	6
Nitzschia scalaris		1
Nitzschia vermicularis	2	4
Synedra hennedyana		1
Thalassiosira sp.	1	

Zone C	Depth (cm)	
	375	385
Achnanthes delicatula	5	
Cocconeis pellucida	3	
Cocconeis placentula		5
Gomphonema insigne	47	6
Gomphonema olivaceum var. staurophorum		2
Navicula cuspidata	1	
Navicula detenta	2	
Navicula mutica	3	
Synedra ulna		1
Synedra undulata	1	

Zone B	Depth (cm)			
	390	400	410	420
Achnanthes conspicua				9
Achnanthes delicatula		1		2
Amphora subcapitata			1	
Anomoeoneis vitrea		1		
Caloneis silicula fo. peisonis			1	1
Cocconeis placentula	2			
Diploneis smithii	2			
Fragilaria capucina				8
Gomphonema angustatum		15	8	
Gomphonema insigne	4			
Mastogloia pumila				6
Navicula cuspidata		2		11
Navicula detenta				1
Navicula pupula				5
Navicula viridula	2			8
Nitzschia sociabilis				8
Nitzschia sp.			1	
Nitzschia umbonata				1
Surirella ovalis				1
Synedra ulna		1		

Zone A	Depth (cm)
	424
Achnanthes conspicua	2
Anomoeoneis sphaerophora	1
Diploneis smithii	3
Fragilaria capucina	6
Navicula pupula	2
Pinnularia borealis	5

Zone D (371–351 cm)

With the beginning of zone D a great number of species belonging to the brackish/marine group appear for the first time, among them marine planktonic species and auxospores of *Chaetoceros. Paralia sulcata,* a marine tychoplankton species with a high tolerance to a low salt concentration, reaches 5.8 percent in the 370 cm sample. At the same level *Opephora martyi* is abundant (16.7 percent). Many marine benthic species occur, the most frequent are *Dimerogramma minor, Diploneis didyma, Navicula palpebralis,* and *Grammatophora oceanica.* The brackish water planktonic diatom *Thalassiosira decipiens* occurs for the first time in the 370 cm sample (1.3 percent). Its values increase to more than 15 percent higher up in zone D. The values of *Cyclotella* cf. *hakanssoniae* remain low (4 percent). Freshwater species are rare. Their values and those of the freshwater indifferent species total to about 20 percent only.

These changes, especially the first occurrence of marine planktonic species, prove the existence of a direct connection of Lake Avernus to the sea. As the heavier salt water flowed in below the freshwater and sank to the bottom of the basin, freshwater diatoms can be found together with brackish/marine species in the sediments. Benthic littoral diatoms, both salt-tolerant freshwater and brackish species, reach higher values than planktonic species. The change of water conditions is also reflected by the comparably low abundance of diatoms per gram of sediment (Fig. 200).

The great number of diatom fragments just above and below the C/D boundary is conspicuous. At the 360 cm and 370 cm levels fragments are even more numerous than intact valves. This abnormality occurs in Lake Avernus within a layer of shells. Great numbers of ostracods known to graze on diatoms were found in this portion of the core, possibly explaining why so many valves are broken.

Zone E (351–301 cm)

A marine diatom flora found optimal growth conditions in the former lake now as the abundance of marine planktonic diatom species like *Thalassionema nitzschioides* (more than 40 percent at the 330 cm level), the large diatom concentrations, and the increase in the number of species from twenty-seven to sixty between the 390 cm to the 350 cm levels indicate. These changes require a fully established connection between the crater and the Mediterranean Sea. Both Lake Lucrinus and Lake Avernus must have been flooded at that time. Typically Mediterranean are the planktonic *Asteromphalus flabellatus* and the auxospores of *Chaetoceros seiracanthus.* Freshwater species are rare, decrease, or disappear in zone E. Surprisingly, the two freshwater thermal/sulfurous species *Achnanthes thermalis* and *Nitzschia valdecostata*

achieve together 3.3 percent at the 330 cm level. This percentage probably indicates that the thermal springs around Lake Avernus were active at this time.

Zone F (301–250 cm)

Decreasing influence of seawater is indicated in this zone. The values of marine planktonic species such as *Chaetoceros* spp., *Thalassionema nitzschioides,* and others decline. Many of these species are no longer found higher up in zone F. On the other hand, several diatom species recorded in zone A are found again in the upper part of zone F.

Cyclotella cf. *hakanssoniae,* unimportant in the preceding zones D and E, dominates again as in zone C, except at the 255 cm level, where its curve temporarily drops to 3 percent. In the other samples its values range between 38 percent and 55 percent. The curves of *Opephora marina, Dimerogramma minor,* and *Paralia sulcata* show a similar pattern. They are interrupted at the 255 cm level. Here the number of freshwater species increases. The curves of *Fragilaria* species and of freshwater diatoms such as *Cymbella affinis* and *Navicula subtilissima* reach maxima at this level (*C. affinis* 28 percent, *N. subtilissima* 22.5 percent). Thus freshwater diatoms are dominant in the 255 cm sample. The uppermost sample, however, shows increased marine influence again, which probably continues into the younger, not yet studied portions of the core. *Nitzschia valdecostata* and *Achnanthes thermalis* are also recorded in zone F. The values of the planktonic species, which slowly decrease throughout zone F, drop to 4 percent in the 255 cm sample. The indicated (first slow, later fast) decrease of water depth must be the consequence of uplift of the surrounding land, by which the inflow of seawater was first diminished and later even interrupted.

Summary

The diatom data from section 3 of core AV 14 K2 allow us to distinguish several phases of changing salinity and water depth in the basin of Lake Avernus. A stage with shallow, slightly brackish water (zone A) was followed by a freshwater lake stage (zone B). Later (zone C) conditions somewhat more brackish than in zone A became established in the basin. Further increase of salinity forces us to assume the existence of a connection with the Mediterranean Sea for zone D. Then continued inflow of salt water (zone E) allowed a rich marine/brackish plankton diatom flora to develop for some time. The inflow of salt water into the crater basin diminished later (zone F). Repeated influence of sulfurous/thermal springs is indicated by two diatom species in zones B, E, and F. Changes of the ratio of planktonic to benthic diatoms reflect changes of the lake level. Periods of changing water

conditions are characterized by low diatom abundances per gram of sediment.

OSTRACODS AND FORAMINIFERA

Ostracods, or "seed shrimps," are tiny marine or freshwater crustaceans enclosed in a pair of hinged chitinous or calcareous shells (valves). Foraminifera are single-celled heterotrophic marine organisms (protists) also enclosed in a calcium carbonate shell (test) that contains one or more chambers. They form chalk or limestone sediments.

A great diversity among the foraminifera and the abundance of foraminifera far exceeding that of ostracods are characteristic of a marine environment. In brackish water, foraminifera are usually less frequent than ostracods. Nevertheless *Ammonia beccarii* (foraminifera) can be the most important, often dominating species in brackish sediments. The ostracod *Cyprideis torosa* is a characteristic and often prevailing member of mesohaline shallow water communities. It forms projections on its valves if salinity decreases below 5‰ (5 parts per thousand).

Freshwater sediments should not contain any foraminifera, while ostracods of the genus *Candona* should be abundant there. Some *Candona* species, however, can live under brackish conditions, as they tolerate a salt content of up to 15‰ (15 parts per thousand).

The results of a qualitative analysis of the foraminifera and ostracods (based among others on the works of Frenzel and Sliter) are shown in Table 19. To facilitate comparisons, the same zonation has been used for ostracods and foraminifera as in the diatom study.

The lowermost sample mainly belonging to zone A contains many valves of *Candona* but no foraminifera. Thus freshwater is indicated. Slight salinity can be deduced for zone B from the occurrence of *Cyprideis torosa* (partly with projections), *Cypridopsis aculeata,* and the first foraminifera shells occurring in the uppermost sample of this zone. Together with *Candona* species and calcified remains of Characeae (green algae), this community points to slightly brackish or freshwater conditions in the crater lake during the time span represented by the deposits of zone B.

Several foraminifera species occur in the sediments of zone C, with a predominance of *Ammonia beccarii.* The valves of *Cyprideis torosa* are smooth. Apparently the water in the crater had become brackish, with a salinity great enough to support bryozoa in the lake. Bryozoa are simple, mostly marine, branching colonies of tentaculate invertebrates, also called "moss animals" from their matlike appearance.

In zone D *Cyprideis torosa* (with smooth valves) was the prevailing ostracod and *Ammonia beccarii* the most

common foraminifera. The lower of the two samples also contained a few shells of the marine *Leptocythere.* The faunal assemblage, dominated by ostracods as in zone C, thus suggests brackish conditions during the time of zone D.

Later (lower part of zone E) an increase of salinity occurred and stable marine conditions were established (upper part of zone E, above 330 cm, and zone F). Brackish water is indicated for part of the period of zone F (at 255–60 cm depth) by the preponderance of *Ammonia beccarii,* the occurrence of *Candona* species, and the low number of foraminifera species.

MOLLUSKS

The mollusks comprise among others the classes Bivalvia and Gastropoda. Bivalves are mostly marine animals with a soft body enclosed by paired, hinged shells (valves); they include clams and mussels. Gastropods are aquatic or terrestrial animals with head, muscular foot, and visceral hump, usually enclosed in a coiled calcareous shell. They include snails and conchs.

Shells of freshwater, brackish, and marine mollusks, gastropods as well as bivalves, were found in zones B to F (no material of zone A was studied). Their frequencies vary greatly within the profile (Fig. 204). Fewer than about fifty shells were found in each 5 cm long portion of zones B and C, in most of zone E, and in the upper part of zone F, the lowest figure (5.5 shells) being reached in zone E. Much greater quantities of shells occurred in the samples of zone D, with up to 1,000 shells, and in the lowermost part of zone F, with more than 500 shells in each of the 5 cm long core sections, that is, in the levels just above the proven (C/D) and the possible (E/F) hiatus.

The freshwater species (Fig. 203) reported here are widespread in Europe and the Mediterranean, where they can be found at places with stagnant or slowly running water. Most of the shells of freshwater mollusks were found in zone B; a few juvenile shells occurred also in samples of zones C, D, and E (Figs. 204, 205). Altogether four shells of Sphaeriidae (Bivalvia), 151 shells of freshwater gastropods, adult as well as juvenile specimens, and 16 shells of the brackish water *Hydrobia* were found in zone B, most of them well preserved.

The shell assemblage of the lowermost sample of zone B (415–18 cm, Fig. 203, Table 20) is the richest in freshwater species and in numbers of specimens. The Sphaeriidae (*Pisidium*) are restricted to this horizon. Species and specimen numbers of freshwater mollusks decrease considerably in the younger parts of zone B. Its uppermost portion (395–99 cm), consisting of sedi-

Table 19. *Distribution of ostracods and foraminifera. The occurrence of* Cyprideis torosa *valves with projections is indicated by* +p. *Otherwise the valves were smooth. The exclamation sign (!) indicates dominance.*

Zones	A	B							C					D			E					F				
Depth (cm) from / to	421/424	416/420	410/415	405/410	406/409	402/404	400/405	395/400	390/395	385/390	380/385	375/380	370/375	365/370	355/365	350/355	340/350	335/340	320/330	300/310	290/300	280/290	270/280	260/270	255/260	255/255
Ostracods							!					!	!	!	!	!										
Freshwater species:																										
Ilyocypris sp.	+	+	+					+																		+
Candona sp.																									++	
Candona parallela			+	+							+															
Candona caudata	+	+																							++	+
Candona angulata	+	+																								
Darwinula stevensonii							+						+													
Brackish water species:																										
Cyprideis torosa		+		+p	+	+(p)	+(p)	+p	+	+	+	+	+	+	+	+				+	+		+			+
Cypridopsis aculeata				+																						
Cypridopsis sp.								+					+							+						
Marine species:																										
Leptocythere pellucida												+													+	
Leptocythere sp.													+	+			+	+				+	+		+	+
Cytherois fischeri																				+						
Cytherura sp.																					+					
Cytheropteron sp.																	+	+	+	+						
Propontocypris sp.																	+		+	+						
Indifferent species:																										
Limnocythere inopinata	+	+				+		+	+	+	+	+	+	+	+	+		+	+	+	+	+		+	+	+
Hirschmannia tamarindus									+	+	++	+	+						+						+	
Loxoconcha impressa																							+			
Loxoconcha sp.							+					+		+				+				+		+		
Aurila convexa														+			+	+	+	+	+		+		+	+
Carinocythereis carinata																	+	+	+							

258

Foraminifera															
Brackish water species:															
Ammonia beccarii	+	++	+	+	+	+	+	+	+	+	++	++	++	++	
Marine species:															
Elphidium macellum	+	+	+	+	+	+	+	+	+	+	+	+			
Peneroplis planatus	+	+	+	+	+	+	+	+	+	+					
Peneroplis sp.	+														
Quinqueloculina seminulum	+	+	+	+	+	+	+	+	+	+	+	+	+		
Triloculina sp	+	+	+	+	+	+	+	+	+						
Spiroloculina sp.	+			+	+	+	+		+	+					
Spirillina sp.	+		+	+	+				+						
Planorbulina mediterranensis	+		+	+	+		+	+							
Discorbis sp.	+		+	+	+		+					+			
Buccella sp.	+	+	+	+	+	+	+	+	+	+	+				
Melonis sp.	+	+	+	+	+	+	+	+	+	+	+				
Glandulina sp.					+					+	+	+			
Bulimina sp.					+		+	+	+	+			+	+	
Vertebralina striata				+											
cf. Nonionella sp.	+		+	+	+	+	+	+	+	+	+	+	+	+	
cf. Stainforthia sp.	+		+	+	+	+	+	+	+	+	+	+	+	+	
cf. Coryphostomum sp.	+							+	+	+	+	+			
cf. Discorbinella sp.		+													
Ecology	mar	bra					marine					mar/bra	brackish	brackish/fresh	fresh

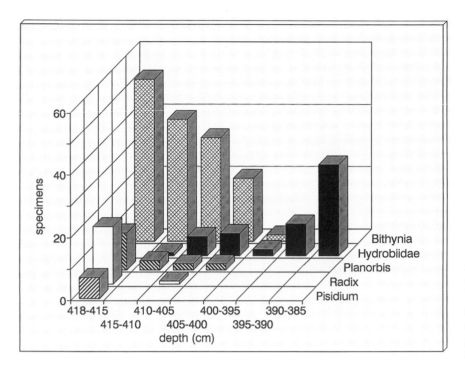

FIGURE 203 Distribution and frequencies of freshwater gastropods. To facilitate comparison not of the actual number of shells but of what a 5 cm long sample would contain is given for the lowest, the 3 cm long sample.

ments deposited during a period of calm sedimentation, is poor in mollusk remains.

The four bivalve shells found in zone B belong to *Pisidium casertanum*, a cosmopolitan species. Unlike all of the other freshwater mollusks from Lake Avernus, *P. casertanum* can live at depths to 40 m below the lake surface, although the preferred habitats are in shallower waters. *P. casertanum* can survive a mean salinity of 0.3 percent. The other freshwater mollusks of Lake Avernus tolerate greater salt concentrations (up to 1.4 percent). Within its genus, *P. casertanum* shows comparatively high resistance to water pollution (Kuiper and Wolff 1970; Piechocki 1989). As shore and water birds spread it easily, the disappearance of *Pisidium* probably indicates that ecological conditions had already turned unfavorable for these mollusks in zone B.

Bithynia leachii is the most common of the freshwater mollusks found in the sediments of Lake Avernus. It is a widespread species occurring in northern Africa as well as in eastern Siberia. The ecological requirements of this species are not very specialized. The species is able to stand extremely low oxygen concentrations, too low for most other freshwater gastropods (Berg and Ockelmann 1959). It also tolerates up to 0.6 percent salt as well as a moderate concentration of hydrogen sulphide (Berg and Ockelmann 1959). *Bithynia leachii* dominates in almost all of the samples of zone B, reaching 50 percent to 90 percent of the total number of gastropods found in each of the 3 cm or 5 cm sections. Most of its shells (70 percent) have the size of Hydrobiidae and come from juvenile animals. Larger shells are more common in the older sediments only. A few

Bithynia shells, of juvenile specimens only, were found in samples from zones C, D, and E.

Two species of Planorbidae (gastropods) occur: *Planorbis planorbis* and *Planorbis* cf. *moquini*. In Europe, *P. planorbis* is widespread, reaching its modern southern limit of distribution south of Naples, whereas *P. moquini* is known as a widely distributed Mediterranean species. Planorbidae possess hemoglobin, which enables them to spread into deeper parts of a lake basin. However, it is unlikely that they are found in large numbers in water deeper than 15 m. The ecology of *P. moquini* is not yet well known. *P. planorbis* tolerates salt concentrations up to 0.4 percent. Most specimens of *Planorbis* occurred in zone B (Table 20), but a few juvenile shells were found in zones D and E (300–10 cm, 350–65 cm).

The large shells of the snail *Radix* cf. *ovata*, up to 2 cm, were found in samples of zone B only. The species is considered as highly adapted to a low oxygen content, to changing water temperatures, and to wave movement. It tolerates a salt content up to 1.4 percent. As a pulmonate (Basommatophora), the snail must live relatively close to the water surface and will unlikely be found living in great numbers more than 5 m below the lake surface.

The occurrence of freshwater mollusk shells in sediments now almost 25 m below the lake surface is baffling and needs an explanation. As the gastropods mentioned here usually do not live in water this deep, it must be concluded either that the level of Lake Avernus was low at the time of deposition of the shells or that we are dealing with allochthonous (foreign) material (taphocoenosis). This means that the mollusks

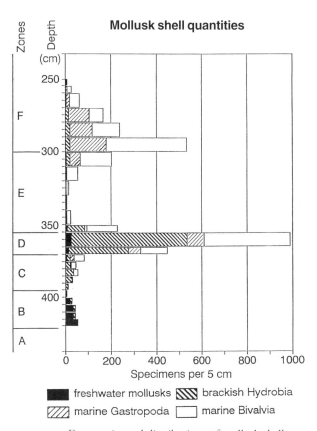

FIGURE 204 Frequencies and distributions of mollusk shells.

FIGURE 205 Mollusk diversity (number of mollusk species).

lived somewhere in areas with shallower water and that their shells were somehow brought together some time after the animals had died.

The characean chalk of zone B is the sediment with the greatest number of freshwater gastropod shells, and like the shells of freshwater mollusks the remains of Characeae (green algae) become less frequent in the younger parts of zone B. Their decrease parallels a change of sediment to a type of fine, laminated gyttja (lake mud). Characeae need light to grow and therefore occur in shallow rather than in deep water. Laminations, on the other hand, are usually preserved only in the deeper parts of the lake basins, especially where microaerobic conditions occur or where a permanent

oxygen deficit exists due to stable stratification. Therefore, the decline of the freshwater gastropod population and of the Characeae in zone B may be related to an increase of water depth and/or a change of water quality. In fact, the fossil record of ostracods and foraminifera indicates freshwater conditions in the initial stage of zone B and increased salinity later on. Also, *Pisidium casertanum*, a species tolerating low salt concentrations (0.3 percent) only, is restricted to the oldest sediments, whereas the *Hydrobia* shells indicating brackish water were found with increasing numbers in the upper sediments of zone B and higher. The great proportion of juvenile gastropods, in other words, the lack of adult specimens in the younger sediments of

Table 20. Freshwater mollusks: species and number of specimens found in zone B.

Depth (cm)	395–400	400–405	405–410	410–415	415–418
Bithynia leachii	2	20	33	39	31
Hydrobia cf. *acuta*	2	7	6	1	
Planorbis planorbis		1	1		3
Planorbis cf. *moquini*		1	1	3	4
Radix cf. *ovata*			1		11
Pisidium casertanum					4
Sum of specimen	4	29	42	43	53

zone B, may also have been caused by increasing salinity or by a decrease of the oxygen content.

The smallest gastropods found in zone B of the Lake Avernus core belong to the Hydrobiidae. Exact determinations within this family require anatomical studies of the animals. In our material we most likely are concerned with the common Mediterranean species *Hydrobia acuta,* which is restricted to brackish water.

The conclusion that water quality started to change during the time of zone B is independent of the possibility that we might be dealing with taphocoenosis.

Shells of brackish water gastropods (*Hydrobia*) occur in almost all samples above 415 cm, that is, from zone B upward (Fig. 204). They are lacking in the oldest sample of zone B and in the 320 to 340 cm section of zone E only. The shells of Hydrobiids are most common in zone D.

The first marine mollusks to occur in our material were Bivalves (Cardioidea), small in size and quantity, found in zone C (Fig. 204, Table 21). Marine bivalves are most common in parts of zones D and F, in samples that are very rich in shells. They were found in zone D together with a large number of brackish *Hydrobia*, some marine and some freshwater gastropods. Marine bivalves and gastropods prevail in zone F, where brackish gastropods are unimportant and freshwater species are missing, but the number of marine mollusks steadily declines in zone F toward the 255 cm level. For this level a strong influence of freshwater is indicated by the diatom, ostracod, and foraminifera records.

Species diversity (Fig. 205) is small in the lower part of the profile. Diversity shows a decline in zone B, when the freshwater phase is ending, but increases with the first occurrence of marine mollusks in the upper part of zone C. It is greatest in zone F. From the earliest occurrence of marine mollusks in zone C, the number of marine bivalve species exceeds that of gastropods up to the first 10 cm of zone F. Above that level gastropod species are more numerous. Species diversity is not always correlated with shell frequencies. Though more than twice the number of mollusk shells was found in the 290–300 cm sample than in the overlying 10 cm of sediment, species diversity is greater at the 280–90 cm level.

Mollusk diversity is small in the uppermost portion of the core at the 250–60 cm level, where most of the shells belong to the genus *Mytilus.* The changes of the aquatic fauna are considerable at this level. They indicate a much reduced marine influence, an increase of freshwater. Thus the small size of the *Mytilus* shells finds its explanation.

Additional marine mollusks and other marine invertebrates (echinoderms, bryozoa, and serpulids) are listed in Table 21. (Serpulids are sedentary polychaete worms that secrete calcareous tubes in which they live.)

DISCUSSION AND CONCLUSIONS

THE AGE OF THE SEDIMENTS

The sediments of Lake Avernus must be less than 3,800 radiocarbon years old, the approximate age of the crater. The two available radiocarbon dates (Alessio et al. 1971; R-591 and R-597), when calibrated, equate to the dates 2282 to 1981 B.C. (Stuiver et al. 1998). Thus the oldest sediments can be dated to the Bronze Age or perhaps younger.

Radiometric determinations on mollusk shells from profile AV 14 K2 yielded unrealistic ages, indicating an age even greater than the age of the crater (350–70 cm: 8560 ± 120 B.P., KI-3564; 290–300 cm: 2700 ± 60 B.P., KI-3563.291; 270–90 cm: 2680 ± 65 B.P., KI-3563.281). The dated shells apparently contained carbon of volcanic origin ("old carbon"). As remains of terrestrial vegetation were not yet found in the lake sediments, we are unable to obtain independent, plant-based carbon-14 data.

For this reason a dating of the Avernus profile can be achieved only by correlating environmental changes deduced from the fossil record with known historical events and with the bradyseismic history of the region.

The changes in the salinity of Lake Avernus indicated by the fossil record are important in this respect. It was found that what was initially freshwater became brackish and later marine (Fig. 206). The period of marine conditions was interrupted by a relatively short period of freshwater in the lake (zone F, 255 cm), when freshwater diatoms and nonmarine ostracods could reinhabit the upper layers of the lake.

Sinking of the land and the construction of a canal that connected the lake with the sea since 37 B.C. are two possible causes of the inflow of salt water into Lake Avernus. Curves illustrating course and intensity of the bradyseismic movements, subsidence as well as uplift, since Roman times have been published by Parascandola (1953) for the Serapeum at Pozzuoli and by Cinque, Russo, and Pagano (1991) for a thermal bath at Misenum. In addition, historical information on the history of Lake Lucrinus, adjacent to Lake Avernus, is available (Parascandola 1947). These sources show that the land was already sinking in Roman times. Subsidence continued into the fifth century A.D. A period of uplift followed during the sixth and part of the seventh centuries (Cinque et al. 1991).

Table 21. *Distribution of macrofossils of marine organisms, fish vertebrae, calcified fragments of Characeae, and pieces of pumice.*

Zone F

250–55 cm:	Small shell fragments only
255–60 cm:	**Bivalves:** *Mytilus* only
	Gastropods: small, undetermined species
	Many small fragments of pumice
260–70 cm:	**Bivalves:** *Mytilus* (many juvenile specimens), *Arca* sp., small shells well preserved, larger ones broken, shells mostly with well-preserved nacreous layer
270–80 cm:	**Bivalves:** *Acmaea* sp., *Ostrea* sp., *Striarca* sp., *Corculum papillosum*
	Gastropods: *Bittium reticulatum*, indet. sp.
	Echinoderms: *Echinocyamus pusillus*
	Other remains: serpulids, incrusting bryozoa, sponge spine
	All remains are of small (juvenile) animals.
280–90 cm:	**Bivalves:** *Arca noae, Chlamys* sp., *Corculum papillosum, Ostrea* (fragment), *Parvicardium* sp., many small shells
	Gastropods: *Bittium reticulatum*, indet. sp.
	Echinoderms: *Echinocyamus pusillus*
	Other remains: serpulids, incrusting bryozoa
	Only a few shells well preserved, most shells badly corroded or broken, some bored by *Cliona*
290–300 cm:	**Bivalves:** *Ostrea* sp. (ca. 2 cm), bored by *Cliona, Cardium* or *Parvicardium*,
	Corculum papillosum, many small shells
	Echinoderms: *Echinocyamus pusillus* (3.5 mm; see Fig. 211), violet spines of sea urchins
	Other remains: *Pomatoceros triqueter* (on several shells) and other serpulids, fragment of a Crustacea claw, encrusting calcareous algae
	Most shells badly corroded, only a few well preserved.

Zone E

300–10 cm:	**Bivalves:** cf. *Arca, Cardium,* or *Parvicardium ovale, Chlamys* sp. (colored, overgrown with serpulids, inner side with grazing traces)
	Gastropods: *Bittium reticulatum*
	Other remains: serpulids
	Remains of small (juvenile) animals only
310–20 cm:	**Bivalves:** *Arcina* (small, very numerous), Cardioidea (many small specimens), small smooth shells (indet.), many very small (juvenile) specimens, one piece of a big shell
	Gastropods: small sculptured shells
	Other remains: serpulids
	Echinoderms: shell fragment and spines of sea urchins
	Other remains: serpulids, sponge spines, calcified fragments of Characeae
	Small fragments of pumice
320–30 cm:	**Bivalves:** Cardioidea, small forms with smooth shells
	Gastropods: *Monodonta turbinata* and other small species
	Echinoderms: several shell fragments and spines of sea urchins
	Other remains: serpulids, sponge spines, skeletal elements of holothurians.
	Small fragments of pumice

330–40 cm:	**Bivalves:** small shells
	Gastropods: small shells
	Echinoderms: shell fragment and spine of a sea urchin
	Other remains: serpulids, sponge spines, numerous vertebrae of fishes, a few calcified fragments of Characeae
	Small fragments of pumice
340–50 cm:	**Bivalves:** small Cardioidea, *Chlamys* sp., small smooth shells, many fragments
	Gastropods: *Bittium* sp.
	Echinoderms: spines of sea urchins
	Other remains: serpulids, calcified fragments, and oogonia of Characeae
	Small fragments of pumice
350–55 cm:	**Bivalves:** many small (2–8 mm), well-preserved shells
	Gastropods: a few small shells (1–2 mm)
	Other remains: oogonia of Characeae

Zone D

355–65 cm:	**Bivalves:** *Cardium* sp. (badly corroded), *Cerastoderma edule* (2.8 cm), *Gourmya* sp., *Mytilus, Ostrea* sp. (inner side overgrown with *Pomatoceros triqueter*), many small undetermined shells
	Gastropods: *Bittium reticulatum* (3 cm), badly corroded shells of undetermined species, opercula
	Other remains: *Spirorbis* sp., calcified fragments of Characeae
	Some shells very well preserved, with nacreous layer, other ones badly corroded.
	Shells of adult and juvenile animals. The biggest shells of the entire core section have been found in this layer.
365–70 cm:	**Bivalves:** *Cardium* sp., *Mytilus* sp., indet. sp. and fragments, well preserved
	Gastropods: *Bittium reticulatum*, opercula, many small shells (1–2 mm)
	Other remains: calcified fragments and oogonia of Characeae
	Many small fragments of pumice

Zone C

370–75 cm:	**Bivalves:** mostly *Mytilus*, small Cardioidea, many shell fragments
	Gastropods: *Bittium* sp.
	Other remains: calcified fragments of Characeae
375–80 cm:	**Bivalves:** small Cardioidea, smooth shells (indet.)
	Gastropods: *Bittium* sp.
	Other remains: vertebrae of fishes, calcified fragments of Characeae
380–85 cm:	**Bivalves:** many small Cardioidea
	Other remains: vertebrae of fishes
385–90 cm:	**Bivalves:** small Cardioidea
	Other remains: calcified fragments and oogonia of Characeae
390–95 cm:	Calcified oogonia of Characeae

Zone B

395–418 cm:	**Gastropods:** opercula
	Other remains: calcified fragments and oogonia of Characeae. The sample consists mainly of Characeae.

Zone A: not studied (Characeae only?)

Sinking started again at the end of the seventh and reached its greatest extent during the ninth and tenth centuries. The maximum uplift occurred during the sixteenth century, when Monte Nuovo was formed. Since then the land has been sinking.

When seawater started to flood the crater, the heavy salt water settled to the bottom and lighter freshwater from springs around the lake formed the uppermost layer of water. The lake became at least partly stratified and from time to time was meromictic (moderately mixed). Remains of animals, such as mollusks, which lived in the bottom of the basin, are therefore the first indicators of increased salinity. Diatoms or animals preferring less salty water would have lived in the upper levels of the lake.

Stratification developed during the period of zone C, but later (zone D) the lake became sufficiently saline so that a rich marine mollusk fauna could develop here for the first time. This change can be related either to the construction of the Roman canal or to one of the two periods of subsidence, which lasted until the fifth and ninth centuries.

Significant amounts of salt water could have flowed into Lake Avernus from Lake Lucrinus at the latest after 37 or 36 B.C., when the construction of the canal between the two lakes was finished. When the levels of the lake and the sea were in equilibrium, salt water could flow into Lake Avernus during periods of high tide. Tidal range in the Gulf of Naples is only 23 cm according to Bundesamt für Seeschiffahrt und Hydrographie in Hamburg (written communication, March 15, 1993). It would nevertheless take only a few months to replace the freshwater of Lake Avernus with salt water, even if the Roman canal was not wider than 5 m and not much deeper than 1 m, the minimum necessary to tow warships through it (Prof. Ellmers, Deutsches Schiffahrtsmuseum, Bremerhaven, written communication, March 4, 1992), and if the inflow of some freshwater from nearby springs continued. The sediments of zone D may therefore date from Roman times.

Cassiodorus (A.D. 490–538) reports that the Via Herculanea was rebuilt by Theodoric soon after being damaged during a seaquake in A.D. 496. This proves that Lake Avernus and Lake Lucrinus had not yet become a bay of the Mediterranean Sea, although subsidence reached a first maximum at this time (Cinque et al. 1991). Subsidence in the ninth century probably opened Lake Avernus to the sea, and this body of water probably was continuous with the sea for several centuries, perhaps until the end of the fifteenth century.

The hiatus between zones 2 and 3 (= C/D boundary) separates periods of highly different intensities of human impact on the vegetation: intact forest in zone 2, but disturbed vegetation and deforestation in zone 3.

At the same time salinity of the lake increased so much that a marine mollusk fauna could develop in the basin.

These facts are in good agreement with the reports of ancient writers, who described the destruction of the sacred grove around the entrance to the underworld and the construction of the military harbor. The crater was probably never more intensely impacted, and the vegetation never more devastated, than during Roman times, especially with the construction and use of the harbor by the Romans and while the thermal bath, the so-called Temple of Apollo, was in use. It is therefore likely that the sediments of zone 3 date from Roman times, a view supported by the fact that the samples of zone 3 (= zones D + E) contain pollen of *Castanea* (chestnut), *Platanus* (planetree), and *Juglans* (walnut). In fact, no pre-Roman section of pollen diagrams from the entire area of the former Roman Empire shows notable pollen values of these taxa.

A further change of vegetation is reflected in the pollen diagram above the 301 cm level (zone 4 = F). Human impact was less intensive during this period than in zone 3 and it seems not to have changed much since then until modern times. With the beginning of the period of much reduced human impact some of the more important arboreal pollen curves (*Platanus, Pinus, Juniperus* type) almost vanished. Assuming a Roman age for the sediments of zone 3, these changes may have happened during the fifth to sixth centuries A.D., a period of much unrest even in the area of the Phlegraean Fields. Barbarian troops pillaged the city of Puteoli in the years 410 (Alaric), 455 (Gaiseric), and 545 (Totila). The city was abandoned and it took ten years before it was resettled after its devastation by Totila. It never reached its former importance again. The same is true for Cumae. During this period subsidence reached a first maximum. It is possible that cultivated tree species like *Platanus orientalis* suffered from increased salinity in the groundwater and died. On the other hand, their almost complete disappearance is highly symptomatic of the changed situation: the former way of life and the former culture had ended. Ornamental trees were no longer favored by man, but had to compete with the natural vegetation, and they lost that struggle.

The assumption that the sediments above the 301 cm level date from post-Roman times is supported by the distinct, though apparently short period of strong influence of freshwater higher in the profile (255–60 cm). Considering the amount of seawater that could enter the basin during the tides, it is evident that a return to fresher conditions was possible only when the inflow of salt water was interrupted, that is, during a period of uplift. Of the two periods of uplift cited by Cinque et al., the older one culminated in the seventh century, whereas the younger one ended with the eruption of

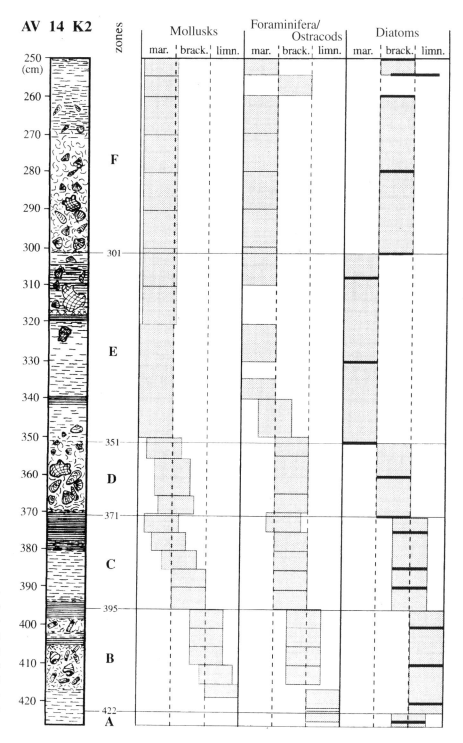

FIGURE 206 Synopsis of the ecological changes of Lake Avernus as indicated by the different groups of fossils. "Mollusks" also include the few other marine organisms listed in Table 21. Thick lines in the diatom section mark the position of the 1 cm thick diatom samples. Abbreviations: mar. = marine, br. = brackish, limn. = limnic.

Monte Nuovo in A.D. 1538. We found Monte Nuovo pumice in several cores from the eastern part of the lake less than 1 m below sediment surface. Considering the depth of the layer to be dated, it is obvious that the freshwater phase must date from the seventh century.

If the marine conditions indicated in zone E would have become established later, during the phase of greatest subsidence in zone E, it would follow that the planetrees and pines around Lake Avernus were not planted in Roman times but during the eighth to eleventh centuries. The lowered salinity of zone F would then have to be attributed to the second period

of uplift. If true, we would also have to conclude that the Roman presence did not affect Lake Avernus and its surroundings to a major extent or that sediments of the Roman period are completely missing. This is most unlikely.

We conclude that zones 3 and 4 (D to F) cover about the first seven centuries after the birth of Christ. If so, and if the gap at the zones 2/3 (= C/D) boundary is not too great, the younger of the underlying sediments (zone 2) must date from the Greek period. More than likely the immigration of the Greeks led to a change of land use in the area. It seems even possible

that human alteration of the vegetation around the lake lessened with the spreading of the belief that Lake Avernus was the entrance to the underworld. Actually, the pollen diagram shows decreased human influence and the establishment of a new type of vegetation in zone 2, namely woods dominated by evergreen oaks (probably *Quercus ilex,* holly oak). Zone 2, we believe, was associated with the Greek and the early Roman periods, until the construction of Portus Julius in 37 B.C. No other possibility exists for any correlation of the vegetational changes occurring below the hiatus with any historic or prehistoric event.

Greek influence in Italy began about 750 B.C., perhaps with the foundation of Cumae. It must have increased considerably toward the sixth century B.C., when Dikaiarchia (Puteoli) was founded. Thus the sediments at the base of zone 2 can be dated from the eighth century B.C. at most.

The age of the basal layers of the profile can be roughly estimated by calculating sedimentation rates. With the presumption that zone 2 covers the Greek period including early Roman times, the sedimentation rate was at least 0.7 mm/a during this period, a low value compared with that of post-harbor Roman times, when the rate was not less than 1.4 mm/a. Annual deposition was small in Greek times because the inner slopes of the crater were wooded at that time and soil erosion was minimal. Accordingly, pollen concentration values are three to four times greater in zone 2 than in any of the overlying layers.

As pollen concentration was somewhat less in zone 1 than in zone 2, the annual sedimentation rate of zone 1 was probably larger. Based on a rate of 1 mm/a, the oldest sediments belonging to pollen zone 1, 0.5 m below, the oldest level shown in the pollen diagram would date from the thirteenth century B.C. or approximately from 3000 B.P.

The lowermost portions of the core AV 14 K2 have not yet been studied. Therefore the beginning of lacustrine sedimentation is unknown. The coarseness of the basal sediments of the profile suggests, however, that the 3800 B.P. limit will not be reached.

When dating the core sequence the possibility of gaps in the profile has not been adequately considered. As the coring point AV 14 K2 is situated on a sub-aquatic slope of about 12 degrees, sliding of sediments downward cannot be excluded.

At the boundary between zones C and D (at 371 cm) the coarse material of zone D rests discordantly upon the well-stratified fine sediments of zone C, indicating a hiatus, also shown by pollen analysis. The sudden occurrence of full grown shells of marine bivalves in zone D is further proof of this hiatus, which clearly covers the time span necessary to establish a marine

fauna in the basin, as sediments of a transitional phase are lacking. Another hiatus seems to exist at the bottom of zone F (= zone 3/4 boundary).

These disturbances may be caused by earthquakes, which occur periodically; only major ones are recorded in the ancient literature. The earthquake of A.D. 62 damaged not only Pompeii and other more distant Campanian cities but also the famous macellum in the nearby city of Puteoli. Possibly the stratigraphic record of sediments in Lake Avernus was also disturbed by it. If this earthquake caused the hiatus at the 371 cm level, the sediments of roughly the first 100 years after the connection of the lake with the sea must be missing. The overlying sediments (zones D + E = 3) would, however, remain of Roman age.

Cinque et al., studying the sediments deposited in the Roman thermal bath of Misenum a few kilometers to the south, found indications of a "crisi sismica" in layers deposited when uplift started again in the fifth century, and Cassiodorus reported a seaquake that destroyed the Via Herculanea in A.D. 496. One of these quakes may have caused the irregularity at the 301 cm level.

Despite the hiatus and the lack of our ability to control the time estimates by radiometric measurements, the agreement between the fossil and the historic records makes the proposed dating most reasonable. We conclude that section 3 of core AV 14 K2 begins with pre-Greek sediments, that it comprises both Greek and Roman times, and that it ends with sediments of the seventh or eighth century, but that some of the Roman sediments are missing.

CHANGES OF THE AQUATIC ECOSYSTEM

Remains of ostracods and of algae such as *Botryococcus, Pediastrum,* and freshwater diatoms found in zone A, together with a fairly large number of diatom species that tolerate low salinity, indicate that Lake Avernus was a freshwater lake with a low salinity in the beginning (Fig. 206). Salinity was caused by electrolytes provided by springs in the crater, probably not by the sea. The diatom flora also indicates that the lake was shallow (Fig. 201), whereas the contemporary sediments are now 24.5 m below the lake surface.

The sediments of the lower part of zone B, yellow to white lake chalks, contain numerous calcified tubes and oogonia of Characeae (Figs. 207–10, 215, 216), many shells of freshwater gastropods (Figs. 215–18), and freshwater diatoms. Salt-tolerant diatoms are rare, but ostracods and mollusks indicate a slight but increasing saline influence, which was probably restricted to the deeper

parts of the lake basin, the hypolimnion. The lake was deeper now, but nevertheless well aerated.

Salinity continued to increase so that the lake became brackish in zone C, where all groups of fossils of aquatic organisms indicate the growing influence of salt water (Fig. 206). Starting with zone B, this must be a consequence of progressing bradyseismic subsidence of the low-lying land south of Lake Avernus in Greek and early Roman times, which made seeping and episodic overflow of seawater into the crater basin possible. Even a few small shells of marine mollusks were found in zone C. The occurrence of the first marine mollusks is also reflected by the start of the aragonite curve in this zone (Fig. 197). The much increased values of organic carbon and sulfur and the partly lami-

nated sediment is evidence of a stagnant hypolimnion and microaerobic to anaerobic bottom waters.

The coarse and graded sediments of zone D are poor in sulfur and organic carbon and contain numerous, mostly rounded pieces of pumice in the lower part of the section. These sediments also contain fossils of different environments: marine bivalves, gastropods, and diatoms, brackish gastropods, foraminifera and ostracods, freshwater Characeae, gastropods and diatoms (Figs. 213, 214). Obviously a mixing of sediments of different origin has occurred. The bivalve shells are from adult as well as juvenile animals. Some are well preserved, others much corroded. The occurrence of epibiontic taxa, corrosion, and borings prove that some of the shells were

FIGURE 207 A slightly calcified Characean tube, indicating carbonate-rich shallow freshwater, 405–18 cm core depth (zone B); scale: 1 mm.

FIGURE 208 A half tube of a more intensively calcified Characean tube, 405–18 cm core depth (zone B); scale: 1 mm.

FIGURE 209 An intensively calcified Characean tube with diatoms on and within the calcareous crust, 405–18 cm core depth (zone B), scale: 1 mm.

FIGURE 210 Detail of a limestone crust on a Characean tube with trapped diatoms, 405–18 cm core depth (zone B); scale: 100 μ.

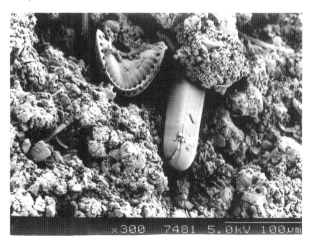

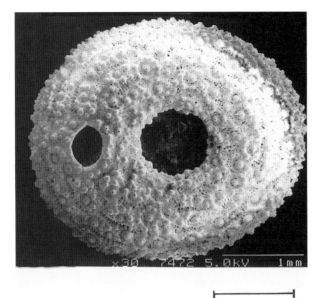

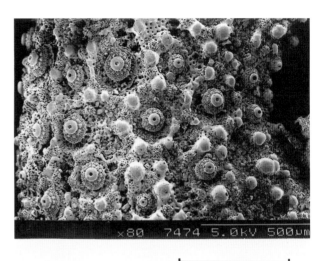

FIGURE 211 The shell of a small irregular endobenthonic sea urchin (*Echincyamus*), 280–90 cm core depth (zone F); scale: 1 mm.

FIGURE 212 Detail of the shell in Figure 211; scale: 500 μ.

FIGURE 213 Shells of marine benthonic organisms, partly broken, corroded, and overgrown by serpulids, 355–65 cm core depth (zone D); scale: 1 cm.

FIGURE 214 Shells of marine benthonic organisms, mostly broken, and some shells of (allochthonous) freshwater gastropods, one piece of a calcified Characeaen tube (allochthonous), 365–70 cm core depth (zone D); scale: 1 cm.

exposed for some time at the sediment surface. The plankton percentage was low, and the benthic littoral diatom species were abundant. Most of the diatom valves and most of the shells in the deepest sample of zone D (and in the uppermost one of zone C) were broken.

The hiatus at the base of zone D, the mixed fauna and flora, and the "chaotic" layering of its sediments are most likely the result of sliding and mixing of sediments due to an earthquake or volcanic phenomena,

which usually accompany bradyseismic movements. A short time before this happened, man had disturbed the sedimentation processes, especially along the southern and western shores where military buildings and the tunnel were constructed. The shoreline, only 100 to 500 m from our coring site, must have been the main dumping area for rock debris from the excavation of the tunnel to Cumae and the other construction sites. The numerous pieces of pumice at the base of zone D are probably some of the excavated debris. The fresh-

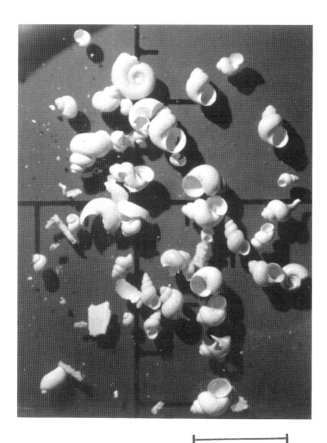

FIGURE 215 Shells of freshwater gastropods, some calcified Characean tubes, indicating carbonate-rich shallow freshwater, 405–10 cm core depth (zone B); scale: 1 cm.

A calcified Characeae oogonium, 405–18-cm core depth (zone B); scale: 500 μ.

FIGURE 217 Shells of freshwater gastropods, some calcified Characean tubes, indicating carbonate-rich freshwater, 410–15 cm core depth (zone B); scale: 1 cm.

FIGURE 218 Partly broken shells of freshwater gastropods, 415–18 cm core depth (zone B); scale: 1 cm.

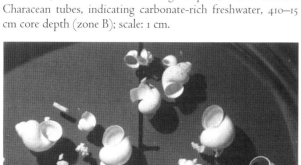

FIGURE 216 A calcified Characeae oogonium, 405–18-cm core depth (zone B); scale: 500 μ.

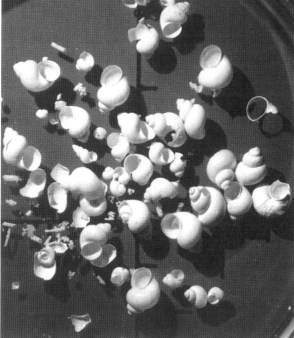

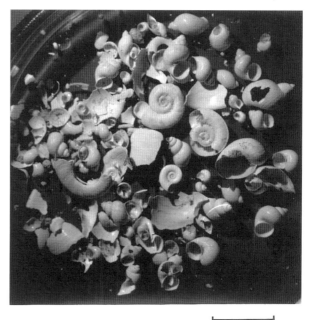

FIGURE 219 Mostly broken shells of marine benthonic mollusks (nearly exclusively of *Mytilus*, one sculptured venerid mollusk), 260–70 cm core depth (zone F); scale: 1 cm.

FIGURE 220 Mostly well-preserved marine benthonic mollusks, 270–80 cm core depth (zone F); scale: 1 cm.

FIGURE 221 Well-preserved, corroded, and broken shells of marine benthonic mollusks (upper left: with the circular bore holes of the sponge *Cliona*), 280–90 cm core depth (zone F); scale: 1 cm.

FIGURE 222 Well-preserved, intensively corroded, or broken shells of marine benthonic mollusks, one broken spine of a sea urchin, and one broken tube fragment of a branched serpulid, 290–300 cm core depth (zone F); scale: 1 cm.

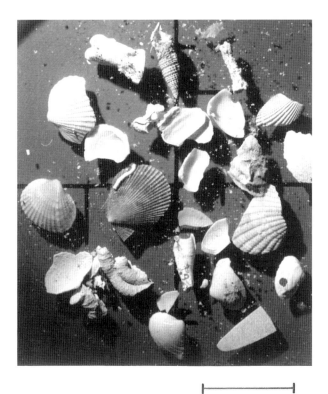

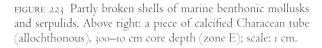

FIGURE 223 Partly broken shells of marine benthonic mollusks and serpulids. Above right: a piece of calcified Characean tube (allochthonous), 300–10 cm core depth (zone E); scale: 1 cm.

FIGURE 224 Mostly broken shells of marine benthonic mollusks and some small shells of freshwater gastropods (allochthonous), 350–55 cm core depth (zone E); scale: 1 cm.

water faunal and floral remains must originate from sediments deposited near the shore, where freshwater flowed into the lake, but they were disturbed and reworked during the construction of the Roman port and other installations. Somewhat later, an earthquake made sediments slide, thus causing the hiatus and the mixing of the sediment. The simultaneous occurrence of species from ecologically different habitats thus finds an easy explanation.

When construction was finished, or at the latest when the military harbor was abandoned, sedimentation normalized, as is indicated by the finer and slightly to well-stratified sediments of part of zone E. The dominance of marine planktonic diatoms and the existence of other fossils prove that truly marine conditions existed during the period of zone E (Figs. 206, 223, 224). The few calcified fragments and oogonia of Characeae and the few specimens of freshwater and brackish gastropods probably come from freshwater lenses next to springs along the shore of Lake Avernus.

Another hiatus may exist at the upper end of zone E (= 3/4 boundary). No mixing of sediment from areas of different salinity is apparent and no pieces of pumice have been found here, probably as man had not disturbed the process of sedimentation just before the hiatus was caused.

Mollusks and foraminifera found in zone F prove a strong marine influence for most of this time (Figs. 211, 212, 219–22). The diatom diagram, however, shows declining values of marine planktonic species, thus indicating shallower water and the increasing importance of freshwater halophilous species. The 255 cm diatom spectrum is even dominated by freshwater species. Ostracods and foraminifera of the adjacent sample indicate brackish conditions. Freshwater from springs in the crater had apparently spread above the heavier salt water, but even in the deeper parts of the lake ecological conditions were no longer favorable for marine organisms, as the small size of the shells (predominantly *Mytilus*) indicates. The connection of the crater with the sea must have been interrupted at this time due to the bradyseismic uplift of the land. Judging from the thinness of its sediments, this freshwater phase can have lasted for a short period of time only (during the seventh century as we concluded earlier).

HUMAN IMPACT ON THE VEGETATION

The pollen record covers roughly the past 4,000 years. It shows that woods dominated by *Quercus ilex*, the assumed climax vegetation (Tomaselli 1970), were present in the area only during Greek and early Roman times and that they were secondary forests.

Human impact on the vegetation is evident in the

pollen diagram for all the time covered by section 3 of core AV 14 K2, that is, from pre-Greek times to the seventh or eighth centuries. Human impact was insignificant during Greek and early Roman times (zone 2). It was more intensive, but still weak during the preceding pre-Greek period (zone 1), and highly destructive when the area was used by the Roman military, beginning in 37 B.C. Later impact intensity declined somewhat, but it certainly did not end as long as the Roman bath was in use on the lake's shore (zone 3). Intensity of land use was less in post-Roman times, probably as cultivation was more and more impaired by rising water level and perhaps also by increasing salinity, both consequences of the sinking of land (zone 4). When uplift started later during zone 4, freshwater replaced the seawater in the basin more and more and land suitable for cultivation reemerged. The pollen diagram shows distinctly that man took advantage of the changing conditions at once and began cultivation into the basin again.

ACKNOWLEDGMENTS

We are grateful to Wilhelmina F. Jashemski for her enthusiastic support of our work; to our colleagues from the University of Naples – Tullio Pescatore, Filippo Russo, and Massimo Ricciardi – for arranging our stay at Lake Avernus, for valuable information on the geology and vegetation of the area, and for helpful discussions; to cavaliere Giuliano Pollio, the owner of the lake, for kindly permitting our work on the lake and for providing space for a camp on the lake shore; to Markus Herrmann and Volker Ratmeyer for their assistance in the field; and to Horst Willkomm for providing radiocarbon determinations. The work was carried out with financial support of the National Geographic Society of Washington, D.C. (grant to W. Jashemski), and of the German Science Foundation (grant to J. Schneider). We are indebted to many people for help with the laboratory work, namely H. Bartens (pollen), R. Mast (diatoms), H. Schuster (sediment analyses), M. Ghorbani, G. Lemcke, C. Ohlendorf, and D. Barnikol-Schlamm (sorting of macrofossils). C. Kaubisch and C. Wernström provided some of the drawings. V. Wiese helped with the determination of the freshwater gastropods. M. Schaefer gave advice concerning the ecology of Hydrobiidae. Parts of the English manuscript have been corrected by A. G. McKay, L. Bull, G. Watson, and F. Meyer.

REFERENCES

Alessio, Marisa, F. Bella, S. Improta, G. Belluomini, C. Cortesi, and B. Turi. 1971. "University of Rome Carbon-14 Dates IX." *Radiocarbon* 13: 395–411.

Behre, Karl-Ernst. 1990. Some Reflections on Anthropogenic Indicators and the Record of Prehistoric Occupation Phases in Pollen Diagrams from the Near East. In *Man's Role in the Shaping of the Eastern Mediterranean Landscape,* edited by Sytze Bottema, G. Entjes-Nieborg, and Willem van Zeist, pp. 219–30. Balkema, Rotterdam.

Berg, Kaj, and K. W. Ockelmann. 1959. "The Respiration of Freshwater Snails." *Journal of Experimental Biology* 36: 690–708.

Cholnoki, Bela Jenoe. 1968. *Die Ökologie der Diatomeen in Binnengewässern.* J. Cramer, Weinheim.

Cinque, Aldo, Filippo Russo, and Mario Pagano. 1991. "La successione dei terreni di età post-romana delle Terme di Miseno (Napoli): nuovi dati per la storia e la stratigrafia del bradisisma puteolano." *Bollettino della Società geologica italiana* 110: 231–44.

D'Arms, John H. 1970. *Romans on the Bay of Naples. A Social and Cultural Study of the Villas and Their Owners from 150 B.C. to A.D. 400.* (Loeb Classical Monographs) Harvard University Press, Cambridge, Mass.

Del Castillo, Alessandro Oliveri, and Ernesto Percopo. 1963. "Rilevamento topografico del fondo del Lago d'Averno." *Bollettino della Società dei Naturalisti in Napoli* 72: 237–48.

Di Fraia, G., and V. Gaudino. 1982. Il Lago di Lucrino e il Porto Giulio nel periodo romano. *Atti del 1. Convegno dei Gruppi Archeologici della Campania, Pozzuoli 1980:* 3–13.

Fabri, Régine, and Louis Leclerq. 1984. Etude écologique des rivières du nord du massif Ardennais (Belgique). *Flore et Végétation des Diatomées et physico-chimie des Eaux* 1: 1–379. Robertville Station scientifique des Hautes-Fagnes, Bruxelles.

Fenaroli, Luigi. 1970. "Note illustrative della carta della vegetazione reale d'Italia." *Collana Verde* 28: 1–127.

Florin, Maj-Britt. 1977. "Late-Glacial and Pre-Boreal Vegetation in Southern Central Sweden. II. Pollen, Spore and Diatom Analysis." *Striae* 5: 1–60.

Follieri, Maria. 1987. L'agriculture des plus anciennes communautés rurales d'Italie. In *Premières Communautés paysannes en Méditerranée occidentale,* edited by Jean Guilaine, Jean Courtin, Jean-Louis Roudil, and Jean-Louis Vernet, pp. 243–7. Centre National de la Recherche Scientifique, Paris.

Frederiksen, M. W. 1959. "Puteoli." In *Paulys Realencyclopädie der classischen Altertumswissenschaft* 23 (2), edited by Konrat Ziegler, pp. 2035–59. Stuttgart.

Frederiksen, Martin. 1984. *Campania.* British School in Rome, Rome.

Frenzel, P. 1990. Die rezenten Ostracoden in den tieferen Teilen der Boddengewässer Vorpommerns. Universität Greifswald, unpublished *Seminary Report,* p. 25, Greifswald.

Giacomini, Valerio, and Luigi Fenaroli. 1958. *La Flora. Conosci l'Italia* 2, Touring Club Italiano, Milan.

Guilaine, Jean. 1976. "Premiers bergers et paysans de l'occident méditerranéen." *Civilisations et Sociétés* 58: 1–286.

Håkansson, Hannelore, Susanna Hajdu, Pauli Snoejis, and Ludmila Loginova. 1993. "*Cyclotella hakanssoniae* Wendker and Its Relationship to *C. caspia* Grunow and Other Similar Brackish Water *Cyclotella* Species." *Diatom Research* 8: 333–47.

Hopf, Maria. 1991. South and southwest Europe. In *Progress*

in Old World Palaeoethnobotany, edited by Willem van Zeist, Krystyna Wasylikowa, and Karl-Ernst Behre, pp. 241–77. Balkema, Rotterdam.

Hustedt, Friedrich. 1927–66. Die Kieselalgen Deutschlands, Österreichs und der Schweiz mit Berücksichtigung der übrigen Länder Europas sowie der angrenzenden Meeresgebiete. *Rabenhorst's Kryptogamen-Flora 7,* Teil I, II, und III. Leipzig.

　1937–9. "Systematische und ökologische Untersuchungen über die Diatomeen-Flora von Java, Bali und Sumatra. Systematischer Teil." *Archiv für Hydrobiologie* Supplement 15: 130–506; II. "Allgemeiner Teil." *Archiv für Hydrobiologie* Supplement 15: 638–790, 16: 1–394.

Kolbe, Robert Wilhelm. 1927. "Zur Ökologie, Morphologie und Systematik der Brackwasser-Diatomeen. Die Kieselalgen des Sperenberger Salzgebietes." *Pflanzenforschung* 7: 1–146.

Krammer, Kurt, and Horst Lange-Bertalot. 1986. Bacillariophyceae, 1. Teil: Naviculaceae, 876 S. (= Ettl, Hanuš, Johannes Gerloff, Hermann Heynig, and Dieter Mollenhauer, eds.): *Süßwasserflora von Mitteleuropa 2/1a.* Jena.

Kuiper, J. G. J., and W. J. Wolff. 1970. "The Mollusks of the Estuarine Region of the Rivers Rhine, Meuse and Scheldt in Relation to the Hydrogeography of the Area." III. The Genus *Pisidium. Basteria* 34: 1–34.

Lirer, L., G. Rolandi, M. Di Vito, and G. Mastrolorenzo. 1987. "L'eruzione del Monte Nuovo (1538) nei Campi Flegrei." *Bollettino della Società geologica italiana* 106: 447–60.

Maiuri, Amedeo. 1958. *Die Altertümer der Phlegräischen Felder.* Führer durch die Museen und Kunstdenkmäler Italiens. Nr. 32:1–181, 3. Auflage. (English edition: *The Phlegrean Fields.* In *Guidebooks to Museums and Monuments in Italy.* Rome.

Müller, German, and Jens Müller. 1967. "Mineralogisch-sedimentpetrographische und chemische Untersuchungen an einem Bank-Sediment (Cross-Bank) der Florida Bay, USA." *Neues Jahrbuch für Mineralogie, Abhandlungen* 106: 257–86.

Pagano, Mario, Michel Reddé, and Jean-Michel Roddaz. 1982. "Recherches archéologiques et historiques sur la zone du Lac d'Averno." *Mélanges de l'Ecole française de Rome* 94: 271–323.

Pallotino, Massimo. 1987. *Italien vor der Römerzeit.* C. H. Beck, Munich.

Parascandola, Antonio. 1947. "Il Monte Nuovo ed il Lago d'Averno." *Bollettino della Società dei Naturalisti in Napoli* 55 (1944–6): 151–305.

　1953. "Ulteriori osservazioni sul Serapeo di Pozzuoli." *Bollettino della Società dei Naturalisti in Napoli* 61: 97–110.

Peragallo, H. 1897–1908. *Diatomées marines de France et des Districts maritimes voisins.* Grez-sur-Loing.

Piechocki, Andrzej. 1989. "The Sphaeriidae of Poland (Bivalvia, Eulamellibranchia)." *Annales zoologici* 42: 249–320.

Ridgway, David, and Francesca R. Ridgway. 1979. *Italy before the Romans.* Academic Press, London.

Rosi, M., and A. Sbrana. 1987. "Phlegrean Fields." *Quaderni de "La ricerca Scientifica"* 114/9, 1–168.

Salden, Norbert. 1978. "Beiträge zur Ökologie der Diatomeen (Bacillariophyceae) des Süsswassers." *Decheniana, Beihefte* 22: 1–238.

Sbordone, Francesco. 1984. Averno. In *Enciclopedia Virgiliana 1,* edited by Francesco Della Corte. Istituto della Enciclopedia Italiana, Rome.

Simonsen, Reimer. 1962. "Untersuchungen zur Systematik und Ökologie der Bodendiatomeen der westlichen Ostsee." *Internationale Revue der gesamten Hydrobiologie, Systematische Beihefte* 1: 1–144.

Sliter, William V. 1980. "Studies in Marine Micropaleontology and Paleoecology." *Cushman Foundation for Foraminiferal Research, Special Publication.* 19: 1–300.

Stockmarr, Jens. 1971. "Tablets with Spores Used in Absolute Pollen Analysis." *Pollen et Spores* 13: 615–21.

Stuiver, Minze, Paula J. Reimer, Edouard Bard, J. Warren Beck, G. S. Burr, Konrad A. Hughen, Bernd Kromer, Gerry McCormac, Johannes van der Plicht, and Marco Spurk. 1998. INTCAL98 Radiocarbon Age Calibration, 24,000–0 cal B.P. *Radiocarbon* 40: 1041–83.

Tomaselli, R. 1970. "Note illustrative della Carta della vegetazione naturale potenziale d'Italia." *Collana Verde* 27: 1–64.

FISH

EVIDENCE FROM SPECIMENS, MOSAICS, WALL PAINTINGS, AND ROMAN AUTHORS

David S. Reese

INTRODUCTION

Fish were very important in the life of the ancient Campanians, but unfortunately little actual evidence has been retrieved in the excavations. Early excavation reports for Pompeii refer to finding fish bones, but these were not saved or identified. For example, G. Fiorelli (1873: 172) found fragments of ceramic and glass containers containing the remains of cooked fish, as well as several amphorae producing fish bones, and the 1879–80 excavations in the rectangular pool of the House of the Centenary also recovered fish bones (Mau *Bdl.* 1881: 169–71), but actual preserved fish bones from the older excavations are very rare. Anchovy bones (P. inv. no. 12963) found in the 1960 excavation of a *garum* shop (I.xii.8) are the only bones whose context is certain. The find spot of the largest fish bone sample (P. inv. no. 18072) is unknown, but it too may be from this shop.

OLDER SAMPLES OF FISH BONES PRESERVED AT POMPEII

P. inv. no. 10137 One large flying gurnard (*Dactyl-opterus volitans*) bone (Fig. 232) In House II.ii (I.vii = old number) (1953, near the pavilion over the fish pool, P. inv. no. 10138)

P. inv. no. 12963 Bag of anchovy (*Engraulis encrasicolus*) bones including 82 neurocrania (Fig. 233) I.xii.8 (1960, inv. no. A IV 2a)

P. inv. no. 18072 Wooden box of anchovy bones including 147 neurocrania Context unknown (inv. no. SN 576)

P. inv. no. 18084B Fish bones in vessel; vessel has diameter of 13.3 cm Context unknown

P. inv. no. 18085B Fish bones in vessel, small sample Context unknown

Recent excavations at the House of Amarantus (I.ix.11–12) have produced fish bones under study by Alison Locker. I thank her for allowing me to include her preliminary identifications here.

Fish were raised in fishponds in Pompeii and its vicinity. There are fishponds in various houses in Pompeii: House of Meleagro (VI.ix.2; 1st c. B.C.), House of Gavius Rufus (VII. ii.16; 1st c. B.C.), House of the Colored Capitals (VII.iv.35/51; 2nd–1st c. B.C.), House VIII.ii.14 (late 1st c. B.C.) (Fig. 225), and House of Julia Felix (II.iv). There are also fishponds in the Villa of Diomede just northwest of Pompeii, in the Palaestra at Herculaneum (II.iv), in the Villa of the Papyri, to the northwest of Herculaneum (1st c. B.C.), and in the *villa maritima* of Pausilypon on the north shore of the Bay of Naples (late 1st c. B.C.). Roman Italian fishponds have recently been studied by J. Higginbotham (1997).

More information regarding the Pompeii area fish come from mosaics and wall paintings than from the preserved bones. Although these examples may be derived Hellenistic stereotypes, the animals portrayed are those still found in the Pompeii area. The illustrated fish may have been chosen because they were the

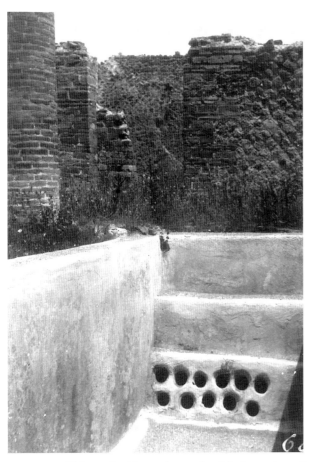

FIGURE 225 Fish pool with amphorae for fish in garden of Pompeii, House VIII.ii.14 of the late 1st century B.C. Photo: T. Warscher.

most interestingly colored or interestingly shaped. One significant food fish, the tunny, is not seen in any mosaic or painting. This omission is probably because most of the animals pictured in mosaics are in shallow water, or near a rocky line; the paintings show mainly fish that could be raised in fishponds. The tunny is found in deeper open waters.

During the early excavations many mosaics and wall paintings were removed from their original sites and taken to the Museum in Naples. Unfortunately, paintings left on the walls and exposed to the elements have badly faded and in some cases have completely disappeared. Some mosaics are also badly damaged or no longer in existence. Descriptions of the early scholars or drawings made at the time of excavation are sometimes our only evidence.

Marine animals are portrayed either in their natural environment or in a still life. Two large mosaics from Pompeii now in the Naples Museum that picture a large number of fish in a marine environment have been much studied. One (NM inv. no. 9997) (Figs. 226, 227) came from the triclinium (dining room) to the left of the tablinum in the House of the Faun (VI.xii.2). The provenance of the second mosaic (NM inv. no. 120177) (Figs. 228, 229) is uncertain, but it is commonly believed to have come from House VIII.ii.16. The two mosaics have certain similarities. Both feature in the center a violent fight between a spiny lobster and the octopus attacking it, surrounded by many marine animals (not all depicted at the same scale). Leonard (1914) was the first to study the Naples mosaics in his book on the mosaics in the House of the Faun. O. Keller (1913) identified those in the other mosaic. A. Palombi (1950) was the first to give an identification of the marine fauna in all the Pompeian mosaics and paintings. More recently T. E. Thompson (1977), P. G. P. Meyboom (1977), and L. Capaldo and U. Moncharmont (1989) have given identifications of the marine fauna in the two large mosaics. Although the fish are carefully depicted, the lack of details not possible in mosaic but necessary in some cases to make a definite identification, the damaged portions in the mosaics, and even artistic license make it inevitable that there is not total agreement among these authors as to the marine animals depicted, as will be pointed out.

Paintings, too, show fish in bodies of water. In the House of the Centenary (IX.viii.3/6), the parapet encircling the four walls of the garden nymphaeum, interrupted only by the large mosaic fountain on the south wall and the large door on the north, was dramatically painted to represent a body of water filled with all manner of marine animals. Excavated in 1879, it was in a bad state of preservation when Palombi identified the animals in 1950. A narrow painting around the walls of the little room to the south of the vestibule in the House of the Vetti pictured marine animals swimming in a body of water (Fig. 230). A well-stocked fishpond pictured in the garden painting of the Villa of Diomede, just outside the Herculaneum Gate, is no longer in existence and is now known only from a drawing (Fig. 231).

Evidence for fishing also comes from the bronze fish hooks and lead weights found in the area of the ancient port of Pompeii, at Pompeii itself (Jashemski 1979: Fig. 150), and from the fishing nets found at Pompeii (Radcliffe 1921: 235 n.1) and Herculaneum (Deiss 1966: 102).

CATALOGUE

In the catalogue that follows, the fish are arranged under their family name in alphabetical order (with a few exceptions, i.e., eels, sharks, and rays).

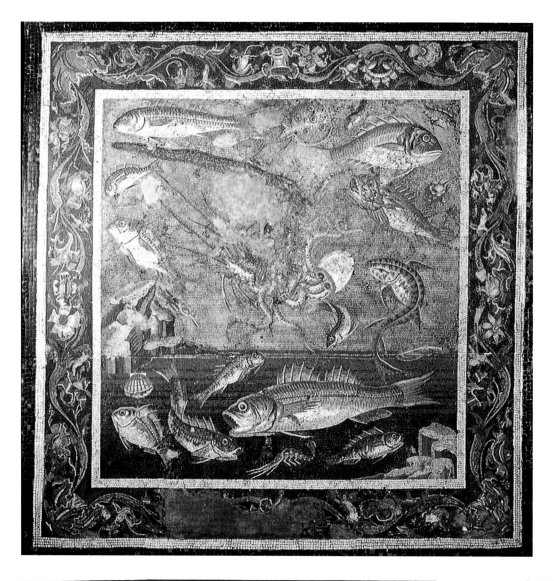

FIGURE 226 *(Above)* Large fish mosaic from the House of the Faun (VI.xii.2), Pompeii (NM inv. no. 9997).

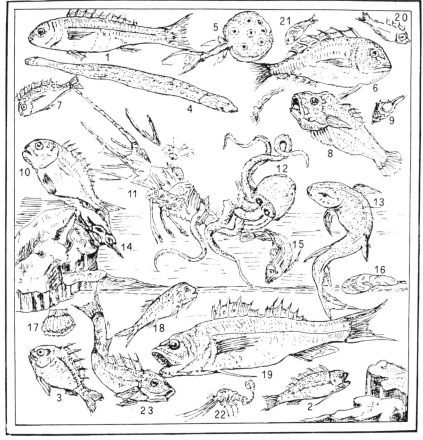

FIGURE 227 Key to fish mosaic from the House of the Faun, Pompeii: 1. *Liza aurata*; 2. *Serranus cabrilla*; 3. *Diplodus vulgaris*; 4. *Muraena helena*; 5. *Torpedo torpedo*; 6. *Sparus auratus*; 7. *Pagrus pagrus*; 8. *Scorpaena scrofa*; 9. *Murex brandaris*; 10. *Dentex dentex*; 11. *Palinurus vulgaris*; 12. *Octopus vulgaris*; 13. *Scyliorhinus stellaris*; 14. *Alcedo atthis* (bird); 15. *Trigla* sp.; 16. Penaeidae; 17. *Pecten jacobaeus*; 18. *Mullus barbatus*; 19. *Dicentrarchus labrax*; 20. *Diplodus sargus*; 21. *Diplodus annularis*; 22. *Leander* sp./*Palaemon* sp.; 23. *Trigla* sp.

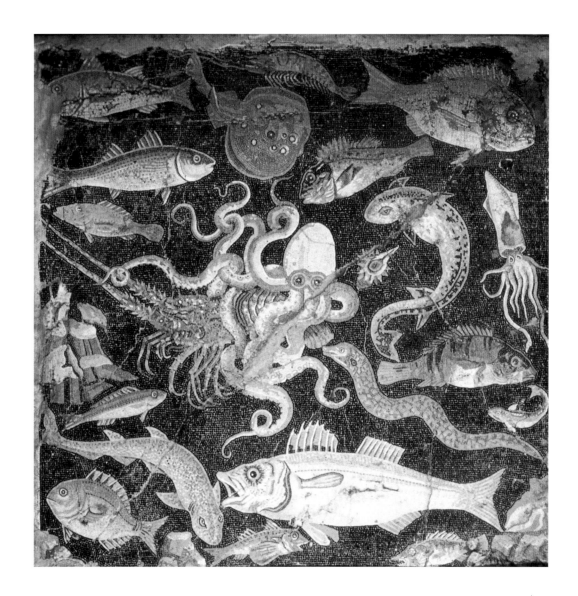

FIGURE 228 (*Above*) Large fish mosaic from Pompeii, House VIII.ii.16 (NM inv. no. 120177).

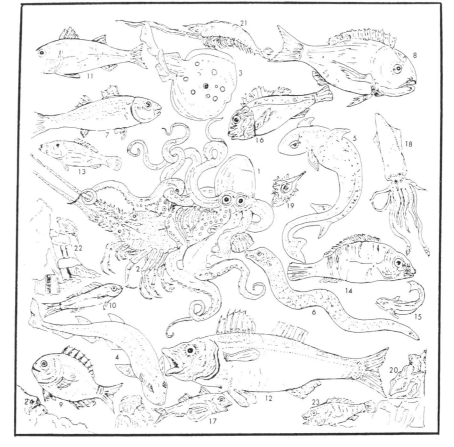

FIGURE 229 Key to fish mosaic from Pompeii, House VIII.ii.16: 1. *Octopus vulgaris*; 2. *Palinurus vulgaris*; 3. *Torpedo torpedo*; 4. *Scyliorhinus canicula*; 5. *Scyliorhinus stellaris*; 6. *Muraena helena*; 7. *Liza aurata*; 8. *Sparus aurata*; 9. *Diplodus sargus*; 10. *Boops boops*; 11. *Mullus surmuletus*; 12. *Dicentrarchus labrax*; 13. *Epinephelus guaza*; 14. *Serranus scriba*; 15. *Trigla* sp.; 16. *Scorpaena porcus*; 17. *Aspitrigla cuculus*; 18. *Loligo vulgaris*; 19. *Murex brandaris*; 20. *Charonia*; 21. *Penaeus kerathurus*; 22. *Alcedo atthis* (bird); 23. *Serranus cabrilla*; 24. *Balanus* sp.

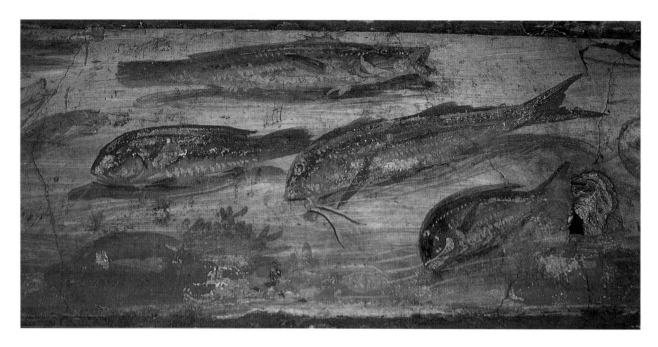

FIGURE 230 Fish painting on the E wall in a room to the south of
the vestibule, House of the Vetti, Pompeii. Photo: S. Jashemski.

FIGURE 231 An old drawing of a garden painting, Villa of
Diomede, Pompeii. In the center a well-stocked fish pool.
From Mazois, Vol. 2, pl. 52. 1.

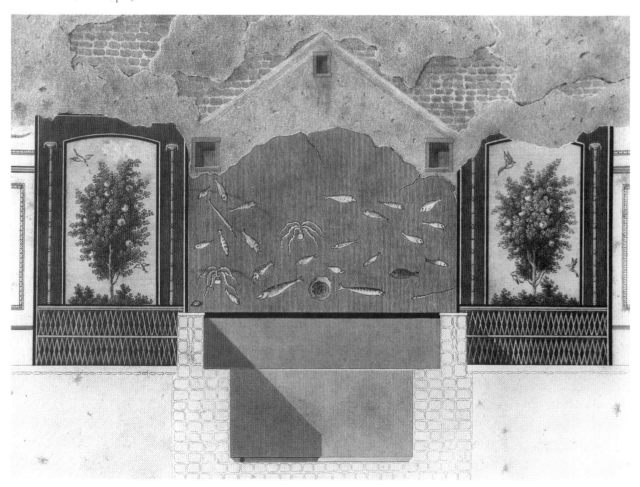

1. FAMILY BELONIDAE

BELONE BELONE L.

English, garfish, (long) needle-fish; Italian, *aguglia, aguglia imperiale*

SPECIMENS PRESERVED

There is 1 bone from the House of Amarantus (I.ix.11, Room 5b) and 1 bone from I.ix.12, Room 2 (Locker n.d.).

WALL PAINTINGS

The garfish is pictured in two paintings.

NM inv. no. 9629 (Palombi, pp. 441–2 as *Tetrapturus belone*);

House of the Vettii, VI.xv.1, in the narrow painting around the walls of the small room to the S of the vestibule, on the E wall (Fig. 230) (Palombi, p. 447 as *T. belone*).

2. FAMILY CARANGIDAE

TRACHURUS TRACHURUS L.

English, scad, horse mackerel; Italian, *scombro bastardo, sorello, sugherello, suro*

SPECIMENS PRESERVED

There is 1 bone from the 2nd to the 1st c. B.C. beneath the House of Amarantus (I.ix.12) (Locker 1999). There are 2 bones from I.ix.11, Room 4, and 47 bones from Room 5b. There are 3 bones from I.ix.12, Room 2, 6 bones from Room 6, 6 bones from Room 8, and 1 bone from Room 9. There are also 6 bones without context (Locker n.d.).

3. FAMILY CLUPEIDAE

SARDINA PILCHARDUS (WALBAUM)

English, sardine, pilchard; Italian, *sarda, sardella, sardina*

ALOSA sp.

English, shad; Italian, *alosa, ceppa, cheppia, salacca, sardone*

SPECIMENS PRESERVED

There are two true herring forms found at Pompeii. There is 1 *S. pilchardus* bone from the 4th to the 3rd c. B.C. beneath the House of Amarantus (I.ix.12) (Locker 1999). There are 3 *S. pilchardus* bones from I.ix.11, Room 4, and 2 *S. pilchardus* bones, 1 *Alosa* sp. bone, and 2 clupeid bones from Room 5b. There is also 1 *Alosa* bone from I.ix.12, Room 2, 1 *S. pilchardus* bone from Room 6, and 2 *S. pilchardus* bones from Room 8 (Locker n.d.).

4. FAMILY DACTYLOPTERIDAE

DACTYLOPTERUS VOLITANS (L.)

English, flying gurnard; Italian, *pesce falcone, pesce rondine*

SPECIMENS PRESERVED

There is 1 large bone from the 1953 excavation in II. xi = I.viii, near the pavilion over the fish pool (P. inv. no. 10137) (Fig. 232).

5. EELS

MURAENA HELENA (L.) (FAMILY MURAENIDAE)

English, moray eel; Italian, *murena, murene*

CONGER CONGER (L.) (FAMILY CONGRIDAE)

English, conger eel; Italian, *grongo*

ANGUILLA ANGUILLA (L.) (FAMILY ANGUILLIDAE)

English, common eel; Italian, *anguilla*

PTEROMYZON MARINUS L. (SUPERCLASS AGNATHA)

English, (sea) lamprey; Italian, *lampreda, lampreda marina*

LAMPETRA FLUVIATILIS (L.) (SUPERCLASS AGNATHA)

English, (river) lamprey; Italian, *lampreda di fiume*

The modern label "eel" denotes several fish of different families, and similarly the Roman use of the term *murena* could have referred to the moray eel (*Muraena helena*), the conger eel (*Conger conger*), the common eel (*Anguilla anguilla*), the sea lamprey (*Pteromyzon marinus*), or the river lamprey (*Lampetra fluviatilis*).

FIGURE 232 Large bone of flying gurnard (*Dactylopterus volitans*) (Boscoreale Antiquarium inv. no. 10137). Photo: F. Meyer.

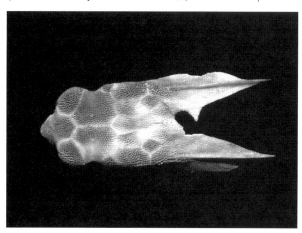

David S. Reese

SPECIMENS PRESERVED

There are 3 *A. anguilla* bones from the 4th to the 3rd c. B.C. beneath the House of Amarantus (I.ix.12) (Locker 1999). There are 3 *A. anguilla* bones from I.ix.11, Room 4, 1 unidentified eel bone from Room 5, and 77 *A. anguilla*, 3 *C. conger*, and 4 unidentified eel bones from Room 5b. There are 10 *A. anguilla* bones from I.ix.12, Room 2, 1 *A. anguilla* bone from Room 6, and 5 *A. anguilla* bones and 1 *C. conger* bone from Room 8. There are also 11 *A. anguilla* bones and 1 *C. conger* bone without context (Locker n.d.).

MOSAICS

The moray is pictured in two mosaics.

- NM inv. no. 9997 (Figs. 226–7: 4) (Palombi, p. 431; Meyboom, pl. 46: III; Capaldo and Moncharmont, p. 57, fig. 2:4);
- NM inv. no. 120177 (Figs. 228–9: 6) (Klunzinger in Keller 1913: fig. 124 and Radcliffe 1921: facing p. 254; Palombi, p. 428; Thompson, p. 294; Meyboom, pl. 47, III; Capaldo and Moncharmont, p. 57, fig. 1:6).

WALL PAINTINGS

The moray is pictured in six wall paintings.

- NM inv. no. 8624 (Palombi, p. 441);
- NM inv. no. 8598 (Palombi, p. 445);
- House of the Vettii, VI.xv.1, S wall of the peristyle (Palombi, p. 447);
- House of the Centenary, IX.viii.6, nymphaeum (S wall, right and left) (Palombi, p. 450; Meyboom, p. 58, pls. 51:12, 52:14);
- House of M. Lucretius, V.iv, S wall (Palombi, p. 451).
- NM inv. no. 8647, House of the Dioscuri (Ward-Perkins and Claridge, 1978: 76, 198)

The lamprey is shown in only one painting from Pompeii (NM inv. 8631; Palombi, p. 442). The river lamprey may be pictured in one painting (NM inv. no. 8633; Palombi, pp. 442–3, fig. 56, as cf. *Lampetra* sp.). *Conger* and *Anguilla* are not pictured.

Eels are shown in one Herculaneum painting.

- Men's frigidarium of the Central Baths (Maiuri 1945: 38; Meyboom, p. 57, pl. 50:7).

REFERENCES IN ROMAN AUTHORS

According to Plautus (*Amphitryo* 319; *Aulularia* 399; *Pseudolus* 382), the eel was popular in Rome as early as the 2nd c. B.C., but it was in the 1st c. B.C. that it was raised on a large scale in fishponds. The raising of the eel was closely associated with L. Lucinius around 62 B.C., who earned the cognomen *Murena* (Pliny *HN* 9.171; Varro *RR* 3.3.10; Columella *RR* 8.16.10). Gaius Hirtius is credited with the invention of fishponds solely for raising eels, with 6,000 eels provided by him for the triumphal banquets of Julius Caesar in 46 and 45 B.C. (Pliny *HN* 9.172; Varro *RR* 3.17.3). Keeping eels was also quite lucrative: Pliny notes (*HN* 9.171) that upon the death of Lucinius Murena the fish from his fishpond sold for four million sesterces.

The orator Quintus Hortensius and the triumvir Marcus Licinus Crassus were said to have kept eels as pets and to have wept when they died (Pliny *HN* 9.172; Macrobius *Saturnalia* 3.15.3; Plutarch *de Sollertia Animalium* 976 A).

Some eels were also adorned with earrings and neckbands and trained to come at the call of their names. A pet *Conger* or *Anguilla* in the ponds of Hortensius at Baculo was adorned with jewelry by Antonia, wife of Drusus (Pliny *HN* 9.172).

Vedius Pollio punished the clumsy or disobedient slave by throwing him into his fishpond, where he was eaten by his *murenae* (Pliny *HN* 9.77). These must be the voracious lampreys. Other ancient writers clearly refer to the lamprey: Columella (*RR* 8.17.2) warning that they destroy other kinds of fish, Pliny (*HN* 9.73) noting that they have no fins or gills, and so on. Pliny notes that the murena (*HN* 32.57) and common eel (*HN* 32.138) were used in medicine.

REMARKS

The moray often contains ciguatoxin, which makes the fish difficult to eat and often poisonous. It is possible that the Romans mainly ate *Conger* and *Anguilla* and that the moray was often kept as a pet.

6. FAMILY ENGRAULIDAE

ENGRAULIS ENCRASICOLUS (L.)

English, anchovy; Italian, *acciuga, alice*

SPECIMENS EXAMINED

A bag of anchovy bones (P. inv. no. 12963, Fig. 233) collected during the excavation of the *garum* shop (II.xii.8) included 82 neurocrania, indicating that at least 82 individual fish were present. They probably came from the dolia or amphorae in this shop, which at the time of excavation contained remains of *allec*, the sediment left over from *garum* production (Pliny *HN* 31.95; Curtis 1979, 1988: 29–30 as I.xii.8). The largest sample of bones (P. inv. no. 18072), which included at least 147 neurocrania from 147 individuals, may also be from this *garum* shop.

FIGURE 233 Anchovy (*Engraulis encrasicolus*) bones from *Garum Shop* I.xii.8 (P. inv. no. 12963). Photo: D. S. Reese.

OTHER SPECIMENS

There are 64 bones from the House of Amarantus (I.ix.11, Room 5b), 2 bones from I.ix.12, Room 2, 1 bone from Room 8, and 3 bones without context (Locker n.d.).

REMARKS

Allec was both a food sauce and a medicine (Pliny *HN* 31.97) and was made in various ways and with varous fish species.

Pompeii was well known for its *garum* (*garum Pompeianum*) production (*CIL* IV 2569; IV Suppl. 5657, 6919, XV 4686; Pliny *HN* 31.94). For details on *garum* and other fish sauces see Curtis (1988, 1991). For more information on salted fish products in medicine see Curtis (1984, 1991).

7. FAMILY EXOCOETIDAE

CHEILOPOGON HETERURUS RAFINESQUE

English, flying fish; Italian, *pesce volante*

WALL PAINTING

A flying fish is shown in one painting.

House of the Ephebe, I.vii.19, on the S wall in the cubiculum SE of the atrium (Palombi, p. 449, as *Exocoetus heterurus*)

8. FAMILY GADIDAE

SPECIMENS PRESERVED

There is 1 small gadid (whiting, pout, bib, pollock, poor cod, rockling, forkbeard) bone from the House of Amarantus (I.ix.11–12) without context (Locker n.d.).

9. FAMILY LABRIDAE

CRENILABRUS MELOPS (L.)

English, (corkwing) wrasse; Italian, *tordo*

LABRUS LIVENS L.

English, wrasse; Italian, *tordo*

LABRUS VIRIDIS L.

English, wrasse; Italian, *tordo*

SPECIMENS PRESERVED

There are 2 Labridae bones from the 4th to the 3rd c. B.C. beneath the House of Amarantus (I.ix.12). There is also 1 *C. melops* bone from the 2nd to the 1st c. B.C. here (Locker 1999).

There are 7 labrid bones from I.ix.11, Room 4, and 16 labrid bones from Room 5b. There is 1 *C. melops* bone and 3 labrid bones from I.ix.12, Room 2, 3 labrid bones from Room 6, and 1 *C. melops* bone and 3 labrid bones from Room 8. There is also 1 labrid bone without context (Locker n.d.).

MOSAICS

Wrasses are shown in two mosaics.

NM inv. no. 9993, House of the Faun, VI.xii.2, right ala (Palombi, p. 432, *Crenilabrus* sp.);

House of the Bear in the mosaic fountain, VII.ii.44 (Palombi, p. 435).

WALL PAINTINGS

Wrasses are shown in the following wall paintings:

NM inv. no. 8621 (Palombi, p. 441, cf. *Crenilabrus* sp.);

NM inv. no. 8633 (Palombi, p. 443, fig. 56, *Labrus*);

NM inv. no. 8639 (Palombi, p. 444);

NM inv. no. 8670 (Palombi, p. 444, *Crenilabrus* sp., *Labrus*);

NM inv. no. 8598 (Palombi, p. 445, *Crenilabrus* sp., *L.* cf. *viridis*);

House of the Vettii, VI.xv.1, in the narrow painting (frieze) around the walls of the small room to the S of the vestibule (Palombi, pp. 446–7, *Crenilabrus* sp., *Labrus*; he says this painting has so many Labridae it could be called the painting of the Labrids) (Palombi, p. 446, *Labrus*) (Fig. 230);

House of Paquius Proculus, I.vii.1, on the left just after entering the atrium are two labrids (Palombi, p. 448, *L. viridis*);

House of the Ephebe, I.vii.19, E wall of the tablinum (Palombi, p. 448, *Labrus*) and cubiculum (SE of atrium) (Palombi, p. 449, *L. livens*, *Labrus*);

House of the Centenary, IX.viii.6, nymphaeum (N wall at left of entrance and S wall, right) (Palombi, p. 450, *Crenilabrus* sp.) and last room to N of peristyle (Palombi, p. 451);

House of M. Lucretius Fronto, V.iv.a/11, N wall of the tablinum (Palombi, p. 451).

REFERENCES IN ROMAN AUTHORS

Pliny (*HN* 32.94) notes that the wrasse (*iulis*) was used in medicine.

REMARKS

There are today about twenty species of labrids in the Mediterranean. These fish eat small mollusks and crustaceans on rocky bottoms.

10. FAMILY MERLUCCIIDAE

MERLUCCIUS MERLUCCIUS (L.)
English, hake; Italian, *asinello, asinel merluzzo, nasello*

SPECIMENS PRESERVED

There are 4 bones from the 4th to the 3rd c. B.C. beneath the House of Amarantus (I.ix.12) (Locker 1999). There are also 2 bones from I.ix.11, Room 5b (Locker n.d.).

WALL PAINTING

The hake is pictured twice on the S wall to the right and left of the fountain in the nymphaeum in the House of the Centenary (IX.viii.6) (Palombi, p. 450).

11. FAMILY MUGILIDAE

CHELON LABROSUS (CUVIER)
English, (thick-lipped) gray mullet; Italian, *muggine chelone*

LIZA AURATA (RISSO)
English, (golden) gray mullet; Italian, *muggine dorato, muggine orifrangio*

LIZA RAMADA (CUVIER)
English, (thin-lipped) gray mullet; Italian, *muggine calamita*

MUGIL CEPHALUS L.
English, (striped) gray mullet; Italian, *cefali, cefalo vero*

SPECIMENS PRESERVED

There are 4 mugilid bones from the 4th to the 3rd c. B.C. and 1 mugilid bone from the 2nd to the 1st c. B.C. beneath the House of Amarantus (I.ix.12) (Locker 1999). There is 1 mugilid bone from I.ix.11, Room 4, and

various bones from Room 5b: 6 *L. ramada*, 3 *C. labrosus*, and 12 mugilid. There is 1 mugilid bone from I.ix.12, Room 2, and 1 *C. labrosus* bone from Room 8. There are also 4 mugilid bones without context (Locker n.d.).

Two mosaics and one painting at Pompeii show the gray mullet.

MOSAICS

NM inv. no. 9997 (Figs. 226–7: 1) (Palombi, p. 431, as *Mullus* cf. *surmuletus*; Meyboom, p. 51, 80 n. 41, pl. 46:X, as *M. cephalus*; Capaldo and Moncharmont, pp. 57, 60, fig. 2:1, as *L. aurata*);

NM inv. no. 120177 (Figs. 228–9: 7) (Kluzinger in Keller 1913: fig. 124 and Radcliffe 1921: facing p. 254, as *Mugil*; Palombi, p. 428, as *Mugil* sp.; Thompson, p. 293, as *Mugil* sp.; Meyboom, pl. 47:X, as *M. cephalus*; Capaldo and Moncharmont, pp. 57, 60, fig. 1:7, as ?*L. aurata*).

WALL PAINTING

House of M. Lucretius, V.iv.a/11, on the N wall of the tablinum (Palombi, p. 451).

REFERENCES IN ROMAN AUTHORS

Gray mullets (*mugil*) of various species were fished for in the Mediterranean (Pliny *HN* 9.29–32, 59; 32.12, 149) and also raised in fishponds. Although a sea fish, they can also live in brackish or freshwater environments and were raised in freshwater ponds and fishponds (Columella *RR* 8.16.1, 17.8). This fish would supposedly come when its name was called (Pliny *HN* 10.193; Martial 10.30.2). Pliny (*HN* 32.77, 105) notes that they were used in medicine.

REMARKS

Gray mullets grow to a maximum of about 90 cm and 5 kg. Today they are a much maligned fish; unless carefully cleaned and washed they have a muddy taste.

12. FAMILY MULLIDAE

MULLUS BARBATUS L.
English, red mullet, goatfish; Italian, *triglia di fango, triglia minore, mullus*

MULLUS SURMULETUS L.
English, surmulet, striped mullet, red mullet, goatfish; Italian, *triglia di scoglio*

SPECIMENS PRESERVED

There is 1 ?*Mullus* bone from the 4th to the 3rd c. B.C. beneath the House of Amarantus (I.ix.12) (Locker 1999). There is also 1 *M. surmuletus* bone from I.ix.11,

Room 5b, and 1 *M. surmuletus* bone from I.ix.12, Room 2 (Locker n.d.).

MOSAICS

Red mullets are the most frequently pictured fish. They are pictured in six mosaics:

NM inv. no. 9997 (Figs. 226–7:18), House of the Faun, VI.xii.2 (Palombi, pp. 430–1; Meyboom, pl. 46, XIV, as *M. barbatus*; Capaldo and Moncharmont, p. 66, fig. 2:18, as *M. barbatus*). What Palombi (p. 431) calls *Mullus* cf. *surmuletus*, Meyboom (pp. 51, 80 no. 41, pl. 46 X) calls *mugil cephalus* and Capaldo and Moncharmont (pp. 57, 60, fig. 2:1) call *Liza aurata*. It is a gray mullet, not a red mullet;

NM 120177 (Figs. 228–9: 11) (Klunzinger in Keller 1913: fig. 124 and Radcliffe 1921: facing p. 254; Palombi, p. 428, as *Mullus* sp.; Meyboom, pl. 47, XV, as *M. surmuletus*; Capaldo and Moncharmont, pp. 60–1, fig. 1:11, as *M. surmuletus*);

NM inv. no. 109371 (Fig. 234), House of the Grand Duke of Tuscany, VII.iv.56 (Palombi, pp. 432–3, as no. 108371; Meyboom, pp. 73, 88 n. 277, pl. 57:20, *Mullus, Mullus/Umbrina*);

House of the Colored Capitals, VII.iv.31/51 (Palombi, p. 434; Meyboom, pl. 48:3, XIV, as *M. barbatus*, pl. 48:3, XV, as *M. surmuletus*);

House of the Bear in mosaic fountain, VII.ii.44 (Palombi, p. 435);

VII.iii.21 (Palombi, p. 436).

WALL PAINTINGS

Red mullets are shown in the following wall paintings:

NM inv. no. 8638 (Fig. 235) (Palombi, p. 437, *M.* cf. *barbatus*);

NM inv. no. 8635 (Palombi, pp. 437–8, fig. 55, *M. barbatus, Mullus*);

NM inv. no. 8621 (Palombi, p. 440, *M. barbatus*);

NM inv. no. 8622 (Palombi, p. 441);

NM inv. no. 8624 (Palombi, p. 441, *M.* cf. *surmuletus*);

NM inv. no. 9629 (Palombi, p. 441, *M. barbatus*),

NM inv. no. 8631 (Palombi, p. 442, *M.* cf. *barbatus*);

NM inv. no. 8633 (Palombi, p. 442, fig. 56, *M.* cf. *barbatus*);

NM inv. no. 8636 (Palombi, p. 443, fig. 57, *M. barbatus*);

NM inv. no. 8639 (Palombi, p. 444);

NM inv. no. 8670 (Palombi, p. 444);

NM inv. no. 8617 (Palombi, pp. 444–5);

NM inv. no. 8619 (Palombi, pp. 444–5);

NM inv. no. 8678 (Palombi, pp. 444–5, fig. 58);

NM inv. no. 8598 (Palombi, p. 445, *M. surmuletus*);

House of the Vettii, VI.xv.1, in the small room to the S of the vestibule (Palombi, pp. 446–7;

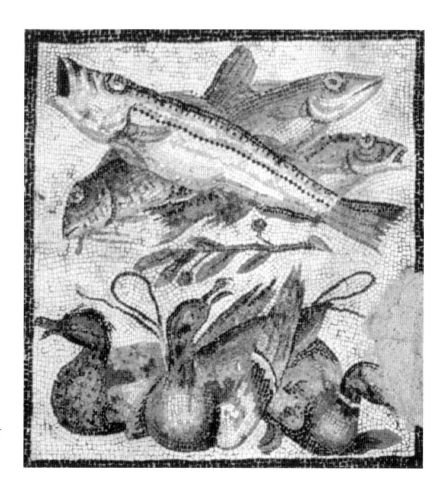

FIGURE 234 Red mullet (*Mullus*) in mosaic from the House of the Grand Duke of Tuscany (VII.iv.65) (NM inv. no. 109371). Photo: S. Jashemski

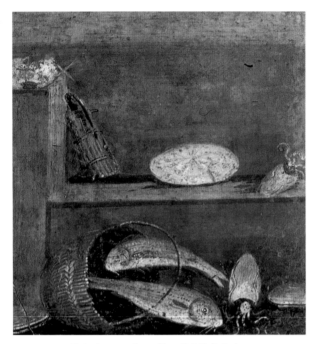

FIGURE 235 Painting: red mullet (*Mullus*) below, asparagus above (NM inv. no. 8638). Photo: S. Jashemski.

Jashemski 1979: 112, fig. 182, *M. barbatus;* S wall of the atrium (Palombi, p. 447, *M. barbatus*); W wall (Palombi, p. 448) (Fig. 230);

House of the Ephebe, I.vii.19, E wall of the tablinum (Palombi, p. 448); on the S wall of the cubiculum (SE of atrium) (Palombi, p. 449, *M. surmuletus*);

House of the Centenary, IX.viii.6, nymphaeum (N wall to the right of the entrance) (Palombi, p. 450, *M. surmuletus*); nymphaeum (S wall, right and left of the mosaic fountain) (Palombi, p. 450); on E wall last room to the N of the peristyle (Palombi, p. 451);

House of M. Lucretius Fronto, V.iv.a/11, N wall of the tablinum (Palombi, p. 451, *M. barbatus*); S wall of the tablinum (Palombi, p. 451, *M. barbatus, Mullus*);

I.x.11 (Palombi, p. 452);

VII.ix.7, on W wall of macellum various examples of *Mullus* (Palombi, p. 452);

Complesso di Riti Magici, II.i.12, rm. 3 (triclinium) (Pugliese Carratelli 1991: 32).

The frigidarium of the Central Baths at Herculaneum also shows this fish (Maiuri 1936:97, fig. 75; Meyboom, p. 57, pl. 50: 7).

REFERENCES IN ROMAN AUTHORS

The Romans generally distinguished the *mulli* by size and by where they were caught – the larger ones were more highly prized. Pliny (*HN* 9.64–7) notes sev-

eral types of *mullus* and their behavior. Some authors state that surmulets could not be raised in fishponds (Pliny *HN* 9.64; Columella *RR* 8.17.7), whereas others note that they were raised there (Cicero *Att.* 2.1.7; Varro *RR* 3.17.6–7; Martial 10.30.24). It seems likely that *M. barbatus* was the form kept in fishponds while the larger *M. surmuletus* was caught only in the sea.

The expense and scarcity of large fish excited the satirists and moralists of the time, who saw in the *mullus* a symbol of decadence and extravagance. For example, Juvenal *Satires* (11.37; 6.40) stated that the *mullus* was beyond a moderate income and was too expensive for a married man. Seneca (*Epistulae Morales* 95.42) tells of an auction where a mullet of over two kilograms was sold for 5,000 sesterces. It is upon hearing that three large mullets were sold for 30,000 sesterces that the emperor Tiberius proposed regulating the price of this fish (Suetonius *Tiberius* 34). By the 5th c. A.D. the craze for mullets had subsided (Andrews 1948–49).

Pliny (*HN* 32.44, 70, 105, 120, 127, 138) notes that the mullet was used in medicine.

REMARKS

These fish have long chin whiskers or barbels that they use to probe the bottom for food, mainly small crustaceans and other invertebrates. The larger *M. surmuletus* reaches 40 cm and weighs more than 1 kg while the smaller and more common *M. barbatus* rarely exceeds 30 cm and is under 1 kg. The fish are actually quite difficult to tell apart except for size.

13. FAMILY PERCICHYTHYIDAE

DICENTRARCHUS LABRAX (L.)

English, sea bass; Italian, *branzino, pesce lupo, spigola*

SPECIMENS PRESERVED

There are 6 *D. labrax* bones from the House of Amarantus (I.ix.11, Room 5b), 1 bone from I.ix.12, Room 2, and also 2 bones without context (Locker n.d.).

MOSAICS

The sea bass is pictured in seven mosaics.

NM inv. no. 9997 (Figs. 226–7: 19) (Palombi, p. 430; Meyboom, pl. 46, IV; Capaldo and Moncharmont, p. 61, fig. 2:19);

NM inv. no. 120177 (Figs. 228–9: 12) (Klunzinger in Keller 1913: fig. 124 and Radcliffe 1921: facing p. 254 as *Labrax lupus*; Palombi, p. 428, as *D. labrax*

or *E. guaza*; Meyboom, pl. 47, IV; Capaldo and Moncharmont, p. 61, fig. 1:12);

NM inv. no. 109371 (Palombi, p. 433, as no. 108371; Meyboom, pp. 73, 88 n. 277, pl. 57:20);

House of the Colored Capitals VII.iv.31/51 (Palombi, pp. 434–5; Meyboom, p. 52, pl. 48:3, IV);

VII.vi.38 (Palombi, pp. 434–5; Meyboom, p. 52, pl. 48:4, IV);

House of the Bear on the mosaic fountain, VII.ii.44 (Palombi, p. 435);

VII.vi.38, only tail end of fish (Jacono 1913: 368, as *Box* (= *Boops*) *salpa* L. or *Anthias anthias* L.; Meyboom, p. 52, pl. 48: 4, IV, as *D. labrax*).

REFERENCES IN ROMAN AUTHORS

Sea bass (*lupus*) was an ideal fish for raising in fish-ponds, and according to Columella (*RR* 8.16.2), it was one of the first fish to be cultivated by the Romans and was even raised in freshwater lakes. The fish from the Tiber River in Rome were particularly esteemed (Pliny *HN* 9.61). A large *lupus* was worth a great deal; in one epigram Martial (11.50.9) lists it in the same category as jewels, earrings, silks, and perfume.

REMARKS

This predatory fish is found in saltwater lakes, the lower reaches of rivers and lagoons, and inshore areas of the sea. It frequents waters where salt water mixes with freshwater, and it often swims far upriver. The sea bass is today considered to be one of the best foodfish from the Mediterranean. They can be up to 100 cm long and 9–13 kg, but normally are about 60 cm. Note that Palombi uses *Roccus labrax* for *D. labrax* (pp. 428, 430, 433, 434–5) and that Higginbotham (1997: 47) is wrong to consider *lupus* a labrid.

14. FAMILY PLEURONECTIDAE

PLEURONECTES PLATESSA (L.).

English, plaice; Italian, *passera di mare*

This is the family of right-eyed flatfish (plaice, flounder, sole, halibut).

SPECIMENS PRESERVED

There is 1 unspecified flatfish bone from the 4th to the 3rd c. B.C. beneath the House of Amarantus (I.ix.12) (Locker 1999). There is also 1 *P. platessa* bone from I.ix.11, Room 4, and 2 flatfish bones from Room 5b. There is 1 *P. platessa* bone from I.ix.12, Room 6, and 1 flatfish bone from Room 8 (Locker n.d.).

15. FAMILY SCIAENIDAE

SCIAENA UMBRA (L.) OR *UMBRINA CIRROSA* (L.)

English, brown maegre, corb, drum fish; Italian, *corvina di sasso, corvo, ombrina*

SPECIMENS PRESERVED

There are 2 sciaenid bones from the 4th to the 3rd c. B.C. and 1 sciaenid bone from the 2nd to the 1st c. B.C. beneath the House of Amarantus (I.ix.12) (Locker 1999). There are 6 ?sciaenid bones from I.ix.11, Room 5b, and 5 sciaenid bones from I.ix.12, Room 2. There are also 6 sciaenid bones without context (Locker n.d.).

16. FAMILY SCOMBRIDAE

(Some experts consider the tuna to be in a separate family, Thunnidae.)

EUTHYNNUS ALLETTERATUS (RAFINESQUE)

English, (little) tuna; Italian, *tonnetto, tonno tonnina*

EUTHYNNUS PELAMIS (L.)

English, (skipjack) tuna; Italian, *tonno bonita*

SCOMBER SCOMBRUS L.

English, mackerel; Italian, *lacerto, maccarello, scombro*

SCOMBER JAPONICUS COLLAS GMELIN

English, spanish mackerel; Italian, *lanzardo*

SPECIMENS PRESERVED

There are 4 scombrid bones from the 4th to the 3rd c. B.C. and 2 ?*E. alletteratus* bones from the 2nd to the 1st c. B.C. beneath the House of Amarantus (I.ix.12) (Locker 1999). There is 1 *S. japonicus collas* bone from I.ix.11, Room 4, and 3 *S. scombrus*, 2 *E. alletteratus*, 3 *E. pelamis*, and 6 scombrid bones from I.ix.11, Room 5b (Locker n.d.). There is also 1 scombrid bone from I.ix.12, Room 2, and 6 *S. japonicus collas* and 2 scombrid bones from Room 8. There is also 1 *S. scombrus* bone and 3 scombrid bones without context (Locker n.d.).

MOSAIC

A mackerel is pictured in one mosaic.

House of Menander, I.x.4, rm. 48 (caldarium) (Palombi, p. 436, as *Scomber* sp.; Pugliese Carratelli 1990: 382, fig. 227).

REFERENCES IN ROMAN AUTHORS

The mackerel (*Scomber*) was, according to Martial

David S. Reese

(13.102), good for fish processing but apparently little else (Pliny *HN* 31.94).

17. FAMILY SCORPAENIDAE

SCORPAENA SCROFA L.
English, (large-scaled) scorpion fish; Italian, *scorfano rosso, scorpena*

SCORPAENA PORCUS L.
English, (small-scaled) scorpion fish; Italian, *scorfano nero, scorpena*

Three mosaics and two paintings show two species of the scorpion fish.

MOSAICS

NM inv. no. 9997 (Figs. 226–7: 8) (Palombi, p. 431, as *S. scropha*; Meyboom, pl. 46, VIII; Capaldo and Moncharmont, p. 64, fig. 2:8) – *S. scrofa*;

NM inv. no. 120177 (Figs. 228–9: 16) (Kluzinger in Keller, 1913: fig. 124 and Radcliffe 1921: facing p. 254 as *Scorpæna*; Palombi, p. 429, as *S. scropha*; Thompson, p. 294, as *S. porcus* or *S. scrofa*; Meyboom, pl. 47, VIII, as *S. scrofa*; Capaldo and Moncharmont, pp. 61–2, fig. 1:16, as *S. porcus*); House of the Bear in the mosaic fountain, VII.ii.44 (Palombi, p. 435).

WALL PAINTINGS

NM inv. no. 8631 (Palombi, p. 442, *S. porcus*); House of the Vettii, VI.xv.1, on the N wall of the little room to the S of the vestibule (Palombi, p. 446).

18. FAMILY SERRANIDAE

EPINEPHELUS GUAZA (L.)
English, sea perch, dusky perch, grouper; Italian, *cernia bruna, cernia*

SERRANUS CABRILLA (L.)
English, comber; Italian, *sciarrano, perchia*

SERRANUS SCRIBA (L.)
English, (painted) comber; Italian, *sciarrano scrittore*

The following mosaics and wall paintings show three species of serranids:

MOSAICS

NM inv. no. 9997 (Figs. 226–7: 2) (Palombi, p. 430;

Meyboom, pl. 46, XIII; Capaldo and Moncharmont, pp. 63–4, fig. 2:2) – *S. cabrilla*;

NM inv. no. 120177 (Palombi, p. 428; Meyboom, pl. 47:2):

E. guaza (Figs. 228–9: 13) (Klunzinger in Keller 1913: fig. 124 and Radcliffe 1921: facing p. 254 as *Labrus*; Palombi, p. 428, as *E. guaza* or *D. labrax*; Thompson, p. 294, as *D. labrax*; Meyboom, pl. 47, XXII, as *Epinephulus guaza?*; Capaldo and Moncharmont, p. 61, fig. 1:13).

S. cabrilla (Figs. 228–9: 23) (Kluzinger in Keller 1913: fig. 124 and Radcliffe 1921: facing p. 254 as *Serranus*; Meyboom, pl. 47, XIII; Capaldo and Moncharmont, p. 61, fig. 1:23).

S. scriba (Figs. 228–9: 14) (Kluzinger in Keller 1913: fig. 124 and Radcliffe 1921: facing p. 254; Palombi, p. 428, as *S. cabrilla*; Thompson, p. 294, as *Lithnognathus mormyrus* [Striped bream]; Meyboom, pl. 47, XII; Capaldo and Moncharmont, pp. 63–4, fig. 1:14);

NM inv. no. 9993 (Fig. 236) (Palombi, p. 432, *S. cabrilla*);

VII.vi.38 (Palombi, p. 433, as *S. cabrilla*; Meyboom, pl. 48: 4, XII, as *S. scriba*);

House of the Bear on the mosaic fountain, VII.ii.44 (Palombi, p. 435, *Serranus* sp.).

WALL PAINTINGS

NM inv. no. 8635 (Palombi, p. 438, fig. 55, *E.* cf. *guaza*);

NM inv. no. 7540, probably from the Villa of Diomede, VIII (Palombi, p. 439, *E. guaza* or *Polyprion cernium*);

NM inv. no. 8624 (Palombi, p. 441, *E. guaza*);

House of the Vettii, VI.xv.1, in the small room to the S of the vestibule (Palombi, p. 446, *Serranus* sp.);

House of the Ephebe, I.vii.19, on the E wall of the tablinum (Palombi, p. 448, *E. guaza*) and cubiculum (SE of atrium) (Palombi, p. 449, *S. cabrilla*);

House of M. Lucretius, V.iv, N wall (Palombi, p. 451, *E. guaza*) and S wall of the tablinum (Palombi, p. 451, *E. guaza, S. cabrilla*).

REFERENCES IN ROMAN AUTHORS

Pliny (*HN* 32.107, 116, 126, 130) notes that sea perch (*perca*) were used in medicine.

REMARKS

Epinephelus live alone in caves or crevices along rocky coasts to depths of 200–300 m and may reach a maximum of 140 cm and 13 kg.

286

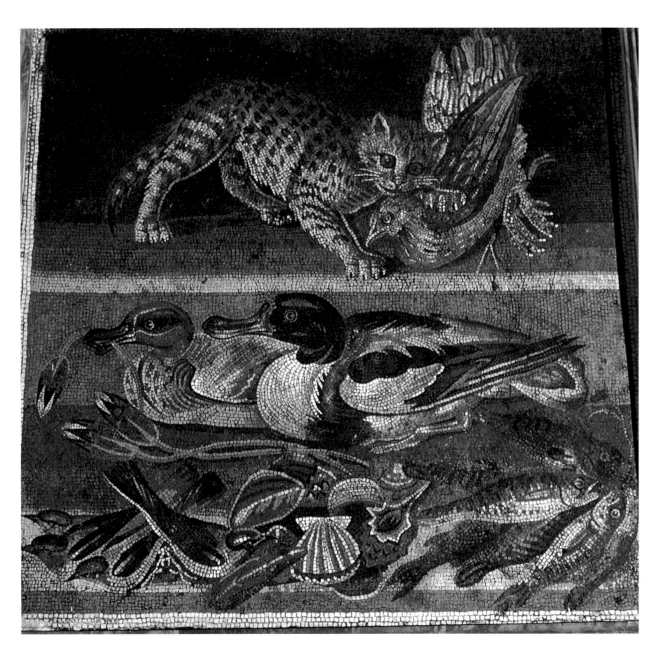

FIGURE 236 Comber (*Serranus cabrilla*). Lower right, four chaffinches on left. Above, teal on left, male shelduck on right. Top, cat with small hen. Mosaic (NM inv. no. 9993). Photo: S. Jashemski.

19. SHARKS AND RAYS (CLASS CHONDRICHTHYES)

LAMNA NASUS BONNATERRE (FAMILY ISURIDAE)

English, porbeagle; Italian, *smeriglio*

SCYLIORHINUS CANICULA (L.) (FAMILY SCYLIORHINIDAE)

English, (lesser) spotted dogfish; Italian, *gattuccio minore*

SCYLIORHINUS STELLARIS (L.)

English, (large) spotted dogfish, nursehound; Italian, *gattuccio maggiore*

SQUALUS ACANTHIAS L. (FAMILY SQUALIDAE)

English, spurdog; Italian, *spinarola*

TORPEDO TORPEDO (L.) (FAMILY TORPEDINIDAE)

English, (ocellated) electric ray; Italian, *torpedine occhiata, tremola*

FAMILY RAJIDAE

English, rays and skates; Italian, *razza*

SPECIMENS PRESERVED

There is a shark or ray bone and a Rajidae bone from the House of Amarantus (I.ix.11, Room 5b). There is also a ?*L. nasus* bone from I.ix.12, Room 8 (Locker n.d.).

MOSAICS

Six mosaics picture sharks.

NM inv. no. 9997 (Figs. 226–7: 13) (Palombi, p. 430; Thompson, p. 294, as *Mustelus mustelus*; Meyboom, p. 51, pl. 46, VI; Capaldo and Moncharmont, p. 57, fig. 2:13, *S. stellaris*);

NM inv. no. 120177 (Palombi, p. 428; Meyboom, pl. 47):

S. *canicula* (Figs. 228–9: 4) (Klunzinger in Keller 1913: fig. 124 and Radcliffe 1921: facing p. 254 as *Scyllium canicula*; Meyboom, pl. 47, VII; Capaldo and Moncharmont, p. 57, fig. 1:4).

S. *stellaris* (Figs. 228–9: 5) (Klunzinger in Keller 1913: fig. 124 and Radcliffe 1921: facing p. 254 as *Scyllium catulus*; Meyboom, pl. 47, VI; Capaldo and Moncharmont, p. 57, fig. 1:5);

VII.vi.38 (Palombi, p. 433; Meyboom, p. 52, pl. 48:4, VII, *S. canicula*);

House of the Colored Capitals, VII.iv.31/51 (Palombi, pp. 434–5; Meyboom, pl. 48:3, VII, *S. canicula*);

House of the Bear, VII.ii.44 (Palombi, p. 435, *Sylliorhiunus* sp.);

House of Menander, I.x.4, rm. 48 (caldarium) (Palombi, p. 436; Pugliese Carratelli 1990: 382, fig. 227, *S. acanthias*).

Two mosaics picture the electric eel:

NM inv. no. 9997 (Figs. 226–7: 5) (Palombi, p. 430; Meyboom, pl. 46, IX; Capaldo and Moncharmont, p. 57, fig. 2:5);

NM inv. no. 120177 (Figs. 228–9: 3) (Klunzinger in Keller 1913: fig. 124 and Radcliffe 1921: facing p. 254 as *T. ocellata* [old name for *T. torpedo*]; Palombi, p. 428; Thompson, pp. 292–3, fig. 1; Meyboom, pl. 47, IX; Capaldo and Moncharmont, p. 57, fig. 1:3).

WALL PAINTING

One painting pictures a shark.

NM inv. no. 8621 (Palombi, p. 440, ?*Lamna*).

REFERENCES IN ROMAN AUTHORS

Pliny (*HN* 9.78) describes the group of cartilaginous fish. He also describes the use of shark skin to polish wood (*HN* 32. 108) and the shark's use in medicine (*HN* 32.79, 108).

The behavior of the electric ray (*torpedo*) is noted by Pliny (*HN* 9.57 and 143), as are its medical uses (*HN* 32.7, 94, 102, 105, 133, 135, 139).

20. FAMILY SPARIDAE

BOOPS BOOPS (L.)

English, bogue; Italian, *boga, bopa, vopa*

DENTEX DENTEX (L.)

English, dentex, porgy, (four-toothed) sparus; Italian, *dentice*

DIPLODUS ANNULARIS (L.)

English, (annular) bream; Italian, *sarago sparaglione*

DIPLODUS VULGARIS (E. GEOFFREY)

English, (two-banded) bream; Italian, *sarago testa nera*

PAGELLUS BOGARAVEO (BRÜNNICH)

English, (red or Spanish) sea bream; Italian, *boca ravaglio, occhialone, pagello bocaravello, rovella*

PAGELLUS ERYTHRYNUS (L.)

English, pandora; Italian, *fragolino, pagello, rosetto*

PAGRUS PAGRUS L.

English, (common or Couch's) sea bream; Italian, *dentice prato, pagro, pagro commune*

SARGUS SARGUS (L.)

English, (white) bream; Italian, *sarago maggiore, sarago*

SPARUS AURATUS (L.)

English, gilthead; Italian, *orada, orata*

SPONDYLIOSOMA CANTHARUS (L.)

English, (black) sea bream; Italian, *cantaro*

SPECIMENS PRESERVED

There is 1 *P. erythrinus* bone and 6 Sparidae bones from the 4th to the 3rd c. B.C. beneath the House of Amarantus (I.ix.12). There are also 2 sparid bones from the 2nd to the 1st c. B.C. there (Locker 1999). There are 26 sparid bones from I.ix.11, Room 4. There is 1 *S. aurata* bone, 1 ?*P. erythrinus* bone, 1 ?*S. cantharus* bone, and 2 sparid bones from Room 5. There are 2 *S. auratus*, 3 ?*P. erythrinus*, 6 ?*S. cantharus*, 2 ?*P. bogaraveo*, and 224 sparid bones from Room 5b. There is 1 ?*P. erythrinus* bone and 29 sparid bones from I.ix.12, Room 2, 19 sparid bones from Room 6, 26 sparid bones from Room 8, and 6 sparid bones from Room 9. There are also 3 *P. erythrinus* and 12 sparid bones without context (Locker n.d.).

MOSAICS

Sea breams of several species are shown in the following mosaics and wall paintings, with *S. auratus* the most commonly pictured (five mosaics, nine paintings):

NM inv. no. 9997 (Palombi, pp. 430–1; Meyboom, p. 51, pl. 46):

D. vulgaris (Figs. 226–7: 3) (Palombi, p. 430 as *Sargus vulgaris;* Meyboom, pl. 46, XI, as *Diplodus sargus;* Capaldo and Moncharmont, p. 64, fig. 2:3);

S. auratus (Figs. 226–7: 6) (Meyboom, pl. 46, V; Capaldo and Moncharmont, p. 60, fig. 2:6);

P. pagrus (Figs. 226–7: 7) (Palombi, p. 431 as *P. erythrynus;* Meyboom, pl. 46, XVII, as *P. erythrynus;* Capaldo and Moncharmont, p. 64, fig. 2:7);

D. dentex (Figs. 226–7: 10) (Meyboom, pl. 46, XVI; Capaldo and Moncharmont, p. 64, fig. 2:10);

S. sargus (Figs. 226–7: 20) (Meyboom, p. 51, pl. 46, XXIII, as *Diplodus annularis?;* Capaldo and Moncharmont, p. 60, fig. 2:20);

D. annularis (Figs. 226–7: 21) (Palombi, p. 431, as *Sargus annularis;* Capaldo and Moncharmont, p. 66, fig. 2:21);

NM inv. no. 120177 (Palombi, p. 428; Meyboom, pl. 47):

S. auratus (Figs. 228–9: 8) (Klunzinger in Keller 1913: fig. 124 and Radcliffe 1921: facing p. 254; Thompson, p. 294, as *D. vulgaris;* Meyboom, pl. 47,V; Capaldo and Moncharmont, p. 60, fig. 1:8);

D. sargus (Figs. 228–9:9) (Klunzinger in Keller 1913: fig. 124 and Radcliffe 1921: facing p. 254, as *Chrysophrys* [now *S. auratus*]; Palombi, p. 428, as *Sargus vulgaris;* Meyboom, p. 52, 80 n. 47, pl. 47, XI; Capaldo and Moncharmont, p. 60, fig. 1:9);

Boops boops (Figs. 228–9: 10) (Klunzinger in Keller 1913: 393, fig. 124 and Radcliffe 1921: facing p. 254, as the wrasse *Coris julis* [L.]; Palombi, p. 428, as *Box boops;* Meyboom, pl. 47, XX; Capaldo and Moncharmont, p. 60, fig. 1:10);

VII.vi.38 (Jacono 1913: 368, as *Sargus rondeletti* Cuv.; Palombi, p. 433; Meyboom, p. 52, pl. 48:4, V) – *S. auratus;*

House of the Colored Capitals, VII.iv.31/51 (Palombi, p. 434) – *D. dentex* (Meyboom, pl. 48:3, XVI); *S. aurata* (Meyboom, pl. 48:3,V);

House of Menander, I.x.4, rm. 48 (caldarium) (Palombi, p. 435; Pugliese Carratelli 1990: 382, fig. 227) – *Sargus* sp.;

House of the Centenary, IX.viii.6 (bath) (Palombi, p. 436) – *S. auratus.*

WALL PAINTINGS

NM inv. no. 8621 (Palombi, p. 440, as *Sargus vulgaris,* now *D. vulgaris*);

NM inv. no. 8633 (Palombi, p. 442, fig. 56, as *Sargus* cf. *vulgaris,* now *D.* cf. *vulgaris*);

NM inv. no. 8636 (Palombi, p. 443, fig. 57, *D. dentex, P. erythrynus, S. aurata*);

NM inv. no. 8598 (Palombi, p. 445, *S. aurata*);

House of the Vettii, VI.xv.1, on the N wall of the small room to the S of the vestibule (Palombi, pp. 446–7; Jashemski 1979: 112, fig. 182) – *S. auratus;*

House of the Centenary, IX.viii.6, nymphaeum, N wall to the left of the entrance (Palombi, p. 450, *D. dentex, S. aurata*) and S wall, right and left (Palombi, p. 450, *S. aurata*);

House of M. Lucretius Fronto, V.iv, N wall of the tablinum (Palombi, p. 451, *D. dentex, S. aurata*) and V.iv.a, S wall of tablinum (Palombi, p. 451, *S. aurata*);

VII.ix.7, W wall of macellum (Palombi, p. 452) – *D. dentex, S. auratus.*

REFERENCES IN ROMAN AUTHORS

The gilthead (*S. auratus*) is the *aurata* of the ancient Romans. According to Columella (*RR* 8.16.2), it was one of the first fish to be cultivated by the Romans and raised in freshwater lakes as well as in fishponds. Sergius Orata built fishponds for the raising of *aurata* and received his cognomen from this association (Pliny *HN* 32.145; Columella *RR* 8.16.1–2, 5; Varro *RR* 3.3.10). Apicius (151; 437) gives several recipes for the preparation of this fish. Pliny (*HN* 32.44) notes that the gilthead was used in medicine.

REMARKS

S. aurata inhabit muddy, sandy, and gravelly grounds and beds of vegetation in relatively shallow waters, to a depth of about 30 m. They eat mollusks and crustacea and may be a pest to shellfish cultivation. They reach a maximum of 60/70 cm and 2.5–5 kg. Young individuals form shoals while larger ones hunt individually. This fish is widely regarded as the best foodfish of the bream family.

21. FAMILY TRIGLIDAE

TRIGLA LUCERNA L.

English, (yellow or tub) gurnard; Italian, *cappone gallinella, pesce cappone*

ASPITRIGLA CUCULUS (L.)

English, red gurnard; Italian, *caviglione, coccio, pesce cappone*

SPECIMENS PRESERVED

There are 2 triglid bones from the 4th to the 3rd c. B.C. beneath the House of Amarantus (I.ix.12) (Locker 1999). There is also 1 triglid bone from I.ix.11, Room 4, and 11 triglid bones from Room 5b (Locker n.d.).

MOSAICS

Three mosaics show gurnards:

NM inv. no. 9997: first fish (Figs. 226–7: 15) (Palombi, p. 431, as *Trigla* sp.; Meyboom, pp. 51, 80 n. 42, pl. 46, XVIII, as *C. julis*; Capaldo and Moncharmont, p. 61, fig. 2:15 as *Trigla* sp.); second fish (Figs. 226–7: 23) (Palombi, p. 430, as *Gadus* sp.; Meyboom, pp. 51, 80 n. 43, pl. 46, XIX, as *Crenilabrus doderleini?*; Capaldo and Moncharmont, p. 61, fig. 2:23, as *T. lucerna?*);

NM inv. no. 120177: *Trigla* sp. (Figs. 228–9: 15) (Klunzinger in Keller 1913: fig. 124 and Radcliffe 1921: facing p. 254, as *Engraulis encrasicolus*; Palombi, p. 429, as *Trigla* sp.; Thompson, p. 294, as *Blennius* or *Gobius;* Meyboom, pp. 52, 80 n. 59, pl. 47, XVIII, as *Coris julis;* Capaldo and Moncharmont, p. 61, fig. 1:15, as *Trigla* sp.;

Aspitrigla cuculus (Figs. 228–9: 17) (Klunzinger in Keller 1913: fig. 124 and Radcliffe 1921: facing p. 254, as *Mullus;* Palombi, p. 429, as *Trigla* sp.; Thompson, p. 294; Meyboom, p. 52, pl. 47, XIV (bottom center), as *Mullus barbatus;* Capaldo and Moncharmont, p. 62, fig. 1:17, as *A. cuculus*);

House of Ariadne, VII.iv.31 (Palombi, p. 435).

22. FAMILY XIPHIIDAE

XIPHIAS GLADIUS L.

English, swordfish; Italian, *pesce spada*

WALL PAINTING

The swordfish is shown in one painting.

House of the Centenary, IX.viii.6, nymphaeum on the N wall to the left of the entrance (Palombi, p. 450).

23. FAMILY ZEIDAE

ZEUS FABER L.

English, John Dory; Italian, *pesce di Cristo, pesce gallo, pesce San Pietro, sampiero*

SPECIMEN PRESERVED

There is 1 *Z. faber* bone from the House of Amarantus (I.ix.11, Room 5b) (Locker n.d.).

Finally, there is 1 freshwater *Tinca tinca* (tench) bone from the House of Amarantus (I.ix.11–12) without context (Locker n.d.).

REFERENCES

Andrews, A. C. 1948–9. "The Roman Craze for Surmullets." *Classical Weekly* 42: 186–8.

Capaldo and Moncharmont = Capaldo, Lello, and Ugo Moncharmont. 1989. "Animali di ambiente marino in due mosaici pompeiani." *Rivista di Studi Pompeiani* III: 53–68.

Curtis, Robert I. 1979. "The Garum Shop of Pompeii (I.12.8)." *Cronache Pompeiane* V: 5–23.

 1984. "Salted Fish Products in Ancient Medicine." *The Journal of the History of Medicine and Allied Sciences* 39/4: 430–45.

 1988. A. Umbricius Scaurus of Pompeii. In *Studia Pompeiana & Classica in Honor of Wilhelmina F. Jashemski* edited by R. I. Curtis, pp. 19–50. Vol. I, Aristide D. Caratzas, New Rochelle, N.Y.

 1991. *Garum and Salsamenta: Production and Commerce in Materia Medica.* E. J. Brill, Leiden.

Deiss, J. J. 1966. *Herculaneum, Italy's Buried Treasure.* Thomas Y. Crowell Co., New York.

Fiorelli, G. 1873. *Gli scavi di Pompei del 1861 al 1872, 5.* Emanuele, Naples.

Giacopini, L., Barbara B. Marchesini, and L. Rustico. 1994. *L'Itticoltura nell'Antichità.* Istituto Grafico Editoriale Romano, Rome.

Heuzé, P. 1990. *Pompéi ou le Bonheur de Peindre.* De Boccard, Paris.

Higginbotham, James. 1997. *Piscinae: Artificial Fishponds in Roman Italy.* University of North Carolina Press, Chapel Hill and London.

Jacono, L. 1913. "Note di archeologia marittima." *Neapolis* I: 353–71.

Jashemski, Wilhelmina F. 1979. *The Gardens of Pompeii, Herculaneum and the Villas Destroyed by Vesuvius.* Vol. 1. Caratzas Brothers Publishers, New Rochelle, N.Y.

Keller, O. 1913. *Die Antike Tierwelt.* Vol. 2. Verlag von Wilhelm Engelmann, Leipzig.

Leonard, W. 1914. "Mosaikstudien zur Casa del Fauno in Pompeji." in *Neapolis. Rivista di archeologia e scienze affini per l'Italia meridionale e la Sicilia,* Naples.

Locker, Alison. 1999. Fish Bones. In Michael Fulford and Andrew Wallace-Hadrill, Towards a History of Pre-Roman Pompeii: Excavations beneath the House of Amarantus (I.ix.11–12), 1995–8. *Papers of the British School at Rome* LXVII: 94, 138.

 n.d. The Fish from House 11 (1995 and 1997) and House 12 (1997): Interim Report.

Maiuri, Amedeo. 1945. *Herculaneum.* Istituto Poligrafico dello Stato, Rome.

Mau, A. 1881. "Scavi di Pompei." *Bullettino dell'Istituto di Corrispondenza Archeologica* 6: 169–75.

Mazois, Charles F. 1824–38. *Les ruines de Pompéi dessinées et mesurées pendant les années 1809, 1810, 1811.* 4 vols. Firmin Didot, Paris.

Meyboom = Meyboom, P. G. P. 1977. "I mosaici pompeiani configure di pesci." *Mededelingen van het Nederlands Instituut te Rome* 39, n.s. 4: 49–93.

Palombi = Palombi, Arturo. 1950. La fauna marina nei musaici e nei dipinti Pompeiani. In *Pompeiana, Raccolta di Studi per il Secondo Centenario degli Scavi di Pompei,* pp. 425–455. Gaetano Macchiaroli, Naples.

1958. "Dipinti di fauna marina e conchiglie rinvenute durante gli scavi di Stabia." *Bollettino della Societa dei Naturalisti in Napoli* 67: 3–7.

1962. "Dipinti di fauna marina del Museo Campano di Capua." *Atti Accad. Pontaniana* (n.s.) 11: 123.

1974. "Anfore e piatti decorati con motivi di fauna marini esistenti nel Museo Nazionale di Napoli." *Atti Accad. Pontaniana* (n.s.) 23: 169.

Pugliese Carratelli, Giovanni, ed. 1990. *Pompei, Pitture e Mosaici* II. Enciclopedia Italiana, Rome.

1991. *Pompei, Pitture e Mosaici* III. Enciclopedia Italiana, Rome.

1993. *Pompei, Pitture e Mosaici* IV. Enciclopedia Italiana, Rome.

Radcliffe, W. 1921. *Fishing from the Earliest Times.* John Murray, London.

Sear, F. B. 1977. "Roman Wall and Vault Mosaic." Römische Mitteilungen, Supp. 23.

Thompson, D'Arcy W. 1947. *A Glossary of Greek Fishes.* London.

Thompson, T. E. 1977. "A Marine Biologist at Pompeii A.D. 79." *Nature* 265/5592 (January 27): 292–4.

Ward-Perkins, J., and Amanda Claridge. 1978. *Pompeii A.D. 79.* Museum of Fine Arts, Boston.

13

MARINE INVERTEBRATES, FRESHWATER SHELLS, AND LAND SNAILS

EVIDENCE FROM SPECIMENS, MOSAICS, WALL PAINTINGS, SCULPTURE, JEWELRY, AND ROMAN AUTHORS

David S. Reese

INTRODUCTION

Mollusks and their shells have a long history of various uses by man – as food, as personal ornaments, as vessels or trumpets, as an indication of high status (such as shells originating from exotic lands), as attached decoration (as in fountains), as money, or as a source of the famed shell purple dye. They may also be naturally occurring in archaeological deposits, such as land snails burying into ancient deposits or shells included in sand brought in from the beach for building construction.

The older excavations in Pompeii and its vicinity produced more than 800 Mediterranean marine invertebrate remains, 61 marine shells from Indo-Pacific waters (Red Sea, Persian Gulf, or waters farther east), 43 freshwater bivalve valves, and about 75 land snails. Actual Mediterranean shells were also used in the decoration of mosaic fountains.

The 61 Indo-Pacific shells (50 cowries [49 large, 1 small], 6 pearl oysters, 2 giant clams, 2 topshells, 1 cone shell) are of particular interest. We are reminded of the other eastern or foreign items found at Pompeii: ceramics, ivory, artifacts from Egypt, and a worked ivory statuette of Indian manufacture (During Caspers 1981).

There are several early reports on the shells from Pompeii: R. Damon (1867), M. di Monterosato (1872, 1879), and N. Tiberi (1879a, 1879b). However, it is unclear if any of the shells seen by these authors were also seen by me in 1987. While most of the Pompeii shells are without provenance or year of excavation, the earliest dated shells seen are 1898 (1 *Lutraria*) and 1899 (2 cowries, 1 Indo-Pacific). However, the undated Pompeii shells in the Naples Museum could belong to these early collections. It is also possible that this early material was destroyed when the Pompeii Antiquarium was bombed in 1943. There are also 10 shells (9 *Glycymeris*, 1 *Chlamys*) from the 1894–6 excavations at Boscoreale preserved at Pompeii.

It seems that between Damon's publication and that of Tiberi a number of genera were found: *Patella, Cerithium, Naticarius, Monodonta, Euthria, Mactra, Spondylus, Arca, Mytilus, Chlamys, Ostrea, Callista, Chamelea, Pinna, Cypraea erosa* (Indo-Pacific), and *Anodonta* (freshwater). It is possible that what Damon calls *Turbo rugosus* is mistakenly called *Trochus articulatum* by Tiberi.

Since the 1879 publications we can add several marine forms: *Gibbula varia, Solen, Venus verrucosa, Lithophaga, Donax, Tellina, Trochus niloticus* (Indo-Pacific), *Tridacna* (Indo-Pacific), as well as coral and sea urchin. Note that many of the scientific names have been changed from that given in the early reports. Several modern authors have examined the treatment of marine animals by the ancient authors, including P.-H. Fischer (1979) on mollusks by the pre-Aristotle Greeks and E. Caprotti (1977) on mollusks in Pliny.

Several marine invertebrate forms are pictured on mosaics, wall paintings, and sculpture.

CATALOGUE

In the catalogue that follows, all measurements given are in millimeters. These are the abbreviations used.

inv. no. = inventory number
l = length
Le = left
MNI = minimum number of individuals
NM = Naples Museum
pres. = preserved
R = right
w = width

MEDITERRANEAN GASTROPODS (SNAILS)

1. *ASTRAEA RUGOSA* (L.)

English, (rough) star shell, turban shell; Italian, *occhio di Santa Lucia, astréa rugosa, astràlia rugosa*

SPECIMENS EXAMINED

There are 2 shells (without inv. no.) from Pompeii in the Naples Museum (NM).

REMARKS

Damon refers to it as *Turbo rugosus.*

2. *CERITHIUM VULGATUM* BRUG.

English, horn shell, needle shell; Italian, *cerizio comune, torricella*

SPECIMENS EXAMINED

Two shells from Pompeii, 1 at Pompeii (inv. no. 18534) with open lip, another in the NM (without inv. no.) water-worn, open mouth, recent hole opposite mouth.

3. *CHARONIA NODIFERA* (LAM.), *CHARONIA SEQUENZAE* (ARADUS ET BENOIT)

English, triton, trumpet shell; Italian, *caronia di tritone, tritone*
There are a total of 62 shells (52 from Pompeii [24 now in the NM], 9 from Herculaneum, 1 from Boscoreale).

SPECIMENS EXAMINED

C. nodifera at Pompeii: inv. no. 116b, l 100 (1907); inv. no. 1081 missing much of apex and much of columella, probably once could be blown, pres. l 198 (1911, I.vi); inv. no. 1563a worn and abraded, worn hole at apex 17+, l 202 (1912, I.vi.12); inv. no. 1563b broken open body, worked apical hole 18.5, l ca. 228 (1912, I.vi.12); inv. no. 1563d has bitumen at apex and added bronze mouthpiece; mouthpiece diameter 33, hole ca. 4 mm, can be sounded, bitumen l 67.5, w 60, shell l 174, total l 252 (1912, I.vi.12); inv. no. 1563e open apex 27, can be blown,

l 236 (1912, I.vi.12); inv. no. 2093a nicely worked apical hole 14, l 155 (1914, I.vi.2); inv. no. 4951c open mouth, broken apex, can be blown, apical hole 27, pres. l 235+, w 135 (1932, House of Menander, I.x.4, atriolum 41, W wall, S jamb, 1.5 m above floor [Allison 1997: 126–7, fig. 6.3; incorrectly called an Indo-Pacific *Strombus* in Skeates 1991: 23]); inv. no. 9323 open hole at apex 18, l 225 (1952, I.ix.8); inv. no. 9793 broken distal, hole at apex 18.5, pres. l 125 (1952, VIII.ii); inv. no. 10693 open apex hole 16, l 235 (1954, II.iv.9); inv. no. 10398 open apex hole 20, l 178 (1953, II.iv.2); inv. no. 11713 worked apex hole 22, can be sounded, l 355 (1956, I.xiii.13 (on display in the Antiquarium at Boscoreale, labeled *C. rubicunda nodifera*, Figs. 237–8); inv. no. 12785 l 146; inv. no. 13533 hole at apex 20, can be sounded, l ca. 275 (1962) (on display in the Antiquarium at Boscoreale, Figs. 239–40), labeled *C. rubiconda nodifera*;; inv. no. 13589 vermetids on exterior, no hole at apex, l ca. 280 (1962, ins. occ.); inv. no. 18509 ground-down and holed apex 19, l ca. 290; inv. no. 18631 apical hole 12.5, l 211; inv. no. 18632 apical hole 23, l 282; inv. no. 18633 slight opening at apex but not holed, vermetids outside shell, l 312; inv. no. 18634 apical hole 19, l 274. In the NM (without inv. nos.): 28 *C. nodifera*: l 145, missing upper apex, probably once could be blown; l 147, open body, blow-hole 14; l 169, broken final whorl, blow-hole 18; l 184, blow-hole 16.25; l 189, missing upper apex, probably once could be blown; l 200+, water-worn, broken apex and distal end, possibly once could be blown; l 207, missing lower spire, probably could be blown; l 215, blow-hole 8.5; l 220, worn exterior, worked open apex 21; l 224, blow-hole 24; l 225+, broken distal end, nicely ground-down blow-hole 16; l 230, blow-hole 18; l 233, blow-hole 18; l 234, blow-hole 13; l 239, vermetids on exterior, small blow-hole can be blown 5 mm; l 247, missing lower part of apex, preserved blow-hole 25; l 253, blow-hole 20.5; l 255, blow-hole 16.5, but not all this width is actual hole, only small hole goes all the way through; l 257, worked apex hole 16; l 261, ground-down blow-hole 21; l 270, missing lower apex, preserved apical opening 32; l 275, nicely ground-down blow-hole 17; l 278, missing lower spire, probably could be blown; l 279, apex a bit worn, hole 17; l 287, now worked at apex; l 305, worked open apex, hole on an angle 18; l 355, worked open apex 21; apical fragment, blow-hole 16.5. At Herculaneum: inv. no. 620 burnt, small, broken tip of apex, cannot be sounded, l 136; inv. no. 1286 broken whorl of mouth, worn and pitted exterior, apex hole 23 (probably now wider than originally), l 285; inv. no. 1684 ground-down apex hole 16, l 222 and two fragments: large lip and siphonal notch; inv. no. 2238 burnt brown interior, open apex now wider than originally, l 205; inv. no. 2417 l 271, open apex now wider than originally, once probably could be blown; inv. no. 2799A open body, open apex, stained greenish, nicely ground-

FIGURE 237 Triton or trumpet shell, labial view (*Charonia nodifera*) (P. inv. no. 11713). Photo: F. Meyer.

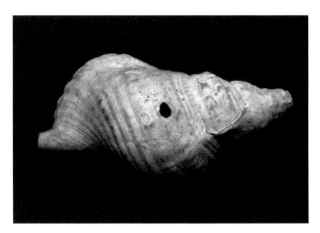

FIGURE 238 Triton or trumpet shell, exterior view (*Charonia nodifera*) (P. inv. no. 11713). Photo: F. Meyer.

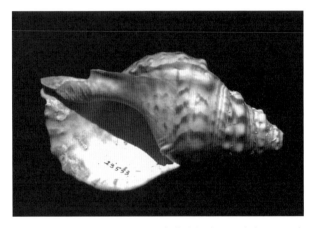

FIGURE 239 Triton or trumpet shell, labial view (*Charonia nodifera*) (P. inv. no. 13533). Photo: F. Meyer.

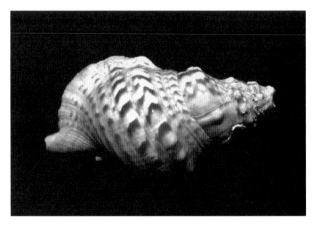

FIGURE 240 Triton or trumpet shell, exterior view (*Charonia nodifera*) (P. inv. no. 13533). Photo: F. Meyer.

down blow-hole 18.5, l 220; inv. no. 2799B broken, open body, open apex now, possibly once could be blown, pres. l 94.

C. sequenzae at Pompeii: inv. no. 18629 apical hole 20.25, l 241; inv. no. 18630 nicely worked apical hole 15.75, l 237. In NM (without inv. no.): l 206, cannot be blown, recent hole on body; l 210, nicely ground-down apex 10. In the Kelsey Museum, University of Michigan, inv. no. 287 with added bronze mouthpiece, bronze piece l 37, w 33.5, hole ca. 9.5, w of bronze at distal end 33.75, l ca. 295, w 150. Purchased by F. W. Kelsey in 1893 from Boscoreale. Formerly used on the estate of Cav. Buoninconte.

MOSAICS

Charonia can be identified in two mosaics from Pompeii now in the NM: inv. no. 9993, House of the Faun, VI.xii.2, right ala (Palombi, p. 432, as *C. nodifera*); and inv. no. 120177 (Figs. 228–9: 20) (Keller 1913: fig. 124 and Radcliffe 1921: facing p. 254, as *Tritonium*; Palombi, p. 429, as *Tritonium*; Meyboom, pl. 47, XXVIII, as *Tritonium nodiferum*; Capaldo and Monchar-

mont, p. 62, fig. 1:20, as ?*Strombus* sp.). Since *Strombus* does not live in the Mediterranean, this is much more likely to be a *Charonia*.

REFERENCES IN ROMAN AUTHORS

Pliny refers to a shell being used as a trumpet (*HN* 9.130). The Romans used the shell trumpet for various purposes, including as a war trumpet (*buccina*). Most Mediterranean shell trumpets were probably made of *Charonia*, but *Cymatium* could also have been used.

REMARKS

Damon calls these shells *Triton nodiferum*, di Monterosato calls them *Tritonium nodiferum*, Tiberi calls them *Triton nodiferus* and says they were made into trumpets (Italian *tofa*), and Palombi (pp. 429, 432) calls them *C. nodifera* (= *Tritonium nodiferum*).

As has been noted, a number of the shells have been worked at the apex and can be blown as trumpets. Four *C. nodifera* trumpets come from the 1912 excavation in I.vi.12. Two specimens are particularly interesting. One (inv. no. 1563d) is a *C. nodifera* with bitumen at

the apex and an added bronze mouthpiece. The second, from Boscoreale and now in the Kelsey Museum, is a *C. sequenzae* with an added bronze mouthpiece.

There is a *C. nodifera* (called *Tritonium nodiferum*) with a ground-down apex from neighboring Greco-Roman Paestum (Settepassi 1967: pl. 4b:17), and a *C. nodifera* (also called *T. nodiferum*) with an attached metal mouthpiece from an unnamed site (Settepassi 1967: pl. 3:6).

For the use of trumpet shells in antiquity elsewhere in the Mediterranean see several recent publications (Reese 1985: 353–64, 1990; Skeates 1991). Shell trumpets could have either a religious or a more utilitarian purpose; they have been used recently in Italy, Sicily, Corsica, southern France, and Crete.

These species are found on rocks and gravel of the lower coastal zone in deep waters. At the turn of the century they were eaten at Marseilles and on Crete.

4. COWRIES: *LURIA LURIDA* (L.), *EROSARIA* (= *CYPRAEA*) *SPURCA* (L.), *CYPRAEA PYRUM* (GMEL.)

English, cowrie; Italian, *ciprea, porciello*

There are a total of 64 Mediterranean cowries of 3 species (62 from Pompeii, 2 from Herculaneum). Twenty-five have been holed. Fifteen holed cowries come from the 1957 excavations in I.xviii.3.

SPECIMENS EXAMINED

At Pompeii, inv. no. 1618 l 34.5: brownish (1899); inv. no. 1947c *E.* cf. *spurca* (1914, I.vi.2); inv. no. 7034a *Luria* (1939, I.viii.5); inv. no. 10455 *Luria* l 36.5, slit hole near posterior end l 6.25 × w 1.5; inv. no. 11901b 15 cowries: all have one hole near anterior end, 1 has brown middle strip, at least 3 are *Luria*, others are smaller (1957, I.xviii.3); inv. no. 15282a *Luria* l 45, carefully made hole near anterior end 3.25; inv. no. 15282d fragment, probably *Luria*; inv. no. 15282e eroded surface; inv. no. 18500 l 33, no color, probably *Luria* or smaller form; inv. no. 18512 l 30.5,

poorly made hole near anterior end, dotted pattern around exterior of shell; inv. no. 18535 *Luria* (on display in the Antiquarium at Boscoreale; Figs. 241–2); inv. no. 18536 *Luria*; inv. no. 18537 *Luria*; inv. no. 18538 *Luria*; inv. no. 18539 *Luria*; inv. no. 18540 l 43, hole off-center near anterior end 3.5; inv. no. 18541 ?*Luria*, l 38, off-brown color, hole drilled off-center near anterior end 3. In the NM, inv. no. 238 *Luria* l 35.5, hole at anterior end 5 × 4, dorsal side gone; inv. no. 84825 (231) *Luria*; inv. no. 84826(?) (232) *Luria*; 28 cowries without inv. nos.: 20 *Luria*: 28.5 (slit hole at anterior end 5.5 × 2.25), 31.5 (hole at anterior end 5.5 × 3), 34 (2; 1 with hole 1.25), 34.5 (slightly burnt), 36 (hole on one side of anterior end), 39 (hole at anterior end 4.25), 44 (drilled hole at anterior end 1 mm), 46 (hole at anterior end 4 × 3), 46.5 (slit hole 7 × 1.25), 47 (hole at anterior end 2.25), 47.75 (nice circular hole 1.75); 4 *C. pyrum:* 34.5 (hole drilled at anterior end 2 mm), 34.5 (hole drilled in middle toward anterior side, nice and circular 2 mm); 4 small cowries: 27 (nice hole at anterior end 3.25). At Herculaneum, inv. no. 2800 2 *C. pyrum:* one l 32, burnt, 3.5 hole at anterior end.

MOSAIC

A cowrie shown on NM inv. no. 9993 was correctly identified by Palombi (p. 432) as *Cypraea.*

REMARKS

Cowries are not an edible form, and they probably were used as ornaments or charms, which may explain why so many have holes. They frequently are considered to be protections against sterility (Tiberi 1879a: 96, 102; 1879b: 141, 148).

5. *CYMATIUM PARTHENOPIUM* (VON SALIS), *CYMATIUM CORRUGATUM* (LAM.)

English, triton shell; Italian, *cimazio corrugato, cimazio partenopeo*

FIGURE 241 Cowrie, dorsal view (*Luria lurida*) (P. inv. no. 18535). Photo: F. Meyer.

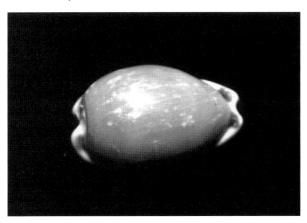

FIGURE 242 Cowrie, ventral view (*Luria lurida*) (P. inv. no. 18535). Photo: F. Meyer.

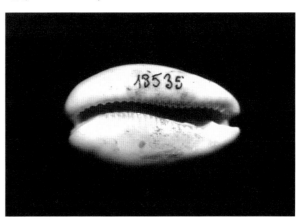

SPECIMENS EXAMINED

There are a total of 19 shells (18 from Pompeii, 1 from Herculaneum). Six can be blown at the apex, like the *Charonia* noted earlier. One has been ground down on the lip and body for some unknown purpose.

At Pompeii, inv. no. 166a *C. parthenopium*, open apex, can be blown, l 101 (1907, second room W of the House of the Silver Wedding); inv. no. 1294 (1912, I.vii.8); inv. no. 2093c open apex, can be blown, slightly burnt area, pres. l 75 (1914, I.vi.2); inv. no. 5079c ground-down lip and center of body, l 78 (1932, I.x.3); inv. no. 5664a *C. parthenopium* l 109 (1933, outside the Porta di Ercolano); inv. no. 12680 iron on exterior (1960, I.xi); inv. no. 15291 fluted lip, broken apex, can be blown, pres. l 63; inv. no. 15292 *C. parthenopium*, fluted lip, small hole at apex, can be blown, iron encrustation at distal end, l 110.5; inv. no. 18528 *C. corrugatum*, thin; inv. no. 18529 *C. corrugatum*, thin; inv. no. 18580 *C. parthenopium*, fluted lip; inv. no. 18581 fluted lip; inv. no. 18582 fluted lip, upper spire gone; inv. no. 18583 fluted lip, can be sounded, apex hole 13.5. In NM, inv. no. 264, and without inv. no. *C. parthenopium*, holed at apex and can be blown, l 77.5, open apex 7, and 2 other shells. At Herculaneum, inv. no. 1002 fluted lip.

REMARKS

Damon called these shells *Triton corrugatum*, Tiberi called them *T. hirsutus* Fabio Colonna (= *Murex parthenopaeus* Salis-Marsclins) and *T. corrugatus* (*tofarella* in Italian), and F. Settepassi (1967: VI) called them *C. hirsutum* Columna.

6. *EUTHRIA* (= *BUCCINUM*) *CORNEA* (L.)

English, whelk; Italian, *buccino corneo* or *eutria cornea*

SPECIMEN EXAMINED

There is 1 shell from Pompeii (inv. no. 18543).

REMARKS

Tiberi records this single shell as *Fusus corneus.*

7. *GALEODEA ECHINOPHORA* (L.)

English, helmet shell; Italian, *galeodea*

SPECIMENS EXAMINED

There are a total of 11 shells, 8 from Pompeii: inv. no. 3000d open apex (1903, VI.xvi); inv. no. 13309c (1961, I.xii.6); inv. no. 18530; inv. no. 18531; inv. no. 18532; inv. no. 18533; inv. no. 18584; inv. no. 18585. Three are from Herculaneum, now in the NM (without inv. nos.).

REMARKS

Di Monterosato called this shell *Cassidaria echinophora/ Tritonium parthenopeum.*

8. *GIBBULA VARIA* (L.)

English, topshell; Italian, *gibbula*

SPECIMEN EXAMINED

There is 1 shell from Pompeii (inv. no. 18486), with broken lip.

9. *HALIOTIS TUBERCULATA* L.

English, ear shell, ormer; Italian, *orecchia marina, patella reale*

SPECIMEN EXAMINED

There is 1 shell from Pompeii in the NM (without inv. no.).

SPECIMENS ON FOUNTAIN

There are actual shells of this species in the first of the fountains in the garden of the House of the Grand Duke of Tuscany (VII.iv.56) (Tiberi 1879a: 100, 103; 1879b: 145, 150).

10. *MONODONTA ARTICULATA* LAM.

English, topshell; Italian, *chiocciola marina, monodonta*

SPECIMEN EXAMINED

There is 1 shell from Pompeii (inv. no. 15289), with open apex.

REMARKS

This single shell is called *Trochus articulatus* by Tiberi.

11. *MUREX* (= *BOLINUS*) *BRANDARIS* L.

English, (dye) murex; Italian, *mùrice, mùrice commune, brandaride, bolino, garuzolo* (Venice), *sconciglio* (Naples)

SPECIMENS EXAMINED

There are a total of 103 shells (102 from Pompeii, 1 from Oplontis).

At Pompeii, inv. no. 449d large, fresh (1909, outside the Porta Vesuvio); inv. no. 449e medium, fresh (1909, outside the Porta Vesuvio); inv. no. 5664c fresh (1933, outside the Porta di Ercolano); inv. no. 5664d fresh (1933, outside the Porta di Ercolano; inv. no. 5832a 5 fresh shells (1934, outside the Porta Vesuvio); inv. no. 5832b 2 shells: 1 broken, 1 fresh (1934, outside the Porta Vesuvio); inv. no. 15132 large, l 85 (1971, ins. occ.); inv. no. 15594 l 63 (1976, outside the Porta Nola); inv. no. 17101 20 fresh shells (1978, near the House of M. Obellius Firmus); inv. no. 17042 fresh (1978, VI.ins. occ.42, possibly from the fountain); inv. no. 18458 2 fresh; inv. no. 18485 6 fresh and medium; inv. no. 18505b fresh; inv. no. 18506 5 fresh; inv. no. 18515 2 shells; inv. no.

18517; inv. no. 18519; inv. no. 18520; inv. no. 18521; inv. no. 18522; inv. no. 18523; inv. no. 18524; inv. no. 18525 1 fresh; inv. no. 18526; inv. no. 18527; inv. no. 18594 1 fresh; inv. no. 21114 2 fresh (1976, from tomb of M. Obellius Firmus outside the Porta Nola). In NM, (without inv. no.): 37 fresh shells.

One shell from Pompeii was found in 1972 in I.xiv.2 between the table and the triclinium in the SE corner of the garden (Jashemski 1979: 95, fig. 79, now in the Department of Invertebrate Zoology, National Museum of Natural History, Smithsonian Institution). At Oplontis 1 shell was found in Garden 59 in the Villa of Poppaea (Jashemski 1993: 295).

SPECIMENS ON FOUNTAINS

Actual shells have been identified in seven Pompeii fountains: House of the Great Fountain, VI.viii.22 (peristyle) (Tiberi 1879a: 104, 1879b: 151; Palombi, p. 427); House of the Little Fountain, VI.viii.23 (peristyle) (Tiberi 1879a: 104, 1879b: 151; Palombi, p. 427); House of the Bear, VII.ii.44–5 (Tiberi 1879a: 103, 1879b: 150; Palombi, p. 435); House of the Grand Duke of Tuscany, VII.iv.56 (Tiberi 1879a: 103–4, 1879b: 150–1); House VI.ins. occid.42, inv. no, 40689A–G (in water triclinium) (Ciarallo and Capaldo 1990: 275–6, 279, 281); Garden II.ix.5.7 (Pugliese Carratelli 1991: 330–1; as *murex brandaris*); in the Hospitium of Fabius Memor and Fabius Celer (IX.vii.25) (Jashemski 1993: 242, fig. 279).

At Herculaneum they are seen on the mosaic and shell-trimmed aedicula in the Casa dello Scheletro (III.3).

MOSAICS

This species is pictured in four mosaics: in the marine scene in the niche underneath the Venus mosaic in the House of the Bear, VII.ii.44 (Palombi, p. 435) and 4 in the NM inv. no. 9993; inv. no. 9997 (Figs. 226–7: 9); inv. no. 120177 (Figs. 228–9: 19) (Thompson, p. 294, notes that it has attached to the spines the eggs of the cuttlefish *Sepia officinalis*).

WALL PAINTINGS

From Pompeii: House of the Vettii, VI.xv.1, W wall (Palombi, p. 448; 2 shells shown); NM inv. no. 8598 (Palombi, p. 445); NM inv. no. 8622 (Palombi, p. 441).

From Herculaneum: NM inv. no. 8644 (Palombi, p. 440).

REFERENCES IN ROMAN AUTHORS

Pliny (*HN* 9.125–40) gives the best Roman description of how purple dye was produced from *Murex* (see also Michel and McGovern 1987), its value, and its use in medicine (*HN* 32.65, 78, 84, 87, 106–7, 120, 125, 127, 129). Dioscorides (2.4) also discusses its use in medicine. *Murex* were also used to hold liquids (Martial 3.82.27) and to decorate grottos (Ovid *Met.* 8.563).

REMARKS

There is 1?*Murex* from the 2nd to the 1st c. B.C. beneath the Pompeii House of Amarantus (I.ix.12) (Robinson, 1999: 144).

M. brandaris was used, like *Murex trunculus*, to make purple dye. The total number of murex shells in the Pompeii collection (less than 150) does not suggest that this was its use here; from modern experiments we know that 12,000 shells are needed to produce enough dye for the trim of a single garment. However, several authors suggest that Pompeii did produce this shell dye (Girardin 1877: 99; Fischer 1887: 14 (as *Purpura*); Settepassi 1967: XLIV), although others thought this unlikely (von Martens 1874: n. 5; Dedekind 1906: 507; Keller 1913: 534). The use of these shells in purple dye production has been dealt with elsewhere (Reese 1980, 1987, 2000), and the industry dates back to the Middle Bronze Age of Greece and Syria. *Murex* is eaten today in parts of the Mediterranean Basin.

12. *MUREX* (= *PHYLLONOTUS*, = *HEXAPLEX*, = *TRUNCULARIOPSIS*) *TRUNCULUS* (L.)

English, (rock) murex; Italian, *mùrice, truncolo, truncolaria, garuzolo* (Venice), *sconciglio* (Naples)

SPECIMENS EXAMINED

There are a total of 43 shells (42 from Pompeii, 1 from Oplontis). At Pompeii: inv. nos. 1083 bit waterworn (1911, I.vi. building NE); inv. no. 5664b (1933, outside the Porta di Ercolano); inv. no. 15290; inv. no. 18498; inv. no. 18501 small hole on body 2.25, probably recent; inv. no. 18505a; inv. no. 18510 1 81.5, cut down columella and polished; inv. no. 18511 animal growth on mouth, broken lip; inv. no. 18512; inv. no. 18513; inv. no. 18514; inv. no. 18635; inv. no. 21114 2 fresh (1976, from tomb of M. Obellius Firmus outside Porta Nola). In NM (without inv. nos.), a shell with half the shell ground down (mouth and area above), 1 61.5, and 27 fresh shells. The Oplontis shell comes from Garden 59 of the Villa of Poppaea (Jashemski 1993: 295).

SPECIMENS ON FOUNTAINS

This species is found in four Pompeii fountains: House of the Great Fountain, VI.viii.22, rm. 10 (peristyle) (Tiberi 1879a: 104, 1879b: 151); House of the Little Fountain, VI.viii.23, rm. 10 (peristyle) (Tiberi

1879a: 104, 1879b: 151); House of the Bear, VII.ii.45 (Tiberi 1879a: 103, 1879b: 150); House of the Grand Duke of Tuscany, VII.iv.56 (Tiberi 1879a: 103–4, 1879b: 151).

REFERENCES IN ROMAN AUTHORS

Pliny writes of the use of this species in medicine (*HN* 32.65, 78, 84, 87, 106–7, 120, 125, 127, 129). Dioscorides also gives its medicinal uses.

REMARKS

This species was used, like *M. brandaris*, to make the famed shell purple dye; the number of shells in the Pompeii collection does not suggest that this was its use here. However, Settepassi (1967: XLIV) writes that shell purple dye was produced at Pompeii using this species.

Two of the Pompeii shells have been cut down and polished for some unknown reason, like 1 *Cymatium*.

This species is today eaten around the Mediterranean. I saw them for sale in the markets of Torre del Greco and Naples in June 1987. They are found mainly on hard, rocky bottoms in the upper coastal zone.

13. *NATICARIUS HEBRAEUS* (MARTYN)

English, moon shell; Italian, *natica*

SPECIMENS EXAMINED

There are 2 shells from Pompeii (inv. no. 18550), red with purple traces, and 1 now in the NM (without inv. no.).

REMARKS

Tiberi reports a single *Natica maculata* Deshayes. I saw this or a related species eaten in Taranto in 1979.

14. *PATELLA CAERULEA* L., *PATELLA FERRUGINEA* GMEL.

English, limpet; Italian, *patella, patella ferruginea, scodellina*

SPECIMENS EXAMINED

There are 4 shells (3 from Pompeii, 1 from Herculaneum). From Pompeii: inv. no. 18464 *P. caerulea*; inv. no. 18504 *P. ferruginea* (I.xi.4; 1 54, on display in the Antiquarium at Boscoreale; Fig. 243). Now in the NM, *P. ferruginea* (without inv. no.). At Herculaneum, inv. no. 2800B *P. caerulea*.

REMARKS

Tiberi reports a single *P. caerulea*. There is also 1 *Patella* sp. from the 2nd to the 1st c. B.C. beneath the House of Amarantus (I.ix.12) (Robinson 1999: 144).

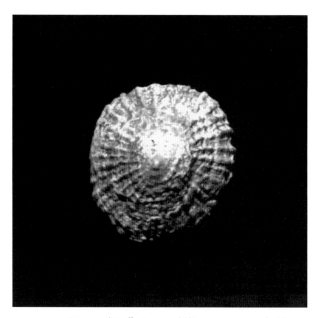

FIGURE 243 Limpet (*Patella ferruginea*) (P. inv. no. 18504). Photo: F. Meyer.

15. *PHALIUM (= SEMICASSIS) GRANULATUM UNDULATUM* (GMEL.)

English, helmet shell; Italian, *casside ondulata*

SPECIMENS EXAMINED

There are a total of 14 shells (11 from Pompeii, 3 from Herculaneum). At Pompeii, inv. no. 5159 l 75 (1932, I.x.8, rm. 1; first room to w of fauces, NW corner, 1 m above the ground floor pavement); inv. no. 9324 ground-down and open apex, apical hole 6, l 84 (1952, I.ix.8); inv. no. 18586; inv. no. 18587; inv. no. 18588; inv. no. 18589; inv. no. 18590; inv. no. 18591; inv. no. 18592 attached to iron nail. In NM, inv. no. 108, and without inv. no. At Herculaneum, inv. no. 1330 recent hole on body; inv. no. 2118 burnt; inv. no. 2800 broken distal end.

REMARKS

Tiberi called this shell *Cassis undulata*. The use of the ground-down shell is unknown. I found this species eaten in Taranto in 1979.

16. *TONNA GALEA* (L.)

English, dolium shell, cask shell; Italian, *tonna galea*

SPECIMENS EXAMINED

There are a total of 34 shells (33 from Pompeii, 1 from Herculaneum). At Pompeii, inv. no. 1578 stained green (found pre-1913); inv. no. 1889a (1913, I.vi.2); inv. no. 4951b (1932, House of Menander, I.x.4, atriolum 41, w wall, S jamb, 1.5 m above floor; Allison 1997: 126–7, fig. 6.3); inv. no. 5210b (1932, I.x.8, garden); inv. no. 15150 (1954, VI.ins. occ.42); inv. no. 15293; inv. no.

18477; inv. no. 18593; inv. no. 18628; inv. no. 18636. In NM (without inv. no.), 23 shells. At Herculaneum, inv. no. 636.

REMARKS

Damon calls this shell *Dolium oleare* L.

MEDITERRANEAN BIVALVES

17. *ARCA NOEAE* L.

English, (Noah's) ark shell; Italian, *arca di Noè, spera*

SPECIMENS EXAMINED

There are a total of 12 valves from at least 6 individuals (11 from Herculaneum, 1 from Pompeii). At Pompeii, inv. no. 18467 R. At Herculaneum, inv. no. 336 7 valves, 3 R, 4 L, 5 MNI; inv. no. 512 4 valves, 2 R, 2 L, 2–3 MNI.

REMARKS

Tiberi recorded a single valve of *Arca noeae*. I saw it eaten in Taranto in 1979.

18. *CALLISTA CHIONE* (L.)

English, (smooth or brown) venus shell; Italian, *issolone; fasolaro* (Naples)

SPECIMENS EXAMINED

There are a total of 3 valves from 3 individuals from Pompeii. In NM (without inv. nos.), 3 R (1 burnt); 2 Le (1 burnt).

WALL PAINTING

This venus shell is shown on one painting from Herculaneum: NM inv. no. 8644 (Palombi, p. 440; Meyboom, pl. 57:22).

REMARKS

Tiberi calls this shell *Cytheraea chione* while Palombi refers to *Meretrix (= Cythera) chione.*

I found them for sale in the markets of Herculaneum, Torre del Greco, and Naples in June 1987 and in Taranto in 1979.

19. *CHAMELEA (= VENUS) GALLINA* (L.)

English, (striped) venus shell; Italian, *vongola*

There is 1 *Chamelea* valve from Pompeii. The larger and closely related *Venus* are found in three Pompeii fountains. A *Venus* or *Callista* is pictured in a Pompeii painting.

SPECIMEN EXAMINED

In NM (without inv. no.), R, worn.

REMARKS

Tiberi also records only a single valve.

20. *CHLAMYS OPERCULARIS* (L.)

English, (queen) scallop; Italian, *pettine, pellerina, canestrello*

SPECIMENS EXAMINED

There are a total of 9 valves from at least 8 individuals, with most from Pompeii but 1 from Boscoreale. At Pompeii, inv. no. 16916 fragment (1894–6, the villa "Pisanella" at Boscoreale); inv. no. 18463 2 valves, 2 individuals; inv. no. 18489 6 valves, 5 upper, 1 lower.

SPECIMENS ON FOUNTAIN

House of the Scientist, VI.xiv.43 (Tiberi 1879a: 103, 1879b: 150, as *Pecten opercularis* Lam.).

21. COCKLES: *ACANTHOCARDIA TUBERCULATA* (L.)

English, (rough-nosed, red-nosed, knotted) cockle; Italian, *cuore rosso, cardio tubercolato, cocciola arena, fasolaro, cocciole* (Naples)

CERASTODERMA EDULE GLAUCUM (BRUG.)

English, (common) cockle; Italian, *cuore edule, cocciola, cocciole, capatonda* (northern Italy)

ACANTHOCARDIA ECHINATA (L.)

English, (prickly) cockle; Italian, *cardio echinato, cuore*

SPECIMENS EXAMINED (*A. TUBERCULATA* UNLESS OTHERWISE NOTED)

There are a total of 56 cockle valves from at least 51 individuals (54 from Pompeii and 2 from Herculaneum). At Pompeii, inv. no. 3000b Le (1903, IV.xvi, Thermopolium); inv. no. 5742b Le (1933); inv. no. 5832d fresh (1934, outside the Porta Vesuvio); inv. no. 9632 18 valves, 12 Le, 6 R, 1 burnt (1952, I.ix.9); inv. no. 15285 Le; inv. no. 18455 6 valves (1 is Fig. 244); inv. no. 18471 l 42.5, w 42, small slit hole at umbo; inv. no. 18492 water-worn, 30 × 27, hole at umbo 5 × 5; inv. no. 18492 *Cerastoderma*; inv. no. 21114 fresh (1976, tomb of M. Obellius Firmus, outside Porta Nola). In NM, inv. no. 254 Le (burnt), and without inv. no. 12 R and 3 others, one 48 mm has orange inside, 11 Le and 4 others, one 38 is burnt and 4 others; 6 *Cerastoderma*, 4 R, 2 Le; 3 *A. echinata*, 2 R, Le, 3 MNI (1 labeled *C. echinatum*). *Cerastoderma* were found at Pompeii in 1972 in the garden in I.xiv.2 (Jashemski 1979: 96, as *Cardium edule* L.). At Herculaneum, inv. no. 103 Le; inv. no. 1922 *A. echinata*, very large, l 150.5, w 139 (labeled *C. echinatum*).

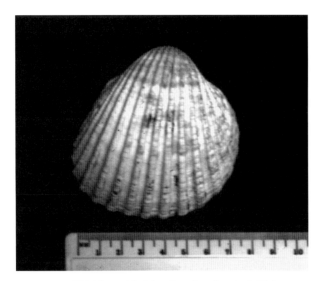

FIGURE 244 Prickly cockle (*Acanthocardia tuberculata*) (P. inv. no. 18455). Photo: D. S. Reese.

SPECIMENS ON FOUNTAINS

A. tuberculata shells are found in seven Pompeii fountains: House of the Great Fountain, VI.viii.22, rm. 10 (peristyle) (Tiberi 1879a: 104, 1879b: 151; Palombi, p. 427); House of the Little Fountain, VI.viii.23, rm. 10 (peristyle) (Tiberi 1879a: 104, 1879b: 151; Palombi, p. 427); House of the Scientist, VI.xiv.43 (Tiberi 1879a: 103, 1879b: 150); House of the Bear, VII.ii.44–45 (Tiberi 1879a: 103, 1879b: 150; Palombi, pp. 427, 435); VII.iv.56, front (Tiberi 1879a: 103, 1879b: 150); VI.ins. occ.42, inv. 40689A–G, at rear wall of the water triclinium (Ciarallo and Capaldo 1990: 275–6, 279, 281, as *Cardium* sp.); II.ix.6.

A. tuberculata are also found at Herculaneum in the nymphaeum in the Casa del Mosaico di Nettuno e di Anfitrite, V.vi–vii (Fig. 245) and in the mosaic aedicula in the Casa dello Scheletro, III.3 (personal observation).

REMARKS

Various scientific names have been assigned these three species in the earlier studies of Pompeii shells. Damon calls them *Cardium rusticum* L. and *Cardium echinatum*. Tiberi calls them *Cardium tuberculatum* and *Cardium echinatum*. Palombi calls it *Cerastoderma tuberculatum* (= *Cardium tuberculatum*) and Jashemski (1979: 96, 1993: 407) calls it *Cardium edule* L.

One water-worn shell from Pompeii has a hole at the umbo and another has a slit hole at the umbo; both were probably ornaments. One has an orange pigment inside the valve and may have been a container, possibly for cosmetics. The large cockle from Herculaneum may also have been used as a container.

There are also 4 *Cerastoderma* from the 4th to the 3rd c. B.C. beneath the House of Amarantus (I.9.12) (Robinson 1999: 144)

A. tuberculata and *Cerastoderma* are commonly eaten throughout the Mediterranean, usually raw, but they may be boiled or steamed. I saw cockles sold in the markets of Herculaneum and Torre del Greco in June 1987 and *A. tuberculata* eaten in Taranto in 1979. Cockles are very abundant both in intertidal and inshore areas, shallowly buried in sand or muddy sand.

22. *DONAX TRUNCULUS* L.

English, (abrupt) wedge shell; Italian, *tellina, calcinello, trílatera* or *arsella* (Tuscany)

SPECIMENS EXAMINED

Three valves of this bivalve were found at Pompeii: in the garden in I.xiv.2, in the Garden of the Fugitives (1974, I.xxi.2), and in the triclinium in the small north garden in I.xxi.3 (Jashemski 1979: 96, 247).

WALL PAINTINGS

This species is pictured in two wall paintings from Pompeii: NM inv. no. 8635 (Palombi, p. 438, fig. 55); NM inv. no. 8638, top right (Palombi, p. 437).

REMARKS

There are also remains from Oplontis. There is 1 shell from the 4th to the 3rd c. B.C. and 12 from the 2nd to the 1st c. B.C. beneath the House of Amarantus (I.IX.12) (Robinson 1999: 144).

They are eaten around the Mediterranean, often raw, but also in soups and with pasta. I saw them sold in the markets of Herculaneum in June 1987. This species is found buried in sand at depths of 10–15 cm.

23. *GLYCYMERIS GLYCYMERIS* (L.), *GLYCYMERIS VIOLASCENS* (LAM.)

English, dog-cockle; Italian, *pié d'asino, pettuncolo violacea, palorde*

SPECIMENS EXAMINED

There are a total of 57 valves from at least 54 individuals (50 from Pompeii, one from Boscoreale, and six from Herculaneum). At Pompeii, inv. no. 4832e water-worn (1934, outside the Porta Vesuvio); inv. no. 5079b *G. glycymeris*, l 75, w 77, large, water-worn, hole poked at umbo 4.5 × 5.5 (1932, I.x.3, in *lapilli* above room 6); inv. no. 15288 *G. violascens*, l 53, w 58, bit worn, hole poked at umbo 9.5; inv. no. 16916 9, 1 water-worn with small umbo hole, 1 water-worn, 1 water-worn and orange inside, 1 worn (1894–6, the villa "Pisanella" at Boscoreale); inv. no. 18456 3, 1 water-worn, 1 with tiny umbo hole, 1 pink inside; 18457 *G. glycymeris*, large; inv. no. 18459 *G. glycymeris*, fresh; inv. no. 18462 water-worn; inv. no. 18464 *G. glycymeris*, fresh; inv. no. 18465 *G. glycymeris*, water-worn, umbo hole

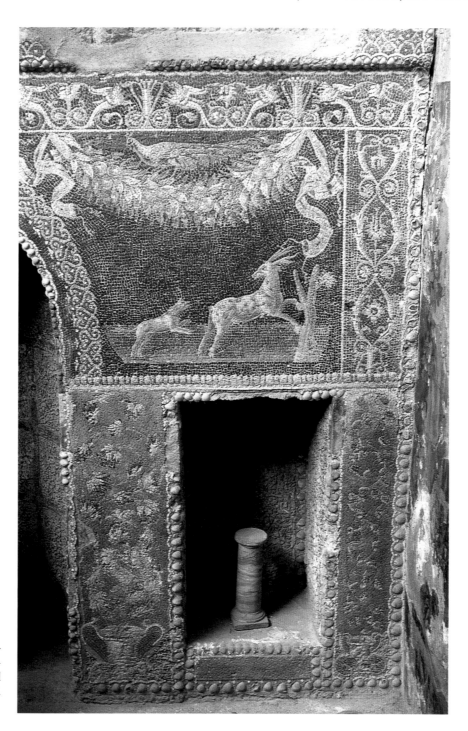

FIGURE 245 Cockle shells (*Acantho-cardia tuberculata*) on mosaic nymph-aeum in the House of Neptune and Amphitrite, Herculaneum. Photo: S. Jashemski.

now enlarged and broken; inv. no. 18466a *G. violascens,* fresh; 18466b *G. violascens,* fresh; inv. no. 18475 *G. glycymeris,* large, water-worn; inv. no. 18476 *G. glycymeris,* large, fresh; inv. no. 18490a water-worn, 45 × 40.2, umbo hole 5.5 × 4; inv. no. 18490b water-worn; inv. no. 18492 water-worn. In NM, inv. no. 119662 (302) *G. glycymeris,* water-worn, 95.5 × 87.5, umbo hole 9.25 × 9, and without inv. nos., 23 shells: water-worn; water-worn; water-worn, 46 × 50.25, umbo hole 9 × 5.25; water-worn, 51 × 48, umbo hole 4.5 × 3, burnt; water-worn, L 92, umbo hole 17 × 8.5; fresh; 68 × 66 (vermetids inside); black valve; 9 water-worn with 5 holed umbo, 5 fresh with 1 holed umbo; *G. glycymeris* (worn exterior). At Herculaneum, inv. no. 2743D *G. gly-*cymeris, fresh, brown stain inside; inv. no. 2800 3 *G. gly-*cymeris, 1 burnt, 3 fresh, and 2 *Glycymeris,* 1 water-worn, worn hole/open umbo, 30; 1 worn.

SPECIMENS ON FOUNTAIN

House of the Gold Bracelet, VI.ins. occ.42, inv. 40689A–G, at rear of the summer triclinium (Ciarallo and Capaldo 1990: 281; rather rare).

MOSAIC

This shell is found on one Pompeii mosaic in VII.iv.31/51 (Meyboom, p. 52, pl. 48:3, XXIX, as *glycimeris glycimeris*).

REMARKS

Twenty-eight of the 57 valves were water-worn and could not be food debris. Fifteen water-worn shells have a hole at the umbo and are probably ornaments. There are 2 other shells that have a poked hole at the umbo.

Damon calls them *Petunculus siculus* Reeve = *P. glycymeris* var. Lam. and *P. violascens*, and Tiberi records *P. glycimeris*, *P. violacescens*, and *P. pilosus* L.

This species is today eaten around the Mediterranean, usually raw, but is considered to be tough. I found it eaten in Taranto in 1979.

24. *LITHOPHAGA LITHOPHAGA* (L.)

English, date shell; Italian, *dattero di mare, dattero de mar*

SPECIMENS EXAMINED

There are 3 samples of this shell from Pompeii, including stone bored by this bivalve. At Pompeii, inv. no. 15284 1 valve; inv. no. 18507 piece of stone with borings in it (made by shells) and shells that made the borings; inv. no. 18508 piece of stone with borings in it (made by shells) and shells that made the borings.

MOSAIC

The date shell is seen in one Pompeii mosaic, VII.vi.38 (Palombi, p. 434; Meyboom, p. 78, pl. 48:4, XXVII).

WALL PAINTINGS

Palombi (p. 450) identified 3 examples of this species in the marine scene on the balustrade of the nymphaeum in the House of the Centenary (IX.viii.6): on the N wall at the right of the entrance, and on the S wall to the right and left of the fountain.

25. *LUTRARIA LUTRARIA* (L.), *LUTRARIA OBLONGA* (CHEMNITZ)

English, otter shell; Italian, *lutraria*

SPECIMENS EXAMINED

There are a total of 23 valves from at least 12 individuals, all from Pompeii.

At Pompeii, inv. no. 1454 R (1898, VI.xv.9); inv. no. 2050 R (1914, I.vi.2, Casa dei Ceii, Rm b, SE corner, from cupboard); inv. no. 9632a Le (1952, I.ix.9); inv. no. 15280a R, red stain inside (perhaps a cosmetic container); inv. no. 15280b R; inv. no. 15280c Le; inv. no. 16473a R; inv. no. 18460 Le; inv. no. 18468a Le; inv. no. 18468b R; inv. no. 18473b R; inv. no. 18478 Le; inv. no. 18479 Le; inv. no. 18480 R; inv. no. 18496 Le; inv. no. 18606 Le. In NM, inv. no. 84809 R, and without inv. no., 6 valves, 4 Le (126, 132, 139, 148.5), 2 R (123, 135.5) (labeled *L. oblonga*).

REMARKS

Damon notes *L. elliptica* Lam. while Tiberi reports *L. elliptica* Lam. and *L. solenoides* Lam.

26. *MACTRA CORALLINA* (L.)

English, (rayed) trough-shell; Italian, *mactra corallina, bibaron de mar, madia, madia bianca*

SPECIMENS EXAMINED

I examined 64 valves of *M. corallina* from at least 42 individuals from Pompeii. A single deposit produced 50 valves from at least 31 individuals. At Pompeii, inv. no. 1889c 2 valves, 2 Le (1913, I.vi.2); inv. no. 3000a Le (1903, VI.xvi, Thermopolium); inv. no. 9632b 50 valves, 31 Le, 19 R, 31 MNI (1952, I.ix.9); inv. no. 18470 8 valves, 5 R, 3 Le, 8 MNI. In NM, inv. no. 320 R and 2 R without inv. nos., 1 burnt.

WALL PAINTING

The trough-shell is shown in one Herculaneum painting: NM inv. no. 8644 (Palombi, p. 440, perhaps *Mactra* or *Venus*).

REMARKS

Tiberi notes that most are *M. corallina*, but reports 1 *M. stultorum* L. I saw this species sold in the markets of Herculaneum and Torre del Greco in June 1987.

27. *MYTILUS GALLOPROVINCIALIS* (LAM.)

English, (Mediterranean) mussel; Italian, *cozza, cozza nera, cozza di Taranto, mitilo* or *mitilo commune, muscolo, peocio* (Venice)

SPECIMENS EXAMINED

There are a total of 10 fresh valves from 5 individuals, all from Pompeii: inv. no. 18607 2 valves, Le, R; inv. no. 18608 2 valves, Le, R; inv. no. 18609 2 valves, Le, R; inv. no. 18610 2 valves, Le, R; inv. no. 18611 2 valves, Le, R.

SPECIMENS ON FOUNTAIN

House of the Grand Duke of Tuscany, VII.iv.56 (Tiberi 1879a: 104, 1879b: 144, 151).

REFERENCES IN ROMAN AUTHORS

Pliny writes of this mussel's use in medicine (*HN* 32.93, 111).

REMARKS

Tiberi refers to this species as *M. edulis* L.

Mussels are eaten all over the Mediterranean today, either raw, cooked, or in soups. I saw them in the markets of Herculaneum, Torre del Greco, and Naples in June 1987, and in Taranto in 1979.

They are found in the intertidal zone attached to rocks by a byssus, and they prefer the area just below the water line, where there is strong wave action.

28. *OSTREA EDULIS* L.

English, oyster; Italian, *ostrica, ostrega*

SPECIMENS EXAMINED

There are a total of 8 valves from 8 individuals, (6 from Pompeii, 2 from Herculaneum).

At Pompeii, inv. no. 18136; inv. no. 18487. In NM (without inv. no.), 4 valves, probably 4 MNI. At Herculaneum, inv. no. 2743A; inv. no. 2797.

REFERENCES IN ROMAN AUTHORS

Pliny describes the behavior of oysters (*ostrea*) and their use as a food and in medicine (*HN* 32.59–64). Oysters have been cultivated since the Roman period. Pliny (*HN* 9.168) credits the orator Sergius Orata around 90 B.C. as the originator of oyster ponds (*ostrearum vivaria*) around the Gulf of Baiae (Eyton 1858). They are mentioned by Horace (*Satires* 2.4.33), Ovid (*Fasti* 6.174), and Juvenal (*Satires* 4.142).

REMARKS

Tiberi records a single valve. F. B. Sear (1977: 67) notes oysters on the mosaic fountain of the House of the Grand Duke of Tuscany (VII.iv.56), but this seems to be an incorrect identification. Roman *ostriaria* are well known from depictions on vessels (Günther 1897). Oysters are eaten throughout the Mediterranean, usually raw but sometimes fried or grilled. I saw them sold in the markets of Herculaneum and Naples in June 1987 and in Taranto in 1979.

Oysters are found from the low-water mark down to about 80 m on a firm, comparatively immobile substrate of mud, rock, muddy sand, hard silt, or shell gravels. Their lower valve is always firmly attached to the substrate.

29. *PECTEN JACOBAEUS* (L.)

English, (Jacob's or pilgrim) scallop; Italian, *ventaglio, cappa santa* (Venice), *conchiglia di S. Giacomo, cozza di Santo Iacovo, conchiglia dei pellegrini, pettine*

SPECIMENS EXAMINED

There are a total of 101 valves from at least 72 individuals (87 from Pompeii, 13 from Herculaneum, and 1 from Oplontis).

At Pompeii, inv. no. 1322 upper (1912, I.vi.7); inv. no. 1350 upper (1912, I.vi.7); inv. no. 1596a upper (found pre-1914); inv. no. 1596b lower (pre-1914); inv. no. 1947b upper (1914, I.vi.2); inv. no. 2093b lower (1914,

I.vi.2); inv. no. 3000c upper, has iron stains (1903, VI.xvi, Thermopolium); inv. no. 3242b upper (1904, VI.xvi.10); inv. no. 5079a upper (1932, I.x.3); inv. no. 5089 2 articulating valves (1932, I.x.1); inv. no. 5122 upper (1932, I.x.1); inv. no. 5185b upper (1932, I.x.8, rm. 10 [ambulatory], NE corner); inv. no. 5335a lower (1932, I.x.7, room above rm. 7 [tablinum], S side, 2 m above ground-floor pavement); inv. no. 12792a 2 articulating valves, l 89 (1960, I.xi.17); inv. no. 12792b 2 articulating valves, l 80 (1960, I.xi.17); inv no. 12792c lower (1960, I.xi.17); inv. no. 15105a 3 valves, 1 lower, 2 upper (1972, I.vi.7); inv. no. 15277 2 articulating valves, l 97, w 116, with holes in each ear 2.25–3.25 (Capaldo and Moncharmont, p. 66); inv. no. 15278a lower; inv. no. 15278b lower; inv. no. 15278c upper; inv. no. 15278d upper; inv. no. 15278e upper; inv. no. 15278f upper; inv. no. 15278g upper; inv. no. 15278h lower; inv. no. 18450 upper; inv. no. 18451 lower, l 108.5, holed in both ears 2.5–3, 2 holes in center upper body 2–2.5; inv. no. 18452 upper; inv. no. 18453 upper; inv. no. 18488 fragment; inv. no. 18499a upper; inv. no. 18499b upper; inv. no. 18595 upper; inv. no. 18596 upper; inv. no. 18597 upper; inv. no. 18598 upper; inv. no. 18599 lower, l 107, one hole in each ear 1.5, also two holes in center of body 2; inv. no. 18600 lower; inv. no. 18601 lower, l 105, holes in both ears 3.5 (Fig. 246); inv. no. 18650 lower. In NM, inv. no. 219 upper; inv. no. 238 upper; inv. no. 247 upper; inv. no. 317 upper; inv. no. 318 lower; inv. no. 1218 upper; inv. no. 84812 (218) upper; inv. no. 84813 upper; inv. no. 84815 upper; inv. no. 84816 upper; inv. no. 119668 (308) upper, l 94, 1 hole in ear 2.5 mm, other broken; inv. no. 119669 (309) upper; inv. no. 119671(?) (311) lower; inv. no. 119674 (?) (314) upper; inv. no. 119675 (315) upper; inv. no. 119676 (316) lower, and without inv. no.: 20 upper, l 45 (in tephra), 62 (burnt), 98 (vermetids inside), and 9 lower. At Herculaneum, inv. no. 103 2

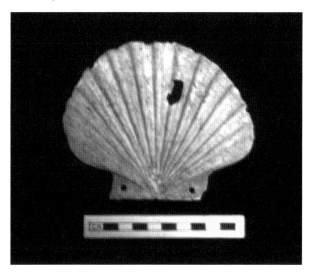

FIGURE 246 Scallop (*Pecten jacobaeus*) holed in both ears (P. inv. no. 18601). Photo: D. S. Reese.

upper valves; inv. no. 279b upper; inv. no. 279c upper, burnt; inv. no. 334 1 upper, 1 lower (2 MNI); inv. no. 335 1 upper, 1 lower (2 MNI); inv. no. 376 upper; inv. no. 377 upper; inv. no. 2743 upper, partly burnt; inv. no. 2798A upper, burnt; inv. no. 2798B upper. The Oplontis fragment comes from Garden 59 of the Villa of Poppaea (Jashemski 1993: 295).

MOSAICS

This species is pictured on two mosaics from Pompeii: NM inv. no. 9993 (Palombi, p. 432; Capaldo and Moncharmont, p. 65, fig. 8); inv. no. 9997 (Figs. 226–7: 17) (Palombi, p. 430, *Pecten* cf. *jacobaeus*; Meyboom, p. 54, pl. 46, XXVI; Capaldo and Moncharmont, p. 66, fig. 2:17, *P. jacobaeus*).

FOUNTAIN

The aedicula shrine in the Casa del Mobilio Carbonizzato (V.5) at Herculaneum has a large model of a scallop in the upper rear (Jashemski 1993: 267, fig. 300).

SCULPTURE

A fountain sculpture of a marine crab on a *Pecten* was found in the House of Julia Felix (Jashemski 1979: 48; Fig. 247).

REFERENCES IN ROMAN AUTHORS

Pliny writes of this scallop's use in medicine (*HN* 32.71, 103).

REMARKS

Two sets of articulating valves and an isolated valve were found at Pompeii in 1960 in I.xi.17. Also, 8 valves

FIGURE 247 Marine crab on a *Pecten*. Fountain sculpture in the House of Julius Felix, Pompeii (P. inv. no. 10703). Photo: S. Jashemski.

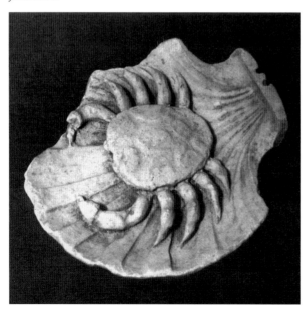

were found together as Pompeii inv. no. 15278. Six valves have holes in each "ear" and probably come from 5 shell containers. There are also 3 other instances of articulating valves that may also have been used as containers.

A lower valve from Herculaneum is pictured by J. J. Deiss (1966: 102). I saw this species eaten in Taranto in 1979.

30. *PINNA NOBILIS* L.

English, (noble) pen shell, fan mussel; Italian, *pinna, pinna nobile*

SPECIMENS EXAMINED

There are 3 fragments of 2 individuals of this shell from Pompeii: in NM (without inv. no.), 3 fragments, 2 MNI.

SPECIMENS ON FOUNTAIN

House of the Grand Duke of Tuscany, VII.iv.56, side (Tiberi 1879a: 104, 1879b: 151).

REFERENCES IN ROMAN AUTHORS

Pliny described the behavior of this shell (*HN* 9.142). See P. J. van der Feen (1949) on the ancient authors' descriptions of *Pinna* byssus (fibers).

REMARKS

I found this species eaten in Taranto in 1979.

31. *SOLEN MARGINATUS* (PENNANT)

English, razor clam; Italian, *cannolicchio*

SPECIMEN EXAMINED

There is 1 valve from Pompeii, inv. no. 13309b brown stripes (1961, I.xii.6).

REMARKS

I saw razor clams for sale in the markets of Herculaneum and Torre del Greco in June 1987.

32. *SPONDYLUS GAEDEROPUS* L.

English, thorny oyster, spiny oyster; Italian, *spuonnolo, spòndilo gaderopo, spòndilo magiore, scataponzolo*

SPECIMENS EXAMINED

There are a total of 68 valves from at least 40 individuals (51 from Pompeii [29+ individuals] and 17 from Herculaneum [11 individuals]). One has a red color inside and possibly was used as a cosmetic container.

At Pompeii, inv. no. 1464 upper, fresh (1912, I.vi.7); inv. no. 1596c upper, very water-worn (found ca. 1914); inv. no. 3667 upper, large (1905, House of

the Mosaic Columns, outside the Porta di Ercolano); inv. no. 5185a lower, fresh (1932, I.x.8, rm. 10 [ambulatory], NE corner); inv. no. 5335b upper (1932, I.x.7, room above rm. 7 [tablinum], S side, 2 m above ground floor pavement); inv. no. 5832c 5 valves, 2 upper, 3 lower, 5 MNI, one a bit worn, one has red color inside and a very pitted exterior (1934, outside the Porta Vesuvio); inv. no. 9713 3 upper valves, 3 MNI (1952, VIII.ii, Viale delle Ginestre); inv. no. 15279a upper, fresh; inv. no. 15279b upper, fresh; inv. no. 15556 upper (1976, house to the N of the House of the Silkworm); inv. no. 17410 lower, fresh; inv. no. 18482 9 valves, 5 upper, 4 lower, 9 MNI; inv. no. 18484 lower; inv. no. 18497 upper; inv. no. 18503 upper; inv. no. 21114 lower, fresh (1976, tomb of M. Obellius Firmus, outside the Porta Nola). In NM, inv. nos. 119658 (298) lower; inv. no. 119659 (299) upper; inv. no. 119660 (300) lower, very water-worn and without inv. nos. 12 upper and 5 lower. At Herculaneum, inv. no. 333 upper; inv. no. 511 4 valves, 3 lower, 1 upper, 4 MNI; inv. no. 2743 2 valves, upper, fresh; lower, fresh, 2 MNI; inv. no. 2797 10 valves, 5 upper, 5 lower (1 very water-worn and pitted).

REMARKS

This shell looks like an oyster with spines on the upper valve but is in fact related to the scallops (*Pecten, Chlamys*). However, the lower valve is attached to the substrate, as in oysters. It is an edible species, but it is rarely eaten in the Mediterranean today (Reese 1982: 93).

33. *TAPES* (= *VENERUPIS*) DECUSSATA (L.)

English, (cross-cut) carpet shell; Italian, *vongola nera, vongola verace, venere incrocicchiata, arselle* (Genoa and Sardinia)

There are a total of 9 valves of 9 individuals from Pompeii. Four valves from 4 individuals were found in 1972 in I.xiv.2 near an arbor post in the garden (Jashemski 1979: 95, fig. 79).

SPECIMENS EXAMINED (5 VALVES, 5 INDIVIDUALS)

At Pompeii, inv. no. 18469a R; inv. no. 18469b R; inv. no. 18469c Le. In NM (without inv. no.), 2 R.

WALL PAINTING

This carpet shell is pictured on one Herculaneum wall painting: NM inv. no. 8644 (Palombi, p. 440; Meyboom, pl. 57: 22).

REMARKS

Damon notes *Tapes pullastra* Forbes & Hanley, Tiberi reports *T. decussatus*, Palombi lists *Amygdala decussata* (= *T. decussatus* Forbes & Hanley), and Jashemski

(1979: 95, 1993: 407) lists *V. decussata*. There is 1 shell from the 2nd to the 1st c. B.C. beneath the House of Amarantus (I.ix.12) (Robinson 1999: 144).

They are eaten today in Italy, France, Tunisia, Greece, and Spain; I saw them for sale in the markets of Torre del Greco in June 1987 and in Taranto in 1979. They are eaten raw with lemon or cooked, and often used in soups. They live deeply buried in sand, muddy gravel, or stiff clay, or between boulders on rocky shores, below the midtide level.

34. *TELLINA PLANATA* L.

English, telline; Italian, *tellina planata*

SPECIMENS EXAMINED

There are 2 *T. planata* valves from Pompeii. They are now in the NM (without inv. no.), Le, R.

WALL PAINTING

A closely related form, *T. nitida* Poli, is pictured in a painting from Pompeii now in the NM, inv. no. 8639 (Palombi, p. 444, as *Peronidia nitida*).

35. *VENUS VERRUCOSA* L.

English, (rough) venus shell; Italian, *cappa*

SPECIMENS ON FOUNTAINS

There are shells on three fountains at Pompeii: House of the Great Fountain, VI.viii.22, rm. 10 (peristyle) (Palombi, p. 427, not noted by Tiberi); House of the Little Fountain, VI.viii.23, rm. 10 (peristyle) (Palombi, p. 427; not noted by Tiberi); House of the Bear, VII.ii.45 (Palombi, pp. 427, 435; not noted by Tiberi).

REMARKS

I saw these shells for sale in the markets of Herculaneum in June 1987.

36. *VENUS* OR *CALLISTA*

WALL PAINTINGS

The marine scene in the nymphaeum of the House of the Centenary (IX.viii.6, N wall, and S wall right and left) shows 3 examples of either *Venus* or *Callista* (Palombi, pp. 449–50, with *Callista* as *Meretrix* [= *Cythera*] *chione*, p. 440).

INDO-PACIFIC GASTROPODS (MARINE SNAILS)

37. *CONUS TEXTILE* L.

English, textile cone; Italian, *cono*

David S. Reese

SPECIMENS EXAMINED

There are 3 of these Indo-Pacific cone shells from Pompeii, 1 of which has a nicely made hole and was probably an ornament.

Damon calls this shell *C. textilis.* Tiberi notes that there were 2 shells, 1 at Pompeii and 1 in the Naples Museum.

At Pompeii, inv. no. 15283 l 60.5, w 30 (Fig. 248); inv. no. 18579 l 68.25, w 32. In NM (without inv. no.), l 73, w 37.5, nicely drilled hole near distal end 2.5–3.

38. *CYPRAEA EROSA* (L.)

English, eroded cowrie; Italian, *ciprea, porcello*

SPECIMEN EXAMINED

There is 1 small Indo-Pacific cowrie from Pompeii (inv. no. 15282c), l 43, with a recent hole near one end.

REMARKS

Tiberi also notes this single shell.

39. *CYPRAEA TIGRIS* L., *CYPRAEA PANTHERINA* LIGHTFOOT

English, tiger or panther cowrie; Italian, *ciprea, porcello*

SPECIMENS EXAMINED

There are 49 of these 2 large Indo-Pacific cowries

FIGURE 248 Indo-Pacific textile cone (*Conus textile*) (P. inv. no. 15283). Photo: D. S. Reese.

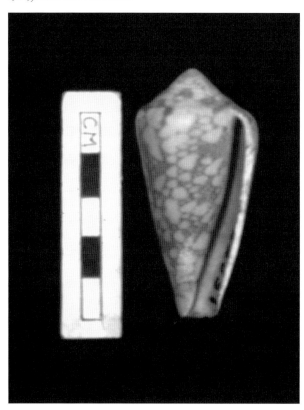

(48 from Pompeii, 1 from Herculaneum). Three of the Pompeii shells have ancient holes at one end and must have been suspended.

At Pompeii, inv. no. 403 l 71, hole near anterior end 3 mm; inv. no. 839b l 83.5; inv. no. 1595 l 69 (1899, V); inv. no. 1853 l 73 (1913, I.vi.2); inv. no. 2939a l 88, rectangular hole near posterior end 5.5 × 3.5, which could be recent (1903, V.iv.13); inv. no. 2939b l 70.5, solid brownish color, hole drilled, then half poked, near the end of the shell, hole 3.5 × 4.5 (1903, V.iv.13); inv. no. 11169b l 61, bright brown (1960, I.xiii.5); inv. no. 11901a l 72 (1957, I.xviii.3); inv. no. 12510 l 72 (1959, I.xviii.5); inv. no. 13309a l 69.5, broken recent hole (1961, I.xii.6); inv. no. 13309d l 69.5 (1961, I.xii.6); inv. no. 13968 l 80.5, brown (1967, ins. occ.); inv. no. 15281a l 68; inv. no. 15281b l 79.5 (label says *C. pantherina*); inv. no. 15281c l 82; inv. no. 15428 l 85, no color; inv. no. 15429 l 90, dark purple-brown; inv. no. 18495 l 94, recent hole on body 9 × 7.25; inv. no. 18565 l 74.5; inv. no. 18566 l 62.5; inv. no. 18567 l 65; inv. no. 18568 l 83; inv. no. 18569 l 73 (on display in the Antiquarium at Boscoreale, labeled *C. pantherina*, Figs. 249, 250); inv. no. 18570 l 85.5; inv. no. 18571 l 68.75; inv. no. 18572 l 75; inv. no. 18573 l 76; inv. no. 18574 l 80; inv. no. 18575 l 81.5; inv. no. 18576 l 74.5; inv. no. 18577 l 83.5, spotted, attached to iron; inv. no. 18578 l 74, dark brown. In NM, inv. no. 256 l 65, hole at anterior end 4 mm; inv. no. 84791 l 83; inv. no. 84798 l 81.5; 13 shells without inv. nos.: l 68, 70.5, 71, 71.5, 72 (2), 74, 75 (2), 76 (brown), 79 (2), 81. At Herculaneum, inv. no. 2743 l 82.5.

REMARKS

The Pompeii tiger cowrie is called *C. tigrina* by di Monterosato (1872; *C. tigrina* var. *nera* in 1879: 203) and Crosse (1873: 164). The panther cowrie is called *C. pantherina* Solan. by Damon, *C. pantherina* Solander by Tiberi (1879a: 96, 102; *Cipraea pantherina* Solander in 1879b: 141, 149–50), and *C. pantherina* Lightfoot by Dance (1966: 31, 1969: 24).

A 1st c. B.C. cinerary urn in Burial 7 at Otranto (Lecce) produced a complete *C. tigris* (Reese, 1991: 173, fig. 20, 1992a: 349). As early as the 7th century B.C. there are two *C. tigris* at Cyrene in Libya (Reese 1991: 172).

In the 1st c. A.D. circum-Mediterranean, the Pompeii area is not the only find-spot of large Indo-Pacific cowries. In 1895 a late 1st c. A.D. grave at Trion (Lyon) in France produced a *C. tigris* (Reese 1991: 179). Numerous later sites in the Mediterranean Basin and Europe also have these cowries (Reese 1991).

Cowries are not an edible form, and they probably were used as ornaments or charms. They frequently are considered to be protections against sterility (Tiberi 1879a: 96, 102, 1879b: 141, 148).

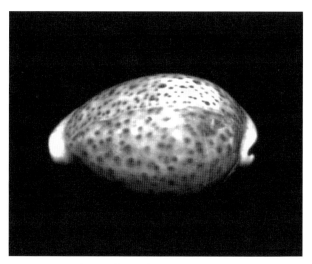

FIGURE 249 Indo-Pacific panther cowrie, dorsal view (*Cypraea pantherina*) (P. inv. no. 18569). Photo: F. Meyer.

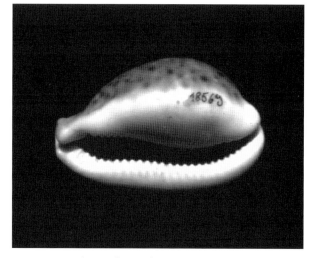

FIGURE 250 Indo-Pacific panther cowrie, ventral view (*Cypraea pantherina*) (P. inv. no. 18569). Photo: F. Meyer.

40. *TROCHUS NILOTICUS* L.

English, topshell; Italian, *troco*

SPECIMENS EXAMINED

There are 2 of these Indo-Pacific topshells from Pompeii (without inv. no.), both l 67. They have not been noted by previous authors.

SUPPOSED INDO-PACIFIC GASTROPODS FOUND AT POMPEII

Triton femorale L. is said to be an exotic shell species found at Pompeii by Damon, but this is an obvious mistake. This name belongs to a Caribbean species, and a Mediterranean *Charonia* or *Cymatium* is probably meant.

Also, R. T. Abbott (1976: 63) says that *Cypraecassis rufa* (L.), the bull-mouth or red helmet shell, has been found at Pompeii, although none of the early authors report it and it was not seen by the present author. It is today sold in the Pompeii area for use in cameo-making and originates in the Indian Ocean or western Pacific Ocean.

INDO-PACIFIC BIVALVES

41. *PINCTADA MARGARITIFERA* (L.)

English, (black-lip) pearl oyster; Italian, *ostrica perlifera*

SPECIMENS EXAMINED

There are 6 valves from at least 6 individuals of this Indo-Pacific bivalve. Two of them have been carefully decorated. Two others have lost the brown exterior, exposing the mother-of-pearl (nacre).

At Pompeii, inv. no. 718 Le valve with an incised ring-and-dot motif at the edge of the hinge. On the interior, from the edge in, it has three solid lines and two pairs of dashed lines. Around the edge are 18 (some are missing) triple ring-and-dot motifs (1910, tomb outside the Porta Vesuvio) (Reese 1991: 173, fig. 21a, b; Michaelides 1995: 221, fig. 16); inv. no. 3550 unmodified, outer brown exterior removed, Le, l 143.5, w 154 (1904, VI.xvi) (Reese 1991: 174); inv. no. 10110 Le valve with incised double line running around the interior of the shell. The lines meet in a 90° corner at the distal edge of the shell, l 150 (1953, II.i.13; on display in the Antiquarium at Boscoreale; Figs. 251, 252; Reese 1991: 173–4); inv. no. 18454 outer brown exterior removed, R, l 124, w 145; inv. no. 18491 umbonal fragment. In NM (without inv. no.), Le, l 135, w 146, not modified.

JEWELRY

A gold earring with mother-of-pearl decorations was found at the *villa rustica* at Oplontis (d'Ambrosio 1990: 215 no. 149, 217). This could have been made from *Pinctada* or the freshwater *Anodonta.*

REFERENCES IN ROMAN AUTHORS

Pliny (*HN* 9.106–7) described the Indo-Pacific pearl oyster.

REMARKS

The 2 worked shells are similar to others from Cyprus (Reese 1991: 168, 1992b: 125, 131, pl. XXVI:2; Michaelides 1995: 215, 218–20) and Athens (Reese 1991: 171). Tomb 4 at Voghenza in Italy may also have *Pinc-*

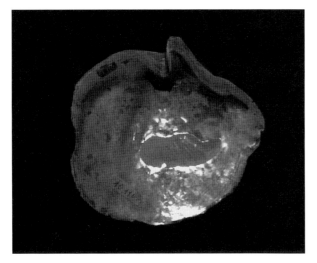

FIGURE 251 Indo-Pacific black-lip pearl oyster, exterior view (*Pinctada margaritifera*) (P. inv. no. 10110). Photo: F. Meyer.

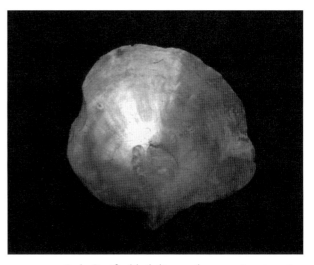

FIGURE 252 Indo-Pacific black-lip pearl oyster, interior view (*Pinctada margaritifera*) (P. inv. no. 10110). Photo: F. Meyer.

tada (Michaelides 1995: 219 n.42; Berti 1984: 83 no. 20, fig. 26, pl. 16:20). Damon and Tiberi call it *Meleagrina margaritifera*.

42. *TRIDACNA SQUAMOSA* LAM.

English, giant clam; Italian, *tridacna*

SPECIMENS EXAMINED

There are 2 valves of 2 individuals from Pompeii (Reese 1988: 41, 1991: 173). Neither has been modified and both may have been used as containers. At Pompeii, inv. no. 9712 l 260, w 150 (1952, VIII.ii) (Fig. 253); inv. no. 11508 l 217, w 134 (1955, I.xiii.1).

REFERENCES IN ROMAN AUTHORS

Pliny writes of these shells as being oysters from the Indian Sea that are a foot long, and that the Latin word *tridacna* was coined in his time to refer to an oyster that is so large it requires three bites (*HN* 32.63).

FIGURE 253 Indo-Pacific giant clam (*Tridacna squamosa*) (P. inv. no. 9712). Photo: D. S. Reese.

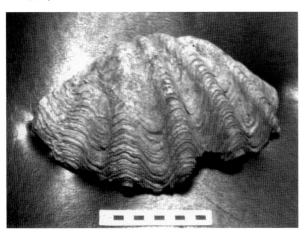

REMARKS

Incised *Tridacna* of the 7th c. B.C. are found as imports in Turkey, Greece, Italy, and Libya (Reese 1988, 1991).

Recent excavations in Naples produced four fragments from the late 5th/early 6th c. A.D. (Cretella 1999). Late 5th/early 6th c. A.D. Carthage produced a *T. squamosa* fragment (Reese 1991: 172, fig. 19).

CEPHALOPODS

43. *LOLIGO VULGARIS* LAM.

English, squid; Italian, *calamaro, calamaro verace*

No remains of the squid are preserved (it has no hard parts).

MOSAIC

The squid is pictured in one mosaic from Pompeii, NM, inv. no. 120177 (Figs. 228–9: 18) (Palombi, p. 429; Thompson, p. 294; Meyboom, pl. 47, XXI; Capaldo and Moncharmont, p. 62, fig 1:18).

WALL PAINTING

Palombi (p. 449) identified a squid in the House of the Centenary, IX.viii.6, nymphaeum (N wall).

REMARKS

I saw squid for sale in the markets of Herculaneum and Naples in June 1987.

44. *OCTOPUS VULGARIS* LAM., *OCTOPUS MACROPUS* RISSO, *OCTOPUS DEFILIPPI* VER.

English, octopus; Italian, *polpo, polpessa*

No remains of the octopus are preserved (it has no hard parts).

MOSAICS

The octopus is pictured in three mosaics from Pompeii: NM inv. no. 9997 (Figs. 226–7: 12) (Palombi, p. 430, as *O.* cf. *macropus;* Meyboom, pl. 46, I; Capaldo and Moncharmont, pp. 56–7, fig. 2:12, as *O. vulgaris*); inv. no. 120177 (Figs. 228–9: 1) (Keller 1913: fig. 124 and Radcliffe 1921: facing p. 254, as *O. vulgaris;* Palombi, pp. 427–9, as *O. macropus;* Thompson, p. 294, as *O. vulgaris;* Meyboom, pl. 47, I; Capaldo and Moncharmont, pp. 56–7, fig 1:1, as *O. vulgaris*); House of the Centenary, IX.viii.6 (Palombi, p. 436).

It is also shown in the woman's *apodyterium* in the Central Baths at Herculaneum (Kraus 1973: fig. 156).

WALL PAINTINGS

The octopus is pictured in two Pompeii paintings, in the House of the Centenary, IX,viii.6, nymphaeum (S wall, left) (Palombi, p. 450; Meyboom, p. 58, pl. 51:12), NM inv. no. 8621 (Palombi, p. 440), and on the frigidarium of the Central Baths at Herculaneum (Maiuri 1936: 97, fig. 75; Meyboom, p. 57, pl. 50:7).

REFERENCES IN ROMAN AUTHORS

Pliny described the behavior of the octopus (*HN* 9.85–7) and also its use in medicine (32.121).

REMARKS

I found them in the markets of Herculaneum and Naples in June 1987.

45. *SEPIA OFFICINALIS* L.

English, cuttlefish; Italian, *seppia*
No remains of the cuttlefish are preserved.

MOSAIC

The cuttlefish is shown in the woman's *apodyterium* in the Central Baths at Herculaneum (Kraus 1973: fig. 156).

WALL PAINTINGS

The cuttlefish is pictured at Pompeii in the House of the Vettii, VI.xv.1, W wall of the peristyle (Palombi, p. 448); House of Paquius Proculus, I.vii.1, on the left wall just after entering the atrium (Palombi, p. 448); NM inv. no. 8638 (Palombi, p. 437); inv. no. 8635 (Palombi, p. 437, fig. 55); NM inv. no. 8622 (Palombi, p. 441); II.i.12, rm. 3 (triclinium) (Pugliese Carratelli 1991: III, 32) and in a wall painting from Herculaneum, NM inv. no. 8644 (Palombi, p. 439; Meyboom, pl. 57:22).

REFERENCES IN ROMAN AUTHORS

Pliny (*HN* 9.84) described the behavior of cuttlefish and the use of its cuttlebone in medicine (32.71–2, 85, 89, 125), as well as the use of its flesh as a laxative (32.100), and the power of its ink (32.141).

REMARKS

I saw cuttlefish being eaten in Taranto in 1979.

CRUSTACEA

46. *BALANUS* sp.

English, barnacle, sea acorn; Italian, *balano*
No remains of the barnacle are preserved.

MOSAIC

The animal is pictured in one mosaic from Pompeii, NM inv. no. 120177 (Fig. 228–9: 24) (Palombi, p. 429; Meyboom, pl. 47; Capaldo and Moncharmont, p. 64, fig 1:24).

47. CARCINIDEA

MOSAIC

An unspecified crab is pictured in one Pompeii mosaic: House of Menander, I.x.4, rm. 48 (caldarium) (Palombi, p. 436; Pugliese Carratelli 1990: 382, fig. 227).

WALL PAINTING

An unspecified crab is shown in one Pompeii painting: House of the Vettii, VI.xv.1, pillar of atrium (Palombi, p. 447).

SCULPTURE

A fountain sculpture of a marine crab on a *Pecten* shell was found in the House of Julia Felix (Fig. 247).

REFERENCES IN ROMAN AUTHORS

Pliny (*HN* 9.97–9) described the behavior of marine crabs and their uses (32.58, 111, 126, 129, 131–2, 134, 135).

48. *ERIPHIA SPINIFRONS* (HERBST)

English, (yellow) crab; Italian, *favollo*

WALL PAINTING

This crab is pictured in one painting from Pompeii: House of the Vettii, VI.xv.1, S pillar of the atrium (Palombi, p. 447).

49. *LEANDER* sp./*PALAEMON* sp.

English, prawn; Italian, *gamberetti, gamberello*

MOSAIC

NM inv. no. 9997 (Figs. 226–7: 22) (Palombi, p. 430, as *Leander;* Capaldo and Moncharmont, p. 67, fig. 2:22, as *Palaemon*).

50. *MAJA SQUINADO* HERBST

English, (spinous) spider crab; Italian, *maia, grancevolo commune*

WALL PAINTING

This crab is pictured in one painting from Pompeii now in the NM (inv. no. 8598) (Palombi, p. 445).

51. *PALINURUS VULGARIS* LATREILLE

English, spiny lobster, crayfish; Italian, *aragosta*
No remains of the spiny lobster are preserved.

MOSAICS

The spiny lobster is pictured in two mosaics from Pompeii: NM inv. no. 9997 (Figs. 226–7: 11) (Palombi, p. 430; DePuma 1970, as lobster; Meyboom, pl. 46, II; Capaldo and Moncharmont, p. 57, fig. 2:11; Ciarallo, 1990: fig. 6); and inv. no. 120177 (Figs. 228–9: 2) (Keller 1913: fig. 124 and Radcliffe 1921: facing p. 254; Palombi, pp. 428–9; DePuma 1970, as lobster; Meyboom, pl. 47, II; Capaldo and Moncharmont, p. 57, fig. 1:2).

WALL PAINTINGS

The spiny lobster is pictured in the following paintings from Pompeii: House of the Vettii, VI.xv.1, on the frieze over the E wall of the little room to the S of the triclinium, and on the N pillar of the atrium (Palombi, pp. 445–7); House of the Centenary, IX.viii.6, nymphaeum (S wall, right) (Palombi, p. 450; Meyboom, p. 58, pl. 52: 14); destroyed wall painting, House of the Vestali, VI.i.7, rm. 39 (peristyle) (Pugliese Carratelli 1993: 27); NM inv. no. 8621 (Palombi, pp. 440–1); NM inv. no. 8624 (Palombi, p. 441), and two paintings from Herculaneum: Frigidarium of the Central Baths (Meyboom, p. 57, pl. 50:7) and NM inv. no. 8644 (Palombi, p. 439; Ward-Perkins and Claridge 1978: 76, 198, a large crayfish; Meyboom, pl. 57: 22).

REFERENCES IN ROMAN AUTHORS

Pliny (*HN* 9.97–9) described the behavior of prawns and crabs.

REMARKS

E. Clark in Jashemski (1993: 407) calls it *Palinurus elephas* Fabr.

52. *PENAEUS KERATHURUS* FORSK.

English, (triple-grooved) shrimp; Italian, *pannocchia, gambero imperiale*

MOSAIC

This shrimp is pictured in one mosaic from Pompeii: NM inv. no. 120177 (Figs. 228–9: 21) (Keller 1913: fig. 124 and Radcliffe 1921: facing p. 254, as *Palaemon*;

Palombi, p. 429, as *Leander* sp.; Thompson, p. 294, as *Crangon vulgaris*; Meyboom, p. 78, pl. 47, XXIV, as *palaemon serratus*; Capaldo and Moncharmont, p. 62, fig. 1:21, as *P. kerathurus*).

53. PENAEIDAE

English, shrimp; Italian, *pannocchia, gambero imperiale*

MOSAICS

Some member of this family, maybe *P. kerathurus*, is pictured in two mosaics from Pompeii now in the NM (inv. no. 9997) (Figs. 226–7: 16) (Palombi, p. 430, a medusa; Meyboom, pp. 51, 54, 80 n. 44, pl. 46, XXVII, as the bivalve *lithophaga*; Capaldo and Moncharmont, pp. 65–6, figs. 2:16, 7, 9, as Penaeidae); inv. no. 9993, House of the Faun, VI.xii.2, right ala (Palombi, pp. 432, 440, as the bivalve *Mytilus*; Capaldo and Moncharmont, p. 62, fig. 8, as Penaeidae).

ECHINODERMS

54. *ECHINUS* sp.

English, sea urchin, echinoid; Italian, *riccio di mare*

WALL PAINTING

An unspecified sea urchin is pictured in a painting from Pompeii in the House of the Vettii, VI.xv.1, w wall (Palombi, p. 448).

55. *PARACENTROTUS LIVIDUS* (LAM.)

English, rock urchin, purple sea egg, sea urchin, echinoid; Italian, *riccio di mare*

SPECIMENS PRESERVED

At Pompeii, inv. no. 13342 27 tests (the body without spines) (1961, VI.ins.occid; on display in the Antiquarium at Boscoreale; Fig. 254); inv. no. 18507 1 complete test. One test fragment was found in Garden 59 of the Villa of Poppaea at Oplontis (Jashemski 1993: 295).

WALL PAINTING

A sea urchin, possibly *P. lividus*, is pictured in a painting from Pompeii, NM inv. no. 8638 (Palombi, p. 437).

REFERENCES IN ROMAN AUTHORS

Pliny (*HN* 9.100) describes the behavior of sea urchins and their use in medicine (32.58, 67, 72, 103, 106, 127, 131).

REMARKS

There is 1 unspecified sea urchin from the 4th to

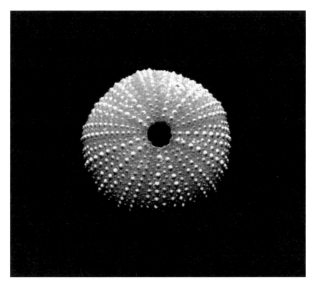

FIGURE 254 Sea urchin (*Paracentrotus lividus*) (P. inv. no. 13342). Photo: F. Meyer.

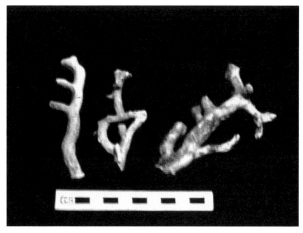

FIGURE 255 Unworked red coral (*Corallium rubrum*) (P. inv. no. 18449). Photo: D. S. Reese.

the 3rd c. B.C. beneath the House of Amarantus (I.9.12) (Robinson 1999: 144).

I found these echinoids for sale in the markets of Torre del Greco in June 1987 and eaten in Taranto in 1979.

CORAL

56. *CORALLIUM RUBRUM* (L.)
English, (precious) red coral; Italian, *corallo rosso, corallo nobile*

SPECIMENS EXAMINED

There are 3 samples of unworked red coral from Pompeii: inv. no. 1432 3 pieces (1912, I.vi.3); inv. no. 11497 1 stalk (1955, I.xiii.5); inv. no. 18449 3 fragments (Fig. 255).

REFERENCES IN ROMAN AUTHORS

Pliny writes of coral (*coralium*) from the Naples area that was valuable, worn as an ornament, and used as a medicine (*HN* 32.21–4). Dioscorides (5.142) also gives its medicinal uses.

REMARKS

Worked red coral has also been found, for instance, in the House of C. Julius Polybius (IX.xiii.1–3) (Jashemski 1979: 28, fig. 40 right). Coral in the Greek and Roman world is described in a recent volume edited by Morel et al. (2000).

57. WHITE CORAL

SPECIMEN EXAMINED

There is 1 white coral remain from Pompeii: inv.

no. 18481 1 24 (?1976, House of the Gold Bracelet, VI.ins. occ.42).

FRESH-WATER BIVALVES

58. *ANODONTA CYGNAEA* (L.)
English, swan mussel; Italian, *anodonta*

SPECIMENS EXAMINED

There are 43 freshwater valves, from at least 21 individuals, from Pompeii. One has an orange pigment inside, and the shell may have been used as a container, possibly for cosmetics. At Pompeii, inv. no. 1157 R (1911, I.vii.3, Thermopolium); inv. no. 1505b R (1912, I.vi.7); inv. no. 1889d 2 R (1913, I.vi.2); inv. no. 1947a Le (1914, I.vi.2); inv. no. 2075 Le (1914, I.vi.2, NW corner, under stairway); inv. no. 2939c R (1903, V.iv.13); inv. no. 5272 2 R, 1 with worn hole near umbo (1932, I.x.7, 1 m above floor, from chest); inv. no. 5945 Le (1936, building S of the House of the Ephebe, I.vii); inv. no. 7561 R (1941, I.viii.14); inv. no. 10831 2 R, 1 Le, 2 or 3 MNI (1954, II.xi); inv. no. 11169a Le (1955, I.xiii.5); inv. no. 11592 2 R (1955, I.xiii.3); inv. no. 14974 fragment (1974, VI.ins. occ.42); inv. no. 15294a Le; inv. no. 15294b Le; inv. no. 18472a Le; inv. no. 18472b Le; inv. no. 18472c Le; inv. no. 18474 R; inv. no. 18483 fragment, orange inside; inv. no. 18493 Le; inv. no. 18602 Le; inv. no. 18603 Le; inv. no. 18604 R; inv. no. 18605 R. In NM, inv. no. 235 R; inv. no. 11848 Le; inv. no. 84828 (234) Le; without inv. nos.: 11 valves, 6 Le, 5 R.

JEWELRY

A gold earring with mother-of-pearl (nacre) was found at Villa B at Oplontis (d'Ambrosio 1990: 215 no. 149, 217). This could be from *Anodonta* or *Pinctada*.

REMARKS

Tiberi (1879a: 97, 98, 1879b: 144, 148) notes that this species today lives in Lake Patria.

59. PEARL

SPECIMEN EXAMINED

There is 1 isolated pearl, holed as a bead, in the sample studied from Pompeii: inv. no. 11501d holed, l 15 (1955, I.xiii.1).

MOSAIC

House of the Faun, VI.xii.2 (Zevi 1991: 205).

JEWELRY

Gold earrings with pearls have been found at Pompeii (Dyer 1891: 571, 572 no. 2), Herculaneum (Waldstein and Shoobridge 1908: 293–4), and Oplontis (d'Ambrosio 1990: 215 no. 150, 217).

REFERENCES IN ROMAN AUTHORS

Pliny (*HN* 9.106–23) gives a lengthy description of pearls and notes that they came from Britain, the Red Sea, the Persian Gulf, and the Indian Ocean, and that they became common in Rome around 100 B.C.

REMARKS

Pearls are found in some Mediterranean bivalves (*Mytilus, Ostrea, Pinna*) and also in some freshwater bivalves.

TERRESTRIAL GASTROPODS (LAND SNAILS)

60. *EOBANIA VERMICULATA* (MÜLL.)
English, land snail; Italian, *chiocciola*

SPECIMEN PRESERVED

There is 1 *Eobania* from Pompeii: inv. no. 15287d color.

REMARKS

Tiberi calls it *Helix vermiculata* Müll., in Neapolitan, *maruzza attummatella*. This species is widely eaten in the Mediterranean Basin. It is found in fields, hedgerows, gardens, vineyards, around stones, and in cultivated areas.

61. *HELIX ASPERSA* MÜLL.
English, common or garden snail; Italian, *lumaca, maruzza ceraiola*

HELIX POMATIA L.
English, edible, vine, Roman or apple snail; Italian, *lumaca*

SPECIMENS EXAMINED

There are more than 60 *Helix* (about 55 from Pompeii, 5 from Oplontis). More than 30 have some color, and they may be intrusive and post-first century A.D. in date. At Pompeii, inv. no. 449a color, lip; inv. no. 449b color, lip; inv. no. 449c color, lip (1909, outside the Porto Vesuvio); inv. no. 1384 no color, hole opposite mouth 3.5 mm (?recent) (1912, I.vi.3); inv. no. 1505c some color (1912, I.vi.7); inv. no. 1889b color (1913, I.vi.2); inv. no. 1951a color, lip (1932, I.x.4); inv. no. 15286 no color; inv. no. 15287a color, lip; inv. no. 15287b color; inv. no. 15287c color, lip; inv. no. 15287e color, lip; inv. no. 17043 color, lip (1978, VI.ins. occ.42); inv. no. 18502 color, lip; inv. no. 18544 color, lip; inv. no. 18545 color, lip; inv. no. 18546 color, lip; inv. no. 18547 lip; inv. no. 18548 color, no lip; inv. no. 18549 color, lip; inv. no. 18551 color, lip; inv. no. 18552 color, lip; inv. no. 18553 color, no lip; inv. no. 18554 color, no lip; inv. no. 18556 color, lip, broken; inv. no. 18557 color, no lip; inv. no. 18558 color; inv. no. 18559 color, no lip; inv. no. 18560 color, lip; inv. no. 18561 color, no lip; inv. no. 18562 little color, lip; inv. no. 18564 color; inv. no. 18566 color, lip; inv. no. 18568 color, lip. In NM (without inv. no.), 18 *Helix* (very large); 1 *Helix* (medium). Several remains come from the Pompeii gardens: *H. aspersa* was found in 1972 in the garden in I.xiv.2; there is 1 *H. pomatia* from the Garden of the Fugitives (1974, I.xxi.2); and there is 1 *H. pomatia* from the 1974 excavation of the garden in I.xxii (Jashemski 1979: 96, 247, 254). Garden 59 of the Villa of Poppaea at Oplontis yielded 5 *H. aspersa* (Jashemski 1993: 295).

SCULPTURE

Matteucig (1974: 219–23) identified six snails in the sculptural decoration around the entrance of the Building of Eumachia and labeled nos. 7, 18, and 45 as probably *Helix* sp. (for illustration of one see Jashemski 1979: fig. 13).

REFERENCES IN ROMAN AUTHORS

H. pomatia was "cultivated" by the Romans and raised on large estates. The first snail gardens (*coclearum vivaria*) was made by Fulvius Lippinius around 50 B.C. (Pliny *HN* 9.173–4); it even contained imported African snails. The Roman cultivation of land snails is fully described by Varro (*RR* 3.14). Snails were a favorite article of the Roman diet. Apicius gives a variety of recipes for cooking snails: fried (7.18.2); roasted (7.18.3); in stuffing for roasted pig (8.7.13); and in vegetable stew (4.5.1). African snails were also used in medicine (Pliny *HN* 32.109). Dioscorides (2.11) also notes many medicinal uses of land and marine snails.

REMARKS

Tiberi reports *H. aspersa, H. ligata* Müll. (as *maruzza di montagna*) and *H. lucorum* Müll., but not *H. pomatia.* Land snails are today eaten around the Mediterranean. *H. aspersa* is found in various habitats and is often associated with man in gardens and parks, but it also may be found in dunes, woods, on rocks, and in hedgerows. It is often a garden pest; it hibernates under rocks in the winter.

62. *OTALA LACTEA* (MÜLL.)

SPECIMENS EXAMINED

This land snail is preserved in the collection from Oplontis. There is also 1 shell from the 1974 excavation of the garden in I.xxii (Jashemski 1979: 254). It was not utilized by man.

63. *RUMINA DECOLLATA* (L.)

SPECIMENS EXAMINED

There are 3 of these land snails from Pompeii gardens: from the 1972 excavation in I.xiv.2, from the 1974 excavation in the triclinium in the small N garden in I.xxi.3, and from the 1974 excavation in I.xxii (Jashemski 1979: 96, 247, 254). It was also found at Oplontis. It was not utilized by man.

REFERENCES

Abbott, R. Tucker. 1976. *Seashells.* Bantam Books, New York.

Allison, Penelope M. 1997. Roman Households: An Archaeological Perspective. In *Roman Urbanism, Beyond the Consumer City,* edited by H. M. Parkins, pp. 112–46. Routledge, New York.

d'Ambrosio, A. 1990. Pair of Earrings. In *Rediscovering Pompeii,* edited by L. F. dell'Orto and A. Varone, pp. 215, 217. L'Erma di Bretschneider, Rome.

Berti, F. 1984. *Voghenza, Una necropoli di età romana in territorio ferrarese.* Ferrara.

Capaldo and Moncharmont = Capaldo, Lello, and Ugo Moncharmont. 1989. "Animali di ambiente marino in due mosaici pompeiani." *Rivista di Studi Pompeiani* III: 53–68.

Caprotti, Erminio. 1977. "Malacologia Pliniana (Studi di malacologia prerinascimentale, IV)." *Conchiglie* 13/11–12: 203–7.

Ciarallo, A. 1990. Le problematiche botaniche dell'area archeologica vesuviana. In *Archeologia e Botanica,* edited by M. Mastroroberto, pp. 17–32. "L'Erma" di Bretschneider, Rome.

Ciarallo, A., and Lello Capaldo. 1990. Appendix: Flora and Fauna. In *Rediscovering Pompeii,* edited by L. F. dell'Orto and A. Varone, p. 281. "L'Erma" di Bretschneider, Rome.

Cretella, M. 1999. I Molluskhia. In *Il Complesso Archeologico del Carminiello del Mannesi, Napoli, Scavi 1983–1984,* edited by P. Arthur. Congedo, Galatina (Lecce), Italy.

Crosse, H. 1873. "Review of T. A. di Monterosato, 1872, Notizie intorno alle Conchiglie Mediterranee." *Journal de Conchyliologie* 21: 164–5.

Damon, Robert. 1867. "Notes on a Collection of Recent Shells Discovered among the Ruins of Pompeii, and Preserved in the Museo Borbonico at Naples." *Geological Magazine* 4/37: 293.

Dance, S. Peter. 1966. *Shell Collecting: An Illustrated History.* University of California Press, Berkeley.
1969. *Rare Shells.* University of California Press, Berkeley.

Dedekind, A. 1906. *Ein Beitrag zur Purpurkunde.* Mayer & Müller, Berlin.

Deiss, J. J. 1966. *Herculaneum, Italy's Buried Treasure.* Thomas Y. Crowell Co., New York.

DePuma, Richard D. 1970. "The Octopus-Eel-Lobster Motif on Hellenistic and Roman Fish Mosaics." *American Journal of Archaeology* 74/2: 191–2 (abstract).

During Caspers, E. C. L. 1981. "The Indian Ivory Figurine from Pompeii – A Reconsideration of Its Functional Use." In *South Asian Archaeology 1979,* edited by H. Härtel, pp. 341–53. Dietrich Reimer Verlag, Berlin.

Dyer, T. H. 1891. *Pompeii, Its History, Buildings and Antiquities.* Rev. ed. G. Bell and Sons, London.

Fischer, P. H. 1887. *Manuel de Conchyliologie et de Paléontologie conchyliologique.* Librairie F. Savy, Paris.

Fischer, P.-H. 1979. "Les connaissances Malacologiques des Grecs avant Aristotle." *Journal de Conchyliologie* 115/4: 104–30.

Eyton, T. C. 1858. *A History of the Oyster and Oyster Fisheries.* Van Voorst, London.

van der Feen, P. J. 1949. "Byssus." *Basteria* 13/4: 66–71.

Girardin, J. 1877. "Sur la pourpre de Tyre." *Bulletin de la Société libre d'Emulation du Commerce et de l'Industrie de la Seine inférieur* 1876–7: 91–103.

Günther, R. T. 1897. "The Oyster Culture of the Ancient Romans." *Journal of the Marine Biological Association* 4: 360–5.

Heuzé, P. 1990. *Pompéi ou le Bonheur de Peindre.* De Boccard, Paris.

Jackson, J. W. 1912. "Cypraea pantherina (Solander MS.), Dillwyn, in Saxon Graves." *The Journal of Conchology* 13/10: 307–8.
1917. *Shells as Evidence of the Migrations of Early Culture.* University of Manchester, Ethnological Series no. 11. London.

Jashemski, Wilhelmina F. 1979. *The Gardens of Pompeii, Herculaneum and the Villas Destroyed by Vesuvius.* Vol. 1. Caratzas Brothers Publishers, New Rochelle, N.Y.
1993. *The Gardens of Pompeii, Herculaneum and the Villas Destroyed by Vesuvius.* Vol. 2. Aristide Caratzas, New Rochelle, N.Y.

Keller, O. 1913. *Die Antike Tierwelt* II. Verlag von Wilhelm Engelmann, Leipzig.

Kraus, Theodor. 1975. *Pompeii and Herculaneum. The Living Cities of the Dead.* Harry N. Abrams, New York.

Matteucig, Giorgio. 1974. "Lo studio naturalistico zoologico del Portale di Eumachia ne Foro Pompeiano." *Bollettino della Società dei Naturalisti in Napoli.* 83: 213–42.

von Martens, E. 1874. *Purpur und Perlen.* Sammlung gemeinverstandliche wissenschoffliche Vortrage, Berlin.

Meyboom = Meyboom, P. G. P. 1977. "I mosaici pompeiani con figure di pesci." *Mededelingen van het Nederlands Instituut te Rome* 39, n.s. 4: 49–93.

Michaelides, Demetrius. 1995. Cyprus and the Persian Gulf in the Hellenistic and Roman Periods: The Case of Pinctada margaritifera. *Proceedings of the International Symposium, Cyprus and the Sea, Nicosia September 25–26, 1993,* pp. 211–26. Nicosia.

Michel, R. H., and Patrick E. McGovern. 1987. "The Chemical Processing of Royal Purple Dye: Ancient Descriptions as Elucidated by Modern Science." *Archaeomaterials* 1: 135–43.

Monterosato, T. di. 1872. Notizie intorno alle Conchiglie Mediterranee. Amenta, Palermo.

 1879. "Nota sull' articolo delle Conchiglie Pompeiane del Dott. Tiberi." *Bollettino della Societa Malacologica Italiana* V: 201–3.

Morel, Jean-Paul, Cecilia Rondi-Constanzo, and Daniela Ugolini, eds. 2000. *Corallo di Ieri, Corallo di Oggi.* Edipuglia, Bari.

Palombi, Arturo. 1950. La fauna marina nei musaici e nei dipinti Pompeiani. In *Pompeiana, Raccolta di Studi per il Secondo Centenurio degli Scavi di Pompei,* pp. 425–55. Gaetano Macchiaroli Editore, Naples.

 1958. "Dipinti di fauna marina e conchiglie rinvenute durante gli scavi di Stabia." *Bollettino della Societa dei Naturalisti in Napoli* 67: 3–7.

 1962. "Dipinti di fauna marina del Museo Campano di Capua." *Atti Accademia Pontaniana* (n.s.) 11: 123.

 1974. "Anfore e piatti decorati con motivi di fauna marina esistenti nel Museo Nazionale di Napoli." *Atti Accademia Pontaniana* (n.s.) 23: 169.

Pugliese Carratelli, Giovanni, ed. 1990. *Pompei, Pitture e Mosaici* II. Enciclopedia Italiana, Rome.

 1991. *Pompei, Pitture e Mosaici* III. Enciclopedia Italiana, Rome.

 1993. *Pompei, Pitture e Mosaici* IV. Enciclopedia Italiana, Rome.

Radcliffe, W. 1921. *Fishing from the Earliest Times.* John Murray, London.

Reese, David S. 1980. "Industrial Exploitation of Murex Shells: Purple-dye and Lime Production at Sidi Khrebish, Benghazi (Berenice)." *Libyan Studies* 11: 79–93.

 1982. The Molluscs. Part VI in D. Whitehouse et al., the Schola Praeconum I. *Papers of the British School of Rome* 50: 91–6.

 1985. The Late Bronze Age to Geometric Shells from Kition. Appendix VIII(A) in V. Karageorghis, *Excavations at Kition* V/II, pp. 340–71. Department of Antiquities, Nicosia.

 1987. "Palaikastro Shells and Bronze Age Purple-dye Production in the Mediterranean Basin." *The Annual of the British School of Archaeology at Athens* 82: 201–6.

 1988. "A New Engraved Tridacna Shell from Kish." *Journal of Near Eastern Studies* 47/1: 35–41.

 1990. "Triton Shells from East Mediterranean Sanctuaries and Graves in P. Åström and D.S. Reese, Triton Shells in East Mediterranean Cults." *Journal of Prehistoric Religion* III–IV: 7–14.

 1991. "The Trade of Indo-Pacific Shells into the Mediterranean Basin and Europe." *Oxford Journal of Archaeology* 10/2: 159–96.

 1992a. The Marine and Freshwater Shells. Chapter 14 in *Excavations at Otranto* II *The Finds,* edited by F. D'Andria and D. Whitehouse, pp. 347–52. Congedo Editore, Galatina (Lecce),

 1992b. Shells and Animal Bones. In *La Nécropole d'Amathonte Tombes 113–367* VI (Etudes Chypriotes XIV), edited by V. Karageorghis, O. Picard, and C. Tytgat, pp. 123–44. A. G. Leventis Foundation, Nicosia.

 2000. Iron Age Kommos Purple-dye Production in the Aegean. In *Kommos* IV *The Greek Sanctuary, 1,* edited by J. W. and M. C. Shaw, pp. 643–5. Princeton University Press, Princeton.

 In press. Marine and Freshwater Shells. In *San Giovanni di Ruoti 4 The Villas and Their Environment,* edited by A. M. Small and R. J. Buck. University of Toronto Press, Toronto.

Robinson, Jenny. 1999. The Marine Shells. In Michael Fulford and Andrew Wallace-Hadrill, Towards a History of Pre-Roman Pompeii: Excavations beneath the House of Amarantus (I.9.11–12), 1995–8. *Papers of the British School at Rome* 67: 102, 144.

Sear, F. B. 1977. *Roman Wall and Vault Mosaic.* Röm. Mitt. Supp. 23. Heidelberg.

Settepassi, Francesco. 1967. *Atlante Malacologico: Mulluskia Marini Viventi nel Mediterraneo* I. Museo di Zoologia del Comune di Roma, Rome.

Skeates, Robin. 1991. "Triton's Trumpet: A Neolithic Symbol in Italy." *Oxford Journal of Archaeology* 10/1: 17–31.

Thédenat, H. 1910. *Pompéi.* Librairie Renouard, H. Laurens, Editeur, Paris.

Thompson = Thompson, T. E. 1977. "A Marine Biologist at Pompeii A.D. 79." *Nature* 265/5592 (January 27): 292–4.

Tiberi, Nicola. 1879a. "Le Conchiglie Pompeiane." In *Pompei e La regione Sotterrata dal Vesuvio nell'anno 79,* pp. 95–104, Naples.

 1879b. "Le Conchiglie Pompeiane." *Bollettino della Società Malacologica Italiana* 5: 139–51.

Waldstein, C., and L. Shoobridge. 1908. *Herculaneum: Past, Present & Future.* London.

Ward-Perkins, John, and Amanda Claridge. 1978. *Pompeii A.D. 79.* Museum of Fine Arts, Boston.

Zevi, Fausto 1991. *Pompei.* Guida Editori, Naples.

14

INSECTS

EVIDENCE FROM WALL PAINTINGS, SCULPTURE, MOSAICS, CARBONIZED REMAINS, AND ANCIENT AUTHORS

Hiram G. Larew

But we marvel at elephants' shoulders carrying castles, and bulls' necks and the fierce tossing of their heads, at the rapacity of tigers and the manes of lions, where as really Nature is to be found in her entirety nowhere more than in her smallest creations.

<div align="right">Pliny HN 11.4</div>

Insects, through recorded history, have captured the eye, imagination, and respect of naturalists. The size of these "smallest creations," we have learned, belies their importance. If the study of insects is fascinating (and it is), the study of how our understanding of insects developed is equally intriguing. The history of entomology has been studied for many years (Howard 1930; Smith, Mittler, and Smith 1973) and provides general insights into how humans relate to their surroundings. For example, many insects and most of their body parts are barely visible to the unaided eye. Entomological depictions and accounts made before the advent of magnifying lenses demonstrate the power and flaw of human perception and interpretive skills.

Pompeii and Herculaneum offer unique windows to the ancient western world. For historians of biology, study of these preserved sites coupled with encyclopedic accounts of natural history left by ancient authors such as Pliny, Cato, Varro, and Columella permit verification and fuller understanding of the sites and the accounts. Preserved remains and unearthed depictions bring life to the written testaments of ancient Roman natural history.

The potential of Pompeii and Herculaneum, however, as sites for entomological remains is largely unexplored. The few biological remains and depictions that have been uncovered add depth to written accounts, but even more, they highlight the need for entomo-sensitive excavations and interpretive studies. By comparing written accounts of the time with the limited amount of physical evidence, this chapter will demonstrate what is known and, in so doing, will attempt to tantalize with suggested potential.

DEPICTIONS

The mosaics, wall paintings, sculpture, and other preserved decorative depictions of insects known from Pompeii, Herculaneum, and the villas destroyed by Vesuvius are important because they indicate how people of the time viewed insects. Unfortunately, the number of known depictions of insects is small, particularly so when compared to avifaunal and botanical artwork. Animals depicted in Pompeii, including insects, were inventoried by Matteucig (*animali*). Of the 218 animal species listed, only 9 (4 percent) were insects. As one might expect, the most decorative of insects, the butterflies, were indeed depicted. But apparently birds and plants were considered more familiar and more indicative of outdoor scenery – perhaps more tranquil and bucolic subjects for illustration in living quarters – than were insects. If art was allegorical, then perhaps the scarcity of known insect illustrations implies that insects bore fewer symbolic traits than other animals. When they *were* used as artwork subjects, insects were often viewed by the artist as an element in the web of life, another indication of nature's bounty. They were not the featured centerpiece but a significant part of interdependent "biovariety." The possibility exists, of course, that depictions of insects are scarce because they simply have been overlooked by modern investiga-

tors, and that rescrutinization of known mosaics, murals, and sculpture will reveal entomological finds.

PRESERVED REMAINS

Unlike depictions, preserved remains confirm the presence of specific types of insects and, depending on the situation in which they are found, may suggest how humans of the time interacted with (e.g., used, controlled, enjoyed) insects. But even rarer than depictions is the extent to which insects were preserved in the eruption. Available evidence is covered in this chapter, and its paucity suggests that a finer-tooth comb, patience, and a keenly trained eye are required to uncover and recognize remains.

ANCIENT LITERATURE

Entomological literature was surprisingly rich at the time of the Vesuvian eruption. Davies and Kathirithamby (1986) provide description of the fairly extensive entomological knowledge in ancient Greece. In their review of the literature, both Bodenheimer (1928) and Morge (1973) indicate that while misconceptions occurred, a rudimentary but often correct understanding of the behavior of some insects was apparent – this in a time when deductive research was unknown and an unaided, lensless mode of observation was, most likely, the natural historian's primary method.

If the length of account and depth of understanding reflects amount of interest, then, much as today, insects took literary third seat to vertebrates and plants. All of the ancients spend much more time discussing crops and cattle than they do insects. As will be seen, however, insects that were important to humans, either as friend or foe, received their fair share of attention.

In three works (*History of Animals, On the Parts of the Animals,* and *On the Generation of Animals*) Aristotle (384–322 B.C.) established a framework for insect classification based on wings and mouthparts. He also described for the first time the notion of developmental stages (i.e., egg, larva or nymph, pupa or chrysalis, and adult), and of molting, reproduction, and the production of sound. He discussed sericulture (silk production) and apiculture (raising honeybees) in detail. Moths, butterflies, house flies, mosquitoes, cicadas, lice, gall wasps, locusts, grasshoppers, bees, and wasps are all discussed by him (see Bodenheimer 1928; Morge 1973; Davies and Kathirithamby 1986). Most important, Aristotle, using an entomological example, took a significant scientific step forward by arguing that the understanding of bee reproduction was best based upon observa-

tion, not hearsay or theory. Although many of his observations are now recognized as inaccurate (for example, like many other ancients, he believed the queen bee was actually a king), he is nonetheless credited with a bold break from his predecessors – trusting his eye.

Aristotle's student, Theophrastus, in his *Enquiry into Plants,* concentrated on botanical descriptions but often included information on insects that injured or were merely associated with plants. He knew flea beetles, wood-boring insects, and pests of beans, grapes, apples, pears, olives, and medicinal plants. He mentioned galls (1.2.1) in passing as a "peculiar part" of an oak. His discussion of apiculture built on that of Aristotle.

Cato and Varro included information on pests in their practical manuals on husbandry and farming that was based on firsthand experience. Columella included practical measures for pest control in his *De re rustica.*

Insects were discussed as sources of medicinal remedies by Dioscorides. In the *Materia Medica* we know that bed bugs, cockroaches, soldier beetles, and scale insects were part of the recognized insect inventory. He also provided a detailed discussion (1.146) of the medicinal uses of insect-caused plant galls from oaks, which he called *omphacitis.*

In Pliny's work *Natural History* (*HN*), we have a large compilation of all that was known at the time of the eruption. Viewed from a modern perspective we see that Pliny owed a tremendous debt to earlier Greek entomological writings, but his contributions to entomology as a compiler are solid. References to insects are found throughout Pliny's treatise. The first half of Book 11 is devoted to a discussion of insects, including their ability to breathe, their body fluids, their lack of bones and skin, the independence of each limb, and special features of their eyes and senses. It also includes accounts of particular types of insects. Insects, spiders, millipedes, and honey are all mentioned as ingredients in various medicines in *HN* Book 30.

Important references are also found in poetry. Vergil's *Georgics,* a poem devoted entirely to agriculture, has much to say about bees in Book 4. He describes hives made of bark, or woven osier (willow twigs), discusses the "king" of the hive and his activities, and is entranced by the hive's "life under majesty of law."

INSECTS OF POMPEII AND VICINITY

The following discussion covers references in ancient literature as well as known depictions and preserved remains of insects from Pompeii and the surrounding area. Coverage is by insect Orders listed alphabetically,

including Coleoptera, Diptera, Hymenoptera, Lepidoptera, and Orthoptera. Spiders and their close relatives, although not insects, are briefly discussed.

1. ORDER COLEOPTERA

English, beetles; Italian, *scarafaggio, maglio*

> . . . in some species the wings are protected by an outer covering of shell, for instance beetles.
>
> Pliny *HN* 11.97

EVIDENCE FROM ANCIENT AUTHORS

Several kinds of beetles (*scarabaei*) are discussed by the ancient writers. Death watch beetles, dung beetles, stag beetles, glowworms, woodworms, fireflies, and fig beetles are each mentioned briefly by Pliny throughout Book 11. He describes medicinal uses of buprestids in Book 30. The agricultural writers such as Columella, Cato, and Varro describe damage caused by grain weevils, flea beetles, and buprestids. Columella (*RR* 1.6.10–7) goes into considerable detail about construction of aboveground grain stores so as to prevent or discourage attack by weevils (*curculiones*). As pointed out by Morge, these recommendations are noteworthy in their timelessness and accuracy. For example, belowground storage as described by Cato (*RR* 92) and Pliny (*HN* 18.301–8) accurately depicts methods used in parts of the world today. Cato (*RR* 92) also discussed a mixture of "slime" made of olive pressings that could be used to line granaries to suppress beetle attack. Varro (*RR* 1.57) describes the use of ashes as a protectant in stored grains — again, a method still used in many countries today. All in all, the detail of the ancients' recommendations regarding beetle pests twenty centuries ago is strikingly familiar today.

CARBONIZED MATERIAL

A specimen of a lathridiid scavenger beetle, *Microgramme ruficolis* Marshen was identified by J. Kingsolver (Research Entomologist, U.S. Department of Agriculture, Smithsonian Institution, Washington, D.C.) in carbonized hay in the *villa rustica* at Oplontis (Fig. 256). The beautifully preserved hind section of another beetle (tentatively identified as a weevil in the genus *Otiorhynchus*) was also found in the hay (Fig. 257). Parts of bruchid weevils have been extracted from boreholes in preserved beans found in the garden of the House of the Ship *Europa* (1.xv) at Pompeii (Fig. 258). This last specimen leaves no doubt that storage pests were encountered in Campanian gardens. The lesson in these discoveries is that all preserved plant materials should be carefully examined for insect remains or damage.

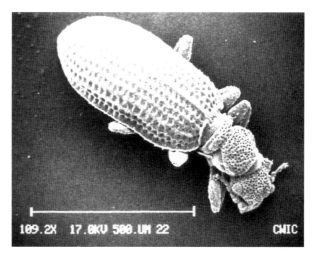

FIGURE 256 Carbonized scavenger beetle, *Microgramme ruficollis*, from hay, *villa rustica*, Oplontis. Photo: F. Heuber.

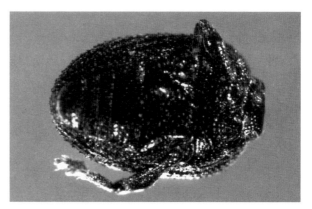

FIGURE 257 Hind quarters of a carbonized beetle, from hay, *villa rustica*, Oplontis; tentatively identified as an *Otiorhynchus* species.

FIGURE 258 Bean with bruchid beetle in hole. Photo: USDA.

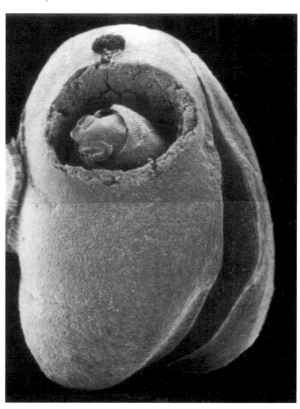

SCULPTURE

Most of the known depictions that are suggestive of beetles are found in the marble frieze of Eumachia. One such rendering shows a lizard or salamander feeding on a relatively large insect (*Melolontha melolontha* according to Matteucig 1974b, no. 5 in his checklist; a June beetle in the family Scarabaeidae) (see Fig. 282). The insect has the overall round head and tapered shape of a fly. The size of the insect, however, relative to the lizard, and its prominent and flatly folded wings that resemble elytra (thickened fore wings) suggest a beetle. Much as the bird/grasshopper predation seen in other parts of the frieze, this depiction indicates an understanding of food webs. Matteucig (1974b) identifies two other animals as beetles in the frieze (nos. 38 and 39 in his list) but does not comment on them. A beetlelike figure is sculpted on the sides of a bronze mantic hand used in the worship of Sabazius (Jashemski 1979: fig 137).

REMARKS

The existence of beetles as specimens from the ruins of Pompeii indicates, as we would expect, that they were present. However, the specimens and depictions do not yet match written accounts for insight into the ancients' understanding of beetles. Additional specimens and less stylized renderings are required.

2. ORDER DIPTERA

English, fly; Italian, *mosca*
English, mosquito; Italian, *zanzara*
English, gnat; Italian, *moscerino*

We shall get rid of the flies which infest wounds by pouring on them pitch and oil or fat.

Columella, *RR* 6.33.1

EVIDENCE FROM ANCIENT AUTHORS

The ancient authors make numerous references to various kinds of flies (*muscae*), including house flies, horse flies, carrion flies, blow flies, gnats, and mosquitoes (*culices*). Columella, as quoted here, describes remedies for livestock flies. Pliny (*HN* 11.120) says that horse flies (*tabani*) die of blindness and that if flies are killed by dampness, they can be resuscitated by being buried in ashes.

SCULPTURE

Matteucig (1974b) lists three flies as being represented in the Eumachia marble frieze (nos. 19, 79, 88 in his checklist). One (Fig. 259) shows a small insect (a muscoid brachyocerid fly according to Matteucig) that has a small head and wings that are flat with nonoverlapping rounded tips – traits that are suggestive of a stationary fly crawling up the frieze. He also lists one of the carved flies as a dung fly, *Cypselus apus* (*animali*), but this identification is problematic given the imprecision of the carving.

3. ORDER HYMENOPTERA

English, bee; Italian, *ape*
English, wasp; Italian, *vespa*
English, hornet; Italian, *calabrone*
English, ant; Italian, *formica*

. . . but among all of these species the chief place belongs to the bees, and this rightly is the species chiefly admired, because they alone of this genus have been created for the sake of man.

Pliny *HN* 11.11

EVIDENCE FROM ANCIENT AUTHORS

Honeybees (*apes*) were the most discussed, observed, respected, and admired insects in antiquity. According

FIGURE 259 Flylike insect and grasshopper, Eumachia. Photo: F. Meyer.

to Varro (*RR* 3.16.), mead was a common beverage, and honey an item of commerce. Beekeeping was described in detail, and not surprisingly, swarms were sold by keepers. In fact, Varro warns buyers to check swarms to make sure the bees are healthy. General instructions for building and siting apiaries (hives) was provided by Varro (*RR* 3.16.15–6), and he mentions at least three kinds of construction materials, namely round hives of twigs, pieces of hollow trees, or earthenware.

Pliny devotes more descriptive detail to bees by far than to any other insect. His wonderment in them is reflected in phrases such as, "they have a system of manners that outstrips that of all the other animals," and "nature is so mighty a power that out of what is almost a tiny ghost of an animal she has created something incomparable" (*HN* 11.12). The initial cause for excitement was undoubtedly honey, but from the lengthy description of hive lifestyle given by most writers of the time it seems clear that colony behavior became a metaphor for human society and thus intrigued the writers. And the level of understanding was remarkable; significant misinterpretations were self-assuredly presented as facts (as they are today), but in large part hive life was understood for the microcosm that it is. For example, Pliny discusses hibernation, hive construction, nectar collection, hive organization, division of labor, honey flavor as determined by flowers visited, smoking as a hive management method, bee stings, and hive pests such as wax moths. He devotes several sections to the description of reproduction. In Book 21, sections 80–1, he discusses apiaries that were made of transparent stone so that the keeper could observe the bees' activities. He also discusses winter protection of hives and control of moths (most likely wax moths). He describes various kinds of honey (21.43–6) and briefly mentions how beekeepers may move their hives to fields of flowers. His confusion about caste, "kings," and drones makes it clear, however, that the level of understanding of some aspect of hive life was only partial.

Varro (*RR* 3.16.13) describes numerous crops known to be favored by bees; rose, wild thyme, balm, poppy, bean, lentil, pea, clover, rush, alfalfa, and snail clover. Columella (*RR* 9.4.4) lists acanthus among those "flowers which are much loved by bees." He also describes how to place hives so as to protect them from the wind (9.7.4–6). For ailing bees, Varro (*RR* 3.16.3) recommends snail clover, while Vergil (*Georgics* 2.97) suggests powdered galls with dried rose as a remedy. Pliny (*HN* 30.58, 62, 73, 107) recommends honey in which bees have died as a treatment for a variety of human illnesses.

Wasps, hornets, ants, and gall wasps, although known, are covered in much less detail by Pliny (*HN* 11.71–4, 108–11), with emphasis being given to descrip-

tions of nest building, food gathering, stings, and the commercial importance of galls. The predatory nature of ichneumonids (*ichneumones*) is also described (*HN* 11.72) — yet another indication of the acuity of the ancients' curiosity. The role of parasitic wasps in the suppression of insects, however, was generally not as fully appreciated by the ancients as was, for example, bird predation on grasshoppers. The minute size and cryptic habits of many parasites (wasps and other insects) undoubtedly explains why they went unnoticed.

CARBONIZED MATERIAL

Cynipid galls that were found in a container (most likely a dolium) in a shop on the Decumanus Maximus (Fig. 260) in Herculaneum are the oldest examples of hymenopteran products in trade (Larew 1987, 1988) and resemble present-day galls caused by cynipid wasps in the genus *Adleria*. They were most likely sold for medicinal purposes, or for dyeing or tanning. Cursory examination of the large collection of preserved galls in the *deposito* at Herculaneum (Larew, unpublished) suggests that such specimens have more to tell (Fig. 261). For example, Dioscorides noted that galls without exit holes (through which the insect emerges) are the best, most tannin-rich galls. Interestingly, most of the Herculaneum galls have no exit holes. When I opened one gall without exit holes, remnants of a wasp (either the gall former or a parasitoid) were revealed (Fig. 262). Clearly, as more of these galls are examined, we will have a sharper picture of how galls were used in ancient times.

SCULPTURE.

Highly stylized insects carved in the Eumachia frieze (Fig. 263) close to an acanthus blossom (in keeping with Columella's observation, cited earlier) resemble bees or butterflies. Their pointed abdomen, short antennae, and vertical flight posture are suggestive of a bee, but the full wings and waist resemble those of a butterfly. There are no known illustrations of hives. This is curious given the interest in honey and beekeeping. Matteucig (1974a) lists no bees in his inventory of animals from the ruins.

Insects that resemble ants are carved in the Eumachia frieze. One (no. 97 in Matteucig's list, 1974b) is in the beak of a small bird, while another (Fig. 264) is crawling up the frieze. Both are stylized but are indicative of wingless ants, which typically have small heads, a large abdomen, and a constricted "waist." Matteucig (1974a) identified these as *Formica rufa*. Such a definitive identification is questionable.

4. ORDER LEPIDOPTERA
English, butterfly; Italian, *farfalla*
English, moth; Italian, *tarma, falena, tignola, tarla*

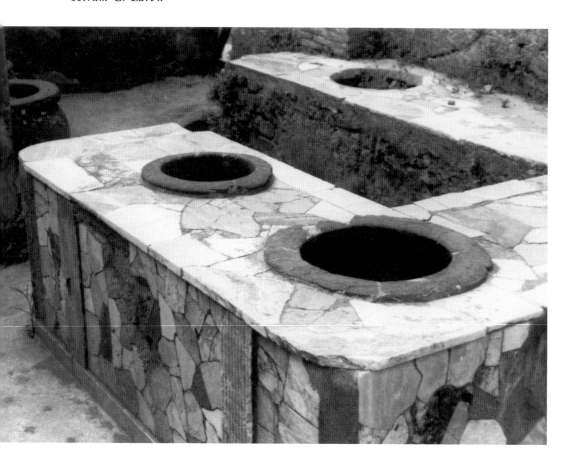

FIGURE 260 *(Above)* Shop on the Decumanus Maximus, Herculaneum, in which galls were found in *dolia*. Photo: H. Larew.

FIGURE 261 *(Left)* Bag of preserved galls in the Herculaneum *deposito*.

FIGURE 262 *(Below)* Cutaway of a carbonized gall from Herculaneum showing remnants of a wasp.

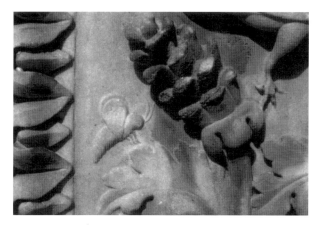

FIGURE 263 Bee/butterfly-like insect, Eumachia. Photo: F. Meyer.

FIGURE 264 Antlike insect, Eumachia. Photo: F. Meyer.

. . . it later becomes a caterpillar which as days are added grows larger, becomes motionless, with a hard skin, and only moves when touched, being covered with a cobweb growth – at this stage it is called a chrysalis. Then it bursts its covering and flies out as a butterfly (*papilio*).

Pliny *HN* 11.116

EVIDENCE FROM ANCIENT AUTHORS

Pliny (*HN* 11.75) briefly discusses the silk moth (*bombyx*), clothes moth, and wax moth; he describes the comfort of clothing made from products of the first, and trouble caused by the latter two. Hornworms and assorted caterpillars are discussed briefly by Theophrastus (*Hist. pl.* 7.5.4 and 8.10.5) as plant pests. Cato suggests an olive oil, tar, and sulfur mixture as a repellant for caterpillars on grape vines (*RR* 95.2) and for moths in stored clothing (*RR* 98).

PAINTING

The butterfly appears in a number of wall paintings. In the garden painting of the House of Adonis (VI.vii.18) at Pompeii there was a butterfly on the left of the acacia bush (Jashemski 1979: fig. 67). Boyce (1937: 25 no. 36) describes two butterflies perched on the flowers in the lararium painting on the W wall of the peristyle portico of the House of the Cryptoporticus (I.vi.2). In a painting in the Naples Museum (inv. no. 9733) a butterfly hovers over 3 fruits of the strawberry tree that a black bird is about to eat (see Fig. 334) A humorous painting of a yellowish butterfly driving a chariot drawn by a griffin is reported by Helbig (1868) (no. 1550) and was originally in the Naples Museum, but has not been found in the collection in recent years. A similar theme is pictured on a Roman gem in which a butterfly drives a cart pulled by a peacock (Lippold 1922).

The beautiful garden painting details in the portico of the lower peristyle of the Villa of Diomedes at Pom-

peii have totally disappeared, but fortunately some details are preserved in an old publication. Butterflies are pictured twice (Figs. 109 and 265). Painted depictions of butterflies or moths have also been noted in the House of the Faun (first style frieze, oecus 44), in the Villa of the Mysteries (frieze above the second style *megalographia*), and in a still-life painting in the House of M. Lucretius Fronto (V.iv.11/a) (Castriota 1995; Tammisto 1997). Two butterfly/moths are depicted alighted on stylized sprigs of ivy in wall paintings of the ambient E of the Villa of Ariadne at Stabia (Longobardi 1997: fig. 99). The painting fragments of an earlier wall painting from House VI (*insula occid.* 42) include a stylized depiction of a moth or butterfly seemingly in flight.

FIGURE 265 Butterfly, roses, and wild strawberry, Villa of Diomedes.

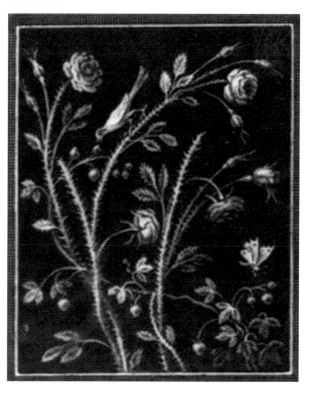

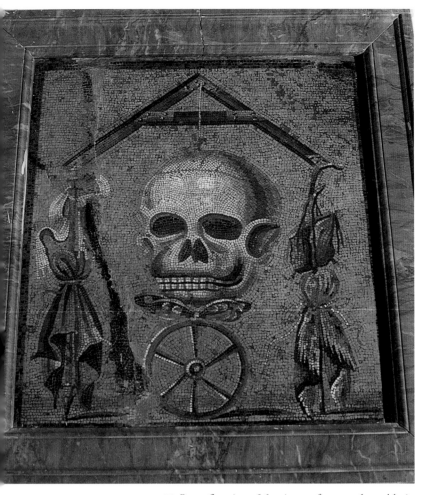

FIGURE 266 Butterfly wings. Mosaic top from garden table in Garden of the Tannery, Pompeii (NM inv. no. 109982). Photo: S. Jashemski.

MOSAIC

A clear depiction of lepidopteran forewings is seen in a well-preserved mosaic that decorated the top of a table in the garden of the Tannery at Pompeii (I.v.2) (Fig. 266). The slim, highly patterned wings appear to belong to a moth in the Suborder Jugatae. The position of the wings directly beneath a human skull and above a wheel, as well as the symmetry of the mosaic, suggests a symbolic intent. The butterfly was the symbol of the soul among the Greeks, who used the same word ψυκή (psyche) for both soul and butterfly. The acanthus border of the fish mosaic (NM inv. no. 9997) from the House of the Faun (Castriota 1995, pl. 65) and the fruited garland border around the Dove mosaic (NM inv. no. 114281) in the House of the Doves (VIII.ii.24) (Castriota 1995, pl. 66) also contain depictions of butterflies or moths, as does the border around the basin in the atrium of baths in the House of Menander (Tammisto 1997, pl. 65).

SCULPTURE

Matteucig (1974b) describes two lepidopterans from the carved doorway at Eumachia, of least one of

which (Fig. 263) (no. 1 in his list) is stylized such that it could represent a butterfly or a bee.

5. ORDER ORTHOPTERA
English, grasshopper; Italian, *cavalletta, locusta*
English, cricket; Italian, *grillo*
English, roach; Italian, *lasca*

. . . they pass over immense tracts of land and cover them with a cloud disastrous for the crops, scorching up many things with their touch and gnawing away everything with their bite, even the doors of the houses as well.

Pliny *HN* 11.104

EVIDENCE FROM ANCIENT AUTHORS

Of all of the insects, the locust (*locusta*) was considered the most damaging by the ancients. As indicated in Pliny's quote, accounts of their damage were graphic. Pliny also briefly discusses migration of swarms as well as sound production (a "grating" of teethlike structures at the shoulder blades — an observation that is remarkable for its near accuracy because the "song" is produced by rubbing the forewings together), mating, sexual dimorphism, and how locusts fall prey to birds.

Pliny confuses grasshoppers and crickets with the "cicada" (*tettigonia*) (Order Homoptera) — a confusion that continues today among the public. He describes grasshopper life cycles and the wings of tree-crickets. What struck the imagination of the ancient observer, however, was not always what we might expect. For example, Pliny did not describe at length the feeding habits of grasshoppers or the cryptic habit of many crickets. Instead he discusses in some detail how locusts can kill snakes, and marvels at accounts of three-foot-long locusts in India.

Pliny (*HN* 11.99) discussed the roaches (*blatta*) in a section devoted to describing different kinds of beetles (Order Coleoptera). He described them as a "nurseling of the shadow" that are "mostly produced in the damp warmth of bathhouses." He provides no other indication that cockroaches were considered the household pests they are today.

PAINTINGS

Recognizable depictions (paintings, sculpture) of this group are almost as numerous as those of butterflies. Although stylized, the distinctively prominent hind legs (femora), cylindrical body with tightly folded wings, and large head and antennae allow for easy recognition. A wall painting on the portico facing the large swimming pool in the Villa of Poppaea at Oplontis (Fig. 267) beautifully depicts a cricket/grass-

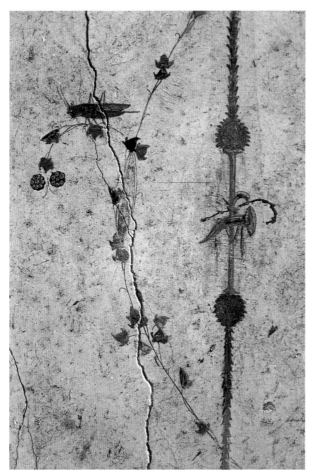

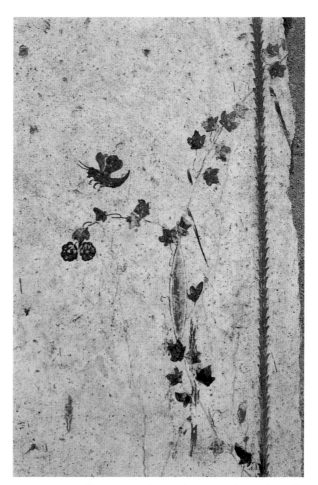

FIGURE 267 Wall painting of a cricket-grasshopper, Villa Poppaea, Oplontis. Photo: S. Jashemski.

FIGURE 268 Wall painting of a grasshopper or butterfly, Villa Poppaea, Oplontis. Photo: S. Jashemski.

hopper resting on a vine with prominent ovipositor, cylindrical body, and jumping legs. The illustrated interaction with a plant reflects a natural association. Another painting on the same wall (Fig. 268; Jashemski 1979: fig. 477) shows a flying insect that resembles a grasshopper or butterfly by virtue of its prominent antennae and large head. A grasshopper was also pictured on the Villa of Diomedes at Pompeii in the portico of the lower peristyle (see Fig. 91). Two beautifully rendered images are depicted in fragments of an earlier wall painting in House VI (*insula occid.* 42). Both show grasshoppers with wings slightly open as if they are ready to alight or embark (Ciarallo and De Carolis

FIGURE 269 Line drawing of a grasshopper in a chariot (Kenner 1970: fig. 8).

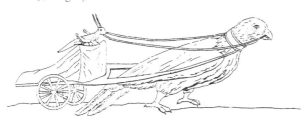

1999, pp. 58–59). The most fanciful depiction is a painting from Herculaneum no longer extant of a grasshopper driving a chariot that is being drawn by a green parakeet. It has been preserved in a line drawing (Fig. 269). A similar depiction on a gem shows a cricket driving a chariot drawn by two hounds (Furtwangler 1896: pl. 88). Kenner (1970: 25f) suggests that these chariot depictions may parody triumphant entries of rulers into Rome. Paintings of grasshoppers or crickets have also been noted in friezes in the House of the Faun and the Villa of the Mysteries (Castriota 1995; Tammisto 1997). A pair of grasshoppers/crickets is depicted on sprigs of stylized ivy (*Hedera*) on the wall paintings of Villa of Ariadne at Stabia (Longobardi 1997: fig. 99).

MOSAIC

The beautiful garland border in the Dove mosaic (NM inv. no. 114281) in the House of the Doves depicts grasshoppers or crickets perched on the ribbon that wraps around the garland (Fig. 270) (Castriota 1995; Tammisto 1997). Tammisto also noted a grasshopper in the basin mosaic in the House of Menander.

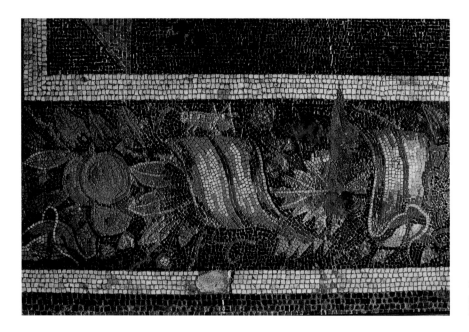

FIGURE 270 A cricket on a mosaic garland (NM inv. no. 114281). Photo: S. Jashemski.

SCULPTURE

The marble frieze of Eumachia at Pompeii has several excellent carvings of grasshopperlike insects (Figs. 259 and 271), some of which are near, or in, a bird's beak or a lizard's mouth. These associations between bird predator and grasshopper prey are some of the earliest and most striking illustrations of trophic interactions between vertebrates and invertebrates. The carver clearly depicted a behavior that indicated an understanding of the interdependence of life, not to mention biological control. Thus it is from bas-relief carvings of the Eumachia frieze that we see a rendering that begins to match the level of entomological understanding of the ancient writers such as Vergil, who speaks of birds that "carry off bees on the wing, dainty morsels for their fierce nestlings" (*Georgics* 4).

Matteucig (1974a, 1974b) identified eight crickets or grasshoppers from the Eumachia frieze and assigned four to species: *Acheta campestris* (no. 1 in his Table 1,

1974a); *Acridium lineola* (no. 2); *Tettigonia viridissima* (no. 20); *Anacridium aegyptium* (no. 61). He assigned two others to genus: *Gryllus* (no. 42) and *Acridium* (no. 85). This level of confidence, especially assignments to the species level, is surprising given the degree of stylization in the frieze. Furthermore, Matteucig (1974b) used his identifications of depicted insects and other animals in the frieze to argue that the entire frieze illustrates a seasonal calendar (*orologio biologico*) — an interpretation that is interesting, but rests on his somewhat unreliable identifications.

OTHER ORDERS

EVIDENCE FROM ANCIENT AUTHORS

At least three other orders of insects are mentioned by Pliny or Columella: Homoptera (cicadas, aphids, spittlebugs), Siphonoptera (fleas), and Neuroptera (lacewings). There is some uncertainty as to the last Order; the ancients may have been referring to mayflies (Order Ephemoptera), which also have large, highly netted wings and iridescent bodies.

DEPICTIONS

A small (6 cm long) carving of a cicada in high quality rock crystal from India was discovered in Pompeii (I.ii.3) on April 12, 1873 (*BdI* 46, 1874: 202) and is now in the Naples Museum (inv. no. 109629). Morge (1973) mentions a Pompeian mosaic that shows a cicada as the driver of a coach to which a parrot is harnessed, but no further details are provided. Matteucig (1974a) lists *Cicada orni* (Order Homoptera) as having been depicted in the Eumachia frieze. Otherwise, depictions from these orders are lacking. In the case of fleas, this is not surprising given their small size, but the eye-catching wings of

FIGURE 271 A cricket-grasshopper in a bird's beak, Eumachia. Photo: F. Meyer.

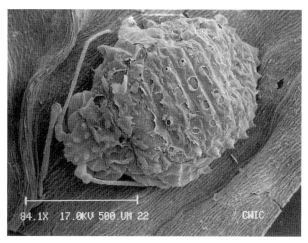

FIGURE 272 Aphidlike insect, *villa rustica*, Oplontis.

the lacewings and/or mayflies suggests that some were most likely depicted in yet unknown decorations.

CARBONIZED SPECIMENS

What has been tentatively identified as a larva of an unidentified insect on a clover leaf in carbonized hay from the *villa rustica* at Oplontis (see Jashemski 1979: 326, fig. 517) may actually be an aphid because it appears to have syringelike (stylet) mouthparts (Fig. 272). The examination of a pregnant young female killed when Mount Vesuvius erupted revealed that her hair had been virtually replaced by iron oxide and also contained an egg of the human head louse (?*Pediculus humanus* var. *capitis*). Head lice were apparently a common infestation during that ancient time (Capasso and Di Tota 1998).

COMMENTS

Given their bright color and flashy habits, it is surprising that dragonflies (Order: Odonata) are not mentioned by the ancient authors or depicted in the numerous murals of waterside habitats.

FIGURE 273 Spiderlike carving, Eumachia. Photo: F. Meyer.

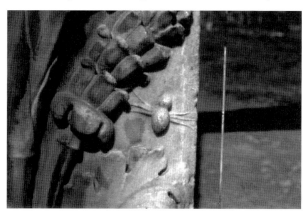

ARTHROPODS OTHER THAN INSECTS

EVIDENCE FROM ANCIENT AUTHORS

Spiders, scorpions, ticks, and mites (scab mites) are discussed by the ancients. Scorpions, for example, were recorded because of their "sting." Livestock afflictions caused by ticks were discussed by Columella (*RR* 7.13.1), as was scabies (*RR* 6.32.1–3) – a skin inflammation often caused by mites. The predatory nature of spiders is documented by Pliny (*HN* 11.85).

SCULPTURE

Matteucig (1974b) lists the spider, *Aranea diademata*, as being depicted in the Eumachia frieze, but it is unclear as to which of the five spider carvings on the frieze that he identified (nos. 2, 41, 60, 67, and 89 in list) this assignment refers. All of the spiderlike organisms in the frieze are depicted with six legs rather than the correct eight (Fig. 273). The two body regions (cephalothorax and abdomen), however, are accurately carved, and this body structure distinguishes these arthropods from insects, which have three body regions.

Although unknown from depictions, spiderwebs were surely drawn; the symmetry and eye-catching dewiness of webs would doubtless have appealed to muralists of the time. Mites and ticks are so small as to perhaps be unknown to artists of the time. Depictions of scorpions are unknown.

CONCLUSIONS

Comparing what we know from ancient literature with the depictions and actual insect specimens from long ago makes one thing clear: Ancient written accounts provide a much more thorough and detailed idea of entomological awareness at the time of the eruption than do preserved specimens or depictions. Even if Matteucig's hypothesis of the Eumachia frieze as a natural calendar is correct, the depth of understanding described in written accounts greatly exceeds that exhibited in depictions. Just as surely, however, there remains undetected a wealth of depictions and specimens that will enrich future understanding of ancient entomology.

What can be said about the renderings and preserved remains that do exist? Those few depictions that are known confirm an early understanding of general insect morphology and behavior. Artists of the day included insects as part of a decorative aesthetic, and perhaps as symbolic images. They knew and cared enough about observing insects so as to represent them with sometimes striking accuracy, but usually with

license. Actual specimens confirm that insects were part of Campanian life in markets and gardens.

As new remains are excavated at these and other ancient sites, methods that capture insects and their parts (Costantini, Tosi, and Vigna Taglianti 1975–7) should be used. If new murals and mosaics are uncovered, accurate written and photographic records should be kept, and the best available means should be used to preserve the depictions. Entomologists should be included in excavation efforts.

ACKNOWLEDGMENTS
The author wishes to thank Wilhelmina Jashemski, Ann Young, and Peter DeWey for assistance in completing this chapter. The National Geographic Society provided partial funding for the work. Much of the study was completed during the author's tenure as Research Entomologist, Agricultural Research Service, U.S. Department of Agriculture.

REFERENCES

Bodenheimer, F. S. 1928, 1929. Materialien zur Geschichte der Entomologie bis Linne. Bd. I, II. Junk, Berlin.

Boyce, G. K. 1937. *Corpus of the Lararia of Pompeii.* MAAR. 14.

Capasso, L., and G. Di Tota. 1998. "Lice Buried under the Ashes of Herculaneum." *The Lancet* 351: 992.

Castriota, David. 1995. *The Ara Pacis Augustae and the Imagery of Abundance in Later Greek and Early Roman Imperial Art.* Princeton University Press, Princeton, N.J.

Ciarallo, Annamaria, and Ernesto De Carolis, eds. 1999. *Homer Faber:* Electra, Milan.

Costantini, L., M. Tosi, and A. Vigna Taglianti. 1975–7. "Typology and Socioeconomic Implications of Entomological Finds from Some Ancient Near Eastern Sites." *Paleorient.* 3: 247–58.

Davies, M., and J. Kathirithamby. 1986. *Greek Insects.* Oxford University Press, Oxford.

Furtwangler, A. 1896. *Beschreibung der geschnittenen Steine im Antiquarium zu Berlin, von Adolf Furtwangler.* Verlag von W. Spemann, Berlin. No. 7958, pl. 88.

Helbig, W. 1868. *Die Wandgemälde der vom Vesuv verschütteten Städte Companiens.* Breitkopf und Härt, Leipzig.

Howard, L. O. 1930. *A History of Applied Entomology,* Smithsonian Miscellaneous Collection, Vol. 84. Smithsonian Institute, Washington, D.C.

Jashemski, W. F. 1979. *The Gardens of Pompeii, Herculaneum and the Villas Destroyed by Vesuvius,* Vol. I. Caratzas Brothers, New Rochelle, N.Y.
1993. *The Gardens of Pompeii, Herculaneum and the Villas Destroyed by Vesuvius,* Vol. II. Aristide D. Caratzas Publisher, New Rochelle, N.Y.

Kenner, H. 1970. *Das Phanomen der verkehrgen Welt in der Griechisch-rominschen antik.* Klagenfurg.

Larew, H. G. 1987. Oak Galls Preserved by the Eruption of Mount Vesuvius in A.D. 79, and Their Probable Use. *Economic Botany* 4(1): 33–40.
1988. Oak (*Quercus*) Galls Preserved at Herculaneum in A.D. 79. In *Studia Pompeiana & Classica,* edited by R. Curtis, pp. 145–8. Orpheus Publishing, New Rochelle, N.Y.

Lippold, G. 1922. Gemmen und Kameendes Altertums und der Neuzeit. J. Hoffman, Stuttgart. Pl. 94, 12.

Longobardi, N., ed. 1997. *Le ville romane di Stabiae.* Assoc. Stabia Duemila. Pl. 99.

Matteucig, G. 1974a. "Aspetti naturalistici desumibili da una prima elencazione delle forme animali rappresentate nell'antica Pompei." *Bollettino della Società dei Naturalisti in Napoli* 83: 177–211.
1974b. "Lo studio naturalistico zoologico del Portale di Eumachia nel Foro Pompeiano." *Bollettino della Società dei Naturalisti in Napoli* 83: 213–42.

Morge, G. 1973. Entomology in the Western World in Antiquity and in Medieval Times. In *History of Entomology,* edited by R. F. Smith et al., pp. 37–80. Annual Reviews Inc., Palo Alto, Calif.

Smith, R. F., T. E. Mittler, and C. N. Smith, eds. 1973. *History of Entomology.* Annual Reviews Inc., Palo Alto, Calif.

Tammisto, Antero. 1997. "Birds in Mosaics: A Study of the Representations of Birds in Hellenistic and Roman-Campanian Tessellated Mosaics in the Early Augustan Age." *Acta Instituti Romani Finlandiae* 37. Gummerus Kiriapaino Oy. Jyväskylä.

15

AMPHIBIANS AND REPTILES

EVIDENCE FROM WALL PAINTINGS, MOSAICS, SCULPTURE, SKELETAL REMAINS, AND ANCIENT AUTHORS

Liliane Bodson

INTRODUCTION

Amphibians and reptiles, although to a far lesser extent than other animals, especially birds and mammals, are depicted in mosaics, wall paintings, bronze and marble sculptures, marble reliefs, terra-cotta statuettes, and gold jewelry (snakes only). Except for Matteucig's limited and often misleading paper (1974), there has been little attempt to systematically identify the herpetological imagery evidenced in the Romano-Campanian cities and other Vesuvian sites destroyed in A.D. 79. Even though often badly damaged, this imagery offers insights on the role and meaning of amphibians and reptiles in house and garden decor and in the life of the people of the Vesuvian region toward the end of the first century A.D.

ZOOLOGICAL FEATURES

Whatever the considered animals, yet in particular regarding amphibians and reptiles, the realism of the depictions is the primary condition of zoological identification, since many of these animals are rather variable. Identification to the genus or to the species can be made in limited instances only. Such identification generally requires an in-depth study combining the naturalistic characteristics, technical rendition, and intended religious, symbolic, or decorative significance (Toynbee 1973: 216–36). Some features are common to all ancient depictions of animals, others due to the imagery inherent in portraying toads and frogs, tortoises and turtles, lizards, snakes, and the like. As a rule, their representations must be examined closely both for their own sake and against all relevant ancient reproductions of the same or of related animal species (see Tammisto 1997: 9–10, regarding birds), much as are actual specimens on the basis of a sophisticated procedure starting with their zoogeographical origin and entailing direct examination and comparison with elaborate identification keys (Arnold, Burton, and Ovenden 1978). It is worth noticing at once that general body proportions, head shape, colors, and patterns, although they are helpful, are not critical characters of most amphibians and reptiles.

TECHNICAL RENDITION

Understandably, the ancient Greek and Roman representations of amphibians and reptiles do not meet the modern standards of zoological illustration intended for Linnean identification (see Hammond 1998). Nonetheless, direct examination of the ancient evidence is the most dependable way of not leaving out significant clues. Indeed, some that prove to be significant are not detectable in two-dimensional images (Bodson 1981: 78). For the present study, however, only published illustrations and photographs were available, in books, exhibit catalogues, slides, and prints. Few of them were close-ups, enlargements, or multifaceted shots of three-dimensional objects that could have partially counterbalanced the distortion of indirect examination.

Various materials were used in making decorative domestic reliefs, statuettes, fountain spouts, and jewels showing reptiles and amphibians. These materials, their techniques, and the artists' greater or smaller accomplishments imposed the varying degrees of herpetological realism observed in ancient depictions. Terra-cotta and metal, especially gold in jewelry, favor the rendition of patterns of snake scales and of toad warts. Wall

paintings, mosaics, and glazed terra-cotta statuettes rarely show snake scales, except for the ventral side of *Naja haje*, where the delineation was rather sketchy, as in the painting (NM inv. no. 110876) (Maiuri 1953: 129) from the House of the Epigrams (V.i.18), and sometimes fanciful due to the addition of a central vertical double line, as in the Nile mosaic (see Fig. 352) from the House of the Faun (VI.xii), but they do show color patterns. As said earlier, these are secondary characters in modern identification keys, and their use regarding ancient depictions would be even more problematic. Indeed, color discrimination was not the same in classical times as it was in later periods. Color pigments had limitations of their own with respect to naturalistic realism. In addition to other damages, colors changed or faded over time. On the other hand, size and measurements that are sometimes useful, even though secondary, criteria to modern herpetologists are not applicable to the ancient reproductions of amphibians and reptiles. These reproductions were intended neither as life-size representations nor as scale models, although some approximations of size and body proportions may be inferred from naturalistic wall paintings (Figs. 280, 283, 284) or mosaics (Figs. 274, 290) that show two or more different animal species.

Many depictions of amphibians and reptiles were rudimentary outlines, identifiable only to higher-level taxa up to orders (for instance, anurans) of the Linnean classification, and may not be termed otherwise than in common vocabulary (toads, frogs, tortoises, turtles, lizards, snakes, crocodiles). Immediate identification to the species level is possible and pertinent when a genus is represented by only a single species in a given geographic area, such as *Crocodylus niloticus* in the Mediterranean range (Steel 1989: 39–43), except for a too sketchy rendition,[1] or when a species has at least one unmistakable external characteristic of its own such as the "hood" (ancient Greek *aspis*, literally "shield"; cf. Skoda 1997: 379–81) of the Egyptian cobra *Naja haje* (Mattison 1995: 126). Yet it would be totally misleading to assume that crude or fanciful traits were restricted to sacred or symbolic representations and a higher degree of naturalism to ornamental paintings and decorative objects. Even elaborate stylization does not preclude naturalistic exactness, as is meaningfully evidenced in the painting of two entwined snakes (Roux and Barré 1870: fig. 17), discussed later.

INTENDED SIGNIFICANCE

The animal depictions studied in this chapter fall into two different, though sometimes overlapping categories, one in relation to religious and symbolic beliefs, the other to decoration. The imaginary crested and bearded snakes painted on the walls of lararia, the lizard sketched on the marble lararium relief (see Fig. 281) in the atrium of the House of L. Caecilius Jucundus (V.i.26), the anurans, tortoises or turtles, lizards, and snakes on the Sabazius's bronze hands (Fig. 276) and ritual terra-cotta vases (Fig. 277) from the House of the Birii (II.i.12) or the cobra in Isis's hand in her Temple (VIII.vii.28) are religious symbols. Conversely, paintings, such as the one (Fig. 280) from the House of the Epigrams (V.i.18) or that other from the House of the Physician (VIII.v.24), mosaics such as the Nile scene (Figs. 274, 290, 352) from the House of the Faun (VI.xii), reliefs of anurans and reptiles as in House VII.vi.38 and on Eumachia's portal (Fig. 282), statues or statuettes such as the two small marble statuettes of toads in House I.ii.17 or the infant Hercules strangling two snakes (Fig. 286) from the House of M. Loreius Tiburtinus (or D. Octavius Quartio) (II.ii.2), and fountain devices involving one snake as in the House of the Citharist (I.iv.5/25) and five (Fig. 285) as in the Great Palaestra in Herculaneum (Insula or. II.4), or a bronze toad now in the Naples Museum (Fig. 275) – all were primarily intended as house and garden ornaments (Hill 1981: 84, 86, 91; Dwyer 1982: 16). As emphasized by Kapossy (1969: 71), animal species that spend much of their time in or close to water, such as amphibians and some reptiles, were especially appropriate decoration on fountain spouts and bases. Gold jewels in the form of a serpent (Figs. 287–8) were presumably both decorative and symbolic due to the snake's "original religious (apotropaic) significance" (Anonymous 1990: 215). The snake is still regarded as a good omen in modern Pompeii (see Orr, later in this chapter).

In all cases, knowing the provenance of the depictions or the source of their cartoons and models is of utmost importance in assessing the degree of accuracy with respect to animal identification. The Nile mosaic of the House of the Faun (VI.xii), numerous paintings of cobras and of Nilotic landscapes with crocodiles, and statuettes of crocodiles in the garden of the House of the Silver Wedding (V.ii.i) are examples of the pervasive influence of Egyptian art (De Vos 1980) in Pompeii and other Campanian sites.

EVIDENCE FROM ANCIENT GREEK AND LATIN AUTHORS

Identification to species in ancient texts involves similar problems to those of art depictions (Bodson 1986). By the first century A.D., textual evidence on amphibians and reptiles was found in a wide range of general and specialized ancient Greek and Latin writings that paved

the way for the later Western tradition of herpetology. The former included all kinds of occasional, more or less extensive information. The latter were zoological, biological, or pharmacological accounts. The earliest references to snakes were in Homer's epics, the herpetological contents of which should not be dismissed as merely poetical or mythological. Indeed, they proved to release enough critical data to identify such a species as the rat snake, *Elaphe quatuorlineata,* in the ominous snake climbing the planetree at Aulis, as reported in *Iliad* 2.308–16 (Bodson 1981: 66–7). A terrestrial tortoise (*Testudo hermanni* in all likelihood) is recorded for the first time in the sixth-century B.C. pseudo-Homeric *Hymn to Hermes* (verses 24–40). The widespread role of reptiles in Greek and Roman cults further enlarged herpetological information. Exotic species from Egypt, Africa, and India (Bodson 1991) were described by travelers, historians, or other writers: for example, Nile crocodile, *Crocodylus niloticus* (Herodotus *Persian Wars* 2.68–70); African horned viper, *Cerastes cerastes* (Herodotus *Persian Wars* 2.74); Egyptian cobra, *Naja haje* (Herodotus *Persian Wars* 4.191); African rock python, *Python sebae* (Agatharchides fr. 80, Burstein ed. 1989: 125–32; Diodorus *Library of History,* 3.36–7; see Bodson 1998: 155–6; Bodson forthcoming); and Libyan snakes (Lucan *Civil Wars* 9.700–838), as well as Asiatic and Indian species (e.g., Strabo 15.1.45, C.706; Arrian *Indica* 15.10–12; Aelian *NA* 16.8.41).

In specialized literature, although Aristotle's (384–322 B.C.) biological account of the differences in animal species is less detailed for amphibians and reptiles than for fishes, birds, or mammals, he mentions many varied aspects, such as the anatomy of the chameleon, *Chamaileon chamaileon* (*HA* 2.503a15-b28; *Parts of Animals* 4.692a21–22), the comparative anatomy of lizards and snakes (*HA* 2.508a8–b8), the reproductive behavior of amphibians and reptiles (*HA* 3.511a14–22, 5.557b31–558a24, b1–3), with special attention to ovoviviparity in vipers (*HA* 3.511a16–17; 5.558a25–31; *Generation of Animals* 2.732b20–1) and egg laying in tortoises, terrapins, and turtles (*HA* 5.558a4–14), the reproductive calls of frogs (*HA* 4.536a8–20), and the gaits of reptiles (*Progression of Animals* 713a15–25, b18–21).

Systematized surveys on amphibians and reptiles, especially snakes, focused on the venomous species for practical reasons. Identifying these species was indeed important to avoid their bites and to cure any bites, should they occur. The earliest extant texts on the subject are two didactic poems by Nicander of Colophon (second century B.C.), *On Venomous Animals (Theriaka)* and *Counterpoisons (Alexipharmaka).* These works were based on two earlier treatises, now lost, by Apollodoros of Alexandria (early third century B.C.). Nicander's sources and competence in herpetology, toxicology, and related problems are still open to discussion.

But his description of the cobra, *Naja haje,* its fangs and lethargical venom and its attack by *Herpestes ichneumon* (*Ther.* 157–208), of the nose-horned viper, *Vipera ammodytes,* and its range (*Ther.* 211–15), of the African horned viper, *Cerastes cerastes* (*Ther.* 258–70), fulfilled the author's stated aim, providing the worker or walker in open fields with effective information on the potential dangers of amphibians and reptiles. These books became the standard sources for pharmacologists (e.g., Dioscorides) and the physicians (e.g., Philumenos in *De venenatis animalibus* during the second century A.D.) interested in venom toxicity and recipes for its most famous antidote, theriac (Watson 1966).

The Roman encyclopedist Pliny the Elder circulated herpetological information to the readership of the Latin language. Relevant chapters concentrate in Books 8 to 11 and 28 to 32 of his *Natural History,* the former focusing on zoological matters, the latter on animal products used in medicines.

———

CATALOGUE

The sequence of items under each entry generally follows the increasing order of identification numbers of the houses or other buildings where findings occurred. Current location and inventory numbers in museum collections are stated for most items not preserved in situ. Although all efforts were made to secure relevant information to the largest possible extent, this catalogue has no claim to exhaustivity. The reader should keep this preliminary remark in mind, especially when turning to the references listed under Suborder: Serpents, Snakes, concerning the depictions of the mystical uraeus and of the mythical and symbolic snakes.

CLASS: AMPHIBIA

ORDER: CAUDATA

FAMILY: SALAMANDRIDAE, SALAMANDERS AND NEWTS

English, salamander; Italian, *salamandra*
English, newt; Italian, *tritone, acquaiola*

SCULPTURE

An overly large fire salamander, *Salamandra salamandra,* straddles the crossbeam of a balance scale in a mar-

ble bas-relief found in Pompeii (NM inv. no. 6575) showing a forge and anvil scene, which may have been the sign for a blacksmith shop (Ciarallo and De Carolis 1999: 178, fig. 201).

ANCIENT AUTHORS

The Greek word *salamandra*, first evidenced by Aristotle, passed to many modern languages through Latin *salamandra.* Both its origin and etymology are still unclear. In folklore and myth, salamanders were associated early with fire and were thought to not be harmed by flames, possibly occasioned by their natural tendency to crawl out of hiding places in damp logs thrown on fires (e.g. , Aristotle *HA* 5.552b16–17, Theophrastus *De Igne* 60, Coutant ed. 1971: 38–40; Pliny *HN* 10.188 and 29.74–6, 93, 116).

REMARKS

Two widespread European terrestrial salamanders (fire salamander *Salamandra salamandra*, spectacled salamander *S. terdigitata*) and three semiaquatic newts (warty newt *Triturus cristatus*, smooth newt *T. vulgaris*, Italian newt *T. italicus*) occur in Campania. The nocturnal fire salamander occurs in damp woodlands and forests in western Europe and ranges into Western Asia and North Africa. It is mainly black with strikingly bright yellow, orange, or red spots and stripes, its coloration serving to warn predators of its noxious skin secretion that causes irritation to mouth and eyes (Arnold et al. 1978: 33–4; Gasc 1997: 68–9).

FIGURE 274 Anuran on a water lily pad. Nile mosaic (detail), House of the Faun (VI.xii) (NM inv. no. 9990). Photo: S. Jashemski.

ORDER: ANURA

FAMILIES: RANIDAE, FROGS; BUFONIDAE, TOADS

English, anuran; Italian, *batrace*
English, frog; Italian, *rana, ranocchia*
English, toad; Italian, *rospo, batta*

WALL PAINTINGS

In the painting on the S wall of the *predella* of the cubiculum to the right of the atrium in the House of M. Lucretius Fronto (V.iv.11), a cattle egret (identified as a great white egret in Tammisto 1997: 290, n. 562) pecks at a frog. Numerous frogs, now badly deteriorated, were formerly visible on the west wall painting of aquatic animals in the small garden (Jashemski 1979: 112 and fig. 181; 1993: 367, no. 98) of the House of the Centenary (IX.viii.3 and 6).

MOSAIC

An anuran (Fig. 274) that rests on a water lily pad and is being eyed with interest by nearby mallard ducks in the Nile mosaic (NM inv. no. 9990) from the exedra in the House of the Faun (VI.xii) (Schefold 1957: 128) is usually identified as "a frog." Its identification, however, is puzzling. The thick body is more typical of a toad than of a frog, and the contrasting yellow-green color pattern, allowing for the limitations of the medium, suggests a green toad, *Bufo viridis*, a species widespread in mainland Italy, Greece and adjacent islands, and eastward to central Asia (Arnold et al. 1978: 74; Gasc 1997: 123). Conversely, the secretive, nocturnal habits typical of toads and their unpalatability (note the interest of the atten-

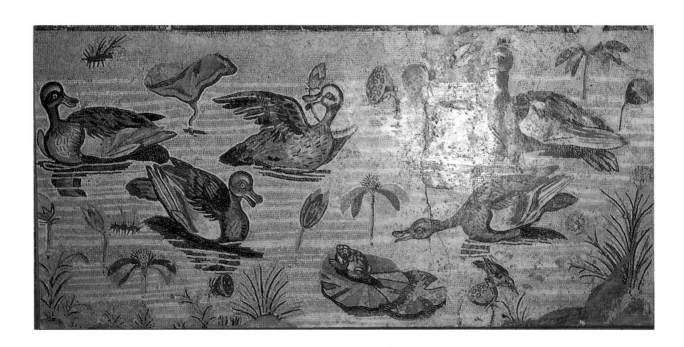

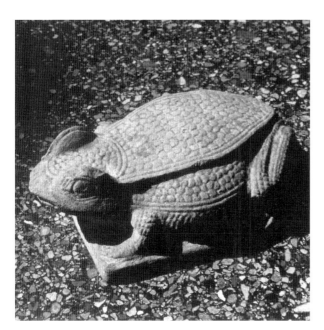

FIGURE 275 Bronze "frog." Fountain device, Pompeii (NM inv. no. unknown). Photo: S. Jashemski.

dant mallard ducks), coupled with the known predilection of frogs for sitting on aquatic vegetation, refute the tentative toad identification, leading to a final conclusion that it was intended to be a frog. Some of its toad morphological and color characters perhaps were licensed on the part of the artist in order to render it more visible on the green water lily pad. More definite identification may only be made when the results of current research on Egyptian amphibians and reptiles and on ancient depictions of anurans become available.

SCULPTURE

Anurans were then, as now, favored models for fountain sculpture. The heavily built bronze so-called frog (NM unknown inv. no.) (Fig. 275) has warty skin (Jashemski 1979: 105, fig. 167), a character more typical of a toad than a frog. It may be compared with the "terra-cotta fountain toad – one of a pair – with traces of blue-green glaze" (Ward-Perkins and Claridge 1976: no. 105) from the House of the Tragic Poet (VI.viii.5 = [Schefold 1957: 103]) (Jashemski 1993: 133, no. 248), now in the Naples Museum, inv. no. 76/166. If the former is a local work, based on an indigenous model or cartoon, it would be a common toad, *Bufo bufo,* in all likelihood, or a green toad, *B. viridis.* Other fountain pieces include two toads on the now fragmented base of a fountain in House VII.vi.38 (Jashemski 1993: 185, no. 362); a marble fountain statuette of "a naked satyr-child seated on a rock, recoiling from the frog at his feet (0.29 m high) whose open mouth served as water spout" (NM inv. no.

6537) found in the House of Camillus (VII.xii.23) (Jashemski 1993: 194–5, fig. 228); and a marble toad fountain (NM inv. no. 120042), lacking head, in the House of Acceptus and Euhodia (VIII.v.39) (Jashemski 1993: 218, no. 445).

"Two small marble statuettes of toads (NM inv. nos. 109609, 109610)" were found in House I.ii.17 (Jashemski 1993: 24, no. 7). A glazed terra-cotta "green frog" (unmentioned inv. no.) and a "yellowish toad" (unmentioned inv. no.), home decorations found in the garden of the House of the Silver Wedding (V.ii.i) (Jashemski 1993: 113, no. 180), were apparently made in Egypt, according to the excavator.

CULT OBJECTS

Amphibians and reptiles depicted on nine mantic hands (four lost) and two vases from the Vesuvian area associated with the worship of the Phrygian-Thracian god Sabazius are recorded in Vermaseren's catalogue (1983: 5–9, pl. VII–XIX). Four out of the preserved five hands have frogs or toads: a "frog or toad" on a hand "found in the vicinity of Naples" (now in the Bibliothèque Nationale in Paris, inv. no. 1064), a "toad" on a hand (NM inv. no. 5506) found in Resina (Herculaneum); and "frogs or toads" on two hands (Pompeii Antiquarium inv. nos. 10485, 10486 = Fig. 276) found in the House of the Birii (II.i.12) (Jashemski 1979: 136, fig. 215, right; 1993: 76, no. 132). A "frog or toad" is depicted on side A of one of the terra-cotta vases found among the cult objects in this house (Pom-

FIGURE 276 Toads or frogs, lizards, tortoises or turtles, and snakes on Sabazius's bronze hand, House of the Birii (II.i.12) (Pompeii Antiquarium inv. no. 10486). Photo: S. Jashemski.

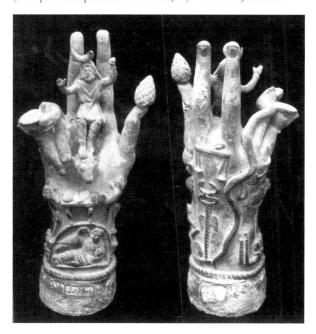

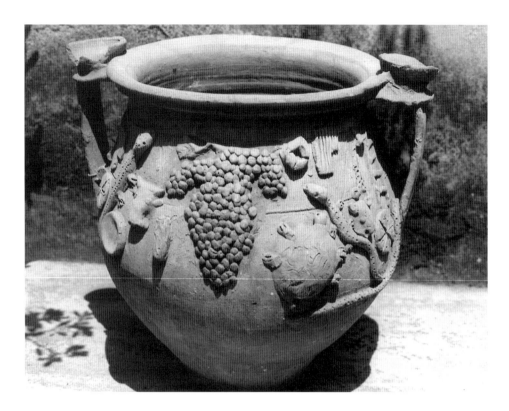

FIGURE 277 Tortoise or turtle, lizard, and snake on Sabazius's terra-cotta vase, House of the Birii (II.i.12) (Pompeii Antiquarium inv. no. 10529). Photo: S. Jashemski.

peii Antiquarium, inv. no. 10529 = Fig. 277) (Jashemski 1979: 135, fig. 214).

SKELETAL REMAINS

Amphibian bones recovered from the excavations conducted by Fulford and Wallace-Hadrill (1999: 93) beneath the House of Amarantus Pompeianus (I.ix.11–12) are not identifiable to species. Bones of an anuran, presumably a toad, were found in the vineyard at Boscoreale (Jashemski 1993: 289, no. 590).

ANCIENT AUTHORS

Anurans are considered by Pliny in *HN* 8.227 and 32.50–2, 70, 92, 122, 139.

REMARKS

Typical frogs of the genus *Rana* are moist- and smooth-skinned long-legged anurans that frequent wet or damp areas. Four European species occur in the Vesuvian area, the agile frog *R. dalmatina,* the stream frog *R. graeca,* the pool frog *R. lessonae,* and the edible frog *R. esculenta.* Toads are heavy-set and have shorter legs and dry, warty skin. They occur in woods and gardens, often away from water, and have parotoid glands on the sides of the head that render them distasteful or even poisonous to predators. The large common toad, *Bufo bufo,* is uniform in color and

occurs throughout Europe; the smaller green toad, *B. viridis,* has a marbled green and white pattern on the back and is found in Europe from "as far north as S. Sweden and as far west as W. Germany" to "Italy, Corsica, Sardinia and the Balearic Islands," in "N. Africa and eastwards to central Asia" (Arnold et al. 1978: 72, 74; Gasc 1997: 118–19, 122–3).

CLASS: REPTILIA

ORDER: TESTUDINATA, TURTLES, TERRAPINS, AND TORTOISES

FAMILIES: TESTUDINIDAE, TORTOISES; EMYDIDAE, TERRAPINS; DERMOCHELYIDAE AND CHELONIIDAE, SEA TURTLES

English, tortoise; Italian, *testuggine, tartaruga*
English, terrapin; Italian, *tartaruga aquatica*
English, sea turtle; Italian, *tartaruga, testuggine di mare*

WALL PAINTING

A tortoise (or terrapin?) upright on rear legs (Cerulli Irelli et al. 1993: II, 163–4, no. 288b = Meyboom 1995: fig. 31) is depicted in the Nilotic landscape (upper level) of the northern frieze in the Palaestra (34) in the House of M. Fabius Rufus (Cerulli Irelli et al. 1993: II, 163–4, VII. ins. occ. 16, 17–22; = Meyboom 1995: 288–9 and fig. 31). A tortoise is likely under Mercury's right foot on the western wall (Reinach 1922: 96, no. 6; Simon 1992b: 518, no. 223) of the left wing (6) in

the House of the Hunt (VII.iv.48) (Schefold 1957: 180). A tortoise is shown at Mercury's right side on a painting from Pompeii, now in the Naples Museum, inv. no. 9452 (Simon 1992b: 517, no. 213).

SCULPTURE

A tortoise fountain (NM inv. no. 120043), lacking a head, was found in the House of Acceptus and Euhodia (VIII.v.39) (Jashemski 1993: 218, no. 445). A tortoise walking beneath a tree in which storks are nesting is depicted on a silver drinking cup from Boscoreale (Héron de Villefosse 1899: 76, no. 13, pl. XIV.1).

CULT OBJECTS

Vermaseren (1983: 5–9, pl. VII–XIX) lists unspecified "turtles" depicted on the preserved five bronze Sabazius hands: one on a hand in the Bibliothèque Nationale in Paris (inv. no. 1064); another on a hand found in Resina (Herculaneum) (NM inv. no. 5506); one each on the two hands found in the House of the Birii (II.i.12) (Pompeii Antiquarium inv. nos. 10485, 10486 = Fig. 276) (Jashemski 1979: 136, fig. 215, right; 1993: 76, no. 132); and one on a hand found in Pompeii (NM inv. no. 5509). There is also a "turtle" on side A of one of the two terra-cotta vases found among the cult objects in the Birii's house (Pompeii Antiquarium inv. no. 10529 = Fig. 277) (Jashemski 1979: 135, fig. 214). Whether all these "turtles" were intended to represent terrestrial tortoises or freshwater terrapins is unclear.

SKELETAL REMAINS

Two tortoise bones, probably Hermann's Tortoise (*Testudo hermanni*), were found beneath the House of Amarantus (I.ix.11–12), at stratigraphic levels dated back to the fourth to the first centuries B.C. (Fulford and Wallace-Hadrill 1999: 93). The bones are a fragment of carapace and a scapula, "the latter exhibiting cut marks at the glenoid articulation." In the excavators' opinion, "the location of the cut marks in this case suggests that the animal was eaten." Tortoise and turtle meat was the basic diet of some Asian and African tribes nicknamed "Tortoise-eaters" (*Chelonophagoi*) by the ancient Greeks. The Greeks and the Romans also ate tortoise meat, yet occasionally and reluctantly. It was rather and mainly used as a pharmacological ingredient going into many external and internal remedies (Pliny *HN* 32.32–40, 43).

A shell of Hermann's Tortoise, *Testudo hermanni* (Figs. 278–9), of unknown provenance is stored in the Boscoreale Antiquarium (inv. no. 14951) (Jashemski, personal communication). Tortoise shells were found in the garden of the House of the Tragic Poet (VI.viii.5 = 3 [Schefold 1957: 103]) (Jashemski 1993: 133, no. 248), in the peristyle garden of the House of C. Julius Polybius

(IX.xiii.1–3), perhaps the damaged remains of a "family pet" (Jashemski 1979: 103), and in the rear garden of the Villa of Poppaea at Torre Annunziata (Oplontis) (Jashemski 1979: 104, fig. 165; 1993: 297, no. 598).

ANCIENT AUTHORS

Turtles, tortoises, and terrapins are discussed by Pliny in *HN* 9.35–8 and 32.32–41.

REMARKS

Only one land tortoise occurs in Campania, Hermann's Tortoise, *Testudo hermanni*, of southeast Europe. It is found in a variety of habitats, usually with dense vegetation (Arnold et al. 1978: 91; Gasc 1997: 178–9). The widespread European pond terrapin, *Emys orbicularis*, is the only freshwater turtle in Italy (Arnold et al. 1978: 93; Gasc 1997: 170–171). Two species of marine turtles, the huge (up to 500 kg) leathery turtle, *Dermochelys coriacea*, and the smaller (up to a meter long) loggerhead turtle, *Caretta caretta*, occur in the Mediterra-

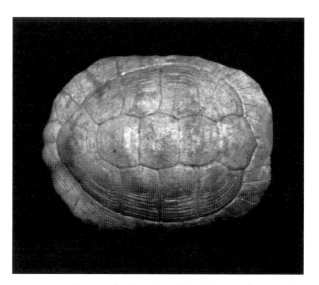

FIGURE 278 Hermann's Tortoise (*Testudo hermanni*), top view (Boscoreale Antiquarium inv. no. 14951). Photo: F. Meyer.

FIGURE 279 Hermann's Tortoise (*Testudo hermanni*), bottom view (Boscoreale Antiquarium inv. no. 14951). Photo: F. Meyer.

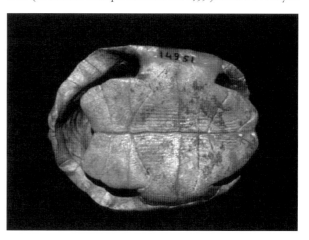

nean Sea. Both are deepwater species that come ashore only to nest on sandy beaches. They are becoming increasingly rare owing to exploitation for food and shell and destruction of breeding beaches (Arnold et al. 1978: 95; Gasc 1997: 162–3, 168–9).

ORDER: SQUAMATA, LIZARDS AND SNAKES

SUBORDER: SAURIA, SAURIAN LIZARDS

FAMILIES: GEKKONIDAE, GECKOS; LACERTIDAE, LACERTIDS; SCINCIDAE, SKINKS

> English, lizard; Italian, *lucertola*
> English, skink; Italian, *scinco*

WALL PAINTINGS

A stork pecks at a lizard (Fig. 280) in a wall painting (NM inv. no. 110877) from the House of the Epigrams (V.i.18) (Schefold 1957: 66, k). A sparrow teases a small lizard in a wall painting in the House of C. Julius Polybius (IX.xiii.1–3) (Jashemski, personal communication). An owl watches a lizard in a wall painting in the House of Menander (I.x.4/15) (Jashemski, personal communication). (Fig. 301). Lizards were also shown, one near a peacock (Castriota 1995: fig. 67) in a painted scroll, badly preserved even at the time of excavation, in room 44 of the House of the Faun (VI.xii) (Schefold 1957: 128), one in the continuous scroll above the megalography (Castriota 1995: fig. 68a6) in the Villa of the Mysteries (Jashemski 1993: 282–3, nos. 575–8), and several (with storks) on "a lush garland of leaves" in "the lower part of the walls below the fish painting . . . next to the ground" of the small garden (c) (Jashemski 1993: 367, no. 98) in the House of the Centenary (IX.viii.3 and 6). These lacertids related likely to the native lizards in Campania, but cannot be identified to species.

SCULPTURE

A marble garden statuette (0.32 m high) of "a bird with a lizard in its mouth" (unmentioned inv. no.) was found in the House of Julia Felix (II.iv.3) (Jashemski 1993: 87, no. 143). Two lizards adorn the fragmented base of a marble fountain (unmentioned inv. no.) from House VII.vi.38 (Jashemski 1993: 185, no. 362). A lizard is pictured on a marble lararium relief (Fig. 281) in the atrium of the House of L. Caecilius Jucundus (V.i.26) (Jashemski 1979: 134).

Matteucig (1974: 220–2) referred all lizards that he found on the Eumachian portal to European *Lacerta*, designating his no. 62 as *Lacerta* sp., nos. 22, 47, 80 as *Lacerta viridis*, and no. 56. as *Lacerta muralis*, but specified no identifying characters. According to Jashemski (personal communication), an additional lizard can be found between Matteucig's nos. 51 and 52. By no means do the general shape and thickness, the proportions of body, head, and tail, and the leg and toe shape, as visible on the slides I have examined, identify all of them as belonging to the lizard genus *Lacerta*. In particular, Matteucig's no. 12 (although much damaged) and no. 80 (Fig. 282) more likely belong to the skink family, *Scincidae*, not, however, the native three-toed skink, *Chalcides chalcides*, but a shorter

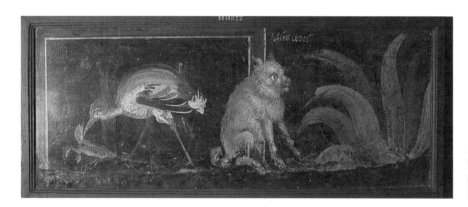

FIGURE 280 Stork pecking at a lizard. Painting, House of the Epigrams (V.i.18), (NM inv. no. 110877). Photo: S. Jashemski.

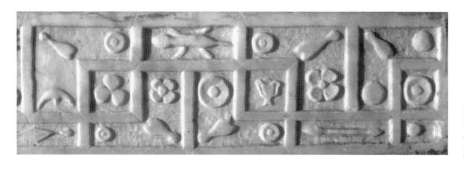

FIGURE 281 Lizard on the marble lararium relief, atrium, House of L. Caecilius Jucundus (V.i.26). Photo: S. Jashemski.

and more heavily built species, such as *Scincopus fasciatus* or *Chalcides ocellatus* (see Remarks), both species reported to be present in Egypt (Anderson 1898: 200–3, pl. XXVI; Schneider 1981: 341–3).

A lizard unidentifiable to species is shown in scrolls on a silver drinking cup from Boscoreale (Héron de Villefosse 1899: 70, no. 9).

CULT OBJECTS

Vermaseren (1983: 5–9, pl. VII–XIX) lists single lizards depicted on four out of the preserved five bronze Sabazius hands: on the hand now in the Bibliothèque Nationale in Paris (inv. no. 1064); on one found in Herculaneum (NM inv. no. 5506); and on the two hands (Pompeii Antiquarium inv. nos. 10485, 10486 = Fig. 276) found in the House of the Birii (II.i.12) (Jashemski 1979: 136, fig. 215, right). Three lizards (one on side A and two on side B) are depicted on one of the two terra-cotta vases (Pompeii Antiquarium inv. no. 10529 = Fig. 277) (Jashemski 1979: 135, fig. 214), and only one ("part of whose tail is broken away") on the second (Pompeii Antiquarium inv. no. 10528) of these vases found among the cult objects in the Birii's house.

SKELETAL REMAINS

The lizard bones retrieved by Fulford and Wallace-Hadrill (1999: 93) from the pre-Roman levels beneath the House of Amarantus (I.ix.11–12) include "cranial and postcranial elements and the species present are probably gecko (*Gekkonidae*) and/or wall lizard (*Podarcis* sp.)." "Bones of a small lizard were found in the garden pool" in the House of the Gold Bracelet (VI.ins. occ.42) (Jashemski 1993: 167, no. 313).

ANCIENT AUTHORS

Pliny has chapters on the chameleon in *HN* 8.120–2 and on lizards in *HN* 8.141, 10.143, 174, 187, 29.129–30 and 136.

REMARKS

Geckos are small, thick-bodied, nocturnal, climbing lizards that are usually seen on walls and ceilings of buildings. They are vocal and their name derives from their repeated call. The tail breaks off easily and regenerates. Two species occur in Campania, the very plump Moorish *Tarentola mauritanica* and the slimmer Turkish *Hemidactylus turcicus*. Lacertids are agile, diurnal, slim-bodied, long-tailed lizards that frequent rocky ground and stone walls. They typically have longitudinal streaking or spotting on the back and often have contrasting color on the underside (Arnold et al. 1978: 108–9; Gasc 1997: 210–11, 214–15). A multiplicity of lacertid lizard species occur in the Mediterranean region, but only three are native to Campania,

FIGURE 282 So-called lizard (Matteucig 1974: no. 80), in foliage scrolls, Eumachia entrance. Photo: F. Meyer.

green lizard *Lacerta viridis*, common wall lizard *Podarcis muralis*, and Italian wall lizard *P. sicula* (Arnold et al. 1978: 132–4, 138–40, 155; Gasc 1997: 266–7, 286–7, 294–5). Skinks are elongate, ground-dwelling lizards with large, smooth shiny scales. They are diurnal, but tend to be timid. The slender three-toed skink, *Chalcides chalcides*, is native in Campania and most of Italy, Sicily, Sardinia, and Spain (Arnold et al. 1978: 180–1; Gasc 1997: 310–11). *Scincopus fasciatus* and *Chalcides ocellatus*, both native in Egypt, are shorter and more heavily built. The latter is found in Sicily, in many other Mediterranean islands ("possibly through introduction by man") (Arnold et al. 1978: 179–80; Schneider 1981: 341–3; Gasc, 1997: 312–13), and in the area of Portici (Naples), to which it is said to have been introduced by man in the eighteenth century (Monticelli 1903). Further research regarding the early spread of *Chalcides ocellatus*, the ancient depictions of skinks, and the origin and background of the herpetological decoration in Eumachia's portal is needed to determine whether this species was known in Italy, if not introduced, much earlier, that is, in Roman antiquity.

SUBORDER: SERPENTES, SNAKES

FAMILIES: BOIDAE, PYTHONS; COLUBRIDAE, TYPICAL HARMLESS AND REAR-FANGED SNAKES; ELAPIDAE, COBRAS; VIPERIDAE, VIPERS

English, python; Italian, *pitone*
English, snake; Italian, *colubro, serpente, serpe, biscia*
English, cobra; Italian, *cobra*
English, viper; Italian, *vipera*

WALL PAINTINGS

EUROPEAN SPECIES

A rat snake, *Elaphe longissima*, climbs a small fig tree (Fig. 283) on the eastern wall of room (c), "off the east side of the peristyle," in the House of the Fruit

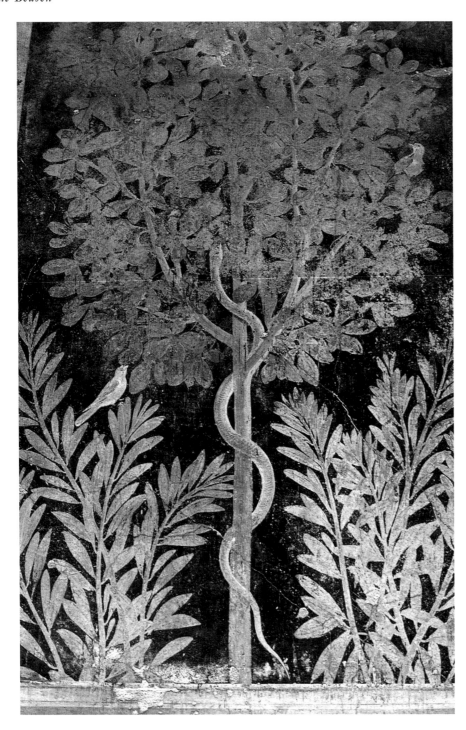

FIGURE 283 Rat snake, *Elaphe longissima*, climbing a small fig tree on the E wall of a room off the E side of the peristyle, House of the Fruit Orchard (I.ix.5). Photo: S. Jashemski.

Orchard (I.ix.5) (Jashemski 1979: 77, fig. 123; 262, fig. 385; 1993: 320–1, no. 13, figs. 366 and 368, right). Like other species of the genus *Elaphe*, semiarboreal *E. longissima* is indeed a skilled climber (as is *E. quatuorlineata* mentioned in Homer's *Iliad* 2.308–16), using its ventral scales to help it grip irregularities on the bole of a tree (Böhme 1993; Schulz 1996: 160 and pl. 51 G). Showing the snake climbing a tree trunk vertically is in conformity with its natural ability, but its sinuous, ribbonlike posture is alien to any climbing snake, imparting an unexpected touch of imaginary stylization in the centerpiece of the otherwise realistic garden landscape (Jashemski 1979: 74–8, figs. 117–22, 124–6; 263, figs. 388, 389; 1993: 320–21, figs. 367, 368, left).

Two crested snakes are entwined together in a grassy background on a fragmented painting from Herculaneum (Roux and Barré 1870: no. 17, undescribed lower vignette, superficially described on p. 258). Their dynamic depiction suggests that they are not motionless. The current status of the painting remains unclear. Being what it may regarding its original location, intended meaning, and possible preservation, this piece combines imagination in the morphology of the snakes' heads and naturalism in their behavior to a significant extent. "Crests" are generally admitted as the ancient, though fanciful way of depicting male snakes in contexts mostly associated with religious symbolism. If the crests, although different in size as far as may be judged

from the old print, identify the two snakes as males, their position refers to the ritualized combat dance between males, a well-known stage of the courtship behavior in many snake species, yet especially observed in *Elaphe longissima* (Schulz 1996: 57–8 and fig. 45, lower). Should the crests prove not to differentiate between sexes in this case, the depiction would refer to the preliminary stage of mating behavior of the same (Schulz 1996: 57) or of other colubrid species.

A brown serpent eyed a forked-tailed bird with "red breast and feet" in a now destroyed garden painting in the House of the Epigrams (V.i.18) (Jashemski 1993: 333–4, no. 31). Another snake (with a wader bird said to be a stork) is reported on a no longer extant garden painting in House V.iii.11 (Neuerburg 1965: 122–3, no. 24). A snake and a cock fighting with each other are shown in the lunette of the tepidarium (46) in the House of the Centenary (IX.viii. 3 and 6) (Schefold 1957: 278). A snake and wineskin (*askos*) and a snake and gold box (*pyxis*) are depicted on the wall of the tepidarium (b) in the House of Menander (I.x.4) (Schefold 1957: 44).

AFRICAN SPECIES

An Egyptian cobra displays the upright forepart of its body and spreads its neckribs to form a hood in its typical defensive posture against a threatening egret or squacco heron in a fragment of wall painting (NM inv. no. 110876) (Maiuri 1953: 129) from the House of the Epigrams (V.i.18) (Schefold 1957: 66, k). Cobralike snakes are pestered by wading birds: a heron in the Gladiatorial Barracks (V.v.3) (Tammisto 1997: 303, n. 645); an egret in a small painting (Fig. 284) "on the low wall enclosing the peristyle in the House of Adonis" (VI.vii.18) (Jashemski 1979: 83, fig. 134); and a heron in Casa del Tramezzo di Legno (III.11) in Herculaneum (Jashemski 1979: 58, fig. 94; 1993: 370, no. 106).

Many snakes are shown on paintings from the Temple of Isis (VIII.vii.[formerly viii].28) now in the Naples Museum. Most of them, although sometimes barely visible (inv. no. 8533, Anonymous 1992: 58–60, no. 1.73: sacrarium, northern wall; inv. Rom. n. MDXII, Anonymous 1992: 60, no. 1.75: sacrarium, northern wall), are cobras (*Naja haje*), whatever the naturalism of their depictions. A cobra is fighting against a mongoose, *Herpestes ichneumon*, on a panel (S. inv. no. 3, Anonymous 1992: 55–6, no. 1.65) of the ecclesiasterion (VI), western wall (Schefold 1957: 233, who refers to additional cobras and mongooses on the main wall basis). Another rising in typical defensive attitude is represented on the frieze scroll of the western portico (inv. no. 8546, Anonymous 1992: 50 and 113, no. 1.37, pl. VIII; Sampaolo 1994: fig. 24). Isis welcoming Io upon arrival at Canopus (on the southern wall of the ecclesiasterion) holds a cobra in her left hand, the snake coiling around her forearm and wrist (inv. no. 9558, Anonymous 1992: 55–6, no. 1.63, unnumbered pl. facing p. 23: detail, pl. X: general), and the handle of the sacred water jug at Harpocrates' side

FIGURE 284 Egret and cobra. Painting on the low wall enclosing the peristyle, House of Adonis (V.vii.18). Photo: S. Jashemski.

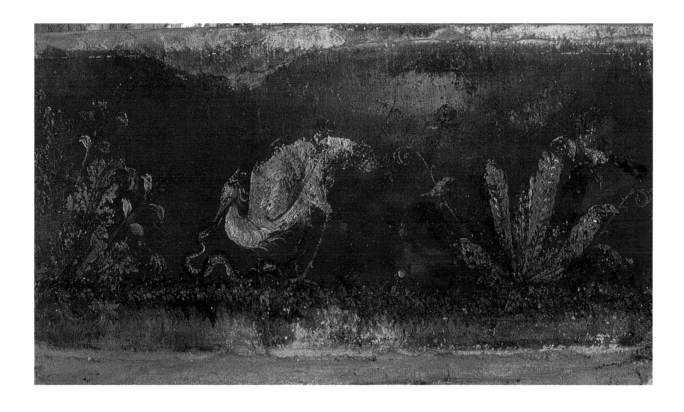

in the lower right corner is cobralike. The same scene, although inferior in style, is depicted in the House of Isis and Io-Casa del Duca d'Aumale (VI.ix.1) (Schefold 1957: 110), now in the Naples Museum, inv. no. 9555 (Tran Tam Tinh 1964: 128, no. 14, pl. XVI.2). In both of those paintings, the male character standing behind Isis holds in his left hand a caduceus coiled with snakes. Several cobras (some being partly faded) are shown among Isis and Osiris's symbolic animals in the sacrarium, western wall (inv. no. 8927, Anonymous 1992: 58–9, no. 1.71). Snakes are held in the hand or presented on plates by priests and priestesses: (1) priest with a snake in the right hand in the eastern portico (inv. no. 8922, Anonymous 1992: 42, no. 1.8 and pl. VII); (2) painted candelabrum in the guise of a priestess with a cobra rising from the plate she holds in her right hand (inv. no. 8915, Anonymous 1992: 54–5, no. 1.57); (3) painted candelabrum in the guise of a priestess with a cobra rising from the plate she holds in her left hand (inv. no. 8929, Anonymous 1992: 54–5, no. 1.60), both in the ecclesiasterion (VI) (Schefold 1957: 233). The sacred cista is flanked with two crested and bearded snakes (inv. no. 8928, Anonymous 1992: 59–60, no. 1.74) personifying Agathodaimon (Good Genius) on a symbolic or religious painting from the peribole of the temple (Tran Tam Tinh 1990: 768, no. 77). Two similarly depicted snakes (Tran Tam Tinh 1964: 147, no. 58 and pl. XIV.1; Dunand 1981: 279, no. 8) flank the altar on a painting of House (bakery) IX.iii.10–12 (Schefold 1957: 250). A snake is coming out of the cista on the wall painting (Borda 1958: 28) of the exedra in the House of P. Fannius Synistor at Boscoreale.

Cobras were the most depicted of the exotic snakes in Pompeii and other Vesuvian cities under the widespreading influence of Egypt on the Roman society. Many of them, either full-size or forepart only, were shown as the mystical uraeus. (1–2) Both the seated divinity on the left pinax of the east wall in the room off the atrium (De Vos 1980: 15–20, 79, no. 9, pl. XV.1) and the white statue standing on a pedestal (De Vos 1980: pl. XIII) in the House of the Fruit Orchard (I.ix.5) (Jashemski 1993: 318, fig. 363) have the uraeus on their forehead. (3) The handle of the sacred water jug (De Vos 1980: pl. XIX) on the lower painting of the same wall is cobra-shaped. (4) Uraei are depicted among other Isiac attributes on the eastern wall of the peristyle (F) in the House of the Golden Cupids (VI.xvi.7) (Schefold 1957: 154) and above craters on the wall of the passageway from the atrium to the garden in the House of Adonis (VIII.iii.13–16) (Schefold 1957: 221). (5) A priestess of Isis presented a snake (probably a cobra) on a plate held in her left hand on a no longer extant painting (Helbig 1868: 218, no. 1095) from the left room to the peristyle in House VIII.iv.12 (Schefold

1957: 225). (6) Two snakes rise at the half-seated man's sides, close to a female character identified as Isis-Fortuna (Tran Tam Tinh 1964: 149, no. 61, pl. VII.3) or as Fortuna (Rausa 1997: 130, no. 62), in a painting (NM inv. no. 112285) from House IX.vii.22 (Schefold 1957: 272, h). (7) The winged female character having the uraeus holds a processional standard with a crowned snake, most likely inspired from a cobra (De Vos 1980: 55–7, fig. 33, pl. XXXIII.2) in the northeastern room of the main atrium in the House of the Centenary (IX.viii.3 and 6). (8) The character bearing the sacred water jug on an unpublished fragment from Pompeii (NM inv. no. 9784) has the uraeus (De Vos 1980: 44–6, no. 22, fig. 25 and pl. XXXII). (9–11) Three Pharaonic characters, one of them handling a snake, on fragments of unknown original location in Herculaneum, now in the Naples Museum, inv. nos. 8515 and 8566, are depicted with the uraeus (De Vos 1980: 22–3, 79, no. 11, pl. XXII–XXIII). (12–13) The bearded character on the right side of the first pinax and probably the unidentifiable character depicted on the left side of the second (NM inv. no. 8974), both from Herculaneum and of unknown original location, hold snakes (most likely cobras) (De Vos 1980: 23, no. 12, fig. 5 and pl. E). (14) A winged and crowned cobra is seen in the tablinum of the House of the Mysteries (De Vos 1980: 9–11, pl. IV). (15–16) The uraeus is represented on the forehead of a sacred character in the cubiculum (19) of the House of Boscotrecase (De Vos 1980: 5–8, no. 3, fig. 3 and pl. II.2), in addition to a rising cobra beneath the central table supporting the bull Apis. (17–20) The acroteria depicted in room M of the House at Boscoreale (Tybout 1989: 337, fig. 30) and in rooms 11 and 23 of the House at Torre Annunziata (Oplontis) are in the form of a winged uraeus (Tybout 1989: 366, figs. 40.1, 55–6) and of unidentified snakes in triclinium 14 of the latter house (Tybout 1989: 366, fig. 44).

The now destroyed "animal painting on the rear garden wall" in the House of Sex. Pompeius Axiochus (VI.xiii.19) (Schefold 1957: 131,) "showed at the time of excavation, an elephant around whose body [was] wound a green snake that was biting the elephant's trunk. Blood ran from the wound" (Jashemski 1993: 344, no. 53). This painting likely illustrated the deadly fight evidenced in ancient literature (see Pliny *HN* 8.33–4) and in mosaic (Dunbabin 1978: 52–3, pl. XIII, fig. 28) between elephants and African (or Indian) giant snakes, namely, in this case, the African species *Python sebae.* A python was probably intended in the now faded snake "coiled around a tree" (Jashemski 1979: 70–1, fig. 115a; 1993: 363, no. 78), in a peaceful gathering of an elephant and other mammals on the animal megalography in the peristyle (p) of the House of Romulus and Remus (VII.vii.10/13) (Schefold 1957:

194). Mielsch (1986: 756 and fig. 81) and Andreae (1990: 81) reported another snake at the upper level (left corner) of the same painting.

"A whitish snake, coming from the trunk of the tree, coils and throws itself toward the bear, attacking the bear to defend the tree (according to Mau)" (Jashemski 1993: 339, no. 40.4) on the badly preserved painting no. 4 of the Gladiatorial Barracks (V.v.3) (Schefold 1957: 89). Three depictions listed by Helbig showed snakes and leopards: (1) a snake attacked by a leopard at the lower step of stairs surmounted by Dionysiac attributes (Helbig 1868: 133, no. 581; Reinach 1922: 370, no. 9) on a painting from Pompeii, unlocated by Schefold (1957: 307) in the Naples Museum; (2) a snake coiled around a leopard on a painting (Helbig 1868: 133, no. 582) unlocated by Schefold (1957: 307); (3) a snake coiling around the trunk of a tree faced a threatening leopard (Helbig 1868: 133, no. 583; Reinach 1922: 357, no. 2) on a no longer extant painting from Pompeii (Schefold 1957: 307).

MYTHICAL AND SYMBOLIC SNAKES

Many myths and legends involving snakes are illustrated in Pompeii and other Vesuvian cities. These snakes, although some are given symbolic, unnaturalistic features (crest, beard) and others are quite sketchy, are mostly shown as constricting serpents.

APOLLO Having just been slaughtered by Apollo, who celebrates his victory under the watchful eyes of Diana, a priest, and the pythia, the Delphic female snake (*drakaina*) finally known as "Python" still coils around the sacred omphalos (Simon 1984: 413, no. 356; Cerulli Irelli et al. 1993: I, pl. 63; II, 125–6, no. 216e) on the left pinax of the eastern wall in the main oecus (q), north of the peristyle, of the House of the Vettii (VI.xv.1) (Schefold 1957: 147). The Delphic she-snake was conceived as constricting her prey (*pseudo-Homeric Hymn to Apollo* 300–4).

Other instances of depictions of snakes coiling around the Delphic omphalos are found (1) with Mercury, instead of Apollo, at its side in the left lararium (Simon 1992b: 521, no. 250a) of the atrium (b) in House V.iv.3–5 (Schefold 1957: 83); (2) on a pilaster painting (Helbig 1868: 7, no. 17; see also no. 15: destroyed, except for a drawing in the Naples Museum) at the entrance of House VI.vii.9 (Schefold 1957: 100); (3) on the kitchen wall (Helbig 1868: 12, no. 37) in the House of Meleager (VI.ix.2) (Schefold 1957: 114, room 38); (4) with Mercury, instead of Apollo, at its side in the *thermopolium* (a) (Simon 1992b: 521, no. 250b) in House VII.xv.5 (Schefold 1957: 207); (5) at the left side of Apollo playing a cithara (Helbig 1868: 63, no. 231; Reinach 1922: 24, no. 5; Simon 1984: 428, no. 471) on the northern wall of the triclinium (20) at the House of M. Epidius Rufus

(Casa di Diadumeno) (IX.i.20) (Schefold 1957: 237); and (6) with Mercury, instead of Apollo, at its side in the faded depiction of Mercury walking to the right (Spinazzola 1953: 166–7, fig. 206; Simon 1992b: 521, no. 250c) on the left pilaster of the stairs in Casa del Primo Cenacolo (IX.xii.1) (Schefold 1957: 289).

ARCHEMOROS Two snakes are attacked by two warriors (Simon 1979: 37–9, no. 6) in the episode of Archemoros's death on a painting from Herculaneum (NM inv. no. 8987) (Pülhorn 1984: 473, no. 3).

BACCHUS'S ATTRIBUTES AND COMPANIONS A snake coiling around a vase (Helbig 1868: 134, no. 599) is shown among Bacchus's attributes and emblems, undetailed by Schefold (1957: 248–9), in the left wing (8) of the House of M. Lucretius (IX.iii.5). A snake coils around a satyr's staff on a faded painting (Helbig 1868: 122, no. 541) in the second room, at the rear of the peristyle (Corinthian oecus 24), of the House of Meleager (VI.ix.2) (Schefold 1957: 113).

ERICHTHONIUS The birth of the Athenian hero Erichthonius in the guise of a snake (Cerulli Irelli et al. 1993: II, 187, no. 336a) is depicted on a rare painting of the western wall of room A' (AA) in the House of C. Julius Polybius (IX.xiii.1–3).

FORTUNA A snake rising its head coils around Fortuna (Helbig 1868: 24, no. 73) on a no longer extant painting of room 12 in the House of the Labyrinth (VI.xi.10) (Schefold 1957: 126).

HERCULES The guardian snake, gently touched by two Hesperides, coils around the altar of their garden (Maiuri 1938: 7, pl. A; Kokkorou-Alewras 1990: 108, no. 2770) on the northern wall painting of the triclinium (b) in the House of the Priest Amandus (I.vii.7) (Schefold 1957: 30–1) and on a painting, only preserved by a drawing (Kokkorou-Alewras 1990: 108, no. 2771, better than Reinach 1922: 191, no. 1), in the cubiculum (q), at the right side of the peristyle, in House V.ii.9–12 (Schefold 1957: 72).

The infant Hercules strangling serpents sent by Hera was shown on three narrative wall paintings: (1) one (Woodford 1988: 831, no. 1656; Cerulli Irelli et al. 1993: I, pl. 56; II, 124, fig. 214b) in the triclinium, at the rear of the left wing (n), in the House of the Vettii (VI.xv.1) (Schefold 1957: 144); (2) one no longer extant (Woodford 1988: 831, no. 1655) in House VII.iii.10 (Schefold 1957: 176); and (3) one (NM inv. no. 9012) from Herculaneum (Woodford 1988: 831, no. 1657). According to Woodford's typology, in the ancient depictions of this episode, the serpents were shown as snakes killing their prey by constriction, with very few, if any, other features supporting identification at either the generic or species level. The earliest Greek accounts described them as rat snakes (*drakontes*), while Theocritus mixed both rat snake and viper characteristics in

Idylls 24.14–33. Roman authors (Plautus *Amphitryon* 1102–9; Vergil *Aeneid* 8.287–9; Pliny *HN* 35.6; Martial 14.177) used *anguis,* one of the general Latin terms for "snake, serpent" (Bodson 1986: 74), when alluding to the story (Woodford 1988: 827–8).

HESIONE (?) A sea monster (*ketos*) is shown as a constricting snake coiled around its victim in a possible depiction of the rescue of Hesione (Rostowzew 1911: 54–5, fig. 30; Oakley 1997: 627, no. 49) on the west wall of the peristyle (9) in the House of the Centenary (IX.viii.3 and 6) (Schefold 1957: 276).

HYGIEIA (?) A snake coils around a woman, its head reaching a plate she is holding, on a painting (Helbig 1868: 428, no. 1819) of the large peristyle (53) in the House of Castor and Pollux (Casa dei Dioscuri) (VI.ix.6–7) (Schefold 1957: 121). The female character was tentatively first identified as Hygieia, Asclepius's daughter and Greek goddess of health, second as a priestess feeding the sacred snake.

LAOCOON The snakes sent by Neptunus against Laocoon and his sons are stated by Vergil, *Aeneid* 2.204, 214, 225 as *angues, serpens,* that is, two general Latin terms for "snake," and *dracones* (same in Pliny *HN* 36.37): (1) rat snakes; (2) pythons (Bodson 1986: 74–6). The snakes that coil around and squeeze Laocoon and one of his sons (the other lying dead) (Maiuri 1933: 41, fig. 17, pl. IV; Simon 1992a: 198, no. 4) on a wall painting of the left wing (4) in the House of Menander (I.x.4) (Schefold 1957: 40) and on the partly destroyed painting (NM inv. no. 111210) (Simon 1992a: 198, no. 5) from the atrium (b) in the House of Laocoon (VI.xiv.28–31) (Schefold 1957: 135) are pythonlike man-killers, whatever the divine power they were invested with.

MEDUSA "Vipers hanging loose over her back but rear erecting over her brow in front" (Lucan *Civil War* 9.633–5), the Gorgon Medusa is beheaded by Perseus in a painting (Helbig 1868: 246, no. 1182; Reinach 1922: 204, no. 4; Jones Roccos 1994: 340, no. 130) in the House of Perseus and Medusa in Herculaneum. Medusa's "snaky head" (Ovid *Met.* 4.771) or *gorgoneion* is shown in many depictions of Perseus rescuing Andromeda, among which: (1) a painting (Jones Roccos 1994: 344, no. 219a) in the cubiculum of House I.iii.25 (Schefold 1957: 13); (2) a painting (Maiuri 1938: 7, pl. A; Jones Roccos 1994: 342, no. 178b) in the triclinium (b), northwest of atrium, in the House of the Priest Amandus (I.vii.7) (Schefold 1957: 31); (3) a painting (Reinach 1922: 206, no. 2) in the triclinium (c) of the House of the Female Dancers (VI.ii.22) (Schefold 1957: 96); (4) a painting (Jones Roccos 1994: 344, no. 204a) from the south pilaster of the large peristyle (53) in the House of Castor and Pollux (Casa dei Dioscuri) (VI.ix.6–7) (Schefold 1957: 121), now in the Naples Museum, inv. no. 8998; (5) a painting (Jones Roccos 1994: 344, no. 204b) from room (b), left of the peristyle, in the Casa dei Cinque Scheletri (VI.x.2) (Schefold 1957: 123), now in the Naples Museum, inv. no. 8993; (6) a painting (Jones Roccos 1994: 344, no. 224d) from House VI.x.2(b), now in the Naples Museum, inv. no. 8995; (7) a painting (Reinach 1922: 206, no. 3; Jones Roccos 1994: 344, no. 224b) on the northern wall in the southwest room (f) to the peristyle of the House of the Prince of Naples (VI.xv.7–8) (Schefold 1957: 152); (8) a painting (Reinach 1922: 206, no. 4; Jones Roccos 1994: 344, no. 224e) from the western wall of room (c) in the House of the Painted Capitals (VII.iv.31/51) (Schefold 1957: 183), now in the Naples Museum, inv. no. 8996; (9) a no longer extant painting (Reinach 1922: 207, no. 2; Jones Roccos 1994: 344, no. 224a) in room (i), right of the entrance, in the House of the Sculptured Capitals (VII.iv.57) (Schefold 1957: 186); (10) a no longer extant painting (Schauenberg 1981: 779, no. 37) in room (c), left of the tablinum, in the House of the Black Walls (Casa dei Bronzi) (VII.iv.59) (Schefold 1957: 187); (11) a painting (Schauenberg 1981: 781, no. 68); in House VII.ins.occ.15 (Schefold 1957: 209), now in the Naples Museum, inv. no. 8997; (12) a no longer extant painting (Jones Roccos 1994: 344, no. 219b) in the left wing of the House of Adonis (VIII.iii.13–16) (Schefold 1957: 221); (13) a no longer extant painting on the western wall of the peristyle (9) of the House of the Centenary (IX.viii.3 and 6) (Schefold 1957: 276); (14) a painting (Reinach 1922: 205, no. 5; Jones Roccos 1994: 344, no. 204c) in the triclinium (l) of House IX.ix.17 (Schefold 1957: 284); (15–20) paintings from Pompeii (Reinach 1922: 205, nos. 1, 5, 7, 8; 206, no. 3; 207, no. 1); (21) a painting in the House of Ariadna at Stabiae (Jones Roccos 1994: 344, no. 224c); and (22) a painting from Boscotrecase, now in New York, Metropolitan Museum of Art, inv. no. 20.192.16 (Jones Roccos 1994: 342, no. 178a).

Medusa's head is depicted on (1) a no longer extant painting (Helbig 1868: 246, no. 1180b) of the oecus (58), west of the peristyle, in the House of the Citharist (I.iv.5/25) (Schefold 1957: 17); (2) the wall painting of the lararium in House I.xii.15 (Orr 1978: 1581–2, pl. 7, no. 15; Paoletti 1988: 346, no. 4); (3) paintings in the atrium (c) and in the great oecus, north of the peristyle (q), in the House of the Vettii (VI.xv.1) (Schefold 1957: 140, 146); (4) paintings in the exedra (f), south of the peristyle, in the House of the Black Walls (Casa dei Bronzi) (VII.iv.59) (Schefold 1957: 187); (5) a destroyed frieze of pinaces in the third room (f), left of the atrium, in the House of Joseph II (VIII.ii.38–9) (Schefold 1957: 218); (6) a painting in the passageway from the atrium to the garden in the House of Adonis (VII.iii.13–16) (Schefold 1957: 221); (7) painted shields on the rear wall in the second room

(7), left of the atrium, in the House of M. Lucretius (IX.iii.5) (Schefold 1957: 247); (8) a no longer extant painting in room (1) of the House of the Centenary (IX.viii.3 and 6) (Schefold 1957: 273); (9) the architrave of alcove B in the House of the Mysteries (Paoletti 1988: 346, no. 1); (10) on a painted ceiling from Pompeii, now in the Naples Museum, inv. no. 9973 (Ward-Perkins and Claridge 1976: no. 152; Paoletti 1988: 346, no. 5); (11–12) paintings from Pompeii (Helbig 1868: 245, nos. 1173 [Reinach 1922: 207, no. 7], 1177: NM inv. no. 8821; Reinach 1922: 208, nos. 7–8; Schefold 1957: 314); (13) a painting from the House in Campo Varano, Castellammare di Stabia, now in the Naples Museum, inv. no. 9896 (Paoletti 1988: 346, no. 2); (14) a ceiling from the Villa of San Marco, now in the Antiquarium of Castellammare di Stabia (Paoletti 1988: 346, no. 3); (15) a painting from Stabiae (Helbig 1868: 244, no. 1172; Reinach 1922: 207, no. 5; Schefold 1957: 314, unknown inventory no.); (16–19) paintings from Herculaneum, unmentioned location (Helbig 1868: 245–6, nos. 1174: NM inv. no. 8818 [Reinach 1922: 207, no. 6]; 1175: NM inv. no. 8821; 1176: NM unknown inv. no.; 1180: NM unknown inv. no.; Schefold 1957: 314); and (20) a painting in the Naples Museum (Helbig 1868: 245, no. 1178; Reinach 1922: 208, no. 6; unlocated by Schefold 1957: 314).

Instances of the *gorgoneion* as a piece of warlike Minerva's armor (*aegis*) are found on (1) a wall painting (Canciani 1984: 1076, no. 2) in the atrium (b) of the House of the Epigrams (V.i.18) (Schefold 1957: 63); (2) probably a relief-like painting (Canciani 1984: 1076, no. 1) of the triclinium (p), rear of the right wing, in the House of the Vettii (VI.xv.1) (Schefold 1957: 145); (3) the external upper painting of the twelve gods (Reinach 1922: 6, no. 2; Spinazzola 1953: 175–8, figs. 215, 216, pl. XVIII; Canciani 1984: 1095, no. 305) in the lararium, southwestern corner, of House IX.xi.1 (Schefold 1957: 288); (4) the western wall in room A' (AA) (Paoletti 1988: 355; Cerulli Irelli et al. 1993: II, 187, no. 336a) of the House of C. Julius Polybius (IX.xiii.1–3); and (5) on a no longer extant painting from Pompeii (Reinach 1922: 20, no. 7; Canciani 1984: 1081, no. 90). The snakes in Medusa's hair are not always distinctly shown in all of these and similar cases, depending on the depiction size and acuteness.

The *gorgoneion* is represented on a shield in Thermopolium I.viii.1 (Schefold 1957: 37) and on Minerva's shield in the painting of Bellerophon taming Pegasus, from Thermopolium I.viii.8, now in Pompeii Antiquarium, inv. no. 1174/4 (Lochin 1994: 222, no. 123).

MERCURY Snakes coil around the caduceus on many depictions, either full-scale or busts, of Mercury alone, with other gods, or in mythical episodes: (1) on the western wall (Simon 1992b: 516, no. 196) of the north portico in the peristyle of the House of the Cryptoporticus (I.vi.2–4) (Schefold 1957: 18); (2) on the southern wall (Simon 1992b: 523, no. 284) of Thermopolium I.viii.8 (Schefold 1957: 37); (3) in the atrium (b) (Simon 1992b: 516, no. 192) of the House of the Epigrams (V.i.18) (Schefold 1957: 63); (4) in the cubiculum (i) (Simon 1992b: 516, no. 193), right of the tablinum, of the House of M. Lucretius Fronto (V.iv.11) (Schefold 1957: 86); (5) on the southern wall (Reinach 1922: 28, no. 5; Simon 1992b: 520, no. 247) of room (29), left of the *prothyron* (*fauces*), in the House of Meleager (VI.ix.2) (Schefold 1957: 110); (6) on the northern wall (Reinach 1922: 163, no. 5; Simon 1992b: 525, no. 302) of room (27), rear of the peristyle (triclinium), in the House of Meleager (VI.ix.2) (Schefold 1957: 113); (7) on a no longer extant painting (Reinach 1922: 97, no. 6; Simon 1992b: 522, no. 271) of the door upright in the *prothyron* (33) of the Houses of Castor and Pollux (Casa dei Dioscuri) (VI.ix.6–7) (Schefold 1957: 115); (8) on the right wall (Simon 1992b: 520, no. 248) of House (*caupona*) VI.xiv (Schefold 1957: 134); (9) on the eastern wall (Reinach 1922: 194, no. 1; Rizzo 1929: pl. 35; Simon 1992b: 530, no. 340) of the triclinium (p), rear left wing, in the House of the Vettii (VI.xv.1) (Schefold 1957: 145); (10) on a painting (Simon 1992b: 516, no. 195), now in the Naples Museum, inv. no. 9518, from an unidentified house of VI.ins.occ. (Schefold 1957: 161); (11) on a no longer extant painting (Reinach 1922: 163, no. 3; Simon 1992b: 525, no. 301) in the tablinum of House VII.ii.14 (Schefold 1957: 169); (12) on the western wall (Reinach 1922: 96, no. 6; Simon 1992b: 518, no. 223) of the right wing (6) in the House of the Hunt (VII.iv.48) (Schefold 1957: 180); (13) on a no longer extant painting (Reinach 1922: 5, no. 2; Simon 1992b: 533, no. 364) on the external wall of Casa delle Grazie (VIII.iii.9–10) (Schefold 1957: 220); (14) on a partly damaged painting in House (shop) VIII.iv.3 (Schefold 1957: 222), now in the Naples Museum, inv. no. 9450 (Reinach 1922: 96, no. 5; Simon 1992b: 517, no. 214); (15–16) on the depictions of Isis being watched by Argus, now in the Naples Museum, inv. no. 9548 (Anonymous 1992: 169, pl. XIV; Simon 1992b: 526, no. 312), from the northern wall of the ecclesiasterion (VI) of the Temple of Isis (VIII.vii[formerly viii].28) (Schefold 1957: 233), on a no longer extant painting of the same topic from Herculaneum (Simon 1992b: 526, no. 311); (17) above the entrance door (Simon 1992b: 516, no. 194) of House (shop) IX.vii.1 (Schefold 1957: 267); (18) on the external wall (Spinazzola 1953: 207–10, figs. 237, 239, pl. XII; Simon 1992b: 518, no. 218) of House IX.vii.7, shop of M. Vecilius Verecundus (Schefold 1957: 267–8); (19) on the upper painting showing the twelve gods (Reinach 1922: 6, no. 2; Spinazzola 1953: 175–6, figs. 215, 216, tav. d'agg., pl.

XVIII; Simon 1992b: 532, no. 363) in the much faded lararium depicted on the external wall of House IX.xi.1 (Schefold 1957: 288), in addition to two snakes, the former reaching the plate presented by a male character (identified as the Genius of Augustus), the latter, being crested, creeping toward offerings; (20) on the southern wall (Cerulli Irelli et al. 1993: II, 191, no. 344) of the lararium depicted on the wall of garden (6) next to the House of C. Julius Polybius (IX.xiii.1–3), in addition to two crested snakes (*agathodaimones*); and (21) on a painting from Pompeii, in the Naples Museum, inv. no. 9452 (Simon 1992b: 517, no. 213).

Vulcan A snake is depicted on the shield made by Vulcan for Achilles at Thetis's request on (1) the painting (Reinach 1922: 19, no. 5, partly faded depiction on shield), Naples Museum, inv. no. 9528, from room (2) of the atrium in the House of Meleager (VI.ix.2) (Schefold 1957: 111); (2) the painting (Rizzo, 1929: pl. 60; Simon 1997: 291, no. 89) in exedra (10), left of the atrium, in the House of P. Vedius Siricus (VII.i.25 and 47) (Schefold 1957: 164); and (3) the painting (Reinach 1922: 19, no. 2; Rizzo 1929: pl. 58; Simon 1997: 291, no. 88) of the western wall of room (n) to the peristyle in House IX.v.2 (Schefold 1957: 252).

MOSAIC

AFRICAN SPECIES

In the Nile mosaic (Fig. 352) from the House of the Faun (VI.xii) and in the Nile frieze probably from the Vesuvian area (NM unmentioned inv. no.) (Tammisto 1997: 372, pl. 28, NS8.1), an Egyptian cobra, *Naja naja*, rises against a mongoose (*Herpestes ichneumon*).

MYTHICAL AND SYMBOLIC SNAKES

MEDUSA Medusa's head is shown on (1) a mosaic from the House of the Silver Wedding (V.ii.i), now in the Naples Museum, inv. no. 112284 (Paoletti 1988: 346, no. 10); (2) on a pavement in the House of the Vestals (VI.i.6–7) (Pernice 1938: 110, 142); and (3) on a mosaic from room 12 in the House of the Centenary (IX.viii.3 and 6), now in the Naples Museum (Pernice 1938: 44; Schefold 1957: 276, unknown inv. no.).

The apotropaic gorgoneion is represented on the breastplate of Alexander the Great (Cohen 1997: pl. II) on the Alexander mosaic in the exedra (37) in the House of the Faun (VI.xii) (Schefold 1957: 128), now in the Naples Museum (inv. no. 10020).

SCULPTURE

EUROPEAN SPECIES

A snake is rising from a cista whose lid is lifted up by a youthful satyr on the *oscillum* (NM inv. no. 6551) from the House of the Citharist (I.iv.5/25) (Dwyer

1981: 261, no. 1 and pl. 83.1; Barbet and Compoint 1999: 94 full color).

A snake coils around a wading bird, identified as a stork by Maiuri, on a silver cup found in the House of Menander (I.x.4) (Maiuri 1933: 347–8, no. 13, pl. XLV). Snakes teased, attacked, or swallowed by waders are depicted on five silver drinking cups from Boscoreale. Héron de Villefosse identifies the birds either as storks (1899: 72, no. 10, pl. X; 76–8, nos. 13, pl. XIV, and 14, pl. XIII) or as cranes (1899: 73–5, nos. 11–12, pl. XI–XII), without stating his criteria. By all means, both species occasionally feed upon snakes.

Matteucig (1974: 220, 222) lists a viper (*Vipera aspis*), without stating his identification keys, and three snakes on the Eumachian portal in Pompeii, his numbers 15, 26, 31, and 90.

Snakes were also favorite models for fountain sculpture and spouts, though sometimes much simplified as in the House of the Ephebe (I.vii.10–12/19) where "the pipe [is] attached . . . to suggest a snake fountain" (Jashemski 1993: 41, no. 42). The 0.225 cm long bronze fountain (NM inv. no. 124913) from the House of M. Pupius Rufus (VI.xv.5) (Jashemski 1993: 156, no. 297) is in the shape of a serpent. "Two serpents were shown on the fragmented base of a marble fountain" from House VII.vi.38 (Jashemski 1993: 185, no. 362). Another fountain (NM inv. no. 67789) was a "bronze tube, which terminated in the form of a serpent from whose mouth the water fountain spouted (tube, including serpent, 0.33 m high)" in the House of Camillus (VII.xii.23) (Jashemski 1993: 195, no. 383 and fig. 224, general view of the courtyard garden). All of these fountain snakes most likely portray common water snakes, *Natrix* sp. Many snakes are good swimmers, but species of the genus *Natrix*, represented by three species in Italy – *N. natrix* (grass snake), *N. tessellata* (dice snake), and *N. maura* (viperine snake) – are the most aquatic of all.

In addition to these more or less natural depictions, other fountain spouts such as the half-meter-high crested and bearded bronze snake (NM inv. no. 4898) (Jashemski 1993: 30, no. 21, fig. 28) from the House of the Citharist (I.iv.5/25) and the monumental (2.42 m high) crested and bearded five-headed snake (Fig. 285) from the Great Palaestra of Herculaneum (Ins. or. II.4) (Jashemski 1979: 162–3, fig. 247; 1993: 276, no. 566) are typical of the more fanciful imagery shown in the snakes (*genius loci, genius familiaris*, Lares, Penates) painted or carved in household shrines (see Orr later in this chapter).

AFRICAN SPECIES

An Egyptian cobra seems to have been intended in the *oscillum* (NM inv. no. 110660) (Dwyer 1981: 264, no.

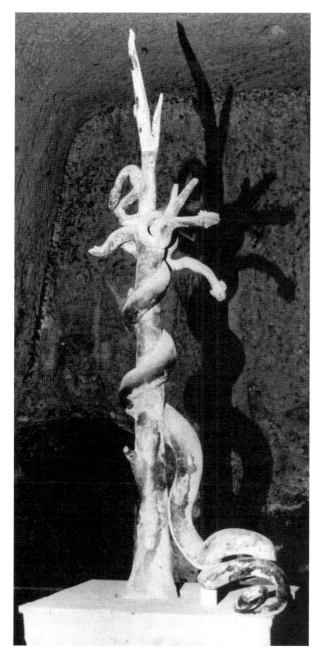

FIGURE 285 Monumental fountain device, Great Palaestra, Herculaneum (Insula or. II.4). Photo: S. Jashemski.

13 and pl. 90, 3.4) from the House of L. Caecilius Jucundus (V.i.26) (Jashemski 1993: 109, no. 168). Indeed, as rightly identified by Dwyer (1978), the subject of the "fowler attempting to catch a bird in a tree and unaware of the snake" that will kill him comes down from the Aesopic fable "The Fowler and the Asp" (= cobra). Yet, the Pompeian marble cutter was no more interested in naturalistic realism than in "the spatial unity of the scene." The reptile creeping from the central scene to the right side is a crude outline of a snake lacking any features that would allow its identification with the species mentioned in the fable.

The Egyptian god Bes has the uraeus on the stucco pilaster of the "purgatorium" in the Pompeian Temple

of Isis (VIII.vii[formerly viii].28) (De Vos 1980: 61, no. 24, pl. XXXVIII). Tran Tam Tinh (1964: 201–2) reports an unpublished terra-cotta lamp (Pompeii Antiquarium inv. no. 10552) showing Isis, Harpocrates, and Anubis holding a caduceus coiled with two snakes, likely cobras. The female character typifying Africa (Alexandria?) on an ornamental silver plate from Boscoreale (Héron de Villefosse 1899: 39–41, 276, no. 1, pl. I) holds a cobra in her right hand, the snake's body coiling around her forearm and wrist, in much the same way as in Isis's hand on the paintings from the Temple of Isis (VIII.vii[formerly viii].28) and from the House of Isis and Io-Casa del Duca d'Aumale (VI.ix.1). Furthermore, Aesculapius's staff coiled with his snake is depicted among other deities' symbols in the lower part of the plate.

The skeleton portraying the Peripatetician philosopher Demetrius of Phaleron who died from a cobra's bite in Upper Egypt around 280 B.C. (Diogenes Laertius *Lives and Opinions of Philosophers* 5.78–9) holds a cobra in his right hand on a silver cup from Boscoreale (Héron de Villefosse 1899: 66, 235, no. 8, pl. VII.1).

MYTHICAL AND SYMBOLIC SNAKES

APOLLO A relief from Stabiae reused as a capital in the cathedral of Castellammare di Stabia shows a snake coiled around the tripod supporting Apollo's lyre (Simon 1984: 416, no. 379). An ivory disk (*oscillum?*) of unmentioned origin (NM unmentioned inv. no.) depicts a snake creeping toward Apollo (Simon 1984: 411, no. 338).

HERCULES The *hydra* (snake with many heads that grew again when they were cut) ranging in the marshes of Lerna and the guardian snake watching the golden apples in the Garden of the Hesperides are shown in the depictions of Hercules's twelve labors on two silver cups from the House of Menander (I.x.4), now in the Naples Museum (Maiuri 1933: 315–16, figs. 122 and 124, pl. XXVII and XXIX; Boardman 1990: 15, no. 1756). The snake of the Hesperides coils around the tree in their garden shown on a glass intaglio from Pompeii (NM inv. no. 118725) (Kokkorou-Alewras 1990: 107, no. 2754).

The marble statuette of a little boy clasping two serpents (Pompeii inv. no. 2932) (Fig. 286) found in the garden of the House of M. Loreius Tiburtinus (II.ii.2) (Jashemski 1979: 45, fig. 76; 1993: 79–81, figs. 82, 86) was ornamental like the other marble statuettes found there. Although unrecorded in Woodford's catalogue (1988), it referred likely to the myth of the infant Hercules. As far as can be judged from the photograph, in spite of their present poor condition, the snakes were constricting reptiles.

FIGURE 286 Infant Hercules strangling two snakes. Marble statuette, House of M. Loreius Tiburtinus or of D. Octavius Quartio (II.ii.2) (Pompeii Antiquarium inv. no. 2932). Photo: S. Jashemski.

MEDUSA The *gorgoneion* is carved on Minerva's *aegis* in the marble statue from Herculaneum, now in the Naples Museum, inv. no. 6007 (Canciani, 1984: 1090, no. 222).

MERCURY Mercury holding the caduceus coiled with snakes is depicted on the stucco frieze (Spinazzola 1953: 890 and 893, figs. 888, 891; 898 and 901, figs. 897, 900, pl. LXXXVI; Simon 1992b: 525, no. 307) in the "sacellum Iliacum" (e), right of the tablinum, in the House of the Cryptoporticus (I.vi.4) (Schefold 1957: 23).

Bronze statuettes show Mercury holding the caduceus coiled with snakes: (1) one from the lararium in peristyle (F) of the House of the Golden Cupids (VI.xvi.7) (Schefold 1957: 154), now in the Naples Museum, inv. no. 133329 (Simon 1992b: 508, no. 48, lost caduceus); (2–3) two from the lararium of Casa delle Pareti Rosse (VIII.v.37) (Schefold 1957: 227), now in the Naples Museum, inv. nos. 113258–113259 (Simon 1992b: 507–8, nos. 35 and 40); (4) one from House IX.vi.5–7, now in the Naples Museum, inv. no. 115554 (Simon 1992b: 508, no. 43); (5) one from Pompeii, unidentified original location, now in the Naples Museum, inv. no. 115553 (Simon 1992b: 507–8, no. 38).

The caduceus was probably painted on a terra-cotta statuette from a grave in Pompeii, now in the Naples Museum, inv. no. 20636 (Simon 1992b: 509, no. 55).

The caduceus coiled with snakes is depicted either with Mercury's head or in Mercury's hand, when he is shown full-size, on ringstones and gems from Pompeii, now in the Naples Museum, inv. nos. 110632, 158756 (Simon 1992b: 511–12, nos. 92 and less clearly 119), and from Herculaneum, Naples Museum, inv. no. 107595 (Simon 1992b: 511, no. 93), and as Mercury's symbol on gem, Naples Museum inv. no. 158749 (Simon 1992b: 514, no. 169) from House II.v.4.

Minerva Vipers (Bodson 1990: 58–60) are carved along the edge of Minerva's *aegis* in the marble statue from Herculaneum, now in the Naples Museum, inv. no. 6007 (Canciani 1984: 1090, no. 222).

CULT OBJECTS

Vermaseren (1983: 5–9, pls. VII–XIX) in his catalogue, completed by Lane in the appendix to his general conclusions (1989: 64–5), described the snakes depicted on the preserved five bronze hands associated with the worship of Sabazius: (1) one on a hand now in the Bibliothèque Nationale, Paris (inv. no. 1064); (2) a snake with its head missing on one hand found in Herculaneum (NM inv. no. 5506); (3–4) a "viper" creeping up against the index finger and a snake winding along the length of an unidentifiable object on one hand (Pompeii inv. no. 10485) found in the House of the Birii (II.i.12) (Jashemski 1979: 135, fig. 215, left; 1993: 76, no. 132); (5–6) a snake resting its crested head upon the ring finger and a "viper" coiled about a cypress tree on the back side of the second hand (Pompeii inv. no. 10486 = Fig. 276) from this house (Jashemski 1979: 135, fig. 215, right; 1993: 76, no. 132); (7) a snake on a hand found in Pompeii, now in the Naples Museum, inv. no. 5509. Vermaseren (1983: 8–9) also described two "snakes" and a "viper" on one of the terra-cotta vases also found in the House of the Birii (II.i.12) (Pompeii Antiquarium inv. no. 10529 = Fig. 277) (Jashemski 1979: 135, fig. 214) and two snakes entwined on each of the two handles of the other (Pompeii Antiquarium inv. no. 10528) from the same place.

Vermaseren (1983) did not define the criteria he applied to differentiate vipers from snakes. Vipers are not evidenced in the extant classical texts on Sabazius's cult. The ancient Greek authors talk of snakes (*opheis*) in general (Lane 1985: 46, 52, nos. 5 and D1) or of rat snakes (*pareias, drakontes*) specifically (Lane 1985: 46, 48, 52, nos. 5, 16, 17, and D1). Latin authors use the words *coluber* (Lane 1985: 49, no. 22) and *anguis* (Lane 1985: 49, no. 23). Lane (1989: 64–5) apparently did not pay attention to Vermaseren's terminology and preferred the word "snakes" in his additional list of Sabazian vases (found in Switzerland). In his commentary on

the animals depicted on Sabazius's hands and vases, he merely refers to Aelian's *Natura animalum,* taken at face value without any contextual approach. Lane's superficial conclusions, which ignore all aspects of naturalism, are both too limited and speculative to shed light on the symbolic meaning of the amphibians and reptiles involved in a cult as focused as Sabazius's.

JEWELRY

The snake was a frequent motif on gold jewelry during the Hellenistic and Roman periods. Among the examples of gold jewelry with a snake motif found in the Vesuvian area are the following: (1–2) two armbands in the form of a snake from the House of the Faun (VI.xii) in the Naples Museum, inv. nos. 24824, 24825 (Anonymous 1995: nos. 15A and B, the former in Ward-Perkins and Claridge 1976: no. 56); (3–4) two snake bracelets from Boscoreale, now in the Louvre (Héron de Villefosse 1899: 265–6, nos. 110–11, fig. 57; Higgins 1980, pl. 62A); (5–6) two now stolen bracelets (Fig. 287) from Herculaneum (Gore and Mazzatenta 1984: 561); (7) a bracelet found at Terzigno, Ranieri quarry Villa 2 (Pompeii Antiquarium inv. no. 30795) (Menotti 1988: 171, fig. 4; Anonymous 1990: 215, fig.

FIGURE 287 Two (stolen) gold bracelets from Herculaneum. (Gore and Mazzatenta 1984: 561). Photo: O. Louis Mazzatenta./NGS Image Collection.

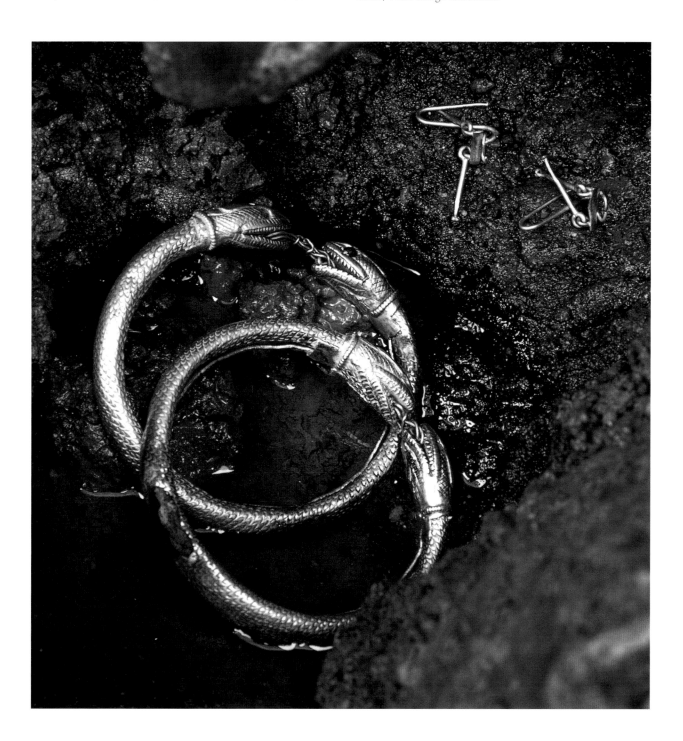

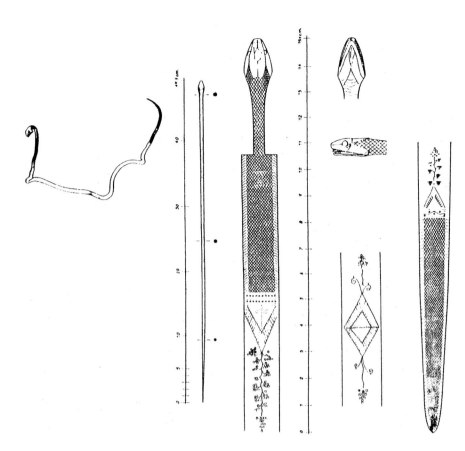

FIGURE 288 Drawing of a gold bracelet from Terzigno, Ranieri quarry Villa 2 (Pompeii Antiquarium inv. no. 30794). (Menotti, in Curtis 1988: 181, fig. 6)

145); (8) another bracelet (Fig. 288) found at Terzigno, Ranieri quarry Villa 2 (Pompeii Antiquarium inv. no. 30794) (Menotti 1988: 171, figs. 5–6; Anonymous 1990: 217, fig. 146); (9–11) three bracelets found in Villa B at Torre Annunziata (Oplontis) (Oplontis inv. nos. 3009, 3406, 4619 broken) (D'Ambrosio 1987: 44–6; Anonymous 1990: 219, fig. 154 = inv. no. 3406); (12) a gold bracelet (Mariemont, inv. no. B 352) from Torre Annunziata (Lamy 1993: 462, no. 2); (13) a finger ring "probably from Campania," now in London, British Museum, inv. no. 1867.5–8.422 (Ward-Perkins and Claridge 1976: no. 51); and (14–20) seven finger rings found at Torre Annunziata (Oplontis), Villa B (Oplontis inv. nos. 3001, 3002, 3314, 3317, 3319, 3324, 3403) (D'Ambrosio 1987: 55–8, nos. 43–9; Anonymous 1990: 221, fig. 158 = inv. no. 3403).

As suggested by Hoffmann and Davidson (1965: 14) about Hellenistic jewelry, "only a comprehensive technical survey will eventually decide the question of the origin" of the bracelets, armbands, and rings uncovered in Pompeii. Regarding their naturalism, they show chased scales on the upper and lower sides of the head, forepart, and tail. Some are cruder or more simplified than others. The bracelet uncovered at Terzigno (Pompeii Antiquarium inv. no. 30794) (Fig. 288) might prove to be a fine example of realism, but the printed reproductions are not detailed enough to decide whether it matches the requirements of modern identification (compare Fig. 289). Firmer conclusions must

await close investigation and extensive comparison with similar pieces. Meanwhile, the rendition of the snakes' scale patterns on head, body, and tail confirms the skillful artisanship of the ancient goldsmiths, whatever their motivations and the resulting degree of accuracy to nature.

SKELETAL REMAINS

A few vertebrae and one rib were the only snake bones found beneath the House of Amarantus (I.ix.11–12). "The morphology of the vertebrae is colubrine (*Colubridae*), but grass snake (*Natrix natrix*) and dice snake (*Natrix tessellata*) can both be ruled out" (Fulford and Wallace-Hadrill, 1999: 93). "An almost complete skeleton of a rat snake" was found in the *villa rustica* at Boscoreale (Jashemski 1993: 291, no. 590).

ANCIENT AUTHORS

Pliny devotes two chapters to pythons in *HN* 8.33–7, in addition to a general survey on snakes (*HN* 8.85–7), comments on snake reproduction (*HN* 10.143, 188), and the earliest evidence of the spitting cobra (*Naja nigricollis*) in *HN* 28.65. Snakes and their medicinal products are discussed in *HN* 29.72, 30.21, 32.53, 82, 102, 104.

REMARKS

Only colubrids (rat and water snakes) and vipers occur naturally in Campania. Two African species, a cobra (*Naja haje*) and a python (*Python sebae*), are also

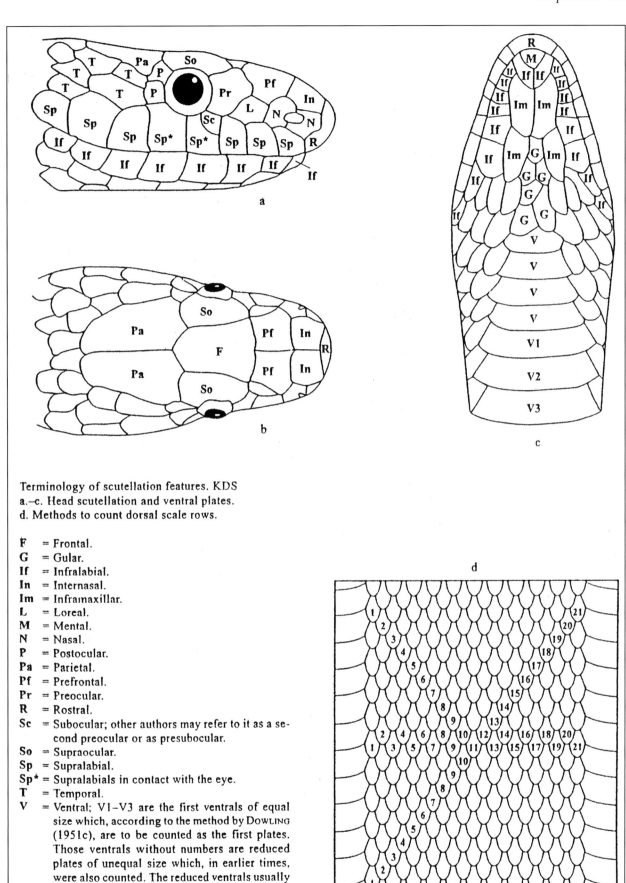

Terminology of scutellation features. KDS
a.–c. Head scutellation and ventral plates.
d. Methods to count dorsal scale rows.

F = Frontal.
G = Gular.
If = Infralabial.
In = Internasal.
Im = Inframaxillar.
L = Loreal.
M = Mental.
N = Nasal.
P = Postocular.
Pa = Parietal.
Pf = Prefrontal.
Pr = Preocular.
R = Rostral.
Sc = Subocular; other authors may refer to it as a se-
 cond preocular or as presubocular.
So = Supraocular.
Sp = Supralabial.
Sp* = Supralabials in contact with the eye.
T = Temporal.
V = Ventral; V1–V3 are the first ventrals of equal
 size which, according to the method by DOWLING
 (1951c), are to be counted as the first plates.
 Those ventrals without numbers are reduced
 plates of unequal size which, in earlier times,
 were also counted. The reduced ventrals usually
 number only 2 to 3, rarely 4 to 5.

FIGURE 289 Key to snakes: scutellation features, Schulz, 1996: 17. Printed with permission of Koeltz Scientific Books and of the author, who generously provided the numbered copy of the drawing.

depicted in Vesuvian art. The harmless colubrid rat and water snakes have rounded snouts and usually benign-appearing round irises. The diurnal Aesculapian snake, *Elaphe longissima,* a kind of rat snake that climbs and feeds mainly on small mammals but also on birds, especially nestlings, is faintly striped and may grow to six feet. It is widespread and common in southern Europe (Arnold et al. 1978: 199–200; Gasc 1997: 356–7). The aquatic grass snake, *Natrix natrix,* which typically has a yellow collar and, in southern Italy, a barred pattern on its back, is slightly smaller and occurs virtually throughout Europe. Its main prey are frogs and toads, newts, and fish (Arnold et al. 1978: 201–2; Gasc, 1997: 370–1). The slow-moving heavy-bodied small vipers are the only dangerous native snakes of Europe. The widespread asp viper, *Vipera aspis,* the only species in Campania, has a flat snout (the Nose-horned viper, *Vipera ammodytes,* has an upturned or "horned" snout) in contrast to the rounded snouts of rat and water snakes. Although generally small and not aggressive, this viper has venom that is lethal to its prey, small mammals, birds, and lizards, which it captures on the ground (Arnold et al. 1978: 218–19; Gasc, 1997: 386–87). The African rock python (*Python sebae*) is a very large, nonvenomous snake up to some 44–5 feet long (13.2–13.5 m) (Bodson forthcoming), though wild specimens rarely exceed 20 feet (6.1 m) in the wild nowadays (Mattison 1995: 20). It constricts its large mammal prey by coiling about it and constricting. It would only have been known in Campania by travelers' accounts. Conversely to crocodiles (see following discussion) and African mammals such as the giraffe or hippopotamus, there is no written record of pythons ever having been taken to Rome in antiquity. Both Mielsch (1986: 754–6) and Andreae (1990: 101–5) speculated on the origin of the big snakes once visible on the Pompeian wall paintings. The matter is still open to further investigation. The highly venomous Egyptian cobra occurs in northeast Africa (Anderson 1898: 212, 362; Schleich, Kästle, and Kabisch 1996: 526) and would only have been known by reputation in Campania, unless the trade in cobras between Egypt and Rome alluded to by Lucan (*Civil Wars* 7.706–7) expanded to Campania.

ORDER: CROCODILIA, CROCODILIANS

FAMILY: CROCODYLIDAE, CROCODILES

English, crocodile; Italian, *coccodrillo*

WALL PAINTINGS

As a typical species of the African fauna, crocodiles were a standard feature of ancient art to iden-
tify or to allude to the land of Egypt. They were often shown on Nile landscape illustrations of which many including "pygmies" were intendedly satirical (Cèbe 1966: 348–350). Thus, depending on the aim and style of representations, the crocodiles were depicted with some, even if sketchy, degree of realism or were given fanciful characteristics such as the dorsal crest of the specimen captured by four pygmies on the painting (NM inv. no. 113195) in the House of the Physician (VIII.v.24) or the exaggerated convex back on the painting in the House of the Ephebe (I.vii.10–12). Among the Pompeian and other Campanian instances on Nilotic wall paintings, a crocodile is represented in the triclinium of the House of the Cryptoporticus (I.vi.2/16) (Tammisto 1997: 282, n. 505).

Crocodiles are shown on Pompeian Nile landscapes with pygmies in a painting (Maiuri 1938: 24–5, pl. IV.1 [= Cèbe 1966: pl. XIII.4; Dasen 1994: 598, no. 47b] and pl. V.1–2) in the triclinium (p) in the House of the Ephebe (I.vii.10–12) (Schefold 1957: 34) and in a fragmentary painting on the northern wall in the atrium (Maiuri 1933: 31, fig. 10; Dasen 1994: 598, no. 47c) of the House of Menander (I.x.4) (Schefold 1957: 39).

Three paintings or fragments of paintings with crocodiles were once recorded in the triclinium of the House of Julia Felix (II.iv.3). One of these paintings is still extant in the Naples Museum, inv. no. 8732 (crocodile in water with plants and duck) (Whitehouse 1977: 54–55 and pl. XIXb). The other two are now lost, except for an eighteenth-century engraving. The left panel showed a crocodile with ducks and water plants. The foreground of the central panel represented a pygmy riding a crocodile (Whitehouse 1977: 55, 65, and pl. XX; Dasen 1994: 598, no. 45 = Helbig 1868: no. 1566; Reinach 1922: 161, no. 3).

A now destroyed painting showing a crocodile and pygmies is reported by Dasen (1994: 598, no. 47d = Helbig 1868: no. 1546b) in the walking place (*xystos*) of the House of Apollo (VI.vii.23) (Schefold 1957: 103).

A sketchy crocodile is shown on a painting (NM inv. no. 27698) (Marcadé 1961: 30; Cèbe 1966: 352, n. 7, pl. XIII.2, forepart only; Dasen 1994: 598, no. 47f) from the peristyle (f) in the Casa delle Quadrighe (VII.ii.25) (Schefold 1957: 173).

A pygmy is holding back his donkey from a crocodile's threatening mouth on a much faded painting (De Vos 1980: 86–7, fig. 40 and pl. LIV.2; Dasen 1994: 598, no. 47g) of the predella of tablinum (10) in the House of the Hunt (VII.iv.48) (Schefold 1957: 181) and on a painting from Herculaneum, now in the Naples Museum, inv. no. 8512 (Helbig 1868: no. 1568; Reinach 1922: 377, no. 2; Foucher 1965: 139, fig. 10).

A now faded painting in the Temple of Apollo (so-called Temple of Venus) (VII.vii.1) evidences a crocodile swallowing a pygmy (Helbig 1868: no. 1544; Reinach 1922: 377, no. 5; Schefold 1957: 192, 319, unclear current status). A watercolor of a painting from the same temple, stored in the archives of the Naples Museum, shows a crocodile in upright position (De Vos 1980: 87, n. 234).

The upper level of the northern wall frieze in the Palaestra (34) of the House of M. Fabius Rufus (VII.ins. occ., [16], 17–22; Cerulli Irelli et al. 1993: II, 163–4, nos. 288a–b = Meyboom 1995: fig. 31) shows three crocodiles, one of them attacking a dog, another swallowing a pygmy.

"A patchily preserved (unpublished) frieze around a bath in VIII,2,17–20 has a pygmy wrenching a friend from the jaws of a crocodile which has half swallowed him" (Whitehouse 1977: 61).

Two crocodiles, one being attacked by a pygmy (on the left side), the other (on the right side) being already controlled by four pygmies, one of them riding it aside, are depicted in the Nile landscape (NM inv. no. 113195) (McDaniel, 1932: pl. IX; Maiuri, 1953: 111, detail of the latter, color; Cèbe 1966: 349, n. 4 and pl. VIII; Dasen 1994: 598, no. 46a), said by Spinazzola (1953: 641, n. 260) to be from the House of the Cock (VIII.v.2) and by McDaniel (1932: 269, n. 2), Schefold (1957: 227), and others from the peristyle of the House of the Physician (VIII.v.24).

A crocodile is on the watch of dancing and defecating pygmies in a painting (Maiuri 1957: 73, pl. I.2; Cèbe 1966: 354, pl. XV.2; Dasen 1994: 598, no. 44) of the dado on the southern wall in the House (workshop) of the Sculptor (VIII.vii.24).

A crocodile is attacked by a pygmy (lower right side) on a wall painting of the oecus (g) (Spano 1955: 338, figs. 1 and 11; Cèbe 1966: 350, n. 3, pl. XII.1; Cerulli Irelli et al. 1993: I, pl. 92; II, 177–8, no. 317e; Dasen 1994: 598, no. 47) in the House of the Pygmies (IX.v.9) (Schefold 1957: 256). On the left side stands a votive column topped by a bronze or gold (gold-plated?) statue of a crocodile. A similar statue is shown on a painting (Peters 1963: 173, pl. XLIV, fig. 171; Kiss, 1998: 279) of the garden (h) in the House of the Ceii (I.vi.15) (Schefold 1957: 28).

A crocodile is shown on the right side of the Nile landscape in the eastern portico of the Temple of Isis (VIII.vii[formerly viii].28) (NM inv. no. 8607; Anonymous 1992: 40, no. 1.2, pl. VI). Two crocodiles arranged face to face to form a circle are depicted in the frieze of the same portico (NM inv. no. 8545; Anonymous 1992: 41, no. 1.4). Another specimen is used by Isis as a footrest in the wall painting of her

welcoming Io upon arrival at Canopus, on the north-western wall of the ecclesiasterion (VI) (NM inv. no. 9558; Anonymous 1992: 55–6, no. 1.63, pl. X), and in the parallel depiction of the House of Isis and Io-Casa del Duca d'Aumale (VI.ix.1) (Tran Tam Tinh 1964: 128, no. 14 and pl. XVI.2), now in the Naples Museum, inv. no. 9555. Two crocodiles are depicted on the main wall of the ecclesiasterion (VI) (Schefold 1957: 233) of the Temple of Isis (VIII.vii[formerly viii].28).

A crocodile is brought on a woman's shoulder (De Vos 1980: 38, no. 20, fig. 15) on the painting of a now faded Isiac procession in the triclinium (61) of the House of the Centenary (IX.viii.3 and 6) (Schefold 1957: 279). Crocodiles are depicted in the Nilotic landscape of the Tomb of C. Vestorius Priscus (Cèbe 1966: 350, n. 1 and pl. XI, 5) and in the Stabian Baths (VII.i.8) (Dasen 1994: 598, no. 47e). A crocodile is reported by De Vos (1980: 86, n. 230) on a candelabrum shown in an unpublished painting of the portico, north of the pool, in the House at Torre Annunziata (Oplontis).

MOSAIC

A crocodile (Fig. 290) is seen on the Nile mosaic (NM inv. no. 9990) from the exedra (37) in the House of the Faun (VI.xii) (Schefold 1957: 128) and in the Nile frieze probably from the Vesuvian area (NM unmentioned inv. no.) (Tammisto 1997: 372, pl. 28, NS8,1). Satirical Nile landscapes on mosaic also show crocodiles threatening pygmies – two on the mosaic in the triclinium of the House of P. Paquius Proculus or of C. Cuspius Pansa (I.vii.1) (Cèbe 1966: 349, n. 3, pl. XII.2; Dasen 1994: 598, no. 50), one on the mosaic in the House of Menander (I.x.4/11) (Maiuri 1933: 58–9, fig. 21 and pl. VII; Pernice 1938: 59, pl. 23.6; Cèbe 1966: 349, pl. XII.3; Dasen 1994: 598, no. 50a), and one in the black and white mosaic probably from Campania, now in the Naples Museum (unmentioned inv. no.) (Marcadé 1961: 40; Dasen 1994: 598, no. 51b).

SCULPTURE

Two yellowish glazed terra-cotta crocodiles (unmentioned inv. no.), the larger one 40 cm long, found in the garden of the House of the Silver Wedding (V.ii.1), are said to be of Egyptian origin by the excavator (Jashemski 1993: 113, no. 180). De Vos (1980: 86, n. 233) alludes to the early-nineteenth-century finding of a black stone crocodile in the House of the Hunt (VII.iv.48). A crocodile lying on a base and supporting the sacred water jug on its back is depicted on a silver tumbler found in the Grand Palaestra (II.vii) of Pompeii, now in the Naples

FIGURE 290. Nile crocodile (*Crocodylus niloticus*). Nile mosaic (detail) from the exedra (37), House of the Faun (VI.xii) (NM inv. no. 9990). Photo: S. Jashemski.

Museum (unmentioned inv. no.) (Fuhrmann, 1941: 594, 599, fig. 115; Kiss 1998: 282, fig. 11).

ANCIENT AUTHORS

Pliny focused on the Nile crocodile in *HN* 8.89–94. He recorded the first crocodiles brought to Rome in 58 B.C. (*HN* 8.96). Their species was appreciated by the Romans for public display until the late Roman Empire (Toynbee 1973: 218–20).

REMARKS

The crocodiles in all of these Egyptian-inspired works are the Nile crocodile, *Crocodylus niloticus*, which nowadays ranges from Egypt south throughout Africa and Madagascar, except for the desert areas of the Sahara and Sahel (Steel 1989: 39–51).

SNAKES ON POMPEIAN HOUSEHOLD SHRINES

David Orr

Pompeii is an archaeological site filled with deep religious and natural power. Even its smallest houses occasionally contain more than one religious shrine and almost every building possesses some sort of religious affiliation (Orr 1972: passim; Boyce 1937: 7–9). Images of snakes are important symbols in these shrines. Indeed, snakes even cover the surfaces of latrines, exterior walls, and temples, where they serve as apotropaic devices or integral elements of diverse religious practices. Yet for the most part, these animals are fantastic creations and do not accurately represent their natural counterparts. This should not be surprising given the complex religious history of serpents in the Mediterranean world. In Roman and Greek religion serpents evolved into a composite symbol that could represent a broad spectrum of values (Orr 1978: 1572; Nilsson 1940: 71; Mundkur 1983: 70–1; and Bodson 1981: passim).

Serpents received extraordinary attention from the Pompeians due to their subtle, captivating nature and the wide range of emotions they can produce upon humans (Mundkur 1983: 1–39). This is not the place to delve into those issues in detail, but the universal appeal of snakes in practically every world religion should always be remembered as we examine their presence in Pompeii. Snakes were important

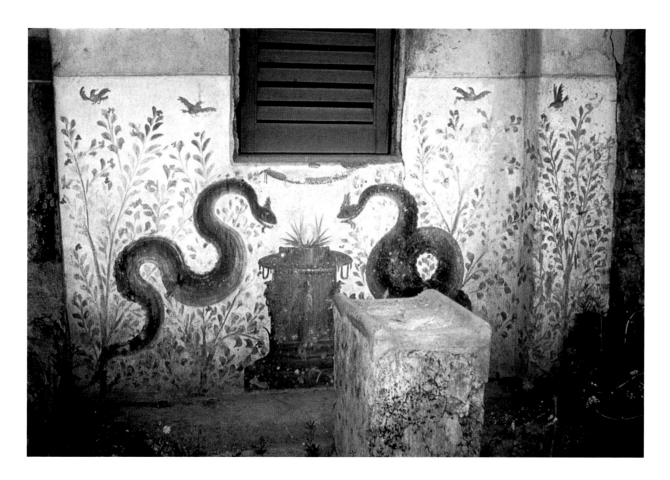

elements in the Aesculapian cult, the cult of Juno Sispes, the worship of Jupiter, and the rites of Fortuna of Antium (Ovid *Met.* 25. 699–740; Propertius *Elegies* 4.8.3; Silius Italicus *Punica* 13.640–4; Latte 1960: pl. 7, respectively). But it is their familiar aspect in the Roman home that makes them so significant in Pompeii.

The serpent was important in the standard painted iconography of the Pompeian house shrine. In these paintings the serpents are offered eggs, pinecones, figs, and dates. A typical house shrine painting (Fig. 291) might have one or two painted serpents flanking an altar with a pair of Lares (the tutelary spirits of the Roman home) accompanying them. A togate painted Genius figure, usually shown sacrificing before the altar, is included on some shrines. The household image of the serpent symbolized two major religious functions in these paintings. The serpent was the "genius" that not only protected the place from harm but also represented the procreative force of the human who lived there (Orr 1978: 1573, Orr 1988: 297–8). The household shrine (lararium) was the center for domestic rituals in the home. The rituals practiced before the shrine demonstrated the reliance of the family on its maintenance and continuity. The shrine bound the Roman family to its past, protected its present, and provided for the future. Within this powerful religious complex the serpents were significant elements.

FIGURE 291 Lararium painting from a garden in Pompeii, I.xi.15. Two Type I serpents flanking a painted altar. Photo: S. Jashemski.

FIGURE 292 Detail of Figure 291. Serpent (Type I) from the garden painting. The egg is a symbol of fertility. Photo: D. Orr.

An examination of the household shrines, or lararia, of Pompeii demonstrates that these serpents are depicted in two main types. Type I reflects a large-necked, thick-bodied, viperine animal (Figs. 291, 292). The bodies of these snakes are covered with both smooth and rough scales. What sets them apart from any real species is their prominent beard and crest. Early Hellenic cults used bearded serpents to

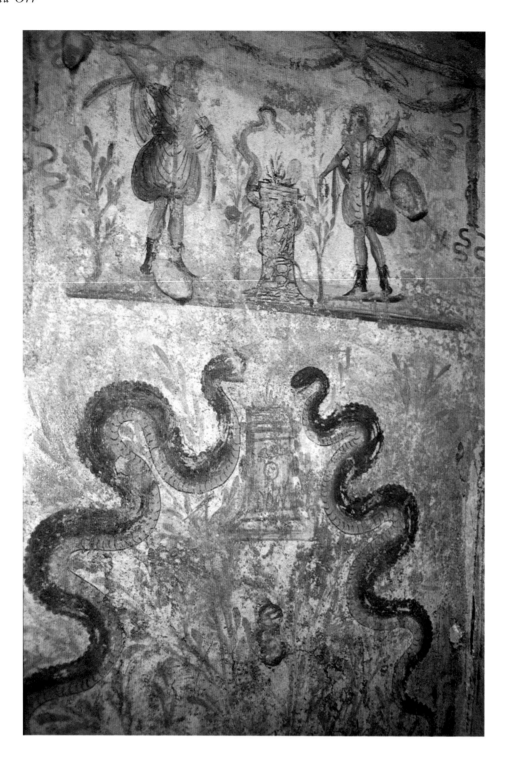

FIGURE 293 Detail of a lararium painting, House of Polybius, Pompeii, IX.ix.1–3. Two flanking Type II serpents beneath a pair of painted Lares. Photo: D. Orr.

represent both Zeus Melichios and the "agathos daimon," a possible Hellenic counterpart to the Roman Genius (Zeus Melichios is illustrated as a snake in Mundkur 1983: 71). Snakes similar to the Type I examples can be seen on the "agathos daimon" types of the coinage of Roman Alexandria (Dattari 1901: pl. XXVIII and XXXI). Pliny states that nobody can be found who has seen a serpent with crests (*HN* 11.122).

He also described the Aspides (asps), which can inflict a mortal bite (*HN* 29.63). Only the European viper ranges into the present-day ruins of Pompeii. The painted snakes of Pompeii do not mirror that species.

Type II snakes do not portray the truly viperine head shown by those of Type I. There is no significant tapering of the body between the neck and head (Fig. 293). The scales are generally smooth and the serpents range from thick-bodied and short examples to those that are quite long and thin. All Type II snakes also possess crests and beards.

In 1966 I observed the snake known as the Aesculapian snake (*Elaphe longissima romana*) while studying a tomb on the north side of the Via Nuceria, located near the amphitheater entrance of Pompeii (Orr 1968: 167). This species is probably the one that was utilized originally in the cult of Aesculapius, the Graeco-Roman god of medicine and healing. The specimen was 155 cm in total length and was dark olive brown with characteristic whitish lines on its scales.

Colubrids probably are the house pets that the Romans described in their literature. They were welcomed into the house where they could eat pests such as mice and other rodents. Pliny describes one of these snakes as a draco and adds that they "do not have venom" (*HN* 29.67). For house pets see Pliny (*HN* 29.72). This practice has continued down into modern times; the local guards at Pompeii distinguish between the colubrids and the vipers. The guard who observed me measuring the snake just described also informed me that I was the beneficiary of "buona fortuna" (Orr 1968: 167). Colubrid-type snakes are used as models for some of the jewelry found in Pompeii. A gold bracelet found in a Pompeian house clearly illustrates a colubrid-type serpent (Ward-Perkins 1976: 32).

In sum, snakes are omnipresent in the archaeological evidence of Pompeii. Rare as exact representations of actual species, they exist more often as symbols of religious forces the Pompeians wished to propitiate and understand.

ACKNOWLEDGMENTS from Liliane Bodson:

I wish to thank Mr. Mathieu Denoël, herpetologist at the University of Liège (Belgium), for allowing me to consult Schleich et al., *Amphibians and Reptiles of North Africa,* and for his helpful comments on some items discussed here, and Prof. Michel Malaise (Deptartment of Egyptology, University of Liège) for allowing me to consult *Alla ricerca di Iside.* I am also most grateful to Dr. George Watson for providing me with additional references, including the marble relief (NM inv. no. 6575) on which he identified a salamandra, and for his copy-editing of my chapter. Above all, I would like to express my gratitude to Dr. Wilhelmina F. Jashemski for enrolling me in this chapter and for her untiring assistance.

NOTE

1 De Vos 1980: 12, no. 4, pl. VI.2 (Villa of the Mysteries), "coccodrillo (my italics) o icneumon." The latter is explicitly dismissed by Kiss 1998: 282, n. 29.

REFERENCES

Anderson, John. 1898. *Zoology of Egypt: I. Reptilia and Batrachia.* Quaritch, London.

Andreae, Maria Theresia. 1990. "Tiermegalographien in pompejanischen Gärten. Die sogenannten Paradeisos Darstellungen." *Rivista di Studi Pompeiani* 4: 45–124.

Anonymous. 1990. *Rediscovering Pompeii. Exhibition by IBM-ITALIA, New York City, IBM Gallery of Science and Art, 12 July–15 September 1990.* "L'Erma" di Bretschneider, Roma.

Anonymous. 1992. *Alla ricerca di Iside. Analisi, studi e restaur dell' Iseo pompeiano nel Museo di Napoli.* Arti, Rome.

Anonymous. 1995. *A l'ombre du Vésuve. Collections du Musée national d'Archéologie de Naples. Paris, Musée du Petit Palais, 8 novembre 1995–25 février 1996.* Paris-Musées, Paris.

Arnold, E. N., J. A. Burton, and D. W. Ovenden. 1978. *A Field Guide to the Reptiles and Amphibians of Britain and Europe.* Collins, London.

Barbet, Alix, and Stéphane Compoint. 1999. *Les cités enfouies du Vésuve. Pompéi, Herculanum, Stabies et autres lieux.* Fayard, Paris.

Boardman, John. 1990. Herakles. IV. Herakles' Labours. In *Lexicon Iconographicum Mythologiae Classicae,* Vol. V, pp. 5–16. Artemis, Zurich and Munich.

Bodson, Liliane. 1981. "Les Grecs et leurs serpents. Premiers résultats de l'étude taxonomique des sources anciennes." *L'antiquité classique* 50: 57–78.

1986. "Observations sur le vocabulaire de la zoologie antique: les noms de serpents en grec et en latin." *Documents pour l'histoire du vocabulaire scientifique* 8: 65–119.

1989. L'évolution du statut culturel du serpent dans le monde occidental de l'antiquité à nos jours. In *Histoire et Animal,* edited by Alain Couret and Frédéric Ogé, Vol. 3, pp. 525–48 Presses de l'Institut d'Etudes politiques de Toulouse, Toulouse.

1990. Nature et fonctions des serpents d'Athéna. In *Mélanges Pierre Lévêque,* edited by Marie-Madeleine Mactoux and Evelyne Gény, Vol. 4, pp. 45–62. Presses universitaires, Besançon. (N.B. fig. upside down)

1991. "Alexander the Great and the Scientific Exploration of the Oriental Countries of His Empire." *Ancient History* 22: 127–38.

1998. "Ancient Greek Views on the Exotic Animal." *Arctos* 32: 61–85.

Forthcoming. A python (*Python sebae* Gmelin) for the King. The Third-Century B.C. Herpetological Expedition to Aithiopia.

Böhme, Wolfgang. 1993. *Elaphe longissima* (Laurenti, 1768) – Äskulapnatter. In *Handbuch der Reptilien und Amphibien Europas,* edited by W. Böhme, Vol. 3/1. *Schlangen* (Serpentes), Vol. 1, pp. 331–72. Aula, Wiesbaden.

Borda, Maurizio. 1958. *La Pittura Romana.* Società editrice Libraria, Milan.

Boyce, George K. 1937. *Corpus of the Lararia of Pompeii.* Memoirs of the American Academy in Rome, Vol. 14.

Burstein, Stanley. 1989. *Agatharchides of Cnidus. Translated and Edited.* The Hakluyt Society, London.

Canciani, Fulvio. 1984. Minerva. In *Lexicon Iconographicum Mythologiae Classicae,* Vol. 2, pp. 1074–1109. Artemis, Zurich and Munich.

Castriota, David. 1995. *The Ara Pacis Augustae and the Imagery of Abundance in Later Greek and Early Roman Imperial Art.* Princeton University Press, Princeton.

Cèbe, Jean-Pierre. 1966. *La caricature et la parodie dans le monde romain antique des origines à Juvénal.* De Boccard, Paris.

Cerulli Irelli, Giuseppina et al. 1993. *La peinture de Pompéi. Témoignages de l'art romain dans la zone ensevelie par Vésuve (sic) en 79 ap. J.-C.* French translation by VV. AA. Hazan, Paris.

Ciarallo, Annamaria, and Ernesto De Carolis. 1999. *Homo Faber. Natura, Scienza e Tecnica nella Antica Pompei.* Electa, Milan.

Cohen, Ada. 1997. *The Alexander Mosaic. Stories of Victory and Defeat.* Cambridge University Press, New York.

Coutant, Victor. 1971. *Theophrastus De igne. A Post-Aristotelian View of the Nature of Fire.* Edited with introduction, translation, and commentary. Royal Vangorcum, Assen.

D'Ambrosio, Antonio. 1987. *Gli ori di Oplontis. Gioielli romani dal suburbio pompeiano. Agrigento, Villa Genuardi 23 agosto–17 settembre 1988.* Bibliopolis, Naples.

Dasen, Véronique. 1994. Pygmaioi. In *Lexicon Iconographicum Mythologiae Classicae,* Vol. 7, pp. 594–601. Artemis, Zurich and Munich.

Dattari, G. 1901. *Monete Imperiali Greche Numi Augg. Alexandrini.* Cairo. Reprinted 1969 Forni Editore, Bologna.

De Vos, Mariette. 1980. *L'egittomania in pitture e mosaici romano-campani della prima età imperiale.* Brill, Leiden.

Dunand, Françoise. 1981. Agathodaimon. In *Lexicon Iconographicum Mythologiae Classicae,* Vol. 1, pp. 277–82. Artemis, Zurich and Munich.

Dunbabin, Katherine M. D. 1978. *The Mosaics of Roman North Africa. Studies in Iconography and Patronage.* Clarendon Press, Oxford.

Dwyer, Eugene J. 1978. "'The Fowler and the Asp': Literary *versus* Generic Illustration in Roman Art." *American Journal of Archaeology* 82: 400–4.

　　1981. "Pompeian oscilla collections." *Mitteilungen des deutschen archäologischen Instituts. Römische Abteilung* 88: 247–306.

　　1982. *Pompeian Domestic Sculpture. A Study of Five Pompeian Houses and Their Contents.* Bretschneider, Rome.

Foucher, L. 1965. Les mosaïques nilotiques africaines. In *La mosaïque gréco-romaine. Paris 29 août–3 septembre 1963,* pp. 137–45. Editions du Centre National de la Recherche Scientifique, Paris.

Fuhrmann, Heinrich. 1941. "Archäologische Grabungen und Funde in Italien und Libyen Oktober 1939–Oktober 1941." *Archäologischer Anzeiger:* 329–733.

Fulford, Michael, and Andrew Wallace-Hadrill. 1999. "Towards a History of Pre-Roman Pompeii: Excavations beneath the House of Amarantus (I.9.11–12), 1995–8." *Papers of the British School at Rome* 67: 37–144.

Gasc, Jean-Pierre, ed. 1997. *Atlas of Amphibians and Reptiles in Europe.* Societas Europaea Herpetologica and Muséum National d'Histoire Naturelle, Paris. (All references to the *Atlas* are made under the editor's name only.)

Gore, Rick, and O. Louis Mazzatenta. 1984. "The Dead Do Tell Tales at Vesuvius." *National Geographic Magazine* (May): 557–613.

Hammond, Nicholas. 1998. *Modern Wildlife Painting.* Pica Press, Bexhill on Sea.

Helbig, Wolfgang. 1868. *Wandgemälde der vom Vesuv verschütteten Städte Campaniens.* Von Breitkopf and Härtel, Leipzig.

Héron de Villefosse, Adrien. 1899. "Le trésor de Boscoreale." *Fondation Eugène Piot. Monuments et mémoires* 5: 1–290.

Higgins, Reynolds. 1980. *Greek and Roman Jewelery.* Second edition. Methuen, London.

Hill, Dorothy. 1981. "Some Sculpture from Roman Domestic Gardens." In *Ancient Roman Gardens,* edited by Elizabeth B. MacDougall and Wilhelmina F. Jashemski, pp. 81–94. Dumbarton Oaks, Washington, D.C.

Hoffman, Herbert, and Patricia F. Davidson. 1965. *Greek Gold. Jewelry from the Age of Alexander.* The Brooklyn Museum, New York.

Jashemski, Wilhelmina F. 1979. *The Gardens of Pompeii, Herculaneum and the Villas Destroyed by Vesuvius.* Vol. 1. Caratzas Brothers, New Rochelle, N.Y.

　　1993. *The Gardens of Pompeii, Herculaneum and the Villas Destroyed by Vesuvius,* Vol. 2, Appendices. Aristide D. Caratzas, New Rochelle, N.Y.

Jones Roccos, Linda. 1994. Perseus. In *Lexicon Iconographicum Mythologiae Classicae,* Vol. 7, pp. 332–48. Artemis, Zurich and Munich.

Kapossy, Balázs. 1969. *Brunnenfiguren der hellenistischen und römischen Zeit.* Juris, Zurich.

Kiss, Zsolt. 1998. Le dieu-crocodile égyptien dans l'Italie romaine. In *L'Egitto in Italia dall'Antichità al Medioevo. Atti del III Congresso Internazionale Italo-Egiziano. Roma, CNR – Pompei, 13–19 Novembre 1995,* edited by N. Bonacasa et al., pp. 275–88. Consiglio Nazionale delle Ricerche, Rome.

Kokkorou-Alewras, Georgia. 1990. Herakles. IV. Herakles' Labours. N. Herakles and the Hesperides (Labour XII). In *Lexicon Iconographicum Mythologiae Classicae,* Vol. 5, pp. 100–11. Artemis, Zurich and Munich.

Küster, Erich. 1913. *Die Schlange in der griechischen Kunst und Religion.* Töpelmann, Giessen. Religionsgeschichtliche Versuche und Vorarbeiten, XIII.2.

Lamy, Véronique. 1993. Bijoux en or trouvés à Torre Annunziata, conservés au Musée Royal de Mariemont. In *Ercolano 1738–1988. 250 anni di ricerca archeologica. Atti del Convegno Internazionale Ravello-Ercolano-Napoli-Pompei, 30 ottobre–5 novembre 1988,* edited by Luisa Franchi dell'Orto, pp. 461–70. "L'Erma" di Bretschneider, Rome.

Lane, Eugene N. 1985. *Corpus Cultus Iovis Sabazii,* Vol. 2, *The Other Monuments and Literary Evidence.* Brill, Leiden.

　　1989. *Corpus Cultus Iovis Sabazii,* Vol. III, *Conclusions.* Brill, Leiden.

Latte, Kurt. 1960. *Römische Religiongeschichte.* Handbuch der Altertumswissenschaft, Vol. 4. Beck, Munich.

Lochin, Catherine. 1994. Pegasos (Pegasos, Bellerophon). In *Lexicon Iconographicum Mythologiae Classicae,* Vol. 7, pp. 214–30. Artemis, Zurich and Munich.

Maiuri, Amedeo. 1933. *La Casa del Menandro e il suo tesoro di argenteria.* La Libreria dello Stato, Rome.

　　1938. *Le pitture delle Case di "M. Fabius Amandio" del "Sacerdos Amandus" e di "P. Cornelius Teges" (Reg. I, Ins. 7).* Istituto poligrafico dello Stato, Rome.

　　1953. *La peinture romaine.* French translation by Skira-Venturi Rosabianca. Skira, Geneva.

　　1957. "Una nuova pittura nilotica a Pompei." *Atti della Accademia nazionale dei Lincei. Memorie,* ser. 8, 7: 65–80.

Marcadé, Jean. 1961. *RomAAmor. Essai sur les représentations érotiques dans l'art étrusque et romain.* Nagel, Geneva.

Matteucig, Giorgio. 1974. "Lo studio naturalistico zoologico del Portale di Eumachia nel Foro Pompeiano." *Bollettino della Società dei Naturalisti in Napoli* 83: 213–42.

Mattison, Chris. 1995. *The Encyclopedia of Snakes.* Facts on File, New York.

McDaniel, Walton B. 1932. "A Fresco Picturing Pygmies." *American Journal of Archaeology* 36: 260–71.

Menotti, Elena M. 1988. Le oreficerie della Villa Rustica 2 di Terzigno. In *Studia Pompeiana & Classica in Honor of Wilhelmina F. Jashemski,* edited by Robert I. Curtis, Vol. 1, pp. 167–78. Caratzas-Orpheus, New Rochelle, N.Y.

Mielsch, Harald. 1986. "Hellenistische Tieranekdoten in der römischen Kunst." *Archäologischer Anzeiger* no. 4: 747–63.

Mitropoulou, Elpis. 1977. *Deities and Heroes in the Form of Snakes,* Athens, Pyli.

Monticelli, Fr. 1903. "Comunicazioni scientifiche." *Bollettino della Società dei Naturalisti in Napoli* 16: 305.

Mundkur, Balaji. 1983. *The Cult of the Serpent: An Interdisciplinary Survey of Its Manifestations and Origins.* State University of New York Press, Albany.

Neuerburg, Norman. 1965. *L'architettura delle fontane e dei ninfei nell'Italia antica.* Gaetano Macchiaroli, Naples.

Nilsson, Martin P. 1940. *Greek Popular Religion.* Columbia University Press, New York.

Oakley, John H. 1997. Hesione. In *Lexicon Iconographicum Mythologiae Classicae,* Vol. 8, pp. 623–9. Artemis, Zurich and Dusseldorf.

Orr, David G. 1968. "*Coluber longissimus* in Pompeii, Italy." *Journal of Herpetology* 2: 167.

1972. Roman Domestic Religion: A Study of the Roman Household Deities and Their Shrines. Ph.D. diss. University of Maryland, College Park.

1978. Roman Domestic Religion: The Evidence of the Household Shrines. In *Aufstieg und Nierdegang der Römische Welt,* edited by Wolfgang Haase, II.16.2, pp. 1557–91. Walter de Gruyter, Berlin.

1988. Learning from Lararia: Notes on the Household Shrines of Pompeii. In *Studia Pompeiana & Classica in Honor of Wilhelmina F. Jashemski,* edited by Robert I. Curtis, Vol. 1, pp. 293–304. Caratzas-Orpheus, New Rochelle, N.Y.

Paoletti, Orazio. 1988. Gorgones Romanae. In *Lexicon Iconographicum Mythologiae Classicae,* Vol. 4, pp. 345–62. Artemis, Zurich and Munich.

Pernice, Erich. 1938. *Pavimente und figürliche Mosaiken.* Walter de Gruyter, Berlin.

Peters, Wilhelmus J. T. 1963. *Landscape in Romano-Campanian Mural Painting.* Van Gorcum & Prakke, Assen.

Pülhorn, Wolfgang. 1984. Archemoros. In *Lexicon Iconographicum Mythologiae Classicae,* Vol. 2, pp. 472–5. Artemis, Zurich and Munich.

Rausa, Federico. 1997. Fortuna. In *Lexicon Iconographicum Mythologiae Classicae,* Vol. 8, pp. 125–41. Artemis, Zurich and Dusseldorf.

Reinach, Salomon. 1922. *Répertoire de Peintures Grecques et Romaines.* Leroux, Paris.

Rizzo, G. E. 1929. *La pittura ellenistico-romana.* Treves, Milan.

Rostowzew, M. 1911. "Die hellenistisch-römische Architekturlandschaft." *Mitteilungen des deutschen archäologischen Instituts. Römische Abteilung* 26: 1–185.

Roux, H., and L. Barré. 1870. *Herculanum et Pompéi. Recueil général des peintures, bronzes, mosaïques, etc.* Vol. 2. New enlarged edition. Didot, Paris.

Sampaolo, Valeria. 1994. "I decoratori del Tempio di Iside." *La Parola del Passato. Rivista di Studi antichi* 49: 57–82.

Schauenburg, Konrad. 1981. Andromeda I. In *Lexicon Iconographicum Mythologiae Classicae,* Vol. 1, pp. 774–90. Artemis, Zurich and Munich.

Schefold, Karl. 1957. *Die Wände Pompejis. Topographisches Verzeichnis der Bildmotive.* Walter de Gruyter, Berlin.

Schleich, H. Hermann, Werner Kästle, and Klaus Kabisch. 1996. *Amphibians and Reptiles of North Africa.* Koeltz, Koenigstein.

Schneider, Bert. 1981. Chalcides ocellatus *(Forskål 1775) –* Walzenskink. In *Handbuch der Reptilien und Amphibien Europas,* 1. *Echsen (Sauria),* edited by Wolfgang Böhme, Vol. 1, pp. 338–54. Akademische Verlagsgesellschaft, Wiesbaden.

Schulz, Klaus-Dieter. 1996. *A Monograph of the Colubrid Snakes of the Genus* Elaphe *Fitzinger.* Koeltz, Havlickuv Brod.

Simon, Erika. 1979. "Archemoros." *Archäologischer Anzeiger,* Vol. 94, pp. 31–45.

1984. Apollo. In *Lexicon Iconographicum Mythologiae Classicae* Vol. 1, pp. 363–446. Artemis, Zurich and Munich.

1992a. Laokoon. In *Lexicon Iconographicum Mythologiae Classicae,* Vol. 6, pp. 196–201. Artemis, Zurich and Munich.

1992b. Mercurius. In *Lexicon Iconographicum Mythologiae Classicae,* Vol. 6, pp. 500–37. Artemis, Zurich and Munich.

1997. Vulcanus. In *Lexicon Iconographicum Mythologiae Classicae,* Vol. 8, pp. 282–98. Artemis, Zurich and Dusseldorf.

Skoda, Françoise. 1997. Principes de formation du lexique animal en grec ancien : illustrations et hypothèses. In *Les zoonymes. Actes du colloque international tenu à Nice les 23, 24 et 25 janvier 1997,* edited by Jean-Philippe Dalbera et al., pp. 369–86. Sophia Antipolis, Publications de la Faculté des Lettres, Arts et Sciences humaines de Nice, Nice.

Spano, Giuseppe. 1955. "Paesaggio nilotico con pigmei difendentisi magicamente dai coccodrilli." *Atti della Accademia nazionale dei Lincei. Memorie,* ser. 8, Vol. 6: 335–368.

Spinazzola, Vittorio. 1953. *Pompei alla luce degli scavi nuovi di via dell'Abbondanza (Anni 1910–1923).* Posthumous edition by S. Aurigemma. Libreria dello Stato, Rome.

Steel, Rodney. 1989. *Crocodiles.* Helm, London.

Tammisto, Antero. 1997. *Birds in Mosaics. A Study of the Representation of Birds in Hellenistic and Romano-Campanian Tessellated Mosaics to the Early Augustan Age.* Acta Instituti Romani Finlandiae 18.

Toynbee, Jocelyn M. C. 1973. *Animals in Roman Art and Life.* Thames and Hudson, London and Southampton. Reprint: 1996. The Johns Hopkins University Press, Baltimore, Md.

Tran Tam Tinh, Vincent. 1964. *Essai sur le culte d'Isis à Pompéi.* De Boccard, Paris.

1990. Isis. In *Lexicon Iconographicum Mythologiae Classicae,* Vol. 5, pp. 761–98. Artemis, Zurich and Munich.

Tybout, Rolf A. 1989. *Aedificiorum figurae. Untersuchungen zu den*

Architekturdarstellungen des frühen zweiten Stils. J. C. Gieben, Amsterdam.

Vermaseren, Maarten J. 1983. *Corpus Cultus Iovis Sabazii,* Vol. 1, *The Hands.* Brill, Leiden.

Ward-Perkins, John, and Amanda Claridge. 1976. *Pompeii* A.D. *79.* Carlton Cleeve, London.

Watson, Gilbert. 1966. *Theriac and Mithridatium. A Study in Therapeutics.* The Wellcome Historical Medical Library, London.

Welch Kenneth, R. G. 1983. *Herpetology of Europe and Southwest*

Asia: A Checklist and Bibliography of the Orders Amphisbaenia, Sauria, and Serpentes. Krieger, Malabar, Fla.

Whitehouse, Helen. 1977. "*In praedis Iuliae Felicis:* The Provenance of Some Fragments of Wall-Painting in the Museo Nazionale, Naples." *Papers of the British School at Rome* 45: 52–68.

Woodford, Susan. 1988. Herakles, III.A. Herakles and the Snakes. In *Lexicon Iconographicum Mythologiae Classicae,* Vol. 4, pp. 827–32. Artemis, Zurich and Munich.

16

BIRDS

EVIDENCE FROM WALL PAINTINGS, MOSAICS, SCULPTURE, SKELETAL REMAINS, AND ANCIENT AUTHORS

George E. Watson

INTRODUCTION

Although birds played an important role in Pompeian gardens and homes as shown by artistic depictions, they have been inadequately covered in scholarly publications of excavations at Vesuvian sites. Nor have there been comprehensive studies of birds in Roman art and literature in general, in contrast to the in-depth analyses of Greek birds by D'Arcy W. Thompson (1895, 1936) and John Pollard (1977) and other references therein. The two major works that discuss Roman-period birds are Otto Keller's *Die Antike Tierwelt*, Vol. 2 (1911) and Jocelyn M. C. Toynbee's *Animals in Roman Life and Art* (1973). Lee Johnson studied some of the birds shown in Pompeian paintings in his dissertation at the University of Maryland, Aviaries and Aviculture in Ancient Rome, (1968), later published in abbreviated form (Johnson, 1971). Giorgio Matteucig (1974) has attempted to identify to species all birds and other animals in the carvings on the Eumachia portal in the Forum at Pompeii. Antero Tammisto has published studies on the phoenix, kingfisher, capercaille, and pheasant (1985, 1986, 1989) in mosaics and a comprehensive corpus, "Birds in Mosaics: A Study on the Representation of Birds in Hellenistic and Romano-Campanian Tessellated Mosaics to the Early Augustan Age" (1997), derived from his earlier thesis. Many of his identifications are based on the consensus opinions of his ornithological colleagues in Helsinki, and he often presents multiple choices, including some "hybrids."

The most plentiful evidence for birds comes from the garden paintings and in interior wall paintings preserved at Pompeii and at other nearby sites or in the Naples Museum, providing insight into how they were regarded by contemporary Campanians. Some birds are obviously so well portrayed that they may be considered portraits, while others are generically depicted and must have been mere decoration or even caricature. Not only are birds found perched in the foliage of the omnipresent plants in the garden paintings, but several species are shown flying in the air above the vegetation or walking on the ground under overhanging plants, interesting early attempts to show birds in natural habitat settings. Birds appear on some panels feeding on fruits or berries placed on shelves, possibly an indication that bird feeding is not just a recent social phenomenon. The numerous depictions of birds drinking or standing on the rim of a pedestal fountain in garden paintings and mosaics suggests that such structures may have been specifically placed in hot, dry Campanian gardens to attract birds. In none of the wall paintings, however, are birds shown actually bathing, a pose that a contemporary artist may have found too challenging before photography. Still-life depictions of game birds destined for the table indicates that hunting or bird trapping were widely practiced as suggested in Pliny's *Historia Naturalis.* Because of the similarity of themes and poses of birds in different houses at Pompeii and elsewhere, artists must have used sketchbooks as models for their paintings or copied earlier Hellenistic works.

The colorful birds that grace floor and wall mosaics in homes, some particularly well executed, are under continuing study by Tammisto. A few birds appear in garden statuary or as fountain decoration, and smaller crystal, bronze, and terra-cotta figures that have been found may have been displayed as home decorations.

One monument in Pompeii shows a number of low-relief sculpted birds and other animals. Giorgio Matteucig (1974) has ambitiously attempted to identify

all birds and other animals in the carvings on the elaborate and well-preserved marble Eumachia portal in the forum at Pompeii. He finds 50 birds out of 97 extant animal images. The other figures include snails, spiders, insects, snakes, lizards, rabbits, and mice, all of which are prey for birds. Remarkably few of the birds does he regard as indeterminable, either because they are damaged or too generalized to show identifying characters. Some are cited only to order, but the majority he names to genus or even species in spite of their lack of identifying color plumage characters. Rightfully, he does qualify many of his determinations as "probable," "apparently," or "could be." Many of his identifications, however, seem contrived and he provides little basis for his conclusions.

Although wild birds would have been able to fly and thus most might have escaped the rain of ash and pyroclastic flow from Vesuvius, domestic fowl and cage birds should have been caught and preserved. Relatively recent archaeological excavations have provided bones of a few wild flying species, but nineteenth-century and earlier twentieth-century archaeologists were only interested in museum objects and, therefore, small and fragile bones were overlooked or discarded, as was the contemporary practice. There are no remains of obvious pet or cage birds. Most of the bones that have been found in excavations were from table scraps in the *villa rustica* at Boscoreale (Jashemski 1993: 288–91) or from altar sacrifices in the forum in Pompeii (King, personal communication). Bones and eggs from a turtle dove nest were found at Pompeii and a single owl skull was preserved at Herculaneum, obviously a dozing daytime victim.

A number of birds were catalogued and commented upon in detail by Aristotle in *Historia Animalium*; others were used as personified characters in Aristophanes' play *The Birds*, and birds are mentioned as omens or symbolically in Homer's epic poems and in the odes of some of the lyric poets. All these Greek works were well known to Latin authors and readers. Pliny discusses some birds in his *Natural History*, the agrarian writers Varro and Columella refer to both wild and domestic birds and scattered references to birds are found in works of other Latin writers and poets. Some of the recipes in Apicius are for chickens and other domestic and wild birds.

Martial (3.58.12–19) lists all sorts of birds that were raised for the table: "All the crowd of untidy poultry-yard wanders here and there, the shrill cackling goose (*anser*), and the spangled peacocks (*pavones*), and the bird that owes its name to its flaming plumes (*phoenicopterus*, the flamingo), and the painted partridge (*perdix*), and speckled guinea fowls (*numidicae*), and the

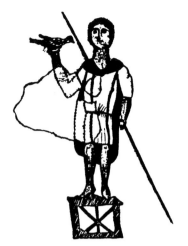

FIGURE 294 A falconer with a tethered hawk on his wrist (*NS* 1942: 53–54).

impious Colchicans' pheasant (*phasiana*). Proud cocks (*galli*) tread their Rhodian dames, and cotes (*turres*) are loud with the pigeons' (*columbae*) croon; on this side moans the wood pigeon (*palumbus*) on that the glossy turtle dove (*turtur*)."

There is little evidence to reveal how birds were hunted or captured in the times before shotguns. A drawing of a falconer with his bird (species undeterminable) in a Pompeian wall painting (*NS* 1942: 53–4) (Fig 294) suggests one method of wild bird capture, and Martial (3.58.26) speaks of setting a "crafty" net (*rete*) for "greedy thrushes" (*turdi*). Two bird peddlers, each carrying four birdcages on a pole across his shoulders, seem to be striding to market in a wall painting from House I.viii.15–16 (Fig 295). It is not possible to determine what species they were carrying or whether their booty was for table, aviary, or sacrifice.

Most of the color slides of wall paintings, mosaics, and sculpture referenced as "Jashemski archive slide"

FIGURE 295 Two bird peddlers carrying their live wares in basket cages. Photo: S. Jashemski.

with an index number indicating box, slide number, and year were taken by Stanley A. Jashemski. The originals are to be deposited in the Garden Library of Dumbarton Oaks in Washington, D.C., and the Getty Museum in Los Angeles.

In the catalogue that follows, all the species of birds known to the inhabitants of the Vesuvian area in A.D. 79 that can be reliably identified in wall paintings, mosaics, sculpture, inscriptions, and graffiti, and the few that are known from actual skeletal remains, are listed along with the relevant evidence and comments from ancient authors. Most of the species were either residents, winter visitors, or passage migrants in Campania two millennia ago, but a few species, such as the peacock and parrots, were familiar exotic cage or aviary birds rather than a part of the native avifauna. Information on range, seasonal occurrence, and habitat is cited briefly under remarks for each species; more extended discussions are available in *Birds of the Western Palearctic* (Cramp et al. 1977–94). The species are arranged in alphabetical sequence, according to their Latin names and a systematic list by family is included in Table 22. The limitations of space have made it necessary to be selective in citing evidence for species on which there is superabundant material, as in the case of waterfowl, domestic fowl, pigeons and doves, and some songbirds.

CATALOGUE

1. *ACCIPITER GENTILIS, A. NISUS, FALCO COLUMBARIUS*

English, goshawk; Italian, *astore*
English, sparrow hawk; Italian, *sparviere*
English, merlin; Italian, *smeriglio*

WALL PAINTING

A gray-backed bird of prey in flight in the upper portion of a garden painting in the room off the N side of the peristyle in the House of C. Julius Polybius (Jashemski 1979: 78, fig. 127) may be a poorly rendered sparrow hawk (*A. nisus*), a merlin (*Falco columbarius*), or even a cuckoo (see *Cuculus canorus*).

SKELETAL REMAINS

Fifty goshawk bones were recovered from excavations of fifth- to seventh-century A.D. deposits at Carminiello ai Mannesi near Naples (King, personal communication).

ANCIENT AUTHORS

Among the kinds of hawks (γένος ἱεράκων), Aristotle (*HA* IX.620a.18) lists ἀστερίας, which is "commonly identified with the goshawk" according to Thompson (1936), but Aelian (*NA* II.39) uses the same word for the golden eagle (see *Aquila chrysaetus*). Firmicus Maternus (*Mathesis* 5.7) includes *astur* between falcons and eagles in his list of birds of prey, obviously the cognate of the modern Italian name.

REMARKS

The goshawk is an uncommon forest predator on other birds. It is resident year-round in Italy. As the largest of the bird hawks of the genus *Accipiter,* it may well have been flown by falconers for hunting. The sparrow hawk is a smaller and more common resident predator on small birds in woodlands. The merlin breeds in northernmost Europe and winters in open country south to the Mediterranean. It preys on flying birds and insects and small mammals.

2. *ACRIDOTHERES TRISTIS*

English, common mynah; Italian, *maina comune*

WALL PAINTING

The exotic mynah has been identified on only one wall painting. A glossy brownish black starlinglike bird with a white patch on the wing and a pale bill is perched on the top of a strawberry tree on the upper left of the E wall in the *diaeta* or garden room of the House of the Gold Bracelet (Jashemski 1993: 353, figs. 414, 416).

ANCIENT AUTHORS

Aelian (*NA* XVI.3) describes a starling-sized, particolored docile bird called κερκίων that learns to speak, which is identified by Thompson (1936: 138) as a mynah. Aelian (*NA* VIII.24) also speaks of ἀγρεύς, of the race and kindred of blackbirds, which, because it is "black, musical and a mimic," Thompson also identifies as a mynah. Pliny (*HN* 10.117–20) writes of talking birds, some of them highly valued, but they may all be parrots and crow relatives, even though he also alludes to a talking starling.

REMARKS

Because the mynah is native to southeast Asia, it would only have been known to the Pompeians as a cage bird.

3. *ACROCEPHALUS* sp.

English, reed warbler; Italian, *cannaiola*

Table 22. *Systematic list of bird species.*

Order	Family	Species (Latin)	English
Ciconiiformes	Ardeidae	13. *Ardea cinerea*	common heron
		14. *A. purpurea*	purple heron
		16. *Ardeola ralloides*	squacco heron
		16. *Bubulcus ibis*	cattle egret
		30. *Egretta thula*	little egret
	Ciconiidae	20. *Ciconia ciconia*	white stork
	Threskiornithidae	56. *Geronticus eremita*	bald ibis
		56. *Plegadis falcinellus*	glossy ibis
		67. *Threskiornis aethiopicus*	sacred ibis
Phoenicopteridae		54. *Phoenicopterus roseus*	flamingo
Anseriformes	Anatidae	6. *Alepochen aegyptiaca*	Egyptian goose
		11. *Anser anser*	graylag goose
		11. *A. albifrons*	white-fronted goose
		7. *Anas crecca*	Eurasian teal
		8. *A. penelope*	Eurasian wigeon
		9. *A. platyrhynchos*	mallard duck
		10. *A. querquedula*	garganey
		29. *Cygnus cygnus*	whooper swan
		26. *C. olor*	mute swan
		65. *Tadorna tadorna*	shelduck
Falconiformes	Accipitridae	1. *Accipiter gentilis*	goshawk
		1. *A. nisus*	sparrow hawk
		12. *Aquila chrysaetus*	golden eagle
		38. *Gyps fulvus*	griffon vultur
	Falconidae	1. *Falco columbarius*	merlin
Galliformes	Phasianidae	5. *Alectoris graeca*	rock partridge
		27. *Coturnix coturnix*	quail
		36. *Gallus gallus*	chicken
		45. *Numida meleagris*	helmeted guineafowl
		51. *Pavo cristatus*	peafowl
		52. *Phasianus colchicus*	pheasant
		66. *Tetrao urogallus*	capercaille
Gruiformes	Rallidae	60. *Crex crex*	corn crake
		33. *Fulica atra*	Eurasian coot
		34. *Gallinula chloropus*	moorhen
		57. *Porphyrio porphyrio*	purple gallinule
		60. *Rallus aquaticus*	water rail
Charadriiformes	Scolopacidae	17. *Calidris alba*	sanderling
		17. *C. alpina*	dunlin
		17. *C. minuta*	little stint
		17. *C. temmincki*	Temminck's stint
		34. *Gallinago gallinago*	snipe
		17. *Tringa glareola*	wood sandpiper
		17. *T. hypoleucos*	common sandpiper
		17. *T. totanus*	redshank
Columbiformes	Columbidae	22. *Columba livia*	rock dove, pigeon
		22. *C. oenas*	stock dove
		23. *C. palumbus*	wood pigeon
		62. *Streptopelia decaocto*	collared turtle dove
		62. *S. risoria*	ringed dove
		61. *S. turtur*	turtle dove
Psittaciformes	Psittacidae	58. *Psittacus erithacus*	gray parrot
		59. *Psittacula derbiana*	Lord Derby's parakeet
		59. *P. himalayana*	slaty-headed parakeet
		59. *P. krameri*	rose-ringed parakeet
Cuculiformes	Cuculidae	28. *Cuculus canorus*	cuckoo

(continued)

Table 22. (continued)

Order	Family	Species (Latin)	English
Strigiformes	Strigidae	15. *Athene noctua*	little owl
		63. *Strix aluco*	tawny owl
Caprimulgiformes	Caprimulgidae	15. *Caprimulgus europaeus*	nightjar
Apodiformes	Apodidae	39. *Apus sp.*	swift
Coraciiformes	Alcedinidae	4. *Alcedo atthis*	kingfisher
	Meropidae	43. *Merops apiaster*	bee-eater
	Coraciidae	44. *Coracias garrulus*	European roller
Piciformes	Picidae	40. *Jynx torquilla*	wryneck
		47. *Picus viridis*	green woodpecker
Passeriformes	Hirundinidae	39. *Hirundo rustica*	swallow
	Laniidae	41. *Lanius excubitor*	great gray shrike
		41. *L. minor*	lesser gray shrike
		41. *L. nubicus*	masked shrike
		41. *L. senator*	woodchat shrike
	Troglodytidae	67. *Troglodytes troglodytes*	wren
Turdidae		31. *Erithacus rubecula*	robin
		42. *Luscinia megarhynchos*	nightingale
		44. *Monticola solitarius*	blue rock thrush
		46. *Oenanthe hispanica*	black-eared wheatear
		47. *O. oenanthe*	common wheatear
		54. *Phoenicurus phoenicurus*	redstart
		68. *Turdus merula*	blackbird
		69. *T. iliacus*	redwing
		69. *T. philomelos*	song thrush
		69. *T. pilaris*	fieldfare
		69. *T. viscivorus*	mistle thrush
	Aegithalidae	49. *Aegithalos caudatus*	long-tailed tit
	Paridae	49. *Parus caeruleus*	blue tit
		49. *P. crestatus*	crested tit
		49. *P. major*	great tit
	Sittidae	47. *Sitta europaea*	Eurasian nuthatch
		47. *S. neumayer*	rock nuthatch
	Sylviidae	3. *Acrocephalus scirpaceus*	reed warbler
		3. *A. schoenobaenus*	sedge warbler
		3. *A. palustris*	aquatic warbler
		3. *Lusciniola melanopogon*	moustached warbler
		3. *Locustella naevia*	grasshopper warbler
		3. *Cisticola juncidis*	fan-tailed warbler
		3. *Hippolais sp.*	
		65. *Sylvia atricapilla*	blackcap
		65. *S. melanocephala*	Sardinian warbler
		3. *Phylloscopus sp.*	leaf warbler
	Emberizidae	32. *Emberiza calandra*	corn bunting
	Fringillidae	32. *Fringilla coelebs*	chaffinch
	Carduelidae	18. *Carduelis carduelis*	goldfinch
		19. *C. chloris*	greenfinch
		21. *Coccothraustes coccothraustes*	hawfinch
		19. *Serinus canaria*	canary
		19. *S. serinus*	serin
	Passeridae	50. *Passer domesticus italiae*	house sparrow
	Sturnidae	2. *Acridotheres tristis*	common mynah
		64. *Sturnus vulgaris*	starling
	Oriolidae	48. *Oriolus oriolus*	golden oriole
	Corvidae	24. *Corvus corax*	raven
		25. *C. corone*	carrion/hooded crow
		26. *C. monedula*	jackdaw
		37. *Garrulus glandarius*	jay
		55. *Pica pica*	magpie

George E. Watson

WALL PAINTING

A vividly depicted warblerlike songbird sits on a hollow cane stake supporting a thorny rose in a garden painting on the S wall of the *diaeta* in the House of the Gold Bracelet (Fig. 147). It shows a brown back, white underparts, and white eye-ring. The underside of the tail is white, but near the tip there appears to be a narrow back bar. The unstreaked back suggests a reed warbler (*Acrocephalus*), but the tail is more typical of one of the streaked warblers (*Locustella*) or even a fan-tailed warbler (*Cisticola juncidis*).

SCULPTURE

Matteucig (1974: no. 54) identifies without basis what seems to him to be a kinglet (*Regulus* sp., Italian, *regolo*) on the Eumachia portal.

ANCIENT AUTHORS

Aristotle (*HA* IX.616b.13) speaks of ἐλέα as an easy-living bird that in summer sits where there is breeze and shade but in winter chooses a sunny sheltered place on the reeds around the marshes. In size it is small and its voice is good – an apt description of a reed warbler.

REMARKS

Reed, sedge, and aquatic warblers (*Acrocephalus scirpaceus, schoenobaenus,* and *paludicola*), moustached warbler (*Lusciniola melanopogon*), grasshopper warbler (*Locustella naevia*), and fan-tailed warbler (*Cisticola juncidis*) occur in marshy areas and are widespread as summer visitors to Italy. On migration they and a variety of other warblers (*Hippolais, Sylvia,* and *Phylloscopus*) could turn up in gardens. The bird in the painting described earlier has been identified as a nightingale, *Luscinia megarhynchos* (Ciarallo and Capaldo, in Franchi dell'Orto and Varone 1990: 237), but the suggestion is not compelling.

4. *ALCEDO ATTHIS*

English, kingfisher; Italian, *martin pescatore*

WALL PAINTINGS

A small, short-tailed, long-billed bird perched on a twig at the feet of the sleeping faun in the right panel of a wall painting on the N garden wall in the House of Adonis (Jashemski 1979: 66, fig. 107; 1993: 130) has been identified by Tammisto (1985) as a kingfisher. Its stance is certainly kingfisherlike, but there are few color cues in the faded painting. Another carefully rendered kingfisher, also recognized by Tammisto, with blue back and red underparts sits on the high handle of a vase surrounded by a trident, lobster, two squid, and mollusk shells on the center panel of a three-part wall painting of game and seafood from the House of the

Deer in Herculaneum (NM inv. no. 8644) (De Caro 1999: 52–3, fig. 21). A purple gallinule with seafood is in the left panel (Fig. 327); a live hare and a hanging dead partridge are on the left panel (Fig. 354).

MOSAICS

Typical of a kingfisher are the stance and color of a small long-billed bird perched on a lotus seed pod in the Nile mosaic from the House of the Faun at Pompeii (NM inv. no. 9990) (Fig 274; Tammisto 1997: pl. 22, fig. NS1,1; pl. 23, fig. NS2,5). In a very similar stance and configuration are small, long- and short-billed, short-tailed birds perched on rocks looking down at the water in fish mosaics from the House of the Faun (NM inv. no. 120177) (Fig. 228) and from House VIII.ii.16 (NM inv. no. 9997) (Fig. 226) that are obviously kingfishers on the basis of posture and color. Tammisto (1997: 42; pl. 14, SS2,2) provides a close-up of the second bird but questions the implied marine habitat in the belief that the kingfisher is predominantly a freshwater species. In the Mediterranean area, however, kingfishers are often seen along coasts in summer and, particularly, in winter. Tammisto (1997: pl. 40, fig. SO2,1) also correctly identifies a kingfisher perched on a ship's rudder in a mosaic in the vestibule of the House of M. Caesius Blandus.

ANCIENT AUTHORS

Pliny (*HN* 10.89), probably based on Aristotle (*HA* IX.616a.13–18), talks of the *halcyon* as a little larger than a sparrow, sea blue in color and reddish only on the underside, blended with white feathers in the neck, with a long slender bill. His description of the nest as a spongelike ball possibly made of fish spines is probably based on bones regurgitated by the chicks mixed with their broken-open feather sheaths.

REMARKS

The kingfisher is a common year-round resident of freshwater streams and lakes as well as shallow coastal waters in Italy. In spite of its diminutive size, its striking colors, fishing habits, and loud call make it conspicuous.

5. *ALECTORIS GRAECA*

English, rock partridge; Italian, *coturnice*

WALL PAINTINGS

A remarkable, realistic rock partridge is depicted on the E wall of the garden room in the House of the Gold Bracelet near a purple gallinule (Fig. 296). The colors and pattern are accurate, suggesting that it was based on a live bird. Another excellent partridge (although the throat is reddish tan rather than white) is

362

perched incongruously on an ivy vine in a wall painting in the portico facing the swimming pool in the Villa of Poppaea at Oplontis (Jashemski archive slide 6-10-77). Although partridge are terrestrial, they may on occasion seek refuge on the branches of low trees, but their cursorial feet are hardly adapted for perching on slim twigs or vines. A partridge looks over its shoulder while standing on a garden lattice fence in a painting (NM inv. no. 9719) (Jashemski 1979: 86, fig. 136). Another partridge is shown perched on a fence beside a fountain in a garden painting in House VII.vi.28 in Pompeii (Jashemski 1993: 362, fig. 427, where it was initially cited as a quail). A recognizable but stiffly depicted partridge appears along with a possible purple gallinule at a much smaller scale (now very faint) in a garden painting in the House of Stallius Eros (Jashemski archive slide 34-30-64). A very slender partridge with a gray back and its distinctive facial pattern and dark gorget surrounding a white throat is portrayed with fruit in a wall painting (NM inv. no. 8754). Three dead partridges hang by their bills from a nail in a wall painting from Pompeii (NM inv. No. 8733) (De Caro 1999: 44, fig. 9). Another dead partridge is shown hanging from a game clip with two quinces in the left-hand panel of a wall painting found in Herculaneum (NM inv. no. 8647) (Fig. 111), three thrushes lie above mushrooms in the right panel. Another partridge hangs behind a live hare nibbling grapes in the right panel of a three-part wall painting from the House of the Deer in Herculaneum (NM inv. no. 8644) (Fig. 354). Obviously, the Campanians hung their game before eating it. Excavators reported partridge among several birds in vegetation surrounding a duck pond in a garden painting on the S wall of the small viridarium at the rear of the tablinum in the House of Apollo. Much of the painting, including the birds, has disappeared (Jashemski 1993: 342).

MOSAICS

A carefully rendered partridge is depicted pecking at a pendant in a small jewelry basket in a mosaic from the House of the Labyrinth (NM 9980) (Tammisto 1997: pl. 35) shows it in comparison with a very similar mosaic from Ampurias (Museo Archeológico de Barcelona 1031).

SCULPTURE

Matteucig (1974: no. 78) cites a galliform eating a fly on the Eumachia portal as a "probable" partridge (*P. perdix*, Italian, *starna*) rather than the more familiar rock partridge.

SKELETAL REMAINS

A previously unreported distal end of a partridge

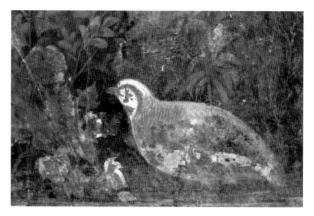

FIGURE 296 A rock partridge. Photo: Foglia.

tarso-metatarsus was found in 1984 with other remains from meals in a garden excavation along the N wall in the House of the Gold Bracelet by Jashemski (1993: 167). King (personal communication) also found an undated single partridge bone in the forum at Pompeii.

ANCIENT AUTHORS

Pliny (*HN* 100–3) discusses at length the libidinous behavior of *perdices* and their nesting habits and combativeness. The territorial cock's boldness in fighting decoy challengers leads to its capture. A hen when cornered lies on her back and picks up a clod of soil in her claws to hide herself. Modern Greek hunters tell the same story of partridge chicks lying on their backs holding a bit of vegetation as camouflage. Apicius lists only one recipe for boiled partridge.

REMARKS

Partridge are easy to capture when young and raised in cages. They were probably kept as ornamentals as well as for use as hunting decoys as they still are in Mediterranean countries. Partridge are widespread in Italy, but since they are hunted intensively, they are not abundant and are found primarily in rugged mountainous terrain with scanty low macchia and scrub.

6. *ALOPOCHEN AEGYPTIACA*

English, Egyptian goose; Italian, *oca egiziana*

MOSAICS

Tammisto (1997: pl. 22, figs. NS2,1, NS2,2, NS2,3) identifies six probable Egyptian geese in the Nile mosaic in the House of the Faun at Pompeii, mainly on the basis of white wing patches and dark eye stripes (Figs. 274, 290, 352).

ANCIENT AUTHORS

Aristotle's χηναλώπηξ (*HA* VII.593b.22), a small gregarious goose, has been identified as this species. Aelian (*NA* V.30), in commenting on the etymology of

its name, says, "that for its mischievousness it might justly be compared to the fox."

REMARKS

The Egyptian goose is a gregarious African wetland species ranging north in the Nile Valley into Egypt.

7. *ANAS CRECCA*
English, European teal; Italian, *alzavola*

MOSAICS

An unmistakable drake teal sits alongside a sheldrake and above four chaffinches in a mosaic from the right ala of the House of the Faun (NM inv. no. 9993) (Fig. 236); a cat has captured a small hen in the upper part of the mosaic. Another male teal, identifiable on the basis of its head pattern, is in the damaged right-hand section of the Nile mosaic in the House of the Faun at Pompeii (Tammisto 1997: pl. 22, NS2,4). Less definite in identification as a male teal is the left-hand one of three ducks in a Pompeian mosaic (NM inv. no. 109371) (Fig. 234).

SKELETAL REMAINS

One teal bone was recovered from fifth- to seventh-century A.D. excavations at Carminiello ai Mannesi near Naples (King, personal communication).

ANCIENT AUTHORS

According to Thompson (1936: 64), small wild ducks were termed βοσκάς, βοσκίς, and φασκάς by various Greek authors including Aristotle (*HA* V.93b.17). Columella (*RR* 8.15) describes conditions for raising ducks including teal (*querquedula*).

REMARKS

European teal are resident in southern Italy where they breed. Their numbers are augmented by migrants from the north in winter.

8. *ANAS PENELOPE*
English, European wigeon; Italian, *fischione*

WALL PAINTING

Three live wigeons hanging upside down on a herm in a wall painting on the N wall of the triclinium in House IX.i. 7 are the offering of a hunter (NM inv. no. ADS 954) (De Caro 1999: 55, fig. 27).

SKELETAL REMAINS

A single wigeon bone was found in fifth- to seventh-century A.D. excavations at Carminiello ai Mannesi near Naples (King, personal communication).

ANCIENT AUTHORS

There is no reliable mention of the wigeon, or its distinctive whistle, by either Greek or Latin authors (Pollard 1977: 66).

REMARKS

The wigeon breeds in northern Europe and is only a winter visitor to freshwater and coastal wetlands in the south.

9. *ANAS PLATYRHYNCHOS, ANAS* sp.
English, mallard duck; Italian, *anitra selvatica*
English, unidentified dabbling duck; Italian, *anitra*

WALL PAINTINGS

Four live mallards hang by their feet above two roe deer in a wall painting in the atrium of the Villa of the Papyri at Herculaneum (NM inv. no. 8759) (De Caro 1999: 44, fig. 10). Three dabbling ducks (*Anas* sp.), so faded and damaged that plumage characteristics cannot be made out, appear in a dado on the N wall of the triclinium in the House of Orpheus in Pompeii (Jashemski archive slide 15-31-59). It is a pity that they are not recognizable to species because their body shapes are so accurate. Two heavyset sleepy ducks were portrayed on either side of a fountain bowl in a wall painting in Casa del Tramezzo di Legno at Herculaneum, obviously a domesticated variety (Jashemski 1979: 58, fig. 94). The plaster on which the one on the left was painted has now fallen from the wall (Jashemski 1997: 370). Ducks once swam in a rectangular pool in a small wall painting in Shop-House I.vii.18, but they are no longer visible (Jashemski 1993: 395). In addition, there are many other small decorative wall paintings of ducks that cannot be identified either because of condition or because they were crudely represented.

MOSAICS

Mallards are depicted with Egyptian geese (*Alepochene aegyptiaca*) (Figs. 274, 290, 352) shelducks (*Tadorna tadorna*) in the Nile mosaic in the House of the Faun at Pompeii (Figs. 274, 290) (Tammisto 1997: pl. 22, NS2,1, NS2,3). Two pairs of mallards in their bright finery are shown in a mosaic (NM inv. no. 9983) (Fig. 297). Of three ducks in another mosaic (NM inv. no. 109371), the one on the right with a white neck ring is definitely a male mallard; the left-hand bird is probably a teal; and the middle bird may be a female mallard or a gadwall (*A. strepera*) (Fig. 234).

SCULPTURE

Children or cupids holding ducks (some identified as "geese" by excavators or other authors) were a

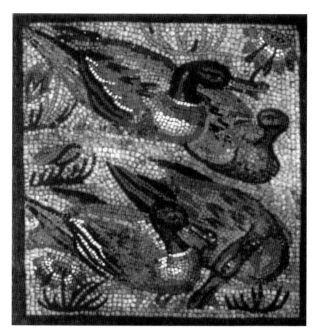

FIGURE 297 Two mallard duck pairs (NM inv. no. 9983). Photo: S. Jashemski.

favorite theme for sculptors. A charming marble fountain statuette of a pet duck (called a goose) held by a putto with a ponytail was found in the Villa of Poppaea at Oplontis (Oplontis inv. no. 56) (Jashemski 1979: 304, fig. 467). A bronze fountain statuette of a cupid holding a duck with outstretched wings was found in the House of the Little Fountain (NM inv. no. 5000); the bird has also traditionally been identified as a goose (Jashemski 1993: 136, fig. 150). A pair of mirror-image bronze statuettes of boys holding ducks and bunches of grapes was found in the garden of the House of the Vettii (NM inv. nos. 1157, 1158) (Jashemski 1993: 154, figs. 167, 168), and a marble hand of a boy who held a duck, which served as a fountain, was in the kitchen of the same house (Jashemski 1993: 153). A small statuette of a duck (Pompeii inv. no. 20377) was found in the House of M. Lucretius (Jashemski 1993: 232). A marble fountain statuette of a boy holding a duck ("goose") (NM inv. no. 6111) from the House of Polybius was probably a garden decoration (Jashemski 1993: 165).

SKELETAL REMAINS

The femur of a young domestic duck, found in a garden (II.i.12) where the Thracian-Phrygian vegetation god Sabazius was worshiped, was either a pet or the remains of a meal or sacrifice (Jashemski 1979: 105–6). Eleven unspecified duck bones were recovered from fifth- to seventh-century A.D. excavations at Carminiello al Mannesi near Naples, and six undated bones were found in the forum at Pompeii (King, personal communication).

ANCIENT AUTHORS

Ducks are frequently mentioned by both Greek and Roman authors, including Columella (*RR* 8.15), who gives extensive directions for building a suitable waterfowl aviary and pool for raising them in captivity. *Anates* seems to have been used generically for both domestic varieties and wild mallards.

REMARKS

Although mallards would have been well known as resident and migratory waterfowl in Campania, the Nile mosaic is intended to depict the fauna of Egypt.

10. *ANAS QUERQUEDULA*
English, garganey; Italian, *marzaiola*

SKELETAL REMAINS

One garganey bone was recovered from fifth- to seventh-century A.D. excavations at Carminiello ai Mannesi near Naples (King, personal communication).

ANCIENT AUTHORS

See citations under *Anas crecca*; although the males in breeding plumage are distinctive, females and eclipse males of this diminutive duck are very similar. Thompson (1936: 138) relates Hesychus's name κερκιθαλίς to Latin *querquedula*.

REMARKS

The garganey, unlike most waterfowl, is a summer visitor to most of Europe and is seen only on passage throughout peninsular Italy. It frequents freshwater streams and pools with shore vegetation.

11. *ANSER ANSER*
English, greylag goose; Italian, *oca selvatica*

WALL PAINTING

A greylag goose shown in a painting (of unknown origin) (NM inv. no. 8749) (Fig. 298) is probably a tame or domestic bird rather than a wild bird. It seems to be feeding on household handouts.

SCULPTURE

A bronze fountain statuette of an amorino holding what has been identified as a goose (Jashemski 1993: 136, fig. 150) from the House of the Little Fountain (NM inv. no. 5000), is more probably a duck on the basis of size.

SKELETAL REMAINS

Twenty-six unspecified goose bones were recovered from fifth- to seventh-century A.D. excavations at

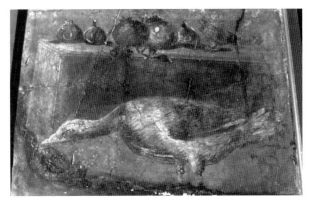

FIGURE 298 A graylag goose, perhaps domestic (NM inv. no. 8749). Photo: S. Jashemski.

Carminiello al Mannesi near Naples and one bone was found in a first-century B.C. to first-century A.D. level deposit in the Forum at Pompeii (King, personal communication).

ANCIENT AUTHORS

Anseri are cited by Pliny (*HN* 10.24, 25) both as watchfowl when the dogs were silent and as food. They were force-fed grain to increase the size of the liver, then as now, a favored table item. Their plumage and down were made into bedding. Apicius has two recipes for boiled goose.

REMARKS

The greylag, which is resident in Mediterranean Europe, is the presumed parental species of most domestic varieties of geese. Another wild species of similar appearance, the white-fronted goose, *A. albifrons*, which breeds in northern Eurasia, would have been a common winter visitor in Campania.

12. *AQUILA CHRYSAETUS*
English, golden eagle; Italian, *aquila reale*

WALL PAINTINGS

A large dark eagle stands with open wings mantling a freshly killed lamb in the back wall garden painting in the House of Orpheus. Both the Niccolini and Presuhn artist copies of the original (Jashemski 1993: figs. 399 and 400) are in enough agreement that the identification may be regarded as reliable. A crested eagle stands erect in a painting in the House of the Labyrinth (Jashemski archive slide 6-14-74), and another large slender bird of prey is imposing in a wall painting (NM inv. no. 8763) (Jashemski archive slide 70-23-57). Several other examples of wall paintings of eagles are reproduced in Cerulli Irelli et al. (1993): a small decorative spread-winged eagle sits atop a lofty

tripod in a wall painting in the House of the Deer (I, pl. 129); the large head of a dark eagle appears to the left in a fragment in the Naples Museum (I, fig. 156); a spread-winged eagle sits on a globe in a painted architrave in House V.ii.1 (II, 150), and another with open wings on an altar on the N wall of the triclinium in the House of the Vettii (I, pl. 55 and 56); and an eagle stands at the feet of Jupiter in a painting in a vaulted niche in the House of the Triclinium (II, fig. 153).

MOSAIC

A golden eagle with a snake clutched in its talons is shown in a damaged mosaic from the supposed temple of Juno in Nola (Tammisto 1997: pl. 53, ES1,1).

SCULPTURE

Eagles with spread wings adorn the handles of two terra-cotta lamps in the Museum in Pompeii (inv. nos. 14040, 1396) (Conticello de' Spagnolis in Franchi dell' Orto and Varone 1990: 182, fig. 69; 183, fig. 70). A marble sculpture of an eagle with a snake is in the Naples Museum (inv. no. 107814) (Fig. 299). On the basis of a snake, rabbit or hare in their talons, Matteucig (1974: nos. 16, 83) identifies two raptors on the Eumachia portal as probably a short-toed eagle and the other more surely an *Aquila* eagle, with finely sculpted plumage.

FIGURE 299 An eagle with a writhing snake. Photo: S. Jashemski.

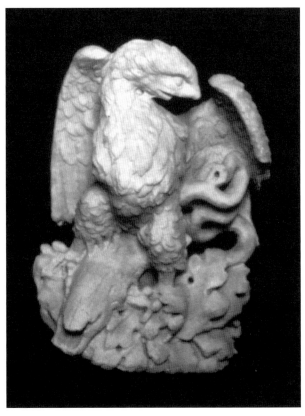

ANCIENT AUTHORS

The eagle, the bird of Zeus in Greek religion and mythology, was a divine and royal emblem in Rome as well. It figured as the omen of approval by Zeus in the *Iliad*, and the *aquila* was the badge (*proprie*) carried either live or symbolically into battle on the standards of the legions according to Pliny (*HN* 10.5). Pliny (*HN* 10.3) also speaks of *aquila* as the most honorable and strongest of birds and then enumerates several kinds of eagles and their habits, obviously based on Aristotle's similar catalogue of the kinds of ἀετός (*HA* VIII.618b.11–619a.13). Columella (*RR* 8.15.1) describes net or lattice covers that were placed over aviary duck ponds to keep out marauding eagles and hawks.

REMARKS

Several species of eagles breed in or migrate through Italy. The golden eagle, *A. chrysaetus,* generally inhabits more remote mountainous regions where it is not subject to human disturbance. It may have been more widespread in the first century A.D. Because of its large size and impressive bearing it was undoubtedly the model for the bird of the imperial standards.

13. *ARDEA CINEREA*

English, common heron; Italian, *airone cenerino*

WALL PAINTINGS

A frontal view of a heron with a crest, dark eye stripe, and wings partly open is on the center of the lower part of the E wall in tablinum c of the House of the Ephebe (Cerulli Irelli et al. 1993: I, pl. 21; II, 35–6, fig. 38c). Two herons stand on the fence at either side of a statue of Mars in a painting on the left side of the E panel of the wall in the peristyle garden in the House of Venus Marina (Jashemski 1979: 62, 128, figs. 101, 204). The left-hand heron (Fig. 300) stands amid an oleander, a mulberry tree, a myrtle, and a small pine in which a song thrush is perched. Virtually the same poses are shown by another pair of herons flanking a fountain basin on the right panel (close-up Jashemski 1993; fig. 382). The dark wings, grayish backs, and elongated crest feathers are not typical of any other heron, but the bodies are now whitish.

SCULPTURE

Matteucig (1974: no. 64) identifies a long-legged slender bird with a long straight bill on the Eumachia portal as a "probable" heron and another bird of similar silhouette (no. 68) as "doubtfully" a least bittern (*Ixobrychos minutus*, Italian, *tarabusino*) or a Eurasian bittern (*Botaurus stellaris*, Italian, *tarabuso*).

ANCIENT AUTHORS

Vergil (*Georgics* 1.364) refers to the wetland habits of the heron. "Even in that hour the reckless surge spares not the curving hull when . . . *ardea* leaves his home in the marshes and soars high above the mist."

REMARKS

The gray heron is a common and conspicuous resident in wetlands in northern Italy, but it occurs only in winter in the south at present. It would have been well known to Campanians and its graceful shape would have lent itself to artistic depictions as it does even now.

14. *ARDEA PURPUREA*

English, purple heron; Italian, *airone rosso*

SKELETAL REMAINS

A single purple heron bone was recovered from fifth- to seventh-century A.D. excavations at Carminiello ai Mannesi near Naples (King, personal communication).

ANCIENT AUTHORS

There is no indication that the purple heron was distinguished from the gray heron by ancient authors (Pollard 1977: 68).

REMARKS

The purple heron, slightly smaller and more strikingly colored than the gray heron, is a summer visitor to the wetlands of southern central and, particularly, southeastern Europe. It is now only a passage migrant in south and central Italy.

15. *ATHENE NOCTUA*

English, little owl; Italian, *civetta*

WALL PAINTINGS

Earless owls are depicted in five wall paintings, none realistically enough to make identification to species absolutely certain. An owl with indistinct damaged eyes, which stalks a lizard on a shelf in the House of Menander (Fig. 301), seems to be small, arguing for identification as the little owl, although its horizontal stance also suggests a short-eared owl, *Asio flammea.* Another crudely executed owl that is badly preserved is perched in a bush in a garden painting in the House of Stallius Eros (Jashemski 1993: 314, fig. 358). Its stance is typical of a little owl. Another little owl peers through the leaves in a poorly preserved garden painting in the calidarium of the House of Fabius Rufus (Jashemski 1993: 364). A fourth little owl (although depicted outlandishly large) is shown riding on a bleaching frame in a painting on a pilaster in the

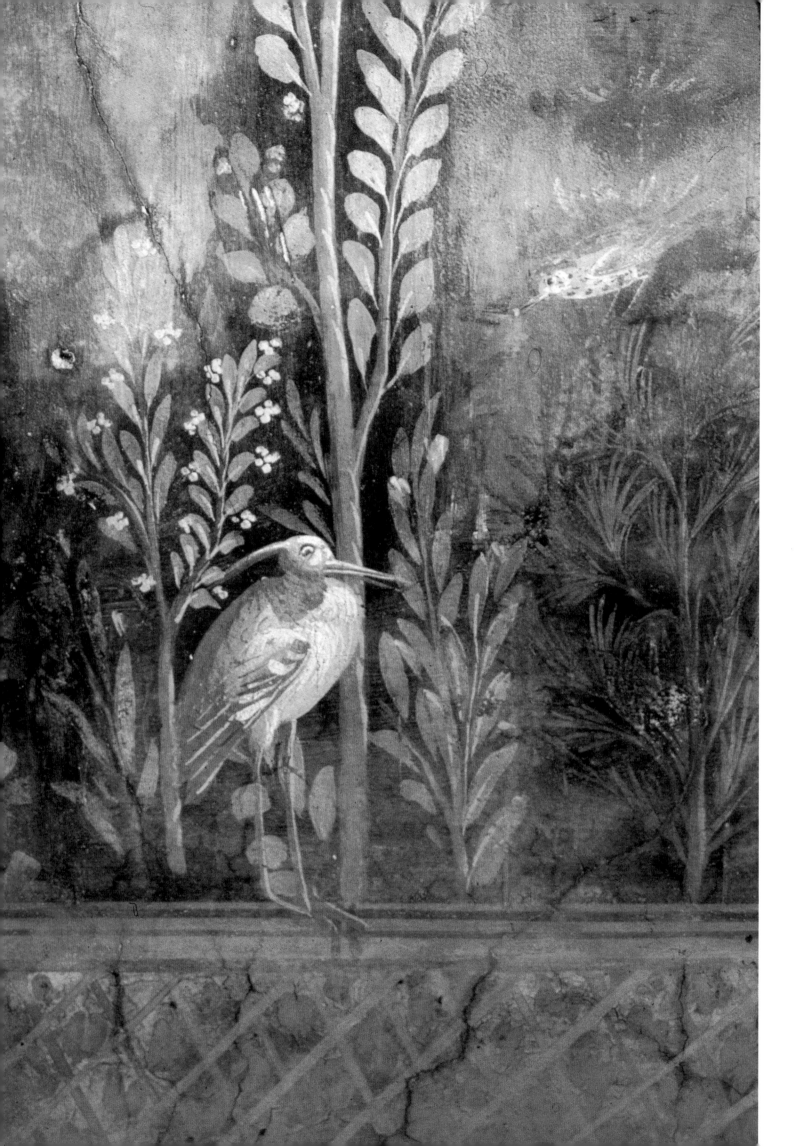

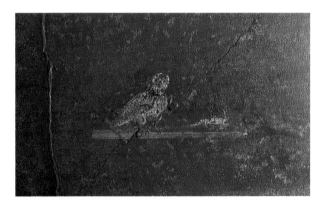

FIGURE 301 A dark-eyed little owl stalks a lizard. Photo: S. Jashemski.

Fullery of L. Veranus Hypsaeus (NM inv. no. 9974) (Ciarallo and De Carolis 1999: 120). Minerva, for whom the little owl was symbolic, was the patron goddess of wool fullers. The fifth owl is discussed under the heading of *Strix aluco*, tawny owl, although it is possible that all five are the much more abundant and partly diurnal little owls and that the usual pene-tratingly yellow eyes of that species were misrepresented or that the artists observed them with wide-open pupils in subdued light.

SCULPTURE

Matteucig (1974: nos. 28, 72) identifies two little owls, the second clutching a mouse, on the Eumachia portal. He also identifies a bird (no. 29) as "almost certainly a nightjar" (*Caprimulgus europaeus*, Italian, *succia-capre*) carved on the same portal, but provides no evidence. Tammisto (1997, pl. 58, fig. SC1,3) shows a dark-eyed, earless owl on the left side scroll of the fish mosaic from the House of the Faun (Fig. 226).

SKELETAL REMAINS

One little owl bone was found in first-century B.C. to first-century A.D. deposits in the forum at Pompeii (King, personal communication) and a skull was found at Herculaneum (personally examined).

ANCIENT AUTHORS

The little owl was the symbol of Athena (Minerva) and her wisdom. It was an important motif on Athenian coins of the fourth century B.C. and later. Apparently, the little owl was of less importance to Pliny and his contemporaries for there is scant mention under the name *noctua* in his *Historia Naturae*.

FIGURE 300 *(Opposite)* A gray heron amid its leafy domain of myrtle, mulberry tree, oleander, and pine; a song thrush perched above a small pine tree. Photo: S. Jashemski.

REMARKS

Little owls are abundant, easy-to-see diminutive residents of rural and urban settings in Italy, where they nest in stone walls and rock piles as well as hollows in trees. They also frequent town buildings, nesting in crevices and niches. They feed on a variety of small vertebrates (mice, rats, birds, lizards), insects, spiders, and centipedes and are active by day as well as at night.

16. *BUBULCUS IBIS*

English, cattle egret; Italian, *airone guardabuoi*

WALL PAINTINGS

Several wall paintings depict yellow-billed and yellow-legged white egrets. They are here identified as cattle egrets but might be inaccurately drawn little egrets, which should have a dark bill and legs with contrasting yellow toes. A cattle egret stands on the trellis to the right of the pinax with a bull in the uppermost zone of a wall painting on the S wall of the room off the atrium in the House of the Fruit Orchard (Fig. 302). Both birds are associated with pastures and bovids. Other egrets with light bills and legs are shown stalking a frog in the *predella* of the cubiculum in the House of Lucretius Fronto (Jashemski archive slide 63-18-57); standing on a fence in House I.ix.13 (Jashemski archive slide 43-14-68); perched below a hooded crow on a planetree behind the fountain on the S wall of the *diaeta* in the House of the Gold Bracelet (Jashemski 1993: 354, 356, figs. 418, 420); and, last, in the House of the Labyrinth (Jashemski archive slide 65-2-57).

ANCIENT AUTHORS

Aristotle (*HA* IX.609b.14) provides a strange account of the emnity between the horse and the ἄνθος, which he says the horse drives from its pasture because it eats grass. Herons actually feed on insects that cattle and other grazing mammals they accompany stir up in grasslands.

REMARKS

The cattle egret is predominantly an African species that is generally associated with herds of large hooved mammals and is far less aquatic than other herons and egrets. Although it occurs in southern Spain and Morocco, the cattle egret was probably known to Campanian wall painting artists through its occurrence in the Nile Valley. It is possible that the Pompeian depictions of chunky white herons with light bills and legs may actually be squacco herons, *Ardeola ralloides*, a related darker and more streaked wet-

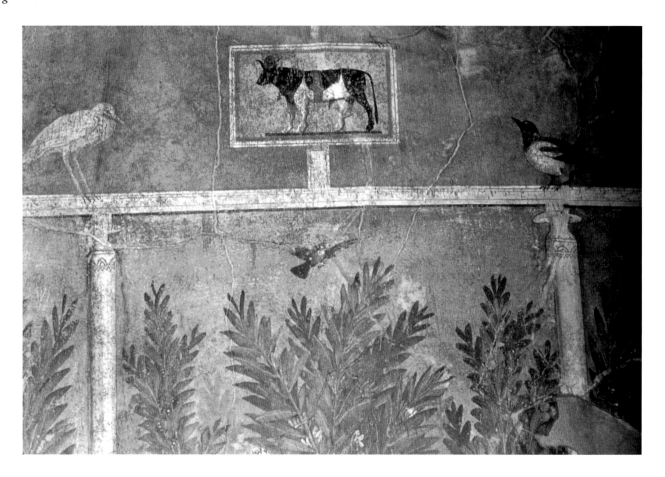

FIGURE 302 A cattle egret and a magpie; below, an unidentified songbird. Photo: S. Jashemski.

land species that used to occur in Italy in summer but is now extirpated.

17. *CALIDRIS* sp.
English, sandpiper; Italian, *gambecchio*

MOSAIC

A short-billed bird with forward-inclined body and striding gait in the floor mosaic in the atrium in the House of Paquius Proculus at Pompeii (Tammisto 1997: pl. 46, fig. SP5,5) can only represent a small sandpiper.

ANCIENT AUTHORS

It is not possible to identify any stint or sandpiper definitively in classical literature, but Aristotle (*HA* VII.593b.5) speaks of three small waterside birds without web feet that may be sandpipers, σχοινίκλος, κίγκλος, and πύγαργος, all three of which are said to wag their tails. The first two may be wagtails or *Calidris* sandpipers (Thompson 1936: 141), the last is the largest, the size of a thrush and has a white rump, possibly the redshank, *Tringa totanus*. The σκαλίδρις (Aristotle, *HA* VII.593b. 6) has speckling, and could well be the common sandpiper, *Tringa hypoleucos,* or the wood sandpiper, *T. glareola.*

REMARKS

Most *Calidris* sandpipers breed in the tundra areas of northern Europe and Asia and are present on coastal beaches and marshes in southern Europe on migration or in winter. Little and Temminck's stints and sanderling, *C. minuta, temminckii,* and *alba,* are spring and fall passage migrants, and the Dunlin, *C. alpina,* is a common winter visitor in Italy. The wood sandpiper, *Tringa glareola,* is a migrant through Italy, the redshank breeds as far south as northern Italy and is present in southern Italy in winter, and the common sandpiper is present all year.

17. *CARDUELIS CARDUELIS*
English, goldfinch; Italian, *cardellino*

WALL PAINTINGS

Male goldfinches are depicted in drawings of the no longer extant decoration on the lower part of two of the pillars on the long side of a portico in the lower peristyle garden of the Villa of Diomedes at Pompeii (Figs. 91 and 115).

SCULPTURE

Matteucig (1974: nos. 49, 24) identifies a "likely" goldfinch and a "probable" linnet on the Eumachia portal without citing evidence.

Petronius (46.4) describes a young boy's three pet *carduelis* that were killed by his father, who blamed the depredation on a weasel. Pliny (*HN* 10.90) describes the ball-shaped nest of the *acanthyllis* ("thistle finch") as woven out of flax.

REMARKS

The goldfinch is an abundant year-round resident of the Italian countryside. Its voice and seed-eating habits render it a valued and easy-to-maintain cage-bird. The remarkably accurate Vesuvian depictions suggest cage bird models.

19. *CARDUELIS CHLORIS*

English, greenfinch; Italian, *verdone*

WALL PAINTINGS

Numerous small yellow or greenish yellow birds with conical bills appear in Campanian wall paintings. They are most probably greenfinches, but depending on fading the artists may have intended to show such other finches as the serin, *S. serinus,* or the canary, *S. canaria.* A colorful greenfinch is portrayed feeding on walnuts with a parakeet in a painting on the dado in the tablinum in the Villa of the Mysteries (Fig. 303). A yellowish greenfinch with conical bill, dark around the eyes, and darker wings and tail is shown in ambient 89 in the last room in the E wing of the Villa of Poppaea at Oplontis (Jashemski archive slide 20-27-78). Another probable greenfinch is perched with a golden oriole in a garden painting in the room off the peristyle in the House of the Fruit Orchard (Jashemski 1979: 263, fig. 389).

ANCIENT AUTHORS

Aristotle speaks of the χλωρίς as a grub eater (σκωληκοφάγος) (*HA* VIII.592b.17), alludes to the greenish color of the underparts (*HA* IX.615b), and describes its nest construction and vulnerability to brood parasitism by the cuckoo (*HA* IX.615b.32,

618a.11). Aelian (*NA* III.30, IV.47) repeats Aristotle's nesting information but confuses the greenfinch with the golden oriole χλορίων. Thompson (1936: 381) knew "no Latin name for certain for this very common bird." This is particularly strange because the male is so conspicuous, both visually and vocally, when singing at the top of a tree, but perhaps it may also be linguistically confused with the oriole in Latin literature.

REMARKS

The male greenfinch is a conspicuous resident in gardens, orchards, parkland, and open woods throughout Italy. It broadcasts its buzzing song from treetop perches and is easy to maintain as a cagebird.

20. *CICONIA CICONIA*

English, white stork; Italian, *cicogna*

WALL PAINTING

A striding stork captures a lizard beside a sitting dog in a wall painting from House V.i.18 (NM inv. no. 110877) (Fig. 280). Another stork is head to head with a cobra in a wall painting in the Naples Museum (no inv. no.). Four other storks in garden paintings that were reported at the time of excavation are no longer extant: in House V.iii.11 (Jashemski 1993: 336), in the House of the Great Fountain (Jashemski 1993: 343), in the House of the Bear (Jashemski 1993: 360) and in the House of the Centenary (Jashemski 1993: 367).

MOSAIC

An unmistakable white stork with dark wings and bill is depicted (with body in red tesserae against a white background) in a spandrel of the medallion in a mosaic floor in the triclinium of the House of Ephebe (Tammisto 1997: 129, pl. 78, fig. GM6,2).

ANCIENT AUTHORS

Ovid (*Met.* 6.97) relates how Antigone was transformed by an angry Juno into a stork that was "clothed

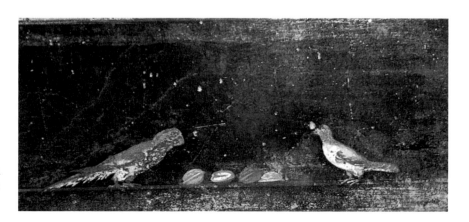

FIGURE 303 A parakeet and a greenfinch with walnuts. Photo: S. Jashemski.

in white feathers and clapped her rattling bill." Horace (*Satires* 2.2.49) talks of the safe nesting of *ciconia*. Columella (*RR* 3.13.11, 12) describes a T-shaped furrow depth gauge called a *ciconia*, because it resembled a stork standing on one leg.

REMARKS

The white stork is now only a rare vagrant on migration through Italy on its way to nesting grounds in north central Europe. It is, of course, well known along its regular routes through the Iberian Peninsula (where it also nests) and around the eastern Mediterranean coasts, where its movement over the Bosporus is a famous natural history phenomenon. Storks generally avoid long overwater crossings and seek thermal updrafts over deserts and along hill and mountain ridges to assist them on their long spring and fall migrations from and to sub-Sahara Africa. Storks presumably bred in the Po Valley in the fourteenth century (Cramp et al. 1977) and sporadically in recent years they have bred elsewhere in northern Italy. The accurate depiction of a stork in a Pompeian wall painting suggests that the artist was familiar with the species, and the inclusion of a dog sitting nearby indicates that the artist knew of its association with human habitations. Also the several references to *ciconia* by Latin authors suggests that in the first century A.D., storks may have occurred more frequently in Italy than at present.

21. *COCCOTHRAUSTES COCCOTHRAUSTES*
English, hawfinch; Italian, *frosone*

WALL PAINTING

A pair of hawfinches is realistically portrayed feeding on cherries in a painting on the N wall of the tablinum in the House of M. Lucretius Fronto (Fig. 304). Their

huge, conical bills, light brown backs, and whitish underparts render them unmistakable.

SCULPTURE

Matteucig (1974: no. 92) identifies a large-billed bird eating grapes or cherries on the Eumachia portal as a "probable" hawfinch.

ANCIENT AUTHORS

The third-century lexicographer Hesychus cites κοκκοθραύστες, the kernel- or seed-breaker, as a bird that uses its heavy bill for opening hard seeds.

REMARKS

The hawfinch is a year-round resident of mixed woodlands, parks, and orchards throughout Europe, where it feeds on large, hard seeds and nuts that it cracks in its massive bill. It is the only bird that can crack cherry pits.

22. *COLUMBA LIVIA, COLUMBA OENAS*
English, rock dove, domestic pigeon; Italian,
 piccione selvatico
English, stock dove; Italian, *colombella*

WALL PAINTINGS

Numerous depictions of pigeons, some wild gray rock doves, but most, domesticated varieties judging from their varied plumage color patterns, grace the walls as garden paintings at Pompeii, Oplontis, and elsewhere. A rock dove is perched with a quail or partridge on the edge of a fountain in a painting in a small raised garden in the Villa of Poppaea at Oplontis (Jashemski 1979: 130, 306, figs. 206, 475; 1993: 297). A rock dove with wings raised is painted in flight on the S wall in the water triclinium of the House of the Gold Bracelet (Fig. 305). A pigeon is perched on a square

FIGURE 304 A pair of hawfinches and cherries. Photo: S. Jashemski.

FIGURE 305 A carefully rendered hovering rockdove. Photo: S. Jashemski.

fountain in a garden painting on the E wall in ambient 70 in the Villa of Poppaea at Oplontis (Jashemski archive slide 4-12-75). Three pigeons, two perched and one in flight, are shown in a garden painting in poor condition in the Caupona of Sotericus (Jashemski 1993: 326, fig. 377).

Several domestic pigeons with white, black, or variegated plumage are found in wall paintings. Examples include the following: a curly-haired young boy labeled *"puer Successus"* holds a white pigeon with open wings in a wall painting on the N wall of the cubiculum to the left of the atrium in the House of Successus (Jashemski 1979: 102, fig. 160). Several wall paintings in the House of the Gold Bracelet depict domestic pigeons: an entirely white one with wings raised on the upper left and a white and buff one on the planetree in the center of the N wall painting in the *diaeta* (Fig. 129) (see also *Streptopelia risoria*); a third with buff on the neck perched on a lattice fence on the S wall in the water triclinium (Fig. 306); and a fourth in flight with a black head (Jashemski 1979: 106, fig. 170). A white pigeon drinks from a pool at the feet of a sleeping faun in the right panel of a wall painting on the N garden wall in the House of Adonis (Jashemski 1979: 66, fig. 107). Another white pigeon is perched above the window on the S wall of the room off the atrium in the House of the Fruit Orchard

(Jashemski 1993: 319, fig. 365). A nearly black, short-legged pigeon is depicted standing flat-footed in the upper zone of another wall painting in the same room (Jashemski archive slide 17-16-77).

MOSAICS

A white pigeon flies above unidentifiable plants in a mosaic incorporated into a fountain niche in the Villa on Cape Posillipo (Jashemski 1993: 394, fig. 479).

SKELETAL REMAINS

Ten rock dove bones were recovered from fifth- to seventh-century A.D. excavations at Carminiello ai Mannesi near Naples, and four bones were found in deposits from fourth century B.C. to first century A.D. in the forum at Pompeii (King, personal communication).

ANCIENT AUTHORS

Varro (*RR* 3.7) discusses two types of pigeons (*columbae*) that live in a dovecote (*peristerotrophius*): "There are usually two species of these: one the wild, or as some call them, the rock (*saxatilis*), which lives in turrets and gable-ends (*columina*), whence the name *columbae*, and these, because of their natural shyness, hunt for the highest peak of the roof . . . flying in from the fields and back again. The other species of pigeon is gentler, and being content with the food of the house usually feeds around the doorstep. This species is generally white, while the other, the wild, has no white but is variously colored." He goes on to instructions for building a dovecote. Pliny (*HN* 10.158) notes that "pigeons go through a special ceremony of kissing before mating." Apicius (6.iv) provides recipes for roast and boiled pigeon and two sauces specifically for pigeons.

REMARKS

The wild rock dove, best separated from the stock dove by its paler, grayer back, white rump, and more strongly barred wings, is at present resident all year in the southern half of Italy where it breeds and roosts in coastal and mountain cliffs and caves. This species is the ancestor of the domestic pigeon, which displays a variety of colors and patterns, some gray, speckled with black, and others, brown or white. Domestic birds are kept in dovecotes or occur feral, often in large flocks, in cities, towns, and rural settings throughout Italy. Although some domestic or feral birds can closely resemble wild-type rock doves, they are most easily identified when seen in groups by the array of plumage colors and patterns. The slightly smaller stock dove is a woodland species also found in more open fields and pastures with scattered trees and in winter in farmland. In most of mainland Italy

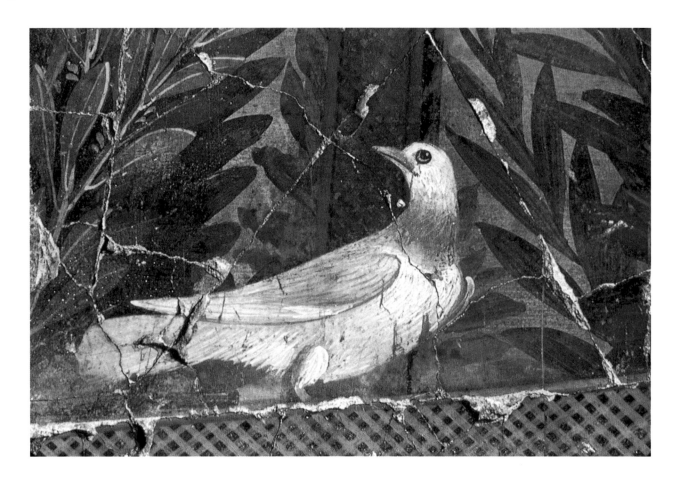

FIGURE 306 A domestic pigeon. Photo: S. Jashemski.

it presently breeds only in the mountains but is abundant in the lowlands in winter. It nests in tree cavities.

23. *COLUMBA PALUMBUS*
English, wood pigeon; Italian, *colombaccio*

WALL PAINTINGS

Two wood pigeons are shown on the N wall of the garden room in the House of the Gold Bracelet. One is perched on a branch of a small planetree behind the fountain in the center (Fig. 129), the other on a bush in back of the pinax above the herm on the right (Jashemski 1993: figs. 2, 406, 410). Both show the conspicuous white neck patch and the white on the wing typical of the species. Another wood pigeon is perched on a small pine tree laden with cones in back of the large crater on the E panel beside the door leading into the shrine room wall of the House of Venus Marina (Jashemski 1979: fig. 104). A proud wood pigeon is depicted walking with one foot lifted high in a wall painting (NM inv. no. 8762) (Jashemski 1993: fig. 452). The large gray pigeon near the reclining Adonis in the House of Adonis shows some traces of white and may just as well be a wood pigeon as a rock dove, see *Columba livia* (no. 22). A pigeon perched on a

wall in the Villa of San Marco at Stabiae (Fig. 307) is also probably a wood pigeon.

SKELETAL REMAINS

Five wood pigeon bones were found in fifth- to seventh-century A.D. excavations at Carminiello ai Mannesi near Naples (King, personal communication).

ANCIENT AUTHORS

Columella (*RR* 8.8.1ff) discusses methods of raising and fattening wood pigeons, *palumbi,* and domestic pigeons, *columbi,* in dovecotes. He discourages routine force-feeding as not economically worth the expense

FIGURE 307 A wood pigeon. Photo: S. Jashemski.

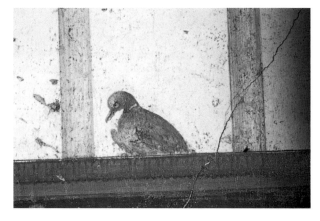

and trouble for regular household or market birds, but does recommend the practice for birds intended for sumptuous feasts.

REMARKS

The very large wood pigeon is widespread in urban and rural wooded settings throughout Europe as long as there are some trees about for perching. Although treated as vermin in Britain, where it competes for food with more desirable game, it is avidly hunted elsewhere in Europe and served as table fare as it was in ancient Campania.

24. *CORVUS CORAX*

English, raven; Italian, *corvo imperiale*

SCULPTURE

A bronze raven with a spout in its bill served as a fountain figure in the Villa San Marco at Stabiae (NM inv. no. 4891). Its distinctively wedge-shaped tail confirms its identity (Jashemski 1979: 332, fig. 531).

SKELETAL REMAINS

A single undated raven bone was found in the forum at Pompeii (King, personal communication).

ANCIENT AUTHORS

On account of its gift of prophesy, the raven was consecrated to Apollo, the god who occasionally assumed the identity of the large black bird (Horace *Odes* 3.27.11). Ovid (*Met* 2.541), in talking of the *loquax corvus*, says, "though white before, had been suddenly changed to black" in punishment for its treachery. "But his tongue was his undoing. Through his tongue's fault, the talking bird which once was white, was now the opposite of white." Pliny (*HN* 10.121.1–123) also refers to talking ravens. Cicero (*De divinatione* 1.39.85) claimed that a raven turning to the right in flight indicated good fortune. And Vergil, too (*Eclog.* 9.15), tells of fortunate signs from the bird: "Had not a raven on the left first warned me from the hollow oak to cut short, as best I might, this new dispute, . . . neither would be alive." Vergil (*Georgics* 1.3.88) also cites the cries of the raven as a sign of rain: "With its deep tones [it] calls down the rain, and in solitary state stalks along the dry sea-sand."

REMARKS

The raven, a large scavenging and predatory crow, is a common resident of Italy, most frequently seen in mountainous terrain or near seaside cliffs. In Roman times, as at present, it would have been attracted to refuse dumps, particularly in winter. Its deep, throaty

croak and heavier, more massive appearance make it easy to differentiate from the smaller hooded crow that caws and from the still smaller jackdaw, which has a ringing, high pitched, metallic call.

25. *CORVUS CORONE*

English, carrion crow, hooded crow; Italian, *cornacchia nera, cornacchia bigia*

WALL PAINTINGS

A hooded crow with gray body and black head, wings, and tail is perched on a railing with a sparrow in a wall painting in the room off the atrium in the House of the Fruit Orchard (Fig. 308). A large bird (note the size in comparison with the egret below it) with black head, neck, and wings perched on a plane-tree behind the fountain on the S wall of the *diaeta* in the House of the Gold Bracelet (Jashemski 1993: 356, fig. 420) is most probably a hooded crow not a rosy starling, *Sturnus roseus*, as its shaggy crest might suggest.

SCULPTURE

Matteucig (1974: no. 43) identifies as "probably" a rook (*C. frugilegus*) a large perching bird on the Eumachia portal without citing his reason. The figure might also be a carrion crow.

SKELETAL REMAINS

A single carrion crow bone was found in fifth- to seventh-century A.D. excavations at Carminiello ai Mannesi near Naples (King, personal communication).

ANCIENT AUTHORS

Pliny (*HN* 10.29–30), in discussing insightful behavior of the *cornix*, says, "If a nut is so hard it resists their beak, they fly up aloft and drop it two or more times onto rocks or roof tiles, til it is cracked and they can

FIGURE 308 A hooded carrion crow and a house sparrow. Photo: S. Jashemski.

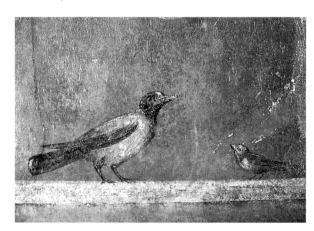

break it open. The bird itself has a persistent croak that is unlucky although some people speak well of it" (the latter sounds more like a raven than a crow). Ovid (*Met.* 2.548) calls the *cornix* "*garrula*," flying after the raven with "flapping wing," and also tells of Medea adding the head of a crow nine generations old to a potion (*Met.* 7.274).

REMARKS

The hooded crow is a ubiquitous, year-round resident in Italy at present as it would have been during antiquity. Crows are omnivorous and are seen feeding in cultivated fields, orchards, woodlands, and, of course, at garbage pits. They are normally wary, especially where persecuted, but are ordinarily seen in urban areas as well as rural settings.

26. *CORVUS MONEDULA*
English, jackdaw; Italian, *taccola*

SKELETAL REMAINS

A single jackdaw bone was found in the first-century B.C. to first-century A.D. level in the forum at Pompeii (King, personal communication).

ANCIENT AUTHORS

Pliny (*HN* 10.77) says of the *monedula* that it is "a bird whose unique fondness for stealing, especially silver and gold is remarkable" and it is notable for "swarming in enormous numbers."

REMARKS

The highly gregarious and noisy jackdaw is a common resident in open country and urban areas throughout Europe. It nests in caves and crevices in cliffs and buildings.

27. *COTURNIX COTURNIX*
English, quail; Italian, *quaglia*

WALL PAINTINGS

Surprisingly, only two extant paintings show the migratory quail. A pair are feeding on millet in a painting (NM inv. no. 8750) (Fig. 120). The colors are bright and fresh against a black background and the depictions are delightfully accurate, especially the erect stance of the presumed male, which has just plucked a grain. In another small wall painting on the center of the E wall in the room to the right of the atrium in House VI.xv.1, three quails stand on a shelf, the two right-hand figures posturing for a fight while the third, on the left, looks over its shoulder at them and the prizes, two palm leaves and a gold amphora (Fig. 309). Another small bird perched above and to the right of a

male golden oriole in a damaged painting on the W wall of the garden in the Casa della Venere in Bikini (Jashemski 1993: 324) is most likely a quail (Jashemski archive slide 15–28-72). A live quail with bound feet is shown on the lower shelf on the right side of a two-part wall painting in the Naples Museum (inv. no. 8634B) (De Caro 1999: 61, fig. 37).

SKELETAL REMAINS

Seven undated quail bones were found in the forum at Pompeii, and one bone was recovered from fifth- to seventh-century A.D. excavations at Carminiello ai Mannesi near Naples (King, personal communication).

ANCIENT AUTHORS

Aristotle (*HA* IX.614a.28) says of the ὄρτυξ (and the partridge) that they are "excited about mating." In discussing migration, Pliny (*HN* 10.64–5) says, "The *coturnix* always actually arrive before the cranes, though the quail is a small bird and when it comes to us remains on the ground more than it soars aloft; but they, too, get here by flying in the same way as the cranes, not without danger to seafarers when they have come near to land, for they often land on the sails and they always do this at night." Varro (*RR* 3.5.7) adds that migratory birds "fly yearly across the sea into Italy about the time of the autumnal equinox and back again whence they came about the spring equinox, as do the turtle doves (*turtur*) and *coturnices* at another season in vast numbers."

REMARKS

The quail is a favored game bird during its periods of fall and, at least in the past, spring passage in Italy. Most of those taken at present breed elsewhere in Europe, but 2,000 years ago, when methods of hunting were not as effective, local breeding was far commoner in Italy and migrants too must have been more abundant. They occur in grain fields and pasture land where they can find seeds, green leaves, and insects and where the ventriloqual "*wet-your-lips*" whistled call of the male

FIGURE 309 Three fighting quails with victor's trophy. Photo: S. Jashemski.

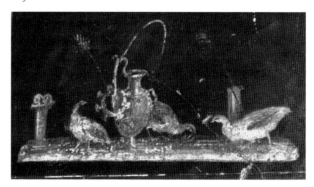

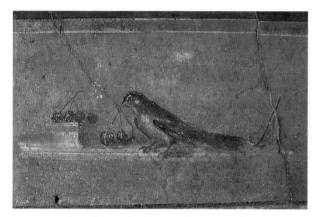

FIGURE 310 A cuckoo with cherries. Photo: S. Jashemski.

the ventriloqual *"wet-your-lips"* whistled call of the male is often heard.

28. *CUCULUS CANORUS*

English, cuckoo; Italian, *cuculo*

WALL PAINTINGS

A male cuckoo is depicted as a long-tailed, short-legged, gray-backed bird with white underparts eating cherries in a wall painting in the House of Menander (Fig. 310). A gray-backed bird in flight in the upper portion of a garden painting in the room off the N side of the peristyle in the House of C. Julius Polybius (Jashemski 1993: 368, fig. 432) has been suggested to be a bird of prey (see *Accipiter nisus*) but may actually be a poorly rendered cuckoo with a short tail (see last sentence in Ancient Authors section, next).

ANCIENT AUTHORS

Aristotle (*HA* VI.563b), Aelian (*NA* III.30), and Pliny (*HN* 10.25–7) all describe in remarkably similar detail the brood parasitic habits of the κόκκυξ and *cuculus.* It lays its eggs in the nest of other smaller birds and leaves its eventual offspring to be reared by the foster parents. Aristotle and Pliny with great insight, point out that the cuckoo, which is present only in spring and summer, resembles a hawk in form, color, and habits. Its raptorial appearance is now thought to frighten a smaller incubating songbird from its nest, and thus allow the female cuckoo to lay her egg in the host's nest.

REMARKS

The cuckoo is a common summer visitor to open woodland, parks, and gardens throughout Europe. Its familiar mellow call is persistent and carries afar.

29. *CYGNUS CYGNUS, C. OLOR*

English, whooper swan; Italian, *cigno selvatico*
English, Mute swan; Italian, *cigno reale*

WALL PAINTINGS

Leda and her swan are shown in several Pompeian wall paintings including one on the center of the W wall of room r in the House of the Lovers (Cerulli Irelli et al. 1993: I, pl. 77; II, 132, fig. 231); another in a small tableau on the N wall of cubiculum 14 in the House of Venus Marina (Cerulli Irelli et al. 1993: II, 125, fig. 125b), and a third on a pedestal in the center of an architectural painting on the E wall of room o in the House of Queen Margherita (V.ii.1) (Cerulli Irelli et al. 1993: II, 91, ent. 150, fig. 150). Swans are used as acroterion decorations in wall paintings on the E wall of room 3 E of the entrance of House I.xvi.4 (Cerulli Irelli et al. 1993: II, 71, ent. 114), and on the S wall of room f in the House of D. Octavius Quartio (Cerulli Irelli et al. 1993: II, 119, fig. 119b).

ANCIENT AUTHORS

There are several versions of the mythical conception of Helen of Troy and the twin heroes Castor and Pollux in Leda, wife of Tyndareus, by Zeus when he assumed the form of a swan. The tale appears first in Sappho (frag. 79) and Euripides (*Helen* 13ff), but not in Homer or Hesiod (Pollard 1977: 159–60). Pliny (*HN* 10.63) writes of the "mournful song" of swans at their death (i.e., "swan song"). Vergil (*Aeneid* 1.393) speaks of twelve swans in exultant line being scattered by an eagle and later regrouping while uttering their songs. He (*Eclogues* 7.38) also says that Galatea is whiter than swans.

REMARKS

Three species of swans occur in European wetlands, including lakes, ponds, marshes, rivers, tidal lagoons, and seacoasts, but none are present in the wild state at present in Campania. The mute swan of Britain and central Europe, however, has been widely domesticated and introduced as an ornamental waterfowl to lakes. Individuals have reverted to the feral state and have become local pests. In antiquity, Campanians would also probably have kept tame swans on larger ponds and lakes. Of course, the Leda myth originated in Greece, where both mute and whooper swans occur in winter.

30. *EGRETTA THULA*

English, little egret; Italian, *garzetta*

WALL PAINTINGS

A white egret with head plumes is about to capture a snake in a wall painting in the House of Adonis (Fig. 284). An erect white egret with prominent head and breast plumes stands between two leafy clumps on a low wall enclosing the peristyle on the W in a garden

painting in the House of Menander (Jashemski 1993: 323, fig. 372). White egrets stand on the extreme right- and left-hand sides of the two painted windows looking out at garden scenes in excavators' artists' drawings of the large wall painting of Orpheus playing his cithara in the House of Orpheus, and another stands by Orpheus's left leg (Jashemski 1993: 344, 345, figs. 399, 400).

REMARKS

The little egret occurs as a winter visitor and passage migrant in Campania in shallow-water wetlands, including swamps, marshes, lagoons, and the edges of ponds and slow-moving streams.

31. *ERITHACUS RUBECULA*
English, robin; Italian, *pettirosso*

WALL PAINTINGS

A small compact songbird with reddish breast and bluish gray back perched on a garland in the portico facing the E garden in the Villa of Poppaea at Oplontis is undoubtedly a robin (Fig. 311). A flying bird with some red on its breast in a garden painting to the left of the windows outside room 78 and facing the pool in the garden at Oplontis is also possibly a robin, although its size seems large in comparison to the peacock perched below (Fig. 312).

FIGURE 311 A vividly red-breasted robin. Photo: S. Jashemski.

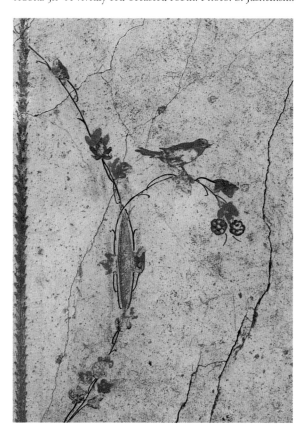

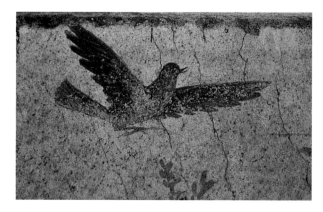

FIGURE 312 A robin in flight. Photo: F. Hueber.

SCULPTURE

Matteucig (1974: no. 51) identifies on the basis of appearance and posture a robin on the Eumachia portal.

ANCIENT AUTHORS

Aristotle (*HA* IX.632B.28) describes the apparent change of the summer redstart, φοινίκουρος, into the winter robin, ἐρίθακος, and Pliny (*HN* 10.86) repeats the same information for *phoenicurus* and *erithacus*.

REMARKS

The robin is a common resident and partial migrant in gardens, hedgerows, open woodlands, and forests with undergrowth. In Campania it is much more abundant in winter when migrants from the north are present. In southern Greece the robin is present only in winter, accounting for the ancient authorities' belief in seasonal change in plumage.

32. *FRINGILLA COELEBS*
English, chaffinch; Italian, *fringuello*

MOSAIC

Four chaffinches are in the lower left portion of a handsome two-panel mosaic (NM inv. no. 9993) with a cat attacking a small hen, a sheldrake, a male teal, a scallop, and fish from the right ala of the House of the Faun (Fig. 236). They each show conical pointed bill, red-pink face and breast, gray back, white wing bar, and white outer tail feathers typical of the chaffinch.

SKELETAL REMAINS

The bill of a chaffinch was found among the debris from meals and other refuse at the edge of the property bordering the Villa in the località Villa Regina on the south side of the country road (Jashemski 1993: 291).

SCULPTURE

Matteucig (1974: no. 66) identifies on the basis of morphology and posture a chaffinch on the Eumachia

portal. He also calls two birds (nos. 94, 95) that are either allopreening or courting "probably" corn buntings (*Emberiza calandra*, Italian, *strillozzo*), another (no. 65) "probably" an unspecified bunting on the basis of "posture and appearance," and a fourth, "apparently" a bunting.

ANCIENT AUTHORS

The σπίζα is cited as a comparison bird for size by Aristotle (*HA* VIII.592b.17), suggesting that its identification as the chaffinch, a widespread and abundant bird, is correct. Aelian (*NA* IV.60) attributes the ability to forecast the coming of winter to the chaffinch, which then seeks asylum in the woods. Varro (*LL* VII.104) asks the *fringuilla, "Quid fringuittis?"* The Latin name, like the Greek, mimicked the bird's ringing call, which carries far in the woods.

REMARKS

The chaffinch is widespread and common in all of Europe, with the numbers of residents in Mediterranean lands increased by northern migrants in winter. It occupies a number of different wooded habitats from lowland open woods, parklands, orchards, and gardens to mountain deciduous and conifer forests.

33. *FULICA ATRA*
English, coot; Italian, *folaga*

MOSAICS

A pair of swimming coots with lobed feet, displaying prominent white frontal shields and carrying pond weeds in their pointed bills, are in the Nile mosaic from the House of the Faun (Fig. 274). Tammisto (1997: 65; pl. 22, figs. NS2,1 and NS2,4) identifies them, and three others, as purple gallinules, moorhens, or, "less probably" coots, dismissing their swimming in their "real aquatic habitat" even though admitting that they are seldom, if ever, shown "as an aquatic species." The purple gallinule does not have lobed swimming toes. In Niccolini's drawing (Jashemski 1993: 344, fig. 399) of the Orpheus wall painting in the House of Orpheus (VI.xiv.20) two birds swimming in the pool at the bottom are shown dark and cootlike, whereas in Presuhn's drawing (Jashemski 1993: 345, fig. 400) of the same wall painting, they are carefully rendered lighter and more ducklike.

SKELETAL REMAINS

Bones of a coot were in the trash pile of the remains of meals around the tree near the main entrance of the Villa in the località Villa Regina at Boscoreale (Jashemski 1993: 289–90).

ANCIENT AUTHORS

Cyranides (99) describes the φαλαρίς as "a bird so-called from its white forehead" that is otherwise entirely black and is found on rivers and lakes (Pollard 1977: 70). Columella (*RR* 8.15.1) states that *Phalarides* are among wild birds that "root about in pools and marshes" and can be kept in captivity. Ovid (*Met.* 8.625) also talks of the marsh as the haunt of *fulica.* There is no recipe for cooking coot in Apicius, and although some modern Greeks hunt them for sport, I found that most think they taste "muddy."

REMARKS

A gregarious aquatic species that inhabits lakes, rivers, and shallow coastal waters, the coot feeds on vegetation and invertebrates that it secures underwater by diving. It is abundant in most of Europe except extreme northern Scandinavia. Numbers in Campania increase in winter when northern migrants are present. Its flesh is generally not regarded as desirable table fare, except apparently in Egypt (Thompson 1936: 298).

34. *GALLINAGO GALLINAGO*
English, snipe; Italian *beccaccino*

WALL PAINTING

Two long-billed snipe face in opposite directions in a marshlike setting in the lower portion of a wall painting in Casa delle Quadrighe (Fig. 313).

MOSAIC

Although Tammisto (1997: pl. 48, no. 39) identifies a plump bird with a long bill looking back over its shoulder in the floor mosaic in the atrium of the House of Paquius Proculus as a kingfisher, it could equally be a snipe.

ANCIENT AUTHORS

The snipe does not appear to be mentioned by ancient authors.

FIGURE 313 A pair of snipes in wetland habitat. Photo: S. Jashemski.

The snipe breeds in northern Europe but in Italy is only a winter visitor in marshes, wet meadows, and swamps. It is cryptic in color and difficult to see on the ground, but its zigzag flight pattern when flushed and very long bill are distinctive.

35. *GALLINULA CHLOROPUS*
English, moorhen; Italian, *gallinella d'acqua*

WALL PAINTING

An immature moorhen stands to the left of a crater fountain in a yellow panel on the W part of the wall in the S courtyard garden (68) in the E wing of the Villa of Poppaea at Oplontis (Jashemski 1979: 307, fig. 471; 1993: 376).

MOSAIC

Tammisto's (1997: 65) suggestion that moorhens are shown in the Nile mosaic in the House of the Faun is implausible owing to the figures' lobed toes (see *Fulica atra*).

ANCIENT AUTHORS

The moorhen is specifically noted by Pollard (1977: 70) as curiously absent in Greek authors and is, therefore, also missing in Thompson (1936). Latin authors refer to small chickens as *gallinulae*.

REMARKS

The moorhen is abundant in wetlands throughout Europe. Although normally shy and secretive, when habituated and not disturbed, moorhens will frequently feed in the open as long as cover is nearby. Probably they are more abundant in winter in Mediterranean wetlands when the residents' numbers are augmented by migrants from the north.

36. *GALLUS GALLUS*
English, chicken; Italian, *pollo*

WALL PAINTINGS

Several wall paintings show brightly colored roosters with golden hackles. They suggest that at the time, farmyard chickens looked much like the wild game fowl of southeast Asia. A cock pecks at a bunch of grapes in a damaged painting on the E wall of the room opening off the E garden peristyle in the House of Chlorus and Caprasia (Taberna Attiorum) (Jashemski archive slide 64-36-57). Another rooster is depicted reaching for grapes in a painting (NM inv. no. 8735). An awkwardly posed crouching cock with legs extended behind is shown on a railing to the left of a tray in the House of Polybius (Jashemski archive slide

FIGURE 314 Four fighting cocks with a trophy and a palm frond. Photo: S. Jashemski.

24-32-75). Another cock is on the N wall to the right of the atrium in the House of the Vettii (Jashemski archive slide 12-10-66). Two hens are perched drinking on the rim of a footed fountain in a damaged painting on the W wall of the room opening off the left side of the Tuscan atrium in the House of C. Julius Polybius (Jashemski 1993: 368, fig. 431).

A number of cocks are depicted fighting or with trophies or betting paraphernalia. Four roosters of various colors are shown with a palm trophy in the room to the right of the atrium in the House of the Vettii (Fig. 314). A similar painting is in a room to the left of the atrium in the same house (Jashemski archive slide 13-10-66).

At least two other wall paintings of cocks are no longer extant. A cock was reported to have been among the birds that Orpheus was charming in a painting on the back wall of the garden behind the House of Stallius Eros (I.vi.13). The painting, already in poor condition at the time of the eruption, was barely visible when excavated and photographed in 1929, and none of the birds could be seen in 1964 (Jashemski 1993: 314). A cock was reported in 1875 to have been depicted on the S wall of the garden in the House of L. Caecilius Jucundus (V.i.26), but it was neither drawn nor photographed before being destroyed (Jashemski 1979: 71–2; 1993: 334).

MOSAICS

In a colorful framed mosaic (NM inv. no. 9982) from the House of the Labyrinth, two roosters contend. Academeus, prize palm frond and a bag, presumably containing wagered coins, stand on a table behind them (Tammisto 1997: pl. 5, fig. LS3,3). A rooster with feet awkwardly depicted is shown with a pinecone, fig, and date beneath a statue of a nude boxer (NM inv. no. 10010) (Fig. 315). A cat has caught a small hen in a mosaic (NM inv. no. 9993) (Fig. 236).

SCULPTURE

Matteucig (1974: no. 96) identifies a chick eating an ant on the Eumachia portal.

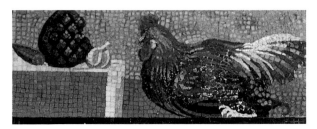

FIGURE 315 A rooster with a pinecone, a date, and a fig. Mosaic (NM inv. no. 10010). Photo: S. Jashemski.

SKELETAL REMAINS

Chicken bones were found with shells and mammal and fish bones along the N garden wall in the House of the Gold Bracelet, undoubtedly remains from meals in the nearby water triclinium (Jashemski 1993: 167). More than 400 chicken bones were recovered from fifth- to seventh-century A.D. excavations at Carminiello ai Mannesi near Naples, and a total of 189 chicken bones were present in deposits in several levels in the forum at Pompeii from the fourth century B.C. to the first century A.D. (King, personal communication).

ANCIENT AUTHORS

The cock is first mentioned by Theognis (*Sent.* 864) in the sixth century: "I will come out in the evening and return at dawn when the ἀλεκτρυών begin(s) to crow." Aristophanes (*Birds* 487) calls it the "Persian bird"; the cock's fleshy comb, "with a stiff tiara on his head," fascinated him. Aristotle (*HA* II.504b.9) was also intrigued, "the cock's comb is unique, for it is not composed of flesh, but is fleshlike." Aeschylus (*Eumenides* 866) mentions the cock's bellicose nature. Hens were known as prolific year-round egg-layers (Aristotle, *HA* VI.558b.12). Plato, Aristotle, and Pausanius (IX.22.4) provided evidence that different breeds of fowl existed, including bantams and color varieties. Chickens were, of course, well known as table fare by the Romans; Apicius lists fifteen recipes for chicken and capons. Martial (3.58.37) speaks of a guest from the countryside bringing *capones* "debarred from love" for the host's table.

REMARKS

The chicken is probably the world's most abundant and widespread bird and was already present as a cage bird and table fare in ancient Greece and Rome. Although chickens are assumed to have been domesticated from the red jungle fowl, *Gallus gallus,* of southeast Asia and the East Indies, any one or more of the four species of jungle fowl in the area may have been the true ancestor. Chickens were known in India as early as 3200 B.C., in Crete and Egypt by 1500 B.C., and in China by 1400 B.C. Although it was unknown to either Homer or Hesiod, the cock appears on Greek coins from Himera on Sicily before 842 B.C. (Thompson 1895, frontispiece) and in Ephesus in 700 B.C. There, and on the Greek mainland, they may have been introduced from Persia in the seventh century and probably entered Italy through Greek colonies shortly thereafter (Wood-Gush 1985: 153).

37. *GARRULUS GLANDARIUS*
English, jay; Italian, *ghiandaia*

WALL PAINTINGS

A superbly rendered jay showing its blue wing patch and black moustache is perched on the E wall of the *diaeta* in the House of the Gold Bracelet (Fig. 116). A less accurately portrayed jay is perched in a bush in a garden painting on the W wall of the cubiculum off the N side of the peristyle in the House of C. Julius Polybius (Jashemski 1979: 78, fig. 127). A jay is perched on the right side of a pear tree on the E panel of the S wall of the room off the peristyle in the House of the Fruit Orchard (Jashemski 1979: 263, fig. 388; 1993: 320, fig. 366). A jay is shown with a woodchat shrike in a wall painting in the Villa of Mysteries (Fig. 316).

ANCIENT AUTHORS

According to Aristotle (*HA* IX.615b.19–23), the κίσσα (κίττα) has the greatest variety of voices for it utters a different one practically every day. . . . When the acorns are getting scarce, it makes a hidden store of them." Although Thompson (1936: 148) gives *gaius, gaia,* and *pica* as Latin names for the species, I am unable to find any valid citations in Latin authors for jays (*pica* is, of course, commonly used of the magpie).

REMARKS

Jays are common and widespread in deciduous and conifer woodlands where their favored foods, nuts, and especially acorns, are available. They are moderately tolerant of suburban areas as long as trees are abundant. The jay's raucous cry is more often heard than

FIGURE 316 A woodchat shrike and a jay. Photo: S. Jashemski.

the wary bird is now seen. Probably, before firearms jays were more confiding and easier to see.

38. *GYPS FULVUS*
English, griffon vulture; Italian, *grifone*

WALL PAINTINGS

A griffon vulture is well depicted in the left-hand panel of a wall painting in the House of the Ceii (Cerulli Irelli et al. 1993: I, pl. 10).

ANCIENT AUTHORS

Vergil (*Aeneid* 6.595) refers to a *vultur* eating the liver of Tityos.

REMARKS

Formerly widespread in southern Europe where it frequented both lowlands and high mountainous terrain, the griffon, like most other vultures, is now rare and seldom seen in peninsular Italy. It requires seclusion for nesting in high mountain ledges and caves, and when disturbed abandons eggs and young. In antiquity it may have been more widespread and abundant when the carrion it depended on was more available.

39. *HIRUNDO RUSTICA*
English, swallow; Italian, *rondine*

WALL PAINTINGS

A single swallow is perched on a bush above the left-hand pinax in the elaborate garden painting on the N wall of the *diaeta* in the House of the Gold Bracelet (Jashemski 1993: figs. 2 and 408). Another sits on viburnum on the S wall in the room off the atrium in the House of the Fruit Orchard (Jashemski 1979: 77, fig. 122) and a pair flies in the lower part of the short exterior wall of the storeroom in the SW corner of the garden in the House of Ceius Secundus (Fig. 317). All four individuals have long, deeply forked tails, but the two perched birds have white, not rusty, underparts.

FIGURE 317 A pair of swallows in flight. Photo: S. Jashemski.

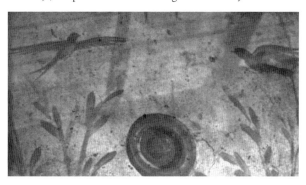

SCULPTURE

Matteucig (1974: no. 75) identifies a "probable" swallow or "doubtful" house martin on the Eumachia portal and another bird in head-down flight (no. 86) as a swift, *Apus*.

ANCIENT AUTHORS

Columella (*RR* 11.2.21; 10.80), in discussing preparing wheat fields for spring planting, cites February 20 as an early arrival date for migrant swallows and talks of seeding times when swallows "hail spring's advent at their nests." Pliny (*HN* 10.72–73) also knew the swallow well. "The *hirundo* is the only bird that has an extremely swift and unswerving flight, owing to which it is not liable to capture by any other kinds of birds. Also the *hirundo* is the only bird that feeds when on the wing" (not strictly true, of course, as the bee-eater, swifts [*Apus* sp.], and some falcons are also aerial feeders). He also provides the following information on nesting and sanitation habits:

> Swallows build with clay and strengthen the nest with straw. If ever there is a lack of clay, they wet their wings with a quantity of water and sprinkle it on the dust. The nest [cup], itself, however they carpet with soft feathers and tufts of wool to warm the eggs and also to prevent it from being hard for the infant birds. They dole out food with extreme fairness. They remove the chicks' droppings with remarkable cleanliness, and teach the older ones to turn round and relieve themselves outside of the nest.

REMARKS

The swallow is a common summer resident throughout Europe where it builds its mud-daubed nest in buildings in urban and agricultural settings. It frequently perches on bare treetop twigs and is easy to observe, particularly when individuals mass for roosting in marshes or for migration.

40. *JYNX TORQUILLA*
English, wryneck; Italian, *torcicollo*

WALL PAINTING

An unmistakable wryneck is depicted feeding on pears on a shelf in a wall painting in the Villa of Poppaea at Oplontis (Fig. 318). The image is quite lifelike and shows a typical wryneck perched stance rather than a more woodpeckerlike vertical climbing pose.

ANCIENT AUTHORS

Aristotle (*HA.* II.504a) describes the ἴυγξ as "somewhat larger than a chaffinch and mottled in appearance.

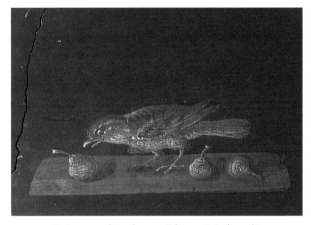

FIGURE 318 A wryneck and pears. Photo: S. Jashemski.

It has two toes in front and two behind and resembles a snake in the structure of its tongue which it can protrude four finger widths and withdraw again. It can also twist its head backwards while keeping the rest of its body still. It has big claws resembling those of a woodpecker. Its note is a shrill chirp." A similar account for the *glottis* appears in Pliny (*HN* 10.67, 11.107).

REMARKS

The species is a summer visitor to Campanian gardens, orchards, parks, and wooded hedgerows, where it typically feeds on ants that it digs out of their nests and, to a much lesser extent, on other insects, spiders, and berries.

41. *LANIUS* sp.
English, shrike; Italian, *averla*

WALL PAINTINGS

A pair of gray shrikes (*L. excubitor*) with distinctly hooked bills and dark eye stripe are perched head by head on a curtain cord in front of Doric column capitals in an architectural painting in the NW corner of cubiculum 46 in the House of the Labyrinth (Cerulli Irelli et al. 1993: I, pl. 51; II, 118, fig. 201b). An overly large gray shrike is perched on the top of an oleander on the left in a painting on the W panel of the long wall at the rear of the garden in the House of Venus Marina (Fig. 17). A woodchat shrike (*Lanius senator*) is shown with a jay in a wall painting in the Villa of Mysteries (Fig. 316).

MOSAICS

A stocky woodchat shrike is perched on a lotus pod above the cobra and mongoose in the Nile mosaic in the House of the Faun at Pompeii (Fig. 352). Tammisto (1997: pl. 23, fig. NS2,6) shows a close-up but misidentifies it as a masked shrike, *L. nubicus,* a much more slender bird.

SCULPTURE

Matteucig (1974: no. 23) identifies a "probable" shrike on the Eumachia portal.

ANCIENT AUTHORS

Aristotle (*HA* IX.617b.6) describes the ashen plumage, big head, powerful, short, round bill and large, for a perching bird, size of μαλακοκρανεύς, πάρδαλος, and κολλυρίων. There is no specific mention of the woodchat.

REMARKS

Two very similar species of gray, black, and white shrikes occur throughout Europe, although neither is at present well known in southern Italy. The lesser gray shrike, *L. minor,* is a summer visitor from Campania northward. The great gray shrike, *L. excubitor,* which breeds in Spain, central Europe, and Scandinavia, winters only as far south as the mid-peninsula of Italy. Both occur in open countryside with scattered small bushes and trees and are usually seen perched on an elevated scanning station looking for insect or small vertebrate prey. Roadsides with utility posts and wires are preferred modern hunting grounds. The shrikes' habit of impaling prey on thorns to provide a larder for future feasting is notorious.

42. *LUSCINIA MEGARHYNCHOS*
English, nightingale; Italian, *usignolo maggiore*

WALL PAINTINGS

A nightingale with a reddish tail is perched on the rim of a rectangular pedestal fountain supported by a sphinx in a painting in the enclosed garden (20) at the rear of the atrium in the Villa of Poppaea at Oplontis (Jashemski 1979: fig. 440). Another bird, previously identified as a possible nightingale, that is perched on the small bush to the left of a fig tree with a coiled serpent on the E wall in the room off the peristyle in House I.x.5 (Jashemski 1993: 321, fig. 368) is actually an oriole.

SCULPTURE

Matteucig (1974: no. 36) identifies a "very probable" nightingale on the Eumachia portal without citing evidence.

ANCIENT AUTHORS

According to Pliny (*HN* 10.81–4), *Luscinia* pours out a ceaseless gush of song for fifteen days and nights on end. He remarks on the small size of such an astounding songster, which has a vast menu of long notes, staccatos, murmurs, and trills.

REMARKS

The nightingale is a common summer visitor to most of Europe, south of Scandinavia where it frequents deciduous lowland woods and moist streamside thickets and hedgerows. Its glorious musical singing, delivered early in the morning or at dusk, is legendary. The nightingale is surprisingly rare in artistic paintings probably because of its drab coloration and is seldom seen owing to its skulking habits.

43. *MEROPS APIASTER*
English, bee-eater; Italian, *gruccione*

WALL PAINTING

Tammisto (1997: pl. 11, fig. SS1,3) identifies as a bee-eater a long-tailed, long-billed bird with bluish green back and tail and eye stripe huddled against a pilaster in a wall painting in the House of M. Obellius Firmus.

MOSAICS

Tammisto (1997: 41, pl. 11, figs. SS1,2) also identifies as a bee-eater, but with some features of a kingfisher ("hybrid" in his terminology), a bird in the lower left-hand corner of the fish mosaic in the House of the Faun (Fig. 226). It is in the same location and is similar in stance to a definite short-tailed kingfisher in the fish mosaic in House VIII.ii.16 (Fig. 228). Because of the aquatic nature of all the other fauna in the mosaic, obviously, it was intended as a kingfisher.

ANCIENT AUTHORS

Aristotle (*HA* VI.559a.3, IX.615b.30, 626a.9) describes the bright plumage of μέροψ, its hole-nesting habits, and how it is so detested by bee-keepers that they destroy its nests near their hives. Pliny's account (*HN* 10.99) of *merops* is similar but shorter.

REMARKS

The bee-eater is a common summer visitor throughout Italy. It is conspicuous, gregarious, vocal in flight, and captures and plays with its insect prey on the wing.

44. *MONTICOLA SOLITARIUS*
English, blue rock thrush; Italian, *passero solitario*

WALL PAINTING

A male blue rock thrush is shown pecking at figs on a shelf in a wall painting in the cubiculum of the House of Fabius Rufus (Tammisto 1997: pl. 62, fig. SC2,8, who identifies the depiction as a roller, *Coracias garrulus;* see Ancient Authors and Remarks).

SCULPTURE

Matteucig (1974: no. 50) identifies as "probably" a blue rock thrush a figure on the Eumachia portal, but adds that it "could be" a house sparrow.

ANCIENT AUTHORS

Aristotle (*HA* IX.617a.15) says λαιός resembles the blackbird but is a little smaller and lacks its orange bill. It lives on rocks and tiled roofs. Thompson (1936: 191) says it is favored as a cage bird because it is a good songster. He suggests that it may have been Lesbia's *passer* (Catullus 2.1). Both Pollard (1977: 55) and Thompson (1936: 159) express surprise that the roller is absent from Greek literary sources, thus casting doubt on Tammisto's suggested identification (see Remarks).

REMARKS

The blue rock thrush is resident in rocky terrain from seacoasts up into the mountains in most of southern Europe. The roller, with its blue-green head and body, chestnut back, and vivid blue wings, is a large, conspicuous, and noisy summer visitor to forests and open country in southern Europe. It is, therefore, peculiar that it does not occur widely in Campanian wall paintings. In fact, it may be a recent invader from the east since it is largely absent from central and western Europe.

45. *NUMIDA MELEAGRIS*
English, helmeted guineafowl; Italian, *faraona*

WALL PAINTING

"A large black guinea hen" was reported to have been among the birds that Orpheus was charming in a wall painting in the House of Stallius Eros. The painting, which was already in poor condition at the time of the eruption and barely visible when excavated and photographed in 1929, is no longer extant (Jashemski 1993: 314).

ANCIENT AUTHORS

Columella (*RR* 8.12.1) says that methods for rearing *numidae* are similar to those practiced for peacocks. Pliny (*HN* 10.74) describes the *meleagris* as "a kind of hen belonging to Africa, hump-backed and with speckled plumage," but strangely talks of its "unpleasant pungent flavor." Aelian (*NA* IV.42) relates the legend that the sisters of Meleager, mourning his death on the island of Leros, were transformed into guineafowl and continue to express their sorrow with their loud cries. He says that out of reverence for the gods, some people do not eat them.

REMARKS

Helmeted guineafowl, native to arid grasslands of sub-Saharan Africa and southernmost Arabia, are the only domesticated animal to have originated solely in Africa. Unlike other domesticated poultry there are no recognized varieties. The species is kept widely, and feral populations occur in lands with mild winters. Apparently they were reared commonly around the temple of the Maiden on Leros and were described by Clytus of Miletus, a pupil of Aristotle in the fourth century B.C. (Pollard 1977: 94), so they must have been in domestication in Greece and Rome very early.

46. *OENANTHE HISPANICA*

English, black-eared wheatear; Italian, *monachella*

WALL PAINTING

A white-breasted bird with black head, wings, and tail, most probably a male black-eared wheatear, is shown perched on the center bush, facing right, in the wall painting on the N wall of the water triclinium of the House of the Gold Bracelet (Fig. 319).

ANCIENT AUTHORS

Greek and Latin authors do not differentiate the species of wheatears, using the names οἰνάνθη and *oenanthe* for both.

REMARKS

The male black-eared wheatear, particularly in summer when its white body and black wings, tail, and mask are most pronounced, is highly conspicuous when perched on top of a bush or on an exposed low tree branch from which it sallies forth to pounce on insects

FIGURE 319 A black-eared wheatear and a song thrush. Photo: S. Jashemski.

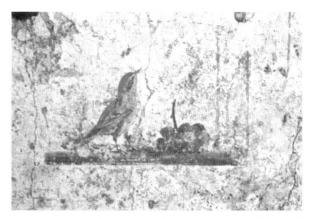

FIGURE 320 A female common wheatear and grapes. Photo: S. Jashemski.

on the ground. The brown females and juveniles hunt in the same manner. The species is only a summer visitor to southernmost Europe, where it is abundant on open and lightly wooded arid flatlands and hillsides.

47. *OENANTHE OENANTHE, SITTA EUROPAEA*

English, common wheatear; Italian, *culbianco*

WALL PAINTINGS

A faded tan female wheatear with a distinct dark eye stripe stands with a bunch of grapes on a shelf in a wall painting in Shop I.vii.5 (Fig. 320), and a gray-backed male, also with an eye stripe, and black wings and tail, is depicted in a garden painting on the N wall of the garden to the right of the doorway leading to the back garden in the *Garum* Shop (Jashemski 1979: 196, fig. 289).

MOSAIC

Tammisto (1997: 119–20; pl. 12, SS1,1a) identifies as wheatears two small birds in the upper corners of the scroll in the fish mosaic in the House of the Faun (Fig. 228). The identifications are not convincing. Even less convincing is his calling another more conspicuous bird image perched on a cup on the left side of the scroll (pl. 58, fig. SC1,4) a "green woodpecker" (*Picus viridis*). Its gray, not green, back, stout, slightly upturned beak, and dark eyestripe render it far more likely that it was intended as an Eurasian nuthatch (*Sitta europaea*) or, if the mosaic was truly based on an Asia Minor model, a rock nuthatch, *S. neumayer*.

ANCIENT AUTHORS

Aristotle (*HA* IX.633a.14), echoed by Pliny (*HN* 10.87), writes that the bird that some call οἰνάνθη (*oenanthe*) disappears "as Sirius [the dogstar] rises but appears as it is setting; for it avoids at one time the

cold and at the other the heat." The modern Italian name, *culbianco*, like the modern Greek ἀσπρόκωλος, calls attention to the bird's white rump, which is also the origin of the English "wheatear" ("white arse"), a name having nothing to do with grain or hearing.

REMARKS

The wheatear is a common fall and spring migrant in Italy where it frequents open ground with low vegetation. It hunts from low exposed perches, including stones and low bushes in pastures and harvested grain fields, but avoids heavy vegetation. In the Mediterranean, common wheatears breed only in mountain habitats except on small islands where breeding occurs near sea level. Eurasian nuthatches are common woodland denizens in Italy; rock nuthatches frequent rocky terrain from the Balkans into southeast Asia.

48. *ORIOLUS ORIOLUS*

English, golden oriole; Italian, *rigogolo*

WALL PAINTINGS

The bright yellow, black, and white male golden oriole appears in numerous Pompeian wall and garden paintings. Obviously, it was a cheery and colorful home decoration. Some depictions of streaked female orioles also are to be found. The following inventory is only a sampling.

A vivid male (Fig. 321) and a somewhat faded female above him (Jashemski 1993: 13, figs. 10 and 11) are perched near a strawberry tree on the E wall of the *diaeta* in the House of the Gold Bracelet. On the N wall of the same *diaeta* a second bright male oriole, apparently based on the same model, is perched on a viburnum to the left of the pinax above the bearded faun herm on the right (Jashemski 1993: figs. 2 and 407). A male in a

similar pose and excellent present condition was found on the S wall of the water triclinium in the same house (Jashemski archive slide 23-23-78). Another vividly depicted, although now somewhat damaged, yellow male with a distinct black wing sits in a more upright posture on an oleander on the W wall of Casa della Venere in Bikini (Jashemski 1979: 83, fig. 133; 1993: 324). A faded male oriole stands on a black background in a wall painting from the cubiculum in the Villa of Fanius Synistor at Boscoreale, now in the Metropolitan Museum of Art in New York (acc. no. 03.14.13). A male feeds on sorb apples in a wall painting in the House of Trebius Valens (Fig. 151). A streaked female is perched just below a male on the right side of a pear tree on the E panel of the S wall of the room off the peristyle in the House of the Fruit Orchard (Jashemski 1979: 263, fig. 388; 1993: 320, fig. 366). Another female is perched in a lemon tree in the middle panel above a window on the same wall (Fig. 322). Two females are in paintings on the N wall. One is perched on an outer branch on the left side of a yellow plum tree on the E panel (Jashemski 1979: 263, fig. 389; 1993: 321, fig. 368); the other is perched near the trunk of a cherry tree in the W panel (Jashemski 1979: 280, fig. 418).

ANCIENT AUTHORS

Pliny (*HN* 10.87) says that the *chlorion*, which is wholly yellow, is not seen in winter but appears at the solstice, essentially quoting Aristotle (*HA* XI.617a.28) on the χλωρίων. Later, Pliny (10.96–7) erroneously describes an oriole nest as that of "one of the woodpeckers (*picus*)," reporting it as hanging at the very end of a bough, like a ladle on a peg, where it is safe from quadruped predators. He goes on to state that the *galgulo* (= *galbula?*) "takes its sleep while hanging suspended by the feet because it hopes to be thus safer."

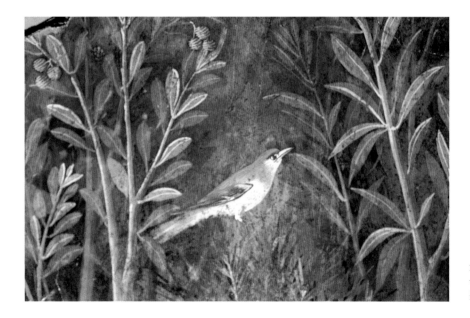

FIGURE 321 A male golden oriole with oleander and strawberry trees in fruit. Foto Fogli.

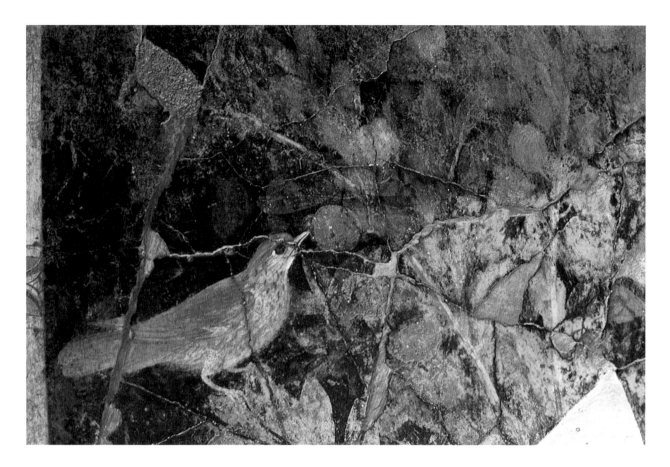

REMARKS

The golden oriole was a familiar spring and fall migrant and summer resident in ancient times in the Campanian countryside as it still is. As a fruit eater (its modern Greek name is συκοφάγος, "fig eater"), the oriole was presumably not a welcome visitor to gardens and orchards in the fall, but the male's bright colors and even the female's more subdued green and streaked plumage account for its artistic popularity. Apicius presents a recipe for cooking "fig peckers" in an asparagus patina and using it as a stuffing for suckling pig.

49. *PARUS* sp.
English, tit; Italian, *cincia*

WALL PAINTINGS

A small bird hangs upside down in characteristic titmouse posture on the E panel of the garden painting on the S wall in the House of Venus Marina (Jashemski 1979: 64, fig. 103). A possible crested tit, *cincia col ciuffo* (*Parus crestatus*), is shown as a cartoon on the W wall of the small raised garden in the Villa of Poppaea (Fig. 323).

SCULPTURE

Matteucig (1974: nos. 37, 58, 59) identifies a "probable" great tit pecking at a bunch of grapes and two other figures as "probable" blue tits on the Eumachia portal, but provides no evidence.

FIGURE 322 A female golden oriole in a lemon tree. Photo: S. Jashemski.

FIGURE 323 A caricature of a crested tit. Photo: S. Jashemski.

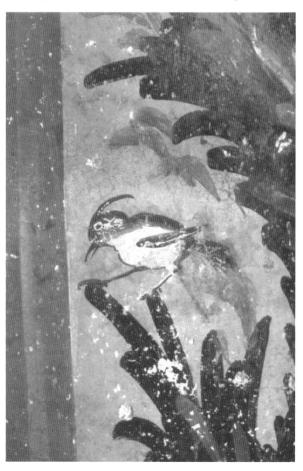

Aristotle (*HA* VIII.592b.18) recognizes three species of αἰγίθαλος, presumably the great (*Parus major*), long-tailed (*Aigithalos caudatus*), and blue (*P. caeruleus*). They are grub eaters, nest in trees, and lay remarkably large clutches of eggs. Pliny (*HN* 10.165) says that the *melanocoryphus* (the great tit) may have a brood of twenty chicks. He also uses the word *vitiparra* (*HN* 10.96) for a kind of small bird that makes a ball nest of dry moss with a hidden entrance, most probably the long-tailed tit. The name may be imitative of its *tzee-tzee-tzee* call. The word *parus* is used for the titmouse in later Latin poetry according to Andrews (1865).

REMARKS

Several species of titmouse commonly occur in a variety of deciduous and conifer habitats at various elevations in Campania. The most familiar are the great, blue, and coal tits, *P. ater.*

50. *PASSER DOMESTICUS ITALIAE*
English, house sparrow; Italian, *passero*

WALL PAINTINGS

A sparrow stands looking up at a hooded crow on the trellis in the uppermost zone of a wall painting on the S wall of the room off the atrium in the House of the Fruit Orchard (Fig. 308). Two male sparrows, one perched on the top of a planetree, the other flying above it, are in the center of an elaborate garden painting on the N wall of the *diaeta* of the House of the Gold Bracelet (Jashemski 1993: fig. 2). A sparrow and another unidentified bird to its right stand with a small lizard in a wall painting from the House of Polybius (Jashemski archive slide 14-25-72).

SCULPTURE

Matteucig (1974: no. 53) identifies what he thinks "could be" a dunnock (*Prunella modularis*, Italian, *passero scopaiolo*) on the Eumachia portal without citing evidence.

ANCIENT AUTHORS

Thompson (1936: 270) was certainly correct about Catullus's famous line (2.1), *Passer deliciae meae puellae*, in saying, "Whatever Lesbia's 'sparrow' may have been, I am pretty sure that it was not *Passer domesticus*, the most intractable and least amiable of cage birds."

Pliny (*HN* 10.111) speaks of the hopping gait of *Passer*. Pliny also notes that *passeri* are the equal of pigeons in salaciousness and have a short life span, the males lasting not longer than a year (females live longer). As evidence he cites the lack of black coloring on the bill of the males early in the spring when they are known to have turned black the previous summer (*HN* 10.107).

REMARKS

It is highly interesting that distinctive brown-crowned and white-cheeked characters have become fixed in the resident house sparrow populations of the Italian peninsula, perhaps as a result of hybridization with the migratory Spanish sparrow, *Passer hispaniolensis.* Probably originally native to the Near Eastern Fertile Crescent, the house sparrow is now a well-established and abundant commensal of man in urban and rural areas throughout its natural European, Asian, and North African range as well as in its introduced populations in America, New Zealand, and oceanic islands.

51. *PAVO CRISTATUS*
English, peafowl; Italian, *pavone*

WALL PAINTINGS

Only one image of a peacock in fully fanned erect display is depicted in extant Campanian wall paintings – in the biclinium in House I.xiii.16 (Jashemski 1993: 58, fig. 67) – but it is difficult to discern in its present damaged condition. The elaborate train of elongated upper tail coverts of the male peacock was a favorite decorative image in Campanian homes and gardens. Only one image of a peahen is to be found. Most of the peacocks in garden paintings are at or near lifesize, but images in decorative panels are much smaller. A majestic peacock is perched cross-legged on the rim of a crater-shaped fountain on the N wall of ambient 70 in the Villa of Poppaea at Oplontis (Jashemski 1979: 306, fig. 470; 1993: 377). In another garden painting in the same villa a male faces left sitting on a fence to the left of the window in the dado on the exterior wall of room 78 (Jashemski 1993: 379). A peacock, with a long drooping train, sits on a lattice fence in a painting (NM inv. no. 9760) (Jashemski archive slide 28-21-66). A striding peacock with an uptilted train and perky crest looks back over its shoulder in a framed painting with fruits on the S wall in a cubiculum to the left of the andron in the House of the Lovers (Fig. 324). A peacock that still shows traces of blue stands beside a crater fountain in a poorly preserved painting on the W wall of the House of Romulus and Remus (Jashemski 1979: 70, figs. 115, 130; 1993: 363, fig. 428 [artist's watercolor restoration]). A pair of peafowl, the left-hand one possibly a hen, face each other on the upper panel of the short exterior wall of the storeroom in the SW corner of the garden in the House of Ceius Secundus (Jashemski 1979: 69, fig. 111). Another less well preserved pair of peafowl, the male on the left with a strongly blue head and breast and the

other smaller and now almost invisible, face each other in a garden painting on the N wall of the *Garum* Shop (Jashemski archive slide 29-38-61). Two stylized decorative peacocks adorn intertwined ivy garlands in the House of L. Tiburtinus (Jashemski 1979: 269, fig. 400). A peacock with curved neck sits on a draped rope on the N wall of the cubiculum to the left of the tablinum in the House and Textrina of Minucius Fuscus (Jashemski archive slide 18-35-66).

MOSAICS

Peacocks are perched facing each other on luxurious garlands in a mosaic decoration on either side of the nymphaeum on the N wall of the small courtyard of the House of the Mosaic of Neptune and Amphitrite at Herculaneum (Fig. 245). A Roman first-century mosaic from Baiae in the FitzWilliam Museum in Cambridge (Jashemski 1979: 67, fig. 108) shows a peacock standing on a fence.

SCULPTURE

Matteucig (1974: no. 9) justifiably identifies a crested gamebird with a full tail on the Eumachia portal as a peacock.

ANCIENT AUTHORS

The *pavo* was called the most beautiful of birds by Varro (*RR* 3.6.2), Columella (*RR* 8.11.1), and Cicero (*Fin.* 3.5), and the ταώς and *pavo* were described at length by Aristotle (*HA* VI.564a.25), Pliny (*HN* 10.43–4), and Columella (*RR* 8.11). Columella (*RR*

FIGURE 324 A peacock with two dates, a fig, and a double almond above and a date and fig below. Photo: S. Jashemski.

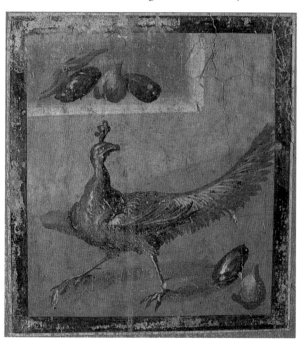

8.12.1) also discusses raising *pavonia* and Varro (*RR* 3.9) recommends incubating peafowl eggs under domestic hens. There are numerous references to peafowl as food in Roman sources (e.g., Pliny *HN* 10.45; Varro *RR* 3.6), and Apicius gives a recipe for peacock rissoles.

REMARKS

Although the peacock is native to the mountain forests of southeast Asia, Samos and its temple to Hera was regarded as the original home of the peacock in Greece. Peacocks appear on the coins of Greek islands (Samos, Kos) and cities on the Ionian mainland (Halicarnassus, Bizya, Pantalia), where it was sacred to Hera as queen of heaven because of its starry tail. It was present, although rare, in Athens at the time of the Peloponnesian Wars and was well known as a captive in Babylon (Diodorus Siculus 2.53), but it was probably introduced independently into Rome. The male birds' habit of roosting on housetops and ringing calls when surprised or disturbed make them, even today, ornamental "watchdogs." They are hardy in winter in south and central Europe and would have been free living garden birds in large homes and villas in ancient Campania.

52. *PHASIANUS COLCHICUS*

English, pheasant; Italian, *fagiano comune*

WALL PAINTINGS

When Shop-House VII.vii.10 was excavated in 1906 a wall painting was found on the right side of the triclinium in which an amorino was shown trying to ward off a pheasant attempting to peck at a bunch of grapes he held (Jashemski 1979: 187; 1993: 221). In 1874 when House I.ii.17 was excavated, the walls of the peristyle garden had garden paintings, one of which was said to show a pheasant. The paintings are no longer extant (Jashemski 1993: 313). Tammisto (1989: 241), on the other hand, states that the only pheasant so far identifiable with certainty in Romano-Campanian wall paintings is in room 15 in the Villa of Poppaea at Oplontis. He says the bird is a female but shows male "horns."

ANCIENT AUTHORS

Aristotle (*HA* V.557a.12; IX.633b.1) cites the φασιανός as a ground bird, loath to fly and fond of taking dust baths to rid itself of lice. Pliny (*HN* 10.132) says that the *phasianus*, the most celebrated bird in Colchis, "droops and raises its two feathered ears." Apicius gives a recipe for pheasant rissoles.

REMARKS

The wild pheasants that occur nearest to Europe are resident in the mountain forests of the Caucasus.

The time of introduction to Europe is unknown, but a yellow-tailed pheasant was mentioned by Aristophanes (*Birds* 69). Because they were easy to keep in captivity and because of the brilliant plumage of the male, pheasants were undoubtedly well known as cage birds in Pompeii and elsewhere in ancient Italy, although they were regarded as a rare table delicacy (Pollard 1977: 93).

53. *PHOENICOPTERUS ROSEUS*
English, flamingo; Italian, *fenicottero*

WALL PAINTINGS

A tall, slender wading bird with a crook in its neck and a down-curved bill, most probably a flamingo, is shown to the left of Orpheus's feet in two artist's copies of a wall painting that is today barely visible in the House of Orpheus (Jashemski 1993: 344–5, figs. 399 and 400).

ANCIENT AUTHORS

The only Greek author to mention the flamingo is Aristophanes, who cites it as a flame-colored marsh bird (*Birds* 273). In contrast, it was well known to Roman authors including Pliny (*HN* 10.48.68), Seneca (*Epistles* 110), Martial (13.71, 3.58), and Juvenal *Satires* (11.139). Apicius (6.6.1–2) provides recipes for both boiled and roasted flamingoes.

REMARKS

The brightly colored, if somewhat gangly, flamingo at present breeds only in the wetlands of southern France, southern Spain, and the Middle East but may occur as a fall and spring vagrant elsewhere in the Mediterranean Basin, although very rarely in Greece. In the past it may well have bred in the wetlands of northern Italy, but its large ground-nesting colonies would have been vulnerable to disturbance and exploitation when marshes were drained for agriculture or building.

54. *PHOENICURUS PHOENICURUS*
English, redstart; Italian, *codirosso*

WALL PAINTING

An accurately depicted male redstart with gray back, red breast, black face, chin, and throat, and rusty tail is shown with a pear on the W atrium wall in the House of Menander (Fig. 325).

ANCIENT AUTHORS

Aristotle (*HA* IX.632b.28) and Pliny (*HN* 10.86) both thought the φοινίκουρος (*phoenicurus*) and the ἐρίθακος (*erithacus*) were summer and winter plumage changes in the same bird.

FIGURE 325 A male redstart with pears. Photo: S. Jashemski.

REMARKS

The redstart is a common passage migrant and summer breeder in the parks, gardens, woodland edges, and open woods of Campania.

55. *PICA PICA*
English, magpie; Italian, *gazza*

WALL PAINTINGS

An extraordinarily accurate magpie stands on the trellis to the left of the pinax with the bull in the uppermost zone of a wall painting on the S wall of the room off the atrium in the House of the Fruit Orchard (Fig. 302). Another magpie is perched on the top of a planetree behind the fountain in the center of a large and elaborate garden painting on the N wall of the *diaeta* of the House of the Gold Bracelet (Jashemski 1993: fig. 2).

SKELETAL REMAINS

Two undated magpie bones and one from the first-century B.C. to first-century A.D. level were found in the forum at Pompeii (King, personal communication).

ANCIENT AUTHORS

Pliny (*HN* 10.78) describes a kind of *pica* called "checkered" that is distinguished by its long tail and "has the peculiarity of molting its tail feathers yearly at the time when the turnip is sown." Reminiscent of the modern maxim to "eat crow," Martial (3.60.7) contrasts in a satyrical epigram the food offered to a no-longer-paying guest, "*a pica* that has died in its cage," with the turtle dove fare enjoyed by the host, a *turtur* "golden with fat" and having a "bloated rump." Ovid (*Met.* 5.294ff) says that magpies "can imitate any sound they please."

REMARKS

The magpie is an abundant resident of open countryside with trees throughout Europe. Its domed nests built of sticks in low trees are conspicuous in the fall

after leaves have fallen. Its loud rattling call, striking coloration, and long tail call attention to its presence. It would have been found in or near towns with orchards and gardens.

56. *PLEGADIS FALCINELLUS*

English, glossy ibis; Italian, *mignattaio*

MOSAICS

A pair of glossy ibises are depicted in the Nile mosaic in the House of the Faun at Pompeii (Fig. 290, where only the left one is shown entirely). The inclusion of such obvious African species as mongoose, hippopotamus, cobra, crocodile, and lotus in the mosaic suggests that it was a copy of exotic inspiration rather than a reflection of flora and fauna of Italian origin. The ibis, unlike the ducks and kingfisher in the mosaic, is a species that does not now regularly occur in southern Italy except as a migrant.

SCULPTURE

Statuettes of two ibis, either this species or more probably the sacred ibis (see *Threskiornis aethiopicus*), were found in the House of M. Lucretius.

ANCIENT AUTHORS

In contrast to the sacred ibis and the bald ibis (*Geronticus eremita*), ancient authors have little to say about the relatively drab glossy ibis (Thompson 1936: 106–14, 295–7). Pliny (*HN* 10.133) talks of *Phalacrocoraces*, which are especially found in the Balearic Islands and (remarkably) in the Alps, the latter most probably a reference to the bald ibis. The all dark ἴβις of Herodotus (2.75–6), formerly thought to be the glossy, is definitely the bald ibis.

REMARKS

The glossy ibis is currently a summer visitor to the wetlands of northernmost Italy and the Balkans in eastern Europe. It winters in North Africa, being common in the wetlands of Egypt. It would have been only a rare transient in Campania.

57. *PORPHYRIO PORPHYRIO*

English, purple gallinule; Italian, *pollo sultano*

WALL PAINTINGS

The most remarkable representation in the wall paintings at Pompeii is a long-legged, plump-bodied, large-headed ground bird that is particularly well portrayed on the E wall of the garden room in the House of the Gold Bracelet (Fig. 326). The dominant body color when preserved is a dull bluish gray. The reddish

FIGURE 326 A purple gallinule. Foto Foglia.

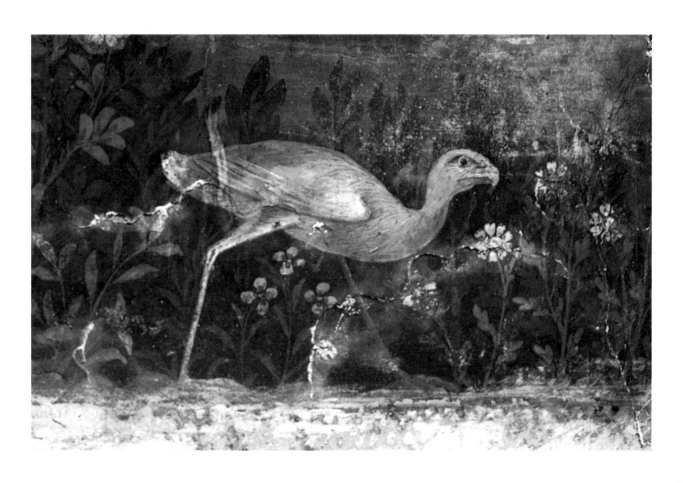

bill is shown to be hooked, suggesting that of a raptor. Although the colors are not vivid and the bill is strangely shaped, the most probable identification is that of a purple gallinule. The overall impression, based on head shape and long legs, is that of a bustard, as it was identified in Jashemski (1993: 353). The purple gallinule in this and all the other representations is in an active cursorial gait with the legs widely extended. The head is held low as if it were picking food from the ground.

The species is also pictured with various shelled seafood in the left panel of a three-part wall painting from the House of the Deer in Herculaneum (NM inv. no. 8644) (Fig. 327). Other more diagrammatic Pompeian representations are in the House of Polybius (Fig. 328); eating a pomegranate in a cubiculum to the left of the entrance in the House of the Little Fountain (Fig. 329) (Jashemski archive slide 65-19-57); in House I.vi.11; high up on the wall in the House of the Lovers; and a tall relatively slender one in a narrow dark panel in the tablinum in the House of Jucundus, but all show the same general unmistakable characters and stance. A possible purple gallinule is depicted with a recognizable but stiffly depicted partridge at a much larger scale in a garden painting in the House of Stallius Eros (Jashemski archive slide 34-30-64). Tammisto (1989: 228–9, 246) cites two additional Pompeian wall paintings of purple gallinules, in the viridaria in the House of Adonis and in the House of the Ceii. The similarity in poses and stance of all the purple gallinule depictions suggest that the artists used related model notebooks. The bird was interesting and attractive enough to be included frequently in the wall paintings.

ANCIENT AUTHORS

Aristotle (*HA* II.509a.10) remarks that "[the esophagus] is exceedingly long in long-necked birds such as the πορφμρίων and . . . the excrement is unusually moist. Pliny (*NH* 10.129) adds, "Only the *porphyrio* drinks by beakfuls; it also eats in a peculiar way of its own, continually dipping all its food in water and then using its foot as a hand with which it brings it to its beak. . . . The most admired variety of has a red beak and very long red legs."

REMARKS

The purple gallinule occurs at present in swamps, reedbeds, and other freshwater wetlands in southernmost Spain, Sardinia, Sicily, Morocco, Tunisia, Nile Egypt, and the Middle East. It feeds on a variety of invertebrates. The purple gallinule is shy where persecuted but elsewhere boldly shows itself. It is safe to assume that it has been extirpated from southern Peninsular Italy, Greece, and Turkey in the last two

FIGURE 327 A purple gallinule with fruits of the sea. Photo: S. Jashemski.

FIGURE 328 A purple gallinule and pears. Photo: S. Jashemski.

FIGURE 329 A purple gallinule eating a pomegranate. Photo: S. Jashemski.

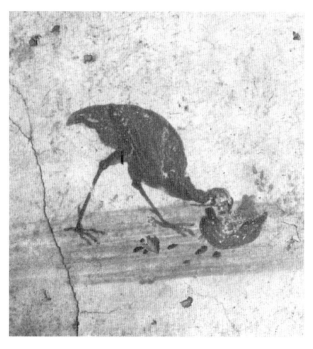

Naples Museum (inv. no. 8640); a female perched on an oleander bush in a garden painting in the room off the atrium in the House of the Fruit Orchard (Jashemski 1979: 274, fig. 408); and a still life of a pair of dead turtle doves and a bowl of olives in another wall painting (NM inv. no. 8634) (Fig. 118).

SKELETAL AND EGG REMAINS

Early excavators reported finding bones and the remains of eggs of a turtle dove on a carbonized branch of a laurel tree in lapilli in the NW corner of the large peristyle garden in the House of the Faun (*PAH* [1862] 2:253–5, for Jan–May 1832; Jashemski 1979: 105; 1993: 146). Five undated turtle dove bones were found in the forum at Pompeii (King, personal communication).

ANCIENT AUTHORS

Pliny (*HN* 10.105) comments on the drinking habits of the *turtur*, which sips continuously rather than tipping its head back after each gulp. He also states that they are migratory (*HN* 10.73) and have two broods in a season, but even if they lay three eggs, they never raise more than two squabs at a time (*HN* 10.158). Varro (*RR* 3.8) says that turtle doves migrate in huge flocks about the time of the equinox. Vergil (*Eclogues* 1.59) comments on the ceaseless moaning of the turtle dove. Apicius lists recipes for turtle dove boiled and in a patina à la Apicius. Martial (3.60.7) prefers turtle dove, served golden with fat, and asks, "When shall I have a fat turtle dove, goodbye lettuce; and keep the snails for yourself. I don't want to spoil my appetite" (13.53).

REMARKS

The turtle dove is an abundant summer visitor to open bushy habitats throughout Europe. It would have been a common inhabitant of gardens, orchards, farmland, and small woods in Campania in antiquity. Birds on migration are particularly fat.

63. *STRIX ALUCO*

English, tawny owl; Italian, *allocco*

WALL PAINTINGS

A well-preserved image of an owl is on the exterior wall of the storeroom in the House of Ceius Secundus and appears to have the dark eyes characteristic of the tawny owl (Fig. 331). It is also possible that it, like the three other owls discussed under *Athene noctua*, was a little owl whose yellow eyes were misrepresented.

MOSAIC

On the right of the scroll around the fish mosaic from the House of the Faun (NM inv. no. 9997) a

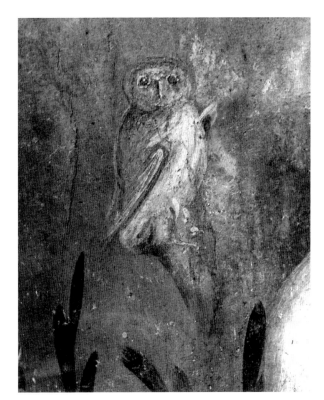

FIGURE 331 A dark-eyed tawny owl. Photo: S. Jashemski.

dark-eyed owl perched on the rim of a large bowl (Tammisto 1997: pl. 58, fig. SC1,3) may be either a tawny or a little owl.

REMARKS

Tawny owls are strictly nocturnal woodland denizens throughout Italy whose calls are heard far more often than the birds are seen. They are primarily mammal eaters.

64. *STURNUS VULGARIS*

English, starling; Italian, *storno*

SCULPTURE

Matteucig (1974: no. 50) identifies a starling on the Eumachia portal without citing his reason.

ANCIENT AUTHOR

Pliny (*HN* 10.73) says that it is a peculiarity of the *sturnus* kind that "they fly in flocks and wheel around in a sort of circular ball, all making towards the center of the flock."

REMARKS

The starling is both an urban and rural resident species in parts of Italy, nesting in holes and crevices in trees and buildings. Its numbers increase in winter, when partial migrants from the north move into more moderate Mediterranean areas.

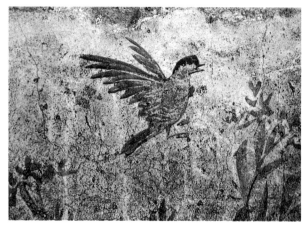

FIGURE 332 A blackcap in flight. Photo: F. Hueber.

65. *SYLVIA ATRICAPILLA, S. MELANOCEPHALA*
English, blackcap, Sardinian warbler; Italian,
capinera, occhiocotto

WALL PAINTINGS

A songbird in flight with a dark crown in the garden painting on the outside wall of room 78 in the Villa of Poppaea at Oplontis (Fig. 332) may be either a male blackcap or a Sardinian warbler (*S. melanocephala*). Another warbler picks a myrtle berry on the right behind the fountain in a painting on the rear wall in the small raised garden in the Villa of Poppaea at Oplontis (Jashemski 1979: fig. 475; 1993: 376).

SCULPTURE

Matteucig (1974: no. 40), without citing his basis, identifies a "probable" blackcap on the Eumachia portal.

ANCIENT AUTHORS

Trimalchio delighted his dinner guests by serving them fat *ficedulae* rolled up in spiced egg yolk (Petronius 33).

REMARKS

The blackcap is a year-round resident in woodland, gardens, and hedgerows in Italy. Migrants on passage from farther north are extraordinarily fat in the fall, when they are even now favored table fare. The Sardinian warbler is also an abundant year-round resident in degraded macchia and low scrub hillsides in Campania. The male's habit of singing from an exposed perch and its noisy alarm call would have rendered it a familiar songbird to townspeople as well as country folk.

65. *TADORNA TADORNA*
English, shelduck; Italian, *volpoca*

MOSAICS

Shelducks are depicted with mallards (*Anas platyrhynchos*) in the Nile mosaic in the House of the Faun at Pompeii (Tammisto 1997: pl. 22). A sheldrake sits with a drake teal, fish, four songbirds, and mollusk shells in another mosaic from the right ala of the House of the Faun (NM inv. no. 9993) (Fig. 236).

ANCIENT AUTHORS

Pliny (*HN* 10.22.29.56) speaks of *chenalopeces*, identified as shelducks by Pollard.

REMARKS

Although shelducks winter in southern Italy, they are shown in this mosaic as part of the exotic Nile fauna.

66. *TETRAO UROGALLUS*
English, capercaille; Italian, *gallo cedrone*

WALL PAINTING

A large game bird standing to the right of the sleeping faun in the right panel of a wall painting on the N garden wall in the House of Adonis (Jashemski 1979: 66, fig. 107; 1993: 341) (Jashemski archive slides 24-15-66, 24-11-68) has been reidentified by Tammisto (1989) as probably a somewhat erroneously depicted male capercaille. He had earlier (1985) thought it to be a pheasant.

MOSAIC

A round-bodied bird with a fanned tail that is portrayed in a floor mosaic in the atrium of the House of P. Paquius Proculus (House of C. Cuspius Pansa) has been identified as a capercaille cock by Tammisto (1989; 1997: 98, pl. 48, no. 22).

ANCIENT AUTHORS

Pliny (*HN* 10.56) notes that there is a dark-colored kind of *tetrao* in the Alps and northern regions that is larger than the vultures, so large that it may at times not be able to fly, probably a reference to the cock's tameness on the display grounds. He adds that they lose their flavor in an aviary and are difficult to keep alive.

REMARKS

The capercaille, a mountain evergreen forest inhabitant, no longer occurs in peninsular Italy, if it ever did. Its conspicuous size, color, and striking display, however, would have made it a challenging candidate for aviary display in Pompeii.

67. *THRESKIORNIS AETHIOPICUS*
English, sacred ibis; Italian, *ibis sacro*

WALL PAINTINGS

An unmistakable wall painting of a single sacred ibis with a lotus flower at the top of the head and an ear of wheat in its beak was in the W wall of the smaller of the two rooms at the W end of the sanctuary of the Temple of Isis (Fig. 333). Three ibises are shown in an Isis ceremony painting found at Herculaneum and now in the Naples Museum (Jashemski 1979: 218); two ibises stand in front of the altar and another is perched on a wall to the right. A pair of ibises flank the altar in the foreground of a painting that depicts an afternoon Isis ceremony (not figured, but mentioned in Jashemski 1979: 137).

SCULPTURE

Two half-size white marble and bronze figures of sacred ibis found in Pompeii, possibly from the Temple of Isis (NM inv. nos. 765, 766) are marvelously naturalistic (Ward-Perkins and Claridge, 1976). Matteucig (1974: nos. 25, 32, 91) identifies as "very probably"

FIGURE 333 A sacred ibis holding a sheaf of wheat (NM inv. no. 8562). Photo: S. Jashemski.

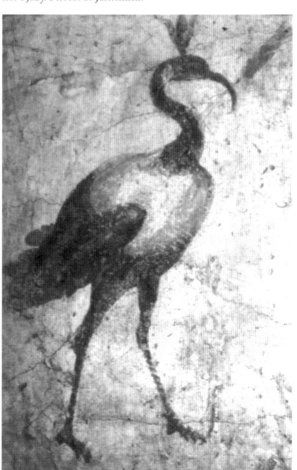

ibises three birds with long curved bills capturing snakes on the Eumachia portal.

ANCIENT AUTHORS

Thompson thoroughly discusses the three species of ibis that figured in classical literature (Herodotus 2.75–6; Aristotle *HA* VIII. 617b.29) and in Egyptian art and hieroglyphics. There were separate glyphs for sacred, glossy, and bald ibis (*Geronticus eremita*). Although Pliny (*HN* 10(30).45) was aware of all three species, only the sacred and glossy were depicted in Campanian art.

REMARKS

The sacred ibis is an African species of symbolic religious significance in Egypt. It is not known to occur in Europe, and thus its accurate depiction indicates either that the artist or his model came from North Africa. In fact, it no longer occurs in lower Egypt, but it still breeds in Sudan and sub-Saharan Africa.

69. *TROGLODYTES TROGLODYTES*
English, wren; Italian, *scricciolo*

SCULPTURE

Matteucig (1974: no. 48) says a chunky small bird with turned-up tail on the Eumachia portal "could be" a wren. The only other, unlikely possibility is the thrush-sized aquatic dipper (*Cinclus cinclus,* Italian, *merlo acquaiolo*), which is restricted to swift-flowing mountain streams.

ANCIENT AUTHOR

Pollard (1977) cites an accurate ancient description by Philagrius Medicus quoted by Aetius (XI.11) that it is "almost the smallest of all birds . . . always has an erect tail and is lightly spotted with white behind. . . . It is more noisy than the kinglet [and] undertakes only short flights, but its physical strength is remarkable."

REMARKS

The wren is a year-round resident in gardens, thickets, woods, and mountainsides with low cover. It is more common in winter in southern Europe when its numbers are augmented by partial migrants from the north.

68. *TURDUS MERULA*
English, blackbird; Italian, *merlo*

WALL PAINTINGS

A realistically rendered subadult blackbird is shown eating the fruit of a strawberry tree in a wall painting

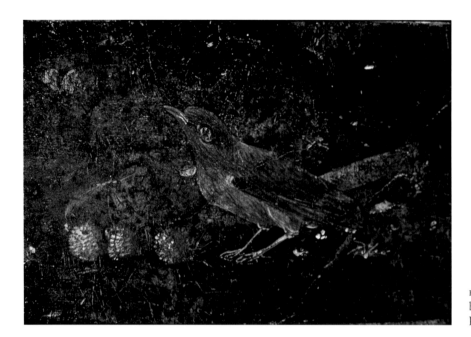

FIGURE 334 A blackbird with straw-berry tree fruit (NM inv. no. 9733). Photo: S. Jashemski.

(NM inv. no. 9733) (Fig. 334). Another blackbird is perched on top of a bush on the left in the middle panel on the S wall of the water triclinium in the House of the Gold Bracelet (Jashemski 1993: 358). A blackbird (with winter dark bill) is perched on the left handle of an urn on the trellis in the uppermost zone of a wall painting on the S wall above a window in the room off the atrium in the House of the Fruit Orchard (Jashemski 1979: 106, fig. 171). Another partly damaged blackbird sits facing left on a planetree behind the fountain on the S wall of the garden room (Jashemski 1993: 356, fig. 418). A blackbird looking over its shoulder is perched on the right on the top of a small bush in a panel to the E of the bay window in courtyard garden 87 of the Villa of Poppaea at Oplontis (Jashemski 1993: 378, fig. 446, bird only partly visible at top).

SCULPTURE

Matteucig (1974) identifies a figure (no. 3) on the lower left side of the Eumachia portal as probably an adult blackbird on the basis of size, morphology, and posture and one just above it (no. 4) as a young black-bird.

ANCIENT AUTHORS

Pliny (*HN* 10.80) shows remarkable insight into plumage succession and seasonal behavior change in the blackbird. "There is another remarkable fact about song-birds; they usually change their color and note with the season and suddenly become different. . . . The blackbird changes from black to red; and it sings in summer, and chirps in winter, but at mid summer is silent; also the beak of the yearling blackbirds, at all events the cocks, is turned to ivory color." He also

alludes to their migrations and local movements (*HN* 10.22).

REMARKS

The blackbird is a common year-round resident of gardens, parks, farmland, and woods in southern Italy, where its numbers in winter are probably augmented by northern European migrants.

69. *TURDUS PHILOMELOS*
English, song thrush; Italian, *tordo*

WALL PAINTINGS

A song thrush is perched on a small pine to the left of the Mars statue and above the heron on the E panel of the wall in the peristyle garden wall in the House of Venus Marina (Fig. 300). Another song thrush is in flight to the right of a mulberry bush in a garden paint-ing on the outside S wall of a small room that extends in the SE corner of the garden in the same house (Jashemski 1979: 65, fig. 105; 1993: 331). A third with wings spread is perched on the top of, or flying just above, a tall strawberry tree on the S wall of the water triclinium in the House of the Gold Bracelet (Jashem-ski 1979: 86, fig. 141) (Fig. 335). A fourth sits with a black-eared wheatear on top of a bush on the right of the water triclinium in the House of the Gold Bracelet (Fig. 319). A thrush flies toward a fountain on which a peacock stands in a wall painting on the S wall of the S courtyard garden (68) of the Villa of Poppaea at Oplontis (Jashemski 1979: 307, fig. 470; 1993: 376). Four thrushes with prominent eye stripes hang by their bills in a still life painting from the House of the Moralist (NM no inv. no.) (Mastroroberto 1990: 13). The eye

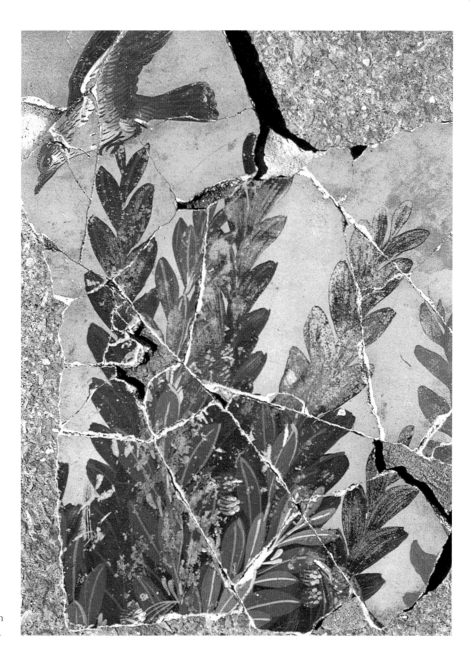

FIGURE 335 A song thrush alighting on a strawberry tree. Photo: S. Jashemski.

stripe suggests that they may be redwings (*T. iliacus*) Italian, *tordo sassello* rather than song thrushes. Three thrushes lie on their backs in the right panel of a wall painting from the House of the Deer in Herculaneum (NM inv. no. 8647) (Fig. 111) that also includes a hanging partridge on the left.

ANCIENT AUTHORS

Pliny (*HN* 10.80) describes *turdus* as "of a speckled color round the neck during the summer, but self colored during the winter." Columella (*RR* 8.10.1) discusses methods for rearing captive thrushes, and Apicius gives recipes for using thrushes in a mold of peas (5.3.1) and in a stuffing for suckling pig (8.7.14). Petronius (40), in a passage reminiscent of the king's four and twenty blackbirds, pictures a big bearded man at the cena plunging his hunting knife into the side of a roasted boar and thereby releasing a number of thrushes. They fluttered around the dining room until caught by fowlers with bird lime, who were ordered by Trimalchio to distribute them to the diners. "Now you see what fine acorns the woodland boar has been eating," he remarked.

REMARKS

The song thrush breeds in northern Italy at present but is an abundant migrant in fall and winter in the south. It frequents gardens, parks, farmland, and open woods. The larger mistle thrush, *T. viscivorus,* and fieldfare, *T. pilaris,* and the smaller redwing, *T. iliacus,* are similar in having spotted breasts and were probably not differentiated in ancient times. The resident mistle thrush breeds in mountain forests in Italy; the fieldfare and redwing are winter visitors.

REFERENCES

Andrews, E. A. 1865. *Copious and Critical Latin-English Lexicon.* Harper & Brothers, New York.

Anonymous. 1789–1808. *Gli Ornati delle Pareti ed i Pavimenta delle Stanze del'Antica Pompei Incisi i Rame.* 3 vols. Stamperia Regale, Naples.

Brilliant, Richard. 1979. *Pompeii A.D. 79: The Treasury of Rediscovery.* Clarkson N. Potter, New York.

Cerulli Irelli, Giuseppina, Masanori Aoyagi, Stefano De Caro, and Umberto Pappalardo. 1993. *La Peinture de Pompéi, Témoignages de l'Art Romain dans la Zone Ensevelie par la Vésuve en 79 ap. J.-C.* 2 vols. Hanzan, Paris.

Ciarallo, Annamaria, and Ernesto De Carolis. 1999. *Homo Faber: Natura Scienza e Tecnica nell'Antica Pompei.* Electa, Milan.

Cramp, Stanley et al., eds. 1977–94. *Handbook of the Birds of Europe, the Middle East and North Africa: The Birds of the Western Palearctic.* 9 vols. Oxford University Press, Oxford, London, and New York.

De Caro, Stefano. 1999. *Still Lifes from Pompeii. Guide to the Exhibition.* Soprintendenza Archeologica di Napoli e Caserta, Naples.

Franchi dell'Orto, Luisa, and Antonio Varone, eds. 1990. Catalogue. In *Rediscovering Pompeii*, pp. 129–283. L'Erma di Breitschneider, Rome. Entries by Marisa Conticello de' Spagnolis, 69. Triple lamp and 70. Lamp: 181–3 , figs. 69, 70; Anna Maria Sodo, 88. Serving dish in the form of a shell (*askos*): 189–91, fig. 88; and Annamaria Ciarallo and Lello Capaldo, 163. Room (*oecus*) with Garden Paintings: 227–39, figs. 163 (multiple).

Jashemski, Wilhemina F. 1979. *The Gardens of Pompeii, Herculaneum and the Villas Destroyed by Vesuvius.* Vol. 1. Caratzas Brothers, New Rochelle, N.Y.

1993. *The Gardens of Pompeii, Herculaneum and the Villas Destroyed by Vesuvius.* Vol. 2, Appendices. Aristide Caratzas, New Rochelle, N.Y.

Johnson, Lee R. 1968. Aviaries and Aviculture in Ancient Rome. Ph.D. dissertation, University of Maryland, College Park.

1971. "Birds for Pleasure and Entertainment in Ancient Rome." *Maryland Historian* 2: 76–92.

Keller, Otto. 1909–13. *Die Antike Tierwel.* 2 vols. Willhelm Engelmann, Leipzig.

Kenner, Hedwig. 1970. *Das phänomen der verkehrten Welt in der griechesch-römiscewhen Antike.* Klangenfurt, Bonn.

Mastroroberto, Marisa. 1990. "Uomo e ambiente nel territorio." In *Antiquarium di Boscoreale, Uomo e Ambiente nel Territorio,* p. 13. Soprintendenza Archeologica di Pompei, Boscoreale.

Matteucig, Giorgio. 1974. "Lo studio naturalistico zoologico del Portale di Eumachia ne Foro Pompeiano." *Bollettino della Società dei Naturalisti in Napoli* 83: 213–42.

Pollard, John. 1977. *Birds in Greek Life and Myth.* Thames and Hudson, New York.

Tammisto, Antero. 1985. "Representations of the Kingfisher (*Alcedo atthis*) in Graeco-Roman art." *Arctos* 19: 217–42.

1986. "Phoenix Felix et Tu: Remarks on the Representation of the Phoenix in Roman Art." *Arctos* 20: 171–225.

1989. "The Representations of the Capercaille (*Tetrao urogallus*) and the Pheasant (*Phasianus colchicus*) in Romano-Campanian Wall Paintings and Mosaics." *Arctos* 23: 223–49.

1997. "Birds in Mosaics: A Study on the Representations of Birds in Hellenistic and Roman-Campanian Tessellated Mosaics to the Early Augustan Age." *Acta Instituti Romani Finlandiae*, Vol. 18.

Thompson, D'Arcy W. 1895. *A Glossary of Greek Birds.* Clarendon Press, Oxford.

1936. *A Glossary of Greek Birds*, 2nd ed. Oxford University Press, London and Oxford (reprinted in 1966 by Georg Olms, Hildesheim, Germany).

Toynbee, Jocelyn M. C. 1973. *Animals in Roman Life and Art.* Cornell University Press, Ithaca, N.Y.

Ward-Perkins, John, and Amanda Claridge. 1976. *Pompeii A.D. 79.* Carlton Cleve, Ltd., London.

Wood-Gush, David G. M. 1985. "Domestication." In *A New Dictionary of Birds,* edited by Bruce Campbell and Elizabeth Lack, pp. 152–4. Buteo Books, Vermillion, S.D., and T. & A. D. Poyser, Calton, England.

17

MAMMALS

EVIDENCE FROM WALL PAINTINGS, SCULPTURE, MOSAICS, FAUNAL REMAINS, AND ANCIENT LITERARY SOURCES

Anthony King

There has been little previous scholarly work devoted specifically to the mammals of the Vesuvian sites. A detailed treatment of Pompeian dogs, both skeletal remains and artistic evidence, was undertaken by Giordano and Pelagalli (1957). Matteucig (1974a; 1974b) made a preliminary list of mammal species from Pompeii as seen in the artistic representations, but his work, unfortunately, is undetailed and consequently not easily verified. To this very brief list can be added those monographs that focus on specific species in the ancient world, notably on horses (Vigneron 1968), apes (McDermott 1938) and elephants (Scullard 1974). These contain all the significant evidence from the Vesuvian sites concerning their subjects. General works on Roman farming (White 1970), artistic representations of Roman animals (Toynbee 1973), and animals in the ancient world (Keller 1963) contain much evidence pertaining to the Vesuvian sites.

Much new evidence is now available, mainly faunal remains from recent excavations, but also surveys and exhibitions of paintings, mosaics, and other media that contain previously unpublished representations of mammals. This survey and catalogue attempt to bring this material together in a systematic fashion.

THE NATURE OF THE EVIDENCE

Evidence for mammals from Pompeii and other Bay of Naples sites can be divided into three major categories: archaeological evidence such as bones, plaster, or resin casts and artifacts; depictions in sculpture, on frescoes, and in mosaics; and last, written evidence, sometimes directly relevant to the area (e.g., inscriptions, graffiti) but more usually general accounts by writers such as Pliny the Elder. Each of these categories yields perspectives on the subject matter that differ in important respects and have significant areas of bias.

Mammal bones survive in profusion in the rubbish dumps and occupation layers of the Bay of Naples sites but have usually been ignored or discarded by excavators. It has been estimated that about 20 million bones are buried within the Pompeii town zone, on the basis of the density of finds made in the forum excavations of 1981 (King, unpublished). This may be misleading, however, since excavations in various houses have yielded only modest assemblages, and it has been suggested that there was organized rubbish disposal within the town (Ciaraldi and Richardson 2000: 79). This suggestion finds some confirmation in the large dump of detritus outside the walls by the Porta Capua (Watanabe 1996).

Three groups of bones have been published: from the gardens of Pompeii and surrounding villas, identified by H. Setzer (Jashemski 1979; 1993; 1994); from early levels under the House of Amarantus (I.ix.11–12; Clark 1999; Powell 1999); and from the House of Ganymede (VII.xiii.4; Kokabi 1982). The first is a relatively small assemblage but an important one since the material derives from A.D. 79 deposits and appears to reflect in situ bone disposal at the time of the volcanic eruption. The published bones from the House of Amarantus all come from early contexts (including ritual deposits), dating mainly from the fourth to the first century B.C. The later material from this site, up to A.D. 79, has not yet been fully published (cf. Fulford and Wallace-Hadrill 1998). The bones from the House of Ganymede mainly derive from sixth-century B.C. to mid-first-century A.D. pits in the rear part of the house and seem to represent a domestic assemblage. The

main unpublished assemblage (King, unpublished) is a much bigger group from archaeological contexts predating the eruption, excavated in and around the forum area of Pompeii (Arthur 1986). The material dates from the sixth century B.C. to the mid-first century A.D., with the majority coming from forum and temple deposits of the second century B.C. to first century A.D. These bone assemblages complement each other very well. Other recent excavations in the House of the Vestals (VI.i.7) and the House of the Wedding of Hercules (VII.ix.47; Richardson 1995; Richardson, Thompson, and Genovese 1997; Ciaraldi and Richardson 2000) and on the site of the Capua gateway (Watanabe 1996) have revealed stratified bone deposits that are currently being analyzed.

To this class of material can be added the miscellaneous finds, usually of complete animal skeletons recovered during nineteenth- and twentieth-century excavations at the Vesuvian sites. Notable among these are the equid and canid skeletons from various locations in Pompeii (Richardson 1995; Richardson et al. 1997), and the recent find of a horse in association with the human remains from the waterfront site at Herculaneum. For such finds see this chapter's catalogue, nos. 5, 7, and 19.

Artifacts associated with mammals range from the highly specific, such as the jars used for fattening dormice, to more generalized objects such as hobbles for large animals. There are also structures such as stalls for cattle and equids within buildings.

One of the major problems inherent in the archaeological evidence is that of preservation. The material that survives today presents a partial view of the species at the Vesuvian sites and distorts their original quantitative representation. At its most graphic, this is the case with those animals that suffered asphyxiation and death as a result of the eruption of A.D. 79. This death assemblage is a highly specialized one, consisting only of those animals that could not escape, or were unwilling to do so. Much domestic stock was probably left behind in the apparent rush to evacuate towns and villas, as Pliny's account leads us to believe occurred. There is a lack of reported remains of small mammals, apart from in the gardens assemblage. Large mammals, birds, and so on, probably could and did escape, but many species such as hedgehogs, mice, and voles would seek the nearest shelter under vegetation or structures and thus perish. The lack of remains of these species may simply be that they have been overlooked by excavators, rather than that they are not there. In this respect, the bones from the gardens are significant, in that they include small mammal species such as dormice, which presumably were in the gardens at the time.

The assemblage from pre-eruption levels is of a different nature, in that it is largely anthropomorphic in origin. Most of the bones would have been waste from food preparation or consumption, while others would have resulted from bone and antler working, hide preparation, and other industrial processes such as glue and grease making. The nature of these activities would expect us to think that the majority of bones are likely to be found beyond the domestic confines of the towns. However, it is clear from excavations in the forum that considerable deposits of bones were allowed to accumulate, and indeed may have been deliberately included as makeup levels during building operations.

Another element in the nature of the bone assemblage is the effect of religious sites such as temple precincts. The forum excavations of 1980–1 included the early precinct of the Temple of Apollo before the expansion of the forum reduced its area in the second century B.C. (Arthur 1986: 34–5). Within the precinct were deposits of bones resulting from sacrifices and other votive offerings. These were left in *favissae* and must have been a noisome feature of temple activity, since rats (and doubtless other vermin) were present among the bones.

The complete species list from excavated material is given in Table 23. Apart from the expected range of domestic species, a variety of hunted prey has been found – red deer, roe deer, hare – in very small quantities compared with the former. In terms of diet at least, hunted animals made little impact. Their cultural significance may of course have been greater than their purely numerical representation, especially in view of the popularity of the hunt in pictorial representations.

The wonderfully preserved depictions, principally on wall paintings (Fig. 336), of land mammals from the Vesuvian sites at first sight gives the impression of a reasonably lucid source of evidence for their conformation, color, and so on. This impression is justified in many instances by the high quality of the depictions. Many animals, even quite exotic ones such as lions, are shown in good anatomical detail and were almost certainly drawn from direct observation (Andreae 1990: 95–6; Dubois 1999: 56–7), as the painter Pasiteles was reputed to have done (Pliny *HN* 36.40).

Beyond the issue of the veracity of the depictions, however, lies a host of problems. The paintings, mosaics, and sculpture rarely show common or domestic species. The circumstances in which such animals are shown are usually in specific genre scenes, such as bulls in *venatio* (hunting) scenes, dogs in *vestibulum* mosaics, or goats in sacro-idyllic landscapes. There is also stylization of the animals, which occurs principally in scenes of third and fourth styles, or as minor decorative elements such as religious attributes (e.g., "pan-

Table 23. Classes of evidence for mammal species identified at the Vesuvian sites.

Name	Catalogue No.	Faunal Rems	Sculpt.	Ptg	Mos.	Graff./Ins.
Hedgehog *Erinaceus europaeus*	20	X				
Mole *Talpa* sp.	47	X				
Bat *Pipistrellus pipistrellus* and *Vespertilio* sp.	43	X				
Rabbit *Oryctolagus cuniculus*	37	X	X	X		
Hare *Lepus europaeus*	29	X	X	X		
Garden dormouse *Eliomys quercinus*	15	X	X			
Edible dormouse *Glis glis*	26	X	?			
Hazel dormouse *Muscardinus avellanarius*	34	X				
Common vole *Microtus arvalis*	33		?			
Savi's pine vole *Pitymys savii*	44	X				
Water vole *Arvicola terrestris*	4	X				
Black rat *Rattus rattus*	45	X		?		
Wood mouse *Apodemus sylvaticus*	3	X	X			
House mouse *Mus musculus*	35	X				
Algerian mouse *M. spretus*	35	?				
Barbary ape and baboon *Macaca sylvana; Papio* sp.	31	X	X	X		
Brown bear *Ursus arctos*	48	X		X	X	X
Jackal *Canis aureus*	6			X		
Wolf *C. lupus*	8		X	X		
Dog *C. familiaris*	7	X	X	X	X	X
Fox *Vulpes vulpes*	49		?	X		
Stoat *Mustela erminea*	36	?				
Weasel *M. nivalis*	36	X		?		
Pine marten *Martes martes*	32	X				
Mongoose *Herpestes ichneumon*	27		X	X		
Lion *Panthera leo*	40		X	X	X	X
Leopard *P. pardus*	41		X	X	X	
Tiger *P. tigris*	42		X	X	X	
Cheetah *Acinomyx jubatus*	1			X		
Lynx *Felis lynx*	22				X	
Wild cat *F. sylvestris*	23				?	
Cat *F. catus*	21	X		X	X	
African elephant *Loxodonta africana*	30	X	X	X	X	
Indian elephant *Elephas maximus*	30			X		
Horse *Equus caballus*	19	X	X	X	X	X
Wild ass and onager *E. africanus; E. hemionus*	16			?		
Donkey *E. asinus*	17	X	X	X	X	
Mule *E. asinus x caballus*	18	X	X	X		
Black rhinoceros *Diceros bicornis*	14		X			
Wild boar *Sus scrofa*	46	X	X	X	X	X
Pig *S. domesticus*	46	X	X	X		
Hippopotamus *Hippopotamus amphibius*	28			X	X	
Roe deer *Capreolus capreolus*	10	X		X		
Fallow deer *Cervus dama*	11		?	?		
Red deer *C. elaphus*	12	X	X	X	X	X
Elk *Alces alces*	2		?			
Giraffe *Giraffa camelopardalis*	25		?			
Ox *Bos taurus*	5	X	X	X		X
Dorcas gazelle *Gazella dorcas*	24		X	X		
Oryx *Oryx gazella*	38			X		
Goat *Capra hircus*	9	X	X	X	X	
Sheep *Ovis aries*	39	X	X	X	X	X
Dolphin *Delphinus delphis*	13		X	X	X	

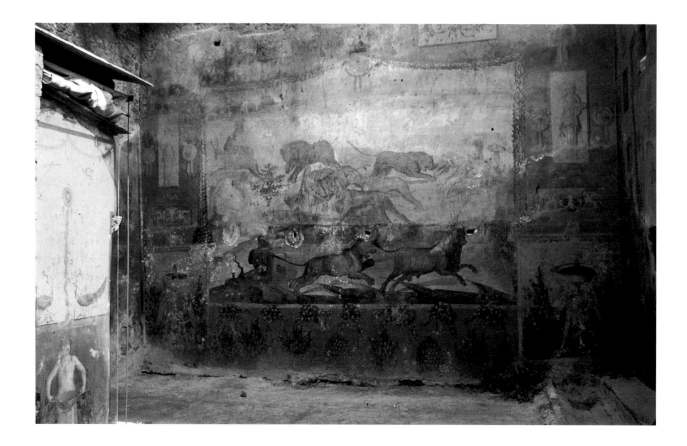

FIGURE 336 A fine example of a *venatio* painting, or *paradeisos*, garden of the House of the Ceii, Pompeii. Mammals depicted include bull, lion, boar, leopard, red deer, ram, and hunting dog. Photo: S. Jashemski.

thers" linked with Dionysus). Even if the anatomical details seem correct, the clear stylization of the humans and the natural scenery gives rise to caution in using paintings as a detailed source for the size or relative proportions (e.g., of limb to body) of those animals depicted. Some of the most realistic renderings of plants and animals are in the garden paintings, which for the most part do not show mammals but do depict birds, which often appear in the foliage.

Venatio scenes pose a particular problem for the natural historian of Pompeii, since it is clear that the species depicted were not native to the region. Table 23 includes a range of exotic animals, such as lions, leopards (the so-called *bestiae africanae*), gazelle, oryx, and onager from North Africa (Bertrandy 1987); species from the Nile (hippopotamus, mongoose); and others from various locations (elephant, tiger, bear, wolf, fox). Some of course may have been found in the mountains inland from Campania (e.g., bear, wolf) or indeed closer at hand (fox), but it must have been the case that the artists depicting these and the foreign animals, apparently from life, saw them either in the amphitheater or in wild animal parks designed to hold these beasts before the fight.

Various interpretations have been made of the pan-

els depicting large mammals attacking prey, the subject matter of which is given in Table 24 (Andreae 1990: 101–14). The scenes have been considered to be Roman versions of the Greek (ultimately Near Eastern) *paradeisoi* (hunting parks) as described by Xenophon (*Anabasis* 1.2.7) and Curtius Rufus (8.1.11), but the lack of humans included in the "hunt" seems to favor an alternative interpretation, that they show animals fighting in the arena. Virtually all the known *venatio* scenes are late in date, that is, just prior to the eruption, and have been linked by Andreae (1990: 108–10, 113–14) to the now destroyed depictions of fighting and chasing animals that decorated the arena wall in the amphitheater. Records of the paintings show a strong stylistic and thematic link between them and the scenes in domestic contexts in Pompeii, and it may have become fashionable after the reopening of the amphitheater to have had such genre scenes in houses and their gardens. If this is the case, the species shown probably once performed in the arena, and it may be that bones of some of them will eventually be found.

The last source of evidence for mammals is also the smallest in terms of its direct relevance to the Vesuvian sites. Written references to animals in inscriptions and graffiti from these sites are very rare.

More important are ancient literary sources. These do not usually refer specifically to the fauna of the Bay of Naples region, but their observations are nevertheless highly significant for our understanding of

Table 24. Mammal species in venatio *paintings (after Andreae 1990).*

Catalogue No. and Name	Definite (X)/Possible (?)
48. *Ursus arctos*, Brown bear	X
8. *Canis lupus*, Wolf	X
7. *Canis familiaris*, Dog	X
49. *Vulpes vulpes*, Fox	?
40. *Panthera leo*, Lion	X
41. *Panthera pardus*, Leopard	X
30. *Loxodonta africana*, African elephant	X
19. *Equus caballus*, Horse	X
16. *Equus africanus*, Wild ass and *E. hemionus*, Onager	?
46. *Sus scrofa*, Wild boar	X
11. *Cervus dama*, Fallow deer	?
12. *Cervus elaphus*, Red deer	X
5. *Bos taurus*, Ox	X
24. *Gazella dorcas*, Dorcas gazelle	X
38. *Oryx gazella*, Oryx	X
39. *Ovis aries*, Sheep	X

human/animal relationships at the time. Probably the best source is Pliny's *Natural History*, Book 8 of which deals with land animals, with detailed and interesting observations on elephants, lions, camels, dogs, horses, sheep, and other species. His discussion, however, is not systematic or comprehensive, and it is clear that many of his observations were of exotic animals viewed in the amphitheater or in vivaria. In this, his experience was probably typical of many Romans and demonstrates how far the amphitheater went in being a formative influence in most people's knowledge of and attitude toward large mammals (cf. Toynbee 1973: 15–23). Pliny himself was not from Campania, and his most accurate descriptions of wild native fauna are concerned with the sub-Alpine region of northern Italy (Bodson 1986). Ultimately, Pliny's work and other Roman philosophical writings on animals, such as Plutarch's *De Sollertia Animalium* (Barigazzi 1992), owe much to Aristotle's classification of animals in his *Historia Animalium* (French 1994: chaps. 4–5).

The other main writers on animals are listed by Jocelyn Toynbee (1973: 23), of which two specific groups can be singled out here. Agricultural writers, chiefly Columella and Varro, have many detailed observations on the raising of domestic livestock. Descriptions of breeds of oxen, sheep, and pigs are given, together with discussions of husbandry practices and the economics of keeping animals for profit (cf. White 1970; Day 1932). Apicius gives a wide variety of often quite complex and exotic dishes that would have been prepared for the Roman aristocracy. The general range of the recipes was probably seen in simpler form in the triclinia of the towns and villas of the Bay of Naples.

The most graphic description of an actual meal, albeit a fictional one, is in Petronius's *Satyricon*, and it is easy to imagine a personage like Trimalchio reclining for a banquet in a large Pompeian house, being served such theatrical dishes as a whole female wild boar laid on its side, with piglets made of marzipan arranged as if suckling. To complete the spectacle, "a large bearded man . . . drew a hunting knife and plunged it into the boar's side. A number of thrushes flew out at the blow. As they fluttered round the dining room, there were fowlers ready with limed twigs who caught them in an instant. . ." (*Satyricon* 40). Other meal descriptions, usually in a satirical vein, are given by Horace (*Satires* II.8) and Juvenal (*Satires* 5.80). Meat and fish predominate over vegetables at these feasts, and it seems to have been a sign of status to have a many-coursed dinner consisting largely of cooked animal products in great variety and profusion (cf. Dosi and Schnell 1984; Salza Prina Ricotti 1988). Another feature, redolent of snobbery and status, is the reference by some hosts to the life histories of the animals served up in their dishes (Horace *Satires* II.8), since this implies that the animals were kept in a vivarium or aviary as a private food supply. Wild mammals, mainly boar and hare, feature prominently in these banquets, in contrast to the evidence from the osteological remains, in which these species are quite rare. This must indicate how rarely such banquets took place and their confinement to a small, wealthy sector of the population.

MAMMAL BONES FROM CAMPANIA: A COMPARISON WITH EARLIER AND LATER SITES

The usual perspective on the Vesuvian sites is one with a very narrow time frame – the moment of the eruption of the volcano in A.D. 79. As discussed earlier, the mammal bone assemblage from this event is not the same as the normal domestically derived groups of bones from general excavation contexts. Any investigation of animal husbandry and the human meat diet is best based on assemblages other than those actually buried by volcanic debris.

It is possible, in fact, to take a much wider chronological perspective by examining bone assemblages from a number of excavations in Campania. Naples in particular has been the focus of a number of excavations that allow us to analyze osteological material of later date. This can be coupled with the bones from the earlier stratigraphy uncovered in the Pompeii forum excavations, to give a 1,500-year survey of bone assemblages, which can provide us with a valuable long-term view of changes in diet and agriculture (Table 25; Fig. 337).

Table 25. Ox, sheep/goat, and pig bone percentages from Campanian excavations (from King 1994: table 51).

Site/Phase	Date	Ox%	Sh/Gt%	Pig%	No. in sample
Pompeii, Forum	C6 B.C.	27.9	30.2	41.2	86
Pompeii, Forum	C4/3 B.C.	47.1	18.2	34.7	478
Pompeii, Forum	C2 B.C.	15.6	18.8	65.6	32
Pompeii, Forum	C2/1 B.C.	2.5	32.5	65.0	80
Pompeii, Forum	C1 B.C.	11.1	38.6	50.4	415
Pompeii, Forum	C1 B.C./C1 A.D.	14.0	20.0	66.0	1478
Pompeii, Forum	C1 A.D.	10.6	27.1	62.4	502
Pompeii, Forum	C4 B.C./C1 A.D.	15.3	29.2	55.6	2730
Naples, S. Sofia	C1 A.D.	21.7	26.1	52.2	46
Naples, Carminiello II	C1 B.C./C1 A.D.	5.5	39.7	54.8	73
Naples, Carminiello III	C1 A.D.	5.8	23.4	70.8	137
Naples, Carminiello IV	C2/3 A.D.	1.9	34.0	64.1	103
Capua	C2/5 A.D.	9.5	23.8	66.7	84
Naples, Girolomini	C4 A.D.	6.9	38.6	54.5	765
Naples, Carminiello VI	C5 A.D.	5.7	33.3	61.6	159
Naples, Carminiello VII	C5/6 A.D.	8.9	56.3	34.8	1928
Naples, S. Maria	C6 A.D.	10.0	27.1	62.9	70
Naples, Carminiello VIII	C6/7 A.D.	8.5	49.8	41.7	1646
Naples, S. Patrizia c.	C8 A.D.	8.7	55.1	36.2	69

Three main phases can be detected. The first runs from the sixth century B.C. to the mid-Republic, and is represented by only two deposits from Pompeii. Ox figures prominently in both, reaching 47 pecent (of ox, sheep/goat, and pig bones) in the fourth- to third-century levels. Beef would have dominated the meat supply, and was perhaps associated with a predominantly agrarian agricultural system with relatively little exploitation of other animals. The percentage of sheep/goat bones is at its lowest level in this phase, which may indicate that meat supplies were fairly localized and did not extend to the uplands (where transhumant sheep ranching was later to develop). There may also have been cultural reasons why sheep and goat meat was not eaten much at this period.

By the second century B.C. changes occur that were to set a dietary pattern that lasted until late Imperial times. Pork becomes very popular, averaging about 60 percent of the bones, and therefore contributing appreciably to the meat supply. Juvenile animals were slaughtered, and the evidence of the age-at-death pattern and the sex ratio shows that there was commercial pig farming in order to supply the demand. Campania was not, in fact, the only area where this trend can be detected, since similar bone assemblages are found throughout west central Italy. At Settefinestre villa in Tuscany, evidence for large-scale pig-keeping during the second century A.D. was uncovered (King 1985: figs. 188, 210). Pork was regarded highly, to judge from the literary sources (e.g., Pliny *HN* 8.209; Dosi and Schnell 1984: 163–4), and the percentages in Table 25 provide archaeological confirmation of this. Sheep and goats, too, were more popular in the meat supply, averaging about 30 percent of the bones found. They were probably exploited primarily for wool and milk, as can be inferred from the age-at-death pattern. By contrast, ox

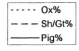

FIGURE 337 Graph of Campanian bone percentages for ox, sheep/goat, and pig. Data from Table 25 (after King 1999: fig. 3).

declines in the meat supply, as low as 2 percent in one of the Naples deposits but usually between 5 and 15 percent of bone numbers. The animals were probably slaughtered as adults after their useful lives were over, although it is clear from the age-at-death evidence that younger animals were eaten as well. It is interesting to note that the Romans had religious sanctions against killing oxen (Varro *RR* 2.5.4; Dosi and Schnell 1984: 165–6), and the decline in beef consumption appears to coincide with Roman cultural dominance in Campania.

The late Republican and Imperial pattern continued until the end of the western Roman Empire, and is still found in the Naples, Santa Maria-la-Nuova, deposit of the late sixth century A.D. This individual assemblage is exceptional, however, since from the late fifth century A.D. changes occur, as seen particularly in the large groups from Naples, Carminiello ai Mannesi, phases VII–VIII (King 1994; Arthur 1995: 25). The percentage of (largely adult) sheep/goat bones increases at the expense of pig, while the ox percentage remains relatively constant. The sheep:goat ratio also indicates that goats are becoming relatively more common at the same time. In all probability, sheep and goats are being exploited for wool and milk, perhaps intensively so. Where these animals were being herded is not easy to determine, since this period was a troubled one in the region, and it may have been difficult to maintain supplies over long distances. The rise in importance of goats may be due to their being grazed on the local hilly scrub. It is also possible that supplies to Naples (and other sites in the area) were brought in by sea, and it is interesting to note in this respect that contemporary assemblages from much of the western Mediterranean are also sheep/goat dominated (King 1999: 190–1). There may have been economic links across this region and with other Byzantine areas to the east.

A conclusion to be drawn from the regional comparison is that within certain limits, contemporary deposits have the same composition, even if they are from different sites. In all probability the general similarity of contemporary assemblages reflects the regional diet and animal husbandry, with factors like differential deposition and the status of the people discarding bones on individual sites accounting for those intersite differences that do exist. Therefore, it is possible to view the data in Table 25 as reasonably representative of regional trends over time.

It is also apparent that the picture painted for Campania fits in a wider frame as well. Assemblages from Rome, Lazio, and Etruria display the same trend of high pig percentages in late Republican to late Imperial times, followed by increasing sheep and goat percentages from the late Imperial period onward (cf. King 1985; 1997; 1999 for further discussion). Western central

Italy as a whole forms a coherent dietary and agricultural zone, especially in the early Imperial period. This is the area to which the ancient agronomists refer in their writings, and it seems from the bone evidence that beyond this zone, agricultural practices were different, and thus less relevant to the agricultural regimes advocated and written about by the ancient authors. If we move farther from this zone into the provinces, the differences become more marked, and it is clear that there were many different dietary and agricultural regions in the Roman Empire (King 1984; 1999).

Returning to Pompeii and the Vesuvian sites, we can conclude from this brief overview that in A.D. 79, the inhabitants of these sites had a diet typical of the early Empire in western central Italy. It was a diet that can possibly be linked with the heavy Romanization of the area after the Social Wars of the early first century B.C., and it was to continue as the norm well after Vesuvius had destroyed the agricultural base of the Pompeian hinterland. The mammal bones can tell us a great deal about the natural history of the region by virtue of the long-term perspective available from the excavations that have taken place, as well as the detailed focus yielded by the wealth of remains and representations buried by the volcano.

CATALOGUE

An alphabetical listing of the scientific names for the species forms the basis for the catalogue's sequence. A more systematic arrangement by orders will be found, as a form of index, in Table 26 at the end of the catalogue.

1. *ACINOMYX JUBATUS* SCHREBER 1775
English, cheetah; Italian, *ghepardo*

PAINTING

Possible cheetahs, together with leopards shown similarly, are found in the House of M. Lucretius Fronto (Fig. 338; V.iv.a/11; Peters et al. 1993: figs. 164–5).

COMMENT

It is difficult to differentiate cheetahs from leopards (*Panthera pardus*) in Roman art, although it is clear from literary descriptions (cf. Toynbee 1973: 82) that both were known. The two species also had Dionysiac connotations. See the entry for *P. pardus* for further evidence and discussion.

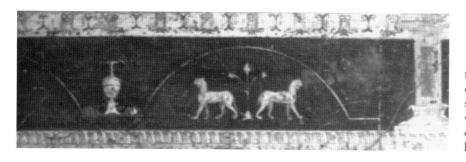

FIGURE 338 Possible depictions of cheetahs, in a pair walking in opposite directions, in a small formal vignette in the tablinum, House of M. Lucretius Fronto, Pompeii. Photo: S. Jashemski.

2. *ALCES ALCES* L.
English, elk; Italian, *alce*

SCULPTURE

Bronze sculpture of elk is reported by Matteucig (1974a: table 1, no. 4) in the Naples Museum.

COMMENT

This is a species unlikely ever to have been found within the Roman Empire, but it is now being distributed in Scandinavia, Russia, and the Baltic region (Corbet and Ovenden 1980: pl. 33, 203). It was mentioned by ancient authors in a somewhat inaccurate fashion and figured in imperial menageries, processions, and *venationes* in the third to fifth centuries (Toynbee 1973: 145).

3. *APODEMUS SYLVATICUS* L.
English, wood mouse; Italian, *topo selvatico*

SCULPTURE

Apparently the wood mouse occurs twice on the Eumachia portal (Matteucig 1974b: 222, nos. 73–4; 1974a: table 1, no. 11).

FAUNAL REMAINS

Seven bones of a wood mouse were found in sixth-century B.C. levels in the forum excavations (King, unpublished). There were also about eighteen bones of this species from various other stratified contexts in the forum excavations. Elsewhere in Pompeii, one bone was found in a fourth- to third-century B.C. context and another five from possible ritual contexts of the second- to the first-century B.C. from under the House of Amarantus (I.ix.11–12; Powell 1999).

COMMENT

There is some difficulty in distinguishing bones of wood mouse from those of yellow-necked mouse (*A. flavicollis*), but it is likely that the specimens reported here are the former species. Wood mouse inhabits buildings as well as more natural habitats, and may have taken a role similar to that of house mouse (*Mus musculus;* see entry), which may not have been present in

Italy as early as the sixth century B.C. Wood mouse is perhaps Horace's *mus rusticus* (*Satires*, 2.6).

4. *ARVICOLA TERRESTRIS* L.
English, water vole; Italian, *arvicola*

FAUNAL REMAINS

A single bone was identified from late-first-century B.C. levels in the forum excavations (King, unpublished).

COMMENT

The English name for this species is a misnomer for Mediterranean habitats, since it can live away from water (Corbet and Ovenden 1980: 164) and has been found in other archaeological contexts associated with dry (and presumably grassy) conditions (Settefinestre villa; King 1985: 288).

5. *BOS TAURUS* L.
English, domestic ox; Italian, *bue*

SCULPTURE

Bulls are depicted on bronze sculpture and on items in the Menander Hoard (Matteucig 1974a: table 1, no. 21; Ciarallo and De Carolis 1999: 149). A good example of the former is the fountain figure of a bull from the atrium of the House of the Bull (V.i.7; Kapossy 1969: 53; Jashemski 1979: fig. 75). It is a finely modeled young animal whose mouth functioned as a spout for the *impluvium*. From the Menander Hoard, a silver cup has a carefully depicted cow with short horns and a small udder, in the act of drinking water from a spring, near another cow that is lying down (Maiuri 1933: 272–9). A bull is portrayed on the base of the altar in the Temple of Vespasian (Fig. 339), and a small seated cow forms one of the marble fountain sculptures in the garden of the House of M. Lucretius (IX.iii.5; Dwyer 1982: 46, fig. 47).

Bulls with the attributes of Apis figure in a variety of sculptural media, such as a gilt silver bowl from the Palaestra in Pompeii (NM; Kater-Sibbes and Vermaseren 1975: 23–4, no. 302). Among the most remarkable examples are the depictions of Apis in white coral inlaid into a pair of obsidian *skyphoi* from Stabiae (NM;

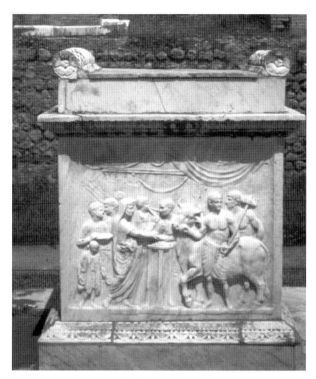

FIGURE 339 A bull on the base of the altar in the Temple of Vespasian, forum of Pompeii. Photo: S. Jashemski.

De Caro 1994: 234; Kater-Sibbes and Vermaseren 1975: 26, no. 308).

PAINTINGS AND GRAFFITI

Bulls feature regularly in *venatio* scenes (listed by Andreae 1990), such as in the large panel in the garden of the House of the Ceii (I.vi.15) showing a lion chasing a brown/buff short-horned bull in the foreground (Fig. 336). In the garden of the House of M. Lucretius Fronto, a bull is again being attacked by a lion and a leopard (Fig. 359; V.iv.11; Jashemski 1993: 336–7, pl. 391; Peters et al. 1993: figs. 248–53). Such scenes usually show bulls (not cows) being chased by or confronting large predators. Occasionally the bull has a beast such as a lion or leopard on top of it, as in a garden painting from the House of the Epigrams (V.i.18; Jashemski 1993: 333; Ward-Perkins and Claridge 1976: 74), or in a scene of a lion attacking a bull, which has fallen to its knees, tongue protruding (House of the Centenary IX.viii.6; Jashemski 1979: 111–12, fig. 181; 1993: 367). Bulls are not the most common of prey animals in the *venationes*, that place being taken by deer, nor are bulls shown as the focus of hunting by humans, despite the other evidence from Pompeii (graffiti, inscriptions) and in the literary sources (see following) to indicate that bullfighting did indeed take place.

Mythological subjects also include bulls, notably the Punishment of Dirce, who was trampled by a bull, as in a painting from the tablinum in the House of the Archduke (NM inv. no. 9042; De Caro 1994: 156). Europa and the Bull, and Jason and Pelias with a bull

for sacrifice are the subjects of a pair of paintings from the House of Fatal Loves (NM inv. nos. 111436, 111475; De Caro 1994: 154–5). They are very similar in style, being probably derived from fourth-century B.C. originals, but what is striking in relation to the two depictions of the bulls is that they are virtually identical in stance, color, and conformation. The very finely modeled animals are brown with short horns, and almost certainly were painted from life, but it is impossible to say whether by the original Greek painters of the fourth century B.C. or by Pompeian copyists.

A bull of very similar type and color, again in a well-executed style from the anatomical point of view, comes from the Temple of Isis (NM inv. no. 8565; Sampaolo 1992: 58–61, no. 1.79; Maiuri 1953: 131; Elia 1942: 22). Because of the sacred context, it is probably a depiction of Apis, very likely modeled from life. However, it does not have the usual sacred attributes of Apis (Kater-Sibbes and Vermaseren 1975: 22, no. 299). Brown short-horned cattle also figure in a pastoral scene in the Naples Museum (inv. no. 9508; De Caro 1994: 186). The depiction of bulls with the attributes of Apis are fairly common from the Vesuvian sites (Kater-Sibbes and Vermaseren 1975: 22–6, nos. 299–308).

Draft oxen feature occasionally in paintings, pulling the triumphal wagon of Bacchus and Ariadne (Reinach 1922: 114, no. 3), and a chariot with Silenus holding the infant Bacchus in his lap (Reinach 1922: 106, no. 3; Toynbee 1973: 162).

A rarer mural theme involving cattle is the still life. Croisille (1965: no. 175C, House of the Lovers, I.x.11, atrium) notes the example of a cow's head, with short horns and light-colored hide, cut off after butchery — the butcher's knife is adjacent.

FAUNAL REMAINS

Two ox skeletons (and four humans) were found in a stall in the House of the Faun (VI.xii.5; *NS* 1900, 31). These were presumably traction or work animals, rather than milk cows, but no anatomical details are recorded. Cow and horse skeletons were also found in a *stabulum* in the slave-run villa of Gragnano (no. 34; *NS* 1923, 275–6). A partial and disarticulated ox skeleton was found in an A.D. 79 layer at the villa at Via Cesare Grotta, Boscoreale (Fergola 1989). The excavator suggests that the bones had been defleshed and left to dry for later utilization, probably in an upper room of the building.

Food remains of ox bones are relatively common, both from A.D. 79 levels (e.g., vineyard II.v, Jashemski 1979; vineyard of the *villa rustica*, Villa Regina, Boscoreale, Jashemski 1994: 111), and from earlier strata (I.ix.11–12, Clark 1999; forum excavations, King, unpublished), but may be underrepresented in the archaeological record due to disposal practices. The consumption of beef was

relatively restricted compared to that of pork, particularly in the Late Republic and Early Empire.

LITERARY REFERENCES

The sale or purchase of six heifers is noted in a graffito from Pompeii (*CIL* IV 5184; Day 1932: 174). This seems to be the only direct reference to cattle, but other written sources, such as the Roman agronomists, often refer to Campania (White 1970: 275–88). Columella (*RR* 6.1.1–2) mentions a Campanian breed that was small, white, and suitable for cultivation of the light soils of the region. Breed improvements were also made by introducing animals from other regions, such as from Greece (Strabo 7.7.5). Also of interest is the use made of cattle, since the overwhelming impression gained is that both oxen and cows were kept for work, that is, plowing and traction, rather than for meat or milk, which in a sense were by-products. This perhaps accounts for the lack of emphasis on the size of cows' udders when discussing breed types (White 1970: 286). Apicius has only a small number of recipes for beef or veal compared with the large number for pork (White 1970: 277; André 1981: 138–9), a lack of emphasis on beef consumption that is confirmed by the osteological evidence from many Italian sites (King 1984: 201; 1999: 169–73).

Another important category are those literary sources that refer to bulls in the amphitheater (Toynbee 1973: 149–51; Blazquez et al. 1990). A Pompeian inscription mentions bulls and bullfighters (*ILS* 5053), and it is likely that wild bulls were captured, or domesticated animals specially bred, for fights in the arena. The fights took place in the context of the *venatio* or mock hunt, and frequently involved other animals as well as hunters. Martial (1.19), for instance, mentions an enraged bull being impaled on the tusks of an elephant. There were also specific bullfights (*taurokathapsia*) involving horsemen, who were perhaps armed with lassos (Vigneron 1968: 218). The bulls were chased to exhaustion and probably killed by strangling rather than piercing with weapons.

COMMENT

A feature of many of the paintings is that the bulls depicted are of modest size, short-horned, and brown in color. If this is not purely a convention repeated from painting to painting, it is tempting to conclude that this type of animal represents one of the breeds of cattle prevalent in Campania at the time. If this is the case, it would add to Columella's reference to the Campanian small white breed by indicating that other types also existed in the region. The surviving cattle bones would tend to uphold the notion of the local cattle being of modest size with relatively small horns.

6. *CANIS AUREUS* L.
English, jackal; Italian, *sciacallo*

PAINTING

An outline of a jackal is included among the animal attributes painted on the walls of the so-called sacrarium of the Temple of Isis in Pompeii, room 1 (NM inv. no. 8533; Sampaolo 1992: 58–61, no. 1.73; Tran Tam Tinh 1964: 146, no. 54; Elia 1942: 22). The creature is dark in color, unlike a jackal, but the attribution can be taken as correct since jackals are an integral part of the cult of Isis (Tran Tam Tinh 1964: 102–3).

COMMENT

Jackals are African mammals, which would probably not have been imported to Italy, although their characteristics were known to Latin authors (Grattius *Cynegetica* 256–9). The depiction here is somewhat conjectural and was clearly executed from another depiction, or from a hazy memory, rather than from life.

7. *CANIS FAMILIARIS* L.
English, dog; Italian, *cane*

SCULPTURE

A bronze fountain sculpture from the House of the Citharist (Fig. 360; I.iv.5; NM inv. nos. 4899, 4901) has a lively and finely modeled pair of hounds attacking a wild boar. Similar small, wiry hunting dogs are shown overwhelming the deer in the marble garden sculptures of deer and dogs from the House of the Stags, Herculaneum (Fig. 345; inv. nos. 519, 524). This scene is repeated on a smaller scale, with only one dog, on two other marble garden sculptures. One shows a leaping stag with a similar type of dog on its back (NM; VII.ix.47/65; Dwyer 1982: fig. 192); the other has a gazelle with a small, vicious-looking dog biting its shoulder and neck (NM inv. no. 6540; House of Camillus, VII.xii.22/23; Dwyer 1982: 65–6, fig. 82).

A very small marble sculpture of a crouching short-muzzled, short-eared dog, probably a house or lapdog, comes from the garden of the House of the Golden Cupids (VI.xvi.7; Jashemski 1979: 40, fig. 66). It was obviously a stock sculptural type, since an almost identical pair of small crouching dogs, one with a thin studded collar and a hole in the mouth for a spout, were found in the garden of the House of M. Lucretius (IX.iii.5; Dwyer 1982: 46–7, figs. 49–50; Kapossy 1969: 50). Dwyer interprets the animals as hares, because of the shape of the eyes and the possibility that the ears were longer and swept back, but the pose is unnatural for a hare and on balance, attribution to dog is preferred.

Dogs of various sizes appear in a hunt scene on the handle of a large *patera* in the Menander Hoard (Maiuri

1933: 355–7; Matteucig 1974a: table 1, no. 27). Elsewhere in the same hoard, the mythical three-headed Cerberus, rather crudely sculpted, is shown at Hercules' feet (Maiuri 1933: 314–18). A terra-cotta antefix from an atrium roof in Pompeii portrays a wolflike hunting dog with large muzzle, alert upright ears, and shaggy coat (Giordano and Pelagalli 1957: 181, tav. II, fig. 10).

PAINTINGS AND GRAFFITI

One of the most interesting depictions is a small terrier-sized dog with buff shaggy coat, curly tail, squat face, and pointed ears, in a garden scene with a heron nearby catching a lizard (see Fig. 280). Above the dog's head is a painted inscription A SYNCLETVS. Is this the name of the dog? This characterful and realistic portrait is probably of a family pet. It seems to have been an addition to the painting, since it is placed over a red and white frame between other scenes.

Another small dog with upright ears, pointed snout, and a hairy tail curled upward can be seen in a still life, beside a plate (House of the Wounded Adonides, viridarium, VI.vii.18; Croisille 1965: no. 216). Apart from these two, lapdogs are unusual, and it is mainly guard or hunting dogs that are found in artistic portrayals. A guard dog is portrayed in the *caupona* of Sotericus (Fig. 340; I.xii.3). It would have been clearly visible from the street, and fulfilled a similar function to the better-known threshold mosaics.

Dogs are common in *venationes* (listed by Andreae 1990), often being shown confronting wild boar or deer. A notable example is in the House of the Ceii, where a hunting landscape includes two large, yellow/brown, wolflike dogs chasing a pair of wild boar, one of which turns to confront the dogs (Fig. 336). The Gladiators' Barracks has several hunting dogs, usually large and wolflike, and white or brown in color (V.v.3; Jashemski 1993: 339–40). Unusually, one of these scenes shows two dogs and a big cat fighting. Not all *venatio* scenes include dogs, particularly when more powerful predators such as lions and leopards are shown.

Similar to the painted hunting scenes is a stucco relief of dogs attacking a boar on the Tomb of Aulus Umbricius Scaurus (Vivolo 1993: 15). An incised graffito of a dog and a boar in an arena context occurs in the House of the Cryptoporticus (I.vi.2, rm 22; PPM I, 265, 271–3; Vivolo 1993: 101).

Among the mythological paintings, the most common scene involving dogs is that of Artemis and Actaeon, where hunting dogs, sometimes the large Molossian type, are shown attacking Actaeon as he turns into a stag (Dawson 1944: 116–19, 136–40).

An interesting genre scene shows a woman in a rustic shelter giving water to a traveler. The latter's small, muscular, and rangy dog sits between them (House of the Dioscuri, tablinum, VI.ix.6; NM inv. no. 9106; De Caro 1994: 179; Ward-Perkins and Claridge 1976: no. 155).

MOSAICS

A well-known feature of Pompeii is the custom of animal threshold mosaics. As might be expected, guard dogs are prominent, most famously in the *vestibulum* of the House of the Tragic Poet (VI.viii.8; Giordano and Pelagalli 1957: 176; Toynbee 1973: 107), which shows a large shaggy black dog with white forelimbs and patch on its head, in the act of menacing the unwary visitor. The length of the animal is 1.60 m, which could be a realistic size. The dog is attached by a collar to a chain, and the inscription CAVE CANEM (beware the dog) reinforces the visual message. Another example in the Naples Museum shows, in a fairly simplistic style, a black short-haired dog with ears and tail pricked up, with a studded collar attached to a rope (Maiuri 1953: 112, 114). From the House of Paquius Proculus *vestibulum* (I.vii.1; Giordano and Pelagalli 1957: 177) comes another dog, again chained, this time to the door. The animal has the typical long snout and bushy upright tail of a relatively undeveloped breed of dog, of the sort that must have been very common in the ancient Mediterranean world. A more welcoming mosaic, of a black dog curled up, comes from the entrance to the House of Caecilius Jucundus (V.i.26; Jashemski 1979: 102, fig. 161).

FAUNAL REMAINS

One of the most haunting images to come from Pompeii is the cast of a dog, writhing on its back with its legs in the air (Fig. 341; House of M. Vesonius Primus, VI.xiv.20; Giordano and Pelagalli 1957: 167–8, fig. 7). The dog was short-haired, narrow-faced, and lean, very similar in conformation to the mosaic depictions of guard dogs. Its shoulder height is 62–4 cm and its length from the occipital to the sacrum 90–2 cm (Giordano and Pelagalli 1957: 169, n. 4). So far, it is the only detailed cast of a dog, and so constitutes a precious source of evidence.

Other skeletons of dogs that were probably left behind have been recovered in the form of bones rather than casts. A good example comes from the House of the Menander, where a largish dog laid on its side was found in the upper level of ashes above the portico of the "rustic" area of the house (I.x.4; Maiuri 1933: 194–5, fig. 91; Giordano and Pelagalli 1957: 168). Maiuri points out that the doors in this part of the house had been shut prior to departure, keeping the dog in, perhaps deliberately. It is curious that it was found in the upper level of ashes, suggesting that the animal was able to keep above the accumulating ash level but eventually succumbed to the outpouring of gas from the volcano. Giordano and Pelagalli give references to other similar skeletal finds

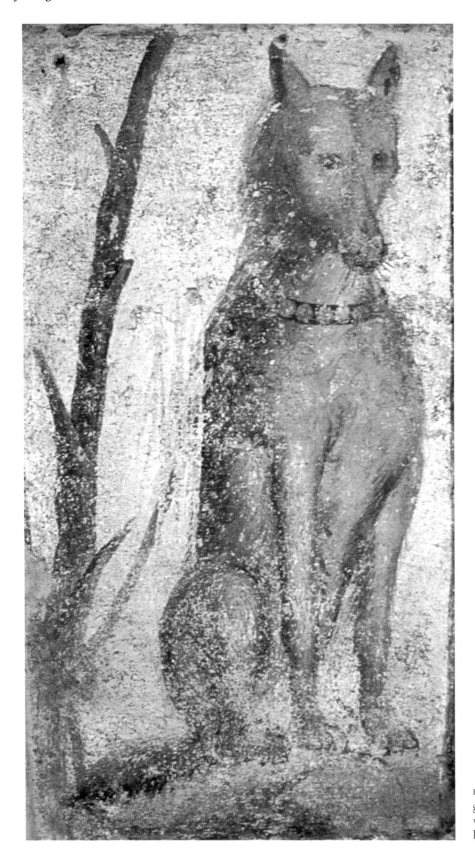

FIGURE 340 A guard dog, with a gem-studded collar, painted on a wall of the *caupona* of Sotericus, Pompeii. Photo: S. Jashemski.

from Pompeii, including some well-preserved bones from House I.xiii.1, which they examined and measured (1957: 168–74, tav. 1). A dolichocephalic skull and slender bones suggest that the animal was a hunting dog. Four other partial skeletons from A.D. 79 levels, now in the Sarno Baths, have recently been studied by Richardson et al. (1997: 94–9; Richardson 1995), and they conclude that

the two surviving skulls represent mesaticephalic animals, probably like the watchdogs in the mosaics. One also had eburnation on the joint articulations, a sign of serious disability. A skeleton in association with a probable mule was recently excavated in a stable in I.ix.12 (Fulford and Wallace-Hadrill 1998: 86–9).

Bones of dogs are relatively common on the Vesu-

FIGURE 341 Plaster cast of a guard dog that died because it was left chained to the *fauces* in the House of M. Vesonius Primus, Pompeii, in a doomed attempt to protect the owner's property. A large collar with two attachment rings is a prominent feature of the cast. Photo: Soprintendenza Archaeologica di Pompeii.

vian sites. Those from the eruption levels tend to be partially or fully articulated skeletons, but equally the pre-A.D. 79 levels more usually contain disarticulated and partial remains. The most likely reason for this is the disposal of dead dogs in general rubbish heaps, where scavengers probably dismembered them. Subsequently, the remains, mixed with other debris, became incorporated into pitfills and other dumps (King, unpublished; Clark 1999). Nearly all the larger garden excavations had dog bones in the assemblages, mostly of large animals, but one small specimen was noted (Jashemski 1979: 103, 217, 242, 247, 254, 279), and one had its shoulder height estimated at 45 cm (House of the Ship *Europa*, I.xv.Jashemski 1979: 242). A skull was found in the *villa rustica* at Villa Regina, Boscoreale (Jashemski 1987: fig. 30; 1994: 111, tav. 19a), of a shape that resembled the animal depicted in Fig. 340 (Jashemski 1987: fig. 31; 1979: fig. 162).

One of the most interesting yet enigmatic finds are two pelves of fairly large dogs from late-fourth-century B.C. levels in the Via Marina between the Temple of Apollo and the Basilica (King, unpublished). The bones had cut marks on the ilium, which indicates dismemberment of the carcass. Were these marks the result of butchery and perhaps removal of the pelt, or were they possibly ritual in nature? The latter suggestion arises from the proximity of the Temple of Apollo, one of the earliest cult sites in Pompeii. No direct link between Apollo and dog sacrifices is known, but in early Rome the worship of the Lares on May 1 (a month protected by Apollo) may possibly have involved dog sacrifice (Scullard 1981: 117–18). Dogs were also sacrificed at the Roman festivals of Robigalia (Ovid *Fasti* 4, 908ff; Smith 1996: 80–3; Scullard 1981:

108–9) and Lupercalia (Plutarch *Romulus* 21, 7–8), and on other propitiatory occasions (Columella *RR* 2.21.4).

Calcified dog coprolites, one with crushed fish vertebral centra visible in it, were recovered from two contexts in the forum excavations (King, unpublished), dating to the late first century B.C./early first century A.D.

KENNELS

Giordano and Pelagalli (1957: 199–201) record two examples of kennels at Pompeii, one in the corner of the tablinum of IX.v.2, made of tiles and plaster (Jashemski 1979: 103, fig. 163), and the other in the garden of II.viii.7, made from a *dolium* split in half longitudinally.

LITERARY REFERENCES

There are many ancient references to dogs (discussed by Merlen 1971; Toynbee 1973: 102–24; and Giordano and Pelagalli 1957: chap. 3), of which the detailed Augustan-period poetic treatise on hunting dogs by Grattius (*Cynegetica*) must be singled out, but of most relevance in the present context is information on types and breeds of dogs. Greek writers (cf. Hull 1964 for texts and discussion) refer to dog breeds, such as the Cretan, which were also known and used in the Roman world. Greece evidently had a good reputation for its hunting and sheepdogs, and two breeds in particular were held in high esteem, the Molossian and the Laconian (Vergil *Georgics* 3.404–13; Horace *Epodes* 6.5–6; Toynbee 1973: 103–4). Molossian hunting dogs were large and heavily built, with massive blunt-snouted heads and a smooth coat, and have been identified by Giordano and Pelagalli on various paintings (e.g., House of the Menander, I.x.4; Giordano and Pelagalli 1957: tav. III, fig. 102; Maiuri 1933: 84). The Laconian breed was swift

and probably more like a greyhound (cf. Petronius *Satyricon* 40), and may be the dogs identified by Giordano and Pelagalli as of greyhound type in Pompeian paintings (e.g., the Gladiators' Barracks, IV.v.3), or in the sculpture of fairly small wiry dogs attacking a boar in the House of the Citharist (Fig. 360).

There were also Italian breeds, of which the Umbrian and Tuscan are named, but the literature lacks specific description (cf. Grattius *Cynegetica* 172–3; Vergil *Aeneid* 12.753; Silius Italicus *Punica* 3.295–6). Dogs were also imported from the western provinces, usually Gaul or Britain, and from Persia and the East (Grattius *Cynegetica* 154ff; Toynbee 1973: 104). Areas known for hunting dogs often had good reputations for their sheepdogs as well, such as the Molossians and the Laconians (Horace *Epodes* 6.5–6), and it is likely that sheepdogs were used for defending flocks from predators (Vergil *Georgics* 3.404–6) rather than for herding, as modern sheepdogs are trained to do. Certainly it was possible for sheepdogs to develop a taste for hunting once they had attacked wolves or bears (Dio Chrysostom *Discourses* 7.15–20).

Hunting dogs in use as guard dogs appear in literary references relevant to life in Pompeii. Lucretius (5.1063–72) refers to Molossians left to guard a house, and Petronius (25, and 64) mentions the presence of Laconians at Trimalchio's dinner and his massive guard dog Scylax that was brought in to impress the dinner guests. Scylax is later found chained at the front door of the house, just like the mosaic images discussed earlier. In fact, the narrator of the *Satyricon* alludes in this passage to being frightened even of a painted dog, implying that the custom of guard dog depictions seen in Pompeii was common elsewhere as well. Varro, in discussing the traits required of guard dogs (*RR* 1.21.1), says that they should be trained to sleep by day and be on watch at night, and that a few good guard dogs are better than a pack.

Performing dogs at the theater are known (Plutarch *De Sollert. Anim.* 19 [973–4]) and also pets. The latter figure in the pictorial evidence, and the impression that pets were generally small lapdogs is reinforced by the literature. The best descriptions are again from Petronius, who has two small dogs present at Trimalchio's banquet (*Satyricon* 64, 71). Trimalchio's dog was to be placed in effigy next to his funerary statue, as was his wife's dog. This implies that ownership of lapdogs was a status symbol, as well as being the focus of apparently genuine affection. That these dogs were valued as happy companions is clearly brought out in Martial's poem about a dog called Issa and her owner Publius (1.109).

A contrast to this impression is provided by references to the consumption of the meat of young puppies as late as the early second century B.C. (Festus 39.8;

André 1981: 140), and even in Pliny's time, meat of dogs formed part of banquets in honor of the gods (*HN* 29.57–8). Dogs were also sacrificed to the gods quite regularly (see faunal remains section earlier; André 1981: 140, n. 94).

COMMENT

Physical remains of dogs from the Vesuvian sites are more likely to have been guard dogs than those used as pets or for hunting. Their size suggests this, with the exception of one smaller-sized animal, and is perhaps to be expected from the circumstances of the eruption. Guard dogs were probably left behind to fulfill their function by protecting their departing owners' properties. Some died in position; others doubtless managed to escape.

Depictions of dogs tend to reinforce this impression, if the mythological and *venatio* subjects are put to one side as not being directly relevant to daily life in the region. Small dogs of the lapdog variety are in a small minority, whereas the majority are short- or long-haired undeveloped breeds shown in the role of guarding persons and property.

Hunting scenes show various breeds of dogs, identifiable in general conformation with the types referred to in ancient literature (see previous discussion). It is noteworthy that they are always depicted chasing or attacking prey, but not pointing or retrieving, which are modern breed characteristics (Giordano and Pelagalli 1957: 178).

8. *CANIS LUPUS* L.
English, wolf; Italian, *lupo*

SCULPTURE

A bronze sculpture in the Naples Museum is noted by Matteucig (1974a: table 1, no. 28). A bronze spout in the form of a wolf's head comes from the Suburban Baths, Herculaneum (inv. no. E2166; Ciarallo and De Carolis 1999: 64).

PAINTING

There is an indistinct depiction of a wolf with Romulus and Remus in a complex painting portraying the origins of Rome, from a cubiculum in the House of M. Fabius Secundus (V.iv.13; Dawson 1944: 103, no. 46, pl. XVIII). A running wolf, or wolflike dog, large with grayish shaggy coat, is among the animals in the tendril scroll on the portico frieze of the Temple of Isis (NM inv. no. 8553; Sampaolo 1992: 50–4, 119, no. 1.42). A similar animal, more like a wolf than a dog, tears at a stag in one of the peristyle paintings in the House of the Menander (I.x.4; PPM I, 267–9; Andreae 1990).

Two themes occupy ancient writers concerning wolves. The first is that the animal was sacred to Mars (Horace *Odes* 1.17.9; Vergil *Aeneid* 9.565–6), and as such, figured as the she-wolf that suckled Romulus and Remus. The less prominent theme is that wolves were considered the enemy of shepherds and their flocks. The guardians of sheep and goats had to be vigilant against attacks by wolves, and hunting dogs sometimes wore collars with spikes to protect them from being seized by the neck (Toynbee 1973: 100–1).

COMMENT

Wolves are rare, but indigenous in peninsular Italy today. Doubtless they were much more common in Imperial times, but their depiction in anything other than a mythological context is distinctly unusual. They do not figure in *venationes,* perhaps because they were difficult to capture alive and difficult to use in the arena. In mythological terms, the Wolf and Twins might be expected to be more common than it actually is in the Pompeian corpus. It is, of course, not a Hellenistic subject, which may account for its rarity in a region dominated artistically by Greek-inspired themes.

9. *CAPRA HIRCUS* L.

English, goat; Italian, *capra*

SCULPTURE

One of the finest animal sculptures from Hercula-neum is a marble group showing the erotic scene of Pan in sexual congress with a nanny goat. The carving is finely executed and the anatomical details of the hair, head, general conformation, and so on are true and show a close understanding of the animal by the sculptor. The horns are small and curve back to the back of the head. The group, a small garden sculpture, is carved in Greek marble, dating to the second/first century B.C., and reflects late Hellenistic style (Villa of the Papyri, peristyle; NM inv. no. 27709; De Caro 1994: 291).

A garden sculpture of a goat comes from the peri-style of a house in Nocera (Fig. 342; NM inv. no. 4903). Another garden ornament, an *oscillum,* depicts a goatherd and three poorly modeled goats in relief (NM inv. no. 120334; House of Fortuna, IX.vii.20; Dwyer 1982: 74, fig. 107). A silver *scyphus* with a sacro-idyllic theme from the House of the Menander treasure shows a large shaggy billy goat being held by the horns in a sacrifice scene (NM inv. no. 145504; De Caro 1994: 229; Maiuri 1933: 265–72). It is possibly a ram, but on balance an attribution to goat is preferred.

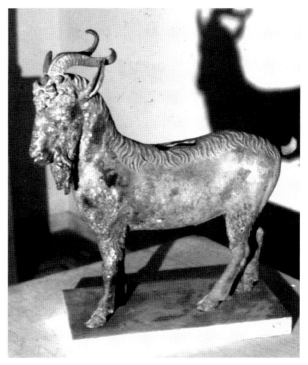

FIGURE 342 A bronze garden sculpture of a short-haired billy goat standing in a rather formal pose, Nocera (NM inv. no. 4903). Photo: S. Jashemski.

PAINTINGS

Goats figure in pastoral and sacro-idyllic scenes in several depictions. An example of this is a gray-coated, fairly shaggy goat standing next to a seated Pan in the House of the Fatal Loves (IX.v.18; NM inv. no. 111473; De Caro 1994: 153). The subject is in a style derived from the fourth century B.C., but the animal could well have been modeled locally.

Mythological scenes of Paris often include goats as part of his pastoral setting. For instance, he is shown seated on a rock near Sparta with a herd of goats grazing around him (IX.ii.18, cubiculum; Dawson 1944: 87, pl. V), or in the Judgment of Paris scene with cattle, sheep, and goats present.

A dark brown hornless goat is shown grazing in the left-hand part of a still life from the triclinium of the House of the Vettii (Croisille 1965: no. 244). The right-hand part of the scene shows cheeses (see Fig. 75), one of the principal products from this species. Elsewhere in the same house, goats are depicted drawing a cart with Cupids and a reclining Dionysus (Toynbee 1973: 166; Reinach 1922: 88, no. 5), and Cupids are shown leading a goat loaded with a flower basket (Fig. 343).

MOSAIC

Goats and a horseman are depicted in a small panel of a mosaic that may have zodiacal significance (I.vii.1, atrium; PPM I, 487, 489).

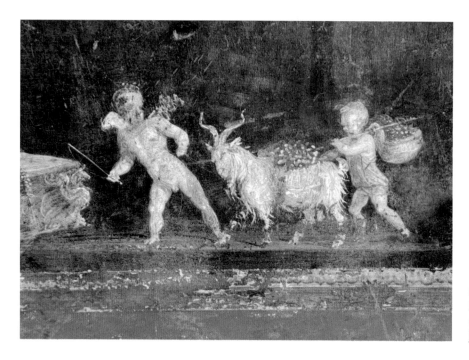

FIGURE 343 Cupids leading a goat loaded with a flower basket, House of the Vettii, Pompeii. Photo: S. Jashemski.

FAUNAL REMAINS

Goat bones are not easy to distinguish morphologically from those of sheep, except on the basis of certain skeletal elements that provide useful indicators (Boessneck 1969; see entry *Ovis aries* here for further discussion). Using these elements, it is possible to establish that goats were much less common than sheep in the forum bone assemblage; there was about one goat for every eight sheep (King, unpublished). Both sheep and goats are less common than the other main domesticates (pig and ox), especially in the early phases of Pompeii, the sixth to the third centuries B.C. There is, however, a rise in their numbers relative to pigs and cattle in the late second century B.C. to A.D. 79, implying a rise in goat meat and mutton consumption. The increase may be due to exploitation of goats and sheep in the Vesuvian region for wool and milk.

A goat skeleton is reported from villa no. 43 (Day 1932: 174, n. 43), and four partial goat skeletons survive in the stores at Pompeii (Richardson, 1995). A skull with fairly short but typically shaped horncores was found in the Villa of Poppaea at Oplontis (Jashemski 1993: 296–7, fig. 330).

LITERARY REFERENCES

Goats were valued for their milk (Vergil *Georgics* 3.314f.; Columella *RR* 7.6.4) and, to a lesser extent, cheese, meat, hair, and skins. They preferred wooded scrubland and rough grazing (Columella *RR* 7.6.1), and their fondness for shoots of bushes and trees was known as a menace to olive and other tree orchards (Varro *RR* 2.3.8f.). At the same time, they were regarded as not being particularly hardy animals, being susceptible to temperature changes and diseases. Both Varro

and Columella have advice on the husbandry techniques to get the best from goats, particularly in relation to their milk yield (White 1970: 313–15). Vergil, too, recommends weaning of kids at birth in order to increase the milk supply (*Georgics* 3.398–9). In respect of their meat, kid was preferred to goat meat, and the former sold for the same price as lamb (André 1981: 139–40). However, the propensity of the animals to disease was thought to make the meat unwholesome, according to ancient medical opinion (Columella *RR* 7.7.2).

COMMENT

Goats in wall paintings tend to look rather similar to sheep and can be difficult to distinguish. They were obviously regarded as the species par excellence of rocky and hilly country, which fits both with their grazing habits and their association with Pan. They would certainly have been herded in the hills of the region, and in all probability formed the main milk supply, but it is clear from the bones that their meat was consumed in relatively small quantities compared to the other main domesticates.

10. *CAPREOLUS CAPREOLUS* L.

English, roe deer; Italian, *capriolo*

PAINTING

A possible roe deer doe (or a female gazelle) without antlers figures in a still life together with a plate and produce – the deer is very small compared with the size of the plate (from the peristyle of the House of Venus, II.iii.3; Croisille 1965: no. 190). A small deer, the size of a roe deer but missing the vital identification zone of the head, occurs on a hunt scene in the

House of the Quadrigae (VII.ii.25; Jashemski 1993: 360; Andreae 1990).

FAUNAL REMAINS

The antlers and frontals of a roe deer, from Pompeii, are now in the Boscoreale Antiquarium (Fig. 344; case VII; inv. no. 11724). Another antler tine was found in republican levels under the House of Amarantus (I.ix.11–12; Clark 1999). Part of the haunch of a roe deer, almost certainly food detritus, was found in late-first-century B.C. levels in the forum excavations (King, unpublished).

COMMENT

Roe deer are currently the most widespread deer species in Italy (Corbet and Ovenden 1980: pl. 34), but their status in the Roman period is difficult to assess. They were undoubtedly hunted in many areas, as the osteological remains testify, but they are rarely depicted in art or mentioned in the literature, and in this respect seem to have been ignored in favor of red deer. Perhaps

FIGURE 344 Antlers and frontals of a roe deer from Pompeii. This is an example of a hunting trophy, which was presumably suspended in a house, and valued for keeping off the "evil eye." Boscoreale Antiquarium. Photo: F. Meyer.

their small size rendered them a less prestigious prize of the hunt than the larger cervids.

11. *CERVUS DAMA* L.

English, fallow deer; Italian, *daino*

SCULPTURE

The fallow deer was noted by Matteucig (1974a: table 1, no. 62) on a bronze sculpture and in the Menander Hoard (not seen in Maiuri 1933). Bronze garden sculptures that may be fallow deer does were also found at the Villa of the Papyri, Herculaneum (NM; De Caro 1994: 212).

PAINTING

A possible fallow deer is seen drinking in a hunt scene in the garden of the House of the Ephebe (I.vii.11; PPM I, 708–9; Jashemski 1993: 316).

COMMENT

Ancient authors refer to *dammae* (e.g., Martial 1.30; 4.35.1–5; 4.74.1–4) or to *cervi palmati* (Scriptores Historiae Augustae *Gordian III* 3.7), which are assumed to be fallow deer. However, the Pompeii pictorial evidence, and indeed that from elsewhere, gives little indication of any extensive knowledge of this species. Red deer are almost exclusively depicted, and it may well have been the case that fallow deer were uncommon in the region, or else were not the main focus of the hunt. Fallow deer bones and antlers have been identified from late Roman levels in Naples (King 1994: 387) and from late Republican to late Imperial strata at the Settefinestre villa (King 1985: fig. 185). The location of the latter site corresponds with the present-day distribution of the species in Italy, being largely confined to the Maremma (Corbet and Ovenden 1980: pl. 32) due to the depredations of hunting.

12. *CERVUS ELAPHUS* L.

English, red deer; Italian, *cervo*

SCULPTURE

The red deer appears on a cup in the Menander Hoard, in which Hercules is shown grasping the golden antlers of the "Hind of Ceryneia" in a scene from his labors (Maiuri 1933: 311–14; Matteucig 1974a: table 1, no. 38). The animal should, of course, rightfully be a stag (or should have been portrayed without antlers). This myth is also depicted on an *oscillum* from the House of the Citharist (inv. no. 20488; Ciarallo and De Carolis 1999: 116). A bronze garden sculpture of a running stag with a good pair of antlers was part of the group from the peristyle of the House of the Citharist (NM inv. no. 4902; Dwyer 1982: 46, fig. 48; Kapossy 1969: 48; Della

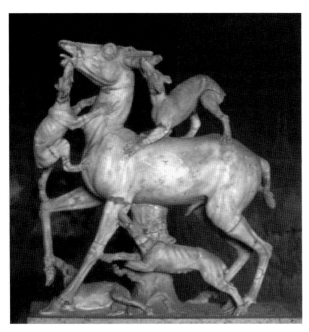

FIGURE 345 Marble garden sculpture of a red deer beset by small hunting dogs, House of the Stags, Herculaneum.

Corte 1965: 251). More famous are the garden sculptures from the House of the Stags, Herculaneum (Fig. 345; IV.21; inv. nos. 519, 524). Similar to this, but with only a single dog on the back of a leaping stag, is a garden sculpture from Pompeii (VII.ix.47/65; NM; Dwyer 1982: fig. 192). A much simpler example with a seated deer comes from the House of M. Lucretius (Dwyer 1982: 46, fig. 48). A sensitively carved relief sculpture of a hind suckling a calf adorns the base of a marble candelabrum in the Naples Museum (inv. no. 6857; Ward-Perkins and Claridge 1976: no. 134). Also in the museum is a small bronze figurine of a red deer stag, with antlers at the six-point stage (albeit rather schematically shown), and a delicately engraved band of flowers around its middle (NM inv. no. 2134; Ward-Perkins and Claridge 1976: 103).

PAINTINGS AND GRAFFITI

Among the mythological genre of paintings is one of the infant Telephus suckling a deer (probably a red deer), in a scene with Hercules and Arcadia ("Basilica," Herculaneum; NM inv. no. 9108; De Caro 1994: 120; Toynbee 1973: 145). It is a fine depiction of a hind, with the typical convention of small white flecks of paint designed to give texture to the coat. She turns to lick Telephus as he suckles her.

More common than the mythological paintings are deer in hunt scenes, where they are among the most common prey (listed in Andreae 1990). A typical scene has hinds or stags being chased by dogs or lions, as in the *venatio* in the House of the Ceii (Fig. 336), where two deer run before two wild boar, in turn being chased by a pair of large dogs. Occasionally, deer are

shown in other poses, such as drinking from a stream (House of the Menander; PPM II, 267–9; Jashemski 1993: 324). Analogous to the painted hunt scenes is a stucco relief of a stag and *bestiarii* on the Tomb of Aulus Umbricius Scaurus (Vivolo 1993: 15).

Stags and hinds are frequent in incised graffiti, usually in the context of *venationes*. The quality of depiction is extremely variable, with the antlers often very caricatured, but those in the House of the Cryptoporticus are of fairly good standard (Vivolo 1993: 81–2, 95, 99, 102). Another simple but lively graffito from Pompeii shows a horseman (a *veles* or *provocator*) throwing a spear while chasing a stag (*CIL* IV 8017; Vivolo 1993: 48–9).

MOSAIC

A small depiction of a red deer stag, being chased by a dog, forms part of the decoration of the nymphaeum in the courtyard/outdoor triclinium of the House of Neptune and Amphitrite, Herculaneum (see Fig. 245). The deer is shown with brown spots on its hide, which is not accurate in terms of color or conformation (since spots that are in fact white in color occur only on juveniles). This may be a convention of the artist, for some of the wall paintings also show spots or short lines to provide texture (see earlier discussion).

FAUNAL REMAINS

Antlers and frontals of red deer stags are known from Pompeii, (NM inv. nos. 286768, 18640; Ciarallo and De Carolis 1999: 63; Pompeii inv. no. 18627, wrongly attributed to roe deer by Ciarallo and De Carolis 1999: 63) and the Boscoreale Antiquarium (case VII, inv. no. 11724). As in the case of the roe deer antlers, these are presumably hunting trophies, hung in houses, that also had an apotropaic purpose. The great majority of the deer remains from the forum excavations are red deer antlers, notably a deposit of sawn tines and a large number of shaved pieces of antler from late-fourth- to the early-third-century B.C. levels in the Via Marina. These clearly indicate antler-working activity nearby (King, unpublished). In contrast, red deer bones were uncommon, consisting solely of a second phalanx and a radius with cut marks indicative of butchery for food.

LITERARY REFERENCES

It is probable that the Latin *cervus* refers to red deer, but it is uncertain if other deer species, particularly fallow deer, were included by ancient authors within the scope of the word. *Cervi* were obviously common in Roman Italy and were hunted both for sport and food, and for *venationes* in the arena (Toynbee 1973: 143–5). Deer were probably the most common prey of the wild beasts in the amphitheater, and there are several references to *cervi* and *dammae* (fallow deer?), sometimes dis-

played on their own (e.g., Pausanias 8.17.4; Scriptores Historiae Augustae *Probus* 19.4). A rare sight was harnessed stags (Martial 1.104.4; Scriptores Historiae Augustae *Elagabalus* 28.2), since they were difficult to train unless raised in captivity. However, deer were tamed and kept for display, such as the deer in Quintus Hortensius's park that came when summoned by a call (Varro *RR* 3.13.3). Stags were also kept as pets (Martial 13.96; Vergil *Aeneid* 8.483–502).

Venison was a valued meat (Apicius 8.2.1; 8.3–8), although medical doctors were divided over its nourishment value (Celsus *De Medicina* 2.18.2; Galen 6.664; André 1981: 116).

COMMENT

Red deer are the most frequently depicted deer species and were probably much more widespread in ancient Italy than they are now (Corbet and Ovenden 1980: pl. 31). Their main role in Roman life was as objects of the hunt, either in the countryside or in the arena, and the deer hunt was undoubtedly a feature of a wealthy Roman's lifestyle (Anderson 1985). Villas such as Settefinestre (King 1985: figs. 185, 187) often have significant numbers of deer bones, and the animals may have been hunted to provide commercially marketable quantities of meat, antlers, and hides. Urban sites such as Pompeii usually have very few deer bones, indicating a low level of venison consumption. However, the forum excavations are noteworthy in having evidence of antler-working, which probably represents an aspect of the industrial life of the town.

13. *DELPHINUS DELPHIS* L.

English, common dolphin; Italian, *delfino comune*

SCULPTURE

A recurrent type of marble garden sculpture in Pompeii is a dolphin rescuing a Cupid from an octopus. Typically, the dolphin is shown vertically, head down, and grappling with the octopus in or just below its beak. The dolphin is always carved unrealistically, in the usual unrepresentational style that emphasizes the animal's sinuosity. Often the dolphin's beak has a spout for a fountain, and in one case color traces have survived (I.ix.13; NM inv. no. 8126; Conticello et al. 1992: no. 188). Other examples include the pair from the House of M. Lucretius (IX.iii.5; Dwyer 1982: 42–3, figs. 34–5) and four from the House of Ceres, of which only one has the octopus (Fig. 346; Dwyer 1982: figs. 184–5). A bronze sculpture with the same iconography comes from the House of the Scientists (VI.xiv.43; NM inv. no. 72291). A variant is seen in the statuette of a standing winged Cupid holding a dolphin on his shoulder, again with the animal's mouth forming a spout (House of Fortuna,

IX.vii.20, peristyle; NM inv. no. 111701; Dwyer 1982: 76, fig. 114). This is similar to the pair of bronzes from the Villa of the Papyri, Herculaneum, showing Cupids with dolphins under their arms, also with spouts in the animals' beaks (NM inv. nos. 5021, 5032). Dolphins are noted on gladiators' helmets and greaves in the Naples Museum (Matteucig 1974a: table 1, no. 64).

PAINTING

A fine and fairly realistic depiction of a dolphin breaking the surface of the sea, with Cupid riding on its back, forms part of the garden painting in the House of Venus in a Shell (II.iii.3; Jashemski 1979: 62, fig. 101). Small, usually highly stylized dolphins figure frequently as decorative motifs in the borders of wall-painting schemes.

MOSAIC

Schematized dolphins occur on various mosaics from Pompeii, usually as minor decorative elements to give a marine context (Matteucig 1974a: table 1, no. 64).

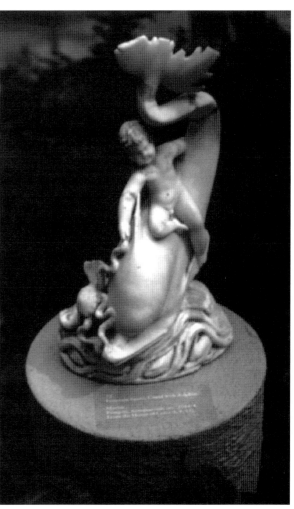

FIGURE 346 Marble garden sculpture of a dolphin rescuing a Cupid from an octopus, House of Ceres, Pompeii. Photo: S. Jashemski.

COMMENT

Dolphins are nearly always stylized, often markedly so, and almost unrecognizable except inasmuch as this is known to be the convention for them. No attempt at verisimilitude is made, perhaps because they were not hunted, except for medicinal purposes, and therefore there were few specimens available to ancient artists (Zeuner 1963). As a result, no differentiation of species can be attempted. (The choice is likely to have been common dolphin (*Delphinus delphis*) or bottle-nosed dolphin (*Tursiops truncatus*), but other species are also a possibility.) Usually, dolphins are accompaniments to mythological scenes, to provide a suitably marine setting. In ancient literature, dolphins were regarded as intelligent creatures, capable of remarkable associations with humans (e.g., Pliny *HN* 9.26, 9.29–32; Beagon 1992: 128–9; Toynbee 1973: 206–8; Zeuner 1963).

14. *DICEROS BICORNIS* L.

English, black rhinoceros; Italian, *rinoceronte*

SCULPTURE

A marble relief from Pompeii shows a rhinoceros with a very large horn correctly positioned and a smaller horn wrongly placed behind the ears (NM; Keller 1963: I, 388, fig. 135; Toynbee 1973: 126).

COMMENT

Rhinoceroses from both India and Africa were known to the Romans, the majority of the references being to the two-horned African variety. Many of the ancient writers add the epithet Ethiopian to the animal, implying that this was the best-known area of origin (cf. Toynbee 1973: 125–7). The animals were used in the arena, sometimes to fight with elephants, which were traditionally regarded as their enemy (Pliny *HN* 8.71). They must have been rare imports, and it is unlikely, therefore, that this species would have appeared in Pompeii's arena, unless under most exceptional circumstances. The black rather than the white rhinoceros is the species most probably encountered by ancient wild beast traders, since it has a range that in recent times encompassed the upper reaches of the Nile (Haltenorth and Diller 1980: 115–19) and is markedly more common today.

15. *ELIOMYS QUERCINUS* L.

English, garden dormouse; Italian, *topo quercino*

SCULPTURE

It is probably this species that is gnawing at an acorn on the Eumachia portal reliefs (Fig. 347; Matteucig 1974b: 220, no. 33; 1974a: table 1, no. 70).

FIGURE 347 A dormouse, probably *Eliomys quercinus*, on the Eumachia portal, Pompeii. Photo: F. Meyer.

FAUNAL REMAINS

Bones of *E. quercinus* were found in the north courtyard garden (70) of the Villa of Poppaea at Oplontis (Jashemski 1979: 308).

COMMENT

This small dormouse was probably not eaten, unlike *Glis glis* (see entry), and the bones are probably those of a wild inhabitant of the villa's garden. Apart from a possible reference to garden dormouse in Pseudophiloxenos, there are no specific mentions of this species, unless they are the *nitellae* refered to by Galen (6.666) as being eaten in Lucania (André 1981: 120). Ancient sources were imprecise about dormice and could be referring to any of the three common species. However, edible dormouse probably attracted the most attention by virtue of its larger size and its consumption as a delicacy.

16. *EQUUS AFRICANUS* (FITZINGER 1857) AND *E. HEMIONUS* L.

English, African wild ass and Asian wild ass (onager); Italian, *onagro*

PAINTINGS

No clear depictions exist, but some of the more indistinct or poorly painted individuals in the *venatio* paintings may be this species, such as in the garden painting in the House of the Chariots (VII.ii.25), which shows two possible startled onagers fleeing the scene (Andreae 1990: 101). In another garden painting of a *venatio* or an Orpheus scene, a group of animals includes a gray donkey that may be a wild ass or onager (VII.vii.10; Andreae 1990: 81; Jashemski 1979: 70–1, pl. 115a).

COMMENT

Wild donkeys occurred in North Africa and the Near East in Roman times and were captured for the

arena. They were also eaten as a delicacy (Pliny *HN* 8.174; Vigneron 1968: 188), especially the meat of young onagers from North Africa. Most of the depictions and literary references are of mid- to late-Imperial date, which may be due to encouragement given by the African emperors to transport of these and other animals from North Africa to Italy for the amphitheater. However, Pliny's, Varro's, and Cicero's comments, mainly relating to Near Eastern animals, all indicate a good knowledge of wild donkeys prior to the eruption of Vesuvius (cf. Toynbee 1973: 192–3).

17. *EQUUS ASINUS* L.

English, donkey; Italian, *asino*

SCULPTURE

A fine humorous bronze statuette of a recalcitrant donkey is in the Naples Museum (inv. no. 4955; De Caro 1994: 245; Ward-Perkins and Claridge 1976: no. 101; Ciarallo and De Carolis 1999: 151; Matteucig 1974a: table 1, no. 74).

PAINTING

A painting with an Egyptian setting shows a man trying to pull a stubborn donkey away from a crocodile. It has a saddle loaded with eight bottles (NM; unspecific provenance from Herculaneum; McDermott 1938: 281, no. 484). Another Nilotic scene in the House of the Ceii shows a barge with its prow in the form of a donkey, designed presumably to reinforce the humorous nature of the painting (I.vi.15, rm h; PPM I, 471). In a lararium painting at Pompeii, two donkeys figure in a scene with a boat loaded with produce (see Fig. 10). They are possibly helping to pull the boat. Two donkeys feature on a no longer extant painting from the *macellum* of Pompeii (see Fig. 348). Last, in a stable larar-

ium (Pompeii IX.ii. 24) a donkey with spindly legs, white muzzle, and a harness and reins is shown carrying a woman who holds a child. She sits across the donkey, sidesaddle, in a pose like the Gallic depictions of Epona (Pompeii, Stable IX.ii. 24; Boyce 1937: pl. 24.2).

MOSAIC

The well-known theme of drunken Silenus on a donkey appears in a mosaic in the Naples Museum. The beast struggles to support the god, and two slaves tug it to its feet by the ears and tail. It is a lively scene, but with little modeling of the animal's body or limbs.

FAUNAL REMAINS

A complete metacarpal, most likely to be of *E. asinus*, comes from the forum excavations (King, unpublished), from a late-fourth-century B.C. level in the Via Marina. A donkey bone was also found in a sixth- to third-century B.C. context in the House of Ganymede (VII.xiii.(13)4; Kokabi 1982). However, no certain attributions of equid bones to donkeys have been made in the study of A.D. 79 era skeletons from Pompeii (Richardson et al. 1997: 95).

LITERARY REFERENCES

Donkeys were bred for two purposes, providing sires and dams for mules and hinnies, and for work. The former were renowned, with high-quality males fetching up to 300,000 or 400,000 sestertii (Varro *RR* 2.8.3; White 1970: 300). The best-quality animals came from Arcadia in Greece and Reate in Italy (Varro *RR*

FIGURE 348 Two donkeys rest from their labor at the mill during a celebration of the Vestalia. Drawing of a painting no longer extant, from the *macellum*, Pompeii. From Jahn 1870: pl. XI, fig. 4.

2.1.13, 2.6.1; Columella *RR* 7.1.1). However, the vast majority of donkeys were of humble stock destined for work as pack animals, in the mills or in the fields (Varro *RR* 2.6.5). They were often used for light and shallow plowing in looser soils such as those of Campania (Pliny *HN* 8.167, 17.41; Varro *RR* 2.6.3; White 1970: 294, 299). Their use for carrying loads was also familiar to ancient writers; according to Apuleius (*Golden Ass* 7.17; Toynbee 1973: 195), they bore burdens heavy enough for an elephant rather than a donkey. Trains of donkeys were used for conveying bulk goods, such as wine, oil, or grain (Varro *RR* 2.6.5; White 1970: 299). Apuleius in *The Golden Ass* has the donkey Lucius describe the grueling work of turning the horse mills at a bakery (9.10–13), probably the heaviest work for donkeys, and remarked on similarly by other writers (cf. Toynbee 1973: 195). As a result of their use for work, donkeys were generally regarded as stupid and stubborn; an animal to be ill-treated and fed very little (Columella *RR* 3.17.6; 7.1; Toynbee 1973: 194).

In contrast to this image, donkey meat was eaten as a delicacy (Pliny *HN* 8.170), apparently having been introduced to the Roman palate by Maecenas, who preferred it to that of the onager (Vigneron 1968: 188). This was probably a passing fashion, however, since Apuleius (7.22) states that donkey carcasses were given to the poor for food. Ass's milk was used medicinally as a purgative (Varro *RR* 2.11.1) and, famously, in baths as a beauty aid (Juvenal *Satires* 6.468–9).

COMMENT

The almost complete lack of zoological remains of this species from Vesuvian sites is noteworthy in view of the literary references, which seem to imply that donkeys should have been fairly common. Perhaps few were kept in the region, or else they were driven away (presumably loaded with people's possessions) at the time of the eruption.

18. *EQUUS ASINUS × CABALLUS*
English, mule; Italian, *mulo*

SCULPTURE

One of the cups from the Menander Hoard shows a rustic scene, with a mule standing by a rocky outcrop while its owner makes sacrifices at a shrine. The animal has its head down, ears back, and is drinking, in a fine portrayal of an animal resting from its labors (NM; Maiuri 1933: 265–72).

A pair of bronze appliqués from Herculaneum show the heads and necks of two mules in relief. Their heads, with typical large ears, turn to face outwards, and they are adorned with ivy wreaths around the ears

and panther skins on the lower neck/shoulder area (NM inv. nos. 72734, 72736; De Caro 1994: 223). The pieces are from a couch, and probably have Dionysiac connotations in view of the ivy and the feline pelt.

A more prosaic representation of a pair of sketchily carved mules is in the marble relief from the House of Jucundus (see Fig. 31).

PAINTING

A probable pair of mules standing near the traces of a large cart with a full wineskin, comes from a tavern near the forum (VI.x.1; Jashemski 1979: 219, fig. 326).

FAUNAL REMAINS

It is generally quite difficult to differentiate mule from horse bones (Armitage and Chapman 1979), but all the faunal remains examined directly by the author are more likely to have been horse. However, a mounted skeleton in a stable in Pompeii (Fig. 349; I.viii.12; *NS* 1946, 101–2), seen only in photographs, shows, from the deep jawline and squat nasal area, the possibility of an attribution to mule. Richardson et al. (1997: 94–9), using measurements, also consider that most, if not all, of the

FIGURE 349 A mule or horse skeleton in a stable (I.viii.12), Pompeii. Photo: S. Jashemski.

available equid skeletons from A.D. 79 levels were in fact mules rather than horses. These include the animals recently excavated in the stable of the House of the Chaste Lovers (IX.xii.6–7; Cocca et al. 1995). Another probable mule comes from a stall in I.ix.12 (Fulford and Wallace-Hadrill 1998: 86–9).

LITERARY REFERENCES

Mule-breeding was very extensive in Roman times (Columella *RR* 6.3.6; Varro *RR* 2.6.3), and the best and largest mules were considered to be those from Reate (Varro *RR* 2.8.3). Since horses were not used for pulling vehicles, mules provided the main source of fast motive power, even for wealthy and prestigious carriages (cf. Toynbee 1973: 190 for references). Appearance and size was therefore important (White 1970: 295), and they could attain the size of horses (Hyland 1990: 35). Mules were also regarded as having "an unequalled robustness for work" (Pliny *HN* 8.171) and were used extensively as pack animals (Toynbee 1973: 191–2), especially males (Columella *RR* 6.37.11). Old animals, like other equines, were not pensioned off but continued to work until they dropped in such activities as baker's horse mills (Apuleius 9.11–13).

COMMENT

Mules seem to take a less prominent place in Pompeii's archaeozoology than they should, to judge from their apparent ubiquity as beasts of burden and transport. Future study of the equine remains may alter this picture, however, and there are several indications from recent research that the equids from A.D. 79 levels are predominantly mules. It is possible that they were left behind in preference to the faster horses used for escape from the eruption. Alternatively, of course, Pompeii had a large population of mules at that time, but not many horses.

19. *EQUUS CABALLUS* L.
English, horse; Italian, *cavallo*

SCULPTURE

Among the most imposing ancient sculptures from the Bay of Naples area are the two life-size marble equestrian statues of M. Nonnius Balbus (Fig. 350, NM inv. no. 6167) and his son, each in military cuirass, riding horses with decorative harnesses ("Basilica," Herculaneum). The sculptures were an early and famous discovery in the eighteenth-century excavations at Herculaneum, and in artistic terms have been favorably compared with the Marcus Aurelius statue in Rome (Haskell and Penny 1981: 160). They were certainly public statues, probably set on plinths like those

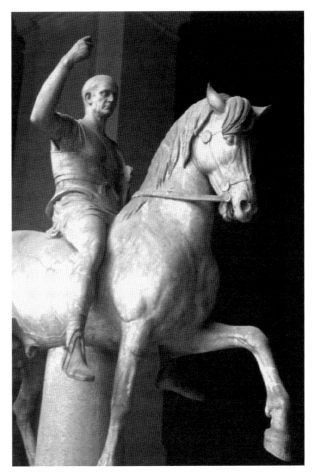

FIGURE 350 Life-size marble equestrian statue of M. Nonnius Balbus, Herculaneum. The horse is naturalistically shown, flicking its ears and high-stepping in a lively manner (NM inv. no. 6167). Photo: S. Jashemski.

in a wall painting of a forum scene from Pompeii (II.iv.3; NM inv. no. 9068; De Caro 1994: 122).

A fine, well-executed head of a horse, once part of a complete equestrian statue, from a series of six or more, comes from early explorations of the Herculaneum theater (NM inv. no. 115391; De Caro 1994: 118; Ward-Perkins and Claridge 1976: no. 73). It is in bronze, originally gilded, and is shown with the cranial part of the mane drawn up into a topknot, presumably to clear the horse's vision. It has a typical harness set, which can also be seen on other horse sculptures of the period (Vigneron 1968: pl. 16).

Other bronze sculptures include a statuette of a fine rearing horse (Bucephalus) with Alexander the Great in the act of jumping off to attack an enemy (NM inv. no. 4996, from Herculaneum; De Caro 1994: 218). It is thought to be a miniature copy of part of a famous group by Lysippos that was brought to Rome after the conquest of Macedonia (Pollitt 1986: 43). As such, its link with the horses present in the Vesuvian area is limited. Similarly, a statuette of a rearing horse carrying an Amazon, from Herculaneum (NM inv. no. 4999;

De Caro 1994: 219), is derived from a possible Greek prototype.

The Menander Hoard includes a pair of cups decorated with the Labors of Hercules: the horses of Diomedes rearing over the body of Biston in one scene and Hippolita on a rearing horse in another (NM inv. nos. 14505–6; Maiuri 1933: 311–18; De Caro 1994: 230; Matteucig 1974a: table 1, no. 75). Other pieces in the hoard portray Cupids riding chariots, in which horses are shown racing or crashing, and a large patera with a hunt scene on the handle, with horses and horsemen (Maiuri 1933: 343–7, 355–7; NM). A bronze *oinochoe*, not from the hoard, without an accurate provenance, has a well-modeled horse head at the top of the handle (NM inv. no. 69082; De Caro 1994: 228). Three equine brooches were found in the peristyle of the House of the Citharist (NM inv. nos. 122648, 122659; Dwyer 1982: 108) and a bronze appliqué from a bed comes from Herculaneum (ins. or. II.8; inv. no. E1118; Ciarallo and De Carolis 1999: 150).

PAINTINGS AND GRAFFITI

A vigorous painting of four-horsed chariots in a circus race comes probably from the House of the Quadrigae (VII.ii.25; Ward-Perkins and Claridge 1976: no. 311). The horses are pulling forward at speed, urged on by their drivers in flimsy two-wheeled chariot frames. The animals are generally brown or black, but with variation between individuals. They seem to have been harnessed so that a pair of blacks took the outer traces and a brown pair the inner set.

Horses and riders are common elements in mythological paintings, such as the Slaughter of the Niobids (VII.xv.2; Dawson 1944: 92, pl. X), or Trojans and Amazons (House of the Cryptoporticus; PPM I, 220), or pulling Apollo's chariot in the Fall of Icarus (I.vii.7, rm 6; PPM I, 595). Otherwise, horses do not feature very commonly, since they are not usually present in *venatio* scenes and do not occur as still life subjects or to any great extent as subsidiary decorative motifs. An exception to this is the unusual *venatio* scene of a leopard pulling a gray stallion to the ground (House of the Centenary; IX.viii.6; Jashemski 1979: 111–12, fig. 181; 1993: 367; Andreae 1990). This may indicate that horses were occasional prey in the arena.

In graffiti, horses and riders of varying accuracy are common in the incised arena scenes from the House of the Cryptoporticus (Vivolo 1993: 84–5, 90–3, 96, 106–7). An energetic depiction of incised horses, perhaps reflecting a theater scene, is in the Corridor of the Theaters (Vivolo 1993: 138–9, 141–2).

MOSAIC

Several horses appear on the famous Alexander mosaic from the House of the Faun (NM inv. no.

10020; De Caro 1994: 144–5; Pollitt 1986: 3–4, pl. 2). This mosaic is thought to be derived, c. 100 B.C., from an early Hellenistic original, thus implying that little if any use was made of local models for the horses. Telling detail in this respect are the horse bits, since the types shown are usually associated with the Greek parts of the Mediterranean (Vigneron 1968: pl. 22–3), rather than local Italian models.

FAUNAL REMAINS

Horse skeletons were found at Gragnano villa, in a *stabulum*, together with cattle remains (no. 34; *NS* 1923, 275–6; Day 1932: 174). A mule or horse skeleton is now visible mounted and articulated in a stable in Pompeii (Fig. 349; I.viii.12; *NS* 1946, 101–2; Morelli del Franco and Vitale 1989: 199–200, fig. 12). The stable had a manger in which straw and feed survived. This is one of a total of fourteen equid skeletons from Pompeii from A.D. 79 levels, including five recently excavated in the House of the Chaste Lovers (IX.xii.6, rm 6; Cocca et al. 1995; Varone 1989: 234–6; Richardson 1995). It is quite likely, however, that most, if not all, of these animals were mules (Richardson et al., 1997: 94–9). The number of individuals is relatively high, suggesting that they were left to their fate at the eruption, which is curious in view of their obvious use for transport of goods and people. Perhaps the ash falls had negated their utilization to a great extent. The remains from the House of the Chaste Lovers suggests that the panicking animals were trapped in their stalls, possibly being overcome by fumes, since the skeletons were found in disarray. Forage of oats and horsebeans was also found. Two horses, one a five-year-old of "eastern breed," and a carriage were found in the House of N. Popidius Priscus (VII.ii.20; La Rocca, de Vos, and de Vos 1994: 290). There was no obvious stable at this house, and the animals and carriage may have been brought from elsewhere to carry refugees and their belongings, a plan that was abandoned and the horses left to their fate. By coincidence, one of the best examples of a stable (for four horses) comes from another house associated with the Popidii, the House of the Citharist (I.iv.25, rm 27; La Rocca et al. 1994: 171; Vigneron 1968: pl. 6).

Apart from the complete or near-complete remains of equid carcasses, bones of horse were actually quite uncommon. Out of nearly 6,000 bones identified to species from the forum excavations, there are only 20 equid bones (King, unpublished), including specimens representing both very large and very elderly individuals, and 1 very probably of *E. asinus*. A rather greater proportion of equid bones (11 out of 198) comes from republican levels under the House of Amarantus

(I.ix.11–12; Clark 1999). A small number of horse bones was excavated from the Large Vineyard (II.v; Jashemski 1979: 216–18, table A), which also represents a relatively high proportion of the bones identified to species (6 out of 38). Interestingly, some of them were butchered, which may indicate that horse meat had been eaten at this location.

HORSE BITS

A bit of "Thracian" type comes from Pompeii, with an incurved mouth bar to provide a severe curb (Vigneron, 1968: pl. 27). It is analogous to the Newstead, Scotland, curb bit, which experiments show would have acted as a severe restraint on the horse, and must have been used by a skilled rider (Hyland 1990: 137–8).

MILLS

A notable feature of bakeries in Pompeii is the presence of horse or donkey mills (Laurence 1994: 55–9), such as the bank of four in the bakery (VII.ii.22) adjacent to the House of Popidius Priscus (La Rocca et al. 1994: 289; see Jashemski 1979: 194–5), or in the bakery of Sotericus (I.xii.1–2; La Rocca et al., 1994: 218, 230). The mills were operated by horses or donkeys attached by a neck harness to the wooden yoke that slotted into the millstone, visible in a sculpted relief in the Vatican Museum (Vigneron 1968: pl. 71).

LITERARY REFERENCES

Much is written about horses by ancient authors, as surveyed by Vigneron (1968) and, more briefly, Toynbee (1973: 167–85). This was due to their usefulness, particularly in warfare and for transport. Varro (*RR* 2.7.15) categorizes their uses as for war, transport, breeding (both for horses and mules), and racing. Vegetius, a fourth-century A.D. military writer, gives the most important uses as warfare, racing, and riding: breeding and farm work were regarded as less worthy (*Ars Mulomed.* 3.6.2). Vegetius also indicates the importance of horses in his extensive discussion of veterinary practice, which is largely concerned with horses rather than other species (Walker 1973). The brief summary of the literature presented here will only deal with aspects relevant to life in Campania, omitting the use of horses in warfare and racing in the circus.

Certain regions were regarded as sources of supply of horses. In Italy, Apulia was a good breeding area, as was Reate (Varro *RR* 2.7.1), and Columella stresses that high-quality bloodstock, for instance for racing, required good pasture and open, hilly, well-watered country (*RR* 6.27.2; White 1970: 288–9). Apulia fitted these conditions well. Horses on stud farms were used for breeding both horses and mules, the latter being as highly regarded as horses (see entry).

Horses in everyday use in provincial Italy were mostly used for riding and hunting, while mules or oxen were used for hauling carriages. Horse equipment is mainly known from pictorial evidence, but writers such as Apuleius (10.18) refer to harness and saddles (Toynbee 1973: 171–3). More is written about how horses should be cared for. Columella has advice on grooming (*RR* 6.30.1) and stabling (6.27.11; 6.30.1–3), while various ancient writers set down recommendations for stable design (Cato 14.2; Varro *RR* 2.7.10; Vigneron 1968: 23ff; Hyland 1990: 37). Varro and Columella devote space to the veterinary care of horses (Walker 1973; White 1970: 291).

The training and breaking in of horses is more briefly referred to. Varro (*RR* 2.7.11–13) has information on how horses were broken in, and Columella mentions the requirements and best age for training racehorses (*RR* 6.29.4; White 1970: 292–3). Besides their use for racing in the circus, which would not have been seen in the Vesuvian towns, horses were used to carry gladiators into the arena (Toynbee 1973: 183–4; Vigneron 1968: 219), and as performers in acrobatic displays – the acrobats (*desultores*) being on horseback as in modern circuses (Vigneron 1968: 209). They were also used in bullfighting (*taurokathapsia*; Pliny *HN* 8.182; Lucretius 5.1323–4) in a similar manner to the modern Spanish *corrida*, but the picadors did not use lances or swords, at the most having a lasso (Vigneron 1968: 218).

Hunting in the countryside probably involved horses, but Vigneron (1968: 227) is of the opinion that huntsmen in the saddle were not very common in Italy until the period of the Empire, because of the difficult terrain and vegetation. Vergil, for instance, mentions deer hunting without horses (*Georgics* 3.409–13), but Martial has horsemen hunting for hares and wild boar (1.49.25, 12.14). Horses were probably most useful in chasing swift prey in open country (i.e., not mountainous or heavily cultivated), conditions that would not have applied in many parts of Campania.

In urban life, horses were mainly kept as personal mounts, but elderly animals suffered the indignity of being harnessed to flour mills, as graphically described by Apuleius (*Met.* 9.10–13) and alluded to by other writers (Juvenal *Satires* 8.66–7; Columella *RR* 6.37.1). Even racehorses ended up tethered to the mills (Toynbee 1973: 185).

The consumption of horse meat was resorted to only by the poor, starving or desperate (Tacitus *Histories* 4.60; *Annals* 2.24; Toynbee 1973: 185; Vigneron 1968: 187–9). Horse milk, blood, and, occasionally, meat

were used in medical remedies for humans or animals (Pliny *HN* 28.147, 159, 224, 265; André 1981: 134).

COMMENT

The regard in which horses were held by the Romans resulted in a somewhat different attitude to the species compared to the general treatment of animals. Horses, especially racehorses, had names and were endowed with anthropomorphic feelings (Toynbee 1973: 177–81). In light of this attitude, the number of equids (probably mules, for the most part) left behind in Pompeii is surprising, and perhaps indicates that animals in more mundane circumstances suffered perhaps as much as other domestic stock. It is probable, in fact, that racehorses were rare in the Vesuvian region, as borne out by the comparative lack of representations of circus scenes.

20. *ERINACEUS EUROPAEUS* L.
English, hedgehog; Italian, *riccio*

FAUNAL REMAINS

A mandible of this species was found in an Augustan or later deposit in the forum excavations (King, unpublished).

COMMENT

Pliny (*HN* 8.133–5) writes of an economic use for the hedgehog, in the utilization of their spiny hides for dressing cloth in the garment industry (cf. Keller 1963: I, 18). The presence of osteological remains of this species in the forum of Pompeii might, just possibly, be linked to human exploitation of the animal, but it is more likely that the bones derive from a natural death.

21. *FELIS CATUS* L.
English, cat; Italian, *gatto*

PAINTING

A possible cat, with plain markings but unrealistic ears, is shown in a still life with a vase, from the triclinium of the House of the Carbonized Furniture, Herculaneum (V.5; Croisille 1965: no. 324). A white silhouette of a crouching cat, head and ears erect, and seated on an upholstered stool, occurs in a painting with Egyptianizing elements from a niche in the kitchen area of the Temple of Isis, Pompeii (NM inv. no. 8648; Sampaolo 1992: 62, no. 1.84; Ward-Perkins and Claridge 1976: no. 98). It may represent Bast, the cat god of Bubastis in the Nile Delta.

MOSAIC

A striped tabby cat is about to dispatch a chicken in the upper part of a probably Hellenistic, second-century B.C. (see Fig. 236). The cat stares realistically at

its quarry, but the tabby stripes are simplified and stylized. The representation is a stock one, since two other versions are known from the vicinity of Rome (Toynbee 1973: 88), and there is the possibility of working from a copybook rather than depicting the animal from life.

Another cat occurs on a mosaic of a birdbath with parakeets and a dove (NM inv. no. 9992) (see Fig. 330). It is at the foot of the pedestal, looking voraciously at the birds, one paw extended with claws out. It is sketchily portrayed, the ears too pointed, the tail too long and thin. Keller (1963: I, 81) identifies the depiction as a swamp cat (*F. chaus* [Guldenstaedt 1776]), on the basis of its appearance and the probable Egyptian setting of the mosaic. It is doubtful that this is correct, however, since the swamp cat has a shorter tail than *F. catus* or *F. sylvestris* (Haltenorth and Diller 1980: 230, pl. 43). It is also generally larger than the wild cat and fiercer, thus making the garden/domestic setting of the mosaic an unlikely milieu. A more probable explanation of the cat's appearance is simply one of artistic stylization or incompetence.

FAUNAL REMAINS

A few cat bones have been recorded from the forum excavations. A maxilla was found in a late-fourth-century B.C. deposit in the Via Marina, and the partial skeleton of a juvenile from an Augustan or later level was found in the *temenos* area of the Temple of Venus (King, unpublished). A mandible was also found in the garden excavation of the Large Vineyard (II.v; Jashemski 1979: 216–18, table A) and a calcaneum from another vineyard (III.vii; Jashemski 1979: 232). These are from eruption-period deposits and, as such, represent virtually the only records of cats from the time of the eruption. Unlike the many dog remains, there are no other cat bones or casts from the ash and volcanic layers (Keller 1963: I, 79; Toynbee 1973: 89).

COMMENT

Cats seem to have been uncommon at the time of the eruption, despite a long history in the region. They are shown on Hellenistic vases and lamps (Toynbee 1973: 89–90), and it may well be the case that the species was introduced to Italy via Magna Graecia. The domestic cat was well known to Pliny (and other early Imperial writers), since he gives a careful description of the animal's stalking and toilet habits (*HN* 10.202). It is probable that cats were mainly used for suppressing vermin, and that they were not particularly regarded as pets. An intriguing possibility is that the weasel also had an important role in suppressing vermin (see entry under *Mustela*), and that the cat was slowly replacing it

during the Roman period because it was cleaner and more companionable. By the later Imperial period cats had become much more common, to judge from the relatively large number of bones from fifth- to seventh-century A.D. deposits in Naples (King 1994: 387, tables 37, 39).

22. *FELIS LYNX* L.

English, lynx; Italian, *lince*

MOSAIC

There is a lynx recorded by Matteucig (1974a: table 1, no. 118) on a mosaic in the Naples Museum.

LITERARY REFERENCES

Lynxes were noted by Pliny as coming from Africa, but also from Europe, including Gaul. (*HN* 8.72, 8.70). He notes that Pompey showed one in games in 55 B.C. (*HN* 8.70), which is the only reference to their use in the arena (Keller 1963: I, 83).

COMMENT

Toynbee (1973: 86–7) does not find any clear depictions of a lynx in Roman art. This rare species may have been present as an arena beast at Pompeii, but it is doubtful.

23. *FELIS SYLVESTRIS* SCHREBER 1775

English, wild cat; Italian, *gatto selvatico*

MOSAIC

Matteucig records *F. sylvestris* not *F. catus* for the mosaics noted earlier for the domestic cat in the Naples Museum (1974a: table 1, no. 81). It is possible that they could be wild cats, that is, *F. sylvestris libyca* (Forster 1780), since the coloring is compatible, but they are small compared with an adult wild cat. The context of the mosaics, too, is that of domestic genre scenes, despite the Nilotic associations of the House of the Faun mosaic.

COMMENT

The wild cat is very rare, but present in peninsular Italy in recent times (Corbet and Ovenden 1980: 188, pl. 26). It was very likely, therefore, to have been present in the montane regions of the Vesuvian area during the early Empire and may have been hunted. Unfortunately, the evidence presented here is not convincing enough to allow us to claim a definite positive attribution to this species.

24. *GAZELLA DORCAS* L.

English, dorcas gazelle; Italian, *gazzella dorcas*

SCULPTURE

A marble garden sculpture from the House of Camillus (VII.xii.22/23) has a gazelle standing with its head up in alarm and a small wiry dog clinging to its back, biting its lower neck (NM inv. no. 6540; Dwyer 1982: 65–6, fig. 82). This is a variant on a common theme that usually consisted of deer and dogs. A dying gazelle under a lion comes from the garden of the House of Octavius Quartio (II.ii.2; inv. no. 2929; Ciarallo and De Carolis 1999: 70)

PAINTINGS

Two gazelles are shown with tied feet in a still life in the House of Castor and Pollux (VI.ix.6–7, peristyle; Croisille 1965: no. 229A). They are quite small, being depicted as the same size as the goose in the panel below. Another pair are on a still life from the Villa of the Papyri (Villa of Piso), Herculaneum (Fig. 351; NM inv. no. 8759; De Caro 1994: 300; Croisille 1965: no. 78).

Dorcas gazelle occurs in two locations in the House of M. Lucretius Fronto, first in a hunt scene in the garden (V.iv.a/11; Jashemski 1993: 336–7; Peters et al. 1993: figs. 248–53) and second in vignettes in the atrium, that show dogs attacking gazelles (Peters et al. 1993: 149–52, figs. 121–2). Other hunting scenes include gazelles and are listed by Andreae. Gazelles are also shown as pairs drawing chariots with cupids at the reins in one of the decorative friezes in the House of the Vettii (Toynbee 1973: 147; cf. Keller 1963: I, 287, fig. 91), and elsewhere (I, iii, 3; PPM I, 68). They are also in the tendril scroll of the portico frieze of the Temple of Isis (NM inv. no. 8549; Sampaolo 1992: 50–4, no. 1.49).

FIGURE 351 A pair of gazelles, Villa of the Papyri, Herculaneum. Both are horned, but very faintly depicted in a still life of hunting spoils. The gazelles are clearly shown, close to actual size, and realistic in appearance: one has its feet tied and the head and neck extended on the ground; the other is holding its head upright. The scene shows that the animals were evidently captured alive, together with the ducks depicted above them. They were perhaps intended for a vivarium. Photo: C. Grande.

Aelian (*NA* 10.23, 10.25, 14.14, 17.31; cf. Toynbee 1973: 147) notes gazelles as being natives of Egypt, Libya, Ethiopia, and Armenia, a zone that more or less corresponds with the present-day range. Pliny (*HN* 8.214) lists animals called *dammae*, probably gazelles, among other species of antelope imported to Italy. Their small size led to recommendations that they were suitable children's pets (Martial 13.99), and their speed was thought to be transmittable to hunting dogs if the females wet-nursed puppies (Grattius *Cynegetica* 1.440–1).

COMMENT

Matteucig (1974a: table 1, no. 90) records *Gazella dorcas* on paintings from Pompeii, but not *Oryx gazella* or *Capra ibex*. This seems to be the case in all instances known to the author, with the exception of the Oryx graffiti catalogued in that entry, despite attributions by other commentators to these creatures being "bouquetins" (i.e., Ibex). Dorcas gazelle is the gazelle of North Africa, the Maghreb, the Sahara, and Saudi Arabia (Haltenorth and Diller 1980: 97), and doubtless was more common and had a more extensive range in the Roman period. It would have been the most likely gazelle species to be found on hunting expeditions within the territory of the Empire.

25. *GIRAFFA CAMELOPARDALIS* L.

English, giraffe; Italian, *giraffa*

SCULPTURE

A possible record of this species is noted by Matteucig in a sculpture in the Pompeii Antiquarium (Matteucig 1974a: table 1, no. 91).

COMMENT

The first giraffe to be seen in Rome was at Julius Caesar's games of 46 B.C. (Pliny *HN* 7.69; Dio Cassius 43.23.1, 2), and after that they appear fairly regularly as curiosities of the arena, sometimes being described or depicted very accurately by ancient authors and painters (Gatier 1996; Blanc 1999; Toynbee 1973: 141–2). A provincial arena, such as that at Pompeii, would have been unlikely to show giraffes, except as a rare and special spectacle.

26. *GLIS GLIS* L.

English, edible dormouse; Italian, *ghiro*

SCULPTURE

Keller (1963: I, 193) refers to a dormouse on one of the pieces of the Boscoreale treasure, but the depiction is not exact, and it is difficult to be sure which dormouse, or indeed which rodent species is shown (see Villefosse 1899).

FAUNAL REMAINS

A cranium and a jaw of *Glis glis*, together with limb bones that best fit with this species, were found in the forum excavations from various stratigraphic contexts, probably of first-century B.C. to first-century A.D. date (King, unpublished). Bones of this species were also found in the north courtyard garden (70) of the Villa of Poppaea at Oplontis (Jashemski 1979: 308).

GLIRARIA

Varro (*RR* 3.15.1–2) refers to special jars in which dormice were fattened prior to being eaten. Pottery jars with internal runways and breathing holes have been found at Pompeii (II.i.2, near lararium; inv. no. 10744; Ciarallo and De Carolis 1999: 153; NM inv. no. 24245; Graham 1978: pl. 14) and elsewhere.

LITERARY REFERENCES

There are many references to dormice among the ancient authors, most of whom seem to be alluding to the edible dormouse. Pliny has a few mentions of dormice; their hibernation (*HN* 8.224) and their diet of beechnuts (*HN* 16.18), while Varro makes several references to the keeping and fattening of the animals (*RR* 3.3.3–4; 3.12.2; 3.15.1–2).

The dormouse is a metaphor for sleepiness, due to its hibernating habit, and this seems to have been its main point of reference among poets and playwrights (e.g., Plautus, Horace). Martial (3.58.36) writes of sleepy dormice brought by country visitors to the farm of Faustinus at Baiae, presumably, although the author does not say so, for fattening and eating.

The edibility of *Glis glis* is the other major preoccupation of the ancient authors (André 1981: 119–20). Apicius (9.1.1) has a recipe for stuffed dormouse (Salza Prina Ricotti 1983: 258–9), and at Trimalchio's feast (Petronius 31.10) dormice are served rolled in honey and poppyseed. It is clear that roast dormouse was regarded as a luxury. Dormice were banned as food items under the sumptuary laws of the lex Aemilia of 78 B.C. (Dosi and Schnell 1984: 293), a law that had little practical effect.

The most curious use of dormice is in a medical prescription for earache, which includes dormouse fat in a warm infusion to be poured into the ear! (Scribonius Largus, *Compositiones* 39).

COMMENT

All three species of dormouse were identified among the bones from the gardens (Jashemski 1993: 407). This

distribution may be significant, in that the gardens are more likely to have supported a wild population that included the largely inedible garden and common dormice, while the forum remains are more likely to have been food refuse. It is therefore not surprising to find *Glis glis* in the context of the forum, and the bones are welcome direct confirmation of the ancient references to the consumption of the edible dormouse.

27. *HERPESTES ICHNEUMON* L.
English, Egyptian mongoose; Italian, *mangusta*

SCULPTURE
A priestess of Isis holds a tray with a mongoose and a cake on it, on a silver vessel found in the Palaestra of Pompeii (Tran Tam Tinh 1964: 173, no. 138a). The vessel may originate from the Temple of Isis in the town.

PAINTING
A pair of rather stylized mongeese confront rearing cobras in a decorative dado on the rear wall of the ekklesiasterion of the Temple of Isis (Elia 1942: tav. 5).

MOSAIC
A mongoose appears on the Nilotic mosaic from the House of the Faun, dated second century B.C. (Fig. 352).

LITERARY REFERENCES
There are several mentions of mongeese by ancient authors as destroyers of snakes and other vermin (Pliny *HN* 8.87–8; Strabo 17.1.39; Cicero *De Natura Deorum* 1.101). Martial says that they were sometimes tamed as pets in Rome, despite their dangerous nature in the wild (7.87.5).

COMMENT
The mongoose is now found in eastern and central Africa, Asia Minor (and further east), the Maghreb, and southwest Spain (Haltenorth and Diller 1980: 201–3; Corbet and Ovenden 1980: 186, pl. 25). In Roman times, all the references to this animal are as a specifically Nilotic creature (Toynbee 1973: 91), and it is probable that its presence in Spain, and perhaps the Maghreb, is a more recent result of Arabic influence. The connection of the animal with Egyptian religion, the cult of Isis in particular, is clear from the Pompeian evidence.

28. *HIPPOPOTAMUS AMPHIBIUS* L.
English, hippopotamus; Italian, *ippopotamo*

PAINTING
A well-executed hippopotamus with realistic ears, nostrils, and body, standing on a rocky island, forms

FIGURE 352 A well-delineated mongoose, somewhat more sharp-nosed than in actuality, advances on a rearing snake. On the left is a palm tree. Also pictured are a mallard duck and a shelduck together with the buds, flowers, leaf, and seed pod of the sacred lotus. Nilotic mosaic, House of the Faun, Pompeii (NM inv. no. 9990). Photo: S. Jashemski.

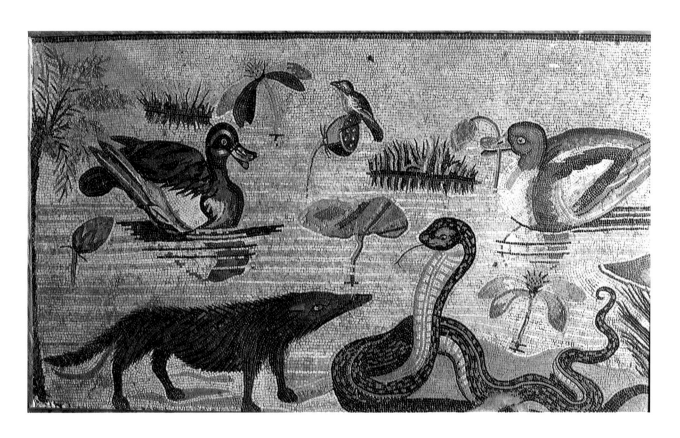

part of a Nilotic scene on a wall painting formerly in Herculaneum (NM inv. no. 8561; Ward-Perkins and Claridge 1976: no. 133). Another hippopotamus, less realistic, is in the act of swallowing an attacking pygmy in a Nilotic painting in the House of the Pygmies (IX.v.9; Ciarallo and De Carolis 1999: 40; Toynbee 1973: pl. 113; Matteucig 1974a: table 1, no. 98). Similarly, garden paintings from the House of the Ceii (I.vi.5; PPM I, 471; Jashemski 1993: 315) and from Herculaneum (NM inv. no. 8561; Ciarallo and De Carolis 1999: 69) have hippopotamuses in Nilotic scenes, the former with hunting pygmies. A small illustration of a hippopotamus comes from the peopled scroll on the frieze of the portico of the Temple of Isis (NM inv. no. 8546; Sampaolo 1992: 50, no. 1.37, tav. VIII). It looks rather like a cow, but it has an open mouth and enough detail of its head to be identified as a hippopotamus.

MOSAIC

The well-known Hellenistic Nilotic mosaic from the House of the Faun shows a hippopotamus emerging from the water (Jashemski, 1979: fig. 29). Another hippopotamus is shown on the mosaic *predella* of a fountain in the viridarium of the garden of the House of the Archduke (VII.iv.56, rm 16; Gierow 1994: taf. 84). It is in a typical small Nilotic scene, aggressively confronting two men (pygmies?) in a rowing boat in marshy water. The Nilotic theme recurs on other Campanian mosaics, summarized by Toynbee (1973: 128–9) and Maiuri (1953: 111).

LITERARY REFERENCES

An accurate description of a hippopotamus is given by Pliny, and he also remarks on its Nilotic habitat (*HN* 8.95; 28.121). The difficulty of hunting them, partly because of their thick hides, is mentioned by Diodorus Siculus *Library of History* (1.35.8–10). However, they were captured and transported to Rome for shows, for the first time in 59 B.C. (Pliny *HN* 8.96), and thereafter in Imperial games up to the fourth century A.D. (Toynbee 1973: 129–30).

COMMENT

The artistic context of the hippopotamus at Pompeii is exclusively a Nilotic one, derived in all probability from Hellenistic originals and representations such as the famous first-century B.C. Nile mosaic pavement from Praeneste (Toynbee 1973: 128; Pollitt 1986: fig. 221), which has a good depiction of the animal. The Nilotic scenes suggest that the species was found much farther downstream on the river in Roman times than today, and was a feature of Roman Egypt. The literary references suggest that the presence of hip-

popotamuses in Italy was a costly element of the games in Rome, and like the rhinoceros, it is very unlikely that the species was actually seen in Pompeii's amphitheater.

29. *LEPUS EUROPAEUS* PALLAS 1778
English, brown hare; Italian, *lepre*

SCULPTURE

A series of marble garden sculptures depict children holding small lagomorphs, which may be young hares or pet rabbits. A good example comes from the House of Camillus (VII.xii.22/23; NM inv. no. 6533; Dwyer 1982: 62–3, fig. 78; Kapossy 1969: fig. 28; Jashemski 1993: 195, fig. 226), which still has traces of red/brown paint on the animal. The child is holding it up by the back legs, apparently about to strike it, as if to make the animal spew water from the spout in its mouth. Others in the group are similar (e.g., Villa of the Mosaic Columns; NM inv. no. 6501; Dwyer 1982: fig. 187; Kapossy 1969: 44; Jashemski 1993: 278, fig. 310), and an example from the House of the Vettii shows the child pulling the animal's ear, probably also trying to make water gush from its mouth (Dwyer 1982: fig. 188). Dwyer (1982: 46–7) interprets another type of garden sculpture as showing crouching hares because of their eyes and the possibility that the ears originally continued along their backs, but their stance and general appearance, and a thin studded collar in one case, favor an attribution to dog rather than hare (see entry *Canis familiaris*). Bronze sculptures of hares are recorded by Matteucig in the Naples Museum (1974a: table 1, no. 111), and more recently from Herculaneum (Palaestra; inv. no. E1483; Ciarallo and De Carolis 1999: 153). There are also relief carvings of lagomorphs, probably hare, on the Eumachia portal relief (Fig. 353; Matteucig 1974b: 219–22, nos. 8, 14, 84).

FIGURE 353 Hare or rabbit on the Eumachia portal, Pompeii. Photo: F. Meyer.

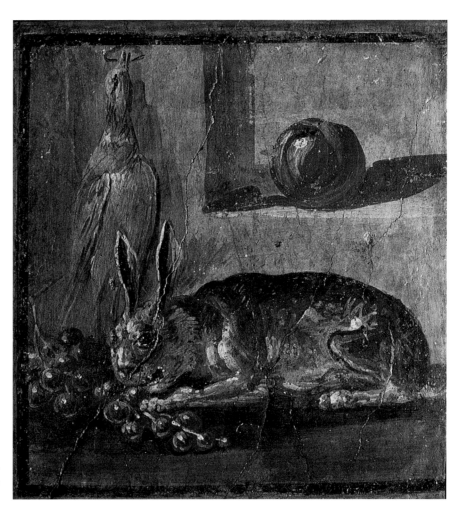

FIGURE 354 Hare nibbling grapes (NM inv. no. 8644). Photo: S. Jashemski.

PAINTING

A hare or rabbit is suspended by its tied rear legs, with its head tilted up to present a frontal view, in a still life of hunting spoils from Pompeii (Villa of Diomedes; NM inv. no. 9847; Croisille 1965: no. 96; De Caro 1994: 149; Ward-Perkins and Claridge 1976: no. 120). A similar still life from Herculaneum shows a hare or rabbit carcass (NM inv. no. 8647; Ward-Perkins and Claridge 1976: no. 255a; Croisille 1965: no. 46). A hare with short ears and an unrealistic bulbous face is shown crouching nibbling a bunch of grapes, together with an apple and a hanging partridge, in a still life from Herculaneum (Fig. 354; NM inv. no. 8644).

FAUNAL REMAINS

These are rare in the forum bone assemblage: a mandible and teeth, and two limb bones, the latter from Augustan first-century A.D. levels (King, unpublished).

LITERARY REFERENCES

Hares were a popular object of the hunt, using hounds and, occasionally, horses (Vergil *Georgics* 1.308; Martial 1.49.25). Arrian (*Cynegetica* 16.1–7) comments that it is better to see the chase and let the hares go free than allow the dogs to kill them, but this view was evidently not shared by others, since both artistic and archaeological evidence testifies to the killing and eating of hares. The species was also kept in hunting parks (*leporaria*), which as the name implies were originally designed only for hares, but by the late Republic contained a large variety of other game (Varro *RR* 3.3.2; 3.12.1–6). Because it was the custom to keep them in semicaptivity, Varro is able to provide us with a good description (*RR* 3.12.6), which makes clear that the Romans knew of three types; the brown hare, which is the subject of this entry, the mountain hare (*Lepus timidus*), which was larger, found in the Alps and characterized by its white winter coat (Calpurnius Siculus *Eclogues* 7.58; Pliny *HN* 8.217), and the rabbit (*Oryctolagus cuniculus*; see separate entry).

Hares were taken from *leporaria* and fattened in cages before being eaten (Columella *RR* 9.1.8), and the meat was considered a delicacy (Martial 13.92; Horace *Satires* 2.4.44; 2.8.89; Apicius 8.8.1–3; André 1981: 118–19). However, artistic depictions indicate that hares were also kept as pets (Toynbee 1973: 201–2).

COMMENT

The evidence combines to suggest that hares were valued in Pompeii for their meat and as pets. They were almost certainly not hunted in the arena, although villa owners in the surrounding countryside may have hunted them for sport.

30. *LOXODONTA AFRICANA* (BLUMENBACH 1797) AND *ELEPHAS MAXIMUS* L.

English, African elephant and Indian elephant;
Italian, *elefante*

SCULPTURE

A fine terra-cotta figurine of an African elephant comes from a house in Pompeii (VI.xv.5; NM inv. no. 124845; Ciarallo and De Carolis 1999: 70; De Caro 1994: 214; Scullard 1974: pl. Xa). Its hide is shown in the common ancient convention of criss-cross lines, but it is executed in a style that conveys the character of the animal well. Its trunk is reaching back to grasp some food being offered by the mahout, behind whom is a castellated tower, with shields attached, fixed to the animal's back by chains. This is a war elephant, perhaps in a triumphal procession. Matteucig records other bronze and glazed terra-cotta (faience) sculptures of elephants in the Naples Museum (1974a: table 1, no. 114).

PAINTINGS

The best-known painting featuring elephants is on the outside wall of the House of Verecundus (IX.vii.9; Fig. 355). Four African elephants are harnessed to a chariot, in which stands the imposing figure of a goddess, variously named as Venus Pompeiana or Aphrodite-Isis. The animals are gray, with trunks down, walking toward the viewer in three-quarter poses that converge toward a central point. The goddess was the protecting deity of Pompeii, and the image had perhaps been exploited by Verecundus (a draper) to protect and promote his business. The elephants also symbolized the town's good fortune and long life.

A painting in the House of the Vettii (VI.xv.1, rm q, *oecus*; Toynbee 1973: 47) shows three probably Indian elephants with flaming torches in their trunks. This depiction refers to the beasts as worshipers of Helios/Sol: they carry torches as a symbol of the victory of light and life over darkness and death (Toynbee 1973: 53). Possibly linked is the depiction in another Pompeian house of two large white elephants on either side of a bronze candelabrum (I.vi.4; Toynbee 1973: 54). Similarly, another

FIGURE 355 Four African elephants drawing a chariot of a goddess on the shop sign of Verecundus. Photo: S. Jashemski.

candelabrum has at the foot of the shaft an African elephant with its trunk around her calf (Scullard 1974: 21; Toynbee 1973: 54; Reinach 1922: 357, no. 9).

An elephant appears as part of the advertisement for a *caupona* (VII.i.44/45; Della Corte 1965: 402–3), positioned in a *tabula ansata* beside the entrance. The animal is guarded by a pygmy but has a large snake wrapped around its body. Associated is a graffito (see following description). Another version of this genre comes from the House of Sex. Pompeius Axiochus (VI.xiii.19/12; Jashemski 1993: 344), in which an elephant has a large green snake wrapped around its body and biting its trunk. A man also holds the animal's trunk.

GRAFFITO

A painted inscription adjacent to the *caupona* advertisement just mentioned (VII.i.44/45; Della Corte 1965: no. 403; *CIL* IV 806) reads *Sittius restituit elep[h]antu[m]*. The name is of one of the more ancient Pompeian families, and it seems to be linked in this instance to the restoration of the sign. There is also an indirect African link between the name and Roman colonies in Numidia, which may be emphasized by this inscription and its reference to an African beast.

LITERARY REFERENCES

There is possibly more written on elephants by ancient authors than on any other animal, due to their exotic appearance, size, and use in battle. The literature has been extensively reviewed by Scullard (1974) and Toynbee (1973: 32–54) and will not be discussed again here, save for certain aspects. Aristotle (*HA* 2.1 and other works; cf. Scullard 1974: 37–52) provides the basis for all later discussion, since he has detailed references to the appearance and behavior of the animal. He must have had either firsthand knowledge or access to people who were closely concerned with elephants. He does not, however, devote his writings to distinguishing Indian from African elephants, but treats them as a single group. Later Greek and Latin writers, such as Megisthenes (*apud* Diodorus 2.35.3), Polybius *Histories* (5.84) and Pliny (*HN* 8.27) start to draw the distinction, stating that Indian elephants were larger than those of Africa. This is not the case today but could have been in ancient times, for reasons outlined by Scullard (1974: 60–3) and discussed here.

Pliny is the main source on elephants in the Imperial period. He has a long description (*HN* 8.1–35) that draws upon earlier writings, a lost source by Juba, and a certain amount of direct observation. Of most relevance to the possible appearance of elephants in the Pompeii amphitheater are his references to their circus tricks (*HN* 8.5–6): performing rhythmic dances, eating banquets, walking on tightropes, or writing in the sand with

their trunks (Scullard 1974: 252–3; Toynbee 1973: 46–9). Elephants had featured regularly in the Circus Maximus and other venues in Rome from the first century B.C. (Pliny *HN* 8.19), and also took part in processions and triumphs (Scullard 1974: 254–9; Toynbee 1973: 39–46). What is not clear, however, is how frequently they appeared in other towns and cities in Italy. A relatively small town like Pompeii may not have had elephants in its arena more than once or twice, if at all.

Among the classical references to elephants are a few that relate the story of a giant snake wrapping itself around an elephant's body, and its eventual death in the ensuing struggle because the elephant fell on its side and crushed the snake (e.g., Pliny *HN* 8.32; Scullard 1974: 216–18). This fable became a popular misconception about elephant (and snake) behaviour, both in the Roman and medieval periods, and is seen at Pompeii in the *caupona* advertisement referred to earlier.

COMMENT

It is clear from Scullard's evaluation of the literary sources that both African and Indian elephants were known and differentiated. This is true also of the artistic depictions, as discussed by Toynbee, in which it is usually possible to distinguish the characteristics of each species. Scullard (1974: 60–3) also examines the frequent assertions in literature that Indian elephants were larger than Africans, which is not the case today. He concludes that the smaller forest elephant (*L. africana cyclotis*; cf. Haltenorth and Diller 1980: 124–7) was the subspecies of the African that was in use in the ancient world, of which the rare modern descendants in the Gulf of Aden area in particular are very small. This would also account for the artistic and literary sources showing African elephants with mahouts and trained for war or work. Forest elephants can be handled and trained, whereas the larger bush elephant, the familiar subspecies of safaris and wildlife films, is usually not amenable to captivity and training.

All the Bay of Naples depictions, with the exception of one from the House of the Vettii, appear to be of African elephants. It is not easy to explain this except in terms of the source of supply. The proximity of North Africa as against India probably meant that any elephants seen by artists or spectators at the arena of Pompeii are likely to have come from the former region.

31. *MACACA SYLVANA* L. AND *PAPIO* sp.
English, barbary ape; Italian, *macaco*
English, baboon; Italian, *babbuino*

SCULPTURE

A statuette of an ape is recorded from the House of the Citharist (I.iv.25; Della Corte 1965: 251, no. 498). It

holds a Phrygian cap and dagger, and is presumably a genre piece of a performing monkey. A small bronze of a baboon or monkey comes from I.xiii.10 (NM inv. no. 10919; Ciarallo and De Carolis 1999: 71).

PAINTING

A tailless ape is shown in a painted sketch on the wall of the sacrarium of the Temple of Isis in Pompeii (NM inv. no. 8533; Sampaolo 1992: 58–61, no. 1.73; McDermott 1938: 278, no. 476; Tran Tam Tinh 1964: 103, 146, no. 54; Elia 1942: 22). The brown-colored animal, seated on a rock and holding a rearing cobra in its hands, is meant to be a baboon, to judge from its dog-like snout and hairy neck and shoulders, in which case the most likely species is the olive baboon (*Papio cyno-cephalus anubis* [Lesson 1827]), now found in northeast Africa as far north as Ethiopia (Haltenorth and Diller 1980: 262), or the Hamadryas (*P. hamadryas* L.), presently distributed in the lower Red Sea area and southwest Arabia (Haltenorth and Diller 1980: 264–5; see also McDermott 1938: 35). The lack of a tail, however, is a problem, unless it is assumed to be tucked out of sight. In addition, the color is wrong for both suggested species, and there is more shoulder hair than might be expected of an olive baboon. These discrepancies can be overlooked if the painting is regarded more in the nature of an inaccurate sketch. All the animals depicted on the painting have similar problems of definite attribution. Another small depiction of a baboon also comes from the portico of the Temple of Isis in a peopled scroll from the frieze (NM inv. no. 8537; Sampaolo 1992: 40–1, 120, no. 1.3). The animal is seated with a possible indication of a tail, and carries a crescent moon on its head, presumably because it is sacred and a symbol of Thot.

An ape in a white jacket with hood and sleeves is shown dancing in a painting from the House of the Dioscuri (VI.ix.6; McDermott 1938: 280, no. 479). Its snout and paws are fairly realistic and the fur is dark brown. Other genre scenes involving apes or monkeys include one of two apes drawing a cart that holds a bowl (now lost, from Pompeii; McDermott 1938: 281, no. 482), and a probable ape in a cart drawn by two pigs from the House of the Wild Boar (VIII.iii.8; McDermott 1938: 281, no. 481).

A curious parody of a mythological scene from Pompeii in the Naples Museum (unspecified provenance) depicts Aeneas fleeing Troy with Anchises on his shoulder and Ascanius, which was a well-known ancient iconographical type. Here the protagonists are dog-headed ithyphallic (except Anchises) baboons with half-human bodies, which McDermott (1938: 278–80, no. 478) suggests is an attack on the Julio-Claudians and also, perhaps, on Vergil.

A monkey of unspecific type is shown watching a hunting scene in a garden painting in the House of the Ephebe (I.vii.11, rm 23; PPM I, 708–9; Jashemski 1993: 316). An ape fighting a tiger is reported as forming one of the wild beast fights that once adorned the amphitheater podium (now destroyed with no drawn record surviving; McDermott 1938: 280–1, no. 480; Andreae 1990: 108, n. 417).

FAUNAL REMAINS

An incomplete postcranial juvenile skeleton of an unidentified monkey species, but probably a macaque, comes from Pompeii (unspecified provenance; inv. no. Lab. 16; Ciarallo and De Carolis 1999: 71).

COMMENT

Pliny has various comments on monkeys in general (*HN* 8.215–16), particularly on their intelligence and cunning, but he only distinguishes tailed from tailless apes in an unspecific way. It does seem, however, that monkeys of various sorts were not uncommon in Italy as novelties and curiosities. Apes and monkeys were often dressed as performers with other items as props (Toynbee 1973: 58; McDermott 1938: 121). They were also part of the sacred group of animals in Egyptian cults, notably that of Isis (Tran Tam Tinh 1964: 102–3). This second aspect has resulted in the importation of artistic conventions in the wake of the spread of Eastern religions to Italy. Indeed, the portrayal of apes is largely derived from Eastern, Greek, and Hellenistic art, as demonstrated by the preponderance of catalogue entries from those sources in McDermott (1938).

Barbary apes would have been more accessible to Roman hunters and trappers than other species, but this does not rule out the importation of specimens of other species from more far-flung areas such as sub-Saharan Africa and India. The skeleton from Pompeii is most likely to have been an exotic pet, probably a macaque, and therefore, on balance, a Barbary ape.

32. *MARTES MARTES* L.

English, pine marten; Italian, *martora*

FAUNAL REMAINS

Bones of this species were identified from the Villa Regina at Boscoreale (Jashemski 1987: 70; 1994: 112).

COMMENT

Pine martens are currently found in Italy, but tend to be confined to hilly (principally coniferous) woodland areas. Such a habitat probably existed around Boscoreale in the first century A.D., and the bones therefore may represent a natural death. Hunting of the

species for its pelt, or to suppress a predator, cannot, however, be ruled out.

33. *MICROTUS ARVALIS* (PALLAS 1779)

English, common vole; Italian, *arvicola campestre*

SCULPTURE

A vole, attributed to *M. arvalis,* was identified by Matteucig on the Eumachia portal relief (Matteucig 1974b: 220, no. 17; 1974a: table 1, n. 17). However, the animal has a long tail and is therefore not likely to be a vole.

COMMENT

Common vole is not now present in peninsular Italy (Corbet and Ovenden 1980: 160, pl. 16), and since the identification is uncertain, it is difficult to accept the Eumachia evidence as demonstrating a formerly more widespread distribution. Given the nature of the sculptural depiction, it is likely that only a generalized small rodent was intended.

34. *MUSCARDINUS AVELLANARIUS* (L.)

English, common or hazel dormouse; Italian, *moscardino*

FAUNAL REMAINS

Bones of this species were found in A.D. 79 levels at the villa at Boscoreale (Jashemski 1987: 70; 1994: 112), and at the House of the Gold Bracelet (VI.ins. occ. 42; Jashemski 1993: 166–7).

LITERARY REFERENCES

Martial refers to *aurea nitella* (golden dormouse) in one of his poems (5.37.8), which may be the hazel dormouse, since it is a conspicuous bright orange-brown color. *Nitella* may conceivably be the Latin for dormice that were not the larger, edible *Glis glis.* Generally, however, ancient references to dormice were unspecific.

COMMENT

This is a small species, about the size of a harvest mouse, and only half the size of *Glis glis.* It is not recorded as having been eaten, and so it is likely that the bones are the remains of wild dormice, not raised in captivity.

35. *MUS MUSCULUS* L. AND *MUS SPRETUS* LATASTE 1883

English, house mouse; Italian, *topo comune*
English, Algerian mouse; Italian, *topo algerino*

FAUNAL REMAINS

Five bones of *Mus* were found in fourth- to third-century B.C. contexts under the House of Amarantus (Powell

1999), together with nine more from possible ritual contexts of the second to the first century B.C. Seven jaws and associated teeth come from late second- to early-first-century B.C. levels associated with the Temple of Apollo in the forum excavations (King, unpublished). In addition, a mandible from the same deposit (without surviving teeth) had alveoli reminiscent of Algerian mouse (*Mus spretus*; tentative identification by Dr. P. Armitage, then of the British Museum [Natural History]).

COMMENT

House mouse was not common in Italy until the later Republic, according to the archaeological evidence and the somewhat unspecific literary references (Cicero *Ad Atticum* 14.9.1; Pliny *HN* 8.103, 8.221), but is found in classical Greek excavations and was probably spreading west through the Mediterranean lands as a result of Greek, Phoenician, and other trading activities. It is noteworthy in this context that a house mouse sniffing at a walnut figures in the famous "unswept floor" (*asaroton*) mosaic from Rome (Vatican Museum; Jashemski 1979: 95; Toynbee 1973: 204, cover), which was essentially a Hellenistic piece.

At Pompeii, bones of wood mouse (*Apodemus sylvaticus*; see entry) in fact occur earlier and are more widespread in the forum excavations than those of house mouse, which may imply that the former was the more common mouse early in the town's history. The intensification in urban living conditions later on may have been a factor in helping to displace wood mouse, essentially an outdoor species, in favor of house mouse. House mouse is perhaps Horace's *mus urbanus* (*Satires* 2. 6).

The identification of Algerian mouse, while not certain because the teeth were missing from the jaw in the specimen examined, is of some interest since the species is now found in the Maghreb, Iberia, and southern France, but not in Italy (Corbet and Ovenden 1980: pl. 20). This probably indicates that the mouse is a stray, perhaps imported on shipping from Iberia or North Africa. This species, like wood mouse, has a preference for outdoor habitats, including cultivated ground, gardens, and scrub, and could have coexisted with the other mice present in Pompeii.

36. *MUSTELA ERMINEA* L. AND *M. NIVALIS* L.

English, stoat; Italian, *puzzola*
English, weasel; Italian, *donnola*

PAINTING

An animal that is possibly a poor representation of a weasel or stoat is depicted among the animal attributes of Isis in the sacrarium behind the Temple of Isis in

Pompeii (NM inv. no. 8533; Sampaolo 1992: 58–61, no. 1.73; Tran Tam Tinh 1964: 146, no. 54; Elia 1942: 22), although, as Sampaolo suggests, an attribution to mongoose (*Herpestes ichneumon;* see entry) is preferable on ritualistic grounds. The portrayal shows a dark brown animal with an indistinct creamy yellow chest and a rather foreshortened snout. In the Egyptian context of the painting, it is relevant to note that weasels are found in the Nile Delta, Palestine, and Asia Minor (Haltenorth and Diller 1980: 179–80), as well as throughout Europe.

FAUNAL REMAINS

Bones attributed to stoat by Setzer were found at the Villa Regina, Boscoreale (Jashemski 1987: 70; 1994: 112). This species is now absent from the Italian peninsula and has been replaced by the weasel, which is consequently larger than its northern European counterpart (Corbet and Ovenden 1980: 180–1). It may be that the identification should be to weasel. Definite weasel skulls were identified from the forum excavations (King, unpublished), of second- to first-century B.C. date, and from various zones, including levels associated with the precinct of the Temple of Apollo. Weasel has also been identified at other Roman sites in Italy (Settefinestre; King 1985: 288).

COMMENT

The weasel has an interesting role in ancient sources, since it is found in domestic contexts hunting mice and birds (e.g., Petronius 46; Pliny *HN* 29.60) where a cat would be expected (Boessneck 1995; Keller 1963: I, 164–71). Possibly this indigenous species was tolerated in the house for chasing vermin before the spread of the cleaner and more approachable cat. The stoat, by contrast, appears not to merit mention by ancient authors.

So far, no remains of the domesticated mustelid, the ferret (*M. furo*), have been found in the Campanian area, but a probable "polecat-ferret" (*M. putorius* × *furo*) has been identified at the Settefinestre villa in Tuscany (King 1985: 288).

37. *ORYCTOLAGUS CUNICULUS* L.

English, rabbit; Italian, *coniglio*

SCULPTURE

Garden sculptures of children holding small lagomorphs come from various houses in Pompeii (see entry *Lepus europaeus* for details). It is difficult to tell whether they are depicting rabbits or young hares, and it is possible on iconographic grounds that an attribution to hare is to be preferred.

A very small marble garden sculpture of a rabbit comes from the House of the Golden Cupids (Jashem-

ski 1979: 40; La Rocca et al. 1994: 283). Bronze sculpture of this species is recorded by Matteucig in the Naples Museum (1974a: table 1, no. 140).

PAINTING

A still life from the House of Venus Marina (II.iii.3) shows a crouching rabbit or hare eating a bunch of grapes (Croisille 1965: no.191). In a variant of this theme, another still life shows a rabbit and figs (Fig. 356; NM inv. no. 8630).

FAUNAL REMAINS

A pelvic fragment of this species was found in an A.D. 79 level in a vineyard (III.vii; Jashemski 1979: 232).

LITERARY REFERENCES

Rabbits were classed by Varro (*RR* 3.12.6) as a third type of hare, found in Spain and known as a *cuniculus* because they dug tunnels, unlike the hares of Italy. Spain and rabbits were closely linked in ancient literature, for instance in the region having the epithet *cuniculosa* (Catullus 37.18) and in Strabo's comment (3.2.6) that Spanish crops were ravaged by rabbits gnawing at their roots. Pliny has the same comment (*HN* 8.217–18), and also refers to their extraordinary powers of reproduction.

Rabbits were known in Corsica by the second century B.C. (Polybius 12.3) and had spread to the Bay of Naples by the early first century B.C., where they are recorded as infesting an island off Pozzuoli (Poseidonius of Apamea, *apud* Athenaeus 401a). Varro (*RR* 3.12.6–7) recommended that they be placed in *leporaria,* from which they doubtless escaped to spread through the Italian mainland. They do not appear to have been hunted, however, and their meat was less valued than that of hares.

COMMENT

The paintings suggest that rabbit was eaten at Pompeii, although the nature of the depictions means

FIGURE 356 *Still life of a crouching rabbit, apparently asleep, beside four figs (NM inv. no. 8630). This depiction is more certainly a rabbit than a hare, unlike many other depictions, which are more ambiguous.* Photo: S. Jashemski.

that certainty of species attribution is not assured. No rabbit bones were found in the forum excavations (King, unpublished), so it may be that rabbit was an unusual food item. However, the bone from the vineyard was probably food refuse.

The literary references strongly imply that rabbits were present in Italy by the first century B.C., but the archaeological evidence tempers this assumption. Rabbit bones and depictions are less common than those of hare, and the species was probably only just gaining a foothold in the region by A.D. 79.

38. *ORYX GAZELLA* L.

English, oryx; Italian, *orice*

PAINTING AND GRAFFITI

An oryx with fairly short but characteristic horns is included among the animals in a possible Orpheus scene in the House of Romulus and Remus (VII.vii.10; Andreae 1990: 81; Jashemski 1979: 70–1, fig. 115a). It is interpreted as a Chamois (*Rupicapra rupicapra*) by Setzer in Jashemski, but the shape of the horns is not correct for this species. The other animals (elephant, onager, etc.) also incline toward an African or Asian zoological context, and thus more in favour of oryx.

A fairly well-executed incised graffito of an oryx with long horns swept back, and another, less carefully cut, occur among the hunting scenes in the House of the Cryptoporticus (Fig. 357; I.vi.2, rm 22; Vivolo 1993: 103, 105).

COMMENT

The animals depicted here are probably the North African or scimitar oryx (*O. gazella dammah*), a subspecies that only a hundred years ago was distributed widely in Saharan and sub-Saharan Africa but is now extinct save for a small enclave on the southern fringe of the Sahara. An alternative attribution could be the Arabian or white oryx (*O. gazella leucoryx*), once common in the Arabian peninsula but now extinct in the wild (Haltenorth and Diller 1980: 67). Roman hunters for the arena could have obtained specimens from either region.

39. *OVIS ARIES* L.

English, sheep; Italian, *pecora*

SCULPTURE

Clearly modeled rams, with curled horns and schematized wool, form the base supports of a marble candelabrum in the Naples Museum (inv. no. 6857; Ward-Perkins and Claridge 1976: 134). Farther up, one of the relief panels of the basal tripod depicts two rams reaching up to nibble grapes from the top of a cande-

FIGURE 357 Graffito of an oryx, House of the Cryptoporticus (after Vivolo 1993: 105).

labrum carved on the panel. Sheep are noted on bronze and faience figurines in the Naples Museum (Matteucig 1974a: table 1, no. 142).

PAINTING

Sheep occur frequently in wall paintings in rustic or sacro-idyllic scenes. Notably, the myth of Polyphemus and Galatea nearly always includes sheep, since Galatea loved Acis, a shepherd. A good example comes from the House of the Ancient Hunt (VII.iv.48), in which a woolly sheep with long, fairly tightly curled horns, possibly a ram, is in the foreground (NM inv. no. 27687; Dawson 1944: 111, pl. XXIV; De Caro 1994: 166; Grant, De Simone, and Merella 1975: 152). Another pastoral myth is that of Paris on Mount Ida, with cattle and sheep around him (Pompeii, uncertain provenance; Dawson 1944: 88, pl. VI). In the Judgment of Paris scene, cattle, sheep, and goats are sometimes present (V.i.18, triclinium; Dawson 1944: 106, 126–8, 149–50 for discussion).

Pastoral scenes do not always have a mythological aspect, and a hornless sheep with white medium-length wool and a tail appears in a scene with cattle (NM inv. no. 9508; De Caro 1994: 186). A still life (Fig. 358; in the House of the Relief of Telephus at Herculaneum, Ins. or. I.2–3) shows a sheep standing next to four containers of cheese. Another still life has a more religious context, showing a hornless sheep's head, cut off after a sacrifice, together with a *cantharus*, an *oinochoe*, a statuette,

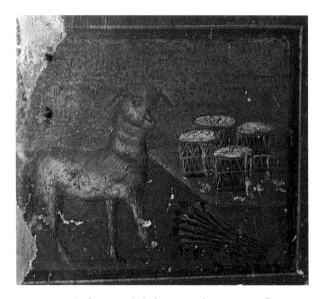

FIGURE 358 A short-wooled sheep standing next to four containers of cheese and a bunch of wild asparagus in a still life from Herculaneum. It is probably hornless, but the head is not very clear. This scene links the animal with one of its chief products. Photo: S. Jashemski.

a pinecone, and a dish of fruit (NM inv. no. 8615: Croisille 1965: no 15).

A stylized sheep, in brown paint on a white background, is one of the group of desert animals of Egypt on the wall of the sacrarium of the Temple of Isis (NM inv. no. 8533; Sampaolo 1992: 58–61, no. 1.73; Tran Tam Tinh 1964: 146, no. 54; Elia 1942: 22). It was probably a sacred symbol, perhaps of Khnum.

MOSAIC

An interesting mosaic, depicting the myth of Phrixus and Helle escaping across the Hellespont on a golden ram (the future Golden Fleece), comes from the nymphaeum of the S. Marco Villa, Stabiae (NM inv. no. 10005; Pisapia 1989: no. 69, tav. XXXIX). The animal is a large, short-wooled ram with tightly curled horns.

FAUNAL REMAINS

A well-known problem in the identification of sheep bones is their differentiation from goat (Boessneck 1969). Not all skeletal elements can be distinguished morphologically between the two species, but certain elements such as the horncore, scapula, pelvis, astragalus, and phalanges provide useful indicators. On this basis, sheep are much more common than goats in the assemblage from the forum excavations, on a ratio of about 1 goat to 8 sheep (King, unpublished). Sheep and goat bones, however, are less common than those of the other main domesticates (pig and ox), especially in the early phases of Pompeii, sixth to third centuries B.C., but from the late second century B.C. up to the time of the eruption, sheep and goat bones became more common than ox but less common than pig.

The breed characteristics of the sheep, from the bone measurements and general conformation, indicate animals of medium/large size compared with the general average in the Roman world (withers height about 65–70 cm; data from King 1994: table 49), with hooves that have some goat-like characteristics (perhaps an adaptation to mountainous terrain), and in some cases, very small horns, probably indicating a tendency to reduced horns or hornlessness in females.

There is clear evidence for horn-working in the forum excavations, with sheep/goat horncores having been broken or cut away from crania. The horn-working activity took place away from the forum, since there is a shortfall in the number of horncores compared with crania. Astragali had also been used as the raw material for bone-working (King, unpublished) and in the game of knucklebones (*fullonica* of Stephanus; I.vi.7; Ciarallo and De Carolis 1999: 149).

Sheep and goat bones are also part of the bone assemblages from the garden excavations (Jashemski 1979: 96, 193, 217), the Villa Regina, Boscoreale (Jashemski 1994: 111), and various urban houses (Kokabi 1982; Clark 1999; Ciaraldi and Richardson 2000).

LITERARY REFERENCES

There are some direct references to sheep among the graffiti from Pompeii (Day 1932: 174); one mentioning a consignment of ewe lambs (*CIL* IV 5450) and others referring to wool (*CIL* IV 5363, 6714).

Otherwise, all the references are from ancient authors, who make some mention of wild sheep (Toynbee 1973: 163) but concentrate almost exclusively on domestic breeds (White 1970: 301–12; Ryder 1983: 156–81). The importance of the species was centered upon their wool, since virtually all Roman clothing was in this material (Frayn 1984). Cheese and milk were also significant (Columella *RR* 7.2.1). Mountainous and dry areas were favored for high-quality wool, which meant that in the southern regions of Italy it was the southeastern parts that had the best reputation (White 1970: 301). Columella states, however, that sheep from northern Italy had replaced those from the south as the breeds regarded as the best for wool (*RR* 7.2.3), and he also dismisses the famous Tarentine soft-fleeced breed as not worth the effort of rearing (*RR* 7.4.1). It is clear from the commentators that breeds with white wool were thought best.

Different husbandry regimes for sheep were known and practiced, varying from the ranching and transhumance system described by Varro (*RR* 2.2.9ff) on the basis of his own experience, to the more intensive suburban rearing of lambs for meat supply to the urban markets (Columella *RR* 7.3.13ff). All the ancient agronomists have much advice on shepherding, breeding,

shearing, culling, and other aspects of husbandry, best summarized by White (1970: 303–10).

Roman taste in sheep meat inclined toward lamb, for flavor, and Columella suggests that suckling lambs should be sent to market (*RR* 7.3.13). Lamb was more expensive than mutton, and Apicius has many more recipes for lamb than adult sheep meat (8.6.1–10; André 1981: 139).

COMMENT

Sheep were certainly farmed in the villas of the Vesuvian region (e.g., Gragnano, no. 34; Day 1932: 174), and supplies of wool, milk, cheese, and meat came to the urban centers. The emphasis on lamb in the ancient sources is not fully reflected in the osteological evidence, since adult animals were definitely present in the forum bone assemblage and their meat consumed. Perhaps this reflects social differences in sheep meat consumption, as André (1981: 139) suggests – the literary references promoting upper-class tastes for lamb, and the bones from Pompeii showing that the general population ate reasonable quantities of mutton. This would make sense economically, since adult sheep were needed to provide the wool necessary for clothing. At the same time, lambs needed to be culled for milk and cheese supplies to be maintained.

40. *PANTHERA LEO* L.
English, lion; Italian, *leone*

SCULPTURE

A lively hunting scene of horsemen and a lion is on the handle of a gilded silver patera from the Menander Hoard (Maiuri 1933: 355–7, no. 17; Anderson 1985:

96–7). The lion is relatively small compared with the horsemen, and is fiercely trying to fight its way out of the encircling hunters. Another item in the Hoard, a cup showing the Labors of Hercules, has the hero and the Nemean Lion (Maiuri 1933: 311–14, no. 3). A bronze fountain statuette of a lion in an attacking pose comes from the peristyle of the House of the Citharist (I.iv.5; NM inv. no. 4897; Kapossy 1969: 51; Dwyer, 1982: 90, fig. 137; Della Corte 1965: 251). A fine marble garden sculpture of a lion on top of a dying gazelle comes from the House of Octavius Quartio (II.ii.2; inv. no. 2929; Ciarallo and De Carolis 1999: 70). Matteucig records a faience figurine of a lion in the Naples Museum (1974a: table 1, no. 145).

PAINTINGS AND GRAFFITI

Several of the *venatio* scenes include lions (listed by Andreae 1990), as in the garden of the House of M. Lucretius Fronto (Fig. 359; V.iv.11). Many of the other *venatio* scenes also have lions (e.g., Fig. 336), as do the Orpheus paintings in the garden of the House of Vesonius Primus (VI.xiv.20; Jashemski 1979: 72–3; 1993: 344–5) and in other houses.

A stucco relief of a dead lion in an arena scene is on the Tomb of Aulus Umbricius Scaurus, Pompeii (Vivolo 1993: 15).

The mythological scene of Hercules and the infant Telephus from the so-called Basilica in Herculaneum

FIGURE 359 A well-depicted lion, leopard, and bull in a *venatio* painting, garden of the House of M. Lucretius Fronto, Pompeii. The animals are chasing or leaping on prey, as well as standing or lying down. The portrayals are presumably of arena animals and are fairly realistic. Photo: Alinari 1992.

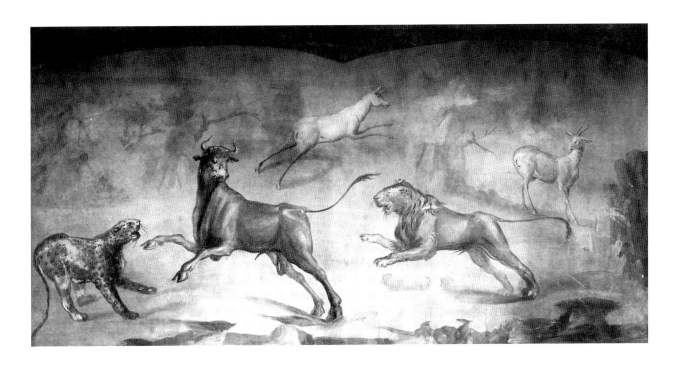

(NM inv. no. 9108; De Caro 1994: 120) includes a seated lion staring out of the painting.

A large outline painting of a walking lion, with a few details sketched in for texture, comes from the wall of the sacrarium of the Temple of Isis (NM inv. no. 8564; Sampaolo 1992: 58–61, 85, no. 1.78). This is one of several desert animals in the room, and presumably the lion, like the others, was a religious attribute of the cult.

MOSAIC

One of the most striking depictions of a lion is in an *emblema* from the House of the Dove mosaic (VIII.ii.34; NM). It is in frontal view, attacking a leopard that lies wounded beneath it. A damaged mosaic from the House of the Faun, dating to the second century B.C., similarly shows a lion and a tiger in combat (VI.xii.2–5; Pollitt 1986: 226). A fine *emblema* from Pompeii, now in the British Museum, shows Cupids with ropes entangling and taunting a well-depicted lion, vast in comparison with the size of the Cupids (Walker 1991: fig. 67). This was evidently a genre motif, since two other fairly close comparisons are known, from Pompeii and Rome (Toynbee 1973: 68–9). A large, well-modeled lion, tethered in the center of a Dionysiac scene, comes from the House of the Centaur (VI.ix.3, triclinium; NM inv. no. 10019).

LITERARY REFERENCES

Lions were familiar to Roman authors through their links with royal (principally Hellenistic) hunting and because they were brought to Italy in some numbers for the amphitheater. Lions were first shown in Rome in 186 B.C., in the earliest record of a wild beast display (Livy 39.22.1–2). Thereafter they were increasingly common and often came to Rome as diplomatic gifts from neighboring kingdoms (Toynbee 1973: 17–18). Pompey displayed six hundred lions in 55 B.C., and Caesar four hundred in 46 B.C. (Pliny *HN* 8.53). These displays were the main opportunity for Romans to see what they regarded as the most noble of beasts, and they allowed writers such as Pliny to give a detailed account (*HN* 8.46–58). Lions, unlike most other wild animals, were thought to be intelligent and to have emotions analogous to those of humans, as illustrated in several graphic stories, most notably the tale of Androcles and the lion (Aulus Gellius *Attic Nights* 5.14).

Androcles' lion ended its days as the freed slave's tame companion, accompanying him on a lead (Aulus Gellius, *Attic Nights* 5.14). Other references also indicate that lions were tamed (Epictetus 4.1.25) and could be remarkably docile (e.g., Martial 9.71). However, like tigers, they were known to be unpredictable (Martial

2.75). Emperors such as Caracalla and Elagabalus took delight in keeping lions that could be used for intimidating dinner guests (Toynbee 1973: 64).

The main source of supply for the lions that came to Italy appears to have been North Africa, although Syria was also known as a source (Toynbee 1973: 60). The large numbers in the wild beast displays came about after Roman conquests had opened up Africa and the Near East to Roman exploitation. It is clear that they were transported by sea in cages, which is the context for Pliny's story of the sculptor Pasiteles nearly being killed by a leopard while observing a caged lion at the docks (*HN* 36.40).

COMMENT

Lions were among the wild beasts most likely to have been shown in Pompeii's amphitheater, in contrast to some of the rarer animals such as the rhinoceros. They are carefully depicted and not uncommon in *venatio* paintings, and the literary references make clear that the animals were not difficult to obtain. They probably came from North Africa, a region in which they are now extinct. Lions were formerly much more widely distributed, and a good case has been made for their presence in the remoter parts of Greece in classical times (Hull 1964: 101–3). Roman sources do not mention this region as a source of supply, which perhaps suggests that hunting had wiped them out in Europe by the time of the Roman Empire. They were probably also in decline in the Near East since, with the exception of the fifth-century Antioch mosaics (Toynbee 1973: 69), later Roman sources focus on Africa as the region from which lions could be obtained. The shrinking distribution of the species is a good instance of Roman depredation of wildlife merely for spectacle.

41. *PANTHERA PARDUS* L.

English, leopard; Italian, *leopardo*

SCULPTURE

A bronze statuette of Bacchus has a small leopard with raised paw at his feet. The animal has sparse spots inlaid in silver damascene (II.ix.2, lararium; NM inv. no. 40170; Conticello et al. 1992: no. 5; Matteucig 1974a: table 1, no. 146).

PAINTING

A dramatic hunt scene in a garden peristyle has a large panel with a leopard leaping on and grasping the neck of a bull, who turns toward it. The leopard has sparse spots and large prominent claws (House of the Epigrams; VI.i.18, rm I; Ward-Perkins and Claridge

1976: 74; Jashemski 1993: 333). Leopards occur several times in the garden hunt scenes in the House of M. Lucretius Fronto (Peters et al. 1993: 310, 340–9, figs. 248–53; Jashemski 1993: 336–7; Andreae 1990), chasing gazelles, tearing at a hind or menacing a bull (with the help of a lion). These are clearly arena *venatio* scenes, realistically shown, with good detail. Other *venatio* scenes include leopards (e.g., Fig. 336) and are listed by Andreae (1990).

Leopards occur frequently as decorative motifs, often in opposing pairs, because of their Dionysiac links. A typical example can be seen in the tablinum of the House of M. Lucretius Fronto (Peters et al. 1993: figs. 164–5), and a well-modeled depiction is in the Naples Museum (inv. no. 8650; Ward-Perkins and Claridge 1976: no. 123). The Dionysiac theme is emphasized in a panel showing cult objects such as a thyrsus and cymbals. In front, a miniature but well-depicted leopard grapples with a snake (Pompeii, uncertain provenance; NM inv. no. 8795; Ward-Perkins and Claridge 1976: no. 203). In two other paintings, a leopard is shown in close association with Dionysus (Reinach 1922: 106, no. 6, 107, no. 9), in one of which the god holds his wine cup out to the animal, which is resting its forepaw on the god's knees (Toynbee 1973: 86).

MOSAIC

An *emblema* shows a well-modeled, fairly realistic leopard with Dionysiac attributes (Pompeii, uncertain provenance; NM; Maiulucci 1988: 61). An arena scene forms the subject of a mosaic showing a lion attacking a leopard, which lies wounded under it (House of the Dove mosaic; VIII.ii.34; NM). Leopards are wary of lions in the wild, since they are weaker and liable to lose their hunting spoils if involved in a fight.

LITERARY REFERENCES

Leopards had three different Latin names: *pardus,* a name first encountered in the mid-first century A.D. (Lucan 6.183); *varia,* or "spotted"; and *panthera*. Pliny tells us that *pardi* and *variae* came from Africa and Syria, and that *pantherae* were different, having a lighter background to their spots (*HN* 8.62–3). This led Toynbee (1973: 82) to suggest that *pardi* and *variae* were leopards, the latter perhaps being females, and that *pantherae* were probably cheetahs. This apparent confusion is also seen in the ambiguity of the pictorial representations of the two species.

The wild beast shows of 186 B.C., at which lions were first seen in Rome, were also the occasion for the first display of leopards (Livy 39.22.1–2). Thereafter they appeared frequently.

COMMENT

The evidence combines to show leopards in two contrasting contexts. The more immediate was as an animal in the amphitheater, quite probably in Pompeii's arena, to judge from their fairly common appearance in hunt scenes in realistic detail. They probably came from North Africa, but Syria and the Near East were also sources. Leopards are still found in all these areas in very small numbers (Haltenorth and Diller 1980: 222–3). The other context for leopards was Dionysiac (Toynbee 1973: 84–5), and the frequency of their depiction suggests that the cult was widespread in the Vesuvian area, with many houses displaying Dionysiac symbols.

42. *PANTHERA TIGRIS* L.

English, tiger; Italian, *tigre*

PAINTING

A garden painting in the House of Caecilius Jucundus is recorded as having a scene with a tiger, a lion, and a stag (Jashemski 1979: 71). A tiger also occurs in another hunt scene, where a bear chases a bull toward a tiger (House of the Ephebe; I.vii.11, garden; PPM I, 708–9; Jashemski 1993: 316; Andreae 1990). In the House of M. Loreius Tiburtinus (or Octavius Quartio), a hunt scene includes tigers, together with lions and leopards (II.ii.2; Jashemski 1993: 328). A tiger and an ape fighting formed part of the wild beast fights that once adorned the podium of the amphitheater (destroyed with no record surviving; Andreae 1990: 108, n. 417; McDermott, 1938: 280–1, no. 480).

MOSAIC

A most interesting depiction from the artistic point of view, if not from anatomical accuracy, is the second-century B.C. mosaic of a Cupid riding a probable tiger, from the House of the Faun (NM; Pollitt 1986: 139, pl. 150; Matteucig 1974a: table 1, no. 147). The animal has a mane and thin rather random stripes, except where they are more regular on the tail. It appears to be a hybrid lion/tiger, and the un-tiger-like stripes strongly suggest a very stylized representation not based on direct observation. Pollitt, in his discussion of Hellenistic art, shows another mosaic from Alexandria that has an animal much more like a lion with a dark mane and thin stripes (1986: 130, pl. 136). A third Hellenistic mosaic, from Delos, shows Dionysus riding an animal much more like a tiger, but it too has thin, rather unrealistic stripes and a slight mane (Pollitt 1986: 219, pl. 231). On balance, all three are probably meant to be tigers but are highly stylized and follow an artistic convention that appears to elide the features of lions and

tigers. In contrast, a much more realistic tiger that was clearly depicted from life is shown on a mosaic that also includes lions and leopards, from Hadrian's Villa, Tivoli (Berlin, Staatliche Museen; Toynbee 1973: 81).

LITERARY REFERENCES

Tigers were latecomers to Rome compared with lions and leopards. Although they were known in the Hellenistic kingdoms, it was not until 20–19 B.C. that Augustus, when in Samos, received a gift of tigers from Indian ambassadors (Toynbee 1973: 70; Dio Cassius 54.9.8). The first tiger in Rome was in 11 B.C. (Pliny *HN* 8.65), and after that small numbers were exhibited in shows by the emperors, culminating in the display of fifty-one by Elagabalus, who also put some of them into harness (Toynbee 1973: 70–1). The reason for their rarity was the distant source, namely India, Hyrcania (south of the Caspian Sea), and, slightly nearer, Armenia (Pliny *HN* 8.66; Vergil *Eclogues* 5.29–30). Tigers are nearly always referred to as females, and specific methods of hunting tigresses by capturing the cubs were known to Pliny (*HN* 8.66), confirmed by the late Roman Antioch hunt mosaics (Toynbee 1973: 71–2, pl. 22–3).

COMMENT

Tigers are undoubtedly much rarer than lions or leopards in hunt scenes, and many of the instances cited here are not certain attributions, due to the fading of the paintings, old recording, and in some cases, ambiguous iconography. It seems very unlikely that tigers were ever seen in Pompeii's amphitheater, which may account for the uncertainty and the rarity of their depiction. The ancient distribution of tigers spread more to the west than at present, and they probably retreated from Armenia in the post-Roman period.

43. *PIPISTRELLUS PIPISTRELLUS* (SCHREBER 1774) AND *VESPERTILIONINAE* sp.
English, pipistrelle bat; Italian, *pipistrello*
English, vespertilionid bat (e.g., Serotine, Noctule); Italian, *serotino*

SCULPTURE

A pipistrelle is recorded on a bronze sculpture in the Naples Museum by Matteucig (1974a: table 1, no. 165). Another possible vespertilionid bat is also recorded on a bronze figurine (NM; Matteucig 1974a: table 1, no. 213).

COMMENT

Bats were not regarded in a particularly benevolent light by ancient authors because of their nocturnal (i.e., daemonic) habits. Various parts of the bat, such as the

blood, liver and gall, were used in medicine according to Pliny (*HN* 29.89), and the blood was regarded as an aphrodisiac (*HN* 30.143; Keller 1963: I, 12). No real attempt at species differentiation was made by ancient authors, and the artistic depictions are not very specific.

44. *PITYMYS SAVII* (DE SELYS-LONGCHAMPS 1838)
English, savi's pine vole; Italian, *arvicola di Savi*

FAUNAL REMAINS

A partial skeleton of this species was found in the Villa Regina at Boscoreale (Jashemski 1987: 70; 1994: 112).

COMMENT

Savi's pine vole is a creature of nocturnal and largely subterranean habits, which is unlikely to have impinged greatly on the inhabitants of the Villa Regina. The specimen found almost certainly met a natural death. *Pitymys savii* is the only small vole species with an extensive distribution in peninsular Italy (Corbet and Ovenden 1980: pl. 17).

45. *RATTUS RATTUS* L.
English, black rat; Italian, *ratto nero*

PAINTING

A possible rat, but brown and with a snout that is too snubby, appears with the desert creatures of Egypt in the sacrarium of the Temple of Isis (NM inv. no. 8533; Sampaolo 1992: 58–61, no. 1.73; Tran Tam Tinh 1964: 146, no. 54; Elia 1942: 22). If this is a correct attribution, the artist was not very familiar with the appearance of the animal. Rats, however, are among the indigenous fauna of Egypt.

FAUNAL REMAINS

Two immature rat femurs were recovered from late-first-century B.C. levels in the forum excavations. Of more significance are a cranium and other bones from late-second-century B.C. levels from the area of the Temple of Apollo adjacent to the forum (King, unpublished). The deposits are probably detritus from sacrifices dumped in sacred *favissae*. The partial skeleton of a rat was found in A.D. 79 levels in the House of the Gold Bracelet (VI. ins. occ. 42; Jashemski 1993: 166–7).

COMMENT

The second-century B.C. bones represent the earliest instance of this species in Italy. Black rats were of eastern origin (Armitage 1994: 231–3), and it is very likely that they came to Italy in ships when trade between the peninsula, the Near East, and Egypt was flourishing

(cf. Arthur 1986: 41; De Bruyn 1981; Keller 1963: I, 203–6; Rackham 1979: 115). They presumably established themselves initially at ports such as Ostia, Pozzuoli, and so on, but soon spread into the urban hinterland, of which these specimens are examples. By the first century B.C. they are found in rural sites, such as the Settefinestre villa (King 1985: 288), and thereafter became a common commensal of humans. By the late Roman period, there is evidence of large numbers of rats in Naples (King 1994: 387–8), which may plausibly be linked with the mid-sixth-century plague that affected much of the Mediterranean (Arthur, 1995).

46. *SUS DOMESTICUS* AND *SUS SCROFA* L.
English, domestic pig/wild boar; Italian,
maiale/cinghiale

SCULPTURE

The best sculpture of a boar comes from the House of the Citharist (Fig. 360; I.iv.5; NM inv. no. 4900). A small illustration of an arena huntsman thrusting a spear at a bristling boar forms part of the decoration of a marble relief from a tomb by the Stabian Gate, Pompeii (Ward-Perkins and Claridge 1976: 66). A hunting scene also forms part of the decoration of a gilded silver *patera* from the Menander Hoard (Maiuri 1933: 355–7, no. 17) in which two cornered boars are defending themselves against dogs. On a cup in the same hoard (Maiuri 1993: 314–18, no. 4), the Labors of Hercules include the hero wrestling with the Erymanthian Boar by dramatically holding it upside down above his head. Another relief sculpture of the Erymanthian Boar occurs on an *oscillum* from the

House of the Citharist (inv. no. 20488; Ciarallo and De Carolis 1999: 116).

A lively bronze sculpture of a leaping piglet comes from the Villa of the Papyri, Herculaneum (NM inv. no. 4893; Jashemski 1979: 328, fig. 523). Another small bronze figurine of a piglet, with an enigmatic inscription possibly to Hercules (to whom pigs were sacrificed), comes from Herculaneum (NM inv. no. 4905; Ward-Perkins and Claridge 1976: no. 211). The well-modeled animal, with the concave snout of a juvenile and a pot-belly, is on an ornamental metal stand and was probably placed in a household shrine. A bronze and lead weight in the form of a fat pig (NM inv. no. 74390; Ciarallo and De Carolis 1999: 152) and terra-cotta figurines of pigs come from Pompeii (Cambridge Museum of Archaeology and Ethnology; Jashemski 1979: 105).

PAINTINGS AND GRAFFITI

Wild boars are a common feature of *venatio* scenes in gardens and elsewhere (listed in Andreae 1990). They are usually shown confronting dogs or being chased by them, as in the House of the Ceii (Fig. 336) where a pair of finely depicted boar are running before two dogs. One of the boars turns to lunge at the dogs.

FIGURE 360 A fine bronze garden sculpture group from the House of the Citharist, Pompeii, showing a wild boar being attacked by two dogs. The boar, which has a spout in its mouth for a fountain, is realistic in its details, and the bristly coat is emphasized. The dogs are short-haired, with muzzles flaring and ears back, and are about to bite the boar in the neck and legs. They are quite small for hunting dogs, in comparison with the boar, and their visible ribs give the impression of a lean, athletic breed (NM inv. no. 4900). Photo: S. Jashemski.

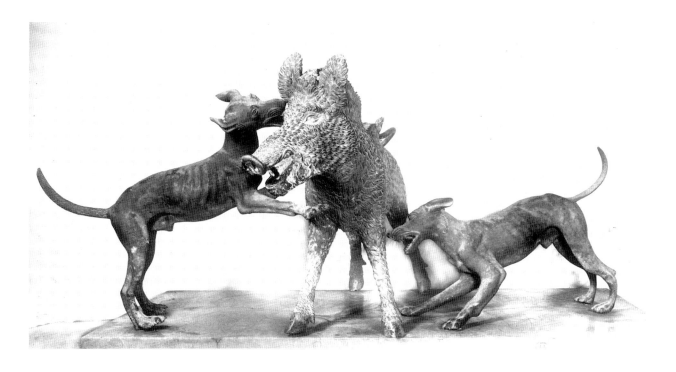

Similar scenes are depicted in the Gladiators' Barracks (V.v.3; Jashemski 1993: 339–40), but less usual is the scene of a lion attacking a boar in the House of the Quadrigae (VII.ii.25; Jashemski 1993: 360). This is undoubtedly an arena scene that would be unlikely to have occurred in the wild. A variant shows men engaged in a boar hunt. In an example from a villa at Gragnano, men with lances and dogs confront a large boar that runs toward them. One of the central figures has a diadem and is thought to be Meleager, in which case the depiction is of the Calydonian boar hunt (NM inv. no. 6656; Gragnano villa on route 145 at km 4.700; Conticello et al. 1992: no. 170). A similar scene from Stabiae villa II has a huntsman wounded by the boar (Stabiae Antiquarium inv. no. 4818).

Related to the hunting paintings is the stucco relief of a boar being attacked by two dogs on the Tomb of Aulus Umbicius Scaurus (Vivolo 1993: 15). A graffito in the House of the Cryptoporticus shows a roughly incised boar in an arena context (Vivolo 1993: 101, 103–4).

Pigs feature in depictions of sacrificial scenes, such as the small, white animal with slender legs being led firmly to the altar by a *victimarius* in a lararium painting (NM inv. no. 8905; Ward-Perkins and Claridge 1976: no. 210; La Rocca et al. 1994: 339), and the fat pig with a red band of cloth around it being driven by a Cupid for a sacrifice to Priapus, from the Villa of the Mysteries (Jashemski 1979: 121, fig. 190).

Another genre to include pigs is the still life. A pig or a small wild boar is laid out, possibly with tied feet, below a plate with fruit and what may be a sausage (House of the Small Fountain, VI.viii.23–4; Croisille 1965: no. 220A). Another, probably laid out dead rather than alive, comes from the House of Castor and Pollux (VI.ix.6–7; Croisille 1965: no. 229F). A pig's head and a ham are shown suspended from a nail in a now destroyed still life from Pompeii (I.x.18; Croisille 1965: no. 177). Similarly, a somewhat caricatured male pig's head in outline is included in a scene with sausages, chops on a kebab, fish, and so on (House of the Pig, IX.ix.18, kitchen; Croisille 1965: no. 297), and a head occurs with a ham on a hook, chops on a spit, sausages, and eels (I.xiii.2; PPM II, 876–7).

MOSAIC

A wild boar is shown on a *vestibulum* mosaic being attacked by two dogs (House of the Wild Boar; VIII.iii.8). The house is connected with L. Coelius Caldus, whose family minted coins in the early first century B.C. with boars on them, commemorating their military connection with campaigns in Hispania (Della Corte 1965: 228–9). The mosaic may therefore have had some emblematic significance to the house's occupants.

FAUNAL REMAINS

A cast of a pig that perished in the eruption was made at the Villa Regina, Boscoreale (Fig. 361). Pig skeletons are also reported from the villa at La Pisanella, Boscoreale (Pasqui 1897: 399).

Bones of domestic pig are very common from Pompeii, and from the second century B.C. up to the time of the eruption, represented the bulk of the meat supply. One earlier assemblage, from under the House of Amarantus (Clark 1999), also had a predominance of pig bones. In the forum excavations (King, unpublished), various houses (Ciaraldi and Richardson 2000: 77–8), and the gardens (Jashemski 1979: 95–6, 120, 193, 216–18, 242, 247, 254), pig bones from all parts of the carcass were found, many with butchery marks. The animals were usually slaughtered young and it is clear that there was a taste for suckling pig and pork from juveniles. Adults were of average size for unimproved breeds and had the straight snout typical of pigs prior to the agricultural revolution of the seventeenth and eighteenth centuries.

Wild boar is difficult to distinguish from domestic pig osteologically, except by a size differential in certain elements such as the mandibular third molar. Bones of wild boar are virtually absent from Vesuvian sites, with the notable exception of the tusks from Pompeii, now in the Boscoreale Museum (inv. no. 3352), that were decorated and had holes for suspension. They were almost certainly used as good-luck pendants. Other large, but undecorated tusks are known, which may have served a similar purpose (I.xi.17; inv. no. 12729; Ciarallo and De Carolis 1999: 117). A single immature femur from a first-century A.D. deposit in the forum excavations was large enough to be of wild stock (King, unpublished), and some of the pig bones from the large vineyard near the amphitheater may also be of wild boar size (II.v; Jashemski 1979: 216–18).

Pigs are depicted in sacrificial scenes, as noted earlier, and possible archaeological evidence for this comes from the gardens excavations. A summer triclinium in the large orchard (I.xxii; Jashemski 1979: 254) had an associated altar, and it is thought that the bones, including piglet and other pig bones, may have been the food consumed at the triclinium after the animals had been sacrificed. Elsewhere, a partial skeleton of a very young piglet has been interpreted as being part of a ritual deposit of fourth to third century B.C. under the House of Amarantus (I.ix.11–12; Clark 1999).

LITERARY REFERENCES

Wild boar was ubiquitous in Italy and the techniques of hunting this dangerous creature were well

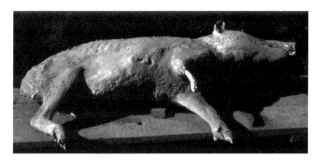

FIGURE 361 Cast of a fairly complete pig at the *villa rustica*, Boscoreale, embellished a little, but nevertheless displaying a smallish animal with the straight snout expected of an unimproved breed. Photo: Orlando Nazzareno.

known to both Roman and Greek authors (Anderson 1985). Boars were also kept in a semiwild state in vivaria or hunting parks (Varro *RR* 3.13; Toynbee 1973: 16), either for hunting or as stock for the amphitheater. Wild boar meat was also highly esteemed (André 1981: 115–16) and formed the centerpiece of Trimalchio's feast (Petronius 40). As for the arena, boars provided good sport to the *venatores* and the spectators (Martial 12.1–3, 15.1–2; Dio Cassius 76.1; Toynbee 1973: 134).

Domestic pigs were important to the agriculture of Roman Italy, and Varro in particular gives a long account of their husbandry, occupying almost a quarter of his *Res Rustica* (White 1970: 316). Varro's work was partly a symposium, one of the participants being the well-known pig breeder Tremellius Scrofa, whose cognomen was used by Linnaeus for the modern scientific name for the species. Scrofa considered that a typical herd of swine on a large villa should number one hundred (Varro *RR* 2.4.22). Varro has a detailed discussion of the ideal conditions for pig rearing (*RR* 2.4.13–20), which has recently received good archaeological confirmation from the excavation of pigsties at Settefinestre (King 1985: 281). Columella has advice on the best methods of raising pigs for urban markets, by maximizing the number of litters per year and the sale of suckling pigs to the market (*RR* 7.9.4). This again finds confirmation from the osteological evidence.

Campania does not figure among those areas best known for pigs and their produce during the early Empire, but by the third century A.D. the area was included with Samnium, Lucania, and Bruttium as a designated zone for the supply of pigs to Rome (White 1970: 320–1). It is probable that the hilly regions with plentiful supplies of nuts were favored for pig-herding (Vergil *Georgics* 2.520; Columella *RR* 7.9.6–7).

Pork was clearly regarded as the prime meat of Italy. Ovid asserts that only pork was consumed in early Rome (*Fasti* 6.169ff), which is contradicted by

the bone evidence. However, it is clear that pork cost more than other common meats (André 1981: 136) even though it was regularly consumed more frequently. Pliny (*HN* 8.209) and Apicius (cf. André 1981: 137–8) demonstrate the wide range of recipes for pork, more than for any other meat. All parts of the animal were used, and a wide variety of charcuterie was prepared.

COMMENT

Wild boars feature in the life of the Vesuvian sites mainly in the context of the hunt and the arena. The species was probably common in the region and they would have been a popular choice for amphitheater *venationes*. Domestic pig was clearly the mainstay of the meat diet and was probably available to all sectors of the population. The extent of meat consumption among the less privileged inhabitants is not at all certain, however.

47. *TALPA* sp.

English, mole; Italian, *talpa*

FAUNAL REMAINS

A tibia of a mole was found in the forum excavations (King, unpublished).

COMMENT

The bone element found could not be identified to species, but it is very likely to have been Roman mole (*Talpa romana*), since it is the only mole species now found in the southern part of peninsular Italy (Corbet and Ovenden 1980: pl. 1). Moles were known to Latin authors for their sightlessness (Vergil *Georgics* 1.183; Seneca *Q. Nat.* 3.16.5), which accords with *Talpa romana* rather than the poorly sighted *Talpa europaea* found farther north in Europe. Ancient authors also remarked on the burrowing habits of moles, particularly as a threat to threshing floors (Varro *RR* 1.51.1; Vergil *Georgics* 1.183) and tree roots (Columella *RR* 4.33.3). Pliny also mentions that moleskins were used for bed counterpanes (*HN* 8.226).

48. *URSUS ARCTOS* L.

English, brown bear; Italian, *orso bruno*

PAINTINGS AND GRAFFITI

Bears occur occasionally in *venatio* scenes (listed by Andreae 1990) and tend to be shown as individuals, rather than as part of scenes of attacking or defending between predator and prey. Examples include the garden paintings of the House of M. Lucretius Fronto (Fig. 362), where a bear collects fruit and another is

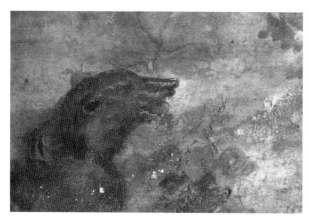

FIGURE 362 A bear devouring fruit in the shade of a tree, House of M. Lucretius Fronto, Pompeii. Photo: S. Jashemski.

about to drink from a stream. Around them lions and leopards chase gazelles and other victims. Similar scenes are in the House of the Menander (PPM I, 267–9; Jashemski 1993: 324) and the Gladiators' Barracks (V.v.3; Jashemski 1993: 339–40). The only depictions of bears in aggressive posture are in the House of the Old Hunt (VII.iv.48; Jashemski 1979: 71, fig. 115c), where a man in a white tunic, hiding behind a bush, is about to throw a lance at a large cornered bear while another smaller animal, probably a cub, is on its back with claws extended in defense against another approaching huntsman with a lance.

Crudely incised bears and *bestiarii* are among the scenes from the arena in the House of the Cryptoporticus (Vivolo 1993: 88, 108).

MOSAIC

A threshold mosaic from Pompeii depicts a brown bear (House of the Bear, VII.ii.44–6; Ehrhardt 1988: 21, taf. 250; Matteucig 1974a: table 1, no. 210).

FAUNAL REMAINS

A bear tooth is recorded from the House of Polybius (IX.xiii.1.3; inv. no. 22459; Ciarallo and De Carolis 1999: 117), probably an individual specimen kept as a good-luck charm or for medicinal use.

LITERARY REFERENCES

Bears were local to Italy in Roman times (Martial 8; Horace, *Epodes* 16.51), as they are today. Pliny (*HN* 8.131) gives a description that is generally knowledgeable about the appearance and habits of the species.

The main interest in bears on the part of the Romans was in connection with hunting. Oppian (*Cynegetica* 4.354–424) describes in detail how to capture bears alive for the arena, and this must have been an important element in the hunting expeditions, to judge from references to bears in the amphitheater, from 169

B.C. onward (Livy 44.18.8). On a smaller scale, there was bear-baiting (Horace *Epistles* 2.1.185–6) and performances (Toynbee 1973: 95). Bears could also be tamed and kept as pets (Seneca *De Ira* 2.31.6).

COMMENT

Bears would not have been the easiest of creatures to display in the amphitheater, nor would they necessarily have given a "good" performance. Nevertheless, it is likely that they figured in the *venationes* at Pompeii. Their Italian distribution in the Roman period appears to have been much more extensive than the restricted Apennine fastnesses of today (Pratesi and Tassi 1977: 235, 243), and undoubtedly they were considerably more numerous than the eighty or so individuals known in the 1970s.

49. *VULPES VULPES* L.
English, fox; Italian, *volpe*

SCULPTURE

Matteucig includes this species in those identified on items from the Menander Hoard, but the attribution is by no means certain (1974a: table 1, no. 216; Maiuri 1933).

PAINTING

An animal that may be a fox is among the creatures in a possible Orpheus painting in the garden of the House of Romulus and Remus (VII.vii.10; Andreae 1990: 81; Jashemski 1979: 70–1, fig. 115a). The species is also identified by Matteucig on a Pompeian wall painting in the Naples Museum (1974a: table 1, no. 216).

COMMENT

Fox is surprisingly uncommon in art, literature, and archaeology, given that it was an indigenous species. The main ancient reference to foxes is in connection with their sacrifice in Rome at the festival of Ceres (Scullard 1981: 103; Ovid *Fasti* 4.681–712). The species does not have a high profile in *venatio* scenes, probably because larger, more prestigious prey such as bear or boar were regarded as the proper focus of the hunt, both in the countryside and in the arena.

ACKNOWLEDGEMENTS
Professor King is very grateful to Dr. Paul Arthur for his assistance in providing facilities for the study of the Pompeii forum bone assemblage. Most of all, he would like to thank Christina Grande for her time and patience in reading the text and making many useful suggestions for its improvement, especially on art historical matters.

Table 26. Systematic list.

Insectivora	20. *Erinaceus europaeus*	Hedgehog
	47. *Talpa* sp.	Mole
Chiroptera	43. *Pipistrellus pipistrellus* and	
	Vespertilio sp.	Bat
Lagomorpha	37. *Oryctolagus cuniculus*	Rabbit
	29. *Lepus europaeus*	Hare
Rodentia	15. *Eliomys quercinus*	Garden dormouse
	26. *Glis glis*	Edible dormouse
	34. *Muscardinus avellanarius*	Hazel dormouse
	33. *Microtus arvalis*	Common vole
	44. *Pitymys savii*	Savi's pine vole
	4. *Arvicola terrestris*	Water vole
	45. *Rattus rattus*	Black rat
	3. *Apodemus sylvaticus*	Wood mouse
	35. *Mus musculus* and *M. spretus*	House mouse, Algerian mouse
Primates	31. *Macaca sylvana* and *Papio* sp.	Barbary ape, baboon
Carnivora	48. *Ursus arctos*	Brown bear
	6. *Canis aureus*	Jackal
	8. *Canis lupus*	Wolf
	7. *Canis familiaris*	Dog
	49. *Vulpes vulpes*	Fox
	36. *Mustela erminea* and *M. nivalis*	Stoat, weasel
	32. *Martes martes*	Pine marten
	27. *Herpestes ichneumon*	Mongoose
	40. *Panthera leo*	Lion
	41. *Panthera pardus*	Leopard
	42. *Panthera tigris*	Tiger
	1. *Acinomyx jubatus*	Cheetah
	22. *Felis lynx*	Lynx
	23. *Felis sylvestris*	Wild cat
	21. *Felis catus*	Cat
Proboscidea	30. *Loxodonta africana* and *Elephas maximus*	African elephant, Indian elephant
Perissodactyla	19. *Equus caballus*	Horse
	16. *Equus africanus* and *E.hemionus*	Wild ass, onager
	17. *Equus asinus*	Donkey
	18. *Equus asinus* x *caballus*	Mule
	14. *Diceros bicornis*	Black rhinoceros
Artiodactyla	46. *Sus scrofa* and *S.domesticus*	Wild boar, pig
	28. *Hippopotamus amphibius*	Hippopotamus
	10. *Capreolus capreolus*	Roe deer
	11. *Cervus dama*	Fallow deer
	12. *Cervus elaphus*	Red deer
	2. *Alces alces*	Elk
	25. *Giraffa camelopardalis*	Giraffe
	5. *Bos taurus*	Ox
	24. *Gazella dorcas*	Dorcas gazelle
	38. *Oryx gazella*	Oryx
	9. *Capra hircus*	Goat
	39. *Ovis aries*	Sheep
Cetacea	13. *Delphinus delphis*	Dolphin

REFERENCES

Anderson, John K. 1985. *Hunting in the Ancient World.* University of California Press, Berkeley.

André, Jacques. 1981. *L'Alimentation et la Cuisine à Rome.* 3rd ed. Les Belles Lettres, Paris.

Andreae, Maria Theresia. 1990. "Tiermegalographien in pompejanischen Garten. Die sogennanten Paradeisos Darstellungen." *Rivista di Studi Pompeiani* 4: 45–124.

Armitage, Philip. 1994. "Unwelcome Companions: Ancient Rats Reviewed." *Antiquity* 68: 231–40.

Armitage, Philip, and Hugh Chapman. 1979. "Roman Mules." *London Archaeologist* 3: 339–46.

Arthur, Paul. 1986. "Problems of the Urbanization of Pompeii: Excavations 1980–1981." *Antiquaries Journal* 66: 29–44.

——— 1995. "Il particolarismo napoletano altomedievale: una lettura basata sui dati archeologici." *Mélanges de l'Ecole Française de Rome, Moyen Age* 107: 17–30.

Barigazzi, Adelmo. 1992. Implicanze morali nella polemica plutarchea sulla psicologia degli animali. In *Plutarco e le Scienze,* edited by Italo Gallo, pp. 297–315. Sagep Ed., Genoa.

Beagon, Mary. 1992. *Roman Nature: The Thought of Pliny the Elder.* Clarendon Press, Oxford.

Bertrandy, François. 1987. "Remarques sur le commerce des bêtes sauvages entre l'Afrique du Nord et l'Italie." *Mélanges de l'Ecole Française de Rome, Antiquité* 99: 211–41.

Blanc, Nicole. 1999. Des girafes dans le thiase. Un stuc de Tusculum. In *Imago Antiquitatis. Religions et Iconographie du Monde romain. Mélanges offerts à Robert Turcan,* edited by Nicole Blanc and André Buisson, pp. 105–18. De Boccard, Paris.

Blazquez Martinez, Jose Maria et al. 1990. "Pavimentos africanos con espectaculos de toros." *Antiquités Africaines* 26: 155–204.

Bodson, Liliane. 1986. Aspects of Pliny's Zoology. In *Science in the Early Roman Empire: Pliny the Elder, His Sources and Influence,* edited by Roger French and Frank Greenaway, pp. 98–110. Barnes & Noble, London.

Boessneck, Joachim. 1969. Osteological Differences between Sheep (*Ovis aries* Linné) and Goat (*Capra hircus* Linné). In *Science in Archaeology,* 2nd ed., edited by D. Brothwell and E. S. Higgs, pp. 331–58. Thames & Hudson, London.

——— 1995. Bones of the Weasel, *Mustela nivalis* Linné, 1766, from Tell Hesban, Jordan. In *Hesban 13: Faunal Remains,* edited by Ø. S. LaBianca and Angela von den Driesch, pp. 121–7. Andrews University Press, Berrien Springs.

Boyce, George K. 1937. *Corpus of the lararia of Pompeii.* Memoirs of the American Academy in Rome, Rome.

Bruckner, A. 1976. Glirarium oder vivarium in dolio. In *Festschrift Waldemar Haberey,* pp. 19ff. Zaben, Mainz.

Ciaraldi, Marina, and Jane Richardson. 2000. Food, Ritual and Rubbish in the Making of Pompeii. In *TRAC 99. Proceedings of the Ninth Annual Theoretical Roman Archaeology Conference, Durham 1999,* edited by Garrick Fincham et al., pp. 74–82. Oxbow Books, Oxford.

Ciarallo, Annamaria, and Ernesto De Carolis, eds. 1999. *Pompeii. Life in a Roman Town* [English]. *Homo Faber. Natura, Scienza e Technica nell'Antica Pompei* [Italian]. Electa, Milan.

Clark, Gill. 1999. Mammal Bones. In Fulford and Wallace-Hadrill 1999: 86–92, 128–35.

Cocca, Tiziana et al. 1995. The Equids Found in the "Casti Amanti" House Stable in Pompei: First Observations. *I International Congress on Science and Technology for the Safeguard of Cultural Heritage in the Mediterranean Basin, Catania 1995* (abstract). Litostampa Idonea, Catania.

Colls, D., C. Descamps, M. Faure, and C. Guerin. 1985. "The Bronze Black Rhinoceros from Port Vendres III." *Antiquity* 59: 106–12.

Conticello, Baldassare et al. 1992. *Rediscovering Pompeii.* Exhibition catalogue, "L'Erma" di Bretschneider, Rome.

Corbet, Gordon, and Denys Ovenden. 1980. *The Mammals of Britain and Europe.* Collins, London.

Croisille, Jean-Michel. 1965. *Les Natures Mortes Campaniennes.* Collection Latomus 76, Brussels-Berchem.

Dawson, Charles M. 1944. "Romano-Campanian Mythological Landscape Painting." *Yale Classical Studies* 9: passim.

Day, John. 1932. "Agriculture in the Life of Pompeii." *Yale Classical Studies* 3: 166–208.

De Bruyn, T. 1981. *Huisrat* (Rattus rattus) *en Bruine Rat* (Rattus norvegicus) *in Archeozoologische Context.* Ghent.

De Caro, Stefano, ed. 1994. *Il Museo Archeologico Nazionale di Napoli.* Electa, Naples.

Della Corte, Matteo. 1965. *Case ed Abitanti di Pompei.* 3rd ed. Fausto Fiorentino, Naples.

Dosi, Antonietta, and François Schnell. 1984. *A Tavola con i Romani Antichi.* Quasar, Rome.

Dubois, Yves. 1999. "La *venatio* d'amphithéâtre: iconographie d'un décor de villa à Yvonand-Mordagne, Suisse." *Revue Archéologique* 1999/1: 35–64.

Dwyer, Eugene J. 1982. *Pompeian Domestic Sculpture: A Study of Five Pompeian Houses and Their Contents.* G. Bretschneider, Rome.

Ehrhardt, Wolfgang. 1988. "Casa dell'Orso (VII, 2, 44–46)." *Häuser in Pompeji* 2.

Elia, Olga. 1942. Le pitture del tempio di Iside. *Monumenti della Pittura Antica Scoperti in Italia, III, Pompei III/IV.* Istituto Poligrafico dello Stato, Rome.

Fergola, Lorenzo. 1989. "Comune di Boscoreale, Via Casone Grotta, proprietà Risi Di Prisco." *Rivista di Studi Pompeiani* 3: 247–8.

Frayn, Joan M. 1984. *Sheep-Rearing and the Wool Trade in Italy during the Roman Period.* Cairns, Liverpool.

French, Roger. 1994. *Ancient Natural History.* Routledge, London.

Fulford, Michael G., and Andrew Wallace-Hadrill. 1998. "The House of *Amarantus* at Pompeii (I, 9, 11–12). An Interim Report on Survey and Excavation in 1995–6." *Rivista di Studi Pompeiani* 7: 77–113.

——— 1999. "Towards a History of Pre-Roman Pompeii: Excavations beneath the House of Amarantus (I.9.11–12), 1995–8." *Papers of the British School at Rome* 67: 37–144.

Gatier, Pierre-Louis. 1996. "Des girafes pour l'empereur." *TOPOI* 6: 903–41.

Gierow, Margareta S. 1994. "Casa del Granduca (VII, 4, 56); Casa dei Capitelli Figurati (VII, 4, 57)." *Häuser in Pompeji* 7.

Giordano, Carlo, and Gaetano Pelagalli. 1957. "Cani e canili

nella antica Pompei." *Atti della Accademia Pontaniana* new series, 7: 165–201.

Graham, A. J. 1978. "The Vari House – an Addendum." *Annual of the British School at Athens* 73: 99–101.

Grant, Michael, Antonio De Simone, and Maria Teresa Merella. 1975. *Erotic Art in Pompeii: The Secret Collection of the National Museum of Naples.* Octopus Books, London.

Haltenorth, Theodor, and Helmut Diller. 1980. *A Field Guide to the Mammals of Africa Including Madagascar.* Collins, London.

Haskell, Francis, and Nicholas Penny. 1981. *Taste and the Antique: The Lure of Classical Sculpture 1500–1900.* Yale University Press, New Haven.

Henig, Martin, ed. 1983. *A Handbook of Roman Art.* Phaidon, Oxford.

Hull, Denison B. 1964. *Hounds and Hunting in Ancient Greece.* University of Chicago Press, Chicago.

Hyland, Ann. 1990. *Equus: The Horse in the Roman World.* Batsford, London.

Jashemski, Wilhelmina F. 1979. *The Gardens of Pompeii, Herculaneum and the Villas Destroyed by Vesuvius.* Vol. 1. Caratzas Brothers, New Rochelle, N.Y.

1987. Recently Excavated Gardens and Cultivated Land of the Villas at Boscoreale and Oplontis. In *Ancient Roman Villa Gardens*, pp. 31–75. Dumbarton Oaks Colloquium in the History of Landscape Architecture 10, Washington, D.C.

1993. *The Gardens of Pompeii, Herculaneum and the Villas Destroyed by Vesuvius.* Vol. 2. Aristide D. Caratzas Publisher, New Rochelle, N.Y.

1994. La terra coltivata intorno alla villa. In Stefano De Caro, *La Villa Rustica in Località Villa Regina a Boscoreale.* G. Bretschneider, Rome.

Kapossy, Balázs. 1969. *Brunnenfiguren der hellenistischen und römischen Zeit.* Juris Druck & Verlag, Zurich.

Kater-Sibbes, G. J. F., and M. J. Vermaseren. 1975. *Apis, II, Monuments from outside Egypt.* Brill, Leiden.

Keller, Otto. 1963. *Die Antike Tierwelt.* Hildesheim (reprint of 1909–13 Leipzig edition).

King, Anthony C. 1984. Animal Bones and the Dietary Identity of Military and Civilian Groups in Roman Britain, Germany and Gaul. In *Military and Civilian in Roman Britain*, edited by Thomas F. C. Blagg and Anthony C. King, pp. 187–217. British Archaeological Reports 137, Oxford.

1985. I resti animali: i mammiferi, i rettili e gli anfibi. In *Settefinestre. Una villa schiavistica nell'Etruria romana, III*, edited by Andrea Carandini, pp. 278–300. Panini Editore, Modena.

1994. Mammiferi. In *Il Complesso Archeologico di Carminiello ai Mannesi, Napoli (scavi 1983–1984)*, edited by Paul Arthur, pp. 367–406. Università di Lecce Dipartimento di Beni Culturali (Collana del Dipartimento 7), Congedo Editore, Galatina.

1997. Mammal, Reptile and Amphibian Bones. In *Excavations at the Mola di Monte Gelato. A Roman and Medieval Settlement in South Etruria*, edited by Timothy W. Potter and Anthony C. King, pp. 383–403 British School at Rome Archaeological Monograph 11, London.

1999. "Diet in the Roman World: A Regional Inter-Site Comparison of the Mammal Bones." *Journal of Roman Archaeology* 12: 168–202.

Unpublished. Mammal Bones from the Impianto Eletrico Excavations at Pompeii, 1980–81. Unpublished report for Paul Arthur.

Kokabi, Mustafa. 1982. "Die Casa di Ganimede in Pompeji VII 13,4: Tierknochenfunde." *Mitteilungen des Deutschen Archäologischen Instituts, Römische Abteilung* 89: 397–425.

La Rocca, Eugenio, Mariette de Vos, and Arnold de Vos. 1994. *Guida Archeologica di Pompei.* Mondadori, Milan.

Laurence, Ray. 1994. *Roman Pompeii. Space and Society.* Routledge, London.

Maiuri, Amedeo. 1933. *La Casa del Menandro e il suo Tesoro di Argenteria.* Libreria dello Stato, Rome.

1953. *Roman Painting.* Editions Albert Skira, Geneva.

Matteucig, Giorgio. 1974a. "Aspetti naturalistici desumibili da una prima elencazione delle forme animali rappresentate nell'antica Pompei." *Bollettino della Società di Naturalisti in Napoli* 83: 177–211.

1974b. "Lo studio naturalistico zoologico del Portale di Eumachia nel Foro Romano Pompeiano." *Bollettino della Società di Naturalisti in Napoli* 83: 213–42.

Maulucci, Francesco P. 1988. *The National Archaeological Museum of Naples.* Carcavallo, Naples.

McDermott, William C. 1938. *The Ape in Antiquity.* Johns Hopkins Studies in Archaeology 27, Baltimore.

Merlen, René H. 1971. *De Canibus: Dog and Hound in Antiquity.* J. A. Allen & Co., London.

Morelli del Franco, Vincenzina C., and Rosa Vitali. 1989. "L'insula 8 della Regio I: un campione d'indagine socio-economica." *Rivista di Studi Pompeiani* 3: 185–221.

Pasqui, Angiolo. 1897. "La villa pompeiana della Pisanella presso Boscoreale." *Monumenti Antichi* 7: cols. 397–554.

Peters, W. J. T. et al. 1993. *La Casa di Marcus Lucretius Fronto a Pompei e le sue Pitture.* Thesis, Amsterdam.

Pisapia, Maria Stella, ed. 1989. *Mosaici Antichi in Italia; Regione Prima; Stabiae.* Istituto Poligrafico e Zecca dello Stato, Rome.

Pollitt, J. J. 1986. *Art in the Hellenistic Age.* Cambridge University Press, Cambridge.

Powell, Adrienne. 1999. Rodent and Non-Mammalian Bone. In Fulford and Wallace-Hadrill 1999: 92–3, 136.

PPM: *Pompei, Pitture e Mosaici.* Istituto della Enciclopedia Italiana, Rome 1990 (continuing).

Pratesi, Fulco, and Franco Tassi. 1977. *Guida alla Natura del Lazio e Abruzzo.* 2nd ed. Mondadori, Milan.

Rackham, James. 1979. "*Rattus rattus:* The Introduction of the Black Rat into Britain." *Antiquity* 53: 112–20.

Reinach, Salomon. 1922. *Répertoire de Peintures grecques et romaines.* E. Leroux, Paris.

Richardson, Jane. 1995. Faunal Remains. In Sara E. Bon, Richard F. J. Jones et al., *Anglo-American Research at Pompeii, 1995. Preliminary Report*, pp. 27–9. Bradford Archaeological Sciences Research I, Bradford and Chapel Hill, NC.

Richardson, Jane, Gill Thompson, and Angelo Genovese. 1997. New Directions in Economic and Environmental Research at Pompeii. In *Sequence and Space in Pompeii*, edited by Sara E. Bon and Rick Jones, pp. 88–101. Oxbow monograph 77, Oxford.

Ryder, Michael L. 1983. *Sheep and Man.* Duckworth, London.

Salza Prina Ricotti, Eugenia. 1983. *L'Arte del Convito nella Roma Antica.* "L'Erma" di Bretschneider, Rome.

 1988. "Cibi e banchetti nell'antica Roma." *Archeo* 46: 52–97.

Salza Prina Ricotti, Eugenia. 1983. *L'Arte del Convito nella Roma Antica.* "L'Erma" di Bretschneider, Rome.

Sampaolo, V. 1992. La decorazione pittorica. In *Alla Ricerca di Iside: analisi, studi e restauri dell'Iseo pompeiano nel Museo di Napoli,* edited by S. A. Muscettola et al., pp. 23–62. (Museo Archeologico Nazionale di Napoli), Arti, Rome.

Scullard, Howard H. 1974. *The Elephant in the Greek and Roman World.* Thames & Hudson, London.

 1981. *Festivals and Ceremonies of the Roman Republic.* Thames & Hudson, London.

Smith, Christopher. 1996. Dead Dogs and Rattles: Time, Space and Ritual Sacrifice in Iron Age Latium. In *Approaches to the Study of Ritual: Italy and the Ancient Mediterranean,* edited by John B. Wilkins, pp. 73–89. Accordia, London.

Toynbee, Jocelyn M. C. 1973. *Animals in Roman Life and Art.* Thames & Hudson, London.

Tran Tam Tinh, V. 1964. *Essai sur le Culte d'Isis à Pompéi.* Editions E. de Boccard, Paris.

Varone, Antonio. 1989. "Attività dell'Ufficio Scavi: 1989." *Rivista di Studi Pompeiani* 3: 225–38.

Vigneron, Paul. 1968. *Le Cheval dans l'Antiquité gréco-romain.* Faculté des Lettres et des Sciences humains de l'Université de Nancy, Nancy.

Villefosse, Antoine Héron de. 1899. "Le Trésor de Boscoréale." *Monuments Piot* 5.

Vivolo, Francesco P. Maulucci. 1993. *Pompei: i graffiti figurati.* Bastogi, Foggia.

Walker, R. E. 1973. Roman Veterinary Medicine. In Toynbee 1973, pp. 301–43.

Walker, Susan. 1991. *Roman Art.* British Museum Press, London.

Ward-Perkins, John, and Amanda Claridge. 1976. *Pompeii, A.D. 79.* Imperial Tobacco Ltd. and Royal Academy of Arts, London.

Watanabe, Makoto. 1996. "The Natural Remains Unearthed from UU.SS.4. Preliminary Reports, Archaeological Investigation at Porta Capua, Pompeii." *Opuscula Pompeiana* 6: 63–5.

White, Kenneth D. 1970. *Roman Farming.* Thames & Hudson, London.

Zeuner, Frederick E. 1963. "Dolphins on Coins of the Classical Period." *Bulletin of the Institute of Classical Studies, University of London* 10: 97–103.

18

HEALTH AND NUTRITION AT HERCULANEUM

AN EXAMINATION OF HUMAN SKELETAL REMAINS

Sara C. Bisel and Jane F. Bisel

For more than two hundred years, scholars and curiosity-seekers excavated the ancient city of Herculaneum without finding more than a couple of skeletons. Archaeologists presumed that the town's population had ample warning of Vesuvius's eruption and the means to escape its destruction. This theory went unchallenged until March 1982, when workmen digging a drainage ditch at the site were surprised to unearth three skeletons on the ancient beach. Further exploration nearby resulted in the discovery of a row of twelve chambers that were found to contain the remains of several dozen people and many of their most prized or necessary belongings (Fig. 363). Skeletons continued to be discovered as three of the chambers were excavated. In time, as more of the beachfront is explored, there is reason to expect that a significant number of the town's approximately four thousand inhabitants will be found.

When this study began in the fall of 1982, its first priority was to clean and restore the newly unearthed bones from the first three chambers. Since the skeletons had remained in an environment of unchanging temperature and humidity for nineteen hundred years, protected by twenty meters of volcanic material and a continuous bath of fresh, pH-neutral water, they were in good to excellent condition. Once exposed to the atmosphere, however, they would decay rapidly.

After being removed from the ground, the bones were washed in water, air-dried, dipped in a water-based acrylic emulsion (Primal), and air-dried again (Fig. 364). Skulls and postcranial bones were restored with an acetone-based acrylic resin (Butvar), using wire supports where needed (Koob 1982). Each skeleton was then assigned an identification number based on the modern Italian name of the site (Ercolano, abbreviated as Erc) and the order in which it was unearthed. In all,

139 Herculaneans — 51 males, 49 females, and 39 children — were excavated and restored.

Two basic anthropological methods then were used to study the skeletons. The first of these was direct measurement and observation of the bones, with particular attention to longevity, stature, pelvic brim index, shaft indices of tibia and femora, dental health, trauma, and such disease conditions as anemia and infection. The second was biochemical analysis of animal and human bone samples for calcium, phosphorus, magnesium, zinc, strontium, and lead. Using these methods, some conclusions can be drawn about the population's general health and further insight can be gained into the lifestyles of certain members of Herculanean society.

AN OVERVIEW OF METHODS AND FINDINGS

DIRECT OBSERVATION AND MEASUREMENT

Demography and Fertility

Usually, one of the most useful indicators of the health of a population is the longevity of its adults. This statistic can be obtained and used because most sites studied are cemeteries. At Herculaneum, however, everyone died accidentally and, thus, prematurely. While this presents an interesting opportunity to catch a cross section of the population at the same moment, it does not permit conclusions to be drawn about the natural life span of ancient Romans.

Even if longevity cannot be considered, the age attained by these people before their premature deaths

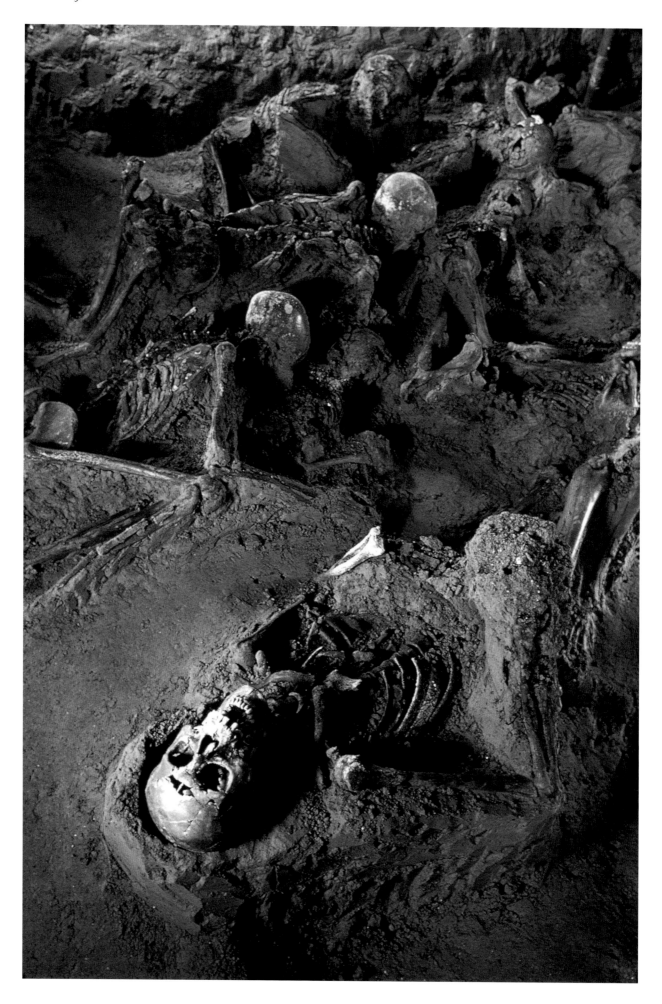

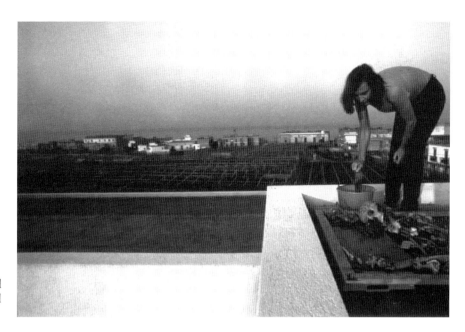

FIGURE 364 Sara Bisel preserving and drying cleaned bones. Photo: Cheryl Nuss/NGS Image Collection.

is useful to know. Age can be determined using several indices. In children, age can be determined fairly accurately by considering the stages of tooth development (Schour and Poncher 1940) and observing epiphyseal closure (McKern and Stewart 1957). The skeletons of adults are somewhat more difficult to age. The most accurate method is based on the observation of changes in the pubic symphysis (Angel 1980; McKern and Stewart 1957). Other, less reliable, methods include assessing the relative amount of arthritic or osteoporotic change in the bones and examining skull sutures (Todd and Lyon 1924).

The age distribution of this group is not at all what normally would be expected. A complete population, if stable in numbers and considered at the same moment like this one, ought to have a larger proportion of infants, children, and youth than were found here. The high incidence of infant and child deaths usual in the ancient world meant that there had to be a high birth rate just to replace those in older age groups as they died. The findings illustrated in Figure 365 suggest that this, evidently, was not happening at Herculaneum. Several hypotheses could be proposed to explain this situation. It is possible that many youngsters, and perhaps even some of the oldest group, had escaped to Neapolis the night before. But there is no real reason for the age mix of the escapees to be different from that of those in the chambers and on the beach. It is even possible that another unexcavated chamber holds these "missing" people. But again, there is no apparent reason for one chamber to have a different age mix than another. A third scenario is also possible and more probable: that

the seeming deficit of infants and youth reflects a real phenomenon, the radically decreasing fertility of this population. It is impossible at this time, as it probably always will be, to prove which of these explanations, or combination thereof, is the true one.

The parity statistics support the idea that fertility was low. Parity is estimated from the relative destruction to the dorsal rim of the pubic symphyses of all females over the age of 15 (Angel 1972). Of the thirty-seven women in this age group for whom parity could be assessed, the mean number of births was calculated to be 1.69. This is much lower than would be expected. It is not nearly enough to maintain the population, even if there were no infant or child deaths to consider. Considering only the sixteen women who were over 40 years of age and thus might be presumed to have finished reproduction, we find the mean number of babies born to each to be 1.81. This is still not even adequate to maintain population numbers, particularly when we consider the rate of infant mortality.

There is ample evidence to support the idea that the low birth rate was at least partially due to practices of contraception and abortion. References to both are common in the literature of the period. The poet Juvenal, for instance, explicitly mentioned "many sure-fire drugs for inducing sterility or killing an embryo child" in his *Satires* (6.592–8). Likewise, the comic playwright Plautus referred to abortion in *Truculentus* (2.1.200), as did the poet Ovid in *Fasti* (621–4) and *The Amores* (2.14). Medical texts of the period recommended a variety of methods, at least some of which might have been effective.

Soranus, an early-second-century gynecologist, discussed both behavioral and medicinal methods of contraception and abortion. He described coital and post-coital techniques designed to impede the progress of

(Opposite) FIGURE 363 Partially excavated skeletons, Herculaneum. Photo: O. Louis Mazzatenta/NGS Image Collection.

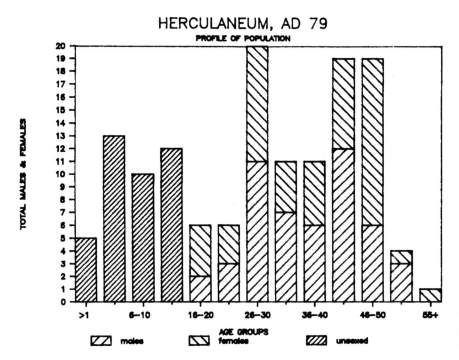

FIGURE 365 Herculaneum, A.D. 79: a profile of the population by age and sex.

seminal fluid and recommended the use of vaginal suppositories as barriers or spermicides (*Gynecology* 1.61–2). Accordingly, a woman's cervix could be plugged before intercourse with wool sponges or pessaries made of old olive oil, honey, cedar resin, balsam sap (alone or in combination with white lead), myrtle oil with white lead, moist alum, or galbanum. Other treatments made of pomegranate peel, with or without moist alum or gum and rose oil, or dried figs also could be applied. Many of the plants used in his prescriptions for oral contraceptives (1.63) are known to contemporary medicine in China, India, and Latin America. In addition, those that have been tested in modern laboratory studies have demonstrated a significant degree of effectiveness (Riddle 1992). Some of his methods to induce abortion in the first weeks of pregnancy included strenuous exercise, diuretics, laxatives, sitz baths prepared with herbs, and a pessary of lupine meal with ox bile and wormwood (1.64). He also recommended wormwood, applied in suppository form, to end a more advanced pregnancy. Alternatively, the woman could be bled (1.65).

Dioscorides, an herbalist contemporary with the Herculaneum population, also treated the subjects of contraception and abortion, recommending oral contraceptives containing white poplar (1.109), white willow (1.136), ivy (2.210), and barrenwort root (4.19), among others. Yet another preparation made of cabbage flowers could be applied to prevent conception after childbirth (2.146). To end a pregnancy, he prescribed preparations made of myrrh with lupine, wormwood, or rue (1.77), chaste tree (1.135), Ethiopian olive sap (1.141), lupine (2.132), cabbage (2.146), wormwood (3.26), and

the seeds and roots of parsley (3.76). Modern studies confirm the probability that these methods were at least somewhat effective (Riddle 1985).

Practices of homosexuality and abstinence also may have contributed to the low birth rate in Roman times. Whatever its cause, there must have been a decrease in the number of births throughout the Roman Empire during the first century that was significant enough to warrant Augustus's enacting a measure penalizing small families and rewarding those with more than their quota of three or more children (*Oxford Classical Dictionary*, 3rd ed., s.v. "Ius liberorum").

Genetic Diversity

The extreme variability of the skulls studied indicates the widely diverse genetic heritage of this population. Eleven skull measurements, each of which more or less quantifies a different part of the growth force of the skull, were taken from each of fifty adult male skulls. These then were compared to a standard developed by W. W. Howells in a 1941 study of Irish monastery burials. Howells calculated the mean and standard deviation (sigma) for each skull measurement in twenty-five historically diverse populations and then determined the mean of these sigmas. He held these mean sigmas to be the norm and assigned each of them a value of 100. Populations with mean sigmas smaller than 100 are very similar in appearance and genetic background; populations with higher means are considered to be more varied, and therefore more diverse genetically.

The mean sigma for males at Herculaneum is 141, exhibiting a very great variability compared to any of

Howells's populations. Although the haphazard methods of some early excavators at Pompeii have scattered or fragmented many of that site's human remains, recent studies of the skeletons found there have yielded similar, albeit necessarily inconclusive, data (Lazer 1997). The extreme variation seen at Herculaneum would indicate that its gene pools were very large, a situation that would have resulted in great hybrid vigor. In other words, the town, if not the region, was a great melting pot of peoples, enjoying the energy and health that result from genetic diversity.

Dental Health

The dental data of this population give a better idea of some aspects of their lives. The mean number of lesioned teeth (antemortem loss plus carious caries and/or abscessed teeth) per mouth is 3.4, essentially equal for males (3.5) and females (3.3). This is very low compared with the mean of 15.7 found in a modern American population (Bisel and Angel 1985). Admittedly, some of this difference could be attributed to the fact that the mean age of the American population sample is greater, but much of it is real.

The low incidence of caries and antemortem loss in the Herculaneans' teeth can be at least partly attributed to the fact that sugar was not in use in the West until the Middle Ages, when the Crusaders brought it back from the Middle East. Honey was available but expensive, so it was used less than modern Western cultures use sugar. Another factor was the greater consumption of abrasive food – such as flour ground in stone mortars, which, consequently, incorporated stone grit. Such food would scour away caries as they developed. A third factor was the heavy consumption of seafood, an excellent source of fluorides.

Slight periodontal disease or alveolar absorption was widespread, especially in the older part of this population. Sixty percent of the sample had the condition in slight degree, while only 9 percent had it in moderate to marked degree. About half of the population sample had horizontal hypoplastic lines in their tooth enamel (Modesti 1984). These would have been caused by situations that prevented these people from assimilating sufficient calcium for forming teeth, such as diseases or periods of starvation in childhood that lasted two weeks or longer (Mellanby 1934; Schour and Poncher 1940). Therefore, we can conclude that childhood illnesses were common in this population.

The dental occlusion of most of these people is very different from that of modern populations. The Herculaneans had edge-to-edge bite without any crowding of the teeth. One contributing factor affecting ancient occlusion is the greater exercise of chewing food without the help of knives and forks. More chewing meant greater stimulation of the jaw bones to grow and develop. Fully developed jaw bones would give more space to accommodate teeth, favoring good occlusion. Another factor contributing to greater stimulation of jaw growth is that ancient infants were nursed for a much longer time than modern American ones, usually until they were three years old (Dupont 1992).

Skeletal Development
Stature

Measurement and observation of long bones reveal more about how these people looked. Stature is a statistic that depends on both genetic and environmental factors. If an individual, particularly a male (Stini 1975), endures poor nutrition or serious disease during the growing years, he or she will be shorter than the maximum stature dictated by genetics. Stature at Herculaneum in A.D. 79 was roughly the same as that of the Hellenistic Greeks. The average man was about 169 cm tall and the average woman about 155 cm tall. But the ancient Herculaneans were significantly taller than the inhabitants of modern Naples, where the average man is 164 cm tall and the average woman is 153 cm tall (D'Amore, Carfagni, and Maratese 1964).

Bone Flattening

Flattening of the long bones of the legs and/or of the pelvis suggests that an individual must have endured both poor nutrition and heavy exercise. More exercise makes larger muscles. The bones, if thin and spindly from poor nutrition, must flatten to provide more bony surface for their attachment (Adams 1969; Buxton 1938). The relative flatness of the shaft of the femur is expressed as a ratio of its anteroposterior thickness to its transverse thickness, multiplied by 100. The higher the resulting value, known as the platymeric index (PMI), the rounder the bone. The mean platymeric index at Herculaneum is 83.1 for females and 81.9 for males. These indices are only slightly flatter than those for modern Americans, which are 86.3 for females and 88.2 for males (Angel and Bisel 1986). A similar ratio, known as the cnemic index (CI), is calculated between the transverse thickness and the anteroposterior thickness, multiplied by 100, of the tibia. At Herculaneum, the mean cnemic index was 71.8 for females and 69.5 for males, compared with 70.2 and 70.3, respectively, in modern America (Angel and Bisel 1986).

The pelvic brim index (PBI) also has a nutritional component. It is computed from a ratio of anteroposterior to transverse measurements, multiplied by 100, of the true pelvic brim (Martin and Saller 1959). The pelvis, because of the weight of the upper body press-

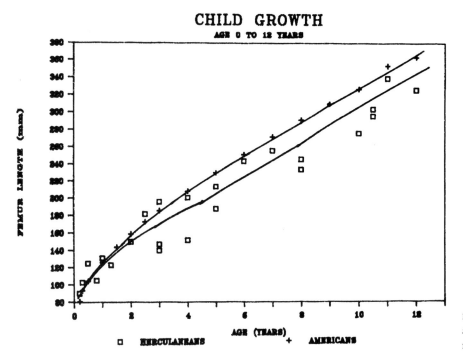

FIGURE 366 Child growth to age 12: a comparison of Herculaneum and modern America.

ing down on it, reflects any slight softening of bone by becoming flattened. Thus, the pelvic brim index can demonstrate long-standing conditions of poor nutrition (Angel 1976; Greulich and Thoms 1938; Nicholson 1945). Whereas the mean pelvic brim index for Herculaneans of both sexes is 83.9, the corresponding mean for modern Americans is significantly better at 93.3, suggesting that they are better nourished (Angel and Bisel 1986).

The robusticity index (RI) is another useful indicator of nutritional status. It is computed as a ratio of anteroposterior thickness plus transverse thickness to bichondylar length, multiplied by 100, of the femur. Mean robusticity indices at Herculaneum were 12.7 for females and 13.3 for males, only slightly higher than findings of 11.9 for females and 12.7 for males in a modern American population (Angel and Bisel 1986).

Child Growth

The child growth study compared the femur lengths of Herculanean children with those of a contemporary Denver, Colorado, pediatric sample (Maresh 1955) from birth to the age of 17. Growth curves were constructed based on femur length for both the modern children and the Herculaneans, who were aged by dental data (Fig. 366).

The Herculanean growth curves are below those of Americans throughout. Newborn infants of both populations are about the same size, but differences quickly become apparent. The adolescent growth spurt starts for both groups at the age of 9, but the American curves rise more steeply. Female curves of both groups level off at about the same age: 14.5 years (Fig. 367). But while the Herculaneum male curve levels off at about 15 years of age, the modern American males continue growing for a longer time (Fig. 368). Males, having a more intense adolescent growth spurt than females, are more subject to nutritional deprivation. Any serious lack of food during the very short period of male adolescence will mean that males will remain shorter than their genetically programmed maximum stature. This is undoubtedly what happened at ancient Herculaneum.

BONE MINERAL ANALYSIS

Diet and Nutrition

When considered with skeletal measurements, an analysis of the mineral content of bones can give further insight into the nutrition of a population. Strontium and zinc levels, in particular, are important indicators of the types of protein consumed.

Zinc in bone directly reflects the presence of red meat in the diet. It also indirectly indicates the consumption of unleavened bread and unrefined cereal protein, since it is bound in the gut by phytate, a substance present in these foods (Reinhold 1972).

The ratio of strontium to calcium in bone can be used to demonstrate the relative amounts of animal and vegetable protein in a population's diet. Strontium exists in plants in about the same proportion as in the soil. Herbivores incorporate some of the strontium they ingest through plants into their bones, where it substitutes for calcium, but none into their muscles. Omnivores feeding on the meat of these herbivores, and relatively fewer plants, then will ingest and absorb less strontium into their bones. Carnivores will have

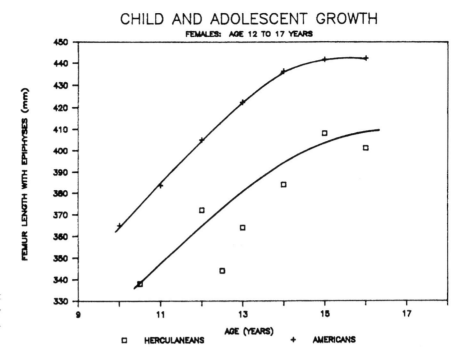

FIGURE 367 Child and adolescent growth of females aged 12 to 17 years: a comparison of Herculaneum and modern America.

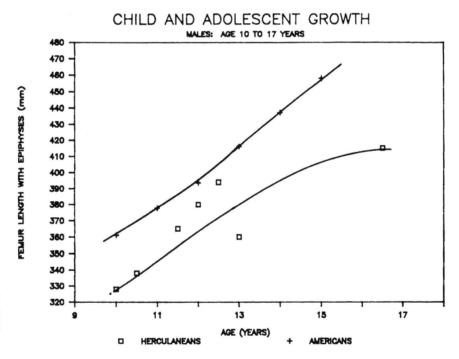

FIGURE 368 Child and adolescent growth of males aged 10 to 17 years: a comparison of Herculaneum and modern America.

even less strontium in their bones, since the direct vegetable source is lacking. Therefore, it should be possible to make inferences about the relative protein sources in human diet by comparing the strontium levels in human bones to those of various animal species raised on the same soil system (Brown 1973; Sillen and Kavanaugh 1982).

One problem with this interpretation of the food chain is that it does not consider the possible consumption of seafood, which is high in strontium. Sea animals, living in an environment rich in strontium,

"breathing" it as well as eating it, have higher levels of strontium in their bones and flesh than do terrestrial animals (Rosenthal 1963). This fact can complicate the reconstruction of human diet. Since the amount of strontium in bone ultimately depends on its level in the soil, which varies in different locations, comparisons between populations of different regions are complicated. In this study, such comparisons were made by the expedient of "standardizing" the mean strontium values for humans at a site with the mean for herbivorous sheep and goats at the same site.

In themselves, calcium and phosphorus values provide less insight into the diet of a population than do zinc and strontium. Calcium values primarily are used in ratios with the other minerals that substitute for it in the bone structure. Since phosphorus does not substitute for calcium, calcium-deficient diets do not cause the calcium/phosphorus ratio to change but result in a thinner cortex or smaller bones. Instead, the calcium/ phosphorus ratio indicates how far the fossilization of the ancient bone has progressed. Magnesium values are primarily useful for the information they provide about the soil ecosystem (Bisel 1980).

In this study, bone samples, mostly from the tibial crest, were cleaned mechanically of surface dirt and dissolved in hydrochloric acid. They were then analyzed with an atomic absorption spectrophotometer to determine their relative content of calcium, magnesium, strontium, zinc, and phosphorus. Soil samples were also analyzed for calcium, magnesium, strontium, and zinc.

The calcium, phosphorus, and magnesium values of skeletal remains at Herculaneum were all what would be expected from partly fossilized bone. The soil values for all minerals were also unremarkable. The zinc and strontium values of the bones were more telling, however. The zinc values were low, about half those of modern Americans (Janes, McCall, and Kniseley 1975), while the site-corrected strontium/calcium values were rather high. These two findings suggest that the Herculanean diet was higher in seafood and vegetable-source protein and lower in red meat than that of modern Americans. Saltwater fish are high in strontium, as are vegetable-source protein foods, but both are low in zinc and iron.

A diet that relies heavily on fish and vegetables could cause a slight to moderate nutritionally based anemia that, in turn, would predispose to frequent infectious diseases (Weinberg 1974). This situation would help to account for the frequency of hypoplastic lines in dental enamel noted at Herculaneum. Healed anemia is detectable in skeletons as porotic hyperostosis, a swelling or thickening of the inner diploe of the parietal bones of the skull. The Herculaneum sample has a much higher rate of incidence of this condition than do modern Americans (Bisel and Angel 1985). This may reflect an inadequate intake of iron and/or it may be a result of heterozygotic thalassemia, the genetic condition arising as a response to the exposure of many generations to malaria (Angel 1966). Nevertheless, nutrition was adequate to permit moderate growth and taller stature than that of modern Neapolitans, with femur, tibia, and pelvis moderately rounded. The high fluoride content of the seafood they con-

sumed would help to account for the lack of caries in these people's teeth.

Literary sources provide a clearer picture of dietary practices at Herculaneum. Food consumption differed greatly among the social classes, with the poorer people eating meat only at festivals. The staple food was wheat, usually prepared in a porridge to avoid the tedium of grinding it into flour by hand in a stone quern. The porridge was made more palatable by cooking it with bits of vegetables, olives, mushrooms, fish, birds, or a little meat. By this time, those who could afford it bought bread at a bakery, where their grain also could be ground in a rotary mill powered by donkeys or horses.

Instead of wheat, barley could be used in these porridges, or even in bread. Although believed to be less nutritious than wheat, it was eaten by the poor, who also ate a porridge made of millet. Any bread they consumed was made of coarsely ground grain that retained the chaff.

Cooking was difficult for the poor, since their kitchens were extremely crude and lacked chimneys. They bought prepared food as often as possible. From the *thermopolia*, the delicatessens of their day, they obtained fresh or salt-dried fish, or a little meat. They also ate foods that did not need to be cooked, like olives, raw beans, figs, or cheese.

Some people, but not all, ate breakfast (*jentaculum*). This was a light meal of bread or a wheat pancake, possibly dipped in wine, eaten just after sunrise. The midday meal (*prandium*), eaten in late morning, was usually a simple repast of bread, meat, and cheese. Or it could be more elaborate, with fish or meat and wine mixed with water. The evening meal (*cena*) was heavier than the others. For an average family, it was fairly modest: whole wheat bread or porridge with vegetables, a bit of meat or fish, and fruit.

The affluent minority served more extravagant meals, especially on social occasions. A full dinner started with hors d'oeuvres (*promulsum*), followed by a sweetened wine (*mulsum*). The meal itself consisted of six or seven courses: elaborate dishes of fish, poultry, and meat. Then came dessert, perhaps honey cakes and fruit. Wine, always mixed with water, flowed freely during and after the meal. Women, however, were not permitted to drink very much. The rationale for this custom, earlier a law, was that alcohol lowered a woman's moral standards, leading her into adultery (Carcopino 1979; Cowell 1961; Tannahill 1973). A gala occasion featured foods and ingredients imported at great cost: Spanish pickles, Gallic ham, Libyan pomegranates, British oysters, and, above all, exotic spices from the East.

Complex sauces were essential to this cuisine. The most popular of these was *garum,* a strong and sometimes very expensive condiment, which was also thought to have medicinal value. Celsus, an encyclopedist known for his documentation of medical practices, prescribed it as a laxative (*De Medicina* 2.29.2) but cautioned against its use by those with weakened constitutions (2.21), while Dioscorides (2.34) recommended *garum* as a treatment for dog bites and dysentery. The naturalist and encyclopedist Pliny the Elder also thought it a useful remedy for various ailments, including skin lesions (*HN* 20.55), mouth and ear pain, dysentery, burns, sciatica, dog bites (*HN* 31.97), and quinsy (*HN* 32.90).

Although formulated from many recipes and produced in several grades, all varieties of *garum* were made from a paste of fermented fish (such as tunny, mackerel, or mullet) and salt, which was optionally mixed with wine, oil, vinegar, herbs, or spices (Curtis 1991; Shelton 1988; Tannahill 1973). *Liquamen, muria,* and *allec* were other, similar fish sauces probably derived from the production of *garum* whose names were sometimes used interchangeably with that of the primary sauce (Curtis 1991).

As the production of fish sauces was particularly time-consuming and inevitably malodorous, *garum* was usually made by commercial salteries, one of which probably existed in Pompeii. Although Pliny (*HN* 31.94) extolled the virtues of Pompeian *garum,* and the fishing port was ideally situated near a saltworks, archaeological evidence of a factory there has not yet been found. Excavated remains of *garum* containers, however, indicate that there were at least ten businesses in the region engaged in the production or distribution of fish sauce, of which one would have been at Herculaneum (Curtis 1991).

Lead Ingestion

The possibility that the ancient Romans suffered from widespread lead poisoning has periodically surfaced as a topic of debate in both scholarly and popular circles. In addition, since high levels of lead in the body can contribute to sterility (Gilfillan 1965) and thus might offer an explanation for the Herculaneans' apparently low birth rate, an analysis of the lead content of these bones seemed worthwhile.

Bone lead content was determined for ninety-seven adult samples from Herculaneum, plus eleven samples from the Hellenistic-period Kerameikos cemetery of Athens and five samples from Franchthi Cave, a pre-metal Neolithic-period site in the Greek Argolid (Fig. 369). Soil samples also were analyzed as a control. There were a few instances of physiologically impossi-

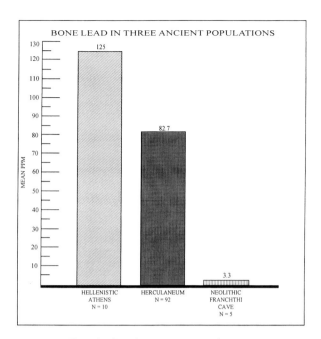

FIGURE 369 Bone lead in three ancient populations.

ble high bone lead: five adults and two children from Herculaneum and two from Hellenistic Athens. These samples were eliminated from the statistical analysis.

The extent to which lead may be absorbed into bones from the soil in which they are buried is a matter of conflict among investigators. This study used hard bone (the cortex) of the tibial crest, which is less easily penetrated by contaminates. It was found that the individuals had widely different bone lead values, some higher and some lower than the mean soil values. They were scattered randomly over the beach; there were no clusters with predominantly high or low values. This indicates that absorption from the soil is of minor significance.

Another problem is that high levels of lead in the bone do not necessarily mean that the person in question had serious symptoms of lead poisoning in life. If lead is taken into the body in small amounts but gradually and steadily (as modern people who live in lead-polluted environments do), that person may not be grossly ill. Lead is cumulatively absorbed into bone and will remain there unless a time of calcium stress occurs, such as in serious illness or starvation. The body then will remove calcium from the bone surface in order to retain blood calcium equilibrium. In so doing, the lead that was deposited on the bone surface also will be released into the circulation. It is while free lead is circulating through the soft tissues of the brain, kidney, or other organs that the symptoms of plumbism occur.

The ten subjects from Hellenistic Athens had higher lead values (mean = 125 µg/g) than did the ninety-two from Herculaneum (mean = 82.7 µg/g). The people of the pre-metal culture of Franchthi Cave

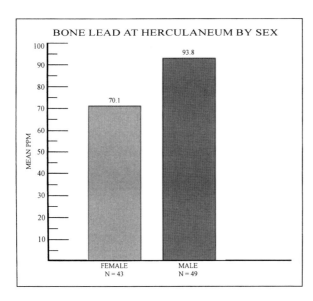

BONE LEAD AT HERCULANEUM BY SEX

FIGURE 370 Bone lead in Herculaneum by sex.

predictably had only trace amounts of lead in their bones. Herculanean males had slightly higher values (mean = 93.8 µg/g) than did females (mean = 70.1 µg/g) (Fig. 370). These differences may have been occupationally related, but this cannot be proved. As far as social class can be determined in the population, there seems to be no difference between lead values of the rich and the poor.

Where were all these people obtaining lead and why? Lead is very easy to smelt since it melts at a relatively low temperature; it is also soft and easy to work. It is a useful by-product of smelting silver ores. It was in widespread use by the Romans, as we know from seeing many lead objects – such as drinking cups, plates, and the lining of copper pots. Many buildings and structures used lead as a structural feature. Aqueducts were lined with lead plates. Paint pigment, especially the Pompeian red, contained lead.

Lead was in wide use in the construction of buildings and water supply systems, as noted by the Roman architect Vitruvius. Lead pipes supplied water to many Roman cities, including Herculaneum. Vitruvius (8.6.10), at least, recognized this as a health risk and advocated earthenware pipes as an alternative.

However, at Herculaneum, the water supply would not have been greatly contaminated by lead, since the very hard water in the area would have lined the pipes thickly with calcium carbonate. But the many people who worked with lead – the miners, smelters, construction workers, plumbers, and others – would all have been at great risk. Vitruvius (8.6.11) cited the customary pallor of these people to caution others of lead's harmful effects. The literature of the period also tells us of other uses of lead, as in cosmetics, medicine, and food additives. In *The Art of Love,* Ovid recommended the

incorporation of white lead carbonate in makeup (70), as did Plautus, in his play *The Haunted House* (1.3).

Medicinal uses were described by two contemporary scholars: Pliny the Elder and Celsus. Although he recognized lead as a "deadly poison," Pliny (*HN* 34.176) proposed tablets made of lead acetate and vinegar to whiten a woman's skin. In addition, he recommended lead to remove scars and to stop bleeding and promote healing, particularly in ulcers, fissures of the anus, or hemorrhoids (*HN* 34.166, 169). Likewise, Celsus *De Medicina* reported lead as an ingredient in treatments for bleeding (5.1.1; 5.19.1–2), superficial wounds (5.19.23–8), burns and ulcerations (5.15; 5.27.13B; 6.8.1), putrification (5.22.2), and pustules (5.28.15E). He maintained lead's effectiveness as a remedy for headache (3.10.2), profuse sweating (3.19.2), and arthritis (4.31), as well.

But one of the most widespread uses of lead during Roman times was as a sweetening agent for wine or other foods. Since sugar was not known to the ancient Romans, they found that the easiest and cheapest way to sweeten large lots of somewhat sour wine was to use a sweet-tasting lead acetate syrup made by boiling the dregs of wine in lead-lined copper pans for several days. Such a method was recommended by Pliny (*HN* 14.136) and the agriculturist Columella (*RR* 12.19.1). This form of sweetening was in very widespread use in Roman times, and continued even into the nineteenth century. In the face of such widespread use of lead in Roman civilization, it is perhaps surprising that the mean bone lead value at Herculaneum is not higher.

A CLOSER LOOK AT SELECTED INDIVIDUALS

THE PRIVILEGED CLASS

The wealthy – their possessions, real estate, pastimes, politics, and thoughts – have been documented by ancient authors and modern scholars to an extent far exceeding their relative numbers in the whole population. It should be remembered that the rich were few and that poor people and slaves greatly outnumbered them. Also, unlike modern Western society, there was a huge gap between the upper classes (equestrians and senators) and the majority of the population (slaves and freedmen).

Erc86: A Paterfamilias

The paterfamilias was the head of a Roman household: his relatives, servants, and clients. Erc86 has been chosen to represent this important part of the Roman social structure, although this is a somewhat speculative assignment, because his bones fit this role well.

Erc86 was about 46 years old, tall at 172.4 cm, and well nourished. His long bones are relatively round (PMI = 81.4, CI = 66.7) and his pelvis is rounder than average (PBI = 85.4). His bones are thick and heavy (RI = 13.5), a sign of very good nutrition. His huge, well-developed muscles tell us that he was very athletic. Muscular development from sports is different from that created by heavy work, as athletes develop muscles throughout the body with no sign of overwork. Laborers may develop generalized musculature, but frequently just one part is well developed. There are also signs of overwork: scars at the insertions of muscles and Schmorl's herniations in the bodies of the lumbar or thoracic vertebrae. There are no signs of real stress on any of Erc86's muscle insertions; apparently he was exercising for the fun of it. He did not exercise beyond his strength, as the working class and slaves did.

Erc86's deltoid and teres major muscle insertions are even larger than those elsewhere on his body, particularly the right ones. The muscle insertions of the lateral head of the triceps and the latissimus dorsi muscles are also enlarged (Fig. 371). Amazingly, his right humerus is 10 cm longer than the left one. Obviously, he was right-handed; but beyond that, such a pronounced difference indicates that he must have used the right arm for some activity needing strong exertion. But he didn't use it to the exclusion of the left arm, since that arm is also very muscular. Were his chief sports hurling the discus, weights, or javelin? Besides hurling, he was active in other sports needing general muscle usage. The leg muscles were also well developed. The crests of the interosseous muscles of the hands show that he used them only moderately. He probably had someone else to do his writing for him, in addition to the many servants he would have had to do any other work, heavy or light. Upper-class Romans took pride in doing no labor. In fact, all full citizens of Rome, rich or poor, felt that doing physical work of any kind to earn a living was beneath them (Carcopino 1979).

For a person of 46 years he had very good teeth, perhaps not quite so good as some others at Herculaneum, but still above average, and excellent periodontal tissue. He has most of his teeth. Missing are five maxillary teeth; the last four molars and one premolar were lost antemortem. There is also one small abscess in a premolar. He had very slight alveolar absorption and almost no periodontal disease.

His lead analysis presents data showing very low values. He was not in a line of work that exposed him to lead poisoning. He probably drank wine produced on his own estates, wine that he did not permit to be contaminated. The strontium/calcium ratio and the other mineral values are more or less the population

FIGURE 371 Erc86: muscle insertions of humeri. Photo: Sara Bisel.

average. The tall stature, heavy round bones, and good teeth all indicate he was very well nourished all his life.

Erc65: A Wealthy Matron

Found at the entrance to one of the chambers was Erc65, wearing and carrying a lot of gold jewelry: two rings on her left hand, plus two bracelets, a pair of earrings, and a few coins in a bag on her hip (Fig. 372). The bag had decayed long before the excavation, but the jewelry and money stayed in a bag-shaped clump at her hip. Having so much expensive jewelry would certainly indicate that she was rich, and her bones corroborate this. She was slightly taller than the mean at 157.2 centimeters. Her leg bones are quite rounded (PMI = 89.4, CI = 66.2). She has heavy, robust bones (RI = 13.16), indicating good nourishment. The pelvic brim index is even more deep than round (PBI = 103.2). With such a deep pelvis, it would have been easy for her to deliver the two or three babies she bore.

Judging from the pubic symphysis, she was also about 46 years old when the volcano ended her life. Although her beauty was marred by dental problems, most notably a pronounced overbite, modern people can marvel at the fact that she had no caries cavities of

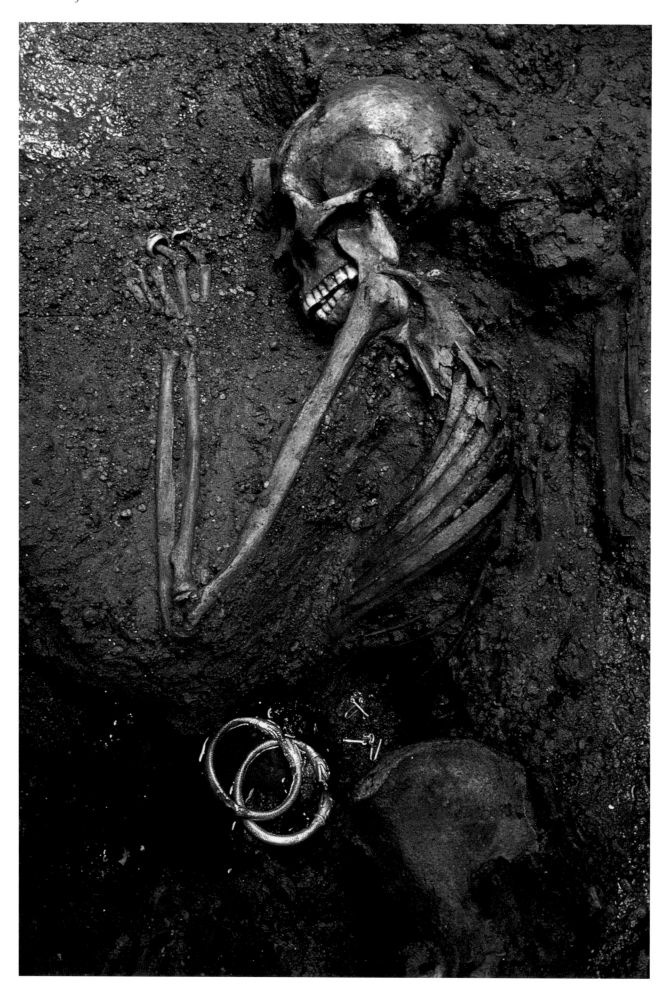

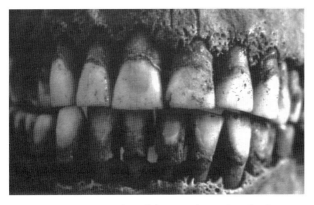

FIGURE 373 Erc65: periodontal disease. Photo: Sara Bisel.

her teeth. She was missing both lower third molars congenitally and one lower second molar was extracted before death. Obviously, the maxillary teeth opposing these molars never had teeth to chew against, since they had grown beyond the line of occlusion. These molars also show no sign of wear. However, she did have a more serious dental problem: advanced periodontal disease. There was significant loss of bone around each alveolus, and many tiny holes in what remained (Fig. 373). These two phenomena are bony responses to increased blood circulation in that area (i.e., bleeding gums). If she had not died prematurely, she would soon have had infection penetrating the bone around and under the teeth, causing abscesses and subsequent tooth loss. But it is obvious that she was nourished well enough in childhood, when the teeth were developing, to make sound, decay-resistant enamel (Clement 1963). There is some slight periostitis of the lower tibiae, suggesting a chronic, low-level blood-borne infection, undoubtedly not at all debilitating (Angel 1980).

Erc46: A Pretty Woman

Erc46 was a woman of about 36 years, judging from the general appearance of her bones and skull sutures (since no pubic symphysis was available). She had a very beautiful face: symmetrical and well proportioned, with perfect teeth and a small nose (Fig. 374). She was slender-boned and delicate, but her muscle insertions show that she was well-muscled, either from games or from work. The muscle markings of the arm bones are more pronounced than those of the legs. There are no fragments of pubic symphysis or rami, so we cannot say how many, if any, children she might have borne. Her stature of 154 cm was average for Herculanean women. She had moderately light bones (RI = 12.6),

slightly flattened femora (PMI = 77.8), rounded tibiae (CI = 82.6), and a moderately flattened pelvis (estimated PBI = 79.5).

She probably had slight anemia in earlier years, but this had been overcome well before her death. Because her skull was so complete, there was no access for calipers to measure its thickness. But the skull feels very heavy and there is porosity of the outer table of the parietals. These signs point to anemia at some time long past. This anemia could have been caused by nutritional deficiencies, heterozygotic thalassemia, or even parasites, such as hookworm (Angel 1966).

Her teeth are virtually perfect. There is an insignificant pit cavity in her right mandibular first molar. Also, there are some light lines of hypoplasia on the incisors and the canines, showing that she had a few childhood diseases. In general, the teeth have not had much wear, indicating that she ate refined bread made at a bakery rather than the rough food of poorer people.

Erc132: An Upper-Class Child

Erc132 was a child, more probably female than male (Reynolds 1945). She was about 8 years old. Her family's wealth is implied by her jewelry: a gold ring with a set stone and some glass beads. She was of average height for her age compared to Herculanean children, but 11 percent smaller than the median for modern American children (Maresh 1955). Her most unusual feature is the presence of five caries cavities in the deciduous teeth, a condition unique in this population. Was she given a lot of honey-laden desserts? There's no way of knowing.

FIGURE 374 Erc46: skull. Photo: Sara Bisel.

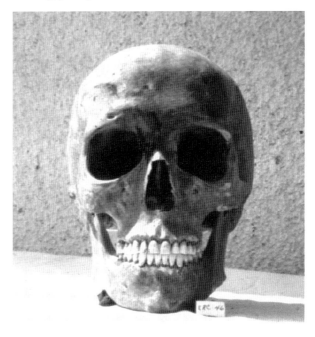

(*Opposite*) FIGURE 372 Erc65: skeleton with jewelry. Photo: O. Louis Mazzatenta/NGS Image Collection.

TYPICAL HERCULANEANS

Erc8: A Child with a Fractured Arm

Erc8, found in the first chamber excavated, is a good contrast to Erc132. This child was also probably a girl and about 7 years old, based on the stage of her tooth development. All four central incisors are erupted with incomplete roots, the mandibular second incisors are erupted, but not yet quite in occlusion, the maxillary second incisors are not yet erupted, and the crowns of mandibular canines are just completed but still in crypt. She also has several very faint lines of hypoplasia on the crowns of the central incisors and canines, also indicating several episodes of childhood illness or malnutrition when she was about 4 or 6 years old (Schour and Poncher 1940).

The lengths of the long bones of this child show her to be smaller than the twenty-fifth percentile for this age in a population studied in the United States. The femur lengths, with epiphyses, are 244 mm for the left and 245 mm for the right. These are 78.9 percent of the corrected femur length of 309.8 mm for the fiftieth percentile of seven-old children in the United States (Maresh 1955). However, the smaller size of this child is the norm for children of her population.

Her deltoid crests are hypertrophied, indicating that she was working much too hard, probably as a slave. More unique, however, was this child's broken arm: a healed green stick fracture of the right forearm that involved both radius and ulna (Fig. 375). There is a marked swelling in both bones at the site of the fracture, making them 30 percent wider than the corresponding bones of the left arm. This fracture probably resulted from a fall or other such accident.

Erc10 and Erc11: A Slave with Her Master's Child

A young girl (Erc10) was found in the first chamber with a baby (Erc11) in her arms. The girl had fallen forward from a squatting position. As they lay there, only the top of the baby's head was visible; the rest of it was shielded by the girl's body. The baby, about ten months old, had some little pieces of bronze jewelry: a cherub and two little bells (fig. 376). This would indicate a child of relatively wealthy parents.

The girl tells a different story. She was pretty and about 14 years old. Although her epiphyses were still open, showing that she had not finished growing, she had already achieved a height of 155.9 cm, slightly taller than the mean female stature for this population. She had some flattening of the femora (PMI = 77.8), but none of the tibia (CI = 76.3) or pelvis (PBI = 100). This can be interpreted to mean that she did a lot of running up and down stairs or hills, developing the muscles of her thighs and requiring her femora to flat-

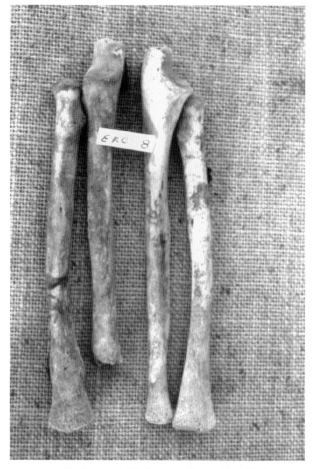

FIGURE 375 Erc8: green stick fracture. Photo: Sara Bisel.

ten slightly to accommodate them, but may not have been faced with serious lifelong malnutrition.

Her teeth reveal more of her story. There are deep grooves of hypoplasia in the enamel, actually so deep that there is no enamel at all in the lines on the incisors and the first molars (fig. 377). These hypoplastic lines are at a place in the crowns of these teeth that would have been developing at the age of eleven months. They indicate that at this young age she was not receiving, or else was not assimilating, calcium in her diet. She had to have been either extremely ill or starved for at least one month at around that time. In itself, this does not necessarily indicate her social status since,

FIGURE 376 Erc11: jewelry. Photo: Sara Bisel.

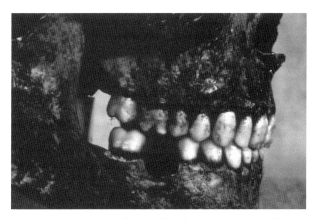

FIGURE 377 Erc10: lateral view of teeth, showing lines of hyperplasia on the upper first molar and the site of extraction of the opposing molar. Photo: Sara Bisel.

although they are not usually starved, rich children also get sick. But the combination of hypoplastic lines with femoral flattening, and even the fact that her charge wore jewelry when she did not, would seem to indicate that she was a slave.

The deep grooves of the first molars became pathological by later childhood. X-ray examination (Modesti 1984) showed persisting large cysts under the roots of these teeth. The mandibular first molars were removed about one or two weeks before the eruption of Vesuvius. This is indicated by the development of new bone, which was beginning to fill the alveoli. Eventually, they would have healed if she had not died in the eruption. However, she must have endured some bad toothache.

Erc52 and Erc110: Two Pregnant Women

Both of these young women were pregnant for the first time, with recoverable fetuses of about the same size and age (seven months), although Erc52 and her fetus are more complete than Erc110 and her fetus (Fig. 378). But the two had very different lives.

Erc52 was about 24 years old, small-boned and slightly shorter at 151.0 cm than the mean for this population. Shortness sometimes suggests poor nutrition, but her other data indicate otherwise. Her long bones and pelvis are round (PMI = 87.3, CI = 81.9, PBI = 94.96) and well proportioned (RI = 12.13). The size of the muscle crests of her arms (deltoid crests) and hands (interosseous crests) are smaller than those of most of the other women of the population. These data suggest that she was much less physically active than they were. She gives the impression of a wealthy or upper class woman. There are no birth scars from previous births, so this must have been her first child. The age of 24 years for a first pregnancy is very late, considering that marriage at age 12 to 14 years was the norm for the Romans and the first pregnancy usually followed soon after.

There must be an interesting explanation for this young woman having her first child at such an advanced age. Unfortunately, we'll never know it.

Her teeth are beautiful, as we have come to expect at this site. Three third molars are missing congenitally. The absence of hypoplastic lines points to a childhood free of serious diseases, infections, or famine. There is one small interproximal caries cavity in the right second premolar of the mandible. The bone minerals are all about the population mean. In all respects, this young woman seems to be very healthy and well nourished, and of a family sufficiently well off that she did not have to work hard.

Erc110, the other pregnant woman, was a youngster of about 16 years. Her third molars are still in crypt and the shoulder and wrist epiphyses are open, while elbow epiphyses are fused. The proximal femoral epiphyses are fused, but the distal ones are open. She was 152.3 cm tall at death and could have grown a bit more, given a few years, but probably not much more.

Her teeth are without lesions of any sort but do have some slight lines of hypoplasia, so she must have had some relatively minor periods of childhood illness. She also had not done really heavy work, as her deltoid crests are small. Her pelvis is fragmented and incomplete, but enough is present to estimate it as having been slightly flattened (PBI = 80.9), although the femora are not (PMI = 86.0). She was probably of a somewhat lower class than Erc52, judging from her teeth and pelvis.

Her most significant pathology is an anomalous third lumbar vertebrae. Half of the arch is separated from the body, probably congenitally. With heavy labor, and perhaps even under the stress of delivering her baby, it is possible that the other side of the arch would have fractured (spondylolysis). Later, this could have caused low back pain upon exertion, or worse. However, it is unlikely that this would have happened. If it had, in any case, this would have been the least of her problems. Her infantile pelvis would have caused her much more serious difficulty. Since the measurements of both the pelvic inlet and outlet are much lower than those of a mature woman, it would have been impossible for her to deliver a full-term baby (Decker 1988). The poor child would have labored until she died, perhaps after several days. A Caesarian section would have been performed only when she was almost dead. Before the days of effective antisepsis, women were not expected to survive this procedure. Given this outlook, it was much better for her to have died quickly in the eruption than slowly in labor. Unfortunately, since they were usually married at such a young age, many women in this society became pregnant before they reached physical maturity. Marriage

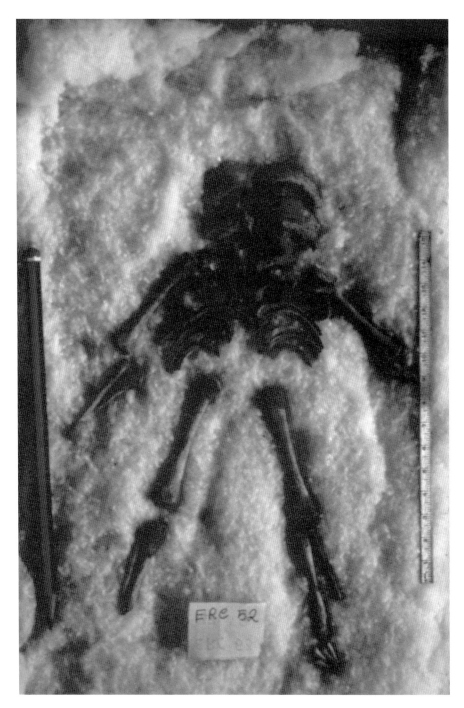

FIGURE 378 Erc52: fetus. Photo: Sara Bisel.

before puberty usually meant that they conceived as soon as was physiologically possible. Many of these girls died trying to give birth with immature pelves.

Erc13 and Erc98: Two Presumed Prostitutes

The hypothesis that Erc13 and Erc98 may have been prostitutes is based on their sharing a pelvic abnormality also seen in the bones of a modern American prostitute. The pubic symphyses of all of these women show a deterioration beyond what would be expected from simple aging, compared to the rest of their bones. If this had resulted from the births of many children, it would include dorsal pitting and holes, but it does not. There is also a series of small bony outgrowths along the rami.

Erc13 was found on the beachfront. She was a woman of about 48 years, but was difficult to age because of the jumbled and fragmentary condition of her skeleton. Her bones were light and slender with minimal degenerative arthritis. There was moderate flattening of both femora (PMI = 86.4) and tibiae (CI = 69.5). The incomplete pelvis was estimated as being fairly round although extremely broken down with many bony outgrowths on the ventral edge of the ascending ramus. She was slightly above average in stature at 155.3 cm. She had lost only two teeth antemortem and had no other dental lesions.

We also presume that Erc98, a woman of about 49 years, was a prostitute. She was wearing a cloth head

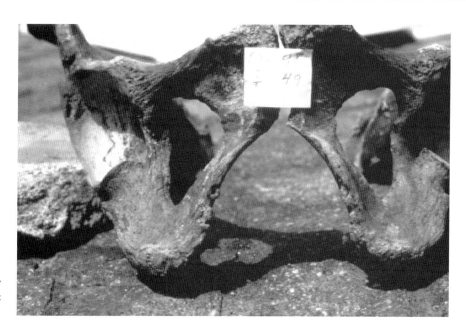

FIGURE 379 Erc98: unusual bony outgrowths on pelvic rami. Photo: Sara Bisel.

covering, of which fragments still remain – as do a few strands of her blond hair. She was above average in stature at 162.2 cm. The enlargement of all of her muscle insertions and crests indicates that she was a hard-working person. The long bones (PMI = 86.5, CI = 70.6) and pelvis (PBI = 103.2) are rounded. She has borne four or five children, which is more than average for this population. Many bony outgrowths on the ischial rami suggest that she also may have been a prostitute (Fig. 379).

Erc28: A Young Fisherman

Erc28, a 16-year-old man, was found at the entrance of one of the chambers. At the time of this study, his pelvis, legs, and feet remained inside, still unexcavated. His stature is estimated at 173 cm, well above the population mean for males. Since this calculation is based on a radius with an open distal epiphysis, it is likely that he would have been taller had he lived longer.

The most interesting data about this man show that for someone so young, he had extremely well-developed musculature of at least the upper body, the lower part being unavailable to study. The crests of the insertions of the deltoid muscle, the pectoralis major muscle, the brachialis muscle, and the costoclavicular ligament are not only extremely large but also show signs of pulling and stress, presumably from overexertion. There are Schmorl's herniations on the bodies of all lumbar vertebrae and on some of the thoracic vertebrae (Fig. 380).

Observations of modern fishermen show that they have a similar development of upper body parts – particularly the older fishermen, who once rowed their own boats. Rowing methods demonstrated by living fishermen indicate strong involvement of legs and lower back, as well.

Examination of the teeth shows them to be without lesion or hypoplastic lines. Naturally, the third molars are still unerupted. Both right maxillary incisors are very worn, but the left ones are not (Fig. 381). This particular wear pattern gives us the best clue to speculate about his occupation, since it must be from some industrial use of the teeth. Again, observation of modern fishermen shows that they use their incisors to hold the bobbin of cord used to repair nets.

Bone mineral of this young man is about the mean

FIGURE 380 Erc28: lumbar vertebrae with Schmorl's herniations. Photo: Sara Bisel.

FIGURE 381 Erc28: teeth with industrial wear. Photo: Sara Bisel.

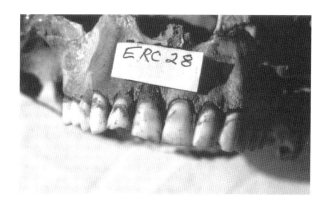

of the population. All the data and the general appearance of the bones suggest that this young man was healthy and well nourished, but worked extremely hard. The use of his muscles, and particularly of his teeth, suggests that his occupation probably was fishing.

Erc26: A Soldier

Another interesting Herculanean is Erc26. Found on the beachfront with his bronze military belt and sword, he is assuredly a soldier. We know from his bones that he was a big, tough, well-exercised, heavy-boned man of about 37 years. He was about 174.5 cm tall, which is well above average for this population. His long bones are above average in roundness (PMI = 88.2). The deltoid crest, like the other muscle markings, is very well developed, indicating a life of active labor and adequate nutrition. His diet, like that of other Roman soldiers, would have consisted mainly of wheat, either as bread or as porridge. Soldiers also ate soup, lard, vegetables, and meat when these were available. Vinegar was their usual beverage, diluted with water, but wine was enjoyed when available. They had no breakfast (Grant 1974).

Apparently, this man had spent much of his career on horseback, judging from the enlarged adductor tubercles at both knees (Fig. 382). The violence of a soldier's lifestyle has left its mark on him. His rugged, masculine face has six missing teeth: three molars probably lost to decay and three incisors more likely lost through trauma, whether from a tavern brawl, military combat, or some other cause. Another sign of violence can be seen in the anterior shaft of the left femur. A 78 mm × 18 mm ectostosis running vertically on the shaft is the remainder of a stab wound into the muscle. Bleeding occurred, followed by ossification of the clot. As the stab was parallel to the rectus femoris muscle fibers, good healing took place, allowing continued full function of the leg.

THE INJURED AND AFFLICTED

Erc27: A Very Poor Man (or a Slave)

Another Herculanean, Erc27, is a direct contrast to the wealthy matron, Erc65. At about the same age (46 years), this man was from the lowest socioeconomic bracket. He was short at 163.5 cm, with spindly and flattened bones (PMI = 78.3) and a rather flattened pelvis (PBI = 82.6). He has large deltoid crests with some pulling at the muscle attachments, showing a life of hard labor. All of these data point to poor nutrition and, by extension, a life of poverty.

His most painful health problem was dental. He had lost seven teeth before death and had four caries

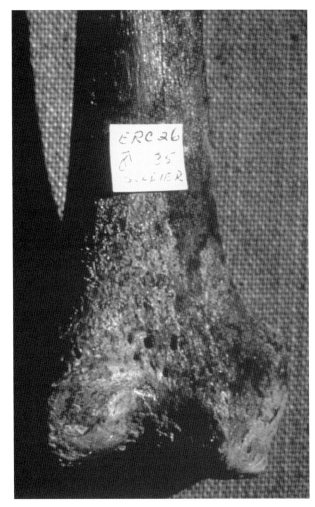

FIGURE 382 Erc26: femur with enlarged adductor tubercle. Photo: Sara Bisel.

and four abscesses in the remaining ones. One of these abscesses was so advanced that it drained into the maxillary sinus. This side of his mouth evidently caused him so much discomfort that he chewed on the other one, even though it had no teeth. Evidence of this is given by the excessive calculus formation on the molars of the unused side of his mouth, caused by disuse and the consequent loss of the cleansing action of abrasive food.

Erc27's most striking pathology, however, is the fusion of the right anterolateral sides of the bodies of seven thoracic vertebrae: T_5 through T_{11}, with T_4 and T_{12} starting to fuse (Fig. 383). The area of fusion is a continuous vertical band of ossification that has the appearance of melted candle wax poured on the spinal column. The rest of the spine exhibits only very minor osteoarthritis, a degenerative arthritis probably due to aging, in the form of some small beaklike osteophytes. Elsewhere, bony outgrowths are very slight, except for calcaneus spurs at the Achilles' tendons.

At first glance, the most obvious explanation for the lumbar fusion might be ankylosing spondylitis, a

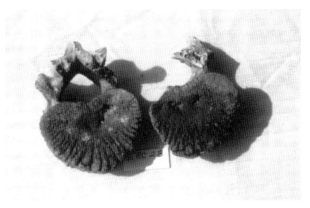

FIGURE 383 Erc27: fused thoracic vertebrae. Photo: Sara Bisel.

progressive inflammatory arthritis primarily affecting the spine. However, for this diagnosis to be correct, the fusion should have started lower, at the sacroiliac joint, then progressed to the sacrum and upward through the lumbar vertebrae to the thoracic vertebrae. And only some of Erc27's thoracic vertebrae, and none of the lumbar ones, are fused.

Fusion originates from the superior edge of the anterior bodies, beginning as flamelike outgrowths that progress to form bony bridges, preserving the disc space. This "candle wax" type of fusion, along with the manner of its formation, could indicate either diffuse idiopathic skeletal hyperostosis (DISH) or Forestier's disease, an ankylosing hyperostosis of the spine. In DISH, other joints are also markedly arthritic, with many sizable bony outgrowths at tendon or ligament insertions. Since Erc27's arthritic pathologies are basically confined to the thoracic vertebrae, Forestier's disease is the best diagnosis.

The fused vertebrae did cause a very slight scoliosis to the right as well as the loss of the normal lumbar curve. While this condition would not have been painful, it could have decreased spinal mobility somewhat. Ultimately, however, it would not have caused any meaningful functional impairment and certainly allowed this man to work very hard all his life.

That he did work very hard, harder than his body could have without great exertion, seems obvious. Since anyone who worked beyond his strength and ability like this probably was not doing it by choice, one can surmise that Erc27 must have been a slave or, at most, of the lowest socioeconomic level of freedmen.

Erc62: A Man with a Parry Fracture and Arthritis

Erc62 is a man who also had experienced some violence. He was, at about age 51, among the older segment of this society. Slightly shorter than the mean at 167.2 cm, with average flatness of long bones (PMI

= 81.1), average roundness of the pelvis (PBI = 87.0), and only two teeth lost antemortem, he was not at either extreme of economic class. He did work hard, resulting in extreme hypertrophy of the deltoid crests and other muscle markings, but we cannot even speculate about the occupation that contributed to his achieving this muscularity.

Earlier in life he had sustained a fracture of the right forearm, both radius and ulna, which subsequently healed. The configuration of these fractures suggests that they occurred when parrying a heavy blow, shielding his head from injury with his right arm. As he was right-handed (right humerus length = 317 mm; left = 308 mm), he could not have been armed. If he had been, he would have used the right arm to strike with a weapon and the left to parry blows. So, it seems likely that he was either trying to prevent some heavy thing from falling on his head or fighting with his bare fists to defend himself against an armed man.

At the moment of impact, the radius and ulna had to have been in a half rotated position, this being the point at which the fractures of both bones together present a straight line. The fragments of each shaft overrode slightly, then healed, shortening the bones by only about 9 to 10 mm. There was some impairment of motion in the rotation of the forearm because of tiny, but critically placed, bony outgrowths that developed during healing. Consequently, the radius did not rotate more than 80° around the ulna. Due also to some minor bony outgrowths on the distal edge of the semilunar notch of the ulna, the forearm did not flex past 90°. This man probably had some professional care for his fracture. If he hadn't, the fractured ends of the bones would have overridden much more.

A more painful problem for Erc62 to endure was the severe arthritis of his knees. The anterior of the condyles of the femora and the articulating surfaces of the patellae were worn smooth, or eburnated, as a result of these areas rubbing against each other without an adequate padding of cartilage and fluid between (Fig. 384). This eburnation had even progressed to the point of forming cysts, a possible indicator of infection, in the condyles behind each patella. He must surely have had very painful knees, interfering with many activities. This condition was not part of the syndrome of DISH, since the vertebral column is not fused at all. Also, arthritis of joints other than the knees is present only in small beaklike osteophytes. The condition of the knees, then, is more likely to be degenerative osteoarthritis. It is possible that obesity contributed to joint damage at the knees and allowed the resulting severe arthritis to develop (Rothschild 1988).

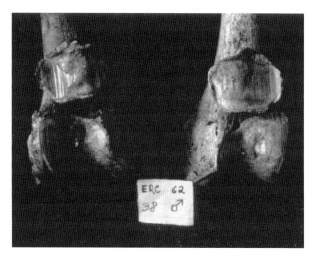

FIGURE 384 Erc62: anterior view of knees, showing abnormal wear on condyles and patellae. Photo: Sara Bisel.

Erc49: A Laborer with Multiple Fractures

Erc49 was a man about 41 years old whose bones were found on the beach. He was about average height at 170.7 cm, with fairly round tibial and femoral shafts and pelvis. He had seven dental lesions: four molars or premolars lost antemortem, two caries cavities, and one abscess. He was very muscular; his deltoid crests are huge, as are the adductor tubercles. These signs indicate that he used his arms for very strenuous manual labor. In addition, the muscularity of his hands suggests that they were greatly involved in this heavy work.

In life, he suffered at least one serious traumatic experience or several smaller ones. A blow to the right of the frontal bone of the skull, 31 mm above the orbit, left a shallow 29 × 17 mm depression. The right radius was fractured 75 mm from the distal end, probably from parrying this blow (Fig. 385). Given that his right humerus is longer (328 mm) than the left one (323 mm), it may be inferred that he was right-handed. Therefore, the radius can be presumed not to have been broken in armed conflict, since his weapon would have been held in his right hand. The fracture was healing, with much new woven bone laid down and the broken ends of the fragments having overridden by 22 mm. The fractured right radius was then 10 mm shorter, and the uninjured right ulna 11 mm longer, than their counterparts on the left side. There are small new facets on the distal articulation of the right ulna and the right radius. Two tiny lumps of new bone on the head of the ulna define the limits of rotation of the radius. It was only a few degrees.

In addition, his right foot was crushed. Particularly damaged were the first four metatarsals, resulting in the right metatarsals being shortened and twisted compared to the normal ones of the left (Fig. 386). The right metatarsals were broken and displaced in

the area of their heads, at the epiphyses. Growth of the damaged bones, therefore, stopped at the time of the injury, which must have been well before age 15, when these bones would have finished growing and the epiphyses united. Age 10 to 12 would be a reasonable guess.

Although not fractured, both ankles (tibiae as well as fibulae) have some new woven bone laid down, which has not yet been replaced by hard bone. This is a probable reaction to stress. There is slight periostitis in the area of the distal tibial and fibular interosseous space, probably also from stress (Jaffe 1972; Rothschild 1988).

The vertebral bony outgrowths are different from any others studied here. The first six thoracic vertebrae are completely without arthritis, as are the cervical and lumbar vertebrae. But T_8 and T_9, as well as T_{10} and T_{11}, are fused along their anterior surfaces. Moreover, T_7 through T_{12} all have funguslike osteophytes and look as

FIGURE 385 Erc49: forearms with fractured right radius. Photo: Sara Bisel.

FIGURE 386 Erc49: left and right metatarsals. Photo: Sara Bisel.

though they were about to fuse, if they had not already done so. However, because these large osteophytes fit together so well, they would never have fused. Although the appearance and location of these characteristics are similar to the anomalies seen in Erc27's vertebrae, the character of Erc49's osteophytes is different. Whereas Erc27's thoracic vertebrae look as if candle wax had been poured down the anterior surface of the spinal column, with a smooth bony surface covering the whole side of each vertebrae, the sides of Erc49's vertebral bodies are not covered by the bony "wax" that characterizes DISH. Furthermore, Erc49's outgrowths originate from both the superior and inferior edges; in DISH, osteophytes originate only on the superior edges. This man's condition, therefore, is best described as degenerative osteoarthritis (Forestier 1956; Janes et al. 1975).

Erc49 also had severe arthritis of the knees for a long time. The anterior parts of the femoral condyles, as well as the patellae, were slightly eburnated as a result of these areas rubbing against each other without normal lubrication. However, his knees do not show the signs of possible infection that were evidenced by the cysts of Erc62's knees (Forestier 1956).

This man was probably a laborer of low socioeconomic class. At least one of his injuries (the crushed foot), if not all of them, happened in late childhood. Since all traumata are of the same side, it is more likely that one terrible experience accounts for all of them. He might have been a horse handler or carter, or a construction worker, since an occupation that used heavy equipment and/or was potentially dangerous would have been required to cause his wounds. After his accident, he continued to live and work for thirty more years, difficult as it may have been.

Erc17: A Man with a Dislocated Temporomandibular Joint

Erc17 was another man who had a traumatic experience earlier in life. He was about 42 years old with a stature of 170.1 cm. He has slightly flattened bones (PMI = 81.2, CI = 73.7, PBI = 80.5) and signs of heavy muscle usage of both arms and legs: muscle attachment crests of both arms (deltoid crests and interosseous crests) and legs (gluteal crests, gastrocnemius origins, abductor tubercles, and popliteal crests) are hypertrophied.

The left knee, the only one present, has a cyst in the anterior part of the lateral condyle of the tibia with a depth of 12 mm and a diameter of 23 mm, opening toward the anterior. There are no changes in the corresponding part of the femur or of the patella. This could be evidence of a localized infection or simply due to degenerative joint disease. There is a slight to moderate degree of arthritic change in many joints. Small outgrowths occur at the clavicular-sternal, shoulder, elbow, knee, and sacroiliac joints. The extensiveness of this man's condition is unusual, but the outgrowths are very small and not really debilitating. As for the vertebrae, a few small, beaklike outgrowths occur on their superior and inferior anterior edges. Since there is no linking of vertebral bodies, this condition cannot be described as DISH. It is more likely to be a degenerative osteoarthritis (Rothschild 1988).

Probably the worst problem Erc17 had to endure was a permanently dislocated right temporomandibular joint. The lower jaw was dislocated, forming a new articular facet just anterior to the normal temporomandibular fossa and just medial to the zygomatic arch. The right mandibular condyle then had flattened to facilitate this new articulation. This situation would

have been quite painful, particularly immediately after it happened. The occlusion of the jaws also was changed, as evidenced by the wear pattern of the right molars. Whereas his original occlusion was edge-to-edge bite, the later occlusion shows a shift to the left by a distance of about three teeth. In addition, there were three dental lesions in the maxillary molars, one caries cavity and two teeth lost before death, as well as a heavy accumulation of calculus on the right side of the mouth. This would have formed when the severe pain of chewing on that side forced this man to chew on the left.

Erc17 also had sustained fractures of the sixth and seventh ribs with minimal displacement. These injuries, as well as that of the temporomandibular joint, had happened many years before he died.

Erc105: A Woman with Bilateral Hip Dysplasia

Erc105 was a woman about 32 years of age. She was quite short at 150.4 cm but had perfect teeth, with no lesions or hypoplastic lines. Her skull presents parietals slightly thickened over the bosses (11 mm), suggesting a very slight, healed anemia.

Her most disabling pathology was congenital bilateral hip dysplasia with grade 3 dislocation of the hip, a rather rare condition. About 1 percent of children are born with a predisposition to dislocation, but only 0.01 percent to 0.02 percent actually do dislocate, with a ratio of 4 females to 1 male for all kinds of hip dislocations (Tönnis, Legal, and Graf 1987). Modern northern Italians seem to have a higher incidence of this problem than some other groups because they still swaddle infants with their legs adducted and extended, as was done in the ancient world (Brashear and Raney 1986).

The anterior portion of her pelvis is missing postmortem, including the original acetabula. The femoral heads, however, have shaped new shallow articulations laterally and just superior to the original acetabula, actually forming new depressions on the rims. The heads of her femora are very much altered: flat, porous, irregular mushroom shapes. The left femur head is only 34 mm maximum diameter, while the right one is broken (Fig. 387). The neck-shaft angles are more nearly acute than normal (left = 100°, right = 103°). The femoral shafts are round (PMI = 93.75), but their necks are markedly eroded. Her gluteal crests are enlarged. The greater trochanters are enormous, as well as very osteoporotic, and there are traces of third trochanters. She has very marked squatting facets on both the tibiae and the tali. The lumbar vertebrae, which are without arthritic change, have an abnormal "C" curve rather than the normal "S" curve.

All of these unusual measurements and observations show that her posture and gait put abnormal stress on her muscles and tendons, as well as the underlying bone. She would have had extreme lordosis, abdominal protrusion, and an awkward gait, as she lurched with each step toward the weight-bearing leg. Consequently, great stress would have been put on the gluteals and the joint capsule. Since the pain of dislocation is stress-related and provoked by prolonged walking or strenuous exertion, increasing with aging (Tönnis et al. 1987), she would have experienced increasing pain and deformity in the hips and lower back as she became older.

Her humeri show much muscular development in the area of the deltoid and the pectoralis major muscles, with the muscles of the legs not well developed at all. Probably, she found work that enabled her to use her arms more than her legs. She also might have used crutches or canes.

Erc103: A Woman with Rickets

Erc103 was a short woman (150.5 cm), approximately 36 years old, whose skeleton exhibits some symptoms of rickets, a systemic disease of early childhood caused by inadequate availability of the vitamin D essential to develop bone. Normally, sufficient vitamin D is either ingested in the diet or manufactured in the skin upon exposure to sunlight. Otherwise, growth will be retarded and softer bones will lead to skeletal deformities. Bone remodeling and healing after the active phase of the disease produces characteristic cortical thickenings to reinforce vulnerable areas throughout the skeleton.

Erc103's bones and skull are very heavy, indicating a thick cortex. The femora have a robusticity index of 16.7. Her skull is so complete that calipers could not be used to measure its thickness except at the occiput, which is markedly thickened at 12 mm. The frontal and parietal bossing is markedly large, but not extreme. Her femora exhibit extreme asymmetrical lateral bowing. The asymmetrical tibiae and fibulae are bowed medially, the right side more than the left. Her pelvis is greatly flattened, with a pelvic brim index of 64.3.

She did, however, bear children. From the appearance of the dorsal rim of the pubic symphysis, she could have borne four to six of them. Considering the difficulty of delivery with such a pelvis, however, she must have borne fewer, perhaps two to four. She has very large deltoid crests, development of the ulnar interosseous crests, and notable crests of the hand phalanges. Apparently, she worked hard with her hands and arms. The gluteal crests also are very pronounced, due mostly to her doubtless peculiar posture and gait.

The teeth reveal more of her pathology. They are generally in poorer condition than those of most of the

FIGURE 387 Erc105: heads of femora with pelvic fragments. Photo: Sara Bisel.

population, with a total of seven dental lesions: five lost antemortem and two abscesses. The teeth present are markedly worn except for the several molars still in place; most of these were not opposed and thus received little wear. In addition, there were large abscesses in the alveoli of both first maxillary molars, which would have made it painful to chew in the distal parts of her dental arch. Alveolar absorption and periodontal disease are severe overall, with green calculus on the necks and roots of the remaining teeth. The most important dental pathology is the presence of many tiny lines of hypoplasia on the incisors and the tips of the canines, indicating serious problems in calcium metabolism. However, no lines of hypoplasia at all are present on the second and third molars. Evidently, the inadequate calcium metabolism associated with the condition of rickets existed between the ages of 18 months and 4 years, when this portion of these teeth was forming (Schour and Poncher 1940).

Afterward, healing took place in the form of continued bone growth of the thigh and leg bones, plus buttressing of the inner arcs of the long bones by the addition of more bone cortex. However, any amount of calcium ingested later could never cause the legs to straighten, the dental hypoplasia to disappear, or the pelvis to deepen. These conditions remained.

Paradoxical as rickets seems in the face of the abundant sun of southern Italy, these observations do lead to that conclusion. Other forms of rickets, such as renal rickets or vitamin D–resistant rickets, are genetic in origin and would not have occurred for the limited time that hers did. Congenital rickets is active until death; it would not have healed without the medical therapy unavailable to ancient people (Jaffe 1972;

Mankin 1974). This, therefore, could not have been the cause of Erc103's bone changes.

One possible explanation of this woman's condition would be that she was nursed for a long period by an inadequately nourished mother, and thus deprived of calcium or vitamin D. Others are that her childhood diet lacked foods containing vitamin D or that she was deprived of sunlight for some reason we cannot possibly know. Or, it could have been a combination of these factors.

CONCLUSION

The habits and pathologies of these people are interesting but do not necessarily represent those of the entire population. Much of the information recorded in their bones is a reflection of their own lifestyles: trauma resulting from accident, employment, or their presence in dangerous situations. Evidence of disease, on the other hand, pertains primarily to the individual who exhibits it but also may relate to the society as a whole. It is apparent that effective treatment was available for some conditions, like abscessed teeth and broken bones, for at least some people at Herculaneum. The presence of other class differences also was manifest: some people were better nourished and less worn by work and hard living than were others.

When considered together, it is clear that most of the town's inhabitants were quite healthy and moderately well nourished. Their dental health was excellent: they had far fewer lesions than do many modern populations and edge-bite occlusion with little crowding of the teeth. Since much of the population had some

hypoplastic lines in the dental enamel, it can be inferred that childhood diseases were common. Although the children at Herculaneum grew at a rate slower than that of modern Americans and ultimately did not achieve as great a stature, the ancient population was still taller than modern Neapolitans are. Anemia, which may have been caused by an infrequent consumption of red meat, was one of the most commonly observed health problems. It affected about a third of these people. Another apparent problem, the seemingly low birth rate, is less easily explained since it may be attributable either to deliberate attempts to control conception or to impaired fertility, whether as a result of lead ingestion or some other cause. Or it may not even be a real phenomenon at all but merely a statistical aberration produced by analyzing only 139 people from a city of several thousand. There are still many more fascinating people on the ancient beach of Herculaneum waiting to tell us their stories, including some recently unearthed from other chambers (Mastrolorenzo et al. 2000; Pagano 1999). Others also may be found in the unexcavated portions of Pompeii and Oplontis, or in any of the five known cities of the Vesuvian region that remain undiscovered. Future excavation is sure to yield other equally interesting people, all different from one another and from those presented here.

REFERENCES

Adams, P. 1969. "The Effects of Experimental Malnutrition on the Development of Long Bones." *Biblioteca Nutritio et Dieta* 13: 69–73.

Angel, J. Lawrence. 1966. "Porotic Hyperostosis, Anemias, Malarias and Marshes in the Prehistoric Eastern Mediterranean." *Science* 153: 760–3.

———. 1972. "Ecology and Population in the Eastern Mediterranean." *World Archaeology* 4: 88–105.

———. 1976. Personal communication.

———. 1980. Physical Anthropology: Determining Sex, Age, and Individual Features. In *Mummies, Disease and Ancient Cultures*, edited by Aidan and Eve Cockburn, pp. 243–57. Cambridge University Press, Cambridge.

Angel, J. Lawrence, and Sara C. Bisel. 1986. Health and Stress in an Early Bronze Age Population. In *Ancient Anatolia: Aspects of Change and Cultural Development*, edited by Jeanny V. Canby, Edith Porada, Brunilde S. Ridgway and Tamara Stech, pp. 12–30. University of Wisconsin, Madison.

Bisel, Sara C. 1980. *A Pilot Study in Aspects of Human Nutrition in the Ancient Eastern Mediterranean, with Particular Attention to Trace Minerals in Several Populations from Different Time Periods.* Ph.d. diss., University of Minnesota, Minneapolis.

Bisel, Sara C., and J. Lawrence Angel. 1985. Health and Nutrition in Mycenaean Greece: A Study in Human Skeletal Remains. In *Contributions to Aegean Archeology*,

edited by Nancy C. Wilkie and William D. E. Coulson, pp. 197–210. Center for Ancient Studies, University of Minnesota, Minneapolis.

Brashear, H. Robert, Jr., and R. Beverly Raney, Sr. 1986. In *Handbook of Orthopaedic Surgery*, 10th ed. Mosby, St. Louis.

Brown, Antoinette B. 1973. Bone Strontium as a Dietary Indicator in Human Skeletal Populations. Ph.d. diss., University of Michigan, Ann Arbor.

Buxton, Leonard H. D. 1938. "Platymeria and Platycnemia." *Journal of Anatomy* 73: 31–6.

Carcopino, Jérôme. 1979. *Daily Life in Ancient Rome: The People and the City at the Height of the Empire.* Edited by Henry T. Rowell; translated by E. O. Lorimer. Yale University Press, New Haven.

Clement, A. John. 1963. Variations in the Microstructure and Biochemistry of Human Teeth. In *Dental Anthropology*, edited by Don R. Brothwell, pp. 245–69. Pergamon Press, New York.

Cowell, Frank R. 1961. *Everyday Life in Ancient Rome.* Putnam, New York.

Curtis, Robert I. 1991. *Garum and Salsamenta: Production and Commerce in Materia Medica.* E. J. Brill, New York.

D'Amore, Concetta, Mario Carfagni, and Giuseppe Maratese. 1964. Definizione antropologica della popolazione adulta di un comune della provincia di Napoli. *Rendiconti dell'Accademia di Scienze Fisiche e Matematiche della Società Nazionale di Scienze, Lettere ed Arti in Napoli* 4,31. G. Genovese, Naples.

Decker, David G. 1988. Personal communication.

Dupont, Florence. 1992. *Daily Life in Ancient Rome.* Translated by Christopher Woodall. Blackwell Publishers, Cambridge, Mass.

Forestier, Jacqueline. 1956. *Ankylosing Spondylitis: Clinical Considerations, Roentgenology, Pathologic Anatomy, Treatment.* C. C. Thomas, Springfield, Ill.

Gilfillan, Seabury C. 1965. "Lead Poisoning and the Fall of Rome." *Journal of Occupational Medicine* 7: 53–60.

Grant, Michael. 1974. *The Army of the Caesars.* Scribner's, New York.

Greulich, William W., and Herbert Thoms. 1938. "The Dimensions of the Pelvic Inlet of 780 White Females." *Anatomical Record* 72: 45–51.

Hornblower, Simon, and Antony Spawforth, eds. 1996. *The Oxford Classical Dictionary.* 3rd ed. Oxford University Press, New York.

Howells, William W. 1941. "The Early Christian Irish: The Skeletons at Gallen Priory. *Proceedings of the Royal Irish Academy* 46C, 3: 103–219.

Jaffe, Henry L. 1972. Rickets and Osteomalacia. In *Metabolic, Degenerative and Inflammatory Diseases of Bones and Joints*, pp. 381–447. Lea and Febiger, Philadelphia.

Janes, Joseph M., John T. McCall, and Ralph M. Kniseley. 1975. Osteogenic Sarcoma: Influence of Trace Minerals in Experimental Induction. In *Trace Substances in Environmental Health: Proceedings of the University of Missouri's Annual Conference on Trace Substances in Environmental Health*, pp. 433–9. University of Missouri, Columbia.

Koob, Steven. 1982. Personal communication.

Lazer, Estelle. 1997. Pompeii A.D. 79: A Population in Flux? In *Sequence and Space in Pompeii*, edited by Sara E. Bon and Rick Jones, pp. 102–120. Oxbow Books, Oxford.

Mankin, Henry J. 1974. "Rickets, Osteomalacia, and Renal Osteodystrophy." *Journal of Bone and Joint Surgery* 56A: 101–28.

Maresh, Marion M. 1955. "Linear Growth of Long Bones of Extremities from Infancy through Adolescence. *American Journal of Diseases of Children* 89: 725–42.

Martin, Rudolph, and Karl Saller. 1959. *Lehrbuch der Anthropologie in systematischer Darstellung mit besonderer Berücksichtigung der anthropologischen Methoden.* 3rd ed. G. Fischer, Stuttgart.

McKern, Thomas W., and T. Dale Stewart. 1957. *Skeletal Age Changes in Young American Males, Analyzed from the Standpoint of Age Identification.* Technical report EP-45. Quartermaster Research and Development Command, Environmental Protection Division, Natick, Mass.

Mastrolorenzo, Giuseppe, Pier P. Petrone, Mario Pagano, Alberto Incoronato, Peter J. Baxter, Antonio Canzanella, and Luciano Fattore. 2001. "Herculaneum Victims of Vesuvius in A.D. 79." *Nature* 410: 769–70.

Mellanby, May. 1934. *Diet and the Teeth: An Experimental Study.* Special report series 191. Medical Research Council, London.

Modesti, D. 1984. Personal communication.

Nicholson, C. 1945. "The Two Main Diameters of the Brim of the Female Pelvis." *Journal of Anatomy* 79: 131–5.

Pagano, Mario. 1999. Gli Antichi ad Ercolano. *Antropologia.* Società Economica, Naples.

Reinhold, John G. 1972. "Phytate Concentrations of Leavened and Unleavened Iranian Breads." *Ecology of Food and Nutrition* 1: 187–92.

Reynolds, Earle L. 1945. "The Bony Pelvic Girdle in Early Infancy." *American Journal of Physical Anthropology* 3: 321–54.

Riddle, John M. 1985. *Dioscorides on Pharmacy and Medicine.* University of Texas Press, Austin.

——— 1992. *Contraception and Abortion from the Ancient World to the Renaissance.* Harvard University Press, Cambridge, Mass.

Rosenthal, Harald L. 1963. "Uptake, Turnover and Transfer of Bone-Seeking Elements in Fishes." *New York Academy of Science Annals* 109: 278–93.

Rothschild, Bruce M. 1988. "Diffuse Idiopathic Hyperostosis." *Comprehensive Therapy* 14, 2: 65–9.

Schour, Isaac, and Henry G. Poncher. 1940. *Chronology of Tooth Development.* Mead Johnson, Evansville, Ind.

Shelton, Jo-Ann. 1988. *As the Romans Did: A Sourcebook in Roman Social History.* Oxford University Press, New York.

Sillen, Andrew, and Maureen Kavanaugh. 1982. "Strontium and Paleodietary Research: A Review." *Yearbook of Physical Anthropology* 25: 67–90.

Stini, William A. 1975. Adaptive Strategies of Human Populations under Nutritional Stress. In *Biosocial Interrelations in Population Adaptation,* edited by Elizabeth S. Watts, F. E. Johnston, and G. W. Lasker, pp. 19–41. Aldine, Chicago.

Tannahill, Reay. 1973. *Food in History.* Stein and Day, New York.

——— 1980. *Sex in History.* Stein and Day, New York.

Todd, Thomas Wingate, and D. W. Lyon, Jr. 1924. "Endocranial Suture Closure, Its Progress and Age Relationship: Part 1, Adult Males of White Stock." *American Journal of Physical Anthropology* 7: 325–84.

Tönnis, Dietrich, with Helmut Legal and Reinhard Graf. 1987. *Congenital Dysplasia and Dislocation of the Hip in Children and Adults.* Translated by Terry C. Telger. Springer-Verlag, New York.

Weinberg, Eugene D. 1974. "Iron and Susceptibility to Infectious Disease." *Science* 184: 952–6.

19

IN CONCLUSION

The sudden and tragic destruction of Pompeii, Herculaneum, and the surrounding countryside in A.D. 79 preserved the remarkable evidence that has made it possible to write a natural history of the Vesuvian sites, such as can be written for no other ancient site. The quantity and quality of the evidence inevitably varies. Much was preserved by chance when pyroclastic flows produced sufficient heat to carbonize floral and faunal remains. In some areas, other conditions produced partially carbonized or mineralized remains. But even this spottily preserved evidence was for the most part not salvaged. It was carried out with the volcanic debris by the early excavators, who were more interested in fine homes and impressive public buildings adorned with wall paintings and furnished with museum-quality objects.

Following the prototype established by Pliny the Elder in his *Natural History,* we have discussed the various aspects of natural history in individual chapters of this book. This approach has resulted in an interdisciplinary study, written by specialists and yet integrated.

Vesuvius, which has preserved the humble evidence discussed in this book, is the dominant physical feature of the area and is quite appropriately examined at the outset by a vulcanologist. The detailed and accurate description of the A.D. 79 eruption in two letters of Pliny the Younger, nephew of the famed author of the *Historia Naturalis,* has given the name Plinian eruption to all subsequent eruptions of this type.

The soil itself is a product of Vesuvius, enriched through the ages by the volcano's many eruptions. The present soil is not unlike that in antiquity, so fertile that even now, as in antiquity, it can produce at least three crops a year. Minute pieces of porous pumice in the soil retain large amounts of moisture and make it available to plants in the drier seasons.

As in Pliny's *Natural History,* the section in this book dealing with plants is by far the longest. Every type of evidence was studied: carbonized and mineralized plant remains, the shape of root cavities, soil contours, plants pictured in wall paintings, mosaics, and sculpture, plants in the graffiti, and those specifically mentioned by the ancient writers, an approach also used in the catalogues of faunal remains. We found evidence of 184 plants known in A.D. 79. Ninety-five others known only from pollen bring the total to 279. Samples of wood from furniture at Herculaneum were analyzed to identify the woods used. The dendrochronologist made the surprising discovery that some large timbers in Herculaneum had been imported from Germany.

Pollen is a valuable source of information about the plants and climate of the area, but it must be used with caution. Adjacent soil samples often contain very different pollens and cannot be used to identify the plant near where it was found. And much of the pollen was windblown, some coming from neighboring mountain slopes. Because volcanic soil does not preserve pollen well, a lake sediment core was taken at Lake Averno. The pollen in the core was more plentiful and better preserved, but it was essentially the same as that found in terrestrial soil.

The plants identified from the A.D. 79 evidence give us a good picture of the Vesuvian landscape. Pompeii must have been very beautiful with its many gardens. The garden was the heart and center of the house. Here the family ate, worshiped, worked, and played. Gardens in the older houses were planted with trees, fruit and nut, and under the trees vegetables and herbs grew. The more recent, formal, ornamental gardens had plantings that were evergreen and beautiful the year-round: clipped box, myrtle, laurel, viburnum, and

ivy. There were accents of color when the oleander, rose, oriental poppy, and stock bloomed. But flowers were not an important part of the Roman garden. Throughout the city, especially in the southeastern part, there were many vineyards, orchards, vegetable gardens, and a large commercial flower garden. In public places, such as the triangular forum and the palaestra, trees provided shade. Although much less of Herculaneum has been excavated, it, too, had its gardens in homes and public places.

The adjacent countryside, as today, was planted with the many fruits and vegetables that formed such an important part of the diet. Wildflowers (for which we have evidence in the carbonized hay at Oplontis) bloomed in pastures, meadows, and vineyards. Wind-blown pollen tells us of the plants that flourished in the nearby maquis, and higher in the mountains grew the trees that we found used for many purposes in the city.

The faunal evidence is likewise rich. Few fish bones have survived. But fish were very important, not only for food but also for ornament and enjoyment. Fish pools in their gardens, handsome fish mosaics carpeting their floors, and paintings of fish on their walls bear out what the ancient writers tell us about the Roman affection for fish. They were favored pets; we hear of wealthy Romans in the resort area at Baiae, across the bay from Pompeii, even training fish to answer their master's call or to feed from his hand. One Roman matron adorned her pet *murena* with earrings, and Hortensius wept at the death of his pet fish.

Marine invertebrate remains are much better preserved. More than 800 have been recovered from the excavations, representing 63 different marine invertebrates. Many shells are debris from meals eaten in the gardens. The same marine invertebrates are popular food in the area today. Shells adorn the mosaic fountains at Pompeii and Herculaneum and are pictured in the mosaics and paintings.

Birds were likewise enjoyed by the residents. In the garden paintings, including those within the house, and in mosaics, colorful and lively birds perch in trees and bushes, fly freely overhead, or stalk their prey on the ground. Individual birds with fruit, flowers, or small animals or insects adorn many walls. The species are a mixture of common residents and migrants with a scattering of ornamental exotics such as Indian peacocks. Evidence exists that some birds were kept in cages or large aviaries, and waterfowl were found in garden pools. Ducks and geese are also among the species portrayed in garden sculpture and ibises are found as cult figures. Few bird bones were preserved and salvaged from the excavations. Most were the remains of meals, but some may have been sacrificed

for religious purposes and others may have been trapped in the ash fall.

The message from the insects is clear. While often stylized, the depictions, remains, and accounts all indicate a fairly sophisticated understanding of the intricacies of insect existence at the time of the eruption. Stunning are the artistically lovely renderings of insects where they should be – alighted on leaves or vines. Equally noteworthy are the quaint but instructive peeks at the food chain – a fly in the mouth of a bird or lizard. As small as most insect remains are, they are nonetheless powerfully associational and rich with information. They must be respectfully studied, never dismissed.

Among the reptiles and amphibians, lizards, geckos, tortoises, frogs, and toads would have been the most easily observed in the Campanian countryside and some of them, particularly lizards and geckos, even in the cities. These are the animals that are portrayed in the wall paintings, sculpture, and jewelry found in the excavations. The numerous tortoise shells found in gardens suggest that some were kept as pets in the garden, as they are today. Snakes, a symbol of good, have been found in garden paintings, but they figure most prominently on household shrines, for they had an important place in religion.

Three main groups of mammals are discussed. Most important for the local economy and ecology are the indigenous and domesticated species, including ox, sheep, goat, horse, dog, and cat, as well as hunted and trapped species. The house mouse and black rat are also present, together with small mammals that give useful indications of the habitats in and around the sites. The second group is much smaller – those exotic and introduced species that were definitely or probably present in the Vesuvian sites, either as pets, in animal parks, or as beasts for the amphitheater. Some, such as monkey, are attested by skeletal remains, but most (e.g. lion and leopard) are known only from artistic representations. This is also true for the third group, those exotic animals unlikely ever to have been present in the Vesuvian sites. This group includes hippopotamus, giraffe, and rhinoceros.

Judging from their skeletal remains, the people of Herculaneum profited from the abundant resources of the Vesuvian region. Their proximity to the sea and the fertile volcanic soil helped ensure that they were relatively well nourished. Plentiful sunshine and a mild climate also benefited agriculture and enabled the upper classes to enjoy outdoor recreation. The lower classes, unfortunately, did not have such opportunities. In fact, many of the health problems observed throughout the otherwise healthy population could be attributed to their rigorous lifestyle of overwork, exposure to

trauma, and lack of access to medical care and nourishing food.

The picture that we have given of the natural history of the Vesuvian sites, essentially in A.D. 79, is only the beginning. Exciting subsoil excavations in progress will provide further evidence of the flora and fauna in the Pompeii area from the foundation of the city. Our hope is that our interdisciplinary approach has produced a natural history upon which succeeding generations of scholars can continue to build.

ENGLISH, LATIN, AND ITALIAN INDEX

References to authors, ancient and modern, cited but not discussed significantly, are not listed in the index. Only houses and public buildings that are discussed significantly are indexed.

abellana (hazelnut), 103
Abies alba, 228
Abies (fir), 226, 248
Acacia
　nilotica, 85
　sp., 85
acacia, see *Acacia* sp.
acacia, see *Acacia* sp.
Acanthocardia
　echinata, 299–300
　tuberculata, 299
Acanthus mollis, 85–86
acanthus, see *Acanthus mollis*
Acanthyllis, 371
acanto, see *Acanthus mollis*
Accipiter
　gentilis, 359
　nisus, 359
Accipitridae, 360
acciuga, see *Engraulis encrasicolus*
Acer, 226
acetosa minore, see *Rumex acetosella*
Acheta campestris, 324
Achnanthes thermalis, 254
Acinomyx jubatus, 407
acoron, 116
acquaiola, see Salamandrae
Acridium, 324
　lineola, 324
Acridotheres tristis, 359
Acrocephalus
　paludicola, 362
　schoenobaenus, 362

　scirpaceus, 362
　sp., 359
addresses in Pompeii, 5
　as organized by G. Fiorelli, 9 (Fig. 4)
Adleria, 319
aegis, 341
Aegithalidae, 361
Aegithalos caudatus, 388
Agapornis sp., 394
Agaricus deliciosus, 128
agathos daimon, 352
aglio, see *Allium sativum*
Agnatha, 279
Agrostis stolonifera, 86
aguglia imperiale, see *Belone belone*
aguglia, see *Belone belone*
Aira caryophyllea, 86
airone
　cenerino, see *Ardea cinerea*
　guardabuoi, see *Bubulcus ibis*
　rosso, see *Ardea purpurea*
alce, see *Alces alces*
Alcedinidae, 361
Alcedo atthis, 362
Alces alces, 408
alder, see *Alnus*
Alectoris graeca, 362
Alepochen aegyptiaca, 363
alfalfa
　little, see *Medicago minima*
　spotted, see *Medicago arabica*
　truncated, see *Medicago truncatula*
　(twisted), see *Medicago intertexta*

alice, see *Engraulis encrasicolus*
allec, 280, 281, 459
Allium
　ampeloprasum, 88
　cepa, 86–87
　porrum, 87
　sativum, 87–88
allocco, see *Strix aluco*
alloro, see *Laurus nobilis*
allseed, see *Polycarpon tetraphyllum*
almond, see *Prunus dulcis*
Alnus, 199, 252
Aloe vera, 88
aloe, see *Aloe vera*
Alosa sp., 279
alosa, see *Alosa* sp.
alzavola, see *Anas crecca*
amaranth, *see* Amaranthaceae
Amaranthaceae, 248
Amarantus, House of (Pompeii
　I.ix.11–12), 4–5, 174
amarena, see *Prunus cerasus*
Ammonia beccarii, 257
Amphibia, 329–32
Amphora lybica, 254
amygdala (almond), 150
Amygdala decussata, 305
Anacridium aegyptium, 324
Anagallis sp., 88–89
anagallis, 89
Anas
　crecca, 364
　penelope, 364

Anas (continued)
 platyrhynchos, 364
 querquedula, 365
 sp., 364
 strepera, 364
anates, 365
Anatidae, 360
anchovy, see *Engraulis encrasicolus*
androsaemon, 115
anemia, 458, 463, 472, 474
angues (snake, serpent), 340
Anguilla anguilla, 279, 280
anguilla, see *Anguilla anguilla*
Anguillidae, 279
 selvatica, see *Anas platyrhynchos*
anitra, see *Anas* sp.
Anodonta cygnaea, 311
Anodonta, 307
anodonta, see *Anodonta cygnaea*
Anser
 albifrons, 366
 anser, 365
Anseriformes, 360
ant, *see* Hymenoptera
Anthemis arvensis, 89
Anthoceros sp., 250
Anthoxanthum odoratum, 89
Anura, 330–32
anuran, *see* Anura
aparine (bedstraw), 112
ape, see Hymenoptera
aphaca, 119
Aphanes arvensis, 89
aphid, 325; *see also* Homoptera
Apodemus sylvaticus, 408
Apodidae, 361
Apodiformes, 361
Apollo, 339, 343
apple, see *Malus* sp.
apple, service, see *Sorbus domestica*
Apus sp., 382
Aquila chrysaetus, 366
aquila reale, see *Aquila chrysaetus*
Arabian or white oryx, see *Oryx*
 gazella leucoryx
aragosta, see *Palinurus vulgaris*
Aranea diademata, 325
arbuto, see *Arbutus unedo*
arbutus (strawberry tree), 91
Arbutus unedo, 89–91
arca di Noè, see *Arca noeae*
Arca noeae, 299
Ardea
 cinerea, 367
 purpurea, 367

Ardeidae, 360
Ardeola ralloides, 369
arenaria (a rami sottili), see *Arenaria*
 leptoclados
Arenaria leptoclados, 91
arietinum, 100
Aristotle
 established framework for insect
 classification, 316
Aristotle's *Historia Animalium*
 source for Pliny the Elder, 2
ark shell (Noah's), see *Arca noeae*
arsella, see *Donax trunculus; Tapes*
 decussata
Artemisia, 201, 248, 249, 250, 252
arthritis, 466, 469, 471
Arundo
 donax, 91–92
 plinii, 91
arvicola
 see *Arvicola terrestris*
 campestres, see *Microtius arvalis*
 di Savi, see *Pitymis savi*
Arvicola terrestris, 408
ascyron, 115
ash, see *Fraxinus* sp.
asinel merluzzo, see *Merluccius merluccius*
asinello, see *Merluccius merluccius*
asino, see *Equus asinus*
Asio flammea, 367
asparago, see *Asparagus acutifolius*
asparagus, 93; see also *Asparagus*
 acutifolius
Asparagus acutifolius, 92–93
Aspitrigla cuculus, 289–90
ass
 wild African, see *Equus africanus*
 wild Asian, see *Equus hemionus*
Asteromphalus flabellatus, 256
astore, see *Accipiter gentilis*
Astraea rugosa, 293
astralia rugosa, see *Astraea rugosa*
astréa rugosa, see *Astraea rugosa*
Athena noctua, 367
attaccamani, see *Galium* sp.
attaccavesti, see *Galium* sp.
Augustus (emperor), 8, 241
aurata (gilthead), 289
Avena
 barbata, 93
 sativa, 93
avena
 selvatica, see *Avena barbata*
 see *Avena sativa*
averla, *see Lanius* sp.

Avernus, Lake, 240
 brackish and freshwater mollusks
 identified, 244, 245, 246, 252,
 257, 260–62, 261 (Table 20)
 cores taken, 243–44
 diatoms, identified, 244, 245–46,
 252–57, rare species (Table 18),
 255
 echo-sounding profiles, 243
 evidence of terrestrial and aquatic
 changes, 262, 264–71
 foraminifera and ostracods,
 identified, 244, 245, 257, 258–59
 (Table 19)
 history of lake and surrounding
 region, 240–43
 marine shells, identified 235, 244,
 247–52
 pollen, identified, 244–52
 sedimentary and mineralogical
 analysis of cores, 244–47, 262,
 264–66

babbuino, see *Papio* sp.
baboon, see *Papio* sp.
Bacchis, 339
Baiae, 241
balano, see *Balanus* sp.
Balanus sp., 309
bambagina (comune), see *Filago vulgaris;*
 Holcus lanatus
bantam, 381
barancle, see *Balanus* sp.
barba di becco, see *Tragopogon porrifolius*
barbary ape, see *Macaca sylvana*
barley
 mouse, see *Hordeum murinum*
 six-rowed, see *Hordeum vulgare*
Basommatophora, 260
bat
 pipistrelle, see *Pipistrellus pipistrellus*
 vespertilionid, see *Vespertilioninae* sp.
batrace, *see* Anura
batta, *see* Bufonidae
bay tree, see *Laurus nobilis*
bear, brown, see *Ursus arctos*
beard, hawk's, see *Crepis neglecta*
bedstraw, see *Galium* sp.
beccacino, see *Gallinago gallinago*
bee-eater, see *Merops apiaster*
bee, *see* Hymenoptera
beech, see *fagus; Fagus sylvatica*
beet, see *Beta vulgaris*
beetle, *see* Coleoptera
bellichina, see *Anagallis* sp.

Belone belone, 279
Belonidae, 279
bestiae africanae, 404
Beta vulgaris, 93–94
Betula, 100
biancospino, see *Crateagus* sp.
bibaron de mar, see *Mactra corallina*
bieta, see *Beta vulgaris*
bietola, see *Beta vulgaris*
bindweed
 see *Calystegia sepium*
 small field, see *Convolvulus arvensis*
birds
 aviaries, 358
 bathing, 357
 falconry, 358
 feeding, 357, 358
 hunting, 357
 occurrence in Campania (exotics,
 passage migrants, residents,
 summer breeders, winter
 visitors), 359
 peddlers, 358
 recipes and food, 358
 sacrifices, 358
 systematic list, 360–61
 trapping and nets, 357, 359
bird's foot
 common, see *Ornithopus compressus*
 pinnate, see *Ornithopus pinnatus*
birth rate, 453, 459, 474
biscia, *see* Colubridae
Bithynia leachii, 260
bittern
 Eurasian, see *Botaurus stellaris*
 least, see *Ixobrychos minutus*
bivalves
 freshwater, 311
 Indo-pacific, 307
 marine, 267
Bivalvia, 257
black medic, see *Medicago minima*
blackberry, elm-leaved, see *Rubus
 ulmifolius*
blackbird, see *Turdus merula*
blackcap, see *Sylvia atricapilla*
Blackstonia perfoliata, 94
blatta, 322
Blennius, 290
bluebottle, see *Centaurea cyanus*
bluegrass, annual, see *Poa annua*
boar, wild, see *Sus scrofa*
boca, see *Pagellus bogaraveo*
boga, see *Boops boops*
bogue, see *Boops boops*

Boidae, 335
Boletaceae, 128
Boletus, 128
boletus, 128
bolino, see *Murex brandaris*
bombyx (silk moth), 321
bone fractures, 464, 469, 470
bone mineral, 456–60
Boops boops, 288, 289
bopa, see *Boops boops*
Bos taurus, 408–10
Boscoreale, in the località Villa
 Regina, *villa rustica*, 24–26
Botaurus stellaris, 367
Box (=*Boops*) *salpa* or *Anthias anthias*, 285
Box boops, 289
boxwood, see *Buxus*
bracken fern, see *Pteridum aquilinus*
bradyseismic activity, 262, 264, 267,
 272
bramble, see *Rubus ulmifolius*
brandaride, see *Murex brandaris*
branzino, see *Dicentrarchus labrax*
Brassica
 oleracea, 94
 rapa, 94–95
Brassicaceae, 248
bream
 annular, see *Diplodus annularis*
 black, see *Spondyliosoma cantharus*
 sea (common or Couch's), see
 Pagrus pagrus
 sea, red or Spanish, see *Pagellus
 bogaraveo*
 striped, see *Lithnognatus mormyrus*
 two-banded, see *Diplodus vulgaris*
 white, see *Sargus sargus*
brillantina, see *Briza minor*
British School at Rome excavations,
 see University of Reading
Briza
 maxima, 95
 minor, 95
broadbean, see *Vicia faba*
bromus (oat), 93
Bromus
 diandrus, 95
 hordeaceus, 95
 madritensis, 95
broom, Scotch, see *Cytisus scoparius*
broomcorn, see *Panicum miliaceum*
broomrape, see *Orobanche* sp.
bruccid weevil, 317
 lathridiid scavenger beetle, see
 Microgramme ruficollis

bryozoa, 262
Bubulcus ibis, 369
buccino conio, see *Euthria cornea*
budellina, see *Stellaria media*
bue, see *Bos taurus*
Bufo
 bufo, 332
 viridis, 332
Bufonidae, 330
bugloss, viper, see *Echium* sp.
bulbi (bulbs), 121
bull, see *Bos taurus*
Bunias erucago, 95
bunting, corn, see *Emberiza calandra*
bustard, 392
buttercup, see *Ranunculus* sp.
butterfly, *see* Lepidoptera
Buxus, 226

cabbage
 see *Brassica oleracea*; Brassicaeae
Caesarian section, 465
cagebird, 371
calabrone, *see* Hymenoptera
calamaro
 see *Loligo vulgaris*
 verace, see *Loligo vulgaris*
calamint savory, see *Calamintha
 nepeta*
Calamintha nepeta, 95–96
calcinello, see *Donax trunculus*
calendola, see *Calendula arvensis*
Calendula arvensis, 96
Calidris
 alba, 370
 alpina, 370
 minuta, 370
 sp., 370
 temminckii, 370
Callista, 305
 chione, 299
Callitris quadrivalvis, 226
Calystegia sepium, 96
camomile
 corn, see *Anthemis arvensis*
 wild, see *Calendula arvensis*
camomilla bastarda, see *Anthemis arvensis*
campanelli, see *Calystegia sepium*
Campania, 3
campion
 evening, see *Silene latifolia*
 white, see *Silene latifolia*
Campylodiscus echeneis, 254
canaioli, see *Lupinus albus*
canary, see *Serinus canaria*

candida lilia (white lily), 122
Candona, 257
cane, see *Canis familiaris*
canestrello, see *Chlamys opercularis*
Canis
 aureus, 410
 familiaris, 410–14
 lupus, 414–15
canna, see *Arundo donax*
Cannabis, 252
cannaiola, see *Acrocephalus* sp.
cannolicchio, see *Solen marginatus*
cannuccia di palude, see *Phragmites australis*
cantaro, see *Spondyliosoma cantharus*
Cantharellus cibarius, 128
capatonda, see *Cerastoderma edule glaucum*
capellini
 see *Agrostis stolonifera*
 see *Aira caryophyllea*
capercaille, see *Tetrao urogallus*
capinera, see *Sylvia atricapilla*
cappa
 santa, see *Pecten jacobaeus*
 see *Venus verrucosa*
cappone gallinella, see *Trigla lucerna*
Capra hircus, 415–16
capra, see *Capra hircus*
Capreolus capreolus, 416–17
Caprimulgidae, 361
Caprimulgiformes, 361
Caprimulgus europaea, 369
capriolo, see *Capreolus capreolus*
Carangidae, 279
carbonized furniture, Herculaneum:
 scientific analyses
 amphora rack, 228
 bed, 228
 bench, 228
 biclinium, 228
 child's bed, 228
 cradle, 228
 cupboard, 228
 stool, 228
 table, 228
carbonized plant materials
 hay at *villa rustica*, Oplontis, 4, 83
 passim
 plants in gardens, 82–83 passim
 in shops and homes, 82
Carcinidea, 309
cardellino, see *Carduelis carduelis*
Carduelidae, 361
Carduelis
 carduelis, 370
 chloris, 371

cardio
 echinato, see *Acanthocardia echinata*
 tubercolato, see *Acanthocardia
 tuberculata*
Cardioidea, 262
Cardium
 echinatum, 300
 edule, 300
 rusticum, 300
 tuberculatum, 300
cardo saettone, see *Carduus pycnocephalus*
Carduus pycnocephalus, 96–97
carduus, 97
Caretta caretta, 333
Carex distachya, 97
carice mediterranea, see *Carex distachya*
carnation
 see *Dianthus caryophyllus*
 wild, see *Dianthus caryophyllus*
Carnivora, 447
caro, 115
carob, see *Ceratonia siliqua*
caronia di tritone, see *Charonia nodifera;
 Charonia sequenzae*
carota selvatica, see *Daucus carota*
carpenter's workshop, Herculaneum,
 235–36
carpet shell (cross-cut), see *Tapes
 decussata*
Carpinus
 betulus, 199, 247
 orientalis, 247
carrot
 see Apiaceae
 wild, see *Daucus carota*
carrubo, see *Ceratonia siliqua*
Caryophyllaceae, 201, 248
cascellore, see *Bunias erucago*
Casella, Domenico, 81
cask shell, see *Tonna galea*
Cassidaria echinophora, 296
casside ondulata, see *Phalium granulatum
 undulatum*
Cassis undulata, 298
castagno, see *Castanea sativa*
castanea (chestnut), 98
Castanea, 247, 249, 251, 252, 264
 sativa, 97–98
cat
 see *Felis catus*
 swamp, see *Felix chaus*
 wild, see *Felis sylvestris*
cat's ear (smooth), see *Hypochoeris glabra*
catchfly
 English, see *Silene gallica*

 French, see *Silene gallica*
 Italian, see *Silene italica*
Cato, 83
cattle stall, 402, 409
Caudata, 329–30
cavalletta, see Orthoptera
cavallo, see *Equus caballus*
caviglione, see *Aspitrigla cuculus*
cavolo, see *Brassica oleracea*
cece, see *Cicer arietinum*
cefali, see *Mugil cephalus*
cefalo vero, see *Mugil cephalus*
Celsus, 459
Centaurea
 cyanus, 98
 sp., 250
centauro giallo, see *Blackstonia perfoliata*
centocchio, see *Stellaria media*
cepa (onion), 87
Cephalopods, 308
ceppa, see *Alosa* sp.
Cerastium sp., 98
Cerastoderma
 edule glaucum, 299
 tuberculatum, 300
cerasus (sour cherry), 147
Ceratonia siliqua, 98–100
cereale papaver (poppy of Ceres), 138
Cerithium vulgatum, 293
cerizio comune, see *Cerithium vulgatum*
cernia
 bruna, see *Epinephelus guaza*
cerris, 157
cervo, see *Cervus elaphus*
Cervus
 dama, 417
 elaphus, 417–19
Cetacea, 447
Chaetoceros
 seiracanthus, 256
 spp., 256
chaffinch, see *Fringilla coelebs*
Chalcides
 chalcides, 334, 335
 ocellatus, 345
Chamelea (=*Venus*) *gallina*, 299
chamois, see *Rupicapra rupicapra*
Chamomila recutita, 89
Characeae, 246, 257, 261, 266, 267, 271
Characiae, 257
characean chalk, 261
Charadriiformes, 360
Charonia, 307
 nodifera, 293–95
 sequenzae, 293–95

Chaste Lovers, House of the
 (Pompeii IX.xii.6,7), 4, 27,
 175–76
cheetah, see *Acinomyx jubatus*
Cheilopogon heterurus, 281
Cheiranthus cheiri (wall flower), 126
Chelon labrosus, 282
Cheloniidae, 332
Chelonophagoi, 333
chenalopeces, 396
Chenopodiaceae, 248
cheppia, see *Alosa* sp.
cherry
 bird, see *Prunus avium*
 sour, see *Prunus cerasus*
 sweet, see *Prunus avium*
chestnut, see *Castanea*
chestnut, European, see *Castanea*
 sativa
chicken, see *Gallus gallus*
chickpea, see *Cicer arietinum*
chickweed
 mouse-ear, see *Cerastium* sp.
 see *Stellaria media*
chiocciola, see *Eobania*; *Monodonta*
Chiroptera, 447
Chlamys opercularis, 299
chlorion, 386
Chondrichthyes, 287
Chrysanthemum segetum, 100
Chrysophrys, 289
Cicada orni, 324
cicada, see *Tettigonia*; *Homoptera*
cicer (chickpea), 100
Cicer
 arietinum, 100–101
 reticulatum, 101
cicerbita, see *Sonchus asper*
cicerchia
 porporina, see *Lathyrus clymenum*
 (*sferica*), see *Lathyrus sphaericus*
cicogna, see *Ciconia ciconia*
Ciconia ciconia, 371
Ciconiidae, 360
Ciconiiformes, 360
cicuta rossa, see *Geranium purpureum*
cigno
 reale, see *Cygnus olor*
 selvatico, see *Cygnus cygnus*
ciliegio, see *Prunus avium*
cimazio
 corrugato, see *Cymatium corrugatum*
 partenopeo, see *Cymatium parthenopium*
cincia
 col ciuffo, see *Parus crestatus*; *Parus* sp.

Cinclus cinclus, 397
cinghiale, see *Sus scrofa*
cinquefoglio, see *Potentilla reptans*
cinquefoil, creeping, see *Potentilla*
 reptans
cipolla, see *Allium cepa*
cipollaccio, see *Leopoldia comosa*
ciprea, see *Cypraea erosa*; *Cyprea pantherina*;
 Cypraea pyrum; *Erosaria spurca*;
 Cypraea tigris; *Luria lurida*
cipresso, see *Cupressus sempervirens*
Cisticola juncidis, 362
citrea, 102
citreum, 102
Citrus, 203, 251
Citrus limon, 101–3, 195
citrus, see *Callitris quadrivalvis*
civetta, see *Athene noctua*
clam
 giant, see *Tridacna squamosa*
 razor, see *Solen marginatus*
Clark, Eugenie, 18
cleavers, see *Galium* sp.
Cliona, 246
clover
 Boccone's, see *Trifolium bocconei*
 burdock, see *Trifolium lappaceum*
 button, see *Medicago orbicularis*
 Cherler's, see *Trifolium cherleri*
 cluster, see *Trifolium glomeratum*
 hare's foot, see *Trifolium arvense*
 hop, see *Medicago lupulina*
 large hop, see *Trifolium campestre*
 Persian, see *Trifolium resupinatum*
 rabbit foot, see *Trifolium arvense*
 red, see *Trifolium pratense*
 slender-leaved, see *Trifolium*
 angustifolium
 subterranean, see *Trifolium*
 subterraneum
 yellow, see *Medicago lupulina*
Clupeidae, 279
cobra, Egyptian, see *Naja haje*
 spitting, see *Naja nigricollis*
cobra, see Elapidae
coccio, see *Aspitrigla cuculus*
cocciola arena, see *Acanthocardia tuberculata*
 (*cocciole*), see *Cerastoderma edule*
 glaucum
cocciole, see *Acanthocardia tuberculata*
Cocconeis placentula, 254
Coccothraustes coccothraustes, 372
cock, 380
cockle
 prickly, see *Acanthocardia echinata*

rough-nosed, red-nosed, knotted,
 see *Acanthocardia tuberculata*
cocodrillo, see Crocodylidae
codino maggiore, see *Gastridium ventricosum*
codirosso, see *Phoenicurus phoenicurus*
Coleoptera, 317
Colocasia esculenta, 132
colocasia, 131, 132
colombaccio, see *Columba palumbus*
coltellacci, see *Iris pseudacorus*
Colubridae, 335, 346
colubro, see Colubridae
columba (*saxatilis*), 358, 373
Columba
 livia, 372
 oenas, 372
 palumbus, 374
columbella, see *Columba oenas*
columbi, 374
Columbidae, 360
Columbiformes, 360
Columella, 84
columina, 373
comber, see *Serranus cabrilla*
come, 164
Comes, Orazio, 80–81 passim
common vole, see *Microtius arvalis*
comper, painted, see *Serranus scriba*
Compositae, 201, 248
conchiglia
 dei pellegrini, see *Pecten jacobaeus*
 di S. Giacomo, see *Pecten jacobaeus*
condition of pollen, 189
cone, textile, see *Conus textile*
Conger conger, 279, 280
Congridae, 279
coniglio, see *Oryctogalus cuniculus*
cono, see *Conus textile*
contraception, abortion (methods),
 453–54
Conus textile, 305–6
convolvolo, see *Convolvulus arvensis*
Convolvulus arvensis, 103
coot, Eurasian, see *Fulica atra*
Coracias garrulus, 384
Coraciidae, 361
Coraciiformes, 361
coral, 311
 (precious) red, see *Corallium*
 rubrum
 white, 311
coralium (coral), 311
Corallium rubrum, 311
Corallo
 nobile, see *Corallium rubrum*

Corallo (continued)
 rosso, see *Corallium rubrum*
corb, see *Sciaena umbra*
corbezzolo, see *Arbutus unedo*
Coris julis, 289, 290
corn rocket, see *Bunias erucago*
cornacchia
 bigia, see *Corvus corone*
 nera, see *Corvus corone*
cornflower, see *Centaurea cyanus*
cornix, 375
Corvidae, 361
corvina di sasso, see *Sciaena umbra*
corvo
 imperiale, see *Corvus corax*
 see *Sciaena umbra*
Corvus
 corax, 375
 corone, 375
 frugilegus, 375
 monedula, 376
Corylus, 247
 avellana, 103–4, 188
costolina (liscia), see *Hypochoeris glabra*
cotogno, see *Cydonia oblonga*
cotonea (quince), 107
coturnice, see *Alectoris graeca*
Coturnix coturnix, 376
covetta, see *Cynosurus echinatus*
cowrie
 see *Cypraea pyrum; Erosaria spurca; Luria lurida*
 eroded, see *Cypraea erosa*
 panther, see *Cypraea pantherina*
 tiger, see *Cypraea tigris*
cozza
 di Santo Jacovo, see *Pecten jacobaeus*
 di Taranto, see *Mytilus galloprovincialis*
 nera, see *Mytilus galloprovincialis*
crab
 (spinous) spider, see *Maja squinado*
 yellow, see *Eriphia spinifrons*
crake, corn, see *Crex crex*
crane, 376
crane's bill, round-leaved, see *Geranium rotundifolium*
Crataegus
 monogyna, 104
 sp., 104
Crateuas, 84
crayfish, see *Palinurus vulgaris*
Crenilabrus
 doderleini, 290
 melops, 381
Crepis neglecta, 104

crespigno, see *Sonchus asper*
Crex crex, 394
cricket, *see* Orthoptera
crocodile, *see* Crocodylidae
Crocodilia, 348
crocodilians, *see* Crocodilia
Crocodylidae, 348
crow
 carrion, see *Corvus corone*
 hooded, see *Corvus corone*
Cruciferae, 201
Crustacea, 309–10
cuckoo, see *Cuculus canorus*
Cuculidae, 360
Cuculiformes, 360
cuculo, see *Cuculus canorus*
Cuculus canorus, 359, 377
Cucumis melo, 251
cucurbita (bottle gourd), 118
cudweed, see *Filago vulgaris*
culbianco, see *Oenanthe oenanthe*
cult objects 331–32, 333, 335
Cumae, 240, 266, 268
Cumean Sibyl, 29
cuore
 see *Acanthocardia echinata*
 russo, see *Acanthocardia tuberculata*
cupressus (cypress), 104, 227
 funebris, 106
Cupressus, 195
 sempervirens, 104–6, 251
curculiones, 317
current excavations
 Italian excavations in House of the Wedding of Hercules (Pompeii VII.ix.47), 5, 174
 University of Bradford in House of the Vestals (Pompeii VI.i.7), 174
 University of Reading/British School at Rome in House of Amarantus (Pompeii I.ix.11–12), 4–5, 174
cuttlefish, see *Sepia officinalis*
cyanus (corn flower), 98
Cyclotella
 cf. *hakanssoniae*, 256
 hakanssoniae, 254
 meneghiana, 254
 ocellata, 254
 sp., 253
 striata, 253
Cydonia oblonga, 106–7
cydonia (quince), 107
cygno reale, see *Cygnus olor*

Cygnus
 cygnus, 377
 olor, 377
Cymatium, 307
 corrugatum, 295–96
 parthenopium, 295–96
Cymbella affinis, 256
Cynodon dactylon, 107
Cynosurus echinatus, 107–8
Cypraea
 erosa, 306
 pantherina, 306
 pyrum, 295
 tigris, 306
Cypraecassis rufa, 307
cypress, see *Cupressus sempervirens*
Cyprideis torosa, 257
Cypridopsis aculeate, 257
Cypselus apus (animali), 318
Cytheraea chione, 299
Cytisus scoparius, 108

Dactylopteridae, 279
Dactylopterus volitans, 279
daikon (Japanese radish), 158
daino, see *Cervus dama*
daisy family, see *Compositae*
dandelion, see *Taraxacum* sp.
date shell, see *Lithophaga lithophaga*
date, see *Phoenix dactylifera*
dattero de mar, see *Lithophaga lithophaga*
dattero di mare, see *Lithophaga lithophaga*
Daucus carota, 108
daucus (wild carrot), 108
deer
 fallow, see *Cervus dama*
 red, see *Cervus elaphus*
 roe, see *Capreolus capreolus*
delfino comune, see *Delphinus delphis*
Delphinus delphis, 419–20
dendrochronology, definition, 235
 samples for dating Campanian buildings and objects, 235–36
 wood sample collection guidelines for dendrochronology, 237
dental health, excellent, 465, 473
dental pathologies
 calculus, 468, 472
 caries, 455, 463
 hypoplastic lines, 464–65, 473, 474
 periodontal disease, 455, 463, 473
Dentex dentex, 288, 289
dentex, see *Dentex dentex*

dentice
 see *Dentex dentex*
 prato, see *Pagrus pagrus*
Dentium repandum, 128
Dermochelydae, 332
Dermochelys coriacea, 333
Dianthus
 caryophyllus, 108–9
 inodorus, 109
 sylvestris, 109
diatoms
 frequency and distribution of rare
 species in Lake Avernus, 255
 (Table 18)
 freshwater, 262, 266, 267
 marine, 267
Dicentrarchus labrax, 284–85
Diceros bicornis, 420
diet, 456–59, 468
 changes in sheep/goat, pig, 405–7
Dimerogramma minor, 254, 256
Dio Cassius
 description of A.D. 79 eruption, 62
 description of Vesuvius, 32
Diocles of Carystus, first known
 herbalist, 84
Diodorus Siculus, recognizes Vesu-
 vius is volcanic, 33
Dioscorides, 84 passim
Diplodis
 annularis, 288, 289
 sargus, 289
 vulgaris, 288, 289
Diploneis didyma, 256
dipper, see *Cinclus cinclus*
Diptera, 318
dock, fiddle-leaved, see *Rumex pulcher*
dog, see *Canis familiaris*
dog-cockle, see *Glycymeris glycymeris*;
 Glycymeris violascens
dogfish
 (large), spotted, see *Scyliorhinus
 stellaris*
 (lesser), spotted, see *Scyliorhinus
 canicula*
dolium shell, see *Tonna galea*
dolphin, common, see *Delphinus delphis*
Donax trunculus, 300
donax (reed), 92
donkey, see *Equus asinus*
donnola, see *Mustela nivalis*
dorcas gazelle, see *Gazella dorcas*
dormouse
 common, see *Muscardinus avellanarius*
 edible, see *Glis glis*

 garden, see *Eliomys quercinus*
 hazel, see *Muscardinus avellanarius*
dove
 collared turtle, see *Streptopelia
 decaocto*
 ringed, see *Streptopelia risoria*
 rock, see *Columba livia*
 stock, see *Columba oenas*
 turtle, see *Streptopelia turtur*
dovecote, 373
dracones (rat snake), 340
dragonflies, *see* Odonata
drum fish, see *Sciaena umbra*
duck
 dabbling, see *Anas* sp.
 domestic, 365
 mallard, see *Anas platyrhynchos*
Dumbarton Oaks 1986 symposium,
 2–3
dung fly, see *Cypselus apus (animali)*
dunlin, see *Calidris alpina*
dunnock, see *Prunella modularis*

eagle, golden, see *Aquila chrysaetus*
ear shell, see *Haliotis tuberculata*
earthquake A.D. 62, 7–8
 description, 34, 35
 rebuilding of Pompeii, 8
ebony, see *hebenus*
echinoderms, 262, 310
echinoid, see *Echinus* sp.
Echinus sp., 310
Echium
 plantagineum, 109
 sp., 109
 vulgare, 109
edera, see *Hedera helix*
eel
 common, see *Anguilla anguilla*
 conger, see *Conger conger*
 moray, see *Muraena helena*
eels, 278–80
 as pets, 280
egg, as fertility symbol, 351
egret
 cattle, see *Bubulcus ibis*
 little, see *Egretta thula*
Egretta thula, 377
El Chichon (Mexican volcano), 1982
 eruption, 37, 60
Elaphe
 longissima, 335, 336, 348, 353
 quatuorlineata, 336
Elapidae, 335
elce, see *Quercus ilex*

elefante, see *Loxodonta africana; Elephas
 maximus*
elephant
 (African), see *Loxodonta africana*
 (Indian), see *Elephas maximus*
Elephas maximus, 432–33
Eliomys quercinus, 420
elk, see *Alces alces*
elm, 251
 see *Ulmus* sp.
Emberiza calandra, 379
Emberizidae, 361
Emydidae, 332
Emys orbicularis, 333
Engraulidae, 280
Engraulis encrasicolus, 280–81, 290
Eobania vermiculata, 312
Ephedra, 248
Ephemeroptera, 324
Epinephelus, guaza, 285, 286
Epithemia argus, 254
Epithemia smithii, 254
Equus
 africanus, 420–21
 asinus, 421–22
 asinus × *caballus*, 422–23
 caballus, 423–26
 hemionis, 420–21
erba cimicina, see *Geranium purpureum*
erba
 (*araba*), see *Medicago arabica*
 di S. Giovanni, see *Hypericum perforatum
 medica*
 medica intrecciata, see *Medicago intertexta*
 medica (orbicolare), see *Medicago
 orbicularis*
 medica troncata, see *Medicago truncatula*
 (*minima*), see *Medicago minima*
Erica, 247, 249, 252
Erinaceus europaeus, 426
Eriphia spinifrons, 309
Erithacus rubecula, 378
Erosaria (=Cypreae) spurca, 295
eruption of Vesuvius A.D. 79
 beginnings of the eruption, 44–47
 Campania devasted, 58–62
 description, *see* Pliny the Younger
 early studies, 37
 effect on Herculaneum, 50–51,
 53–55
 effect on Pompeii, 48–50
 new interpretations, 37–38
 victims in Herculaneum, 55–58,
 451, 460–73
 victims in Pompeii, 49

ervum (bitter vetch), 169

Eumachia, sculptured relief framing entrance, 9 passim

Euthria (=*Buccinum*) *cornea*, 296

Euthynnus
 alletteratus, 285
 pelamis, 225

eutria cornea, see *Euthria cornea*

Exocoetidae, 281

Exocoetus heterurus, 281

faba Aegyptia, 131

faggio, see *Fagus sylvatica*

fagiano comune, see *Phasianus colchicus*

fagus (beech), 109

Fagus, 227, 248, 251
 sylvatica, 109, 199

Falco columbarius, 359

Falconidae, 360

Falconiformes, 360

falena, see Lepidoptera

far (emmer wheat), 166

faraona, see *Numida meleagris*

farfalla, see Lepidoptera

farro, see *Triticum dicoccon*

fasolaro
 see *Acanthocardia tuberculata*
 see *Callista chione*

fava, see *Vicia faba*

favollo, see *Eriphia spinifrons*

felce aquilina, see *Pteridium aquilinum*

Felis
 catus, 426–27
 chaus, 426
 lynx, 427
 sylvestris, 427

fenicottero, see *Phoenicopterus roseus*

fenugreek, little horned, see *Trigonella balansae*

fern
 bracken, see *Pteridium aquilinum*
 eagle, see *Pteridium aquilinum*
 hart's tongue, see *Phyllitis scolopendrium*

fertility, human, 453, 474

fescue, rattail, see *Vulpia myuros*

fetus, 465

ficedulae, 396

fico, see *Ficus carica*

ficus (fig), 110

Ficus, 227, 248, 250
 carica, 109–11

field lady's mantel, see *Aphanes arvensis*

fieldfare, see *Turdus pilaris*

fienarola (annuale), see *Poa annua*

fieno greco (cornicolato), see *Trigonella balansae*

fig pecker, 387
 see *Ficus; Ficus carica*

figwort, annual, see *Scrophularia peregrina*

Filago vulgaris, 111

filix (bracken fern), 152

finch, thistle, 371

fior di loto, see *Nelumbo nucifera*

fior galletto, see *Lathyrus aphaca*

fiordaliso, see *Centaurea cyanus*

fir
 see *Abies*
 Alpine, imported to Herculaneum, 236–37
 silver, see *Abies*

fischione, see *Anas penelope*

fish, few preserved bones, 274

fish ponds in the Pompeii area, 274
 invented by Gaius Hirtius, 280

fishing equipment
 hooks, 275
 lead weights, 275
 nets, 275

flamingo, see *Phoenicopterus roseus*

flax, pale, see *Linum bienne*

fleas, *see* Siphonoptera

fluffweed, see *Filago vulgaris*

fly, *see* Diptera

flying fish, see *Cheilopogon heterurus*

flying gurnard, see *Dactylopterus volitans*

folaga, see *Fulica atra*

Fondo Bottaro, 49, 59

foraminifera, 257
 brackish, 267
 in Lake Avernus, 258–59 (Table 19)

forasacchi
 (*dei muri*), see *Bromus madritensis*
 squala, see *Bromus diandrua*

Forestier's disease, 469

Formica rufa, 319

formica, see Hymenoptera

Fortuna, 339

fox, see *Vulpes vulpes*

fraga (strawberry), 91, 111

Fragaria vesca, 91, 111

Fragilaria, 256

fragola, see *Fragaria vesca*

fragolino, see *Pagellus erythrynus*

frassino, see *Fraxinus* sp.

Fraxinus
 excelsior, 199
 ornus, 111, 247, 248
 sp., 111

Fringilla coelebs, 378

Fringillidae, 361

fringuello, see *Fringilla coelebs*

fringuilla, 379

frog
 agile, see *Rana dalmatina*
 edible, see *Rana esculenta*
 pool, see *Rana lessonae*
 see Ranidae
 stream, see *Rana graeca*

frosone, see *Coccothraustes coccothraustes*

Fruit Orchard, House of the (I.ix.5), 17–18

Fulica atra, 379

funghi, 128–29

fungus (mushroom), 128

gadid, see Gadidae

Gadidae, 281

gadwall, see *Anas strepera*

gaia, 381

gaius, 381

Galactites
 sp., 111
 tormentosa, 111

galbulo, 386

Galeodea echinophora, 296

galeodea, see *Galeodea echinophora*

galgulo, 386

Galium
 aparine, 112
 sp., 111–12

galliform, 363

Galliformes, 360

Gallinago gallinago, 379

Gallinariae silvae, 241

gallinulla
 chloropus, 380
 d'acqua, see *Gallinula chloropus*

gallinule, purple, see *Porphyrio porphyrio*

gallo cedrone, see *Tetrao urogallus*

galls, cynipid, see *Adleria*

Gallus gallus, 380

gambecchio, see *Calidris* sp.

gamberello, see *Leander* sp.; *Palaemon* sp.

gamberetti, see *Leander* sp.; *Palaemon* sp.

gambero imperiale, see *Penaeus kerathurus*; Penaeidae

garbanzo, see *Cicer arietinum*

garden paintings, 17–18 passim

gardens, archaeological evidence, 16

garfish, see *Belone belone*

garganey, see *Anas querquedula*

garlic, see *Allium sativum*

garofanina (vellutata), see *Petrorhagia velutina*

garofano, see *Dianthus caryophyllus*

Garrulus glandarius, 381

garum, 280, 281, 459

garuzolo, see *Murex brandaris; Murex trunculus*

garzetta, see *Egretta thula*

Gastridium ventricosum, 112

Gastropoda, 257

gastropods (snails)

 brackish, 267

 freshwater, 267

 Indo-Pacific, 305

 marine, 267

 terrestrial (land snails), 312

gatto, see *Felis catus*

gatto selvatico, see *Felis sylvestris*

gattuccio

 maggiore, see *Scyliorhinus stellaris*

 minore, see *Scyliorhinus canicula*

Gazella dorcas, 427–28

gazza, see *Pica pica*

gazzella dorcas, see *Gazella dorcas*

gecko, *see* Gekkonidae

Gekkonidae, 334

gelso nero, see *Morus nigra*

genetic diversity, 454–55

geranio malvaccino, see *Geranium rotundifolium*

geranion (geranium), 112

Geranium, 201

 purpureum, 112

 rotundifolium, 112–13

geranium, round-leaved, see *Geranium rotundifolium*

Geronticus eremita, 391, 397

ghepardo, see *Acinomyx jubatus*

ghiandaia, see *Garrulus glandarius*

ghiro, see *Glis glis*

giaggiolo

 acquatico, see *Iris pseudacorus*

 see *Iris* sp.

Gibbula varia, 296

gibbula, see *Gibbula varia*

giglio

 dei morti, see *Iris foetidissima*

 di S. Antonio, see *Lilium candidum*

gilthead, see *Sparus auratus*

ginepro, see *Juniperus* sp.

ginestra dei carbonai, see *Cytisus scoparius*

ginestrino sottile, see *Lotus angustissimus*

ginestrone, see *Cytisus scoparius*

Giraffa camelopardalis, 428

giraffa, see *Giraffa camelopardalis*

giraffe, see *Giraffa camelopardalis*

Glis glis, 428–29

glottis, 383

Glycymeris

 glycymeris, 300–302

 violascens, 300–302

glycyside, 136

gnat, *see* Diptera

goat, see *Capra hircus*

goatfish, see *Mullus barbatus; Mullus surmuletus*

goat's beard, see *Tragopogon porrifolius*

Gobius, 290

Gold Bracelet, House of the (VI. ins. occid. 42/36), 20–21

goldfinch, see *Carduelis carduelis*

goose

 domestic, 366

 Egyptian, see *Alepochen aegyptiaca*

 greylag, see *Anser anser*

 white-fronted, see *Anser albifrons*

goosefoot, *see* Chenopodiacae

gorgoneion, 340

goshawk, see *Accipiter gentilis*

gourd, bottle, see *Lageneria siceraria*

gramen (Bermuda grass), 107

gramigna, see *Cynodon dactylon*

Gramineae, 188

Grammatophora oceanica, 256

granato, see *Punica granatum*

grancevola comune, see *Maja squinado*

grano canino, see *Hordeum murinum*

grape, see *Vitis; Vitis vinifera*

grass

 bent, see *Agrostis stolonifera*

 Bermuda, see *Cynodon dactylon*

 big quaking, see *Briza maxima*

 brome (large), see *Bromus diandrus*

 common velvet, see *Holcus lanatus*

 hare's-tail, see *Lagurus ovatus*

 little quaking, see *Briza minor*

 nit (large), see *Gastridium ventricosum*

 prairie June, see *Rostraria cristata*

 rabbit-tail, see *Lagurus ovatus*

 rough dog's tail, see *Cynosurus echinatus*

 silver hair, see *Aira caryophyllea*

 soft brome, see *Bromus hordeaceus*

 Spanish brome, see *Bromus madritensis*

 sweet vernal, see *Anthoxanthum odoratum*

grasses, 248, 250

grasshopper, *see* Orthoptera

great white hedge, see *Calystegia sepium*

Grecian laurel, see *Laurus nobilis*

greenfinch, see *Carduelis chloris*

grespignolo, see *Lapsana communis*

grifone, see *Gyps fulvus*

grillo, see Orthoptera

grongo, see *Conger conger*

grouper, see *Epinephelus guaza*

gruccione, see *Merops apiaster*

Gruiformes, 360

Gryllus, 324

guineafowl, helmeted, see *Numida meleagris*

gurnard

 red, see *Aspitrigla cuculus*

 yellow or tub, see *Trigla lucerna*

Gyps fulvus, 382

hake, see *Merluccius merluccius*

Haliotis tuberculata, 296

hare

 brown, see *Lepus europaeus*

 mountain, see *Lepus timidus*

harundo, (reed), 92

 Cypria (Cyprian reed), 92

hawfinch, see *Coccothraustes coccothraustes*

hawk, sparrow, see *Accipiter nisus*

hawthorn, see *Crateagus* sp.

hazelnut, see *Corylus avellana*

hebenus, 227

Hedera (ivy), 248

 helix, 113–14

hedera (ivy), 114

hedgehog

 dog's tail, see *Cynosurus echinatus*

 see *Erinaceus europaeus*

helix (ivy), 114

Helix

 aspersa, 312, 313

 ligata, 312

 lucorum, 312

 pomatia, 312

 vermiculata, 312

helmet shell

 see *Galeodea echinophora*

 see *Phalium granulatum undulatum*

Hemidactylus turcicus, 335

Heracles, 339–40, 343

herb Robert, see *Geranium purpureum*

herbals, 84

Herculaneum

 beach in Roman times, 51–53

 made a Roman *municipium* 89 B.C., 7

 origin and early history, 6

heron
 common, see *Ardea cinerea*
 purple, see *Ardea purpurea*
 squacco, see *Ardeola ralloides*
Herpestes ichneumon, 337, 342, 429
heterozyogotic thalassemia, 463
Hevel, Gary, 17
hip dysplasia (hip, dislocated), 472
Hippolais sp., 362
Hippopotamus amphibius, 429–30
hippopotamus, see *Hippopotamus amphibius*
Hirundinidae, 361
Hirundo rustica, 382
hobbles, 402
Holcus lanatus, 114
holly oak, see *Quercus ilex*
Homoptera, 324
hookworm, 463
hophornbeam, European, see *Ostrya*
horedeum (barley), 115
Horedeum
 distichon, 115
 murinum (mouse barley), 114
 vulgare, 115
horn shell, see *Cerithium vulgatum*
hornbeam, Oriental, see *Carpinus orientalis*
hornet, *see* Hymenoptera
horse, see *Equus caballus*
household shrines, *see* lararium
Howells, W. W., 454–55
Hueber, Francis, 16, 27, 83
human impact on vegetation, 271–72
Humulus/Cannabis type, 252
hyacinth, tassel, see *Leopoldia comosa*
Hydnaceae, 128
Hydrobia, 257, 261, 262
 acuta, 262
Hydrobiidae, 260, 262, 267
Hymenoptera, 318–19
Hypericum, 115
 perforatum, 115
Hypochoeris glabra, 115

ibis sacro, see *Threskiornis aethiopicus*
ibis
 bald, see *Geronticus eremita*
 glossy, see *Plegadis falcinellus*
 sacred, see *Threskiornis aethiopicus*
ichneumones, 319
ichneumonids, 319
ingrassabue, see *Chrysanthemum segetum*
ilex (holm oak), 155, 157, 227

illness, childhood, 463, 464, 474
infection, chronic, 463
Insectivora, 447
ippopotamo, see *Hippopotamus amphibius*
ireos, see *Iris* sp.
iride gialla, see *Iris pseudacorus*
iride, see *Iris* sp.
Iris
 albicans, 116
 candida, 116
 florentina, 116
 foetidissima, 116
 germanica, 116
 pallida, 116
 pseudacorus, 116–17
 sp., 116
iris
 candida, 116
 see *Iris* sp.
 puzzolente, see *Iris foetidissima*
 rufa (red iris), 116
 stinking, see *Iris foetidissima*
 water, see *Iris pseudacorus*
ironwort, see *Sideritis romana*
issolone, see *Callista chione*
Isuridae, 287
iulis (wrasse), 282
ivy, see *Hedera helix*
Ixobrychos minutus, 367

jackal, see *Canis aureus*
jackdaw, see *Corvus monedula*
jay, see *Garrulus glandarius*
jewelry, 345–46, 461, 463, 464, 465
John Dory (fish), see *Zeus faber*
juglans (walnut), 117
Juglans, 247, 248, 249, 251, 252, 264
 regia, 117–18, 188
jungle fowl, red, 381
juniper, see *Juniperus* sp.
juniperus (juniper), 118
 oxycedrus, 251
 sp., 118
 type, 249, 251, 264
Juniperus, 251
Jynx torquilla, 382

kennels, 413
keratia (carob), 100
ketos (sea monster), 340
kingfisher, see *Alcedo atthis*
kinglet, see *Regulus* sp.
Kingsolver, John, 17

Labrax lupus, 284

Labridae, 281–82
Labrus
 livens, 281
 viridis, 281
Lacerta
 muralis, 334
 viridis, 334, 335
Lacertidae, 334
lacerto, see *Scomber scombrus*
lacewings, *see* Neuroptera
Lageneria siceraria, 118–19
Lagomorpha, 447
Lagurus ovatus, 119
Lamna nasus, 287
lampascione, see *Leopoldia comosa*
Lampetra fluviatilis, 279–80
lampreda
 di fiume, see *Lampetra fluviatilis*
 marina, see *Pteromyzon marinus*
 see *Pteromyzon marinus*
lamprey
 river, see *Lampetra fluviatilis*
 sea, see *Pteromyzon marinus*
lanciuola, see *Plantago lanceolata*
Laniidae, 361
Lanius
 excubitor, 383
 minor, 383
 nubicus, 383
 senator, 383
lanzardo, see *Scomber japonicus collas*
lapathum (sorrel), 161
lapilli (pumice), 42 passim
Lapsana communis, 119
lararium (household shrine), 351
lasca, *see* Orthoptea
lassana, see *Lapsana communis*
lathridiid scavenger beetle, see *Microgramme ruficolis*
Lathyrus
 aphaca, 119
 clymenum, 119
 sativus, 169
 sphaericus, 119
lauro, see *Laurus nobilis*
Laurus nobilis, 119–20
laurustinus, see *Viburnum tinus*
lead
 environmental, 459, 460
 medicinal, 460
Leander sp., 309
Leccinum, 128
leccio, see *Quercus ilex*
leek, see *Allium porrum*
lemon or citron, see *Citrus*

lemon, see *Citrus limon*

lens (lentil), 121

Lens culinaris, 120–21

lente, see *Lens culinaris*

lenticchia, see *Lens culinaris*

lentil, see *Lens culinaris*

leone, see *Panthera leo*

leopard, see *Pantherus pardus*

leopardo, see *Panthera pardus*

Leopoldia comosa, 121

Lepidoptera, 319–22

lepre, see *Lepus europaeus*

Leptocythere, 257

Lepus

 europaeus, 430–31, 436

 timidus, 431

Lesbia's *passer*, 384

Lesbia's sparrow, 388

Ligustrum, 190

lilium (lily), 121

Lilium candidum, 121–22

lily

 Madonna, see *Lilium candidum*

 water, see *Nymphaea alba*

lime, see *tilia*

limone, see *Citrus limon*

limpet, see *Patella ferruginea*

lince, see *Felis lynx*

lingua

 cervina, see *Phyllitis scolopendrium*

 di cane, see *Plantago lanceolata*

Linnaeus, Carl, 83

linnet, 370

lino, see *Linum bienne*

Linum

 bienne sp., 121

 usitatissium, 122

lion, see *Panthera leo*

liquamen, 459

Lithognatus mormyrus, 286

Lithophaga lithophaga, 302

liverworts, see *Anthoceros* sp.

Liza

 aurata, 282

 ramada, 282

lizard

 saurian, *see* Sauria

 see Lacertidae

lizards, three species native to

 Campania, 335

lobster, spiny, see *Palinurus vulgaris*

località S. Abbomdio in the

 commune of Pompeii, 4, 174,

 175–76

locusta, *see* Orthoptera

Locustella naevia, 362

loglierella, see *Lolium* sp.

Loligo vulgaris, 308

lolium (darnel), 123

Lolium

 perenne, 123

 sp., 123

 temulentum, 123

loto

 egizio, see *Nelumbo nucifera*

 see *Nymphaea alba*

Lotus angustissimus, 123

lotus

 Indian, see *Nelumbo nucifera*

 sacred, see *Nelumbo nucifera*

 see *Nymphaea alba*

louse, head, see *Pediclus humanus* var.

 capitis

Loxodonta africana, 432–33

lucertola, *see* Lacertidae

Lucrino, Lake, oyster breeding,

 241–42

lumaca, see *Helix aspersa*

lupinarius (dealer in lupines), 123

lupine

 blue, see *Lupinus angustifolius*

 see *Lupinus albus*

lupinipolus (dealer in lupines), 123

lupino

 selvatico, see *Lupinus angustifolius*

 see *Lupinus albus*

lupinus (lupine), 123

Lupinus

 albus, 123

 angustifolius, 123–24

lupo, see *Canis lupus*

lupulina, see *Medicago lupulina*

Luria lurida, 295

Luscinia megarhynchos, 383

Lusciniola melanopogon, 362

Lutraria

 lutraria, 302

 oblonga, 302

 see *Lutraria lutraria*; *Lutraria oblonga*

Lycopodium tablets, 190, 246

lynx, see *Felis lynx*

Macaca sylvana, 433–34

macaco, see *Macaca sylvana*

maccarello, see *Scomber scombrus*

macchia mediterranea (maquis), 92

mackerel

 horse, see *Trachurus trachurus*

 see *Scomber scombrus*

 Spanish, see *Scomber japonicus collas*

macrofossils of marine organisms, fish

 vertebrae, calcified fragments of

 Characae, and pumice in Lake

 Avernus, 263 (Table 21)

Mactra corallina, 302

mactra corallina, see *Mactra corallina*

madder, field, see *Sherardia arvensis*

madia bianca, see *Mactra corallina*

maegre, brown, see *Sciaena umbra*

maglio, *see* Coleoptera

magpie, see *Pica pica*

maia, see *Maja squinado*

maiale, see *Sus domesticus*

maina comune, see *Acridotheres tristis*

Maiuri, 81 passim

Maja squinado, 310

Malcolm and Carolyn Wiener

 Laboratory, 237

mallow, wild, see *Malva sylvestris*

Malus sp., 124–25

malus

 apple, 125

 Punica (pomegranate), 154

malva (mallow), 125

 see *Malva sylvestris*

Malva sylvestris, 125

Malvaceae, 201, 250

mammal remains, 401–2

mandorlo, see *Prunus dulcis*

mangusta, see *Herpestes ichneumon*

manyseed, see *Polycarpon tetraphyllum*

maple, see *Acer*

maquis, 66, 174

marena, see *Prunus cerasus*

marigold

 corn, see *Chrysanthemum segetum*

 field, see *Calendula arvensis*

marten, pine, see *Martes martes*

Martes martes, 434–35

martin pescatore, see *Alcedo atthis*

martora, see *Martes martes*

maruzza

 attummatella, see *Helix vermiculata*

 ceraiola, see *Helix aspersa*

 di montagna, see *Helix ligata*

marzaiola, see *Anas querquedula*

Mastogloia smithii, 254

Matteucig, 315, 319, 327, 357, 401

Matthiola incana, 125–26

mayflies, *see* Ephemoptera

meadowgrass, annual, see *Poa annua*

Medicago

 arabica, 126

 intertexta, 126

 lupulina, 126

Medicago (continued)
 minima, 126
 orbicularis, 126
 truncatula, 126
Mediterranean bivalves, 299–305
Mediterranean gastropods (snails), 293–99
mela cotogna, see *Cydonia oblonga*
melo, see *Malus* sp.
melograno, see *Punica granatum*
Melolontha melolontha, 318
melon, see *Cucumis melo*
mentuccia, see *Calamintha nepeta*
Mercurialis annua, 249, 250, 252
Mercury, 344
mercury, see *Mercurialis annua*
Meretrix (=Cythera) *chione*, 299, 305
merlin, see *Falco columbarius*
merlo
 acquaiolo, see *Cinclus cinclus*
 see *Turdus merula*
Merlucciidae, 282
Merluccius merluccius, 282
Meropidae, 361
Merops apiaster, 384
mestolaccio, see *Plantago lanceolata*
Microgramme ruficolis, 317
Microtius arvalis, 435
migliarina, see *Polycarpon tetraphyllum*
miglio, see *Panicum miliaceum*
mignattaio, see *Plegadis falcinellus*
milium (millet), 137
millet
 common, see *Panicum miliaceum*
 foxtail, see *Setaria italica*
 Italian, see *Setaria italica*
mirto, see *Myrtus communis*
mirtum (myrtle), 129
Misenum
 Roman harbor, 38, 62 passim
 thermal bath, 266
mite (scabmite), 325
Mithridates VI (king of Pontus), a herbalist, 34
mitilo comune, see *Mytilus galloprovincialis*
mitilo, see *Mytilus galloprovincialis*
mochi, see *Vicia ervilia*
mole, see *Talpa* sp.
mollusks, 257, 260–62, 266, 267
 and their shells, uses in antiquity, 292
 marine, 267
monachella, see *Oenanthe hispanica*
mongoose, see *Herpestes ichneumon*

Monodonta articulata, 296
monodonta, see *Monodonta articulata*
Monte Nuovo, 29, 264–65
Monte Somma volcano, 29–30
Monticola solitarius, 384
moon shell, see *Naticarius hebraeus*
moorhen, see *Gallinula chloropus*
mora di rovo, see *Rubus ulmifolius*
mordigallina, see *Anagallis* sp.
morning glory, wild, see *Calystegia sepium*
morus (mulberry), 127
Morus nigra, 126–27
mosca, see *Diptera*
moscardino, see *Muscardinus avellanarius*
moscerino, see *Diptera*
mosquito, see *Diptera*
moth, see *Lepidoptera*
mother-of-pearl (nacre), 307, 311
mouse
 Algerian, see *Mus spretus*
 house, see *Mus musculus*
 wood, see *Apodemus sylvaticus*
mudflows, 38 passim
muggine
 calamita, see *Liza ramada*
 chelone, see *Chelon labrosus*
 dorato, see *Liza aurata*
 orifrangio, see *Liza aurata*
mugil (mullet), 282
Mugil cephalus, 282
Mugilidae, 282
mugwort, see *Artemisia*
mulberry, see *Morus nigra*
mule, see *Equus asinus* × *caballus*
mullet
 (golden) gray, see *Liza aurata*
 red, see *Mullus barbatus*; *Mullus surmuletus*
 striped, see *Mullus surmuletus*
 (striped) gray, see *Mugil cephalus*
 (thick-lipped) gray, see *Chelon labrosus*
 (thin-lipped) gray, see *Liza ramada*
Mullidae, 282–84
Mullus
 barbatus 282–84
 surmuletus, 282–84
mullus, see *Mullus barbatus*
mulo, see *Equus asinus* × *caballus*
Munsell notation, 68
Muraena helena, 279
Muraenidae, 279
murena, see *Muraena helena*

Murex
 (=*Bolinus*) *brandaris*, 296–97
 parthenopaeus, 296
 (=*Phylionotus* = *Hexaplex* = *Trunculariopsis*) *trunculus*, 297–98
murex (dye), see *Murex brandaris*
murex, rock, see *Murex trunculus*
muria, 459
mùrice
 comune, see *Murex brandaris*
 see *Murex brandaris*; *Murex trunculus*
Mus
 musculus, 435
 spretus, 435
muscae (flies), 318
Muscardinus avellanarius, 435
muscolo, see *Mytilus galloprovincialis*
mushrooms, 128–29
mussel
 fan, see *Pinna nobilis*
 (Mediterranean), see *Mytilus galloprovincialis*
 swan, see *Anodonta cygnaea*
Mustela
 erminea, 435–36
 nivalis, 435–36
Mustelus mustelus, 288
mynah, common, see *Acridotheres tristis*
myrtle, see *Myrtus*; *Myrtus communis*
myrtus (myrtle), 129
Myrtus, 248, 252
 communis, 129–30
Mytilus, 262, 271
 galloprovincialis, 302–3

Naja
 haje, 337, 346
 nigricollis, 346
narciso, see *Narcissus* sp.
Narcissus
 poeticus, 131
 pseudonarcissus, 13
 serotinus, 131
 sp., 130–31
 tazetta, 131
narcissus, see *Narcissus* sp.
nasello, see *Merluccius merluccius uccius*
Natica maculata, 298
natica, see *Naticarius hebraeus*
Naticarius hebraeus, 298
Natrix
 maura, 342
 natrix, 342, 346
 tessellata, 342, 346

natural history
 definition, 1
Navicula
 palpebralis, 256
 subtilissima, 254, 256
Neapolitan tuff, 51
nebbia, see *Aira caryophyllea*
needle shell, see *Cerithium vulgatum*
needle-fish (long), see *Belone belone*
Nelumbo nucifera, 131–32
nepetella, see *Calamintha nepeta*
Nerium, 203
 oleander, 132–33, 195
Nero (emperor), 7, 35
Neuroptera, 324
newt
 Italian, see *Triturus italicus*
 see Salamandrae
 smooth, see *Triturus vulgaris*
 warty, see *Triturus cristatus*
nightingale, see *Luscinia luscinia*
nightjar, see *Caprimulgus europaeus*
ninfea, see *Nymphaea alba*
Nitzschia valdecostata, 256
nocciolo
 see *Corylus avellana*
 d'Europa, see *Corylus avellana*
noce, see *Juglans regia*
noctua, 369
noctule, see *Vespertilioninae* sp.
North African or scimitar oryx, see
 Oryz gazella damah; *Oryx gazella*
 leucoryx, 437
nose-horned-viper, see *Vipera*
 ammmodytes
nuclear magnetic resonance (NMR)
 spectra of Vesuvian samples,
 221–24
 spectroscopy, 217–24
nuées ardentes, 37 passim
Numida meleagris, 384
numidicae, 358
nursehound, see *Scyliorhinus stellaris*
nuthatch
 Eurasian, see *Sitta europaea*
 rock, see *Sitta neumayer*
nux, 227
Nymphaea
 alba, 133
 coerulea, 134
 lotus, 134
 sp., 134

oak
 common, see *Quercus robur*

English, see *Quercus robur*
holly, see *Quercus ilex*
holm, see *ilex*; *Quercus ilex*
pubescent, see *Quercus pubescens*
oat
 see *Avena sativa*
 slender, see *Avena barbata*
oca
 egiziana, see *Alopochen aegyptiaca*
 selvatica, see *Anser anser*
occhialone, see *Pagellus bogaraveo*
occhiata, see *Torpedo torpedo*
occhio
 di bue, see *Chrysanthemum segetum*
 di Santa Lucia, see *Astraea rugosa*
occhiocotto, see *Sylvia melanocephala*
Octopus
 defilippi, 308–9
 macropus, 308–9
 vulgaris, 308–9
octopus, see *Octopus defilippi*; *Octopus
 macropus*; *Octopus vulgaris*
Odonata, 325
Oenanthe
 hispanica, 385
 oenanthe, 385
olea (olive), 135
Olea, 181, 227, 247, 248, 249, 250, 252
 europea, 134–36, 188
 europaea var. *sylvestris*, 136
Oleaceae, 190
oleander, see *Nerium oleander*
oleandro, see *Nerium oleander*
olive, see *Olea*
olive, see *Olea europaea*
olmo, see *Ulmus* sp.
Olson, Storrs L., 17
ombrina, see *Sciaena umbra*
omphacitis (insect galls), 316
onager, see *Equus hemionis*
onagro, see *Equus africanus*; *E. hemionus*
onion, see *Allium cepa*
Opephora marina, 256
Opephora martyi, 254, 256
Oplontis (Torre Annunziata)
 villa of Poppaea, *see* villa of Poppaea
 villa rustica, carbonized hay, 4
 passim
orada, see *Sparus auratus*
orecchia marina, see *Haliotis tuberculata*
orice, see *Oryx gazella*
oriole, golden, see *Oriolus oriolus*
Oriolidae, 361
Oriolus oriolus, 386
ormer, see *Haliotis tuberculata*

Ornithopus
 compressus, 136
 pinnatus, 136
Orobanche sp., 136
orobanche (broomrape), 136
 see *Orobanche* sp.
orso bruno, see *Ursus arctos*
Orthoptera, 322
Oryctogalus cuniculus, 431, 436–37
Oryx
 gazella, 437
 gazella dammah, 437
 gazella leucoryx, 437
oryx, see *Oryx gazella*
orzo
 selvatico, see *Hordeum murinum*
 see *Hordeum vulgare*
ostracods, 257, 266, 267, 271
 brackish, 267
 in Lake Avernus, 258–59 (Table 19)
 nonmarine, 262
ostrea (oyster), 303
ostrearum vivaria (oyster ponds), 303
Ostrea edulis, 303
ostrega, see *Ostrea edulis*
ostrica
 see *Ostrea edulis*
 perlifera, see *Pinctada margaritifera*
Ostrya, 247, 249
Otala lutea, 313
Otiorhynchus sp., 317
otter shell, see *Lutraria lutraria*; *Lutraria
 oblonga*
Ovis aries, 437–39
owl
 little, see *Athene noctua*
 short-eared, see *Asio flammea*
 tawny, see *Strix aluco*
ox, domestic, see *Bos taurus*
oyster plant, see *Tragopogon porrifolius*
oyster
 (black-lip) pearl, see *Pinctada
 margaritifera*
 see *Ostrea edulis*
 spiny, see *Spondylus gaederopodus*
 thorny, see *Spondylus gaederopodus*

Paeonia sp., 136
paeonia (peony), 136
pagello
 bocaravello, see *Pagellus bogaraveo*
 see *Pagellus erythrynus*
Pagellus
 bogaraveo, 288
 erythrynus, 288, 289

pagro
 comune, see *Pagrus pagrus*
 see *Pagrus pagrus*
Pagrus pagrus, 288, 289
Palaemon sp., 309
paleino odoroso, see *Anthoxanthum odoratum*
paléo
 (*crestato*), see *Rostraria cristata*
 (*sottile*), see *Vulpia myuros*
paleosoils
 definition, 65
 genesis in Pompeii area, 76–77
Palinurus vulgaris, 310
palm, date, see *Phoenix dactylifera*
palma (date, date palm), 140
palma da datteri, see *Phoenix dactylifera*
palorde, see *Glycymeris glycymeris*;
 Glycymeris violascens
palumbus, 358, 374
pandora, see *Pagellus erythrynus*
panico, see *Setaria italica*
panicum (Italian millet), 162
Panicum miliaceum, 137
pannocchia, see *Penaeus kerathurus*;
 Penaeidae
Pansa, House of (VI.vi.1/12), 15
Panthera
 leo, 439–40
 pardus, 440–41
 tigris, 441–42
Papaver
 apulum, 137–38
 rhoeas, 138
 rhoeas subsp. *rhoeas*, 138
 rhoeas subsp. *strigosum*, 138
 somniferum, 139
 somniferum subsp. *setigerum*, 138
papavero
 see *Papaver rhoeas*
 da oppio, see *Papaver somniferum*
 (*pugliese*), see *Papaver apulum*
 (*setoloso*), see *Papaver somniferum*
 subsp. *setigerum*
papilio (butterfly), 321
Papio
 cynocephalis anubus, 434
 sp., 433–34
pappagallo inseparabile, see *Agapornis* sp.
pappagallo, see *Psittacula* sp.; *Psittacus
 erithaeus*
Paracentrotus lividus, 310–11
paradeisoi, 404
parakeet
 Lord Derby's, see *Psittacula derbiana*
 rose-ringed, see *Psittacula krameri*

 slaty-headed, see *Psittacula
 himalayana*
Paralia sulcata, 256
Paridae, 361
Parietaria, 249
parity, human, 453
parrochetto, see *Psittacula* sp.
parrot, gray, see *Psittacus erithacus*
parsley piert, see *Aphanes arvensis*
partridge
 see *Perdix perdix*
 rock, see *Alectoris graeca*
parus, 388
Parus
 ater, 388
 caeruleus, 388
 crestatus, 387
 major, 388
 sp., 387
Passer domesticus italiae, 388
passera di mare, see *Pleuronectes platessa*
Passeridae, 361
Passeriformes, 361
passero
 see *Passer domesticus italiae*
 scopaiolo, see *Prunella modularis*
 solitario, see *Monticola solitarius*
Patella
 caerulea, 298
 ferruginea, 298
 ferruginea, see *Patella ferruginea*
 reale, see *Haliotis tuberculata*
 see *Patella ferruginea*
pattern (sketch) books, 81, 82, 357
Pavo cristatus, 388
pavone, see *Pavo cristatus*
pavones, 358; see also *Pavo cristatus*
pavonia, 389
pea vine
 see *Lathyrus sphaericus*
 purple, see *Lathyrus clymenum*
peach, see *Prunus persica*
peacock see *Pavo cristatus*
peafowl, see *Pavo cristatus*
peahen, see *Pavo cristatus*
pear, see *Pyrus communis*
pearl, 312
pecora, see *Ovies peccora*
Pecten jacobaeus, 303–4
Pediastrum, 201, 266
Pediculus humanus var. *capitis*, 325
pedologic (soils) history of Pompeii
 area, importance, 65–66
Pelée, Mount, 1902 eruption, 44
pellerina, see *Chlamys opercularis*

pen shell (noble), see *Pinna nobilis*
Penaeidae, 310
Penaeus kerathurus, 310
pentorobon, (peony), 136
peocio, see *Mytilus galloprvioncialis*
peonia, see *Paeonia* sp.
peony, see *Paeonia* sp.
perca (sea perch), 286
perch
 dusky, see *Epinephelus guaza*
 sea, see *Epinephelus guaza*
perchia, see *Serranus cabrilla*
Percichythidae, 284–85
Perdix perdix, 363
perdix, 358; see also *Alectoris graeca*
Perissodactyla, 447
peristertrophius, 373
pero, see *Pyrus communis*
Peronidia nitida, 305
persica (peach), 152
pesce
 cappone, see *Aspitrigla cuculus*; *Trigla
 lucerna*
 di Cristo, see *Zeus faber*
 falcone, see *Dactylopterus volitans*
 gallo, see *Zeus faber*
 e lupo, see *Dicentrachus labrax*
 rondine, see *Dactylopterus volitans*
 San Pietro, see *Zeus faber*
 spada, see *Xiphias gladius*
 volante, see *Cheilopogon heterurus*
pesco, see *Prunus persica*
Petrorhagia velutina, 140
pettine
 see *Chlamys opercularis*
 see *Pecten jacobaeus*
pettirosso, see *Erithacus rubecula*
pettuncolo violacea, see *Glycymeris glycymeris*;
 Glycymeris sp.
peverina, see *Cerastium* sp.; *Stellaria
 media*
phalacrocoraces, 391
Phalium (=*Semicassis*) *granulatum
 undulatum*, 298
phasiana, 358
Phasianidae, 360
Phasianus colchicus, 389
pheasant, see *Phasianus colchicus*
Phillyrea, 247, 248, 249
Phlegrean Fields
 history of the region, 243
 in legend, 29
 Monte Nuovo eruption in 1538,
 29, 243
 sinking of land, 243

Phoenicopteridae, 360

Phoenicopterus roseus, 390

phoenicopterus, 358

Phoenicurus phoenicurus, 390

Phoenix dactylifera, 140–41

phragmites (reed), 142

Phragmites australis, 98, 141–42

Phyllitis scolopendrium, 142–43

Phylloscopus, 362

piantaggine (piede di lepre), see *Plantago lagopus*

Pica pica, 390

piccione selvatico, see *Columba livia*

Picidae, 361

Piciformes, 361

Picus viridis, 385

pié d'asino, see *Glycymeris glycymeris*; *Glycymeris violascens*

pig, domestic, see *Sus domesticus*

pigeon
 domestic, see *Columba livia*
 wood, see *Columba palumbus*

pilchard, see *Sardina pilchardus*

pimpernel, scarlet, see *Anagallis* sp.

Pinacaea, 188

pinaster (pine), 144

Pinctada margaritifera, 307–8

Pinctada, 307

pine
 family, see Pinaceae
 see *Pinus; Pinus pinea*
 stone, see *Pinus pinea*

pink
 clove, see *Petrorhagia velutina*
 see *Dianthus caryophyllus*
 family, *see* Caryophyllaceae

pinna
 da pinoli, see *Pinus pinea*
 domestico, see *Pinus pinea*
 nobile, see *Pinna nobilis*
 see *Pinna nobilis*

Pinna nobilis, 304

pinus (pine), 144

Pinus, 201, 247, 251, 252, 264
 halepensis, 144
 pinaster, 144
 pinea, 143–44, 188, 190

pioppo, see *Populus* sp.

pipistrello, see *Pipistrellus pipistrellus*

Pipistrellus pipistrellus, 442

pirus (pear), 155

piscialletto, see *Taraxacum* sp.

Pisidium, 257
 casertanum, 260, 261

Pistacia, 247, 248, 249, 252

Pitone, *see* Boidae

Pitymys savii, 442

piumino, see *Lagurus ovatus*

plaice, see *Pleuronectes platessa*

plane tree
 Oriental, see *Platanus orientalis*
 see *Platanus*

Planorbidae, 260

Planorbis cf. *moquini*, 260

Planorbis planorbis, 260

plant names, Latin and English, 214–15 (Table 14)

Plantago
 lagopus, 144–45
 lanceolata, 145, 248, 249, 250, 252

plantago (plantain), 144

plantain
 buckhorn, see *Plantago lanceolata*
 hare's foot, see *Plantago lagopus*

plants
 ancient names, difficult to identify, 83
 depictions, where found, 80
 in graffiti, 81
 known from spores and pollen, 175–77 (Table 5)
 photographic documentation, 81–82
 scientific names, *see* Linnaeus, Carl
 styled motifs, 82
 uses by Romans, 85

platano, see *Platanus orientalis*

Platanus, 247, 249, 251, 252, 264
 acerifolia, 146
 occidentalis, 146
 orientalis, 145–46, 195, 264

platanus (plane tree), 146

Plegadis falcinellus, 391

Pleuronectes platessa, 285

Pleuronectidae, 285

Plinian eruption
 definition, 30
 origin of name, 42

Pliny the Elder's death in A.D. 79, 2

Pliny the Elder's *Historia Naturalis* (Natural History)
 content and sources, 1, 2
 contribution to science, 2
 methodology, 1
 recent reevaluation of the work, 2

Pliny the Younger (nephew of Pliny the Elder), description of
 A.D. 79 eruption, 40–41
 his uncle's death, 38–40
 his uncle's method of work, 1

plum, see *Prunus domestica*

Poa annua, 146

Poaceae, 252

Podarcis
 muralis, 335
 sicula, 335, 345
 sp., 335

pollen
 analysis of soil samples taken by Superintendency of Pompeii, 4
 problems of identification in garden soils in archaeological sites, 181
 source and preservation, 182–83, 190
 types in Lake Avernus, rare, 250 (Table 16)
 types in Lake Avernus, common, 251 (Table 17)
 in volcanic soils of Columbian Andes, 182, 190

pollen, Vesuvian sites sampled, pollen and spore counts
 Garden of Hercules (Pompeii II.viii.6), 185 and Tables 5, 6
 Garden in House of the Chaste Lovers, (Pompeii IX.xii.6–7), 4, 174, and Table 5
 Garden in House of the Gold Bracelet, (Pompeii, VI. ins. occid. 42), 195, 196, and Tables 5, 9c, 10, 11c
 Garden in House of Polybius (Pompeii IX.xiii.1–3), 185–87, and Tables 5, 6
 Garden in House of the Ship *Europa* (Pompeii I.xv), 183 and Table 6
 località S. Abbondio, commune of Pompeii, 4, 174, and Table 5
 Oplontis, villa of Poppeae, 183, 195, and Tables 5, 6, 9c, 10, 11c
 Pompeii I.xiv.2, 183 and Tables 5, 6
 Pompeii I.xxi.2, Garden of the Fugitives, Table 6
 Pompeii I.xxi.3, small north garden, 185 and Table 6
 Pompeii I.xxii (large orchard), 183–84 and Table 6
 Pompeii III.vii, vineyard, Table 6
 villa rustica, Boscoreale, 190, 195, and Tables 5, 9a, 9b, 10, 11a, 11b
 villa rustica of L. Cornelius Jucundus, 4, 174, and Table 5

pollo
 see *Gallus gallus*
 sultano, see *Porphyrio porphyrio*
polpessa, see *Octopus defilippi; Octopus macropus; Octopus vulgaris*
polpo, see *Octopus defilippi; Octopus macropus;* and *Octopus vulgaris*
Polybius, House of (IX.xiii.1–3), 19–20
Polycarpon tetraphyllum, 146
Polygonatum sp., 146
Polypodium, 211
polypody, common, 187–88
pomegranate, see *Punica granatum*
Pompeiana cepa (Pompeian onion), 87
Pompeii
 became a Roman colony 80 B.C., 7
 gardens, private and public, 15–16
 history during empire 27 B.C.–A.D. 79, 7–8
 houses, types, 13–15
 land use, 16
 origins and early history, 6–7
 plan of the city, 9 (Fig. 4)
 port, 10, 13
 public buildings, 8–10
poplar, see *Populus* sp.
poppy
 Apulic, see *Papaver apulum*
 bristle bearing, see *Papaver somniferum* subsp. *setigerum*
 corn, see *Papaver rhoeas*
 garden, see *Papaver somniferum*
 opium, see *Papaver somniferum*
Populus
 alba, 147
 nigra, 147
 sp., 146–47
porbeagle, see *Lamna nasus*
porcello, see *Cypraea erosa; Cypraea pantherina; Cypraea pyrum; Cypraea tigris; Erosaria spurca; Luria lurida*
porciglione, see *Rallus aquaticus*
porgy, see *Dentex dentex*
porro, see *Allium porrum*
porrum
 capitatum (headed leek), 87
 sectivum (chives), 87
Portus Julius (military harbor), 241
Porphyrio porphyrio, 391
Potentilla reptans, 147
prawn, see *Leander* sp.; *Palaemon* sp.
pregnancy, 465
primates, 447
Proboscidea, 447

prostitutes, 466–67
prugno, see *Prunus domestica*
Prunella modularis, 388
prunus (plum), 149
Prunus
 avium, 147
 cerasus, 147–48
 domestica, 148–49
 domestica subsp. *domestica*, 149
 domestica subsp. *insititia*, 149
 dulcis, 149–51
 dulcis var. *amara*, 150
 fruticosa, 148
 persica, 151–52
Psittacidae, 360
Psittaciformes, 360
Psittacula
 derbiana, 394
 himalayana, 394
 krameri, 394
 sp., 393
Psittacus erithacus, 394
Pteridium, 248, 249, 250
 aquilinum, 152, 188
Pteromyzon marinus, 279
Punica granatum, 152–54
purse tassel, see *Leopoldia comosa*
Puteoli (modern Pozzuoli), 240–41, 266
puzzola, see *Mustela erminea*
pyroclastic surges and flows, 37–38 passim
Pyrus communis, 154–55
Python (*drakaina*), Delphic female snake (pythia), 339
Python sebae, 338, 348
python, *see* Boidae

quaglia, see *Coturnix coturnix*
quail, see *Coturnix coturnix*
Queen Anne's lace, see *Daucus carota*
quercus (oak), 156
Quercus
 cerris, 157
 ilex, 155–56, 249, 266, 271
 ilex type, 247, 252
 macrolepis, 157
 petraea, 157
 pubescens, 156
 pubescens type, 247
 robur, 156–57
 sp., 99
 suber, 157
quince, see *Cydonia oblonga*

rabbit, see *Oryctolagus cuniculus*
radicchiella minore, see *Crepis neglecta*
radish
 see *Raphanus sativus*
 wild, see *Raphanus raphanistrum*
Radix cf. *ovata*, 260
rafano, see *Raphanus raphanistrum*
rail, water, see *Rallus aquaticus*
Rajidae, 287
Rallidae, 360
Rallus aquaticus, 394
ramolaccio, see *Raphanus raphanistrum*
Rana
 dalmatina, 332
 esculenta, 332
 graeca, 332
 lessonae, 332
 see Ranidae
Ranidae, 330
ranocchia, *see* Ranidae
ranuncolo, see *Ranunculus* sp.
Ranunculus sp., 157
rapa, see *Brassica rapa*
rapastrello, see *Raphanus raphanistrum*
raphanus (radish), 157
Raphanus
 raphanistrum, 157, 158
 sativus, 157–58
rapum, rapa (turnip), 94
rat, black, see *Rattus rattus*
ratto nero, see *Rattus rattus*
Rattus rattus, 442–43
ravaglio, see *Pagellus bogaraveo*
ravanello, see *Raphanus sativus*
raven, see *Corvus corax*
ray (ocellated), electric, see *Torpedo torpedo*
rays, 287
 see Rajidae
razza, see Rajidae
Rectina, 39, 47
redshank, see *Tringa totanus*
redstart, see *Phoenicurus phoenicurus*
redwing, see *Turdus iliacus*
reed
 common, see *Phragmites australis*
 giant, see *Arundo donax*
regolo, see *Regulus* sp.
Regulus sp., 362
Reptilia, 332–50
rhinoceros (black), see *Diceros bicornis*
ribwort, see *Plantago lanceolata*
riccio di mare, see *Echinus* sp.; *Paracentrotus lividus*
riccio, see *Erinaceus europaeus*

rickets, 472–73

rigogolo, see *Oriolus oriolus*

rinoceronte, see *Diceros bicornis*

roach, *see* Orthoptea

robin, see *Erithacus rubecula*

robur, 157

Roccus labrax, 285

rock thrush, blue, see *Monticola solitarius*

Rodentia, 447

roller, European, see *Coracias garrulus*

Roman Comagmatic Province, 29

ròmice

 capo di bue, see *Rumex bucephalophorus*

 cavolaccio, see *Rumex pulcher*

rondine, see *Hirundo rustica*

rook, see *Corvus frugilegus*

rooster, 380

rosa (rose), 156

 see *Rosa* sp.

Rosa sp., 158–60

Rosaceae, 188

rose, see *Rosa* sp.

rosetto, see *Pagellus erythrynus*

rosolaccio, see *Papaver rhoeas*

rospo, see Bufonidae

Rostraria cristata, 160

rovella, see *Pagellus bogaraveo*

rovere, see *Quercus robur*

roverella, see *Quercus pubescens*

rovo, see *Rubus ulmifolius*

rubus (bramble, blackberry), 160

Rubus

 spp., 188

 ulmifolius, 160–61

Rumex, 252

 acetosella, 161

 bucephalophorus, 161

 pulcher, 161

Rumina decollata, 313

Rupicapra rupicapra, 437

ryegrass, English, see *Lolium* sp.

Sabazius, 331, 333, 335, 344

salacca, see *Alosa* sp.

salamander

 fire, see *Salamandra salamandra*

 see *Salamandridae*

 spectacled, see *Salamandra taedigita*

Salamandra

 salamandra, 329, 330

 terdigita, 330

Salamandridae, 329

salix, 227

sampiero, see *Zeus faber*

sanderling, see *Calidris alba*

sandpiper

 common, see *Tringa hypoleucos*

 wood, see *Tringa glareola*

sandwort, thyme-leaved, see *Arenaria leptoclados*

sarago

 maggiore, see *Sargus sargus*

 see *Sargus sargus*

 sparaglione, see *Diplodus annularis*

 testa nera, see *Diplodus vulgaris*

sarda, see *Sardina pilchardus*

sardella, see *Sardina pilchardus*

Sardina pilchardus, 279

sardina, see *Sardina pilchardus*

sardine, see *Sardina pilchardus*

sardone, see *Alosa* sp.

Sargus

 annularis, 289

 rondeletti, 289

 sargus, 288

 vulgaris, 289

Sarno, river, 65, 116

Sauria, 334

scad, see *Trachurus trachurus*

scallop

 Jacob's or pilgrim, see *Pecten jacobaeus*

 (queen), see *Chlamys opercularis*

scanning electron microscope photographs (SEM), 3, 228, 231 passim

scarabaei (beetles), 317

scarafaggio, see Coleoptera

scarlina, see *Galactites tomentosa*

scataponzolo, see *Spondylus gaederopodus*

Schmorl's herniations, 461, 467

Schouw, Joachim, 80, 81, 82 passim

sciacallo, see *Canis aureus*

Sciaena umbra, 285

Sciaenidae, 285

sciarrano, see *Serranus cabrilla*

sciarrano scrittore, see *Serranus scriba*

Scincidae, 334

scinco, see Scincidae

Scinopus fasciatus, 335

scodellina, see *Patella ferruginea*

scoliosis, 469

Scolopacidae, 360

scolopendria, see *Phyllitis scolopendrium*

Scomber

 japonicus collas, 285

 scombrus, 285–86

Scombridae, 285

scombro

 bastardo, see *Trachurus trachurus*

 see *Scomber scombrus*

sconciglio, see *Murex brandaris*; *Murex trunculus*

scorfano rosso, see *Scorpaena scrofa*

Scorpaena

 porcus, 286

 scrofa, 286

Scorpaenidae, 286

scorpena, see *Scorpaena porcus*; *S. scrofa*

scorpion fish

 large-scaled, see *Scorpaena scrofa*

 small-scaled, see *Scorpaena porcus*

scorpions, 325

scricciolo, see *Troglodytes troglodytes*

scrofularia annuale, see *Scrophularia peregrina*

Scrophularia peregrina, 161

scutellation features, snake, 347

Scyliorhinidae, 287

Scyliorhinus

 canicula, 287, 288

 sp., 288

 stellaris, 287

Scyllium

 canicula, 288

 catulus, 288

sea acorn, see *Balanus* sp.

sea bass, see *Dicentrarchus labrax*

sea egg, purple, see *Paracentrotus lividus*

Secale, 252

sedge, Mediterranean, see *Carex distachya*

sedges, 247

Seneca, description of A.D. 62 earthquake, 34

Sepia officinalis, 309

seppia, see *Sepia officinalis*

serin, see *Serinus serinus*

Serinus

 canaria, 371

 serinus, 371

serotine, see *Vespertilioninae* sp.

serpe, see Colubridae

serpens (snake), 340

serpente, see Colubridae

Serpentes, 335–48

serpents, on houseold shrines, 351–52

serpulids, 262

Serranidae, 286

Serranus

 cabrilla, 286

 scriba, 286

Setaria

 italica, 161–62

 viridis, 162

Setzer, Henry, 17, 18

shabdar, see *Trifolium resupinatum*

shad, see *Alosa* sp.

sharks, 287

sheep, see *Ovis aries*

Sheldon, Joan, 16–17, 83

shelduck, see *Tadorna tadorna*

Sherardia arvensis, 162

Ship *Europa*, House of the (I.xv), 23–24

shrike
 great gray, see *Lanius excubitor*
 lesser gray, see *Lanius minor*
 masked, see *Lanius nubicus*
 woodchat, see *Lanius senator*

shrimp
 see Penaeidae
 triple-grooved, see *Penaeus kerathurus*

Sideritis romana, 162

sigillo di Salomone, see *Polygonatum* sp.

silene
 (*bianca*), see *Silene latifolia*
 (*gallica*), see *Silene gallica*

Silene
 alba, 162
 gallica, 162
 italica, 162
 latifolia, 162–63

silene italica, see *Silene italica*

siligo (common wheat), 166

siliqua Graeca (Greek pod or carob), 100

silvester raphanus, 157

Siphonoptera, 324

Sitta
 europaea, 385
 neumayer, 385

Sittidae, 361

skates, *see* Rajidae

skeletons
 animal, 402, 409, 411–13, 422–23
 human 409, 451, 460–73

skink, *see* Scincidae

smeriglio, see *Falco columbarius*; *Lamna nasus*

snail garden (*coclearum vivaria*), 312

snail
 common or garden, see *Helix aspersa*
 edible, vine, Roman or apple, see *Helix pomatia*
 land, see *Eobania vermiculata*
 pulmonate, see *Basommatophora*

snake
 African spcies, 337–39, 342–43

see Colubridae
 crested, 336–37, 352
 dice, see *Natrix tessellata*
 fountain, 342
 grass, see *Natrix natrix*
 mythical and symbolic, 339–42, 343–44
 on cult objects, 344–45
 on jewelry, 345–46
 rat, see *Elaphe longissima*
 rear-fanged, *see* Colubridae
 scutellation features, 346, 347
 typical harmless, *see* Colubridae
 viperine, see *Natrix maura*

snipe, see *Gallinago gallinago*

soffione, see *Taraxacum* sp.

soil fertility, 77–78

soils studied: sites sampled
 Boscoreale, 66, 69, 75–77
 Garden, House of Polybius (Pompeii, IX.xiii.1), 66, 69–70, 75–77
 Herculaneum, 66, 74
 Oplontis (Torre Annunziata), 66, 70–71, 74
 Orchard (Pompeii, I.xxi), 66, 69–70, 75, 77
 Ottaviano quarry, 66, 71–72, 75, 76
 Pozzelle quarry, 66, 72–74, 76
 Terzigno quarry, 66, 77

Solen marginatus, 304

Solomon's seal, see *Polygonatum* sp.

sonaglini, see *Briza maxima*

Sonchus
 asper, 163
 oleraceus, 163

soporiferum papaver, 139

Soranus, gynecologist, 453–54

sorb apple, see *Sorbus domestica*

sorbo domestico, see *Sorbus domestica*

sorbum (sorb apple), 163

Sorbus domestica, 163

sorello, see *Trachurus trachurus*

sorrel
 dock, see *Rumex bucephalophorus*
 sheep, see *Rumex acetosella*

sow thistle, prickly, see *Sonchus asper*

spadone, see *Iris pseudacorus*

Sparidae, 288

sparrow
 house, see *Passer domesticus*
 Spanish, see *Passer hispaniolensis*

Spartacus, leader of slave revolt 73 B.C., 32

Sparus auratus, 288, 289

sparus, four-toothed, see *Dentex dentex*

sparviere, see *Accipiter nisus*

speedwell
 common, see *Veronica arvensis*
 wall, see *Veronica arvensis*

spera, see *Arca noeae*

Sphaeriidae, 257

spiders, 325

spigola, see *Dicentrarchus labrax*

spigolina, see *Bromus hordeaceus*

spinarola, see *Squalus acanthias*

spittlebugs, *see* Homoptera

spòndilo
 gaderopo, see *Spondylus gaederopodus*
 maggiore, see *Spondylus gaederopodus*

Spondyliosoma cantharus, 288

spondylitis, ankylosing, 468

spondylolysis, 465

Spondylus gaederopodus, 304–5

sponge, see *Cliona*

spuonnolo, see *Spondylus gaederopodus*

spurdog, see *Squalus acanthias*

squala, see *Bromus diandrus*

Squalidae, 287

Squalus acanthias, 287, 288

Squamata, 334

squid, see *Loligo vulgaris*

St. Helens, Mount
 eruption 1980, 48, 49
 victims, 49

St. John's bread, see *Ceratonia siliqua*

St. John's wort, common, see *Hypericum perforatum*

Stabiae destroyed by Sulla, 7

stables, 409, 422

star shell (rough), see *Astraea rugosa*

starling
 rosy, see *Sturnus roseus*
 see *Sturnus vulgaris*

starna, see *Perdix perdix*

stature, 455, 461, 463 465, 467, 468

Stellaria media, 163

stint
 little, see *Calidris minuta*
 Temminck's, see *Calidris temminckii*

stoat, see *Mustela erminea*

stock, see *Matthiola incana*

stork, white, see *Ciconia ciconia*

storno, see *Sturnus vulgaris*

Strabo, description of Vesuvius, 32

strawberry
 tree, see *Arbutus unedo*
 wild, see *Fragaria vesca*

stregonia comune, see *Sideritis romana*

Streptopelia
 decaocto, 394
 risoria, 394
 turtur, 394
Strigidae, 361
Strigiformes, 361
strillozzo, see *Emberiza calandra*
Strix aluco, 395
Sturnidae, 361
Sturnus
 roseus, 375
 vulgaris, 395
suber, 157
succiacapre, see *Caprimulgus europaeus*
succiamele, see *Orobanche* sp.
sugherello, see *Trachurus trachurus*
surmulet, see *Mullus surmuletus*
suro, see *Trachurus trachurus*
Sus
 domesticus, 443–45
 scrofa, 443–45
susino, see *Prunus domestica*
swallow, see *Hirundo rustica*
swan
 mute, see *Cygnus olor*
 whooper, see *Cygnus cygnus*
swift, see *Apus* sp.
swordfish, see *Xiphias gladius*
Sylvia
 atricapilla, 396
 melanocephala, 396
Sylviidae, 361

tabani (horse flies), 318
taccola, see *Corvus monedula*
Tacitus, 38 passim
Tadorna tadorna, 396
Talpa sp., 445
talpa, see *Talpa* sp.
Tapes
 pullastra, 305
 (=*Venerupis*) *decussata*, 305
taphocoenosis, 267
tarabusino, see *Ixobrychos minutus*
tarabuso, see *Botaurus stellaris*
Tarentola mauritanica, 335
tarassaco, see *Taraxacum* sp.
Taraxacum sp., 163
tarla, *see* Lepidoptera
tarma, *see* Lepidoptera
tartaruga
 acquatica, *see* Emydidae
 see Chelonidae; Dermochelyidae;
 Testudinidae,
teal, Eurasian, see *Anas crecca*

Tellina planata, 305
tellina
 see *Donax trunculus*
 planata, see *Tellina planata*
telline, see *Tellina planata*
temporomandibular joint, dislocated,
 471–72
tench, see *Tinca tinca*
terebinthus, 227
terrapin
 see Emydidae
 European pond, see *Emys orbicularis*
Terzigno, 30
 villa rustica, 47
Testudinata, 332
Testudinidae, 332
Testudo hermanni, 333
testuggine di mare, see Chelonidae;
 Dermochelyidae
testuggine, *see* Testudinidae
Tetrao urogallus, 396
Tetrapturus belone, 279
Tettigonia viridissima, 324
tettigonia, 322
Thalassionema nitzschioides, 256
Thalassiosira decipiens, 256
Theophrastus, source for Pliny the
 Elder, 2
Thera (Santorini), eruption, 30
thistle, slender, see *Carduus pycnocephalus*
Threskiornis aethiopicus, 397
Threskiornithidae, 360
thrush
 mistle, see *Turdus viscivorus*
 song, see *Turdus philomelos*
Thunnidae, 285
tibulus (pine), 144
ticks, 325
tiger, see *Panthera tigris*
tignola, *see* Lepidoptera
tigre, see *Panthera tigris*
Tilia, 199
tilia, 227
timber merchant, Roman, 237
Tinca tinca, 290
tino, see *Viburnum tinus*
tinus (laurustinus, viburnum), 168
tit
 blue, see *Parus caeruleus*
 coal, see *Parus ater*
 crested, see *Parus crestatus*
 great, see *Parus major*
 long-tailed, see *Aegithalos caudatus*
Titus (emperor), 35
toad, *see* Bufonidae

toccamano, see *Sherardia arvensis*
Tonna galea, 298–99
tonna galea, see *Tonna galea*
tonnetto, see *Euthynnus alletteratus*
tonnina, see *Euthynnus alletteratus*
tonno
 bonita, see *Euthynnus pelamis*
 see *Euthynnus alletteratus*
topo
 algerino, see *Mus spretus*
 comune, see *Mus musculus*
 quercino, see *Eliomys quercinus*
 selvatico, see *Apodemus sylvaticus*
topshell
 see *Gibbula varia*
 see *Monodonta articulata*
 see *Trochus niloticus*
torcicollo, see *Jynx torquilla*
tordo
 see *Crenilabrus melops; Labrus livens;
 Labrus viridis*
 sassello, see *Turdus iliacus*
 see *Turdus philomelos*
torpedine, see *Torpedo torpedo*
torpedo (electra ray), 288
Torpedo torpedo, 287
Torpedinidae, 287
torricella, see *Cerithium vulgatum*
tortoise
 Hermann's, see *Testudo hermanni*
 see Testudinidae
tortora, see *Streptopelia risoria; Streptopelia
 turtur*
Trachurus trachurus, 279
Tragopogon porrifolius, 163–64
tragopogon, 164
trefoil
 slender bird's-foot, see *Lotus
 angustissimus*
 yellow, see *Medicago arabica*
tremola, see *Torpedo torpedo*
tritone, *see* Salamandrae
Tridacna squamosa, 308
tridacna, see *Tridacna squamosa*
trifoglio
 (*angustifoglio*), see *Trifolium angusti-
 folium*
 (*arvense*), see *Trifolium arvense*
 (*campestre*), see *Trifolium campestre*
 (*di Boccone*), see *Trifolium bocconei*
 (*di Cherler*), see *Trifolium cherleri*
 (*glomerato*), see *Trifolium glomeratum*
 (*lappaceo*), see *Trifolium lappaceum*
 pratense, see *Trifolium pratense*
 (*resupinato*), see *Trifolium resupinatum*

trifoglio (continued)
 rosso, see *Trifolium pratense*
 (*sotterraneo*), see *Trifolium subterraneum*
 violetto, see *Trifolium pratense*
Trifolium
 angustifolium, 164
 arvense, 164
 bocconei, 164
 campestre, 164
 cherleri, 164–65
 glomeratum, 165
 lappaceum, 165
 pratense, 165
 resupinatum, 165
 subterraneum, 165
Trigla lucerna, 289
triglia
 di fango, see *Mullus barbatus*
 minore, see *Mullus barbatus*
 scoglio, see *Mullus surmuletus*
Triglidae, 289–90
Trigonella
 balansae, 165
 corniculata, 165
trilatera
 see *Donax trunculus*
Tringa
 glareola, 370
 hypoleucos, 370
 totanus, 370
Triticum 248, 251, 252
 aestivum, 166
 dicoccon, 165–67
 durum, 166
 type, 250
triticum (hard or macaroni wheat), 166
Triton
 corrugatum, 296
 femorale, 307
 hirsutus (*hirsutum*), 296
 nodiferum, 294
triton shell
 see *Cymatium corrugatum; Cymatium parthenopium; Charonia nodifera; Charonia sequenzae*
tritone, see *Charonia nodifera; Charonia sequenzae*
Tritonium
 nodiferum, 294
 parthenopium, 296
Triturus
 cristatus, 330
 italicus, 330
 vulgaris, 330

Trochus
 articulatus, 296
 niloticus, 307
troco, see *Trochus niloticus*
Troglodytes troglodytes, 397
Troglodytidae, 361
trough-shell, rayed, see *Mactra corallina*
trumpet shell
 see *Charonia nodifera; Charonia sequenzae*
truncolaria, see *Murex trunculus*
truncolo, see *Murex trunculus*
tuff, *see* Neapolitan tuff
tuna
 (little), see *Euthynnus alletteratus*
 skipjack, see *Euthynnus pelamis*
tunic flower, little-leaved, see *Petrorhagia velutina*
turban shell, see *Astraea rugosa*
Turdidae, 361
Turdus
 iliacus, 399
 merula, 397
 philomelos, 398
 pilaris, 399
 viscivorus, 399
turdus, 358
turnip, see *Brassica rapa*
turpentine tree, see *terebinthus*
turres (dove cotes), 358
Tursiops truncats, 420
turtle
 leathery, see *Dermochelys coriace*
 loggerhead, see *Caretta caretta*
 sea, *see* Chelonidae; Dermochelyidae
turtur, 395
Typha, 252

U.S. National Arboretum, 82
uccellina
 comune, see *Ornithopus compressus*
 pennata, see *Ornithopus pinnatus*
ulmus (elm), 167
Ulmus, 199, 247, 248, 251
 sp., 167
umbrella or stone pine, see *Pinus pinea*
Umbrina cirrosa, 285
unedo (strawberry tree), 91, 111
University of Bradford excavations, 174
University of Reading/British School at Rome excavations, 174
upochoiris, 115
urchin
 rock, see *Paracentrotus lividus*
 sea, see *Echinus* sp.

Ursus arctos, 445–46
Urtica, 249
usignolo maggiore, see *Luscinia megarhynchos*
utrumque porrum, 87
uva, see *Vitis vinifera*

Varro, 83 passim
veccia
 (*a due semi*), see *Vicia disperma*
 dolce, see *Vicia sativa*
 (*gialla*), see *Vicia lutea*
 (*villosa*), see *Vicia villosa*
veccioli, see *Vicia ervilia*
vegetation of countryside, 174
venatio, 404, 409, 411
venere incrocicchiata, see *Tapes decussata*
ventaglio, see *Pecten jacobaeus*
ventolana, see *Cynosurus echinatus*
Venus Pompeiana, tutelary deity of Pompeii, 7
venus shell
 rough, see *Venus verrucosa*
 (smooth or brown), see *Callista chione*
 striped, see *Chamela gallina*
Venus, 305
Venus verrucosa, 305
Verdone, see *Carduelis chloris*
veronica (*dei campi*), see *Veronica arvensis*
Veronica arvensis, 167
vespa, see Hymenoptera
Vespasian (emperor), 35
Vespertilioninae sp., 442
Vestals, House of the (Pompeii VI.i.7), 4, 174
Vesuvius, Mount
 area: present climate, vegetation, and landscape, 66–79
 early evolution, 29–30
 eruption A.D. 79, see eruption of Vesuvius, A.D. 79
 pre-A.D. 79 volcanic activity, 30–32
vetch
 bitter, see *Vicia ervilia*
 common, see *Vicia sativa*
 hairy, see *Vicia villosa*
 Russian, see *Vica villosa*
 two-seeded, see *Vicia disperma*
 yellow, see *Vicia lutea*
vetchling
 see *Lathyrus sphaericus*
 purple, see *Lathyrus clymenum*
 yellow, see *Lathyrus aphaca*

vetriolo, see *Lathyrus aphaca*
Viburnum tinus, 167–68
viburnum, see *Viburnum tinus*
Vicia
 disperma, 168–69
 ervilia, 169
 faba, 169–70
 lutea, 170
 sativa, 170
 villosa, 170
Villa of Poppaea, Oplontis, 26–27
villa rustica
 of L. Caecilius Jucundus, 4, 174, 175–76
 in the località Villa Regina, Boscoreale, 24–26
 at Oplontis, 4, 27, 83
 at Terzigno, 47
vilucchio, see *Convolvulus arvensis*
vilucchione, see *Calystegia sepium*
viola, 125
 alba (white violet), 125
 see *Viola arvensis*
Viola
 arvensis, 170–71
 odorata, 171
violacciocca, see *Matthiola incana*
violaria (violet beds), 125
violet, see *Viola arvensis*
violetta, see *Viola arvensis*
viper, *see* Viperidae
Vipera
 ammodytes, 348
 see Viperidae
Viperidae, 335
viperina, see *Echium* sp.
vite, see *Vitis vinifera*
vitiparra, 388
vitis (vine, grapevine), 174
Vitis, 201, 247, 248, 249, 251, 252
 sylvestris, 174
 vinifera, 171–74, 188
vole
 savi's pine, see *Pitymys savii*
 water, see *Arvicola terrestris*

volpe, see *Vulpes vulpes*
volpoca, see *Tadorna tadorna*
vongola
 see *Chamelea gallina*
 nera, see *Tapes decussata*
 verace, see *Tapes decussata*
vopa, see *Boops boops*
vulgaris harundo (common reed), 92
Vulpes vulpes, 446
Vulpia myuros, 174
vultur, 382
vulture, griffon, see *Gyps fulvus*

wagtail, 370
walnut
 English, see *Juglans regia*
 see *Juglans*; *nux*
 Persian, see *Juglans regia*
warbler, 362
 aquatic, see *Acrocephalus paludicola*
 fan-tailed, see *Cisticola juncidis*
 grasshopper, see *Locustella naevia*
 moustached, see *Lusciniola melanopogon*
 reed, see *Acrocephalus scirpaceus*
 Sardinian, see *Sylvia melanocephala*
 sedge, see *Acrocephalus schoenobaenus*
wasp, *see* Hymenoptera
watchfowl, 366
weasel, see *Mustela nivalis*
Wedding of Hercules, House of the (Pompeii VII.ix.47), 5, 194
wedge shell (abrupt), see *Donax trunculus*
weevil, 317
wheat
 emmer, see *Triticum dicoccon*
 see *Triticum*
wheatear
 black-eared, see *Oenanthe hispanica*
 common, see *Oenanthe oenanthe*
whelk, see *Euthria cornea*
wigeon, Eurasian, see *Anas penelope*
willow, see *salix*
Wittmack, L. M. C., 81, 82 passim

wolf, see *Canis lupus*
wood analysis techniques, 217–20
 cellulose measurement, 218–20
 lignin measurement, 218–20
wood in Roman furniture
 ancient references, 226–27
 common furniture, 225
 identification, previous studies, 225, 232
 luxury furniture, 225
wood used in dendrochronological analysis
 Abies sp., 235
 cypress, 235
 oak, 235
 Picea sp., 235
 pine, 235
wood, Latin words for
 lignum, 226
 materia, 226
wood, states of preservation
 carbonization (charcoalification), 217–18
 microbiological degradation, 217, 218–24
woodpecker, 386
 green, see *Picus viridis*
woundwort, iron, see *Sideritis romana*
wrasse
 (corkwing), see *Crenilabrus melops*
 see *Labrus livens*; *Labrus viridis*
wren, see *Troglodytes troglodytes*
wryneck, see *Jynx torquilla*

Xiphias gladius, 290
Xiphiidae, 290
xyris (wild iris), 116

yellow wort, see *Blackstonia perfoliata*

zanzara, see *Diptera*
Zeidae, 290
Zeus faber, 290
zucca da vino, see *Lageneria siceraria*

GREEK INDEX

ἀγρεύς, 359
ἀγρία δάφνη, 133
ἀγριόμηλα, 125
ἄγρωστις, 107
ἀετός, 367
αἴγειρος, 147
αἰγίθαλος, 388
Αἰγύπτιος κύαμος, 132
αἱμόδωρον, 136
αἴρα, 123
ἀκακία, 85
ἄκανθα, 85, 86
ἀλεκτρυών, 381
ἀλόη, 88
ἀναγαλλίς, 89
ἀνδρός, 133
ἀνήρ, 133
ἄνθος, 369
ἀπαρίνη, 112
ἄρκευθος, 118
ἀρνόγλωσσον, 144
ἄσκυρον, 115
ἀσφάραγος, 92
ἀσπρόκολος, 386
ἀστερίας, 359
ἀφάκη, 119

βολβός, 121
βολβός ἐδώδιμος, 121
βοσκάς, 364
βοσκίς, 364
βουμέλιος, 111
βούφθαλμον, 100

γάλιον, 112
γένος ἱεράκων, 359

γεράνιον, 112
γέρανος, 113
γογγύλη, 95
γογγυλίς, 94

δαῦκος, 108
δεκοχτούρα, 394
Διός ἄνθος, 109
διόσανθος, 109
δρῦς, 157

ἐλέα, 362
ἐρέβινθος, 101
ἐρίθακος, 378, 390
ἔχιον, 109
ἔχις, 109

θέρμος, 123, 124

ἴβις, 391
ἴον τό λευκόν, 125, 171
ἴον τό μέλαν, 171
ἴυγξ, 382

κάλαμος, 91
κάλαμος ὁ πλόκιμος, 142
κάρυα ποντικά, 104
κάστανα, 98
κέγχρος, 137
κεδρομηλά, 102
κέρασος, 147
κερατέα, 100
κεράτιον, 100
κερκιθαλίς, 365
κερκίων, 359
κερωνία, 100

κίγκλος, 370
κιχόριον, 83
κίσσα, 381
κίττα, 381
κιττός, 114
κοκκοθραύστες, 372
κοκκυμηλέα, 149
κόκκυξ, 377
κολλυρίων, 383
κολοκασία, 132
κόμη, 164
κόρχορος, 89
κριθή, 115
κρίνον, 115
κρίνον βασιλικόν, 122
κρόκος, 83
κρόμυον, 87
κύανος, 98
κυκλάμινος, 83
κυνόσβατος, 158
κυπάρισσος, 106
κυπάριττος, 106

λαιός, 384
λάπαθον, 161
λείριον, 121
λεύκη, 147
λεκυόϊον, 126

μαλακοκρανεύς, 383
μαλάχη, 125
μελίνη, 162
μέλι, 162
μέροψ, 384
μήκων, 139
μηλέα, 125

μύκης, 128

νάρκισσος, 131
νήριον, 133
νήρος, 133

ξυρίς, 116

ὄη, 163
οἰνάνθη, 385
ὀλλύω, 133
ὀξύη, 109
ὄροβος, 170
ὀρτυγομήτρα, 394
ὄρτυξ, 376

παιωνία, 136
πάρδαλος, 383
πλάτανος, 146
πορφυρίων, 392
πράσον, 87

πρῖνος, 155
πτελέα, 167
πτέρις, 152
πύγαργος, 370

ῥάφανος ἡ ἀγρία, 157
ῥοδοδάφνη, 133
ῥοδόδενδρον, 133
ῥοδωνία, 158

σικύα, 118
σκαλίδρις, 370
σκόροδον, 88
σκωληκοφάγος, 371
σμῖλαξ λεία, 96
σόγκος, 163
σπίζα, 379
συκάμινος, 126
σῦκον, 110
συκοφάγος, 387
σχοινίκλος, 370

ταώς, 389
τεῦτλον, 93
τραγοπώγων, 164

ὑποχοιρίς, 115

φαλαρίς, 379
φασιανός, 389
φασκάς, 364
φλεγυρός, 29
φοινίκουρος, 378, 390
φοῖνιξ, 141
φυλλῖτις, 142

χηναλώπηξ, 363
χλωρίς, 371
χλωρίων, 371, 386

ψυχή, 322